American Figurative Sculpture

in the
Museum
of Fine Arts
Boston

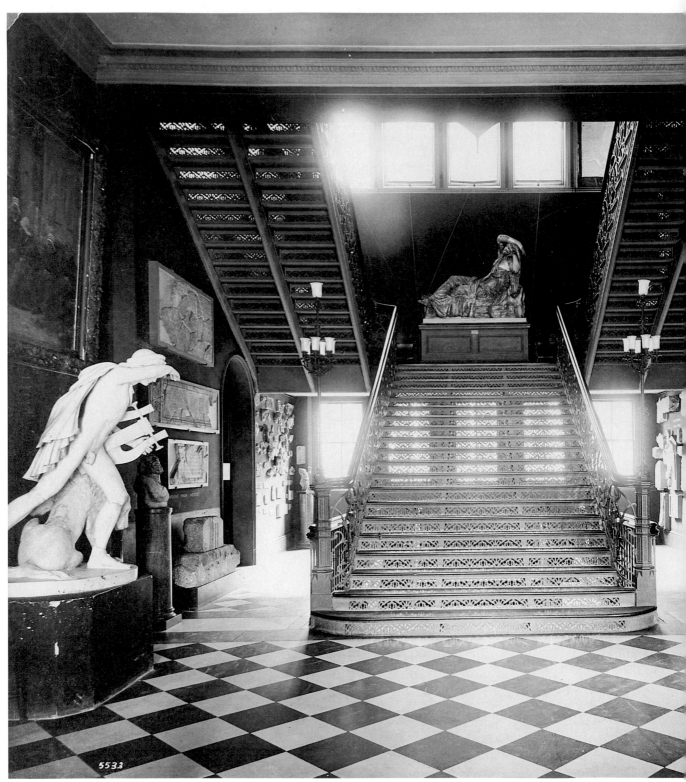

Entrance to the Museum of Fine Arts at Copley Square

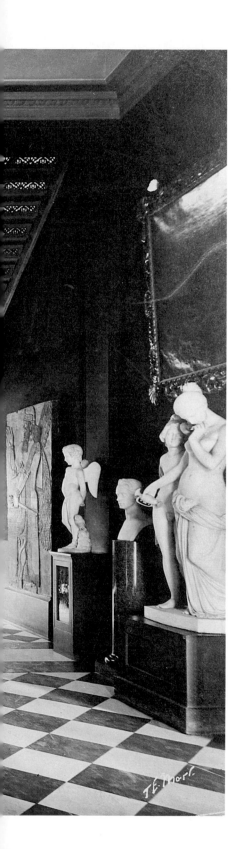

American Figurative Sculpture

in the

Museum of Fine Arts

Boston

Catalogue by
KATHRYN GREENTHAL
PAULA M. KOZOL
JAN SEIDLER RAMIREZ

Introductory Essay by
JONATHAN L. FAIRBANKS

Distributed by
NORTHEASTERN UNIVERSITY PRESS

Museum of Fine Arts
Boston

Contents

FOREWORD v

ACKNOWLEDGMENTS vii

INTRODUCTORY ESSAY xi

PLATES xix

USE OF THE CATALOGUE xxxix

CATALOGUE 1

ABBREVIATED REFERENCES 474

APPENDIX 477

ADDENDA 483

INDEX 484

PHOTOGRAPH CREDITS 487

Copyright © 1986
by the Museum of Fine Arts, Boston, Massachusetts

Library of Congress catalogue card no. 85-62903
ISBN: 0-87846-272-4

Typeset and printed by
Acme Printing Co., Medford, Massachusetts

Designed by Carl Zahn and
Cynthia Rockwell Randall

Cover illustration:
Chauncey Bradley Ives, *Pandora*,
before 1891 (modeled in 1863)

This publication is supported by a grant from the National
Endowment for the Humanities, a Federal agency. Additional
support has been provided by the generous donation of Mr. and
Mrs. Henry R. Guild, Jr.

Foreword

The figurative sculpture of the nineteenth to mid-twentieth century in the Department of American Decorative Arts and Sculpture represents one of the major collections of its kind in this country. Understandably, Boston's assemblage is particularly rich in sculpture by artists who were born in New England, such as Horatio Greenough, or who made it their home, such as Augustus Saint-Gaudens.

The Museum's collection recorded in this catalogue consists of 171 works by 74 sculptors, ranging from freestanding figures and portrait busts to bas-reliefs, medals, and small studies. Most sculptors are represented by one or two examples, but a few exceptions are worth noting: there are eleven pieces by Greenough, fifteen by Saint-Gaudens, and six or more works each by William Wetmore Story, Cyrus Edwin Dallin, Bela Lyon Pratt, Victor David Brenner, Richard H. Recchia, and Katharine Lane Weems. Not all the artists are well known, but many of them have provided impressive public monuments that grace our cities and towns.

One of the strengths of the collection is sculpture created by artists during the nineteenth century, many of whom trained in Italy. These works, at present the focus of attention in the exhibition "Carved in Marble: American Sculpture, 1830-1880," are closely related to the history of the Museum and to the development of taste in this city. Several of these were on display in the Museum's first building, opened in 1876 in Copley Square: in the entrance hall, Greenough's *Love Prisoner to Wisdom*, 1836, and Thomas Crawford's *Charles Sumner*, 1842, *Orpheus and Cerberus*, 1843, and *Hebe and Ganymede*, about 1851 (modeled in 1842); and in the upper hall, Story's *Venus Anadyomene*, 1864. The collection is also rich in objects by sculptors who turned away from Florence and Rome as centers in which to study and work and chose Paris instead. Principally because of their affiliation with the Ecole des Beaux-Arts or their preference for bronze over marble as their medium, these artists came to be known as Beaux-Arts sculptors. Among the examples of their creativity included here are the superb relief of Jules Bastien-Lepage, 1880, by Saint-Gaudens, the delightful statue *Bacchante and Infant Faun*, about 1901, by Frederick William MacMonnies, and the charming statuette *The Scarf*, 1908, by Bessie Potter Vonnoh. Early modernism has its place, too, with a small but no less distinguished selection: *Lyric Muse*, 1912, by Paul Manship, *Head of a Woman*, 1918, by Gaston Lachaise, and the haunting *Senta*, 1919, by Maurice Sterne.

The most visible example of American sculpture at the Museum stands in front of the south entrance: the bronze Indian on horseback entitled *Appeal to the Great Spirit*, 1909, by Dallin. Created in the year the Huntington Avenue building was opened, the *Appeal* was donated through public subscriptions in 1912. It was then a matter of intense pride for Bostonians that Dallin's statue should ennoble their city, and in subsequent years this imposing figure has become a familiar and cherished landmark.

An important aspect of the Museum's collection is its association with the development in Boston of instruction in sculpture. Many of the sculptors represented taught at the School of Drawing and Painting, forerunner of the present School of the Museum of Fine Arts, which had its beginnings in the basement of the Copley Square building and later moved to permanent quarters in Museum Road. For three years the gifted sculptor-physician William Rimmer provided instruction in anatomy for students of the School in a lecture hall at the Massachusetts Institute of Technology (then in Boylston Street). The first course in modeling was given in the fall of 1877 by Franz Xavier Dengler, whose ill health forced him to resign by winter of that year. The appointment in 1893 of Bela Pratt marked the beginning of regular classes in modeling as part of the School's curriculum, and during his tenure and that of his assistant, Frederick Warren Allen, enrollment increased. After Pratt's death in 1917, the respected Philadelphia sculptor Charles Grafly joined the faculty to head sculpture instruction. Succeeding Grafly, Allen continued to teach at the School until the mid-fifties. Also included in the Museum's collection are works by former students at the School, among whom may be mentioned Edward Clark Potter, Mary Orne Bowditch, Amelia Peabody, Bashka Paeff, George Aarons, and Katharine Lane Weems. Providing an additional link between the instruction and the collecting of sculpture at the Museum is the beneficence of Mrs. Weems, (daughter of Gardiner Lane, the Museum's fourth president), who has been instrumental in making possible the greatly needed expansion and renovation of the School's buildings and has endowed a curatorial chair for the Department of American Decorative Arts and Sculpture.

The growth of the sculpture collection has taken place chiefly through gifts and bequests as New England families, in particular, have come to realize that their treasures are best preserved and offer the

greatest pleasure in the Museum. Such was the case when Mrs. Henry Lyman donated in 1956 *Infant Bacchus on a Panther*, 1863, by Story, and *Faith*, about 1872, by Hiram Powers. Some of the gifts, such as works by Horatio Greenough, Rimmer, and Aarons, have come from the sculptors and their families. Since the founding of the Department of American Decorative Arts and Sculpture in 1970, objects have been acquired both through outright gift and with funds donated for specific purchases. Especially noteworthy are the outstanding marble that marked Crawford's Boston debut at the Athenaeum, *Orpheus and Cerberus*, donated by Cornelius and Emily Vermeule in 1975; Saint-Gaudens's *Head of Victory*, 1907 or after, purchased through the Helen and Alice Colburn Fund in 1977; and Anna Hyatt Huntington's *Young Diana*, 1923, acquired through the gift of M. Virginia Burns and the Harriet Otis Cruft Fund in 1979. More recently, Story's arresting figure of Medea, 1868-1880, has fittingly been brought back to Boston, thanks to funds given by an anonymous "friend of the Department."

In 1976 the American bicentennial helped to turn the attention of historians toward art created by Americans. During the past ten years, scholarship has greatly enhanced our understanding, for example, of nineteenth-century sculpture. Victorian marbles, once seen as lifeless copies of ancient prototypes, are newly appreciated for their symbolism and literary allusions; forms inspired by works from pagan antiquity are now perceived with their intended meanings derived from Christianity and revivalist attitudes. Beaux-Arts bronzes, formerly viewed as outmoded owing to the supremacy of abstraction, are enjoyed afresh for their pleasing form and vigorous modeling. Exhibitions organized by the Department of American Decorative Arts and Sculpture have further helped to celebrate a portion of outstanding works from this period: "Confident America" (1973) and "The Sublime and the Beautiful: Images of Women in American Sculpture, 1840-1930" (1979).

The Museum is proud to present a record of its important collection at a time when current scholarship is reassessing the history of American sculpture. Although the catalogue focuses on the Museum's collection, it interprets in great breadth American taste and aesthetics in the nineteenth and early twentieth centuries. For each of the seventy known sculptors, a biography gives a full account of the artist's origins, training, and career. All objects are illustrated and discussed in detail. Also included

are an introductory essay and a technical analysis of the bronzes. The catalogue represents a joint endeavor, involving consulting scholars and the Department of American Decorative Arts and Sculpture. Research, photography, and conservation in connection with the project were funded by a grant from the National Endowment for the Arts, a Federal agency, and the publication has been made possible through the patronage of Mr. and Mrs. Henry R. Guild, Jr., and a grant from the National Endowment for the Humanities, a Federal agency. We would like to express our appreciation for the generosity that enabled the production of this timely volume.

JAN FONTEIN
Director

Acknowledgments

This catalogue is the first to document the collection of American figurative sculpture, created principally before 1940, in the Museum of Fine Arts, Boston. In 1979 the Department of American Decorative Arts and Sculpture received a planning grant from the National Endowment for the Arts to fund photography, conservation, and research for this important collection. The grant also supported original research in Italy on the work of nineteenth-century American sculptors who lived abroad.

Further preparation and publication of the catalogue were made possible by generous grants from the National Endowment for the Humanities in 1983 and from Mr. and Mrs. Henry R. Guild, Jr., in 1984. This funding enabled additional research to be carried out, the purchase of photographs of artists, as well as the production of the book.

It gives us great pleasure to thank the many individuals who have helped with this volume over the last few years. At the beginning of our research, staff members of many institutions promptly answered our letters of inquiry regarding versions of the Museum's objects. In addition, we were assisted by colleagues from numerous institutions and organizations: ACA Galleries, New York: Althea Viafora; Albany Institute of History and Art, N.Y.: Norman S. Rice, Christine Robinson; Albright-Knox Art Gallery, Buffalo, N.Y.: Laura Catalano; Allen Memorial Art Museum, Oberlin College, Ohio: Jeffrey Weidman; The American Numismatic Society, New York: Alan M. Stahl; The Antiquarian and Landmarks Society, Hartford, Conn.: Arthur W. Leibundguth; Archives of American Art, Smithsonian Institution, Boston, New York, and Washington, D.C.: especially Robert F. Brown, Erica Ell, William P. McNaught, Joyce Tyler; Art Commission of the City of New York: Michele Cohen; The Art Institute of Chicago, Ill.: Milo M. Naeve, John Zukowsky; Bank of New England, North Shore, Gloucester, Mass.: Frederik C. Hoffmann; The Bennington Museum, Vt.: Ruth Levin; Boston Art Commission: Mary O. Shannon; Boston Athenaeum: Jonathan Harding, Harry L. Katz, Donald Kelley, Sally Pierce; Boston Public Library: Theresa Cederholm, Janice Chadbourne, Y.T. Feng, Charles S. Longley; Boston University: Patricia Hills; The Bostonian Society: Mary Leen, Thomas Wendell Parker; Brookgreen Gardens, Murrells Inlet, S.C.: Robin Salmon; The Brooklyn Museum: Linda Ferber; C.G. Rein Co., Minneapolis, Minn.: Roslye B. Ultan; Christie's, New York: Alice Levi Duncan, Richard Wunder; Cincinnati Art Museum, Ohio: Margaret Gillham, Millard F. Rogers, Jr.; City University, New York: William H. Gerdts, Marlene Park; Concord Art Association, Mass.: Patsy B. McVity; Conner-Rosenkranz, New York: Janis C. Conner, Joel Rosenkranz; Conway Library, Courtauld Institute of Art, London: Philip Ward-Jackson; The Corcoran Gallery of Art, Washington, D.C.: Katherine M. Kovacs; Cyrus E. Dallin Society, West Hanover, Mass.: Arnold Mills; Dartmouth College Library, Hanover, N.H.: Kenneth C. Cramer, Philip N. Cronenwett; Edwin A. Ulrich Museum of Art, Wichita State University, Kans.: Gary A. Hood; The Fine Arts Museums of San Francisco, Calif.: Laura Camins, Donald Stover; Forest Hills Cemetery, Jamaica Plain, Mass.: Albert Olsen; Fred L. Emerson Gallery, Hamilton College, Clinton, N.Y.: Ruth Travato; Fruitlands Museums, Harvard, Mass.: Richard S. Reed; Gorham Bronze Division of Textron, Providence, R.I.: Douglas S. Ward; Graham Gallery, New York: James Graham, Sandra Leff, Cameron Shay; The Grolier Club, New York: Robert Nikirk; Harvard Portrait Collection: Louise Todd Ambler; Herbert F. Johnson Museum of Art, Cornell University, Ithaca, N.Y.: Thomas W. Leavitt; Hirschl & Adler Galleries, New York: Stuart Feld, Susan E. Menconi; Hood Museum of Art, Dartmouth College, Hanover, N.H.: Rebecca Buck; Houghton Library, Harvard University: Rodney Dennis, Elizabeth Ann Falsey; Indiana University Art Museum, Bloomington: Leslie Schwartz; The Lachaise Foundation, Boston: John B. Pierce, Jr.; Longfellow National Historic Site, Cambridge, Mass.: Kathleen Catalano; Los Angeles County Museum of Art: Michael Quick; Massachusetts Art Commission, Boston: Susan Greendyke; Massachusetts General Hospital, Boston: Martin Bander; Massachusetts Historical Society, Boston: Peter Drummery, Louis L. Tucker; Mead Art Museum, Amherst College, Mass.: Judith A. Barter; The Metropolitan Museum of Art, New York: Lauretta Dimmick, Donna J. Hassler, Jeanie M. James, James Parker, Lewis I. Sharp, Clare Vincent, William B. Walker, Linden Havemeyer Wise; Miller Library, Colby College, Waterville, Maine: Frances M. Parker; Musée de la Monnaie, Paris: Jean-Marie Darnis, Yvonne Goldenberg; Musée d'Orsay, Paris: Anne Pingeot, Antoinette Le Normand-Romain; Museum of American Folk Art, New York: Robert Bishop; National Academy of Design, New York: Abigail Booth Gerdts, Barbara Krulik; National Museum of American Art, Smithsonian Institution, Washington, D.C.: George

Gurney, Michael W. Panhorst; National Numismatic Collections, Smithsonian Institution, Washington, D.C.: Cora Lee Gillilland; National Portrait Gallery, Smithsonian Institution, Washington, D.C.: Carolyn Kinder Carr, Richard Doud, Robert G. Stewart; National Sculpture Society, New York: Theodora Morgan, Claire Stein; National Trust for Historic Preservation, Washington, D.C.: Michael Richman; The Nelson-Atkins Museum of Art, Kansas City, Mo.: Henry Adams; New England Historic Genealogical Society, Boston, Mass., Library: George Sanborn; The New-York Historical Society, New York: Thomas Dunnings; New York University, New York: the late H.W. Janson; The Newark Museum, N.J.: Gary Reynolds, the late Fearn Thurlow; North Shore Arts Association, Gloucester, Mass.: Laura Smith Hersey; Norton Gallery and School of Art, West Palm Beach, Fla.: Bruce Weber; Old Dominion University, Norfolk, Va.: Betsy Fahlman; The Parrish Art Museum, Southampton, L.I., N.Y.: Alicia Longwell; The Pennsylvania Academy of the Fine Arts, Philadelphia: Linda Bantel, Susan James-Gadzinski, Judith E. Stein; Peabody Institute Archives, Johns Hopkins University, Baltimore, Md.: Elizabeth Shaff; Portland Museum of Art, Maine: Barbara Redjinski; Post Road Gallery, Larchmont, N.Y.: Robert Bahssin; Rhode Island School of Design Museum, Providence: Daniel Rosenfeld; Robert Schoelkopf Gallery, New York: Robert Schoelkopf; Robert W. Skinner Inc., Bolton, Mass.: Marilee Meyer; Rockport Art Association, Rockport, Mass.: Ann Fisk; Saint-Gaudens National Historic Site, Cornish, N.H.: John H. Dryfhout; The Saint Louis Art Museum, Mo.: Michael Shapiro, Doris C. Sturzenberger; Sawyer Free Library, Gloucester, Mass.: Stillman P. Hilton; The Schlesinger Library, Radcliffe College, Cambridge, Mass.: Anne Engelhart, Elizabeth Shenton; Smithsonian Institution, Washington, D.C.: Peter Powers; The Society for the Preservation of New England Antiquities, Boston: Brock Jobe; Southern Methodist University, Dallas, Tex.: Eleanor Tufts; Stanford University Museum and Art Gallery, Calif.: Carol Osborne; Sterling and Francine Clark Art Institute, Williamstown, Mass.: Jennifer Gordon; University of Delaware, Newark: Wayne Craven; University of Massachusetts, Boston: Ruth Butler, Clara Kozol; Vassar College Art Museum, Poughkeepsie, N.Y.: Sally Mills; Waltham Public Library, Mass.: Elizabeth D. Castner; Warren Anatomical Museum, Harvard Medical School, Boston, Mass.: David Gunner; Washington and Lee University, Lexington, Va.: Pamela H. Simpson; Wells College, Aurora, N.Y.: Sheila Edmunds; Weyhe Gallery, New York: Gertrude Dennis; The William Benton Museum of Art, University of Connecticut, Storrs, Conn.: Hildegard Cummings; William A. Farnsworth Library and Art Museum, Rockland, Maine: Christine Bauer Podmaniczky; Worcester Art Museum, Mass.: Stephen B. Jareckie; Worcester Historical Museum, Mass.: Sara Callahan Lenis; Yale University Art Gallery, New Haven, Conn.: Paula B. Freedman.

We also should like to thank for their help in many ways both those who wish to remain anonymous and the following individuals: Mrs. Frederick W. Allen, Foxboro, Mass., Mrs. Gertrude Aarons, Gloucester, Mass., Susanna D. Beetham, Wellesley, Mass., Douglas Berman, New York, Mrs. Nelson Bigelow, Westwood, Mass., Annette Blaugrund, New York, Mrs. Peter Borie, New York, Carol Bradley, Florence, Italy, Dorothy P. Cavanagh, Milton, Mass., Mrs. Nathaniel D. Clapp, Prides Crossing, Mass., Sylvia Crane, New York, Mrs. John Crocker, Cambridge, Mass., Joseph L. Curran, Watertown, Mass., Jacques Davidson, Tours, France, Peter de Brandt, London, Donald DeLue, Leonardo, N.J., Alastair Duncan, New York, Robert A. Edwards, Beverly, Mass., Clinton Elliott, Tyringham, Mass., Avard Fairbanks, Salt Lake City, Utah, Daniel and Jessie Lie Farber, Worcester, Mass., Rell Francis, Springville, Utah, Gordon D. Friedlander, White Plains, N.Y., Walker Hancock, Lanesville, Mass., May Brawley Hill, New York, Gail Homer, Needham, Mass., Roland Houle, Quincy, Mass., Mr. and Mrs. William White Howells, Boston, Mrs. Franz Ingelfinger, Cambridge, Mass., Mrs. Charles Jackson, Dover, Mass., Linda Wesselman Jackson, Lenox, Mass., Elizabeth deBlasiis Karrick, Washington, D.C., John Keck, New York, Elizabeth B. Kelley, West Park, N.Y., George Kemeny, Pittsburgh, Pa., Evelyn J. Kilbourn, Quincy, Mass., Wendy Kozol, Oberlin, Ohio, David A. LaRocca, Belmont, Mass., Mrs. Eric Lagercrantz, Dobbs Ferry, N.Y., Mrs. Austin Lamont, Falmouth, Maine, Cyrus Lipsitt, Worcester, Mass., Don R. Lipsitt, Brookline, Mass., Mrs. Hilton Long, Dover, Mass., Augustus P. Loring, Boston, Elizabeth Lowell, Cambridge, Mass., John and Margaret Cassidy Manship, Gloucester, Mass., Deborah Menaker, Williamstown, Mass., Ginette de B. Merrill, Belmont Hill, Mass., Larry Nathanson, New York, Charles Nichols, Portsmouth, N.H., Bettina A. Norton, Boston, Carol Olsen, Mystic, Conn., Carl Pa-

lusci, New York, Helena Pappenheimer, Cambridge, Mass., the late Amelia Peabody, Boston, Lewis S. Pilcher, West Newton, Mass., Mrs. H. Irving Pratt, New York, Beatrice Proske, Ardsley, N.Y., James Ricau, Piermont, N.Y., Harry I. Rice, Boston, Susan Saltonstall, Dover, Mass., Cynthia Pratt Kennedy Sam, Cambridge, Mass., Mrs. Mason Sears, Dedham, Mass., Dolly Sherwood, Saint Louis, Mo., Mary Smart, Lyons, N.Y., Glenn B. Smedley, Colorado Springs, Colo., Mrs. Nicholas Strekalovsky, Yarmouth, Maine, Katharine Lane Weems, Boston, Alison West, New York, Farida A. Wiley, West Melbourne, Fla., Erving and Joyce Wolf, New York and Houston, Avis Jones Woodman, Waltham, Mass.

Among our colleagues at the Museum of Fine Arts, in the Department of American Decorative Arts and Sculpture, Jonathan L. Fairbanks, offered encouragement throughout the project. Edward S. Cooke, Jr., graciously contributed the biography and entry for Donald DeLue. Joy Cattanach Smith admirably coordinated a vast amount of material, edited early drafts of the manuscript, and helped in the search for photographs of artists and locations of works in other collections. A number of volunteers and interns, both past and present, attended to many time-consuming details: Lisa Melas Kyriazi, who aided in the search for artists' photographs, checked bibliographic references and conscientiously provided research assistance, as well as Rebecca Gardner, Sarah Giffen, Karen Guffey, and Sharon Odekirk. Rachel Camber, Cathy Zusy, and the late Mary Quinn eased daily tasks with cheerful good spirit.

Throughout the Museum, colleagues have given their expertise to various aspects of this project. The authors gratefully acknowledge the administrative support of Jan Fontein, director, and Ross W. Farrar, deputy director. Janet H. Spitz, grants officer, ably supervised all reports to the National Endowment for the Humanities concerning the grant. The Museum's Research Laboratory conducted a pioneering technical analysis of bronze sculpture in the Museum's collection (the results of which are tabulated in an appendix to the catalogue). Supplementing the analysis performed by Lambertus van Zelst and Pamela A. England was the examination of the bronzes for methods of production and patination carried out by Arthur Beale, now director of the laboratory, who also advised on many technical problems encountered in the writing of the catalogue. Richard Newman reviewed the final manuscript of the analytical report. Jean-Louis Lachevre undertook the conservation and cleaning of all the sculpture before photography. Robert Walker and Susan Odell of the Museum's Furniture Restoration Laboratory restored a wooden sculpture and period base.

Janice Sorkow and her staff, including Sandra Mongeon, Ann Petrone, and Jenni Rodda, in the Photographic Services department were responsible for the administration of rephotographing virtually all the sculpture. Wayne O. Lemon and Alan B. Newman, assisted by Rudolph Robinson, Donald Stott, and John Woolfe, provided fine photographs, printed by Thomas Lang and Joseph E. Logue. Supervised by John E. Morrison and J. Clifford Theriault, the staff of the Buildings and Grounds department efficiently moved the sculpture for conservation and photography.

Documentation of the American sculpture in the Museum's collection was immeasurably facilitated by the William Morris Hunt Library. Nancy S. Allen and her staff, especially Laila Abdel-Malek, Lee-Anne Famolare, Eve Morgan, Bonnie Porter, and Bridget Mooney, willingly assisted with numerous queries and interlibrary loans. No less essential to our research was the Registrar's Office: Linda Thomas and her staff, particularly Francine Flynn, Deborah Haynes, and Galen Mott, checked accessions records and verified provenances. Staff from the Museum School searched their archives for information on the sculptors associated with the Museum and the School. Bruce K. MacDonald, John Carmichael, and Amy Kaczur were most resourceful in this endeavor.

A project of this scope eventually involves staff from all curatorial departments whose collections are related. We extend our appreciation to the Paintings Department, particularly Theodore E. Stebbins, Jr., Carol Troyen, and Trevor Fairbrother; to the Department of Prints, Drawings, and Photographs, especially Barbara Stern Shapiro; to the Classical Department, above all Cornelius C. Vermeule, as well as John J. Herrmann, Jr., and Florence Z. Wolsky; and to the Department of European Decorative Arts and Sculpture, especially Anne L. Poulet. All provided guidance and information with customary kindness and erudition.

The preparation, design, and production of this catalogue would not have been possible without the talented members of the Office of Publications and their freelance assistants. Paul Godwin, who was responsible for entering and correcting the manu-

script on the word processor, was aided by Katharine A. Dusenbury, Victoria B. Jennings, and Wendy Moran; Stella Gelboin carefully read the galley proofs. We were fortunate indeed to have Carl Zahn and Cynthia R. Randall design this handsome volume.

Finally we wish to express our deepest gratitude to our husbands, Theodore A. Stern, Lee H. Kozol, and Carlos Ramirez, who, more than anyone else, have lived with this book as much as we have. Their support at every stage of the project has made the difficult moments easier to surmount and the many pleasant ones all the more rewarding.

K.G., P.M.K, J.S.R.

A Century of Classical Tradition in American Sculpture, 1830–1930

The large number of works in the sculpture collection of the Department of American Decorative Arts and Sculpture dating from the nineteenth and early twentieth centuries and their broad stylistic range provide a unique survey of American sculpture of that period.[1] The collection reveals the influence of classical antiquity upon five "generations" of sculptors: that is, groups of sculptors working contemporaneously, many of whom knew each other personally or took instruction from each other. Often successive generations shared studio space, tools, materials, and craftsmen (for example, casters, enlargers, and carvers). Such common and transmitted experiences nurtured the continuity of artistic theories bound to classical traditions. Remote references to these traditions filtered through mannerist Italy and were exported from England and Northern Europe to Boston and its environs with the immigration of English settlers in the seventeenth century. Latin was learned by the well-educated; classical references were quoted in decorative accents (such as turned balusters and ornamental festoons) applied to furniture, architecture, silver, and tombstones. Marble monuments imported from England in the eighteenth century increased the colonists' exposure to Anglo-European taste. In Boston three elaborate imported wall memorials were installed in King's Chapel: the *William Shirley Monument*, by Peter Scheemakers (1691-1781), the *Charles Apthorp Monument*, by Sir Henry Cheere (1703-1781), and the *Samuel Vassall Monument*, 1766, by William Tyler (died 1801). Although these mid-eighteenth-century marble memorials incorporate classical details and Latin inscriptions, they are more closely related to the Anglo-Palladian-rococo style rather than the neoclassical taste, which became popular in America after the Revolution.

Neoclassicism flourished in eighteenth-and nineteenth-century America as citizens were encouraged to feel special kinship with the Roman Republic. Local carvers were gainfully employed producing urns and swags as ornaments for ships, tombstones, furniture, architecture, and frames. In Boston many carvers, including the Skillins—John (1746-1800) and Simeon, Jr. (1756-1806)—were well patronized.[2] These artisans produced work that mainly served functional or decorative needs.[3] Some provincial neoclassical sculpture went beyond pure ornament. An important example of this transition is *Liberty*, about 1790-1800 (no. 168), by an unknown carver. Made from New England white pine and painted to look like stone, the figure bears a wreath and costume that distantly reflect the influences of antiquity. A charming expression of grand European traditions, *Liberty* is the work of a professional wood carver with limited exposure to academic training. The figure, which probably once functionally embellished a niche in a public building, now provides an illuminating contrast to achievements of later sculptors who produced freestanding works for viewing as independent fine art.

In the early nineteenth century both Bostonians and Philadelphians proclaimed their respective cities as the "Athens of America." Neither, however, actually displayed much marble sculpture in the classical tradition before 1818, when J.B. Binon, a French sculptor, arrived in Boston. Although he had hoped to obtain lucrative commissions for monumental sculpture in marble, he instead found only modest employment making portraits, including an over life-size, massive-looking marble bust of John Adams, which Binon hoped to reproduce for profit. The original marble was placed in Faneuil Hall, and the plaster model was later given to the Boston Athenaeum, but no sales resulted. Adams warned Binon that the age of sculpture had not yet arrived in the United States. Discouraged by slim prospects, the Frenchman departed Boston about 1820. His brief presence and work nevertheless served to inspire the young Horatio Greenough (1805-1852), who is reported to have drawn a chalk copy of the Adams bust displayed in the Athenaeum. William Smith Shaw, librarian of the Athenaeum, had first introduced Greenough to that institution's fine arts room when he was thirteen; an architect, Solomon Willard (1783-1861), showed Greenough how to model in clay; and a local stonecutter, Alpheus Cary (active 1810-1868), gave him instructions in carving marble.[4] The limited assistance available in Boston, however, could not provide the aspiring sculptor with adequate training for the commissions to which he aspired.

Boston's first heroic freestanding sculpture was not made by an American. The commission for the treasured marble memorial to George Washington, awarded in the 1820s, went to the English sculptor Sir Francis Chantrey (1781-1841). He produced a handsome figure wrapped in a cloak ample enough to satisfy the fashion for classical allusions without recreating specific details of ancient costume. The sculpture, signed by Chantrey and inscribed "London, 1826," was placed two years later in Doric Hall in Boston's new State House. At the time,

Horatio Greenough was en route to Italy for a second time, determined to build a reputation beyond that which he had already acquired through his well-received portrait busts of John Quincy Adams, 1828 (no. 4), and John Adams, about 1830 (no. 5). At the relatively youthful age of twenty-seven, Greenough received a major commission from the United States Congress to make a colossal marble of George Washington, the pose of which was inspired by a nineteenth-century reconstruction of Phidias's *Olympian Zeus*. Greenough's marble was shipped to America in 1841 for installation in the rotunda of the United States Capitol.[5] The *Washington* was the first large-scale marble sculpture by an American in the Greek revival manner. The figures and motifs in bas-relief on the sides of Washington's chair, however, make allegorical references to America and its place in the history of Western culture.

In Boston several local influences helped to encourage the taste for sculpture made in the tradition of classical antiquity. By 1827 the Boston Athenaeum played an important role by opening its collections of casts, copies, and original works to aspiring artists three nights each week. When the Athenaeum relocated from Pearl Street to Beacon Street in 1849, it contained a sculpture gallery as well as a library and painting gallery. Twenty years later the conflicting needs of the expanding library and sculpture collection led trustees and officers of the Athenaeum to join with colleagues from the Massachusetts Institute of Technology and Harvard College in founding the Museum of Fine Arts, Boston.

In 1876 Charles Callahan Perkins, an advocate of sculpture at the Athenaeum, became the new Museum's honorary director and chairman of the collections committee. Perkins had studied music in Paris and written books on Tuscan and nineteenth-century sculpture. In Rome he was acquainted with expatriate American sculptors and created a makeshift academy in his quarters, where he offered life drawing classes. In the 1840s he became a patron of the sculptor Thomas Crawford (1811/1813?-1857) and, fittingly, gave the Museum in 1876 its first life-size American sculpture, Crawford's *Hebe and Ganymede*, modeled in 1842 (no. 26). Crawford's talents as a sculptor became known to Bostonians in 1844, when his life-size marble *Orpheus and Cerberus* was placed on special view at the Athenaeum, through the efforts of Charles Sumner, the famous abolitionist senator from Massachusetts, who successfully raised the necessary purchase funds for the statue. In 1872 the sculpture was lent to the Museum, which two years later received by bequest a bust of Sumner, 1842 (no. 24), also by Crawford. Over the next fifty years, the Museum formed a collection including works by Americans trained abroad, plaster casts of ancient Greek and Roman prototypes, and selected pieces by modern European sculptors. It became customary for Bostonians to donate American sculpture to the Museum, sometimes while the artists were still alive. Many of these pieces were displayed in the entry hall of the Museum's first building, located in Copley Square. Among the earliest acquisitions were marbles by Greenough and his fellow Bostonian William Wetmore Story (1819-1895),[6] who likewise pursued the study of sculpture in Italy.

The influence of many prominent Athenaeum officers and members also extended beyond Boston to Cambridge, where they helped to found Mount Auburn Cemetery. Established in 1831, this was the first picturesque garden cemetery in the United States. Its growth created a demand for funerary monuments, which resulted in commissions for many American sculptors. The death in 1845 of the first president of Mount Auburn, Justice Joseph Story of the United States Supreme Court, led friends to honor his memory with a sculptural portrait (now at Harvard Law School), the commission for which was awarded to his son, William Wetmore Story. Athenaeum members were acquainted with Story, since he had written critical reviews of their exhibitions, expressing his disapproval of American sculpture that was, in his words, gripped by "Grecianism." The award of the commission, Story's first work in marble, caused him to abandon a promising legal career and depart for Italy in 1847 to study sculpture. Under the guidance of Mount Auburn's next president, Dr. Jacob Bigelow – physician to the Massachusetts General Hospital and professor of clinical medicine at Harvard University – the cemetery's sculptural holdings grew to include works by well-known sculptors such as Horatio Greenough, Thomas Crawford, and Randolph Rogers (1825-1892).

The study of classical antiquities in Italy was the primary resource for sculpture students determined to understand artistic principles that had governed the sculpture of ancient Greece and Rome. The first generation of American sculptors to travel abroad included Horatio Greenough, Hiram Powers (1805-1873), and Thomas Crawford,

who produced sculpture best defined as Graeco-Roman revival rather than neoclassical. While neoclassical sculptors approached their work in the spirit of the ancients, the younger Graeco-Roman revivalists like Greenough were more thoroughly archaeological in the pursuit of ancient form. A remarkable example in the Museum's collection is Greenough's *Castor and Pollux*, about 1847 (no. 14), which shows the artist's indebtedness to the horsemen from the west frieze of the Parthenon (now part of the Elgin Marbles in the British Museum).

The direct study of classical prototypes was only one means by which Americans absorbed artistic principles of ancient sculpture. Another process involved emulating the work of a living master, who was usually trained in Europe. *Hebe and Ganymede* demonstrates Crawford's success in absorbing the aesthetic systems of composition, proportion, and surface finish that were championed by his mentor Bertel Thorwaldsen (1768-1844). Although themes drawn from classical mythology held predictable appeal for Americans who had traveled abroad, by contrast, recognition was given by the American press to expatriate sculptors whose works dealt with national subjects. In 1858, for instance, the *Cosmopolitan Art Journal* extolled Hiram Powers's *Daniel Webster*, which now stands to one side of the facade of the Massachusetts State House.[7] The writer attempted to describe the awe felt by visitors to Powers's studio as they viewed the sculpture. Whether their respect was aroused by the artistic merits of the sculpture, the fame of the artist, or their remembrance of the revered subject's powerful presence is unclear. Certainly today this figure elicits no critical adulation commensurate with the celebrity of either Powers or Webster. Sadly unheroic are Webster's everyday clothing and unimaginative pose replicated in bronze.

The second generation of American sculptors who studied and resided abroad were mid-Victorian, romantic classicists who produced works in a more melodramatic vein than did their predecessors. Like the first generation, William Rinehart (1825-1874), Story, Randolph Rogers, Harriet Hosmer (1830-1908), of Watertown, Massachusetts, and Franklin Simmons (1839-1913), from Maine, continued to create marbles imbued with symbolism and inspired by literary themes. Although classical and historical figures were shown with authentic details in costume and jewelry, the physiognomy and overall mood of the compositions were unmistakably original and Victorian. Both the artists and

patrons of the second generation found that themes derived from the classical past were more artistically moving than contemporary subjects. The evocation of mood prompted by historical reverie was pervasive in this period. Nathaniel Hawthorne expressed this sentiment in his famous novel *The Marble Faun*, which was inspired, in part, by his visits to the Italian studios of Story and Hosmer, among other American expatriate artists in Italy. As if standing in the sculpture gallery of the Roman Capitol, Hawthorne wrote: "We glance hastily at these things — at this bright sky, and those blue, distant mountains, and at the ruins, Etruscan, Roman, Christian, venerable with a threefold antiquity, and at the company of world-famous statues in the salon — in the hope of putting the reader into that state of feeling which is experienced oftenest at Rome. It is a vague sense of ponderous remembrances; a perception of such weight and density in a bygone life, of which this spot was the centre, that the present moment is pressed down or crowded out, and our individual affairs and interests are but half as real here as elsewhere."[8]

The art of the second generation of American sculptors was based on their study of the figural proportions and the costume used by sculptors in classical antiquity. They soon discovered that this approach did not fully meet contemporary needs. When the romantic classicists began making commemorative sculpture of recent heroes in modern dress, they found themselves ill-equipped. The results were often stiff and visually unsatisfactory, one such example being Story's awkwardly gesturing bronze figure of Edward Everett in contemporary costume, which was erected in Boston's Public Garden in 1867 (now in Richardson Park, Dorchester, Massachusetts). One solution to the problem of modern dress was to select subjects that could be depicted appropriately as unclothed or semi-clothed. Harriet Hosmer's *The Sleeping Faun*, after 1865 (no. 52), Chauncey Bradley Ives's *Pandora* (1810-1894), modeled in 1863 (no. 21), and William Rinehart's *Sleeping Children*, after 1859-1874 (no. 50), illustrate this choice.

A few American sculptors of the second generation who did not travel abroad for training seem to have accepted the conventions imposed by the classical tradition while contributing to the gradual development of realism in American sculpture. In 1860 John Quincy Adams Ward (1830-1910) executed *The Indian Hunter* (no. 53), which was acclaimed by both his teacher Henry Kirke Brown

(1814-1896), who had studied in Italy for four years, and the well-known New York sculptor Erastus Dow Palmer (1817-1904) as "the greatest work of the kind yet produced in this country."[9] Although Ward made direct studies of Native Americans in preparation for modeling *The Indian Hunter*, the pose, proportions, and general composition of the semiclothed figure strongly recall the *Greek Hunter* by the English neoclassical sculptor John Gibson (1791-1866), which had been exhibited in London's Crystal Palace in 1851. Another American who did not study abroad was Dr. William Rimmer (1816-1879) from Boston. *The Falling Gladiator*, modeled in 1861 (no. 28), demonstrates a remarkable knowledge of human anatomy that far exceeds the understanding of musculature seen in the works of many contemporary American and European sculptors. The assertive anatomical statement made by *The Falling Gladiator* obscures the work's possibly symbolic references to the artist's father as well as to the Civil War, and its probable inspiration from ancient prototypes, such as the action-filled *Borghese Warrior* (Louvre).[10] Rimmer, however, also struggled with problems inherent in combining contemporary dress with classical form. Described by a newspaper writer as "an addition to the artistic and monumental features for which Boston is becoming distinguished among American cities,"[11] Rimmer's granite monument to Alexander Hamilton, unveiled in 1865 (Commonwealth Avenue Mall, Boston) concealed eighteenth-century costume beneath a profusion of folded drapery that made reference to the ancient past. This, his only clothed statue, was considered a failure by many.

More successful in representing modern dress was the sculptor Thomas Ball (1819-1911), born in Charlestown, Massachusetts. Through his naturalistic portrayals he provided a transition between second- and third-generation sculptors. Although Ball had studied antique sculpture in Italy, he was able to produce the realistic aspect and details increasingly demanded in public memorials commissioned after the Civil War. Perhaps his best work is the heroic bronze equestrian figure of George Washington, dedicated in 1869 in the Public Garden, Boston. Washington is depicted wearing an accurately rendered eighteenth-century military uniform rather than classical garb. The handling of contemporary clothing is equally successful in the Museum's small bronze of Daniel Webster, 1853 (no. 35), cast from Ball's proposed over life-size statue for a commission, that was awarded to Powers.[12]

The major commissions awarded to Ball's gifted pupil Martin Milmore (1844-1883) further illustrate Boston's growing confidence in local sculptors in the years following the Civil War. Among Milmore's most outstanding works are a vigorously modeled bronze to John Glover, 1875 (Commonwealth Avenue Mall); an enigmatic granite sphinx, 1872, in front of the Bigelow Chapel at Mount Auburn Cemetery; and the *Soldiers' and Sailors' Monument*, completed in 1877 and erected on Boston Common. A decade after Milmore's death, his family commissioned Daniel Chester French (1850-1931) to design a memorial relief at Forest Hills Cemetery in Jamaica Plain, Massachusetts, commemorating both Martin and his elder brother Joseph, who had been a stonecutter. *Death and the Sculptor*, dedicated in 1893, proved a fitting allegorical tribute to early efforts in sculpture and to precocious talents that helped to pave the way for the American sculptors who achieved artistic maturity in the 1880s.

With the third generation of American sculptors, the artistic center for innovative teaching and technical work in sculpture had shifted from Italy to France. Studying in Paris, these artists brought international recognition to the profession of sculpture in America. Lorado Taft (1860-1936), a prominent sculptor and author of the influential book *History of American Sculpture* (first published in 1903), noted that the centennial year marked a turning point in the development of American sculpture, introducing a new era of confidence, training, and achievement.[13] Under the influence of the Ecole des Beaux-Arts and other Parisian schools, this new generation of Americans abroad adopted the stylistic advances of the third quarter of the nineteenth century in the high (or late) Victorian period. Motivated by a keen interest in the richly textured surfaces and free compositional devices of Renaissance sculpture, the artists moved away from smooth surface treatments characteristic of Graeco-Roman classicism toward more lively modeling. Creative eclecticism encouraged exploration in clay with replication in bronze rather than marble.

Major American sculptors who trained in Paris included Olin Levi Warner (1844-1896), Augustus Saint-Gaudens (1848-1907), and Daniel Chester French. Warner's sense of composition, involving alternating rhythms and vigorous modeling, are well represented in Boston with his seated bronze figure of William Lloyd Garrison, 1886 (Commonwealth Avenue Mall). That Saint-Gaudens was par-

ticularly esteemed in Boston is testified to by the size of the Museum's collection: fifteen works (nos. 65-79). His most complex group, a bronze memorial to Robert Gould Shaw, 1897 (Boston Common), is considered by many to be the finest piece of sculpture in America. Saint-Gaudens's international acclaim was so firmly established by the turn of the century that after a plaster cast of *The Puritan* (see no. 74, for a bronze reduction) was exhibited at the Exposition Universelle in Paris in 1900, an illustration of the statue was included in a sample book of decorative arts from classical to modern times.[14] Through the efforts of the third generation, the National Sculpture Society was established in 1893 in New York, to encourage commissions and ensure high standards of quality in American sculpture.

During the same era the World's Columbian Exposition in Chicago brought together architects and over fifty sculptors in an ambitious collaboration to design major exhibitions and architectural programs involving sculpture.[15] Younger artists joined the mature artists of the 1880s to execute these sculptural extravaganzas. The result was an extensive use of allegorical imagery for libraries, courthouses, and churches. In public monuments that commemorated recent events and persons, modern figures were depicted in the full realism of modern dress but with accompanying ideal personifications. An example of such sculptural programming is a monument to honor the poet, patriot, and orator John Boyle O'Reilly. It stands near the Museum at the head of Boylston Street on the Fenway. In this piece by Daniel Chester French, dated 1896, a bronze portrait bust of O'Reilly is backed with a granite plinth carved with Celtic interlace ornament.[16] The opposite side features allegorical figures of Poetry and Patriotism handing leaves of laurel and oak to Erin, the personification of Ireland, who weaves a wreath for her heroes.

The fourth generation of American sculptors who trained abroad gained technical and compositional virtuosity. Their accomplishments through study at the Ecole des Beaux-Arts, Académie Julian, and other Parisian schools equaled those of the best sculptors in Europe. Their work, which won frequent honors in Paris expositions, was often integrated into the public buildings erected during America's gilded age. Artists from this era who are represented in the Museum's collection include Frederick MacMonnies (1863-1937), a former studio assistant of Saint-Gaudens; Cyrus E. Dallin (1861-1944); and Bela Lyon Pratt (1867-1917).

Even during the late nineteenth century, after the center of sculptural activity had shifted to New York, Boston continued to play an important role in displaying major commissioned sculpture. With John La Farge (1835-1910), Saint-Gaudens worked on Trinity Church in the 1870s, forming a lifelong friendship with the architect Stanford White (1853-1906). The Boston Public Library featured works of MacMonnies, French, and other sculptors who matured artistically in an era now identified as the American Renaissance. Saint-Gaudens sketched figures (Saint-Gaudens National Historic Site, Cornish, New Hampshire) to flank the entrance of the library, but because he was unable to finish them before his death, the commission was turned over to Pratt, who for many years taught modeling at the School of the Museum of Fine Arts. Unlike the figures that Saint-Gaudens had proposed, Pratt's *Art* and *Science*, 1910 (nos. 102, 103), were designed to be seen at close range by the viewer and without deep recesses in their forms. These works represent a new phase in American sculpture, characterized by a breadth of surface treatment and largeness of composition. The sculptor Lorado Taft frequently wrote of the importance of keeping sculpture "white," an expression that referred to a consideration of overall effect in daylight, rather than the actual color of the stone or bronze.[17] Sculpture that was "white" was free of deep undercutting and relied on strongly massed form. This trend toward the elimination of deep hollow spaces or shadow-catching pockets in sculpture developed in the work of the fifth generation of American sculptors. In a sense this paralleled the lightening of the tonal palette of painters during the period that followed the optical discoveries of impressionism.

The fifth and last generation of sculptors represented in this collection introduced new decorative surface treatments and reinfused classical influences from Rome and Florence. Each sculptor individualized his or her work with impressionistic handling or the incorporation of geometric or architectonic qualities. *Lyric Muse*, 1912 (no. 136), by Paul Manship (1885-1966), reflects the decorative aspects of archaic Greek sculpture. The animal figures of Anna Hyatt Huntington (1876-1973)[18] and Amelia Peabody (1890-1984) illustrate convincing form and surface textures inspired by famous nineteenth-century animal sculptors, for example, Henri-Alfred-Marie Jacquemart (1824-1896), and Antoine-Louis Barye (1796-1875), achieved through direct observation of subjects in controlled

environments conducive to precise measurements. Peabody's *End of an Era* (no. 147) particularly demonstrates Taft's principle of keeping sculpture "white." Among the youngest sculptors of this last generation represented in the Museum's collection are Donald DeLue (born 1897), Avard T. Fairbanks (born 1897), Katharine Lane Weems (born 1899), and Walker Hancock (born 1901), whose works enlarge upon late nineteenth-century attitudes toward form, content, and proportion.

Sculptors from all the generations touched upon in this essay shared art theories and practices rooted in the traditions of classical art. Each artist faced the problem of modeling the human figure according to a system or systems of mathematical relations between parts, known as commensurate measure. No work was wrought within the tradition of Western sculpture without requiring the artist to first explore the systematic division of form in the human body. The sculptor's concern with proportional standards was not undertaken merely for technical purposes. The search also involved important philosophical issues. Several artists represented in this catalogue produced original observations on the subject of proportion that shed insight on working methods and motivations. In order to outline subtle but major shifts in attitudes toward human proportion embodied in American sculpture of the past century, it is necessary to review chronologically some selected examples.

The anonymous figure of *Liberty* (no. 168) illustrates one of the earliest systems of proportion used in America by pragmatic wood carvers. Detailed by Samuel McIntire (1757-1811), the famous Salem carver-architect, in a drawing he produced sometime before 1802 (Essex Institute, Salem), the system designated the length of the nose as the basic unit of human measure, called a "part," each part containing twelve equal subdivisions. Male and female figures stood thirty-one parts tall. Using a rule and compass, the carver could easily develop a template for enlarging the sculpture to any size.

Subsequent generations of neoclassical sculptors chose to follow more complex proportional theories imported from abroad. Harriet Hosmer's teacher in Rome, John Gibson, collaborated with Joseph Bonomi (curator of Sir John Soane's Museum, London) to publish an illustrated book that became a popular guide for those who modeled figures to be carved in marble. Entitled *The Proportions of the Human Figure*, it presents the definitions of Vitruvius as translated by Leonardo da Vinci, along with

a "method of measuring the figure" invented by Gibson.[19] Also included are charts with the precise measurements of famous antique statuary, such as the *Venus de Medici* (Uffizi Gallery, Florence). Demonstrating the universality of the laws of proportion according to the ancients, the charts were intended to serve as a guide for modern sculptors.

William Wetmore Story challenged the methods of Gibson and Bonomi without substantially altering the visible results. In *The Proportions of the Human Figure According to a New Canon* (1866), Story searched the writings of Pliny the Elder for the meaning of the proportional canon allegedly used by the Greek sculptor Polyclitus in the fifth century B.C.[20] Story concluded that Pliny's text referred both to Polyclitus's *Doryphoros*, or *Spear Bearer* (a Roman copy of which is in the National Museum, Naples), and to a missing ancient treatise on proportions. Story attempted to reconstruct the precepts of the canon through measuring antique sculpture and pursuing other historical investigations. He believed these efforts would imbue his works with universal qualities unaffected by changes of fashion. His precepts were meant to provide fellow sculptors with a new system of sculptural measurements based upon immutable laws. Religion was also tied to Story's investigation. By researching ancient Hebrew writings, Story invoked signs, symbols, and number sequences to match the geometric figures of the circle, square, and equilateral triangle and to arrive at a new, complex system of divisions for the human body. The resulting measurements of the classical human figure drew specific religious and symbolic ideas from early sources and invested pagan Greek forms with Judeo-Christian meanings. Such an approach to proportions is at the root of both continuity and change in sculpture of this era. Story's book included plates of two figures used to illustrate the findings he had incorporated into his marble figures *Bacchus*, 1863 (no. 41), and *Venus Anadyomene*, 1864 (no. 44). However, the complex symbolic system used by Story in arriving at these proportions seems obscure to the twentieth-century eye.

Although later sculptors undoubtedly found Story's system impractical, they shared his belief in absolute rules of beauty derived from a cosmic scheme based on the geometry of the triangle (representing the Trinity), the circle (the celestial sphere), and the rectangle (the measure of things on earth). This ideal persisted in American sculpture throughout the nineteenth century and well

into the second half of the twentieth century. Dr. William Rimmer, in his richly illustrated *Art Anatomy* (1877), explored variations between the proportions of normal and abnormal figures from infants to giants. Unlike Story, who maintained that female and male proportions were identical, Rimmer observed that the female body was three-quarters the size of the male. Despite Rimmer's lack of formal training in sculpture, his *Seated Man*, or *Despair*, 1831 (no. 27), and *The Falling Gladiator*, modeled in 1861 (no. 28), demonstrate the effective use of appropriate proportional schemes for wholly different subjects.

The later nineteenth-century recognition of variability in human proportions complicated the search for ideal beauty without diminishing the quest. A new approach evolved through what was called anthropometric research on living figures. The Boston sculptor Henry Hudson Kitson (1863-1947) collaborated with Professor Dudley Allen Sargent, at Harvard University's gymnasium, to measure the proportions of college students. The results were tabulated for averaged or composite proportional standards, both male and female. Using these measurements, Kitson and Sargent concurred that within the Aryan race "only one type of beauty [existed]"; the ideally proportioned American woman was considered one of beauty's most perfect expressions.[21] These ethnocentrically oriented studies were expressive of the prevailing sense of nationalism paralleled in many professions throughout the United States, following World War I.

During the twentieth century repeated measurements of living human subjects yielded proportions that broke with the Victorian canons of Greek sculpture. The system adopted by most members of the National Sculpture Society and art teachers reaffirmed that the body was divisible into 7½ to 8 units with a standard head length.[22] Torso and limbs were divisible into equal thirds. The distance from the chin to the anterior superior spine of the ilium (crest of hip) equalled the distance from the latter to the knee and from the knee to the sole of the foot. Identical divisions occurred in the female figure. Each tripart division equaled 21 inches on a 6-foot male and 16½ inches on a 5½-foot female. Some artists also had individual theories on proportions that varied from these norms. Donald DeLue, for example, regularly produced figures with small head-to-body ratios.

Sculptors who were busy with commissions could not continually engage in personal investigations of nature's harmonic proportions. In the 1920s that task was pursued instead by art theorists such as Jay Hambridge, Samuel Colman, C. Arthur Coan, and Claude Bragdon, who published inspiring writings on proportion, dynamic symmetry, root rectangles, whirling squares, and other devices for sculptors and designers seeking ideal beauty and cosmic unity.[23] A close study of the Museum's American sculpture collection helps to illuminate some of the abstract concepts with which sculptors have been concerned.

JONATHAN L. FAIRBANKS
Katherine Lane Weems Curator
of American Decorative Arts
and Sculpture

Notes

1. For assistance in the preparation of this brief introduction to the first century of American sculpture, I am most grateful to Jan Seidler Ramirez, who has made a special study of Boston sculptors and their patrons, and Joy Cattanach Smith, whose editorial suggestions are always valuable.

2. A striking example of the Skillinses' work is an original wood capital from the State House, designed by Charles Bulfinch (1763-1844) in 1795. Though acquired by the Museum in 1979, the carved ornament was excluded from this catalogue because it represents a fragment of a larger architectural composition rather than a freestanding sculpture.

3. The Museum's collection includes numerous examples of nonacademic work (i.e., vernacular, provincial, and folk sculpture), which have been omitted from this catalogue because they do not conform with the academic figural tradition in sculpture. Most of these pieces are published in the Museum of Fine Arts, Boston, *M. and M. Karolik Collection of American Watercolors and Drawings, 1800-1875*, 2 vols. (1962).

4. Lee 1854, pp. 131-132. See also Greenough 1887, pp. 42-43; Wright 1963; Thomas B. Brumbaugh, "Horatio and Richard Greenough: A Critical Study with a Catalogue of Their Sculpture," Ph.D. diss., Ohio State University, 1955.

5. Craven 1968, pp. 105-109.

6. Mary E. Phillips, *Reminiscences of William Wetmore Story, the American Sculptor and Author* (Chicago: Rand, McNally, 1897), and Henry James, *William Wetmore Story and His Friends*, 2 vols. (Boston: Houghton Mifflin, 1903), have long been the standard biographies on this sculptor. Despite their insights, these authors obscured many of the aesthetic achievements of the artist. This failure has been corrected with a reassessment by Jan M. Seidler, in "A

Critical Reappraisal of the Career of William Wetmore Story (1819-1895), American Sculptor and Man of Letters," Ph. D. diss., Boston University, 1985.

7. *Cosmopolitan Art Journal* (Mar.-June 1858), p. 137.

8. Nathaniel Hawthorne, *The Marble Faun: or, the Romance of Monte Beni* (Boston: Houghton Mifflin, 1860), p. 2.

9. "Fine Arts," *Boston Sunday Herald*, Nov. 19, 1865.

10. See Brockton Art Museum-Fuller Memorial, Brockton, Mass., *William Rimmer, a Yankee Michelangelo*, essays by Jeffrey Weidman, Neil Harris, and Philip Cash (1985; distributed by University Press of New England, Hanover, N.H.), pp. 40-41.

11. *Boston Sunday Herald*, Sept. 10, 1865.

12. Although Ball did not receive the award, his realistically modeled statuette of 1853 was a commercial success when cast by the Ames Foundry, Chicopee, Mass. This multiple edition of forty parlor-size bronzes was one of the first enterprises of its kind. The popularity of these bronzes encouraged the funding of a colossal bronze version, 1876 (Central Park, New York). See Ball 1891. See also Sterling and Francine Clark Institute, Williamstown, Mass., *Cast in the Shadow: Models for Public Sculpture in America*, catalogue by Jennifer R. Gordon (1985), pp. 13-16.

13. Taft 1930, p. 256. Taft was not alone in pointing to the Centennial as an important era of change for American sculpture. This view was shared by Caffin 1903, p. v., and by the more distinguished Post 1921, p. 227, who wrote: "Until about the time of the Centennial of 1876, American sculptural aspirants, isolated from new European developments, did not cease to get their training, especially for ideal themes, from the tradition of Canova and Thorvaldsen in Italy." An important publication of the Centennial era is Clark 1878, which, in the main, illustrates marbles made by Americans in Italy (Story and Rogers, for example).

14. See A. Raguenet, *Matériaux et documents d'architecture*, vol. 5 (Paris, about 1900), "Statue," p. 37. For a discussion of *The Puritan*, see Kathryn Greenthal, *Augustus Saint-Gaudens, Master Sculptor* (New York: The Metropolitan Museum of Art, 1985), pp. 127-130.

15. For a reevaluation of architectural sculpture at the turn of the century, see Michele H. Bogart, "In Search of a United Front," *Winterthur Portfolio* 19 (summer-autumn 1984), pp. 151-176.

16. See Michael Richman, *Daniel Chester French, an American Sculptor* (1976; reprint ed., Washington, D.C.: Preservation Press, 1983), pp. 24-26.

17. See, for example, Taft 1921, p. 127, where he discusses MacMonnies's *Princeton Battle Monument*, unveiled in 1922.

18. In 1923 Anna Hyatt married Archer Milton Huntington. Their large estate at Murrells Inlet, South Carolina, purchased in 1930, eventually became a nature reserve and sculpture garden, known as Brookgreen Gardens. See Proske 1968; and Brookgreen Gardens, *A Century of American Sculpture: Treasures from Brookgreen Gardens* (New York: Abbeville, 1980).

19. Joseph Bonomi and John Gibson, *The Proportions of the Human Figure, According to the Ancient Greek Canon of Vitruvius*, 2nd ed. (London: Chapman & Hall, 1857).

20. William W. Story, *The Proportions of the Human Figure, According to a New Canon, For Practical Use; With a Critical Notice of the Canon of Polycletus, and of the Principal Ancient and Modern Systems* (London: Chapman & Hall, 1866).

21. C. Sadakichi-Hartmann, *A History of American Art*, rev. ed. (New York: Tudor, 1934), p. 89. Sargent taught at the Hemenway Gymnasium of Harvard on Everett Street. Sargent College of Allied Health Professions at Boston University was named in his honor.

22. Malvina Hoffman, *Sculpture Inside and Out* (New York: Norton, 1939), pp. 229-254, illustrates the complexity of proportional problems involved with enlarging calipers and instruments, Headlength studies are charted by Brenda Putnam, *The Sculptor's Way* (New York: Farrar & Rinehart, 1939), pp. 155-156. Proportional studies based upon a doctoral dissertation written by Avard T. Fairbanks at the University of Michigan were published in lecture notes for students of sculpture in 1936.

23. See Jay Hambridge, *Dynamic Symmetry: The Greek Vase* (New Haven: Yale University Press, 1902); Samuel Colman and C. Arthur Coan, *Nature's Harmonic Unity: A Treatise of Its Relation to Proportional Form* (New York: Putnam, 1912); idem, *Proportional Form* (New York: Putnam, 1920); Claude Bragdon, *The Frozen Fountain* (New York: Knopf, 1932); Matila Ghyka, *The Geometry of Art and Life* (New York: Shead and Ward, 1946). This is a small sample from a large field of theoretical writing, an activity that continues to the present day.

Plates

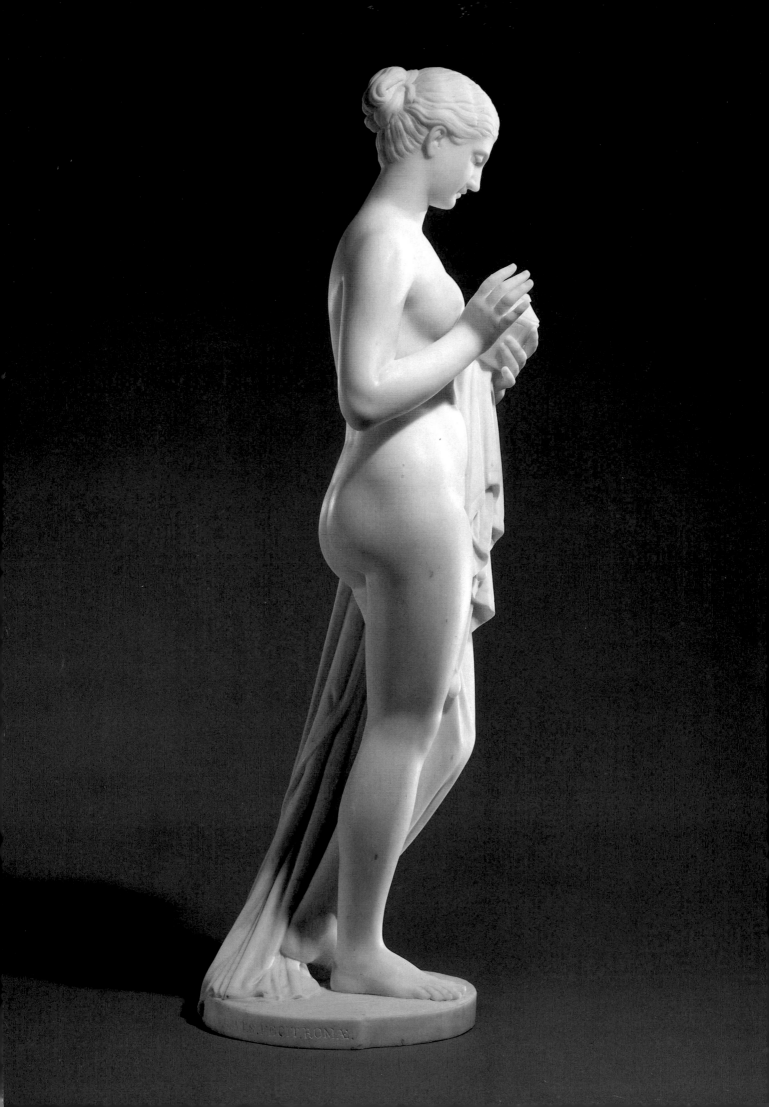

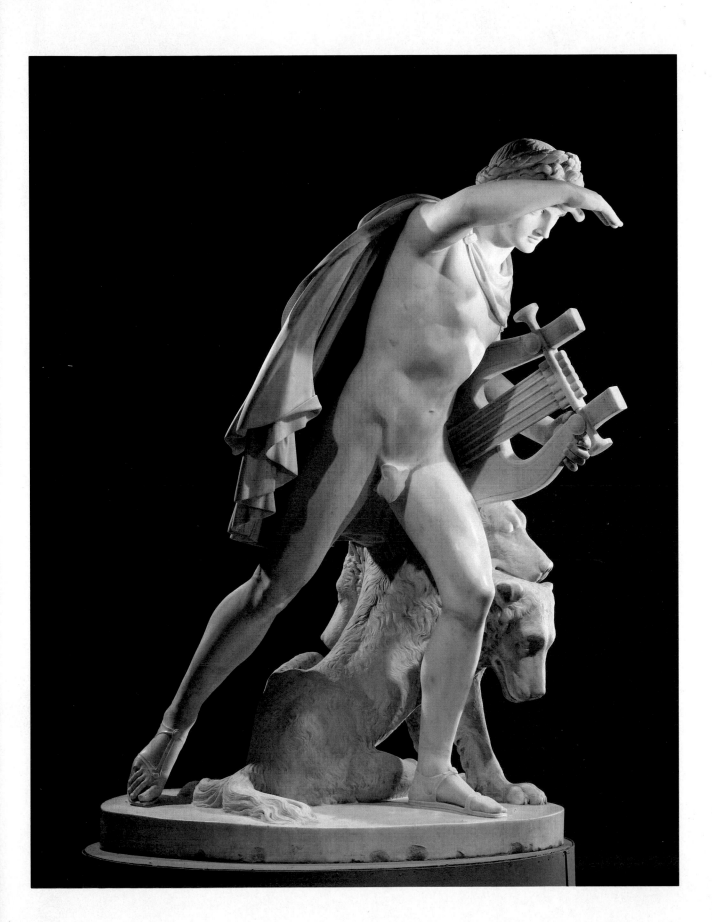

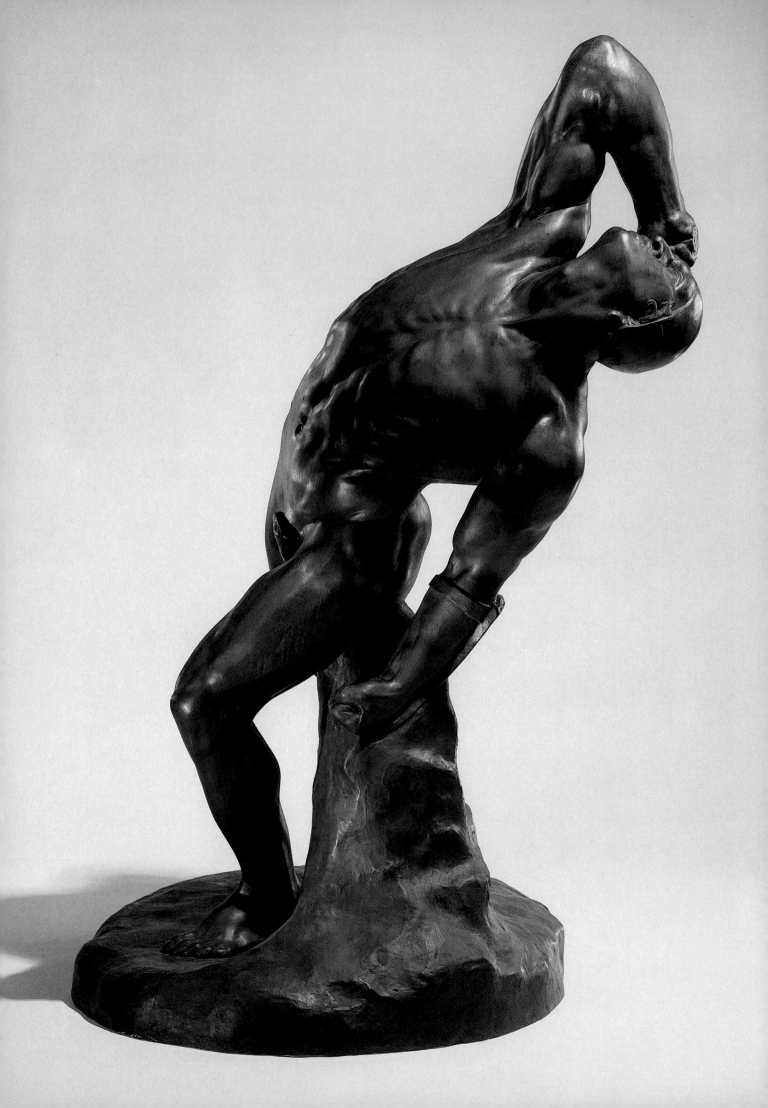

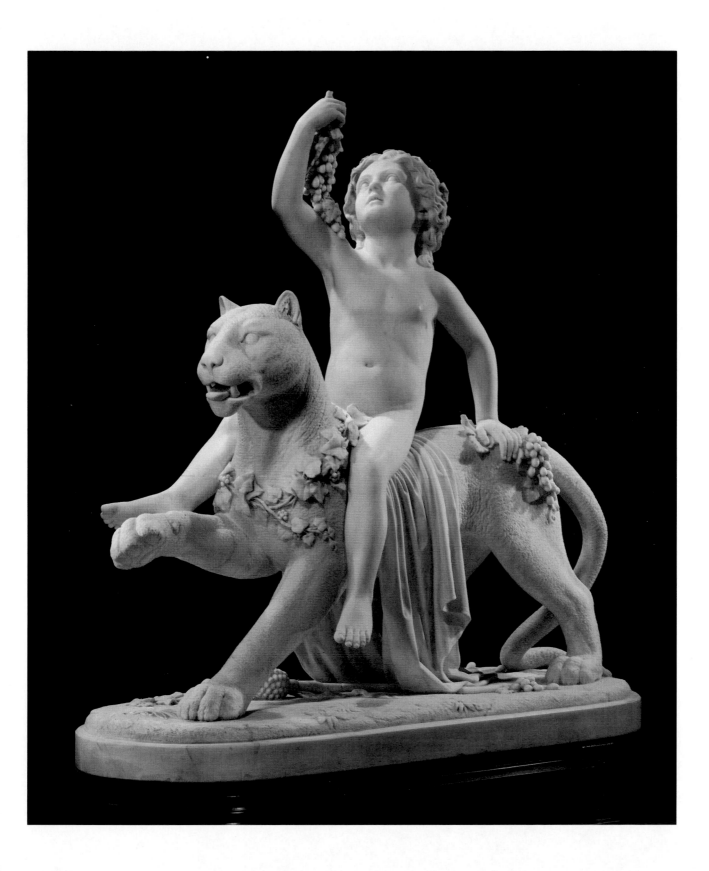

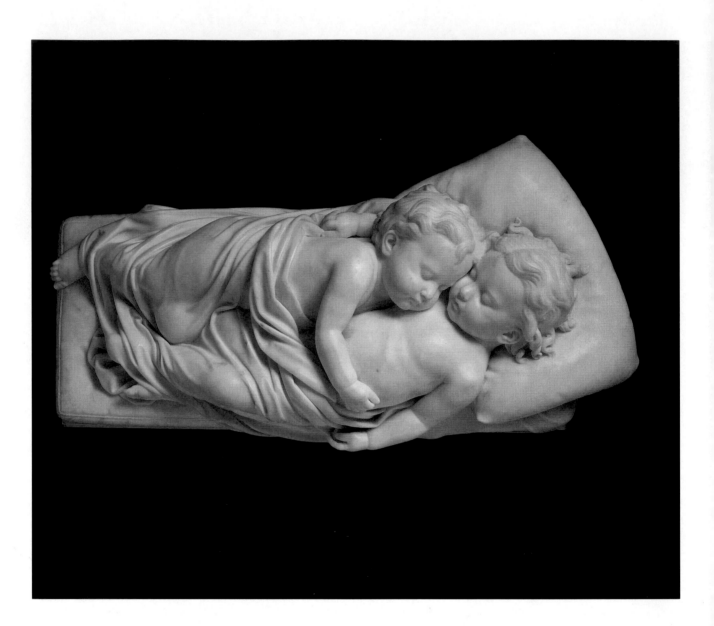

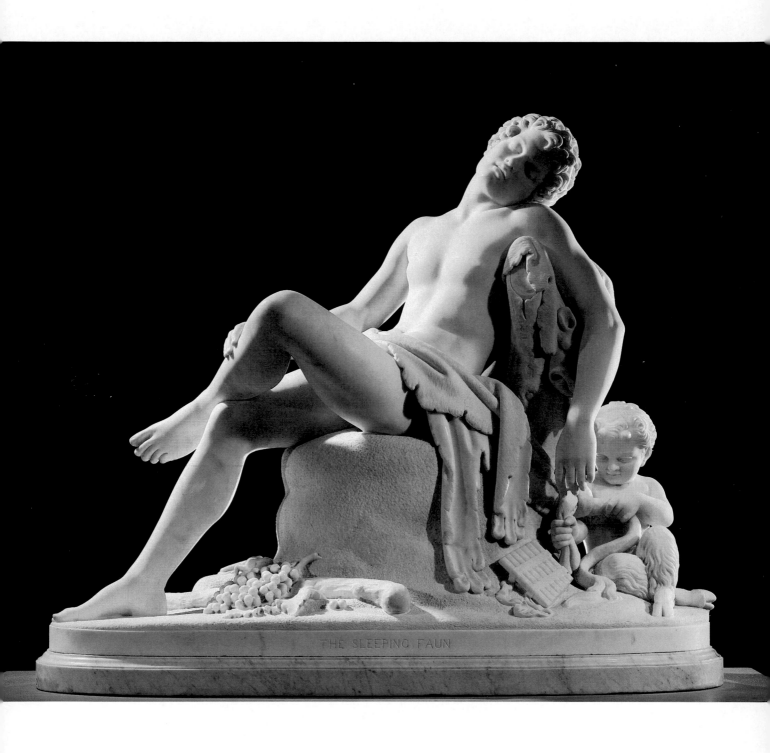

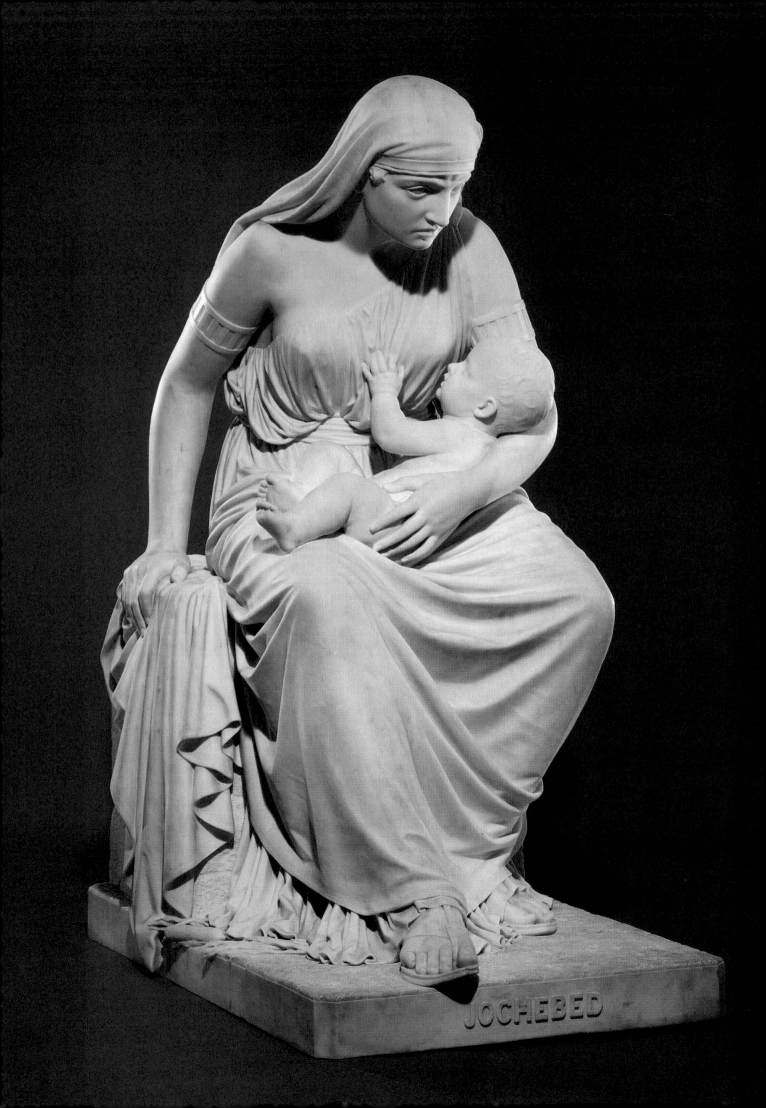

AUGUSTUS SAINT-GAUDENS
67 *Jules Bastien-Lepage*, 1880

FRANKLIN SIMMONS
57 *Jochebed, the Mother of Moses*, 1873

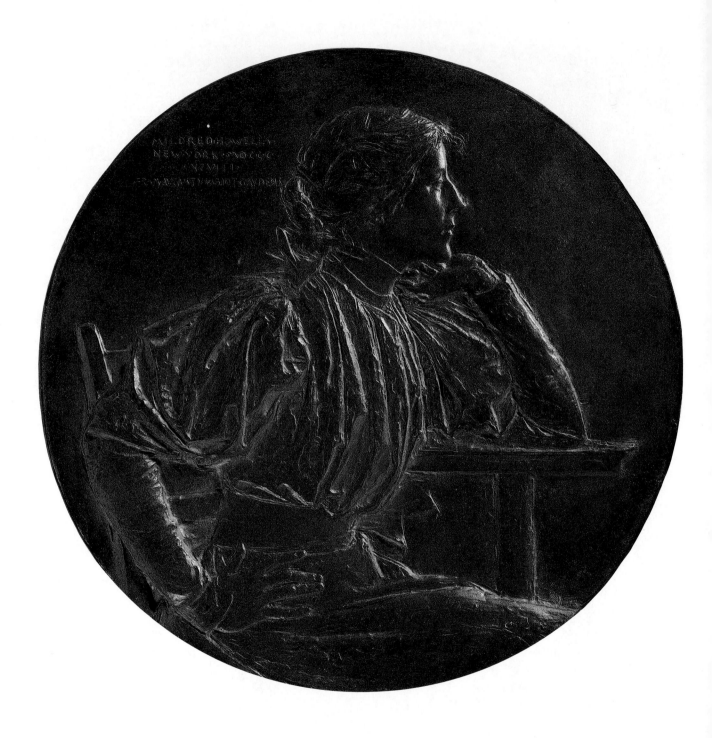

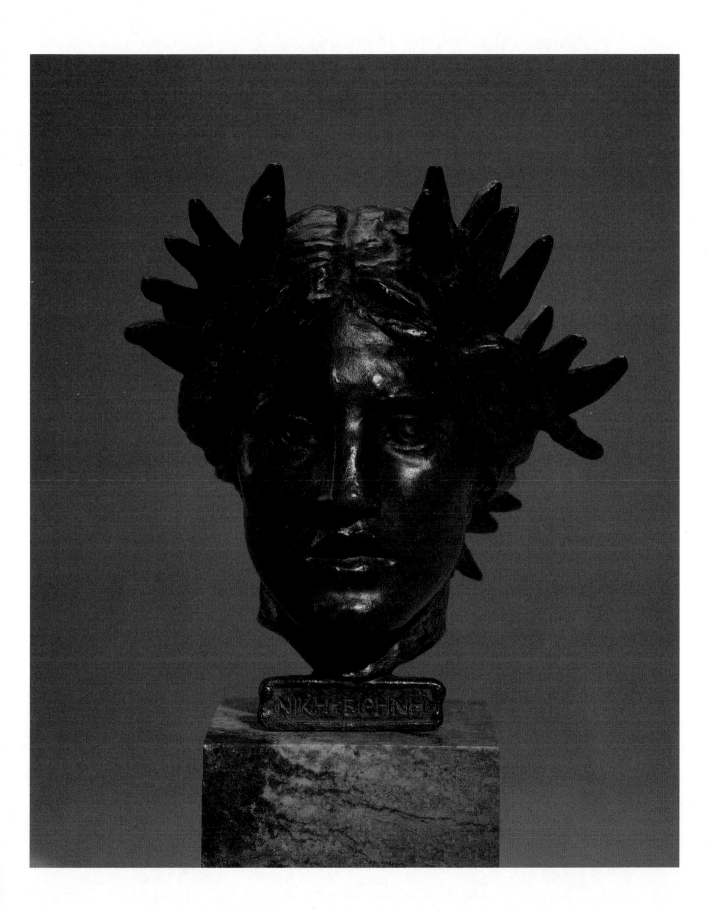

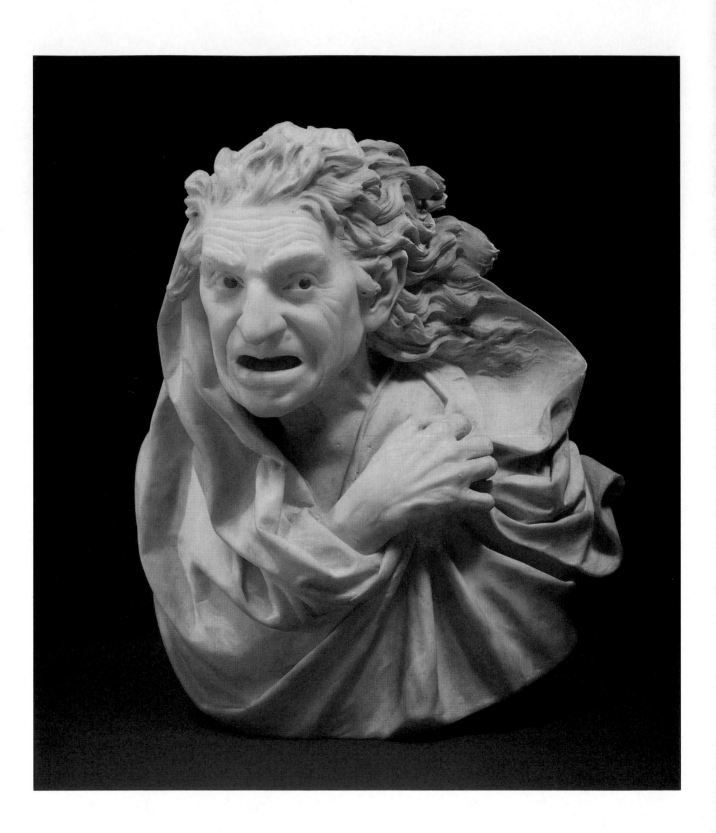

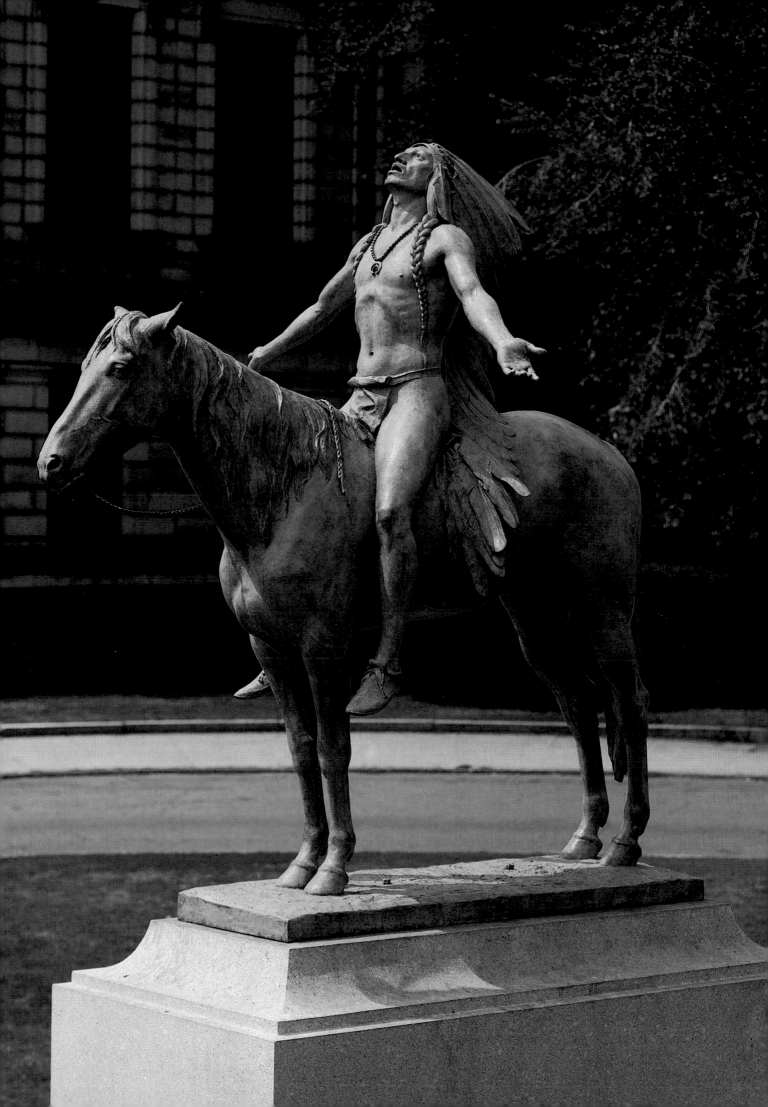

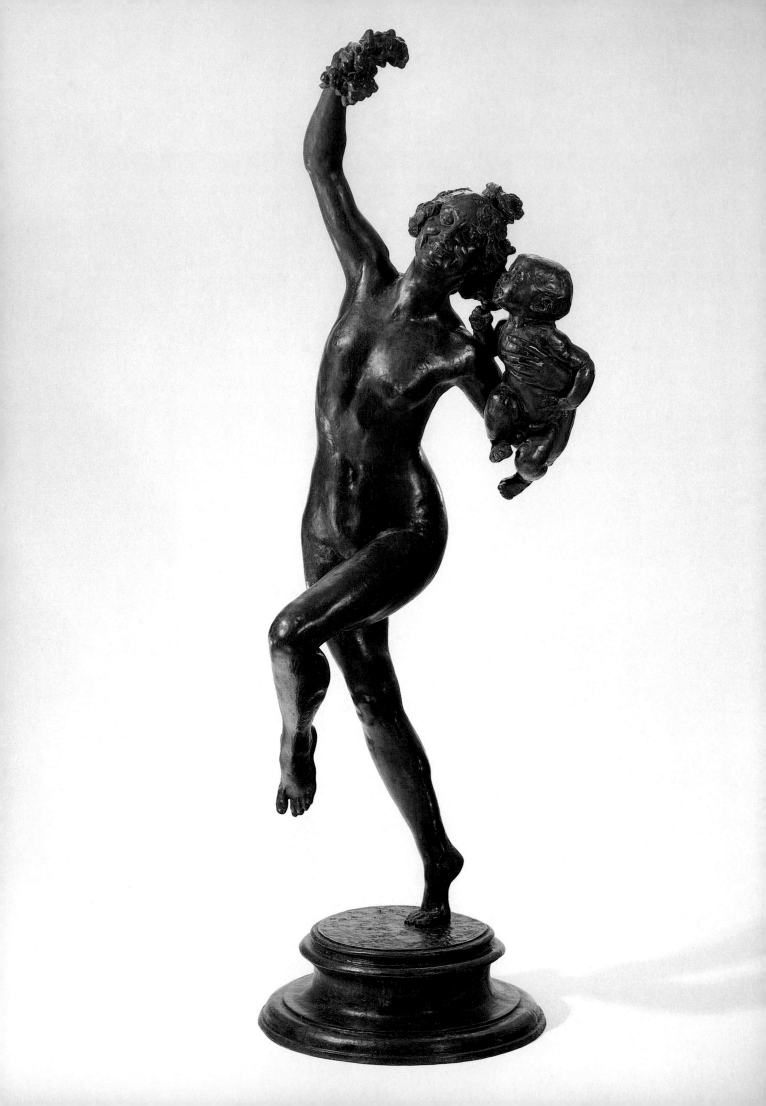

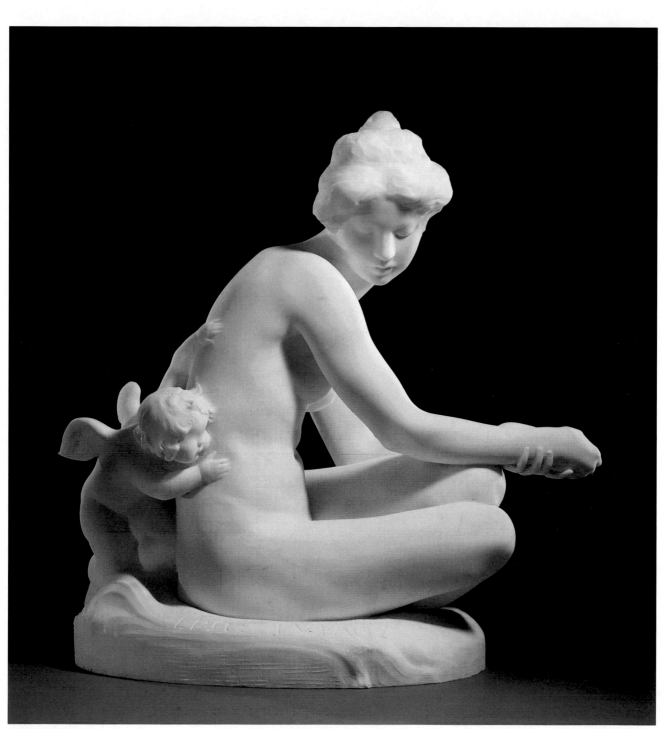

Bela Lyon Pratt
107 *Blind Cupid*, 1917

Frederick William MacMonnies
97 *Bacchante and Infant Faun*, 1901 (modeled in 1893)

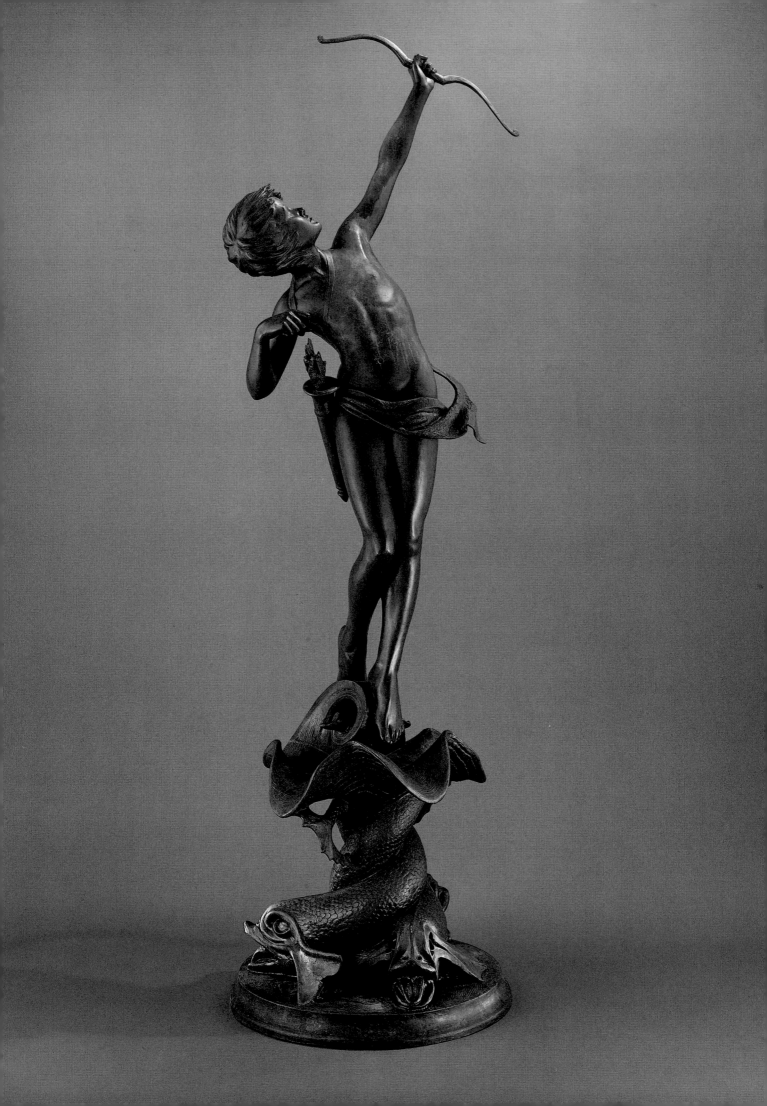

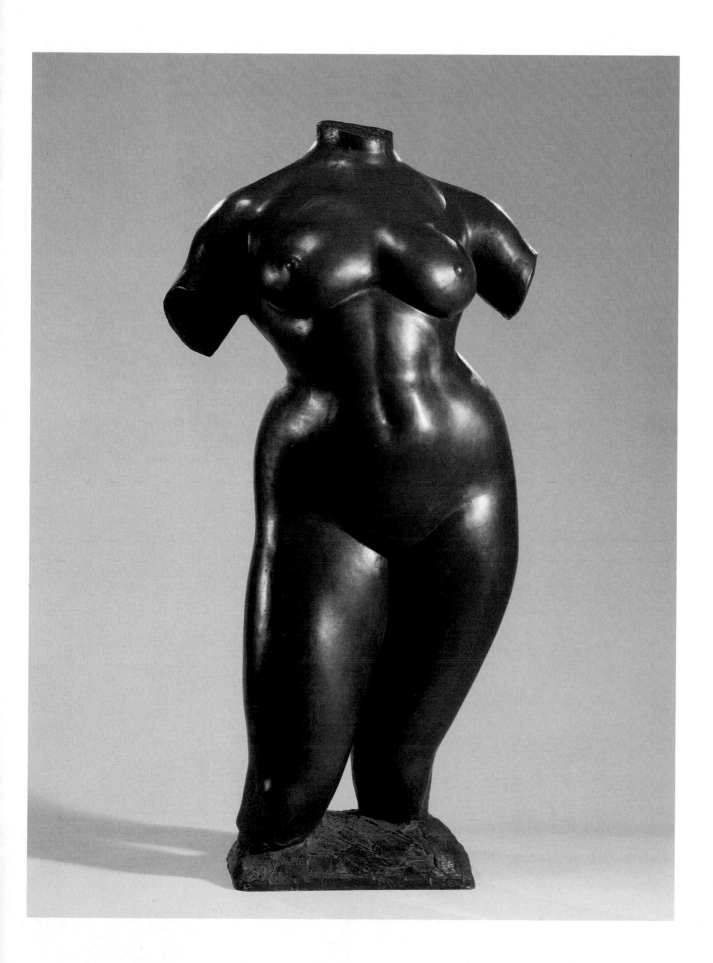

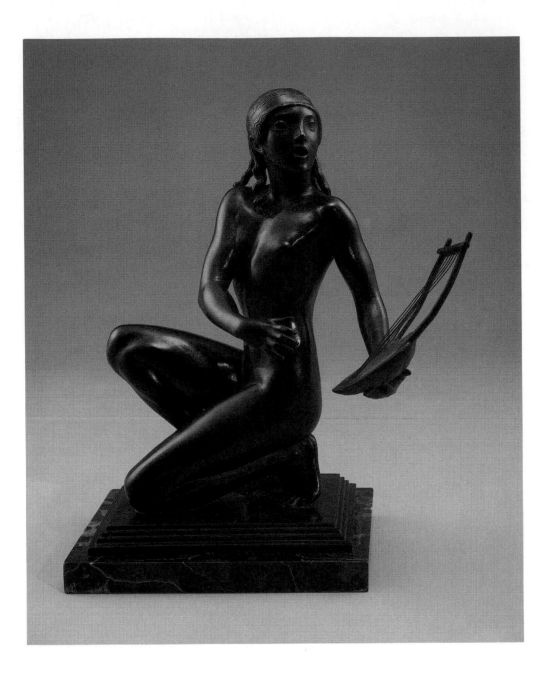

KATHERINE LANE WEEMS
160 *Narcisse Noir*, 1927

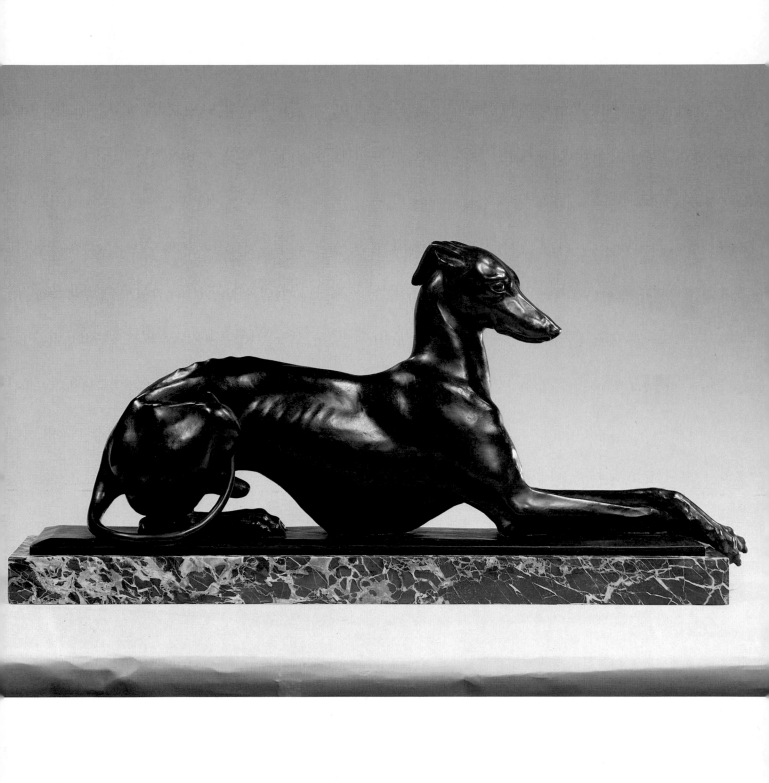

Catalogue

Use of the Catalogue

ARRANGEMENT

The catalogue is arranged chronologically according to the date of birth of the sculptor. Works by anonymous sculptors are listed last. If two or more sculptors were born in the same year, they are listed alphabetically. There is a full biography of the seventy known sculptors, accompanied by a list of references. Individual objects in the collection of the Museum of Fine Arts are discussed in entries following the biographies. For each sculptor, works are discussed in order of the date of manufacture of the Museum's example, that is, by date of modeling in wax, firing of terracotta, carving, casting, or electrotyping. When two or more works were produced in the same year, they are listed alphabetically by title within that year unless the chronological sequence is known. Preceding the entry, data are supplied in the following order: title, date, medium (including color of patination of bronzes and method of production), dimensions, markings, credit line and accession number, provenance, exhibition history, and versions. Following is a list of the various categories and methods of treating them.

CROSS REFERENCES

When works that have their own entries are mentioned elsewhere in the catalogue, they are indicated by "(q.v.)."

DATES FOR ARTISTS AND WORKS OF ART MENTIONED IN TEXT

When sculptors represented in the Museum are mentioned in passing in text, their birth and death dates are not supplied. It should be noted that dates are given only for painters, sculptors, architects, and works of art of the nineteenth and twentieth centuries (the period covered by this catalogue). Inevitably, dates are not known in all cases.

REFERENCES

References relate both to the artist's biography and to the sculpture under discussion. Omitted from these are standard publications of a dictionary type (for example, *American Art Annual*, *Dictionary of American Biography*, Mantle Fielding, *Dictionary of American Painters, Sculptors and Engravers*, and *Who's Who in American Art*) unless they are the principal sources of information. Death notices as well as obituaries from journals and newspapers are designated as "obit." in references and footnotes. Titles cited frequently are abbreviated. Repositories of papers concerning the sculptor under discussion are listed alphabetically under the name of the repository. For example, Philip S. Sears Papers are listed under AAA, SI, rather than under Sears. The name of the manuscript collection is omitted here but is included in the footnotes.

DATING OF OBJECTS

The date given for the Museum's work is that of manufacture. Dates are also given, as far as possible, for other works by the sculptor that are mentioned in the biography and entries. An attempt has been made to give the date of the piece in the particular collection, using date of creation, the date inscribed on the object, or the date of manufacture. In the case of a public monument, dates provided are generally for installation, dedication, or unveiling and are usually indicated with these terms.

DIMENSIONS

Overall dimensions are given in inches and centimeters: height, width (or length), and depth. Depth is not given for reliefs.

SIGNATURES AND INSCRIPTIONS

Signatures and inscriptions are transcribed as found on the object, reading from the viewer's left to right. Idiosyncrasies in a sculptor's signature (e.g., dots over capital letters, backwards letters) are not transcribed. Monograms and ciphers are noted, but no indication is made of cursive signatures. The method of signing or marking a piece (such as incising or stamping) has not been given. Ornamental devices such as rosettes are not recorded.

PROVENANCE

Provenance is indicated only if there has been an owner prior to the Museum. If the object was acquired directly from the sculptor, or indirectly through subscribers, no provenance is given. Nor is provenance mentioned in the case of a gift for which the donor requested anonymity. The earliest owner is mentioned first.

EXHIBITED

Care has been taken to ensure that the exhibitions listed refer specifically to the Museum's piece. In a few instances, where it has not been possible to establish this with any certainty, the terms "possibly" or "probably" are used.

VERSIONS

For the purpose of this catalogue a version is defined as an object that bears such close resemblance to the Museum's piece that it appears to be essentially the same, although it may vary in medium and in size. A list of locations for versions in both public and private collections is given as a guide to the reader and is not intended to be comprehensive, since objects in private collections frequently change hands. In the case of an extremely large edition, no attempt has been made to enumerate all examples. The list of versions should be read in conjunction with the text, where the size of the edition of a work and its enlargements, reductions, and replicas are often discussed. Related works that do not fall into the category of versions as defined are also discussed in the text.

Media are listed in the following sequence: plaster, metal (bronze, aluminum, etc.), and stone. For sculpture in the round, size is indicated in relation to life-size (between five and six feet); the smallest size (quarter-life-size) is given first. If an object was produced in only one size, that is, with dimensions identical with that of the Museum's piece, size is not indicated. For reliefs, medallions, and medals, size is given in inches (since objects of this type are usually less easily categorized in terms of life-size than is sculpture in the round). Reductions of reliefs follow all other sizes. Electrotypes are listed last.

Information on versions in other collections has been provided by the owners and from published references. In many cases, the authors have not seen the versions and have relied upon data supplied for dimensions, medium, and methods of production.

Johann Christian Rauschner
(1760 – after 1812)

Before the emergence of a native American school
of sculptors in stone in the first half of the nine-
teenth century, wax artists supplied their country-
men with small-scale portrait studies of political and
historical personalities. Unlike marble, the material
of their craft was modestly priced, easily worked,
and readily available for purchase in the Colonies.
Wax had the additional advantage of assuming a
variety of visual effects, whether left shell-white like
a cameo or color-tinted like a painted portrait
miniature.

The popularity of wax sculpture in America had
its seeds in Europe during the Renaissance, when
craftsmen involved in that era's major revival of
bronze casting developed an appreciation for the
versatility of the medium and for the independent
ornamental qualities of the waxen images that were
designed as preliminary models in the casting pro-
cess. The traditional skills of wax modeling, trans-
mitted through generations of continental crafts-
men, were in demand in this country by the early
decades of the eighteenth century. Among the spe-
cialties of colonial wax artists were diminutive por-
trait reliefs of influential local citizens, likenesses of
the English royal family, and tableaux representing
genre scenes, historical dramas, or biblical tales. Sex
was no barrier against achieving prominence in this
special branch of sculpture. Several women wax
artists dominated the craft, the most celebrated of
whom was the hard-working and independent-spir-
ited Patience Lovell Wright (1725-1786), whose bas-
reliefs were admired in New York, and whose ca-
reer flourished after she moved to England in 1772.
Although modest fame warmed the lives of
America's most accomplished wax artists, fortune
was usually not its companion. Most wax artists
were forced to travel widely to earn a decent living,
often practicing supplementary trades as well.

Trained as a plaster and stucco worker in Frank-
furt, Germany, where he was born, Johann Chris-
tian Rauschner emigrated to the United States after
the Revolution. From 1799 to 1808, according to
New York City directories, Rauschner worked in
New York, presumably as a portrait modeler; a
number of his molds and portrait profiles are still
extant at the New-York Historical Society. The fi-
nancial precariousness of his profession, however,
prompted Rauschner to make frequent excursions
along the Eastern seaboard in search of sitters and

orders for work; he is reported to have stopped at
odd intervals in Charleston, South Carolina; in Phil-
adelphia before 1801 and from 1810; and in Boston
and Salem, where he appears in area directories
from 1809 to 1810. After 1812 Rauschner's where-
abouts are unknown.

Forsaking the convention of modeling subjects in
white wax, in the fashionable cameo format,
Rauschner tinted his wax with a variety of fine
pigments, producing portraits that were raised,
three-dimensional equivalents of the delicate minia-
ture paintings that were in vogue by the beginning
of the nineteenth century. His techniques included
mixing pigments directly into the wax to achieve
colored effects and then building his image accord-
ing to a preconceived color pattern. Rarely did he
rely on the superficial application of paint except
for special emphasis, such as highlights in eyes and
eyebrows. Enterprising in the way that economic
circumstances forced itinerant artists to be,
Rauschner also made plastic molds from many of
his wax subjects so that multiple impressions of the
sitter could be produced according to demand. Al-
though the mold accelerated the rate at which the
artist could achieve a positive image in wax, hand-
finishing was required and permitted Rauschner
considerable latitude in exploring individual ac-
cents. A plaster mold of one of the artist's sitters,
Isaac McComb, and its finished wax impression,
survive as an instructive comparative pair in the
Newark Museum, New Jersey.

Of the hundred or so profiles by Rauschner that
have been identified, many are characterized by an
elegant, discriminating contour line and the selec-
tive modeling of fine details in his sitter's costume
and coiffure. Typically, his portraits were mounted,
with a thin layer of wax, on circular or oval pieces of
glass, measuring four to five inches in diameter.
Often, the torso of the sitter is truncated with an
almost straight base line rather than with a curvilin-
ear treatment that would have echoed the graceful
elliptical contours of the frame.

Among Rauschner's sitters were the affluent
merchants and successful immigrants who inhab-
ited the larger cities of the East coast in the early
federal period. Only rarely were his subjects por-
trayed in an imaginative setting, such as that fea-
tured in the composition for *Joseph B. McComb*,
about 1797 (The Newark Museum, New Jersey),
which shows the child clutching a pet rabbit in his
arms, encircled by a rural landscape.

J.S.R.

References

Ethel Stanwood Bolton, *Wax Portraits and Silhouettes* (Boston: Massachusetts Society of the Colonial Dames of America, 1914), pp. 18-24; "Cobwebs and Dust," *Antiques* 2 (May 1923), p. 203; Craven 1968, pp. 29-30; "The Editor's Attic," *Antiques* 5 (Feb. 1924), p. 1; ibid. 30 (Sept. 1936), p. 101; ibid. 32 (Nov. 1937), p. 227; ibid. 33 (May 1938), p. 246; Gerdts 1973, pp. 11-12; "More Waxes by Rauschner," *Antiques* 21 (Apr. 1937), pp. 186-187; A.J. Wall, "Wax Portraiture," NYHS, *Quarterly Bulletin* (Apr. 1925), pp. 19-20.

JOHANN CHRISTIAN RAUSCHNER

1

Joseph Eaton, about 1809
Colored wax
H. 3 in. (7.6 cm.), w. 1½ in. (3.8 cm.)
Bequest of Lucy Houghton Eaton. 33.1

Provenance: Eaton family, Boston; Lucy Houghton Eaton, Boston

The sitter is said to be Joseph Eaton (1774-1809), a Boston housewright. Born in Dedham, Massachusetts, he was the sixth generation removed from John Eaton, who emigrated to Dedham from Dover, England. In 1798 Joseph Eaton married Hannah Bass, who was a descendant of John Alden and Priscilla Mullins of Plymouth, Massachusetts.[1] The white collar, vest, and black coat in which Eaton is attired were fashionable for gentlemen in the federal era. The portrait was probably modeled by Rauschner in Boston, shortly before Eaton's death in February 1809. The piece was donated to the Museum by Lucy Houghton Eaton, a direct descendant of the sitter.

J.S.R.

Note

1. See "Records and Items of Genealogy of the Eaton-Bass-Reed-Houghton Families," compiled by Catherine Swanton Eaton and Lucy Houghton Eaton (1912), New England Historic and Genealogical Society, Boston.

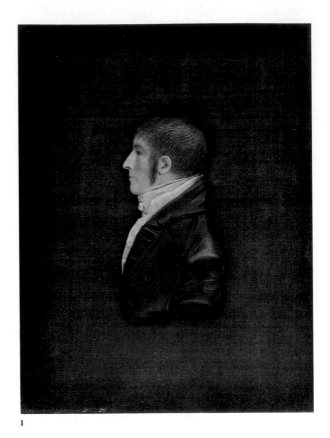

1

JOHANN CHRISTIAN RAUSCHNER

2, 3

Johann Christian Gottlieb Graupner and *Catherine C. Hillier Graupner*, about 1810
Colored wax
Johann Graupner: H. 4 in. (10.2 cm.), w. 3 in. (7.6 cm.)
Catherine Graupner: H. 4⅜ in. (11.1 cm.), w. 3 in. (7.6 cm.)
Gift of Louise C.D. Stoddard. 12.1094, 1095

Provenance: Catherine Graupner Stone, Santa Cruz, Calif.; Louise C.D. Stoddard

Portrayed in these diminutive glass-mounted wax reliefs are Mr. and Mrs. Johann Christian Gottlieb Graupner. Prussian by birth, Gottlieb Graupner (1767-1836) was a musician, who arrived in America in 1795 to play in a theater orchestra based in Charleston, South Carolina. There he met the distinguished English opera singer Catherine Comerford Hillier (1765?-1821), a widow, whom he subsequently married. In 1796 the talented couple moved to Boston. Mr. Graupner played the oboe at the Federal Street Theater, opened a music store and music printing establishment on Franklin Street, and founded an academy for the instruction

of music.[1] He and his wife also entertained local
audiences with their special concerts; she sang, ac-
companied by his piano, oboe, or stringed instru-
ment. Around the time that they sat for these por-
traits, Graupner was busy organizing Boston's Phil-
harmonic Society, an ensemble of musicians chiefly
of foreign birth and training that developed into
one of the country's finest orchestras. Several years
later, he helped to found the city's first important
choral group, the Handel and Hayden Society,
which gave its premier performance at King's
Chapel on Christmas Day, 1815. Mrs. Graupner
was the leading female soloist of the society. Her
repertoire ranged from difficult oratorios sung in
German to sentimental popular ballads. Upon their
deaths (hers in 1821, his in 1836) the Graupners
were buried at Mount Hope Cemetery in West
Roxbury, Massachusetts.

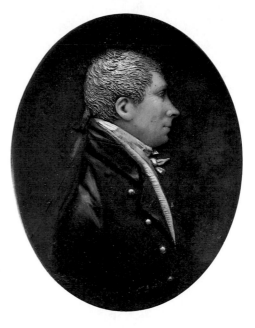

According to the Graupners' granddaughter,
Catherine Graupner Stone, these wax portraits
were modeled in South Carolina, shortly after the
couple's marriage.[2] Stylistically, the portraits sug-
gest a later date, probably sometime after the
Graupners' arrival in Boston. The Boston City Di-
rectory of 1810 lists "J.C. Rauschner—Artist in
Wax" living at 2 Winter Street; thus it is possible
that the portraits date from 1810. Both sitters are
dressed in the fashion of the period. The artist took
great care to reproduce in miniature the accessories
of Mrs. Graupner's costume, which include ruffled
lace on her dress, jewels in her coiffure, and a ring
on her finger.

J.S.R.

Notes

1. See *DAB*, s.v. Graupner, Johann; see also letter from
Louis C. Elson, musicologist, to W.H. Downes, March 20,
1913, BMFA, ADA.

2. Letter from Catherine Graupner Stone to Miss Paull,
May 11, 1915, BMFA, ADA.

2

3

Horatio Greenough (1805 – 1852)

During Charles Sumner's journey through Italy in
1839, he stopped in Florence to introduce himself
to a fellow Bostonian residing there who, in ten
short years, had distinguished himself as America's
leading sculptor. "Greenough I like infinitely,"
Sumner reported to a friend. "He is a person of
remarkable character in every way, — with scholar-
ship such as few of our countrymen have, with a
practical knowledge of his art, and the poetry of it;
with an elevated tone of mind that shows itself
exclusively in his views of art, and in all his conver-
sation. . . . he is a superior person to any of the
great artists now on the stage."[1]

The first American to pursue sculpture as his
exclusive profession, Greenough was also the first
native sculptor to seek training in Italy. Although
he adopted the fashionable pseudo-Hellenistic id-
iom of the Danish virtuoso Bertel Thorwaldsen
(1768-1844) and his numerous disciples in Italy,
Greenough imbued his own work with a romantic
sentimentality that distinguished it from the cold
detachment of doctrinal neoclassicism. An articu-
late art theorist, Greenough produced a body of
original writings on American sculpture, architec-
ture, and aesthetics that has survived close critical
inspection far better than his sculpture.

That Greenough's sculpture encountered misun-
derstanding and neglect from subsequent genera-
tions of critics is comprehensible when one consid-
ers how remote were his chances of success as a raw
American recruit to one of the world's oldest art
professions centered in one of nineteenth-century
Europe's most sophisticated art communities. Inex-
perience and inadequate theoretical training con-
spired against Greenough's full attainment of his
ambitious goals as a sculptor. While critics could
excuse his rudimentary preparation in the craft,
they still faulted him for failing to produce sculp-
ture that measured up to the promise of his genteel
background, cultured tastes, and fund of talents.

Greenough, who was born in Boston in 1805,
enjoyed a privileged though not always affluent
upbringing. His father, David Greenough, a
wealthy real-estate dealer, exposed his children to
conversation on art, literature, architecture, and
history at an early age. Even after the family for-
tunes suffered reverses after the War of 1812, the
children were given an education deemed proper
for Boston's upper-class society. In secondary
school and at Harvard (1821-1825), Horatio Green-

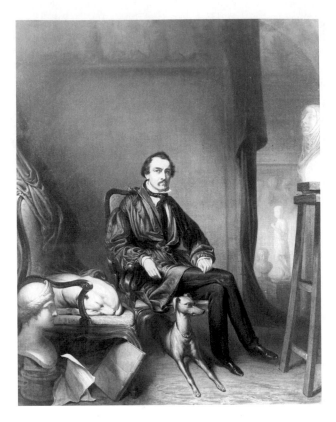

ough, always a quick student, distinguished himself
as a classical scholar. He was also a popular young
man, admired for his handsome looks, his wit, and
his polished manners.

From an early age, Greenough gravitated toward
sculpture, seeming to possess an instinctive fascina-
tion for plastic form. Childhood acquaintances re-
called that he occupied himself carving figures in
chalk and attempted to teach himself clay modeling
from instructions printed in the *Edinburgh
Cyclopedia*. His perseverance and obvious talent im-
pressed the director of the Boston Athenaeum, who
allowed him to study and sketch from the library's
limited collection of plaster casts of antique sculp-
ture. In adolescence, Greenough received instruc-
tion in carving from Solomon Willard (1783-1861),
an architect and carver, and Alpheus Carey (active,
Boston, 1815-1825), a tombstone maker. The
French sculptor J.B. Binon (active, Boston, 1818-
1820), who was then in Boston modeling portrait
busts, also allowed the ambitious young amateur to
observe his carving technique.

At Harvard, Greenough's inclination toward
sculpture was further strengthened by attending
lectures on anatomy given by the eminent Boston
physician George Parkman and by intensive study

of classical literature and mythology. During his junior year, Greenough came under the spell of Boston's aging doyen of art Washington Allston (1779-1843), who encouraged him to seek professional training in sculpture in Italy, where the painter himself had spent some profitable time as a young man. Despite the demands of his undergraduate courses, Greenough also managed to model a number of busts and develop a design for the proposed Bunker Hill Monument. Permitted by his parents and the college to leave for Italy before his scheduled graduation, Greenough sailed for Rome in the spring of 1825, his ship's passage and traveling expenses having been donated by several wealthy Boston merchants who believed in Greenough's artistic promise. Arriving in Rome in the autumn, he shared an apartment with the American painter Robert Weir (1803-1889) in a house on the Via Gregoriana, where the landscape painter Claude Lorrain had once lived. Immediately, he began his art studies, a regimen that included visits to museums and galleries, life-drawing lessons at the French Academy (Villa Medici), and participation as a provisional apprentice in Bertel Thorwaldsen's studio.

Greenough had hoped to remain in Rome for several years, but a severe attack of so-called Roman fever, possibly malaria, obliged him to depart for home in the winter of 1827. Once in Boston, his health returned, and after a short recuperation period spent sketching, modeling, reading, and writing, he felt well enough to solicit orders for portrait busts and to arrange a commission-seeking tour through the nation's capital. During this expedition, he met Robert Gilmor, Jr., a prosperous Baltimore merchant who was to become an important patron; he also arranged sittings with such Washington luminaries as John Quincy Adams and Chief Justice John Marshall.

In May 1828, his confidence buoyed by new orders for portrait busts and by his election to the National Academy of Design in New York, Greenough again set sail for Italy. Upon his arrival, he spent several months in the marble quarries near Carrara, presumably selecting stone and supervising preliminary cutting work on the commissions for busts he carried with him. He next traveled to Florence, where he decided to take up permanent residence. Not only did the Tuscan city boast superb art collections and a mild climate, but it was also home to a number of American artists whom Greenough knew, such as Samuel F.B. Morse

(1791-1872), Christopher Cranch (1813-1892), and Thomas Cole (1801-1848).

Another factor that influenced Greenough's choice of Florence as a center for his professional studies was the presence there of Lorenzo Bartolini (1777-1850), the renowned professor of sculpture at the Accademia di Belle Arti. Bartolini's insistence that his students sketch from life models impressed Greenough, who had been disturbed by the fussy attention to surface finish and the slavish devotion to copying from antique casts that had been advocated by contemporary Roman sculptors. Although Bartolini's style was neoclassical in its foundation, he infused a startling naturalism into his work (a style the Italians described as "verismo") that Canova (1757-1822) and Thorwaldsen would have heartily disapproved. Greenough applied to study with Bartolini and was accepted in his studio, where he had access to models, tools, and workmen, often observing dissections of human cadavers that Bartolini arranged. Unfortunately, the relationship between teacher and pupil soured by the 1830s, probably as a result of the Italian master's growing envy over Greenough's rapid artistic progress.

In Florence, Greenough's work began to develop the grace of design, nobility of thought, and refinement of tooling that characterized his mature sculpture. Two patrons emerged in this period to assist his career. The American novelist James Fenimore Cooper was Greenough's earliest benefactor in Florence and encouraged him to branch out from portraiture and apply his talents to imaginative compositions that dealt with literary themes. For Cooper, he executed his first ideal group in marble, *The Chanting Cherubs*, 1830 (present location unknown), which brought the sculptor both acclaim and notoriety. (See the discussion of this statue in the entry at cat. no. 9.) Robert Gilmor similarly fostered Greenough's inventive faculties by ordering a statue of Medora (present location unknown), the beautiful, doomed heroine of Lord Byron's poem *The Corsair*. Completed in 1832, the statue was exhibited with much fanfare at Harding's gallery in Boston before its shipment to Baltimore.

Following the successful debut of his sculpture in America, Greenough received numerous orders for ideal conceits as well as for individual and group portraits. He yearned, however, to create monumental sculpture that would assure him immortality in the annals of American art. In 1832 that opportunity arrived when he received a commission from the federal government to execute a colossal seated

figure of George Washington for the rotunda of the United States Capitol. Inspired by the pose of Phidias's *Olympian Zeus* (destroyed; reconstructed by a nineteenth-century French archaeologist) and indebted to Houdon's famous study of the statesman-soldier, 1789, for its features and expression, Greenough's *Washington* represented his most ambitious undertaking. After laboring on it for nearly eight years, Greenough was disappointed that his magnum opus received only mixed reviews when it reached Washington. Although his loyal supporters and a few critics wrote glowingly of the statue, the general public seemed bewildered by its complex symbolism. Many were offended by the figure's partial nudity and distressed that the sculptor had not interpreted America's "Cincinnatus" in the full glory of military dress. The statue suffered further insult when it was removed from the rotunda of the Capitol into the harsh glare and climate of the mall outdoors. Despite the controversy over the monumental *Washington*, Greenough was awarded a second government commission in 1837 for a group sculpture to adorn the east landing of the Capitol's entrance that would serve as a companion to Luigi Persico's (1791-1860) *Discovery Group* on the west landing. He chose a compositional theme illustrating what he considered white civilization's rightful conquest over the savage American Indian, which dramatized a frontiersman's valiant efforts to restrain an Indian from assaulting a white woman and her infant. Greenough worked diligently on the project until his death but did not live to see it installed. Known as *The Rescue*, the finished group took its place at the Capitol but eventually was removed from public view because of its objectionable racist connotations.

As Greenough's artistic career spiraled upward, his personal life prospered as well. In 1837 he married Louisa Gore from Boston, and their home in Florence soon became a genial gathering spot for a colorful international circle of artists and writers. Despite the political unrest prevalent in the Tuscan capital during this period, the sculptor purchased land on which to erect a studio in the Piazza Maria Antonia, now the Piazza Indipendenza. In 1840 Greenough's attachment to his adopted city strengthened considerably when he was elected a member of the faculty at the Accademia di Belle Arti.

Greenough's reputation was judged principally by the production of his studio; among his peers assessment of his work was generally high. Henry Tuckerman wrote admiringly: "His works are marked by purity of conception, correctness of taste, graceful design, and rare delicacy of sentiment."[2] Later generations of critics, less captivated by the aesthetics of neoclassicism, often found Greenough's personality more interesting than his sculpture. Today he is often studied as a progressive spokesman for functionalist design. Throughout his career he concentrated much of his intellectual energy on drafting proposals for the directions and principles he felt American artists and architects should pursue in their work. He urged his countrymen to stop plagiarizing the Greeks for themes and forms and to explore instead the inspirational material offered by their native land. Greenough's aesthetic theories, however, often contradicted his sculptural production. His most eloquent discourses on art were published as *The Travels, Observations, and Experiences of a Yankee Stonecutter* (1852) under the pseudonym Horace Bender.

In 1851 Greenough returned to America in expectation of undertaking an equestrian monument to George Washington. He also used the occasion to deliver lectures on art and to visit family and friends in Boston and Newport. In December 1852 he fell ill with a high fever that quickly claimed his life. His body was interred at Mount Auburn Cemetery in Cambridge. In Florence and Rome news of his death stunned the art communities, which had long ranked Greenough as one of their consummate professionals. His fellow sculptors Thomas Crawford and William Wetmore Story organized a memorial meeting in Rome, where Greenough was accorded the honorary title of "Pioneer of American Sculpture" and eulogized for his accomplishments in both art and art scholarship.

J.S.R.

Notes

1. Sumner to George W. Greene, Sept. 11, 1839, quoted in Edward Lillie Pierce, *Memoir and Letters of Charles Sumner* (Boston: Roberts, 1877-1893), vol. 2, p. 110.

2. Tuckerman, 1853, p. 235.

References

J.N. Bellows, "Horatio Greenough," *Knickerbocker Magazine* 7 (Apr. 1836), pp. 343-346; Benjamin 1880, pp. 138, 142; S.G.W. Benjamin, "Sculpture in America," *Harper's New Monthly Magazine* 58 (Apr. 1879), pp. 657-672; Theodore Brown, "Greenough, Paine, Emerson, and the Organic Aesthetic," *Journal of Aesthetics and Art Criticism* 14 (May 1956), pp. 304-317; Thomas B. Brumbaugh, "Horatio and Richard Greenough: A Critical Study with a

Catalogue of Their Sculpture," Ph.D. diss., Ohio State University, 1955; Clark 1878, pp. 50-60; Sylvia Crane, "Aesthetics of Horatio Greenough in Perspective," *Journal of Aesthetics and Art Criticism* (spring 1966), pp. 415-427; Crane 1972, pp. 21-168; Craven 1968, pp. 100-111; William Dunlap, *History of the Rise and Progress of the Arts of Design in the United States*, new ed. (Boston: Goodspeed, 1918), vol. 3, pp. 215-217; Edward Everett, "American Sculptors in Italy," *Boston Miscellany of Literature and Fashion* 1-2 (Jan.-July 1842), p. 4; "Fine Arts Gossip," *Bulletin of the American Art Union* 2 (Dec. 1849), pp. 21-23; James Fitch, "Horatio Greenough and the Art of the Machine Age," *Columbia University Forum* 2 (fall 1959), pp. 20-27; Gardner 1945, pp. 39-43; Gerdts 1973, pp. 22-25; Greenough 1887; Henry Greenough, "Horatio Greenough, the Sculptor," *American Magazine of Useful and Entertaining Knowledge* 2 (1834-1837), p. 367; Horatio Greenough, *Travels, Observations, and Experiences of a Yankee Stonecutter* (New York: Putnam, 1852); "Greenough, the Sculptor," *Bulletin of the American Art Union* 1 (May 1851), p. 61; "Greenough, the Sculptor," *Putnam's Monthly Magazine* 1 (Mar. 1853), pp. 317-321; "Horatio Greenough," *Boston Daily Advertiser and Patriot*, Oct. 25, 1833; Lee 1854, pp. 130-145; Charles Metzger, *Emerson and Greenough, Transcendental Pioneers of American Esthetics* (Berkeley: University of California Press, 1954); NYPL; Samuel Osgood, "American Artists in Italy," *Harper's New Monthly Magazine* 41 (1870), pp. 420-425; "Our Sculptors," *American Literary Magazine* 3 (1848), pp. 368-373; "Portrait Sculpture," *Crayon* 2 (Sept. 1855), pp. 165-166; Julia Shedd, *Famous Sculptors and Sculpture* (Boston: Houghton Mifflin, 1896), pp. 288-292; Harold A. Small, ed., *Form and Function: Remarks on Art by Horatio Greenough* (Berkeley: University of California Press, 1947); W.J. Stone, "Sketchings [Horatio Greenough's Sculpture at Washington]," *Crayon* 2 (Dec. 1855), pp. 392-393; Taft 1930, pp. 37-56; Thorp 1965, pp. 57-70; Tuckerman 1853; Tuckerman 1867, pp. 247-275; Henry Tuckerman, "Greenough, the Sculptor," *American Monthly Magazine* 1 (1836), pp. 53-56; Louis Viardot, *Wonders of Sculpture* (New York: Scribner, Armstrong, 1875), pp. 349-350; Nathalia Wright, "Horatio Greenough, Boston Sculptor, and Robert Gilmor, Jr., His Baltimore Patron," *Maryland Historical Magazine* 51 (Mar. 1956), pp. 1-13; Wright 1963; Wright 1972; Nancy Wynne and Beaumont Newhall, "Horatio Greenough, Herald of Functionalism," *Magazine of Art* 32 (Jan. 1938), pp. 12-15.

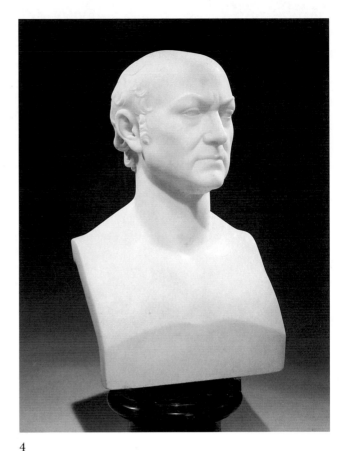

4

HORATIO GREENOUGH

4
John Quincy Adams, 1828
Marble
H. 12⅝ in. (32 cm.), w. 7½ in. (19 cm.), d. 6 in. (15.3 cm.)
Bequest of Mrs. Horatio Greenough. 92.2857

Provenance: Mrs. Horatio Greenough, Boston
Exhibited: Boston Athenaeum, 1830, 1839, 1841, 1843-1848, 1853-1855.
Versions: *Marble*, life-size: (1) Boston Athenaeum, (2) The New-York Historical Society

In January 1828, having recuperated from the virulent fever that had forced his temporary return to Boston the previous year, Greenough traveled to Washington, D.C., with the intention of modeling a portrait bust of President John Quincy Adams (1767-1848). While convalescing in Boston, Greenough had renewed his friendship with Washington Allston and found time to make a bust of Boston's mayor (and later Harvard president), Josiah Quincy. Both these influential men came to the young sculptor's aid by supplying him with letters of introduction to prominent artists, politicians, and

society figures whom he planned to contact during his stay in the capital. Quincy specifically addressed a request on Greenough's behalf to President Adams, who consented to sit for the sculptor on February 20. Adams recorded in his diary, "Mr. Greenough brought me a letter from Josiah Quincy, the Mayor of Boston, and asked permission to take my bust, to which I assented."[1]

Greenough modeled Adams's portrait at the studio he temporarily engaged in the home of Charles King (1785-1862), the portrait painter. Within two weeks the bust was finished and ready for casting in plaster. In the course of his sessions with the president, Greenough described his impressions of the sitter to his brother Henry. On February 21 he wrote, "Mr. Adams gave me my first sitting yesterday morning. A President is a man, you know, and so I put him in. He is much fallen away in flesh since Cardelli modelled him, and the character of his head is improved by it. His brow is unique. He gave me this morning nearly two hours. I think I have a likeness of him."[2] Despite his austere appearance, Adams proved to be an interesting conversationalist who could chat with animation about art as well as politics. It was, however, Adams's sober dignity that most impressed Greenough, who observed to his brother: "I shall not attempt (as Sully and others have done) to make him look cheerful. He does not and cannot. Gravity is natural to him, and a smile looks ill at home."[3] The resulting portrait, with its slightly taut, furrowed brow, is accordingly stern in feeling. The herm form that Greenough adopted intensified the severe and solemn effect of Adams's chiseled features and unadorned upper torso.[4]

Adams was apparently satisfied with Greenough's likeness of him. He implicitly showed approval by engaging the sculptor to carve a marble bust of his famous father for the Adams family monument in the United First Parish Church, Quincy, Massachusetts. Members of the Boston Athenaeum were also pleased with Greenough's portrait, for they ordered a copy of it for $200.[5] Presumably others were pleased as well, for Greenough made several life-size copies and at least one reduced version of the bust. These were probably carved in marble under Greenough's supervision during his three-month stay in Carrara in the summer of 1828. The sculptor evidently felt some special attachment to the double portraits he carved of the famous Adamses, father and son, for he kept custody of two half-size marble duplicates of the busts until his

death. His widow later bequeathed them both to the Museum of Fine Arts.

J.S.R.

Notes

1. John Quincy Adams, *The Memoirs of John Quincy Adams, Comprising Portions of His Diary from 1795-1848* (Philadelphia: Lippincott, 1875), vol. 8, p. 434.

2. Greenough 1887, pp. 25-26.

3. Ibid.

4. For other representations of Adams, see Andrew Oliver's "Portraits of John Quincy Adams and His Wife," *Antiques* 98 (1970), pp. 748-753. See also National Portrait Gallery, Washington, D.C., *A Man for All Seasons: The Life Portraits of John Quincy Adams* (1970), no. 18.

5. See Boston Athenaeum 1984, p. 139, pl. 63.

HORATIO GREENOUGH

5
John Adams, about 1830
Marble
H. 11½ in. (29.9 cm.), w. 6¹³⁄₁₆ in. (17.8 cm.), d. 6 in. (15.3 cm.)
Bequest of Mrs. Horatio Greenough. 92.2856

Provenance: Mrs. Horatio Greenough, Boston
Versions: *Marble*, life-size: (1) United First Parish Church, Quincy, Mass.

On February 28, 1828, eight days after his first sitting with John Quincy Adams, Greenough wrote with excitement to his brother Henry, "the President has given me a most gratifying proof of his respect for my talents, — an order for a marble bust of his father, to be placed on a monument in the granite church at Quincy and to be modelled after my own heart."[1] Although Greenough consulted a daguerreotype of John Adams (1735-1826) as a guide in preparing his sketch of the former president, he had committed Adams's features to memory years earlier. According to Henry Greenough, it was the convincing chalk bust of John Adams copied by Horatio, at the age of twelve, from a plaster likeness by the French sculptor J.B. Binon, 1819, in the Boston Athenaeum that had first gained him access to the fine arts room at the Athenaeum, after the library's director had admired the precocious talent evident in the young boy's facsimile.

For the bust of John Adams, Greenough chose the herm form and indicated to his brother that he would "treat the hair *au naturel*."[2] The resulting

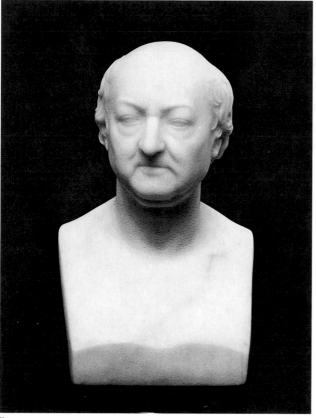

5

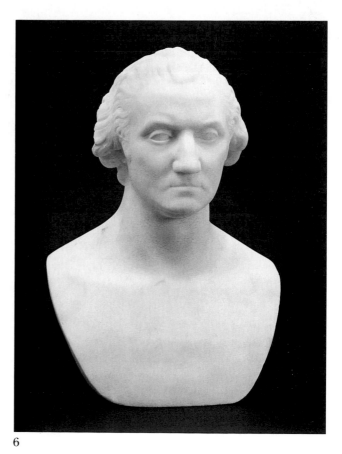

6

image proved less rigid than the previous Adams portrait, suggesting an air of benign calm rather than stiff reserve. In October 1829 the bust was installed and dedicated in the Adams family church in Quincy. The example in the Museum of Fine Arts is a reduced version of the life-size bust placed in the Stone Temple, or United First Parish Church, in Quincy. Together with the *John Quincy Adams* portrait (q.v.), the piece was given to the Museum in 1892 through the bequest of Greenough's widow.[3]

J.S.R.

Notes

1. Greenough to Henry Greenough, Feb. 28, 1828, published in Greenough 1887, p. 31.

2. Greenough to Henry Greenough, March 8, 1828, ibid, p. 32.

3. In his letter of June 7, 1892, to Charles G. Loring, informing the Museum's trustees of the terms of Louisa Gore Greenough's will, the sculptor's son, Horatio S. Greenough, referred to the two Adams portraits as "half size" busts. See BMFA, 1870-1900, roll 555, in AAA, SI.

HORATIO GREENOUGH
6
George Washington, about 1831
Marble
H. 14½ in. (36.9 cm.), w. 9⅝ in. (24.5 cm.), d. 7¾ in. (19.7 cm.)
Bequest of Mrs. Horatio Greenough. 95.1385

Provenance: Mrs. Horatio Greenough, Boston
Versions: *Marble,* life-size: (1) present location unknown, formerly Commander James Biddle, Philadelphia, (2) present location unknown, formerly James P. Roosevelt, Jr., New York

Charles Sumner once remarked that to produce a faithful likeness of George Washington was the noblest project an American sculptor could undertake. Scores of aspiring sculptors, both native and foreign-born, welcomed the challenge of such a venture as a means of achieving fame and profit from the potential sales of replications and reductions of their image to patriotic clientele. Moreover, a portrait that successfully expressed the magnetism, dignity, and sympathy of Washington's character invariably attracted the notice of government committees assembled to commission statues of the

first president for public squares and federal or municipal buildings.

The subject of George Washington preoccupied Horatio Greenough for much of his career, inspiring some half-dozen works or projected works,[1] the most notable and notorious of which was his colossal seated *pater patriae* (1832-1840) executed for the rotunda of the United States Capitol.[2] He first attempted to capture Washington's likeness when he was an undergraduate at Harvard, modeling a bust (present location unknown) based on a portrait by Gilbert Stuart (1755-1828). The exhibition of Stuart's *Washington at Dorchester Heights* at the Boston Athenaeum and the exciting unveiling of Sir Francis Chantrey's (1781-1841) full-length marble statue of Washington at the State House in Boston, in 1827, undoubtedly stirred Greenough's ambitions to produce his own interpretation of and tribute to the great military hero, politician, and gentleman farmer. Sketchbooks surviving from this early phase of his career show detailed studies of Washington's head and features and of the postures and costumes in which Washington had been immortalized by other artists of Greenough's generation.[3]

In 1832, after Greenough had lived in Italy for several years, his yearning for official recognition from his own country was amply gratified when he received an assignment from the American government for a heroic-sized monument to George Washington. Not only was Greenough keenly interested in the project, but he also enjoyed the distinction of being the first native-born sculptor to be honored with a federally subsidized commission for sculpture.

Greenough's commission was chiefly the result of determined lobbying on his behalf by several distinguished, well-connected supporters, including Washington Allston and James Fenimore Cooper. (The favorable criticism Greenough had received for his work to date, which consisted of a dozen creditable portrait busts and a couple of ideal studies, contributed less directly to the government committee's decision.) His champions probably called attention to the fine bust of Washington that the young sculptor had executed about 1830-1831 for the New York lawyer and congressman James P. Roosevelt, Jr., a replica of which he later made for Commander James Biddle, a naval officer from Philadelphia.[4] The bust was inspired by the French sculptor Jean Antoine Houdon's (1741-1828) authoritative bust of General Washington, finished in Paris in 1789 and familiar to most American and

European artists of the nineteenth century through its numerous casts and reproductions.[5]

Both Greenough's and his patron's respect for Houdon's work is readily understood when one considers that the French sculptor's bust was one of the rare studies taken of Washington from life. The bust and full-length portrait of the first president made by Houdon for the State Capitol, Richmond, Virginia, were based on a cast of Washington's face and on minute measurements of both head and figure that Houdon recorded during sittings he arranged with Washington at Mount Vernon in 1785. So accurate was his statue considered that when Congress authorized Greenough's *Washington* in 1832, it dictated that the head of the proposed figure be based explicitly on Houdon's prototype, permitting the sculptor to use his judgment on all other compositional matters.

The small bust of George Washington in the Museum of Fine Arts is believed to be a reduced copy of the portrait carved by the sculptor for James Roosevelt. Because it is undated and the circumstances of its genesis are unclear, it is also possible that the work was conceived by Greenough as a preparatory study for the Zeus-like image of Washington he executed for the nation's Capitol. The latter figure's debt to Houdon's famous portrait is obvious, particularly in the sitter's expression of stern concentration and air of strength and self-assurance. In the process of converting the features of Houdon's bust to a monumental format, the sculptor was obliged to make adjustments to the head, expression, and hairstyle to ensure that viewers would be able to see the piece from a distance. Although this half-life-size bust is not absolutely identical to the Houdon portrait or to Greenough's colossal *Washington*, it forms a recognizable transition between the French source the sculptor was instructed to follow and the resolution of facial expression, profile, and characterization or mood he effected in the Capitol's massive seated figure of the commander in chief. The marble bears a striking resemblance to the original plaster bust of Washington (Chicopee Public Library, Massachusetts) that Greenough modeled as a preliminary study for the monument in 1830,[6] except that the Museum's bust lacks the classical drapery.

J.S.R.

Notes

1. Wright 1963, p. 118.

2. See Wayne Craven, "Horatio Greenough's Statue of Washington and Phidias' Olympian Zeus," *Art Quarterly* 26 (winter 1963), pp. 429-440; see also Alexander Everett, "Greenough's Statue of Washington," *United States Magazine and Democratic Review* 14 (June 1844), pp. 618-621.

3. Sketchbooks are in the John Davis Hatch Collection, Lenox, Mass. Several of the sketches are reproduced in Thomas B. Brumbaugh, "Horatio and Richard Greenough: A Critical Study with a Catalogue of Their Sculpture", Ph.D. diss., Ohio State University, 1955, pp. 61-63.

4. According to Crane 1972, p. 442, Roosevelt commissioned the bust of Washington in 1830, and the copy later made by Greenough for Commander Biddle is that owned by the Museum of Fine Arts. There is no documentation to support the idea that the Museum's bust was owned by Biddle; it descended through the Greenough family and was given to the Museum by Horatio Greenough's widow in 1895; it may be a third replica of the bust modeled after Houdon's.

5. See Frances D. Whittemore, *George Washington in Sculpture* (Boston: Marshall, Jones, 1933), pp. 20-31; see also Mantle Fielding and John Hill Morgan, *Life Portraits of George Washington* (Philadelphia: Lancaster Press, 1931); John S. Hallam, "Houdon's *Washington* in Richmond: Some New Observations," *American Art Journal* 10 (Nov. 1978), pp. 73-80.

6. The plaster bust of Washington was given to the Chicopee Public Library in 1895 by Melzar Hunt Mosman, a sculptor and local bronze founder. According to the library's records, Mosman purchased the bust in Florence from the sculptor Larkin Mead, who had obtained the plaster from Greenough's heirs when Greenough's studio was dismantled. The gift is discussed in "Report of the Trustees of the Public Library," *Chicopee Municipal Register* (Chicopee, Mass., 1913), pp. 309-310.

I am indebted to Annette Dulude, reference librarian of the Chicopee Public Library, for sending me information on and illustrations of the Washington bust.

HORATIO GREENOUGH

7

Alexander Hamilton, about 1832
Marble
H. 20½ in. (52 cm.), w. 12¼ in. (31.2 cm.), d. 10⅞ in. (27.7 cm.)
Bequest of Mrs. Horatio Greenough. 92.2644

Provenance: Mrs. Horatio Greenough, Boston
Exhibited: Boston Athenaeum, 1855, 1856.

The sudden, tragic death of Alexander Hamilton (1757-1804) instantly secured him a revered place in history as one of America's great patriots. The popular demand for portraits of Hamilton, who, as first secretary of the United States Treasury, had been celebrated for his rational conservatism, was enormous. One artist whose reputation gained posthumously from this popular demand was an Italian sculptor named Giuseppe Ceracchi (1751-1801), who had taken Hamilton's bust from life in 1794. Ceracchi's Italianate portrait of Hamilton (The New York Public Library) was one of a series of busts he had modeled in the 1790s as part of an ambitious project to record the likenesses of the young Republic's leading citizens.[1] Of the twenty-seven busts Ceracchi completed (originally modeled in potter's clay and later carved in Italian marble), Hamilton's was judged the most successful. Upon Hamilton's death in 1804, numerous casts were made of the bust and distributed to purchasers in various cities and states.

Horatio Greenough's bust of Alexander Hamilton is unquestionably based on Ceracchi's 1794 portrait. One of a small group of portrait studies the sculptor made of American statesmen in the late 1820s and 1830s, it was probably modeled in the summer of 1832,[2] when Greenough was also occupied with finishing busts of his friend James Fenimore Cooper and of the fur trader John Jacob Astor, both of whom were then traveling in Europe. Although the facial expression and features depicted in Hamilton's bust were considered faithful to his appearance and to Ceracchi's life portrait of him, critics have objected to Greenough's monotonous and mechanical treatment of the sitter's Alexandrian or Augustan coiffure.[3]

The sculptor's son, Horatio, had the bust in his possession at his home on Beacon Hill in Boston by 1882, when he first communicated with the Museum of Fine Arts about it and other marbles by his father that the Greenough family was considering donating to the institution.[4] The bust was part of the group of statues bequeathed to the Museum ten years later through the estate of the sculptor's widow.

J.S.R.

Notes

1. See Ulysses Desportes, "Great Men of America in Roman Guise, Sculptured by Giuseppe Ceracchi," *Antiques* 96 (July 1969), pp. 72-75.

2. Wright 1963, p. 96.

3. See, for example, Taft 1930, p. 47.

4. Horatio S. Greenough to Charles G. Loring, Jan. 24, 1882, BMFA, 1876-1900, roll 550, in AAA, SI.

—

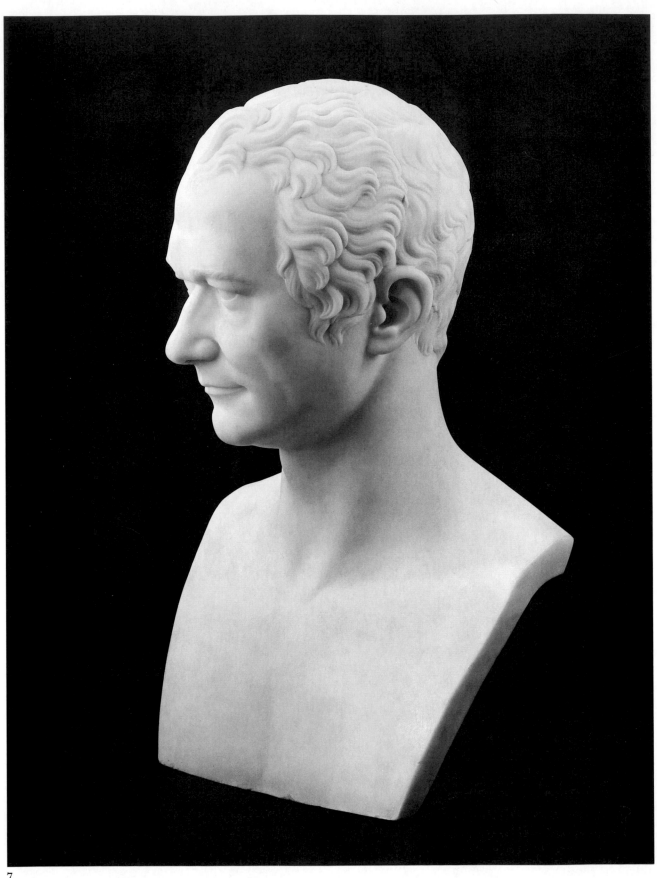

7

HORATIO GREENOUGH
8
Marie Joseph Paul Yves Roch Gilbert du Mortier, Marquis de Lafayette, about 1833
Marble
H. 13 in. (33 cm.), w. 11¼ in. (28.6 cm.), d. 7 in. (17.8 cm.)
Bequest of Mrs. Horatio Greenough. 95.1386

Provenance: Mrs. Horatio Greenough, Boston
Exhibited: Boston Athenaeum, 1855, 1856.
Versions: *Marble,* life-size: (1) Massachusetts State House, Boston, (2) The Pennsylvania Academy of the Fine Arts, Philadelphia

In the winter of 1830 Greenough formulated the idea of modeling a bust of France's venerable statesman and military hero the Marquis de Lafayette (1757-1834). Lafayette's voluntary service as a major general in Washington's army during the American Revolution had ensured his lasting popularity with American audiences.[1] Vivid proof of that appeal was demonstrated anew just as Greenough was preparing to embark on his first journey abroad. In 1824 the French general accepted President James Monroe's invitation to visit the young nation he had once aided, and his triumphant tour through each of the new republic's twenty-four states not only renewed but also enhanced the legend of Lafayette as liberty's inveterate champion. Greenough thus was well aware of the favorable publicity such a bust would attract, confessing, "His portrait would be worth a fortune to me hereafter."[2]

Doubtful of securing permission to model the famous man on his own application, Greenough prudently forwarded his proposal through James Fenimore Cooper,[3] who was then living in Paris. Although Lafayette was at first reluctant to grant Greenough a sitting, he soon yielded under Cooper's persuasion, on condition that the celebrated writer supervise and entertain him during the sessions. In February 1831, Cooper informed Greenough that the general had agreed to sit for him later that spring. The sculptor was detained in Florence by studio work, however, and it was not until August that he was able to leave for France.

Greenough's arrival in Paris in late summer proved inconvenient for Lafayette's hectic political schedule. During the July Revolution of the previous year, the seventy-two-year-old Frenchman had assumed the post of commandant of the National Guard. Although he technically resigned from public service that December, the task of reestablishing public order had pursued Lafayette into retire-

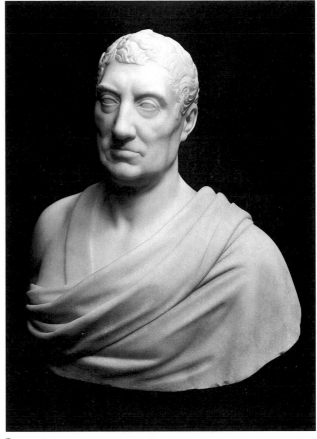
8

ment, burdening him with many government responsibilities. Greenough had originally been promised six hour-length sittings with the general but was forced to settle for the free minutes that Lafayette could spare him. In a letter to his brother Henry, dated October 14, 1831, Greenough complained, "Lafayette has been so much occupied with public duties that although he had the best will in the world, he has not been able to sit until now. I had half an hour with him yesterday, and made a sketch which is recognized by everyone."[4] Over the next few weeks Greenough lingered on at Lafayette's country estate, La Grange, outside Paris, waiting to advance the bust when time and conditions permitted. During this interlude, he amused himself by visiting art museums, socializing with members of Lafayette's republican circle, and modeling a bust of Cooper, his frequent companion and confidant. He constantly lamented the interruptions delaying his progress on Lafayette's bust. "Circumstances required that I should be on the alert for more than a fortnight to seize such pitiful quarter of an hour afforded by the pressure of General Lafayette's affairs," he wrote to the painter Rem-

brandt Peale (1778-1860).[5] Yet his patience was re-warded, for his letter to Peale continues: "I have finished (the bust), however, and they say it's like him—thanks to Cooper, who pinned the old gentleman to his chair one morning for two whole hours with stories and *bons mots*—I believe that was the saving of my bust—for I had become out of humour with it and you know how fatal that often proves."

Despite the frustrations encountered in his efforts to capture the likeness and personality of the preoccupied French politician, Greenough was very pleased with the end result. After leaving Paris for Marseilles in December, he confessed to his brother, "my bust of Lafayette would alone repay my journey."[6] In 1833 he transferred the bust into marble (The Pennsylvania Academy of the Fine Arts, Philadelphia) and had a print made of it, so that others could judge and admire it. One of those who saw the print and expressed a high opinion of the work illustrated was Dominique Ingres (1730-1867), the French painter who had been recently appointed director of the French Academy at Rome. According to Greenough, he "had the pleasure of hearing it called 'very like, and in a beau style,' by a man who never flatters."[7] Cooper wrote an enthusiastic description of the recently finished bust to William Dunlap, who quoted the comments in his book *History of the Rise and Progress of the Arts of Design in the United States* (1834). Comparing Greenough's portrait of Lafayette with that by the French artist Jacques Louis David (1748-1825), Cooper reflected that "the bust of Greenough is the very man, and should be dear to us in proportion as it is faithful." As Lafayette himself expressed it, "one is a French bust, the other an American."[8]

The frank realism of the reduction in the Museum of Fine Arts of Greenough's original life-size bust of Lafayette is somewhat startling considering the conventional neoclassical staging of the portrait.[9] Although the sculptor costumed his sitter with drapery and a sword strap reminiscent of Greek and Roman military figures, bestowing him with the type of stylized, curled coiffure found in portraits from classical antiquity, he did not attempt to idealize Lafayette's homely features. The marquis's conspicuously large nose, sagging flesh, and flat ears peculiarly tight to the head are clearly depicted in the portrait. Such accuracy of reporting was not intended to detract from the dignity of his sitter. Rather, Greenough intended the honest portrayal to refresh public memory of the man—

admittedly odd-appearing—of forceful personality whose dedication to civil liberties, individual rights, and religious tolerance had fired and sustained the republican impulses of Frenchmen and Americans alike for over half a century.

J.S.R.

Notes

1. On the subject of Lafayette's popularity and influence in America, see Robert I. Goler, *The Legacy of Lafayette*, exhib. cat. (New York: Fraunces Tavern Museum, 1984).

2. Greenough to James Fenimore Cooper, Dec. 6, 1830, The Collection of American Literature, Beinecke Rare Book and Manuscript Library, Yale University, New Haven.

3. Ibid.

4. Greenough 1887, pp. 87-89.

5. Greenough to Rembrandt Peale, Nov. 8, 1831, NYHS.

6. Greenough to Henry Greenough, Dec. 1832, published in Greenough 1887, p. 90.

7. Greenough to Henry Greenough, Sept. 3, 1834, ibid., pp. 97-98.

8. William Dunlap, *History of the Rise and Progress of the Arts of Design in the United States*, new ed. (New York: Scott, 1834), vol. 3, pp. 227-228.

9. The original bust of Lafayette was purchased in 1834, the year of Lafayette's death, by Francis Kinlock of South Carolina, a friend of the sculptor's and an aspiring artist himself, and was given to the Pennsylvania Academy of the Fine Arts in 1847.

A life-size bust of Lafayette in contemporary dress at the New-York Historical Society may be a work of Richard Greenough, done in the 1850s. See Thomas B. Brumbaugh, "The Art of Richard Greenough," *Old-Time New England* 53 (Jan.-Mar. 1963), p. 70.

HORATIO GREENOUGH

9

The Ascension of a Child Conducted by an Infant Angel, 1833

Marble

H. 32⅞ in. (81.9 cm.), w. 23¼ in. (59.1 cm.), d. 13 in. (33 cm.)

Signed (on back of base): H⁰ GREENOUGH.Fᵗ.1832

Inscribed and gilded (across front of base): QUAENUNC ABIBIS IN LOCA

Gift of Laurence Curtis. 26.46

Provenance: Samuel Cabot; Thomas B. and Laura Greenough Curtis; Horatio Greenough Curtis; Laurence Curtis (all of Boston)

Exhibited: Amory Hall, Boston, Nov. 1834-Feb. 1835; Boston Athenaeum, 1840; The Newark Museum, N.J.,

Classical America 1815-1845 (1963), no. 251; University Art Museum, Berkeley, Calif., *The Hand and the Spirit: Religious Art in America, 1700-1900* (1972), no. 24; BMFA, "Confident America," Oct. 2-Dec. 2, 1973; The Museums at Stony Brook, N.Y., *A Time to Mourn: Expressions of Grief in the Nineteenth Century* (1980), no. 1.

The Ascension of a Child Conducted by an Infant Angel, otherwise known simply as *Angel and Child* or *Journey to Heaven,*[1] evolved from the time-honored tradition of sculptural putti that Horatio Greenough first explored in his work in the winter of 1829. That year, he received an order for an ideal group in marble from the American novelist James Fenimore Cooper, who had befriended Greenough in Florence. The commission was not only professionally important to Greenough, since his previous work had been confined to portraiture and plaster sketches; it was also of historical importance in American art because no native-born American sculptor had yet attempted to model two interrelated figures in a single marble statue.

Greenough's venturesome patron had first discerned the young sculptor's talent when he engaged him to model his portrait bust (Boston Public Library) in the winter of 1828-1829. Cooper thereafter resolved to underwrite a "vehicle" to propel his protégé into the public eye. Borrowing an idea from a favorite painting he admired in the Pitti Palace, Raphael's *Madonna del Baldacchino,* Cooper proposed the theme of two singing cherubs. Happy to comply with his client's request, Greenough had discharged by 1830 the order for the *Chanting Cherubs* (present location unknown),[2] a study of two naked putti warbling a song. At Cooper's recommendation, the group was shipped to America for exhibition. Greenough arranged for the statue's debut in Boston, a decision its owner regretted, fearing that Boston's prudish citizens might protest the nudity of the two figures. Cooper's premonition was partially justified; although many Bostonians who viewed the group were favorably disposed toward it, another group denounced the unclothed twosome and, at one point, actually tied aprons around the cherubs' waists. Fortunately, the apron-diapers were removed quickly and the infants restored to their pristine condition, but the incident continued to rankle the indignant sculptor for many months.

Understandably, Greenough felt somewhat apprehensive about the fate of a second statue of naked boys he began in 1832. The work was commissioned by Samuel Cabot, a Boston merchant who had lived briefly in Florence and knew Green-

ough's artistic skill through a bust the sculptor had carved of Cabot's eleven-year-old daughter, Elizabeth. Drawing inspiration again from the tradition of endearing juvenile conceits formularized in the sculpture of Donatello and Luca della Robbia, Greenough described his theme as illustrating "a young angelic figure conducting a babe to the other world. The points of expression will be the contrast between the ideal forms and face of the cherub and the milky fatness of the baby, the half-doubting, half-pleased look of the child."[3]

Greenough meditated at length on the issue of nudity before committing himself to a design that might threaten his reputation or alienate his patron. Choosing to respect both the purity of his artistic motive and the convention of nudity in classical sculpture, he portrayed the figures "stark naked," as he phrased it. The decision had involved mutual concession between client and artist, for, as Greenough facetiously confided to Cooper, "The conversation that passed between me and the gentleman who ordered the group was a scene. I fought hard and carried the day—the little fellows are to be provided with alabaster fig leaves which shall fall at the tap! of the hammer when the discerning public shall have digested the fruit of the knowledge of good and evil."[4]

With the provision of detachable fig leaves as his safeguard, Greenough began to block out the statue that winter. By the following spring, the model was on the verge of completion, and Greenough reported to an American colleague, "My journey to Heaven groupe [*sic*] is far advanced, I feel confident it will take quite as well as the former one."[5] He finished the work in marble about a year later (although he inscribed on the statue the year he received the commission, 1832) and shipped it to Boston in the autumn of 1834.[6] When the time came for Cabot to make final payment on his new acquisition, Greenough reduced the original price of 700 Tuscan crowns[7] as a gesture of courtesy to Cabot's father-in-law, Colonel Thomas Handasyd Perkins, one of the sculptor's earliest generous supporters. "I trust you do not think I went too far in taking off two hundred dollars from the price of the work," he wrote his brother Henry in February 1835; "I am under obligation to the Perkins family, and was very unwilling to have the charge appear extortionate."[8] The sum that Greenough received from Cabot in fact barely covered the costs of the stone and marble cutting.

On November 4, 1834, *Angel and Child* was placed

on exhibition for three-and-a-half months at Boston's Amory Hall. Proceeds from the sale of tickets were donated to a fund for the children of indigent seamen, a pet charity of Samuel Cabot's. Installed in front of a green screen and bathed in sunlight filtered through a rose-colored silk curtain, Greenough's statue attained overnight celebrity, eliciting an outpouring of grandiloquent prose and effusive verses from spectators who flocked to examine the "exquisite" group. (It is uncertain whether the two marble children were equipped with alabaster coverings at the time of their debut, but remonstrances against their nudity were significantly absent in the press notices of the statue published in 1834 and 1835.) Washington Allston, among other local artists and literati, made a special visit to inspect Greenough's production, afterwards composing a rapturous poetic tribute to it.9 Deeply touched by his aging mentor's compliment, Greenough wrote a note thanking him for the "verses . . . as far from being addressed to the mind of the many as my composition was from being adapted to their tastes," adding the announcement, "I have made up my mind to look for the approbation of a few."10

Despite Greenough's pronouncement of indifference to popular acclaim, he shrewdly incorporated elements into *Angel and Child* that guaranteed its favorable reception by the American public: uplifting thought, tender sentiment, clever composition and workmanship, and a high-quality medium (white marble) that complemented the composition's narrative. Critics praised at length the uncommon purity of the statue's marble,11 a feature that assumed peculiar emblematic importance in light of the spiritual innocence of the two prepubescent subjects. Greenough's workmanship and staging of theme were equally commended for their "truth and grace," and his rendering of the two boys' bodies was cited as physiological perfection transferred to stone.

In an age when infant mortality was high, the contemporary art public interpreted Greenough's statue as conveying a message of hope to viewers troubled by or grieving over the death of a child. The composition supplied an implicit answer to the question emblazoned in gilt across the front of the base, QUAENUNC ABIBIS IN LOCA, translated by nineteenth-century viewers as "Whither now wilt thou pass?" The angel's assuring look and gentle nudging of the child insinuated the response, "To Heaven, Come hither and I will show thee."12 The comforting sentiment inferred from Greenough's conceit was precisely that disseminated in the popular genre of consolation literature and was related to the emotion that motivated Americans to replace dreary graveyards with cemeteries conceived as sculptural gardens where pleasant memories of the "dearly departed" could be savored.

The expression and physical attitudes of the two infants were the central themes around which critics embroidered their extravagant tributes to *Angel and Child*. George Hillard, who wrote an extensive critique of the group for *New England Magazine*, called the statue a "fine poem in marble" and elaborated on the meaning Greenough had compressed into the figures' faces and postures. He described the mortal child as shrinking back, "dazzled and half-appalled, from the 'sapphire-blaze' which bursts upon his eyes. Wonder, doubt, and delight are mingling and struggling in his baby face. The attitude of his body and limbs shows that he has been arrested in his onward progress, and stands uncertain whether to advance or retreat; fervently longing to proceed, yet shrinking back in vague apprehension or deep humility."13 Of the child's angel guide, Hillard wrote, "[he] is a being of a different order from the child. . . . He approaches the open splendours of Heaven with the assurance of one who is drawing nigh to his own home; and yet his countenance beams with sympathy and love for his earthly brother, whom he has been commissioned to bring into the presence of their Common Father. His attitude is expressive of kindness and protection, but of no arrogant assumption of superiority." To appreciate the full drama of these emotions, Hillard recommended that spectators view the face of the angel in profile and that of the child's in full, for "the serene and tranquil assurance of the former is seen in the well-defined outline of his countenance; while it is only by a front view of the delicate features of the child, that we can gather the various emotions by which they are possessed."14

Repeatedly, critics praised the narrative clarity of *Angel and Child*, noting that unlike most statues by Greenough's contemporaries, his needed no accompanying text to explain its theme. Henry Tuckerman attributed the statue's success to Greenough's balance of contrasting moods in the work and to the sensitive exchange created between terrestrial and celestial affections. The essence of the group's drama was epitomized for him by "the baby outline of the child, rounded, natural, and real—and the mature celestial grace of the angel—his look of holy courage and his attitude of cheer."15

Modern viewers rarely approach sculpture with

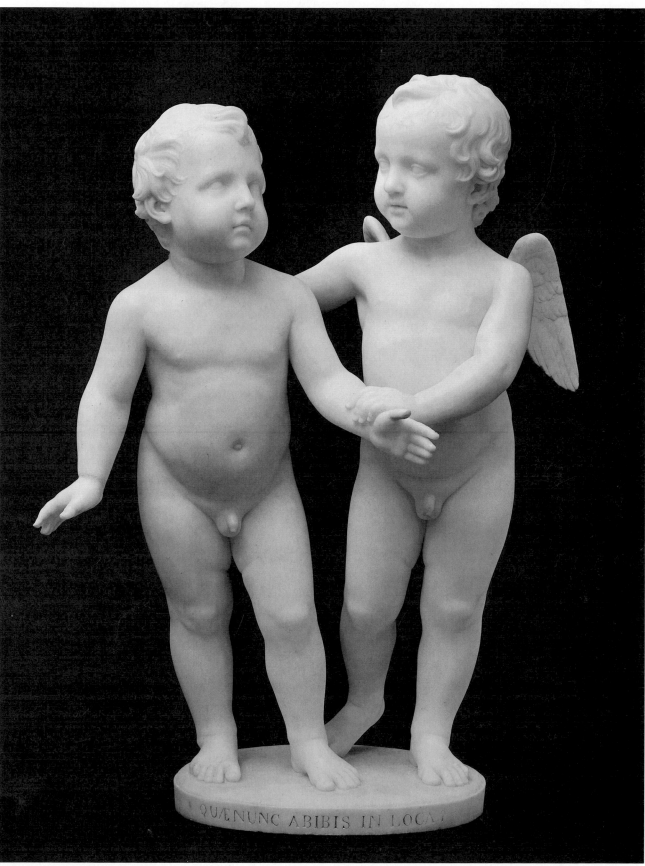

QUÆNUNC ABIBIS IN LOCA

the same emotional receptivity as did nineteenth-century spectators, who were primed to appreciate the psychological and spiritual nuances of a statue on the virtue of its title or announced theme alone. In the 1830s Americans had little familiarity with marble sculpture and therefore tended to judge it with less critical detachment than did the more sophisticated art public in England and Europe. Meaning rather than form or technical execution served as the standard by which accomplishment was measured. The accolades bestowed on *Angel and Child* by contemporary American critics were motivated less by its aesthetic merits than by its poignant theme and its rarity as an example of marble workmanship by a native sculptor; the reputation of both the statue and Greenough profited accordingly. One enthusiastic commentator for the American Art Union likened Greenough's sculpture to that of Michelangelo and reflected that what excited him about the American's statues was "the mental action of the figures—the inner and intense spirit which flames forth from them . . . we contemplate (them) and muse rather than gaze."[16]

Although Samuel Cabot was the first owner of *Angel and Child*, the statue passed back into the hands of the Greenough family later in the nineteenth century. It is worth noting that the piece was lent to the Museum of Fine Arts in the 1890s[17] by the grandchildren of the sculptor, at least thirty-five years before the statue became part of the Museum's permanent collection.

J.S.R.

Notes

1. Tuckerman 1853, p. 54, no. 4, lists the work as *Angel and Child* and also as *The Ascension of the Infant Spirit*.

2. Wright 1963, p. 321, records that a plaster group of two small nude figures was given to the Museum of Fine Arts in 1892 through the bequest of Mrs. Horatio Greenough. It is possible that this group represented the *Chanting Cherubs* and was accessioned as part of the Museum's plaster cast collection, much of which was either sold or broken in the early decades of this century. Horatio S. Greenough, in his 1892 letter to the Museum's trustees specifying the works by Greenough bequeathed to the institution by his mother, mentioned a "plaster group of two boys." H.S. Greenough to Charles G. Loring, June 7, 1892, BMFA, 1876-1900, roll 555, in AAA, SI.

3. Greenough to James F. Cooper, Dec. 18, 1832, published in Wright 1972, pp. 152-154.

4. Greenough to Cooper, Jan. 29, 1833, published in James Fenimore Cooper, *Correspondence of James Fenimore Cooper* (New Haven: Yale University Press, 1922), vol. 1, p. 309.

5. Greenough to Samuel F.B. Morse, quoted in Crane 1972, p. 90.

6. The clay or plaster study for the statue remained in the sculptor's studio, where Henry Tuckerman saw it when he visited Greenough in 1837; see Tuckerman, *The Italian Sketch-Book* (Philadelphia: Key and Biddle, 1837), p. 259.

7. See Greenough to Samuel Cabot, Nov. 12, 1832, published in Wright 1972, p. 149.

8. Greenough to Henry Greenough, Feb. 17, 1835, published in Greenough 1887, pp. 104-105.

9. See *Boston Daily Advertiser*, Dec. 30, 1834, reproduced in Tuckerman 1853, appendix.

10. Greenough to Allston, Mar. 7, 1835, Dana Papers, MHS.

11. See Rev. C. Follen's 1840 tribute in *The Boston Athenaeum Art Exhibition Index 1827-1874*, ed. Robert F. Perkins and William J. Gavin (Boston: The Library of the Boston Athenaeum, 1980), pp. 296-297.

12. Ibid., p. 297.

13. George S. Hillard, "Mr. Greenough's New Group of Statuary," *New England Magazine* 8 (1835), pp. 41-44.

14. Ibid.

15. Tuckerman 1853, p. 30; see also Tuckerman 1857, p. 258.

16. *Bulletin of the American Art-Union*, Sept. 1851, pp. 96-97.

17. The statue's presence at the Museum by 1891 is confirmed in Laurence Curtis's letter to Charles G. Loring on March 17 of that year, mentioning his plans to retrieve a marble bust of a child by Greenough then on loan to the Museum and stressing, "the marble bust is not to be confounded with my marble group of *Angel and Child* by Greenough which will remain with you." BMFA, 1876-1900, roll 555, in AAA, SI.

HORATIO GREENOUGH
10
Love Prisoner to Wisdom, 1836
Marble
H. 43¼ in. (110 cm.), w. 12½ in. (31.8 cm.), d. 14½ in. (36.9 cm.)
Bequest of Mrs. Horatio Greenough. 92.2643

Provenance: Mrs. Horatio Greenough, Boston
Exhibited: Boston Athenaeum, 1854-1856.

In 1835 Horatio Greenough was occupied with the commission for *George Washington* as well as inundated by urgent orders for over a dozen portrait busts. Despite these commitments, he found time to produce models for two statues of a more blithesome, imaginative nature: playful group portraits of the Sears children, 1835-1837 (Massachusetts Historical Society, Boston), and Thomson chil-

dren, about 1837 (private collection), of Boston and New York, depicting the subjects sporting with a pet squirrel (Sears) and engaged in a shuttlecock match (Thomson). His labors on these juvenile images may have inspired Greenough to complete an ideal subject that had diverted him for several years involving the youthful god Cupid.

The idea for this statue had occurred to the sculptor after reading a Renaissance sonnet by Petrarch in *Trionfo della Castità*, concerning a battle between Chastity and her sensual foe Cupid.[1] In the poem Chastity eventually conquers Cupid by catching and fettering him. According to a letter from Greenough to Robert Gilmor in 1835,[2] the sculptor originally planned to depict the feelings of mischief and shame experienced by a god of love who has been chained to a rock, guarded over by a bird of wisdom. He slightly altered this idea by dramatizing not the adult but the boy-god Cupid chained to rocks on which an owl, symbolic of wisdom, stood watch. In March of that year he described his progress on the revised statue to Washington Allston: "I have a statue rough hewn which I wish to finish but have not the time—Love Prisoner—to wisdom— His feet are chained and the Bird of Minerva sits by on the stone where his chain is fastened. I have tried to represent that twisting impatience which a boy manifests at restraint in his form and an expression of treachery and mischief on his face."[3] This theme of prudence restraining reckless love represented precisely the sort of banal moral indoctrination that Greenough's American public prescribed for art. Greenough may have consciously or subconsciously sympathized with his impetuous Cupid, however, for at the time he was a reluctant thirty-year-old bachelor.

Visually, *Love Prisoner to Wisdom* reflects a compositional technique that Greenough had learned from studying the ancient sculpture of Praxiteles and his school (4th century B.C.). Cupid is posed in a graceful contrapposto stance, a challenging posture for a sculptor to master because it demands perfect understanding of the human body's weight and shifting balance. The rhythmic flow of subtle, sinuous lines makes the figure appear more mature than the pudgy cherubs depicted in *Angel and Child* (q.v.). Less successful, though typical of American neoclassical sculpture, is Greenough's management of props and textural effects. The owl, which is a crucial narrative clue to the sculptor's theme, appears squat, lifeless, and seemingly incidental to the composition. Exaggerated attention has been di-

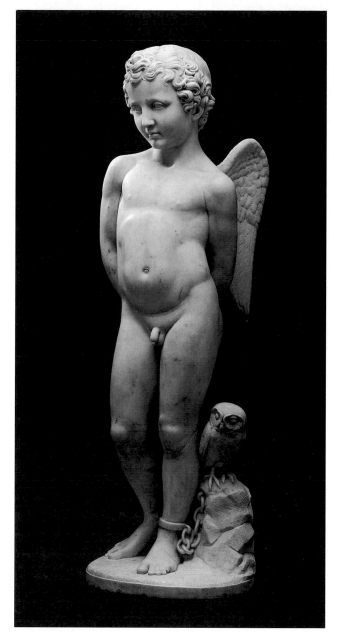

10

rected to the individual links of the chain that binds Cupid to the rocks, a bit of technical "showmanship" that lures attention away from the central figure to an accessory of the composition.[4] The viewer's eye is similarly distracted by the intricate ornamental patterns of Cupid's wings and by his coiled hair, an effect that Lorado Taft likened to a profusion of curled "marble watchsprings."[5]

Serious critics of sculpture virtually ignored this marble anecdote of Greenough's in the antique style.[6] Nevertheless, tourists who saw *Cupid* in Greenough's studio were often charmed by it. Frances (Fanny) Appleton, who became the sec-

ond wife of the poet Henry Wadsworth Longfellow in 1843, traveled through Florence, including the *de rigeur* stop at Greenough's studio on her itinerary. On May 15, 1836, she noted in her diary that she had visited the American sculptor's working quarters and recalled a small statue, probably only recently finished in marble, that had amused her: "Here is his last work, a lovely Cupid with hands tied—a very original expression to the beautiful face of his hacknied Godship."[7]

Love Prisoner to Wisdom typifies the genus of "fancy work" that amused Greenough when he could spare time from his steady studio trade in portraits and more heroic ideal statues. There is no evidence of his having sold any copies of the piece, and thus it may be assumed that this marble is a unique image. Greenough kept the statue in his personal collection until his death, at which time his widow lent *Love Captive* (her abbreviated name for the work) to the Boston Athenaeum. In a letter of 1882, reviewing the compositions by Greenough that the sculptor's widow intended to donate to the Museum of Fine Arts, Horatio S. Greenough described the piece as "an ideal statue of Love (Restrained) to an Owl (the emblem of the Goddess of Wisdom.)"[8]

J.S.R.

Notes

1. This statue is known under a variety of titles, including *Love Captive* and *Cupid Bound*. Greenough referred to it as *Love Prisoner to Wisdom* in a letter to Washington Allston, Mar. 7, 1835, Dana Papers, MHS. The Greenough family called the piece *Love Captive* in their correspondence with the Museum of Fine Arts.

2. Greenough to Gilmor, Nov. 28, 1835, published in Wright 1972, pp. 190-191.

3. Greenough to Allston, Mar. 7, 1835, Dana Papers.

4. Taft 1930, p. 47, interpreted this chain as a bit of showmanship on Greenough's part, in that it required "costly workmanship" to produce.

5. Ibid.

6. I have been unable to locate any critical commentary on this particular statue in the art periodicals and American newspapers of the 1830s and early 1840s. The piece is not listed in Tuckerman 1853.

7. Diary of Frances E. Appleton, vol. 11, May 15, 1836, Longfellow National Historic Site, Cambridge, Mass.

8. Horatio S. Greenough to Charles G. Loring, Jan. 24, 1882, BMFA, 1876-1900, roll 550, in AAA, SI.

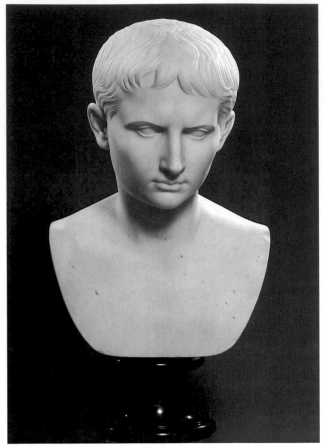

11

HORATIO GREENOUGH
11
The Young Augustus, about 1838
Marble
H. 19⅞ in. (50.6 cm.), w. 10⅝ in. (27.1 cm.),
d. 8⅜ in. (21.3 cm.)
Bequest of Charlotte Gore Greenough Hervosches du Quilliou. 21.108

Provenance: Charlotte Gore Greenough Hervosches du Quilliou (third daughter of Horatio Greenough)
Version: *Marble:* (1) present location unknown, formerly Francis Calley Gray, Boston

In the early summer of 1837,[1] Greenough received a commission to carve two busts: an idealized head of Psyche and one of Emperor Augustus Caesar as a boy, copied from the famous antique portrait of the youthful Augustus in the Sala dei Busti in the Vatican. The order came from Greenough's early patron, the Boston lawyer Francis Calley Gray, a prominent collector of European master prints, whom the sculptor described as "the most charming, best informed, and worthiest of men."[2] By the following winter, the busts were finished and shipped to Gray in America.[3]

This bust is probably not the original one made for Gray but a duplicate executed by Greenough at a slightly later date, perhaps as a display item for his studio. Portraits of the *Young Augustus* were in considerable vogue by the mid-nineteenth century. Greenough and his American colleagues William Wetmore Story and Paul Akers were among the hundreds of neoclassical sculptors residing in Italy who attempted reproductions of this immensely popular bust. A well-known contemporary travel book by the Boston lawyer George Hillard, *Six Months in Italy* (1853), suggests the appeal this portrait held for nineteenth-century viewers: "The bust of the Young Augustus (in the Museo Chiaramonti of the Vatican) is one of the most beautiful things in Rome. It represents him about sixteen or eighteen years old. The face is of delicate and dreamy beauty. The brow is intellectual and thoughtful, but the chief charm of the work is in the exquisite refinement of the mouth. . . . It is the face of a poet and not a statesman. The expression is that of one dwelling in a soft, ideal world. It looks as Virgil might have looked when the Genius of Latin Poetry met him on the banks of the Mincius, and threw her inspiring mantle over him."[4]

During Augustus's reign (27 B.C.-A.D. 14), the emperor's image was esteemed as a symbol of enlightened, divinely sanctioned rule, a fact that encouraged the mass production of marble portrait facsimiles. Copies of this particular image were readily available in the Victorian art market. In 1860 Story informed his friend Charles Sumner, who (like Francis Gray) wished to acquire copies of both *Young Augustus* and *Psyche*, "As for the head of Young Augustus, it will cost from 70-80 dollars for a really good copy—a poor one can be had for 60-70."[5]

J.S.R.

Notes

1. Greenough to Henry Greenough, June 16, 1837, published in Greenough 1887, p. 114.

2. Greenough to Henry Greenough, Jan. 17, 1838, ibid., p. 120.

3. Wright 1963, p. 204. See also Greenough to Henry Greenough, Feb. 25, 1839, published in Greenough 1887, p. 129, asking Henry to examine the bust of Psyche for Francis Gray "when it arrives." Presumably, *Young Augustus* had been sent with *Psyche*.

4. See George Stillman Hillard, *Six Months in Italy* (Boston: Ticknor and Fields, 1853), vol. 1, p. 241.

5. Story to Charles Sumner, June 22, 1860, Ho, HU.

HORATIO GREENOUGH

12

Arno, 1839
Marble
H. 25¼ in. (61.1 cm.), l. 51½ in. (130.8 cm.), d. 22½ in. (57.1 cm.)
Arthur Tracy Cabot Fund. 1973.601

Provenance: Mr. Whitwell, Boston; William Sturgis, Boston; Peter Charden Brooks, Medford, Mass.; Edward Everett, Cambridge, Mass.; William Everett, Quincy, Mass.; John Horrigan, Quincy; Gerald Horrigan, Braintree, Mass.

In 1835 Horatio Greenough acquired an English greyhound, whom he named Arno after the famous river in Florence. Several years earlier, he had taken pleasure in another greyhound sent to him by his younger brother Alfred[1] to provide the sculptor with some companionship as he worked in his studio. Greenough had begun a model of that dog, but the pet died, leaving the owner saddened and the statue incomplete. Arno proved to be a delightful successor. "I have at this moment," wrote the sculptor to his brother Henry, "a fine, tall milk-white greyhound frolicking about me. He puts his forepaws on my shoulders as I stand erect. His nose is pink, and his ears look like roseleaves. Everybody is enamoured of him. I gave five dollars for him, and have already received fifty-five dollars worth of pleasure."[2] In 1839 the Virginia painter William J. Hubard (1807-1862) visited Florence and painted Greenough's portrait (reproduced here) with Arno and another pet greyhound resting by their master's side.

Approximately three years after Arno's arrival in the Greenough household, the sculptor decided to resume his earlier project of modeling a greyhound and initiated a life-size study of Arno. The model progressed quickly, no doubt forwarded by the offer of a Mr. Whitwell of Boston to purchase it when finished.[3] He completed the composition in the spring of 1839. By 1840, the statue had arrived in Boston, where it was featured, along with six other works by Greenough, in the Boston Athenaeum's second annual sculpture exhibition. (By this date, ownership had passed to William Sturgis, a Boston lawyer.)

Greenough's composition captures Arno in a characteristically alert pose, lying on the floor with outstretched paws and with ears perked attentively and a thin, chiseled snout tilting slightly to the side, as if anticipating his master's whistle. Reflected in the dog's sleek beauty is the principle "form follows

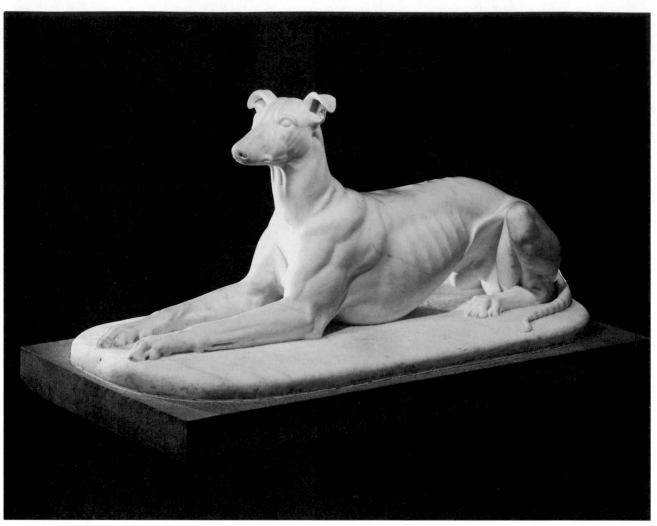

12

function" that Greenough admired in nature and promoted through his critical writings on art and architecture.[4] While *Arno*'s attitude recalls the stylized grace found in ancient Greek and Roman animal sculpture,[5] the statue's anatomical precision and intelligent mien distinguish it from the sentimental depictions of animals that predominated in the work of Victorian sculptors.

The assertive realism and exquisite modeling and finish of *Arno* made strong impressions on those who viewed the piece. Colonel Thomas H. Perkins, the affluent Boston philanthropist and merchant, greatly admired the statue and in 1843 commissioned Greenough to model a portrait of his St. Bernard dog, a work later used to mark the Perkinses' family burial plot in Mount Auburn Cemetery in Cambridge. Edward Everett mentioned Greenough's statue in an article on Ameri-

can sculptors in the *Boston Miscellany of Literature* (1842): "A Mr. P.C. Brooks [Peter Chardon Brooks, who apparently acquired the piece from William Sturgis] possesses at Medford a splendid greyhound, executed from life." Having visited Greenough in Florence, where he met the statue's lively model, Everett also interjected, "We are happy to add that his noble animal, Arno, destined no doubt to share in marble the immortality of his owner the artist, has recovered from the effect of a sad accident which befell him the past winter, by which one of his legs was fractured."[6]

Everett's tribute to Greenough's *Arno* was not idle, for he became the sculpture's subsequent owner. When Greenough returned to Boston in 1852, the year of his death, Everett sought his advice on where to place the piece in his library.[7] The following year Henry Tuckerman, in his *Memorial of*

Horatio Greenough, recollected the sculptor's fondness for Arno and noted the statue's current placement in Everett's house: "We were usually accompanied by a remarkably fine English greyhound, a great pet of Greenough's, called Arno, whose intelligent gambols always amused him; this favorite dog lived to a green old age, and his marble effigy, in an attitude peculiar to him, from the chisel of his master, now ornaments the library of the Hon. Edward Everett."[8] Another reference to *Arno* and its ownership by Edward Everett appears in Henry Adams's autobiography (1906);[9] he remembered seeing the marble greyhound in a drawing room of the Cambridge residence occupied by Everett during his presidency of Harvard, a house Adams visited around 1847, when he was nine years old. *Arno* remained in the Everett family's possession for many years, until acquired by the sculptor John Horrigan (1864-1939) in 1910.

J.S.R.

Notes

1. Crane 1972, p. 87.

2. Greenough to Henry Greenough, Jan. 18, 1835, published in Greenough 1887, p. 102.

3. Wright 1963, p. 205.

4. A drawing by Greenough of a greyhound, possibly of Arno (Nathalia Wright, Maryville, Tenn.), is reproduced in University of Michigan, Ann Arbor, *Art and the Excited Spirit: America in the Romantic Period,* exhibition catalogue by David C. Huntington (1972), pl. 89. Huntington discusses the drawing (p. 28, "Greenough: Functionalism à la the *Apollo*") as an illustration of the idealizing instinct in American art of the romantic period, likening it in its "grace and elegance" to a painting of deer by the younger Audubons (pl. 68).

5. Vermeule 1975, p. 980, draws parallels between *Arno* and a hound modeled in marble about 325 B.C.

6. Edward Everett, "American Sculptors in Italy," *Boston Miscellany of Literature* 1 (1842), p. 6.

7. Wright 1963, p. 274.

8. Tuckerman 1853, p. 25.

9. Henry Adams, *The Education of Henry Adams,* paperback ed. (Boston: Houghton Mifflin, 1961), p. 299. (The autobiography was first published in 1906.)

13

HORATIO GREENOUGH

13

Napoleon I, 1847
Marble
H. 23⅛ in. (58.8 cm.), w. 14 in. (35.5 cm.), d. 10¾ in. (27.4 cm.)
Bequest of Mrs. Horatio Greenough. 92.2645

Provenance: Mrs. Horatio Greenough, Boston; Boston Athenaeum; on deposit after 1852 until 1892
Exhibited: Boston Athenaeum, 1855.

In the summer of 1847 Margaret Fuller, the Boston transcendentalist editor and overseas correspondent for Horace Greeley's *New York Tribune,* visited Florence, making a customary inspection of expatriate artists' studios during her brief stay. In a letter that she dispatched to New York, August 9, 1847, she described a meeting with Horatio Greenough and a tour of his sculpture studio. Having commented on a bas-relief and clay study of David currently in process, Fuller noted, "he is also modelling a head of Napoleon, and justly enthusiastic in the study."[1]

Greenough adopted the severe herm form for this portrait of Napoleon (1769-1821) and consulted a death mask of the French emperor as his authoritative reference. Although the Bonapartes did not commission the bust, members of the Bonaparte family who were living in Florence examined Greenough's portrait bust and judged it a "fine likeness."[2]

Over the years, the bust has been dated erroneously as a product of Greenough's college years. Henry Tuckerman noted that Greenough carved an excellent facsimile of Napoleon as a Harvard undergraduate.[3] Nevertheless, the mature neoclassical style of this bust places the date of its execution at a later point in Greenough's career, after the sculptor had taken up permanent residence in Florence.

J.S.R.

Notes

1. Margaret Fuller, *At Home and Abroad* (Boston: Crosby, Nichols, 1856), p. 231.
2. Mrs. Horatio Greenough to E.N. Perkins, Fine Arts Committee, Boston Athenaeum, July 21, 1890, Letter Book, Boston Athenaeum. The sculptor's son also reported to the director of the Museum of Fine Arts that his father's bust of Napoleon I, "modeled from a cast taken after death," had been pronounced a "fine likeness" by a member of the Bonaparte family who "saw this bust in Italy." Horatio S. Greenough to Charles G. Loring, Jan. 24, 1882, BMFA, 1876-1900, roll 550, in AAA, SI.
3. Tuckerman 1853, pp. 17-18.

HORATIO GREENOUGH
14
Castor and Pollux, about 1847
Marble
H. 34⅝ in. (88 cm.), w. 45³⁄₁₆ in. (114.8 cm.), d. 1¾ in. (4.5 cm.)
Bequest of Mrs. Horatio Greenough. 92.2642

Provenance: Mrs. Horatio Greenough, Boston

Greenough's exposure to classical mythology as a child and as a student at Harvard made a lasting impression on his imagination. Throughout his career, the sculptor repeatedly consulted this source of legends in devising ideas for statues that would appeal to the public's fondness for poignant romance and inspirational heroes. The myth of the famous twins, Castor and Pollux, touched both these sentiments.

According to one version of the myth, Castor was mortal while his brother Pollux was immortal. When Castor was killed in combat, Zeus allowed the grief-stricken Pollux to continue communication with his beloved brother by permitting each to spend alternately one day among the gods and the other on earth, enabling them to meet in passing. Another version of the story alleged that Zeus rewarded Castor and Pollux for their brotherly love and courage by setting them eternally in the sky as the constellation of the Twins, or the morning and evening stars. Greenough's interpretation alludes to elements in both accounts. He depicts the brothers at the fleeting moment of reunion as they cross each other's paths en route to their respective destinations among gods or mortals. Puffy clouds and a crescent moon modeled in low relief symbolize their celestial encounter and their permanent station among the stars.

In ancient Rome, Castor and Pollux were worshipped for their assistance at the fabled battle of Lake Regillus in 426 B.C. The cult that arose in Italy to honor them commemorated their images on coins, in architectural friezes and sarcophagi reliefs, and in civic and religious monuments. Greenough was probably aware of this artistic tradition and accordingly conceived his elliptical bas-relief in imitation of these neo-Attic effigies and figurative ornaments.[1] He demonstrates familiarity with specific sculptural antecedents in Roman art by representing Castor and Pollux with their horses, Xanthus and Cyllarus, and by crowning them with their traditional oval-shaped helmets surmounted by stars.

Many American sculptors of the neoclassical school were drawn to the planar format of low relief, in part through their early training with cameo cutters and ornamental plaster workers. Bertel Thorwaldsen's enormous success in that medium also aroused widespread interest in the bas-relief, as did the general vogue for the delicate antique motifs designed by John Flaxman (1755-1826) to enrich the plaques, medallions, and vases manufactured at Josiah Wedgwood's factory in England.

Greenough frequently explored the form and technique of the bas-relief in his work of the late 1830s and 1840s. In *Castor and Pollux* he delineated his subject in stone with a fineness of line clearly influenced by the calligraphic quality of Flaxman's designs. He also modeled the figures with a smooth-

14

ness of surface that resembles the satin-like polish Thorwaldsen imparted to his reliefs. The overall composition of the relief testifies to Greenough's skill as a designer, for he sensitively resolved the potentially awkward arrangement of ten legs (of horses and humans) within the borders of the oval. Preliminary sketches made for *Castor and Pollux* indicate that Greenough relied on a technique of drawing interlocking circles to balance his composition, a method recommended in a book he acquired in Munich entitled *The Secret of the Porportions, Attitudes, and Composition of the Ancients*.[2]

By May 1847, it was reported that Greenough was at work on *Castor and Pollux* for a Boston client who had ordered the relief in marble (present location unknown).[3] According to one source, he modeled the composition at least twice in an effort to perfect the balance of shapes in the design.[4] The revised version, or second copy, that he achieved attracted favorable notice from a French draughtsman who, as Greenough wrote to his brother, approached him in 1851 and requested permission to lithograph the work.[5] The art critic James Jackson Jarves also discerned the subtle elegance of Greenough's relief. In *The Art-Idea* (1864), Jarves praised the piece (which he called "Castor Gemelli"), describing the sculptor's horses as "beautiful creations, full of fire and spirit; steeds of eternity, like

those of Phidias," and the figures of Castor and Pollux as "replete with the best classical feeling. They are severely composed, and vital with inward

The relief in the Museum of Fine Arts is probably Greenough's second copy of the subject, which he reserved for himself. After his death, his widow exhibited a marble bas-relief of *Castor and Pollux*, along with six of Greenough's other works, at the Boston Athenaeum from 1854 to 1856. (Tuckerman lists the relief in his *Memorial* [1853] as no. 17 but does not indicate its owner.) In 1880 Mrs. Greenough wrote to the director of the Museum, expressing her desire to donate the relief. "It is the last finished production of my husband's chisel," she wrote, "and most persons who know it admire it exceedingly—a duplicate of it in plaster is at Mr. Henry Greenough's where you could look at it."[7] A month later she offered the Museum the original black walnut frame that the sculptor had carved for *Castor and Pollux* in Florence.[8] Both the relief and its wooden pedestal entered the Museum's permanent collection in 1892 as part of Mrs. Greenough's bequest.

J.S.R.

Notes

1. See Vermeule 1972, p. 872.

2. Wright 1963, p. 250; Greenough to Henry Greenough, Oct. 15, 1846, published in Greenough 1887, pp. 199-200. The sculptor gave no bibliographical information about the book, and details about its origin remain to be discovered.

3. Wright 1963, p. 250. The author does not identify Greenough's Boston patron.

4. Ibid., p. 250.

5. Greenough to Henry Greenough, Jan. 30, 1851, published in Greenough 1887, p. 229.

6. Jarves 1864, p. 260.

7. Mrs. Greenough to Charles G. Loring, Oct. 29, 1880, BMFA, 1876-1900, roll 574, in AAA, SI.

8. Mrs. Greenough to Loring, Nov. 15, 1880, BMFA, 1876-1900, roll 574, in AAA, SI.

Hiram Powers (1805 – 1873)

Hiram Powers enjoyed more genuine appreciation from the public in his lifetime than any other American sculptor of his day. Only a handful of critics (many of whom were jealous colleagues) dared to protest the extravagant praise of his talents, proclaiming that his genius was mechanical rather than miraculous.

Along with Horatio Greenough and Thomas Crawford, Powers was a pioneering practitioner of the neoclassical style in American sculpture, and like his two contemporaries, he chose to pursue his career in Italy. Powers's arrival in Florence in 1837 signaled for the sculptor the culmination of years of hardship and the beginning of a new phase of prosperity.

Powers's early life as an impoverished emigrant to the western frontier had not presaged an august future. Born in Woodstock, Vermont, to a large family that eked out a marginal existence as farmers, Powers had moved west to Ohio in 1818, after a depression depleted his family's resources. When his father died of malaria the following year, Powers sought employment in Cincinnati, which was already a commercial and cultural center. Over the next eight years, he worked at a variety of jobs, including bill collecting for a clock and organ manufacturer, Luman Watson.

As a child, Powers had displayed precocious mechanical and artistic aptitudes in the various toys he carved and tools he invented, and in the caricatures he sketched of his family. (These talents were later apparent in his sculpture, the technical brilliance of which was partly the result of the ingenious instruments Powers devised to manipulate plaster and stone.) He impressed Luman Watson, his employer, by his facility for finishing surfaces of factory organ parts and by his invention of an improved machine for mass-producing clock wheels. Watson encouraged the young man to cultivate his unusual skills at the short-lived Academy of Fine Arts, which operated in Cincinnati in the mid-1820s. From 1823 to 1825 Powers studied drawing and modeling in his spare time under the Prussian sculptor Frederick Eckstein (1775-1852), who supervised the academy. At the same time he began to astonish his friends with remarkably realistic portraits executed in beeswax. The general public became aware of Powers's talents when he accepted a job repairing wax figures at Joseph Dorfeuille's Western Museum in Cincinnati, then an unprofit-

able enterprise housing an assortment of scientific specimens and curiosities. Powers soon achieved celebrity for improvising waxen effigies into which an assortment of devices were installed, permitting the figures to groan and emit smoke.

Powers's imaginative if lurid tableaux, his uncanny ability to simulate human flesh in wax, and his contribution to the Western Museum's improved fortunes attracted considerable notice locally. Nicholas Longworth, a wealthy Cincinnati businessman and art patron, soon persuaded Powers that his future lay in stone rather than wax and offered him funds to study sculpture in Italy. Since personal circumstances were not favorable for a visit to Europe at that time, Powers embarked instead on a tour of the East Coast to seek commissions for portrait busts. Equipped with letters of introduction from Longworth to many of America's leading political figures, Powers was able to arrange sittings in the nation's capital with several eminent statesmen, including Andrew Jackson. The bust that he modeled of the aged president in 1835 (The Metropolitan Museum of Art, New York) showed the wrinkled, weather-beaten face of a man whose cheeks had sunk from loss of teeth. Such veracity was antithetical to the vogue of the period for ideal-

ized marble portraits representing the sitter as a Grecian philosopher or Roman patrician, but it pleased Jackson. "Make me as I am, Mr. Powers, and be true to nature always, and in everything; it's the only safe rule to follow," he had confided to Powers.[1] Other Washington political luminaries were also impressed with the naturalistic reporting of Powers's chisel, and he was engaged to immortalize the features of men such as John Calhoun, John Quincy Adams, John Marshall, and Daniel Webster, complete with wrinkles, jowls, and moles.

After concluding a successful working tour to Philadelphia, Boston, and New York (where he was elected an honorary member of the National Academy of Design), Powers considered himself adequately prepared to test his talents abroad. With the encouragement and backing of Longworth and Colonel John S. Preston, a friend from South Carolina, he embarked for Italy in 1837, arriving in Florence in November of that year. Aided by the friendly ministrations of Horatio Greenough, Powers immediately set to work and was soon able to settle his family into a house on the left bank of the Arno, on the Via di Serragli. In 1841, only four years after Powers had established residence in the city, he was given an associate professorship in sculpture at the prestigious Accademia de Belle Arti, an appointment that earned the former Midwestern handyman wide respect among his new professional colleagues, Italian and American alike.

Although his income at this time derived principally from the growing American market for portrait busts, Powers aspired to create statues in the ideal mode. Unintimidated by his lack of experience in this genre, he ambitiously set to work on a life-size study of *Eve Tempted* (National Museum of American Art, Washington, D.C.), which he completed in marble in 1842. For a novice the statue was an extraordinary technical triumph. Upon seeing it in Powers's studio, the Danish sculptor Bertel Thorwaldsen (1768-1844) congratulated him, "You say, sir, it is your first statue—any other man might be proud of it as his last."[2] Powers also began modeling ideal busts of comely women of classical aspect, which he provided with mythological titles and narrative accessories. *Proserpine,* modeled in the spring of 1841, characterized the goddess as emerging from a nest of flowers and leaves symbolic of spring and regeneration. In the first marble he cut of the subject, 1844 (Honolulu Academy of Arts, Hawaii), the sculptor simplified the scheme to show a corsage of acanthus leaves. This intentionally ornamental treatment of the bust, in which Powers

substituted a softer, more graceful line for the traditionally severe, truncated-appearing herm form, was considered an important design innovation. The piece enjoyed such immediate popularity with visitors that Powers had multiple copies of it cut, two of which he presented to his loyal benefactors Longworth and Preston. The mass-production of idealized female sculptures, all of which seem related in their antique source and classical physiognomy, and each of which personifies a specific goddess or Christian virtue, soon became the chief sustaining source of revenue in Powers's atelier.

The statue most frequently associated with Powers's name is the *Greek Slave* (Yale University Art Gallery, New Haven), a quintessential rendition in marble of the perennially popular theme of womanhood in distress, which he carved in 1844. Extensive commentary has been published on this famous image of a modest Greek maiden who, according to the plot Powers concocted, was the hapless victim of slaveholders, forced to stand chained in humiliating nakedness in the market of Constantinople. His melodramatic account of the Christian girl's enslavement by a band of heathen Turks was corroborated through the clever, selective use of narrative props. Chains, manacles, and a discreetly positioned crucifix generated sympathy for the *Slave,* whose nudity undoubtedly would have otherwise offended prudish Victorian viewers. Powers was an astute entrepreneur as well as a shrewd observer of the public's penchant for moralism incarnated in innocent feminine pulchritude. From 1847 to 1849, the exhibition of the *Greek Slave* throughout the United States netted the sculptor over $25,000 in profits, attracted exuberant press, and resulted in orders for full-size replicas as well as busts of the demure *Slave.* (Six full-size copies were cut during Powers's lifetime; three two-thirds life-size versions were produced after his death by his studio carvers under the direction of Longworth Powers, the sculptor's eldest son.) The triumphant English premiere of a replica of the statue at the 1851 Crystal Palace exhibition solidified the *Slave*'s popularity internationally. In addition to advancing Powers's reputation, the *Greek Slave* promoted the qualities of Seravezza marble, the stone he had purposely selected for his magnum opus, believing the marble from that Italian quarry was finer and harder than that of Carrara and less apt to have "blemishes."

The acclaim and publicity attending the *Greek Slave* on its travels catapulted Powers into the limelight of the mid-nineteenth-century art world. For almost three decades thereafter, he earned fame

and fortune by interpreting allegories, literary themes, and mythological subjects in white marble, producing a continuous flow of statues that were noted for their classic grace and exquisite surface finish. Among his better-known works are *The Fisher Boy*, 1846, and *California*, 1858 (both at The Metropolitan Museum of Art), *Eve Disconsolate*, 1871 (The Hudson River Museum, Yonkers, New York), and *The Last of the Tribe*, 1859-1873 (National Museum of American Art). He also made over a dozen popular ideal busts personifying virtues (e.g., *Hope*, 1869, The Brooklyn Museum, New York) or mythological deities (e.g., *Diana*, 1853, Corcoran Gallery of Art, Washington, D.C.). Powers's mechanical aptitude facilitated the rate at which his studio was able to dispatch these statues since he designed many of his own labor-saving tools out of dissatisfaction with the inefficiency of traditional implements. He invented not only a practical file for manipulating the surfaces of marble, for example, but also the machine to manufacture the file. Furthermore, he devised an effective pointing machine.

Although Powers was acknowledged as a master interpreter of the ideal, his greatest contribution to sculpture lay in the field of portraiture. Between 1842 and 1855 he completed over 150 busts, which commanded sizeable sums (approximately $1,000 each) on the Victorian art market. Although his tone and style were predominantly neoclassical, it was Powers's unwavering realism that distinguished his busts from the stereotyped portraits executed by most of his contemporaries, which were characterized by a generic prettiness. Usually reluctant in his praise of American sculpture, James J. Jarves hailed Powers's busts as "faithful portraits, concealing nothing, exalting nothing, yet vigorous, natural, and effective."[3] Powers neatly expressed his philosophy of portraiture in his observation, "the face is the true index of the Soul, where everything is written had we the wisdom to read it. People think I am needlessly anxious and careful about the small and fine lines in human faces. It is because I know how much each line represents, and what great distinctions dwell in small hiding places."[4]

The speed with which Powers completed his commissions was attributable in part to the assistance he received from his loyal Italian carvers and in part to his working technique. He shunned the tradition of casting a sitter's head in plaster and instead formed his model directly in plaster, utilizing special chisels and rasps he had designed for carving in that brittle medium.

Among his contemporaries, Powers's fame as a sculptor was almost overshadowed by his personal renown as a lively, opinionated conversationalist whose topics ranged from Swedenborgian religion and spirit rappings to the shortcomings of ancient Greek art. To the astonishment of tourists who visited him at his Florentine studio, Powers freely criticized such titanic figures in art history as Michelangelo (whom he labeled a trickster) and blithely called attention to the failings in proportion and physiognomy of the celebrated *Venus de' Medici*. Some found these ideas (proclaimed by a man largely ignorant of art in its broad historic and aesthetic sense) amusing. Others marveled at the self-confidence of this "granite boulder from the Green Mountains of Vermont,"[5] who remained curiously indifferent to the spell of the delightful country he inhabited. To most of his brother artists, Powers's opinions were irritating and naive. In his travel notebooks, Nathaniel Hawthorne commented on Powers's attitude that nobody else was "worthy to touch marble," noting that he was the most professionally contentious of the "foreign" sculptors he had encountered in Italy.[6] Nevertheless, Hawthorne wrote cordially about the ideas and confidence of this compatriot of his, who remained staunchly American in spirit and habits despite his lengthy residence abroad. Critics and visitors who interviewed Powers habitually remarked on his ardent patriotism. He and his family were, by choice, uninstructed in Italy's language and literature, except for mastering the necessary shop language to communicate with tradesmen and technicians in the studio; yet they lived in the heart of one of the most cosmopolitan, educated, and fluid societies in nineteenth-century Europe. Ironically, although Powers continually professed his loyalty to America, he never returned to his native country. He remained a resident of Florence until his death.

Powers was not rich by comparison with America's new industrialist millionaires, but he amassed a comfortable fortune that permitted him, in 1869, to build a spacious villa and studio on the Viale Michelangelo, near the site of the Grand Duke of Tuscany's country palace. Powers's impressive villa soon encouraged other sculptors and expatriates, including Thomas Ball, to purchase land and erect homes nearby. Fatigue and illness beleaguered Powers in old age, but he continued working in his new studio, aided by his sons and faithful Italian carvers. His death in 1873 elicited eulogies from critics and colleagues in the United States,

Italy, and England. Powers's studio remained a viable operation for nearly five years after his death, since his assistants continued to honor orders for copies of statues in the late sculptor's oeuvre until 1878.

J.S.R.

Notes

1. Quoted in Gardner 1965, p. 4.

2. Remark quoted in Charles E. Lester, "Genius and Sculptures of Hiram Powers," *American Whig Review* 2 (1845), p. 204.

3. Jarves 1864, p. 275.

4. Quoted in Charles E. Lester, *The Artist, the Merchant, and the Statesman of the Age of the Medici and of Our Own Time* (New York: Paine and Burgess, 1845), vol. 1, p. 654.

5. James J. Jarves, "Pen-Likenesses of Art-Critics and Artists: Hiram Powers, and His Works," *Art-Journal* (London) 36 (n.s. 13)(1874), p. 37.

6. Nathaniel Hawthorne, *Passages from the French and Italian Note-Books* (Boston: Houghton Mifflin, 1881), vol. 2, p. 24.

References

AAA, SI; Benjamin Paul Akers, "Our Artists in Italy: Hiram Powers," *Atlantic Monthly* 5 (Jan. 1860), pp. 1-6; "Art in Continental States: America," *Art-Journal* (London) 13 (n.s. 3)(May 1851), p. 147; Samuel Y. Atlee, "Hiram Powers, the Sculptor," *Littell's Living Age*, 2nd ser. 42 (1854), pp. 566-571; Samuel Bassett, "Hiram Powers," in *Vermonters: A Book of Biographies*, ed. Walter H. Crockett (Brattleboro, Vt.: Daye, 1931), pp. 173-176; Henry W. Bellows, "Seven Sittings with Powers, the Sculptor," *Appleton's Journal of Literature, Science and Art* 1 (1869), pp. 342-343, 359-361, 402-404, 470-471, 595-597; ibid. 2 (1870), pp. 54-55, 106-108; Benjamin 1880, p. 138; S.G.W. Benjamin, "Sculpture in America," *Harper's New Monthly Magazine* 58 (Apr. 1879), pp. 659-662; Henry Boynton, "Hiram Powers," *New England Magazine*, n.s. 20 (July 1899), pp. 519-533; Cincinnati Historical Society, Ohio; Clark 1878, pp. 45-50; Crane 1972, pp. 169-272; Craven 1968, pp. 111-123; Clara Louise Dentler, "White Marble: The Life and Letters of Hiram Powers, Sculptor," Clara Louise Dentler Papers, AAA, SI; Edward Everett, "Hiram Powers, the Sculptor," *Littell's Living Age* 15 (1847), pp. 97-100; Hiram Fuller, *Sparks from a Locomotive* (New York: Derby and Jackson, 1859), pp. 260-262; Albert T.E. Gardner, "Hiram Powers and William Rimmer, Two 19th Century American Sculptors," *Magazine of Art* 36 (Feb. 1943), pp. 42-47; Gardner 1945, pp. 27-32; Horace Greeley, *Glances at Europe* (New York: Dewitt and Davenport, 1851), p. 216; Vivien Greene, "Hiram Powers's *Greek Slave*, Emblem of Freedom," *American Art Journal* 14 (autumn 1982), pp. 31-39; *Harper's Magazine* 33 (June 1866), p. 101; "Hiram Powers," *Littell's Living Age* 44 (Jan.-Mar. 1855), pp. 703-704; "Hiram Powers," *Eclectic Magazine* 71 (Aug. 1868), pp. 1028-1029; "Hiram Powers, Obituary," *Art-Journal* (London) 35 (n.s. 12)(Aug. 1873), p. 231; "Hiram Powers, the American Sculptor," *Knickerbocker*, Dec. 1841, pp. 523-529; Linda Hyman, "The Greek Slave by Hiram Powers: High Art as Popular Culture," *Art Journal* 25 (spring 1976), pp. 216-223; Jarves 1864, pp. 275-277; James Jackson Jarves, "Pen-Likenesses of Art-Critics and Artists: Hiram Powers, and His Works," *Art-Journal* (London) 36 (n.s. 13)(1874), pp. 37-39; Lee 1854, pp. 146-153; Charles E. Lester, *The Artist, the Merchant, and the Statesman of the Age of Medici and of Our Own Time* (New York: Paine and Burgess, 1845) vol. 1; idem, "The Genius and Sculptures of Hiram Powers," *American Whig Review* 2 (Aug. 1845), pp. 199-204; "Letter from Hiram Powers—The New Method of Modelling in Plaster for Sculpture," *Putnam's Monthly Magazine* 2 (Aug. 1853), pp. 154-155; Anna Lewis, "Art and Artists of America: Hiram Powers," *Graham's Magazine* 46 (Nov. 1855), pp. 397-401; Paul B. Metzler, "The Sculpture of Hiram Powers," Master's thesis, Ohio State University, 1939; "Powers and Clevenger," *Bulletin of the American Art Union*, July 1850, p. 65; Hiram Powers, "The Perception of Likeness," *Crayon* 1 (Apr. 1855), pp. 229-230; Donald Reynolds, *Hiram Powers and His Ideal Sculpture* (New York: Garland, 1977); idem, "The 'Unveiled Soul': Hiram Powers and the Embodiment of the Ideal," *Art Bulletin* 59 (Sept. 1977), pp. 394-414; C.S. Robinson, "A Morning with Hiram Powers," *Hours at Home* 6 (Nov. 1867), pp. 32-37; Benjamin Silliman, *A Visit to Europe in 1851* (New York: Putnam, 1853), vol. 1, p. 91; Taft 1930, pp. 57-71; Thorp 1965, pp. 70-78; Thomas A. Trollope, "Some Recollections of Hiram Powers," *Lippincott's Magazine* 15 (Feb. 1875), pp. 205-215; Tuckerman 1867, pp. 276-294; Henry Tuckerman, *Italian Sketch Book* (New York: Ricker, 1848), pp. 262-264; *United States Magazine and Democratic Review* 14 (Feb. 1844), pp. 202-206; Richard Wunder, *Hiram Powers, Vermont Sculptor* (Woodstock, Vt.: Woodstock Historical Society, 1974); idem, "The Irascible Hiram Powers," *American Art Journal* 4 (Nov. 1972), pp. 10-15.

HIRAM POWERS
15
Aaron Corwine, 1823
Wax
H. 2 in (5.1 cm.), w. 1½ in. (3.8 cm.)
Rebecca Richardson Joslin Fund. 38.681

Provenance: Henry Lea, Cincinnati, Ohio; J. Henry Lea, Cincinnati; Mrs. J. Henry Lea, Cincinnati

In 1823 Hiram Powers modeled this small, sensitive wax portrait of Aaron Houghton Corwine (1802-1830), a youthful portrait painter from Kentucky who had studied painting with Thomas Sully (1783-1872) in Philadelphia. Powers first made Corwine's acquaintance at Frederick Eckstein's art academy in Cincinnati, an organization that Corwine had as-

sisted in establishing. Under Eckstein, Powers had
received instruction in the rudiments of design,
drawing, and casting. He was soon demonstrating
his aptitude for fashioning miniature portraits in
beeswax of Cincinnati's citizenry.[1] The relief of
Corwine is an early example of these. Powers de-
picts him as a young man with a fashionable mass of
curly hair, wearing a high collar and a loose cloak,
or studio smock. In style, the delicate image resem-
bles the finely rendered portrait medallions and
classical cameos that John Flaxman (1755-1826) de-
signed for Josiah Wedgwood's factory in England.

Considering the fragile nature of wax, the sur-
vival of this wax profile for over a century and a
half is remarkable and can be attributed chiefly to
its careful handling by successive generations of the
Lea family of Cincinnati. Although the relief is
unsigned, its provenance provides convincing
ground for assigning the piece to Powers. In 1913 J.
Henry Lea offered the piece to the Cincinnati Mu-
seum Association with the explanation that it repre-
sented "a little bas-relief portrait head (with no
backing) evidently intended to be mounted on vel-
vet or the like and marked in my Father's writing,
Corwin's (sic) likeness by Powers in 1823."[2] Lea's refer-
ence to his father, Henry Lea, furnishes the plausi-
ble connection between Lea, Powers, and Corwine,
for when Corwine died of tuberculosis in 1830, it
was Lea who wrote the short but gracious obituary
of him for the *Cincinnati Chronicle*.[3]

Presumably, the portrait by Powers was found
among Corwine's possessions at the time of his
death and was given to Henry Lea by the deceased
painter's heirs, perhaps in gratitude for his kind
remarks about Corwine in the local newspaper.

J.S.R.

Notes

I wish to thank Richard Wunder for permitting me to
read his catalogue entries on Powers's *Aaron Corwine,
Horatio Greenough, Abbott Lawrence, Eve Disconsolate,* and
Faith from his forthcoming catalogue raisonné on Hiram
Powers.

1. For discussion of Powers's early wax busts, see Charles
E. Lester, *The Artist, the Merchant, and the Statesman of the
Age of Medici and of Our Time* (New York: Paine and
Burgess, 1845), vol. 1, pp. 19-21.

2. J. Henry Lea to J.H. Gest, director of the Cincinnati
Museum, Aug. 7, 1913, Cincinnati Art Museum,
Archives.

3. *Cincinnati Chronicle*, July 17, 1830, obit.

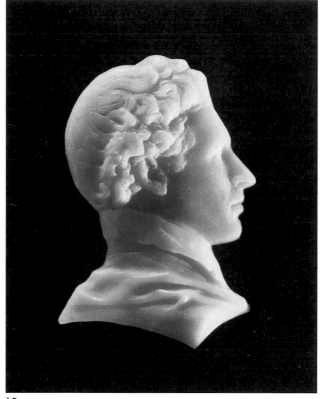
15

HIRAM POWERS
16
Horatio Greenough, 1854-1859 (modeled in 1838)
Marble
H. 26½ (67.3 cm.), w. 14 in. (35.5 cm.), d. 9¼ in.
(23.5 cm.)
Signed (on base): H. Powers / Sculp.
Bequest of Charlotte Gore Greenough Hervosches
du Quilliou. 21.107

Provenance: Mrs. Horatio Greenough, Boston;
Charlotte Gore Greenough Hervosches du Quilliou
Exhibited: BMFA, "Confident America," Oct. 2-Dec. 2,
1973; The Newark Museum, N.J., *A Survey of American
Sculpture* (1962), no. 10; Whitney 1976, no. 190.
Version: *Plaster:* (1) National Museum of American Art,
Washington, D.C.

In the late winter of 1837, Hiram Powers arrived in
Florence with his wife and two small children, untu-
tored in the Italian language, unsophisticated in
European manners, and unknown to the affluent,
educated foreigners who made the beautiful Tus-
can city their home. Despite these handicaps, Pow-
ers was determined to succeed as a sculptor. Boldly
optimistic as he was, he nevertheless welcomed the
attention and advice offered to him by Horatio

Greenough, the only other American sculptor then living in Florence.

Powers had met Greenough, who was his exact contemporary, in Washington, D.C., the year before his departure for Italy. Their shared status as outsiders in Florentine society and their common experience as American pioneers in their chosen profession soon transformed their casual acquaintance into a warm friendship. Greenough, whose cultivated upbringing enabled him to mingle comfortably in Florence's aristocratic circles, organized a reception for Powers, with the intent of introducing the sculptor to prospective patrons and influential art critics. His family also extended kindness to the Powerses. Greenough's younger sister Louisa attended Elizabeth (Mrs. Hiram) Powers at the birth of her first daughter, who was named Louisa Greenough Powers in her honor. Powers modeled Louisa Greenough's bust in return for her ministrations to his wife, although it was never put into marble.

Greenough's flattering courtesies to Powers were motivated not only by good fellowship but also by the sculptor's sincere admiration for Powers's work. In the spring of 1838 Greenough had his own portrait bust modeled by Powers, an exercise that Greenough hoped would draw beneficial attention to Powers as well as relieve the depression from which he had been suffering over the recent death of his oldest son, Jimmy. As Greenough wrote to his brother Henry in late April, "Mr. Powers has suffered over the death of his child, but is at work again and cheerful—he is making an admirable bust of me. I like him very much, and esteem his talents as highly as ever."[1]

The bust that Powers created of his friend and colleague illustrates the combined style and spirit that prompted the famous Italian sculptor Lorenzo Bartolini (1777-1850) to pronounce him one of the greatest sculptors of the nineteenth century. The clean shaven face, framed by fashionable heavy whiskers and offset by a lofty brow crowned with thick, wavy hair, is sensitively modeled to convey the intelligence and urbanity for which Greenough was known. Although the undraped shoulders, angle and tilt of the head, and somewhat stylized arrangement of the sitter's hair show the influence of classicism on Powers, the sculptor's attentiveness to expression and to the sitter's "modern" features aligns the bust with the mood of romantic naturalism that was on the ascendancy in painting and literature of the period. One critic has found in this perceptive and handsome portrait "a Byronic element, where refinement, genius, comeliness, and the prime of life have been sought and captured."[2] Although in the subsequent fifteen-year period Powers produced over one hundred fifty marble portraits, commanding one thousand dollars apiece, this early and very personal study of his colleague and friend remains one of his best busts.

Greenough did not live to admire this marble version of his bust. The original study of 1838 was modeled in plaster (National Museum of American Art, Washington, D.C.), and although Powers apparently set about transferring the bust into marble around this time, it was left unfinished when one of his studio assistants blundered in carving the subject's hair. After Greenough's death in 1852, his widow wrote to Powers from Boston, requesting a marble replica of the bust, an order the sculptor executed for the price of the marble alone.[3] Although Powers's studio records indicate that the bust was cut by his chief carver Antonio Ambuchi in 1859, Powers informed the art historian Henry Tuckerman (Greenough's biographer, who had asked Powers to make a duplicate of the bust for himself) that the piece was in the process of being cut in 1854; this suggests the possibility that two replicas of the work exist.

Apparently the Greenough family felt great sentimental attachment to their copy of Powers's bust of the sculptor. Mrs. Greenough specifically exempted the portrait from her bequest of statues and casts to the Museum of Fine Arts,[4] preferring, it may be assumed, to entrust such an heirloom to the care of her children. The bust eventually joined the Museum's collection through the gift of the sculptor's daughter Charlotte.

J.S.R.

Notes

1. Greenough to Henry Greenough, Apr. 27, 1838, published in Greenough 1887, p. 126.

2. Craven 1968, p. 114.

3. Powers to Louisa Gore Greenough, May 19, 1853, explaining the error that occurred in carving the first marble bust and indicating his wish to accept remuneration only for the cost of a new block of marble. See also Henry Tuckerman to Powers, July 30, 1854, Hiram Powers Papers, AAA, SI.

4. See letter from Horatio S. Greenough, executor of his mother's estate, to Charles G. Loring, June 7, 1892, describing the terms of the bequest, BMFA, 1876-1900, roll 555, in AAA, SI.

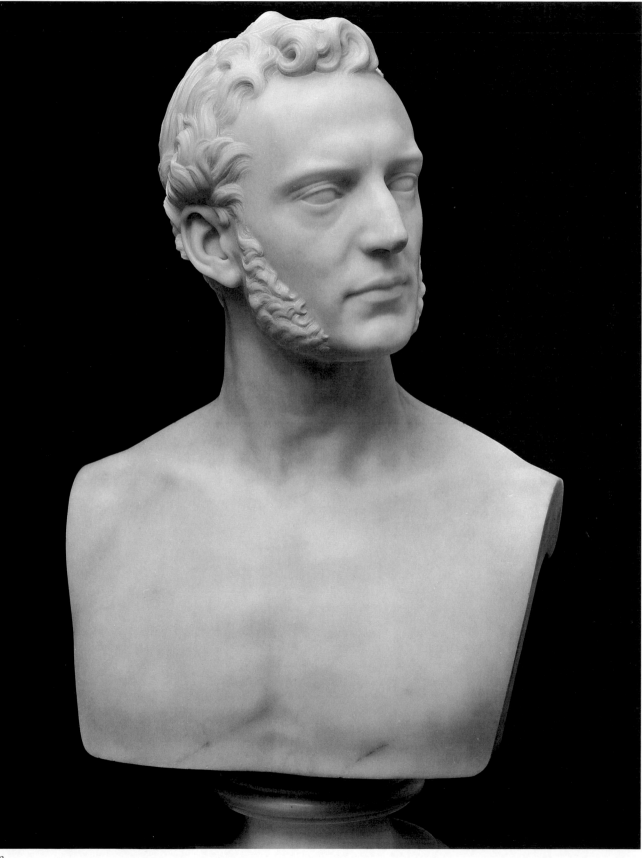

16

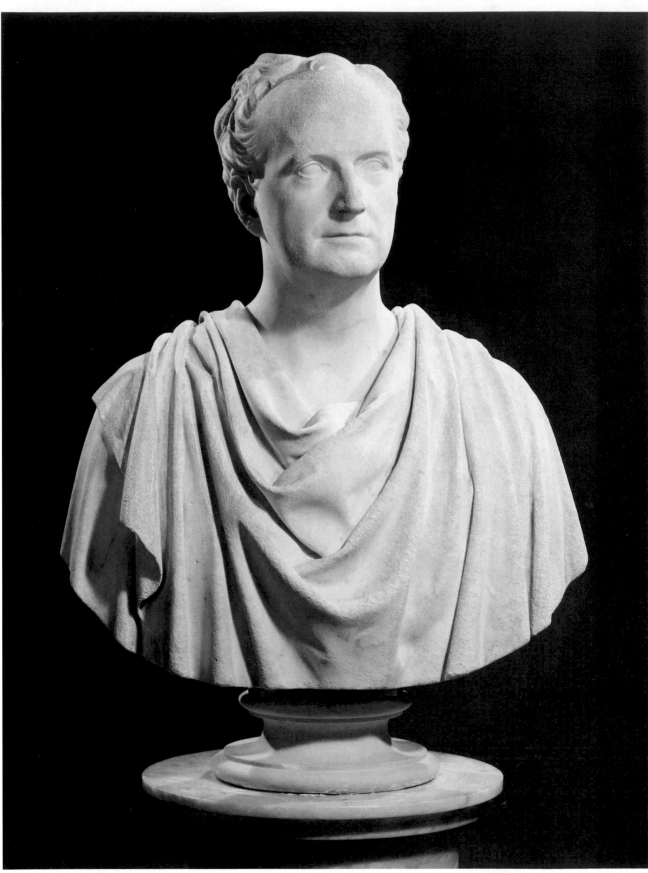

HIRAM POWERS
17
Abbott Lawrence, 1865 (modeled in 1837)
Marble
H. 26¾ in. (68 cm.), w. 21 in. (53.3 cm.), d. 13⅛ in. (33.3 cm.)
Signed (on back): H POWERS/Sculp
Gift of James Lawrence, John Endicott Lawrence, and Dorothy Lawrence Stevens. 1980.495

Provenance: James Lawrence, Boston; Lawrence family, Groton, Mass.
Versions: *Plaster:* (1, 2) Boston Athenaeum, (3) Fogg Art Museum, Harvard University, (4) National Museum of American Art, Washington, D.C.

In January 1835, after Hiram Powers had arrived in Washington, D.C., he received a letter from his friend Robert Montgomery Bird, a writer with social connections, inquiring about the success of the sculptor's visit to the capital and offering suggestions as to how he might acquire additional commissions for work: "I have it in my power, at least, to direct public attention toward you in Philadelphia, and procure the same thing to be done in New York, and perhaps in Boston. I can cast about, too, to see if any of our nabobs want their heads clapped on a pier table. By the way, the Bostonians are the very men for that sort of vanity."[1] Bird's comment was apparently prophetic, for the following year Powers made the acquaintance in Washington of Abbott Lawrence, a Boston diplomat, industrialist, and philanthropist whose wealth had accrued as a result of his family's expertly managed dry-goods business. In the late spring of 1837, the sculptor traveled to Boston to model the busts of Lawrence and his wife, Katherine Bigelow Lawrence, and is thought to have made busts of Lawrence's brother William and his wife at the same time.

The bust that Powers produced of Abbott Lawrence, modeled originally in clay or plaster and then transferred to marble after the sculptor's arrival in Florence, displays a clean-shaven man with thick, unbrushed hair setting off a broad brow, with a small mole clearly indicated over the sitter's right eye. Even in this early work characteristics of Powers's mature portrait style are discernible: meticulous attention to detail and probing study of the sitter's physiognomy, softened under neoclassicism's ennobling influence.

At the time Lawrence and Powers were introduced, the careers of both were on the rise. Politics were of special interest to Lawrence, who was an ardent Whig party member. In 1834 and 1838 he

was elected a representative to the United States Congress; in 1844 he served as a party delegate to the national electoral convention, and under President Taylor's administration, he was appointed to the Court of St. James in England. With his brother Amos and a few other enterprising business investors from Boston, Abbott Lawrence engineered the development of the New England textile industry. In 1845 he established his own cotton and woolen mills on a river site northwest of Boston that rapidly became the bustling mill town of Lawrence, Massachusetts.

Aside from political and business activities, Lawrence lent energy, ideas, and funds to various charities and educational causes, a favorite of which was the establishment of the Lawrence School for scientific research at Harvard University. The textile manufacturer also took an active role in promoting the careers of young artists and the broad cause of the arts in America. With Henry Wadsworth Longfellow and Charles Sumner, he served as an honorary director of the New England Art Association, a short-lived organization founded in 1848 and modeled after the popular New York counterpart.[2]

Powers shipped the portraits of Mr. and Mrs. Abbott Lawrence to Boston from Florence in 1844. In 1865, ten years after Lawrence's death, his eldest son, James, contacted the sculptor, requesting a duplicate of the original bust of his father but expressing the wish to have the upper torso "formalized" with a classical toga. In his letter of December 7, 1865, Powers replied that he would be happy to comply with the request, although work on the bust could not begin immediately.[3] Despite the warning of possible delay, the revised bust was shipped to Boston the following August. The promptness with which the commission was completed was probably due to Powers's assigning the task of cutting the duplicate bust to Antonio Ambuchi, his efficient master carver. Lawrence also ordered from Powers two ideal busts: *Hope* and *Faith*.

The model for the original marble bust of Abbott Lawrence was retained by Powers in his Florentine studio. He evidently used it to take a number of plaster casts: one of these was owned by Joshua Wolcott (who gave it to the Boston Athenaeum in 1844),[4] and another was presented by the sitter to the Massachusetts Historical Society, which made an appropriate present of it to the Lawrence Scientific School (incorporated in 1906 into the Department of Applied Sciences) at Harvard University. This

marble version of the bust descended in the family of James Lawrence and for many years remained in the family's home in Groton, Massachusetts, where it was installed out-of-doors. Unfortunately, the climate took its toll on the marble's highly polished surface.

<div align="right">J.S.R.</div>

Notes

1. Robert Bird to Powers, Jan. 26, 1835, quoted in Clara L. Dentler, "Robert Montgomery Bird and Hiram Powers," *Library Chronicle* 27 (winter 1961), p. 65.

2. See F.W. Ballard, *The Stewardship of Wealth, as Illustrated in the Lives of Amos and Abbott Lawrence* (1865); *Boston Daily Journal*, Aug. 20, 1855, obit.; *DAB*, s.v. Lawrence, Abbott.

3. Powers to James Lawrence, Dec. 7, 1865, Hiram Powers Papers, AAA, SI. Powers wrote that he would charge Lawrence "£ 120 stg." for the bust.

4. For the plaster copies of this bust, see Boston Athenaeum 1984, pp. 52-53.

HIRAM POWERS
18
Eve Disconsolate, 1871-1872
Marble
H. 28 in. (71.1 cm.), w. 20½ in. (52.1 cm.), d. 13 in. (33 cm.)
Signed (under shoulder at back): H. Powers / Sculp.
Gift of Mrs. Thomas O. Richardson. 07.714

Provenance: Possibly Mrs. Sidney Brooks, New York; Mrs. Thomas O. Richardson, Boston
Exhibited: BMFA, "Confident America," Oct. 2-Dec. 2, 1973; BMFA 1979, no. 11.
Versions: *Plaster*, two-thirds-life-size: (1, 2) National Museum of American Art, Washington, D.C. *Marble*, two-thirds-life-size: (1) Hirschl & Adler Galleries, New York, (2) private collection, Florence, (3) The Toledo Museum of Art, Ohio; life-size: (4) Archer M. Huntington Art Gallery, Austin, Tex., (5) The Brooklyn Museum, (6) Dayton Art Institute, Ohio, (7) Hausner's Restaurant, Baltimore, (8) Museum of Art, Rhode Island School of Design, Providence, (9) National Museum of American Art, (10) James Ricau, Piermont, N.Y., (11) Utah Museum of Fine Arts, Salt Lake City

Eve was the personality from the Bible most frequently selected for representation by American neoclassical sculptors. Her complex character and remarkable history offered a rich range of interpretive possibilities. She was the quintessential woman, Adam's innocent playmate in Eden, the beguiling mother of mankind, the originator of sin on earth, and, as the mother of the first murderer and his

victim, the earliest witness to violent death. In theory, Eve was the *tabula rasa* on which the sweep of mankind's story could be epigrammatized. Moreover, sculptors who wished to model a nude female figure without incurring criticism could safely carve an undraped form and entitle her "Eve before the Fall."

The theme of Eve held an appeal for Powers throughout his career. Soon after arriving in Florence, he began work on *Eve Tempted*,[1] his first full-length ideal statue, which was inspired by Salomon Gessner's popular idyllic pastoral *Der Tod Abels* (1758). To achieve the perfection of form and detail that such an image of divine beauty seemed to demand, the sculptor employed approximately thirty models, selecting various anatomical features from each. As the legend dictated, *Eve* was designed to dramatize the moment of enticement, as she contemplated the forbidden fruit held in her hand with a mingled look of longing and hesitation. Anticipating public objection to the statue's nudity, Powers asserted that "clothing would be preposterous for she [Eve] was naked only *after* she had fallen. History and nature both require entire nudity."[2] After completing an initial version of *Eve* in 1842, the sculptor continued to revise the composition, selling a slightly altered *Eve Tempted* (1845) to the wealthy New York merchant A.T. Stewart.

In 1859 Powers returned to the subject of Eve again, but his interest had shifted to the theme of Eve's sorrow and guilt after sin was committed. In his new interpretation, which was finished in plaster in 1862, he tried to convey a sense of shame and painful reflection. This aspect of the character may have been drawn from Milton; the alternative title Powers gave to *Eve Disconsolate* is *Paradise Lost*. (There is no specific evidence of Powers's indebtedness to Milton for this conception of *Eve*, but it is pertinent to note that he used Milton as a source elsewhere, for his statue *La Pensierosa* [present location unknown, formerly New York Public Library].) Unlike the first *Eve*'s serene and vaguely quizzical expression, the demeanor of this *Eve* is mature and sober, suggesting awareness of the unique burden she has bequeathed to her sex.

In a letter to Edward Everett, Powers described his idea for the statue, noting that Eve was "standing in the act of advancing, . . . her face raised to Heaven with an expression of deep contrition; one hand upon her breast, and the other pointing downward at the serpent, as if sensible of the accusation."[3] Powers attempted to dramatize the statue

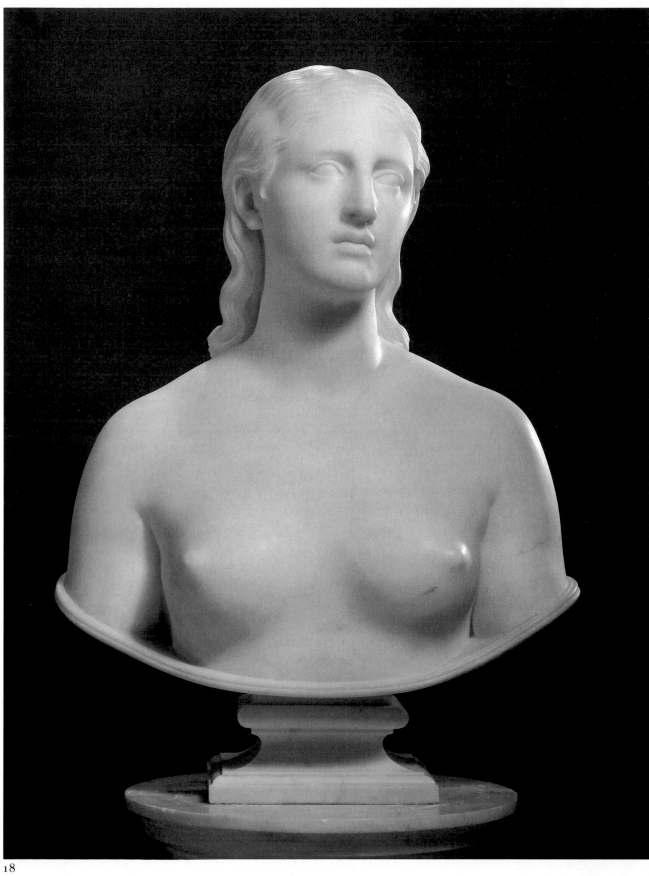

by implying the presence of another figure who stood in judgment of Eve, a role assumed by the spectator. At the order of Nathan D. Morgan, the full-length *Eve Disconsolate* (The Hudson River Museum, Yonkers, New York) was executed in marble in 1870.[4] The task of cutting the figure consumed Powers's time for a full year, for, as he remarked to his patron, he "continually found something to be improved."[5] With his advancing age, Powers recognized that the statue might be one of his last compositions and thus was "trying to make it my best."[6] By 1872 Morgan's statue had been purchased by A.T. Stewart, owner of *Eve Tempted*, and the two interpretations of *Eve* were thus united in the same collection. Powers perceived the two statues as complementary, *Eve Disconsolate* "being, as it were, the second act in the story."[7]

Possibly as early as 1862, Powers began accepting orders for busts derived from the model of *Eve Disconsolate*, although alterations to the pose were necessary. Specifically, the theatrical arm gestures of the life-size version, which shield Eve's bosom and point incriminatingly at the serpent coiled around a tree stump, were modified to conform to a standard portrait-bust design. Four examples were completed before Powers's death, and at least seven additional replicas were issued by his workmen before his studio closed in 1878. The bust of *Eve Disconsolate* is representative of many ideal female heads the sculptor produced, which were routinely based on antique Roman portraits with costume attributes added or, in *Eve*'s case, subtracted. This version may have been inspired by a late Hellenistic Aphrodite or by a Julio-Claudian head believed to represent Antonia, mother of Germanicus and the emperor Claudius.[8] Similarities in expression also exist between *Eve Disconsolate* and Titian's famous painting of the repentant *Magdalen* (Pitti Palace, Florence). Powers departed from these sources, however, in the innovative design of Eve's hair; he described Eve as wearing her hair "in a natural and most primitive manner—drawn back . . . and hanging loose behind, thus exposing that very ugly feature in woman—temples."[9]

Boston's copy of *Eve Disconsolate* may be the bust once owned by Mrs. Sidney Brooks,[10] widow of Powers's New York banker, who acquired the original marble bust in 1870. Brooks had also owned busts of *America* and *Proserpine* by Powers, which were listed in the sale of the banker's statuary collection auctioned at the Redwood Library and Athenaeum in Newport, Rhode Island, August 13,

1879. (Charles G. Loring, then director of the Museum of Fine Arts, received an announcement of the sale.)[11] The donor, Mrs. Thomas O. Richardson, who summered in Newport, may have obtained the bust from the Brooks sale.

J.S.R.

Notes

1. *Eve Tempted* (National Museum of American Art, Washington, D.C.) may be Powers's original *Eve*, modeled in 1842, or a replica carved by Powers's studio workers after his death. Powers's mastercarvers, Remigio Peschi and Antonio Ambuchi, also completed a replica of *Eve Disconsolate* (Cincinnati Art Museum, Ohio) in 1874, begun prior to the sculptor's death.

2. Charles E. Lester, *The Artist, the Merchant, and the Statesman of the Age of the Medici and of Our Own Time* (New York: Paine and Burgess, 1845), vol. 1, p. 85.

3. Powers to Everett, May 16, 1869, Edward Everett Papers, MHS.

4. See April Kingsley, *Hiram Powers' Paradise Lost*, exhibition catalogue (Yonkers, N.Y.: The Hudson River Museum, 1985). I am indebted to Ms. Kingsley, who kindly made her manuscript available to me.

5. Powers to N.D. Morgan, quoted by Clara L. Dentler, "White Marble: The Life and Letters of Hiram Powers, Sculptor," p. 228. Clara Louise Dentler Papers, AAA, SI.

6. Powers to George Peabody, Oct. 24, 1861, quoted by Donald Reynolds, *Hiram Powers and His Ideal Sculpture* (New York: Garland, 1977), p. 202.

7. Powers to Henry W. Bellows, May 18, 1869, Henry W. Bellows Papers, MHS.

8. Vermeule 1975, p. 975.

9. Powers to Sidney Brooks, Dec. 4, 1849, quoted by Reynolds, *Hiram Powers*, p. 158. In this letter Powers described his conception of *Eve* in detail.

10. See Richard Wunder's forthcoming catalogue on Powers; he notes that the bust was offered in two sizes: slightly over life-size and two-thirds life-size.

11. See BMFA, 1876-1900, roll 549, in AAA, SI.

HIRAM POWERS
19
Faith, about 1872
Marble
H. 27 in. (68.6 cm.), w. 20½ in. (52.1 cm.), d. 13 in. (33 cm.)
Signed (on back): H. Powers / Sculp.
Gift of Mrs. Henry Lyman. Res. 56.70

Provenance: Nathan Denison Morgan, New York; Mrs. Henry Lyman, Boston
Exhibited: BMFA, "Confident America," Oct. 2-Dec. 2, 1973; BMFA 1979, no. 10.

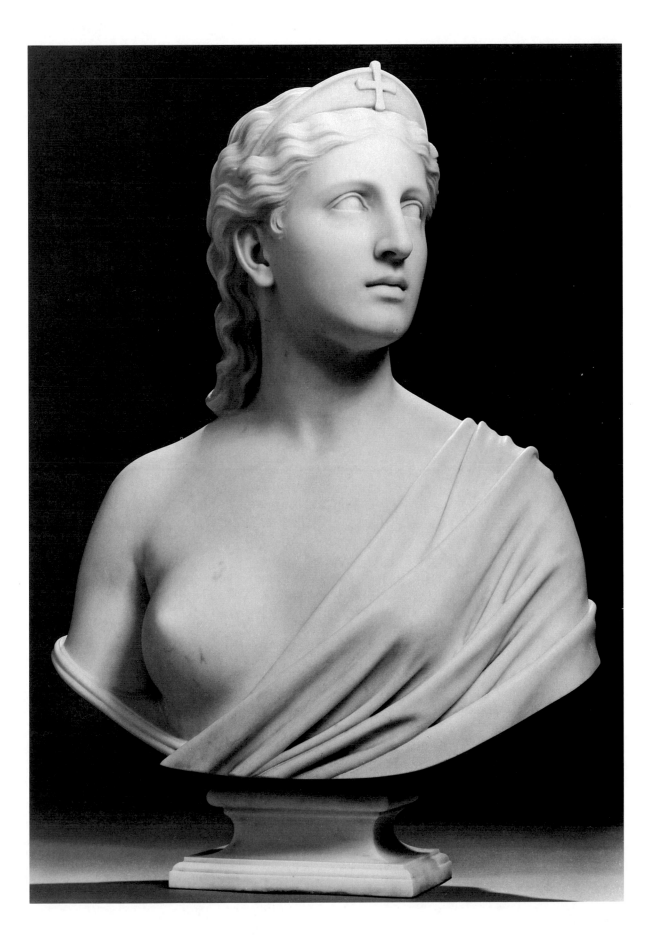

Versions: *Plaster:* (1) National Museum of American Art, Washington, D.C. *Marble:* (1) American Red Cross National Headquarters, Washington, D.C., (2) Mount Holyoke College Art Museum, South Hadley, Mass., (3) New York Society Library, New York, (4) The Saint Louis Art Museum, Mo., (5) The Valentine Museum, Richmond, Va.

In Sylvester Judd's popular novel *Margaret* (1851), a promising young sculptor, bolstered by the patronage of a woman who has inherited an unexpected fortune, travels abroad to Italy to study art and to produce a set of ornamental statues for his local village.[1] His commissions are not, as might be expected, for marble portraits of the town fathers but rather for sculptures of the virtues: Truth, Penitence, Fortitude, Temperance, and Diligence. Although this episode in Judd's novel is fictitious, there are notable parallels between the careers of the novelist's artist and that of Hiram Powers. Like Judd's aspiring stonecutter, Powers was aided by liberal subsidies from his hometown benefactor, Nicholas Longworth. Once he was established in Florence, Powers's studio specialized in producing marble personifications of virtues and other "consecrated" allegorical themes.

The moral and mythological effigies that Powers carved were invariably interpreted as comely goddesses outfitted with pertinent narrative accessories: a star-spangled headband for *America*, 1854 (Wadsworth Atheneum, Hartford); a crescent-moon crown for *Diana*, deity of the night, 1853 (Corcoran Gallery of American Art, Washington, D.C.); and a diadem with an anchor superimposed on it for *Hope*, 1869 (The Brooklyn Museum). *Faith* appropriately wears a simple tiara ornamented with a Greek cross, an emblem of the Eucharist.

Powers consulted a common source for the majority of these ideal themes: a standard type of Roman imperial portrait bust that was familiar to him in the ducal and municipal art collections of Florence. *Faith*, for example, quotes several Graeco-Roman portrait conventions: a himation, or cloth, drawn partially across the upper torso to reveal one breast; hair arranged with a central part, pulled back above the ears in groove-like waves and falling loosely at the nape of the neck; the head placed in partial profile to the right; and a blank, calm facial expression becoming to an Olympian Juno or Athena.[2] Another possible inspiration for the combined facial type and tiara Powers adopted for *Faith* is the antique *Venus of Capua* in the Naples Museum.

The original idea for *Faith* came to Powers when a client, Marshall Woods, commissioned him to fashion a pair of ideal heads of subjects not represented in his existing repertoire. During 1866 and 1867 the sculptor responded by executing thematic studies of Hope, who peers forward into the future, and of Faith, who gazes slightly upward as if to heaven. In 1871 he completed a bust of the third heavenly grace, Charity (The Newark Museum, New Jersey), who looks modestly downward. Of the three busts, *Faith* was described in a contemporary periodical as having a countenance that was "calmly assured, more rapt and exalted."[3]

The association of women with virtues, particularly that of piety, was commonplace in Victorian culture. Genteel society regarded religion as the core of a good woman's character and the source of her strength. Images of saintly women stoically bearing the cross of Christian faith in the fallen world were bountiful in novels, women's magazines, and religious literature. Not surprisingly, Powers's pure white *Faith* was one of his most appealing ideal busts; fifteen copies were made from the original model.

J.S.R.

Notes

1. See Thorp 1965, p. 4.

2. See Vermeule 1972, pp. 873-874.

3. *Appleton's Journal of Literature, Science and Art* 1 (1869), p. 597.

Henry Dexter (1806 – 1876)

The considerable respect that Henry Dexter earned as a sculptor in the nineteenth century was proportionate with the community's wonder that a country blacksmith could capture so effectively the likenesses of cultured city dwellers without benefit of formal training or study abroad. Born into grim poverty in rural New York, Dexter devoted his earliest years to farming and later to blacksmithing, the trade to which he was apprenticed while in his teens. In this period of economic hardship and cultural isolation, Dexter developed an enthusiasm for painting, although his efforts were confined to sketching naive portraits of friends and family members in paint concocted from berry juice.

In the spring of 1836 Dexter abandoned his forge for a studio in Providence, Rhode Island, where he announced his new profession as a painter of "likenesses." The following year he moved to Boston, where his amateur talent was encouraged and supervised by his wife's uncle, the Boston portrait artist Francis Alexander (1800-1880). Frustrated by the scarcity of work to be found in the city, which was suffering from the effects of a national economic depression, Dexter contemplated renouncing art altogether until Alexander urged him to explore the three-dimensional possibilities of portrait sculpture. The suggestion proved timely, for Horatio Greenough was preparing to leave Boston for Italy again and made his clay and plaster stock available to Dexter at a modest price. Heeding Alexander's advice, Dexter soon began producing competently modeled busts of distinguished Boston citizens. Among his first sitters were the city's mayor, Samuel Eliot (Boston Athenaeum), and its leading art patron and philanthropist, Thomas H. Perkins. The community was soon marveling at the skill and versatility of this neophyte sculptor, attributing his facility for modeling in clay and marble to the manual dexterity he had acquired working at the anvil.

In 1841 Dexter established a studio on Tremont Row, a fashionable address for aspiring painters and sculptors. Shortly thereafter, he enjoyed his first public recognition by producing a convincing bust of Charles Dickens modeled from life during the English novelist's American tour in 1842. Over the next three decades, Dexter secured his reputation as an accomplished and prolific sculptor by immortalizing many of Boston's merchant princes and political potentates in marble, plaster, and clay. Among his more interesting enterprises was an ambitious scheme to carve busts of each of the United

States governors. To that end, he embarked on an eighteen-month tour of America in 1859, returning with individual studies of thirty-one different politicians. The busts were exhibited in Boston in the rotunda of the State House, where they generated considerable public interest. The outbreak of the Civil War unfortunately ruined Dexter's goal of translating the plaster busts into permanent marble form.

Although Dexter was best known for his realistic portraiture, his occasional essays in the more creative "ideal" mode were well received. Particularly praised in his time were the sentimental, recumbent statue he designed as a monument to the deceased Binney child, 1839 (Mount Auburn Cemetery, Cambridge), and his rugged portrayal of an *American Backwoodsman*, 1847 (present location unknown).

Dexter never attained the international reputation of a Greenough or a Story or the national recognition of a Thomas Ball, yet he remained an influential and respected member of the Boston art community until his death in 1876. Despite his humble rural origins, he was the sculptor whom the trustees of the prestigious Boston Athenaeum approached to make the necessary repairs to Craw-

ford's damaged *Orpheus* (q.v.) when it reached America in 1842. And his critical opinions on art were solicited frequently by local committees charged with awarding commissions to sculptors, although records do not indicate that Dexter himself was a recipient of their official "largesse." As Henry Tuckerman commented of him, "Left to his untrammelled way, his conception and execution are alike worthy in power and beauty. His life has been given with enthusiasm to art. He has spared nothing of toil or devotion to it, nothing of negation of most that would win or draw from it."

J.S.R.

References

John Albee, *Henry Dexter, Sculptor: A Memorial* (Boston: privately printed by University Press, 1898); Benjamin 1880, p. 156; Craven 1968, pp. 192-196; Lee 1854, pp. 154-166; Taft 1930, pp. 92-94; Tuckerman 1867, pp. 586-589.

HENRY DEXTER
20
Theodore Lyman, 1850 (modeled in 1842)
Marble
H. 22½ in. (57.1 cm.), w. 15¾ in. (40 cm.), d. 10¾ in. (27.3 cm.)
Signed (on back of base): DEXTER. / 1850.
Gift of Mrs. Henry Lyman. 56.66

Provenance: Lyman family, Boston
Exhibited: Boston Athenaeum, 1842.
Versions: *Plaster:* (1) Massachusetts Horticultural Society, Boston, (2) present location unknown, formerly Lyman School, Westborough, Mass.

The Honorable Theodore Lyman (1792-1849), former mayor of Boston, sat for his bust in Dexter's Tremont Row studio in 1842, the year in which the sculptor's career benefited from the favorable press that had greeted his recently modeled bust of Charles Dickens.[1] A prescriptive, stylistic exercise in neoclassical portraiture, Lyman's bust lacked psychological complexity and assertiveness in modeling technique. Yet his contemporaries apparently considered it a fine likeness of Lyman, who had distinguished himself as an author, a politician, and a philanthropist, concerned in particular with establishing correctional institutions for juvenile offenders. Two plaster copies of the bust were ordered: one for the Farm School at Westborough, a juvenile reformatory that Lyman had liberally supported, and the second for another favorite pursuit and organization, the Horticultural Society of Boston.

The bust in the Museum of Fine Arts, which is dated 1850, may have been reordered in marble by the family after Lyman's death the previous year.

Dexter's portraiture was never profound in its probing of character, but it was faithful to fact. His mentor, the portrait painter Francis Alexander, commented about the young sculptor in a letter to Hiram Powers of October 10, 1838: "Dexter has done some good busts lately—good for a Blacksmith—."[2] As his technique matured, his peers found his work executed with improved "skill and taste."[3] Perhaps the most discerning judgment of his sculpture was offered by Lorado Taft nearly thirty years after Dexter's death: "Mr. Dexter's busts show good, honest work and often a large simplicity. They can hardly be called intimate or profound; but their superficial resemblance is at least free from petty details as it is from significance of pose and complexity of analysis."[4]

J.S.R.

Notes
1. See John Albee, *Henry Dexter, Sculptor: A Memorial* (Boston: privately printed by University Press, 1898), no. 36.
2. Alexander to Powers, Oct. 10, 1838, Hiram Powers Papers, AAA, SI.
3. Tuckerman 1867, p. 586.
4. Taft 1930, p. 93.

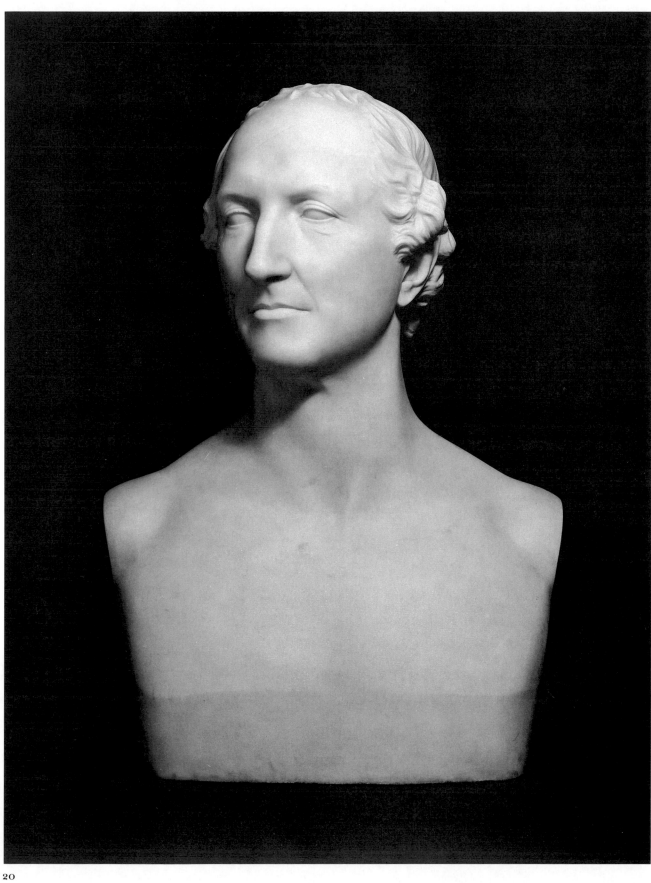

Chauncey Bradley Ives (1810 – 1894)

A family predisposition toward lung ailments was Chauncey Ives's deliverance from a life devoted to farm work. Having lost four of his children to tuberculosis, Ives's father, a Connecticut farmer, excused his sixteen-year-old son from farming responsibilities and apprenticed him to a woodcarver, Rodolphus Northrop, in New Haven. Ives, who had shown early interest and skill in woodcarving, studied diligently under Northrop, and he may have sought additional instruction from Hezekiah Augur (1791-1858), a local woodcarver who, by the 1820s, had become one of America's pioneering marble sculptors.

Ives devoted nearly ten years to developing proficiency at woodcarving. By 1837 a new ambition to sculpt in stone led him to Boston, where he began to model and carve competent portrait busts. His success in Boston was almost immediate, suggesting that his previous training had been broad enough to permit him to make the transition from wood to stone fairly easily. The first piece he made in Boston, a bust of Sir Walter Scott based on the well-known image by the English sculptor Sir Francis Chantrey (1781-1841), was acquired by the New York Apollo Association (later the American Art Union) to be dispensed as one of their annual lottery prizes.

Over the next few years, Ives traveled extensively in New England and New York, obtaining portrait commissions and exhibiting examples of his workmanship at the National Academy of Design in New York. During a visit to Meriden, Connecticut, in 1841, a doctor warned him that his health was failing and prescribed a stay in warmer climates. Three years later, with funds provided by several patrons, Ives sailed for Italy with the intention of improving both his health and his artistic reputation. From 1844 to 1851, he worked and studied in Florence, where he continued to carve portrait busts and began to explore ideal subjects. His attentions were increasingly absorbed by imaginative and picturesque "fancy" works, such as the *Boy with the Dove*, 1847, and a popular *Bacchante* (present location unknown) the following year.

In 1851 Ives moved to Rome, which became his headquarters until his death at age eighty-four. At first he worked in the courtyard of a house occupied by the American painter William Page (1811-1885); he later had various studios on the bohemian Via Margutta and Via di San Basilio, where his neighbors were Harriet Hosmer, Randolph Rogers,

and Paul Akers. During the first few years of his Roman residence, Ives modeled the original version of his graceful, much-repeated statue *Pandora* (q.v.) and other critically admired full-length ideal statues, such as *Rebecca at the Well*, 1854 (The Metropolitan Museum of Art, New York) and *Undine Receiving Her Soul*, 1859 (Yale University Art Gallery, New Haven). One of his most popular and playful works, *Sans Souci*, 1863 (Corcoran Gallery of Art, Washington, D.C.), was also created in Rome. Representing a young girl seated daydreaming, with a book held listlessly in one hand, the piece was considered by contemporary viewers as the incarnation of childish abandon and naive enjoyment. Such genial and innocent themes embodied in white marble struck at the heart of Victorian sentimentality and satisfied a growing demand for light-hearted, parlor-size statuary. Italian sculptors of the mid-nineteenth century, such as Pietro Magni (1817-1877), had made a profitable business out of such winsome studies of prepubescent children and may have inspired Ives to try to "tap" this established market.

Although Ives preferred inventing idealized subjects in white marble, he continued to execute portrait busts and began to receive commissions for full-length statues and public monuments in bronze. From the late 1860s on, he produced a number of heroic statues of historic personalities, such as those of Roger Sherman and Jonathan Trumbull, which were ordered by his home state of Connecticut for the National Statuary Hall, United States Capitol, and a bronze portrait statue of Bishop Thomas Brownell, 1867, for Washington College (now Trinity College), Hartford. He also worked on an ambitious bronze monument, *The Willing Captive*, which a local patron of the arts gave to the city of Newark, New Jersey, in 1886. The group, initially modeled in marble in 1868, depicted a white woman torn between staying with the Indian captor she had grown to love and returning to the Christian civilization from which she had been abducted long ago.

In the 1870s, when neoclassicism was losing favor elsewhere as a sculptural style, Ives's Roman studio held fast to the production of statues based on classical and mythological themes. Although it emphasized the duplication of compositions already entrenched in the sculptor's repertoire, his studio occasionally contributed new works, these, too, carved in a serenely sweet, idealized mode. At the Philadelphia Centennial Exposition of 1876, for example, Ives entered a statue of Ino and Bacchus (present location unknown) that had been modeled

in 1873, the style and theme of which represented his unswerving devotion to a smooth, lyrical neo-classicism. His career began to decline, along with his health, after the Centennial Exposition. In 1894 he died in Rome and was buried in the Protestant Cemetery.

Although Ives was neither a profound nor highly original sculptor, he was an accomplished practitioner of his craft, with great sensitivity to the prescribed moods and morals of Victorian viewers. As Lorado Taft observed, "he possessed the true Italian instinct for pretty, merchantable wares."[1] A contemporary visitor to Ives's Roman studio summed up her feelings toward his work and reputation with the fair-minded statement: "If not an enthusiast, he seems a conscientious student of his art. If he does not produce works startlingly powerful and original, whatever he does, he does well. He models with taste, feeling, and careful finish."[2]

J.S.R.

Notes

1. Taft 1930, p. 112.
2. Grace Greenwood (Sara J. Clarke Lippincott), *Haps and Mishaps of a Tour in Europe* (Boston: Ticknor and Fields, 1854), p. 223.

References

American Art Galleries, New York, *Catalogue of Important Sculptures by the Late C.B. Ives* (1899); J. Beavington Atkinson, "English and American Sculpture," *Art-Journal* (London) 24 (n.s. 1) (Dec. 1862), p. 230; Benjamin 1880, p. 156; "Chauncey B. Ives," *Cosmopolitan Art Journal* 4 (Dec. 1860), pp. 163-164; Craven 1968, pp. 284-288; Gardner 1945, p. 67; William H. Gerdts, "Chauncey Bradley Ives, American Sculptor," *Antiques* 94 (Nov. 1968), pp. 714-718; *Harper's New Monthly Magazine* 41 (Aug. 1870), pp. 420-425; Hawkes LeGrice, *The Artistical Directory; or Guide to the Studios of the Italian and Foreign Painters and Sculptors Resident in Rome* (Rome: Tipografia Legale, 1856), p. 61; Dorothy Manchester, "Neoclassic Sculptor Once Store Clerk," *Bristol Connecticut Press*, Apr. 3, 1969; Taft 1930, pp. 112-113; William Todd, *Chauncey B. Ives, Sculptor* (Hamden, Conn.: Hamden Historical Society, 1938), no. 1.; Tuckerman 1867, pp. 582-583.

CHAUNCEY BRADLEY IVES
21 (color plate)
Pandora, before 1891 (modeled in 1863)
Marble
H. 37½ in. (95.2 cm.), w. 11 in. (28 cm.), d. 14 in. (40.7 cm.)
Signed (on back of base): C.B.IVES.FECIT.ROMAE.
Gift of Mr. and Mrs. Edward L. Stone and a Friend of the Department. 1979.200

Provenance: Hirschl & Adler Galleries, New York; Mr. and Mrs. Edward L. Stone, Manchester, Mass.
Exhibited: BMFA 1979, no. 6.
Versions: *Marble*, half-life-size: (1) The Brooklyn Museum, (2) Passaic County Historical Society, Paterson, N.J., (3) James Ricau, Piermont, N.Y., (4) Saint Johnsbury Athenaeum, Vt.; life-size: (5) The Brooklyn Museum, (6) The Detroit Institute of Arts, (7) National Museum of American Art, Washington, D.C.

American sculptors in the mid-nineteenth century frequently depicted personalities from the pagan world who had symbolic counterparts in the scriptures. Pandora, the heathen sister to the biblical Eve, was a popular subject for artists who wished to furnish mythological deities with genteel Christian sentiment.[1] For Ives, Pandora served as the inspiration for one of his most beautiful and classically orthodox works.

Ives became absorbed with his design idea for *Pandora* prior to his departure for Rome in late 1851. A visitor to his Florentine studio in January 1851 commented on the sculptor's plaster study: "His dream, to be chiselled in marble, is Pandora; and well has he modelled out his dream. She stands erect, half-draped from the left arm to the feet, in the most bewitching attitude. The form is perfect in its easy, natural grace, while the face cast down upon the box of mischief (held in the left hand) has a mingled expression of reflection, curiosity and beauty, which awakes one to love. She seems to hesitate whether to open the box or not, and the doubt pervades the whole expression. We all know that curiosity overcomes her at last, for she was a woman."[2] Another caller at his studio that year, Benjamin Silliman, reported: "We found Mr. Ives at work upon a fine female form, an allegorical figure of a lady well known to fame, who holds in her hand a casket full of evils, and long renowned as the box of Pandora."[3] It is significant that neither writer felt compelled to explain or excuse the statue's nudity, an omission that tacitly suggests a more tolerant attitude on the part of Americans toward the representation of nudity in art.

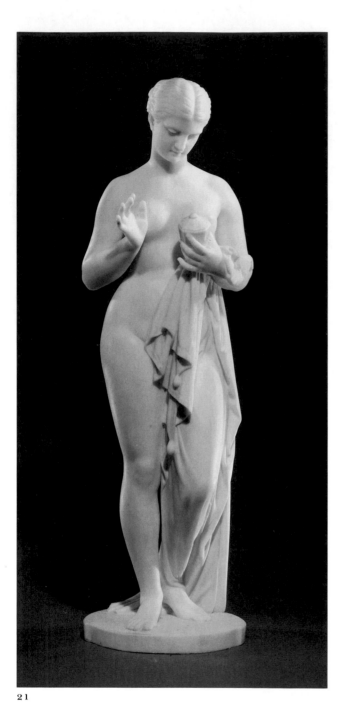

21

Ives's interest in the myth of Pandora was shared by many nineteenth-century artists, particularly British sculptors, whose marble incarnations of her were sprinkled throughout public and private art collections abroad by midcentury. It was the provocative incongruity of innocent beauty and mischievous wrongdoing that made Pandora an ideal study of visual and intellectual paradox. According to the myth, the Olympic gods fashioned Pandora as a mate for the titan Epimetheus, and each endowed her with a precious quality or unique charm. After they had finished conferring treasures upon the beautiful nymph, they dispatched her to earth with a casket, which she was commanded to keep shut, containing an assortment of both good and evil wedding presents. Seized with curiosity, Pandora unfortunately opened the box, releasing all the good gifts as well as a multitude of plagues. Appalled by the horror of her deed, she clamped the box's lid shut in time to capture one blessing, hope, the gift that enabled subsequent generations to endure the world's misfortunes. Pandora's encounter with the infamous box thus provided a symbolic rationale for mankind's miseries and linked the physical image of feminine beauty with the concept of affliction.[4] The popularity of the myth among sculptors in the first half of the century foreshadowed the emergence of the alluring character of the *femme fatale* in late nineteenth-century fiction and paintings.

For Ives, the contemplation of future action rather than the act itself offered the most intriguing compositional potential for sculpture. Critics appreciated the subtle drama expressed in *Pandora*'s pose and expression, which were considered the perfect embodiments of doubt and curiosity. Special praise was given to Ives's delineation of the nymph's "joyous smile, wicked yet bewitching"[5] and to the coquettish posture of her hands as she fondled the box's lid. (The sculptor initially decorated the lid with a carved serpent, but he removed it in later modifications of the statue as too conspicuous.) Other critics commented on how cleverly Ives captured the look of momentary indecision in Pandora's face, which reflected a "hesitant, half-formed determination to open the fatal box."[6]

The overall composition and modeling of *Pandora* also were acclaimed, particularly the balance between severe classicism and graceful naturalism.[7] Critics noted Ives's deft management of drapery in the folded robe that cascaded down the left side of *Pandora*'s body,[8] forming a pleasing contrast to the

soft contours of her own form. The sculptor's accurate rendering of female anatomy was considered particularly commendable, given his lack of formal academic instruction. A contributor to *Cosmopolitan Art Journal* not only equated *Pandora* with Hiram Powers's celebrated *Greek Slave* but also went so far as to call it "equal to the *Greek Slave* in anatomical symmetry and superior to it in grace and disposition, and much above it in ideality and power of rendering emotion."[9]

The attention *Pandora* received in international art periodicals naturally prompted many of Ives's sculptor colleagues and competitors to visit his studio so that they might pass judgment on the miraculous nymph. One of the statue's distinguished inspectors was the English sculptor John Gibson (1790-1866). Gibson had carved his own version of Pandora earlier in the century, but he was nonetheless impressed by Ives's performance and bestowed upon it one of his rare, unreserved compliments.[10] A correspondent for the Chicago *Art Journal* was similarly affected and pronounced Ives's work to be at least commensurate in form and beauty with the same subject carved by the late and renowned sculptor Sir Richard Westmacott (1775-1856).[11] It is interesting that none of these reviewers commented on the similarities between Ives's statue and the *Psyche*, 1792 (Ince Blundell Hall, Lancashire, England), of the famous Italian neoclassicist Antonio Canova (1757-1822), which the *Pandora* resembled in pose and in its narrative symbolism. Because of the parallels between the myths of these two lovely victims of irresistible curiosity, Canova's *Psyche* would have been an appropriate source for Ives. Psyche was represented by Canova as gazing at a butterfly, the symbol of the soul's immortality, which is held in her hand. Ives's figure imitated the pose, although the insect was substituted by the casket containing not only the afflictions of man but also the salvation of Christian hope.

Ives carved the original 1851 marble *Pandora* for Major Philip Kearney of New York, a loyal patron of his. Almost a decade later he exhibited a replica at the 1862 International Art Exposition in London. The favorable attention the statue received prompted Ives to make over nineteen replicas of the theme, offered in two sizes, life-size (65 inches high) and half-life-size (37½ inches high).[12] According to William Gerdts, Ives remodeled the statue in 1863, altering his design of the box and the tilt of Pandora's head.[13] The many copies produced by Ives's studio until 1891 reflected these revisions. The reduced version of *Pandora* in the Museum of Fine Arts, representing the reworked version, is equipped with its original marble pillar and revolving base.

Several copies of *Pandora* were in New England collections by the latter half of the nineteenth century. Period photographs of Archer C. Wheeler's Gothic-revival mansion Walnut Wood, in Bridgeport, Connecticut, for example, illustrate a half-scale *Pandora* ornamenting the parlor.[14]

J.S.R.

Notes

1. See Florentia, "A Walk through the Studios of Rome," pt. V, *Art-Journal* (London) 17 (n.s. 1) (Aug. 1855), p. 228.

2. Letter, Florence, Jan. 20, 1851, from *Newark Daily Advertiser*, reproduced in *Bulletin of the American Art-Union*, Apr. 1851, pp. 12-13.

3. Benjamin Silliman, *A Visit to Europe in 1851* (New York: Putnam, 1853), p. 91.

4. See Dora and Erwin Panofsky, *Pandora's Box: Changing Aspects of a Mythological Symbol*, Bolligen Series 52 (New York: Pantheon Books, 1956).

5. Florentia, "A Walk," p. 228.

6. "Chauncey B. Ives," *Cosmopolitan Art Journal* 4 (1860), pp. 163-164.

7. See J. Beavington Atkinson, "International Exhibition, 1862, no. VII: English and American Sculpture," *Art-Journal* (London) 24 (n.s. 1) (Dec. 1862), p. 230.

8. Florentia, "A Walk," p. 228.

9. "Chauncey B. Ives," pp. 163-164.

10. James Freeman, *Gatherings from an Artist's Portfolio* (New York: Appleton, 1877), p. 254.

11. See [Queros], "Letter from Rome," *Art Journal: An American Review of the Fine Arts* (Chicago) 2 (May-June 1869), p. 112.

12. For a discussion of both versions of the statue, see Hirschl & Adler 1982, p. 25.

13. Information kindly supplied by Professor Gerdts in conversation.

14. Wayne Andrews, "A Gothic Tragedy in Bridgeport," *Antiques* 72 (July 1957), p. 51.

Shobal Vail Clevenger (1812 – 1843)

During the eight years in which Shobal Clevenger practiced his profession, he established a reputation as an exceptionally skillful and sensitive portrait sculptor, whose talents were comparable to those of Hiram Powers.

Like Powers, Clevenger was introduced to his prospective career indirectly, in Cincinnati, Ohio, where he had settled at the age of fourteen. Having previously worked as a stonemason on the canal in Centerville, Ohio, Clevenger found employment in Cincinnati with a gravestone cutter named David Guion. Impressed by his proficiency in carving freestone, the fine-grained rock abundant in the region, Guion permitted Clevenger to concentrate his attention on ornamental carving. His young employee was soon cutting freestone busts and figures that brought favorable local notice. The editor of the *Cincinnati Evening Post*, Ebenezer S. Thomas, who had seen a cherub on a gravestone carved by Clevenger, went so far as to hail him as "the future Canova of this country."[1] Fortunately for Clevenger, his work also attracted the interest of a well-known patron of the arts in Cincinnati, Nicholas Longworth, who provided him with funds to attend anatomy lectures at the Ohio Medical College. Clevenger sought additional instruction from a Prussian sculptor named Frederick Eckstein, who had given lessons several years earlier to Hiram Powers in modeling and carving, emphasizing the importance of working from nature.

On the advice of Longworth and others, Clevenger left Cincinnati in 1837 to begin a commission-seeking tour through the Midwest and on the East Coast. In Lexington, Kentucky, he arranged a sitting with the statesman Henry Clay, which resulted in a fine portrait of about 1842 (The Metropolitan Museum of Art, New York), that Clay himself certified as a correct likeness.[2] Stops in Washington, D.C., New York, and Philadelphia reaped orders for him to model busts of such public figures as William Henry Harrison, 1837, Daniel Webster, 1838, and Jeremiah Mason, 1839 (all Boston Athenaeum). A journey to Boston rewarded him with additional commissions for portrait busts of noteworthy Yankee politicians and patricians and the privileged opportunity to model a bust of Washington Allston, 1840 (Boston Athenaeum). Clevenger's extended tour was a triumphant success, and public recognition of his talent quickly followed.

With funds supplied by Nicholas Longworth, Clevenger was finally able to realize his ambition of studying sculpture abroad. In the fall of 1840 he and his family sailed for Italy. Establishing himself in Florence, Clevenger immediately set to work translating into marble many of the plaster portrait studies he had taken with him. He also tentatively explored several ideal conceptions, an imaginative portrait of *The Lady of the Lake*, and a life-size figure of an Indian warrior (present location unknown). Tragically, his health began to fail, and his family departed for America, hoping for his recovery. He died at sea, however, having succumbed to tuberculosis, which was believed to have been aggravated by inhaling marble dust.

Clevenger's premature death at thirty-one was mourned by admirers in America and in Italy. Though almost illiterate and lacking the cultural polish that traditionally assisted artists in their interactions with patrons and other colleagues, Clevenger seems to have been universally popular in art circles at home and abroad. His contemporaries appreciated his warmth, diligence, simple dignity, and his rare humility before those whose artistic talents were greater than his. His art was eulogized not for sentimental reasons but for its genuine merit: a refreshing directness and realistic approach to modeling and the "perfect flexibility" of flesh that he was able to impart to the medium of cold marble. Henry Tuckerman observed, "Clevenger began in art where all noble characters begin action—in truth. . . . There was an exactitude in his busts that gave assurance of skill founded upon solid principles."[3] This quality, however, was not appreciated by all observers of Clevenger's work. Charles Sumner confided in a letter to Thomas Crawford that Clevenger's busts were "very good portraits but devoid of grace, poetry, and artistic finish. He preserves all the hardness of features, every wrinkle, and even multiplies the crow's feet at the corners of the eye. In this way he gives you an unmistakable face but a wretched bust."[4]

J.S.R.

Notes

1. Ebenezer S. Thomas, *Reminiscences of the Last Sixty-five Years . . .* (Hartford: Published by the author, 1840), vol. 2, p. 202, cited in Thomas Brumbaugh, "Shobal Clevenger, an Ohio Stonecutter in Search of Fame," *Art Quarterly* 29 (1966), p. 31.

2. Thomas, *Reminiscences*, vol. 2, p. 202, cited in Brumbaugh, "Shobal Clevenger," p. 32.

3. *Columbian* 1 (1844), pp. 10-11, obit.

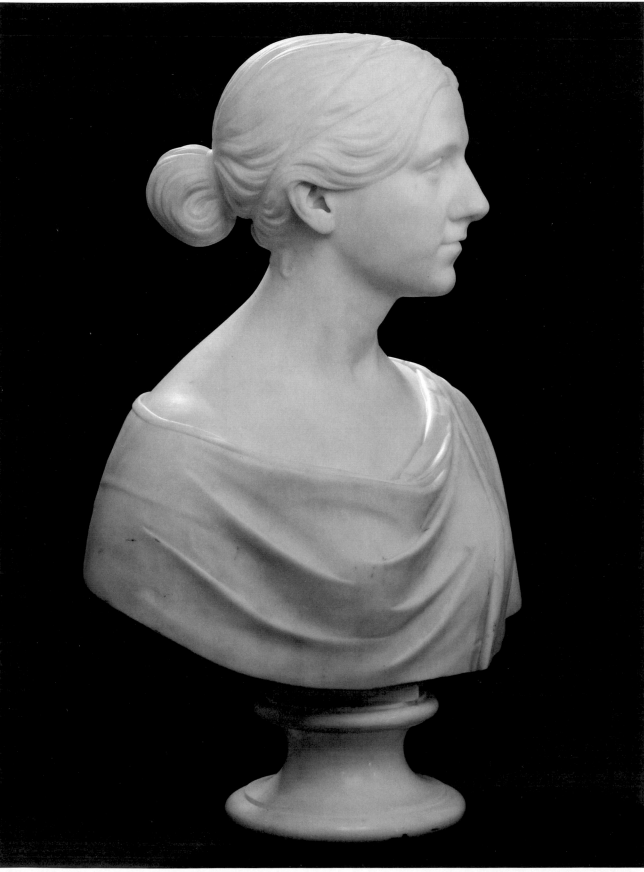

4. Sumner to Crawford, Mar. 31, 1841, quoted in Edward Lillie Pierce, *Memoir and Letters of Charles Sumner* (Boston: Roberts, 1877 - 1893), vol. 2, p. 175.

References

Benjamin 1880, pp. 138, 145; *Boston Evening Transcript*, Nov. 13, 1843, obit.; Thomas Brumbaugh, "Shobal Clevenger, an Ohio Stonecutter in Search of Fame," *Art Quarterly* 29 (1966), pp. 29-45; *Columbian* 1 (1844), pp. 10-11, obit.; Craven 1968, pp. 180-187; Pickering Dodge, *Sculpture and the Plastic Art* (Boston: Jewett, 1850), pp. 332-333; Lee 1854, pp. 167-173; Edward Lillie Pierce, *Memoir and Letters of Charles Sumner* (Boston: Roberts, 1877 - 1893), vol. 2, p. 175; "Sculpture in America," *Harper's Monthly Magazine* 58 (Apr. 1879), p. 662; "Shobal Vail Clevenger, the Sculptor," *Southern Literary Messenger* 5 (Apr. 1839), pp. 262-265; Taft 1930, pp. 104-106; Tuckerman 1867, pp. 605-609; "Clevenger," *United States Magazine and Democratic Review* 14 (Feb. 1844), pp. 202-206.

SHOBAL CLEVENGER
22
Annie Bigelow Lawrence, 1840-1843 (modeled in 1839)
Marble
H. 21½ in. (54.6 cm.), w. 18 in. (45.8 cm.), d. 11 in. (28 cm.)
Signed (on back): S.V. CLEVENGER / 1839
Gift of Aimée and Rosamond Lamb. 69.12

Provenance: Annie Bigelow Lawrence (Mrs. Benjamin Rotch), Boston; Aimée Rotch (Mrs. Winthrop Sargent), Fishkill-on-the-Hudson, N.Y.; Annie Lawrence Rotch (Mrs. Horatio Appleton Lamb), Milton, Mass.; Aimée and Rosamond Lamb, Boston
Exhibited: BMFA, "Back Bay Boston: The City as a Work of Art," Nov. 1, 1969-Jan. 11, 1970; BMFA 1979, no. 3.

Shobal Clevenger's bust of Annie Bigelow Lawrence (1820-1893) was referred to many years later by the sitter, then Mrs. Benjamin Rotch, in a note to her daughter: "I send this ancient daguerreotype of my bust by Clevenger who died in Italy as he was beginning to be eminent as a sculptor, after a struggle with poverty and obscurity. You may like to have this relic of bygone days—I was about 18 or 19 when the bust was modeled in clay and reproduced in marble in Florence."[1]
Shobal Clevenger's bust of Annie Bigelow Lawrence was modeled during the sculptor's brief but extraordinarily successful sojourn in Boston in 1839. In the early fall of that year, local newspapers had noted his arrival and were favorably impressed by the skill and speed with which he worked. In

September Clevenger had exhibited eleven portrait busts at the Boston Mechanics Institute, which were said to have displayed "talents of the highest merit."[2] On October 11, 1839, the *Salem Gazette* reported that he had modeled nearly twenty portraits already and had been forced to decline approximately two hundred applications for his services.[3] The reporter also wryly noted that Clevenger's inability to accept new commissions would save prospective sitters $300 apiece, the rate charged per bust by the sculptor. Art columns published in periodicals as far south as Richmond, Virginia, commented on Clevenger's auspicious reception in Boston.[4]

This midwestern sculptor initially had endeared himself to the New England populace by executing busts of two universally admired "native" residents, Daniel Webster and Washington Allston. Within several months, this list expanded to include other local personalities such as Edward Everett, 1839, Lemuel Shaw, 1839, and Andrews Norton, 1840 (all Boston Athenaeum). By April 1840 the register of Clevenger's Boston and North Shore sitters was literally rich enough to permit him to raise his fee to $500 per bust, a price that included the costs of transferring the plaster study into marble.[5] The trustees of the Boston Athenaeum invited Clevenger to open a temporary studio in their building,[6] which gave him greater access to other prominent citizens and their families as prospective sitters.

Clevenger probably modeled this portrait of Annie Bigelow Lawrence in his makeshift quarters at the Boston Athenaeum, although she is not recorded as having frequented his studio (probably because of her youth). A member of a wealthy family of industrialists and philanthropists, Annie Lawrence is aptly interpreted as a patrician maiden, fashionably attired in classical dress and coiffure: the style is similar to that of Roman imperial portrait busts of the first and second centuries A.D.[7] Though inscribed with the date "1839," the portrait was carved in marble sometime between the fall of 1840, when Clevenger left for Italy, and 1843, the year of his death.

Clevenger is known to have also carved a bust of Annie Lawrence's uncle, Amos Lawrence.[8] Lawrence was one of several prominent Bostonians who subscribed to a fund for the casting of the statue of the Indian warrior, which was left in Clevenger's Florentine studio at the time of his death. Unfortunately, the project was never accomplished; thus, Clevenger's legacy to posterity consists solely of a

group of finely modeled and realistically sensitive portrait heads.

J.S.R.

Notes

1. A.L. Rotch to Aimée Rotch Sargent, undated letter; the letter and this daguerreotype (1973.595) are in the BMFA, Department of Prints, Drawings, and Photographs; a second daguerreotype (1983.237) of the same subject is in the Department of American Decorative Arts and Sculpture.

2. See Boston Museum (not to be confused with the Museum of Fine Arts), *Catalogue of Paintings and Portraits* (1847), no. 960. The busts were not catalogued individually.

3. Thomas Brumbaugh, "Shobal Clevenger, an Ohio Stonecutter in Search of Fame," *Art Quarterly* 29 (1966), p. 34.

4. See "Shobal Vail Clevenger, the Sculptor," *Southern Literary Messenger* 5 (Apr. 1839), pp. 262-264.

5. In April 1840 Nicholas Longworth wrote to Hiram Powers, "Clevenger has been doing well in Boston," remarking that, instead of $150 per bust, the sculptor now received $500 per bust; see Craven 1968, p. 184.

6. For busts by Clevenger now in the Boston Athenaeum, see Boston Athenaeum 1984, pp. 20-22.

7. Vermeule 1975, p. 975.

8. Craven 1968, p. 184.

Thomas Crawford
(1811/1813?–1857)

In the eulogy George Hillard wrote for Thomas Crawford in the *Atlantic Monthly*, he summarized his deceased friend as "at once the most modern and the most Greek of sculptors—modern, in his sympathy with the age in which he lived, and his power of embodying its ideas; Greek—in the purity of his forms, and the serene atmosphere of repose that hangs over even his most animated works."[1] Admirers who mourned Crawford's premature death voiced similar judgments of his artistic importance, claiming his sculpture was of inspired genius, distinguished by its perfect integration of classical grace and romantic spirituality. Although his career spanned less than a quarter of a century, Crawford was enormously prolific, producing more than sixty statues. This body of work, which consisted of public monuments, ideal compositions, and portrait busts, earned him the reputation in his lifetime as one of America's most gifted artists. Subsequent generations of critics applied the title of "the Allston of American sculpture" to him in recognition of his special poetic vision and the intellectual substance of his statues as well as the major monuments he left unfinished when he died.

Crawford shares honors with Horatio Greenough and Hiram Powers for his pioneering contributions to nineteenth-century American sculpture. But unlike their desultory beginnings in the craft, Crawford's career was facilitated by a technical background in art. In New York, his presumed birthplace, Crawford took drawing lessons as a boy, modeled in clay, and worked for several years as a woodcarver's apprentice. At age nineteen his mechanical skills were further improved in the prominent stonecutting studio of John Frazee (1790-1852) and Robert E. Launitz (1806-1870). Crawford was apprenticed to Frazee and Launitz for two and one-half years, and under their tutelage he became an adept carver of marble mantelpieces and funerary ornaments. His special expertise lay in carving floral designs, although he occasionally aided Frazee with portrait busts. Eager to perfect the nicer aspects of sculpture, he spent his evenings sketching and drawing from casts at the National Academy of Design.

Crawford's apprenticeship with Frazee and Launitz whetted his appetite to study sculpture in Rome, where Launitz had briefly worked. It was Launitz who urged Crawford to seek further training in Italy under the preeminent neoclassic sculptor Bertel Thorwaldsen. In September 1835 Crawford arrived in Rome, the first American sculptor to establish himself in the "Eternal City." He quickly sought out Thorwaldsen and presented him with a letter of introduction from Launitz. To his delight, the celebrated Dane agreed to take him as a student for one year, an experience that had a profound effect on the American's stylistic approach to sculpture.

Rome itself was a feast for the inquisitive young artist. Crawford's daily schedule included regular tours of the city's churches and museums, classes at the French Academy in drawing and modeling from life, visits to hospital mortuaries to observe dissections and study anatomy, and coffee at the Café Greco, where instructive chatter on art always abounded. To Launitz he wrote, "Rome is the only place in the world fit for a young sculptor to commence his career in. Here he will find everything he can possibly require for his studies; he lives among artists, and every step he takes in this garden of the Arts presents something which assists him in the formation of his taste."[2]

Crawford's enthusiasm for sightseeing in Rome was tempered by his realization that study alone would not feed him or pay his rent. After leaving Thorwaldsen's studio he eventually found his own

space, on the Via de Orto di Napoli, "three obscure, sunless apartments, so cold and damp that they strike a chill through you."[3] There he pursued an arduous regimen, staving off hunger while endeavoring to maintain confidence in the unsure profession he had chosen. At first he confined his work to executing portrait busts and copies of antique marbles. As an American sculptor in Rome, he stirred the interest of English-speaking tourists, and he used his unique status to his advantage. In one ten-week period in 1837 he completed seventeen busts as well as a marble copy of the famous *Demosthenes* in the Vatican Museums.

Crawford confronted the challenge of ideal subject matter in 1838, with the creation of the full-length statue *Orpheus and Cerberus* (q.v.), which featured Orpheus descending into Hades in search of Eurydice. Crawford attempted to wed this pagan theme with Christian sentiment and to emulate the pure aesthetics of revived classicism. So exhaustive were his labors in completing the monumental opus that he collapsed with a severe case of so-called Roman fever. The young sculptor's enervation was surely relieved by news that *Orpheus* had attracted a patron who wished to see the work reproduced in marble. Charles Sumner of Boston had admired the plaster model in Crawford's Roman studio and persuaded a group of Boston connoisseurs to raise funds to acquire a facsimile in marble for the Boston Athenaeum. In 1843 the finished *Orpheus* arrived in Boston, where its enthusiastic reception made history both for the cause of sculpture in America and for Crawford, whose fortunes propitiously altered as a result.

With the major success of *Orpheus and Cerberus* behind him, as well as half a dozen other creditable performances in the ideal mode, Crawford's career flourished. His personal life also brightened through his marriage in 1844 to Louisa Ward,[4] the wealthy New York sister of Julia Ward Howe. For the next thirteen years his bustling studio, at one time consisting of twelve rooms and a work force of fifty assistants, produced statues with mythological and scriptural themes, executed with consummate regard for classic technique, sweet or uplifting sentiment, and smooth textural finishes. Among his better known works of this temper are *Hebe and Ganymede* (q.v.), *Anacreon Ode* LXXII, 1842 (Boston Athenaeum), *Christian Pilgrim in Sight of Rome*, 1847 (Boston Athenaeum), *Flora*, 1853 (The Newark Museum, New Jersey), *Peri at the Gates of Paradise*, 1855 (Corcoran Gallery of Art, Washington, D.C.), and *Adam and Eve*, 1855 (Boston Athenaeum). Crawford

also specialized in compositions of semi-idealized children such as *Babes in the Woods*, 1851 (The Metropolitan Museum of Art, New York), adapted from a sentimental English ballad, or such amiable studies of playful youth as *Genius of Mirth*, 1843 (The Metropolitan Museum of Art), and *Boy Playing Marbles*, 1853 (Worcester Art Museum, Massachusetts).

Beyond designing parlor sculpture for his affluent clientele, Crawford aspired to create heroic public monuments of lasting importance. He therefore willingly entered into governmental competitions, from which resulted an enviable number of significant commissions. In 1851 he began work on a monumental equestrian statue of George Washington for the state of Virginia, intended for placement in Richmond. The work represented a departure from Crawford's routine classical idiom, for it was realistic in spirit and cast in bronze, a medium that he utilized frequently after this time. Tragically, he never lived to see the monument in its final position; Randolph Rogers, a friend and colleague in Rome who was sympathetic to Crawford's ideas, assumed the assignment to complete the monument after Crawford's death. Other principal commissions received from the United States government were for major adornments to the Capitol: bronze doors for the Senate and House of Representatives wings, 1856, modeled after Lorenzo Ghiberti's renowned prototypes in Florence and illustrating in relief aspects of Washington's military and civic career; a pedimental sculpture, *The Progress of American Civilization*, 1856, symbolizing the advances of the white man over the noble American "savage," and a colossal bronze figure, *Armed Freedom*, to crown the top of the building. Although these orders consumed much of Crawford's time in the 1850s, he also managed to produce a seven-foot bronze statue of Beethoven for Boston's Music Hall, 1855 (New England Conservatory of Music, Boston), a forcefully naturalistic figure that was cast at the Royal Academy of Munich, Germany, and displayed in Munich with much public fanfare before its departure for Boston.

After 1848 Crawford's sculptural work was composed and completed at the rambling Villa Negroni (located near the Baths of Diocletian), which he had secured on a lifetime contract from its owner, Prince Massimo. In a maze of rooms above the ground floor the Crawfords entertained prospective clients, fellow expatriates, and visiting tourists. Within the extensive grounds Crawford built a series of studios against the foundations of ruins.

There he worked industriously, inventing new compositions and directing his workmen.

Crawford died at age forty-four, in October 1857, at the height of his productivity as a sculptor. The cause of death was a brain tumor that had first blinded him in one eye. His passing elicited eulogies and tributes from a vast number of friends and fellow sculptors. In Rome a group of forty-five artists convened to adopt a unanimous resolution of deepest sympathy for Crawford's widow and family. Members of the National Academy of Design in New York (which had elected him an honorary member in 1838) wore black badges of mourning for a month. The Century Club of New York organized a memorial meeting to read a special eulogy written by Thomas Hicks. The art critic Henry Tuckerman composed an effusive dirge describing "The Funeral of Thomas Crawford."

Louisa Crawford assumed responsibility for supervising the completion of the sculptor's important government commissions. She also arranged for the exhibition of Crawford's studio casts, over eighty-five in number, at the New York Armory, with the objective of forming a nucleus for a gallery devoted to her husband's work in his native city. Unfortunately, these casts were subsequently destroyed by fire.

A few of Crawford's contemporaries disparaged his contributions to American sculpture, accusing him of a deficiency in his knowledge of anatomy, a want of spatial sensitivity in designing large-scale groups, and a stubborn preference for passive literary themes cloaked in antique idiom rather than active realism. Most critics, however, credited him with ushering in a new era of American art. As his friend George Washington Greene wrote, "With a mind so thoroughly artistic in its mould and its training, he was governed throughout his whole career by motives worthy of the genius which heaven had bestowed upon him. He looked upon art as an instrument of national and individual culture; . . . the natural expression of beautiful thoughts, tender feelings, and noble aspirations. . . . He would have wished that all should learn to love her, with a love as pure and as worthy as his own."[5]

J.S.R.

Notes

1. George S. Hillard, "Eulogy on Thomas Crawford," *Atlantic Monthly* 24 (July 1869), p. 52.

2. Crawford to Launitz, June 27, 1837, quoted in "Reminiscences of Crawford," *Crayon* 6 (Jan. 1859), p. 28.

3. As described by Catherine Maria Sedgwick, *Letters from Abroad to Kindred at Home* (New York: Harper, 1841), vol. 2, p. 157.

4. The Crawfords had four children; their son Francis Marion became a well-known novelist.

5. George Washington Greene, *Biographical Studies* (New York: Putnam, 1860), p. 153.

References

"American Sculptors in Rome," *Bulletin of the American Art-Union*, Oct. 1851, pp. 13-14; "Art in America," *Art-Journal* (London) 12 (Sept. 1850), p. 295; Benjamin 1880, pp. 138, 145, 149; Clark 1878, pp. 61-73; Crane 1972, pp. 273-408; Jane Crawford, "The Sculptor in His Studio," *United States Magazine and Democratic Review* 12 (June 1843), pp. 567-568; "Crawford's *Beethoven*," *Crayon* 2 (Sept. 1855), p. 166; "Crawford and His Washington," *Cosmopolitan Art Journal* 1 (Nov. 1856), p. 46; "Crawford and Ives," *Cosmopolitan Art Journal* 4 (1860), pp. 524-526; S. Eliot, "Thomas Crawford," *American Quarterly Church Review and Ecclesiastical Register* 11 (Apr. 1858); Florentia, "Crawford and His Last Work," *Art-Journal* (London) 17 (n.s. 1) (1855), p. 41; "Fine Arts Gossip," *Bulletin of the American Art-Union*, May 1849, pp. 25-26; Mrs. Hugh [Mary Crawford] Fraser, *A Diplomatist's Wife in Many Lands*, 2 vols. (London: Hutchinson, 1911); Hiram Fuller, *Belle Brittan on Tour* (New York: Derby & Jackson, 1858), pp. 239-243; Robert L. Gale, *Thomas Crawford, American Sculptor* (Pittsburgh: University of Pittsburgh Press, 1964); George Washington Greene, *Biographical Studies* (New York: Putnam, 1860), pp. 121-154; idem, "Crawford, the Sculptor," *Knickerbocker* 17 (Feb. 1846), p. 174; Thomas Hicks, *Eulogy on Thomas Crawford* (New York: Appleton, 1857); George S. Hillard, "Eulogy on Thomas Crawford," *Atlantic Monthly* 24 (July 1869), pp. 40-54; idem, *Six Months in Italy* (Boston: Ticknor & Reed, 1853), pp. 260-265; W.H. Ingersoll, "Crawford the Sculptor as Represented in Central Park," *Aldine* 2 (Aug. 1869), pp. 87-88; Lee 1854, pp. 173-177; Samuel Osgood, "Crawford, the Sculptor," *Cosmopolitan Art Journal* 3 (Mar. 1859), p. 59; idem, *Thomas Crawford and Art in America: An Address before the New York Historical Society* (New York: Published by the Society, 1875); "Reminiscences of Crawford," *Crayon* 6 (Jan. 1859), p. 28; Julia Shedd, *Famous Sculptors and Sculpture Illustrated* (Boston: Osgood, 1881), pp. 293-296; "Sketchings: Domestic Art Gossip," *Crayon* 7 (Nov. 1860), p. 325; William Stillman, "American Sculpture," *Cosmopolitan Art Journal* 4 (Mar. 1860), pp. 1-4; "Thomas Crawford," *Art-Journal* (London) 20 (n.s. 3) (Nov. 1857), p. 348, obit.; "Thomas Crawford," *Crayon* 4 (Dec. 1857), p. 380, obit.; "Thomas Crawford," *Cosmopolitan Art Journal* 2 (Dec. 1857), pp. 27-28, obit.; "Thomas Crawford," *Littell's Living Age* 56 (Jan. 1858), pp. 274-280; Thorp 1965, pp. 30-41; Tuckerman 1867, pp. 306-320; Henry Tuckerman, "Crawford and Sculpture," *Atlantic Monthly* 2 (June 1858), pp. 64-78.

THOMAS CRAWFORD

23

Venus as Shepherdess, about 1840
Marble
H. 22¾ in. (57.8 cm.), w. 21⅝ in. (54.9 cm.), d. 3⅜ in. (8.6 cm.)
Bequest of Ida Elizabeth Deacon. 83.30

Provenance: Ida Elizabeth Deacon, Boston
Exhibited: BMFA, "Confident America," Oct. 2-Dec. 2, 1973; BMFA 1979, no. 1.

During Crawford's apprenticeship to John Frazee and Robert Launitz in New York, he often admired the plaster casts of Bertel Thorwaldsen's work deposited in the study collection of the National Academy of Design. Consequently, when he arrived in Rome in the autumn of 1835, he eagerly sought out the renowned sculptor at his suite of studios near the Piazza Barberini. For a brief time Crawford received instruction in one of Thorwaldsen's three Roman studios, concentrating on the principles of perspective, "the nature of masses and the law of proportions,"[1] and learning to reproduce faithful copies from casts of famous antique statues.[2]

This bas-relief, presumably made about 1840 during this early phase of Crawford's residence in Rome, is a direct quotation of a prototype carved by Thorwaldsen. It may have been executed as an atelier exercise at the teacher's suggestion or to fulfill a client's order for a copy of this specific work.[3] The subject of the relief is a variation on the popular artistic theme of the *Seller of Cupids*,[4] or, as the Italians called it, *La Mercantessa d'Amore*.[5] In the nineteenth century Thorwaldsen's relief, 1831 (Thorwaldsen Museum, Copenhagen), was known as *A Basket of Loves* because of the nest of plump cupids cuddled in the shepherdess Venus's lap.[6] Contemporary critics appreciated the fine sense of composition exhibited in the relief. One wrote, "Attention should be directed to the upper end of the staff, which, by being thus placed, fills up what would otherwise be a blank space, giving to the whole composition a complete, pyramidal form. This portion of the staff, seen behind the female, acts as a balancing power to the group of small figures projecting in the same line with it, on the opposite side."[7]

The Victorian art public considered the general disposition of the subject not only pleasing pictorially but also significant allegorically, since the assembly of cupids was interpreted to represent love's fascinating diversity and subtlety: "One love is not yet awake; faithful love caresses the dog; the third is soothed by laying his hand on the arm of the shepherdess; two others kiss passionately; and fickle love flies away, into the air."[8] Thorwaldsen's treatment of the shepherdess was also seen as having moral import. Compared with the traditional personification of Venus as a seductive and scantily dressed love goddess, his figure is modestly clothed in rustic robes. Having relinquished her tambourine and her shepherd's crook, she is presented as the *amorini*'s bucolic babysitter, delegated with the responsibility of controlling her passionate charges rather than arousing them. Thorwaldsen's goddess is sedate and matronly, an intellectual embodiment of love, vigilant in her duties of governing the heart's desires. This may explain why Crawford chose to copy this subject, since it would have been acceptable to moralistic Americans who staunchly opposed the exhibition of the naked body, particularly when its exploitation was excused in the name of art.

Venus as Shepherdess should not be regarded as a reflection of Crawford's early imaginative bent or original design capability. It does reveal, however, the impressive technical facility in bas-relief work that he had acquired carving mantelpiece ornaments for Launitz and Frazee in New York.[9] Henry Tuckerman later compared the masterful workmanship and pictorial grace of Crawford's mature low-relief compositions to the superlative marble reliefs of Thorwaldsen.[10]

J.S.R.

Notes

1. George Washington Greene, *Biographical Studies* (New York: Putnam, 1860), p. 131.

2. For Crawford's description of his early experiences in Thorwaldsen's studio, see his sister Jenny's letter to Francis Leiber, Apr. 4, 1855, Ho, HU.

3. Though unsigned and undated, the piece has been traditionally assigned to Crawford and dated about 1840. Crawford executed other copies of works by Thorwaldsen, such as *Day* and *Night*, 1815 (Thorwaldsen Museum, Copenhagen), famous bas-reliefs that Crawford reproduced for George Tiffany of Baltimore, about 1843 (present location unknown).

4. See Robert Rosenblum, *Transformations in Late Eighteenth-Century Art* (Princeton: Princeton University Press, 1967), p. 3, n. 1.

5. Thorwaldsen's relief was referred to as *La Mercantessa d'Amore* in Count Hawkes Le Grice, *Walks through the Studii of the Sculptors at Rome* (Rome: Puccinelli, 1841), vol. 1, p. 91.

6. See "A Basket of Loves: From the Bas-Relief by Thorwaldsen," *Art-Journal* (London) 27 (n.s. 4) (Jan. 1865), p. 28.

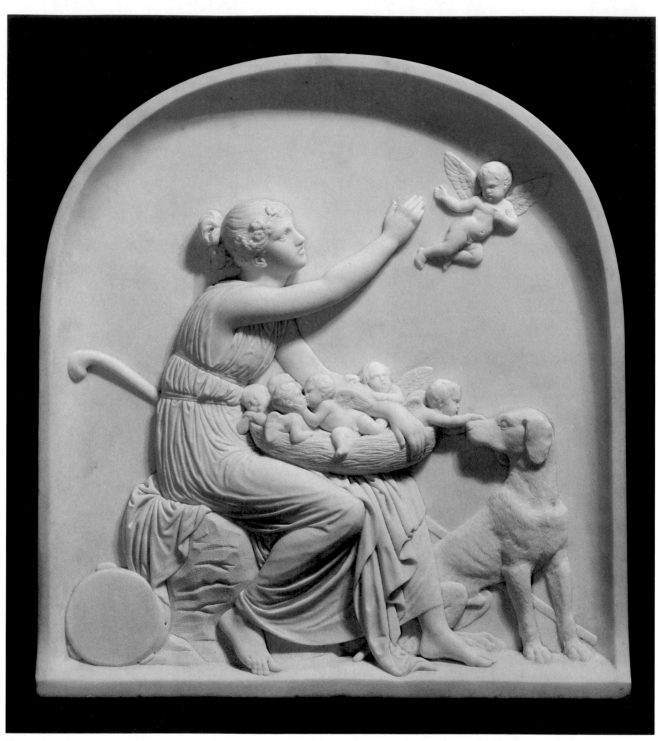

23

7. Ibid.

8. See Gerdts 1973, p. 80.

9. See Vermeule 1972, pp. 872-873.

10. Henry Tuckerman, "Crawford and Sculpture," *Atlantic Monthly* 2 (June 1858), p. 70.

THOMAS CRAWFORD

24

Charles Sumner, 1842
Marble
H. 27 in. (68.6 cm.), w. 14 in. (35.5 cm.), d. 10⅜ in. (26.4 cm.)
Bequest of Charles Sumner. 74.30

Provenance: Charles Sumner, Boston
Version: *Marble:* (1) Massachusetts Historical Society, Boston

In December 1837 Charles Sumner (1811-1874), the cultivated and brilliant young Boston lawyer and future senator, embarked on his first Grand Tour of Europe. His journey led him through England, France, and finally, in the spring of 1839, to Rome, where he lingered for five months, attempting to learn the Italian language. Although legal affairs and politics engaged his time at home, Sumner devoted much of his Italian sojourn to the study of art and literature, interests that remained absorbing preoccupations throughout his career. In Boston he was an active participant in a variety of local art causes and institutions. He emerged as an articulate spokesman on behalf of native-born artists, using his considerable public influence to secure government commissions for them.

While in Rome, Sumner was introduced by his friend George Washington Greene, the American consul, to Thomas Crawford, who was then a struggling, unknown artist. Sumner, who was two years Crawford's senior, immediately befriended the impoverished sculptor, whom he found to be a congenial conversationalist and companion as well as an enormously talented artist. Having surveyed the clutter of bas-reliefs, ideal studies, and portrait busts strewn about his studio, Sumner wrote enthusiastically of Crawford's work, describing it as "simple, chaste, firm, and expressive, and with much of that air (heaven-descended, I would almost call it) which the ancients had, which was first reproduced in modern times by Canova, and has since been carried so far by Thorwaldsen."[1] Sumner recognized that praise alone would not satisfy his young protégé's artistic ambitions or correct the sorry state of his finances. He therefore committed himself to finding patrons for Crawford's work and, in particular, someone to commission in marble the remarkable model of *Orpheus* (q.v.) that had attracted his notice in Crawford's studio.

Sumner's confidence in Crawford and his promotional campaign on his behalf were deeply appreciated by the sculptor. In gratitude, he offered to model Sumner's bust, a proposition that initially unsettled the modest Bostonian until Greene convinced him that by consenting, he would be furthering Crawford's reputation and career. That summer, Sumner sat for his bust in Crawford's humble studio. The finished plaster model was displayed for many months in George W. Greene's library, so that it could be seen and admired by the company of expatriates and travelers who had business to transact with the consul. Its strategic exhibition proved successful in generating additional orders for Crawford; both Sir Charles Vaughan and John Kenyon saw it in Greene's library on different occasions and were so impressed that each commissioned his own bust from the sculptor.[2] William Hickling Prescott, the Boston historian, advanced Crawford's reputation in America by writing warmly of Sumner's bust in 1844, "It is a very good likeness, and a beautiful piece of work, like everything else from Crawford's chisel."[3]

Sometime in 1842 Crawford finished cutting the bust in marble. Sumner had acknowledged receiving it by the following summer. In a letter to the sculptor he thanked him "for the beautiful bust you have sent me. I have felt humbled by such a gift, for I am in no way worthy of being preserved in marble in so noble a work of art; it seems to me like a travesty. I am, however, none the less grateful to your friendship, and too favourable appreciation of my character. Your present is the most valuable article of property I possess; but it is more valuable to me as a testimony of your kindness and regard."[4] Despite his evident pleasure with the bust, Sumner had offered one discreet criticism of it earlier on, when he wrote of the plaster model to Greene shortly after departing Rome, "I cannot help saying how sorry I am that Crawford has put those books under my bust. Can't you saw them off? It will seem to everybody a cursed piece of affectation and vanity on my part."[5] The substructure of books was intended as an allusion to Sumner's learning and scholarly disposition, but obviously the symbolism seemed too pretentious to him. To comply with his friend's wishes, Crawford removed the books when he transferred the bust to marble.

24

Crawford's portrait of Charles Sumner incorporates many of the best qualities of the sculptor's style: classic elegance, dignity of mood, and an ability to record a sitter's features truthfully without sacrificing the noble idealism prescribed by popular taste. When Sumner died in 1874, he bequeathed the bust to the city of Boston,[6] but it was immediately conveyed to Boston's new art museum, along with a number of paintings owned by the distinguished senator.

J.S.R.

Notes

1. Edward Lillie Pierce, *Memoir and Letters of Charles Sumner* (Boston: Roberts, 1877-1893), vol. 2, p. 105. Sumner also wrote of Crawford's portrait busts, "They are remarkable for the fidelity with which they portray the countenance, and for the classic elegance and simplicity of their composition." See C.E. Lester, *The Artists of America* (New York: Baker & Scribner, 1846), p. 241.

2. Charles Vaughan was the British minister to America, and John Kenyon was an English poet and generous patron of the arts.

3. Quoted in Pierce, *Memoir of Sumner*, vol. 2, p. 94.

4. Sumner to Crawford, Aug. 1, 1843, ibid., p. 265.

5. Sumner to Greene, Sept. 11, 1839, ibid., p. 110.

6. Pierce, *Memoir of Sumner*, vol. 2, p. 94. See also Walter Muir Whitehill, *Museum of Fine Arts, Boston: A Centennial History* (Cambridge, Mass.: Harvard University Press, Belknap Press, 1970), vol. 1, p. 22.

THOMAS CRAWFORD
25 (color plate)
Orpheus and Cerberus, 1843
Marble
H. 67½ in. (171.5 cm.), w. 36 in. (91.4 cm.), d. 54 in. (137.2 cm.)
Signed (on base at left): T. G. CRAWFORD.FECIT. / ROMAE / MDCCCXLIII
Gift of Mr. and Mrs. Cornelius Vermeule III. 1975.800

Provenance: Boston Athenaeum; lent to Museum in 1872
Exhibited: Boston Athenaeum, 1844, 1846-1848, 1851-1867.

Less than three years after Thomas Crawford's arrival in Rome, he announced to his sister Jenny that he had begun work on his first full-length statue in the ideal mode. Ambitious for this maiden work to exhibit both original design and noble sentiment, Crawford searched antique literary sources for a suitably grand theme. "You will be anxious to know something of the subject I have chosen," he wrote

to his sister. "You will find it in the tenth book of Ovid's Metamorphoses, where Orpheus is described as leaving the realms of life and upper air to seek his lost Eurydice in the infernal regions. You will find it also in the fourth Georgic of Virgil. I have selected the moment when Orpheus, having tamed the dog Cerberus, ceases playing upon the lyre and rushes triumphantly through the gate of hell. The subject is admirably adapted to the display of every manly beauty; into the face I shall endeavor to throw an expression of intense anxiety softened by the awe which would naturally be caused by such a sight as we may suppose the realms of Pluto to present."[1]

The touching tale of Orpheus's descent into Hades to retrieve his lost bride had inspired countless artistic interpretations since Ovid's poetic rendition of the myth. Yet Crawford's exposition of the legend offered a daring departure from honored tradition because he chose to illustrate an incident from the story that had never before been treated in Hellenistic or Graeco-Roman sculpture, let alone in the work of Crawford's contemporaries.[2] The boldness of the young American's compositional scheme may have been considered pretentious by some, but Crawford's efforts were not motivated by any proud notion that antique sculpture was unworthy of his emulation. On the contrary, he revered antique sculpture's physical elegance and dignified spirit and purposely sought to instill an air of classic beauty into his composition "by keeping clear of all extravagance in the movement, and working as nearly as possible in the spirit of the ancient Greek masters."[3] So genuine was his admiration for the *Apollo Belvedere* (Vatican Museums) that he directly quoted from its pose in the figure of Orpheus.[4] Anxious, however, that viewers not mistake Orpheus for Apollo, Crawford carefully incorporated the grotesque image of the three-headed hellhound Cerberus, observing to his sister, "this is important, for the attributes of lyre and wreath also belong to Apollo; but with Cerberus, any one having the slightest knowledge of mythology must know that the figure is Orpheus in search of Eurydice."[5] Crawford's earnest desire was to graft Christian sentiment onto forms that reflected the physical perfection of antique art. In Crawford's mind, few—if any—sculptural prototypes could guide him in the accomplishment of this goal.

Orpheus and Cerberus absorbed Crawford's energies for over a year as he worked to capture his idea in clay and then refine it in plaster. So intense were

his efforts on this piece that he reportedly collapsed in a "brain fever" around Christmas 1838.

With the restoration of his health in the late spring of 1839, Crawford resumed work at his studio near the Piazza Barberini. By November he had completed the plaster model for *Orpheus*. The career anxieties that had plagued him over the preceding four years must have been appeased somewhat by the universal praise that *Orpheus* elicited from the throngs of artists and tourists who now congregated at his studio. In a letter to his sister Crawford described the extraordinary impression *Orpheus* had made on him one evening, shortly after the model's completion, as his studio reverberated with the noise and light of a violent thunderstorm. Alluding to the tale of the sculptor Phidias who, upon finishing his magnificent statue of Jove, was granted with a sign of the gods' approval when the image became suddenly encircled by miraculous lightning, he wrote, "Were we living in that age, or were ours the religion of the ancient Greeks, I too might interpret the sign in my favor."[6]

Nevertheless, Crawford remained discouraged that no benefactor had yet stepped forward offering to underwrite the costs of translating the figure into marble. This situation was soon remedied through the kind attentions of Charles Sumner, who had been struck by the elegance and originality of Crawford's work during his 1839 visit to Rome. With the ultimate objective of securing the statue for permanent display in Boston, Sumner determined to champion the sculptor's dream of transferring the *Orpheus* to marble. Through his campaign he hoped both to resuscitate the sculptor's faltering fortunes and to draw international attention to America's emerging school of professional sculptors. He launched his plan with letters to prominent acquaintances in Boston and New York, soliciting their cooperation in helping to advance Crawford's career in America. Upon returning to Boston in 1840, he continued his efforts by praising the remarkable work to friends and associates while canvasing them for contributions.[7] Within several months Sumner had raised over $2,000 in pledges toward its purchase for the Boston Athenaeum. On March 31, 1841, Crawford and the statue's subscribers signed a contract stipulating that the sculptor execute *Orpheus and Cerberus* within twenty months for the sum of $2,500.[8] Although he was dismayed by the unrealistic timetable and grossly inadequate fee, Crawford accepted the assignment and set to work procuring a spotless piece of Seravezza marble from which to carve the composition.[9]

Crawford persevered with *Orpheus and Cerberus* throughout the winter and spring of 1842, constantly fretting over the payment terms of his commission, which forced him to cover many studio expenses on his own long before he received the Athenaeum's belated cash installments on his fee. By the spring of 1843 the statue was finished and ready for shipment to Boston. Taking great care to have the precious, bulky cargo properly crated, Crawford consigned the statue on a vessel bound to New York, whence it would be reshipped to Boston. Unfortunately, when the statue was uncrated at dockside in Boston on September 13, 1843, serious breakage to the marble was discovered. Sumner catalogued the damage as involving broken chips off the lyre, major breaks to Orpheus's legs above the knees and at the ankles, and "the dog broken into two pieces, the rent running from the back to the belly."[10] Aghast at the mischief the sea voyage had perpetrated on their prized investment, the Athenaeum's trustees hired a local sculptor, Henry Dexter, to repair the breakage for a fee of $200.[11] To the relief of the subscribers and the sculptor, Dexter performed a fine mending operation on *Orpheus*. In January 1844 Sumner wrote confidently to Crawford that his magnum opus was restored to the satisfaction of all and was being readied for exhibition in the spring, when winter ice and cold would not deter crowds from attending the statue's triumphant American debut.[12]

The impression that Crawford's statue made on the curious spectators who flocked to the Athenaeum's spring exhibition was dramatic. The enthusiastic reviews assured the success of the thirty-one-year-old sculptor's career and signaled a new popular interest in neoclassical sculpture, a stylistic idiom with which American audiences were generally unfamiliar. The statue's extraordinary reception was due not only to its intrinsic artistic merits but also to the elaborate preparations surrounding its unveiling. The committee responsible for supervising the statue's installation convinced the Athenaeum's trustees to erect a special viewing gallery adjacent to the main Pearl Street building in which to display *Orpheus*, along with several smaller reliefs and busts by Crawford. Care was also taken in "priming" the gallery space for the statue. Crawford had given Sumner several instructions for lighting and mounting the work but left other aesthetic decisions up to his friend.[13] His trust was well rewarded, for Sumner painted the gallery walls a

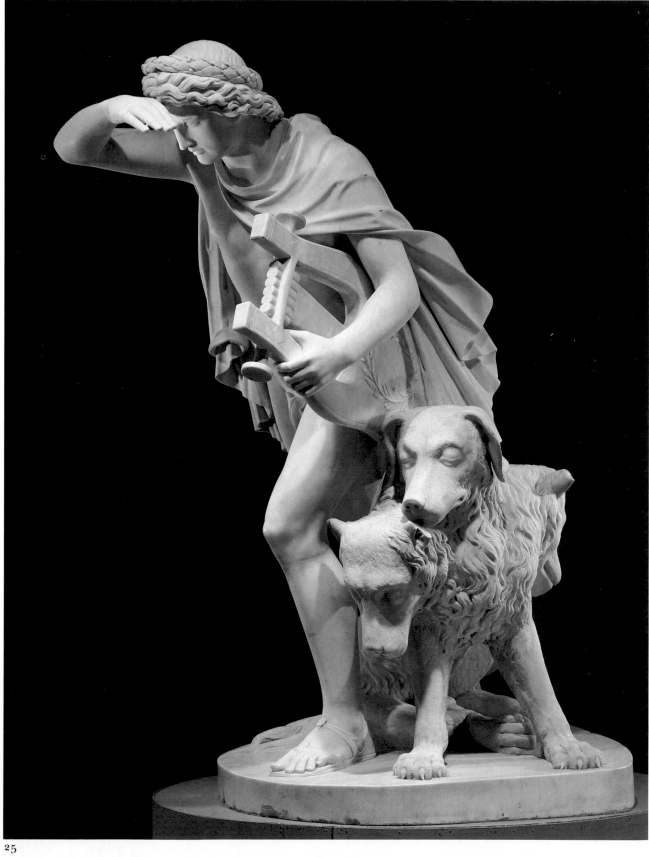

25

rich mahogany brown, installed red carpeting on the floors, and veiled the windows with thin curtains of pink and crimson gauze,[14] all effects contributing to the impact that the white, godlike *Orpheus* had on spectators entering the space.

To arouse interest in the statue among the public and to stimulate sales of entrance tickets, provocative leaders and gossip items were placed in local periodicals hailing the yet unseen masterpiece. Ticket profits from the 1844 exhibition were not sufficient to offset the full expenses involved in building the statue's annex; nevertheless the Athenaeum's fine arts committee was pleased with the exhibition's success, recording in their annual report: "the unqualified admiration and praise which this statue elicited from the best qualified judges should satisfy the proprietors, that the Athenaeum has secured to itself (at a cheap rate) one of the most meritorious productions of the modern chisel, and this too, it is gratifying to add, the work of American genius."[15]

The fanfare accompanying the exhibition of Crawford's "primum opus" was merited, for it was an accomplished performance, technically and conceptually. Visually, the narrative of Orpheus's adventure was explicit enough to be easily read. As George Washington Greene expounded, in one of a series of promotional letters that he wrote on the sculptor's behalf, "Before [Orpheus] you feel the black jaws of hell; you see him rushing onward through the opening, his face beaming with the passion that steels him to their terrors, and his whole frame glowing with the beauty of his divine origin. Cerberus at his side, has yielded to the powers of his lyre, and the three heads of the monster, drooping in sleep, leave the passage free. He has caught his lyre in his left hand; his right is raised to protect his eyes from what remains of the light of day: . . . the rapidity of his movements is strikingly displayed in the action of the limbs, of the body, and the swelling folds of drapery."[16]

Crawford obviously designed the striding figure of Orpheus with great care. As the half-mortal son of the muse Calliope reputed for his heroic proportions, he stands midway in size between the gods and man, as classical custom dictated. In the words of Greene, "the frame is neither powerful, nor slight, but that well balanced medium, which belongs to health, and a perfect command of all the physical powers."[17] The anatomical knowledge Crawford had absorbed in Rome is demonstrated in *Orpheus*'s scrupulously articulated physique.[18] Craw-

ford adroitly contrived the action of the figure to suggest the energetic pace at which Orpheus plunged into Hades. Motion is diffused throughout the body, and the limbs ripple with tensed musculature. The forward movement is underscored by the treatment of the drapery, which seems to flutter vigorously in the implied winds from the cavern's entrance. Mindful of the baroque excesses epitomized in Bernini's waving drapery, Crawford purposely restrained his use of this convention so that this subsidiary apparel would not overwhelm the expression or conceal the underlying form of his hero.

For nineteenth-century viewers, the focal point of Crawford's composition was *Orpheus*'s expressive face. George Washington Greene described *Orpheus*'s features in detail: "The forehead clear, full, intellectual; . . . the nose projecting in a simple straight line, with a delicate and spirited expansion of the nostrils; lips . . . modeled with a certain sharpness of effect, which adds greatly to the general forces of expression. There is a peculiar earnestness about the brow that I have never seen surpassed. The eyes, too . . . are bent forward with a deep fixedness of gaze that seems as if it would read at one glance the secret of the abyss to which he is approaching. And over all is diffused a tenderness so deep and so pure, an intensity of feeling, a glow of passion, that add, if possible, new grace to his beauty, and give it something irresistible and divine."[19]

The great popularity of *Orpheus and Cerberus* stemmed primarily from its compelling theme. The sculpture depicted an episode from the ancient myth of Orpheus and Eurydice that held special appeal to modern audiences. On one level it could be interpreted as an exciting adventure tale involving travel into a dark, secret realm. It was also meaningful as a sentimental romance about a husband who suffers inconsolably over the loss of his beloved spouse.[20] Christian moralisms could be deduced; fidelity and chastity were only two of the virtues that the devoted couple represented to a religious-minded Victorian public.

To many American art critics Crawford's work exemplified a new quality in modern sculpture, which they saw as presaging a unique and meliorating change in the art form. For them *Orpheus* represented an amalgam of the ancient classic and modern romantic schools: "the classic school that insists most upon the body and form of things," wrote Samuel Osgood, "and the romantic school,

that insists most upon the soul and spirit of things. . . . "Orpheus is a Greek and a Christian, too," continued Osgood, "and he faces toward the Shades or Erebus with limbs trained in the palaestra and with a soul illuminated by the light that is not of this world. This work is a prophecy of our coming literature as well as art. It is one of the signs of the new age of Germanic inwardness and Greek outwardness."[21]

In addition to praising Crawford's masterful projection of theme and mood, critics approved the convincing Hellenism of his modeling style. According to the many encomiums published about the statue before its arrival in Boston, Crawford's composition had earned rare applause from John Gibson for its beautiful form and proportions, as well as warm praise from Crawford's mentor, Bertel Thorwaldsen, for its antique grace. Once the statue arrived in Boston, it was hailed as the embodiment of ancient manhood, its creator extolled as the modern Phidias. One local admirer of *Orpheus* announced to a friend, "It excels all the sculpture in America, and tweaks antiquity itself by the nose. Phidias and Michael Angelo would die with envy if they saw it, or at least would lampoon its author in the penny papers."[22]

Over the past century *Orpheus and Cerberus* has been subjected to a variety of critical reappraisals, ranging from reaffirmations of its excellence as an archetype of American neoclassical sculpture to denouncements of it as a weak and trite artistic endeavor.[23] Yet it remains irrefutably a landmark of paramount importance in the history of American taste. *Orpheus and Cerberus* continued to be a central attraction at the Boston Athenaeum through the third quarter of the nineteenth century. By the 1870s, however, the Athenaeum's corridors had become so crowded with statuary and objets d'art that the trustees voted to restore the institution to its original function as a library, hence necessitating the removal of much of its accumulated art holdings. In 1872 *Orpheus and Cerberus*, along with other works from the Athenaeum's collection, were deposited on permanent loan at the new Museum of Fine Arts. Crawford's masterpiece became part of the Museum's permanent collection in 1975 through the gift of Cornelius and Emily Vermeule, scholars of classical sculpture who greatly appreciated the expression of Greek and Roman classicism in American sculpture and recognized the unique role played by *Orpheus and Cerberus* in promoting that aesthetic.

J.S.R.

Notes

1. Crawford to his sister Jenny, May 1839, quoted in George S. Hillard, "Thomas Crawford: A Eulogy," *Atlantic Monthly* 24 (July 1869), p. 45. Jenny Crawford Campbell later helped to promote her brother's statue through her poem *Orpheus: The Sculptor in His Studio*, published in *United States Magazine and Democratic Review*, n.s. 12 (June 1843), pp. 567-568.

2. Antonio Canova had made two small figures of Orpheus and Eurydice, but these figures were little known in Rome and did not illustrate this particular incident in the myth.

3. Crawford to Jenny Crawford, quoted in Hillard, "Thomas Crawford," p. 46.

4. Several other antique statues have been suggested as sources for Crawford's composition, including a statue of Apollo playing his lyre in the Vatican Museums and the famous *Borghese Warrior* in the Louvre. Orpheus's outreaching right arm echoes the pose of the *Gladiator*, but the softness and polish of Crawford's figure align it more closely with the *Apollo Belvedere*. Numerous sculptural prototypes existed for the three-headed dog Cerberus. Two notable statues incorporating this strange animal that Crawford may have known were Giovanni Bologna's bronze *Hercules and Cerberus*, early seventeenth century (Walters Art Gallery, Baltimore), and Bernini's *Rape of Proserpina*, about 1620 (Borghese Gallery, Rome).

5. Crawford to Jenny Crawford, quoted in Hillard, "Thomas Crawford," pp. 45-46.

6. Ibid.

7. Crawford to George Washington Greene, cited in G.W. Greene, *Biographical Studies* (New York: Putnam, 1860), pp. 138-139. According to Greene, p. 141, two engravings of *Orpheus* had been made before the statue's arrival in America: the first for the *Roman Bee*, a publication devoted to engravings and descriptions of important art works of the day, and the second by the German engraver Ludwig Gruner (1801-1882), who worked in Rome from 1836 to 1843. Sumner probably showed the engravings to associates in Boston to prove the statue's merits.

8. Boston Athenaeum Archives. According to Robert L. Gale, *Thomas Crawford, American Sculptor* (Pittsburgh: University of Pittsburgh Press, 1964), p. 25, a Mr. Homer of Boston ordered a marble copy of the head of Orpheus in 1842.

9. Crawford to Sumner, Jan. 4, 1843. "The marble for the statue has been obtained but at an expense far beyond what I supposed at first. I have to pay $700 for it." Charles Sumner Papers, H0, HU.

10. Sumner to Francis Lieber, Oct. 14, 1843, published in Edward Lillie Pierce, *Memoir and Letters of Charles Sumner* (Boston: Roberts, 1877 – 1893), vol. 2, p. 274.

11. See Report of the Fine Arts Committee, Jan. 1, 1844, Letterbook, Boston Athenaeum.

12. Sumner to Crawford, Jan. 1844, published in Pierce, *Memoir of Sumner*, vol. 2, p. 298.

13. Crawford requested that a wooden pedestal be built for the statue "of strong, well-seasoned wood," supported and railed and cut to the dimensions of 52 by 38 by 30 inches. He also provided Sumner with diagrammed instructions concerning the statue's lighting: "You are aware that light and shadow is . . . the life and soul of art." Crawford to Sumner, Mar. 16 [1843], quoted in Gale, *Crawford*, p. 27.

14. Sumner to Crawford, Apr. 30, 1844, quoted in Pierce, *Memoir of Sumner*, p. 304.

15. See Rosemary Booth, "A Taste for Sculpture," in *A Climate for Art: The History of the Boston Athenaeum Gallery 1827-1873*, exhibition catalogue (Boston: Boston Athenaeum, 1980), p. 29.

16. George Washington Greene, "Letters from Modern Rome," *Knickerbocker* 15 (June 1840), pp. 490-491.

17. Ibid., p. 493.

18. For commentary on the anatomical correctness and other design strengths of *Orpheus and Cerberus*, see Count Hawkes Le Grice, *Walks through the Studii of the Sculptors at Rome* (Rome: Puccinelli, 1841), vol. 1, pp. 57-59.

19. Greene, "Letters from Modern Rome," p. 494.

20. The sentimental meaning of the statue for Victorian viewers is discussed in Craven 1968, p. 127.

21. Samuel Osgood, *Thomas Crawford and Art in America: An Address before the New York Historical Society* (New York: Published by the Society, 1875), pp. 13-14.

22. E.P. Whipple, Boston, to Mrs. Anna Cora Mowatt, New York, May 28, 1844, Norcross Papers, MHS.

23. In a lecture William Rimmer stated that Crawford's *Orpheus* was one of the worst examples of modern art. See *Providence Daily Journal*, Feb. 28, 1872, p. 2; see also Taft 1930, pp. 73-74.

THOMAS CRAWFORD
26
Hebe and Ganymede, about 1851 (modeled 1842)
Marble
H. 69 in. (175.2 cm.), w. 32 in. (81.2 cm.), d. 20½ in. (52.1 cm.)
Signed (at left side of base): T. CRAWFORD. / FECIT. ROMAE / MDCCCXLII
Gift of Charles C. Perkins. 76.702

Provenance: Charles C. Perkins, Boston
Exhibited: Boston Athenaeum, 1855-1867; BMFA, "Confident America," Oct. 2-Dec. 2, 1973; BMFA 1979, no. 2.

Crawford conceived the idea for *Hebe and Ganymede*, his most studiously Graeco-Roman creation, in 1841, while still absorbed with completing his heroic statue of *Orpheus and Cerberus* (q.v.). Determined to prove his technical skill in complex compositions, in this case two interconnected figures, he

persevered with the clay *bozzetto* for the group, finishing it the following spring. He described his concept and progress on the group to Charles Sumner in January 1842: "There is a group life-size—Hebe and Ganymede—at the moment Hebe is leaving the service of the gods and in sorrow giving her cup to the Shepherd Boy who offers his Consolation to the virgin. She stands in a pensive attitude which is also expressive of deep grief—Ganymede is leaning carelessly upon her shoulders and hesitates to take the vase she offers—he already holds the cup which signifies the office he is about to undertake. This group is very far advanced in the clay—and in a few months will be terminated."[1]

According to most mythological sources, Hebe, the beautiful goddess of youth, resigned her office as cupbearer to the gods upon her marriage to Hercules. But in an alternate account of Hebe's history, her dismissal from office was explained as the result of an unfortunate spill she took while serving nectar at an Olympian feast, causing her to indecently expose herself before this august assembly. Although other modern sculptors, most notably Antonio Canova,[2] had produced comely studies of Hebe gracefully performing her serving duties, Crawford's interpretation of the goddess is more probing, for he chose to present her at the humiliating moment of disgrace following her accident.

Visually, the statue dramatizes the Trojan boy Ganymede's tender attempt to console the forlorn goddess, who surrenders the ewer—symbol of her former job—to him with quiet dignity and implied resignation. Hebe's downcast eyes and sober expression emphasize the shame that haunts her, called to mind by the disheveled dress hanging at her hips.

When Crawford carved the exposed *Hebe* and her naked attendant, most Americans were unfamiliar with and uneasy about the nude in art. *Hebe*'s undraped upper torso, not to mention *Ganymede*'s state of greater undress, would have offended the sculptor's audience had he not balanced the physical fact of nudity with a plausible intellectual justification for it. Approval of the statue rested on the idea that Hebe's partial nudity was accidental, and on the understanding that her immodesty, however unintentional, had been punished. Thus, Crawford used the work as a vehicle to tantalize while moralizing. It is curious that no art critic or viewer of the work seems to have raised objections to the proximity of the nearly naked *Ganymede* to the scantily clad *Hebe*. However, by so reducing *Ganymede* in size and scale

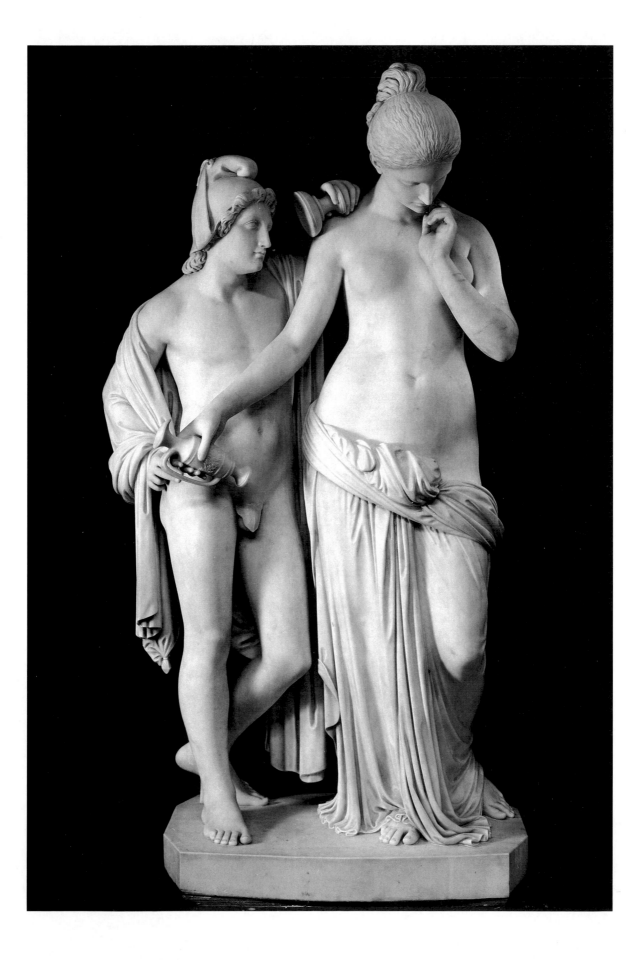

compared with his womanly companion, Crawford seems to have underscored his boyish immaturity and, by implication, his inability to perpetrate additional harm on the grieving goddess.

The austerely classical style in which the statue was modeled also contributed to its public acceptance. In this work, Crawford sought to reproduce the mood of calm and dignity and the universalized perfection of the human figure embodied in Hellenistic sculpture, attributes of ancient statuary that had been conscientiously emulated by Crawford's foreign contemporaries, including Thorwaldsen, John Flaxman, and John Gibson.3 Crawford's smooth, generalized modeling converts his marmoreal subjects into symbols of anatomical perfection rather than scientific studies in mortal flesh. The pure white marble from which the group was carved also imparts a virginal, abstract quality to the figures, aligning them with the ethereal world of mythic deities.

In 1844 Hebe and Ganymede was commissioned in marble by Charles Callahan Perkins, son of a Boston art critic and philanthropist, and an art patron and scholar in his own right. Perkins traveled extensively in Europe in the 1840s, studying music in Germany and painting in Paris, and periodically visiting Rome, where he met Thomas Crawford. Perkins befriended many American artists who were working in Rome, permitting them to use his comfortable apartments as a quasi academy for life classes. He also contributed significant information and insights to the study of both ancient and modern sculpture with his books Tuscan Sculptors (1864) and Italian Sculpture (1868). Crawford was much impressed by this amiable, generous Bostonian.

Crawford's personal enthusiasm for Perkins was somewhat dimmed, however, by the troubles he encountered in extracting payment for Hebe and Ganymede. The statue sat in Crawford's Roman studio for two years, nearly finished but unpaid for, until Crawford happened to encounter Perkins in Paris and demanded final payment for the work.4 Despite his reported wealth, Perkins was either unable or unwilling to produce the sum of $500 owed to Crawford, and the sculptor reluctantly accepted his offer to pay off the amount in installments. Crawford characterized the agreement as causing him "inconvenience and trouble of spirit" in a note he wrote to George Washington Greene about the affair.5 Presumably, artist and client resolved their differences amicably since Perkins later led the drive for Boston's Music Hall to acquire Crawford's impressive bronze statue of Beethoven, 1855 (New England Conservatory of Music).

The process of transferring Hebe and Ganymede to marble moved slowly, probably because of Perkins's delinquent payment. In April 1851 Crawford was still at work on the statue, as documented by a notice in the Bulletin of the American Art Union: "[Crawford's] Hebe and Ganymede, which is almost finished in marble for Mr. Perkins of Boston, is exceedingly graceful."6 Soon thereafter he completed the piece and shipped it to Boston. It was one of several sculptures by Crawford included in the Boston Athenaeum's 1855 annual exhibition,7 remaining on view at the library for twenty years. In 1876 Hebe and Ganymede became one of the first works of American art acquired by the newly instituted Museum of Fine Arts through the gift of Charles C. Perkins, a principal incorporator and honorary director of the Museum.

J.S.R.

Notes

1. Crawford to Sumner, Jan. 4, 1842, Gratz Collection, Historical Society of Pennsylvania, Philadelphia, roll P22, in AAA, SI.

2. Crawford seems to have been influenced by Canova's Cupid and Psyche, 1800 (Louvre), rather than his Hebe, 1796 (National Gallery, State Museums, East Berlin). Several antique sources also may have contributed to his visualization of the composition, such as Bacchus and Cupid and Ganymede and the Eagle in the National Archaeological Museum, Naples.

3. Cornelius Vermeule has compared Crawford's statue to the works of the Augustan, neo-Attic pupils of the sculptor Pasiteles; Vermeule 1972, p. 873.

4. See Crane 1972, p. 320.

5. Crawford to G.W. Greene, June 20, 1844, in Crane 1972, p. 320.

6. Bulletin of the American Art Union, Apr. 1851, p. 13. For additional contemporary commentary and a negative review, see "Crawford's Hebe and Ganymede," Crayon 2 (Aug. 1855), pp. 82-83.

7. "The Athenaeum Exhibition at Boston," Putnam's Monthly Magazine 6 (Sept. 1855), pp. 331-332. The reviewer praised the "fine form" of Hebe, characterizing the image as one of "reluctant beauty, with drooping eyes and sorrowful face." The figure of Ganymede was called "less pleasing," however, prompting the critic to observe, "Mr. Crawford has certainly not yet mastered, in the fulness, the anatomical secrets of his art."

William Rimmer (1816 – 1879)

The term "lonely genius" has been applied to William Rimmer by critics wishing to characterize his original vision and his unique status among nineteenth-century American artists. Certainly Rimmer's unusual upbringing must have contributed to his independent temper and to the sense of isolation he apparently experienced throughout his career. The artist's father, Thomas Rimmer, presumed himself to be the deposed French Dauphin, the son of Louis XVI and Marie Antoinette, and spent his early manhood in England awaiting his recall to the French throne. When politics and poverty conspired to shatter this hope, Rimmer fled to America with his wife and young son William, who had been born in Liverpool. They eventually relocated in Boston, where Rimmer, the father, worked "in cognito" as a cobbler. Rimmer's children were all raised with full knowledge of their father's secret royal pedigree.

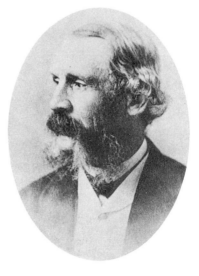

As the eldest of the seven Rimmer children, William started working in his early teens at a variety of odd jobs to supplement his family's income. Over a six-year period he was at various times employed as a soapmaker, a typesetter, a cobbler's assistant, a sign painter, and as a lithographer at Thomas Moore's Lithographic Shop in Boston, where he specialized in designing sheet-music covers. Encouraged by his parents to further develop the aptitude for art that he had displayed as a boy, Rimmer took a studio in town and began to paint portraits and large allegorical and religious canvases. By 1840 the newly married artist, intent on pursuing his painting career, organized a tour through southeastern Massachusetts to seek commissions for portrait studies. In Brockton he met a physician named A.W. Kingman, who persuaded him to advance his appreciation of form by studying human anatomy. Following this advice, Rimmer sought instruction in the subject at the Massachusetts Medical College, where he observed the dissection of human cadavers. The experience had significant repercussions on Rimmer's future, not only expanding his knowledge of the human body and its extraordinary beauty of design but also stimulating his serious interest in medicine. In fact, from the mid-1840s on, Rimmer practiced medicine in the vicinity of Brockton, Massachusetts, as a self-taught and probably unlicensed physician.

Although Rimmer's medical practice kept him busy, the remuneration he gained from this occupation was meager, and thus to add to his income he continued to paint portraits and to cobble shoes. In 1855 he moved his family to East Milton, Massachusetts, where he tended the sick and injured workmen from the nearby quarries of Quincy. It was at this time that he began to carve portraits directly in granite supplied to him by his patients. A head that Rimmer cut in granite, possibly of his wife, impressed one of the directors of the quarry, whose enthusiasm soon aroused the curiosity of Stephen H. Perkins, an affluent patron of the arts from Milton. Perkins insisted upon meeting the author of the unusual portrait and convinced Rimmer to explore sculpture as a possible alternative career. In gratitude for Perkins's flattering attentions and confidence in his abilities, Rimmer set about carving for him an image of the martyred *Saint Stephen* in granite. Completed in 1860 in four weeks' time, the stone head, with its haunting expression of suffering, attracted considerable comment when Perkins displayed it at Williams and Everett's Art Gallery in Boston that year.

Impressed by his protégé's natural genius for plastic composition, Perkins advanced Rimmer funds to begin a life-size figure in clay of *The Falling Gladiator*, a plaster cast of which he arranged to have sent to him in Europe, with the expectation of selling the sculptor's work there.

With Perkins as a reassuring patron and ardent promoter, Dr. Rimmer acquired a growing reputation as an artist. He joined the influential Boston Art Club in 1862 and was invited the following year to lecture on art anatomy at the prestigious Lowell Institute. His talks were instantly popular and unparalleled in their scope, so much so that he was pressed to offer extra sessions for ladies and re-

ceived applications from other notable institutions to deliver courses. Harvard University appointed him a lecturer in art anatomy in 1865. Rimmer eventually recorded his comprehensive knowledge of the subject in his book *Art Anatomy* (1877), which was illustrated with nine hundred of his own accomplished drawings.

By the mid-1860s Boston's patrician class acknowledged the unusual sculptural talent of this eccentric physician-artist by commissioning him to create a monument to Alexander Hamilton, historic spokesman for the rich and well born. Cut from a solid block of Quincy granite, the statue unfortunately failed to meet public expectations when it was unveiled in 1865. The assigned biographical subject had not allowed Rimmer the freedom of imagination that he customarily exercised in his sculptural inventions; moreover, the work revealed that his talents lay in carving a nude figure rather than one that demanded historical costuming. Other painting and modeling projects, however, helped to assuage his disappointment over the imperfect *Hamilton* monument. Rimmer's spirits were also bolstered, for instance, by the unequivocal success of his first publication, *The Elements of Design* (1864).

In 1866 Rimmer left Boston to assume the position of director and chief instructor at the Cooper Union School of Design for Women, New York. His relatively happy and productive tenure there ended in 1870, however, when his appointment was not renewed as the result of a personal conflict that had arisen between the artist and the school's administration. Rimmer thus returned to Boston, where he resumed his career as an instructor in art anatomy and modeling at several local art schools. Among the institutions he served were the Massachusetts Normal Art School, where he taught from 1874 to 1876, and the new School of the Museum of Fine Arts, opened in 1877. He also lectured extensively on the subject of anatomy throughout New England. It was in this late phase of his career that he executed some of his most memorable and representative paintings and drawings, including the mysterious *Flight and Pursuit*, 1872 (Museum of Fine Arts, Boston). In this period he also obtained his second important commission for a public monument, through the personal influence of Joseph Billings, for the town of Plymouth, which had requested a heroic figure of *Faith* to surmount the town's Pilgrim Memorial. Much to his annoyance, Rimmer discovered that his design, completed in 1875, had been drastically altered by a plasterer working for the Plymouth town committee before the statue's installation.

Although Rimmer had attained a certain celebrity as an artist by the 1870s, he never enjoyed the comforts or public accolades a man of his position and experience might have expected. Financial hardship continued to plague his family, and the bitter realization haunted Rimmer that the public valued him more for his gift as an art educator than as a creator of art. "He consented to become a teacher because he felt that he was excluded from public recognition as a producer," reflected Rimmer's earliest biographer, Truman H. Bartlett; "the more he became an expositor of his knowledge, the farther he left behind him every possibility of production."[1] Frustration over his subverted art career gnawed at Rimmer as he grew older. His health failed rapidly, and he died at the age of sixty-three following what was rumored as a complete nervous breakdown. When Daniel Chester French, who had been one of many local art students to benefit from Rimmer's lectures on art and anatomy, heard the news of Rimmer's death, he wrote to Mrs. Thomas Ball, "Poor long-suffering doctor! His was an unhappy and unsuccessful life. He just missed being great."[2]

Ironically, eight months after Rimmer's death the Museum of Fine Arts organized a memorial exhibition of his work, which was greeted with much public acclaim. The inventive range of his imagination now appeared striking to a generation that was losing its taste for the placid and polished classical conceits produced by most other American sculptors of Rimmer's period. Tribute again was paid to Rimmer at the Museum of Fine Arts in 1916, when another exhibition of his art was mounted to honor the centennial year of his birth.

As a sculptor, Rimmer's ambitious desire to immortalize the drama of human suffering and physical strain through plastic shape was unquestionably impeded by his insufficient technical training and by the impulsive speed at which he designed his figures in clay or stone. Although his total sculptural output was modest, this body of work is distinguished by a gripping physicality, uncommon anatomical veracity, and an insistence on the visual primacy of form over intellectual content. Modern critics have marveled at Rimmer's extraordinary achievement, especially when taking into account his aloofness from the mainstream of nineteenth-century art, and have pointed out that his approach to composition foreshadowed by several decades the compressed, nervous force and tactile vitality of

Auguste Rodin's (1840-1917) sculpture and the principles of direct carving adopted by twentieth-century modernists.

J.S.R.

Notes

1. Truman H. Bartlett, "Dr. William Rimmer," *American Art Review* 1, pt. 2 (1880), p. 512 (reprinted in Walter Montgomery, ed., *American Art and American Art Collections: Essays on Artistic Subjects* [Boston: Walker, 1889] vol. 1, p. 348).
2. French to Mrs. Ball, Sept. 10, 1879, quoted in Whitney 1946, text p. [17].

References

Truman H. Bartlett, *The Art Life of William Rimmer: Sculptor, Painter, and Physician* (Boston: Osgood, 1882); idem, "Dr. William Rimmer," *American Art Review* 1, pt. 2 (1880), pp. 461-468, 509-514 (reprinted in Walter Montgomery, ed., *American Art and American Art Collections: Essays on Artistic Subjects* [Boston: Walker, 1889], vol. 1, pp. 333-352); Benjamin 1880, p. 163; Gutzon Borglum, "Our Prophet Unhonored in Art," *New York Evening Post*, June 18, 1921; *Boston Transcript*, Aug. 21, 1879, obit.; Brockton Art Museum-Fuller Memorial, Brockton, Mass., *William Rimmer, a Yankee Michelangelo*, essays by Jeffrey Weidman, Neil Harris, and Philip Cash (1985; distributed by University Press of New England, Hanover, N.H.); J. Eastman Chase Gallery, Boston, *Catalogue of Drawings, Paintings, and Sculpture by the Late Dr. Rimmer* (1883); F.W. Coburn, "Exhibit Revives Reminiscences of Rimmer," *Boston Sunday Herald*, Feb. 20, 1916; Craven 1968, pp. 346-357; Almira Fenno-Gendrot, *Artists I Have Known* (Boston: Warren, 1923), pp. 36-38; Albert T. Gardner, "Hiram Powers and William Rimmer: Two Nineteenth-Century American Sculptors," *Magazine of Art* 36 (Feb. 1943), pp. 42-47; Gardner 1945, pp. 38, 70; Marcia Goldberg, "William Rimmer, an American Romantic Sculptor," Master's thesis, Oberlin College, 1972; "Our Prophet Unhonored in Art," *New York Literary Digest*, July 9, 1921; William Rimmer, *Art Anatomy* (Boston: Little, Brown, 1877); Taft 1930, p. 18; Thorp 1965, pp. 101-110; Tuckerman 1867, pp. 593-594; Weidman 1982; Jeffrey Weidman, "William Rimmer: Creative Imagination and Daemonic Power," in *The Art Institute of Chicago Centennial Lectures* (Chicago: Contemporary Books, 1983), pp. 146-163; Whitney 1946, no. 1.

WILLIAM RIMMER
27
Seated Man or *Despair*, 1831
Gypsum with bronzed paint
H. 10¼ in. (26 cm.), w. 7¾ in. (19.7 cm.), d. 4 in. (10.2 cm.)
Signed (back of base): W. Rimmer / 1831
Inscribed (right side of base): W.R.
Gift of Mrs. Henry Simonds. 20.210

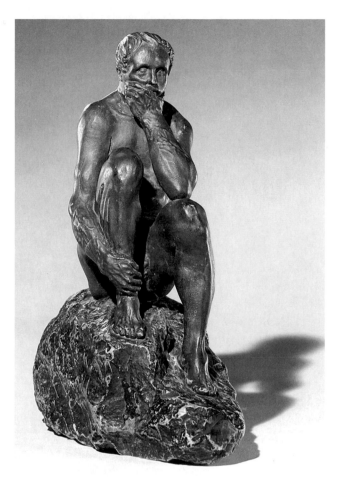

27

Provenance: Caroline Hunt Rimmer, Belmont, Mass.; Edith Rimmer Durham Simonds, South Milford, Mass.; lent to Museum in 1916
Exhibited: Possibly Colton's Art Store, Boston, 1838; J. Eastman Chase Gallery, Boston, *Catalogue of Drawings, Paintings, and Sculpture by the Late Dr. Rimmer* (1883), no. 93; BMFA 1916; Whitney 1946, no. 1; BMFA, "Confident America," Oct. 2 - Dec. 2, 1973; Brockton Art Museum – Fuller Memorial, Brockton, Mass., *William Rimmer, a Yankee Michelangelo* (1985), no. 2.

Miniature in scale but nonetheless moving in its visual and emotional impact, *Seated Man* is Rimmer's earliest surviving figural sculpture, having been carved when he was fifteen. The composition was cut from gypsum, a readily available stone. For other specimens of his juvenilia, Rimmer used such makeshift substances as chalk, shoemaker's wax, and india rubber. The small figure is frequently cited in the literature on Rimmer as both an authentication of the artist's precocious genius and as a noteworthy example of the nude in American sculpture, extraordinary because of its forward and realistic treatment of that genre.[1]

Tradition holds that Thomas Rimmer provided his son with the idea for this statuette, which critics have interpreted as an allegorical portrait of the artist's exceptional parent. At the time of its creation, Thomas Rimmer, then in his mid-forties, was becoming a psychological burden to his family, often lapsing into severe bouts of depression over his failed fortunes and growing increasingly disoriented as a result of delusions about his royal lineage. Despite its condensed dimensions, the figure of the meditating man creates an impression of disturbed tranquillity and wistfulness of mood that connects the image, subjectively at least, to the troubled Thomas Rimmer alluded to in biographies of the sculptor. Whether the specific facial features delineated are his is impossible to say, although one eminent Rimmer scholar, Lincoln Kirstein, has described the piece as exhibiting the "famous lobeless ears, the nose and chin of the Bourbons."[2]

Rimmer designed the composition with impressive economy, forgoing the conventional postures of frenzied gesticulating limbs and hyperbole of facial expression employed by sculptors in the past to suggest states of heightened emotion. The compact form and withdrawn, seemingly hollow gaze of the figure communicate the subject's psychological state with quiet force. The knees are drawn up near the body in what appears to be a protective manner; one arm clutches a leg, and the other hand is cupped over the mouth in an attitude of introspection. Writing of the statuette in 1889, Truman Bartlett remarked on the "strange expression" of the eyes and characterized the figure as "gathered together in wondering despair."[3] Rimmer's small *Seated Man* recalls the mood of brooding defeat embodied in John Vanderlyn's (1775-1852) acclaimed painting of the exiled Roman general *Caius Marius amidst the Ruins of Carthage*, 1807 (The Fine Arts Museums of San Francisco).

Seated Man conveys an intensity of thought and despondency of mood that few of Rimmer's contemporaries could capture in their overcharged theatrical studies of melancholy mortals and aggrieved deities. The anatomical detailing, including the modeling of distended veins, also imparts a realistic immediacy to the image conspicuously absent from the sleek-surfaced, idealized bodies favored by neoclassical sculptors. The strain of internalized anguish implied in the *Seated Man*'s pose and expression, as well as the concern with anatomical truth that informs this early composition, was further probed and elaborated in Rimmer's mature art.

Since the publication of Truman Bartlett's *The Art Life of William Rimmer* (1882), this statuette has been known as *Despair*, an apt poetic title suiting the figure's mood but not one assigned to it by the artist. When it was lent by Rimmer's family to the J. Eastman Chase Gallery, Boston, in 1883, it was called simply *Figure in Gypsum*, probably at the direction of the family, who were unaware of any special title. Rimmer's daughter Caroline, herself a sculptor and watercolorist, later referred to it in her will as "the statuette 'Gypsum Figure', cut by my father Dr. William Rimmer from a piece of crude plaster when he was a boy between the age of fifteen and sixteen years."[4] In the Museum's 1916 exhibition of Rimmer's work, the figure, on loan to the institution from Caroline Hunt Rimmer, was designated *Seated Youth*.

When Caroline Rimmer was preparing her will, she expressed her intention of giving the statuette to the Smithsonian Institution (now the National Gallery of Art, Washington, D.C.), along with several other works by Rimmer. After the National Gallery declined the offer, her niece and executrix of the will, Edith Rimmer Simonds,[5] determined that the figure should be given to the Museum of Fine Arts, where it has been since the 1917 Rimmer exhibition.

<div style="text-align: right">J.S.R.</div>

Notes

1. Scholars have speculated on possible sources for this statuette, suggesting that Rimmer may have been familiar with particular antique casts or ancient drawing books or been prompted to try his hand at "the nude" in the wake of the publicity attending Horatio Greenough's *Chanting Cherubs* (present location unknown) exhibited in Boston in 1830-1831. Rimmer's youth and comparative isolation in South Boston argue against the influence of any specific antique statue or print source, and the figure's utter opposition in mood and composition to neoclassical sculpture (particularly to the work of Greenough) would seem to indicate that the composition was solely a product of Rimmer's imagination rather than a conscious effort to surpass existing prototypes.

2. Kirstein 1946, p. 3.

3. Truman H. Bartlett, "Dr. Rimmer," *American Art Review* 1, pt. 2 (1880), p. 465 (reprinted in Walter Montgomery, ed., *American Art and American Art Collections* [Boston: Walker, 1889], vol. 1, p. 337).

4. Will of Caroline Hunt Rimmer, Feb. 10, 1917, Middlesex County Probate Court, Cambridge, Mass. Cited in Weidman 1982, p. 142.

5. Edith Rimmer Simonds was the daughter of Adeline Rimmer Durham and George Durham, at whose home in South Milford, Mass., Rimmer died in 1879.

WILLIAM RIMMER
28 (color plate)
The Falling Gladiator, 1907 (modeled in 1861)
Bronze, brown patina, lost wax cast
H. 63¼ in. (160.6 cm.), w. 42⅝ in. (108.3 cm.),
d. 42¾ in. (108.6 cm.)
Signed (on top of base between feet): W. Rimmer /
Sc
Caster's mark (on top of base, illegible): (possibly)
Caproni Brothers Plaster Casts, Boston
Foundry mark (on top of base): JNO. WILLIAMS.
INC. / BRONZE FOUNDRY N.Y.
Gift of Caroline Hunt Rimmer, Adeline R. Durham, and various subscribers. 08.74

Provenance: Rimmer Memorial Committee, New York;
Caroline Hunt Rimmer, Belmont, Mass., and Adeline
Rimmer Durham, South Milford, Mass.
Exhibited: BMFA 1916; BMFA, *William Rimmer 1816-1879*
(1947), no. 4; BMFA, "Confident America," Oct. 2-Dec. 2,
1973; Brockton Art Museum – Fuller Memorial, Brockton, Mass., *William Rimmer, a Yankee Michelangelo* (1985),
no. 5.
Versions: *Plaster:* (1) National Museum of American Art,
Washington, D.C., (2) present location unknown, formerly The Avery Library, Columbia University, New
York, (3) present location unknown, formerly Stephen H.
Perkins, Florence, Italy (destroyed). *Bronze:* (1) The Metropolitan Museum of Art, New York

On January 27, 1861, Rimmer noted in his diary
that he had received one hundred dollars from
Stephen Perkins to begin *The Falling Gladiator*,[1] a
work illustrating a mortally wounded man reeling
backwards onto the battlefield. Perkins's investment
paid impressive dividends, for the resulting statue
was a remarkable accomplishment on the part of
the still inexperienced, middle-aged sculptor and
served to broadcast his credentials as a serious
sculptor throughout art circles from Boston to
Paris.

That Rimmer managed to achieve a statue at all,
let alone such a powerfully expressive representation of psychic and physical suffering, is noteworthy. Work on the piece was subject to continual
interruptions from curious visitors and by the
pressing demands of his patients and family. Rimmer's working environment, a dim, unheated basement studio, nine feet high, also slowed the project
since annoying delays ensued whenever his clay
froze or dried out. His decision to dispense with the
costs of hiring a life model and to compose the
figure according to his own knowledge of anatomy
compounded his problems. Throughout this exercise, however, the most serious obstacle he had to
contend with was his ignorance of sculpture's technical preparatory procedures. Because Rimmer had
neglected to construct an armature to support the
weight of the heavy clay, the statue was structurally
unstable and broke frequently. He probably introduced the tree stump around which the *Gladiator*
pivots to fortify the composition and to buttress the
mass of the falling figure. Rimmer is also reported
to have approached his modeling material as if it
were stone, choosing to cut away at the clay to
reveal form rather than building up the form out of
clay. The difficulties he encountered in following
this method ultimately caused him to finish only the
right side and thigh of the figure in clay and to
work the remainder in plaster.[2]

Despite these hindrances, by June 1861 Rimmer
had completed the composition and readied it for
casting in plaster. The costs involved in the casting
were defrayed by the successful sale of photographs
of the *Saint Stephen* (The Art Institute of Chicago),
which Rimmer had presented to Perkins in 1860.
Perkins arranged to have a plaster replica of the
Gladiator (and the *Saint Stephen*) sent to him in Europe in 1862, with hopes of raising a subscription
fund to have the work cut in marble. "If we can
make one good sale the battle will have been won,"
his solicitous patron wrote confidently from Florence; "Buyers are like sheep. They follow the
bellwether."[3]

In Paris, Perkins made preparations for the *Gladiator* to be delivered to the studio of Pierre Loison
(1816-1886), a former pupil of David d'Angers and
a regular exhibitor at the official Salon. This plan
proved unexpectedly well timed since substantial
damage had been inflicted on the piece in transit
(both legs had been broken, and a stain transferred
to the plaster from the mahogany chips used for
packing), requiring Loison's professional services to
supervise its proper restoration. By November 1862
the repaired *Gladiator* was displayed in the French
sculptor's studio, where its virile naturalism astonished and confused many of his colleagues to the
extent that many pronounced the plaster study a
fraud. Rimmer was accused of having composed
the statue from the mold of the body of a real man.
(This charge was subsequently leveled at Rodin for
his *Age of Bronze*, 1877 [Albright-Knox Gallery, Buffalo, New York].) Informing Rimmer of the controversy the plaster had stirred among visitors to
Loison's atelier, Perkins observed that the majority
of viewers believed that part of the *Gladiator* "could
never have been modelled by any one, concluding
that those sections had been " 'cast on nature'."[4]
Such an accusation, of course, represented an indi-

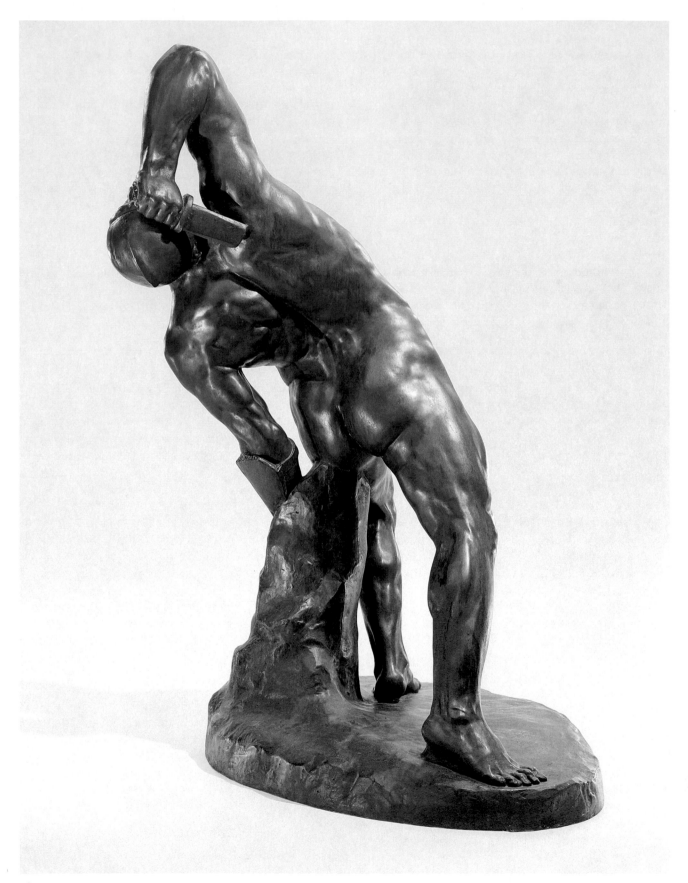

28

rect tribute to Rimmer's anatomical erudition and convincingly realistic modeling. Perkins recognized the favorable aspects of the debate: "the more it is criticised before it goes before the public the better—that is by artists." "The more it is studied," he wrote, "the more they will be satisfied that there is but one possible theory which will explain it, viz a combination of knowledge, skill & imagination enough for the work." He also reported Loison's endorsement of the *Gladiator*: "never was nature better rendered, or a movement more truly given."[5]

Perkins's hopes of having the *Gladiator* accepted for exhibition at the official Paris Salon in May 1863 were dashed when the judges rejected it, along with more than half the entries submitted.[6] To appease the disgruntled artists excluded from the Salon, Emperor Louis Napoleon arranged for an exhibition of the rejected works to run concurrently with the Salon. Rimmer's *Gladiator* consequently made its debut abroad at the Salon des Refusés, a questionable public exposure that held prophetic significance when account is taken of Rimmer's continuing thwarted ambition for the piece. The French critic Paul Mantz paid the unknown American's work terse acknowledgment in the *Gazette des beaux-arts* (July 1863), but the notice was of dubious value to Rimmer since Mantz misspelled the sculptor's name, "Rimmel."[7]

From Paris, Perkins traveled to Florence, securing viewing space for the *Gladiator* in a studio he rented jointly with Larkin Mead. There, reviews of Rimmer's work were more appreciative, especially after Giovanni Dupré (1817-1902), the local doyen of sculpture, passed favorable judgment upon the little-known American's work.[8] It was probably in Florence that James Jackson Jarves, the American art critic, saw Rimmer's cast. In *The Art-Idea* (1864) he wrote, "The knowledge of anatomical science displayed is wonderful, although the choice of time and action partake more of mechanical than aesthetic art. Its chief merit is its difficulty of execution and truth of detail."[9]

In Boston the original plaster of *The Falling Gladiator* was stirring considerable local interest at the Tremont Street Studio Building, where Rimmer exhibited it between 1861 and 1866. Viewers were struck by the figure's pronounced deviation from the conventional nudes and prescribed literary subject matter of neoclassical sculpture. Rimmer's command of form and bold veracity were especially evident in his handling of anatomy. An action as potentially awkward as that of a warrior twisted in

the paroxysms of death could have foiled sculptors who lacked Rimmer's thorough comprehension of human musculature and skeletal structure, or his sensitivity to the body's aspect when taxed by pain. (Some critics interpreted the anguish and torsion conveyed so assertively in the *Gladiator*'s strained features and pose as evidence of the special gift of expression that Rimmer had acquired as a physician.) Recognition was also paid to Rimmer for his deftness at composing powerful plastic forms, or masses, that retained their vigor of movement and emotional intensity from multiple viewing angles.

The question of possible sources for and interpretations of *The Falling Gladiator* has been debated endlessly by scholars. Visually, the composition recalls several famous antique studies of athletes engaged in heroic combat. The *Dying Gaul* (Roman National Museum of the Thermae) and the *Borghese Warrior* (Louvre) are the most obvious parallels, although the figure bears an affinity as well to the type of helmeted, muscular nude warriors often emblazoned on Graeco-Roman vases and funerary monuments. The charged emotion projected by Rimmer's *Gladiator* also calls to mind the sentiments of pathos and torment embodied in Hellenistic masterworks such as the *Laocoön* (Vatican Museums) and the *Dying Niobid* (Roman National Museum of the Thermae) or in certain images of the late Renaissance such as Michelangelo's *Dying Captive* (Louvre).[10] (Rimmer's apparent gravitation toward such visually dramatic art-historical sources is itself significant since most of his American contemporaries favored the serene mood of doctrinal classicism.) Any of these well-known models may have influenced Rimmer's selection of and approach to theme, but his execution of *The Falling Gladiator* remained highly personalized. Stephen Perkins acknowledged its singular impression when he wrote to Hiram Powers of the work: "The whole treatment combines the vigor and purity of the antique with an original modern treatment. . . . It is all alive."[11]

Rimmer's forthright and unsentimentalized handling of the subject of physical suffering and impending death is particularly arresting. In comparison with his stricken *Gladiator*, contemporary statues with similar themes—Thomas Crawford's *Dying Mexican Princess*, 1848 (The Metropolitan Museum of Art, New York), Peter Stephenson's *The Wounded Indian*, 1850 (private collection, on loan to the Newark Museum, New Jersey), and Ferdinand Pettrich's *The Dying Tecumseh*, 1856 (National Mu-

seum of American Art, Washington, D.C.)—appear unnaturally placid. Because its execution coincided with the beginning of the American Civil War, *The Falling Gladiator* has been interpreted by some critics as representing Rimmer's portent of the fate, at once grim and glorious, awaiting participants in that conflict. Rimmer is known to have produced other clay sketches and drawings inspired by the Civil War: for example, the drawing *Dedicated to the Fifty-Fourth Regiment Massachusetts Volunteers*, 1863 (Museum of Fine Arts, Boston), in which four gigantic armed soldiers symbolize the theme. It seems a reasonable assumption that the *Gladiator* was conceived in response to his dismay over this erupting national tragedy and the loss of life it signaled. Apart from the particular allusions it invites to the Civil War, *The Falling Gladiator* can also be considered a universal symbol of war's agony and man's struggle against inevitable death.

Although *The Falling Gladiator* enjoyed a favorable critical reception in Boston and subsequently in New York, when it was exhibited at the National Academy of Design (1866) and at the Cooper Union (1868-1872), the statue proved a financial disappointment for the artist. During Rimmer's lifetime, funds were never raised to have the work transferred to a lasting medium such as stone or bronze, and the plaster figure slipped into relative obscurity until the 1880 memorial exhibition held at the Museum of Fine Arts. In fact, not until twenty-seven years after the artist's death did a group of his former students and friends belatedly raise the necessary monies to cast this figure—and two other Rimmer compositions, *Fighting Lions*, 1907 (The Metropolitan Museum of Art), and *The Dying Centaur* (q.v.)—in bronze. Those responsible for organizing the "Rimmer Memorial Committee" were Daniel Chester French, once a pupil of Rimmer's; Edward R. Smith, reference librarian at the Avery Library, Columbia University, who had also profited from Rimmer's teaching; and the architect William R. Ware (1832-1915), who, along with Perkins, had assisted Rimmer early in his career. Complaining of the limbo to which the piece had been consigned during the artist's lifetime, Rimmer's biographer and apologist T.H. Bartlett wrote, "We have not yet begun to care or know what form in sculpture or sculpture in form is or means. . . . Any image with a name, any attractive personality, we like better than we do art in sculpture."[12]

The fragile condition of the original plaster of *The Falling Gladiator*, which was retained by members of Rimmer's family, convinced the committee to request the firm of P.P. Caproni and Brothers in Boston to take another plaster cast of the figure, from which a bronze version could be produced. From this sturdier, fresh plaster, made by Caproni in December 1905 or January 1906, two bronze copies of the *Gladiator* were cast by the John Williams Foundry, New York, in 1907.[13] The first of these was purchased by the Metropolitan Museum of Art, New York, and the second (cast sometime after June 11, 1907) was acquired by the Museum of Fine Arts in 1908 as a gift from Rimmer's daughters, Caroline Hunt Rimmer and Adeline Rimmer Durham. Some of the funds required for casting the duplicate bronze were raised privately by a group of Boston subscribers.[14] In 1915 the original plaster of *The Falling Gladiator* was given by Caroline Hunt Rimmer to the National Collection of Fine Arts (now National Museum of American Art), Washington, D.C. For many years, Boston's bronze version was displayed outside in the Museum's courtyard. In 1973 the weather damage the statue had sustained prompted its installation indoors and the restoration of its surface and patina.

J.S.R.

Notes

1. Quoted in Truman H. Bartlett, *The Art Life of William Rimmer: Sculptor, Painter, and Physician* (Boston: Osgood, 1882), p. 31.

2. Perkins described Rimmer's problems in modeling the figure in clay to the sculptor Hiram Powers. See Perkins to Hiram Powers, Nov. 2, 1861, quoted in Weidman 1982, p. 187. I gratefully acknowledge the cooperation of Dr. Jeffrey Weidman, who generously shared chapters of his dissertation with me before completion. He is currently preparing a book on Rimmer for Cambridge University Press's new monograph series on American artists.

3. Stephen H. Perkins to Rimmer, Jan. 10, 1864, Rimmer Collection, Boston Medical Library in the Francis A. Countway Library of Medicine, Harvard University.

4. Perkins to Rimmer, Nov. 15, 1862, Rimmer Collection.

5. Ibid.

6. See the enlightening essay on the French reception of Rimmer's *Gladiator* by Marcia Goldberg, "An American in Paris: William Rimmer's *Falling Gladiator* in the Salon des Refusés," *Gazette des beaux-arts* 94 (Nov. 1979), pp. 175-182.

7. Paul Mantz, "Salon de 1863," *Gazette des beaux-arts* 15 (July 1863), p. 62. Mantz, who had earlier seen and admired Rimmer's cast of the *Falling Gladiator* in Loison's studio, made only the brief comment: "La sculpture refusée ne présente pas un intérêt aussi vif: nous avons remarqué néanmoins *le Gladiateur*, du docteur Rimmel."

See also Goldberg, "An American in Paris," pp. 177, 180.

8. See "Studios in Florence," *Once a Week* (London), Dec. 19, 1863, p. 722. Although the review was favorable, Rimmer again suffered the indignity of having his name erroneously published, this time as "Bremner."

9. Jarves 1864, p. 278. According to Bartlett, *Art Life*, p. 37, the plaster cast that was sent to Perkins in Europe was destroyed in Florence about 1880, several years after Perkins's death.

10. For a summary discussion of possible influences, see Weidman 1982, pp. 215-216.

11. Perkins to Hiram Powers, Nov. 2, 1861, ibid., p. 188.

12. Truman H. Bartlett, "Dr. William Rimmer," *American Art Review* 1, pt. 2 (1880), p. 467 (reprinted in Walter Montgomery, ed., *American Art and American Collections* [Boston: Walker, 1889], p. 341).

13. The president of John Williams Foundry reported to the Catalogue Division, The Metropolitan Museum of Art, New York, Dec. 20, 1938: "We made two (2) bronze castings in 1907. One was shipped during 1907 and the second in January 1908." Quoted in Weidman 1982, p. 207.

14. W.R.W. [William Robert Ware], "Dr. William Rimmer," *Bulletin of the Museum of Fine Arts* 6, no. 32 (Apr. 1908), p. 16, records that French supervised the statue's casting in bronze and that the Williams Foundry declined to accept any remuneration beyond the costs of labor.

WILLIAM RIMMER

29

The Dying Centaur, 1869

Plaster

H. 21 in. (53.3 cm.), l. 27 in. (68.5 cm.), d. 24 in. (61 cm.)

Signed (on top of base between hooves): W. Rimmer

Bequest of Caroline Hunt Rimmer. Res. 19.127

Provenance: Caroline Hunt Rimmer, Belmont, Mass.; lent to Museum in 1883; removed and returned to Museum in 1905

Exhibited: Cooper Union School of Design for Women, New York, "Annual Exhibition," 1869; Boston Art Club, Mar.-Apr. 1871; BMFA, *Exhibition of Sculpture, Oil Paintings and Drawings by Dr. William Rimmer* (1880), no. 2; J. Eastman Chase Gallery, Boston, *Catalogue of Drawings, Paintings, and Sculpture by the Late Dr. Rimmer* (1883), no. 94; BMFA 1916; Whitney 1946, no. 5; BMFA, "Confident America," Oct. 2 - Dec. 2, 1973; Brockton Art Museum – Fuller Memorial, Brockton, Mass., *William Rimmer, a Yankee Michelangelo* (1985), no. 6.

Versions: *Plaster:* (1) present location unknown, formerly The Avery Library, Columbia University, New York, (2) Yale University Art Gallery, New Haven. *Bronze:* (1) The Art Institute of Chicago, (2) Fine Arts Museums of San Francisco, (3) The Metropolitan Museum of Art, New York

In June 1869 the *Boston Evening Transcript* carried a review of the annual art exhibition held at the Cooper Union School of Design for Women in New York. This seemingly inconsequential event in the art world was, in fact, of considerable local interest to the *Transcript*'s readers, for the exhibition featured sculpture and drawings by the School of Design's current director, Dr. William Rimmer of Boston. The newspaper's correspondent reported that the works on display included Rimmer's latest creation, a "*Centaur*, in which the Doctor shows his thorough knowledge of the animal as well as the human figure, to say nothing of the difficult combination of horse and man."[1]

Known today as *The Dying Centaur*, this modest-sized plaster is one of Rimmer's finest extant sculptures, striking in the drama of its concept and composition. The mythological subject would have been immediately familiar to Rimmer's classically oriented generation, conversant with artistic representations of centaurs in works as ancient as the Lapith and Centaur metopes of the Parthenon (drawings and casts of which were common in America by this date) as well as the well-known modern treatments of centaurs by the neoclassicists Antonio Canova and Bertel Thorwaldsen.

Rimmer's plaster depicts a centaur sprawled on the ground, its half-human body tense from recent physical exertion and straining upwards. Stretching its amputated arm heavenwards, the creature seems to implore aid or reassurance from the gods who have provoked the primordial conflict in process. The vertical-horizontal thrusts of these two independent yet connected body masses create a dynamic feeling of tension in the piece. The fragmented appearance of the truncated arms, if not a specific visual metaphor for the centaur's impotence to surmount the cosmic struggle that has prostrated it, reinforces the figure's "kinship" with antique sculptural counterparts. Its creator implicitly begs the question, Couldn't this centaur be taken, too, as the fractured masterpiece of some ancient Greek sculptor?

Thematically, *The Dying Centaur* relates to other plaster and pictorial images by Rimmer that presented the human or animal form pushed to the point of physical collapse; his are corporeal compositions intended to mirror the spiritual anguish endured by those who faced imminent death or were victims of pain and defeat. The specific choice of the centaur subject may also suggest something about Rimmer's view of man's nature. Half-animal

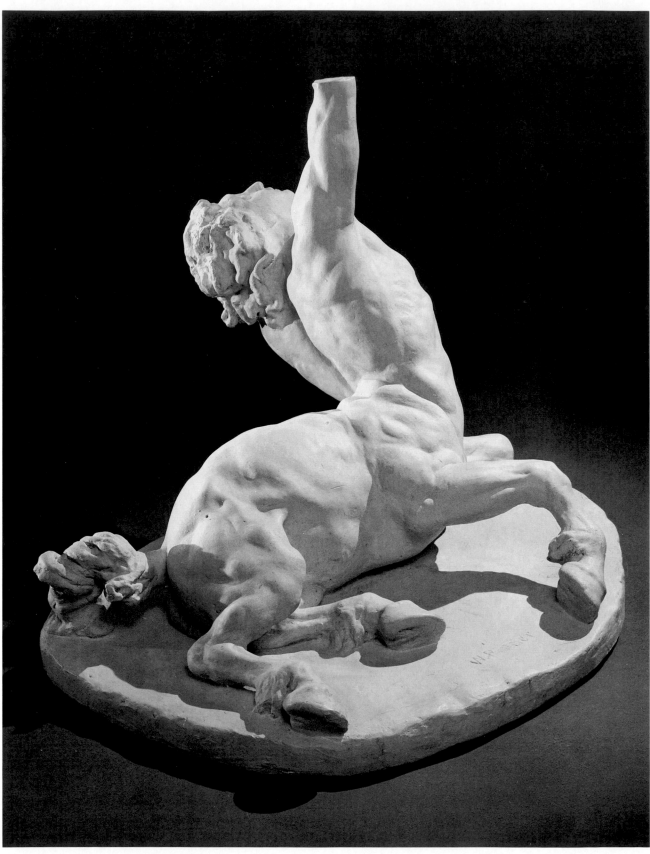

in its appetites and impulses, the centaur eternally grasps at unattainable goals. Antoine-Louis Barye's (1796-1875) emotionally charged animal bronzes were popular by this time, and it is conceivable that Rimmer's interest in the centaur was influenced in part by the raw energy, anatomical veracity, and philosophical overtones he saw in the French sculptor's animal studies. Other sources from antiquity may have influenced Rimmer, such as the pair of upright centaurs with fully developed musculature in Rome's Capitoline Museum, published in guides and art texts of the day. However, the extent of Rimmer's acquaintance with and quotation from foreign artistic sources, ancient and modern, remains to be firmly documented.[2]

Certain critics have interpreted Rimmer's sculpture as an expressly autobiographical symbol of his many personal disappointments and his dashed hopes of recognition as an artist. Albert Ten Eyck Gardner saw in the centaur's tortured form evidence of what "society could do to an artist who loved art more than literature, who dared to express ideas by form rather than by the trumpery props prescribed by convention."[3] The image itself, however, seems to invoke a more universalized reading. As a plastic expression of the unresolved war between the cerebral and the bestial, and as a graphic depiction of physical torment, *The Dying Centaur* is a conspicuously powerful, even profound statement. It should be noted that an analogous vision of the human condition pervaded the fiction of the contemporary American writers Nathaniel Hawthorne and Herman Melville, who frequently portrayed the darker aspects of man's nature.

Like *The Falling Gladiator,* the *Centaur* was not cast in bronze until a quarter of a century after Rimmer's death, although signs of blowholes near the *Centaur*'s face and chest suggest that the sculptor hoped the plaster would be resurrected in bronze at some future date. During the artist's lifetime, the plaster original was exhibited at the newly established Boston Art Club in the spring of 1871. After Rimmer's death, it was included in the 1880 Rimmer memorial exhibition at the Museum of Fine Arts and, three years later, displayed at the J. Eastman Chase Gallery in Boston. Rimmer's family thereafter deposited the piece at the Museum of Fine Arts, where it resided in the plaster cast gallery for many years. The artist's daughter eventually bequeathed the *Centaur* to the Museum in 1919.

The Dying Centaur holds distinction as the first composition selected by the Rimmer Memorial Committee for casting in bronze. Because traces of the "blowholes" and several minor nicks were discernible on the original plaster, the committee determined that a fresh plaster cast should be taken. In 1905 arrangements were made to have a replica cast produced by the Gorham Manufacturing Company, Providence, under the supervision of Gutzon Borglum (1867-1941), an admirer of Rimmer's work, who took an interest in the Memorial Committee. (Borglum was to take charge of patinating the bronze *Centaur*.) This fresh plaster cast, or moulage, served as the "parent" from which the bronze cast was made at Gorham in 1905.[4] Edward Holbrook, president of the Gorham Manufacturing Company, presented the latter to the Metropolitan Museum of Art, New York, in the spring of 1906.

The plaster cast of *The Dying Centaur* now in the Yale University Art Gallery, acquired from the Kennedy Galleries, New York, in 1968, is most likely the 1905 version executed under Gutzon Borglum's direction. It had been owned by Borglum and his son Lincoln prior to its purchase by the Kennedy Galleries in 1967. (It is conjectured that Borglum obtained the cast either through his professional ties with the Gorham foundry or through his personal ties with Edward Holbrook.) The Yale cast differs slightly from the original plaster in the Museum of Fine Arts in that its surface texture is smoother. A second plaster cast of *The Dying Centaur* is presumed to have been made at the Gorham foundry in 1905.[5] It was acquired by Edward R. Smith, a member of the Rimmer Memorial Committee. That second duplicate is probably the cast that Edward Smith presented in November 1906 to the Avery Library at Columbia University, where he was reference librarian.[6]

When the 1905 plaster cast of *The Dying Centaur* acquired through Lincoln Borglum was in the possession of the Kennedy Galleries in 1967, it was used as the model for an edition of fifteen numbered bronzes, cast by Joseph Ternbach. Many art museums and collectors in the United States moved quickly to acquire one of the modern bronze casts of the *Centaur*,[7] certainly a posthumous tribute to the freshness of vision and powerful anatomical modeling of Rimmer's original plaster study.[8]

J.S.R.

Notes

1. *Boston Evening Transcript*, June 2, 1869, p. 2.

2. In a brief but perceptive discussion of *The Dying Centaur* in *19th-Century Art*, the late H.W. Janson raised the question of the European "resources—plaster casts, prints, magazine illustrations, copies, etc." Rimmer may have consulted before modeling this and other of his sculptures. See Robert Rosenblum and H.W. Janson, *19th-Century Art* (New York: Abrams, 1984), p. 321.

3. Gardner 1945, p. 38.

4. Records in the Registrar's Office at the Museum of Fine Arts indicate that the *Centaur*, on loan until it was acquired as a permanent addition to the collection in 1919, briefly left the Museum in 1905, an exit that coincides with the year in which Gorham made the initial plaster and bronze casts of the *Centaur*. Gutzon Borglum presumably arranged for the delivery of the original plaster to the Gorham foundry so that the duplicate plaster cast could be made and the original be returned safely to the Museum.

5. On Dec. 13, 1905, Daniel Chester French, another Rimmer Memorial Committee member, wrote to Borglum, inquiring whether one or more copies of Rimmer's *Centaur* had been made. Borglum replied two days later that he had made "one or more casts." See also Gutzon Borglum to Daniel Chester French, Jan. 19, 1906. Gutzon Borglum Papers, Library of Congress, Washington, D.C.

6. At the same time (Nov. 1906) Smith also gave Avery Library plaster casts of Rimmer's *Fighting Lions* and *Falling Gladiator* (q.v.).

7. Mr. and Mrs. John D. Rockefeller III acquired the first of the fifteen numbered modern bronze replicas of *The Dying Centaur* and donated it to the Fine Arts Museums of San Francisco. See Donald L. Stover's remarks on this cast in *American Sculpture: The Collection of the Fine Arts Museums of San Francisco* (1982), p. 17.

8. For additional commentary and interpretation, see William H. Gerdts, *The Great American Nude* (New York: Praeger, 1974), pp. 101-102; Milo M. Naeve, "A Picture and Sculpture by William Rimmer," *Bulletin of the Art Institute of Chicago* 71 (Mar.-Apr. 1977), pp. 16-19; Weidman 1982, pp. 329-346.

WILLIAM RIMMER

30

Torso, 1877

Plaster

H. 11¼ in. (28.6 cm.), w. 14½ in. (36.8 cm.), d. 7½ in. (18 cm.)

Signed (on top of base at front): W. Rimmer 1877

Bequest of Caroline Hunt Rimmer. Res. 19.128

Provenance: Caroline Hunt Rimmer, Belmont, Mass.; lent to Museum in 1916

Exhibited: BMFA 1916; Brockton Art Museum– Fuller Memorial, Brockton, Mass., *William Rimmer, a Yankee Michelangelo* (1985), no. 8.

The date of this male torso, 1877, coincides with the publication of Rimmer's much-heralded treatise *Art Anatomy* and with the period of his tenure as professor at the art school of the Museum of Fine Arts, then called the School of Drawing and Painting. It may be that Rimmer devised the torso as an instructional aid for the classes he taught on anatomy and modeling. The vigorous, almost rough handling of form and material brings to mind Rimmer's earlier practice of composing quick anatomical studies of patients whose diverse body types attracted his attention. The nervous quality of modeling also suggests the speed at which the sculptor reportedly worked when sketching in plaster or clay. Light and shadow flicker across the *Torso*'s irregular surface, accentuating the body's crevices and muscular projections that Rimmer's modeling tools had registered on the wet and malleable clay. The evidence of tooling throughout the composition separates it stylistically from mainstream neoclassical sculpture, in which traces of the implements used to shape and manicure the surface of a work were diminished.

It is conceivable that Rimmer intended the *Torso* as an independent sculptural statement beyond its putative function as a pedagogical lesson for his students. Like Michelangelo and countless other sculptors throughout history, Rimmer is known to have greatly admired the powerful emotion and compressed athleticism of the monumental *Belvedere Torso* (Vatican Museums),[1] a replica of which was probably familiar to him in the Boston Athenaeum's cast collection. In this much reduced rendition of the same theme, Rimmer may have sought to convey a sense of the organic vitality and beauty of design condensed so efficiently in the adult male torso. Aside from the exemplar of the *Belvedere Torso*, Rimmer's plaster echoes other sculptural documents from antiquity, although whether these represent conscious references on the sculptor's part is subject to question. Parallels in pose can be drawn between Rimmer's *Torso* and the muscular, reclining figure of Theseus (now known as *Herakles* or *Dionysos)* from the east pediment of the Parthenon.[2] This celebrated Greek sculpture—part of the marble booty brought to England by Lord Elgin—was a standard object of study in nineteenth-century art classes on modeling, anatomy, and perspective. Rimmer probably was acquainted with the figure through the study casts and plaster reductions of it available locally. Another source proposed as a possible influence on the *Torso* is the figure of the river god Ilissos from the west pediment of the Parthe-

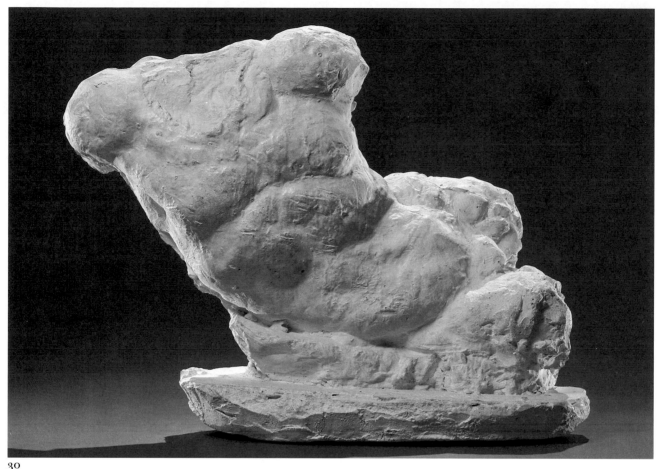

30

non. Rimmer had professed a particular esteem for the statue's remarkable, if unconventional beauty and its truth to nature, in a lecture he gave in Providence, Rhode Island.[3] Critics have also cited Michelangelo's well-known figures on the Sistine Ceiling (particularly that of Adam) as possible inspirations for Rimmer's *Torso*.[4]

While exhibiting similarities to these Graeco-Roman models and Renaissance masterworks, Rimmer's *Torso* also appears to anticipate modernism in the force of its execution and the power projected by its pure, elemental form. It exists without relying upon the costume trappings or narrative allusions that distinguished the neoclassical sculpture of Rimmer's contemporaries. Even in its fragmentary form, the composition possesses an artistic integrity and a vitality that invite comparison with Auguste Rodin's contemporaneous *Torso*, 1878 (Petit Palais, Paris).[5] Like Rodin's bronze, Rimmer's *Torso* has a dynamic physical presence, which is augmented by the work's animated, textural surfaces. The tension and spontaneity distilled in Rimmer's *Torso* would seem to support Rodin's argument that the partial figure was often more evocative than the human body in totality.

Torso is Rimmer's last dated sculpture. At the time of his death, the piece passed to his daughter Caroline, who lent it to the Museum of Fine Arts for the 1916 Rimmer exhibition. She bequeathed it to the Museum three years later.

J.S.R.

Notes

1. See Truman H. Bartlett, *The Art Life of William Rimmer, Sculptor, Painter, and Physician* (Boston: Osgood, 1882), p. 118.

2. The similarities were observed by Lincoln Kirstein, in Whitney 1946, no. 12.

3. Weidman 1982, p. 389, notes that Rimmer spoke of his admiration for this antique work in a lecture given Feb. 19, 1872; *Providence Daily Journal*, Feb. 21, 1872, p. 2.

4. Marcia Goldberg, "William Rimmer, an American Romantic Sculptor," Master's thesis, Oberlin College, 1972, p. 50, suggests this source; Craven 1968, p. 355, also refers to the *Torso* as a "Michelangelesque sketch."

5. See Janson's discussion of the "puzzling parallels" between Rimmer's *Torso* and that of Rodin in Robert Rosenblum and H.W. Janson, *19th-Century Art* (New York: Abrams, 1984), p. 496.

Erastus Dow Palmer (1817 – 1904)

Erastus Dow Palmer gained celebrity during his lifetime as one of America's leading sculptors even though he worked in Albany, New York, removed from the mainstream of sculptural activity. Critics compared his talent to that of Horatio Greenough and Hiram Powers. Unlike these eminent colleagues, however, Palmer succeeded without benefit of European travel and study. He proved that fine sculpture could be produced on American soil and achieve distinction without affecting an "Italianate" look, or drawing on inappropriate foreign subjects, or relying on antique themes. His deliberate dissociation from the company of American sculptors trained in Rome or Florence made Palmer's work stylistically divergent from conventional neoclassical sculpture; a pronounced naturalism distinguished it from the studious Hellenism that governed most contemporary compositions.

As a youth Palmer practiced carpentry in Onondaga County, New York, and eventually settled in Utica, where he carved wooden pattern molds for local industries. His conversion to sculpture began by chance about 1845, when he saw a portrait cameo owned by an acquaintance. Apparently the elegance of the miniature spurred Palmer to attempt a similar portrait of his wife; the successful result persuaded him to explore cameo portraiture as a means of livelihood.

Palmer moved in the late 1840s to Albany, where the city directories list him as a *conchiglia* (shell) artist. The eyestrain associated with this delicate work forced his retirement within two years, at which time he shifted his attention to clay modeling. By 1849 the *Albany Evening Journal* was referring to Palmer as "a sculptor of this city,"[1] which suggests that he had made the transition to this new medium and larger format. Several works from this period of experimentation confirm Palmer's instinctive plastic facility, notably *The Infant Ceres*, 1850 (private collection, Santa Barbara, California), his first work "in the round." Originally undertaken as a study of his daughter Fanny, the bust was later renamed (and perhaps reworked) with a mythological title, probably to enhance its salability.[2] Palmer repeatedly adopted the strategy of using family members and friends as models and then fabricating titles and adjusting narrative details to achieve a thematic universality.

By the 1850s Palmer had acquired full technical confidence, as well as an influx of commissions for

portrait busts and ideal sculptures. The latter included subjects such as *Resignation, Innocence, Spring, Night, Sappho,* and *The Sleeping Peri.* While nominally associated with the prescriptive allegorical and literary motifs that dominated mid-nineteenth-century neoclassical sculpture, Palmer's creations were praised for their fresh conceptualization and direct presentation. "His ideal busts are exceedingly beautiful, yet without ever departing from individuality, or introducing any of the insipid idealities which have so pestered and injured some modern sculptors," editorialized the *Crayon* in 1855. "His ideas and feelings have been derived . . . entirely from nature, without any reference to the antique," continued the commentary, "and so have an originality and freshness which are very forcible and . . . very rare."[3]

Palmer's fame reached national proportions in 1856 with the publicity attending his first one-person sculpture exhibition at the Church of Divine Unity on Broadway in New York. The dozen works chosen for display, consisting of realistic portraits, ideal bas-reliefs, and free-standing figures, demonstrated the broad range of Palmer's abilities. Although his ideal busts and relief medallions generated much complimentary press, the life-size, seminude statue *The Indian Girl* (or *The Dawn of Christianity*), 1856 (The Metropolitan Museum of Art, New York) clearly upstaged the rest of Palmer's offerings. A parable of Christianity's conquest over paganism, the image illustrated the awakening of religious sympathy in the soul of an Indian girl as she contemplated a crucifix discovered in the woods; according to the story the emblem was dropped by an early missionary traveling

through the American wilderness to convert the heathen tribes. With its righteous message and carefully delineated props and costuming, the piece exemplified the style of sententious realism that impressed the art public of Palmer's day. Enthusiastic reviewers praised the sculptor for bypassing the antique to illustrate an indigenous historical theme. News of the popular exhibition traveled quickly to Boston, prompting a local committee, led by Edward Everett, Henry Wadsworth Longfellow, James Russell Lowell, and Louis Agassiz to request that the exhibition be sent to New England.

After the exhibition, Palmer's status as a professional artist rose appreciably, and he continued to enjoy prestige throughout his long career. His Albany studio (depicted by Tompkins H. Matteson [1813-1884] in a well-known painting of 1857 [Albany Institute of History and Art, New York]) required numerous assistants to handle the steadily inpouring commissions.[4] As a sculptor of portrait busts, bas-reliefs, funerary memorials, and ideal figures imbued with spiritual sentiment and nationalistic symbolism, Palmer was in continual demand. The sculptor's sole transaction with the federal government, involving the design of a pediment group for the House wing of the United States Capitol, ended in failure. This outcome thwarted what may have been an ambitious bid by Palmer to move beyond the remunerative realm of "parlor" sculpture. A proposal for a historical tableau, modeled in 1857 and illustrating the landing of the Pilgrims at Plymouth in 1620, was discarded by officials in Washington, D.C., who objected to the narrow geographical appeal of Palmer's theme.

Many critics consider Palmer's *White Captive*, 1859 (The Metropolitan Museum of Art), to be the finest of his ideal compositions. Whereas *The Indian Girl* proposed the idea of Christianity's salutary influence upon the Indian, *The White Captive* suggested the pernicious influence of the Indian upon America's white (and Christian) settlers. According to the explanatory tale that accompanied the piece, the statue's subject was an adolescent frontier girl who, abducted by Indians, suffered the indignity of being stripped, bound, and ogled by her captors. The staging of the piece deliberately quoted the formula of "virtuous maiden in undressed distress," exploited so successfully by Hiram Powers in *The Greek Slave*, 1844 (Yale University Art Gallery, New Haven). Like the slave, Palmer's defenseless victim invited the audience's immediate sympathy; the imprisoned girl's nudity

was blamed on her barbaric attackers, the sensuality of her exposed body defused by her moral defiance and spiritual strength. Palmer's public applauded his innovative recasting of Powers's sculptural yarn in an American setting and its consequent transformation into a narrative of colonial captivity.

Throughout Palmer's career, critics and public alike commended the moralistic vision that informed his compositions while marveling at the soft, fleshy palpability he imparted to marble. The sculptor would have disclaimed the latter compliment. He disapproved of colleagues whose focus on pleasing tactile surfaces and picturesque silhouettes undermined the larger inspirational message of their statues. "No work in sculpture," Palmer wrote, "however well wrought out physically, results in excellence, unless it rests upon, and is sustained by the dignity of a moral or intellectual intention."[5]

Palmer traveled only once to Europe. In 1873 he took a studio in Paris to expedite work on a statue of the chancellor and jurist Robert Livingston, commissioned by New York State for the National Statuary Hall, United States Capitol. After attending to its casting in bronze abroad, Palmer returned to Albany, and the portrait of Livingston was shipped to Washington, D.C. A replica subsequently earned a first-class award at the Philadelphia Centennial of 1876.

Palmer remained active into his eighties, accruing numerous honors, including election as fellow of the National Sculpture Society in 1896. In his old age, he heard himself extolled as "the Nestor of American Sculpture" in recognition of the years of wise counsel he had offered his fellow sculptors.[6] By the time of Palmer's death in 1904, the popularity of his polished, pedagogical sculptural style had waned.

J.S.R.

Notes

1. *Albany Evening Journal*, July 18, 1849.

2. In 1851 *The Infant Ceres* was exhibited at the National Academy of Design, New York, as *Bust of a Child*.

3. William J. Stillman, "Editorial Correspondence," *Crayon* 1 (Mar. 1855), p. 202.

4. Several of Palmer's assistants achieved independent reputations in sculpture, the most noteworthy of whom were Charles Calverly, Launt Thompson (1833-1894), and Jonathan S. Hartley (1845-1912).

5. Erastus Dow Palmer, "The Philosophy of the Ideal," *Crayon* 3 (Jan. 1856), pp. 18-20.

6. Letter from Lorado Taft to Palmer, Dec. 5, 1902,

Erastus Dow Palmer Papers, Albany Institute of History and Art.

References

Adeline Adams, *The Spirit of American Sculpture* (New York: National Sculpture Society, 1929), pp. 31-32; Benjamin 1880, pp. 140, 156, 161; Samuel G.W. Benjamin, "Sculpture in America," *Harper's New Monthly Magazine* 58 (1878-1879), pp. 666, 669; L.J. Bigelow, "Palmer, the American Sculptor," *Continental Monthly* 5 (1864), pp. 58-64; *Catalogue of the Collection of Marbles at the Hall Belonging to the Church of Divine Unity, 548 Broadway, New York* (New York: Church of Divine Unity, 1856); Clark 1878, pp. 111-112, 117-119; Clement and Hutton 1894; Craven 1968, pp. 158-166; Gardner 1945, pp. 32-33; Gardner 1965, pp. 16-18; Gerdts 1973, pp. 44-45; Charles A. Ingraham, "Erastus Dow Palmer, a Great American Sculptor," *Americana* 24 (1930), pp. 7-21; Jarves 1864, pp. 278-281; "Masters in Art and Literature II: Erastus D. Palmer," *Cosmopolitan Art Journal* 1 (1856), pp. 48-49; Erastus D. Palmer, "The Philosophy of the Ideal," *Crayon* 3 (Jan. 1856), pp. 18-20; "Palmer, the Sculptor," *New Path*, July 1863, pp. 25-30; Post 1921, vol. 2, pp. 230, 236; Helen E. Richardson, "Erastus Dow Palmer, American Craftsman and Sculptor," *New York History* 27 (1946), pp. 324-340; William J. Stillman, "The Palmer Marbles," *Crayon* 4 (Jan. 1857), pp. 18-19; Taft 1930, pp. 132-141; Thorp 1965, pp. 132-133, 144-148; Tuckerman 1867, pp. 355-369; Henry T. Tuckerman, "The Sculptor of Albany," *Putnam's Monthly Magazine* 7 (1856), pp. 394-400; J. Carson Webster, "A Check List of the Works of Erastus D. Palmer," *Art Bulletin* 49 (June 1967), pp. 143-151; idem, "Erastus D. Palmer: Problems and Possibilities," *American Art Journal* 4 (Nov. 1972), pp. 34-43; idem, *Erastus D. Palmer: Sculpture—Ideas* (Newark: University of Delaware Press, 1983).

ERASTUS DOW PALMER

31

Charlotte Wood Morgan, 1880 (modeled in 1864)
Marble
H. 19 in. (48.3 cm.), w. 15 in. (38.1 cm.)
Signed (lower left): PALMER SC
Gift of the estate of Mrs. Thomas P. Beal. 1984.639

Provenance: Henry Augustus Morgan, Aurora, N.Y.; Edith P. Morgan, Aurora; May Morgan Beal (Mrs. Thomas P.), Chestnut Hill, Mass.; Thomas P. Beal, Jr., Lincoln, Mass., and Judith Beal Nadai, San Francisco, Calif.
Version: *Marble:* (1) Wells College, Aurora

Credit for Palmer's prospering career belonged in part to his patrons in Aurora, New York, the Morgan family. His friendship with this prominent upstate family was forged during a series of summer holidays taken in Aurora, a village on the shores of Lake Cayuga, during the 1850s. Scattered through

Palmer's correspondence are frequent affectionate references to two of the six Morgan brothers: Colonel Edwin Barber Morgan, businessman, philanthropist, and occasional congressman, and his younger brother Henry, a local businessman.[1] Palmer also maintained personal and professional ties with their cousin, Edwin Denison Morgan, a New York City merchant who twice served as governor of New York. Beyond offering hospitality and companionship, the Morgans took an active interest in Palmer's studio affairs and demonstrated their support by commissioning portraits and purchasing ideal statues.

During a stay in Aurora in 1864, Palmer modeled a portrait relief of Charlotte Wood Morgan (1806-1879), Edwin Barber's wife.[2] Charlotte was not the first member of the Morgan clan to be so memorialized. The sculptor had earlier executed busts of Edwin Denison Morgan, 1859 (Union Theological Seminary, New York), and his wife, Elizabeth Waterman Morgan, 1852 (present location unknown), as well as reliefs of Henry Morgan, 1863 (present location unknown), his daughter Kate, 1855-1856 (present location unknown), and Mrs. Christopher (Nancy) Barber Morgan, 1862 (Wells College, Aurora), the matriarch of the family. In spite of their friendship, Palmer apparently failed to persuade Edwin Barber Morgan to pose for his portrait. Although Palmer's summer residence at Aurora was theoretically devoted to leisure, he in fact spent these months industriously, initiating several other portrait busts and ideal compositions.[3]

Palmer recorded in his diary at least one modeling session with Charlotte Morgan, on August 30, 1864.[4] Evidently he arrived at a satisfactory likeness quickly, for the entry in his diary on September 5 indicates that the model for the medallion had been cast,[5] probably in plaster so that it could be transported easily to his Albany studio for later transfer to marble. The following February, Palmer informed Edwin Barber: "[Your wife's] medallion is now at hand, and will be done in two or three weeks. The frame is being made."[6] The oval-shaped portrait (Wells College) was finished by April and delivered to Morgan, who paid Palmer $300 for it.[7]

The medallion format was a technique at which Palmer excelled, as he had demonstrated in the early pair of reliefs *Morning*, 1850, and *Evening*, 1851 (Albany Institute of History and Art). His experience in cutting cameos helped him to achieve a convincingly real and detailed image in low relief. The subtle planar modulations and shadows registered in the shallow surfaces of the stone enlivened

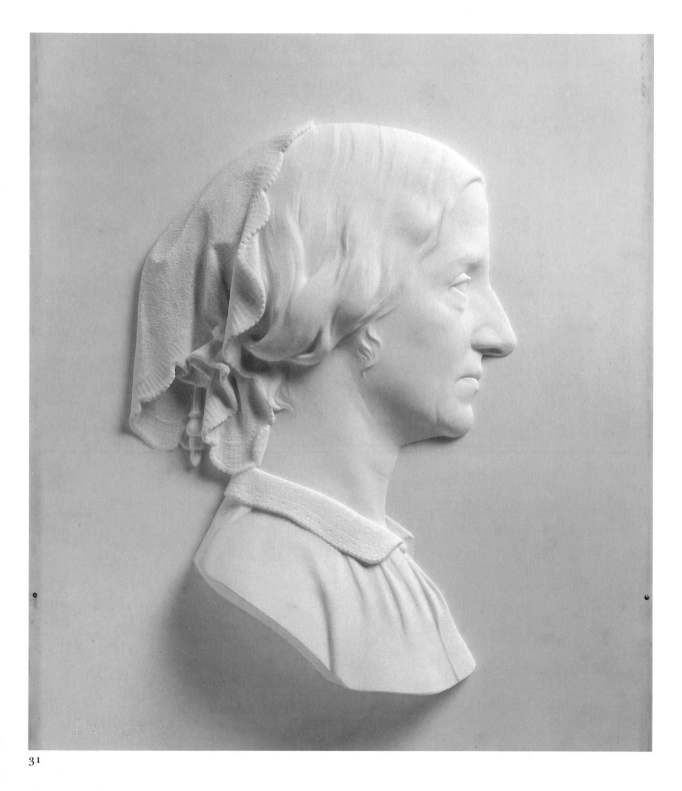

31

the essentially flat aspect of the bas-relief by creat-
ing an illusion of greater depth. Though acclaimed
for his elegant reliefs of idealized subjects such as
Peace in Bondage, 1863 (Albany Institute of History
and Art), Palmer rendered portrait medallions that
reveal a striking expressiveness and uncommon
immediacy.

These qualities are evident in the sensitively
modeled portrait of Charlotte Morgan. At the time
she sat for Palmer, she was in her fifty-eighth year,
the mother of three children. Although traces of
fatigue, perhaps resignation, are discernible in her
expression, the portrayal is one of a handsome,
middle-aged woman whose features have softened

with time. Visual emphasis alternates between the fine, linear profile and the more complex silhouette and surface patterns created by the kerchief covering the back of the head. The sculptor refrained from elaborating additional costume details that might distract the viewer from concentrating on the characterization. Thus the collared dress is treated with utmost simplicity, its presence serving to balance the medallion's design. The resulting portrait avoids sentimentality while at the same time transcending literal documentation.

After Charlotte Morgan's death in 1879, Colonel Edwin B. Morgan requested a duplicate of the portrait. From Albany, Palmer replied, "The work will be put in hand immediately, . . . unless you desire otherwise, I am going to have the marble (like Henry's) of an oblong square, for I make nothing oval or round any more. This change will always mark the distinction between the first and second one."[8] A penciled notation on paper formerly attached to the frame of the rectangular portrait also clarifies its later date of production: "Modelled in the year 1864 / This marble wrought 1880." The revised replica was finished by late spring. Apparently it met with Colonel Morgan's approval, for the sculptor wrote to him on June 25, 1880, "I am glad the marble reached you in safety, and that you all are pleased with it. My vanity led me to believe that it would 'pass.' " He also offered to reframe the earlier oval portrait "so that it would be quite as much liked as the new one."[9]

Both portraits descended to the next generation of Morgans.[10] The earlier version became the possession of Nicholas Lansing Zabriskie through his first wife, Louise, eldest of the Morgans' children.[11] Zabriskie, who succeeded his father-in-law as chairman of the board of trustees at Wells College, kept the portrait in his Aurora residence before presenting it to the college. The rectangular replica in the Museum of Fine Arts was once the property of Charlotte Morgan's son Henry, who served Wells College as treasurer of the board of trustees. Family records indicate that the portrait next passed to Charlotte's granddaughter, Edith Pierpont Morgan, who gave it to her niece, May Morgan Beal. The donors are the children of May Morgan Beal.

J.S.R.

Notes

1. The Morgan brothers amassed a sizeable fortune organizing and managing early express companies. In 1868 they financed the establishment of Wells College in Aurora. For further information see The Morgan Ancestral Records, a genealogical ledger compiled by descendants. See also Temple R. Hollcroft, *Aurora: Village of Constant Dawn* (Ovid, N.Y.: Morrison, 1976); and Elliot G. Storke, *History of Cayuga County, New York* (Syracuse: Mason, 1879).

2. Charlotte's father, Walter Wood, was a local judge and affluent businessman. Her mother, Paula Mosher Wood, was said to be the first Quaker to settle in the region. Charlotte and Edwin were married in 1829 and had five children, two of whom died in infancy. She became known for actively promoting educational opportunities for women.

3. Palmer modeled portraits of local residents and executed ideal figures, such as *The Sleeping Peri*, 1856, *The Little Peasant*, 1856, and a bas-relief, *Hope*, 1863 (all Albany Institute of History and Art). For further discussion of his work in Aurora, see Temple R. Hollcroft, "The Palmer Medallions in Aurora," *Wells College Alumnae News* 15 (Jan. 1950) pp. 4-6.

4. See J. Carson Webster, *Erastus D. Palmer: Sculpture—Ideas*, An American Art Journal - Kennedy Galleries Book (Cranbury, N.J.: Associated University Presses, 1983), pp. 225-226. Webster cites a manuscript by the sculptor's daughter, Frances Palmer Gavit, "Extracts of Interest from the Diaries of Erastus Dow Palmer, with Notations Largely by F.P.G." Palmer's diaries are now considered lost. Webster's book is the definitive study of Palmer.

5. Ibid.

6. Palmer to E.B. Morgan, Feb. 19, 1865, Archives, Wells College Library; reproduced in Webster, *Palmer*, p. 292.

7. The price appeared in Palmer's studio account book; present location unknown. See Webster, *Palmer*, p. 225.

8. Palmer to E.B. Morgan, Jan. 24, 1880, Archives, Wells College Library; reproduced in Webster, *Palmer*, p. 310.

9. Palmer to E.B. Morgan, June 25, 1880, Archives, Wells College Library; reproduced in Webster, *Palmer*, p. 310.

10. See Terrence J. Kennedy, "Art and Professional Artists of Cayuga County," *Auburn Bulletin*, Mar. 13, 1978, p. 3; Hollcroft, "The Palmer Medallions," p. 4; and J. Carson Webster, "A Check List of the Works of Erastus Dow Palmer," *Art Bulletin* 49 (June 1967), p. 149.

11. See Webster, *Palmer*, pl. 112, p. 220, for the earlier oval version.

Edward Augustus Brackett
(1818 – 1908)

Born in Vassalboro, Maine, Edward Brackett moved to Cincinnati, Ohio, at the age of seventeen. His interest in sculpture began in that bustling mid-western metropolis, noted for its patronage of aspiring resident artists. When Brackett arrived in the city in 1835, he undoubtedly heard talk about the emerging careers of two sculptors, Hiram Powers and Shobal Clevenger, who had received early local support.

Initially, Brackett worked as a block cutter for a Cincinnati printer and studied art only in his spare time. Within several years, however, his artistic skills had progressed sufficiently to encourage him to pursue the profession of sculpture in earnest. Spurred by the reported successes of Powers and Clevenger, Brackett went to Washington, D.C., and New York in the fall of 1839, an excursion that helped him procure several prestigious portrait commissions. In New York, where he decided to settle, several of his portrait busts attracted favorable critical attention when they were exhibited at the National Academy of Design and the Apollo Art Association. The city proved a disappointment financially, however, for over the next two years commissions for his busts were few and ill-paying. Thus, in the summer of 1841, Brackett moved to Boston, equipped with a letter of introduction from a former client and friend, William Cullen Bryant. He established a studio on Tremont Row and soon began modeling accomplished portraits of such notable sitters as Charles Sumner, about 1855 (Harvard University), and John Brown, about 1857 (Boston Athenaeum).

In 1844 Brackett exhibited a marble bust of Washington Allston (The Metropolitan Museum of Art, New York) at the Boston Athenaeum, an impressive, sensitive likeness of the artist that was acclaimed as his greatest achievement in portraiture. Commissioned by members of the Dana family, the bust was based on the death mask the young sculptor had taken of Allston in July 1843. Despite its firm reliance on this physical data, the portrait was also idealized enough to soften the evidence of pain and old age in Allston's face. The bust moved Allston's many admirers when they saw it on exhibition.

Brackett experienced a comparable popular response in 1852 when he displayed at the Boston Athenaeum his pathetic and melodramatic *Ship-wrecked Mother and Child* (Worcester Art Museum, Massachusetts), a composition he had begun in October 1848. The marble group attracted great crowds to the viewing gallery on Pearl Street. Many drew an eerie parallel between the sculptor's subject and the recent, tragic drowning of the Marchioness Ossoli (née Margaret Fuller) of Boston and her child in a boat wrecked in a storm off the coast of Long Island. Aside from its sentimental timeliness, Brackett's statue received considerable attention from the medical community for its accuracy in depicting the bloated appearance of drowning victims.

Although Brackett continued to carve portrait busts throughout the 1850s and 1860s, his energies were not dedicated exclusively to sculpture. Over the years he had devoted himself intermittently to writing poetry (he published several volumes of verse, including the popular collection *Twilight Hours* in 1845), raising pheasants, growing plants, and experimenting with the breeding of fish. Eventually, these naturalist's pursuits absorbed his complete attention. In 1869 Brackett was appointed state commissioner on land fisheries, and in 1873 he abandoned sculpture altogether to accept a position as director of the Massachusetts Fish and Game Commission.

J.S.R.

References

Boston Daily Globe, Mar. 16, 1908, obit.; Craven 1968, pp. 187-189; Gardner 1945, p. 62; Albert T. Gardner, "Memorials of an American Romantic," *Metropolitan Museum of Art Bulletin* 3 (Oct. 1944), p. 57; William J. Hennessey, "White Marble Idealism: Four American Neo-Classical Sculptors," *Worcester Art Museum Bulletin*, n.s. 2 (Nov. 1972), pp. 1-9; Lee 1854, pp. 194-202; Charles Leland, "Brackett's Wreck," *Sartain's Union Magazine of Literature and Art* 6 (Jan.-June 1850), pp. 370-374; Taft 1930, pp. 200-201; Tuckerman 1867, p. 599.

EDWARD AUGUSTUS BRACKETT
32
Francis Dana, about 1843
Marble
H. 15¾ in. (40 cm.), w. 10¼ in. (26.1 cm.), d. 7⅛ in.
(18.1 cm.)
Gift of Mrs. I.H. Dana, Boston. 19.120
Provenance: Dana family, Boston; I.H. Dana, Boston

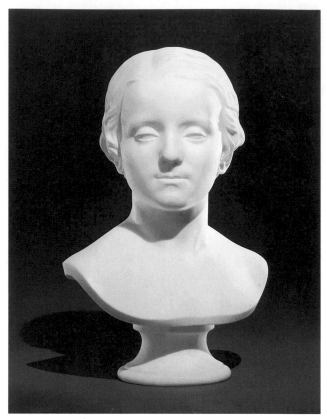

32

In a letter written shortly after his first year in
Boston, Edward Brackett commented with satisfac-
tion, "I am getting to be quite famous here in Bos-
ton, and as a sculptor no doubt I shall do well."[1]
Brackett's skill as a portrait artist and his felicitous
association with the family of Richard Henry Dana,
Sr., were equally responsible for the good fortune
he met with in the city. In the early months of
Brackett's residence in Boston, Dana had commis-
sioned a portrait bust of himself, thereby encourag-
ing other friends and associates to patronize the
young sculptor. When Dana's illustrious brother-in-
law, Washington Allston, died in July 1843, the
family retained Brackett to take a death mask of the
painter, which resulted in the handsome bust of
Allston that was completed in marble the following
year.

Tragedy struck the Dana family twice in 1843, for
Dana's eight-year-old son, Francis (1835-1843), also
died unexpectedly. In all probability, Richard Dana
ordered this marble bust from Brackett to memori-
alize the deceased child. The sculptor again may
have composed the portrait from a death mask, for
the boy's somber, pensive, and seemingly rigid
countenance belies the animated expression and
fullness one expects to see in the face of an eight-
year-old child.

A Dana family descendant gave this bust to the
Museum of Fine Arts with a note stating that the
boy was named for his great-grandfather, Francis
Dana, chief justice of Massachusetts.[2] The child was
also the great-great-grandson of William Ellery, an
original signer of the Declaration of Independence,
and of Richard Dana, the justice of the peace who
administered to Andrew Oliver the oath by which
he was bound never to enforce the Stamp Act in
America.

J.S.R.

Notes

1. Brackett to unknown correspondent ("My Dear
Friend"), Sept. 2, 1842, Gratz Collection, Historical Soci-
ety of Pennsylvania, Philadelphia, roll P22, in AAA, SI.

2. BMFA, ADA.

Thomas Ridgeway Gould
(1818 – 1881)

The Boston-born artist Thomas Ridgeway Gould, like his friend William Wetmore Story, did not wholeheartedly pursue a career in sculpture until he was nearly forty years old. He devoted his earlier life to business, working as a representative for his brother's profitable dry-goods firm. For relaxation, Gould dabbled in modeling and painting, regularly renewing his artistic ambitions by attending informal classes at the studio of the Boston portrait painter Seth Cheney (1810-1856), where Story also received instruction. One of Gould's first amateur compositions was a clay head of Jupiter, about 1854 (present location unknown), which he reworked several times before achieving the "majestical Olympian" effect he desired.[1]

Gould's formal break with commerce occurred when the Civil War ruined his family's business. Heeding the advice of friends, he opened a studio in Boston and was soon producing capably modeled ideal works as well as "portrait likenesses" (as they were called at that time) of prominent men. Portrait busts he carved during the 1860s included those of Ralph Waldo Emerson, 1861 (Harvard University), and John Albion Andrew, the wartime governor of Massachusetts, about 1863 (Boston Athenaeum). Among the imaginative compositions dating from this period were two plaster heads exhibited at the Boston Athenaeum in 1864: a *Christ* ("in its godly sanctity and blessed humanity") and a *Satan* ("in its blasted cunning and infernal pride"),[2] which were not carved in marble until 1878 (Boston Athenaeum).

The favorable attention that Gould's work attracted in Boston fortified his decision to further cultivate his talents abroad, where he intended to attach himself to the international artists' colony in Florence. He arrived in the Tuscan capital in 1868 and established himself in a studio near the Porta Romana, a neighborhood favored by American and English expatriates. The following year he modeled one of his best-known and most controversial statues, a female embodiment in marble of the West Wind (Mercantile Library, Saint Louis). This popular (it was repeated seven times) though somewhat awkwardly modeled work, exhibited at the Philadelphia Centennial in 1876, elicited an unpleasant dispute between the sculptor and certain critics over the issue of plagiarism. Gould's detractors claimed that his statue was a direct quotation of Antonio Canova's *Hebe*, 1796 (National Gallery, East Berlin),

clothed anew in a starry belt. The argument was settled in the sculptor's favor, and the resulting publicity of the affair, in the end, proved beneficial to his business and reputation. He soon rented a larger studio to accommodate his increasing commissions and the additional workmen required to execute them.

The decade of the 1870s was particularly active for Gould. He produced a series of busts and bas-reliefs based on Shakespearean themes, including *The Ghost of Hamlet's Father*, 1880 (Worcester Art Museum, Massachusetts), *Timon of Athens* and *Ariel* (present locations unknown), the last one once owned by the daughter of Edwin Booth. In 1873 he carved his dramatic and sensuous full-length statue of Cleopatra (q.v.), inspired by the character from Shakespeare's play *Antony and Cleopatra*. He executed a heroic bronze statue of John Hancock, 1875, for the town of Lexington, Massachusetts; completed a full-length portrait monument to Governor Andrew, 1875, for the cemetery in Hingham, Massachusetts; and in 1880 tackled an unusual order for a nine-foot imaginary representation in bronze of King Kamehameha I of the Hawaiian Islands, now on the grounds of the Kohala Court House, Kapua, Hawaii.

After settling in Florence, Gould returned to the United States only twice, on brief visits, in 1878 and 1881. He died in Florence in November 1881, aged seventy-three, soon after his last visit to Boston.

As a sculptor, Gould possessed an originality and scholastic sensitivity that were not always well served by his technique. Despite his lack of formal training, however, his accomplishments in sculpture well surpassed the amateurish. His most successful and critically acclaimed compositions, the Shakespearean themes, express a range of dramatic passions and subtle psychological states that distinguish them from the commonplace character studies and prescribed sentiments that preoccupied many second-generation neoclassical sculptors. Gould's interest in sculpture, like that of his townsman Story, was matched and enhanced by an appreciation of great literature. Through much of his adult life Gould enjoyed an independent reputation as a Shakespearean scholar and respected drama critic. Numbered among his friends were such well-known actors and interpreters of Shakespeare as William Warren, Edwin Booth, and Edwin's father, Junius Brutus Booth. (In 1868 Gould published a study of the elder Booth, entitled *The Tragedian: An Essay on the Histrionic Genius of Junius Brutus Booth*.) One senses that it was also Gould's genial charm

and cultured upbringing that equipped him to perform the role of "artist" so well. He was remembered by a Boston friend and admirer as "the Adonis of the circle; [his] black curling hair, not in those days shaved to the crown like a monk's, with a dark, rich complexion, soft, melting eyes, and a voice with profound tragedy and tender sweetness in it, gave him an almost irresistible fascination for the moment. . . . He had a remarkable ability in imitating celebrated actors, especially Booth, and filled you with horror as he recited tragic pieces. Starr King said of him that he was 'almost a genius – not quite.' "[3]

<div style="text-align: right">J.S.R.</div>

Notes

1. Gould recorded his "problems" and progress on the *Jupiter* in his journal from 1852 to January 1854, when the piece was finally cast to his satisfaction. See Memoranda & Journal, vol. 1, Mar. 1850 - [Sept. 1854], Ho, HU.

2. Samuel Osgood, "American Artists in Italy," *Harper's New Monthly Magazine* 41 (Aug. 1870), pp. 422-423.

3. Ednah Dow Cheney, *Reminiscences of Ednah Dow Cheney* (Boston: Lee & Shepard, 1902), pp. 41-42.

References

Benjamin 1880, pp. 152, 154; Samuel G.W. Benjamin, "Sculpture in America," *Harper's New Monthly Magazine* 58 (Apr. 1879), pp. 667-668; Ednah Dow Cheney, *Reminiscences of Ednah Dow Cheney* (Boston: Lee & Shepard, 1902), pp. 41-42; Clark 1878, pp. 122-127; Craven 1968, pp. 204-205; Almira Fenno-Gendrot, *Artists I Have Known* (Boston: Warren, 1923), pp. 39-40; Gardner 1945, p. 65; Thomas R. Gould, Memoranda & Journal, vol. 1, Mar. 1850 - [Sept. 1854], Ho, HU; William J. Hennessey, "White Marble Idealism: Four American Neoclassical Sculptors," *Worcester Art Museum Bulletin* 2 (1972), pp. 1-9; James Jackson Jarves, "The Progress of American Sculpture in Europe," *Art-Journal* (London) 33 (n.s 10) (1871), pp. 7-8; Samuel Osgood, "American Artists in Italy," *Harper's New Monthly Magazine* 41 (Aug. 1870), pp. 420-425; Taft 1930, pp. 188-190; Tuckerman 1867, p. 600.

THOMAS RIDGEWAY GOULD

33

Imogen, 1866

Marble

H. 20 in. (50.8 cm.), w. 15 in. (38.1 cm.), d. 11⅜ in. (28.9 cm.)

Signed (on back of base): T.R. GOULD SC: 1866

Inscribed (on back of base): IMOGEN

Gift of Mrs. Thomas R. Gould, accessioned as abandoned property. 1979.265

Provenance: Mrs. Thomas R. Gould, Boston

Exhibited: BMFA 1979, no. 9.

Among the earliest works produced by Gould, after formally declaring himself a sculptor, was this ideal study of *Imogen* drawn from Shakespeare's play *Cymbeline*. It was also one of three busts singled out for praise by the Boston art critic Henry Tuckerman, who lauded *Imogen*, along with a *Mephistopheles* and a piece entitled *Childhood*, for their subtle expressiveness and careful finish. *Imogen*'s characterization in particular was described as a "very graceful embodiment."[1]

As the virtuous and wronged heroine of *Cymbeline*, Imogen was among Shakespeare's most admired female characters. In the play, she is falsely accused of infidelity to her husband, Posthumus, and is forced to endure hardship and sorrow in the attempt to vindicate her reputation and be reunited with her husband. To Victorian theater audiences, Imogen embraced all the important qualities of the constant wife: loyalty, patience, innocence, simplicity, and purity of soul.[2] A number of other American sculptors, such as Erastus Dow Palmer,[3] were drawn to Imogen as a subject for an idealized bust.

In interpreting this familiar and revered personality, Gould appealed to the literary bent of his cultured friends and patrons while demonstrating his aptitude with a chisel, a proficiency revealed in the carving of *Imogen*'s curled coiffure. He may also have modeled the bust as an affectionate tribute to his wife, Becky. In a diary that Gould kept from 1850 to 1854, charting his courtship with the pretty Philadelphia girl whom he married in the spring of 1854, Becky's face is described as possessing the beauty "of Imogen."[4] Gould's diary also chronicles his keen interest in the writings of Shakespeare—one of its earliest entries records his purchase of the ten-volume Chiswick edition of Shakespeare—and his growing fondness for his hobby, sculpture.

<div style="text-align: right">J.S.R.</div>

Notes

1. Tuckerman 1867, p. 600.

2. The virtues and vices of Shakespeare's heroines were examined in several nineteenth-century publications; among these, Anna Jameson, *Characteristics of Women*, 2 vols. (London, 1832), and Helena Saville Martin, *Shakespeare's Female Characters* (Edinburgh: Blackwood, 1885), were widely read in the United States.

3. A bronze cast of Palmer's characterization of Imogen (1874) was acquired by the preeminent landscape painter Frederic E. Church (1826-1900) for his Moorish home, Olana, on the Hudson River, N.Y.

4. Thomas R. Gould, Memoranda & Journal, vol. 1, June 25, 1851, Ho, HU.

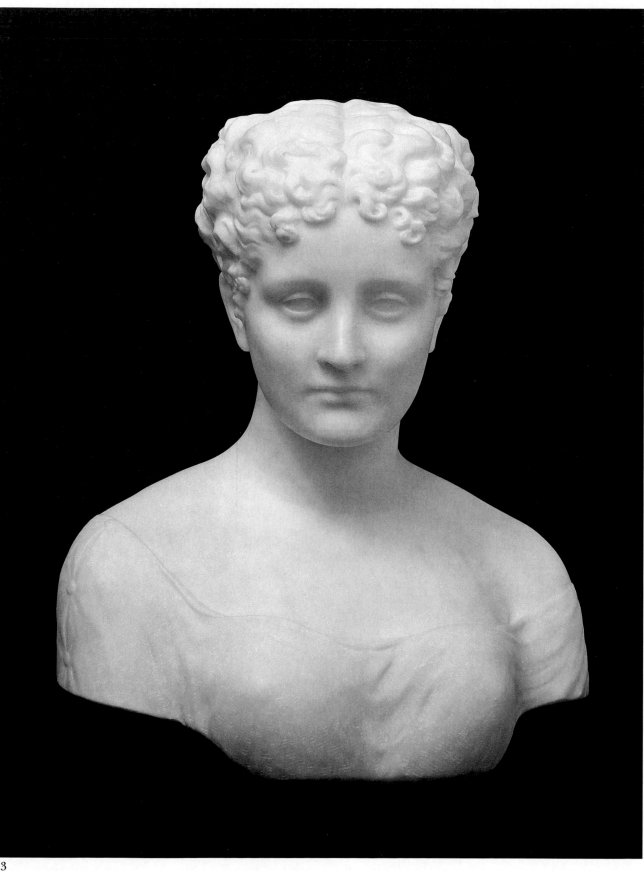

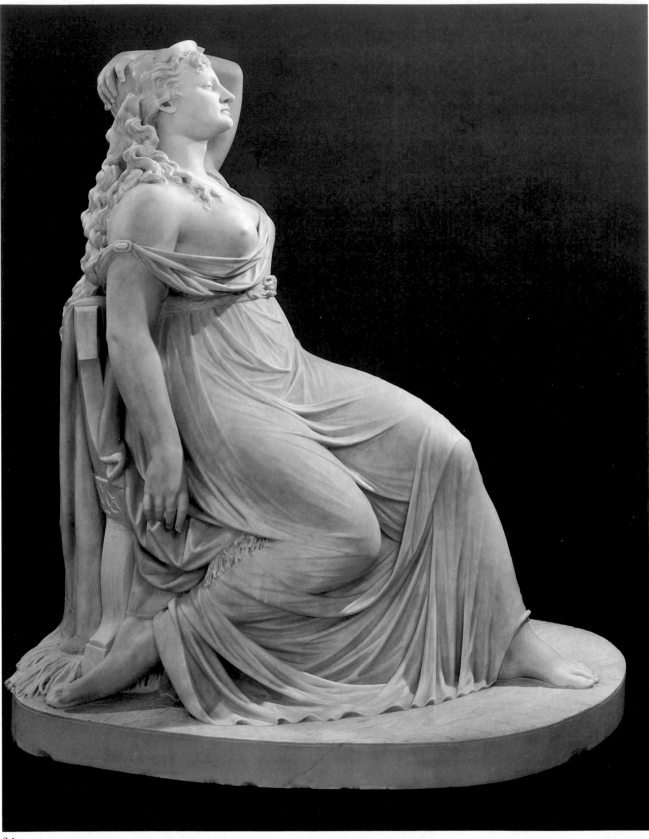

34

THOMAS RIDGEWAY GOULD

34

Cleopatra, 1873

Marble

H. 57 in. (144.7 cm.), w. 24¾ in. (62.8 cm.), d. 49½
in. (125.8 cm.)

Signed (on back of base): T.R. GOULD / INV. et FECIT.
FLORENCE 1873.

Inscribed (on back of base): CLEOPATRA

Gift from the Isaac Fenno Collection. 18.404

Provenance: Isaac Fenno, Roxbury Highlands, Mass.;
Mrs. Isaac Fenno-Gendrot, Boston
Exhibited: BMFA, "Confident America," Oct. 2 - Dec. 2,
1973; BMFA 1979, no. 13.

Several years after completing *Imogen* (q.v.),
Thomas Gould again consulted Shakespeare's rep-
ertoire of female characters, selecting the notorious
Egyptian queen from *Antony and Cleopatra* as a
sculptural subject. He began work on the model for
Cleopatra around 1870, at a time when public inter-
est in ancient Egypt's history and art was intense.
With the opening of the Vatican's Egyptian Mu-
seum thirty years earlier, a large audience of curi-
ous sightseers had been given their first significant
exposure to the treasures of the ancient empire.
Travel books on Egypt and scholarly studies of
Egyptian civilization and its context within biblical
history proliferated from that period forward. Play-
wrights, novelists, and painters were assured a fol-
lowing if their protagonists or subject matter
evoked some of the exoticism of the Land of the
Nile.[1]

As Egypt's last queen, Cleopatra (69-30 B.C.) was
one of history's most captivating personalities.[2] Her
fierce ambition, volatile temper, and imperial *hau-
teur,* frightening in their force, were provocatively
counterbalanced by her regal dignity and fabled
feminine allure. Not surprisingly, many artists felt
challenged to convey her spirit and charm on can-
vas or in stone. In the Victorian period she served
as the subject of numerous marble busts and full-
length statues by American sculptors,[3] including
William Wetmore Story, who modeled a seated
Cleopatra, 1858 (Los Angeles County Museum of
Art), which attracted much critical acclaim when
displayed at London's International Art Exposition
in 1862.

Thomas Gould's depiction of Cleopatra in the
throes of death was calculated to appeal to the
public's love of morbid melodrama. He conse-
quently represented the Egyptian queen at her ca-
reer's fatal climax, the dramatic moment in Shake-

speare's play when she utters her tragic yet tri-
umphant soliloquy, "The stroke of death is as a
lover's pinch, / Which hurts and is desir'd" *(Antony
and Cleopatra,* act 5, scene 2). Posture and expres-
sion are carefully contrived to emphasize the inevi-
table result of her suicidal act. Cleopatra is draped
languidly across the chair, with drooping eyelids
and loosened hair, her right foot curled back un-
naturally, her right arm dangling limply at her side,
and her left arm arched with careless abandon
above her head; Gould's sculpture theatrically mir-
rors the numbing progress of the asp's poison. The
impact of the piece confirms the observation made
by Edgar Allen Poe that there was no topic in the
world "more poetical," "melancholy," and absorb-
ing than "the death of a beautiful woman."[4]

Cleopatra's face, with its look of "dreamy ease,"[5]
may have been suggested to Gould by an antique
statue of Aphrodite or Hera, with the pupils of the
eyes drilled out in proper Roman imperial fashion.
He handled the queen's clinging robes with a fussy
attentiveness to underlying form that enticed Victo-
rian audiences by the veiled eroticism while im-
pressing them with the artist's carving technique
and compositional skill. Gould also demonstrated
his regard for authentic narrative costume effects
by adorning the figure with a girdle replete with
symbols of ancient Egypt and of the Ptolemaic dy-
nasty, which followed Alexander the Great.[6]

Contemporary viewers of *Cleopatra*, which the
sculptor completed in marble in 1873, were quick to
make comparisons between Gould's sensual, rather
Western interpretation and Story's somberly medi-
tative, African rendition of the famous woman.
James Jackson Jarves commented at length on the
differences between the two conceits: "Story's Cle-
opatra is the beautiful, accomplished, intellectual
mistress of pleasure in a meditative pose, the para-
gon of feminine fascination. But Gould has ven-
tured on the more dubious roll of presenting her at
a moment when the strong tide of Oriental volup-
tuousness courses warmest through her veins. She
becomes indeed the most passionate woman of his-
tory, whose name is a byword for the force of
sensual attraction and dominion over men. . . .
Her features are sufficiently comely, but more
American than Eastern in type. There is a serpent-
like elasticity and flexibility in the entire figure; but
the outlines of the body and a portion of its anatom-
ical physiognomy are not equal in grace and preci-
sion, and indeed voluptuous *abandon* to the head,
which is better modelled in every respect."[7]

Another critic judging Gould's statue, William Clark, credited him with giving *Cleopatra* a Grecian cast and also warmly praised the statue's expressive pose, "which even in its perfect freedom and abandonment is inspired by a queenly grace and dignity."[8]

Undoubtedly much of the attention directed toward Gould's and Story's statues, as well as to the dozens of other painted and carved representations of Cleopatra dating from this period, rested upon the subject's historical notoriety as the cunning, comely mistress to Caesar and to Antony. Her flagrant defiance of societal laws and her physical magnetism associated her in the popular mind with the stock female character of the "Dark Lady," who was predictably pleasure-seeking, passionate, and amoral. These traits, embodied to perfection in Shakespeare's deadly temptress, both tantalized and troubled people in the Victorian era. Typically, American sculptors deflected attention away from their obvious artistic delight in such voluptuously risqué subjects by portraying their "Dark Ladies" as suffering the dire consequences of unbridled passion. Thus, Gould presented Cleopatra not as a seductress anticipating her prey but as a stupefied victim of suicide. Similarly, Story represented her mourning Octavius's insensitivity to her charms and the doom it spelled for her and her kingdom.

Gould's *Cleopatra* was purchased by Isaac Fenno, an affluent wool manufacturer and clothing merchant from Boston. Fenno exhibited the statue in a special gallery he built adjoining his mansion on the Roxbury Highlands, a building he commenced, his wife recalled, "with the fond anticipation of founding a collection of representative New England art."[9] The sculpture stirred considerable interest locally and was visited by many art enthusiasts, professional and amateur. Among the crowd that ventured to Roxbury to inspect Fenno's acquisition was the sculptor-physician Dr. William Rimmer, who pronounced it a "fine, enjoyable work of art; the hand and arms might stand as models in sculpture. I much prefer it to Storey's [*sic*] Cleopatra."[10]

J.S.R.

Notes

1. Events that heightened the American public's awareness of Egypt were the opening of the Suez Canal in 1869, the 1872 unveiling of Martin Milmore's massive *Sphinx* in Mount Auburn Cemetery, Cambridge, memorializing the Civil War dead, and the first performance in New York of Verdi's opera *Aida* in 1873. For Egyptian themes treated by American artists, see William H. Gerdts, "Egyptian Motifs in Nineteenth-Century American Painting and Sculpture," *Antiques* 90 (Oct. 1966), pp. 495-501. For an appraisal of how their European counterparts responded to Egypt and the Near East, see Donald Rosenthal, *Orientalism: The Near East in French Painting, 1800-1880* (Rochester, N.Y.: University of Rochester Memorial Art Gallery, 1982). Egyptian influences were also reflected in American architecture and interior furnishings of the period, ranging from designs for massive cemetery gates and impregnable prison fortresses to seating furniture with griffin arm supports and sphinx-shaped inkwells.

2. The extent of mid-nineteenth-century interest in Cleopatra is suggested by an issue of the *Cosmopolitan Art Journal* 3 (1858-1859), which included an article, "Cleopatra, the Queen, the Mistress, the Suicide"; a poem, "Antony and Cleopatra"; and, as the frontispiece, a print, *Cleopatra Applying the Asp*, after Guido's famous painting.

3. American sculptors who carved images of Cleopatra included James Henry Haseltine (1833-1907), Edmonia Lewis (1843/45-after 1911), and Margaret Foley (about 1820-1877).

4. Edgar Allen Poe, "The Philosophy of Composition" (1846), reproduced in *American Literature*, ed. Richard Poirier and William L. Vance (Boston: Little, Brown, 1970), vol. 1, p. 662.

5. As described by Samuel Osgood, "American Artists in Italy," *Harper's New Monthly Magazine* 41 (Aug. 1870), pp. 420-425.

6. See Vermeule 1975, p. 979.

7. James Jackson Jarves, "Progress of American Sculpture in Europe," *Art-Journal* (London) 33 (n.s. 10) (1871), p. 7.

8. Clark 1878, pp. 126-127.

9. See Almira Fenno-Gendrot, *Artists I Have Known* (Boston: Warren, 1923), regarding the art collection of her first husband, Isaac Fenno.

10. Quoted by Fenno-Gendrot, *Artists*, p. 38.

Thomas Ball (1819–1911)

Thomas Ball was introduced to art through his father, a house and sign painter in Charlestown, Massachusetts, whose eventual insolvency compelled Ball to quit school and begin contributing to the family's income. Ball soon found a job cleaning glass cases and repairing wax figures at the New England Museum in Boston, an establishment housing a curious assortment of art and oddities. Inquisitive about the portraits and paintings he saw on display there, Ball began to impress fellow employees with his precocious aptitude for reproducing these works. To cultivate this talent, he apprenticed himself to a local wood engraver in the evening. Within several years, he had gained enough experience to establish a business cutting profile silhouettes and painting miniatures. Before long, he graduated to painting life-size portraits and ambitious religious and historical canvases. Although he was considered a competent painter (several of his works were exhibited at the Boston Athenaeum and at the Apollo Art Association in New York in the 1840s), the uncertainty of commissions made it necessary for him to supplement the modest income he earned as a painter. Fortunately, the musical gift of a resonant bass voice enabled him to obtain a paid position in the choir of Boston's Saint Paul's Church.

Ball's first direct encounter with sculpture occurred at the suggestion of a friend and local portrait sculptor, John Crookshanks King (1806-1882). King reportedly recommended clay modeling to Ball as a distraction after an unlucky love affair. The advice proved auspicious. Ball executed an enormously successful cabinet bust of the great coloratura Jenny Lind, 1851 (The New-York Historical Society, New York), who had captured the hearts of American audiences during her two-year tour of the United States (1850-1852). A fine life-size portrait bust of Daniel Webster followed (Boston Athenaeum). Thereafter Ball enjoyed a steady stream of orders for small plaster statuettes and portrait studies. His personal fortunes also improved when he married Ellen Louisa Wild, a young woman he met through musical acquaintances.

With expectations of a bright future in the sculpture profession, Ball and his bride sailed for Italy in October 1854. They established residence in Florence in an apartment formerly occupied by the painter William Page (1811-1885) and the sculptor Shobal Clevenger. There, he worked diligently to

improve his technique by studying the masterpieces of ancient, Renaissance, and modern sculpture, while benefitting from the friendly counsel of other American artists living in the Tuscan city, such as Hiram Powers, who befriended Ball. Among the compositions he initiated after settling in Florence were ideal studies of Pandora, 1855, a *Shipwrecked Boy*, and a small statuette of Washington Allston, which was greatly admired (present locations of all these unknown).

In 1857 Ball returned to Boston with the plan of assuming responsibility for a monument that had been awarded originally to Thomas Crawford but had been delayed because of Crawford's untimely death. After completing a sketch of his proposed design, Ball inherited the commission to produce a colossal bronze equestrian statue of George Washington for Boston's Public Garden. Over the next three years, he labored on the model in a barnlike studio space allotted to him on the grounds of the Chickering Piano Factory on Tremont Street. (He later fashioned the well-known Chickering monument [*The Realization of Faith*], 1872, for Mount Auburn Cemetery, Cambridge.) Aided by a young pupil and apprentice, Martin Milmore, Ball succeeded in creating a spirited image of Washington. Proud American critics immediately compared Ball's striking composition to the heroic equestrian

monument of Colleoni, about 1488, by Andrea del Verrocchio in Venice. Cast in bronze at the Ames Foundry in Chicopee, Massachusetts, Ball's statue was erected in 1869 and still dominates the Public Garden today.

Invigorated by the success of the Washington statue, Ball returned to Florence in 1865. He immediately set to work on another monument that would bring him public acclaim (and notoriety in the American South). The artist's so-called *Emancipation Group*, dedicated in 1876 (Lincoln Park, Washington, D.C.), features a beneficent Lincoln extending a protective hand over a kneeling slave, a conception motivated by Ball's horror at the news of Lincoln's assassination.

In the following decades Ball's career flourished. His services were in constant demand for portrait statues, outdoor bronze monuments, and cemetery memorials. He received commissions in Boston for full-figure portrait statues of Charles Sumner, 1878, (Public Garden, Boston), and Josiah Quincy, 1879 (in front of Old City Hall, Boston), and an order for a colossal statue of Daniel Webster for New York's Central Park, erected 1876. Although he had not graduated from high school, Ball was awarded an honorary degree from Dartmouth College in recognition of the series of portraits he had made of illustrious alumni and administrators, such as Webster, Rufus Choate, 1880, and President Nathan Lord (both Hood Museum of Art, Hanover, New Hampshire). Ball's imaginative or ideal conceptions were also popular.[1] He was noted in particular for sweet, coquettish representations of children with such endearing titles as *Christmas Morning*, about 1873, *St. Valentine's Day*, about 1873 (both on loan to Museum of Fine Arts, Boston), and *La Petite Pensée*, 1873 (National Museum of American Art, Washington, D.C.). Many of the vignettes depicted in these sentimental conceits were inspired by the frolics of his daughter "Kitty" (Eliza).

By the third quarter of the nineteenth century, Ball had become an affluent artist, the frequent beneficiary of lucrative commissions for monuments as well as orders for "parlor" marbles. He built a villa near the Poggia Imperiale in Florence and traveled back and forth to America at his convenience. In 1891 he decided to preserve his life's recollections in an autobiography, *My Threescore Years and Ten*. The book is an unpretentious, colloquial account of a self-made man's rise from obscurity to prominence in his profession. Its modest tone reveals an attractive simplicity of character that seems not to have suffered under the pressures of fame and competition.

In 1897 Ball retired and moved to Montclair, New Jersey, to live with his daughter and her husband, William Couper (1853-1942), a former sculpture student of Ball's. He dabbled in his original field of painting until his death in 1911.

J.S.R.

Note

1. When the Museum of Fine Arts opened in 1876, Ball offered one of his ideal busts, *La Penserosa*, for sale to benefit the Museum, an arrangement that quickly netted the institution a five-hundred-dollar profit. BMFA, *Proceedings at the Opening of the Museum of Fine Arts, with the Reports for 1876* (1876).

References

Ball 1891; Benjamin 1880, pp. 149-150; BMFA, WMH; *Boston Evening Transcript*, Dec. 12, 1911, obit.; BPL; Cheryl A. Cibulka, *Marble and Bronze: 100 Years of American Sculpture 1840-1940* (Washington, D.C.: Adams Davidson Galleries, 1984), pp. 10-11; Craven 1968, pp. 219-228; Wayne Craven, "The Early Sculptures of Thomas Ball," *North Carolina Museum of Art Bulletin* 5 (fall 1964-winter 1965), pp. 3-12; Gardner 1945, p. 60; Gardner 1965, pp. 20-21; *Harper's New Monthly Magazine* 41 (Aug. 1870), pp. 420-425; ibid. 43 (Apr. 1879), p. 665; Lee 1854, pp. 212-213; MMA; *Montclair Times*, Dec. 16, 1911, obit.; William O. Partridge, "Thomas Ball," *New England Magazine* 12 (May 1895), pp. 291-304; Post 1921, vol. 2, pp. 229-230; Taft 1930, pp. 141-149; "The Thomas Ball Centenary Today," *Boston Herald*, June 3, 1919; Lillian Whiting, "Memories of a Visit to the Home of Thomas Ball at Florence," *Boston Herald*, Dec. 31, 1911.

THOMAS BALL

35

Daniel Webster, 1853

Bronze, brown patina, sand cast

H. 29¾ in. (75.6 cm.), w. 13¼ in. (33.6 cm.), d. 11 in. (28 cm.)

Signed (on back of draped column): T Ball Sculp / Boston Mass / 1853

Foundry mark (on back of draped column): Ames Foundry / Chicopee Mass.

Gift of a Friend of the Department. 1984.22

Provenance: Museum purchase at sale, Adam A. Weschler & Son, Washington, D.C., Dec. 11, 1983, lot 1334
Exhibited: Sterling and Francine Clark Art Institute, Williamstown, Mass., *Cast in the Shadow: Models for Public Sculpture in America*, catalogue by Jennifer A. Gordon (1985), no. 1.

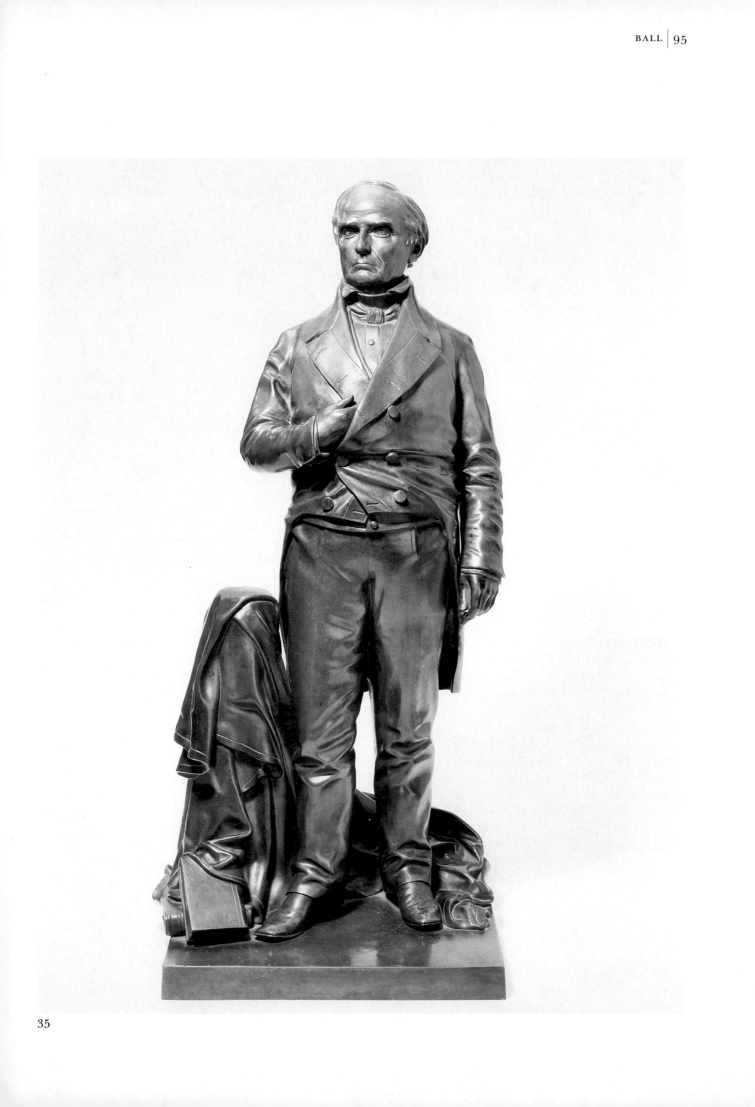

Versions: *Bronze,* half-life-size: (1) The Athenaeum of Philadelphia, (2) Beverly Historical Society and Museum, Mass., (3) Boston Public Library, (4) The Century Association, New York, (5) Christie's, New York, (6-8) Hood Museum of Art, Hanover, N.H., (9) The Detroit Institute of Arts, (10) The Hudson River Museum, Yonkers, N.Y., (11) Lafayette College, Easton, Pa., (12) Mead Art Museum, Amherst, Mass., (13) The Metropolitan Museum of Art, New York, (14) New Hampshire Historical Society, Concord, (15) The New-York Historical Society, New York, (16) Jane Voorhees Zimmerli Art Museum, New Brunswick, N.J., (17) Smith College Museum of Art, Northampton, Mass., (18) Victor Spark, New York, (19) The White House, Washington, D.C.; over life-size: (20) Central Park, New York

This small-scale but nonetheless forceful characterization of Daniel Webster (1782-1852), the renowned statesman and orator, occupies a significant place in Thomas Ball's oeuvre, technically and thematically. It was through his early experiments in the diminutive format of the so-called cabinet bust that Ball achieved his first demonstrable success as a sculptor. Although he claimed to have undertaken these miniature modeling exercises for his own amusement, the extraordinary popularity of his *Jenny Lind* portrait, 1851 (The New-York Historical Society, New York), probably convinced Ball that there were substantial profits to be made through marketing these recreational compositions. Orders for copies of the bust apparently deluged the artist until an unscrupulous *formatore* (vendor of plastic images) pirated his design, hence glutting the art market with cheap, unauthorized facsimiles.[1] While he professed annoyance at this plagiarism, the ubiquitousness of the *Jenny Lind* very likely proved advantageous to Ball professionally by attracting wide notice to his skills as a portraitist in three dimensions. By the early 1850s, his services as a modeler of such inexpensive portrait statuettes were in considerable local demand. A number of prominent Boston citizens, including Charles C. Perkins, future president of the Museum of Fine Arts, commissioned cabinet busts from him, frequently ordering multiple casts for distribution to friends.

One of Ball's most accomplished performances in this compact portraiture mode was the full-figure study (height approximately 30 inches) of Daniel Webster he executed in 1853. The evolution of this modeling project merits review because of the unusual interest Webster held for Ball as an artistic subject. In his autobiography, Ball wrote that the idea of commemorating Webster's "godlike head"[2] on canvas had been his ambition since boyhood.[3] Discouraged, however, by the unpromising pace of

his painting career, he determined to attempt a bust of Webster instead, confident that he could obtain a competent portrait in the medium of clay.

According to Ball, his initial trial at a cabinet bust ended in failure. In the constricted dimensions required, he felt unable to project the strength of character and intelligence animating Webster's features. A second essay proved more satisfactory. Ball this time chose to enlarge the composition to life-size, interpreting Webster in the fashionable classical guise of a Roman senator, with shoulders loosely draped in a toga. The resulting plaster portrait (Boston Athenaeum)[4] was praised as an "excellent" and ennobling likeness by many of the politician's acquaintances, among them, Chester Harding (1792-1866), who had painted Webster several times from life.[5] That Ball managed to achieve both a convincing resemblance of Webster and an evocative record of his personality was an impressive feat, considering the subject had never sat for him and that the image had been constructed chiefly from Ball's memory of the man.[6]

Reportedly, Ball completed his bust of Webster only days before the statesman's death on October 24, 1852. The contemporaneity of the two events naturally heightened the public's curiosity about Ball's portrait memento, and a subscription fund was promptly organized to arrange for its translation in marble.[7] Soon thereafter, a drive was launched to erect a monument to Webster in Boston.[8] Sensing opportunity in the mood of this campaign, Ball conceived the notion of modeling a small statue of the deceased suitable for mass production and sale to Webster's mourning friends and admirers.

In his haste to expedite the project, Ball ruined the first figure he completed when the makeshift armature—an umbrella stick—collapsed under the weight of the wet clay. Equipped with proper modeling irons (and using the head he had salvaged from the broken study), the sculptor repeated the exercise. This renewed effort resulted in the figure of Webster illustrated here, which he perfected in 1853.

With erect stance and right hand thrust into jacket breast in Napoleonic fashion, Webster is portrayed on the verge of addressing his congressional colleagues. The props adjacent to the figure, a partially draped, fluted half-column with books strewn at the base, allude to Webster's reputation as an orator.[9] Utilizing his earlier bust of Webster as the basis for the figure's head, Ball effectively recreated in reduced dimensions a vivid semblance of his

subject's distinctive physiognomy: large cranium, deep-set eyes, prominent brow, hollow cheeks, and sternly set mouth. He abandoned the classical toga of the former statue, however, opting to depict Webster in the formal, modern dress coat, high-collared shirt, and thick cravat that were his trademarks. So meticulous was his transcription of dress details that even the wrinkles of Webster's ill-tailored outfit were reproduced.

The finished composition, displayed at Ball's Tremont Street studio, quickly elicited a proposal from an enterprising local art dealer named C.W. Nichols, who offered to purchase the model, and the rights to reproduce it, for five hundred dollars. Flattered by what seemed the generosity of the terms,[10] the sculptor accepted his bid, and Nichols secured a patent to protect the design against encroachment. Initially, Nichols issued plaster replicas of the figure. (Parian-ware versions of the *Webster* are also known that Nichols, too, probably authorized.) In response to the popularity of the image, Nichols next approached James Taylor Ames, owner of an arms and cannon foundry in Chicopee, Massachusetts, to arrange for the manufacture of a bronze edition.[11] The production of Ball's *Webster* by the Ames Foundry, begun in 1853, represented one of the pioneering efforts at volume-casting art bronzes in this country.[12]

Although its medium is bronze, the sculpture's composition betrays Ball's indebtedness to the stylistic approach to modeling then favored by marble sculptors, in which details were carefully delineated, surface contours sleekly polished, and the pose of the figure remained static rather than animated. It was not until American sculptors and foundries became proficient in the rediscovered casting technique known as *cire perdue* (the lost-wax method) toward the end of the nineteenth century that artists fully exploited the ductile properties and sketchlike vibrancy associated with bronze. Ball himself netted little income from the sales of these replicas, but he maintained that he was "only too delighted" by the *Webster*'s success, and by the first-class gold medal awarded to it by the Massachusetts Charitable Mechanic Association.[13] The commercial viability of the statuette encouraged him to model a pendant study of the United States senator and secretary of state Henry Clay, in 1858, for multiple production in bronze.[14] Although he personally judged this figure less pleasing than its precursor, the two formed a complementary pair. The wiry incarnation of Clay (North Carolina Museum of Art, Raleigh) neatly balanced the more ample-bodied *Webster*.

As an artistic subject, Daniel Webster appealed to Ball throughout the remainder of his career. He painted several portraits of the statesman and was twice commissioned to execute monumental statues of Webster, one for New York, 1876, and another for Concord, New Hampshire, 1886. It is interesting that the patron of the New York monument, Gordon W. Burnham, had owned Ball's small bronze *Webster*, a work he esteemed enough to later order magnified as a fourteen-foot statue for Central Park. The piece did not survive the amplification especially well, however. In the colossal version the intimacy and immediacy of the small 1853 portrait were necessarily sacrificed, and the tailoring imperfections of Webster's outfit (less assertively apparent in the earlier statuette) were exaggerated to the point of gross distortion. The natural environs of the statue's site also made its pose seem overly contrived and rigid.[15] Probably to remedy these problems, Ball reduced the scale of the heroic *Webster* he designed for the State House in Concord, New Hampshire, in 1885, also altering the figure's pose and costume.

J.S.R.

Notes

1. The pirating of sculptors' designs by image vendors prompted the *New York Daily Tribune* to discuss these unscrupulous peddlers in "The Vagabond Sculptors," May 21, 1855. See also Michele H. Bogart, "The Development of a Popular Market for Sculpture in America, 1850-1880," *Journal of American Culture* 4 (1981), pp. 15-17.

2. Ball 1891, p. 136.

3. Other American sculptors were similarly intrigued by Webster's strong, conspicuous features. Among those of Ball's contemporaries who modeled busts or full-length studies of the statesman were Shobal Clevenger, John Frazee, John A. Jackson (1825-1879), John Crookshanks King, Hiram Powers, Martin Milmore, and Ferdinand Pettrich (1798-1872).

4. For discussion of this 1852 bust, see Boston Athenaeum 1984, p. 15; Walter Muir Whitehill, "Portrait Busts in the Library of the Boston Athenaeum," *Antiques* 103 (June 1973), p. 1153.

5. For period commentary on the bust and its success, see Lee 1854, p. 212; William O. Partridge, "Thomas Ball," *New England Magazine* 12 (1895), pp. 300-301; Tuckerman 1867, p. 578. A marble version of the bust, dated 1868, was given to the Metropolitan Museum of Art, New York, by the sculptor's daughter, Mrs. William Couper.

6. Ball modeled the bust guided by photographs and his vivid boyhood recollections of Webster. He recalled the

coincidence of his completion of the bust in the early autumn of 1852 with Webster's final tour through Boston: "While I was at work upon it, the announcement was made that the great man was to arrive [in Boston] on a certain day, and be received and escorted through the city on his way to Marshfield. As the procession was to pass through Tremont Street, you may be sure I was at the door to have a good look at him. We little thought that he was then going home to die." Ball 1891, p. 137.

7. Ball wrote of the public reaction to the bust, "It was pronounced a wonderful success, and numerous demands were made for casts of it. I put a subscription paper in front of it, and in a very few days had nearly a hundred names upon it." Ball 1891, pp. 137-138.

8. The commission for the Webster monument was assigned to Hiram Powers. See Walter Muir Whitehill, *Boston Statues* (Barre, Mass.: Barre Publishers, 1970), p. 27, illus.

9. For a more extensive study of how oratorical gestures and postures were adapted for sculpture in Ball's era, see John Stephen Crawford, "The Classical Orator in 19th-Century American Sculpture," *American Art Journal* 6 (Nov. 1974), pp. 56-72.

10. In *My Threescore Years and Ten*, p. 142, Ball noted the irony of his having sold the model of *Webster* to Nichols for five hundred dollars when the art dealer reaped "five thousand dollars . . . at the very least" in profits.

11. The exact number of the edition of bronzes issued at the Ames Foundry under the Ball design-Nichols patent is unknown, but the number *40* found on the base of one such bronze would seem to indicate that at least that many casts were produced in the original series. A number of the small *Webster* statues inscribed with the Ames Foundry mark are known in museum collections. At least half a dozen have been recorded in private art collections as well. Some of the bronzes retain what appears to be a number code relating to the series.

12. Few native attempts at casting sculpture in bronze resulted in success prior to the Ames Foundry's participation in this manufacturing challenge. The Ames Foundry dominated the field of professional art-bronze casting during the latter half of the nineteenth century. For a detailed history of bronze casting in this country, see Michael Edward Shapiro, *Bronze Casting and American Sculpture, 1850-1900* (Newark: University of Delaware Press, 1985). On the involvement of American sculptors in bronze casting and reproductions, see Michele H. Bogart, "Attitudes toward Sculpture Reproductions in the United States, 1850-1880," Ph.D. diss., University of Chicago, 1979.

13. Ball 1891, p. 142, and Taft 1930, p. 142, refer to the sculptor's receipt of an honorary medal for this statuette.

14. Clay, like his colleague Webster, was famous as an orator; hence, Ball repeated the motif of the draped half-column in this composition, switching its location to the left of the figure. The statuette, which also bears the C.W. Nichols patent inscription, is discussed by Wayne Craven in "The Early Sculptures of Thomas Ball," *North Carolina*

Museum of Art Bulletin 5 (fall 1964 - winter 1965), pp. 3-12.

15. For additional comments on this *Webster* monument (which is near the entrance to Central Park at 72nd street), see "Notes," *Art-Journal* (New York), n.s. 1 (July 1875), p. 223; ibid., n.s. 3 (Jan. 1877), p. 32; Sharp 1974, no. 14.

THOMAS BALL
36
Edward Everett, 1859
Plaster
H. 11 in. (28 cm.), w. 9 in. (22.8 cm.)
Signed (on back): T. BALL Sculp 1859
Helen and Alice Colburn Fund. 1979.164

Provenance: Karolynne McAteer, Brooklyn Heights, N.Y.

Best known for his brilliant rhetorical skills and for his distinguished career as a Greek scholar and public servant, Edward Everett (1794-1865)[1] was also a passionate champion of American artists, writing and speaking persuasively on their behalf.[2] Ball's plaster profile relief of Everett documents the friendship and mutual admiration that existed between the two Boston men.

In 1858, shortly after his return to Boston from Italy, Ball met Everett and invited him to visit his studio, where he was at work on a small statue of Henry Clay. Everett expressed admiration for Ball's portrayal of Clay,[3] whom he knew well, and befriended the sculptor immediately. The following year, Ball modeled this relief of Everett, whose portrait he chose to interpret in a classical manner befitting a great statesman. The resulting image projects a certain look of weariness and care, which is understandable in light of Everett's troubled political career in antebellum New England. An ardent believer in preserving union between the North and the South, Everett had engendered the wrath of many of his radical abolitionist friends by remaining open to compromise on the hotly debated question of slavery. During the presidential campaign of 1860, the ailing man reluctantly agreed to accept the nomination as vice-president of the Constitutional Union party in order to underscore his disapproval of the sectional strife that had arisen over the issue. When the electoral and popular votes were tabulated, Everett and his party ranked last.

Ball's regard for Everett was apparently unaffected by politics. Late in 1864, prior to his departure for Italy, he composed a plaster bust of Everett (Massachusetts Historical Society, Boston), guided by a life mask and careful facial measurements he

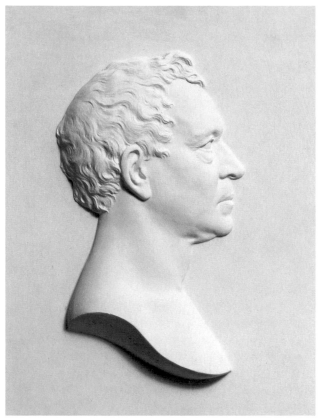

36

reportedly had taken of the subject.[4] The likeness achieved was widely acknowledged to be convincing and ennobling. Ironically, a year later, after Everett's death, Ball failed to obtain a commission offered by a local citizen's group in Boston to erect a full-size memorial statue of Everett. It was awarded instead to William Wetmore Story, who became embroiled in a bitter debate with Ball over the "rights" to study Ball's life mask document of the orator. When Ball refused the request, Story ungraciously accused him of basing his bust merely on photographs and his insubstantial memory of Everett rather than on sittings from life.[5] It must have been somewhat comforting to Ball to hear about the cool reception Story's bronze statue of Everett encountered after its arrival in Boston in the summer of 1867. As a compensation prize, the Everett Statue Committee paid a handsome stipend of $2,500 for a copy of Ball's bust, which they presented to the Boston Public Library.

J.S.R.

Notes

1. See *DAB*, s.v. Everett, Edward; *Boston Daily Advertiser*, Jan. 16, 1865, obit.

2. See Edward Everett, "American Sculptors in Italy," *Boston Miscellany of Literature* 1 (Jan. 1842), pp. 4-9.

3. Edward Everett to Thomas Ball, Sept. 13, 1858, quoted in Ball 1891, p. 210. Everett wrote, "the likeness is excellent and the carriage of the figure true to life."

4. A marble copy of the bust, 1865, is in University Hall, Harvard University.

5. Story to Ball, Nov. 20, 1865, William Warland Clapp Papers, Ho, HU.

THOMAS BALL

37
Elizabeth Prescott Lawrence, 1864
Marble
H. 25⅜ in. (64.5 cm.), w. 21 in. (53.3 cm.), d. 11½ in. (29.3 cm.)
Signed (on back): T. BALL. 1864
Gift of James Lawrence, John Endicott Lawrence, and Dorothy Lawrence Stevens. 1980.494

Provenance: James Lawrence, Boston; James Lawrence family, Groton, Mass.

This bust is believed to represent Elizabeth Prescott Lawrence (1828-1864), wife of James Lawrence of Boston and daughter of the Boston historian William Hickling Prescott. Dated 1864, the bust was probably ordered by James Lawrence as a memorial to his wife, who died on May 24 of that year. The features are soft and generalized, suggesting that Ball may have relied on a daguerreotype of the deceased woman as his guide. Although the bust has suffered unfortunate weather damage over the years, it still reveals the likeness of a poised, handsome middle-aged woman neatly modeled in the classical manner.

At the time of Mrs. Lawrence's death, James Lawrence was engaged in transactions with Hiram Powers in Florence to produce a duplicate bust of the portrait of his well-known father, Abbott Lawrence (q.v), that Powers had carved more than twenty-five years earlier. Correspondence between the sculptor and his client regarding the order indicates that Ball, Powers's Florentine neighbor, was then filling a request from Lawrence for several marble pedestals, presumably for Powers's bust and possibly for the bust Ball had modeled of Elizabeth Lawrence. In 1863 Ball executed a marble bust of James Lawrence's cousin-in-law, Sarah Elizabeth Appleton Lawrence (Boston Athenaeum), a commission that confirms the professional affiliation the sculptor already had established with the Lawrence clan.

J.S.R.

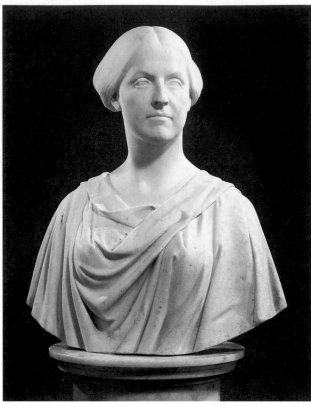

37

THOMAS BALL

38

Edward Wigglesworth, 1877

Marble

H. 24¼ in. (61.6 cm.), w. 21 in. (53.4 cm.), d. 11¾ in. (29.9 cm.)

Signed (on back of base): T. BALL / 1877

Gift of a Friend of the Department. 1979.161

Provenance: Wigglesworth family, Boston; New England Gallery, Andover, Mass.

Prominent among the scientists and physicians who made Boston famous as a center for medical research and treatment in the second half of the nineteenth century was Dr. Edward Wigglesworth (1840-1896), a graduate of Harvard College in 1861 and of Harvard Medical School in 1865. Although a sizable family inheritance would have permitted him to lead a life of gentlemanly leisure, Wigglesworth devoted himself energetically to improving the welfare of others. In 1865 he embarked on a five-year tour of Europe to study dermatology, a subject little investigated or understood in America. When he returned to Boston, he established a public clinic and dispensary for skin diseases at his own

expense. He also served as an instructor in dermatology at Harvard Medical School, supervised the newly established department of skin diseases at Boston City Hospital, published a quarterly medical journal on the subject, and took a lively interest in founding the Boston Medical Library. His sudden death by stroke at age fifty-five deprived Boston of one of its most dedicated, selfless medical practitioners.[1]

When Thomas Ball modeled this bust of Wigglesworth in 1877, Wigglesworth had already distinguished himself as one of this country's foremost authorities in the field of dermatology. Yet it is not the lofty, erudite physician that Ball has attempted to capture but the generous, genial man loved by his family and friends.

Ball's portrait style has been criticized for lacking psychological drama or intellectual content and for its immoderate concern with articulating superficial details of the sitter's physiognomy. (In *My Three Score Years and Ten*, the sculptor stressed the importance of paying scrupulous attention to the "parts that the 'gods only see,'—such as . . . the inside of the nostrils, inside and behind the ears, under the chin, . . . etc.")[2] Yet even Ball's detractors admit that these failings were occasionally overcome (as appears to be the case in Wigglesworth's bust), resulting in "some very fine straightforward, unpretentious portraiture."[3]

Wigglesworth's bust demonstrates Ball's transition from the formal neoclassical to a looser, more naturalistic style that prevailed in portraiture during the third quarter of the century. The modern dress of the sitter is handled unobtrusively; the distinctive yet sensitively recorded features do not distract from the general mood of thoughtfulness and the quiet wit mirrored in the face. Wigglesworth was one of a circle of intelligent and influential men whose portraits Ball was commissioned to carve when he returned to Boston on intermittent visits.

J.S.R.

Notes

1. See *Boston Evening Transcript*, Jan. 23, 1896, obit.; *Boston Medical and Surgical Journal* 134 (Jan. 1896), pp. 125-126; *DAB*, s.v. Wigglesworth, Edward; Henry P. Quincy, "Memoir of Edward Wigglesworth," in *The Colonial Society of Massachusetts* (Cambridge: Harvard University Press, 1897), pp. 3-5.

2. Ball 1891, p. 182.

3. Craven 1968, p. 219.

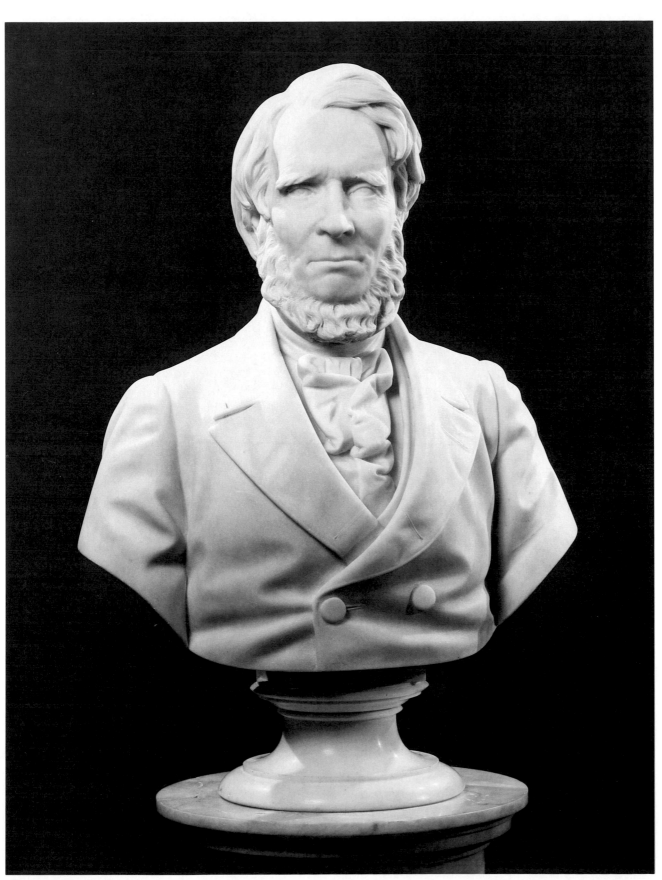

Richard Saltonstall Greenough
(1819 – 1904)

David Greenough's profitable Boston real-estate business had suffered distressing reverses by the time the youngest of his eleven children, Richard (born in 1819), was ready for college. Although four older brothers, including Horatio, had attended Harvard University, Richard resigned himself to working in the counting room operated by two other siblings when he finished Boston Latin School. Family members were sympathetic to his artistic aspirations, however, and in 1837, his brothers released him from the drudgery of his clerkship and arranged for his passage to Italy. For seven months Richard Greenough absorbed the artistic sites and atmosphere of Florence under the watchful supervision of Horatio, who steered him through the studios of promising local artists and introduced him to numerous well-known sculptors. Ironically, like Horatio before him, Richard was forced by illness to terminate his educational sojourn abroad prematurely and return home.

Once recuperated, Richard Greenough opened a studio in Boston in 1839 but failed to generate much business. Reluctantly, he returned to the family's counting room, working there intermittently over the next five years. In 1844 the frustrated sculptor's fortunes took a turn for the better when the historian William Hickling Prescott commissioned a portrait bust as a favor to the Greenough family. When the plaster study was presented by Prescott to the Boston Athenaeum in 1844, its favorable reception quickly led to other commissions for portrait busts, ideal heads, and occasional small statues.

Encouraged by this local success, Greenough returned to Europe to pursue further training in his craft. In 1848 he settled in Rome and began tapping the market for portrait busts sustained by the perpetual inflow of American tourists to the city. He also developed several studies for freestanding compositions, of which his *Shepherd Boy with Eagle*, 1853 (present location unknown), is the best known. Modeled in plaster, the group featured a young boy attempting to rob an eagle's nest. The droll, anecdotal charm of this composition, as well as its allusions to Bertel Thorwaldsen's acclaimed *Ganymede and the Eagle* (Thorwaldsen Museum, Copenhagen), delighted viewers who saw it displayed at the Boston Athenaeum in the mid-1850s, prompting a group of local admirers to organize a subscription

fund so that the work could be cast in bronze. Under Greenough's direction, the *Shepherd Boy* was cast successfully at the Ames Foundry in Chicopee, Massachusetts, granting it distinction as one of the earliest "parlor-size" artworks to be cast in bronze in America. Fittingly, the statue was purchased for the library of the Boston Athenaeum.

In 1853 Greenough received the prestigious commission to design a bronze memorial to Benjamin Franklin for the city of Boston, where the great American diplomat and scientist had been born and had lived as a child. To ensure the accuracy of the figure (and undoubtedly to avoid unleashing the sort of public indignation that had been aroused by Horatio Greenough's pseudo-antique image of George Washington clad in a skimpy Roman toga), the supervising committee provided the sculptor with the clothing reputedly worn by Franklin on the historic day he signed the Treaty of Alliance with France in 1778. With great pomp and ceremony, the completed *Franklin* was erected in front of Boston's City Hall in 1856, installed on a special pedestal devised for it by Greenough's architect brother Henry. Critics and public alike were impressed by Greenough's facile handling of the monument; his characterization of Franklin was praised as dignified, the likeness judged authentic, and the techni-

cal workmanship considered superior in all respects.

With the important *Franklin* commission to verify his professional qualifications, Greenough's career advanced quickly. While engaged in modeling the *Franklin* monument, he was approached by the proprietors of Mount Auburn Cemetery in Cambridge and persuaded to undertake a portrait statue of John Winthrop, first governor of Massachusetts Bay Colony, for placement in the cemetery's chapel. Though a skillful summation of the sculptor's proficiency with the chisel, the resulting figure (completed by 1856) lacked the probing psychological interest or defined sense of individuality basic to compelling portraiture. In the attempt to reproduce the tailoring peculiarities of Winthrop's seventeenth-century costume, Greenough unwittingly distracted the viewer from contemplating the character of the man depicted and shifted the statue's focus to the supplementary ornamental staging. In spite of the apparent weaknesses in this academic costume piece, the *Winthrop* commission signaled Boston's confidence in the sculptor's ability to produce an artistic monument compatible with the other handsome memorials installed at Mount Auburn and confirmed that Greenough was as equipped to excel at his craft as his more celebrated older brother.

It is significant that Greenough executed the *Winthrop* statue in Paris, where he had moved in 1855. One of the first of his countrymen to choose Paris over Rome as a European post for work and study, he anticipated by several years the wholesale convergence on the French capital by American painters, sculptors, and architects. Although by the third quarter of the nineteenth century Parisian art schools and ateliers were actively promoting the invigorated naturalism of the new Beaux-Arts style, Greenough's oeuvre exhibited few traces of this French influence, remaining tenaciously neoclassical in its aesthetics and subject matter. Through the latter half of his career he continued to execute mythological figures borrowed from Greek and Roman sculptural prototypes, characterized by smoothly contoured surfaces and an assemblage of archaeologically correct props. Among the better known conceits in this vein are his *Carthaginian Girl*, 1863 (Boston Athenaeum), recalling the motion of the *Venus de Milo*'s torso in the manner she postures to cut her long hair; *Cupid Riding the Tortoise*, before 1880 (private collection), a variation on the numerous whimsical Cupid-riding-animal themes found

in antique art, and the monumental *Circe*, 1882 (The Metropolitan Museum of Art, New York), shown enticing Ulysses to sip the enchanted wine from her cup. Occasionally, however, Greenough's work in the neoclassical mode showed a surprising drift, such as his swooning, Bernini-esque *Mary Magdalen at the Tomb*, 1866 (Cooper-Hewitt Museum, New York), a biblical subject infrequently interpreted by American sculptors of this period, and all the more unusual because of the sculptor's animated, sensual modeling of the figure.

Although Greenough shared the intellectual pretensions and academic literalism of his colleague William Wetmore Story, his work failed to convey the same dramatic intensity and monumental grandeur; nor did his art attain Story's level of conceptual originality and technical facility. Never securing the enduring reputation of his brother Horatio, Richard Greenough was nonetheless an adroit interpreter of the neoclassical aesthetic.

The waning years of Greenough's career were divided between residences he maintained at Newport, Rhode Island, and Rome. He died in Rome in 1904 but was buried at Mount Auburn Cemetery.

J.S.R.

References

Truman H. Bartlett, "Civic Monuments in New England," *American Architect and Building News* 9 (June 1881), p. 201; idem, "Sitting Statues, III," ibid. 14 (June 1886), p. 200; Boston Athenaeum 1984, pp. 36-38; Thomas B. Brumbaugh, "The Art of Richard Greenough," *Old-Time New England* 53 (Jan.-Mar. 1963), pp. 61-73; idem, "Horatio and Richard Greenough," Ph.D. diss., Ohio State University, 1955; Craven 1968, pp. 269-274; Clement and Hutton 1894; Gerdts 1973, pp. 72-73, 105, 114-115; "Portrait Sculpture," *Crayon* 2 (Sept. 1855), p. 165; Post 1921, p. 234; Nathaniel Shurtleff, *Memorial of the Inauguration of the Statue of Franklin* (Boston: Prepared and printed by authority of the City Council, 1857); W.J. Stillman, "R.S. Greenough's Franklin," *Crayon* 1 (Mar. 1855), p. 186; Tuckerman 1867, p. 593.

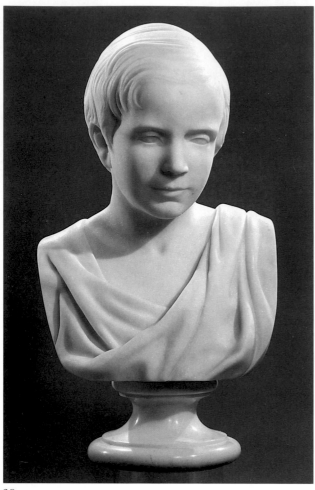

39

RICHARD SALTONSTALL GREENOUGH
39
Augustus Edward May, 1846
Marble
H. 19⅞ in. (50.6 cm.), w. 10⅝ in. (27.1 cm.), d. 8⅜ in. (21.3 cm.)
Signed (on back): R.S. GREENOUGH. S. / 1846.
Gift of John Pierpont May. 20.865

Provenance: John Pierpont May, Boston

This portrait of a young boy is one of Richard Greenough's earliest known works in marble.[1] The mood of pensive calm mirrored in the subject's face recalls many of the serene portrait studies executed by the sculptor's older brother Horatio.[2]

The toga draping the boy's shoulders is typical of neoclassical portraiture, although its popularity as a costume treatment was beginning to wane by the mid-1840s. The simplified arrangement of the drapery folds probably indicates the young sculptor's inexperience at carving in marble and his hesi-

tancy to attempt more adventurous experimentations with costume. The child's face and expression are nevertheless modeled with sensitivity and project a special blend of innocence and sweetness, suggesting that even in his earliest essays, the reputation Greenough's contemporaries conferred on him for successful portrait busts was deserved.[3] With the increased confidence in his craft that time and accumulating commissions helped to instill, Greenough soon incorporated more elaborate, fashionable staging in his portrait busts. A measure of the distance he traveled in the treatment of costume is reflected in the minutely observed, intricately pierced and undercut ruffled lace ornamenting the dress neckline of *Cornelia Van Rensselaer* (The New-York Historical Society), a portrait executed by the sculptor only three years after the *Augustus Edward May* commission.

The sitter is assumed to be the donor's eldest brother, Augustus Edward May, who was born in Boston in 1838 and died at age eight in February 1846.[4] In all probability, the bust is a posthumous portrait, commissioned by the family shortly after the boy's death. This convention of memorialization was also observed by the Dana family when their son Francis died and a bust (q.v.) was promptly ordered from the sculptor Edward Brackett.

J.S.R.

Notes

1. See Thomas B. Brumbaugh, "Horatio and Richard Greenough," Ph.D. diss., Ohio State University, 1955, pp. 149-150.

2. Thomas B. Brumbaugh, "The Art of Richard Greenough," *Old-Time New England* 53 (Jan.-Mar. 1963), pp. 62-63.

3. Tuckerman 1867, p. 593.

4. John Franklin May, *Descendants of John May of Roxbury, Mass., 1640* (Baltimore: Gateway, 1978), p. 53.

ATTRIBUTED TO RICHARD GREENOUGH
40
George Washington, about 1858
Terracotta
H. 16½ in. (41.9 cm.), w. 12 in. (30.5 cm.), d. 9 in. (22.9 cm.)
Gift of David Richardson. 1979.33

Provenance: Probably Henry Greenough, Cambridge, Mass.; Mrs. Arthur W. (Frances Laura Greenough) Blake, Brookline, Mass.; Mrs. Frederick L.W. Richardson, Needham, Mass.; David Richardson, Washington, D.C.

The number of portraits of George Washington surviving from the nineteenth century attests to the inroads made by the cult of *pater patriae* on the imaginations of America's first and second generation professional sculptors. In his roles as soldier, statesman, and latter-day Cincinnatus, Washington held singular symbolic appeal for the new republic. Rembrandt Peale (1778-1860), who had turned a neat profit from replicating his well-liked "porthole" portrait of the first president, summarized the prevailing attitude of his artistic colleagues toward this revered subject with the pronouncement, "Nothing can more powerfully carry back the mind to the glorious period which gave birth to this nation—nothing can be found more capable of exciting the noblest feelings of emulation and patriotism [than a] portrait of George Washington."[1] Aware of the professional advantages that a convincing likeness of Washington might supply, sculptors of Peale's era regularly sought to promote their reputations by modeling their own interpretations. The Museum's terracotta bust typifies the popular genre of Washington effigies that had infiltrated the American and European art markets by the middle decades of the nineteenth century, when sculptors started to favor a more naturalistic, animated presentation of this familiar subject.

The authorship of the bust, which is unsigned, poses a question of considerable speculative interest in light of its provenance. The bust was owned consecutively by members of the Henry Greenough family, the original owner being the brother of the Boston sculptors Horatio and Richard Greenough. A painter and architect, Henry (1807-1883) was not himself schooled in the technicalities of carving but possessed considerable personal knowledge of the craft, which he drew upon for his novel about expatriate art life in Italy, *Ernest Carroll* (1858). As a young man he made several trips abroad, residing periodically with his brother Horatio in Florence. During the long intervals of their separation, the two brothers maintained a steady correspondence, a literary exchange that was preserved and edited by Henry's wife, Frances Boott Greenough, in 1887.

Family tradition has presumed that the *Washington* terracotta represents the workmanship of the elder Greenough sculptor, Horatio. Although no reference exists explaining how or from whom Henry acquired the bust,[2] it is feasible that Horatio presented the piece to him, perhaps along with other *bozzetti* and working models that went unmentioned in family correspondence and descriptions

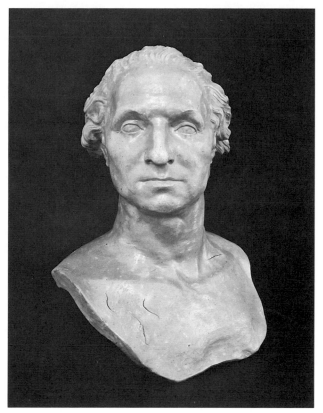

40

of Greenough's studio inventory. Much of Horatio's career had been devoted to the production of sculptural images of George Washington, for which numerous preparatory sketches were required. Moreover, the apparent source of this terracotta—Jean Antoine Houdon's well-known terracotta bust—was the reference Greenough consulted for his monumental and much-maligned seated *Washington* at the United States Capitol. Possibly the sculptor executed the terracotta portrait at a preliminary conceptual stage in the lengthy process (1832-1840) of resolving that colossal composition.

Close comparison of the terracotta bust and the half-dozen or so images of Washington documented as the work of the elder Greenough, however, casts doubt on his execution of the former.[3] On stylistic grounds the bust can be more soundly attributed to the younger of the two Greenough sculptors, Richard, whose receptivity to the mid-century trend toward naturalism exceeded that of his more classically steeped brother. The looser, even robust approach to modeling that informs the terracotta *Washington* appears inconsistent with the smooth, technical control Horatio Greenough customarily asserted over his sculptural essays.

In Paris Richard Greenough designed an equestrian statue of George Washington, *Washington Sheathing His Sword*, 1858 (West Point Museum, New York; plaster model, Louvre), which corresponds strongly to the terracotta bust in its more invigorated modeling and overall mood and in the placement and expression of its head. Apparently George Washington intrigued the sculptor as a subject from that date forward. In 1872 he published an article entitled "The Countenance of Washington," an interesting exposition of the "noble" traits of character ingrained in Washington's physiognomy.[1] Although no reliable evidence has surfaced to verify the supposition, the terracotta may have been created as a study for Richard Greenough's 1858 bronze equestrian monument or perhaps as a demonstration exercise applying information assembled from his research on Washington's distinctive features.

During Richard Greenough's Parisian residence, he would have had ample opportunity to examine facsimile copies of Houdon's *Washington*, which were then in circulation abroad. From French sculptors—and perhaps from the example of Houdon's original terracotta *Washington* bust, later painted white—Greenough may have acquired the habit of utilizing terracotta for his compositions. Except for its notable use by the Philadelphia sculptor William Rush (1756-1833),[5] whose interest in the medium was fanned by the profit incentive of selling replica casts of famous sitters, terracotta seems to have been employed only conservatively by American neoclassical sculptors. As the author of this portrait probably recognized, however, terracotta was a medium ideally suited to exploring advanced design ideas before committing a work to the more expensive and immutable material of marble. Moreover, the sense of movement preserved in the clay image as well as the ruddy glow it assumed when fired were attributes of terracotta that made it an equally pleasing material for finished studio products.

J.S.R.

Notes

1. Rembrandt Peale, *Porthole Portrait of George Washington* (Philadelphia, 1857), p. 5, quoted in Linda Ayres, "The American Figure: Genre Painting and Sculpture," in National Gallery of Art, Washington, D.C., *An American Perspective: Nineteenth-Century Art from the Collection of Jo Ann and Julian Ganz, Jr.* (1981), p. 42.

2. None of the principal monographs or biographical essays published on Horatio or Richard Greenough refer to a terracotta bust of George Washington, nor is it recorded in any catalogues of the sculptors' work.

3. Wright 1963, p. 118.

4. Richard Greenough, "The Countenance of Washington," *Old and New* 5 (Feb. 1872), pp. 221-222.

5. For further commentary on Rush's terracotta portraiture and other considerations of the medium, see the essays by Frank H. Goodyear, Jr., " 'Tolerable Likenesses': The Portrait Busts of William Rush," and Virginia Norton Naudé, "Toolmarks and Fingerprints: A Technical Discussion," in *William Rush, American Sculptor* (Philadelphia: The Pennsylvania Academy of the Fine Arts, 1982), pp. 47-56, 77-91.

William Wetmore Story (1819 – 1895)

To concentrate on William Wetmore Story's career and reputation as a sculptor is to abbreviate his impressive range of contributions to the fields of law, literature, and scholarship in the fine arts. For in addition to distinguishing himself as one of America's preeminent neoclassical sculptors, Story gained recognition as a prolific poet and prose writer, an able amateur playwright, a gifted draughtsman, an astute lawyer who authored several influential legal tomes, and an expert critic on art, theater, history, music, and philology. He was, moreover, a celebrated host and raconteur whose intimate friends included such well-known litterateurs as Robert and Elizabeth Barrett Browning, William Thackeray, Walter Savage Landor, and James Russell Lowell. Story's apartments in Rome's venerable Palazzo Barberini served as social headquarters to an illustrious circle of Anglo-European intellectuals who congregated in this historic European art center. Not surprisingly, Story's importance as a serious sculptor has often been obscured by the glamour of his public persona.

If genealogy is accepted as a reliable gauge of an individual's future prospects, then Story's extraordinary accomplishments in so many different cultural and artistic spheres were, to a degree, predictable. He was the grandson, on the paternal side, of a respected Marblehead physician and revolutionary war hero and, on the maternal side, of a high-ranking English officer who commanded at the Siege of Louisburg. His parents were Joseph Story, justice of the Supreme Court, congressman, and brilliant professor of law at Harvard University, and Sarah Waldo (Wetmore) Story, daughter of a prominent Boston judge. Born in Salem, Massachusetts, and raised in Cambridge, Story enjoyed a happy childhood in an affluent, liberal household. By his teens, he had proved himself a lively wit and quick student possessed of precocious literary tastes. His former classmates remembered Story as "the Steerforth among Cambridge boys,"[1] an admiring allusion to the schoolboy of versatile talents in Charles Dickens's *David Copperfield*. Upon graduation from Harvard College in 1838, Story prepared to follow his father's footsteps in the legal profession. He enrolled in Harvard Law School, receiving his LL.B. degree in 1840. He thereafter found employment in the highly regarded law office of Charles Sumner and George Hillard and set to work writing several learned treatises on contracts

and personal property sales as well as serving as a reporter for the United States circuit courts.

Although Story's professional life may have revolved around issues of jurisprudence, his creative energies were devoted to two favorite pastimes: art and literature. As a Harvard undergraduate, he had made frequent pilgrimages to the Cambridgeport studio of the aging painter Washington Allston, where local artists gathered to discuss painting, sculpture, and the art scene abroad. Together with his boyhood friend, James Russell Lowell, Story had also discovered the pleasure of writing poetry and became known for the poems and discerning literary criticism he regularly contributed to local periodicals. He also pursued sketching and clay modeling as hobbies.

The initiative for Story's transformation from lawyer to sculptor was unwittingly provided in 1845 by a group of Cambridge citizens who were eager to erect a memorial to the recently deceased Justice Joseph Story in Mount Auburn Cemetery. The group empowered to oversee the fund-raising approached Story for consultation and concluded by awarding him the commission. The committee's decision probably reflected a certain naive confidence in Story's artistic abilities since the late jurist's son was, at best, a gifted amateur, with no major statue to his credit to prove his technical understanding of monumental sculpture.

To prepare for this endeavor, Story arranged first to travel abroad in order to familiarize himself with the modern genre of portrait memorials and advance his modeling skills. Selecting Rome as the site for his self-directed art apprenticeship, he settled himself and his family into comfortable lodgings near the Piazza di Spagna and began his studies with great diligence. By 1853 the model for his father's monument had won the universal approval of the Mount Auburn Committee. The finished marble reached Boston eighteen months later, where it was received as a remarkably sophisticated achievement for a novice. Although Story returned to Boston in 1855 with the intention of resuming his legal career, his experiences in Rome had permanently altered his loyalties. Oppressed by what he perceived as the provincialism of Boston and increasingly disenchanted with the law, he resolved to live permanently in Italy and in 1856 departed Boston, having declared sculpture as his full-time profession.

Despite Story's delight with Italy, his aspirations as an artist were repeatedly humbled during the early years of his residence abroad. Commissions were few and far between, and he was depressed by the failure of his ideal sculpture to attract serious attention from critics in America. His professional affairs improved immeasurably, however, when Pope Pius IX grew interested in the talented foreigner's work and offered him assistance by assuming the costs of transporting two of Story's recent, monumental marble inventions to the 1862 International Exhibition in London. The uniform praise that English critics lavished on these two idealized works, the notorious Egyptian queen *Cleopatra*, 1858 (Los Angeles County Museum of Art), and the mysteriously musing *Libyan Sibyl*, 1860 (The Metropolitan Museum of Art, New York), catapulted Story into the front ranks of the international art world. Concurrently, Hawthorne's novel about modern art life in Italy, *The Marble Faun* (1860), also focused public attention on Story. Hawthorne (unbeknown to Story) had appropriated *Cleopatra* as the masterpiece of his fictional sculptor, Kenyon. The writer's graphic description of the fiery, tiger-like *Cleopatra*, which he had seen only as a clay model in Story's studio, aroused great curiosity among the book's readers about the identity of the real creator of this dramatic sculpture. In later years Story recalled the ironies of having had the inaugural "milestones" of his career as an American sculptor promoted by a Roman Catholic pope who

maneuvered their display in England, where they were first unveiled at exhibition under the category of modern Roman art. He also acknowledged that his name was familiar to the majority of his countrymen not through published art criticism but through a romance written by an old acquaintance from Salem.

Although Story's original involvement in sculpture was sparked by a portrait commission, the memorial to his father, he gravitated increasingly toward the greater challenges of ideal subjects. This did not mean that he refused portrait orders altogether. Over the course of his career, he produced a small but sensitive group of studies of special friends and social acquaintances, including an affecting likeness of the fragile poet Elizabeth Barrett Browning, 1866 (Boston Athenaeum), and a bust of the abolitionist minister Theodore Parker in the guise of a modern-day Socrates, 1860 (Boston Public Library). He also designed over ten impressive public portrait monuments, best exemplified by *Josiah Quincy*, about 1861 (Harvard University), *Colonel William Prescott*, 1881 (Bunker Hill Park, Charlestown, Massachusetts), and *Chief Justice John Marshall*, 1884 (United States Supreme Court, Washington D.C.). Nevertheless, he preferred to define himself as a sculptor of "the Ideal," drawing on a timeless cast of characters from the Bible, history, mythology, and world literature, whose complex interior lives he sought to expose through plastic means. As he confessed to his friend and former law colleague Charles Sumner, "I have no ambition in the direction of portrait statues. It is in the ideal range of art that I prefer to work—where I can give expression to all that is best and deepest in me."[2]

Story preferred to depict personalities whose passions were on the brink of eruption: the notorious, the wronged, and the martyred—villains as well as saints. He was particularly attracted to melancholy, brooding females as sculptural subjects. Seeking inspiration from Greek tragedies, ancient history, and from writers such as Spenser, Milton, and Shakespeare, he selected characters that would appeal to the popular appetite for melodrama, equipping his figures with narrative props and attributes easily construed by viewers of all levels of literacy. Spectators need not have read Euripides to appreciate the seething revenge disfiguring the brow of Story's *Medea* (q.v.) or to understand the meaning of the dagger that she fondled in one tensed marble hand. In style his works varied from the sweet sentimen-

tality of *Little Red Riding Hood* (present location unknown), sketched and modeled in the early 1850s, to the antique grace of the *Arcadian Shepherd Boy*, 1855 (Boston Public Library), to the Michelangelo-like majesty of *King Saul When the Evil Spirit Was upon Him*, 1863 (remodeled in 1882, The Fine Arts Museums of San Francisco).

Few nineteenth-century American sculptors received the public recognition and international renown that Story enjoyed in his lifetime. His clientele included the rich and aristocratic of two continents. Among the titles awarded him in his own country and abroad were Fellow of the American Academy of Arts and Sciences; Honorary Fellow for Life at the Metropolitan Museum of Art, New York; Member of the French Legion of Honor; and Honorary Doctor in Civil Law, Oxford University. His studio, for many years situated on Rome's Via San Nicolo di Tolentino and relocated in the mid-1870s to the Via San Martino, remained commercially active through the remainder of the century while retaining the attraction as a scheduled stop for tourists. Although a younger generation of sculptors began to abandon Rome and academic classicism to pursue the new, vibrant Beaux-Arts style taught in Parisian ateliers, Story steadfastly adhered to the theoretical and aesthetic principles of neoclassicism into old age. Only after his beloved wife's death in 1893 did the sculptor's enthusiasm for work languish. After mustering his strength one final time to produce a monument for her grave, the elegiac *Angel of Grief Weeping Bitterly over the Dismantled Altar of His Life* (Protestant Cemetery, Rome), he relinquished his studio affairs to his son, Thomas Waldo Story (1854-1915), a promising sculptor in his own right. Story retired to Florence to live with his daughter Edith Peruzzi, who had married the legal heir to the great Medici dynasty, at her country villa in Vallombrosa, where he died in 1895.

Posthumous tributes unanimously proclaimed Story as one of America's paramount artists. Nevertheless, critics were generally divided in their reasons for assigning him this status. Some were impressed with his sculpture, others were enthusiastic about his poetry and numerous other writings, and still others revered the matchless style with which Story had performed his role as artist, remembering him as the impresario of Rome's international literati. Even Story's biographer, Henry James, was hard pressed to define the true nature of his sculptural style or enduring contributions to the art. James conjectured that Story's eclectic talents and

varied intellectual gifts may have handicapped his efforts to refine his voice as a sculptor or poet. "He had not enough indifferences," reflected James in his two-volume book on the sculptor; "one might wish him the comparative rest of an exclusive passion."[3]

In the published judgments of the twentieth century, Story has not been treated with as much charity as he was in James's biography. His sculpture has been accused of emotional sterility, technical monotony, and an overreliance on anecdotal props. Although his work gives evidence of these faults in certain instances, it had a powerful influence on contemporary viewers and deserves recognition for the original impulse it brought to neoclassical sculpture: a compelling interest in the motives of human personality. As James perceptively observed, Story was "frankly and forcibly romantic . . . so that he penetrated the imagination of his public as nobody else just then could have done. He told his tale with admirable emphasis and straightness, and with a strong sense both of character and of drama, so that he created a kind of interest for the statue which had been, up to that time, reserved for the picture. He gave the marble something of the color of the canvas."[4]

J.S.R.

Notes

1. Thomas W. Higginson to Mary E. Phillips, May 8, 1896, quoted in Phillips, *Reminiscences of William Wetmore Story, the American Sculptor and Author* (Chicago: Rand, McNally, 1897), p. 37.

2. Story to Sumner, June 22, 1860, Charles Sumner Papers, Ho, HU.

3. Henry James, *William Wetmore Story and His Friends* (Boston: Houghton Mifflin, 1903), vol. 2, pp. 215-216.

4. Ibid., pp. 77-78.

References

AAA, SI; "American Artists and American Art, pt. 5: William Wetmore Story," *Magazine of Art* 2 (1879), pp. 272-276; "American Studio Talk," *International Studio* 8 (Aug. 1899), Supplement, p. viii; ibid. (Sept. 1899), Supplement, p. [ix]; "Art Notes and Minor Topics," *Art-Journal* (London) 36 (n.s. 13) (1874), p. 223; Benjamin 1880, pp. 152-154; Samuel G.W. Benjamin, "Sculpture in America," *Harper's New Monthly Magazine* 58 (Apr. 1879), p. 688; W. Stanley Braithwaite, "William Wetmore Story, Sculptor—Poet of Salem," *Boston Evening Transcript*, Feb. 12, 1919; Anna Brewster, "American Artists in Rome," *Lippincott's Magazine of Popular Literature and Science* 3 (Feb. 1869), p. 196; Clark 1878, pp. 81-95; Craven 1968, pp. 274-281; Peter deBrant Collection, London; Eugene L. Didier, "American Authors and Artists in Rome," *Lip-*

pincott's *Magazine of Popular Literature and Science*, n.s. 8 (1884), p. 491; Frank DiFederico and Julia Markus, "The Influence of Robert Browning on the Art of William Wetmore Story," *Browning Institute Studies* 1 (1973), pp. 63-85; "Editor's Easy Chair," *Harper's New Monthly Magazine* 27 (June 1863), p. 133; ibid. (Sept. 1863), pp. 566-567; ibid. 49 (Sept. 1874), pp. 587-588; Edward W. Emerson, "William W. Story," in *Later Years of the Saturday Club*, ed. M.A. deWolfe Howe (Boston: Houghton Mifflin, 1927); Gardner 1945, pp. 33-37; Albert T.E. Gardner, "William Story and 'Cleopatra,'" *Metropolitan Museum Bulletin*, n.s. 2 (Dec. 1943), pp. 147-152; Gerdts 1973, pp. 76, 82-83, 94, 110, 112, 114; William H. Gerdts, "William Wetmore Story," *American Art Journal* 4 (Nov. 1972), pp. 16-33; Ho,HU; Gertrude Reese Hudson, ed., *Browning to His American Friends* (New York: Barnes and Noble, 1965); *L'Illustrazione italiana* 41 (Oct. 1895), p. 230, obit.; Henry James, *William Wetmore Story and His Friends*, 2 vols. (Boston: Houghton Mifflin, 1903); Jarves 1864, pp. 281-285; James Jackson Jarves, *Art Thoughts: The Experiences of an American Amateur in Europe* (New York: Hurd & Houghton, 1869), p. 295; MHS; MMA; NYPL; *New York Times*, Oct. 8, 1895, obit.; Mary E. Phillips, *Reminiscences of William Wetmore Story, the American Sculptor and Author* (Chicago: Rand, McNally 1897); Pierpont Morgan Library, New York; "Portrait Sculpture," *Crayon* 2 (Sept. 1855), p. 165; Herbert M. Schneller, "An American in Rome: The Experiments of W.W. Story," in *Frontiers of American Culture* (West Lafayette, Ind.: Purdue University, 1968), pp. 41-68; Jan M. Seidler, "A Critical Reappraisal of the Career of William Wetmore Story (1819-1895), American Sculptor and Man of Letters," Ph.D. diss., Boston University, 1985; William Wetmore Story, *Conversations in a Studio*, 2 vols. (Boston: Houghton Mifflin, 1890); idem, *Excursions in Arts and Letters* (Boston: Houghton Mifflin, 1891); Taft 1930, pp. 150-159; Thorp 1965, pp. 41-50; UTA; Mrs. Lew Wallace, "William Wetmore Story: A Memory," *Cosmopolitan Magazine* 21 (Sept. 1896), pp. 464-472.

WILLIAM WETMORE STORY
41
Bacchus, 1863
Marble
Signed (on back): W.W. STORY / ROMA. 1863
H. 40¼ in. (102.2 cm.), w. 14 in. (35.6 cm.), d. 13 in. (33 cm.)
Gift of Mrs. Russell Sturgis. 88.328

Provenance: Russell and Julia Sturgis, Walton-on-Thames, Surrey, England
Exhibited: BMFA, "Confident America," Oct. 2-Dec. 2, 1973.
Versions: *Marble:* (1) Present location unknown, formerly William Stirling Crawford, Scotland; (2) present location unknown, formerly Thomas Critchley, London

Bacchus, fabricated by Story after completing his first marble version of *Venus Anadyomene* in 1860, was conceived as a companion piece for the diminutive neo-Hellenistic goddess. Both Thomas Critchley and William Stirling Crawford, owners of copies of *Venus Anadyomene*, also ordered copies of *Bacchus*, according to the roster of statues and clients compiled by the sculptor.[1]

As was his usual practice, Story equipped the figure with specific accessories that readily identify the subject. *Bacchus* holds in his left hand the ewer denoting his status as god of wine. His right hand grasps the thyrsus (a pinecone-topped staff), symbol of Bacchic power and hospitality. The ivy encircling the tree stump was a decorative convention associated with the god's cults.

The general attitude and narrative imagery of Story's youthful *Bacchus* have prototypes in archaic art as well as in an assortment of Graeco-Roman relics of fauns and bacchantes known to frequenters of Rome's municipal and papal museums. The sober, reflective aspect of this mid-nineteenth-century marble god distinguishes it, however, from the succession of memorable sculpted images that represent Bacchus as a mirthful, wine-flushed libertine. In pose, proportions, and air of composure, it more closely resembles the antique figure of Hypnos (otherwise known as Thanatos) in the Vatican Museums.[2] The temper of the piece also presents a marked contrast to the droll study *Infant Bacchus* (q.v.), which Story began in 1859 and completed in marble in 1863. The divergence in mood between the depiction of the god as a convivial *bacchino* astride a panther and this more mature, serious counterpart was probably a deliberate effort by Story to invite comparison. It was customary for sculptors of the period to model pairs of statues that, while composed to permit interpretation of their separate artistic merits, were designed to reinforce each other as thematic pendants. Although the two statues vary significantly in size, spirit, and compositional approach, they are related in terms of the psychological perspective that Story applied to his examination of his subject. Considered in the broad context of human emotions, the statues illustrate the difference between the child's joyful irresponsibility and the adult's solemn accountability for his transgressions. As a pair, the images also dramatize the dual nature of Bacchus, whom mythology chronicles as having fluctuated between unbridled gaiety and calm despondency. Story's Italian contemporary, the sculptor Giovanni Dupré

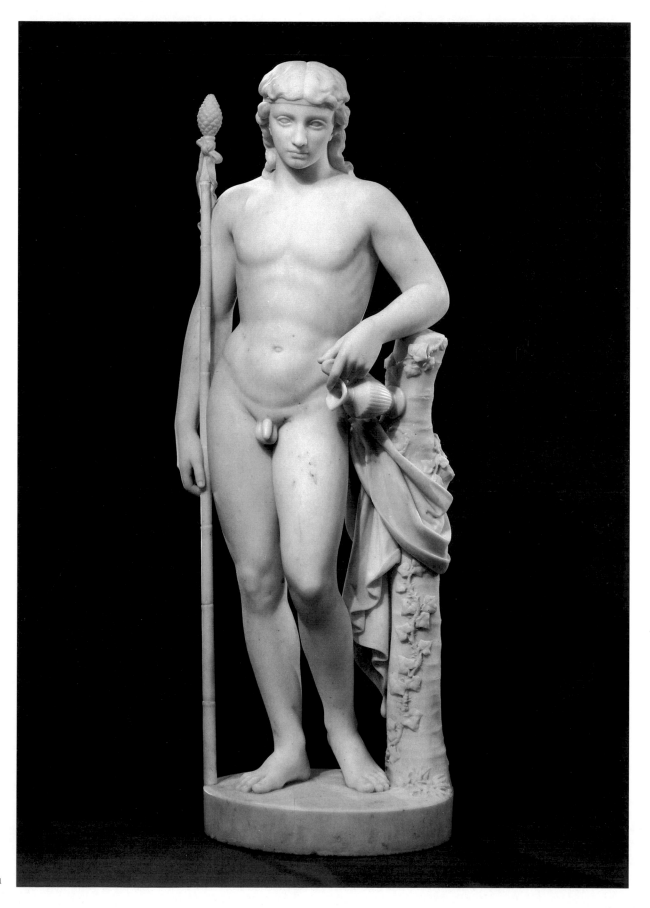

41

(1817-1882), carved two popular, much replicated conceits of Bacchus in the mid-nineteenth century. Dupré's *Bacco Dolente*, 1854, and *Bacco Festante*, 1860 (executed, like Story's figures, several years apart) illustrated the alternating temperament of the god and may have created a momentary vogue for such diametric Bacchic images.

Despite the omission of *Bacchus* from the list of known statues by Story published in Mary Phillips's biography of the sculptor,[3] there can be little question of its authorship when one examines a photograph that documents the work in Story's studio (see illustration).[4] Here the three-foot marble *Bacchus* is shown displayed on a modeling stand, with Story, adorned in his favorite tam o'shanter, posed next to it. The photograph may have been taken about 1863, when he completed the original marble, or during the summer of 1866, when the sculptor's studio diary refers to his work on a replica of the *Bacchus*.[5] To the left of the statue is seen a plaster model of the famous figure from the west pediment of the Parthenon variously identified as Theseus or an Athenian river god.

Bacchus, together with the accompanying *Venus*, was donated to the Museum of Fine Arts by the widow of one of the sculptor's most valued friends and financial advisors, Russell Sturgis, former senior partner of the London banking firm Baring Brothers. In 1888 Julian Sturgis wrote to the Museum on behalf of his mother, Julia Boit Sturgis, advising the trustees of her desire to donate some Chinese ivory carvings along with "two statuettes in marble (a Bacchus & Venus) by my father's old friend, William Wetmore Story, the eminent sculptor of Rome."[6] Presumably the pair of statues formerly resided at Mount Felix, the Italianate villa in Walton-on-Thames, Surrey, owned by the Boston expatriate couple that had served as social headquarters in England to hundreds of touring Americans, including William and Emelyn Story.

<div align="right">J.S.R.</div>

Notes

1. See Story's list compiled about 1890, Story Family Papers, UTA.

2. See J.C. Eger, *Le Sommeil et la mort dans la Grèce antique* (Paris: Sicard, 1966), pl. XIV.

3. Mary E. Phillips, *Reminiscences of William Wetmore Story, the American Sculptor and Author* (Chicago: Rand, McNally, 1897), pp. 295-298. This list is incomplete and should not be consulted as a comprehensive record of Story's statues.

4. The photograph was donated in 1981 to the Archives of American Art, Smithsonian Institution, by a descendant of the American painter John Rollin Tilton (1828-1888). Tilton lived in Rome in the mid-nineteenth century and was a fellow tenant with the Storys in the Palazzo Barberini.

5. Diary, June 1, 1866, Story Family Papers.

6. Julian Sturgis to the Museum of Fine Arts ("Dear Gentlemen"), Jan. 22, 1888, BMFA, 1876-1900, roll 553, in AAA, SI.

WILLIAM WETMORE STORY
42 (color plate)
Infant Bacchus on a Panther, 1863
Marble
H. 48 in. (122 cm.), w. 50 in. (127 cm.), d. 18½ in. (47 cm.)
Gift of Mrs. Henry Lyman. 56.65

Provenance: Theodore Lyman, Boston; Lyman family, Boston; Mrs. Henry Lyman, Brookline
Exhibited: BMFA, "Confident America," Oct. 2 - Dec. 2, 1973.

William Wetmore Story periodically digressed from the intellectually ambitious themes that were his customary sculptural fare by interpreting in marble a whimsical subject that captured his imagination. Such was the case in 1859, when, upon completing his model for the biblical heroine *Judith*, 1863 (National Botanic Gardens, Glasnevin, Dublin), he created this light-hearted study of the child Bacchus, a conceit Story described as "purely lyrical in treatment."[1]

Infant Bacchus on a Panther[2] derives its motif from the classic conception of Bacchus as the bibulous deity who possessed the traits of both man and animal. In antique Greek and Roman sculpture,[3] the god was sometimes depicted with an animal companion and more often attired in an animal skin, symbolic of his affinity to nature and of his wild appetites. The ubiquitous grape clusters inserted in these compositions figured as narrative clues to the god's dipsomania. Story's statue also reflects the prevailing interest in themes of childhood, evident in the carved cherubs, puerile portraits of famous individuals, and comical images of pixies perched on unlikely steeds that crowded the Victorian art market.

Story's personification of Bacchus as a toddler riding a panther, with gaze directed fondly at the bunch of grapes he flourishes in one hand, probably embraced a more sophisticated humorous intent

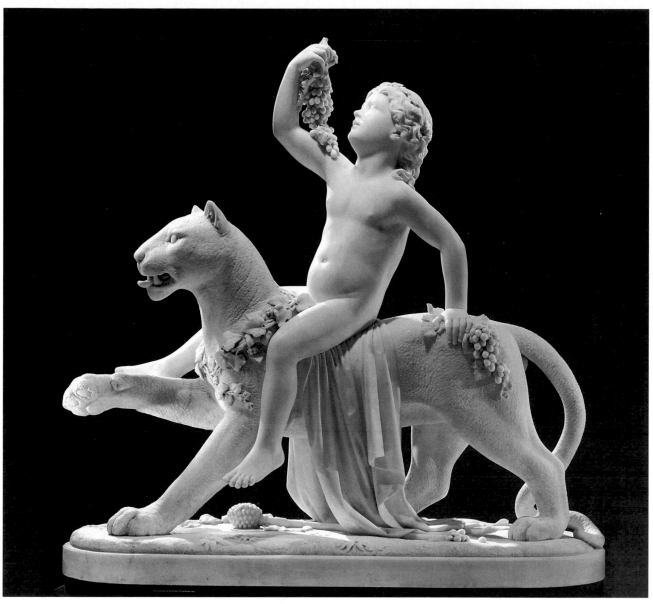

42

as well. The sculptor may have fashioned the piece as a witty allusion and youthful parallel to Peter Paul Rubens's well-known painting of a dissipated adult Bacchus straddling a wine cask, 1640 (Hermitage, Leningrad), copies of which were known in Italy. Story also could have had in mind a reference to the grotesque *Bacchino* seated on a tortoise in the Boboli Gardens, Florence, a work that was commonly mistaken for a small drunken Bacchus but in fact represents Pietro Barbino, the corpulent dwarf jester to Cosimo I di Medici. Story's piece also echoes the pose of *Ariadne on a Panther*, 1814 (Liebieghaus Municipal Gallery, Frankfurt), Johann Dannecker's (1758-1841) celebrated statue that fea-

tures the naked goddess lying across the beast's back. This work drew many travelers, including Story, to Frankfurt. (Americans of Story's generation who had not seen the original in Germany were nevertheless familiar with the image through Parian-ware reproductions and stereoptican views.) If Story's purpose was to playfully quote Dannecker's conceit, he prudently defused potential moral objection to the suggestive juxtaposition of the nude woman against the wild animal by substituting an immature male child for Ariadne. Those conversant with mythology would know, however, that this innocent-looking "bambino" later matured into Ariadne's carousing lover.

Except for its sportive mood, *Infant Bacchus on a Panther* exhibits many characteristics of Story's major ideal sculpture. Symbolic, storytelling props, such as the grape clusters, have been introduced selectively into the work. The thyrsus, the deity's staff, lies forgotten beneath the panther's body. Story also paid attention to differentiating surface textures in the statue, as seen in the taut smoothness of the grapes, the curling fragility of the leaves, the supple plumpness of the young god's flesh, the dense pile of the panther's coat, and the sinuous folds of the robe draped over the animal's back. This treatment of textures has its roots in the same precious late Hellenistic or Graeco-Roman milieu as Harriet Hosmer's *Sleeping Faun* (q.v.).[4]

The sculptor also took pains in his composition to convey a sense of uneven distribution of weight, arranging the child's figure to sway precariously, indeed tipsily, across the panther's back. Since modeling animals was not one of Story's technical fortes, there is a rigid, unconvincing quality in his handling of the panther. Although he incorporated animals in several of his early statues and bas-reliefs, such as *Red Riding Hood and the Wolf*, about 1853 (present location unknown), and *Race with Goats*, 1863 (present location unknown, formerly collection of E.S. Bergen, London), he virtually abandoned them in his later compositions, except for an occasional faun or centaur, which bore closer resemblance to the human than the animal form.

Story neither signed nor dated *Infant Bacchus on a Panther*, a fact that has caused some confusion about the circumstances surrounding its creation and presumed commission. Although he probably finished the statue in marble in 1863, his letter to Charles Sumner of January 2, 1859, indicates that he began the composition at least five years earlier. "I must go to my studio," he remarked, "and commence *Bacchus on a Panther—or Saffo*."[5] He was obviously hard at work on the model by the winter of 1861-1862, when he mentioned having made the *Boy Bacchus on a Panther* in a letter to Charles Eliot Norton.[6]

The *Infant Bacchus*, though begun for the sculptor's amusement, quickly found a purchaser: Theodore Lyman, a Boston zoologist and fellow Harvard graduate of Story's, who visited Rome in 1861. In the winter of that year Story acknowledged receipt of Lyman's order for the statue at the price of $1,500, a fee substantially reduced in light of their newly forged friendship.[7] He first promised to complete the statue in marble by the late autumn of 1862, but because of difficulties encountered as the work progressed, he was compelled to remodel Bacchus's torso "to improve the turn of the figure and the line of the composition."[8] Not until July 1863 was the statue finished and ready for shipment to Lyman. Story explained the delay to its impatient purchaser: "The little details consumed an immense amount of time and patience and I could not be hurried."[9]

After receiving *Infant Bacchus on a Panther*, Lyman engaged two Boston cabinetmakers to create a special wooden base for the statue. This handsome stand in Renaissance-revival style bears an original inscription in pencil documenting it as the work of Toussaint and Kurtz, whose business address is given as 526 Washington Street.[10]

J.S.R.

Notes

1. Story to Charles Eliot Norton, Aug. 15, 1861, Charles Eliot Norton Papers, Ho, HU.

2. This statue has been referred to as *Infant Dionysius* by modern art historians. Story's correspondence refers to the god by his Roman name, Bacchus, and both his studio records and photographs designate the statue as *Infant Bacchus on a Panther* or *Boy Bacchus on a Panther*.

3. See Vermeule 1975, p. 980, who compares the statue with a Graeco-Roman *Dionysos* or *Satyr on a Donkey*, of about A.D. 50-150, now owned by the Minneapolis Institute of Arts. Among the other possible prototypes for Story's conceit is a sixteenth-century Tuscan statue, *Bacchus with a Panther*, which Story may have encountered at the Bargello Museum, Florence.

4. Vermeule 1975, p. 980.

5. Story to Sumner, Jan. 2, 1859, Charles Sumner Papers, Ho, HU.

6. Story to Norton, Feb. 10, 1862, Norton Papers.

7. Story to Lyman, Feb. 5, 1861, Theodore Lyman III Papers, MHS. Story told Lyman that the price "to an outsider" would be $2,200. Several years later he reported to Lyman that the price for replicas had escalated to $3,600.

8. Story to Lyman, June 18, 1862, Theodore Lyman III Papers.

9. Story to Lyman, July 29, 1863, Theodore Lyman III Papers.

10. The 1865 Boston Directory lists Toussaint and Kurtz at 526 Washington Street.

WILLIAM WETMORE STORY

43

Sappho, 1863

Marble

H. 54⅞ in. (139.4 cm.), w. 32⅛ in. (81.6 cm.), d. 34 in. (86.4 cm.)

Signed (on back): wws (monogram) / ROMA 1863

Otis Norcross Fund. 1977.772

Provenance: William Stirling Crawford, Scotland; Castle Hill Antiques, Edinburgh, Scotland; Arnette Antique Galleries, Murfreesboro, Tenn.

Exhibited: Brockton Art Center - Fuller Memorial, Brockton, Mass., "Artful Toil: Artistic Innovation in an Age of Enterprise," Sept. 8, 1977 - July 1978; BMFA 1979, no. 5.

Versions: *Marble:* (1) Drexel University, Philadelphia, (2) Post Road Gallery, Larchmont, N.Y.

As a thematic type, Sappho is characteristic of the tragic, brooding female personalities from antiquity, including Semiramis, Cleopatra, Delilah, and Medea, that inspired William Story's best ideal sculpture. The statue reflects the artist's penchant for probing the psychological depths of a subject and attempting to translate the drama of a troubled soul into physical form. Story repeatedly selected individuals from history and literature whose passions were ripe for eruption or whose predicaments caused them to vacillate between resignation and action. Most of Story's perplexed characters are therefore interpreted as grappling with a confusion of emotions created by the contradictory needs of the heart and the intellect. Here Story's heroine passively contemplates suicide while wrestling inwardly with the turmoil of a broken heart.

Story considered undertaking a study of Sappho as early as 1859;[1] progress on the model was delayed, however, because of his need to finish *Cleopatra* and the *Libyan Sibyl* in time for display at the 1862 International Exposition in London. By the winter of 1862, having concluded that task, he returned to his idea for a representation of the Greek poetess. In a letter to Charles Eliot Norton in February, he complained that a winter's cold had kept him from his studio, where he was at that moment "very busy putting up a statue of Sappho."[2] By early spring the preliminary model was nearing completion. On April 6 he announced his goal to Charlotte Cushman, the celebrated actress who was his Roman neighbor, of having his "Sappho out of the mould . . . and in the cast" by the following Saturday.[3] In a letter to Norton he described the composition, finished that May, as "a lovelorn lady dream-

ing of him, whoever he was; Phaon, Anacreon, or any other 'on'; very tender, very sweet, very sentimental." "In this statue," he wrote, "I have gone into Greekland, as in the Sibyl I went into Africa, and in the Cleopatra into Egypt."[4]

Story's characterization of Sappho as "tender" and "sweet" assumes significance when one considers his subject's historical reputation.[5] For centuries Sappho's name had provoked both praise and reproach from scholars. Plato eulogized her as the "Tenth Muse" in recognition of her undisputed position as head of Greece's Aeolic school of poets in the sixth century B.C. Her poetry, which survives only in fragments, was acclaimed by other classical writers for its lyrical intensity and economy of expression. Some of Sappho's poems, dedicated to the adoring female disciples who formed her "circle" on the island of Lesbos, are passionately amorous. For this and other reasons, another school of critics denounced her as a voluptuary with depraved habits. In A.D. 380 the Church pronounced Sappho a menace to public morals and in an act of ecclesiastical vandalism, ordered her writings burned.

The tangle of literary and mythological information that surrounded Sappho heightened her mysterious charm for people of Story's romantic generation. Throughout the century, artists and writers attempted to immortalize the enigmatic woman on canvas, in verse, in prose, and even in the opera. Although Sappho's poetry was not available in English translations until the latter half of the nineteenth century, Story must have been aware of its controversial history, having been drilled in the Greek classics at Harvard. Even in Story's day, the question of Sappho's morality was still igniting scholarly argument. An article published in the New York-based *Crayon* in 1859 summarized the current spectrum of critical positions by describing Sappho as a woman of "warm poetic temperament, of great lyric power, of voluptuous, passionate yearnings, and of many moral short-comings."[6] Story's conceptualization of Sappho completely ignored the lurid slander clouding her historical personality and emphasized instead the less objectionable account of her life furnished by Ovid in the *Heroides* ("Epistle from Sappho to Phaon").

According to Ovid's tale, the poetess suffered from a severe depression as the result of an unrequited heterosexual love affair. When her advances to the handsome Greek ferryman Phaon were rejected, the disconsolate poetess, whose lyric powers were now incapacitated, decided to end her misery

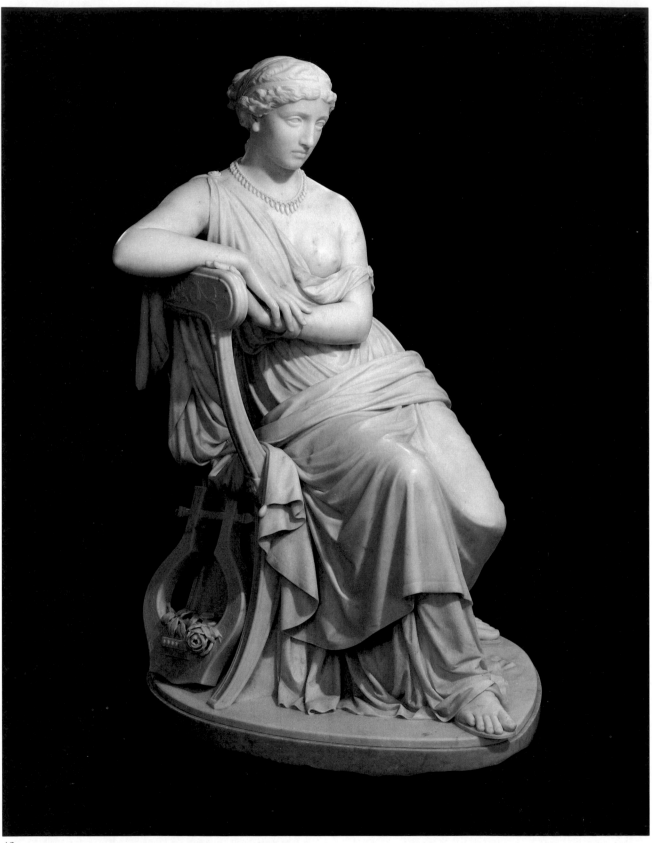

43

by jumping off the cliffs of Leucadia into the sea. Story's interpretation presents her in the waning moments of life before taking this cataclysmic action. Firmly resigned to her drastic fate, Sappho appears wholly self-absorbed, as if lingering on the pathetic yet tender memory of her past love. Prior to executing his statue, Story composed a poem that served as a companion to the sculpture by articulating the dramatic subtleties of Sappho's meditations.[7] In the sculpture Story has carefully arranged the figure's posture and props to convey the woman's despair. Sappho sits carelessly to the side of her antique chair with arms folded in a relaxed, contemplative attitude.[8] Her head is slightly bowed as she gazes vacantly out to sea. Her sober expression suggests the finality of her suicidal plan and the ephemeral moment of peace this promise of relief permits her. Sappho's lyre, symbol of poetic genius, leans abandoned and unstrung against her chair; it is garnished by a wilting rose, emblematic of her withered love affair with Phaon and her own life's approaching conclusion. According to Story's poem, she will throw the necklace she wears, a gift from the now indifferent Phaon, into the sea in an ultimate gesture of angry despair.

James Jackson Jarves, who objected to Story's sensationalist themes, admired the accuracy of detail he insisted upon for his marble subjects from antiquity: "[Story's] antiquarian knowledge serves him well in the decorative part of his sculpture. Ornaments and accessories are rightly chosen and tastefully placed."[9] As the statue's scheme confirms, Story indeed designed *Sappho*'s accessories with a sensitive eye for historical and archaeological authenticity. Her profile and hairdo (with a *sakkos* bound around her head) reflect the sculptor's knowledge of Sappho's traditional representation on ancient coinage. The facial features bear close resemblance to those in the antique portrait of Sappho at the Villa Albani, Rome, which in Story's day was assumed to be a genuine image of the poetess. The chair (*klismos*) on which she sits is a credible "artifact" in the style of Sappho's era; her necklace and bracelet, too, are faithful facsimiles. Story has dressed his subject in a *chiton*, a costume appropriate for a woman of Sappho's position in ancient Greece; the asymmetrical draping of the robe, revealing one breast, was occasionally found in Greek ideal sculpture from the followers of Phidias in the late fifth century B.C. to Roman times.

The composition of *Sappho* demonstrates Story's fondness for modeling figures in a seated position;

it was a pose he adopted frequently for his major ideal statues. His detractors argued that his preference was dictated by necessity, claiming that Story's inadequate professional training forced him to rely on heavy pyramidal supports for his large-scale marbles. Although there may be some truth to this theory, Story's frequent use of the seated pose was more likely influenced by his awareness of numerous prototypes in Greek and Roman sculpture in which this "cogitating" posture had been employed with imposing effect. Moreover, by the mid-nineteenth century, sculptured images of classically garbed women sitting in dreamy reverie were enjoying great vogue, especially in France, precisely because of the pose's antique connotations and the mood of melancholic introspection it evoked.

Sappho became one of the most popular artistic subjects of the Victorian period, for her tale involved the themes of rejected love and watery death then current in romantic fiction and painting as well as deal sculpture. As a personification of musical and poetic genius, she appealed in particular to American sculptors, who, like the American transcendentalists, greatly admired those particular creative attributes.[10] In less than a century Sappho's artistic representation progressed through a sequence of archetypes, each stressing different aspects of her reputation: Sappho as poetic muse, as Venus, as suicide victim, as melancholic, and, by the late nineteenth century, as homosexual voluptuary.[11] During the first half of the century, the first three archetypes were examined by English and European artists, whose explorations culminated in memorable images depicting Sappho either passively writing poetry or, in Gothic antithesis, plunging in frenzy from the Leucadian Cliffs.[12] By the 1840s the romantic movement had focused attention on the intimate relationship and delicate balance between the heart and the head, or the emotions and the intellect. This emphasis prompted artists to investigate Sappho as an individual whose intellectual gifts had been ravaged by romantic disappointment. Hence emerged the familiar archetype of Sappho as melancholic genius, a woman whose suffering caused her to reel precariously between extreme creativity and paralyzing inertia. Story obviously derived his *Sappho* from this interpretation.

If Story was indebted to any of the renditions of Sappho by his European contemporaries, he probably owed inspiration to Giovanni Dupré's *Saffo Dolente*, 1858 (National Gallery of Modern Art,

Rome).[13] The Italian sculptor portrayed Sappho as a lovely young woman overwhelmed by sorrow but nevertheless composed in her despair. She is seated on a rock in a posture of dejection, with eyes fixed in a vacant stare. A lyre with broken strings rests by her side, apparently forgotten in her present state of depression. The pattern of flowers and vines, modeled in low relief around the lyre, is reproduced almost identically on the instrument featured in Story's *Sappho*. Dupré's conceit, like that of Story, captures Sappho at the critical moment between thought and action, deliberating the alternatives of life or suicide.[14]

Story may have seen Dupré's marble in the artist's studio in Florence, or at the first National Exposition of Art in that city in 1861, or at the annual exhibition of the Florentine Academy the following year. Unlike the majority of his expatriate colleagues, Story enjoyed mingling with the native populations of Rome and Tuscany; he befriended many Italian artists, with whom he was able to converse freely in fluent Italian. That Dupré was among these Italian associates is certain; in 1886 Story provided a warm introduction to the English edition of the Italian sculptor's autobiography, which was translated by his daughter, Edith Story Peruzzi.[15] The correspondence between Story's and Dupré's works underscores the similarities in approach to style and thematic interests between the American and Italian sculptors who lived in Rome and Florence in the nineteenth century, renting studios adjacent to one another and exhibiting their works at the same local galleries and art associations.

Story's completed model for *Sappho* drew three orders for copies in the 1860s, the first from William Stirling Crawford of Scotland and the other two from Americans, J.C. Peterson of Philadelphia and Martin Brimmer of Boston. The version in the Museum of Fine Arts is the original marble Story carved for Crawford, a friend and patron whom the artist and his family occasionally visited in Scotland. In May 1863 Robert Browning had informed Story that London art gossip intimated his newest statue was promised to an English client.[16] Story confirmed the report in a letter to Charles Sumner, August 9, 1863, declaring that *Sappho* had been sold to "Stirling Crawford, cousin of William Stirling."[17] After Crawford's death, the statue evidently remained in Scotland, later appearing in a men's club in Edinburgh, where it is said to have been lodged for many years until passing into the hands of a Scottish antiques dealer.

The 1867 replica of *Sappho* (Post Road Gallery, Larchmont, New York) was bought by Martin Brimmer, first president of the Museum of Fine Arts. Story had an opportunity to inspect this version in situ at Brimmer's house on Arlington Street when he traveled through Boston in 1877. The third copy of *Sappho*, ordered by J.C. Peterson in 1866, was donated by his widow, Sarah H. Peterson, to Drexel University in Philadelphia in 1892, a year after the institution's founding.[18]

Story considered his tranquil but troubled *Sappho*, monumental in scale yet delicate in detail, one of his most appealing idealizations in marble. Upon completing his model for the statue, Story confided to Charles Eliot Norton, "I fancy just at this moment of time that you would think it my best work—I have put all the Love into it I could."[19]

J.S.R.

Notes

1. Story to Charles Sumner, Jan. 2, 1859, Charles Sumner Papers, Ho, HU. For further discussion of the significance of this statue in Story's oeuvre, see Jan Seidler Ramirez, "The Lovelorn Lady: A New Look at William Wetmore Story's *Sappho*," *American Art Journal* 14 (summer 1983), pp. 80-90.

2. Story to Norton, Feb. 10, 1862, Charles Eliot Norton Papers, Ho, HU.

3. Story to Charlotte Cushman, Apr. 6, 1862, Archival Collection, The Charlotte Cushman Club, Philadelphia. I am indebted to Dr. Judith E. Stein for calling this reference to my attention.

4. Story to Norton, May 3, 1862, Norton Papers.

5. See Arthur Wiegall, *Sappho of Lesbos: Her Life and Times* (New York: Stokes, 1932). See also Judith E. Stein, "The Iconography of Sappho, 1775-1875," Ph.D. diss., University of Pennsylvania, 1981, pp. 10-39.

6. "Sappho, the Greek Poetess," *Crayon* 6 (Feb. 1859), p. 39.

7. See W.W. Story, "Sappho," in *Poems* (Boston: Little, Brown, 1856), unpaginated.

8. For a contemporary description, see "Editor's Easy Chair," *Harper's New Monthly Magazine* 27 (Sept. 1863), pp. 566-567.

9. James Jackson Jarves, *Art Thoughts: The Experiences and Observations of an American Amateur in Europe* (New York: Hurd & Houghton, 1869), p. 311.

10. See Gerdts 1973, pp. 112-113. Among the American neoclassicists who produced idealized sculptures of Sappho were Hezekiah Augur (1791-1858), Edward Sheffield Bartholomew (1822-1858), Thomas Crawford, Alexander Galt (1827-1863), Vinnie Ream Hoxie (1847-1914), Chauncey B. Ives, and Erastus Dow Palmer. The majority of their works portrayed Sappho in her role as pensive muse, equipped with lyre and the poet's laurel wreath.

11. See Stein, "Iconography of Sappho," pp. 10-39.

12. Among the representations of Sappho of this time by English sculptors were William Theed's (1804-1891) *Sappho*, 1846, executed for Queen Victoria, and John Gibson's (1790-1866) bas-relief, *Sappho*, 1849 (Ellams Collection, Liverpool); by Continental sculptors: Carlos Marochetti's (1805-1867) *Sappho*, about 1850; James Pradier's (1790-1852) *Sapho*, Salon of 1852; Guillaume Grootaers's *Les Derniers Moments du Sapho*, Exposition Universelle, Paris, 1855; Auguste Clesinger's (1814-1883) *Sapho terminant son dernier chant*, 1857; a monumental standing *Sapho* by Pierre Travaux (1822-1869) and another by Pierre Loison (1816-1886), Salon of 1859; Pietro Magni's (1817-1877) *Sappho*, about 1865.

13. See Henry S. Frieze, *Giovanni Dupré* (London: Sampson, Low, Marston, Searles, and Rivington, 1886); see also Ashton R. Willard, *History of Modern Italian Art* (London: Longmans, Green, 1902), pp. 119-125.

14. For a contemporary critical reading of Dupré's *Saffo*, see Theodosia Trollope, "Notes on the Most Recent Productions of Florentine Sculptors," *Art-Journal* (London) 23 (n.s. 7) (Jan. 1861), p. 20; see also *Rivista di Firenze e Bulletino delle arti de disegno* 3 (1858), pp. 230-231.

15. Giovanni Dupré, *Thoughts on Art and Autobiographical Memoirs*, trans. Edith S. Peruzzi (London: Blackwood, 1886).

16. Browning to Story, July 17, 1863, quoted in Gertrude Reese Hudson, ed., *Browning to His American Friends* (New York: Barnes and Noble, 1965).

17. Story to Sumner, Aug. 9, 1863, Sumner Papers.

18. The three versions are identical in overall dimensions and decorative detailing, with minor variations in the treatment of *Sappho*'s bracelet (plain in the earliest, ornamented with cross banding in the later copies), the ground of the statue's base (smooth and unornamented in the 1863 version but incised with shallow checkerboard or diamond patterns in the other two), and the treatment of *Sappho*'s coiffure (smoother in the 1863 version and slightly textured in the other copies). These differences may be explained as the idiosyncratic carving "signatures" of Story's studio assistants.

19. Story to Norton, May 3, 1863, Norton Papers.

WILLIAM WETMORE STORY

44

Venus Anadyomene, 1864
Marble
H. 40⅛ in. (102 cm.), w. 12 in. (35 cm.), d. 10 in. (25.5 cm.)
Signed (on back of base): w.w. STORY / ROMA 1864
Gift of Mrs. Russell Sturgis. 88.329

Provenance: Russell and Julia Sturgis, Walton-on-Thames, Surrey, England

Exhibited: BMFA, "Confident America," Oct. 2-Dec. 2, 1973; BMFA 1979, no. 7.
Versions: *Marble:* (1) present location unknown, formerly William Stirling Crawford, Scotland, (2) present location unknown, formerly Thomas Critchley, London

Story's *Venus Anadyomene*, first modeled in 1860, is one of the sculptor's most consummately classical works. In pose and expression it derives from a group of late Hellenistic images of Aphrodite and marine nymphs that were dispersed through Europe's distinguished public and private art collections by the mid-nineteenth century.[1] Although compositional variations occur between individual examples of these antique statues, they share an interpretation of Venus as a goddess born of the sea; the Greek word *anadyomene* signifies "she who rises," as from the sea. Typically, these ancient marbles portray Venus at the moment she emerges from a bath, usually accompanied by aquatic attributes such as sea shells, dolphins, or swans. Story quotes this visual tradition; with robe cast off on an urn behind her, the goddess completes her toilet, twisting up her long, wavy tresses.

Antique art dominated the mood and style of Story's sculpture during the formative years of his career abroad. Not until *Cleopatra* and the *Libyan Sibyl* achieved critical success at the London Exposition of 1862 did Story feel encouraged to concentrate on more inventive subject matter with a psychological orientation. The Graeco-Roman literalism that inspired *Venus*, as well as the half-dozen other compositions in that vein he modeled in the 1850s and early 1860s, such as *Arcadian Shepherd Boy*, 1855 (Boston Public Library), *Hero Searching for Leander*, 1858 (Post Road Gallery, Larchmont, New York), and *Bacchus* (q.v.), signals not only his responsiveness to the current popular taste for antique themes and sentiment in sculpture but also his deep respect for the expert workmanship and masterly sense of composition evident in those venerable sculptural survivals from ancient Greece and Rome.

Story's appreciation of classical sculpture was an acquired affection. Before changing professions and moving to Italy, he had openly criticized American artists for their groveling subserviency to foreign art traditions. In his 1844 Phi Beta Kappa address *Nature and Art*, afterwards published as a poem, he urged his countrymen to "break the shackles of slavish custom" and dedicate themselves to commemorating indigenous American themes; to structuring an aesthetic or style that incorporated

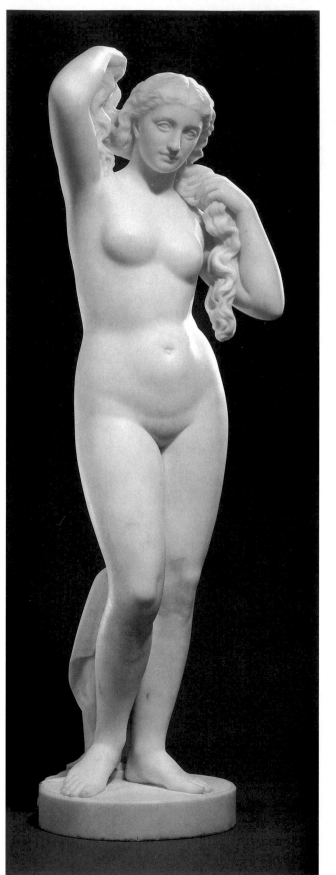

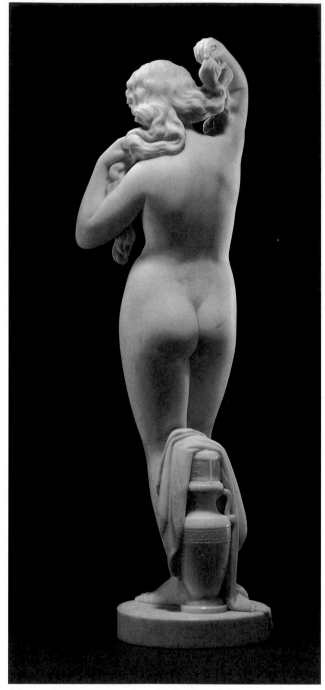

44

local idiom and native materials: "In foreign soil that seed was never sown / which when transplanted can adorn our own; / Not in Italian moulds of ages past / shall the free spirit of our age be cast."[2]

These nativist, even visionary sentiments coloring Story's youthful notions about American art were shared by many of his contemporaries whose passions had been likewise enlisted in the campaign for cultural independence in American arts and letters. Nevertheless, once Story had relinquished New England and his legal practice for Europe and the artist's life, his beliefs underwent rigorous trial and reappraisal. In spite of his recent inveighing against servility to European culture, he found himself enchanted by Italy's romance, customs, and provocative antiquity. He soon became convinced that "foreign art," especially the sculpture of ancient Greece, merited careful study and selective imitation.

Venus Anadyomene, however, was not carved merely for instructive exercise by a freshman enthusiast of Hellenistic marbles. According to the sculptor, he conceived the piece as a prank, with the intention of duping his friend Charles T. Newton, the English consul and archaeologist—"almost the only capable critic" he knew on sculpture—into proclaiming his creation an authentic antique. In a letter to Charles Eliot Norton, September 1860, Story confided his conspiracy and its subsequent miscarriage: "I took it into my head to endeavor to cheat [Newton] and model a small Venus after the style of the Antique—with the intention of casting it and then knocking off the head & arm & legs and imposing it on him as an Antique—from a Greek figure. I kept the whole matter secret until I had nearly finished it when suddenly one day having forgotten to lock my door he burst in and saw it—to my great disappointment. But not to throw away my work I finished it—and he liked it—so much that he persuaded me to have it cut in marble. I yielded to persuasion—and it is now nearly through—It is only about 3 feet high—the marble is spotless and perhaps as it is a naked woman it will sell."[3]

The timing of Story's miscarried ruse is significant. In the spring of 1859 a great commotion had arisen in Rome over the discovery of a headless marble figure in a vineyard outside the Porta Portese. The unearthed statue, carved in Parian marble, was pronounced by experts an ancient Greek Venus; some authorities even speculated that it was the original from which the *Venus di Medici* (Pitti Palace, Florence) was copied.[4] Story had visited the excavation site several times that year, once

accompanied by Nathaniel Hawthorne, who recorded their expedition in his *French and Italian Notebooks*.[5] Story may have "hatched" his plot to deceive Sir Charles Newton with a counterfeit "masterpiece" in response to the excitement and controversy surrounding the uncovering of the mysterious "Porta Portese" *Venus*.[6]

It is also possible that Story modeled *Venus* to test his own theory of proportion. By 1859 he was researching the proportional codices used by the ancient Greeks in their three-dimensional studies of the human figure, an investigation that culminated in the publication of his *Proportions of the Human Figure According to a New Canon* (1866).

Venus Anadyomene is Story's only known female figure that is completely nude, the circumstances surrounding its creation having dictated this condition as essential to the statue's meaning. As Henry James observed, Story was respectful of the Victorian public's "felt demand for drapery."[7] Ordinarily, he preferred to outline the body's contours with carved folds of clinging cloth, thereby establishing an exciting visual dialogue between the drapery and the figure beneath. Story's views on nudity in art, like those of many Americans of his day, were ambivalent. As an artist, however, he appreciated the beauty of design and principles of proportion exhibited in the human form. While he could condone nudity if a statue's theme warranted it, he had little tolerance for sculptors whose motives for utilizing nudity in their work were insincere—who camouflaged eroticism by "dressing" a figure with fig leaves or contriving a scenario to legitimize nakedness. Equally reprehensible in Story's eyes were sculptors who designed half-clad statues in coquettish postures. For example, he pronounced the "spirit" of Canova's *Venus Italica*, 1812 (Pitti Palace, Florence), "detestable," likening the statue's pose to that of a "lascivious courtesan who feels her nakedness and endeavors to heighten her charms by half-covering them."[8]

As a subject for a mid-nineteenth-century sculptor, Venus was inherently problematic because of her mythological reputation as a temptress who made a mockery of modesty, fidelity and other mores revered by genteel Victorians. Perhaps for this reason the goddess was infrequently interpreted by Story's American colleagues in sculpture. Despite her revealing pose, Story's *Venus* possesses none of the sensual allure of the innumerable unclad Aphrodites, odalisques, and Rubenesque nudes that postured on pedestals in European salons of the

period, especially in France. The severity of its modeling divorces the image from any taint of voluptuousness. With its universalized proportions and features, small breasts, and polished surface, the statue represents classical femininity as perceived intellectually by a mid-Victorian sculptor.[9]

Story's confidence that his marble goddess would find a purchaser was rewarded. A handwritten list he compiled about 1890 indicates that two marble copies of *Venus* were sold, one to Thomas Critchley of London and the other to Story's loyal patron, William Stirling Crawford of Scotland.[10] No purchaser is mentioned in Story's inventory for the third replica of the *Venus Anadyomene*, which is now in the Museum of Fine Arts. This statue was presented to the Museum in 1888 by Mrs. Russell (Julia) Sturgis, wife of the sculptor's close friend.[11] The Sturgises, who lived in England, were often hosts to the Storys during their periodic stays there.

J.S.R.

Notes

1. See Vermeule 1975, p. 978. Vermeule compares Story's image with a marine *Venus*, about 50 B.C.-A.D. 100 (Newby Hall, Yorkshire, England), and another maritime *Venus*, about A.D. 100-200 (Louvre). Relationships with the *Venus of Cyrene* (Roman National Museum of the Thermae) and with the *Venus Gnidia* and *Venus del Balsamario* (Vatican Museums) are also possible.

2. William Wetmore Story, *Nature and Art: A Poem* (Boston: Little, Brown, 1844), p. 33.

3. Story to Norton, Sept. 23, 1860, Charles Eliot Norton Papers, HO, HU. The stratagem of breaking and burying a modern statue to deceive prospective discoverers about its provenance was not original to Story. Michelangelo had perpetrated the same trick centuries before when he mutilated and buried one of his statues with the aim of defrauding the pompous cognoscenti, who would be led to it and inevitably declare it the work of a hitherto unknown Greek master or member of Praxiteles' school.

4. The *Venus di Medici* was the object of passionate admiration among nineteenth-century tourists and authors of travel books. In his opinion of the unearthed "Porta Portese" *Venus* in Rome, which was alleged to be the model for the *Venus di Medici*, Story differed from the general consensus, judging the "new Venus" to be "in all respects inferior in execution and finish to the celebrated Venus de' Medici." W.W. Story, *Roba di Roma*, (London: Chapman & Hall, 1866),vol. 2, pp. 40-41.

5. Nathaniel Hawthorne, *French and Italian Notebooks* (Boston: Houghton Mifflin, 1881), pp. 210-212.

6. Discovery of the *Venus* was reported in American newspapers and periodicals. See "Foreign Art Gossip," *Cosmopolitan Art Journal* 3 (June 1859), p. 130.

7. Henry James, *William Wetmore Story and His Friends* (Boston: Houghton Mifflin, 1903), vol. 2, p. 81.

8. Notebook, Oct. 6, 1849, Story Family Papers, UTA.

9. For additional discussion of this work and the companion piece *Bacchus* (q.v.), see Jan Seidler Ramirez, "William Wetmore Story's *Venus Anadyomene* and *Bacchus*: A Context for Reevaluation," *American Art Journal* 14 (winter 1982), pp. 32-41.

10. List of statues, about 1890-1894, Story Family Papers.

11. See Julian Sturgis's letter to the Museum of Fine Arts ("Dear Gentlemen"), Jan. 22, 1888, offering the pair of small statues by Story, *Venus Anadyomene* and *Bacchus* (q.v.) on behalf of his mother, Julia Boit Sturgis. BMFA, 1876-1900, roll 551, in AAA, SI.

WILLIAM WETMORE STORY

45
Medea, 1868-1880
Marble
H. 77 in. (195.6 cm.), w. 27 in. (68.6 cm.), d. 26½ in. (67.4 cm.)
Inscribed (on front of base): MEDEA
Gift of a Friend of the Department. 1984.202

Provenance: Story family, Rome; Society for the Preservation of New England Antiquities, Boston; Isidore and Molly Bromfield, Milton, Mass.; Post Road Gallery, Larchmont, N.Y.; Carlos Conde III, San Juan, Puerto Rico
Versions: *Marble:* (1) Essex Institute, Salem, Mass., (2) Richard L. Feigen & Co., P. and D. Colnaghi, and Cyril Humphris, London, (3) The Metropolitan Museum of Art, New York

"The very embodiment of jealousy and feminine revenge" was one nineteenth-century critic's summary description of Story's imposing marmoreal effigy of Medea, the Greek sorceress.[1] The statue visualizes the scene from ancient legend when Medea, to take vengeance upon Jason for his marital infidelities and rejection, plots the assassination of their two children. The figure stands rapt in thought, her head appearing to lift with the firmness of newborn purpose. One hand ominously clutches the dagger that will perform the hideous crime; the other fondles the beads around her throat in a distracted manner. Medea's furrowed brow evokes a sense of the pain, anger, and despair that have provoked this extreme resolution. Through this clever staging Story suggests some of the complex, contradictory passions tyrannizing the woman's heart at this critical moment. The figure persuasively elicits from the viewer a mixture of emotions that range from sympathy for the spurned

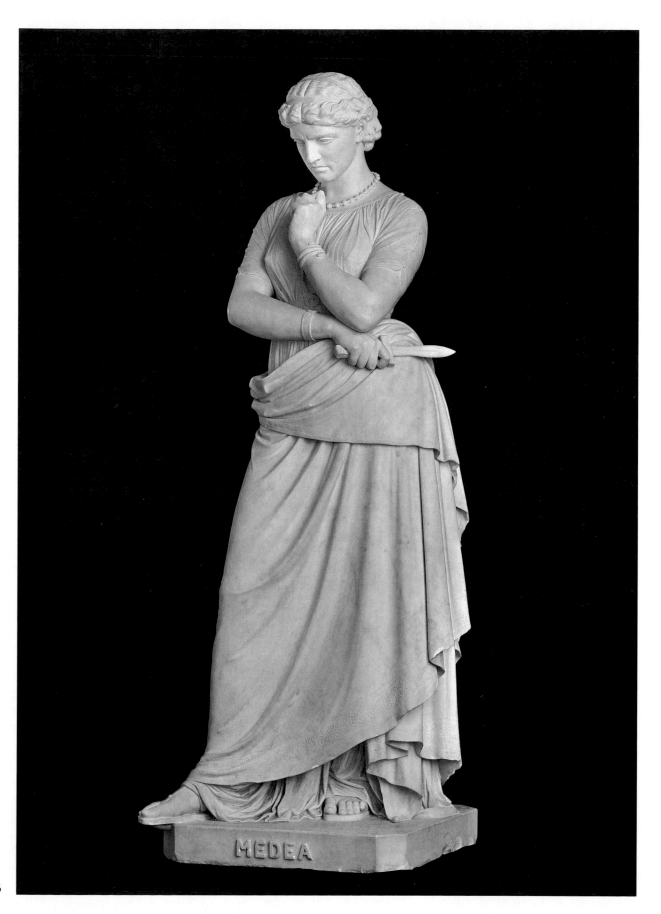

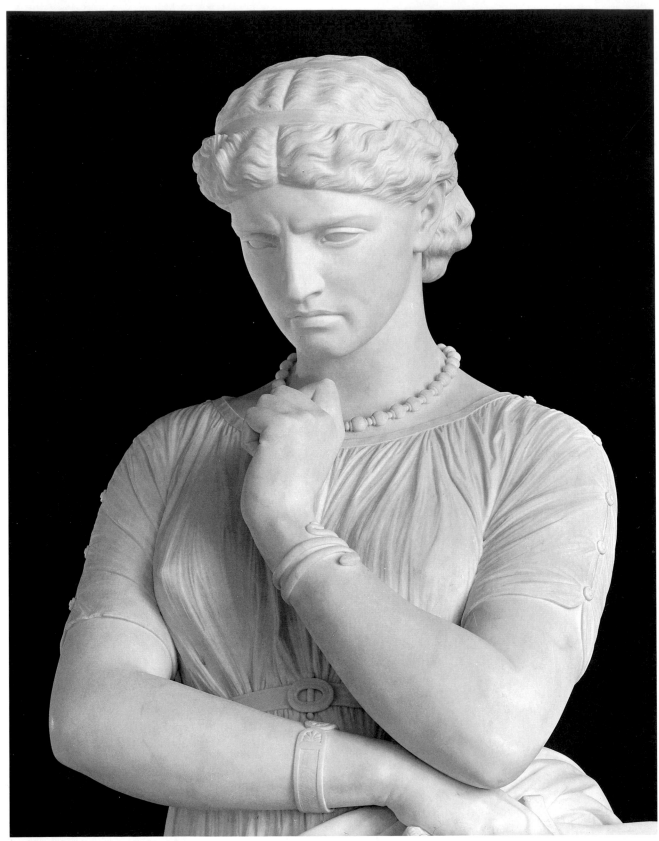

45 (detail)

wife to repulsion at the murderous mother.

In *Medea* the psychological probing first evident in Story's sculptural conceits of the late 1850s achieved a conceptual maturity and compositional sophistication that earned the statue distinction as one of the sculptor's most powerful inventions. Like *Sappho* (q.v.), *Medea* dramatizes the mental and spiritual fermentation preceding a climactic act of violence. Relying on his viewer's knowledge of ancient tragedy, Story generated subtle theatrical tension by inviting the audience to witness not the denouement of Medea's fury but the scheme in the making: the portentous moment when she determines the ultimate form of her revenge. The statue's dramatic impact is heightened when the viewer contrasts this deceptively benign, meditative image with the scene of brutal infanticide soon to be perpetrated. As was often his practice, Story composed a pendant poem to help his audience envisage the statue's *mise en scène*. Published in the collection of his poems entitled *Graffiti d'Italia* (1868), the verse characterized Medea's expression as "fixed and mute / Her brow shut down, her mouth irresolute," and invoked the audience to behold the "rage, fury, love, and despair" etched on her "dark face," and the "fearful purpose" in her stance.[2]

Story first conceived the idea for the statue in 1864, as evidenced by his letter to Charles Sumner in October of that year, "I have my head full of a new statue of Medea."[3] By June 1865 he was blocking out the figure in stone and reporting on its progress to his wife, "The *Medea* is coming out very well."[4] With regret, he also noted that a stain had materialized in the marble "just below the knee" during the cutting of *Medea's* leg.[5] Story's studio diaries indicate that he remodeled the figure the following year, making minor adjustments to the drapery.[6]

The timing of *Medea* has a twofold significance in Story's artistic development. Initiated in the wake of his triumph at the 1862 London Exposition, the statue demonstrates an important stylistic shift occurring in his work over this decade away from the conventional neoclassical aesthetic epitomized in the modeling of *Bacchus* (q.v.) and *Sappho* (q.v.) toward the expressive naturalism and romantic temperament that infused the literature and painting of the period. The statue also documents the emergent influence of contemporary drama on Story's art. An amateur actor, aspiring playwright, and accomplished vocalist in his own right, Story frequented the opera and theater in Rome, Paris, and London.[7] During his career's major phase, these forms of entertainment provided a fertile source for the dramatis personae he interpreted in marble.

Although the ancient Greek tragedy by Euripides presumably supplied the impulse for Story's choice of subject, his conceptualization of Medea was most likely inspired by the Italian actress Adelaide Ristori, whose performance in the title role of Ernest Legouvé's *Médée* (1855) catapulted her to fame as one of the century's leading tragediennes. Her innovative acting technique merged the "new" naturalism of the French School of drama with the élan and emotional intensity of the Italian method.[8] At least one contemporary critic attributed Ristori's commanding stage presence to her sculpturesque physique. He observed that she possessed the hands and feet of the *Venus of Arles*, a tall, beautifully proportioned frame, a finely formed head with an "open, intelligent brow," a "fair and flexible neck," and "smooth white shoulders" that boasted "the rare median line so dear to sculptors."[9] Undoubtedly, Ristori exploited these artistic contours to professional advantage, since it was common for performers of her era to study the poses of antique sculpture for adaptation on stage.

Story's introduction to Ristori's work occurred in 1848 before the actress had attained international celebrity. Once exposed to her mesmerizing personality on stage at Rome's Teatro Valle, he reportedly trailed Ristori "like a shadow,"[10] taking a keen, even possessive interest in her career. To James Russell Lowell, a fellow fan of the actress, he reflected that Ristori's Italian blood probably equipped her with an instinctive "*clou* of passion," enabling her to "move enthusiasm and sympathy in others."[11] Subliminally at least, Story appropriated Ristori's technique and best-known roles in much of his own art. The combination of smoldering violence and pathos that were Ristori's signature as an actress found a plastic parallel in many of the sculptor's characterizations.[12]

In the mid-1850s, during a visit to Paris, Story attended Legouvé's *Médée*, in which Ristori starred while making her debut in the French capital. Like others in the audience, he was deeply moved by her electrifying portrayal. "Her *Medea* is as affecting as it is terrible. . . . An infinite grief and longing possesses her . . . the horror of the deed is obscured by the pathos of the acting and the exigencies of the circumstances."[13] Nearly a decade passed before Story turned full attention to his statue of the enraged sorceress. Perhaps he was prompted to begin the composition by the news that Ristori planned

to tour the United States, her American premiere having been scheduled for New York's French Theater in September 1866.[14] It is conceivable that Story knew the actress had selected *Médée* to begin her American repertoire and calculated that his countrymen would appreciate a memorial capturing the passion and poignancy she brought to the role.

Whatever Story's motives were for undertaking the statue,[15] the resulting image was a resounding success. The initial marble version, which he completed in 1866, was acquired by William H. Stone of London. Story also received orders for replicas from W. Dudley Pickman of Salem, Massachusetts, and William Tilden Blodgett, a New York entrepreneur and philanthropist.[16] For many years the arresting plaster model occupied a prominent spot in Story's Roman studio, attracting enthusiastic notice from tourists and visiting critics alike. *Medea* was first exhibited publicly in America in 1874, when William Blodgett lent his 1868 version of the statue to the new Metropolitan Museum of Art, of which he was a trustee. Two years later *Medea* was one of five American sculptures to earn a medal for "artistic excellence" at the Philadelphia Centennial Exposition, an international event at which Italian sculpture predominated.[17] Although Story must have felt gratified by the statue's favorable reception, his private letters indicate that he was disgruntled by the Philadelphia Centennial officials' insensitive handling of the piece. The lighting of the figure was unflattering: a glaring spotlight illuminated the top of the statue's head, casting the face in shade. Moreover, the exceptional popularity of the statue posed a threat to its safety. *Medea's* poniard became the frequent target of overzealous souvenir hunters, and the sculptor objected to the brusque way the breakage was reported to him, as if the piece were a damaged "old wheelbarrow." He lamented, "I was a fool to send it."[18]

In versions of the statue issued after 1866, Story decided to revise the earlier composition by decorating the base with an incised diamond pattern (a conceit perhaps suggested by his studio carvers) and modifying the fall of the drapery encircling Medea's hips. In the initial statue, bought by a British client, the cloth's overlapping arrangement had resulted in a visually confusing intersection of lines. In later models Story bunched the cloth at the right hip so that the drapery folds sloped without interruption across the figure's midsection.

A list of statues and owners that Story prepared late in his career registers copies of *Medea* made in 1866, 1867, and 1868 but omits mention of a fourth (undated) replica of the statue. Nevertheless, the provenance of the last, the version now in the Museum of Fine Arts, suggests that Story may have executed this particular *Medea* to retain for his personal collection or to serve as an extra stock item should an order be received at some future date. The work remained unsold at the time of Story's death and was among the statues Story's heirs tried to place in selected American museums when they closed the family's apartments and studio in Rome in the mid-1920s. In 1924 Story's daughter-in-law, Maud Broadwood Story, donated this *Medea*, along with *Salome*, 1871 (private collection, New York), and *Canidia*, 1882 (New York art market), to the Society for the Preservation of New England Antiquities in Boston.[19] The statue stood in the assembly hall of the society's headquarters at the Harrison Gray Otis House until 1949, when shortage of space and problems of storage necessitated its deaccession. *Medea* became the property of Isidore and Molly Bromfield, who had amassed a collection of neoclassical sculpture in Milton, Massachusetts, later passing into the art market and ultimately into a private art collection in Puerto Rico. The statue's recent return to Boston seems especially appropriate in view of Story's early residence in the city and his family's intention of finding a permanent local home for *Medea*.

J.S.R.

Notes

1. Edward Strahan, *Illustrated Catalogue: The Masterpieces of the International Exhibition 1876. The Art Gallery* (Philadelphia: Gebbie & Barrie, 1877), p. 216.

2. W.W. Story, "Cassandra," in *Graffiti d'Italia* (London: Blackwood, 1868), pp. 158-159.

3. Story to Sumner, Oct. 22, 1864, Charles Sumner Papers, Ho, HU.

4. Story to Emelyn Story, June 6, 1865, Story Family Papers, UTA. There is no evidence to prove that Story executed his first *Medea* in 1864, the date traditionally assigned to the composition. Although evidence suggests he was contemplating such a statue by the autumn of that year, he did not begin substantive work on it until 1865.

5. Story to Emelyn Story, June 2, 1865, Story Family Papers.

6. Story, studio diary, May 23, 24, 30, and June 1, 1866, Story Family Papers.

7. Story was friendly with many of the leading stage actors and actresses in Europe, including the Italian actor Tomasso Salvini, whose performance as Saul may have

influenced the sculptor's marble incarnation of the de-
mented king, and the French tragedienne Madame
Rachel, née Elisa Félix, who reportedly inspired Story's
statue *Clytemnestra*, 1876 (present location unknown, for-
merly Johann Palffey, Paris).

8. See Eleanor Conner, "Great Dramatic Artists of the
Nineteenth Century," *Call Board* (Apr. 1939), p. 5. For
contemporary descriptions of the actress, see "Adelaide
Ristori," unidentified journal (Sept. 1857), in bound vol-
ume of articles (MWEZ, n.c. 4008), The Billy Rose Theatre
Collection, The New York Public Library at Lincoln
Center, Astor, Lenox and Tilden Foundations; *Frank Les-
lies's Illustrated Newspaper*, Oct. 6, 1866, pp. 33-34; ibid.,
Oct. 13, 1866, pp. 50, 53. See also Stead Scrapbooks, The
Billy Rose Theatre Collection.

9. "Adelaide Ristori"; see note 8 above.

10. See Katherine Walker, "American Studios at Rome,"
Harper's New Monthly Magazine 33 (June 1866), p. 101.
Story's fascination with Ristori is mentioned in Henry
Greenough's fictionalized account of the Italian expatri-
ate art colony, *Ernest Carroll; or, Artist-Life in Italy* (Boston:
Ticknor & Fields, 1858), pp. 212-214.

11. Story to Lowell, Dec. 30, 1855, quoted in *Browning to
His American Friends: Letters between the Brownings, the
Storys, and James Russell Lowell, 1841-1890*, ed. Gertrude
Reese Hudson (New York: Barnes and Noble, 1965), p.
304. References to the Italian diva and deflationary com-
ments about her chief rivals are sprinkled through the
sculptor's correspondence of the 1850s and early 1860s.
In *Roba di Roma* (1862), Story's affectionate book about
contemporary Roman culture, he described Ristori's spe-
cial gift as the ability to project the intricate web of moods
that governed and animated the female heart. "Her act-
ing is more of the heart," he wrote; "love, sorrow, noble
indignation, passionate desire, heroic fortitude, she ex-
presses admirably." W.W. Story, *Roba di Roma* (London:
Chapman and Hall, 1866), vol. 1, p. 228.

12. Lady Macbeth, Semiramis, and Judith, all played by
Ristori, were subjects of Story's ideal statues.

13. Story, *Roba di Roma*, vol. 1, p. 228.

14. For a portrait of Ristori contemporaneous with her
departure for New York, see "Our Portrait Gallery," *Bal-
lou's Pictorial Drawing Room Companion*, Aug. 23, 1863, p.
668.

15. Various antique sources have also been suggested,
including masculine portrait busts of the late Roman
period, various ancient draped figures in the Vatican
sculpture collection, and figural images excerpted from
certain Pompeian frescoes. See also Frank diFederico and
Julia Markus, "The Influence of Robert Browning on the
Art of William Wetmore Story," *Browning Institute Studies*
1 (1973), pp. 63-85; the authors hypothesize that Story's
Medea may represent a collateral descendant of the so-
called *Barbarian Woman* or *Thusnelda* (Loggia dei Lanzi,
Florence).

16. The original marble version acquired by W.H. Stone
was purchased at auction in 1894 by London's Worship-
ful Company of Goldsmiths; see general ledger no. 15
(1888-1898), Mar. 15, 1894, Royal Goldsmiths Company,
London. This version was sold at Christie's, London,
Nov. 1982, lot 105, to Richard L. Feigen & Co., P. and D.
Colnaghi, and Cyril Humphris.

W. Dudley Pickman of Salem, Massachusetts, acquired
the 1867 version, which he donated in 1898 to the Essex
Institute, Salem. Pickman first offered *Medea* to the Mu-
seum of Fine Arts, but it was refused, allegedly on the
grounds that it represented the work of a modern artist
and thus fell outside the acquisition guidelines for the
Museum's permanent collection.

The 1868 version owned by William T. Blodgett was
later acquired by Henry Chauncey, who in 1894 lent it to
the Metropolitan Museum of Art, of which he was a
trustee. That version was made a permanent gift to the
Metropolitan Museum by Chauncey's heirs.

17. *Medea* was listed as item 1184 in the Exposition's art
catalogue. On the sculpture exhibited at the Philadelphia
fair, see National Collection of Fine Arts, Washington,
D.C., *1876: American Art of the Centennial*, text by Susan
Hobbs (Washington, D.C.: Smithsonian Institution Press,
1976), pp. 21-22. The version of *Medea* exhibited in Phila-
delphia, where it was listed "for sale," is probably the one
acquired by W. Dudley Pickman.

18. Story to John W. Fields, Oct. 6, 1876, Pierpont Mor-
gan Library, New York. Because the blade of *Medea*'s
knife was manufactured separately, it was especially vul-
nerable to breakage and vandalism.

19. Correspondence between Maud Broadwood (Mrs.
Thomas Waldo) Story and William C. Endicott, treasurer,
and William Sumner Appleton, corresponding secretary,
of the Society for the Preservation of New England An-
tiquities, Apr.-Oct. 1924, SPNEA, and private collection,
London. I am indebted to Linda Wesselman, SPNEA, for
confirming information about the statue's deaccession in
1949.

WILLIAM WETMORE STORY
46
Christ, about 1890
Marble
H. 76 in. (193.1 cm.), w. 29½ in. (74.9 cm.), d. 28¼
in. (71.8 cm.)
Inscribed (around base): COME UNTO ME ALL YE WHO
ARE HEAVY LADEN AND I WILL GIVE YOU REST
Gift of the grandchildren of William Wetmore
Story through Mrs. Thomas Waldo Story. 24.118
Provenance: Mrs. Thomas Waldo Story and family, Wal-
ton-on-Thames, Surrey, England
Exhibited: BMFA, "Confident America," Oct. 2-Dec. 2,
1973.

"He is by eminence our spiritualist in art," praised the critic Samuel Osgood in a review of William Wetmore Story's sculpture. "He is modeling nature and history from within outward, and proving that marble, as well as canvas and paper, can speak from within outward." Osgood noted, however, that Story had yet to master "the true aim" of modern sculpture—"to make the Christian sentiment live under the beautiful form of antiquity."[1]

By 1870, when Osgood's article was published, Story had produced a noteworthy group of monumental statues inspired by biblical legends and personalities. His incentive for memorializing such themes arose not from personal piety but from an instinctive, secular fascination with the morbid pageantry, theatrical events, and impassioned characters of Scripture. Toward the end of his career, however, Story's focus on biblical sources shifted from the suffering that predominated in the Old Testament to the consoling promise contained in the chronicle of Christianity. As if in rebuttal to Osgood's criticism, Story decided to commemorate the revelation of hope expressed in the New Testament by creating an idealized statue of Christ, an ambitious project he initiated in 1886-1887.

Other nineteenth-century American sculptors before Story had attempted portraits of Christ in marble, but most of these depictions seem to have issued from a common model: Bertel Thorwaldsen's well-known *Blessing Christ*, 1821 (Church of Our Savior, Copenhagen). In contrast, Story's interpretation, which bears compositional resemblance to the Italian sculptor Giovanni Dupré's imploring *Risen Christ* (Villa Arganini, Fiesole?, Italy), was considered a novelty in its period costuming and ethnic characterization. Story visualized Christ as a mysteriously hooded man wearing the exotic robes of an Arab sheik. The six-foot figure dramatizes the moment when Christ entreats, "Come unto me, all ye who labor and are heavy laden, and I will give you rest" (Matthew 11:28).

As was his customary practice, Story took pains to ensure the historical authenticity of his subject's attire, borrowing a set of ancient oriental robes from Wilfrid Scawen Blunt, an English diplomat and poet who resided near Cairo. Describing the composition to a friend's wife, the sculptor emphasized the appropriateness of the outfit to Christ's era, noting the loose undervestment and sash, the "coat without seam," and the head covering, which simulated "the napkin folded & laid on his [Christ's] sepulcher." "This was undoubtedly the actual dress he wore," Story insisted; "fashions do not change in

the East & this dress always has been worn for 2000 years as far as I know."[2] Story must have spent long hours studying the billowing movement and complex effect of folds created by the fall of these yards of cloth over a supporting figure.

Story seems to have devoted similarly careful thought to the historical question of Christ's physical appearance.[3] Eschewing conventional Renaissance images that depicted the Savior with westernized features, Story portrayed his subject with a Semitic physiognomy, suggested in the prominent forehead, deep-set eyes, and slightly aquiline nose. "I have given him . . . the oriental Jewish face," he wrote.[4] The esoteric issue of historical documentation, however, was less involving than the larger challenge of conveying a sense of Christ's hypnotic presence and expressing the abstract spiritual qualities he symbolized.

In a poem published in his *Graffiti d'Italia* (1868), Story pondered the imagined difficulties encountered by Leonardo da Vinci in devising Christ's portrait for *The Last Supper*. The fictional Leonardo begins his monologue with a defense of his delay in completing Christ's likeness; he reflects, "What should be / the pure perfection of our Saviour's face— / What sorrowing majesty, what noble grace." The character further acknowledges his fruitless search for a model to pose as a "fitting type of that divinest worth / That has its image solely in the mind." In frustration, he concedes, "Vainly my pencil struggles to express / The sorrowing grandeur of such holiness. / In patient thought, in ever-seeking prayer, / I strive to shape that glorious face within, / But the soul's mirror, dulled and dimmed by sin, / Reflects not yet the perfect image there."[5]

Unlike the protagonist of his poem, Story was not daunted by the exercise of modeling Christ's "perfect image." In his statue he managed to synthesize both human and otherworldly qualities. The figure's hands, with their graceful elongated fingers, have been sensitively posed to suggest the subtle, invocatory manner in which Christ preached his philosophies, the outstretched arm symbolizing his accessibility to the common crowd. The pensive, ascetic face emanates a compassion befitting the Man of Sorrows. Yet at the same time, Christ's eyes, with their deep sockets and drilled pupils, appear fixed in an inscrutable, penetrating gaze that eludes contact with the viewing audience and seems to focus somewhere beyond our powers of observation—or comprehension. A visitor to Story's studio described the monumental figure as "moved with the tender compassion for tired and tried human-

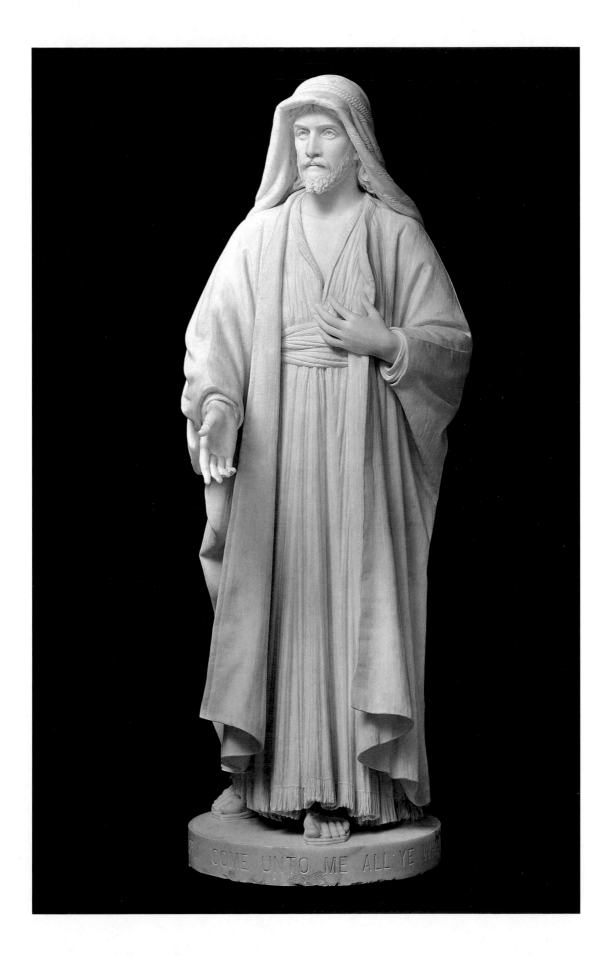

ity. It is a most powerful sermon in stone, and if placed in a Christian temple where the light might fall full upon it, no word or preacher nor song of choir would be needed to draw men to the feet of the loving, tender Master, who uttered the most significant invitation ever given—the invitation that is carved deep into the marble pedestal."[6]

The process of supervising the transfer of *Christ* from plaster to marble proved time-consuming for the elderly sculptor. As he informed his son Thomas Waldo, in November 1890, "All is going on well in the studio . . . the Christ nearly blocked out."[7] There is no evidence that the finished marble was ever commissioned or sold by the sculptor, although he apparently hoped to interest a buyer in it. He is reported to have asked a price of eight thousand dollars for the statue.[8] Despite the absence of a patron, Story probably proceeded to execute the figure in marble so that he could conclude his sweep of historical character studies on an exalted, spiritual note.

Story's *Christ*, which remained unsold in the sculptor's lifetime, was entrusted to the care of his children after his death. A moratorium seems to have been imposed on dispersing or otherwise settling the destiny of the contents of his studio until the early 1920s, when the surviving family members made plans to dispose of their property in Rome. Through Mrs. Thomas Waldo Story (née Maud Broadwood), widow of Story's eldest son, *Christ* was offered to the Museum of Fine Arts as a gift of the sculptor's grandchildren.[9]

J.S.R.

Notes

1. Samuel Osgood, "American Artists in Italy," *Harper's New Monthly Magazine* 41 (Aug. 1870), p. 423.

2. Story to Eliza (Mrs. John W.) Fields, Mar. 9, 1887, Pierpont Morgan Library, New York.

3. Nineteenth-century scholars provided artists intent on representing a "factual" Christ with abundant documentation on the subject. For an example, see Thomas Heaphy, "An Examination into the Antiquity of the Likeness of Our Blessed Lord," *Art-Journal* (London) 23 (n.s. 7) (1861), pp. 1-5, 33-37, 65-68, 109-113, 129-132, 177-178, 205-207, 233-236.

4. Story to Eliza Fields, Mar. 9, 1887, Pierpont Morgan Library.

5. W.W. Story, "Leonardo da Vinci Poetises to the Duke in His Own Defense," in *Graffiti d'Italia* (London: Blackwood, 1868), pp. 90-91.

6. Unidentified visitor, quoted in Mary E. Phillips, *Reminiscences of William Wetmore Story, the American Sculptor and Author* (Chicago: Rand, McNally, 1897), pp. 248-249.

7. Story to Thomas Waldo Story, Nov. 23, 1890, Story Family Papers, UTA.

8. Phillips, *Reminiscences*, p. 233.

9. See *Bulletin of the Museum of Fine Arts* 22 (1924), p. 19.

Anne Whitney (1821–1915)

Anne Whitney first distinguished herself as a poet, but she became best known for her sculpture, which she created both in the United States and abroad. Born in Watertown, Massachusetts, into a family of comfortable means, she was the youngest of the seven children of Sarah (Stone) and Nathaniel Ruggles Whitney, Jr. Before she turned twelve, the family moved to East Cambridge, where her father served as justice of the peace from 1839 to 1859; in 1850 the Whitneys returned to a part of Watertown that later became Belmont. Educated chiefly by private tutors, Whitney showed a spirited intellect, which her parents encouraged. She inherited their abolitionist sympathies, and her ardent support of social reform had a decided influence on the subject matter of her sculpture.

During the late 1840s and 1850s Whitney's verse was published, and in 1859 her collected *Poems* appeared.[1] In the interim, a trivial incident reportedly sparked her interest in becoming a sculptor. When a pot of sand was accidently overturned in a greenhouse, Whitney found herself deriving great pleasure from modeling the damp material.[2] Her first tentative efforts at sculpture date from about 1855 and were portrait busts, mainly of relatives. In about 1857 she made a bas-relief of Chaucer (present location unknown), whose witty and pointed satire of social conditions appealed to her.[3] Determined to acquire some instruction, Whitney spent a year in Philadelphia and New York drawing, modeling, and studying anatomy at a Brooklyn hospital. By 1860 she was skillful enough to have a sculpture accepted for exhibition at the National Academy of Design, New York, where she showed a marble bust of a child, *Laura Brown*, 1859 (National Museum of American Art, Washington, D.C.).

The outbreak of the Civil War interrupted Whitney's plans to go to Italy, where American sculptors had trained since the 1820s, and she spent the war years at her family home in Belmont. She lost no time in seeking further instruction and found it at the hand of William Rimmer, with whom she studied privately for two years. Needing work space of her own, Whitney established a studio at her house and in several rented locations in Boston. Her first important sculpture was a life-size marble, 1863, representing Lady Godiva at the moment she resolved to ride naked through the streets to lessen the oppressive tax burden of the peasants. In selecting Alfred Tennyson's heroine, Whitney appears to have been airing her own views about the courage

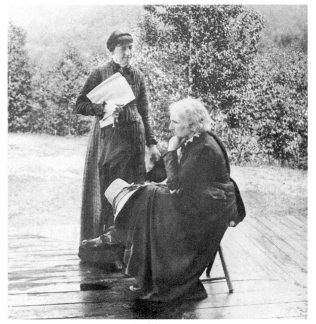

Anne Whitney (seated) and Abby Adeline Manning

required to achieve justice. It was Whitney's portrayal of the subject's lofty sentiment that appealed to Victorian sensibility, and *Lady Godiva* (private collection, Dallas) drew considerable attention in 1864 when it was exhibited at Boston's Childs & Jenks Gallery and at New York's Schauss Gallery.

Another major work from this decade was *Africa*, 1864, a large plaster representing a recumbent female who, scarcely awake from slumber, shades her eyes from the blinding light of newly won freedom. The piece was exhibited at Childs & Jenks in 1864-1865 and at the National Academy of Design, New York, in 1865, receiving mixed reviews. Although the figure clearly expressed Whitney's antislavery beliefs, it was never cast in bronze or cut in marble, and, in fact, the sculptor destroyed it some years later.

When the Civil War ended, Whitney left for Europe in 1867 with her companion the painter Abby Adeline Manning (1836-1906). For almost four years, Whitney stayed principally in Rome, making visits to Florence, Munich, and Paris, but in 1870, when Garibaldi lay siege to the city, she returned briefly to America. Drawing in the galleries and modeling in her studio in Rome kept Whitney busy, and not wishing to be distracted, she generally shied away from the active social life around her. Whitney was nevertheless friendly with Harriet Hosmer, her fellow townswoman, and Edmonia Lewis (1843/1845–after 1911) who, along with Whitney and several other American women sculptors in the

mid- to late nineteenth century, were pursuing their careers in the Eternal City.

Upon arriving in Rome, Whitney executed *The Chaldean Shepherd*, or *The Astronomer*, about 1868 (Smith College Museum of Art, Northampton, Massachusetts), and produced a plaster statuette, *The Lotus Eater*, 1868 (The Newark Museum, New Jersey), which was based on a life-size plaster of this subject, conceived in Boston in 1862 and destroyed in shipment to Rome in 1867. Both works show a languid youth represented in a classicizing vein. During this period Whitney created two more statuettes, *Roma*, 1869,[4] and *Toussaint L'Ouverture*, about 1870 (present locations unknown), that reflected her continuing advocacy of social change. Always the champion of the oppressed, in her powerful figure *Roma* she exposed the wretched condition of Roman peasants. The peasants were not the sole object of her concern, however, and no contemporary viewer misunderstood the sculpture's symbolism. The city, in the guise of an old beggar woman, long familiar from Hellenistic prototypes, was portrayed as impoverished under papal control, reflecting Whitney's belief that the situation could be improved only by the unification of Italy under a free and liberal government. According to Elizabeth Rogers Payne, the sculptor had the audacity to place a satiric mask of a certain influential cardinal in the folds of the figure's dress. As soon as the identity of the cardinal was recognized, the statuette was sent to the American minister in Florence for fear of harm to the work or to the sculptor herself. Later Whitney removed the mask and substituted a mitre.[5] *Roma* proved to be a popular piece: it existed both in marble and in bronze, 1890 (The Wellesley College Museum, Massachusetts), and was exhibited in one form or another at the International Exposition in London in 1871, at the Philadelphia Centennial in 1876, and at the World's Columbian Exposition in Chicago in 1893.[6] The haunting statuette of *Toussaint L'Ouverture* pays homage to the celebrated Haitian leader who liberated his people. Whitney presented the black hero in jail, where Napoleon I had sent him to die, leaning forward and tracing on the floor the words "Dieu se charge." The sculptor later exhibited this stirring work in Boston.

After her return to Boston in 1871, Whitney opened a studio and received a commission in 1873 from the state of Massachusetts for a marble statue of Samuel Adams to be placed in the new Statuary Hall of the United States Capitol. The committee stipulated that the carving be done in Italy and, obliged to oversee the selection of the stone, Whit-

ney departed for her third trip to Europe in 1875. While the marble cutters blocked out the statue, Whitney passed the summer and autumn months in the countryside of France where she made *Le Modèle* (q.v.). Completed in 1875, the *Adams* was shipped to Boston and exhibited at the Athenaeum the following year. Bostonians found that the statue, showing the patriot with his arms folded across his chest, perfectly conveyed their native son's forceful personality and commissioned a bronze replica that was erected in 1880 in Dock Square in front of Faneuil Hall.

Whitney resumed permanent residence in the United States in May 1876 and the following autumn bought a house at 92 Mount Vernon Street in Boston, where she worked for almost twenty years in an increasingly naturalistic style. During this period she created a great many portraits, including marble busts of such notable reformers as William Lloyd Garrison, after 1878 (Massachusetts Historical Society, Boston); Harriet Beecher Stowe, 1892 (Hartford Public Library, on loan to the Stowe-Day Foundation, Hartford, Connecticut); Lucy Stone, 1892 (Boston Public Library); and Francis Willard, 1892 (The Willard House [WCTU Museum], Evanston, Illinois). She also executed two major late statues: the heroic-size seated marble of the English author and reformer Harriet Martineau, 1883 (destroyed by fire at Wellesley College, 1914), and the bronze *Leif Ericsson*, 1885, erected on the Commonwealth Avenue Mall, Boston, in 1887.

The last two decades of Whitney's life were spent in a spacious apartment on the top two floors of the Charlesgate Hotel, where, into her eighties, she produced busts and medallions with characteristic energy. Of particular note is Whitney's final sculpture, a life-size seated bronze statue of Charles Sumner, 1900, which was executed from an earlier model. In 1875 the sculptor had anonymously entered the model in a competition, which she won; the commission was given to Thomas Ball, however, after the judges learned that the victor was a woman. For twenty-five years the injustice rankled Whitney, and, in the end, the subject became the most important of her life.[7] In December 1902, on a day when Whitney must have experienced keen satisfaction, the *Sumner* was unveiled in Harvard Square in Cambridge, Massachusetts. Her last years passed quietly, and in 1915 at the age of ninety-three, Whitney died of cancer in Boston.

K.G.

Notes

1. Anne Whitney, *Poems* (New York: Appleton, 1859).

2. Mary A. Livermore, "Anne Whitney," in *Our Famous Women* (Hartford, Conn.: Worthington, 1883), p. 673.

3. Elizabeth Rogers Payne, "Anne Whitney: Art and Social Justice," *Massachusetts Review* 12 (spring 1971), p. 246. Payne, former editor of the Whitney Papers, Wellesley College, has provided the most thorough listing of Whitney's sculpture to date in "Anne Whitney, Sculptor," *Art Quarterly* 25 (autumn 1962), pp. 248-261.

4. For an enumeration of the different sizes and materials of *Roma*, see Payne, "Anne Whitney, Sculptor," pp. 250-251.

5. Payne, "Whitney: Art and Social Justice," p. 248.

6. See note 4.

7. Payne, "Whitney: Art and Social Justice," p. 260.

References

Boston Globe, Jan. 24, 1915, obit.; BMFA 1979, p.14 and no. 15; BPL, BAA; E.H.C., "Miss Anne Whitney," *Boston Evening Transcript,* Jan. 25, 1915; Clara Erskine Clement, *Women in the Fine Arts* (Boston: Houghton Mifflin, 1904), p. 362; Craven 1968, pp. 228-232; Joseph L. Curran, *Watertown's Victorian Legacy: A Bicentennial Art Exhibition* (Watertown: Free Public Library, 1976), pp. 13-14; Detroit 1983, pp. 71-73; Kathryn Greenthal, "Late Nineteenth Century American Sculpture in Its International Context," in *La Scultura nel XIX Secolo*, edited by Horst W. Janson, *Atti del XXIV Congresso Internazionale di Storia dell'Arte*, vol. 6 (Bologna: C.L.U.E.B., 1984), pp. 243-244; Mary A. Livermore, *Our Famous Women* (Hartford, Conn.: Worthington, 1883), pp. 668-690; *National Cyclopaedia of American Biography*, vol. 7, p. 72; *Notable American Women*; Elizabeth Rogers Payne, "Anne Whitney: Art and Social Justice," *Massachusetts Review* 12 (spring 1971), pp. 245-260; idem, "Anne Whitney, Sculptor," *Art Quarterly* 25 (autumn 1962), pp. 244-261; Rubinstein 1982, pp. 82-83; Harriet Prescott Spofford, *A Little Book of Friends* (Boston: Little, Brown 1916), pp. 43-66; Taft 1930, pp. 213-214, 542; Robert Taylor, "The Roving Eye: Who Was Anne Whitney?" *Boston Herald*, June 10, 1963; Margaret Farrand Thorp, "The White, Marmorean Flock," *New England Quarterly* 32 (June 1959), pp. 165, 167-168; Vassar College Art Gallery, Poughkeepsie, N.Y., *The White, Marmorean Flock: Nineteenth Century American Women Neoclassical Sculptors*, catalogue by Nicolai Cikovsky, Jr., Marie H. Morrison, and Carol Ockman (1972); Wellesley College Archives, Mass.; Whitney 1976, p. 320; Frances E. Willard and Mary A. Livermore, *American Women: Fifteen Hundred Biographies*, rev. ed. (New York: Mast, Crowell & Kirkpatrick, 1897), vol. 2, p. 769.

ANNE WHITNEY

47

Le Modèle, 1875
Bronze, green over brown patina, sand cast
H. 18½ in. (47 cm.), w. 11¼ in. (28.6 cm.), d. 13 in. (33 cm.)
Signed (on base at right side): A.W. /1875
Inscribed (on front): Le Modele
Foundry mark (on sitter's left shoulder): Gruet Jeune F.deur
Gift of Mrs. Maria Weston Chapman. 85.423

Provenance: Maria Weston Chapman, Boston
Exhibited: Centennial Exhibition, Philadelphia, 1876, no. 987; BMFA, *Catalogue of Works of Art Exhibited on the Second Floor*, pt. 2, *Paintings, Drawings, Engravings, and Decorative Art* (1886), no. 20; BMFA 1979, no. 15.

Le Modèle is the title Anne Whitney gave to her portrait (inscribed "Le Modele," without the grave accent) of an old peasant woman who frequently posed for artists. The bust was modeled in the summer of 1875 during Whitney's stay in Ecouen, France, and was cast in Paris later that year by the Gruet Jeune Foundry. It appears to be the first work the sculptor had cast in bronze.[1]

In the spring of 1875, on her third trip to Europe, Whitney arrived in Italy to select the marble for the statue of Samuel Adams. She then joined her friend, the painter Abby Adeline Manning in Paris, where they both studied the sculpture in the current Salon exhibition. Although Whitney found the subject matter of the French entries too frivolous, she had praise for their technique. Like dozens of fellow Americans before her, she realized that Paris was where one really learned one's art: "Everybody is struck with the amazing talent of the French. . . . Their knowledge + mastery of technique are a splendid possession—but they show up at the same time a painful inadequacy of aim + idea. . . . The powerful things want thought the thoughtful works want power—but it is the place to learn the alphabet + grammar of art. . . . Paris is the great, beautiful center of the world."[2]

In July, Whitney and Manning traveled to Ecouen, a picturesque village near Paris that was popular with artists. Ecouen proved to be an ideal environment for their endeavors, and they abandoned plans to go to Switzerland. They spent their time working, taking walks, and visiting studios, such as that of Jean François Millet (1814-1875). By August, Whitney was creating *Le Modèle*, and on September 6, she wrote: "My last bust, the head of an old peasant woman—has been a pretty severe

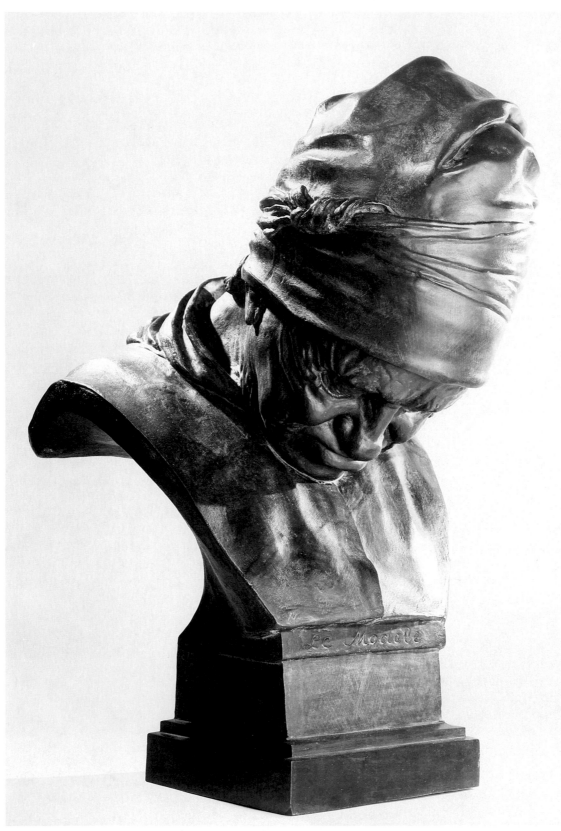

47

study + lacking something of being finished it has not been seen xcept [*sic*] by our friends here."[3] She also called her sitter "a venerable witch."[4] The aged model had the reputation of falling asleep the moment she started to pose, and, as was her custom, her eyes closed and her head dropped upon being seated in Whitney's studio. Unable to keep her awake, Whitney proceeded to model her asleep, and the sculptor's versatility delighted the French artists who had been tormented by the peasant's somnolent habits.

Shown with her chin touching her chest and wearing the *marmotte*, the traditional headdress of the peasant, the old woman is the very embodiment of the weary laborer. Every sun-induced wrinkle is recorded, and, altogether, the bust is a superb example of realism. Further, *Le Modèle* can be interpreted as representing an entire class of people. Mary Livermore, Whitney's first biographer, felt the bust symbolized France itself: "Broken by revolutions, worn out by war, overcome by domestic violence, degraded by submission to a despotism under the name of a republic—desiring only rest."[5]

The atmosphere and timing were right for Whitney to experiment with bronze as the medium for *Le Modèle*. On a practical level she was well aware that it was less expensive to have the piece cast in bronze than to have it carved in marble, and the process was of shorter duration.[6] In terms of technical skill Whitney could find no better foundry than the firm of Gruet in Paris. In the end what she created was a work of astonishing originality and prescience. This naturalistic head of a peasant is remarkable for its early and profound interpretation of the subject in sculpture. Although the working peasant became the focus of attention in paintings by Gustave Courbet (1819-1877), Jean Francois Millet, and others after the 1848 Revolution, sculptors were slower to adopt the image. Whitney's *Le Modèle* has the distinction of predating sculpture with the theme of labor by contemporary European artists like Jules Dalou (1838-1902), Achille d'Orsi (1845-1929), Vincenzo Vela (1820-1891), and Constantin Meunier (1831-1905).

Whitney was so pleased with the bust that she showed it at the Centennial Exhibition in Philadelphia in 1876. In 1879 *Le Modèle*, recorded as "bronze head of a French peasant," was lent to the Museum of Fine Arts by the sculptor. By 1883 it belonged to Maria Weston Chapman, organizer of the Boston Female Anti-Slavery Society, onetime assistant to William Lloyd Garrison on the *Liberator*,

the abolitionist newspaper, and the person who commissioned from Whitney the eight-foot marble statue of Harriet Martineau, 1883 (destroyed by fire at Wellesley College, 1914). Mrs. Chapman first offered the bust to the Museum in a letter to Charles G. Loring, director, in May 1883 but withdrew her proposal when it appeared that the work might not be "entirely welcome." In his reply, Loring recalled that the head, which he referred to as "a very forcible work," had been on exhibition at the Museum for a year at his request; he himself felt that it ought to "have a home" in the Museum and that "all Boston artists should be represented here at their best." As he explained, however, "some of our committee have very decided options on this matter of modern sculpture." In 1885, while Loring was still director, Mrs. Chapman renewed her offer, which was accepted, and she gave *Le Modèle* to the Museum shortly before her death.[7]

K.G.

Notes

1. See Elizabeth Rogers Payne, "Anne Whitney, Sculptor," *Art Quarterly* 25 (autumn 1962), pp. 248-261.

2. Whitney to unidentified correspondent, June 8, 1875, Anne Whitney Papers, Wellesley College Archives, Mass.

3. Whitney to unidentified correspondent, Sept. 5, 1875, Whitney Papers.

4. Whitney to her sister, Sarah, Sept. 19, 1875, Whitney Papers.

5. Mary A. Livermore, *Our Famous Women* (Hartford, Conn.: Worthington, 1883), p. 688.

6. Whitney to her brother Edward, Oct. 17, 1875, Whitney Papers.

7. See correspondence between Chapman and Charles G. Loring, May 17, [18-21], 22, July 2, 1883, July 5, 1885, and between Whitney and Loring, May 21, 1885, BMFA, 1876-1900, rolls 547, 551, 552, in AAA, SI.

William Morris Hunt (1824 – 1879)

Best known as a portrait and landscape painter and dynamic teacher of drawing, William Morris Hunt confined his sculpture production to his student days. Hunt was also the earliest champion in Boston of the Barbizon School and an avid promoter of the work of other Americans. In 1852 he purchased Jean François Millet's (1814-1875) *The Sowers*, about 1850 (Museum of Fine Arts, Boston), which inspired the collecting habits of Martin Brimmer and Quincy Adams Shaw, both generous patrons and founders of the Museum. Hunt's influence as an artist, his popularity as a raconteur, and his handsome if eccentric appearance—all contributed to his acceptance as an arbiter of taste in mid-nineteenth-century Boston.

Hunt was born in Brattleboro, Vermont, to Jane Maria (Leavitt) and Jonathan Hunt, who represented the state in Congress. When his father died in 1832, the family moved to New Haven, and Hunt, his mother, and sister Jane took painting lessons with a Sicilian political refugee and portraitist, Spiridione Gambardella (active 1838-1872).[1] In 1838 the family relocated to Boston, where Hunt studied modeling with the sculptor John Crookshanks King (1806-1882) and learned to cut cameo portraits.[2] A gold bracelet (Museum of Fine Arts, Boston; see illustration) made up of shell cameos of himself and his three brothers, Richard Morris, Jonathan, and Leavitt, was skillfully done by Hunt about the time he entered Harvard in 1840.[3]

A mediocre student but an accomplished wit, Hunt was dismissed at the end of his junior year for caring more for "his drawing, carving, his music, and his various accomplishments" than for his studies.[4] That fall he traveled in Europe with his family and toured the Apennines with the future historian Francis Parkman, a Harvard classmate. In 1844 he entered the Rome studio of the American sculptor William Kirke Brown (1814-1886), where he again

Cameo bracelet. 08.211

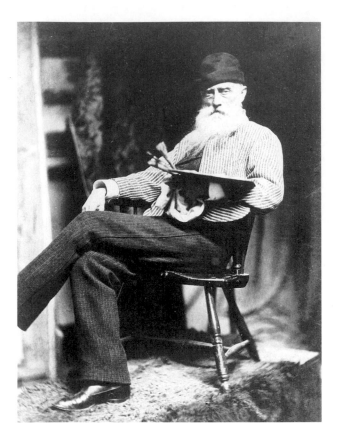

carved cameos and modeled a head of *Psyche* (present location unknown) after the Hellenistic *Psyche of Capua* in Naples (National Museum).

In 1845 Hunt went to Düsseldorf but found the curriculum at the Academy there repetitive and stultifying. After nine months he left for Paris to study with the eminent classicist James Pradier (1790-1852). Finding the popular sculptor's classes filled, Hunt entered the studio of Thomas Couture (1815-1879), whose painting *The Falconer*, about 1845 (The Toledo Museum of Art, Ohio), with its bold brushwork and luminous color, had excited him on his arrival. He quickly became Couture's favorite pupil, changing his focus to painting and incorporating many of his teacher's allegorical subjects, compositional devices, and painting methods into his own compositions. Hunt's bronze medallion of Couture, 1848 (Brooks Memorial Library, Brattleboro, Vermont) shows his early shift from neoclassicism to a bolder and freer romanticism. In *The Prodigal Son*, 1851 (Brooks Memorial Library), and *The Fortune Teller*, 1852 (Museum of Fine Arts, Boston), Couture's influence is especially evident: large, sharply outlined figures are placed against a neutral background, close to the picture plane, emphasizing the flatness of forms. While Couture was working

on his monumental history painting *The Enrollment of the Volunteers*, 1848 (Museum of Fine Arts, Springfield, Massachusetts), Hunt was encouraged to begin the relief of *The Flight of Night*. During this time, William and his brother Richard Morris (1827-1895), an architecture student at the Ecole des Beaux-Arts, also became closely associated with the famed animalier Antoine-Louis Barye (1796-1875), from whom they took classes.

In 1851 Hunt saw Millet's paintings for the first time at the Paris Salon and was deeply impressed by his heroic depiction of peasant life. Within the year Hunt moved to Barbizon to live and work with him. Under Millet's influence, Hunt began using rural subjects and softening the edges of his forms, as seen in his painting *Girl Reading*, 1853 (Museum of Fine Arts, Boston). Later commissioned portraits such as the full-length *Judge Lemuel Shaw*, 1859 (Essex Bar Association, Salem, Massachusetts), which brought him much acclaim (as well as criticism), are more like idealized character studies than realistic portrayals.

On his return to Boston in 1855, Hunt married Louisa Dumaresq Perkins, granddaughter of Colonel Thomas Handasyd Perkins, one of the wealthiest merchants in America. From 1856 to 1862 the couple lived in Newport, Rhode Island, at Hilltop, where they built a studio large enough for the many students who flocked to Hunt's classes. Henry James, who studied with Hunt in 1859 and 1860 along with his brother William and the artist John La Farge (1835-1910), later recalled that his teacher had "an easy lightness, a friendliness of tact, a neglect of conclusion."[5] Although Hunt soon lost touch with the avant-garde of Paris, his philosophy continued to reflect a belief in originality and spontaneity.

Until the mid-1860s Hunt exhibited regularly at the Boston Athenaeum, primarily showing landscapes and portraits. In 1866 he helped found the Allston Club of Boston, an artists' group that opposed the conservatism of the Athenaeum and the Boston Art Club. From then on, he showed his works almost exclusively at his own studio or other private galleries. During the 1870s, as Hunt's brushstrokes became looser and his forms more simplified, his work was compared with the subjective, painterly landscapes of George Inness (1825-1894). In 1872 his personal fortunes changed, however, when the great Boston fire destroyed the contents of his Summer Street studio, and shortly thereafter he separated from his wife. From then

on he traveled restlessly, as he searched for companionship.

Considered by many the hoped-for successor to Washington Allston, Hunt, too, was obsessed with an "incompletable masterpiece."[6] Like *Belshazzar's Feast*, 1817-1843 (The Detroit Institute of Arts), which Allston never finished, *The Flight of Night* became Hunt's nemesis. Invited to decorate the Assembly Chambers of the new State Capitol in Albany, New York, in 1878, Hunt was excited by the prospect of realizing his lifelong desire to paint the allegory of Anahita, the Persian goddess of the moon and night. The pressure, however, of producing the murals in one year and his anxiety about their artistic shortcomings caused Hunt's nervous collapse. On the day before he drowned on the Isles of Shoals off the coast of New Hampshire, Hunt told the writer Celia Thaxter that he had "only just begun to have a shadow of an idea how to paint! That the Albany work has taught me. And I shall never paint again."[7]

Two months after Hunt's death in November 1879, the Museum held a memorial exhibition of his work, which included over three hundred and twenty paintings and drawings. The following February an estate sale of Hunt's paintings and charcoal drawings was held at Horticultural Hall, Boston, achieving a record amount for the sale of paintings in Boston. But by 1914, when Mabel Hunt Slater endowed a room at the Museum where her father's paintings were hung until 1944, Hunt's reputation was on the decline. Another generation had found his brown palette out-of-fashion, and, despite a Museum-sponsored retrospective of his work in 1924, Hunt's strengths were not considered again until 1979, when a second memorial exhibition organized by the Museum helped to reestablish his importance both as an inspired teacher and as an innovative artist.[8]

P.M.K.

Notes

1. Jane Maria Hunt's portrait of William at age fourteen was shown at the Museum's memorial exhibition for Hunt in 1879. See BMFA, *Exhibition of the Works of William Morris Hunt* (1879), p. 60.

2. For a discussion of nineteenth-century cameo-cutters including Hunt, see Gertrude S. Cole, "Some American Cameo Portraitists," *Antiques* 50 (Sept. 1946), pp. 170-171. See also Howard M. Chapin, *Cameo Portraiture in America* (Providence: Plimpton, 1918). The Museum of Fine Arts also owns three shell cameo portraits by King, of Horace Greeley, Benjamin Franklin, and Sir Walter

Scott (after a bust by Sir Francis Chantrey), and a portrait of Otis Norcross by an unknown cameo cutter. See BMFA, ADA.

3. The bracelet was a 1908 bequest to the Museum by Hunt's sister Jane (1822-1874), a watercolorist who lived in both California and Newport. Hunt's brothers (reading from left to right, after Hunt's self-portrait) all received professional training abroad. Richard Morris was the first American architect to be trained at the Ecole des Beaux-Arts, Paris. He studied there with Hector Martin Lefuel (1810-1880), chief architect to the Louvre under Napoleon III, who inspired him to incorporate the French Renaissance Revival style into his own later designs for Newport, R.I., and New York's Fifth Avenue residences. Jonathan (1826-1874) studied at the Ecole de Médecine in Paris in 1845, later devoting his practice to helping the poor. He committed suicide after a severe illness and over worry about his illegitimate daughter, who was mentally ill. Leavitt (1830-1907), a law and language student at the University of Heidelberg, became a colonel during the Civil War. Although he practiced law in New York, he was never financially solvent and was always in debt to the family. See Paul R. Baker, *Richard Morris Hunt* (Cambridge: MIT Press, 1980).

4. Henry C. Angell, *Records of William M. Hunt* (Boston: Osgood, 1881), p. xi.

5. Henry James, *Notes of a Son and Brother* (New York: Scribner's, 1914), p. 83. From 1868 to about 1875 Hunt also taught classes for women in Boston, in which he emphasized the importance of feeling over discipline. Elizabeth Boott Duveneck (whose tomb effigy [q.v.] was executed by Frank Duveneck) was one of about fifty women who studied with him. See Martha J. Hoppin, "Women Artists in Boston, 1870-1900: The Pupils of William Morris Hunt," *American Art Journal* 13 (winter 1981), pp. 17-46.

6. See Henry Adams, "William Morris Hunt's 'Chef d'Oeuvre Inconnu,' " *Proceedings of the New York State Capitol Symposium* (Albany: Temporary State Commission on the Restoration of the Capitol, 1983), pp. 103-104.

The idealism of Hunt was linked with that of Allston in Clarence Cook's obituary for Hunt, *New York Herald Tribune*, Sept. 9, 1879. Henry James immortalized the artist who struggles in vain to create the perfect painting in his short story "The Madonna of the Future," in *A Passionate Pilgrim and Other Tales* (Boston: Houghton Mifflin, 1884), pp. 261-325. Henry Adams also points out the irony that Couture, too, never finished his masterpiece *The Enrollment of the Volunteers*. See Adams, "The Development of Hunt's Murals at Albany" [1980], p. 18, copy of essay in BMFA, ADA.

7. Celia Thaxter, "Last Days of William Morris Hunt" (1925), p. 36, Houghton Mifflin Papers, Ho, HU. Despite Hunt's self-condemnation, however, most contemporary critics thought the murals were "the finest of all Hunt's work." [Maria R. Oakey], "William Morris Hunt," *Harper's New Monthly Magazine* 61 (July 1880), p. 162.

Hunt's death was described as a suicide "caused by melancholia" in the *Boston Daily Advertiser*'s obituary, Sept. 10, 1879.

8. In John Marquand's 1939 novel *Wickford Point*, the young mural painter Archie Wright is quick to minimize Hunt's artistic merits, even to the local pastor who remembers Hunt's summers at the resort (Magnolia, Mass.). See Henry Adams, "The Contradictions of William Morris Hunt," BMFA, *William Morris Hunt: A Memorial Exhibition* (1979), p. 20.

References

Henry Adams, "The Development of Hunt's Murals at Albany" [1980], p. 18, copy of essay in BMFA, ADA; idem, "The Development of William Morris Hunt's *The Flight of Night*," *American Art Journal* 15 (spring 1983), pp. 43-52; idem, "William Morris Hunt's 'Chef d'Oeuvre Inconnu,' " *Proceedings of the New York State Capitol Symposium* (Albany: Temporary State Commission on the Restoration of the Capitol, 1983), pp. 97-105; Henry C. Angell, *Records of William M. Hunt* (Boston: Osgood, 1881); BMFA, *William Morris Hunt: A Memorial Exhibition* (1979), essays by Henry Adams and Martha Hoppin, catalogue by Martha Hoppin; Albert Boime, *Thomas Couture and the Eclectic Vision* (New Haven: Yale University Press, 1980); *Boston Daily Advertiser*, Sept. 10, 1879, obit.; Edward Waldo Emerson, *The Early Years of the Saturday Club, 1855-1870* (Boston: Houghton Mifflin, 1918), pp. 465-473; Gardner 1945, pp. 67, 75; Gardner 1965, pp. 21-23; Harvard College, Class of 1844, *Fiftieth Anniversary Report* (1896), pp. 133-141; Isabella Stewart Gardner Museum, Boston, *Sculpture in the Isabella Stewart Gardner Museum* (1977), catalogue by Cornelius C. Vermeule III, Walter Cahn, and Rollin van N. Hadley (1977), p. 159; Helen Knowlton, *Art-Life of William Morris Hunt* (Boston: Little, Brown, 1899); idem, "William Morris Hunt," *New England Magazine* 10 (Aug. 1894), pp. 685-705; MMA; The Metropolitan Museum of Art, New York, *American Painting in The Metropolitan Museum of Art* (1985), vol. 2, pp. 199-201, 213-217; *New York Herald Tribune*, Sept. 9, 1879, obit.; [Maria R. Oakey], "William Morris Hunt," *Harper's New Monthly Magazine* 61 (July 1880), pp. 161-166; University of Maryland, Art Gallery, College Park, *The Late Landscapes of William Morris Hunt*, catalogue by Marchal E. Landgren and Sharman Wallace McGurn (1975).

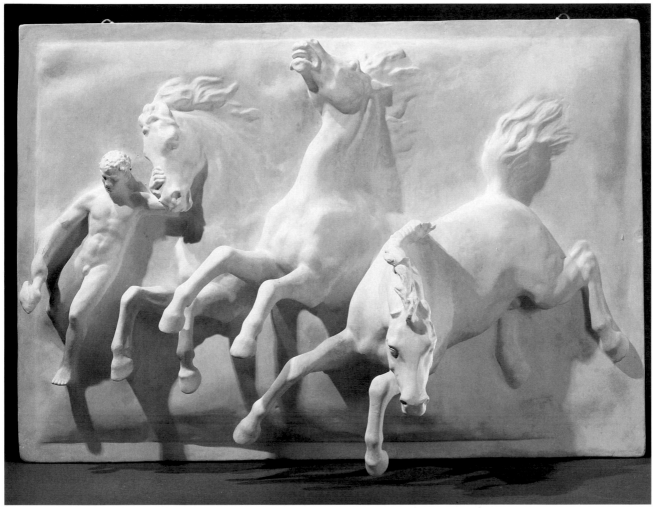

48

WILLIAM MORRIS HUNT
48
The Flight of Night, about 1880 (modeled in 1848)
Plaster
H. 19½ in. (49.5 cm.), w. 28½ in. (72.4 cm.), d. 12
in. (30.5 cm.)
Lent by Estate of Louisa D. Hunt. 2206.13a

Provenance: Louisa D. Hunt, Boston; lent to Museum in
1896*
Exhibited: BMFA, "Confident America," Oct. 2 - Dec. 2,
1973.
Versions: *Plaster:* (1) The Detroit Institute of Arts, (2)
William Morris Hunt II, Boston, (3) Isabella Stewart
Gardner Museum, Boston, (4) The Metropolitan Mu-
seum of Art, New York, (5, 6) Museum of Fine Arts,
Boston (2206.13b,c), (7) Pennsylvania Academy of the
Fine Arts, Philadelphia, (8) private collection, formerly
James Gregerson, Boston. *Bronze:* (1) The Butler Institute
of American Art, Youngstown, Ohio, (2) Newport Art
Association, R.I., (3) private collection

This three-quarter relief of three plunging horses,
one of which is restrained by a youthful attendant
holding an inverted torch, was modeled in 1848
while Hunt was working in Thomas Couture's stu-
dio. Representing the first romantic work by an
American sculptor, *The Flight of Night* predates Wil-
liam Rimmer's *The Falling Gladiator* (q.v.) and *Torso*
(q.v.) in its boldly expressive modeling and exploita-
tion of light and shadow.[1] Hunt became fascinated
by the myth of Anahita, goddess of night, in 1846,
when he read his brother Leavitt's translation of a
sixth-century Persian poem that described her flight
from "her realms of Fantasy and Unreality, im-
pelled by the dawn of civilization."[2] From the begin-
ning, Hunt envisaged Anahita illuminated from be-
hind by the crescent moon and riding a cloud as she
drives three charging horses, one of which is held
back by a slave.

Couture's preliminary efforts for *The Enrollment of the Volunteers*, 1848 (Musée Départemental de l'Oise, Beauvais), may also have inspired Hunt to begin his own allegorical painting. The swirling outlines of Couture's earliest sketch of 1847 (Museum of Fine Arts, Springfield, Massachusetts), which shows Liberty seated in a chariotlike form, is strikingly similar to Hunt's expressive, if vaguely rendered, conception of Anahita reining in her steeds in his first drawing of *The Flight of Night*, about 1848 (American Institute of Architects, Washington, D.C.).[3] Hunt's association with Antoine Barye may help explain why he worked out a sculptural maquette for the detail of the horses; at the time, Hunt owned a cast of Barye's *Turkish Horse*, before 1847 (William Morris Hunt II, Boston), which would have provided him with an ideal model for the central animal.

Although three-quarter reliefs were rarely shown in the Paris Salons,[4] there were architectural decorations in Paris that might have influenced Hunt's composition. For instance, the stucco relief *Horses of the Sun*, 1718, ascribed to Robert Le Lorrain (1666-1743), was on the facade of the Hôtel de Rohan, within walking distance of the apartment that Hunt shared with his brother Richard.[5] The similarity between the *Horses of the Sun* and *The Flight of Night* suggests that all Hunt had to do was rearrange and simplify Le Lorrain's composition, eliminating one horse, one figure, and the chariot.[6] Like Le Lorrain, Hunt went beyond the limits of traditional bas-relief, modeling the horse's forelegs completely in the round. *The Flight of Night* also recalls the bronze relief of plunging horses by Pierre-Louis Rouillard (1820-1881) over the door of the stables of the new Louvre, completed in 1861. This relief may have been known to Hunt in an earlier version since Richard Morris Hunt was a consulting architect for the additions to the Pavillon de la Bibliothèque, Louvre.[7] The attendant in Hunt's relief can be compared with Augustin Dumont's (1801-1884) torch-bearing *Genius of Liberty*, erected around 1840, on the July Column in the Place de la Bastille.[8] Hunt's inversion of the symbolism from "Horses of the Sun" to "Horses of the Night" may have been due to his melancholy nature as well as to his desire to be original. Whereas Le Lorrain's subject is freedom, the sun's horses released from their day's work, Hunt's relief represents the opposite, since his horses run from the dawn's illumination.

In 1866 Richard Morris Hunt lent a relief of *The Flight of Night* to the annual exhibition of the National Academy of Design in New York, possibly the same cast he gave to the Metropolitan Museum of Art, New York, in 1880. Indeed, by 1866 there may have been two reliefs: the original clay brought to Boston by Hunt after he left Paris and another cast in plaster. When the Boston fire of 1872 destroyed the contents of Hunt's studio, one relief, at least, was at a local plasterer's for casting.[9] This version, the early pencil sketch, and a Japanese tea tray decorated with the Anahita theme (Museum of Fine Arts, Boston; formerly hung in a plush frame in Hunt's sister's parlor) were all that remained of his efforts to conceptualize the Persian goddess. Lost was a huge canvas, measuring fifty feet wide.[10] Fortunately, Hunt had taken a photograph of the painting, which he sent to a Boston architect and decorator, J.P. Rinn. This he was able to retrieve in 1875 when he tried to reconstruct the painting.

Of the twelve known examples of *The Flight of Night* relief, the plaster versions with distinct modeling lines (e.g., at the Metropolitan Museum of Art, New York, and the Isabella Stewart Gardner Museum, Boston, both tinted brown) either were cast from the original *modello* or were part of a small edition cast in Paris by Hunt. Another group in white plaster, which includes the example in the Museum of Fine Arts, may be part of a larger edition cast about 1880 that used one of the Paris-cast plasters as the model. A third group was cast in a large edition by P.P. Caproni and Brother, Boston, which held the mold of *The Flight of Night* from the early 1900s until the 1930s.[11]

Thirty years after Hunt first formulated his idea for *The Flight of Night*, he received the commission to decorate two lunettes in the Assembly Chambers of the New York State Capitol, Albany. In 1878 the earlier plaster relief became the study for the central detail of one of the two monumental murals (16 by 40 feet). For the companion mural, *The Discoverer*, Hunt created an allegory of Columbus crossing the Ocean of Destiny, with the figures Fortune, Faith, Hope, and Science swimming before him. Along with John La Farge's murals for Trinity Church, Boston, completed two years earlier, Hunt's Albany frescoes became the first monumental public murals in America. Within a short time, however, an improperly constructed roof caused the paint to flake, and eventually the frescoes (which had been applied directly on the sandstone walls) were beyond repair. Ten years later a false ceiling was installed, which concealed the damaged murals.

P.M.K.

Notes

* This piece has been on loan to the Museum for so many years that it has become associated with the permanent collection and is therefore included in this catalogue.

1. The influence of Antoine Barye's romantic style on Hunt was transmitted to Rimmer through casts of the French sculptor's work that Hunt brought back to America. See Henry Adams, "William Morris Hunt's 'Chef d'Oeuvre Inconnu,'" *Proceedings of the New York State Capitol Symposium* (Albany: Temporary State Commission on the Restoration of the Capitol, 1983), pp. 99, 104, n. 9.

2. Louisa Dumaresq Hunt, *The Paintings on Stone at the Albany Capitol, New York, U.S.A., by William Morris Hunt, Completed A.D. 1879* (Washington, D.C.: Privately printed, 1888), quoted in The Metropolitan Museum of Art, New York, *American Paintings in the Metropolitan Museum of Art* (1985), vol. 2, p. 214. Hunt's widow explains the mural's complex symbolism in this pamphlet.

3. See Adams, "'Chef d'Oeuvre Inconnu," pp. 98-99; idem, "The Development of William Morris Hunt's *The Flight of Night*," *American Art Journal* 15 (spring 1983), pp. 44-46.

4. A notable exception was Antonin Moine's (1796-1849) plaster relief *Falling Horseman*, shown in the Salon of 1831. See Adams, "Hunt's *The Flight of Night*," p. 47.

5. Adams, "'Chef d'Oeuvre Inconnu,'" p. 99. Kathryn Greenthal was the first to suggest this relief as a source for Hunt. The relief may have been done later, between 1723 and 1735. See Wend Graf Kalnein and Michael Levy, *Art and Architecture of the Eighteenth Century in France* (Harmondsworth, England: Penguin Books, 1972), pp. 47, 362, n. 77, pl. 43.

6. Henry Tuckerman, in his review of Hunt's relief in 1868, erroneously but revealingly called it *The Horses of the Sun*. See Tuckerman 1867, p. 449.

7. Greenthal to Adams, Jan. 31, 1981, BMFA, ADA. Greenthal also points out the two reliefs with horses over the stables at Versailles, which may have inspired Rouillard.

8. Adams, "'Chef d'Oeuvre Inconnu,'" p. 99.

9. See Helen M. Knowlton, *Art-Life of William Morris Hunt* (Boston: Little, Brown, 1899), p. 81.

10. Hunt executed two large-scale oil studies of *The Flight of Night*, dated 1878 (Museum of Fine Arts, Boston, and Pennsylvania Academy of the Fine Arts, Philadelphia). Other studies are in the Metropolitan Museum of Art, New York; The Art Museum, Princeton University, N.J.; and Colby College Museum of Art, Waterville, Maine.

11. See P.P. Caproni and Brother, Boston, *Caproni Casts* (1932), no. 10009; see also no. 10055, *Flight of Day*, with no attribution, a relief showing three rearing horses and a figure with raised arms and flowing robes.

Benjamin Paul Akers (1825–1861)

Paul Akers's twelve-year career, though brief, showed enormous promise. Had he not contracted tuberculosis, which debilitated him throughout his relatively short life, his productivity might have been greater. Nevertheless, the small group of statues by Akers that survive are evidence that he deserved the reputation his contemporaries assigned to him as a fine craftsman whose aesthetic sense was enriched by a deeply ingrained literary imagination. Understandably, the literati of Akers's era were especially intrigued by the bookish bent of his art. Nathaniel Hawthorne, who met the sculptor in Rome in 1858, was so impressed by Akers's studio creations that he appropriated several of them for fictional use in his novel *The Marble Faun* (1860). In a complimentary letter of introduction about the artist to his famous Concord neighbor Ralph Waldo Emerson, Hawthorne wrote: "He has the faculty of putting thought and feeling into marble, and is one of the very few sculptors whose productions are worthy of the material in which he works."[1]

Like the majority of American sculptors of his generation, Akers evolved as an artist from inauspicious beginnings. The eldest of eleven children born to a Maine lumberman and his wife, Akers spent his childhood in the rural town of Saccarappa, where opportunities for formal education were scarce. Most of his time was spent at his father's wood-turning shop, where he apparently demonstrated a precocious aptitude for ornamental carving and mechanical invention. (He is credited with devising a machine for manufacturing shingles that proved a commercial success.) In his youth Akers began to exhibit the first symptoms of tuberculosis and, not inappropriately, acquired the nickname "Saint Paul" because of his serious, sensitive disposition. Professionally, Akers later dropped his baptismal name, opting to be called simply "Paul."

Despite the practical orientation of his upbringing, Akers was an avid reader, perusing Plato and Aristotle with the same enthusiasm as he did Goethe, Henry Wadsworth Longfellow, and the English romantic poets. A brief semester of schooling in Norwich, Connecticut, presumably strengthened his literary interests and led him to embark on a writing career. In his early twenties, he managed to find employment as a printer at a newspaper office in Portland, Maine, where he tried to turn his writing to good account. Although he received minimal recognition for his work in fiction, Akers eventually became a respected art critic and contributor

to such prominent journals as the *Atlantic Monthly* and the *Crayon.*

It was during his stint at the Portland *Transcript* that Akers first realized his artistic aspirations. Tradition attributes this awakening to his admiration of an unspecified statue by Edward Brackett then on local view. One critic believed that Sir Francis Chantrey's (1755-1828) *George Washington,* 1826 (State House, Boston), spurred Akers's initial fascination with sculpture. Curious to experiment in three-dimensional modeling, Akers acquired clay from a nearby pottery and executed a series of earthenware figures and diminutive portraits. Desiring to expand his knowledge of other sculptural procedures, he ventured to Boston in 1849 to learn the art of plaster casting from Joseph Carew (active 1843-1870), and a brief period of study there represented the extent of his technical training in the craft.

By 1850 Akers had returned to Portland, where he shared a studio with the landscape painter John Rollin Tilton (1828-1888). Approximately a dozen busts and portrait medallions of notable local citizens date from this first professional phase, together with an ideal head of Christ (United States Ministry, The Hague) and a bas-relief of Charlotte

Corday (present location unknown). In 1851 a second visit to Boston resulted in additional commissions for Akers, the most prestigious being those for busts of Henry Wadsworth Longfellow (Boston Athenaeum) and Samuel Appleton (q.v.).

With this reserve of models awaiting transfer to stone, Akers decided to supervise the carving where it could be accomplished most efficiently and thus sailed for Italy in 1852. After a year in Florence, he returned to Portland, intent on beginning his first large ideal composition. This piece was entitled *Benjamin in Egypt*, 1853, a subject derived from a passage in Genesis. The finished statue received appreciative criticism when it was displayed in 1853 at New York's Crystal Palace Exhibition, its workmanship commended as notably assured and the composition judged extremely effective in its communication of sentiment. Regrettably, the piece was destroyed later in a fire at the Portland Customs House.

After the success of *Benjamin in Egypt*, Akers launched into his career as a sculptor with fresh confidence. In 1854 he wintered in Washington, D.C., where his skills as a portraitist were in considerable demand. Likenesses of President Franklin Pierce, Speaker of the House of Representatives Linn Boyd (present locations unknown), Judge John McLean (United States Supreme Court, Washington, D.C.), and Edward Everett, 1856 (Maine Historical Society, Portland), were modeled during this period. A summer journey to Newport, Rhode Island, also netted Akers commissions for copies of antique sculpture. Though disdained by more seasoned sculptors, this remunerative practice probably appealed to a novice like Akers since it afforded him an opportunity to study famous classical marbles while turning his copywork to profit.

To dispatch the multiple orders for busts and antique replicas he had in hand, Akers sailed to Italy once again. He secured a studio in Rome, on the Via de' Greci, which Canova had once occupied. He also engaged a pupil and studio assistant, Emma Stebbins (1815-1882), who had recently come to Rome from New York. Although Akers's letters of this period reveal a lingering homesickness for the Maine countryside, Rome clearly delighted and energized him: "All that my intellect craves is within my reach; . . . all the demands of my taste may be here satisfied," he rejoiced to a friend.[2] In spite of the distractions of Roman society, an extensive tour of the Continent taken in 1856, and intermittent bouts of bad health, Akers was surprisingly active.

Apart from ongoing work on orders from clients in Washington and Newport, he initiated about fourteen ideal compositions during this second Italian sojourn.

As their titles imply, the subjects of these statues (the majority of which can no longer be located) ran the gamut of conceits then popular with the Victorian art public and included genre pieces like *Girl Pressing Grapes*, about 1857; mythological works such as *Diana and Endymion*, 1858; and sculpture based on biblical and literary themes such as *Isaiah*, about 1855, *Una and the Lion* (from Spenser's *Faerie Queene*) about 1855, and *Undine*, about 1855, from Motte-Fouqué's romance.

The three masterworks of Akers's oeuvre also belong to this period: a bust of the Puritan poet *John Milton*, 1857 (Colby College Museum of Art, Waterville, Maine), *Saint Elizabeth of Hungary*, 1855 (private collection, New York), an idealization of the eleventh-century heroine queen, possibly inspired by Charles Kingsley's dramatic poem *The Saint's Tragedy* (1846), and the macabre *Dead Pearl Diver*, 1858 (Portland Museum of Art, Maine). This last composition, which may have been influenced by a tale of the German poet-dramatist Friedrich von Schiller, incorporated all the cardinal ingredients guaranteed to win an appreciative audience. The vignette—a youth who has drowned while seeking an elusive prize—was touching, moralistic in tone, and vividly conveyed through the figure's limp form. The piece also evoked the mysterious affinities between death and sleep, a comparison that fascinated Akers's romantically inclined contemporaries, and a theme previously touched upon by Akers in such works as *Diana and Endymion* and *The Sleeping Child*, about 1858 (Maine Historical Society, Augusta). The *Dead Pearl Diver* is also distinguished by a "hyper-realistic" articulation of surface textures: flesh, hair, seaweed, sand, shells, and twine, this last material composing the fishnet that discreetly shields the diver's nude loins.

Following this period of industry, Akers's health began to decline, as did the quantity of new work issuing from his studio. While recuperating in Maine from a bout of illness, he met (and subsequently married) Mrs. Elizabeth Taylor (1832-1911), a modestly popular poet and journalist whose income-earning potential probably intensified the ailing sculptor's ardor. In the spring of 1859 the couple traveled to Europe, where Akers's health momentarily rallied. By the summer of 1860, however, a recurrence of illness sent Akers and his

wife back to Maine. That winter they moved to Philadelphia at the advice of Akers's physician. The change of locale was an ineffective remedy, for Akers succumbed to tuberculosis the following May. He died before completing the preliminary model for a heroic statue of Commodore Matthew Perry commissioned by August Belmont, the New York banker and financier. Had the figure been executed, it would have been Akers's first public monument.

Critics and patrons familiar with Akers's work regretted his premature death and eulogized him as a man of genius. Public opinion long upheld this exalted image, although the artist's widow offered a darker picture of him in the memoirs she later wrote about their married life. Beneath his veneer of personal charm and magnanimity, she maintained, breathed an irresponsible, quixotic man whose numerous peccadillos (financial and amorous) precipitated his descent into an early grave. The embittered tone of her reminiscences probably had roots in the impoverished circumstances of her brief marriage to the sculptor and in the unconscionable behavior of her brother-in-law, whom she accused of confiscating the trifling estate left by her husband.

J.S.R.

Notes

1. Hawthorne to Ralph Waldo Emerson, April 24, 1858, Akers Manuscript Collection, Colby College, Waterville, Maine.

2. Akers to unknown correspondent, quoted in Leila Woodman Usher, "Benjamin Paul Akers," *New England Magazine*, n.s. 11 (Dec. 1894), p. 463.

References

Benjamin 1880, p. 151; "Benjamin Paul Akers," *Maine Library Bulletin* 13 (Jan. 1928), pp. 65-71; Richard Cary, "The Misted Prism: Paul Akers and Elizabeth Akers Allen," *Colby Library Quarterly*, ser. 7, no. 5 (Mar. 1966), pp. 193-227; Clark 1878, pp. 132-133; Akers Manuscript Collection, Colby College, Waterville; Craven 1968, pp. 281-284; *Dedicatory Exercises at the Portland Library* (pamphlet), Feb. 21, 1889, pp. 26-34 (contains biographical verse about Akers written by his wife); "Editor's Easy Chair," *Harper's New Monthly Magazine* 20 (May 1860), pp. 845-847; Gardner 1945, p. 21; Gerdts 1973, pp. 44-45, 90, 110; *Lewiston Journal*, magazine section, Jan. 14, 1911; ibid., section A-4, July 13, 1946; ibid., section 3A, Jan. 21, 1961; Akers Letters, Maine Historical Society, Portland; Roscoe R. Miller, "An American Sculptor of Note," *Americana* 27 (Oct. 1933), pp. 452-455; William B. Miller, "A New Review of the Career of Paul Akers, 1825-1861," *Colby Library Quarterly*, ser. 7, no. 5 (Mar. 1966), pp. 225-256; Rose D. Nealley, "The Sculptor and *The Pearl Diver*,"

Maine in History and Romance (Lewiston: Maine Federation of Women's Clubs, 1915), pp. 191-197; Taft 1930, pp. 195-199; Tuckerman 1867, pp. 612-619; Henry Tuckerman, "Two of Our Sculptors: 1. Paul Akers. 2. E. Bartholomew," *Hours at Home: A Popular Monthly* 2 (Apr. 1866), pp. 525-532; Leila Woodman Usher, "Benjamin Paul Akers," *New England Magazine*, n.s. 11 (Dec. 1894), pp. 460-468.

BENJAMIN PAUL AKERS

49
Samuel Appleton, 1851
Plaster
H. 22¾ in. (57.8 cm.), w. 15 in. (38.1 cm.), d. 13⅝ in. (34.7 cm.)
Signed (on back): Executed by Paul Akers
Inscribed (on back): July / 1851 / S. Appleton
H.E. Bolles Fund. 1983.341

Provenance: Mary Jane Appleton Plaisted; Aaron Appleton Plaisted; Emily Redington Plaisted; Hope Bunker—all of Waterville, Maine
Versions: *Plaster:* (1) Appleton Academy, New Ipswich, N.H., (2) Barrett House, Society for the Preservation of New England Antiquities, New Ipswich, N.H., (3) Boston Athenaeum. *Marble:* (1) Longfellow National Historic Site, Cambridge, Mass.

"Mr. Akers of Portland arrived. He is to pass a week or so with me and make my bust; a young man of superior talent and high ideas of his art."[1] Paul Akers's appearance in the Boston-Cambridge area, alluded to in Henry Wadsworth Longfellow's journal entry for June 12, 1851, proved particularly advantageous for the young sculptor. Of immediate benefit was the assignment to model a bust of the well-known poet (Longfellow National Historic Site, Cambridge, Mass.), whose writings he greatly admired. Adding an individual of Longfellow's celebrity to his roster of sitters assured Akers an increase in his professional stature and helped expand his potential clientele to the larger and more affluent Boston art market.

Of greater consequence was the acquaintance Akers made that spring with Samuel Appleton,[2] the aged uncle of Longfellow's wife, Fanny. Through this opportune introduction, arranged by Mrs. Longfellow, Akers gained several additional orders for work. These included a commission for a portrait bust of Appleton, adjudged by Fanny Appleton Longfellow "a great head for [Akers] and which he is quite ambitious to undertake,"[3] and another for a pair of marble reliefs, *Night* and *Morning*, 1852 (present locations unknown), presumably modeled

49

after Thorwaldsen's famous pendant reliefs. While the artist already had demonstrated competence in portraiture, the latter commission offered him an opportunity to extend his repertoire. The ample fee Appleton agreed to pay also provided Akers with the means to finance a much sought-after study tour to Italy.

When Akers met Appleton in 1851, the wealthy Boston industrialist and philanthropist was retired from business and occupied with dispersing portions of his accumulated fortune to his favorite charities and cultural causes. Among the institutions he helped to endow were the Boston Athenaeum, the American Academy of Arts and Sciences, the Massachusetts Historical Society, the Massachusetts General Hospital, and Amherst, Dartmouth, and Harvard colleges. Local artists of promise were favorite beneficiaries, both Horatio Greenough[4] and Harriet Hosmer having profited from Appleton's munificence. In his youth, Appleton had experienced poverty and other hardships imposed by his rural upbringing in a large family from New Ipswich, New Hampshire. Perhaps the memory of those circumstances persuaded Appleton to become a patron of Akers, whose background was similar.

The young sculptor's gift for candid observation is readily apparent in the bust he executed of his benefactor, for which this plaster probably served as a model. Akers interpreted Appleton in what might be termed the Roman senatorial mode. Yet the work is free of the gloss of idealism characteristic of so many nineteenth-century neoclassical busts. Naturalistic modeling and an unflinchingly precise transcription of the sitter's facial topography combine to create a forthright, unsentimentalized image of old age. The sculptor has not attempted to disguise Appleton's bulbous, broken nose or his Neanderthal jaw and the absence of his upper teeth. The literalism of approach recalls the arresting realism of first-century Roman portrait busts.

Like Hiram Powers, Akers considered portraiture a challenging art: if performed honorably, with truth as its uppermost objective, the exercise of bust-making could yield a rare record of "soul" and personality. "No artist was ever great enough to invent the combination of lines, curves, and planes which composes the face of man," he wrote. "There is the accumulated significance of a lifetime—subtle traces of failures or of victories wrought years ago."[5]

Most nineteenth-century art critics seem to have agreed that Akers's bust of Samuel Appleton forwarded his reputation as a sculptor by publicizing his talent for capturing both likeness and character in marble.[6] Those close to the sitter also judged the bust a success. "Went to see Uncle Sam's bust by Paul Akers," noted Longfellow in his journal, July 22, 1851. "Quite grand and striking, and finely done. Very few people look so at eighty-five."[7]

Although Samuel Appleton's marriage to Mary Gore (widow of John Gore) in 1819 produced no children, he is said to have shown great paternal affection for his numerous nieces and nephews, leaving them handsome legacies in his will. The half-dozen or so surviving plaster replicas of Akers's bust[8] of the Boston merchant suggest that casts of the original model (which was used to point up the marble facsimile now at the Longfellow National Historic Site, Cambridge) may have been ordered as keepsakes by members of the younger Appleton generation, whose fond memories of their uncle presumably deepened upon learning of the disposition of his estate.

J.S.R.

Notes

1. Henry Wadsworth Longfellow, quoted in William B. Miller, "A New Review of the Career of Paul Akers, 1825-1861," *Colby Library Quarterly*, ser. 7, no. 5 (Mar. 1966), p. 234.

2. Shrewd investments in the railroad and cotton industries were responsible for the vast financial empire, political influence, and social position that Appleton and his brother Nathan accrued in their lifetimes. For additional discussion of Samuel Appleton's career, see Ephraim Peabody, "A Memorial to Samuel Appleton," *New England Historical and Genealogical Register* 8 (Jan. 1854); Isaac Appleton Jewett, *Memorial of Samuel Appleton of Ipswich, Mass.* (Boston: privately printed, 1850); and Louise Hall Tharp, *The Appletons of Beacon Hill* (Boston: Little, Brown, 1973), pp. 81-94.

3. Diary of Fanny Appleton Longfellow, quoted in Tharp, *The Appletons*, p. 93.

4. In middle age, Appleton had sat for a bust by Greenough, about 1836 (Memorial Hall, Harvard University). Fanny Appleton Longfellow described this likeness of her balding, long-faced uncle as "frowning down in Cato-like majesty." Ibid., p. 92.

5. Akers elaborated his theories of portraiture in an essay, "Art Expression," for the *Crayon*, excerpts of which are cited in Henry Tuckerman, "Two of Our Sculptors: Benjamin Paul Akers and Edward Sheffield Bartholomew," *Hours at Home: A Popular Monthly of Instruction and Recreation* 2 (Apr. 1866), pp. 529-530.

6. For supporting critical viewpoints, see Tuckerman, "Two of Our Sculptors," pp. 527-528; Clark 1878, p. 132; Taft 1930, p. 199.

7. Quoted in William B. Miller, "A New Review of the Career of Paul Akers, 1825-1861," *Colby Library Quarterly*, ser. 7, no. 5 (Mar. 1966), p. 234.

8. A plaster bust of Appleton, identical to that owned by the Museum of Fine Arts and similarly signed and inscribed on the back "July 1851 / S. Appleton / Executed by Paul Akers," was given to the Boston Athenaeum by Dora May Spaulding. For comparison, see Boston Athenaeum 1984, pl. 111 and p. 11.

William Henry Rinehart (1825 – 1874)

Through most of his career William Henry Rinehart was the principal creator of portrait busts and ideal statuary for Baltimore's mercantile elite. His reputation as Maryland's favorite sculptor endured into the twentieth century, perpetuated by the unique legacy that would link his name permanently with "the promotion of interest in and cultivation of taste for art" among the people of his state:[1] the Rinehart School of Sculpture, opened at the Maryland Institute in 1896, and the Rinehart Scholarship, a fund established to finance the professional studies of young American sculptors in Europe. Supported by monies bequeathed under Rinehart's will, these contributions to the cause of art education were a reflection of the sculptor's deep gratitude for Baltimore's consistent patronage.

Like many of the local industrialists who made up his clientele, Rinehart was a plain-born man of limited education but immense drive. Any incentive he might have had in childhood to pursue a future in farming, as his parents wished, seems to have been extinguished during his agrarian upbringing in Carroll County, Maryland. He likewise exhibited little facility or enthusiasm for the alternative activity his family pressed on him—schooling. Resigned that neither husbandry nor scholarship was a realistic career prospect for Rinehart, his father reluctantly agreed to let him seek instruction in a practical trade. A convenient opportunity arose to arrange such an apprenticeship when a quarry that had started operation on the family farm enlisted the young man's service.

Rinehart quickly became proficient at performing such routine tasks as cutting, polishing, and lettering stone. Barely twenty and eager to obtain additional training in the craft, he moved to Baltimore, where he found employment at the firm of Baughman & Bevan (later Bevan & Son), one of the city's largest and most modernized marble yards. He achieved the rank of foreman within two years, a promotion warranted by his industry and pronounced talent in carving mantelpiece and architectural ornaments. To supplement the technical experience he was acquiring on the job, Rinehart enrolled in evening classes at the Maryland Institute of the Mechanic Arts, where he learned mechanical drawing and studied mythology, ancient history, and anatomy, all of which proved useful to him in his later career.

By the early 1850s the independent compositions

carved by this journeyman stonecutter began to attract public notice. In 1851, Rinehart won a gold medal for a small bas-relief he submitted to a fair at the Maryland Institute. In an exhibition otherwise dominated by orthodox neoclassical art themes, Rinehart's contribution, *The Smokers*, 1851 (National Museum of American Art, Washington, D.C.) must have been a novelty because of its unconventional source: a seventeenth-century genre scene by the Flemish painter David Teniers. He earned another medal for excellence in statuary when he exhibited several portrait busts and an idealization of Faith (present location unknown) at the Maryland Institute in 1853.

At the urging of a number of local art enthusiasts who recognized the potential in these amateur compositions, Rinehart journeyed to Florence in 1855 to further hone his sculptural skills. Although the meagerness of his budget compelled him to return home in 1857, his sojourn in Italy resulted in a small cargo of finished works that confirmed his professional progress. Among the better-known pieces he carried back were two pairs of marble medallions, *Morning* and *Evening*, 1856 (Peabody Institute of the Johns Hopkins University, Baltimore), and *Winter* and *Spring*, 1857 (National Museum of American Art), modeled in high relief and reminiscent of the bas-reliefs of Bertel Thorwald-

sen, Antonio Canova, and John Flaxman. A large share of Rinehart's time during this two-year Florentine residence was also occupied in modeling studies for statues incorporating distinctly American motifs, such as *The Backwoodsman*, about 1855 (present location unknown); *Indian Girl*, 1859 (private collection, Arizona), probably inspired by Henry Wadsworth Longfellow's *Hiawatha*; and *Pioneer and Family*, 1856 (present location unknown).

Newly established in a Baltimore studio, Rinehart found himself suddenly busy executing orders for portrait busts and ideal compositions. The most important and unusual of the latter were commissions for a clock in the United States House of Representatives (for which he created two figures using the backwoodsman and Indian themes) and a fountain figure for the Washington, D.C., Post Office (now in the United States Capitol). Rinehart also took time to renew and strengthen ties with the coterie of supporters who had initially encouraged his professional ambitions. Preeminent among these patrons was the affluent Baltimore financier and wine importer William Thompson Walters, whom the sculptor is said to have met when called to Walters's home to repair a fractured mantelpiece. Walters's collecting tastes were broad in scope and, to Rinehart's good fortune, encompassed a partiality for sculpture in the neoclassical style.

Impressed by Rinehart's artistic progress, Walters provided him with the essential funds to recommence his sculpture studies abroad. In 1858 the sculptor arrived in Rome for an extended residence of eight years. "The advantages for study here are much better than Florence," he informed a friend in explaining his selection of Rome as a professional anchorage, adding humbly, "if it was not for that I would not stay among the great swarm of sculptors—a small potato like myself is lost intirely [*sic*]."[2]

During Rinehart's previous expedition to Italy, he had been nagged by poverty, but his finances were now bolstered regularly by portrait commissions and sundry other requests from his Baltimore clientele. The continuing patronage of Walters, however, enabled him to channel a substantial portion of his creative energies into the more challenging field of ideal composition. Among the most successful of these essays was *The Woman of Samaria*, 1860 (Walters Art Gallery, Baltimore), a serene and studiously Hellenistic marble figure commissioned by Walters. "I have treated it with as much simplicity as I could and perhaps with more severity than is common in modern works," he wrote of his treat-

ment of this New Testament subject; "I have made no effort to get Prettiness. I believe it to be unworthy of sculpture intirely [*sic*]."[3] The observation proved prophetic of the sculptor's mature style, for much of his oeuvre would be characterized by an elegant severity of line, a reserved attitude toward action, and a conscious avoidance of overly precious tactile detailing. These qualities informed another of the ideal figures conceived by Rinehart during the early years of his Roman stay, the handsome and heroic visualization of Leander, 1859 (James Ricau, Piermont, New York), a subject taken from the ancient myth of the doomed nocturnal lovers. Rinehart later modeled an equally fine characterization of Hero, 1868 (Ganz Collection, Los Angeles), Leander's paramour.

In 1861 an unexpected boost to Rinehart's national reputation occurred when he was entrusted to complete the ambitious iconographic program of doors planned for the chambers of the House of Representatives and Senate in Washington, D.C. This project, originally consigned to Thomas Crawford, had been only partially completed when the famous sculptor died in 1857. Although Gustav Kaupert (1819-1897), a German studio assistant of Crawford's, was appointed successor to the commission, nationalistic sentiment ran against a foreigner's inheriting this prestigious assignment. Rinehart was nominated for the task at the insistence of Crawford's widow, who praised him as "the most promising of the American artists now in Rome."[4] Over the next four years, Rinehart struggled to resolve the door series, eventually arriving at a scheme that struck a harmonious balance between the character of Crawford's sketches and his own individualistic designs.

The final decade of Rinehart's career witnessed a prolific outpouring of work from his Roman studio. Dozens of portrait busts date from this period. Tomb monuments also seem to have emerged as a specialty of the sculptor's, as evidenced by the mausoleum schemes (most incorporating freestanding figures) he executed for Captain Richard Fitzgerald, 1865 (Loudon Park Cemetery, Baltimore); the Walters family, 1867 (Greenmount Cemetery, Baltimore); and John Paine, 1873 (Oakwood Cemetery, Troy, New York). In 1867 the General Assembly of Maryland awarded him his first major commission for a public monument in tribute to Roger Brooke Taney, chief justice of the United States Supreme Court from 1836 to 1864. Rinehart attended the formal unveiling of the bronze statue on the

grounds of the Maryland State House, Annapolis, in 1872, when critics wrote appreciatively of its dignified characterization and commanding composition.

Tranquility of mood and pure academic classicism are innate in Rinehart's ideal compositions dating from the latter part of his career. The antique legends and mythological personalities that appealed to his imagination found a perfect aesthetic vehicle in his subdued, controlled modeling style. Among the finest conceptions Rinehart embodied in marble are *Antigone*, 1870 (The Metropolitan Museum of Art, New York), which shows the daughter of Oedipus pouring a ritual libation over the corpse of her slaughtered brother, against her uncle's command; *Endymion*, 1874 (Corcoran Gallery of Art, Washington, D.C.), a representation of the eternally peaceful shepherd boy; *Latona and Her Children*, 1872 (The Metropolitan Museum of Art), a tenderly maternal portrait of the goddess of night with her infant twins; and *Clytie*, 1872 (The Metropolitan Museum of Art), a demure nude study of the beautiful nymph who earned immortality as a heliotrope for her constant love of Apollo, the sun god.

The compliment that Frank Frick, a prosperous Baltimore merchant, paid to Rinehart's accomplished performance in this ideal mode reflects the local favoritism that aided the sculptor's career throughout its twenty-odd-year duration. In comparing Rinehart's oeuvre with the grand, historically erudite inventions of William Wetmore Story, Frick reflected that while Rinehart's subjects were "chosen from a field of limited education," his work nonetheless displayed more "feeling and sentiment"[5] than that of his illustrious contemporary and competitor.

Death abruptly terminated Rinehart's career in his forty-ninth year. Appropriately, two of the sculptor's most generous benefactors, William T. Walters and Benjamin F. Newcomer, were named trustees of his estate. It was through their expert maneuvering and their respect for Rinehart's wishes that the best of the late sculptor's casts and models were removed from his Roman studio and sent to Baltimore's Peabody Institute. The remainder of the studio contents was sold at auction in 1875 and the proceeds invested to accumulate interest. By 1895 this fund had appreciated enough to permit the award of scholarships to subsidize sculptural studies for two deserving candidates at the newly formed American Academy in Rome and in Paris. Alexander Phimister Proctor (1862-1950)

and Hermon MacNeil (1866-1947) were the first recipients of the Rinehart Scholarship, which has enabled many American sculptors to profit from European training.

J.S.R.

Notes

1. William Sener Rusk, *William Henry Rinehart, Sculptor* (Baltimore: Munder, 1939), p. 83.

2. Rinehart to Frank B. Mayer, Dec. 7, 1859, quoted in Marvin Chauncey Ross and Anna Wells Rutledge, "William H. Rinehart's Letters to Frank B. Mayer, 1856-1870," *Maryland Historical Magazine* 43 (June 1948), p. 135. The letters published in this article are in MMA, ALS.

3. Rinehart to Mayer, Dec. 9, 1859, quoted in Ross and Rutledge, "Rinehart's Letters," p. 136.

4. Louisa Crawford to Captain W.B. Franklin, June 1861, quoted in Craven 1968, p. 292.

5. Frick Diary, Mar. 27, 1867, Archives of the Peabody Institute of the Johns Hopkins University, Baltimore.

References

Baltimore Sun, Oct. 30, 1874, Jan. 4, 1875, Nov. 15, 1881, supplement; Benjamin 1880, pp. 152, 154; Thomas B. Brumbaugh, "A Recently Discovered Letter of William Henry Rinehart," *Journal of the Walters Art Gallery* 33-34 (1970-1971), pp. 53-57; Gardner 1945, pp. 17, 22-23; Gardner 1965, pp. 24-25; Gerdts 1973, pp. 37-39, 55-57, 72, 79, 86, 90-91, 95, 116, 118; William H. Gerdts, *The Great American Nude* (New York: Praeger, 1974), pp. 94, 96; MMA 1970, p. 163; National Gallery of Art, Washington, D.C., *An American Perspective: Nineteenth-Century Art from the Collection of Jo Ann & Julian Ganz, Jr.*, catalogue by John Wilmerding, Linda Ayres, and Earl A. Powell (1981), pp. 60-61, 160-162; Archives of the Peabody Institute of the Johns Hopkins University, Baltimore; Post 1921, vol. 2, p. 236; Lilian M.C. Randall, "An American Abroad: Visits to Sculptors' Studios in the 1860s," *Journal of the Walters Art Gallery* 33-34 (1970-1971), pp. 42-51; "Return of a Baltimore Artist," *American Art Journal*, July 12, 1866, p. 187; Marvin Chauncey Ross and Anna Wells Rutledge, "William H. Rinehart's Letters to Frank B. Mayer, 1856-1870," *Maryland Historical Magazine* 43 (June 1948), pp. 127-138; ibid. 44 (Mar. 1949), pp. 52-57; William Sener Rusk, "New Rinehart Letters," *Maryland Historical Magazine* 31 (Nov. 1936), pp. 225-242; idem, "Notes on the Life of William Henry Rinehart, Sculptor," ibid. 29 (1924), pp. 309-338; idem, "Rinehart's Works," ibid. 20 (Dec. 1925), pp. 380-383; idem, *William Henry Rinehart, Sculptor* (Baltimore: Munder, 1939); Taft 1930, pp. 171-180; Elihu Vedder, *Digressions of V* (Boston: Houghton Mifflin, 1910), pp. 157, 329-332; Walters Art Gallery, Baltimore, *A Catalogue of the Work of William Henry Rinehart, Maryland Sculptor, 1825-1874*, by Marvin Chauncey Ross and Anna Wells Rutledge (1948); idem, *The Taste of Maryland: Art Collecting in Maryland 1800-1934* (1984), pp. 50-56; Whitney 1976, pp. 43-44, 58.

WILLIAM HENRY RINEHART
50 (color plate)
Sleeping Children, after 1859-1874
Marble
H. 15 in. (38.1 cm.), l. 37 in. (94 cm.), d. 18 in.
(45.7 cm.)
Gift of Daniel and Jessie Lie Farber, Roy Taylor,
and Mary E. Moore Gift. 1984.268

Provenance: Roy Taylor, Pawtucket, R.I.
Versions: *Plaster*, life-size: (1) Peabody Institute of the
Johns Hopkins University, Baltimore, (2) formerly studio
inventory (destroyed). *Marble*, life-size: (1) John de K.
Alsop and sisters, Middletown, Conn., (2) Joseph Henry
Collyer, Jr., West Brattleboro, Vt., (3) Greenmount Cem-
etery, Baltimore, (4) Munson-Williams-Proctor Institute
Museum of Art, Utica, N.Y., (5) National Museum of
American Art, Washington, D.C., (6) Ian Robson, Spoth-
swoode, Bordon, Berwickshire, Scotland, (7) W. Plunkett
Stewart, Unionville, Pa., (8) Wadsworth Atheneum, Hart-
ford, (9) Yale University Art Gallery, New Haven

Originally conceived in 1859, William Rinehart's
Sleeping Children epitomizes the sort of sentimental
puerilities that so enthralled the Victorian public.
Tradition holds that Rinehart modeled the pair of
slumbering babes at the request of Hugh Sisson, an
early Baltimore patron who was the proprietor of a
local marble works noted for its pioneering use of
steam-powered equipment. (Sisson also commis-
sioned portrait busts of himself and his wife from
the sculptor.) In a letter from Rome on Dec. 9,
1859, to Frank B. Mayer (1827-1878), the Maryland
painter, Rinehart wrote, "I have just finished a
group of Sleeping Children for Sison [*sic*]. I sent
[William T.] Walters a Photograph of them."[1] In
time, the completed marble found use as a memo-
rial to the deceased Sisson children at the family's
lot in Greenmount Cemetery, Baltimore.

According to one acquaintance's recollection of
the commission, Rinehart modeled the figures of
the two children from life, taking sketches from a
pair of toddlers brought to his Roman studio to
nap. A drawing of a sleeping child that bears resem-
blance to one of the figures survives in the sculptor's
sketchbooks.[2] It is uncertain, however, whether it
depicts one of the dozing models he supposedly
invited to his studio or an antique statue he may
have studied in Rome, as the notation accompany-
ing the drawing would seem to imply. Certainly,
numerous sculptural prototypes existed for this
type of conceit, including several modern examples
which Rinehart probably knew. Perhaps closest in
composition was William Geefs's (1805-1883) *Paul et
Virginie*, 1851 (Royal Collection, Osborne House,

Isle of Wight), a literary study depicting two nap-
ping infants that attained wide publicity when
Prince Albert bought the piece from the 1851 Crys-
tal Palace Exposition as a Christmas gift for Queen
Victoria.[3]

Thomas Crawford executed a marble group enti-
tled *Babes in the Wood* in 1851 (The Metropolitan
Museum of Art, New York), a pictorial exploration
of the analogies between sleep and death. (The
subject of Crawford's composition derived from the
familiar nursery rhyme of that title, which was a
reworking of a sinister old English ballad, "The
Norfolk Gentleman's Last Will and Testament.")
Around the time Rinehart embarked on his rendi-
tion of the theme, Paul Akers, another compatriot
in Rome, also modeled a *Sleeping Child*, about 1858
(Maine Historical Society, Augusta), its morbid in-
nuendos suggested by its Italian title, *Moribundo
Putto*. The most celebrated of these marmoreal exe-
geses, however, was Sir Francis Chantrey's 1817
recumbent tomb effigy of the Robinson sisters in-
stalled in England's Lichfield Cathedral.[4] By Rine-
hart's time, this unabashedly sentimental monu-
ment was widely known through engravings, post-
card reproductions, and biscuit-ware miniatures.

Vignettes involving slumbering children were a re-
curring motif in nineteenth-century art, their perio-
dicity no doubt explained by the double-freighted
romantic themes they called to mind. The bliss of
youthful sleep symbolized the innocence ascribed to
children and invited the adult onlooker to consider,
with nostalgia, the celestial purity of soul said to
accompany the infant upon his arrival in the world.[5]
Yet images of children in deep repose were often
meant to be read at another level as well. Clearly the
stillness of their forms, together with the cool white-
ness of the marble, led the viewer to ponder the
similarities between the deathlike state of sleep and
the eternal sleep of death.

The lifelike modeling of Rinehart's sleepers inten-
tionally created just such a "yoked" viewing context.
The informality of the children's pose—one child
nestled against the shoulder of its sibling, with
an arm draped protectively across its waist—sug-
gests the possibility of imminent life: that the chil-
dren might wake, refreshed from their nap. But a
melancholy undercurrent of permanent sleep also
suffuses their motionless bodies, causing the viewer
to wonder whether it might be a deathbed on which
they rest. The ambivalence of the scenario height-
ened its appeal. Significantly, the theme of eternal
sleep was again investigated by Rinehart in his

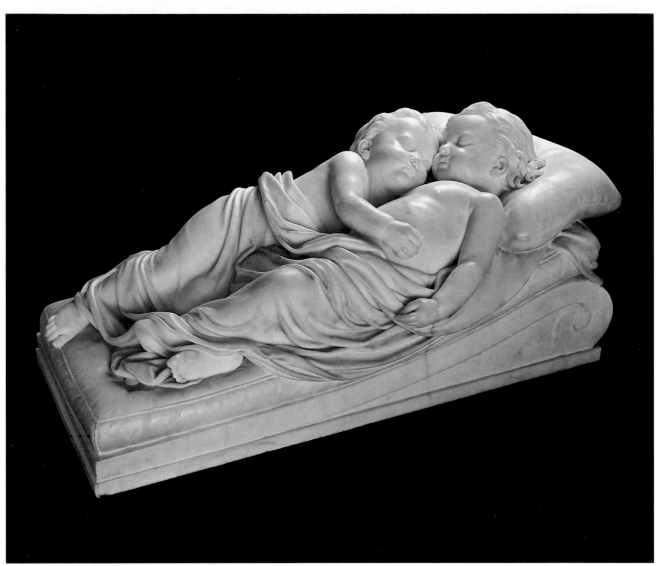

50

statue *Endymion*, 1874 (Corcoran Gallery of Art, Washington, D.C.), a conceit so tranquil in its plastic realization that a bronze replica was chosen to mark the sculptor's grave. Rinehart's fondness for such inanimate figures might be construed as indicative of a certain reluctance to cope with the problems of depicting the human form in motion, for "action" was rarely represented in his oeuvre.

From a technical perspective, *Sleeping Children* demonstrates Rinehart's skill at exploiting the pleasingly palpable qualities of his medium.[6] The marble pillow and mattress seem convincingly comfortable supports for the sleepers. The flesh of the two figures also has been worked to evoke the chubby, dimpled softness characteristic of a baby's skin. Though a bachelor, Rinehart was not immune to the winsome beauty and elfin charm of young children. These qualities he captured in his sensitive figural portraits of Henry Elliot Johnston, Jr., 1874 (National Museum of American Art, Washington, D.C.), posed as Cupid with a bow; Harriet Newcomer, 1863 (private collection, Virginia), holding a butterfly; and the pensive Roma Lyman, 1873 (Corcoran Gallery of Art), clutching flowers in her hand.

Evidence of the commercial popularity that *Sleeping Children* enjoyed in Rinehart's lifetime is contained in the sculptor's studio account book, *Libro Maestro*, which registers multiple orders for replicas.[7] At least eighteen marble copies were commissioned between 1860 and 1874 by clients in America, England, and Scotland. At the time of the sculptor's death, two additional marbles remained in his studio, one of which was sold for $750 to William W. Corcoran, the prominent art collector and merchant from Washington, D.C. (now Joseph Henry Collyer, Jr., West Brattleboro, Vermont), and the other (which required several weeks' additional carving) to the Duchess of Serradifaleo of Palermo, Italy (present location unknown). An interesting notation in Rinehart's studio book, under one of the orders he logged for *Sleeping Children* in 1866, suggests that he may have been willing to make adjustments to the basic design of the piece to suit the special needs of the destined owner. Mrs. H. Ackler of New York evidently requested that he cut the names "Laura and Corinne" on the statue's base along with the inscription "twin sisters," a petition that perhaps obliged Rinehart to further clarify the sexual identities of this otherwise androgynous sleeping pair.

Approximately a half-dozen versions of *Sleeping Children* are known in American museum collections, and other copies of the work occasionally sur-face in the art market.[8] Although the version of *Sleeping Children* acquired by the Museum of Fine Arts is undated, it seems logical that it represents a replica marble that Rinehart sent to America in the late 1860s or early 1870s to one of the clients mentioned in his *Libro Maestro*. The piece came to the Museum with a twentieth-century history of ownership in Rhode Island.

J.S.R.

Notes

1. Rinehart to Mayer, Dec. 9, 1859, quoted in Marvin Chauncey Ross and Anna Wells Rutledge, "William H. Rinehart's Letters to Frank B. Mayer, 1856-1870," *Maryland Historical Magazine* 43 (June 1948), p. 136.

2. See Walters Art Gallery, Baltimore, *A Catalogue of the Work of William Henry Rinehart, Maryland Sculptor, 1825-1874*, by Marvin Chauncey Ross and Anna Wells Rutledge (1948), pl. XLVII, identified as a "sleeping child after the antique."

3. See Benedict Read, *Victorian Sculpture* (New Haven: Yale University Press, 1982), p. 132 and illus. no. 163.

4. See Nicholas Penny, *Church Monuments in Romantic England* (New Haven: Yale University Press, 1977), pp. 115-120. Chantrey's novel and poignant church monument elicited an outpouring of maudlin verse tributes that Rinehart may have known.

5. This religious notion gained popular currency through William Wordsworth's famous ode *Intimations of Immortality from Recollections of Early Childhood* (1807).

6. Lorado Taft wrote of Rinehart's sculpture: "Such a subject may seem trivial, but its success depends largely on its treatment. This group is certainly a work of art. Its sentiment and its execution together make it important, like Jean Dampt's babies and those fascinating little nestlings in the arms of Paul Dubois's 'Charity.' " Taft 1930, pp. 178-179.

7. See account book of 1862-1874, known as the *Libro Maestro*, Archives of the Peabody Institute of the Johns Hopkins University, Baltimore; see also William Sener Rusk, *William Henry Rinehart, Sculptor* (Baltimore: Munder, 1939), pp. 68-69; and Walters Art Gallery, Baltimore, *Rinehart*, pp. 33-35.

8. For former locations of ten other versions of which the present locations are unknown, see Walters Art Gallery, Baltimore, *Rinehart*, pp. 33-34.

Randolph Rogers (1825–1892)

Born in Waterloo, New York, in 1825, Randolph Rogers grew up in Ann Arbor, Michigan, which was still a territory when his family moved west in 1834. Since opportunities for formal schooling were scarce, the future sculptor spent most of his adolescence working, as an apprentice to a baker, as a clerk in a dry goods store, and as an occasional freelance illustrator for Ann Arbor's newspaper, *The Michigan Arbus*. At twenty-two Rogers left for New York, hoping to find a job in an engraver's office. Although this scheme failed, he managed to secure work in a dry-goods firm owned by John Steward and Lycurgis Edgerton. According to tradition, Rogers's employers recognized their clerk's artistic talent, apparent in the plaster statuettes and chalk busts he executed in his spare time, and subsidized a trip to Italy for Rogers so that he could receive proper artistic training.

Rogers arrived in Florence in 1848 with the immediate goal of introducing himself to Lorenzo Bartolini (1777-1850), the leading talent in Tuscan sculpture and a distinguished professor at the famous Accademia San Marco. Although Bartolini was a neoclassicist by training, his style incorporated a refreshing naturalism that many Americans preferred to the correct, labored classicism of Canova and his disciples in Rome. Under Bartolini's instruction, Rogers soon mastered modeling in clay and plaster. He apparently remained untutored in the art of marble carving, a process that he relinquished to his studio assistants, as was the custom of many contemporary sculptors.

Upon Bartolini's death Rogers moved to Rome, taking a studio at no. 4 Piazza Barberini in the heart of the English-speaking community. Except for a brief visit to America in 1855 (when he gratefully repaid the loan from his former New York employers), Rogers worked at this address almost continuously for twenty years. In 1853 he modeled one of his greatest and most successful statues, *Ruth Gleaning* (The Metropolitan Museum of Art, New York), a work that focused international attention on Rogers. This sweet portrayal of the biblical heroine, shown crouching in the wheat fields of Boaz, anticipated many of the appealing characteristics of Rogers's later ideal sculpture: the source was literary, the sentiment was religious, and the carefully delineated narrative props and costume accessories readily identified the subject. The figure itself was loosely inspired by a well-known antique model, the *Crouching Venus* (Uffizi Gallery, Florence), copies of

which abounded in nineteenth-century Italy. Rogers deliberately tempered the neoclassical styling of the work with a romantic strain, reflected in the subject's theatrical gesture and touching expression. Not surprisingly, *Ruth Gleaning* was one of Rogers's favorite display pieces; the twenty replicas he produced also vouch for the statue's popularity with Victorian sculpture enthusiasts.

The success of *Ruth Gleaning* secured important patronage for Rogers as well as earning him a reputation as a skillful interpreter of biblical and literary themes. Among his better-known and most technically accomplished sculptural inventions in this vein are *Atala and Chactas*, 1854 (present location unknown), based on the Indian love story by the French writer Chateaubriand; *Isaac*, 1864 (Wadsworth Atheneum, Hartford), depicting the Hebrew boy bound for sacrifice, kneeling on the pyre; *The Lost Pleiad*, 1875 (The Brooklyn Museum), a representation of the tragic nymph in Ovid's *Fasti*; and *Nydia*, the blind girl of Pompeii (q.v.). A loyal following also developed for his droll and sentimental genre sculpture. Typical of these fanciful conceits

are *The Truant*, 1854 (National Museum of American Art, Washington, D.C.), a study of a young boy skating; *Children Playing with a Tortoise*, 1865 (present location unknown); and *The Infant Psyche*, 1871 (Evansville Museum of Arts and Science, Indiana), a delightful portrait of Rogers's daughter Nora shown sprouting from a clump of acanthus leaves, with a butterfly alighting on her shoulder.

Although he worked comfortably and profitably on ideal and anecdotal statues, which constituted the major portion of his work, Rogers aspired to win public recognition for portraiture and monumental civic sculpture as well. In 1854 he received his first public commission from a citizens' group representing Mount Auburn Cemetery in Cambridge. The assignment, a life-size statue of John Adams, was intended for the portrait series of prominent Massachusetts citizens conceived for the cemetery's chapel. The positive reception of the finished statue in Boston resulted in the award of other important public commissions, the most prestigious of which was an order for a massive pair of bronze doors for the entrance from the rotunda to the House Chamber in the United States Capitol. Using Lorenzo Ghiberti's great *Gates of Paradise* for the Baptistry in Florence as models, Rogers labored on the project from 1855 to 1858. The finished design, cast in bronze in 1860, featured a richly decorated doorway with eight low-relief panels depicting scenes from the life of Christopher Columbus.

In 1857 Rogers was engaged by the governor of Virginia to complete the colossal *Washington Monument* in Richmond, which had been left unfinished by the untimely death of Thomas Crawford. After the Civil War Rogers also enjoyed the steady patronage of town committees and citizens' groups, which hired him to create heroic-size memorials to honor local soldiers who had died in combat. In 1863 Mrs. Samuel Colt, widow of the famous inventor of the revolver, commissioned Rogers to design a funerary monument to her recently deceased husband. The result was a boldly modeled bronze angel of resurrection holding a trumpet (inspired by verses from 1 Corinthians), somewhat incongruously perched on a tall shaft embellished with Egyptian motifs.

Rogers relocated his studio in the early 1870s to the Via Margutta, settling into a spacious palazzo at no. 53, which housed the studios of several other American sculptors, including Chauncey B. Ives. Upon visiting Rogers, whose studio was among the most active in Rome, a contributor to *Harper's New Monthly Magazine* remarked, "Rogers seems to me to have the boldest, strongest hand of any American sculptor, and to do things on a grander scale," adding, "it may be the sculptor's danger that he is tempted to sacrifice delicacy to force, and to be content with the large instead of the great; but he certainly has his share of gentle sentiment as well as fine thought."[1]

As his artistic stature rose, Rogers began to reap appreciable professional rewards from his hard work and talent. The Accademia di San Luca in Rome, for example, conferred one of its highest honors on him in 1873 by electing him an academician of merit and resident professor in the class of sculpture. This title carried with it considerable prestige, especially considering Rogers's nationality and "foreign" status, and served to attract many new orders.

In 1882 Rogers suffered a paralyzing stroke, which effectively terminated his career. (Jealous competitors hinted that his debilitation was precipitated by an over fondness for food and drink.) Although he would never practice his craft again, his contributions to sculpture were not forgotten. Two years after the onset of his illness, Rogers was knighted by King Umberto of Italy and decorated with the order of Cavaliere della Corona d'Italia, an honor he shared with his colleagues Franklin Simmons and William Wetmore Story. During this period of studio inactivity Rogers initiated a project to ship a collection of his casts to the art gallery at the University of Michigan, Ann Arbor. This extensive gift, which served as a valuable index to the vast scope of Rogers's work and to the taste of his American patrons, was in time neglected and placed in storage at the university. Most of the casts eventually were broken or became soiled.

Rogers remained a Roman resident, occupying a stately townhouse on the Via Magenta, until he succumbed to complications arising from pneumonia in the winter of 1892. Friends and colleagues mourned the death of the affable Michigan sculptor, whose title "Professor of the Academy of St. Luca" was prominently printed on his funeral notices. Rogers and his wife, both converts to Catholicism, were interred at Rome's central cemetery, the Campo Verano. Their burial place was marked by a copy of Rogers's earlier monument *Flight of the Spirit*, produced about 1868 (Elmwood Cemetery, Detroit, Michigan), which was inscribed with the terse lines from Longfellow, "Dead he is not, but departed—for the artist never dies."[2]

J.S.R.

Notes

1. Samuel Osgood, "American Artists in Italy," *Harper's New Monthly Magazine* 41 (Aug. 1870), p. 422.

2. Quoted in Millard F. Rogers, Jr., *Randolph Rogers, American Sculptor in Rome* (Amherst: University of Massachusetts Press, 1971), p. 153.

References

"American Sculptors in Italy," *Aldine* 7 (Sept. 1874), p. 187; "Art in Florence," *Crayon* 2 (July 1855), pp. 20-21; Anna Brewster, "American Artists in Rome," *Lippincott's Magazine* 3 (Feb. 1869), pp. 196-199; Clark 1878, pp. 75-80; Craven 1968, pp. 312-319; Martin D'Ooge, *Catalogue of the Gallery of Art and Archaeology in the University of Michigan* (Ann Arbor: University of Michigan, 1892); Florentia, "A Walk through the Studios of Rome," *Art-Journal* (London) 16 (n.s. 6) (June 1854), pp. 184-187; Henry S. Frieze, "Randolph Rogers," *Michigan Alumnus* 4 (Dec. 1897), pp. 59-63; Gardner 1965, pp. 26-27; James J. Jarves, "Visits to the Studios of Rome," *Art-Journal* (London) 33 (n.s. 10) (1871), pp. 162-164; Michigan Historical Collections, Ann Arbor; MMA 1970, no. 114; *New York Times*, Jan. 16, 1892, obit.; Samuel Osgood, "American Artists in Italy," *Harper's New Monthly Magazine* 41 (Aug. 1870), p. 422; "Randolph Rogers, the Sculptor," *Harper's Weekly*, Feb. 6, 1892, p. 465; Millard F. Rogers, Jr., *Randolph Rogers, American Sculptor in Rome* (Amherst: University of Massachusetts Press, 1971); Rosa G. Rogers, "Biography of Randolph Rogers," n.d., Michigan Historical Collections, Ann Arbor; "The Sculptors of the Doors of the Capitol," *Harper's Weekly*, Jan. 30, 1892, p. 116; "Sculpture in the United States," *Atlantic Monthly* 22 (Nov. 1868), p. 559; Taft 1930, pp. 159-170; Tuckerman 1867, pp. 591-592; Katherine C. Walker, "American Studios in Rome and Florence," *Harper's New Monthly Magazine* 33 (June 1866), pp. 101-105.

RANDOLPH ROGERS

51
Nydia, 1856
Marble
H. 57 in. (144.8 cm.), w. 24½ in. (62.2 cm.), d. 33⅛ in. (84.2 cm.)
Signed (on back of capital): Randolph Rogers / Rome 1856
Gift of Dr. and Mrs. Laurence Perchik. 1973.617

Provenance: Possibly J.D. Bates, Boston; possibly Carroll B. Hills, Ipswich, Mass.; Dr. and Mrs. Laurence Perchik, Brookline, Mass.
Exhibited: Brockton Art Center-Fuller Memorial, Brockton, Mass., *Artful Toil: Artistic Innovation in an Age of Enterprise*, catalogue by Jan Seidler (1978), p. 26; BMFA, *Visions of Vesuvius*, catalogue by Alexandra Murphy (1978), p. 17; BMFA 1979, no. 4.
Versions: *Marble*: (1) The Art Institute of Chicago, (2)

The Art Museum, Princeton University, (3) The Brooklyn Museum, (4) Crocker Art Museum, Sacramento, Calif., (5) The Detroit Institute of Arts, (6) Evansville Museum of Arts and Science, Ind., (7) Fogg Art Museum, Harvard University, (8) Mr. and Mrs. James C. Hall, Pea Ridge, Ark., (9) Hausner's Restaurant, Baltimore, (10) The High Museum of Art, Atlanta, (11) Los Angeles County Museum of Art, (12) Masonic Temple Association of Saint Louis, (13) The Metropolitan Museum of Art, New York, (14) Museum of Art, Rhode Island School of Design, Providence, (15) National Museum of American Art, Washington, D.C., (16) Oshkosh Public Museum, Wis., (17) The Pennsylvania Academy of the Fine Arts, Philadelphia, (18) Philadelphia Museum of Art, (19) present location unknown, formerly Cathedral School of Saint Mary, Garden City, N.Y., (20) University of Michigan Museum of Art, Ann Arbor

Randolph Rogers's melodramatic rendering of Nydia, the blind flower girl of Pompeii, captured the hearts and imaginations of the nineteenth-century public.[1] Not only did the statue confirm the thirty-year-old sculptor's reputation as a creative artist of great technical ability; it also brought him bountiful financial rewards. From the time he first modeled the piece in October 1855 until his death in 1892, orders for *Nydia* netted Rogers approximately seventy thousand dollars, a staggering sum for the time.[2]

The subject was based on the female protagonist of Sir Edward Bulwer-Lytton's sensational novel Last Days of Pompeii (1834). Rogers chose to dramatize the blind Nydia's touching search for friends from whom she had been separated during the chaotic eruption of Vesuvius in A.D. 79. The vignette he presented was emotionally and visually theatrical: oblivious to the showers of sooty ash and ruins littering the street, Nydia bravely groped her way through the burning city in an effort to find her companions and lead them to safety. As the tale makes clear, Nydia's handicap became an asset, for her acute sense of hearing and deft manipulation of the guiding staff enabled her to navigate in the darkness with greater speed and agility than the sighted fugitives. The character's undespairing faith, as well as her courage, impressed the novel's readers. "Poor girl," the author wrote, "her courage was so beautiful to behold and Fate seemed to favour one so helpless!" To Bulwer-Lytton Nydia epitomized "the very emblem of Psyche in her wanderings; of Hope, walking through the Valley of the Shadow; of the Soul itself—lone, but undaunted amidst the dangers and snares of life."[3]

Rogers's interpretation of the passage was calculated to exploit the full pathos of Nydia's situation.

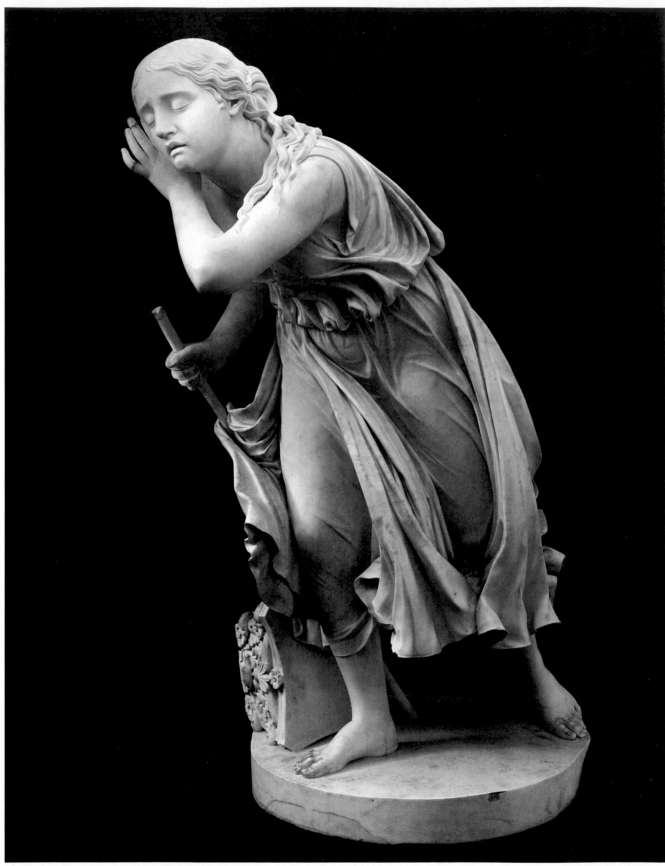

51

With economy he suggested the crumbling city's destruction by placing the fragment of a Corinthian column at Nydia's feet. The girl's troubled countenance (which echoes the distraught features of a running Niobid from the famous antique group of Niobe and her children in the Uffizi Gallery, Florence) reflects her deep concern and concentration as she listens for her friends, as does the gesture of her hand cupping her left ear as she strains to hear their voices. Nydia's baroque, billowing robes—the technical tour de force of the piece—underscore the concept of her onward rush. The disarray of her clothing, with portions entangled in her staff and others clinging about her knees, aptly creates an impression of her stormy, windswept surroundings. Even Nydia's exposed right breast seemed unobjectionable to American viewers in light of her plight; obviously the wind had disturbed the dress, and in her haste the girl was either unaware of her exposure or too preoccupied with her friends' safety to take the time to rearrange her garment.

Although the sculptor-critic Lorado Taft complained that "the flying drapery seems very mechanical with its parallel ribs and grooves,"[4] most people admired the virtuosity of the undulating carving and undercutting.[5] Optical appeal notwithstanding, the complexity of the drapery certainly contributed to the statue's overall production costs. As Rogers explained, "The Nydia is a very expensive statue to execute in marble, on account of the position of the figure. Then the flying drapery, deep cutting, and undercutting make it a very laborious undertaking."[6]

Which sources, if any, inspired Rogers's composition loomed as an issue of speculation among nineteenth-century critics. James Jackson Jarves referred to Nydia in a discussion of plagiarism he raised in The Art-Idea (1864), in which he berated modern sculptors for the shameless pillage of ancient sources without properly acknowledging them. He conjectured: "The Nydia of Randolph Rogers evidently is an exaggeration of a well-known mutilated statue of the Vatican, probably one of the Niobe group."[7] Other antique sculptures commonly proposed as sources for Nydia were Hellenistic copies of an Old Market Woman, known in both the municipal and papal art collections of Rome, and of the Winged Psyche in the Capitoline Museum. Although Rogers was no doubt acquainted with these statues, Nydia is less a specific imitation or composite of them than it is a general allusion to the theatrical sentiment suffusing classical sculpture made in Rome at the height of the empire (50 B.C. to A.D. 150), which itself was derivative of Greek sculpture of the fifth century B.C.[8] Rogers probably sensed that greater sympathy for his fictional flower girl would be generated if he quoted selective poses and expressions from antique models that his contemporaries recognized as universal evocations of anguish and suffering. As one observer remarked, the afflicted Nydia was a haunting image, not unlike the strain of sweet music.[9]

Nydia made an immediate impression on Rogers's sentimentally inclined countrymen. Shortly after completing the statue, he received a request for a copy from the Rogers Art Association in Ann Arbor, intended for presentation to the University of Michigan.[10] When the sculptor shipped the replica in 1862, it attracted considerable attention not only because it represented the work of a famous native son but also because it had the distinction of being one of the first examples of ideal neoclassical sculpture exhibited in the state. Rogers also sent a copy of Nydia to the 1876 Centennial Exposition in Philadelphia.[11] Its enormous popularity there contributed to the increasing demand for replicas. To satisfy the steady stream of orders and to appeal to prospective purchasers with incomes varying from ample to modest, Rogers offered two versions of Nydia: a life-size, or first, version (55 inches) for $2,000, and a reduction (36 inches), for $800.[12]

The practices of replicating a favorite statue and reducing it to a half-size model seem contrary to the romantic notion of art's uniqueness. Rogers, however, would have scoffed at the insinuation that by mass-producing statues with the aid of mechanical tools and hired workmen he was somehow compromising his artistic integrity. His studio practices were consistent with the tradition that valued the singular genius embodied in the sculptor's original design or clay sketch; skilled artisans, not endowed with the same inventive powers, were employed to reproduce the artist's archetype in a more permanent and salable format. These copies, by extension, increased appreciation of the original model. As Rogers's account books attest, there was an audience eager to buy replications of Nydia. His journal records fifty-two entries for orders.[13] One visitor to the sculptor's studio reported on the quasi factory Rogers had organized to supply this market demand, recalling with mixed humor and distaste the seven Nydia's he saw, "all in a row, all listening, all groping, and seven marble cutters at work, cutting them out. It was a gruesome sight."[14]

According to the unpublished biography of Rogers prepared by his wife, Rosa, her husband commenced work on *Nydia* in the fall of 1855, after returning to Rome from America.[15] During this trip the sculptor had visited Boston to finalize his plaster study of John Adams for Bigelow Chapel at Mount Auburn Cemetery in Cambridge. Mrs. Rogers believed that *Nydia* may have been commissioned by J.D. Bates, an international banker the sculptor met in Boston. (The statue now in the Museum's collection is dated 1856, lending credence to the notion that Rogers's Boston trip of the previous year had occasioned the commission.) In March 1859 the *Crayon* reported that Rogers's *Nydia* was owned by J.D. Bates of Mount Vernon Street (Boston), although no mention of the statue survives in records relating to Bates's art collection. Conceivably, the Museum's version may be the *Nydia* owned originally by Bates.[16] Even if that is not the case, the statue's inscribed date (1856) confirms that it was among the earliest full-size marble copies produced in this long line of blind flower girls. The statue retains its original pedestal base and turning ring.

J.S.R.

Notes

1. See Millard F. Rogers, Jr., *Randolph Rogers, American Sculptor in Rome* (Amherst: University of Massachusetts Press, 1971), pp. 33-40; idem, "Nydia, Popular Victorian Image," *Antiques* 97 (Mar. 1976), pp. 374-377.

2. See "Randolph Rogers, the Sculptor," *Harper's Weekly*, Feb. 6, 1892, p. 465.

3. Edward Bulwer-Lytton, *The Last Days of Pompeii* (Boston: Phillips and Sampson, 1834), p. 348.

4. Taft 1930, pp. 160-161. Taft also objected to Rogers's treatment of Nydia's extremities, a criticism recalling that the ability to impart "character" to feet and hands was considered an important criterion for nineteenth-century sculpture. "The fingers and toes," he wrote, "are monotonously rounded without characterization."

5. See Clark 1878, pp. 75-79. Clark's discussion of Rogers contains a lengthy and appreciative description of *Nydia*.

6. Rogers to Henry Frieze, Apr. 3, 1859, Michigan Historical Collections, Ann Arbor, quoted in Millard Rogers, *Randolph Rogers*, p. 39. Frieze, who became associated with the University of Michigan, Ann Arbor, and later served as president (1869-1871, 1880-1882), was instrumental in founding the Rogers Art Association.

7. Jarves 1864, p. 274.

8. Vermeule 1975, p. 976.

9. See Hiram Fuller, *Sparks from a Locomotive: or Life and Liberty in Europe* (New York: Derby and Jackson, 1859), p. 270.

10. See Rogers to Henry Frieze, Apr. 3, 1859, quoted in Millard Rogers, *Randolph Rogers*, p. 39. Rogers seems to have been eager to exhibit the statue in both Ann Arbor and Detroit. As he told Frieze, his subject was "so beautiful, and the character of the blind flower girl so pure, that all who have hearts must feel interested in her."

11. See Detroit 1983, no 15. In his contemporary account of the sculpture exhibited at the Philadelphia Fair, William Clark called *Nydia* "one of the most popular statues ever created by an American." Clark 1878, p. 75.

12. Millard Rogers, *Randolph Rogers*, p. 40. The author (pp. 202-203) lists forty-six reductions in private collections. As a result of the use of different materials for the pedestal bases, such as alabaster or colored marble, there were minor discrepancies in the quoted prices.

Reductions are not listed with "Versions" in this catalogue entry.

13. Quoted in Millard Rogers, *Randolph Rogers*, p. 39.

14. David Maitland Armstrong, *Day before Yesterday* (New York: Scribner, 1920), p. 194. Armstrong was American Consul to the Papal States at the time of his visit.

15. Rosa G. Rogers, "Biography of Randolph Rogers," n.d., Michigan Historical Collections, Ann Arbor.

16. In 1971, when Millard Rogers's *Randolph Rogers* was published, the Museum had not yet acquired *Nydia*, so that its version does not appear in the author's list of full- and half-size copies. Since the list does not include reference to the statue under former owners, Millard Rogers may have been unaware of this particular example. Rogers, however, cites a *Nydia* in the collection of Carroll B. Hills, Ipswich, Mass. Since the Perchiks, who donated the statue, purchased their version from a dealer who maintained that the statue came from the Crane estate in Ipswich, Mass., it is possible that the Museum's *Nydia* was at one time owned by Hills.

Millard Rogers lists the *Nydia* owned by J.D. Bates as a reduction (p. 202), although he notes that the reference is from Mrs. Rogers's biography rather than the account book. Since Randolph Rogers did not marry Rosa Gibson until 1857, a year after he signed his name and the date on the base of the Museum's statue, his wife may have been uncertain about the size of the original *Nydia* carved for Bates and hence may have mistakenly called it a reduction. See also an early reference to Rogers's *Nydia* in *The Artistical Directory; or Guide to the Studios of Italian and Foreign Painters and Sculptors in Rome* (Rome: Tipografia Legale, 1856).

Another version of *Nydia* with a local provenance, dated 1859, is in the Fogg Art Museum, Harvard University. See H. Wade White, "Nineteenth Century American Sculpture at Harvard: A Glance at the Collection," *Harvard Library Bulletin* 18 (Oct. 1970), pp. 359-366.

Harriet Goodhue Hosmer (1830–1908)

Of the many notable players who made up America's cast of second-generation neoclassical sculptors, Harriet Hosmer figured as one of the most accomplished and colorful. Despite the controversy that her ambitions and unorthodox lifestyle provoked among her contemporaries, she achieved exceptional success in a profession dominated by men. She also attained distinction as the leader of a small group of American women (including Anne Whitney) who pursued art careers in Italy during the second half of the nineteenth century, a feminine fellowship dubbed "the white, marmorean flock" by the writer Henry James.[1] Hosmer's rapid ascent to international celebrity and the impressive patronage she gained en route undoubtedly provided incentive for women of similar aspirations to pattern their training after her example.

Professionally, Hosmer profited from the spirit of independence that had been instilled in her by her father, a prominent physician. Hiram Hosmer, who had lost his wife and three other children to tuberculosis, was determined that his surviving daughter (and only child) enjoy an active outdoor life and pursue intellectual interests of her own choosing. She received her early schooling near home in Watertown, Massachusetts, where her classroom deportment evidently fell short of acceptable standards, as she was expelled from school three times. At age fifteen she was sent away to the progressive educational boarding school run by Charles and Elizabeth Sedgwick in Lenox, Massachusetts. There, she came into contact with a number of creative women who befriended and inspired her, among whom were the popular writer Catharine Maria Sedgwick, sister-in-law of the headmistress; Lydia Maria Child, the feminist author and antislavery advocate; and Fanny Kemble, the well-known English actress, who came to Lenox to enjoy the company of the many literary notables summering in the area.

Encouraged by her mentors to seek a life beyond respectable matronhood, Hosmer returned to Watertown in 1849 with the goal of becoming a sculptor. She studied drawing and modeling for a brief time with Peter Stephenson (1823-1861), an English-born sculptor then working in Boston, and also began to study anatomy under her father's supervision. Prohibited because of her sex from taking formal courses in anatomy at the local medical school, she was nonetheless eager to progress

with her studies and in November 1850 persuaded her father to arrange for private instruction through Dr. Joseph McDowell, chairman of the medical department at McDowell Medical College in Saint Louis, Missouri. Hosmer proved to be a committed, hardworking student and completed her training in six months' time, earning a certificate of proficiency along with the all-male graduating class.

During Hosmer's midwestern sojourn she lived as the guest of Cornelia Crow, a close chum from her school days in Lenox. The relationship she forged with the Crow family later assumed advantageous professional dimensions for her. Cornelia Crow (the future Mrs. Lucien Carr) became her steady correspondent and literary executor; Cornelia's father, Wayman Crow, an affluent businessman, civic leader, and politician, helped to underwrite Hosmer's studies abroad and remained a lifelong benefactor.

When Hosmer returned to Watertown, she established her own studio and determinedly set to work modeling portrait medallions and several ideal conceits, including her first major composition, an idealized bust of Hesper, 1852 (Watertown Free Public Library, Massachusetts), inspired by Tennyson's poem *In Memoriam*. In spite of the favorable response that greeted this maiden work, Hosmer felt frustrated by the limited professional opportunities

for a woman artist in Boston. At the urging of the American tragedienne Charlotte Cushman, who resided in Rome and whom Hosmer had lately met during the actress's Boston tour, she resolved to pursue her career abroad. In the autumn of 1852 she traveled to Rome accompanied by her father and Cushman.

Rome's advantages to the artist were immediately apparent to the eager American newcomer. Hosmer reflected, "You entered its gates, they closed behind you and the nineteenth century disappeared from view; you entered upon a sphere purely ideal —the ideal of the scholar, the poet, and the artist."[2] With daguerreotypes of *Hesper* in hand, she soon persuaded England's preeminent neoclassical sculptor John Gibson (1790-1866) to accept her as a pupil in his Rome studio. During her seven-year apprenticeship there, Hosmer's relationship with Gibson grew in mutual admiration. She worked daily in a special garden atelier Gibson equipped for her, adjoining his studio on the Via della Fontanella. Following the discipline Gibson devised of copying from the antique, she quickly mastered the lessons of technique, proportion, and mood manifested in the sculpture of Praxiteles and his Hellenistic followers. Among her first classically informed works were ideal busts of Daphne, 1854 (Washington University Gallery of Art, Saint Louis), and Medusa, 1854 (The Detroit Institute of Arts), which her teacher proudly admitted did "her great honor."[3] Gibson's pristine, academic tastes are imprinted on Hosmer's first full-length ideal marble, *Oenone*, 1856 (Washington University Gallery of Art), a portrayal of the grieving shepherdess abandoned by Paris for Helen of Troy. The melancholy figure, which had its probable source in Tennyson's poem *The Death of Oenone*, was commissioned in marble by Wayman Crow, Hosmer's accommodating patron.

In 1854 Hosmer's father, pleading financial reverses, rescinded his support, threatening her continued residence in Rome. Wayman Crow quickly interceded on the young sculptor's behalf, allowing Hosmer to draw on his New York bank account. To further bolster her finances, she modeled the playful conceit *Puck on a Toadstool*, 1856 (National Museum of American Art, Washington, D.C.). This image of the mischievous elf from Shakespeare's *A Midsummer Night's Dream* enjoyed immediate commercial success and continuing popularity. Over thirty replications were sold—one to Britain's Prince of Wales—earning the sculptor more than thirty thousand dollars in profits. The

multiple sales of *Puck* and copies of the related "fancy pieces" she produced in this same genial vein, *Puck and the Owl*, about 1856 (Boston Athenaeum), and *Will-o'-the-Wisp*, 1866 (James Ricau, Piermont, New York), helped to finance Hosmer's work on more demanding ideal compositions.

From the mid-fifties on, critics recognized Hosmer as a serious artist whose sculpture merited praise for its aesthetic qualities and fine workmanship rather than for its novelty value alone. Styling her work after the exacting neo-Hellenism and restrained sentimentalism of Gibson's oeuvre, she typically drew ideas for compositions from mythology, ancient history, and literary sources, effecting a temper in her sculpture that was tender, dignified, or, sometimes, amusing. Her best work shared with Gibson's an acute sensitivity to scrupulously defined surfaces and silhouettes and a pleasing grace of composition. Critics reacted warmly to her statue of Beatrice Cenci, 1856, commissioned by the Mercantile Library, Saint Louis, through the efforts of Wayman Crow, and first exhibited at London's Royal Academy in 1857. Inspired by Shelley's poem *The Cenci* (and perhaps by the universal curiosity her contemporaries felt for the famous painting, assigned to Guido Reni, of the young Italian noblewoman who had committed patricide to halt the incestuous advances of her father), Hosmer depicted the subject asleep in her prison cell on the eve of her execution.

Also attracting critical acclaim was Hosmer's stately marble figure of the ancient queen of Palmyra, Zenobia, 1859 (present location unknown; reduction, Wadsworth Atheneum, Hartford), shown walking in chains in the triumphal procession of her captors. Displayed at the 1862 International Exposition, London, the arresting image captured the public's imagination; the original was sold to the New York millionaire Alexander T. Stewart, and replicas were ordered by several notable patrons, including the Prince of Wales and Mrs. Potter Palmer of Chicago. From 1864 to 1865 thousands of Americans were given the opportunity to inspect *Zenobia* when Hosmer toured the piece in the United States. As *Beatrice Cenci* and *Zenobia* suggest, Hosmer was sympathetic to the historical injustices inflicted on women, and she devoted considerable energy to exploring themes of feminine suffering that illustrated the grace of women under pressure.

Like most neoclassical sculptors, Hosmer rarely worked in bronze, preferring white marble as the expressive vehicle for her ideal inventions. In 1860, however, she chose bronze as the medium for her

important *Thomas Hart Benton* commission for the city of Saint Louis, assisted again by her patron Crow. Hosmer's colossal, realistic representation of this Missouri senator represented one of her few essays in heroic portraiture. Cast in bronze at the Royal Foundry in Munich, the *Benton* monument was dedicated in 1868 at a ceremony attended a crowd estimated at forty thousand. She returned to marble for the full-length portrait she carved of Maria Sophia (present location unknown), Naples's exiled queen, one of Hosmer's helpful international allies.

Although literary and historical themes held greatest imaginative appeal for her, Hosmer departed every so often from her standard studio fare. She designed architectural ornaments and fountain sculpture for the country estates of her moneyed and titled English friends. In 1857 she executed a funerary monument to the teenage girl Judith Falconnet. Modeled after Renaissance tombs, the memorial featured the recumbent figure of the young woman on her deathbed, which Hosmer interpreted as a neoclassically styled couch. Installed in the church of S. Andrea delle Fratte, Rome, this monument represented the first commission awarded to an American for decoration in a Roman church. Ironically, one of the sculptor's best-known works is also atypical: the life cast of the clasped hands of Robert and Elizabeth Barrett Browning, 1853 (Schlesinger Library, Radcliffe College). Made at Mrs. Browning's request, the sentimental conceit celebrated the love binding the two poets as well as their friendship with Hosmer, to whom they extended many kindnesses in Rome. The cast acquired a certain cult status because of the many bronze replicas ordered by contemporary Browning enthusiasts.

In Rome Harriet Hosmer attained distinction as not only a fine artist but also a vivacious and witty presence. She was embraced as an intimate in the circle of precocious, talented women who orbited around Charlotte Cushman. Among the British aristocracy, European royalty, and other prominent expatriate figures, this spirited woman was herself a tourist attraction and a welcome fixture at their international salons. Elizabeth Barrett Browning was a particular admirer of "Hattie," as friends fondly called Hosmer. The poet respected her diligence and her absence of pretentions in business dealings with colleagues and clients. Nathaniel Hawthorne, after visiting her at her studio in 1858, marveled at the success and fierce independence of this transplanted New Englander. (Her career is thought to have influenced the writer's characterization of Hilda in *The Marble Faun*.) In his journal Hawthorne described Hosmer with such approving adjectives as brisk, frank, simple, and jaunty. Others were more reserved in endorsing her emancipated existence abroad. That she rode horses wildly across the Roman *campagna*, dressed in mannish attire like the French painter Rosa Bonheur (1822-1899), and openly renounced marriage as incompatible with her professional aspirations made her the object of unflattering gossip at home.

Controversy plagued her professional reputation as well as her personal life. Certain detractors (no doubt goaded by male colleagues envious of her rapid rise to fame) accused Hosmer of technical incompetence, shameless plagiarism of antique sculpture, and overreliance on her Italian carving assistants. In 1863 she became embroiled in an unpleasant scandal. The English press insisted that *Zenobia* was the product of an Italian studio worker, reasoning that the craftsmanship was beyond the capabilities of a woman. A number of Hosmer's defenders protested, John Gibson and William Wetmore Story among them, and the charge was retracted. The sculptor retaliated with an essay, "The Process of Sculpture," published in the *Atlantic Monthly* (December 1864), explaining her working techniques and clarifying the differences between the master sculptor's creative responsibilities in the studio and those delegated to her hired assistants. One contemporary art critic, James Jackson Jarves, observed that although Hosmer had achieved mechanical mastery of her profession through her protracted studies, she lacked the powerful originality essential to generating great art. Nevertheless, among the public her statues found a consistently receptive audience since prevailing taste judged the clever or charming enactment of a literary theme a more valuable attribute than expert plastic design.

As Hosmer's social connections with British aristocracy grew more extensive, her artistic output declined. After 1875 she directed increasing amounts of her time to various mechanical inventions and became consumed in a study of perpetual motion. She closed her studio and moved into the household of Lady Ashburton, a favorite patron, at Melchet Court in England. Few statues date from this phase, an exception being the historical portrait of Queen Isabella, 1892 (present location unknown), which she executed for the city of San Francisco and exhibited two years later at the San Francisco Fair.

Harriet Hosmer died of pneumonia in 1908 in Watertown, Massachusetts, having returned to her hometown eight years before. A fitting testimonial to the courage of conviction that fortified the sculptor during her career is provided in her remark to Phebe Hanaford in 1868: "I honor every woman who has strength enough to step outside the beaten path when she feels that her walk lies in another; strength enough to stand up and be laughed at, if necessary."[4]

J.S.R.

Notes

1. Henry James, *William Wetmore Story and His Friends* (London: Blackwood, 1903), vol. 1, p. 257.

2. Speech to Fortnightly Club, Chicago, n.d., p. [3]; Harriet Hosmer Collection, Schlesinger Library, Radcliffe College.

3. Quoted in Cornelia Crow Carr, ed., *Harriet Hosmer: Letters and Memories* (New York: Moffat, Yard, 1912), p. 24.

4. Quoted in Phebe Hanaford, *Daughters of America or Women of the Century* (Boston: Russell, 1877), p. 269.

References

"Art in Continental States: Rome," *Art-Journal* (London) 35 (n.s. 12) (Jan. 1873), p. 12; Benjamin 1880, pp. 152,156; Samuel W.G. Benjamin, "Sculpture in America," *Harper's New Monthly Magazine* 63 (Apr. 1879), pp. 657-672; W.H. Bidwell, "Harriet Hosmer," *Eclectic Magazine* 77 (Aug. 1871), pp. 245-246; *Boston Evening Transcript*, Feb. 21, 1908, obit.; *Boston Globe*, Mar. 1, 1908, obit.; Ruth A. Bradford, "The Life and Works of Harriet G. Hosmer, the American Sculptor," *New England Magazine* 45 (Nov. 1911), pp. 265-269; Cornelia Crow Carr, ed., *Harriet Hosmer: Letters and Memories* (New York: Moffat, Yard, 1912); Lydia M. Child, "Harriet E. [*sic*] Hosmer: A Biographical Sketch," *Ladies' Repository* 21 (Jan. 1861), pp. 1-7; idem, "Miss Harriet Hosmer," *Littell's Living Age* 61 (Mar. 1858), pp. 697-698; Clara Eskine Clement, *Women in the Fine Arts* (Boston: Houghton Mifflin, 1904) p. 165; Craven 1968, pp. 325-330; Joseph L. Curran, ed., *Hosmeriana: A Guide to Works by and about Harriet G. Hosmer* (Watertown, Mass.: Watertown Free Public Library, 1975); Mrs. Ellet, *Women Artists in All Ages and All Countries* (New York: Harper, 1859), pp. 367-369; Alicia Faxon, "Images of Women in the Sculpture of Harriet Hosmer," *Woman's Art Journal* 2 (spring-summer 1981), pp. 25-29; Gardner 1945, pp. 49, 66-67; Gerdts 1973, pp. 62, 84, 123, 136; William H. Gerdts, "The *Medusa* of Harriet Hosmer," *Bulletin of the Detroit Institute of Arts* 56 (1978), pp. 97-107; Barbara Groseclose, "Harriet Hosmer's Tomb to Judith Falconnet: Death and the Maiden," *American Art Journal* 12 (spring 1980), pp. 78-89; M.H.H., "Harriet Hosmer," *Englishwoman's Journal* 1 (July 1858), pp. 295-306; Nathaniel Hawthorne, *Passages from the French and Italian Notebooks* (Boston: Houghton Mifflin,

1899), vol. 1, pp. 140-143, 204-205, vol. 2, pp. 202-205; Harriet Hosmer, "The Process of Sculpture," *Atlantic Monthly* 14 (Dec. 1864), pp. 734-737; Jarves 1864, p. 276; James Jackson Jarves, "Progress of American Sculpture in Europe," *Art-Journal* (London) 33 (n.s. 10) (Jan. 1871), pp. 6-8; Margaret Wendell LaBarre, "Harriet Hosmer: Her Era and Art," Master's thesis, University of Illinois, 1966, Watertown Free Public Library, roll 1045, in AAA, SI; Joseph Leach, "Harriet Hosmer, Feminist in Bronze and Marble," *Feminist Art Journal* 5 (summer 1976), pp. 9-13; Lee 1854, pp. 221-226; "Life of Harriet Hosmer," *Nation*, Oct. 10, 1912, pp. 340-342; "Miss Hosmer's Studio at Rome," *Harper's Weekly*, May 7, 1859, pp. 293-294; *New York Times*, Feb. 22, 1908, obit.; Schlesinger Library, Radcliffe College; Lilian M.C. Randall, "An American Abroad: Visits to the Sculptors' Studios in the 1860s," *Journal of the Walters Art Gallery* 33-34 (1970-1971), pp. 48-49; Rubinstein 1982, pp. 75-79; Dolly Sherwood, "My Dearest Mr. Crow," *Washington University Magazine* 51 (1981), pp. 4-7; Taft 1930, pp. 203-211; Susan Wingate Taylor, "Harriet and the Browning Hands," *Yankee* 21 (Oct. 1957), pp. 46-47; Thorp 1965, pp. 79-88; Margaret F. Thorp, "The White Marmorean Flock," *New England Quarterly* 32 (June 1959), pp. 147-169; Rev. R.B. Thurston, *Eminent Women of the Age* (Hartford, Conn.: Betts, 1869), pp. 566-598; Tuckerman 1867, pp. 601-602; Susan Van Rensselaer, "Harriet Hosmer," *Antiques* 84 (Oct. 1963), pp. 424-428; Vassar College Art Gallery, Poughkeepsie, N.Y., *The White Marmorean Flock: Nineteenth Century American Women Neoclassical Sculptors*, catalogue by Nicholas Cikovsky, Jr., Marie H. Morrison, and Carol Ockman, introduction by William H. Gerdts (1972); "Visits to the Studios of Rome," *Art-Journal* 33 (n.s. 10) (June 1871), pp. 162-164; H.W., "Lady-Artists in Rome," *Art-Journal* (London) 28 (n.s. 5) (June 1866), pp. 177-178; Susan Waller, "The Artist, the Writer, and the Queen: Hosmer, Jameson, and *Zenobia*," *Woman's Art Journal* 4 (spring-summer 1983), pp. 21-28; Watertown Free Public Library; *Watertown Tribune-Enterprise*, Feb. 21, 1908, obit.; Whitney 1976, pp. 280-281; Josephine Withers, "Artistic Women and Women Artists," *Art Journal* 35 (summer 1976), pp. 330-336.

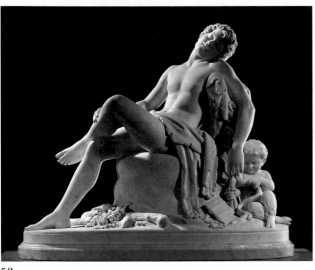

52

Harriet Goodhue Hosmer
52 (color plate)
The Sleeping Faun, after 1865
Marble
H. 34½ in. (87.6 cm.), l. 41 in. (104.1 cm.), d. 16½
in. (42 cm.)
Signed (back of base): HARRIET HOSMER FECIT ROMAE
Inscribed (on front of base): THE SLEEPING FAUN
Gift of Mrs. Lucien Carr. 12.709

Provenance: Mrs. Lucien Carr, Cambridge, Mass.
Exhibited: BMFA, "Confident America," Oct. 2-Dec. 2,
1973.
Versions: *Marble*: (1) present location unknown, formerly
Radcliffe College, Cambridge, Mass., (2) Walker Art Gal-
lery, Liverpool, England, (3) Mrs. Laurence C. Andrews,
Portland, Maine (presumed destroyed); life-size: (4)
Iveagh House, Dublin, Ireland, (5) Marquess of North-
ampton, Castle Ashby, England, (6) private collection,
United States (West Coast)

In an account of the exceptionally handsome group
of statues displayed at the Dublin Exhibition of
1865, the London *Times* isolated one entry for ad-
miring commentary: "The Sleeping Faun and
Satyr, by Miss Hosmer. . . . It is a curious fact that
amid all the statues in this court, contributed by the
natives of lands in which the fine arts were natural-
ized thousands of years ago, one of the finest should
be the production of an American artist. But she
has received her inspiration under Italian skies, in
presence of the great models of ancient Greece and
Rome."[1] This judgment of Harriet Hosmer's *The
Sleeping Faun* was sounded in most of the leading art
periodicals of nineteenth-century Britain and
America. A staff reporter for the New York *Watson's
Weekly Art Journal* praised Hosmer's *Faun* during its

Dublin showing as "a capital little figure, full of life,
truth and vigor."[2] Critics generally agreed that the
statue's most distinguished features were its antique
grace and appealing playfulness, attributes that
Hosmer's study of Hellenistic sculpture under John
Gibson had qualified her to reproduce with
authority.

In mood and technique, *The Sleeping Faun*, model-
ed in 1864 and completed in marble early the next
year,[3] is an accomplishment partially indebted to
Hosmer's earlier imaginative works in marble.
Chronologically, it succeeded her whimsical *Puck on
a Toadstool* (1855) and her moving characterization
of the afflicted Beatrice Cenci (1855), duplicating
the comic temper of the former composition and
refining the textural differentiation of props and
other surface illusions evident in the latter. The
statue's narrative is also communicated with the
same clarity that informed Hosmer's preceding
ideal creations. Essentially a group composition, the
statue stages an amusing drama enacted by two of
mythology's more fanciful creatures. The dominant
figure is that of a youthful faun, who dozes against a
tree stump, a tiger skin draped across his lap. A
mischievous satyr, crouching behind the stump,
binds this unwary victim to the trunk with the ends
of the tiger skin.

The faun's form is that of a beautiful, perfectly
proportioned adolescent; only his pointed ears pro-
vide a clue to his mythological origins. Anecdotal
accessories furnish allusions to his sylvan activities.
A lounging lizard at the base of the tree stump
suggests the sleeper's languorous disposition, while
the bunch of grapes discarded on the forest floor
connotes his carousing habits. The faun's tiger-skin
drapery implies his intimacy with the animal king-
dom; the panpipes and staff, temporarily forsaken,
refer to his roving merry-making through the woods.
Interest in fauns (and other Arcadian conceits) re-
vived in America in the 1860s in part as a result of
the romantic movement. Curiosity about this legen-
dary species was also heightened by Nathaniel Haw-
thorne's imaginative characterization of Donatello
in *The Marble Faun*. Donatello, who is the modern
emissary of the natural world, resembles the *Faun* of
Praxiteles and reveals his ancestry through his pas-
toral sympathies and untutored responses.

Compositional skill and carving expertise are
readily apparent in *The Sleeping Faun*. Hosmer's ele-
gant, fluid control of lines coaxes the viewer's eye to
ascend the composition, proceeding from the faun's
extended limb and rising up the graceful curve of

the torso, to pause at the face before descending to the figure's limp arm. The satyr nestled against the tree stump completes the design, having been introduced for purposes not only of story and contrast of mood but also of balance, or to provide what one contemporary critic termed "symmetry."[4]

Hosmer accurately distinguished tactile qualities through her adroit management of chisels, rasps, and drills. She tooled and polished the faun's body, for example, to simulate the smoothness and almost effeminate quality of adolescent male flesh. The faun's velvety body-contours contrast with the rough, mottled tree stump and mossy forest floor. The skin and underside of the tiger pelt have been ingeniously discriminated, with dull scratching employed to represent the rough skin and a slick, glossy polish to suggest the underside. The faun's tight ringlets have been nimbly undercut to impart a sense of depth and wavy thickness. A drill was utilized to precisely define every grape in the bunch near the faun's foot, each individual fruit having been burnished to achieve a pearl-like luster resembling the tautness of grape skin. Hosmer's preoccupation with investigating the special decorative materials of the statue's narrative components, such as her delineation of the annual growth rings at the branch points on the tree stump and her representation of the intricate pattern of scales ornamenting the lizard's back, at times infringes on the overall compositional scheme. Such optical displays carry the risk of detracting from the image as an integral design.

Cognoscenti of the mid-nineteenth-century art world recognized the influence of a legacy of late Hellenistic fauns and satyrs on the New England sculptor. As a commentator in London's *Art-Journal* remarked of her modern statue, "No one can look at the 'Sleeping Faun' of Miss Hosmer without feeling that the artist was penetrated with the very spirit of the antique; that she has produced a work which, were it dug out of the ruins of the Forum Romanum, might be held in public estimation as a fit companion for the Apollo Belvedere."[5] Sir Charles Eastlake, director of London's National Gallery, who epitomized educated Victorian taste, asserted that if the *Faun* had been discovered among the ruins of Rome or Pompeii, "it would have been pronounced one of the best Grecian statues."[6] Even John Gibson departed from his usual restraint in commending the work of his contemporaries when he said of his pupil's invention, "It is worthy to be Antique."[7]

In letters and interviews Hosmer freely acknowledged her indebtedness to classical art, claiming that "it had proved to be the true and lasting fount of inspiration of all great art. . . . lovers of all that is beautiful and true in nature will seek their inspiration from the profounder and serener depths of classical art."[8] Her concentrated study and copying of antique models under Gibson exercised a perceptible impact on her mature sculptural style, as did the pseudo-Praxitelean tastes of her mentor, Gibson. In their admiration of the sculpture of Praxiteles and his school (fourth century B.C.), Hosmer and Gibson were not alone. Most of their American and English colleagues likewise esteemed the ancient Greeks' sensuous evocation of flesh, the graceful flow of curves in their compositions, and the silky finishes they imparted to marble. American neoclassicists seem to have been especially intrigued by the playful, narrative quality of late Hellenistic sculpture and often sought to incorporate these characteristics in their own ideal compositions and "fancy pieces." Hosmer was a particularly convincing imitator of these antique properties. "If the chisel of Praxiteles has not been forever lost," wrote a visitor to her Roman studio, "Harriet Hosmer has found it. Under her hand the beautiful old myths live again, and all her works are suggestive of noble meaning, not only expressive of genius themselves, but so full of exquisite fancy that they would inspire genius in others."[9]

Several specific antique prototypes can be identified as probable influences on Hosmer's conception. The relaxed pose of *The Sleeping Faun* strongly recalls a sleeping bronze faun from Herculaneum (National Museum, Naples), especially in the position of the head and arms. Another well-known drowsy faun that Hosmer must have been conversant with was the Hellenistic *Barberini Faun*, about 220 B.C. (Glyptothek, Munich), a source often cited by critics in their discussion of *The Sleeping Faun*.[10] Like Hosmer's rendition of the subject, the *Barberini Faun* sprawls on a seat in an inebriated stupor. A panther skin of Dionysiac connotations is flung over his dangling arms. Hosmer's deviations from this Hellenistic faun imply her mindfulness of the Victorian censure—unwritten but understood—of complete nudity and frank sensuality in sculpture. Whereas the *Barberini Faun*, naked except for the panther skin, sleeps with his legs spread apart in overt erotic display, Hosmer's *Faun* dozes with his legs crossed, his genitals discreetly shielded by the animal-skin "apron" resting in his lap. The restless,

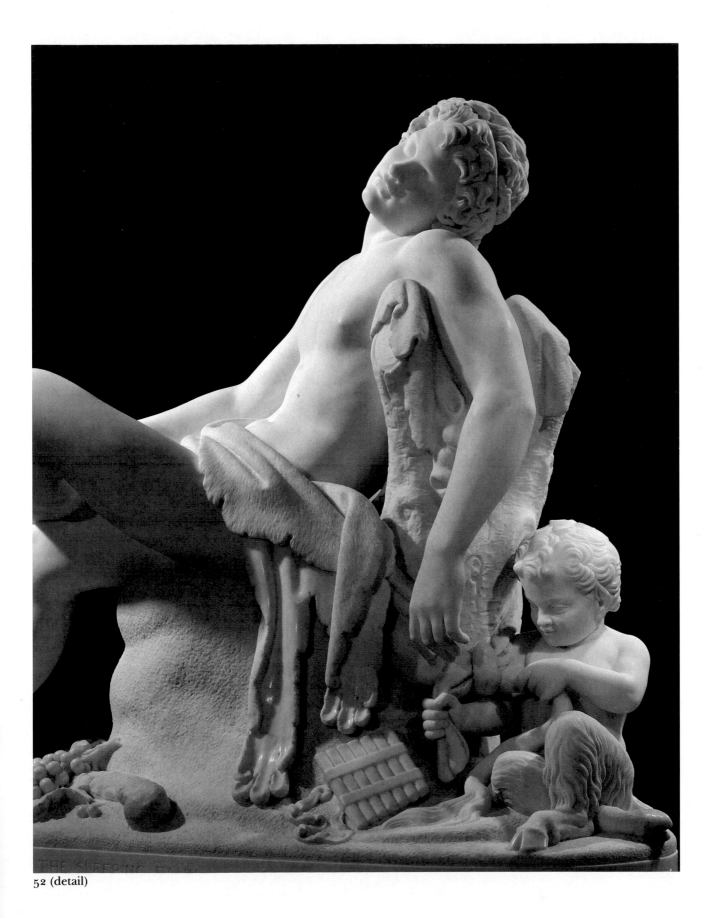

52 (detail)

troubled expression that viewers detected in the features of the adult *Barberini Faun* also has been omitted or reformed in Hosmer's creature, which appears to be an innocent, catnapping wood sprite barely into puberty. Like so many of her American colleagues in sculpture, Hosmer synthesized or admixed antique sources rather than creating literal facsimiles.

Before *The Sleeping Faun* made its debut at the 1865 Dublin Exhibition, it was admired at a private viewing by Sir Benjamin Guiness, the wealthy brewer and art collector, who immediately offered Hosmer one thousand guineas for it. According to Cornelia Carr, the sculptor at first declined the sale, since she intended to send the piece to America for exhibition along with her statues *Beatrice Cenci* and *Zenobia*. Guiness persisted, however, proposing to double the sum of his original offer. On the exhibition's opening date, she consented to sell the work to Guiness for the equivalent of five thousand dollars, not because of the tempting terms of his bid (she refused to accept double payment for it) but rather because it pleased her to know that the statue would be owned by a person who truly valued it. The wisdom of Guiness's early efforts to secure the work was demonstrated by the *Faun*'s instant popularity. Critics and public alike read the statue as an image of ideal Arcadian life or, to quote the period phraseology, "Life as the prophets tell there yet shall be in some Age of Gold hidden in the dim vistas of the Future."[11] As a youthful artist of the New World whose work was nurtured in the ambience of the Old, Hosmer was considered uniquely equipped to have given birth to such an embodiment of "ease and joy, and sensuous, delight-brimming existence."[12]

Two years after its auspicious display in Dublin, *The Sleeping Faun* was shown at the 1867 Exposition Universelle in Paris, an event attended by some eleven million visitors. "Miss Hosmer's Sleeping Faun which won a reputation in Dublin, is again an object of attraction in Paris," reported the *Art-Journal*.[13] Since the majority of entries showcased the work of contemporary French, Bavarian, and British sculptors, Hosmer's representation at the exhibition was all the more noteworthy;[14] among the small group of her compatriots whose sculpture was included—Leonard Volk (1828-1895), Launt Thompson (1833-1894), and John Quincy Adams Ward—she was also the only woman. American reviewers noted that, as proof of her patriotism, Hosmer had assumed the costs of transporting the

Faun to Paris on her own, refusing to accept the Italian government's offer to cover shipping costs if she would agree to place her statue in the Roman Court.[15] *The Sleeping Faun* enjoyed renewed popularity when the *Art-Journal* reproduced a steel engraving of the image in 1878.[16]

In addition to the life-size marble *Faun* purchased by Benjamin Guiness, Hosmer produced at least five versions of the statue in two sizes: life-size (50 inches high by 60 inches long) and a reduced size, or two-thirds-life size (34½ inches high by 41 inches long), of which the Museum's *Faun* is an example. The sculptor is reported to have received orders for replicas from the Prince of Wales (later Edward VII), Lady Louisa Ashburton, Charlotte Cushman, and John George Shortall of Chicago.[17] The version in the Museum of Fine Arts was donated by the sculptor's friend Cornelia Crow Carr and had at one time stood in Mrs. Carr's summer home in Newport, Rhode Island.[18]

In 1866 Hosmer catered to the Victorian public's fondness for contrast of mood and narrative sequence in art by creating a pendant to *The Sleeping Faun*. Entitled *The Waking Faun*, the companion piece dramatized the consequences that befell the satyr when the faun awoke and grasped the culprit by the hair. This pendant, exhibited along with *The Sleeping Faun* at the 1867 Paris Exposition, was also acquired by Hosmer's great English patron and friend, Lady Ashburton.

J.S.R.

Notes

1. Quoted in Cornelia Crow Carr, ed., *Harriet Hosmer: Letters and Memories* (New York: Moffat, Yard, 1912), p. 210.

2. *Watson's Weekly Art Journal*, June 10, 1865, p. 10.

3. In a letter of Dec. 30, 1864, Hosmer referred to the *Faun* as "getting on rapidly" and noted the excellent quality of the marble. This suggests that the figure was in the process of being cut in stone by the early winter of 1864. Letter quoted in Margaret Wendell LaBarre, "Harriet Hosmer: Her Era and Art," Master's thesis, University of Illinois, 1966, p. 212; Watertown Free Public Library, roll 1045, in AAA, SI.

4. Quoted from the Italian journal *Galignani*, in Carr, *Hosmer*, p. 210.

5. *Art-Journal* (London) 27 (n.s. 4) (Nov. 1865), p. 346.

6. Quoted in Craven 1968, p. 329.

7. Carr, *Hosmer*, p. 210.

8. Quoted in Susan Van Rensselaer, "Harriet Hosmer," *Antiques* 84 (Oct. 1963), p. 427.

9. Rev. Robert Coolyer to a friend, 1867, quoted in Carr, *Hosmer*, pp. 223-224.

10. For an illustration of the *Barberini Faun*, see Francis Haskell and Nicholas Penny, *Taste and the Antique: The Lure of Classical Sculpture, 1500-1900* (New Haven: Yale University Press, 1981), fig. 105, p. 202. Julia Ward Howe was one of Hosmer's contemporaries who noted the statue's similarity to the *Barberini Faun*, yet she was unusual in her failure to applaud the sculptor's clever reworking of the theme: "Miss Hosmer's Faun is a near relative in descent from the Barberini Faun, and, however good in execution has little originality of conception." Quoted in *From the Oak to the Olive: Records of a Pleasant Journey* (Boston: Lee & Sheperd, 1868), p. 97.

11. Francis P. Cobbe, "Ireland and Her Exhibition in 1865," *Fraser's Magazine* 72 (Oct. 1865), p. 422.

12. Ibid. See also Henry Parkinson and Peter L. Simmons, *The Illustrated Record and Descriptive Catalogue of the Dublin International Exhibition of 1865* (1865), pp. 474-475, 478, illus. p. 479; and Homan Potterton, "Harriet Hosmer's Sleeping Faun," *Arts of Ireland* 2 (1973), pp. 222-224.

13. *Art-Journal* (London) 29 (n.s. 6) (June 1867), p. 156.

14. Regrettably for Hosmer, her first name was erroneously listed in the catalogue as "Henrietta." See Carol Troyen, "Innocents Abroad: American Painters at the 1867 Exposition Universelle, Paris," *American Art Journal* 16 (autumn 1984), p. 27.

15. *Art Journal* (Chicago) 2 (Dec. 1868), p. 20.

16. *Art-Journal* (New York), n.s. 4 (Nov. 1878), facing p. 345.

17. These are the patrons mentioned by Carr, in *Hosmer*, p. 209. See also Hirschl & Adler 1982, p. 34. Susan Menconi, director of the gallery's sculpture department, has noted that the version of *The Sleeping Faun* illustrated in the catalogue is not the large version owned by the Marquess of Northampton, as published, but the version of the *Faun* formerly owned by the Borough Museum in Kendal, Westmorland, England, which was sold at auction in 1977 to a private collector in the United States (West Coast). She speculates that this may have been the *Faun* originally owned by Edward VII. The replica commissioned by J.G. Shortall, which has been missing since 1967, was formerly at Radcliffe College.

18. According to letters to the Museum from Mrs. Carr (then a resident of Cambridge, Mass.), Hosmer had priced the piece at $2,500. When Mrs. Carr offered the Faun to the Museum, she also offered to donate a version of *Puck*, which was in her possession. *Puck* was declined, however, with the judiciously worded explanation that the late sculptor's reputation would be best served by the exhibition of *The Sleeping Faun*. Carr to Arthur Fairbanks, director of the Museum, Apr. 12, 21, and May 10, 1911, and Fairbanks to Carr, May 28, 1911, BMFA, 1901-1954, roll 2444, in AAA, SI.

John Quincy Adams Ward
(1830–1910)

"In American art," John Quincy Adams Ward was "at once ancestor and descendant—a precursor, yet a modern instance."[1] A member of the second generation of American sculptors, he inherited the neoclassical tradition from Horatio Greenough and Hiram Powers but shared in the pioneering efforts of Henry Kirke Brown (1814-1886) and Daniel Chester French to cast both public and private sculpture in bronze. When the tragedy and disillusionment of the Civil War called for a new realism, Ward was able to create memorable portraits of prominent citizens that were truthful and objective. By temperament a leader, he published statements that prompted many artists to adopt native themes in their work. As president of the National Academy of Design in 1874, first president of the National Sculpture Society (1893-1905), and one of four professional artists on the board of trustees of the Metropolitan Museum of Art, New York (1870-1901), Ward exercised enormous influence.

Born in Urbana, Ohio, Ward was one of seven children of Eleanor (Macbeth) and John Anderson Ward. Mindful of the joy her brother had experienced early on in modeling clay, Ward's sister, who lived in Brooklyn, helped him gain entrance in 1849 as a paying student to Brown's New York studio, where he became his assistant for the next seven years, learning to cast in bronze as well as carve in marble. Brown was a genial and supportive teacher who gave Ward early recognition by adding the young man's name on the base of his bronze equestrian statue of George Washington, unveiled in 1856 (Union Square, New York).

At age twenty-six Ward left Brown's employ and within a year moved to Washington, D.C., hoping to receive a government commission that would establish his reputation. None materialized, but Ward kept busy modeling busts of members of Congress and working on the statuettes of *Simon Kenton*, 1857 (Cincinnati Art Museum), the legendary Ohio backwoodsman, and *The Indian Hunter* (q.v.).

Ward returned to New York in 1861 and supported himself by designing sword hilts and other decorative accessories for the Ames Manufacturing Company of Chicopee, Massachusetts. After exhibiting *The Indian Hunter* at the National Academy of Design, New York, in 1862, he was elected an associate. It was not until 1865, however, when an enlarged plaster model of *The Indian Hunter* was

shown at John Snedicor's gallery on Broadway that Ward received the critical praise that helped to launch his career. The financier August Belmont was so impressed with the model that he requested Ward to execute a bronze statue of the naval hero Commodore Matthew C. Perry, Belmont's father-in-law, 1868 (Newport, Rhode Island).

From this time on, Ward was assured of commissions. For the Gothic-style, granite *Ether Monument*, 1866 (Public Garden, Boston), designed by the Boston architectural firm of Ware and van Brunt, he was asked to create the *Good Samaritan*, a sculptural group representing a turbaned patriarch administering to a reclining nude youth. In addition, he modeled the marble bas-reliefs set into the base, which portray the use of ether on the battlefield and in the hospital. In 1867 he was awarded the commission for a statue of William Shakespeare to commemorate the tricentennial of the dramatist's birth. Unveiled in Central Park in 1872, the *Shakespeare*, like the *Good Samaritan*, proved to be a Victorian "costume piece" superimposed on a Praxitelean figure, despite Ward's determined efforts at historical accuracy. By contrast, the realism of his depiction of a weary soldier leaning on his rifle for the *Seventh Regiment Memorial*, 1874 (Central Park, New York) set a standard for Civil War memorials.

In 1872 Ward went to Europe for the first time. His fellow Ohioan the writer William Dean Howells had earlier proclaimed that Ward was "about as great as anything we've got in his way. Judging from sculptors at Florence, however, he would only unlearn greatness and generosity by coming abroad."[2] But Ward at forty-two was well established professionally and ready for the experience. The time he spent in Europe observing contemporary sculpture served him particularly well, as evidenced by the liveliness that infused his subsequent work.

In a succession of bronze public monuments Ward showed how thoroughly he had absorbed the freedom of gesture and expressive modeling of Beaux-Arts impressionism. His equestrian statue of Major General George Henry Thomas, 1879 (Thomas Circle, Washington, D.C.), subtly balances relaxed rider and excited horse with a realism that is novel for the time, while the heroic figure of George Washington, 1883 (Federal Hall, Wall Street, New York), conveys the dignity of the first president in a straightforward manner. In the *Horace Greeley*, 1890 (City Hall Park, New York), the ardent abolitionist and founder of the *Tribune* is shown seated informally, holding a newspaper but gazing outward as if contemplating the day's news. For the tribute to Henry Ward Beecher, 1891 (Borough Hall Square, Brooklyn), Ward added youthful figures around the base to enliven the "mountainous image"[3] of the liberal preacher and powerful orator. In all of these public commissions, Ward remained true to the character of his subjects.

Acknowledged as the head of his profession, Ward was asked to create the quadriga, *Victory upon the Sea*, crowning the colossal triumphal arch, temporarily erected in 1899 at the intersection of Fifth Avenue and Madison Square, to celebrate Admiral Dewey's visit to New York. In 1903 he completed the important commission for the pedimental sculpture on the New York Stock Exchange. An ambitious undertaking, "Integrity Protecting the Works of Man" allegorically depicts typical American workers—a farmer, a mechanic, an architect, and a prospector—who flank the personification of Integrity. Whether the average man in the street distinguished one idealized figure from another appears not to have been at issue.[4]

Ward retired eighteen months before he died at the age of seventy-nine, although he continued to work on the equestrian statue of General Winfield Scott Hancock, 1910 (Fairmount Park, Philadel-

phia) and a heroic seated bronze of his longtime patron August Belmont, 1910 (on loan to the Metropolitan Museum of Art, New York). His support of young sculptors, notably Daniel Chester French and Augustus Saint-Gaudens, and his leadership of the National Sculpture Society during the time of the great international expositions at Chicago (1893), Buffalo (1901), and Saint Louis (1904) deeply affected the direction of American sculpture.

P.M.K.

Notes

1. Adeline Adams, *John Quincy Adams Ward: An Appreciation* (New York: National Sculpture Society, 1912), p. 2.

2. Howells to William Swinton, Oct. 22, 1863, BPL

3. Craven 1968, p. 255.

4. Lorado Taft felt that it didn't matter to the public whether the pediment "represents 'The Balance of Trade' or 'The Triumph of Bacchus'; whether the central figure up there is called 'Freedom' or 'Money,' or whether it has any name at all. What does matter," the sculptor-historian admonished, "is whether the sculpture makes the building look well or not." For Taft, the collaboration of Ward and Paul Bartlett (1865-1925), who modeled the over life-size figures, was "a very notable achievement." Taft 1930, p. 230. See also Michele H. Bogart, "In Search of a United Front: American Architectural Sculpture at the Turn of the Century," *Winterthur Portfolio* 19 (autumn 1984), pp. 170-174.

References

Adeline Adams, *John Quincy Adams Ward: An Appreciation* (New York: National Sculpture Society, 1912); *American Art News*, May 7, 1910, obit.; Craven 1968, pp. 245-257; Hirschl & Adler 1982, no. 15; Gustave Kobbe, "Honors the Memory of J.Q.A. Ward," *New York Herald*, Aug. 4, 1912, magazine section; MMA; *New York Times*, May 2, 1910, obit.; Proske 1968, pp. 3-7; Michael Edward Shapiro, *Bronze Casting and American Sculpture, 1850-1900* (Newark: University of Delaware Press, 1985), pp. 61-76; Sharp 1974, no. 13; Lewis I. Sharp, "A Catalogue of the Works of the American Sculptor John Quincy Adams Ward, 1830-1890," Ph.D. diss., University of Delaware, 1980; idem, *John Quincy Adams Ward, Dean of American Sculpture* (Newark: University of Delaware Press, 1985); idem, "John Quincy Adams Ward: Historical and Contemporary Influences," *American Art Journal* 4 (Nov. 1972), pp. 71-83; G.W. Sheldon, "An American Sculptor," *Harper's New Monthly Magazine* 57 (June 1878), pp. 62-68; Russell Sturgis, "The Work of J.Q.A. Ward," *Scribner's Magazine* 32 (Oct. 1902), pp. 385-399; Taft 1930, pp. 216-233, 539; William Walton, "The Works of John Quincy Adams Ward, 1830-1910," *International Studio* 40 (June 1910), pp. 81-88.

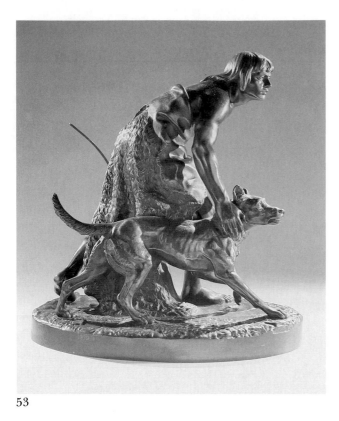

53

JOHN QUINCY ADAMS WARD
53
The Indian Hunter, about 1860
Bronze, gray-black over red-brown patina, sand cast
H. 15½ in. (40 cm.), w. 14 in. (36.8 cm.), d. 10½ in.
(27.4 cm.)
Signed (on top of base): J.Q.A. WARD / 1860
Frank B. Bemis Fund. 1979.11

Provenance: Plaza Art Galleries, New York; Mr. and Mrs.
Ward Melville, New York;[1] Museum purchase from the
Museums at Stony Brook, N.Y.
Exhibited: Sterling and Francine Clark Art Institute, Wil-
liamstown, Mass., *Cast in the Shadow: Models for Public
Sculpture in America,* catalogue by Jennifer A. Gordon
(1985), no. 33.
Versions: *Plaster:* (1) Erving and Joyce Wolf, (2) Washing-
ton's Headquarters, Newburgh, N.Y. *Bronze:* (1) Ameri-
can Academy and Institute of Arts and Letters, New
York, (2) Dolores C.B. Aymes, N.J., (3) The Century
Association, New York, (4) Los Angeles County Museum
of Art, (5) Mr. and Mrs. Ward Melville, New York, (6)
The Metropolitan Museum of Art, New York, (7) The
Museums at Stony Brook, N.Y., (8) The New-York His-
torical Society, New York (9) present location unknown,
formerly Mrs. R. Ostrander Smith, (10) Richard
Schwartz, New York, (11) Erving Wolf

Ward probably made his first sketches for *The In-
dian Hunter* in 1857 after leaving Henry Kirke

Brown's studio. Brown, an outspoken advocate for
the use of native themes by American sculptors and
a severe critic of the neoclassicists living in Italy,
must have influenced his young assistant with his
own seven-foot statue *Indian and Panther,* 1850 (pres-
ent location unknown), on which Ward also
worked. Then, too, he may have been inspired by
the *Crayon's* call in 1856 for American artists to
record, before it was too late, the Indian "seen, in
his primitive garb . . . a sublimely eloquent repre-
sentative of the hidden recesses, and the mental
solitude of the uncivilized wilderness."[2]
 Ward's statuette shows a young Indian warrior
leaning forward to restrain a snarling dog. Al-
though the triangular composition, with its strong
diagonal thrust, derives from the *Borghese Warrior*
(Louvre), the expressive modeling and naturalistic
features convey an emotionalism that was unprece-
dented in American sculpture.[3] As Russell Sturgis
pointed out in *Scribner's Magazine* in 1902, "the
lithe, sinewy, crouching, watchful creature had
nothing in common with the 'Classical Athlete.' It
was a new type of sculpture because it was the result
of a faithful study of a type in life."[4]
 Perhaps that is why *The Indian Hunter* was so well
received when a plaster sketch (Erving and Joyce
Wolf) was exhibited in 1859 at the Washington Art
Association and at the Pennsylvania Academy of the
Fine Arts, Philadelphia. Americans, it seems, were
ready to accept realistic themes in sculpture so long
as the subjects retained an ideal framework. Ward's
equally popular depiction of a slave freed of his
chains, *The Freedman,* 1865 (United States Capitol,
Washington, D.C.), was modeled from life, but the
torso recalls the *Belvedere Torso* (Vatican Museums).[5]
 In 1859-1860 Ward, now living in Washington,
D.C., had six copies of *The Indian Hunter* cast in
bronze, which "were flatteringly received and well
paid for."[6] In 1864, having decided to enlarge the
sculpture, Ward traveled to the Midwest to observe
the Dakota Indians. While there, he made a num-
ber of pencil and red wax sketches (American Acad-
emy and Institute of Arts and Letters, New York),
which Henry Tuckerman found to be "amongst the
most authentic aboriginal physiognomical types ex-
tant in plastic art."[7]
 In the fall of 1865 the over life-size plaster of *The
Indian Hunter* (destroyed, formerly Corcoran Gal-
lery of Art, Washington, D.C.) was shown at John
Snedicor's gallery in New York, and Ward became
the favorite of the press. His changes from the
statuette had been minor, consisting mainly of more

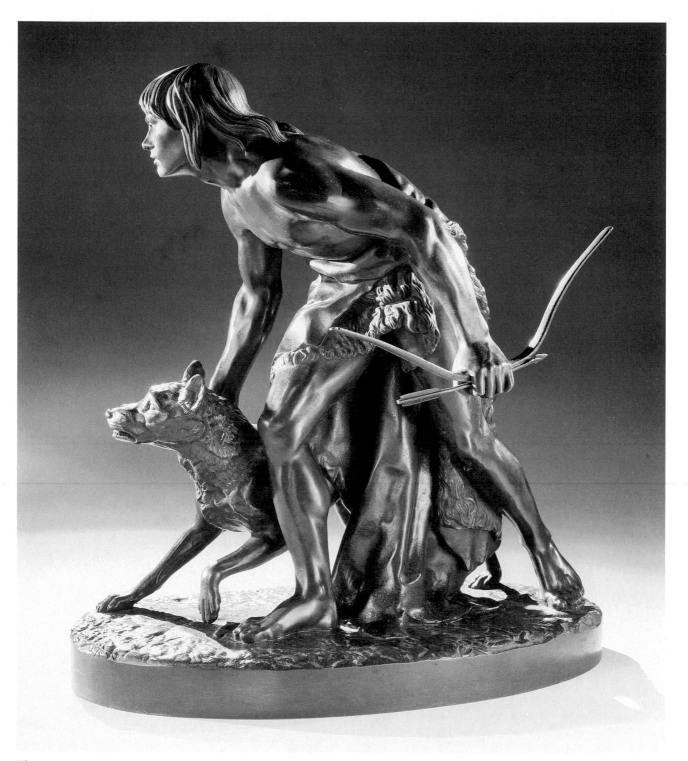

53

emphasis on the ethnic features and a simplification of the animal skin. The bow arm was raised and the base made rectangular. The following spring, Ward contracted the founder L.A. Amouroux of New York to cast the plaster in bronze. This version was sent to the Paris Exposition of 1867 and also shown at the National Academy of Design in 1868. On December 28, 1868, twenty-three subscribers, including the notable art patrons H. Pierpont Morgan, John Taylor Johnston, and William Hayes Fogg, underwrote the erection of the heroic bronze in Central Park. When it was unveiled on the South Mall in February 1869, *The Indian Hunter* became the first American sculpture to be placed in the park.

The original bronze "pin model" was kept by Ward, and at least thirteen statuettes were cast from this.[8] There are also three over life-size versions in bronze: at Lakefront Park, Cooperstown, New York, supervised by Ward and unveiled in 1898; at Delaware Park Meadow, Buffalo, erected in 1926; and at Ward's grave in Oakdale Cemetery, Urbana, Ohio, given in memorial by his wife in 1914.[9] Ward's earliest work and his first important commission, *The Indian Hunter* has remained his most popular piece of sculpture.

<div align="right">P.M.K.</div>

Notes

1. The Museum's version or another with the foundry mark (monogram) of the Henry-Bonnard Bronze Co. (The Museums at Stony Brook, N.Y.) was purchased by the Melvilles at Plaza Art Galleries, New York, Sept. 13, 1950, or Apr. 13, 1951. See Lewis I. Sharp, *John Quincy Adams Ward, Dean of American Sculpture* (Newark: University of Delaware Press, 1985), pp. 148-149.

2. "The Indian in American Art," *Crayon* 3 (Jan. 1856), p. 28.

3. See Sharp, *Ward*, pp. 38-39.

4. Russell Sturgis, "The Work of J.Q.A. Ward," *Scribner's Magazine* 32 (Oct. 1902), p. 399.

5. See Sharp, *Ward*, pp. 37-38.

6. D.O.C. Townley, "J.Q. Adams Ward," *Scribner's Monthly* 2 (Aug. 1871), p. 406.

7. Tuckerman 1867, p. 581. Sharp points out that Ward may have taken an earlier trip to the Dakotas in 1857; see *Ward*, p. 149, n. 7.

8. Ward's wife used the term "pin model" for the original bronze statuette that she bequeathed to the American Academy and Institute of Arts and Letters in 1933. The Indian and the dog unscrew from the base, and a pin in the back holds the figures together. Because the model could be disassembled, sand casting was accomplished with ease, resulting in a clear, sharp replica. See letter from Lewis I. Sharp to Paula M. Kozol, Nov. 25, 1985, BMFA, ADA.

Two other statuettes were on the New York art market in 1977-1978.

9. See "Memorial to J.Q.A. Ward Unveiled," *Urbana Daily Citizen*, June 29, 1914.

Charles Calverley (1833 – 1914)

Never one to experiment with the type of sculpture he created, Charles Calverley executed portraits almost exclusively. According to Wayne Craven, Calverley "during his entire career only twice undertook anything more ambitious than a bust or a profile relief."[1] Nevertheless, his medallions have been highly regarded, and Lorado Taft believed them to be "in their precision and firmness of construction . . . among the admirable products of the art."[2]

Born in Albany, New York, Calverley received his earliest training at the age of thirteen when he was apprenticed to a local marble cutter. He served six years and four months of his prescribed seven-year apprenticeship before leaving to assist Erastus Dow Palmer, the up-and-coming sculptor from Albany, who paid for the eight months that remained of Calverley's time. Starting in the spring of 1853, Calverley was employed by Palmer for fifteen years, spending ten hours a day cutting and finishing marble. During this period, Calverley helped with two of Palmer's best-known marble statues, *The Indian Girl*, 1856, and *White Captive*, 1859 (both in the Metropolitan Museum of Art, New York), and gained experience in modeling by using his free hours to make portrait medallions of members of his family and of friends. According to the sculptor, at least forty individuals sat for him between 1853 and 1868.[3] Calverley's diligence was rewarded when two of his marble reliefs of 1868, a likeness of the painter Charles Loring Elliott (1812-1868) (The Metropolitan Museum of Art), and *Mr. Lincoln* (The Union League Club, New York), were shown that year in the annual exhibition of the National Academy of Design in New York. Bearing the influence of Palmer's style, which had a strong enough naturalistic strain to distinguish it from the purely neoclassical, both efforts are assured in handling and handsome in appearance.

Perhaps feeling the need to break free from Albany, Calverley moved in December 1868 to New York, where he established himself in his own studio, not surprisingly, as a portrait sculptor. Before long, he was fully occupied with commissions from a growing clientele. Calverley was equally active during the 1870s as a regular participant in the annual exhibitions of the National Academy of Design, where he was made an associate member in 1871 and a full member in 1874. In 1876 he exhibited a bronze bust of John Brown, 1873 (present location unknown, formerly the Union League

Club), at the Centennial Exhibition in Philadelphia. For his sculptures of the 1870s and 1880s, Calverley seems to have generally favored marble for small and average-size portraits, among which, for example, were the medallion of Peter Cooper, 1872 (present location unknown), and the busts of Hon. William F. Havemeyer (present location unknown),[4] and Hon. Lafayette Sabine Foster, 1879 (Vice-President's Room, United States Capitol). Heroic-size busts, such as those of John Brown, Horace Greeley, 1876, and Elias Howe, 1884 (the latter two in the Green-Wood Cemetery, Brooklyn), were cast in bronze.

In the 1880s and 1890s Calverley increasingly chose bronze as the medium for his sculpture. One of his most important subjects from these years was Robert Burns, whom he portrayed in bronze in full-length, bust, and medallion form. The full-length, nine-foot version, showing the poet seated, was unveiled in Washington Park, Albany, in 1888. In the sculptor's words, it was "my first statue (rather late to begin)."[5] The only other full-length figure the sculptor produced was a life-size female allegory in bronze representing Meditation, 1902, which was placed on the Boulware family lot in the Albany Rural Cemetery.[6]

Throughout the 1890s and early 1900s Calverley

continued to make portrait busts and medallions, a number of which were exhibited at the Pennsylvania Academy of the Fine Arts, Philadelphia, in 1898 and 1899 and at the National Academy of Design in 1900. In 1903 the sculptor estimated that he had probably made over 250 pieces—including busts, medallions, tablets, and the two statues—after arriving in New York in 1868.[7] His style appears to have undergone a change as a result of his working more extensively in bronze. Calverley understood that this medium offered a greater textural variety than marble, and in his more actively modeled conceptions, like the bust of Edward C. Moore, about 1890, or the bust of Robert Burns, 1890 (both in the Metropolitan Museum of Art), he was clearly trying to demonstrate his mastery of the prevailing Beaux-Arts style. For the most part, however, his bronze portraits lack the competence and authority of those in marble, which he often pointed and always finished himself.[8]

During the last years of his life, until his death in 1914, Calverley lived with his daughter, Mrs. Francis Byrne-Ivy, in her home in Essex Falls, New Jersey. Though not influential to any degree as a sculptor, Calverley was significant as an image maker of eminent men of his day.

K.G.

Notes

1. Craven 1968, p. 209.

2. Taft 1930, p. 432.

3. Letter from Charles Calverley to Francis Edwin Elwell, curator of Ancient and Modern Statuary, The Metropolitan Museum of Art, Nov. 12 [probably 1903], MMA, ALS.

4. In a letter to Isaac H. Hall, Aug. 21, 1892, Calverley included the name of Hon. William H. [sic] Havemeyer in a "list of the more prominent persons" of whom he had made busts and medallions. However, in his letter to Elwell of Nov. 12 [probably 1903], the sculptor listed a marble bust of Hon. Henry Havemeyer, giving a date of 1877. MMA, ALS. Calverley may well have made busts of two members of the Havemeyer family, although it seems more likely that the portrait was of William F. (mayor of New York for three terms) and that Calverley confused the first names.

5. Ibid.

6. A collection of Calverley's portrait busts and reliefs, in plaster, bronze, and marble, and a number of his pencil and ink drawings can be found in the Albany Institute of History and Art, the major art museum of his hometown.

7. Calverley to Elwell, Nov. 12 [probably 1903].

8. Ibid.

References

Boston Evening Transcript, Feb. 27, 1914, obit.; Charles Calverley, letters to Isaac H. Hall, Aug. 21, 1892, and Francis Edwin Elwell, Nov. 12 [probably 1903], MMA, ALS; Clement and Hutton 1894; Craven 1968, pp. 209-210; Gardner 1965, pp. 33-35; *New York Times*, Feb. 27, 1914, obit.; Taft 1930, pp. 432, 538.

CHARLES CALVERLEY

54

James Russell Lowell, 1896
Gilded bronze, lost wax cast
Diam. 6¾ in. (17.2 cm.)
Signed (near lower rim): CHAS. CALVERLEY.S^C MDCCCXCV
Inscribed: *obverse:* (near upper rim) JAMES RUSSELL LOWELL (at left of subject) SAPIENS / HAEREDITABIT / HONOREM·ET / NOMEN ILLIVS / ERIT VIVENS / IN AETERNVM· / Ecclus·XXXVII·26 (at right of subject) FEB·22·1819 / AUG·12·1891 (near lower rim, in circular seal) ·GROLIER CLUB·NEW-YORK; *reverse:* (near lower rim) COPYRIGHTED 1896.
Gift of the Council of the Grolier Club. 96.46.
Provenance: The Grolier Club, New York
Versions: *Plaster:* (1) The Grolier Club. *Bronze:* (1) Albany Institute of History and Art, N.Y., (2) The American Numismatic Society, New York, (3) Boston Public Library, Department of Rare Books and Manuscripts, (4) The Century Association, New York, (5) Collection of American Literature, Beinecke Library, Yale University, New Haven, (6, 7) The Grolier Club, bronze proof and silvered bronze, (8) Houghton Library, Harvard University, (9) The Metropolitan Museum of Art, New York

The idea of the Grolier Club (a society in New York devoted to the art of the book) to commemorate the author James Russell Lowell (1819-1891) was stimulated by a desire to have a companion piece for the highly successful medallion of Nathaniel Hawthorne, produced by the club in 1893.[1] In seeking an American writer worthy of the honor, the name of Lowell was prominent among the suggestions offered by club members. Having decided upon Lowell, the club's Committee on Publications sought the advice of Professor Charles Eliot Norton of Harvard University and relatives of the author for the most characteristic likeness.[2] Norton furnished a photograph taken in England by Elliot & Fry Studio and also selected an appropriate legend from the Book of Ecclesiastes.[3] The commission was given to Calverley, who, at the time he modeled the medallion in 1895, was a full member of the Na-

tional Academy of Design and was known for busts of Horace Greeley and Elias Howe in Green-Wood Cemetery, Brooklyn, and for the statue of Robert Burns in Albany. The object was to be the same size (seven inches in diameter) as that representing Hawthorne. The guiding spirit in bringing about both the Hawthorne and Lowell medallions was the philanthropist, art adviser, and connoisseur Samuel P. Avery, vice-president of the Grolier Club in 1895 and president from 1896 to 1900.

In the spring of 1896 John Williams, a notable New York founder, made the casts; the number in the edition was determined by how many were ordered by Grolier Club members. Each member was permitted to purchase no more than two casts at the cost of ten dollars apiece. Altogether, 372 copies were made in bronze (with at least one gilded, as in the example here), including several that were to be given to museums, to Professor Norton, and to Lowell's daughter, Mabel. In addition, three were cast in silvered bronze.[4]

On May 24, 1896, the *New York Times* published a glowing review of Calverley's medallion: "The memorial medallion of James Russell Lowell is now almost ready for delivery to members of the Grolier Club of this city. . . . The medallion, unlike some former issues by the Grolier Club, is a purely American production. It was designed in this country by an American sculptor, and the casting is being done in an American foundry. Judging it simply from an artistic point of view, it is infinitely superior to any medallion yet issued by the Grolier Club. It is the work of a moster [*sic*], for instance, compared with the memorial plaque of Hawthorne, which was cast in Paris, long supposed to be the only place in the world where such work could be perfectly done. That the Lowell medallion is appreciated by the members of the Grolier Club is apparent from the fact that about 150 copies more have been subscribed for than for that of Hawthorne."[5]

The medallion shows Lowell in bust form and full face. His mustache and beard are richly rendered and flow freely over his shirt, vest, and jacket. Most striking is the perfect balance in composition between the forceful characterization of Lowell and the many and varied inscriptions. The complex lettering begins at the top with the sitter's name intertwined with laurel. Lowell's birth and death dates are recorded on the right side, and, on the left, is a Latin verse from the Book of Ecclesiastes, which can be translated as "A wise man shall inherit honor among his people, and his name shall live forever."

At the bottom, the seal of the Grolier Club is set between two branches of laurel. Lastly, Calverley's signature and the date of the medallion's execution are placed on either side of the seal. Stylistically, the piece is typical of the Beaux-Arts mode and is a particularly fine example of Calverley's endeavors in bronze. On the whole, it is far removed indeed from Calverley's classicizing beginnings.

K.G.

Notes

1. The Hawthorne medallion was created by Désiré Ringel d'Illzach (1847-1916). The club later issued portrait reliefs of Edgar Allan Poe, 1909, by Edith Woodman Burroughs (1871-1916); Ralph Waldo Emerson, about 1910, by Victor David Brenner; and Henry Wadsworth Longfellow, 1911, by John Flanagan (1895-1942).

2. Report of the Committee on Publications, Jan. 23, 1896, *Annual Report of the Grolier Club of the City of New York*, 1896, pp. 93-95.

3. See pamphlet, Feb. 23, 1896, announcing the publication of the Lowell medallion, in Memorabilia Book, May 1892-Mar. 1903, The Grolier Club Library, New York.

4. For information on the production and distribution of this medallion, see ledger, 1891-1901, p. 194; and pamphlet, Feb. 23, 1896, in Memorabilia Book, May 1892-Mar. 1903, The Grolier Club Library. For information on the number of casts made, see *List of Publications, Exhibition Catalogues, and Other Items Issued by the Grolier Club, 1884-1948* (New York, 1948), p. 24.

5. "Charles Calverley's Memorial Nearly Ready for the Grolier Club," *New York Times*, May 24, 1896.

Larkin Goldsmith Mead
(1835 – 1910)

Larkin Mead is popularly known as the "Vermont sculptor," although he worked in Italy for almost half a century. One of several talented children of a prominent Brattleboro attorney, Mead grew up in an affluent household where art and other cultural subjects were familiar topics of conversation. While in his teens, he worked part-time in a hardware store, devoting his leisure hours to drawing and modeling. An ailing artist, who had visited Brattleboro for the "water cure," apparently saw a marble pig modeled by the young store clerk and was so impressed by this bit of amateur workmanship that he persuaded Mead's family that their son should refine his skills in a more disciplined and professional way. To that end, Mead went to New York at the age of eighteen and secured an assistant's position in the studio of the eminent sculptor Henry Kirke Brown (1814-1886), who included among his young protégés John Quincy Adams Ward. Mead remained at Brown's studio for two years and then returned to Brattleboro with the hope of achieving fame in his new profession.

Notoriety came to Mead almost immediately. On New Year's morning 1856, Brattleboro's citizens awoke to find occupying the village center a heroic-size snow sculpture, *Recording Angel*, devised by Mead as a prank. In one hand the eight-foot angel held a stylus while in the other she clutched a tablet on which to register the events that had transpired in the community during the previous year. The artistic skill evident in the *Angel*'s design impressed townspeople even more than the work's novelty and humorous import. News of the remarkable *Angel* and its creator quickly spread to other New England communities. James Russell Lowell alluded to it in his poem *A Good Word for Winter*. Reports of Mead's exploit ultimately reached the Cincinnati art patron Nicholas Longworth, the benefactor of promising young sculptors, most notably Hiram Powers and Shobal Clevenger. Longworth contacted Mead and gave him encouragement by commissioning him to reproduce his celebrated snow angel in marble. Other orders followed in the wake of this gesture of patronage, including those for a nineteen-foot figure of Ceres, 1857, for the dome of the Vermont State House in Montpelier, and a statue of the revolutionary war hero Ethan Allen, 1861, to adorn the portico of the same building.

The outbreak of the Civil War brought an end to

Mead's active career as a sculptor in Vermont. He briefly contributed illustrations of Potomac River battle scenes to *Harper's Weekly* but in 1862 abandoned that means of livelihood to accompany his sister Elinor to Italy. Elinor was engaged to marry the United States consul in Venice, William Dean Howells, the aspiring writer whose flattering biography of Abraham Lincoln had netted him his consular post abroad. Mead's plan was to escort his sister to Paris for her wedding ceremony, arranged for Christmas eve, 1862, and then resume his sculpture studies in Florence. According to plan, Mead settled himself in that city at the Casa Grazzini, where the sculptor Joel T. Hart (1810-1877) of Kentucky was a fellow tenant. Hart offered Mead space at his studio on the Piazza Indipendenza, a working address favored by American sculptors in Florence.

As an initial compositional exercise, Mead undertook to copy in clay an antique female torso from one of the Florentine art collections. At the suggestion of Hart, he later added limbs to the figure and labeled it with the Italian word *Ecco!* ("Behold!"), which Mead mistakenly believed was the name of the mythological deity Echo. He sold a marble copy, 1865, to the wealthy American art collector William Corcoran, whose accumulated artworks formed the core of the Corcoran Gallery of Art, Washington,

D.C. Other statues from this period purchased by
Americans were *The Returned Soldier*, 1865 (present
location unknown), and *Columbus and Isabella*, 1870
(California State Capitol, Sacramento).

In 1868 Mead returned to America and received
what amounted to his most important and ambi-
tious commission to date: a bronze memorial to
Abraham Lincoln for Oak Ridge Cemetery, Spring-
field, Illinois. He labored for more than six years on
the monument's complex scheme, which consisted
of a portrait statue of the late president encircled at
the base by supplementary figural groups repre-
senting the four branches of the military: infantry,
artillery, cavalry, and navy. As an ensemble design,
the composition (cast at the Ames Foundry in Chi-
copee, Massachusetts) lacked cohesion. When un-
veiled in 1874, the monument was still missing sev-
eral of the decorative panels and auxiliary narrative
groups Mead had proposed. These were not added
for almost another decade. Regrettably for the
sculptor, the *Lincoln Memorial* encountered a con-
troversial reception. Critics found his portrait
rather lackluster and the martial emphasis of the
conceit strangely out of keeping with Lincoln's pre-
ferred image as the nation's architect of freedom
and union. Mead fared better with an order en-
trusted to him by the state of Vermont for another
Ethan Allen, this one intended for the National Stat-
uary Hall, United States Capitol, Washington, D.C.
Loosely based on Michelangelo's *David*, the statue,
dedicated in 1876, featured Allen dressed in the
uniform of the period, demanding the surrender of
Fort Ticonderoga.

For most of his career, Mead resided in Florence,
working on orders for statues at a slow but steady
pace befitting a financially comfortable "gentleman-
artist." A bas-relief of the American art critic James
Jackson Jarves (Yale University Art Gallery, New
Haven), and a marble facsimile of Mead's earlier
Recording Angel (All Souls' Church, Brattleboro)
date from the mid-1880s. Increasingly, Mead pre-
ferred designing large-scale public works. During
the early 1890s he executed several plaster pedi-
mental decorations, including *The Triumph of Ceres*
for the Agricultural Hall at the World's Columbian
Exhibition in Chicago, a structure designed by his
brother William's firm, McKim, Mead and White.
Also conceived at this time was his architectural
allegory of the Mississippi River, *Father of the Waters*
(Minneapolis Municipal Building, Minnesota).

Like many New Englanders of his generation,
Mead developed a special bond of affection with his
adopted country of residence; he was a willing con-

vert to the Italian approach to living—to that agree-
able, leisurely rhythm of existence so perfectly ex-
pressed in the well-known phrase "dolce far
niente." Mead married an Italian woman and lived
happily in Florence until his death in 1910, undis-
turbed by the fact that the city had passed out of
favor as a "watering hole" for expatriate artists. One
of the new generation of American sculptors who
sought his counsel abroad in this late phase of his
career was Bessie Potter Vonnoh, who spent a brief
time at his studio in 1897.

J.S.R.

References

American Art News, Oct. 22, 1910, p. 2, obit.; Benjamin
1880, pp. 152-153; *Boston Transcript*, Oct. 17, 1910, obit.;
BPL; Craven 1968, pp. 321-325; *Harper's New Monthly
Magazine* 41 (Aug. 1870), pp. 420-425; *New York Times*,
Oct. 16, 1910, obit.; Arthur W. Peach, "The Snow An-
gel," *News and Notes, Vermont Historical Society* 5 (Jan.
1954), pp. 33-35; Oran Randall, *History of Chesterfield,
Cheshire County, New Hampshire* (Brattleboro, Vt.: Leo-
nard, 1882), pp. 389-390; John Sartain, *The Reminiscences
of a Very Old Man, 1808-1897* (New York: Appleton,
1899), pp. 237-238; Lewis A. Shepard, *American Art at
Amherst: A Summary of the Collection at Mead Art Gallery,
Amherst College* (Amherst, Mass.: Mead Art Gallery, 1978),
p. 141; Taft 1930, pp. 236-244; Thorp 1965, pp. 149-
150.

LARKIN GOLDSMITH MEAD
55
Venezia, 1865-1866
Marble
H. 25 in. (63.5 cm.), w. 25 in. (63.5 cm.), d. 10⅞ in.
(27.7 cm.)
Signed (on back): L.G. MEAD
Inscribed (on hair clip): VENEZIA
Helen and Alice Colburn Fund. 1981.85
Provenance: Richard Mills, New York; Childs Gallery,
Boston
Versions: *Marble*: (1) Professor and Mrs. William White
Howells, Boston, (2) New Hampshire Historical Society,
Concord, (3) private collection, New York, (4) James Ri-
cau, Piermont, N.Y.

The marriage of Larkin Mead's sister Elinor to
William Dean Howells in 1862 provided Mead with
numerous opportunities to visit the couple in Ven-
ice, where Howells was serving as consul. These
trips were not consumed in sightseeing exclusively,
for Howells occasionally enlisted the young sculptor
to serve as vice-consul when he and his wife were
absent from the city.

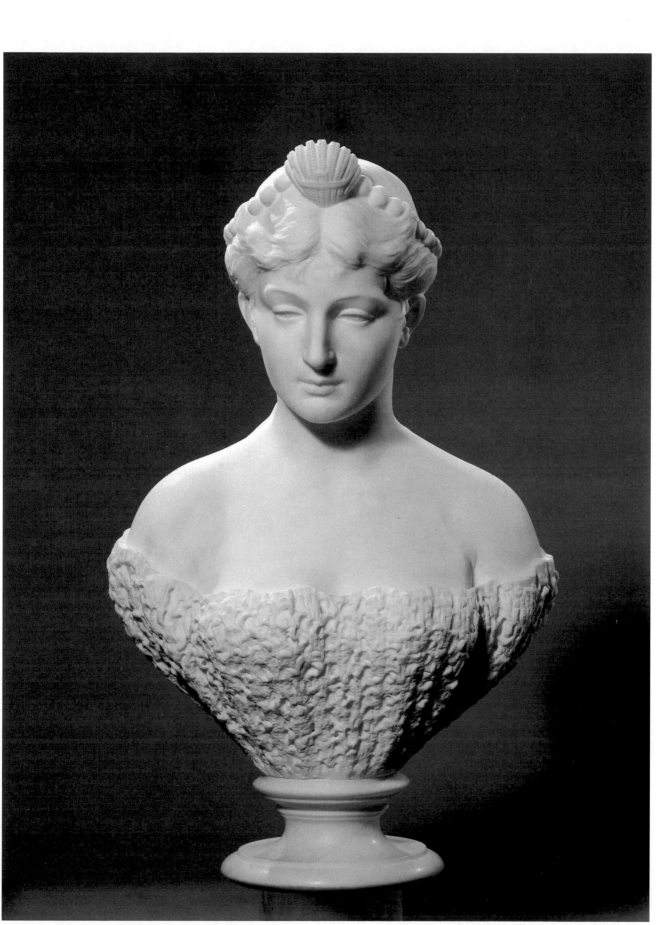

55

During one of these terms as consular attaché, Mead met and became enamored of a local beauty named Marietta di Benvenuti, whose family lived in rooms above the Howellses' apartment. He subsequently married her on February 26, 1866.[1] According to family reports, the Catholic Benvenuti clan disapproved of the marriage, and the wedding was performed against papal wishes and without dispensation. Despite the obstacles confronting the newly married pair (including a mutual deficiency in each other's language), the union was apparently happy.

Tradition holds that Mead's young Venetian bride served as both the inspiration and model for this idealized bust. The portrait simultaneously celebrates a nuptial and an aquatic theme, for the city that had produced Mead's bride was also referred to traditionally as the Bride of the Sea. The latter title derived from the ancient ceremony at which the Venetian doge hurled a gold ring from his finger into the Adriatic Sea, chanting ritualistically, "We wed thee, O sea, in token of perpetual domination." The mock wedding, celebrated each year on Ascension Day, commemorated the victory of the Venetian fleet over Frederick Barbarossa at Istria in the twelfth century. Mead's *Venezia* was known alternately as *Venice, Bride of the Sea*.[2]

At the time Mead modeled the piece, the Victorian art public relished imaginative renderings of water nymphs and watery motifs.[3] In keeping with this vogue, Mead depicted his idealized bride as rising out of sea foam, a torso treatment that served to soften the usual truncated appearance of shoulders and arms in undraped portrait busts.[4] A tiara composed of beads and a central scallop or cockle-shell with a miniature gondola crowns *Venezia*'s head. Her hair, arranged in a partial, low chignon, is accented by a hair clip inscribed with her name. As was the period fashion, the subject's pupils and irises have been delineated, and the distinctive natural textures of sea foam, flesh, hair, and shell have been carefully simulated. A version of *Venezia* (possibly the original marble) with a shell-encrusted pedestal, owned by descendants of William Dean Howells, suggests that Mead carried the aquatic theme of the conceit through to its support.

Venezia was Mead's most frequently reproduced ideal bust. His Italian bride may have posed for another of his sculptural personifications, a statue of *La Contadinella*, or *The Country Girl* (present location unknown), which dates from the period of the couple's engagement. As a frequent visitor to Italy's galleries and museums, Mead was surely conversant with Roman portraits dating from the Augustan period that depicted the artist's favorite mistress in the guise of a mythological goddess or beautified in some equally fictitious, winsome role. Like the *Venezia* bust, the resulting image was commonly a romanticized likeness instead of a literal transcription of the model's features.

<div align="right">J.S.R.</div>

Notes

1. See Charles E. Crane, "Larkin G. Mead," *Vermonters: A Book of Biographies*, ed. Walter H. Crockett (Brattleboro, Vt.: Daye, 1932), pp. 160-161.

2. Oran Randall, *History of Chesterfield, Cheshire County, New Hampshire* (Brattleboro, Vt.: Leonard, 1882), p. 390, refers to the bust as *Venice, Bride of the Sea*. Randall's account also includes a genealogy and biography of the Mead family.

3. See Gerdts 1973, pp. 88-91.

4. Hiram Powers pioneered a solution to this jarring compositional scheme in his first ideal bust, *Proserpine*, 1839 (Milwaukee Art Center, Wis.), which depicted the torso of the goddess nestled in a bed of acanthus leaves.

George Edwin Bissell (1839–1920)

George Bissell's oeuvre, which consists chiefly of public monuments, is, for the most part, typical of a straightforward, rather uninspired naturalism found in American sculpture in the years following the Civil War. Bissell nevertheless achieved greatness in two especially dignified and powerful statues, *Chancellor John Watts*, 1886 (Trinity Churchyard, New York), and *Chancellor James Kent*, 1894 (Library of Congress, Washington, D.C.), which are marked by their lively handling and superb characterization.

Bissell was in his thirties before he commenced his career in earnest, although he had long been exposed to sculpture through his father, a prosperous quarryman and marble worker. Born at New Preston, Connecticut, to Hiram and Isabella (Jones) Bissell,[1] George moved with his family to Waterbury, Connecticut, in 1853. He was educated at the Northville Academy and at the Gunnery in Washington, Connecticut, and throughout his youth he was employed as a clerk in a store in Waterbury. Before he could finish preparing for college, the Civil War broke out, and Bissell enlisted as a private in the Twenty-third Regiment of the Connecticut Volunteers in 1862, serving one year until his regiment was discharged. He then became a paymaster in the United States Navy until the close of the war. Shortly thereafter he married and joined his father and brother in the marble business in Poughkeepsie, New York. In addition to performing routine tasks in the stone yard, Bissell distinguished himself by making extremely decorative gravestones and designs and models for monuments. In 1871 he welcomed an order to execute a life-size marble figure of a fireman for the fire department of Poughkeepsie. Without previous experience, he modeled the figure from life and cut it in marble, prompting Lorado Taft to comment that Bissell compassed "in his first efforts the sculptural and mechanical processes of the art."[2] Attracted, no doubt, by the creative aspect of fashioning a statue, Bissell determined to become a sculptor.

In 1875 Bissell went abroad, and despite his somewhat late start as an artist, he lost little time in following a suitable course of study and travel. In Paris, during this stay as well as during a subsequent period, he trained at the Académies Julian and Colarossi, at the Ecole des Arts Décoratifs under Aimé Millet (1819-1891), and at the Ecole des Beaux-Arts under Paul Dubois (1827-1905).

During 1876 he was a pupil at the English Academy in Rome.

Upon returning to Poughkeepsie in 1876, Bissell established a studio and became the local sculptor in residence, bringing forth a great many portrait busts and reliefs. Larger orders were hard to come by, and, apart from making the enormous granite figure for the John C. Booth family monument of 1878, Bissell had to wait until the 1880s and 1890s before he began to obtain major commissions. The first of these important pieces was the *Soldiers' Monument*, 1884, for Waterbury, Connecticut. It was created in Paris, where for more than a decade Bissell was principally located. A statue of John Chatfield, 1887, was another endeavor made in Paris for Waterbury, but, like the *Soldiers' Monument*, it in no way reflected the Beaux-Arts sculpture Bissell must have seen all around him. His next significant statue, the *Watts*, though conceived in Poughkeepsie, did bear the influence of Beaux-Arts modeling. In the *Watts* and in the equally impressive bronze representation of Kent, Bissell clearly demonstrated an understanding of the anatomy be-

neath the richly textured, skillfully rendered drapery folds. These statues have an imposing grandeur that make them his two finest accomplishments. The *Lincoln Monument* (Edinburgh, Scotland), executed in Paris in 1892 and 1893, is interesting for Bissell's incorporation of an attendant figure at the base whose purpose is to celebrate the subject being commemorated, a device commonly used by French Beaux-Arts sculptors. Here, a barefoot kneeling slave looks up toward the Emancipator, raising his right hand.

Throughout his career Bissell received private commissions. The de Peyster family, and in particular General John Watts de Peyster (grandson of Chancellor John Watts), proved to be his most devoted patrons. Portrait busts exist of Frederick de Peyster, about 1875 (The New-York Historical Society), Mary Justina (Watts) de Peyster, about 1886 (The Metropolitan Museum of Art, New York), and John Watts de Peyster, 1897 (The New-York Historical Society). Notable among the de Peyster portraits is the seated image of the seventeenth-century colonel Abraham de Peyster, installed in 1896 in Bowling Green, New York, shown in contemporary dress of flowing robes, high boots, and wig.

After thirteen years of dividing his energies between Paris and Poughkeepsie, Bissell settled in Mount Vernon, New York, in 1896. There he produced the turgid bronze statue of Chester A. Arthur, 1898 (Madison Square Park, New York), which is similar in composition, but not in spirit, to Augustus Saint-Gaudens's *Abraham Lincoln* ("The Standing Lincoln"), 1887 (Lincoln Park, Chicago). In New York Bissell became involved in a number of local collaborative projects at the turn of the century. His contributions included the navy group on the colonnade leading to the Dewey Arch (made of staff, an impermanent material) in 1899, and *Lycurgus*, 1900, for the Appellate Court House.

Although Bissell turned out much of his work dating from 1900 to 1910 in New York, he maintained a studio in Florence, Italy, from 1902 to 1905 and from 1907 to 1909. In Florence, for example, he made the highly embellished *Elton Memorial Vase*, 1905, commemorating Mr. and Mrs. John P. Elton, that was placed at the entrance to the Riverside Cemetery in Waterbury.

Bissell participated in some of the great international exhibitions of his era, showing a replica of *John Watts* at the Columbian Exposition, 1893, in Chicago and a statue of Admiral Farragut at the Louisiana Purchase Exposition, 1904, in Saint Louis. He also entered sculpture that was placed out-of-doors at two of the fairs, *Hospitality* for the Pan-American Exposition, 1901, in Buffalo and *Music* and *Science* for the Louisiana Purchase Exposition. Bissell's influence on American sculpture was not exceptional. As he was not a teacher, he left no students; however, he enjoyed the respect and admiration of younger sculptors, who affectionately termed him "père Bissell."

K.G.

Notes

1. The *Boston Evening Transcript*, Aug. 31, 1920, gives Isabella Bissell's maiden name as James.

2. Taft 1930, p. 245.

References

AAAn 17 (1920), p. 265, obit.; Truman H. Bartlett Papers, Mugar Memorial Library, Special Collections, Boston University; F. Laurison Bullard, *Lincoln in Marble and Bronze* (New Brunswick, N.J.: Rutgers University Press, n.d.), pp. 94-99; Craven 1968, pp. 243-245; Donald Charles Durham, *He Belongs to the Ages: The Statues of Abraham Lincoln* (Ann Arbor, Mich.: Edwards, 1951), pp. 64-67; "The Elton Memorial Vase by George E. Bissell," *International Studio* 28 (Apr. 1906), pp. XLIII-XLVI; Gardner 1965, pp. 36-37; Franklin B. Mead, *Heroic Statues in Bronze of Abraham Lincoln* (Fort Wayne, Ind.: Lincoln National Life Foundation, 1932), pp. 39, 73; MMA; MMA, ALS; *New York Times*, Aug. 31, 1920, obit.; NYPL; Taft 1930, pp. 245-247, 538; Fearn Thurlow, "Newark's Sculpture: A Survey of Public Monuments and Memorial Statuary," *Newark Museum Quarterly* 26 (winter 1975), p. 4.

GEORGE EDWIN BISSELL
56
Abraham Lincoln, 1906 or after
Bronze, brown patina, lost wax cast
H. (incl. base) 16½ in. (41.9 cm.), w. 10¼ in. (26.1 cm.), d. 6¼ in. (15.9 cm.)
Signed (on back between shoulders): Geo E Bissell / Sculpt / Copyrighted
Foundry mark (on back near base): GORHAM CO FOUNDERS Q46
Gift of Maxim Karolik. 53.2523

Provenance: Maxim Karolik, Boston
Versions: *Bronze:* (1) private collection, Cambridge, Mass.

Few honors could be deemed greater for an American sculptor than to receive a commission for a monument to George Washington or Abraham Lincoln. In some instances, not only would an artist's reputation be advanced by the execution of the

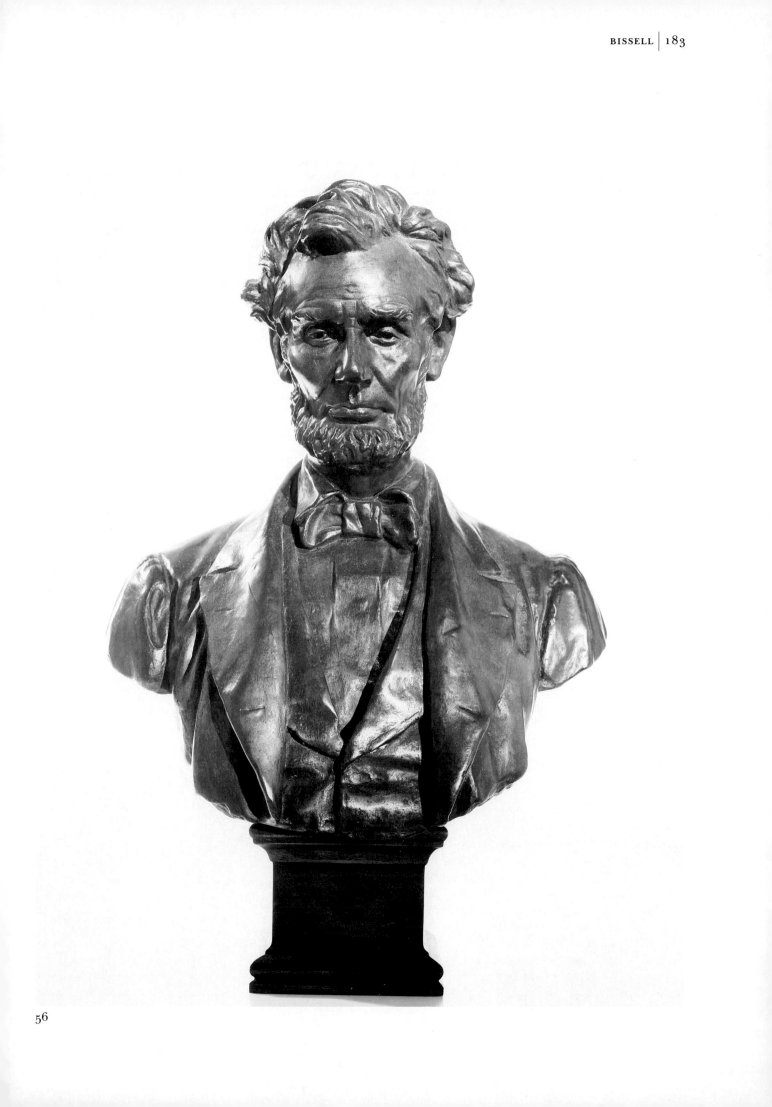

monument itself, but also his income would be sizably increased through the sale of reductions (often in great number and in different sizes) to a patriotic public. Bissell's portrait of Lincoln in the Museum of Fine Arts is an example of a work intended for a wide audience: it is a reduction in bust form of his figure of Lincoln in the 1893 *Lincoln Monument* in Edinburgh, Scotland. In this case the distribution of reductions would inevitably enhance Bissell's renown and, more precisely, benefit the coffers of the foundry, Gorham Manufacturing Company, which actually owned the model.[1]

The movement to create the Edinburgh monument was initiated in 1892 by the poet and orator Wallace Bruce, who served as the United States consul in Edinburgh from 1889 to 1893. Through his efforts, funds for the monument were raised with the idea that the memorial should commemorate Lincoln and the Scottish-American soldiers who had fought in the Civil War.

The commission was awarded to Bissell late in 1892, in the middle of his career and during one of his stays in Paris. In order to portray Lincoln, Bissell called upon his memory of the great leader, whom he had seen many years before: "I watched Lincoln carefully while he was delivering his Astor House speech, on his way through New York to his inauguration. I still can recall the deep impression he made on me as he spoke. That impression I tried to reproduce in my statue for Edinburgh."[2] Lincoln had already been represented by nineteenth-century artists as different as Leonard Volk (1828-1895), Randolph Rogers, Thomas Ball, and Augustus Saint-Gaudens and would continue to be a suitable subject for twentieth-century sculptors as dissimilar as Charles Keck and Boris Lovet-Lorski. For his version, Bissell chose to show Lincoln standing, delivering a speech, with his left arm thrust behind his back and his right hand holding a scroll by his side. In a manner similar to that of Thomas Ball in his *Emancipation Monument*, dedicated in 1876 (Washington, D.C.), Bissell added a barefoot emancipated slave to the composition but placed him lower in the grouping than Ball had done in his work. Bissell's slave kneels at the base, raises his right arm in honor of Lincoln and holds a book in his left hand. Beside him are battle flags and a wreath. Altogether, the monument is about fifteen feet high, with the life-size figure of Lincoln standing about nine feet above the ground on a granite pedestal. The monument was installed in the historic old Calton Hill Burial Ground, where a plot had been set aside for the Scottish-American soldiers. Unveiled on August 21, 1893, it was reputed to be the first bronze figure of Lincoln erected outside the United States.[3]

Although this bust was made for a commercial market, it is a sensitive portrait that conveys Lincoln's somber turn of mind. The modeling is expertly handled, particularly in the area of the vest, where the folds give the sense of a body beneath the clothing. The Museum's bust is one in a series cast by the Gorham foundry beginning in 1906. It is 16½ inches high, including base (Q46), and the smallest of three sizes in this particular series, the other two being 18 inches, including base (Q47), and 26¾ inches, including base (Q48).[4]

Bissell's bust of Lincoln was cast by several different foundries, in a number of sizes and with variations in form, base, and copyright date. During the early years of the twentieth century, perhaps to meet a demand or to promote one, Gorham initiated the production of two bronze busts (Q239 and Q437) in addition to the 1906 series.[5] A variant of the bust (31 inches, apparently with no Q number) located in Newark City Hall was cast by Gorham and stamped by Tiffany & Company.[6] Gorham was further responsible for an abbreviated version of the bust, omitting the shoulders and part of the vest. An example (18 inches, Q47) is at present on the New York art market. (It is interesting that Gorham's serial number Q47 seems to have been assigned to both the full and abbreviated versions of the bust.) The Henry-Bonnard Bronze Company also produced an abbreviated version of the bust (25⅛ inches), an example of which is in the Thomas Gilcrease Institute of American History and Art, Tulsa, Oklahoma. Another abbreviated version, measuring 24 inches (present location unknown), was offered in an advertisement by James Graham & Sons (now Graham Gallery), New York, in *Antiques*, January 1959, without mention of the foundry.[7]

No opportunity was lost to cast statuettes of Bissell's *Lincoln* figure in various sizes and forms. Gorham issued a series in three sizes: 5½ inches (Q378), 8¼ inches (Q438), and 15¾ inches (Q441).[8] An example of this last size is in the Museum of Fine Arts, University of Utah, Salt Lake City. Another, later and larger statuette measures 33 inches (QTC).[9] Bissell had casts of the statuette made in Paris by Barbedienne (about four feet high?)[10] and by E. Gruet foundry as well, one of which, 16¾ inches high, can be found in the Mattatuck Museum

of the Mattatuck Historical Society in Waterbury, Connecticut.

<div align="right">K.G.</div>

Notes

1. See Casting records of statuary and small bronzes owned by the Gorham Manufacturing Company, 1905-1970, p. 2. Gorham Company Bronze Division Papers, roll 3680, in AAA, SI.

2. Quoted in Gustave Kobbe, "While Controversy Rages over Barnard Lincoln, for London, Another American's Lincoln Stands Calmly in Edinburgh," *New York Herald*, Feb. 10, 1918.

3. A replica of the *Lincoln* was erected in Clermont, Iowa, in 1902 and was dedicated to the soldiers and sailors of the Civil War on June 19, 1903. In the replica the figure of the kneeling slave was omitted, the base bears a different inscription, and the pedestal has on each of its four sides a bronze relief of a war scene by Bissell.

4. See Casting records of statuary . . . owned by Gorham, p. 2. Gorham Company Bronze Division Papers. According to the records, these three sizes are referred to, respectively, as half-life-size (Q46), three-quarter-life-size (Q47), and life-size (Q48). However, these designations seem to have been given rather loosely, perhaps in reference to visual appearance rather than in accordance with accurate mathematical calculation. Douglas S. Ward, manager, special projects, Gorham Bronze Division of Textron, in a letter of May 25, 1982, to Kathryn Greenthal, mentions that there is no record as to how many casts in this series were sold. BMFA, ADA. Nor, in fact, is there any record of how many were made.

5. For the various casts made by Gorham, see Casting records of statuary . . . owned by Gorham, pp. 2, 10, and 18; see also Photograph files of statuary and small bronzes. Gorham Company Bronze Division Papers.

6. See Fearn Thurlow, "Newark's Sculpture: A Survey of Public Monuments and Memorial Statuary," *Newark Museum Quarterly* 26 (winter 1975), p. 4. No Q mark is indicated in the entry.

7. *Antiques* 75 (Jan. 1959), p. 6. Graham Gallery has no record of the founder.

8. There is a discrepancy in the Gorham Company Papers for the height of Q441. The Casting records of statuary . . . owned by Gorham, p. 18, list it as 16½ inches high, whereas the Photograph files list it as 15¾ inches.

9. See Casting records of statuary . . . owned by sculptors, 1906-1930, p. 170; and Photograph files of statuary and small bronzes. Gorham Company Papers.

10. Kobbe, "While Controversy Rages."

Franklin Simmons (1839–1913)

A member of the second generation of expatriate American neoclassical sculptors, Franklin Simmons was born in Lisbon (now Webster), Maine. During his adolescence, he worked as an errand boy for a Lewiston, Maine, cotton mill. In his spare time he modeled figures from coarse local clay, an activity inspired, as biographers tell it, by the excited accounts of Hiram Powers's *Greek Slave*, 1844 (Yale University Art Gallery, New Haven), circulating at the time. He also received some instruction in drawing from the landscape painter John Bradley Hudson, Jr. (1832-1903), who resided in Maine in the 1850s. Encouraged by Hudson as well as his fellow employees, Simmons went to Boston in 1854 to seek professional training in sculpture. There, he found a teacher and mentor in John Adams Jackson (1825-1879), a former resident of Bath, Maine, who presided over a moderately successful sculpture studio. Within five years Simmons had mastered the rudiments of the art and returned to Maine with the ambition of opening his own studio.

After working in Lewiston and Bowdoin, Simmons relocated his studio to the more populated city of Portland, where he quickly built up a promising trade carving portrait busts and cameo medallions of Portland's clerics, academicians, and other dignitaries. In 1863 his local reputation was further promoted when the town of Rockland commissioned him to execute Maine's first full-length portrait statue, a memorial to honor the state's great soldier Major General Hiram Berry, killed at the battle of Chancellorsville in 1863. Completed in 1865, the monument earned considerable critical praise for the young sculptor, which in turn bolstered Simmons's confidence to test his talents farther afield.

With the goals of broadening his geographic horizons and expanding his roster of clients, Simmons left Maine in search of more lucrative and prestigious employment, with Washington, D.C., as his destination. His arrival in the nation's capital coincided with the termination of the Civil War. The patriotic fever accompanying the close of these hostilities resulted in an immediate market for sculptural images of the nation's new and fallen war heroes, and Simmons stood ready to cater to that mood of congratulatory pride and decorous reflection. Between 1865 and 1866 he accumulated numerous orders for portraits of members of Lincoln's cabinet and of distinguished military officers, including generals Grant, Hooker, and Sheridan, and admirals

Farragut and Seward. A major project was the "National Bronze Picture Gallery," a patented series of two dozen relief likenesses of prominent Union officials and cabinet members commissioned by William C. Miller, the Rhode Island bronze founder. A marble bust of the controversial general of the Union army, William Tecumseh Sherman, about 1866 (Fine Arts Museums of San Francisco), is one of the most sensitive, individualized portraits that culminated from Simmons's Washington expedition.

The renown Simmons gained from this succession of military portraits prompted the town of Lewiston to engage him to design a bronze monument in tribute to its residents who fought in the war, the first of many contracts for Civil War memorials assigned to Simmons in the course of his career. His interpretation—a straightforward design featuring the solitary figure of a Union soldier standing in his overcoat and wearing a forage cap—was a formula adopted repeatedly through the remainder of the century by community groups in New England empowered to commission such Civil War memorials.

While engaged in these various war-related projects, Simmons was approached by representatives from Rhode Island, at the recommendation of General Grant, to create a life-size portrait of the fa-

mous Puritan clergyman Roger Williams, one of two historical personalities selected by the state for the newly established National Statuary Hall of the United States Capitol. The commission challenged the sculptor's intellectual and imaginative resources, for no authentic likeness of Williams existed. Undaunted, Simmons researched the extant scholarship on the subject and completed his preliminary designs for the statue in 1867. Determined to execute the piece abroad, where materials and assistants were in ample supply, he sailed for Italy in the spring of 1868 for a projected three-year stay.

After briefly stopping in Florence, Simmons moved on to Rome and found studio space on the Via San Nicolo da Tolentino, a street lined with the painting and sculpture ateliers of other expatriate artists. He worked diligently on the *Williams* statue, completing it in 1870. At the official dedication ceremony held in Washington, D.C., in January 1872, critics hailed Simmons's portrayal of the courageous religious leader as inspired and noble. The piece established his national reputation, and other major commissions followed. These included a Naval or Peace memorial, 1878, erected in front of the United States Capitol, an elaborate allegorical construction that featured a personification of History poised with tablet in hand, preparing to record the names of the war dead confided to her by a mourning figure of America, and a bronze equestrian monument to the intrepid General John A. Logan, commenced in 1897 and unveiled at Iowa Circle, Washington, in 1901.

Although he returned to the United States on visits, Simmons, like his colleague William Wetmore Story, chose to settle permanently in Rome. He received the honor of being made Knight of the Crown of Italy by King Humbert in 1900 in recognition of his contributions to art and probably, too, in grateful acknowledgment of his frequent patronage of Roman foundries. Simmons's villa on the Via Settembre Venti became a fashionable gathering place for fellow Americans living in or traveling through Rome; regular musicales and Saturday-night suppers of fish cakes and baked beans figured prominently in his program of hospitality.

Despite Simmons's European residence, orders for portrait busts and public monuments continued to be conveyed to him from America on a steady basis. Among the more accomplished if lesser-known compositions dating from the Roman phase of his career is the one-foot bronze *Washington at Valley Forge*, 1879 (The Valley Forge Historical Soci-

ety, Pennsylvania; larger 1905 version, Portland Museum of Art, Maine), a scene invented from George Washington's encampment during the harsh winter of 1777-1778. Although the assembly of carefully observed details reproduced in the figure's uniform qualifies the statue as a historical "costume piece," the sculptor's interpretation of Washington in a rare, despairing moment, slumped in a chair with sword deposited on his lap and head bent in a dejected attitude, lifts the image to the level of psychologically revealing portraiture. The man Simmons portrays is not the stout-hearted soldier of history but the discouraged leader of an army devastated by hunger, cold, and deteriorating morale.

Simmons is best known for his public monuments of a patriotic nature. Still, he was not indifferent to the popular taste for idealized subjects in the neoclassical style and often explored mythological themes and biblical legends. Such works include the Old Testament subjects *Jochebed, the Mother of Moses*, 1873 (q.v.), and *The Promised Land*, 1874 (The Metropolitan Museum of Art, New York); *Penelope*, about 1890 (Portland Museum of Art, Maine), a portrayal of Ulysses' patiently waiting wife; *The Woman of Endor*, 1909 (Portland Museum of Art), a bronze study of a seated mystic that recalls the enigmatic brooding figure of Saint-Gaudens's *Adams Memorial*, 1891 (Rock Creek Cemetery, Washington, D.C.); and *Hercules and Alcestis*, about 1912 (Portland Museum of Art), a dual-figure composition completed in plaster shortly before Simmons's death.

When Simmons died in Rome in 1913, leaving no heirs from two marriages, he left a sizable collection of his marbles, bronzes, and studio casts, along with a large portion of his estate, to the Portland Society of Art, Maine, trusting that his gift would contribute to the local efforts then underway to establish a permanent institution for the display of fine arts. Today, this collection is housed at the Portland Museum of Art, a block away from the site of two of the sculptor's important public monuments: the *Longfellow Monument*, 1888, and the towering Civil War memorial *The Republic*, 1891, the latter designed in collaboration with the architect Richard Morris Hunt. Simmons's grave in the Protestant Cemetery, Rome, is marked by the commanding *Angel of Resurrection* of his own design.

J.S.R.

References

"Among the Artists," *American Art News*, Oct. 28, 1905, p. 3; Benjamin 1880, p. 154; BMFA, WMH; BPL; Henry Burrage, "Franklin Simmons, Sculptor," *Maine Historical Memorials* (1922), pp. 109-147; Stephen Cammet, "Franklin Simmons, a Maine-Born Sculptor," *Pine Tree Magazine* 8 (Aug. 1907), pp. 92-96; Cheryl A. Cibulka, *Marble and Bronze: 100 Years of American Sculpture 1840-1940* (Washington, D.C.: Adams Davidson Galleries, 1984), p. 12; Clark 1878, pp. 128-131; Craven 1968, pp. 295-300; Gardner 1945, p. 71; Pamela W. Hawkes, "Franklin Simmons, Yankee Sculptor in Rome," *Antiques* 128 (July 1985), pp. 125-129; John Heffernan, "Yankee Sculptor," *New England Galaxy* 7 (1966), pp. 26-31; MMA; NYPL; Taft 1930, pp. 247-252; *Tribuna* (Rome), Dec. 10, 1913, obit.; "A Veteran Sculptor," *Outlook Magazine* 98 (May 1911), pp. 213-215; Lilian Whiting, "The Art of Franklin Simmons," *International Studio* 25 (May 1905), pp. LII-LVI.

FRANKLIN SIMMONS
57 (color plate)
Jochebed, the Mother of Moses, 1873
Marble
H. 55¼ in. (140.3 cm.), w. 26 in. (66 cm.), d. 42½ in. (108 cm.)
Signed (on back of base): FRANKLIN SIMMONS / FECIT.ROMA 1873
Inscribed (on front of base): JOCHEBED
Gift of William Sumner Appleton and his five sisters. 10.114

Provenance: William Sumner Appleton (senior), Boston; William Sumner Appleton, Boston
Exhibited: BMFA, "Confident America," Oct. 2–Dec. 2, 1973; BMFA 1979, no. 12.
Version: *Marble*: (1) Portland Museum of Art, Maine

"There is no subject an artist can choose that is as absolutely certain of gaining him an admiring audience as a mother and her babe," observed the art critic William Clark in 1878.[1] This opinion was shared, it seems, by Franklin Simmons, who selected the Old Testament figures of Jochebed and the infant Moses as the theme for his first major statue in the ideal mode. Having already distinguished himself in portraiture, Simmons no doubt was eager to apply his talents to the more challenging imaginative genre of ideal sculpture, particularly after his arrival in Rome in 1868. As he confided to a friend in America, "I have a great partiality for ideal work and portrait statues take one's mind from that."[2]

Artistic interpretations of Jochebed, the mother of Moses, had attained considerable international appeal by the 1870s. At the Royal Academy in London in 1870, Frederick Goodall (1848-1871) exhibited a painting of Jochebed that illustrated the young mother about to consign her child to the bulrushes skirting the Nile. In 1872 the Italian sculptor Francesco Barzaghi (1839-1892) represented Jochebed as an exotically jeweled and coiffed woman cradling a basket in which reclined the plump infant Moses. Although Simmons's interest in the theme was therefore not original, his particular sculptural dramatization of it was.

Simmons's statue does not restrict itself to the picturesqueness of the subject; rather, it concentrates on the sentiment involved. His *Jochebed* is cast in the role of an apprehensive mother, intently reflecting on the fate of her son, whose life has been imperiled by the Pharaoh's decree: "Every son that is born ye shall cast into the river, and every daughter ye shall save alive." The Hebrew mother seems torn between hope and fear, as she contemplates her alternatives: whether to sacrifice Moses to an uncertain fate by launching him on the Nile in a bulrush basket or to indulge her maternal urge by keeping the baby hidden, aware of the dire consequences he would suffer if found.

Contemporary viewers of the statue noted with approval that Simmons clearly suggested Jochebed's faith in the future salvation of her people by directing her gaze toward an implied river flowing nearby. A critic for the *Art-Journal* speculated: "Possibly she may be watching Miriam preparing the little basket of rushes, some of which lie at the feet of the mother, and with a feeling of deep anxiety as to the success of the plan that is to save the future great leader and lawgiver of the tribes of Israel, yet searching, as it were, into the hidden years to come for that promised deliverance which she believes must yet appear."[3] Viewers also praised the sculptor's contrast of Jochebed's physical repose with what all presumed to be her mental agitation, and his clever juxtaposition of the pensive mother with her squirming, smiling offspring.

The general composition of Simmons's statue and his unerring attention to historical costume accessories suggest the influence of William Wetmore Story, the sculptor's neighbor on the Via San Nicolo da Tolentino. Story's famous oeuvre of heroic marble women in ancient garb probably inspired the brooding, seated pose of Simmons's *Jochebed*, as well as the treatment of her Egyptian coif and the elaborately conceived arrangement of drapery clinging about her matronly form.[4] Whereas Story took

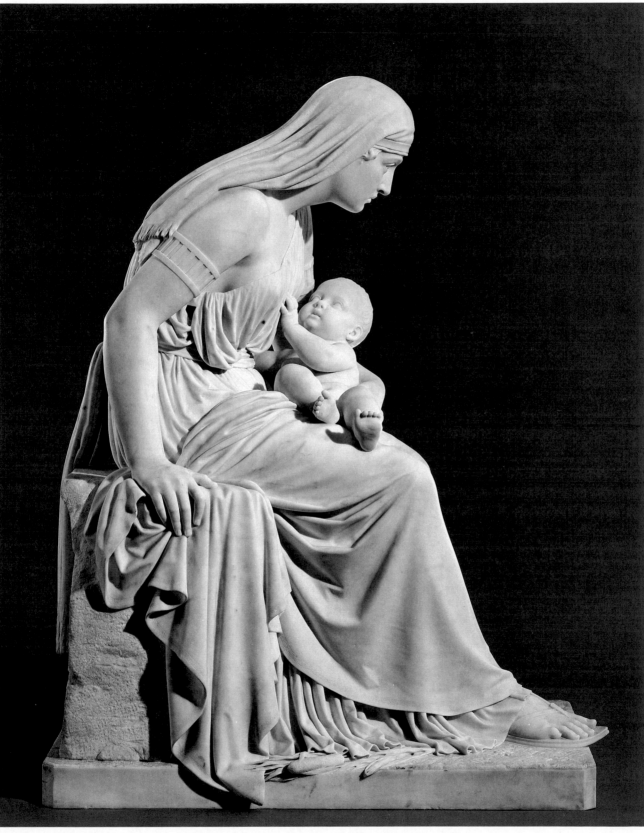

great pains to project a Nubian appearance in the features of his Egyptian personalities, in acknowledgment of their African origins, Simmons gave Jochebed a more modern, Mediterranean peasant aspect. In the management of her dress and demeanor, Simmons's biblical heroine also resembles the Near Eastern women featured in the popular Orientalist canvases of such contemporaries as Frederic Bridgman (1847-1928) and William Holman Hunt (1827-1910).[5] (An element of Eastern exoticism also informs an earlier work that he created as a thematic analogue to *Jochebed—The Promised Land*, 1874 [The Metropolitan Museum of Art, New York], which depicts a Hebrew woman contemplating the horizon of the Promised Land as she rests, weary from travel, against a palm-tree stump within its borders.)

Simmons's interest in the Jochebed and Moses theme may have been stimulated also by the fascination with motherhood that reached cult proportions in the Victorian period.[6] Painters and sculptors were besieged with requests for copies of Raphael's *Madonna of the Chair* (Pitti Palace, Florence) and for low reliefs in the Della Robbia vein. Since the 1840s American book publishers and ladies' magazine editors had capitalized on the growing market for biographies of the mothers of celebrated men and for sentimental fiction extolling the maternal virtues of instinctive wisdom, gentle strength, and unflagging piety. Women from the Bible were frequently studied for their formative contributions to the ideal of modern motherhood, and among Old Testament characters, Jochebed was held in the highest esteem because of her magnanimous moral sense.[7] The public of Simmons's day would not only have approved the moral import of the sculptor's conceit but would also have known and felt touched by Jochebed's poignant saga—one that probably helped to console mothers who had lost sons in the recent Civil War.

As the strategy of selling sculpture directed, *Jochebed, the Mother of Moses* was first exhibited in plaster so that the sculptor's compositional scheme could be viewed by prospective buyers without the artist having to invest in an expensive block of marble before a firm commission was in hand. In Simmons's Roman studio, the study for *Jochebed* caught the attention of William Sumner Appleton, the thirty-one-year-old scion of the prominent Appleton clan of Boston, who was then abroad on his honeymoon. An avid genealogist and amateur historian, Appleton was the half-brother of Thomas

Gold, the Boston wit, writer, and painter who served as a founding trustee of the Museum of Fine Arts. His son and namesake would later organize the Society for the Preservation of New England Antiquities. Of Appleton's visit Simmons wrote to a friend, "I am sure you will be pleased to know that my statue of *Jochebed, the Mother of Moses* has not only been successful in winning words of praise but a commission for it in marble. It will pass into the hands of Mr. William Appleton of Boston where I hope you will sometime see it."[8] The sculptor had completed the piece in marble by the middle of 1873, for when he traveled to Boston in the latter part of that year, Appleton and his wife held a reception in his honor, inviting guests to admire the newly acquired statue at their home on Beacon Street.[9]

J.S.R.

Notes

1. Clark 1878, p. 126.
2. Simmons to Mr. Hewett, June 14, 1874, Philadelphia Museum of Art, roll P14, in AAA, SI.
3. "Jochebed," *Art-Journal* (London) 35 (n.s. 12) (1873), p. 304.
4. The influence of Story on Simmons was noted by Taft 1930, pp. 247-252. "It [*Jochebed*] reminds me of Mr. Story's seated figures, but is better modelled and better carved. It lacks also the exaggerated expression of his perturbed heroines, but it is, on the other hand, equally lacking in appeal." For a discussion of the Orientalist currents in American neoclassical sculpture, see William H. Gerdts, "Egyptian Motifs in Nineteenth Century American Painting and Sculpture," *Antiques* 90 (Oct. 1966), pp. 495-501.
5. See Vermeule 1975, p. 978.
6. See Ann Douglas, *The Feminization of American Culture* (New York: Avon, 1977), pp. 86-90. For an earlier review of manifestations of the motherhood theme in American sculpture, see Frank Owen Payne, "Motherhood in American Sculpture," *Art and Archaeology* 12 (1921), pp. 255-263.
7. For an assessment of Jochebed's character by one of Simmons's contemporaries, see Sarah J. Hale, *Woman's Record; or Sketches of All Distinguished Women from the Creation to A.D. 1868*, 3rd ed. (New York: Harper, 1874), p. 87.
8. Simmons to Hewett, Mar. 24, 1872, Philadelphia Museum of Art, roll P14, in AAA, SI.
9. Henry Burrage, "Franklin Simmons, Sculptor," *Maine Historical Memorials* (1922), p. 120.

FRANKLIN SIMMONS
58
Robert Treat Paine, 1892
Marble
H. 23⅝ in. (60 cm.), w. 19 in. (48.2 cm.), d. 11½ in. (29.2 cm.)
Signed (on back): FRANKLIN SIMMONS / ROME 1892
Gift of Mrs. George Lyman Paine. 69.1289

Provenance: Paine family, Boston; Mrs. George Lyman Paine, Boston
Version: *Marble*, life-size: (1) present location unknown, formerly William Sumner Appleton, Boston

Franklin Simmons produced approximately one hundred portrait busts over the course of his career, including more than a dozen portraits of members of President Grant's administration. Simmons's other sitters were chiefly politicians, military figures, and businessmen. Although his contemporaries praised Simmons's facility and sensitivity as a portraitist,[1] many of his busts seem undistinguished and formulaic today. In this particular work, the double-breasted suit, necktie, and carefully defined buttonholes focus undue emphasis on the sitter's upper torso. The hair appears sketchily chiseled compared with the labored finish of the costume; the sitter's bushy mustache, modeled with furrowed strokes, draws attention away from the facial expression of reserved confidence.

The subject of this bust, Robert Treat Paine (1835-1910) of Boston, was the great-grandson of a signer of the Declaration of Independence of the same name.[2] A Harvard graduate and lawyer by training, Paine made his fortune through shrewd investments in railroads and western mining properties, which enabled him to retire early and devote himself to numerous philanthropic projects. With his interest in charitable enterprises, Paine was pleased, while a member of the Massachusetts House of Representatives in 1884-1885, to oversee the Committee of Charitable Institutions. Sympathetic to the problems of working people, he labored indefatigably to improve their housing conditions and financial status, and to arrange educational programs for them at trade and industrial schools. He was also interested in penal reform and was instrumental in establishing a Children's Aid Society in Boston. At the time Simmons carved this bust, Paine was serving as president of the Associated Charities of Boston, continuing in that office until his death. The motto "Not alms, but a friend," widely used for this new welfare movement, was his invention. The sculptor may have arranged sittings with his client

58

during Paine's 1891 visit to Europe, when the Boston philanthropist was elected president of the American Peace Society.

The bust in the Museum's collection descended through the family of Paine's son, the Reverend George Lyman Paine, who for many years was rector of Saint Paul's Church in New Haven, Connecticut.

J.S.R.

Notes

1. For a favorable view of Simmons's portraits, see Stephen Cammett, "Franklin Simmons, a Maine-Born Sculptor," *Pine Tree Magazine* 8 (Aug. 1907), p. 96: "In the creation of his portraits and his memorials of great men, Simmons infuses an indefinable quality of extended relation which relegates his work to the realm of the universal, and therefore to the immortality of Art, rather than restricting it to the temporal locality. . . . The face which takes form beneath his chisel has the play of vitality in its every feature."

2. *DAB*, s.v. Paine, Robert Treat. See also Mary Caroline Crawford, *Famous Families of Massachusetts* (Boston: Little, Brown, 1930), vol. 2, pp. 19-23.

Martin Milmore (1844–1883)

In 1851 Martin Milmore's widowed mother left her native town of Sligo, Ireland, and settled her family of four young sons in Boston. Martin attended the Latin School and also took art lessons at the free Lowell Institute, where he learned to draw from casts and paint with watercolors, and possibly studied anatomy. His older brother Joseph, who earned his living first as a cabinetmaker's assistant and then as a stonecutter, shared these artistic interests and taught Martin how to carve in wood and stone. In 1858, when the sculptor Thomas Ball returned home from Italy to open a Boston studio, the fourteen-year-old Milmore applied for lessons. At the outset Ball was hesitant to take on a young and unproven pupil but agreed to let Milmore perform simple custodial chores in the studio. For the next four years Milmore worked hard and loyally for Ball, winning the sculptor's respect and acquiring much technical expertise in the process. (During Milmore's tenure Ball was immersed in the studio work for the equestrian monument of George Washington, which was afterwards installed in the Public Garden, Boston.) Ball encouraged his junior assistant to design and execute several compositions on his own; Milmore responded by carving an able self-portrait, several small statuettes, and a relief of Phosphor (q.v.), a copy of which he sold to the prominent Boston lawyer Turner Sargent, who later became his benefactor.

After his employer and teacher departed Boston for Italy, Milmore opened his own local studio, inheriting many of Ball's former clients and unfinished orders. The first products to issue from the new studio were two well-received cabinet-size busts of 1863, *Henry Wadsworth Longfellow* (New Hampshire Historical Society, Concord) and *Charles Sumner* (present location unknown), modeled from life. He later worked Sumner's likeness into a critically acclaimed portrait bust, 1865 (Senate Wing, United States Capitol), which the Massachusetts legislature presented as a gift to George William Curtis, a well-known Boston editor, publicist, and reformer. In the fall of 1864 Milmore received an important public commission to produce three colossal granite figures for Boston's Horticultural Hall, an order that was assigned to him on the petition of Turner Sargent. The project took two years to complete, during which time Milmore sought assistance from his brothers in the cutting of the figures (*Ceres, Flora,* and *Pomona*). This family collaboration proved advantageous in subsequent commissions of

Milmore's whenever the help of skillful stonecutters and finishers was required.

After the Civil War Milmore won the town of Roxbury's design competition for a bronze soldiers' memorial proposed for placement in Forest Hills Cemetery (Jamaica Plain). Awarded in March 1867, the monument was interpreted by the sculptor in a novel way, featuring not the high-ranking Union officer but the common foot soldier or volunteer leaning against his rifle, wistfully contemplating the graves of his fallen companions. The emotional impact of the piece was strong and affecting.

The success of the *Roxbury Soldiers' Monument* led to a series of lucrative monument orders for Milmore from such cities as Fitchburg, Massachusetts, Keene, New Hampshire, and Erie, Pennsylvania. In 1874, nearly a decade after the end of the Civil War, he obtained his most prestigious commission from the city of Boston for a heroic monument to the area's fallen soldiers and sailors. The design solution he devised was innovative and became a fashionable prototype for other Civil War memorials in the United States. Erected on Boston Common in 1877, Milmore's *Soldiers' and Sailors' Monument* featured a towering shaft crowned by a figure of Liberty and supported by a massive granite base ornamented with bronze pictorial reliefs representing four stages in the city's involvement in the Civil War. Allegorical representations of the North, South, East, and West embellished the base of the column, and bronze figures of Peace, the

Sailor, the Soldier, and Muse of History encircled the subordinate four piers.

Milmore completed most of the work on the monument in Rome, where he lived from 1870 until the end of 1876, renting a studio on the Via di San Basilio near that of Chauncey B. Ives. Among the major projects that occupied the sculptor during and immediately following this Italian interval were commissions for a life-size marble angel to surmount the Coppenhagen Tomb, 1874 (Mount Auburn Cemetery, Cambridge, Massachusetts), and for bronze portrait statues of General Sylvanus Thayer, about 1880 (West Point, New York), the military engineer and educator, and of John Glover, Marblehead's revolutionary war hero, 1875 (Commonwealth Avenue Mall, Boston).

Milmore's busy career as a portrait sculptor and designer of public monuments, principally of commemorative war subjects, was terminated when he died in Boston at the age of thirty-eight, probably from tuberculosis. In their efforts to assess Milmore's contributions to sculpture, contemporary critics generally agreed that, although his work was not epic in concept or lyric in treatment, it was dignified in spirit, competently modeled, occasionally striking in its mass and line. "Mr. Milmore stands for good workmanship rather than poetic expression," concluded Lorado Taft in his summary remarks about the artist in *The History of American Sculpture.*[1] Appropriately, his grave in Forest Hills Cemetery was marked by a moving sculptural tribute produced by Daniel Chester French symbolizing the regret Milmore's contemporaries felt over the artist's abruptly canceled career. French's *Death and the Sculptor*, 1893, depicts the Angel of Death restraining a lithe, muscular young sculptor from using the chisel that he clutches in his hand. It is significant that French chose to portray this idealized sculptor working on an Egyptian sphinx, a vivid reference to Milmore's own monumental and enigmatic *Sphinx*, 1872, commissioned as a memorial to the Union dead for Mount Auburn Cemetery. "Milmore was a picturesque figure," French later recalled, "somewhat of the Edwin Booth type, with long dark hair and large dark eyes. He affected the artistic (as all of us artists used to, more or less), wearing a broad-brimmed soft black hat, and a cloak. His appearance was striking, and he knew it."[2]

J.S.R.

Notes

1. Taft 1930, p. 255.

2. Letter from French to Adeline Adams, quoted in *DAB*, s.v. Milmore, Martin.

References

American Architect and Building News, Aug. 18, 1883, obit.; Benjamin 1880, p. 154; *Boston Evening Transcript*, July 23, 1883, obit.; Clement and Hutton 1894; Craven 1968, pp. 232-237; Walter G. Strickland, *A Dictionary of Irish Artists* (Dublin: Maunsel, 1913); Taft 1930, pp. 252-255; Tuckerman 1867, p. 600.

MARTIN MILMORE
59
Edith Rotch, 1862
Marble
H. 22¼ in. (56.5 cm.), w. 19¾ in. (34.5 cm.)
Signed (across bottom under neck): M. Milmore. 1862
Gift of Aimée and Rosamond Lamb. 68.735

Provenance: Mrs. Horatio Lamb, Boston; Aimée and Rosamond Lamb, Boston

Milmore's first experiments in portraiture are said to have been confined to small cabinet busts and a self-portrait modeled with the aid of a looking glass.[1] When his mentor, Thomas Ball, persuaded him to open his own Boston studio, in operation by 1864, Milmore gained the confidence to concentrate on establishing a serious clientele for these portrait studies. His admirably animated likeness of Charles Sumner of 1865 (Senate Wing, United States Capitol) for the Massachusetts legislature helped substantiate his professional credentials. In the following years he executed well-received portraits of such local and world personalities as the Boston author, linguist, and scholar of Spanish literature George Ticknor, 1868 (Boston Public Library); Ralph Waldo Emerson, about 1874 (private collection, Alexandria, Virginia); Pope Pius IX, modeled in Rome in 1874 (present location unknown); and even the irascible reformer Wendell Phillips, 1869 (Bostonian Society, Old State House), who was vociferous in his distaste for Boston sculptors and their products. Abraham Lincoln, Ulysses S. Grant, and Daniel Webster were also subjects of busts by Milmore.

This portrait relief was modeled during Milmore's employment with Ball; it represents a successful early trial at portraiture, predating Milmore's bust of Sumner and perhaps his cabinet-size portrait essays as well. The sitter is Edith Rotch (1847-1897), who was the oldest daughter of Benjamin Rotch, a trustee of the Museum of Fine Arts,

59

MARTIN MILMORE
60
Phosphor, 1866 (modeled in 1862-1863)
Marble
Diam. 23 in. (58.4 cm.), d. 4¾ in. (12.1 cm.)
Signed (lower right near edge) : MILMORE. / 1866.
Bequest of Mrs. Amelia J. Sargent. 94.187

Provenance: Turner Sargent, Boston; Mrs. Amelia J. Sargent, Boston
Exhibited: BMFA 1979, no. 8.
Versions: *Marble*: (1) present location unknown, formerly private collection, Boston, (2) present location unknown, formerly private collection, Berlin

One of the first fanciful compositions Milmore produced under Thomas Ball's tutorship was this high relief of Phosphor, an ideal representation of the "bringer of light," or morning star, probably modeled between 1862 and 1863. The relief was soon thereafter placed on exhibition and purchased by "a gentleman from Boston,"[1] according to Henry Tuckerman. It apparently made a favorable impression on those who saw it, for Milmore received orders for two copies of the piece, one for a man from Berlin and another for Turner Sargent, a Boston lawyer, art collector, and original subscriber to the Museum of Fine Arts. Fittingly, the replica made for Sargent, dated 1866, is that now owned by the Museum.

The choice of Phosphor for an initiation piece in the ideal mode was both ambitious and discerning on Milmore's part. There was an immediate technical challenge posed in attempting to communicate an evanescent quality such as light in a medium as substantial and uniform in color as white marble. Still, Milmore could draw upon an extensive tradition of sculptural interpretations of the elements, usually in the form of fairylike females since ancient cultures had associated the feminine temperament with the capricious moods of the universe. Milmore conceptualized Phosphor as a beautiful, youthful goddess with a jewel-like star on her forehead. Her long tresses recede into the marble oval as if the wind is gently blowing them aside as she ushers dawn across the sky.

Milmore's relief was one of hundreds of nineteenth-century sculptures that dealt with ethereal concepts such as light and darkness, a thematic type that became popular early in the century through Thorwaldsen's famous paired reliefs *Day* and *Night*, 1815 (Thorwaldsen Museum, Copenhagen). (The Boston Athenaeum owned plaster casts of Michelangelo's tomb personifications of Day and Night, which Milmore also may have known.) By mid-

and Annie Bigelow (Lawrence) Rotch, whose own youthful likeness (q.v.) had been modeled by Shobal Clevenger. The fact that the socially eminent Rotch family patronized Milmore suggests how promising the eighteen-year-old's talents must have seemed at the time.

The profile of Miss Rotch projects a tranquil mood and demure, feminine modesty; in its delicate appearance the portrait resembles a large but still intimate cameo medallion. Though unrecorded by the few writers who have offered accounts of Milmore, the work may be the "marble portrait of a beautiful child" that Henry Tuckerman mentioned as having been modeled by the sculptor in 1863.[2] Edith Rotch was in her teens when Milmore carved the relief, but her diminutive features and innocent aspect, accentuated in white marble, could have been mistaken by Tuckerman as those of a young girl.

J.S.R.

Notes

1. Tuckerman 1867, p. 600.

2. Ibid. Tuckerman may have seen the relief in 1863, when Milmore contributed a small statuette called *Devotion* (present location unknown) to the local Sanitary Fair. The statuette's favorable reception drew attention to the sculptor and curious visitors to his studio.

60

century aerial subjects were enjoying particular vogue, ranging from the atmospheric canvases of the French Barbizon painters to the literal portrayals of deities of wind and sky like Erastus Dow Palmer's bas-relief *The Evening Star*, 1851 (Albany Institute of History and Art, New York); Harriet Hosmer's bust *Hesper*, 1852 (Watertown Free Public Library, Massachusetts); Alexander Galt's (1827-1863) full-length statue *Aurora*, 1860 (present location unknown); and Thomas Gould's aerial *West Wind*, 1869 (The Mercantile Library of Saint Louis, Missouri).[2] The year that Milmore finished this copy of *Phosphor* for Turner Sargent, the English sculp-

tor Joseph Edwards (1814-1882) exhibited an almost identical female figure, with starlike tiara and flowing tresses, called *The Spirit of Love and Truth*, at the Royal Academy of Arts in London, which suggests the international appeal of these celestial marble goddesses.[3]

J.S.R.

Notes

1. Tuckerman 1867, p. 600.

2. Gerdts 1973, pp. 84-87.

3. For an engraving of this relief, see *Art-Journal* (London) 29 (n.s. 6) (Jan. 1867), facing p. 28.

Preston Powers (1843 – after 1925?)

When Hiram Powers's wife gave birth to a third son in 1843, the parents named the child Preston to honor his father's loyal patron, Colonel John Smith Preston, a wealthy lawyer and politician from South Carolina. In his youth Preston Powers explored many vocations before resolving, shortly after his twenty-fifth birthday, to practice the same profession as his famous father. This decision may have been motivated in part by conscience. By the late 1860s the elder Powers's health was failing, having been exacerbated by the rigors of his demanding workload. Thus, to lend him assistance both Preston and his older brother Longworth (named after Hiram Powers's Cincinnati patron, Nicholas Longworth) assumed responsibility for the daily operation of their father's Florence studio. After the sculptor's death in 1873, they stayed on to supervise the completion of a number of outstanding orders.

An additional incentive for Preston Powers's gravitation to sculpture was the relief it afforded from the nagging indecision about what career would best accommodate his scattered interests and abilities. Having inherited his father's mechanical aptitude, the young Powers first trained as a technical draftsman and subsequently found work in the repair shops of railroad barns in Florence, Paris, and later New Jersey. Because he enjoyed the adventure of traveling, Powers enlisted in the United States Navy as a captain's clerk, in time serving as chief interpreter aboard the U.S.S. *Canandaigua.* Family correspondence dating from this period indicates the concern with which the elder Powers watched his son's peripatetic existence. Letters exchanged between father and son contain pointed exhortations for the sailor to reestablish himself in Florence and contribute his energies to the running of Powers's busy studio.

Preston Powers eventually yielded to his father's advice and returned to Florence. By the fall of 1868 he had secured his own studio space in the building adjoining his father's, where he practiced photography, specializing in still-life studies of the senior Powers's marbles. His services were soon thereafter enlisted to help with the pressing commitments of his father's sculpture studio, a situation that absorbed increasing amounts of his time, especially in the months following Hiram Powers's death. To expedite the residual orders for portrait busts at Powers's studio he became adept at using the pointing machine. Evidently he confined his efforts to

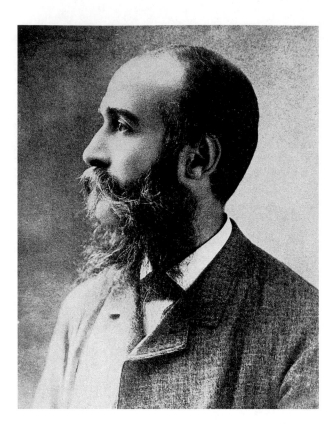

working up the sitters' heads, relying on the expertise of the Italian studio assistants to execute the rest of the design and carving. A rift that afterward developed between Preston and other family members obscures the precise nature of his activities in the Florence studio. He is reported to have impounded records and archival materials connected with his involvement in the studio operation, and these papers have not yet been located.

Apparently Powers remained in Italy only briefly after 1873, for by 1874 the *Aldine*, an American art journal, announced that he had taken a studio in the basement of the Senate Hall of the State House in Boston and was busily engaged in making a portrait bust of the late Charles Sumner (exhibited at the Philadelphia Centennial in 1876). The sculptor's primary source of income seems to have derived from his facility as a portraitist. As the small corpus of known busts by Powers suggests, he managed to cultivate a clientele among prominent American politicians, entrepreneurs, and intellectuals. Among the more noteworthy of the sitters whose likenesses he modeled were the poet John Greenleaf Whittier, 1877 (two later versions survive, Boston Public Library, dated 1881 and 1893); the Swiss-born Harvard naturalist Louis Agassiz,

1874 (Corcoran Gallery of Art, Washington, D.C.); the Vermont senator and financial authority Justin Smith Morrill, 1875 (National Museum of American Art, Washington, D.C.); President James A. Garfield, 1888 (National Museum of American History, Washington, D.C.); and the Swedish theologian Emanuel Swedenborg (Argyle Square Church, London), whom his father greatly admired. Men of commerce also sought out Preston Powers's services, as demonstrated by his busts of the successful iron manufacturer John Augustus Griswold of Troy, New York (Rensselaer County Historical Society, Troy), and the affluent Cincinnati merchant Job M. Nash, 1884 (The Metropolitan Museum of Art, New York).

Although realistic portraiture dominated his oeuvre, Powers ventured into other sculptural formats from time to time, such as the memorial he designed for the Lowndes family of South Carolina, 1882 (Magnolia Cemetery, Charleston). Another interesting departure was the ideal head of Longfellow's *Evangeline*, exhibited in 1882 at the Royal Academy of Arts in London, where he resided for a time. In 1881 Powers's most ambitious effort at heroic portraiture was unveiled: a life-size figure of the Vermont legislator and jurist Jacob Collamer, which the state of Vermont presented to the National Statuary Hall of the United States Capitol, Washington, D.C.

During his various periods of residence in the United States, Powers supplemented his studio earnings by working as an art instructor. In 1880 he taught modeling in Cincinnati when visiting relatives in the area. In 1892 the Denver University School of Fine Arts appointed him to the faculty. While living in Colorado, he received a commission to create a sculpture to commemorate the national mood prevailing as the century neared conclusion and the American frontier came to its "official" close. Appropriately titled *The Closing Era* (State Capitol grounds, Denver, Colorado), the monument depicted a pondering Indian standing over a huge buffalo that he had killed. The piece and its sentiment attracted considerable attention when Powers exhibited it at the 1893 World's Columbian Exposition in Chicago.

The final years of Preston Powers's career were spent in Florence, at the villa he had constructed adjacent to his family's spacious home on the Viale Michelangelo. His contributions to sculpture were plainly less innovative and technically accomplished than those of his celebrated father. A competent craftsman, he seems to have resigned himself to perpetuating the traditional style of neoclassical portraiture for which the original Powers's studio was renowned, rarely achieving the consistently impeccable finish, arresting naturalness, or degree of physiological acuity that had characterized the senior Powers's best portraits.

J.S.R.

References

AAA, SI; "Art, Some Recent Statues," *Aldine* 7 (1874), p. 168; BMFA, *M. and M. Karolik Collection of American Water Colors and Drawings 1800-1975* (1962), vol. 1, p. 315, fig. 157; Brown University, Department of Art, Providence, R.I., *The Classical Spirit in American Portraiture* (1976), p. 98, no. 38; Craven 1968, pp. 210-211; Charles Fairman, *Art and Artists of the Capitol of the United States of America* (Washington, D.C.: U.S. Government Printing Office, 1927), pp. 388-389; Gerdts 1973, p. 108, fig. 112; Algernon Graves, *The Royal Academy of Arts, A Complete Dictionary of Contributors and their Work from its Foundation in 1769 to 1904* (London: Henry Graves, 1906), p. 195; "Letter from Florence," *Art Journal: An American Review of the Fine Arts* (Chicago) 3 (Oct. 1869), p. 167; "A Neglected Artist," *Boston Evening Transcript*, Apr. 30, 1925.

PRESTON POWERS
61
Nathaniel Hawthorne (?) or *Unknown Man*, 1875
Marble
H. 25¾ in. (65.4 cm.), w. 21 in. (53.3 cm.), d. 14½ in. (36.9 cm.)
Signed (on back): No = 13 / P. POWERS / Sculp. 1875
Gift of Maxim Karolik. 60.476

Provenance: Mrs. George Waldo Emerson, Concord, Mass. (?); Maxim and Martha Karolik, Boston
Exhibited: Brown University, Department of Art, Providence, R.I., *The Classical Spirit in American Portraiture* (1976), no. 38.

The identity of this portrait, ostensibly of Nathaniel Hawthorne (1804-1864), poses a number of historical puzzles if the attribution claimed in the sculpture's registration records is correct.[1] Executed in marble more than a decade after the distinguished author's death, the bust has long been considered a posthumous likeness modeled from Powers's memory of Hawthorne, whom he first met when he was in his teens. It has also been conjectured that the marble bust, composed in three-quarter-life size, may have been based on a life sketch Preston made of Hawthorne during the writer's tour of Italy in

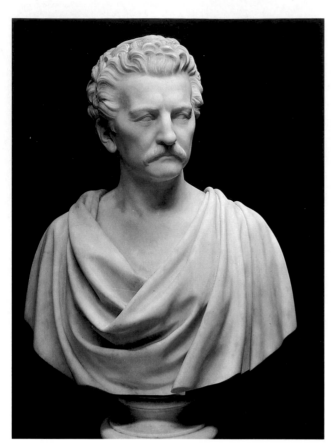

61

1858-1859, or possibly on a study of Hawthorne modeled by Hiram Powers, which his son later transferred to marble after assuming many of the studio projects left undone at the time of Hiram's death. The bust's questionable provenance at the very least invites reexamination of Hawthorne's connections with both Hiram and Preston Powers as well as a reappraisal of the portrait's plausibility as an image of the extensively portrayed writer.

At the conclusion of his term as United States consul in Liverpool, England, Hawthorne took his family to Italy for an extended sojourn. During this stay the Hawthornes divided their time principally between Rome and Florence, enthusiastically studying the art treasures and historic sites of each city. In Florence, Hawthorne settled into a comfortable rented villa procured for him by Hiram Powers. The two men and their wives became immediately attached, exchanging social visits and conversation on topics ranging from art to spiritualism.

The cordial friendship that developed between Hawthorne and Hiram Powers in many ways typified the mutual admiration and sociability existing

between American writers and artists in the nineteenth century, particularly when they were abroad, where a shared sense of national identity and vocational purpose precipitated intimacy. While Hawthorne was in Italy, for example, he befriended the expatriate sculptor Louisa Lander (1826-1923), a former resident of Hawthorne's hometown of Salem, Massachusetts. Lander's independent existence abroad greatly impressed her compatriot, probably furnishing him with ideas for his fictionalized character Miriam in *The Marble Faun* (1860). In February 1858 he consented to Lander's request to model his bust; the experience proved to be reciprocal, with Hawthorne "taking a similar freedom with her oral likeness to that which she was taking with my physical one."[2]

Hawthorne recorded his sittings with Lander in the journal he kept during his foreign travels,[3] notebooks that also chronicled his intermittent encounters with Hiram Powers and his social contacts with other colorful members of the Anglo-American communities of Rome and Florence. In neither his diary nor any of his published correspondence dating from this Italian interlude did the characteristically observant Hawthorne mention sitting for his portrait for Hiram or Preston Powers. The absence of such a notation on Hawthorne's part is significant, for the writer was intrigued by art and its processes (subjects he often explored in his fiction) and as a matter of course would probably have commented on his participation in any modeling sessions arranged during his stay in Florence. Nor do studio memoranda of Hiram Powers's contain any reference to a plaster or marble bust of Nathaniel Hawthorne. Thus, although the approximate age of the man depicted in the Museum's bust corresponds with that of Hawthorne at the time of his Italian expedition, and the handling of classical drapery accords very closely with that found on a number of later portrait busts by Hiram Powers, no convincing evidence can be assembled to support the notion that it derived from a study undertaken of the author by the senior Powers.

Nor is there proof that Preston Powers, who was only fifteen when Hawthorne visited Florence, attempted to draw or model the author's likeness from life. Furthermore, although a mustache is rendered on the marble bust, Hawthorne did not in fact grow a mustache until the summer of 1859, as he was leaving Italy. When he encountered the Powers family in Florence, he was clean-shaven, just as Louisa Lander's 1858 bust of him in Rome indi-

cates. It seems unlikely, therefore, that either Powers, father or son, modeled this bust during Hawthorne's tour of Italy.

In all probability Preston Powers conceived the bust during the period of his early residence in Boston in 1874, when he was engaged in modeling portraits of notable New England people, and translated it to marble in 1875. If the identity of the individual portrayed in the Museum's bust is accepted as Hawthorne, then a guess could be hazarded that Powers carved it for display in the studio he occupied in the basement of the Senate Hall, not only to demonstrate his facility as a portraitist but also to impress prospective patrons with the fact of his acquaintance with the late, renowned man of American letters.

For the portrait, Preston Powers chose to interpret his subject in an imperial, classical guise,[4] draped in a Roman toga, which, by the mid-1870s, was slightly out of fashion. Hawthorne, had he had the opportunity to react to this pick of wardrobe, probably would have criticized the costume. Of Hiram Powers's statue of Daniel Webster, portrayed in modern dress, 1859 (Massachusetts State House, Boston), he wrote appreciatively, "I respect him [Hiram Powers] . . . for recognizing the folly of masquerading our Yankee statesman in a Roman toga." (Still, Hawthorne would have preferred the toga to nothing at all, for he similarly deplored what he termed the "indecorousness" of "brassy nudity.")[5] The modern aspect and naturalistic modeling of the head appear stylistically incompatible with the formulaic classical robes.

If Preston Powers's intention was to achieve a convincing posthumous likeness of Hawthorne, there were, by the 1870s, a wealth of pictorial sources available to assist the sculptor in that endeavor, including portrait paintings, engravings, drawings, and daguerreotypes.[6] Yet if Powers's bust is compared with the known photographs and oil portraits of the writer taken from life, it becomes apparent that his image is, at best, an idealized but confusing composite, relying on no single likeness of the writer as its authority and projecting no definite sense of age.

Although the general form of the face and placement of the features resemble Hawthorne's, other aspects of the portrait are disconcerting. The mustache and eyebrows of the sitter are not as thick and shaggy as those recorded in Hawthorne's portraits and photographs, and the face seems leaner and more muscular than the author's middle-aged

countenance. The treatment of the sitter's hair is also inconsistent with Hawthorne's distinctive hairline, which was receding by the late 1840s. The curly coiffure and low browline represented in the bust do not accord with the thinning wisps of hair indicated in Hawthorne's more mature portraits and photographs. The variations between the reliable images of Hawthorne and Powers's purported representation of him raise the question whether this bust was conceived as a portrait of that celebrated writer, or whether it depicts some other Victorian gentleman whose passing resemblance to Hawthorne caused a misattribution of identity after the bust passed out of the hands of the sculptor or the original owner.[7] Perhaps the visual discrepancies can be explained as the result of Powers's poor memory of Hawthorne or of his desire to construct an idealized image of Hawthorne that would appear at once dignified and perpetually hale and handsome. In a comprehensive study of Hawthorne's portraits and imagery in the visual arts, Rita Gollin has classed the Museum's bust as an "apocryphal likeness," observing, "the large and pendulous earlobes, the short-cropped curly hair, and the low browline are surely not those of Nathaniel Hawthorne." She wryly noted: "the mustached face with set lips and staring eyes resembles Mark Twain or William Faulkner as much as it does Hawthorne."[8]

In his lifetime Hawthorne expressed little confidence in the various attempts artists had made to capture his likeness for posterity, believing that the face he saw reflected in the mirror each morning "eluded" the efforts of those who "tried to give it fixed form."[9] Most likely he would have disapproved of the attention focused on any sculpted bust of him, real or alleged, for Hawthorne was not an enthusiast of the practice of immortalizing contemporary men and women in marble. In a passage in *The Marble Faun*, he editorialized: "But this is an awful thing, this endless endurance, this almost indestructibility of a marble bust! Whether in our own case, or that of other men, it bids us sadly measure the little, little time during which our lineaments are likely to be of interest to any human being. . . . And it ought to make us shiver, the idea of leaving our features to be a dusty-white ghost among strangers of another generation, who will take our nose between their thumb and fingers (as we have seen men do by Caesar's), and infallibly break it off if they can do it without detection!"[10]

J.S.R.

Notes

1. The bust was one of 102 American artworks given to the Museum in Jan. 1960 by Maxim Karolik for the proposed M. and M. Karolik Collection of American Art. Records and correspondence relating to the gift indicate that the bust was included among 31 pieces "of American sculpture by various artists." The piece was catalogued through the Department of Prints in Apr. 1960 as a "Bust of Nathaniel Hawthorne."

2. Hawthorne's "pen-portrait" of Lander is reproduced verbatim in Julian Hawthorne, *Hawthorne and His Wife* (Boston: Houghton Mifflin, 1884), vol. 2, p. 182. Completed in the spring of 1858, Lander's original marble bust of the author (which his son Julian described as resembling a combination of Daniel Webster and George Washington) was presented by the Hawthorne children to the Concord Free Public Library, Concord, Mass. A copy was acquired by the Essex Institute, Salem, Mass.

3. On Hawthorne's reactions to and philosophical insights drawn from the experience of having Lander model his portrait, see John L. Idol, Jr., and Sterling Eisiminger, "Hawthorne Sits for a Bust by Maria Louisa Lander," *Essex Institute Historical Collections* 114 (Oct. 1978), pp. 207-212.

4. See Brown University, Department of Art, Providence, R.I., *The Classical Spirit in American Portraiture* (1976), no. 38.

5. Nathaniel Hawthorne, *The French and Italian Notebooks* (Boston: Houghton Mifflin, 1913), p. 428.

6. For a comprehensive recent study of the subject, see Rita K. Gollin, *Portraits of Nathaniel Hawthorne: An Iconography* (DeKalb: Northern Illinois University Press, 1983).

7. For additional discussion of the confusion surrounding the identity of this bust, see Bettina Eichel, "Nathaniel Hawthorne by Preston Powers," term paper, sculpture seminar, Wellesley College, May 1979, in BMFA, ADA.

8. Gollin, unpaged section "Apocryphal Likenesses," in *Portraits of Hawthorne.*

9. Ibid., p. 1.

10. Nathaniel Hawthorne, *The Marble Faun* (1860; reprint ed, New York: Airmont, 1966), p. 84.

Olin Levi Warner (1844–1896)

Olin Levi Warner was twenty-five before he received his first formal training in sculpture. The son of itinerant New England lay preachers who appreciated his artistic talent but lacked the means to support it, Warner worked as a railroad telegrapher for six years, saving money to study in Paris. Although as a child he had made some chalk carvings of heads and figures from popular engravings, his determination at nineteen to pursue a career as a sculptor was based largely on the success of a life-size, plaster-of-Paris bust he modeled of his father (Westminster Historical Society, Massachusetts) that was exhibited at the Vermont state fair in 1863.

Warner's original plan was to spend two years in Paris, after which he felt sure that he could return to America and earn a living as a sculptor. In choosing Paris over Rome, like Richard Greenough and Augustus Saint-Gaudens before him, he helped to set in motion the shift of American sculptors from concentration on Italian neoclassicism to emphasis on the pictorialism and naturalism practiced at the Ecole des Beaux-Arts.[1]

In 1869 Warner sailed for France, with neither a letter of introduction nor a knowledge of the French language. After spending the summer visiting the Louvre and getting to know Paris, Warner wrote reassuringly to friends in America, "I could not have gone to a better part of the world to study than here. The greatest living artists are in France. . . . I am continually surrounded by some of the finest works of modern & antique art."[2] Saint-Gaudens and Truman H. Bartlett (1835-1923) had resided there since 1867, but Warner seems to have been very much on his own.[3]

Warner was admitted to the Petite Ecole in January 1870 in order to receive the requisite training for admittance to the Ecole des Beaux-Arts. In March he entered the studio of François Jouffroy (1806-1882), who presented him to the Ecole des Beaux-Arts, where he enrolled the following October. Easily adapting to the life of a Parisian student, Warner reputedly made friends with Jean Falguière (1831-1900) and Antonin Mercié (1845-1916), whose early critical successes could be credited to their training and encouragement under Jouffroy. For the next two years Warner spent much of his time on preparatory studies for an ideal standing female figure, which he called *May* (present location unknown). Briefly, during the siege of Paris by the Germans in September 1870, he helped defend the city by joining the French Foreign Legion.

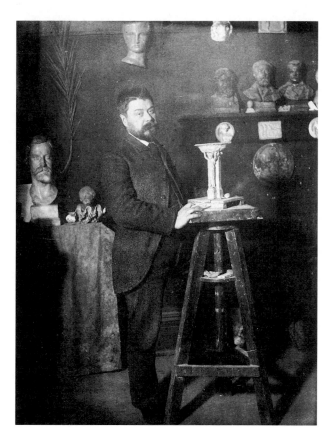

In late February 1872 Jean-Baptiste Carpeaux (1827-1875), the celebrated if controversial sculptor for the decoration of the facade of the Paris Opera, invited Warner to join his studio as an assistant. Warner accepted this unprecedented honor for an American student but remained with Carpeaux only until the summer. Weary of the unstable political situation in France, which had often caused interruptions in his studies, and short of money, Warner decided to return to America in July. Carpeaux's efforts at reproducing his own works in terracotta for a popular market undoubtedly suggested to Warner the means by which he might supplement his income while awaiting recognition.

Settling in New York, Warner tried to convince an American foundry to sell castings of his statuette *May* and some other small studies. This proved fruitless, but he signed a contract with a lighting fixture company to reproduce *May* as an ornamental gaslight fixture. Over the next four years Warner apparently received just nine portrait orders; he also failed to win either of the open competitions for memorials to Major General George Henry Thomas, 1879 (Thomas Circle, Washington, D.C.), and to Admiral Farragut, 1881 (Farragut

Square, Washington, D.C.), which were awarded respectively to John Quincy Adams Ward and Vinnie Ream Hoxie (1847-1914). During this period only one of his pieces was reviewed, a colossal portrait medallion of the actor Edwin Forrest, 1876 (present location unknown), exhibited in plaster at the Philadelphia Centennial Exposition. The flamboyant personality of the sitter was evidently well served by Warner's Paris training, although one later critic found the impressionistic modeling to be "almost brutal."[4]

The turning point in Warner's career and fortune came in 1877. He became an early member of the Society of American Artists, newly formed on Saint-Gaudens's initiative to promote the interests of artists who were dissatisfied with what they considered were conservative attitudes promulgated by the National Academy of Design. From the beginning, the society had the support of two of New York's most influential writers: Clarence Cook, art critic for the New York Daily Tribune, and Richard Watson Gilder, poet and editor of Century Magazine. Warner got to know both of them, and at the society's first exhibition in 1878, Cook singled out Warner's bas-reliefs and portrait bust as "the first contribution of sculpture, rightly so called, by an American sculptor to an American exhibition."[5] At the same time, Warner became close friends with the English dealer Daniel Cottier, who promoted the sculptor's compositions in the Fifth Avenue showrooms of Cottier and Company.

By the end of 1880 Warner's financial condition had improved. That year he executed more portraits than in any other of his career (at least five busts and eight medallions). His busts of the harpist Maud Morgan (Portland Museum of Art, Oregon) and his artist friend Julian Alden Weir (1852-1919) (American Academy and Institute of Arts and Letters, New York) are generally considered among his most successful. Like the portrait of Weir, Maud Morgan faithfully reproduces the sitter's classic beauty but with a contemporary liveliness. On January 20, 1881, the Museum of Fine Arts purchased the plaster bust of Morgan (later destroyed) and became the first such public institution to acquire and exhibit a work by Warner.[6]

Through limited competitions Warner won in quick succession in 1882 and 1883 his first two of three major portrait commissions for public sculpture: memorials to the Civil War governor of Connecticut, William A. Buckingham, 1884 (State Capitol, Hartford), and the Boston abolitionist and editor William Lloyd Garrison, 1886 (Commonwealth Avenue Mall, Boston), both of whom he portrayed as seated figures. Warner's third bronze statue of the Boston jurist and Civil War general Charles Deven, 1894 (Charles River Esplanade, Boston), his only heroic-size standing figure, was not dedicated until two years after Warner's death. Although Truman Bartlett had helped Warner to get the Buckingham and probably the Garrison commissions, in an intemperate review for American Architect and Building News, he assailed Warner for his careless modeling, lack of characterization, and "meaningless simplicity" in the Buckingham.[7] The Garrison fared better with the critics; Lorado Taft rated the monument "among the great statues of America."[8] During this period Warner continued to create bas-relief portraits, a format that he and Saint-Gaudens preferred. Warner's approach was far more sculptural than Saint-Gaudens's, however, and he frequently chose the tondo form rather than a rectangular framework to emphasize his modeling, as in his series of eight portrait medallions of Native American chiefs (The Metropolitan Museum of Art, New York), produced during two trips to the Pacific Northwest in 1889 and 1891. Like John Quincy Adams Ward's Indian Hunter (q.v.), these studies were based on first-hand observation.

In May 1889 Warner and Saint-Gaudens were made academicians of the National Academy of Design, only the sixth and seventh sculptors since the institution's founding in 1825 to be so honored. Clearly this was a vindication of the efforts of both artists to promote Beaux-Arts standards of training.[9]

In spirit a classicist with a strong sense of form, Warner might have created more allegorical figures if he had remained longer in Paris, where Carpeaux and others had capitalized on the French tradition for such sculpture. As it was, on his return to America, Warner spent most of his time executing portraits to earn a living; of the approximately one hundred and fifty works that he produced over his career, about forty-five are portrait busts, forty-seven are portrait medallions, and five are portrait statues. Most of Warner's remaining sculpture consists of architectural decoration.

The few ideal subjects Warner created were done mainly on his own account. The small-scale, half-draped female figure Twilight, modeled in 1878 (The Art Institute of Chicago), and the nude statuette Dancing Nymph, 1881 (The Brooklyn Museum), remain within the neoclassical tradition, but the

half-life-size *Diana*, 1887 (The Metropolitan Museum of Art), with its animated naturalism, is clearly in the Beaux-Arts style. *Diana*, whose prototype seems to have been Henri Chapu's *Joan of Arc*, 1872 (Louvre), has even been compared to the modernist inventions of Aristide Maillol (1861-1944) in the "studio-realism" of the figure and its economy of line;[10] the only concessions to classical symbolism in the piece are the goddess's attribute, an arrow, which she grasps in her hand, and her sidelong glance, which seems to suggest her intuitive response to the sudden appearance of the young prince Actaeon.

If Warner had not died at age fifty-two, the sensitivity and subtlety that his contemporaries found in his work undoubtedly would have generated more public commissions. Warner was too independent for the atelier system, but just three years before his death he served as a juror at the World's Columbian Exposition in Chicago and was involved in the sculptural programs for the New York State building, as well as the design for the souvenir half-dollar. At the time he died of injuries resulting from a bicycle accident in Central Park, Warner was at work on the decoration of two doors for the Library of Congress, Washington, D.C., a commission that signified recognition of his talents.[11]

Any comparison of Warner's oeuvre with that of Saint-Gaudens or Daniel Chester French, the foremost American sculptors at the end of the nineteenth century, necessarily falls short because Warner's limited production of public sculpture only begins to suggest his powers. Some historians in this field like Chandler Post and Adeline Adams, however, have ranked Warner second only to Saint-Gaudens in the skill and subtlety of his modeling. "Without descending to neoclassical plagiarism," as Post wrote, "he exemplified both the feeling for physical beauty and the moderation of antiquity, retaining vague reminiscences of Hellenic loveliness of line and form."[12]

P.M.K.

Notes

1. Although Warner did not indicate in his letters home why he preferred Paris to Rome, he may have been anticipating the appetite of Americans for the sophisticated products of Parisian ateliers. For the definitive study on Warner, see George Gurney, "Olin Levi Warner (1844-1896): A Catalogue Raisonné of His Sculpture and Graphic Work," 3 vols., Ph.D. diss., University of Delaware, 1978. I wish to acknowledge my debt to Gurney's scholarship.

Kathryn Greenthal provided information on Warner's enrollment at the Petite Ecole and the Ecole des Beaux-Arts, Paris, from the records of the Archives de l'Ecole Nationale Supérieure des Arts Décoratifs and Archives de l'Ecole Nationale Supérieure des Beaux-Arts, Archives Nationales, Paris (AJ53-143, AJ52-246, AJ52-235).

2. Warner to "Friends in America," Aug. 9, 1869, Olin Levi Warner Papers, AAA, SI, quoted in Gurney, "Warner," vol. 1, pp. 22-23.

3. Gurney, "Warner," vol. 1, p. 19. Gurney points out that Warner never mentioned in his letters home any artists he knew or studied with in Paris.

4. Henry Eckford [Charles De Kay], "Olin Warner, Sculptor," *Century Magazine* 37 (Jan. 1889), p. 393.

5. Clarence Cook, "A New Art Departure," *New York Daily Tribune*, Mar. 9, 1878. Warner's subjects are not given in the exhibition's catalogue.

6. See letter from R.G. Rosegrant to Mrs. Carlyle Jones, Warner's daughter, May 3, 1931, Warner Papers, informing her that the Museum, which destroyed the plaster in 1931, had paid $50 for the bust. *Maud Morgan* appeared in the Museum's "Exhibition of Works by Living American Artists," Nov. 9 - Dec. 20, 1880, as no. 4.

7. Truman Bartlett, "Sitting Statues," I, *American Architect and Building News*, Feb. 20, 1886, p. 88.

8. Taft 1930, p. 273.

9. See "Art Notes," *New York Times*, May 20, 1889.

10. See Jeremy Cooper, *Nineteenth-Century Romantic Bronzes: French, English and American Bronzes, 1830-1915* (Newton Abbot, Devon: David & Charles, 1975), p. 114.

11. One door was ready for casting: the tympanum *Oral Tradition* and the panels *Imagination* and *Memory*. Herbert Adams completed the other door in 1898.

12. George Henry Chase and Chandler Rathfon Post, *A History of Sculpture* (New York: Harper, 1924), p. 502.

References

AAA, SI; Archives de l'Ecole Nationale Supérieure des Arts Décoratifs and Archives de l'Ecole Nationale Supérieure des Beaux-Arts, Archives Nationales, Paris; Truman H. Bartlett, "Sitting Statues," I and II, *American Architect and Building News*, Feb. 20, 1886, pp. 87-88, Feb. 27, 1886, pp. 101-102; W.C. Brownell, "The Sculpture of Olin Warner," *Scribner's Magazine* 20 (Oct. 1869), pp. 429-441; Caffin 1903, pp. 131-146; Craven 1968, pp. 406-409; Henry Eckford [Charles De Kay], "Olin Warner, Sculptor," *Century Magazine* 37 (Jan. 1889), pp. 392-401; Gardner 1965, pp. 40-45; George Gurney, "Olin Levi Warner (1844-1896): A Catalogue Raisonné of His Sculpture and Graphic Work," 3 vols., Ph.D. diss., University of Delaware, 1978; Hirschl & Adler 1982, no. 17; Ripley Hitchcock, "Notes on an American Sculptor," *Art Review* 1 (Mar. 1887), pp. 1-5; William Donald Mitchell, "Connecticut's Contributions in Art," *Connecticut Magazine* 1 (1908), pp. 127-129; MMA; *New York Times*, Aug. 15, 1896, obit.;

Post 1921, vol. 2, pp. 238-240; Proske 1968, pp. xviii-xix; "The Society: Sculptors," *Magazine of Art* 15 (1892), p. xxviii; Taft 1930, pp. 268-276; Whitney 1976, p. 318; C.E.S. Wood, "Famous Indians, Portraits of Some American Chiefs," *Century Magazine* 46 (July 1893), pp. 436-445.

OLIN LEVI WARNER
62
Thomas Allen, Jr., 1889
Marble
H. 16 in. (40.6 cm.), w. 8¾ in. (22.2 cm.), d. 7⅛ in. (18.2 cm.)
Signed (on back side of base): Olin L. Warner /
Sculptor
Inscribed (on back below shoulders): Thomas Allen
Jr / September / 1889
Gift of Mrs. Thomas Allen. 25.21

Provenance: Mr. and Mrs. Thomas Allen, Brookline, Mass.
Exhibited: Boston Art Club, *Forty-second Exhibition: Watercolors* (1890), no. 277; Society of American Artists, New York, *Fourteenth Exhibition of the Society of American Artists* (1892), no. 233; National Sculpture Society, New York, *Third Exhibition* (1898), no. 204.
Versions: *Plaster*: (1) National Museum of American Art, Washington, D.C., (2) Westminster Historical Society, Mass. *Marble*: (1) Hirschl & Adler Galleries, New York. *Bronze*: (1) present location unknown, formerly Sylvia M. Warner, New York

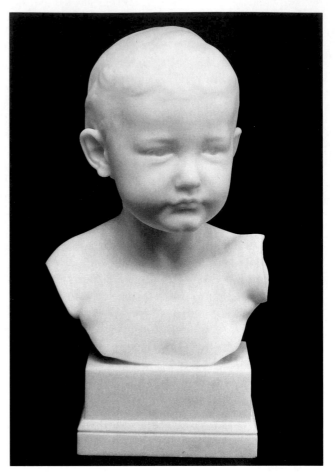

62

In September 1889 Olin Levi Warner finished the portrait of Thomas Allen, Jr. (1887-1965), the two-and-a-half-year-old son of his friend, the Boston painter Thomas Allen (1849-1924).[1] This was only the second bust of a child that Warner had modeled.[2] The year before he had executed one of his infant daughter Rosalie (National Museum of American Art, Washington, D.C.), which was exhibited at the spring show of the National Academy of Design, New York, in 1889. Allen also had two paintings in that show and probably commissioned his son's portrait at the time.

Warner and Allen knew each other well since both were artistic advisers to the Bennington Battle Memorial Association, Vermont, and founding members of the Society of American Artists, the cooperative venture initiated by Augustus Saint-Gaudens in 1878. In 1890, when the Museum's bust was shown for the first time at the Boston Art Club's "Forty-second Exhibition: Watercolors," Allen was vice-president of the club, chairman of the committee on exhibitions, and a member of the jury on admission and the hanging committee. He also had

close associations with the Museum, serving as trustee from 1909 to 1924 and as chairman of the Boston Art Commission (representing the Museum) from 1910 to 1924.[3] His son Thomas Allen, Jr., a longtime resident of Brookline, attended Harvard University and its law school and was a corporate and tax lawyer with the Boston firm of Wardwell, Allen, Brownell, and McLaughlin.[4]

As George Gurney has pointed out, the Allen boy's serious expression and dignified bearing, as well as the unusual truncation of his arms, are features more generally associated with representations of mature individuals. Although childlike characteristics—full cheeks, cupid mouth, short, dimpled chin, and undeveloped chest—are carefully delineated, there is a "sense of the 'little man,'"[5] which deepens the portrait's appeal. Indeed, when the bust was exhibited in 1892 at the Society of American Artists, New York, the reviewer for the *New York Times* found the portrait contained "something of that immutable grace, that abiding dignity which we find in antique art."[6]

Like Warner's 1880 portrait of Julian Alden Weir, the *Allen* exhibits the irregular termination of the bust that Jean-Baptiste Carpeaux employed in his portraits of bare-chested adults. Even though Warner had assisted Carpeaux for only a brief time in 1872, the Parisian sculptor's influence on him remained strong.

After Warner died in 1896, his widow helped to arrange an exhibition of fifty-five of his sculptures, including a version of the *Allen* bust, at Tiffany and Company, New York, in the spring of 1897. A number of original plasters were shown in an effort to promote commissions in marble and bronze or to "secure reproductions in plaster."[7] Around this time Mrs. Warner had the *Allen* cast in bronze (present location unknown), for which the second plaster (National Museum of American Art, Washington, D.C.) may have been made.[8] In 1925 Thomas Allen's widow gave this marble bust of their son to the Museum in memory of her husband.

P.M.K.

Notes

1. See letter from Warner's friend and patron Charles Erskine Scott Wood to Warner, July 12, 1889, Olin Levi Warner Papers, AAA, SI, noted in George Gurney, "Olin Levi Warner (1844-1896): A Catalogue Raisonné of His Sculpture and Graphic Work," Ph.D. diss., University of Delaware, 1978, vol. 2, p. 683, n. 4. Wood mentions that Warner had to finish the bust before he could leave for Portland, Ore. A second marble (New York art market) may also have been carved at this time for the family of the sitter.

2. Warner did two other portraits of children in 1889: a small medallion of Caroline Weir (private collection), the five-year-old daughter of the artist Julian Alden Weir, and a half-length bas-relief of Florence Dillon Wyckoff (The Brooklyn Museum), age eleven.

3. See "Thomas Allen," *Museum of Fine Arts Bulletin* 23 (Feb. 1925), p. 6. Information on the bust's first Boston showing was provided by Kathryn Greenthal.

4. See *Boston Sunday Globe*, Apr. 25, 1965, obit.; Harvard College, Class of 1909, *Fiftieth Anniversary Report* (1959), pp. 16-17.

5. Gurney, "Warner," vol. 2, no. 110.

6. "Work by Sculptors at the Society," *New York Times*, May 12, 1892.

7. For a checklist of the show and an appeal to potential buyers, see "Collections at Tiffany & Co.'s," *Collector* 8 (Apr. 15, 1897), p. 184.

8. At the third exhibition of the National Sculpture Society in 1898, a marble bust of Thomas Allen, Jr., was shown, but there is no record of whether this was the Museum's example or the second marble currently on the New York art market. A year later the *Allen* was also included in the sixty-eighth annual exhibition of the Pennsylvania Academy of the Fine Arts, Philadelphia, but no medium or lender's name was listed.

John D. (Daniel?) Perry
(1845– after 1879)

John D. Perry is one of a number of nineteenth-century American sculptors whose backgrounds and careers remain largely obscure. Conflicting accounts of his place of birth and proper name further confuse the bare outline that may be traced of his early professional life. Whereas a consensus of opinion seems to exist about his year of birth—1845—and the name of the town where he was born—Swanton—some biographical dictionaries assign Virginia as his native state while others report it as Vermont.[1] The latter is probably correct since Perry is credited with designing a Civil War memorial for Swanton, Vermont, and local histories dating from the period make a point of noting that the monument's sculptor was a native resident. The many quarries located in the vicinity attracted stonecutters to the area, and thus it would seem likely that Perry was related to the family of that name who town records indicate were active in a local marble and granite works.[2]

The details of Perry's youth are unknown except that he lacked formal training in art but managed to attain competency in that pursuit through diligent study of nature and of the scarce examples of paintings and statues, mainly of foreign manufacture, available to him. The first notable sculptural undertaking associated with Perry was the *Swanton Soldiers' Memorial*, 1868, erected to commemorate the town's Civil War dead. Carved from locally quarried marble, the monument represented the Goddess of Liberty, styled in Grecian dress, pondering the unfortunate but valiant sacrifices that Freedom's cause entailed. Where or from whom the twenty-one-year-old sculptor obtained the technical knowledge required to execute such an ambitious project (the total height of the figure and its substructure measured twenty feet) remains undetermined. An additional puzzle surrounds the given names of the author of the *Swanton Memorial* since published histories of the town and county identify the sculptor as Daniel J. Perry rather than John D. Perry. Presumably, the names were either confused or inverted by one writer, whose error was then perpetuated, or for some unexplained reason Perry himself later rearranged the order of his first names. According to a nineteenth-century biographical source, Perry visited New York City in 1869-1870, where he conceivably received some formal studio instruction. The catalogue for the forty-fifth annual juried exhibition at the National Academy of Design in New York (1870) registers two portrait medallions, contributed by "John Daniel Perry." Although the identities of the sitters are not recorded in the catalogue, the owners of the medallions are listed as August Binsse and Wyatt Eaton (1849-1896), the latter a prominent painter.[3] The entry provides support for the theory that Perry's name was erroneously cited in connection with the *Swanton Soldiers' Memorial*, if one accepts the "John Daniel Perry" listed in the National Academy of Design's catalogue as the same sculptor newly arrived in New York from Vermont.

Shortly after participating in this exhibition (presuming he did so), Perry joined the growing ranks of aspiring American sculptors who sought further training abroad. At several different intervals during the 1870s he lived in Rome: initially from 1872 to 1874 and again from 1876 to 1878, the latter trip including a stay in Paris. Between these Roman sojourns, Perry resided in Boston, working and teaching at the Studio Building on Tremont Street, where the young Maine sculptor Edward R. Thaxter received instruction from him.

Although few statues documented to John D. Perry have come to light in recent times, the scarcity of his surviving body of work should not be construed as indicating a modest talent or sparse production. According to the sprinkling of comments published about him in his day, he experimented with a broad spectrum of sculptural categories ranging from realistic portraiture to playful "fancy pieces," and from intimate bas-reliefs to heroic-size public monuments. Two ideal compositions attributed to Perry, a *Beggar Maid*, inspired by a poem of Tennyson's, and *Christmas Morning* (present locations unknown), an imaginative tribute to childhood's wonder and delight in that holiday ritual (both commissioned for the private library of a Canadian patron, Mr. C. Baker, of Stanbridge), suggest the sculptor's sensitivity to the prevailing popular taste for literary themes and endearing studies of innocent, inquisitive children. Harriet Beecher Stowe, the celebrated author, owned his plaster bas-relief *The Two Buds* (present location unknown), a conceit typifying the benign, sentimental strain of Victorian parlor sculpture. At an exhibition held at the Boston Mechanics' Institute in the 1870s, Perry presented yet another piece in this mood called *The Butterfly*, about 1878 (present location unknown), a semi-ideal marble bust depicting a child contemplating an insect that has alighted on

its shoulder. Critics commented favorably on the soft texturing of the subject's skin and also wrote admiringly of the charming bouquet of sculpted roses out of which the child's shoulders emerged. A columnist for the *Boston Evening Transcript*, arguing that Perry's heads of children represented his most successful realizations of character, remarked that the sculptor had a "decided sympathy with childhood" and always managed to capture the "natural ways and unstereotyped expressions" of children.[4]

Perry's capabilities as a sculptor also encompassed the production of large-scale public monuments, an example being the seated allegorical figure of Morality he executed for the base of a civic memorial in Plymouth, Massachusetts. Occasionally he worked in a more intimate scale. His small statuette of Charles Sumner sitting at his desk was highly praised for its dignified characterization and easy, lifelike pose. Perry copyrighted the figure in 1874 and granted James Carr of the prominent New York pottery firm permission to reproduce the composition in Parian. The seated Parian-ware portrait of Sumner was included in Carr's exhibition at the 1876 Philadelphia Centennial. Another piece singled out by Perry's contemporaries for special comment was his life-size plaster study *The Widow's Mite*, about 1878 (present location unknown), which Perry apparently had exhibited in his Roman studio with the intention of attracting a patron to underwrite its transfer to marble.

After Perry's return from Rome in 1878, he renewed his ties to Boston by taking up residence at 5½ Beacon Street. His artistic activity mysteriously declined thereafter. He moved away from the city the following year, or so the city directories suggest, and out of the public eye. The reasons for the move are unknown, as is the artist's year of death.

J.S.R.

Notes

1. Among the artists' dictionaries that give Virginia as Perry's birthplace are Mantle Fielding, *Dictionary of American Painters, Sculptors and Engravers*, rev. ed. by Glenn B. Opitz (Poughkeepsie, N.Y.: Apollo, 1983); and William Young, *A Dictionary of American Artists, Sculptors and Engravers: From the Beginnings through the Turn of the Twentieth Century* (Cambridge, Mass: Young, 1968). But Clement and Hutton 1894 record his state of origin as Vermont.

2. I am grateful to Marilyn J. Foster, librarian, Swanton Public Library, Vt., for supplying me with information culled from local histories and records in the town clerk's office about the various Perrys living in Swanton in the mid-nineteenth century. Philip F. Elwert, deputy director and curator of the Vermont Historical Society in Montpelier, kindly checked the Vermont Vital Records for information on Perry but was unable to find a birth, marriage, or death listing for him.

3. See *The National Academy of Design Exhibition Record, 1861-1900*, ed. Maria Naylor (New York: Kennedy Galleries, 1973), vol. 2, p. 740. Perry's portrait medallions are listed as nos. 473 and 475 in the catalogue for the forty-fifth annual exhibition (1870).

4. "Art and Artists," *Boston Evening Transcript*, Oct. 29, 1878.

References

Lewis Cass Aldrich, *History of Franklin and Grand Isle Counties, Vermont* (1891), p. 206; "Art and Artists," *Boston Evening Transcript*, Oct. 29, 1878; George Barney and Rev. J.B. Perry, "The History of the Town of Swanton," in *Vermont Historical Gazetteer*, ed. Abby M. Hemenway (Montpelier, Vt., 1882), vol. 4, pp. 1063-1064; Hamilton Child, *Gazetteer and Business Directory of Franklin and Grand Isle Counties, Vt., for 1882-83* (Syracuse, N.Y.: Child, 1883); Clement and Hutton 1894; *The National Academy of Design Exhibition Record, 1861-1900*, ed. Maria Naylor (New York: Kennedy Galleries, 1973), vol. 2, p. 740; J.G. Stradling, "American Ceramics and the Philadelphia Centennial," *Antiques* 110 (July 1976), pp. 147 and 152, fig. 8.

JOHN D. PERRY
63
Harvey D. Parker, 1874
Marble
H. 27⅝ in. (70.2 cm.), w. 20 in. (50.8 cm.), d. 11⅜ in. (29 cm.)
Signed (on back of base): J.D. Perry, / Roma, 1874
Gift of Mrs. Hiram Whittington. 02.446

Provenance: Mrs. Hiram Whittington, Brookline, Mass.

Modern museums and municipal buildings often serve as repositories for portrait busts of minor political potentates, merchant princes, and other stewards of civic culture whose specific contributions to local history have long been forgotten. The origins of these busts, many now unidentified, usually can be traced to the second half of the nineteenth century, when marmoreal effigies of local luminaries proliferated in public buildings, private clubs, and company board rooms. Their commissioning was a courtesy paid to a departing president or committee chairman, as well as a gesture of appreciation shown to gratefully remembered benefactors. Furthermore, the exhibition of the finished product on institutional premises symbolized to employees and passersby that a life of hard work and virtuous citizenship would not go unrecog-

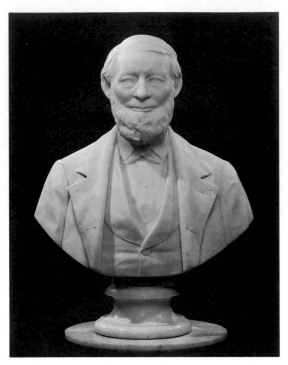

63

nized. "They cannot be said to be entirely forgotten men," reflected the biographer of one Boston sculptor whose livelihood depended on this custom, "for Boston cherishes the memory of her prominent citizens beyond most cities, and ever anon exhibits her marbles and canvases with considerable pride."[1] Whether Boston revered its native dignitaries more than did New York or Philadelphia is a moot point; that so many portraits of obscure Victorian citizenry exist demonstrates how prevalent was the practice of commemorative bust-making across nineteenth-century America.

John Perry's portrait of Harvey D. Parker (1805-1884), the founder and millionaire proprietor of the well-known Parker House hostelry in Boston, represents a routine marble memorial to one of Boston's entrepreneurial aristocracy. Conceivably, the piece at one time ornamented the hotel's lobby or offices. Dressed in business attire, Parker appears appropriately ponderous for the owner of an establishment celebrated for its hearty victuals. No doubt his beard disguises ample jowls. The subject's fleshy, orblike face and placid demeanor suggest a man who, at age seventy, has permitted himself to enjoy the fruits of his labor rather than remain labor's slave. The crow's feet delineated at the corners of Parker's eyes imply a jovial disposition, surely an advantageous personality attribute for the owner of a hospitable inn.

Parker probably sat for his bust in Boston in the early 1870s. The inscription on the resulting portrait, "J. D. Perry, / Roma, 1874," suggests that Perry executed the marble in Italy after his return to Rome, sometime in late 1873 or early 1874.[2] Parker's portrait is one of a half-dozen busts by Perry cited in Clara Clement's and Laurence Hutton's biographical summary of the sculptor's oeuvre, a grouping that included likenesses of the newspaper editor and reformer Horace Greeley, C.R. Train, the Attorney General of Massachusetts, and Dr. Winslow Lewis.[3] In a notice in the *Boston Evening Transcript* (1878), Perry's busts were praised as "full of character" and as demonstrating the sculptor's "decided sympathy with his subjects."[4] In style, costume treatment and projection of the sitter's essential personality, the portrayal of Harvey Parker calls to mind Thomas Ball's bust of Edward Wigglesworth (q.v.) of about the same date.

Historically, Parker's name is best known through his association with Boston's hotel industry, but at the Museum of Fine Arts he is remembered as one of the institution's important early benefactors. Parker, who died on May 31, 1884, left an unconditional bequest of $100,000 to the Museum,[5] a gift that continues to generate funds for the purchase of prints and drawings. Because he never expressed great interest in art during his lifetime, the unsolicited bequest came as a surprise to the Museum's trustees, as well as to Parker's widow, who allegedly was aghast at the meager sum he had allotted to her. A correspondent for the *Art Amateur*, in reporting this generous gift to the Museum, speculated that Parker may have recognized that, in order to draw people to Boston (and to his hotel, of course), the city had to attract travelers not only with commercial advantages but also with mind-enriching and properly endowed cultural institutions.[6]

J.S.R.

Notes

1. John Albee, *Memorial to Henry Dexter* (Boston: privately printed, 1898), p. 68.

2. *Aldine* 7 (Jan. 1874), p. 27, reported: "J.D. Perry, the Boston sculptor, has returned to Rome."

3. Clement and Hutton 1894.

4. "Art and Artists," *Boston Evening Transcript*, Oct. 29, 1878.

5. See remarks on Parker's career and bequests in the *Boston Evening Transcript*, May 31, 1884, obit.; *Boston Advertiser*, June 2, 1884, obit.; ibid., June 5, 1885.

6. Greta, "Boston Correspondence: Gifts to the Museum—The Parker Bequest," *Art Amateur* 11 (Sept. 1884), p. 74.

Frank Duveneck (1848–1919)

Frank Duveneck, like his enthusiastic Boston pro-
moter William Morris Hunt, was a portrait and
landscape painter, known for his innovative teach-
ing and radical subject matter. A leading inter-
preter in the 1870s and 1880s of the Munich
School's bold realism, Duveneck adopted a rich,
dark palette and broad, bravura brushstrokes,
which reminded contemporary critics of the work
of the seventeenth-century Dutch and Spanish mas-
ters Frans Hals and Diego Velázquez.[1] A prolific
painter, he also collaborated with the Cincinnati
sculptor Clement J. Barnhorn (1857-1935) on three
works commissioned by his father-in-law, Francis
Boott: the tomb effigy to his wife, Elizabeth Boott
Duveneck (q.v.); a marble bust of Harvard presi-
dent Charles William Eliot, 1905 (Harvard Univer-
sity); and a life-size, seated bronze figure of the
Concord philosopher Ralph Waldo Emerson, 1905
(Emerson Hall, Harvard University). A fourth
piece, a bust of Elizabeth Duveneck's uncle, the
prominent Boston textile merchant Arthur Theo-
dore Lyman, 1893 (Boston Athenaeum), was proba-
bly done as a family favor.[2] Of these, the tomb
received recognition equal to that of his best can-
vases, prompting Daniel Chester French, in his ca-
pacity as chairman of the Committee on Sculpture
at the Metropolitan Museum of Art, New York, to
wish that Duveneck had done more in this medium.[3]

Born Frank Decker to German immigrants in
Covington, Kentucky, across the Ohio River from
Cincinnati, Duveneck took the surname of his step-
father after his father died. While still in school he
worked as a sign painter, composing his first easel
paintings around age fourteen. In 1862 he began
an apprenticeship, similar to those taken by early
Renaissance artists, with the ecclesiastical decorators
Wilhelm Lamprecht (1838-1901) and Rudolph
Schmidt (1825-1898), learning to paint frescoes,
carve figures, and gild alterpieces for Catholic
churches in both the United States and Canada. At
twenty-one he went to Munich to continue this
training but was drawn to the liberal atmosphere at
the Royal Academy, where Wilhelm Leibl (1844-
1900) and Wilhelm von Diez (1839-1907) stressed
the dark tonalities and contemporary realism of
Gustave Courbet (1819-1877) and Edouard Manet
(1832-1883). Duveneck quickly won friends and
prizes with his warmth, confident manner, and ob-
vious talent, remaining in Munich until 1873, when
cholera broke out.

Forced to return to Cincinnati, Duveneck again

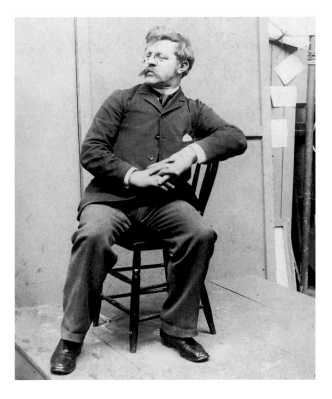

assisted a decorator of church interiors and taught a
class in life drawing and painting for aspiring artists
at the Ohio Mechanics Institute in 1874-1875. In
the spring of 1875 Duveneck achieved a notable
success in his debut at the Boston Art Club and his
summer show at Doll & Richards, where most of his
paintings were sold. Henry James, at that time art
critic for the *Nation*, recorded his "discovery" of
Duveneck's work, proclaiming him an "unsuspected
man of genius" and a "painter of the rigidly natural
school,"[4] an approbation that took note of his lim-
ited color range—all blacks and grays—and his un-
conventional subjects—bohemian painters and
friends he knew in Munich as well as an old man in
ill-fitting clothes.

Although Duveneck received promising offers in
Boston, he returned to Munich in 1876 and began
teaching his own painting classes, sharing a studio
with another midwesterner William Merritt Chase
(1849-1916). In paintings like the *Turkish Page*, 1876
(The Pennsylvania Academy of the Fine Arts, Phila-
delphia), a portrait of a peasant boy with a cocka-
too, he displayed his virtuoso technique, combining
an apparently effortless impasto brushstroke with a
close study of picturesque details.

For the next thirteen years Duveneck remained
in Europe, attracting a loyal band of students, who
became known as the "Duveneck Boys."[5] Summers
were spent in Venice, and in 1880 he made a num-

ber of etchings while James Abbott McNeill Whistler (1834-1903) was there, the two artists' styles often seemingly indistinguishable. Meanwhile, Duveneck's palette began to lighten under the growing influences of French impressionism and Elizabeth Boott. An American-born, Florentine watercolorist and genre painter, Boott had first been attracted to Duveneck in 1875, when she saw his paintings on exhibition in Boston. As his pupil beginning in 1879, and then during their five-year-long courtship, she introduced Duveneck to the more luminous colors of the Italian countryside, while gaining in turn a new freedom of execution in her own work.

On Boott's urging, the couple moved to Florence, where they were married in 1886, despite her father's protestations and her friends' misgivings about Duveneck. The Bootts belonged to a European social milieu that found the midwesterner fascinating but viewed him as an outsider. "His talent is great, though without delicacy," James wrote to a Parisian friend, "but I fear his indolence is greater still."[6] Two years later the Duvenecks, with their infant son, moved to Paris so that he could prepare for the spring Salon. Suddenly in March his wife was dead after a short illness, and his tenuous association with international society was over.

Distraught, Duveneck returned again to Cincinnati and from 1890 to 1892 taught at the Cincinnati Art Museum. In 1891 he began his first effort in sculpture with Barnhorn, the *Tomb Effigy of Elizabeth Boott Duveneck*.[7] Along with intermittent travel in Europe, Duveneck gave classes at the all-male Cincinnati Art Club until he was appointed a painting instructor at the Art Academy in 1900, at the same time Barnhorn began teaching sculpture there. In 1901 Barnhorn became head of the sculpture department, while in 1903 Duveneck was made chairman of the faculty, positions the two artists retained for the rest of their lives. Barnhorn became Duveneck's devoted friend and executed the tomb over his grave in Covington, dedicated in 1925.

Duveneck's paintings were never as bold or as inspired after his wife's death, but his dedication to teaching remained strong. Beginning in 1900 he spent summers in Gloucester, Massachusetts, producing over sixty canvases that are noticeably impressionistic in style. In 1915, for study purposes and with the same generosity that he had always shown his students, Duveneck donated his entire collection of paintings, etchings, and sketches to the

Cincinnati Art Museum, where he had also served as artistic adviser.[8]

P.M.K.

Notes

1. See Henry James, "Notes," *Nation*, June 3, 1875, p. 376.

2. Both the bust of Eliot and the seated figure of Emerson were gifts to Harvard from the Class of 1831 through Francis Boott, whose will provided that his family friend William James, along with the trustees of his estate, had the right to approve the compensation to Duveneck for these sculptures. See letter from Charles C. Jackson and Arthur Lyman, trustees, to the President and Fellows of Harvard University, Dec. 23, 1905, Harvard University Corporation Records. See also H. Wade White, "Nineteenth-Century American Sculpture at Harvard: A Glance at the Collection," *Harvard Library Bulletin* 18 (Oct. 1970), p. 363, pl. viii. For the *Lyman* bust, see Boston Athenaeum 1984, p. 28.

3. See letter from French to Frank Boott Duveneck, the sculptor's son, Apr. 24, 1926, MMA, in which French also called the tomb "a very beautiful and sensitive work of art."

4. James, "Notes," *Nation*, June 3, 1875, p. 376.

5. Among the best known are John White Alexander (1856-1915), Joseph DeCamp (1852-1923), and John H. Twachtman (1853-1902).

6. James to Henrietta Reubell, Mar. 11, 1886, quoted in Henry James, *Henry James: Letters*, vol. 3, *1883-1895*, ed. Leon Edel (Cambridge: Harvard University Press, Belknap Press, 1980), p. 117.

7. Barnhorn had taken Duveneck's life class at the Ohio Mechanics Institute, while studying modeling in night classes at the Cincinnati Art Academy in 1874 under Louis T. Rebisso (1837-1899). After Duveneck returned to Munich in 1875, Barnhorn occasionally traveled and studied with him, and during the five years the sculptor spent at the Académie Julian on a Cincinnati Art Museum scholarship, studying with Denys Puech (1854-1942), Emmanuel Fremiet (1824-1910), and Antonin Mercié (1845-1916), Duveneck often visited him. In 1895 Barnhorn received an honorable mention in the Salon for a reclining nude figure entitled *Magdalen* (Cincinnati Art Museum) and jointly with Duveneck for the tomb effigy. In 1934 the Cincinnati Art Museum held a retrospective of Barnhorn's work and named him honorary curator of sculpture. See Cincinnati Art Museum, Ohio, *Retrospective Exhibition of Sculpture by Clement J. Barnhorn* (1934); Mary L. Alexander, "The Week in Art Circles," *Enquirer* (Cincinnati), Jan. 14, 1934. I wish to thank Margaret Gillham, Intern in American Sculpture, Cincinnati Art Museum, for sharing her research on the Barnhorn-Duveneck relationship.

8. Duveneck had been buying back his canvases for some years prior to 1915 so that this gift represents the range of his work.

References

AAA, SI; BMFA, *A New World: Masterpieces of American Painting 1760-1910* (1983), pp. 296-297; *Boston Evening Transcript*, Mar. 27, 1888, obit. (Elizabeth Boott Duveneck); Chapellier Gallery, New York, *Frank Duveneck*, catalogue by Francis W. Bilodeau (1972); Cincinnati Art Museum, Ohio, *The Golden Age: Cincinnati Painters of the Nineteenth Century Represented in the Cincinnati Art Museum* (1979); idem, *Sculpture Collection of the Cincinnati Art Museum* (1970), pp. 146-147; E.B. Crocker Art Gallery, Sacramento, Calif., *Munich & American Realism in the 19th Century*, essays by Michael Quick and Eberhard Ruhmer, catalogue by Richard V. West (1978); Josephine W. Duveneck, *Frank Duveneck, Painter-Teacher* (San Francisco: Howell, 1970); Leon Edel, *Henry James: A Life* (New York: Harper & Row, 1985); Gardner 1965, pp. 56-57; Norbert Heermann, *Frank Duveneck* (Boston: Houghton Mifflin, 1918); Henry James, *Henry James: Letters*, vol. 3, *1883-1895*, ed. Leon Edel (Cambridge: Harvard University Press, Belknap Press, 1980); MMA; The Metropolitan Museum of Art, New York, *American Painting in The Metropolitan Museum of Art* (1980), vol. 3, pp. 61-63; Rubinstein 1982, pp. 122-123; Anna Seaton-Schmidt, "Frank Duveneck: Artist and Teacher," *Art and Progress* 6 (Sept. 1915), pp. 386-394; Taft 1930, p. 525; Triton Museum of Art, Santa Clara, Calif., *Elizabeth Boott Duveneck: Her Life and Times*, text by Michael P. Vargas (1979); Mahonri Sharp Young, "The Two Worlds of Frank Duveneck," *American Art Journal* 1 (spring 1969), pp. 92-103; idem, "Duveneck and Henry James: A Study in Contrasts," *Apollo* 92 (Sept. 1970), pp. 210-217.

FRANK DUVENECK
CLEMENT J. BARNHORN

64

Tomb Effigy of Elizabeth Boott Duveneck, 1894
Marble
H. 28 in. (71.1 cm.), w. 86 in. (218.4 cm.), d. 39½ in. (100.3 cm.)
Signed (on left side below head): F. Duveneck. 1891.
Gift of Frank Duveneck. 12.62

Provenance: Francis Boott, Cambridge, Mass.; Frank Duveneck, Covington, Ky.
Exhibited: BMFA, "Confident America," Oct. 2-Dec. 2, 1973; BMFA 1979, no. 18.
Versions: *Plaster*: (1) Cincinnati Art Museum, Ohio, bronzed, (2) The Art Institute of Chicago (destroyed), (3) The Pennsylvania Academy of the Fine Arts, Philadelphia (destroyed), (4) San Francisco Art Association (destroyed), (5) School of Fine Arts, University of Nebraska, Lincoln (destroyed). *Bronze*: (1) Allori Cemetery, Florence, Italy, (2) The Metropolitan Museum of Art, New York, gilded

Three years after the death of Elizabeth Otis Lyman Boott Duveneck (1846-1888), Frank Duveneck conceived the idea of creating a memorial to his wife and turned to his friend the Cincinnati sculptor Clement J. Barnhorn for critical advice. Barnhorn gave him space in his Pike Building studio, lent him tools, and before leaving to study in Paris, helped Duveneck prepare the work in plaster (given by Duveneck to the Cincinnati Art Museum in 1895). From this model, a bronze was cast by the Galli Brothers, Florence, in 1892.[1] Placed on her grave in the Campo Santo degli Allori, the American cemetery in Florence, the tomb proved a balm for Elizabeth Duveneck's friends and family and quickly became a popular attraction for visitors to the city.

In 1893 her father, Francis Boott, commissioned Duveneck to make a marble version of the bronze, with the idea of lending this tomb effigy to the Museum of Fine Arts, where Boott and his American friends could easily view it. By September Duveneck had arranged with his former pupil William Couper (1853-1942), a sculptor living in Florence, to have a block of Severezza marble brought to his studio on Via Dante da Castiglione and roughed out by local stonecutters.[2] A year later Duveneck assisted in the finishing of the marble, and in late fall it was shipped to Boston.[3] On January 30, 1895, Boott wrote to Charles G. Loring, the Museum's director, that "Mr. Duveneck's wishes have been carried out fully, & I am sure he will be most pleased & grateful."[4] That spring at the Paris Salon a version, probably the plaster model for the marble, received an honorable mention.[5]

Like a "Knight's Lady in death,"[6] the tomb effigy of Elizabeth Boott Duveneck, with its serene expression and classic features, recalls fourteenth-century Gothic *gisant* (recumbent) figures, who appear to be praying in their sleep.[7] Elizabeth's arms are folded sedately across her chest, and a single palm branch, the Christian symbol for victory over death, is carefully arranged along the length of her body. Her head rests on a wedge-shaped pillow. A shroudlike gown, with deep pleats at the top, falls in soft drapes over the side of the thin mattress and plain slab base.

The Duveneck-Barnhorn treatment of this popular European form is similar to other nineteenth-century French and Italian funerary monuments of solitary figures, which also emphasize a strong horizontalism and sense of repose.[8] Like Harriet Hosmer's earlier marble *Tomb of Judith de Palezieux Fal-*

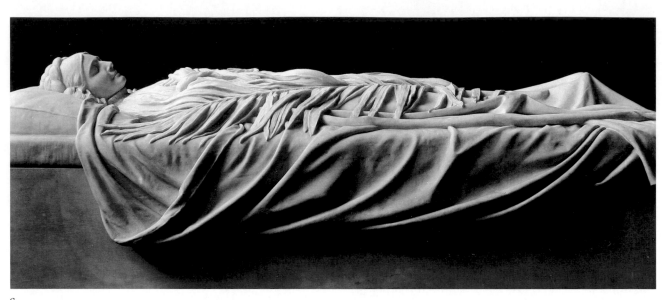

64

connet, 1858 (S. Andrea delle Fratte, Rome), the Duveneck memorial represents a simplified, unadorned design, undoubtedly reflecting Barnhorn's preference for broadly modeled forms over the flickering, impressionistic surfaces favored by his French contemporaries, and is in keeping with Duveneck's own straightforward painterly style.[9]

A talented watercolorist and painter of genre subjects and still life, Elizabeth Boott was born into the rarefied air of Brahminic Boston. Protected as that world might be, it did not ensure the health of her mother, who died of pneumonia when Elizabeth was eighteen months old. Following this, her father, an amateur composer of songs and marches under the pen name Telford,[10] who had long resisted the pressure to conform to Yankee practicality, took his young daughter to Florence and settled into the Villa Castellani above the Arno at Bellosguardo. Elizabeth grew up fluent in French, German, and Italian, comfortable with such expatriate luminaries as Horatio Greenough, William Wetmore Story, Franz Liszt, and the Brownings, and intent on a career in art.

On her return to New England at age nineteen, Elizabeth took drawing classes with William Morris Hunt in Newport and became acquainted with Henry James and his family in Cambridge.[11] In 1875 she saw Duveneck's paintings for the first time at the Boston Art Club and persuaded her father to buy the portrait of William Adams, 1874 (Milwaukee Art Center, Wisconsin). Two years later she sought out Duveneck in Munich in hopes of studying with him. Attracted to his own natural gifts and easy midwestern manner, the Florentine-bred sophisticate pursued him, even talking him into coming to Florence to teach.

In 1881 they became engaged, but it was another five years before they were married, her father's dependency being an obvious deterrent to her betrothal. Meanwhile she contributed regularly to exhibitions at the National Academy of Design, New York, and Doll & Richards, Boston, while arranging her own studio receptions in Florence. In 1884 her one-person show at Doll & Richards received glowing praise from most viewers, who particularly favored her bold colors. Her detractors, on the other hand, were troubled by the lack of finish, a legacy, they thought, of her Hunt-Duveneck training.

A year after Boott and Duveneck were married, their son was born, and for the next year the couple were evidently content.[12] In the winter of 1887 they moved to Paris, where Duveneck prepared for the Salon of 1888 with the portrait of his wife in her wedding dress (Cincinnati Art Museum, Ohio). Ironically, the Bootts' tragic history was now repeated, for in March, within five days after contracting pneumonia, Elizabeth Duveneck was dead. Henry James, whose affection for her had colored his view of Duveneck, wrote sympathetically, if somewhat equivocally, to Francis Boott: "It is essentially true that she had undertaken an effort beyond her strength. . . . I was conscious of this as long ago as during those months in Florence when superficially she seemed so happy and hopeful. The infirmity was visible beneath the optimism. . . . It is no fault of *his*—but simply the stuff he is made of."[13]

Later, James asked Boott to extend his gratitude to Duveneck for executing the memorial. "One

sees, in its place, and its *ambiente*, what a meaning and eloquence the whole thing has—and one is touched to tears by this particular example which comes home to one so—of the jolly great truth that it is *art* alone that triumphs over fate."[14]

At the beginning of 1898 Boott gave permission to the Art Institute of Chicago to have the Museum of Fine Arts reproduce his daughter's tomb in plaster (later destroyed). That spring the tomb was exhibited at the National Sculpture Society in New York, where it moved Lorado Taft to comment: "so exquisite is its sentiment, so worthy its execution that even the plaster cast seemed to convert its surroundings into a memorial chapel."[15]

In 1909, five years after his father-in-law died, Duveneck received the consent of the trustees of the Boott estate to allow the Museum to retain custody of his wife's memorial, and in 1912 he officially gave the tomb.[16] In appreciation of his gift, the Museum sent a plaster version to the 1915 Panama-Pacific International Exposition in San Francisco for a display of works by Duveneck, who was honored there with a commemorative medal.[17]

<div align="right">P.M.K.</div>

Notes

Archival information used in this entry was provided by Kathryn Greenthal.

1. The bronze is signed below her head on the left side: Frank Duveneck 1891 / CINCINNATI O. There is a foundry mark on the right side: FᴸᴸI Galli fusero / 1892 Firenze. On the rose-colored granite base is inscribed: ELIZABETH BOOTT DUVENECK / BORN IN BOSTON U.S. APRIL 13ᵀᴴ A.D. 1846 / DIED IN PARIS MARCH 22ᴰ A.D. 1888. Photographs of the tomb were supplied by Leslie Schwartz, curatorial assistant, Indiana University Art Museum, Bloomington. See BMFA, ADA.

2. Itemized bills from Couper to Duveneck indicate that the block of marble costing 600 francs was paid for on Sept. 2 and brought to Couper's studio on Sept. 5. From Sept. 23, 1893, to Oct. 20, 1894, Couper paid the stone-cutter Elisio to block out and finish the marble, and for work done from May 12 to July 25, 1894, he paid the stone carver Gabriella to cut out the palm leaf. Frank Duveneck Papers, AAA, SI.

3. See the account, possibly apocryphal, by the Boston artist C. Howard Walker (1857-1936) of Duveneck's solitary weekend effort to finish the face and his fear that he had cut the marble too far, in Josephine W. Duveneck, *Frank Duveneck, Painter-Teacher* (San Francisco: Howell, 1970), p. 127.

4. Boott to Loring, Jan. 30, 1895, BMFA, 1876-1900, roll 558, in AAA, SI.

5. Société des artistes français, Paris, *Salon de 1895: Expli-*

cation des ouvrages de peinture, sculpture . . . (Paris: Dupont, 1895), no. 3059. See also letter from Couper to Duveneck, Feb. 25, 1895, Duveneck Papers, informing him that the piece had been sent by slow freight from Florence to Paris. Since there is no bill for another marble, this version is probably the plaster cast presented to the Cincinnati Art Museum by Duveneck in 1895.

6. Leon Edel, *Henry James: A Life* (New York: Harper & Row, 1985), p. 349.

7. See Francis Hamilton, "Contemporary Tomb Figures," *International Studio* 82 (Oct. 1925), pp. 23-27.

8. See, for example, Lorenzo Bartolini's earlier *Tomb of Countess Zamoyska*, 1837 (S. Croce, Florence), and Henri Chapu's more contemporary *Tomb of the Duchesse de Nemours*, about 1880 (Chapel of St. Charles Borromeo, Weybridge, Surrey); BMFA 1979, no. 18. Compare also William Henry Rinehart's *Sleeping Children* (q.v), for a more sentimental treatment of the theme of eternal sleep.

9. For a discussion of nineteenth-century tombs commemorating female subjects, see Barbara S. Groseclose, "Harriet Hosmer's Tomb to Judith Falconnet: Death and the Maiden," *American Art Journal* 12 (spring 1980), pp. 78-79.

10. See *Boston Evening Transcript*, Mar. 1, 1904, obit.

11. The Villa Castellani and Elizabeth's singular upbringing provided James with the setting and the character of the young Pansy Osmond for his novel *Portrait of a Lady* (1880); and the lifelong relationship between Elizabeth and her father inspired that between Maggie and Adam Verver in his later novel *The Golden Bowl* (1904); see Edel, *Henry James: A Life*, pp. 259, 330-331. See also Mahonri Sharp Young's interpretation of James's relations with the Duvenecks and Francis Boott, in "Duveneck and Henry James: A Study in Contrasts," *Apollo* 92 (Sept. 1970), pp. 210-217.

12. As Elizabeth Duveneck wrote to a friend, Dec. 5 [1886], "I have been perfectly well + very active + this no doubt prevents my misgivings about the future. Frank is of a calm agreeable, placid temperament which is very soothing, + my married life so far has been most peaceful + full of happiness + rest." Duveneck Papers.

13. James to Boott, Apr. 3 [1888], quoted in Henry James, *Henry James: Letters*, vol. 3, *1883-1895*, ed. Leon Edel (Cambridge: Harvard University Press, Belknap Press, 1980), p. 232.

14. James to Boott, July 14 [1893], ibid., pp. 417-418.

15. Taft 1930, p. 526.

16. William J.E. Sander, on behalf of the trustees of the Boott estate, affirmed Duveneck's decision in a letter to Benjamin Ives Gilman, secretary of the Museum, Apr. 9, 1909, BMFA, 1876-1900, roll 558, in AAA, SI.

17. In 1917 Frank Duveneck gave the Metropolitan Museum of Art, New York, a plaster version of the tomb. After this was cast in bronze by Gorham Manufacturing Company, Providence, in 1927, the plaster was sent to the School of Fine Arts, University of Nebraska, Lincoln (later destroyed).

Augustus Saint-Gaudens (1848–1907)

Supremely gifted and influential, Augustus Saint-Gaudens was one of America's greatest artists. His talent and ambition helped him direct the course of sculpture during the late 1870s and 1880s away from the waning neoclassical mode toward the Beaux-Arts style that would set the tone for progressive sculptors in this country until the First World War. Almost singlehandedly, he liberated his profession from the lifeless conventions unimaginative minds still embraced. Indeed, Saint-Gaudens broke new ground to such a degree that he raised the medium of bronze to heights previously unexplored in the United States, producing superb monuments that enrich the nation's parks and squares, and achieving a vitality in relief sculpture unrivaled in American art. His genius and dexterity were fundamental to his early success as a cameo-cutter and later served him well in his brilliantly modeled portrait reliefs. This natural ability, coupled with a keen sensitivity and power of invention, brought him commissions in large number at home and, occasionally, abroad. His collaboration with the celebrated architects Henry Hobson Richardson (1838-1886), Charles McKim (1847-1909), and especially Stanford White (1853-1906) gave birth to strikingly original solutions for outdoor monuments and sculpture that decorated public buildings and private residences. At the end of his life, Saint-Gaudens was showered with honors and possessed a reputation of international acclaim.

He was born in Dublin, Ireland, in March 1848 to Bernard Saint-Gaudens, a French bootmaker, and Mary (McGuiness) Saint-Gaudens, an Irishwoman. With the potato famine worsening, the family fled to America when Augustus was about six months old. Upon landing, they stayed briefly in Boston, then settled in New York, where Bernard opened a fancy shoe and boot shop.

As a boy, Saint-Gaudens went to local schools in New York, manifesting artistic rather than academic leanings. His creative impulse found its first expression when, as a child, he made pen drawings of the shoemakers in his father's shop. His interest in becoming an artist led his father to arrange an apprenticeship for him at the age of thirteen with Louis Avet, a French cameo-cutter living in New York. Three years were enough with the tempestuous Avet, whom Saint-Gaudens described as a hard, scolding taskmaster,[1] and one day he walked out the door, following an argument over crumbs he failed to sweep after lunch. Admittedly, Avet had been

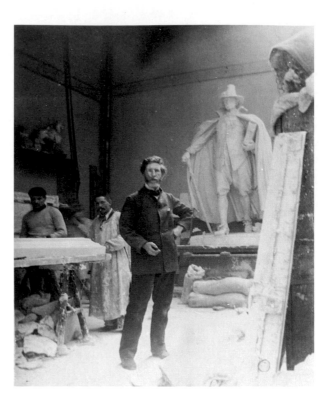

demanding, yet Saint-Gaudens's years with him were productive; they provided him with discipline and skill. *John Tuffs*, about 1861 (private collection)—apparently Saint-Gaudens's earliest extant cameo, created when the sculptor was no more than about thirteen years old—is a telling demonstration of his industry and self-confidence. The portrait shows the subject full-face, probably the most taxing angle to render in a relief. It was most likely done from a photograph (since it was executed for Tuffs's widow a few years after her husband's death), so that the young Saint-Gaudens would have been unable to choose a pose.

Anxious to continue his cameo work, he next gained employment with another French cameo-cutter, Jules Le Brethon. During this period with his second cameo teacher, Saint-Gaudens studied at Cooper Union and at the National Academy of Design to satisfy his desire for a more formal artistic education. His busy schedule of cutting cameos and attending drawing classes only increased his drive to become an artist. In February 1867 he left for Paris, with the professed intention of seeing the Exposition Universelle. Clearly, he made the trip with more in view for, a day or two following his arrival, he sought admission to the Ecole des Beaux-Arts. Saint-Gaudens learned that enrollment there was not just a matter of presenting himself at the

door; a formal application had to be submitted to the American consulate, requiring several months to process (perhaps as a means to weed out the less serious students). Determined to obtain instruction, Saint-Gaudens registered at the Ecole Gratuite de Dessin, known as the Petite Ecole, since a certain number of its students went on to the Ecole des Beaux-Arts each year. Diligent, enterprising, and both in need of money and wishing to stay in Paris as long as he possibly could, he immediately found work with an Italian jeweler named Lupi and put his cameo training to good use. After about six months at the Petite Ecole, where he took classes in sculptural composition and drawing from casts, from life, and from nature, Saint-Gaudens entered the studio of François Jouffroy (1806-1882), one of the three professors of sculpture at the Ecole des Beaux-Arts. Having proved his worth, Saint-Gaudens, on Jouffroy's recommendation, was accepted as a student at the Ecole in March 1868.

Had it not been for the outbreak of the Franco-Prussian War, Saint-Gaudens might have remained in Paris for the rest of his life, so happy was he with his studies, friends, and walking excursions. His mother, however, was deeply concerned for his safety and wanted him to return home. Instead, he decided to pursue his studies and departed Paris for Rome in late 1870. He enrolled in no academy and trained with no professor, but Rome itself was both school and master. Saint-Gaudens quickly set up a studio, which he shared with a fellow student from the Ecole des Beaux-Arts, in the gardens of the Palazzo Barberini.

Shortly thereafter, he began *Hiawatha*, 1872 (private collection), his first full-length statue. With characteristic self-assurance, he vowed it would "astonish the world."[2] Though made independently of any commission, *Hiawatha*, with its brooding and introspective spirit, was more than a mere exercise in fashioning a muscular, three-dimensional figure. Saint-Gaudens hoped it would further his career by attracting a patron who might advance him the funds to have the clay model transferred to plaster and then into marble. Support did come from two men, Montgomery Gibbs and Edwin D. Morgan, and the latter paid to have *Hiawatha* put into marble and became its original owner. These two men, together with William Maxwell Evarts, became ardent patrons of the young sculptor, and it was through their enthusiastic championing that Saint-Gaudens made the important contacts he needed to gain commissions.

To support himself during the early 1870s in Rome, Saint-Gaudens practiced his cameo trade and made copies of classical busts for erudite Americans. He received orders for marble portrait busts that were fundamentally realistic in detail but neoclassical in form. A few of these commissions were obtained during Evarts's sittings for his own portrait in New York, where Saint-Gaudens returned for the year 1872-1873. None of these busts, however, has the nobility of the *William Maxwell Evarts*, 1874 (private collection), which is the sculptor's most forceful characterization among his youthful efforts.

In New York again in 1875, the year he met John La Farge (1835-1910), White, McKim, and probably Richardson, Saint-Gaudens was bent on having a major commission. This was realized in December 1876, when John Quincy Adams Ward declined the offer of the *Farragut Monument*, 1879-1880 (Madison Square Park, New York), in favor of Saint-Gaudens. In the spring of 1877 Saint-Gaudens left for Paris accompanied by his bride, the former Augusta Homer of Boston, and with projects in addition to the *Farragut*: the Saint Thomas Church reredos, 1877 (destroyed), and the King family tomb, 1878 (Island Cemetery, Newport, Rhode Island), both executed in collaboration with La Farge.

Unencumbered by the need to win commissions, Saint-Gaudens was able to unleash his talent during the late 1870s and early 1880s, above all in his bronze portrait reliefs. Inspired by sculptors ranging from the Italian Renaissance masters Pisanello and Donatello to his French contemporary Henri Chapu (1833-1891), Saint-Gaudens created reliefs in which the surface is both subtle and daring, the background is as significant as the foreground, and decorative details such as inscriptions and borders assume a role as important to the composition as the subject. Saint-Gaudens's textures are frequently so alive that the sitter is virtually a means to an end, that is, an excuse for the exploration of the physical potential of the medium of bronze. In *Rodman de Kay Gilder*, 1879 (private collection), for instance, the boy's lower tresses are boldly treated, more as abstract decorative swirls than as hair, and in *Dr. Henry Shiff*, 1880 (Saint-Gaudens National Historic Site, Cornish, New Hampshire), the sitter's beard measures two-thirds the length of the bronze and is shimmering, impressionistic, and dazzling in effect.

Saint-Gaudens's reliefs are often small in scale, but their presumed intention is staggeringly large.

The sculptor appears to have incorporated every branch of the fine arts in his bronze pieces: some are sketches, with painterly touches; others have qualities of a print, with hatch marks as in etchings; while still others have architectural details like entablatures and cornices, which from time to time serve as the frames.

In about 1876 Saint-Gaudens began a collaboration with White that endured for a quarter of a century. The two men shared a special affinity, and besides enjoying professional relations, they had a warm and fun-loving friendship. Their joint enterprises were of enormous variety. White designed frames for Saint-Gaudens's reliefs, such as *Dr. Henry Shiff* and *Bessie Springs Smith* (Mrs. Stanford White), 1884 (The Metropolitan Museum of Art, New York), and pedestals and bases for the *Farragut Monument*; *The Puritan*, 1886 (Merrick Park, Springfield, Massachusetts); *Abraham Lincoln* ("Standing Lincoln") 1887 (Lincoln Park, Chicago); *Adams Memorial*, 1891 (Rock Creek Cemetery, Washington, D.C.). Saint-Gaudens designed sculpture for White's buildings: decoration for the Villard House, 1881-1883 (451 Madison Avenue, New York), with his brother Louis (1854-1913), who was also a sculptor, and *Diana*, 1894 (Philadelphia Museum of Art) for Madison Square Garden, 1891 (demolished in 1925).

The first major collaboration between White and Saint-Gaudens was the *Farragut Monument*. In the over life-size bronze statue of the late admiral, Saint-Gaudens strove to make the commander a heroic figure without overwhelming him with the particulars of the naval uniform. It was Farragut's moral strength, authority, and fortitude that the sculptor wanted to transmit to the viewer. He posed him dramatically and richly modeled the surface in a manner that would become his trademark. Farragut is shown with his eyes gazing out to sea and his coat whipped back by the wind, standing as if on deck. On White's granite pedestal (a copy of the original bluestone base now at the Saint-Gaudens National Historic Site), which the architect treated as an integral part of the whole, are stylized rippling waves, symbolic of the ocean beneath Farragut, surrounding Saint-Gaudens's allegorical figures of the admiral's attributes: Courage and Loyalty. When it was unveiled in New York in 1881, the statue was hailed by critics as the dawn of a new era. It established Saint-Gaudens and the Beaux-Arts style as the dominant forces in American sculpture for the next twenty-five years.

The 1880s and 1890s were decades of feverish activity for Saint-Gaudens, and he could barely keep up with the demand for his work. His studios in New York and in Cornish, New Hampshire—where he had a country estate he called Aspet, for the French Pyrenees town in which his father was born—were filled with assistants, the most promising of them being Frederick W. MacMonnies. The commissions Saint-Gaudens cared most about took the longest to complete, with modifications made in an attempt to refine the piece to perfection. Labor on the *Robert Gould Shaw Memorial*, 1897 (Boston Common), for example, stretched to thirteen years.

Between 1886 and 1893, nearly every year resulted in a sculpture of consequence. In 1887 *The Puritan*, an over life-size bronze statue, was installed in Springfield, Massachusetts; it is the very embodiment of rectitude and moral conviction. Saint Gaudens's "Standing Lincoln," also a heroic-size bronze, was unveiled in Chicago in 1887; as resolved and expansive as Deacon Chapin appears in *The Puritan*, Abraham Lincoln is represented deep in thought, quiet, and self-contained. White's exedra for the statue was a masterly stroke—an audience chamber in which the visitor can sit and sense he is about to hear Lincoln's speech. In 1887 Saint-Gaudens had the opportunity to model Robert Louis Stevenson's portrait, and in 1888 he created several splendid bronze portraits: a bust of General William Tecumseh Sherman and a relief of Mrs. Schuyler Van Rensselaer (both in the Metropolitan Museum of Art) and reliefs of William Merritt Chase (American Academy and Institute of Arts and Letters, New York) and Louise Miller Howland (private collection).

The *Adams Memorial* was Saint-Gaudens's ode to the ultimate mysteries: life and death. It was commissioned by the historian Henry Adams in 1886 to commemorate his wife, the former Marian Hooper, who had died by her own hand the previous year. Whatever torment she endured and whatever turmoil her husband suffered seemed to find a resolution in the bronze figure radiating solace and peace. From the shrouded figure in the *Adams Memorial*, Saint-Gaudens turned his attention to an utterly different allegorical type: the completely nude *Diana*, all elegance and grace, thirteen feet high, and made in gilded sheet copper as a weather vane for White's pleasure house, Madison Square Garden.

The *Shaw Memorial*, considered by many to be Saint-Gaudens's masterpiece, is the work in which the sculptor accomplished everything an artist hopes to achieve: inventiveness of design, brilliant technique, and universal emotive power. A bronze Civil War monument in high relief, with an archi-

tectural framework (in marble on a granite base) designed by McKim, it honors Robert Gould Shaw and his black volunteer regiment, the Fifty-fourth Massachusetts Volunteer Infantry. These Union soldiers fell in disastrous numbers in an assault on Fort Wagner in South Carolina in the summer of 1863. Originally, the Boston Brahmin William Wetmore Story had been approached to make an equestrian statue of Colonel Shaw, and although he produced sketches and a model, the statue advanced no further. After Saint-Gaudens received the commission, the more he worked on it, the more it absorbed him. At one point the Shaw committee, exasperated by Saint-Gaudens's delays, considered replacing him with the reliable Daniel Chester French, the patrician Yankee sculptor. Saint-Gaudens's sensibilities could not have been more alien from those of the well-born Story or French, and in this may lie the heart of the moving statement that is the *Shaw Memorial*. It would have to have been Saint-Gaudens, the Irish-Catholic immigrant, whose exquisite being could understand the plight of the black, whose deftness as a modeler could individualize his portrait, and whose imagination and soul could tell his story with an unmatched empathic and spiritual bond.[3] Most of all, Saint-Gaudens, so profoundly stirred by the event he commemorated and its timeless application, brings forth feelings that refer not simply to Shaw and his men but also to endless lines of young men marching off to countless wars.

For a change of pace, Saint-Gaudens traveled in late 1897 to Paris, where he stayed for nearly three years. There he prepared his final major public sculpture, the *Sherman Monument*, 1903 (Grand Army Plaza, New York), a bronze equestrian group of General William Tecumseh Sherman led by a figure of Victory. It was the climax of an extraordinarily distinguished career. Every element—wing, drapery, cloak, and tail—is perfectly conjoined to highlight the drama of the subject. Curiously, Sherman, like Shaw, though in command, seems passive, as if carried forward almost in spite of himself by destiny.

In 1900 Saint-Gaudens became ill, and it was discovered that he had cancer. He made Aspet his year-round home, and his last works, with the exception of the very beautiful *Stevenson Memorial*, 1902 (Saint Giles' Cathedral, Edinburgh), and the magnificent ten- and twenty-dollar gold coins, were of lesser quality, not the least because they were executed to a large extent by his assistants.

Saint-Gaudens's charm was irresistible, and his many acquaintances—painters William Merritt Chase (1849-1916) and John Singer Sargent (1856-1925), writers Robert Louis Stevenson and William Dean Howells, and statesmen John Hay and Theodore Roosevelt—counted themselves fortunate to have his witty and endearing companionship. Moody and temperamental as he could be at times, Saint-Gaudens was generous with younger sculptors and affectionate with friends, and he was cherished by those who knew him.

K.G.

Notes

1. Saint-Gaudens 1913, vol. 1, pp. 38-39.
2. Ibid., p. 108.
3. Kathryn Greenthal, "An Exhibition of Saint-Gaudens's Work," *Antiques* 129 (Nov. 1985), pp. 977-978.

References

David M. Armstrong, *Day before Yesterday: Reminiscences of a Varied Life* (New York: Scribner's, 1920); John W. Bond, "Augustus Saint-Gaudens: The Man and His Art," Office of Archaeology and Historic Preservation, National Park Service, Washington, D.C., 1968; *Boston Evening Transcript*, Aug. 5, 1907, obit.; *Boston Globe*, Aug. 4, 1907, obit.; Margaret Bouton, "The Early Works of Augustus Saint-Gaudens," Ph.D. diss., Radcliffe College, 1946; BPL; Caffin 1903, pp. 1-17; Royal Cortissoz, *Augustus Saint-Gaudens* (Boston: Houghton Mifflin, 1907); Craven 1968, pp. 373-392; Saint-Gaudens Papers, Baker Library, Dartmouth College, Hanover, N.H.; Dryfhout 1982; John H. Dryfhout, "Augustus Saint-Gaudens," "Robert Louis Stevenson," and "Diana," in Jeanne L. Wasserman, ed., *Metamorphoses in Nineteenth-Century Sculpture* (Cambridge, Mass.: Fogg Art Museum, 1975), pp. 180-217; Gardner 1965, pp. 45-56; Kathryn Greenthal, *Augustus Saint-Gaudens, Master Sculptor* (New York: The Metropolitan Museum of Art, 1985); C. Lewis Hind, *Augustus Saint-Gaudens* (New York: International Studio, John Lane, 1908); Lincoln Kirstein, *Lay This Laurel* (New York: Eakins, 1973); Will H. Low, *A Chronicle of Friendships, 1837-1900* (New York: Scribner's, 1908); McSpadden 1924, pp. 29-70; Lois G. Marcus, "Studies in Nineteenth-Century American Sculpture: Augustus Saint-Gaudens (1848-1907)," Ph.D. diss., The City University of New York, 1979; MMA; National Portrait Gallery, Washington, D.C., *Augustus Saint-Gaudens: The Portrait Reliefs*, catalogue by John H. Dryfhout and Beverly Cox (1969); *New York Times*, Aug. 5, 1907, obit.; NYPL; Proske 1968, pp. 7-11; Saint-Gaudens 1913; Taft 1930, pp. 279-309, 539, 542, 551-552, 556-557, 568, 576; Louise Hall Tharp, *Saint-Gaudens and the Gilded Age* (Boston: Little, Brown, 1969); Whitney 1976, pp. 47, 50-53, 62-66, 114-117, 120, 136-137, 306-307.

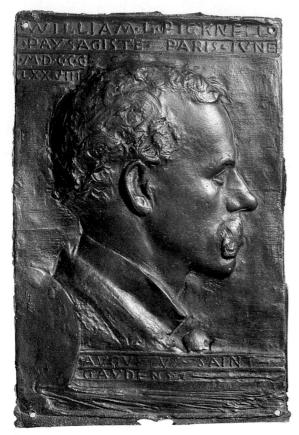

65

AUGUSTUS SAINT-GAUDENS
65
William L. Picknell, 1878
Bronze, red-brown patina, sand cast
H. 7⅝ in. (19.4 cm.), w. 5 in. (12.7 cm.)
Signed: (at bottom) ·AVGVSTVS·SAINT- / GAVDENS
Inscribed: (at top)·WILLIAM·L·PICKNELL /
·PAYSAGISTE·PARIS·IVNE / ·M·D·C·C·C· / LXXVIII
Gift of George W. Picknell. 36.156

Provenance: William L. Picknell; George W. Picknell, Watertown, Mass.
Exhibited: BMFA, *Catalogue of the Fourth Annual Exhibition of Contemporary American Art* (1883), no. 235; BMFA, *Catalogue of Paintings by William L. Picknell* (1898), p. 13; Saint-Gaudens Memorial (later Saint-Gaudens National Historic Site), Cornish, N.H., annual loan, 1946-1970.
Versions: *Plaster*: (1) Saint-Gaudens National Historic Site. *Bronze*: (1) private collection, New York, (2) Saint-Gaudens National Historic Site

William Lamb Picknell (1853-1897) was a landscape painter whose most accomplished works are characterized by a crisp delineation of form, dazzling color effects, and, as the critic William Howe Downes wrote, "an invigorating atmosphere . . . of fresh air and strong sunlight."[1] His career, which was cut short by his premature death, lasted only about twenty years, but in that time he had earned enough of a reputation to be viewed as "one of the brightest lights of the American school of landscape painting."[2]

Born in Hinesburg, Vermont, Picknell was the son of William Lamb Picknell and Ellen Maria (Upham) Picknell. He lived in North Springfield, Vermont, from 1857 until 1867, when his father, a Baptist minister, died. After spending several years in the custody of guardians in Boston, Picknell departed for Europe in the early 1870s to obtain training that would satisfy his growing wish to become an artist. He studied first with the landscape painter George Inness (1825-1894) in Rome for two years and then moved to Paris where he received instruction for two more years in the class of Jean Léon Gérôme (1824-1904) at the Ecole des Beaux-Arts.

Although his training was essentially complete, Picknell decided to remain abroad, despite the urging of friends at home, since he felt he could learn more in France than in New England. Thus, in 1876 he relocated to the fishing village of Pont-Aven in Brittany, where he came under the influence of the Anglo-American painter Robert Wylie (1839-1877) from whom he absorbed a number of painting techniques. In the same year Picknell began exhibiting his pictures at the Paris Salon, and in 1880 he won an honorable mention for *The Road to Concarneau*, 1880 (Corcoran Gallery of Art, Washington, D.C.).

Feeling the need for a change of scenery, Picknell passed two winters in England in the mid-1880s before returning to New England. During the late 1880s he painted chiefly in Annisquam and Coffin's Bay, Massachusetts, in the summer months. In the winter he traveled to warm climates so that he could work out-of-doors: he usually selected the Mediterranean, but one season he went to Florida, and another he painted in California. In 1889 he married Gertrude Powers and settled in France the following year. There, too, he divided the year between two locations, in the summer painting in Moret-sur-Loing near Fontainebleau, where he created canvases such as *Banks of the Loing*, 1897 or before (The Metropolitan Museum of Art, New York), and in the winter heading south to Antibes. His health declined after his visit to California, and it worsened following the death of his only child in Antibes in 1897. Determined to visit friends and relatives again in New England, he sailed for the

United States in July of that year. He died of heart disease a few weeks later, on August 8, in Marblehead, Massachusetts.

Saint-Gaudens and Picknell became acquainted in Europe, presumably in Paris, after the sculptor had returned there in June 1877 to execute a number of commissions, the most important of which was the statue of Admiral David Glasgow Farragut. Contemporaries who shared the same enthusiasm about living and practicing their art in France, Saint-Gaudens and Picknell formed a friendship of mutual admiration and affection. Twenty years later, their bond was still strong. Picknell wrote what must have been one of his last letters to Saint-Gaudens on August 2, 1897. Addressing the sculptor as "Dear Master & Dear Friend," he spoke of having just seen the *Shaw Memorial* (which had been unveiled May 31 on Boston Common) and was moved to write in praise of it.[3] Further evidence of their rapport is found in a letter from Picknell's widow to Saint-Gaudens acknowledging his condolences: "Thank you for your kind letter, with its message of *love for him who is gone*. . . . You know how dearly he loved and prized his friends, and that you were not only one of the most cherished, but the most warmly admired as America's greatest artist, and one of the pleasantest memories I have of him is as he stood before the Shaw Monument, thrilled through and through by the beauty and grandeur of his friend's work."[4]

The Museum's relief of Picknell is part of a splendid series of intimate relief portraits that Saint-Gaudens made of his artist friends when he was in his early thirties. He created them either as gifts or in exchange for a work of art by the sitter. Inspired in part by the French sculptor Henri Chapu's reliefs of his artist friends, Saint-Gaudens produced nine reliefs of this type between June 1877 and July 1880, during his second stay in Paris. All were of painters except for the portrait of the architect Charles F. McKim, 1878 (The New York Public Library).

The inscription on the *Picknell* states that the portrait was fashioned in Paris in June 1878. It is the fourth relief in the series, and as in the earlier three—*David Maitland Armstrong*, 1877 (Maitland A. Edey, New York), *William Gedney Bunce*, 1877 (Wadsworth Atheneum, Hartford, Connecticut), and *George Willoughby Maynard*, 1877 (The Century Association, New York)—the sitter is represented in profile. In the four reliefs, the figure's head, neck, tie knot, and shirt and coat collars are shown with the emphasis quite naturally placed on the individual's head. Also, in these four reliefs—as in virtually all the reliefs Saint-Gaudens made throughout his career—the inscription, given in Roman capital letters, is an important descriptive and decorative element. In the *Picknell*, as in the *Bunce, Andrew Fisher Bunner*, 1878 (Saint-Gaudens National Historic Site, Cornish, New Hampshire), *McKim*, and some reliefs of nonartists dating from this period, the inscription and signature are separated by fillets, with the upper inscription tightly compressed in the space around the sitter's head. Often in these portraits Saint-Gaudens would record an attribute of the subject. Palette and brushes are introduced in the *Picknell*, as they are in the *Armstrong, Francis Davis Millet* (q.v.), and *Jules Bastien-Lepage* (q.v.), though in the last one on a much grander scale. In the *Picknell*, however, they are used less like symbols of the sitter's occupation than like abstract ornaments that make the composition more complex, with the curve of the palette providing a pleasing repetition of the shape of Picknell's forehead.[5]

Perhaps not as richly textured as some of the other reliefs from these years, the *Picknell* nevertheless contains superb passages, such as the contrast between the smooth handling of the flesh and the lively rendering of the hair. A fascinating feature that the Museum's cast of the *Picknell* and the New York Public Library's *McKim* share is the uneven edge of the bronze, which the sculptor chose to leave in a rough state after its casting. Saint-Gaudens was deeply interested in the resulting irregular border, which he continued to explore in various degrees in other reliefs during this brilliant early phase of his career.

The *Picknell* came into the Museum's collection in March 1936 as a gift from the sitter's brother George W. Picknell (1864-1943), also a painter. Edwin J. Hipkiss, curator of decorative arts, had called on George Picknell in October 1935 to examine the relief. In reporting to George H. Edgell, director of the Museum, Hipkiss said, "as one of St. Gaudens' [*sic*] early portraits of a confrère in Paris it seems to have been done with a combined sensitiveness and vigor that interests me very much."[6] Edgell then wrote to Picknell, having understood that he had contemplated giving the relief to the Museum, and advised him that the Museum would be more than delighted to have it.[7]

<div align="right">K.G.</div>

Notes

1. *DAB*, s.v. Picknell, William L. For information about Picknell, see also Edward Waldo Emerson, "Foreword," in BMFA, *Catalogue of Paintings by William L. Picknell* (1898), pp. 5-10; idem, "An American Landscape-Painter: William Picknell," *Century Illustrated Magazine*, n.s. 40 (Sept. 1901), pp. 710-713; The Metropolitan Museum of Art, New York, *American Paintings in the Metropolitan Museum of Art*, vol. 3, catalogue by Doreen Bolger Burke (1980), pp. 145-146.

2. "Memorial Exhibition of Picknell's Pictures at the Museum of Fine Arts, "*Boston Transcript*, Feb. 12, 1898, p. 13.

3. William Picknell to Augustus Saint-Gaudens, Aug. 2, 1897, Saint-Gaudens Papers, Baker Library, Dartmouth College, Hanover, N.H.

4. Gertrude Picknell to Saint-Gaudens, Aug. 19, 1897, Saint-Gaudens Papers.

5. Margaret Bouton, "The Early Works of Augustus Saint-Gaudens," Ph.D. diss., Radcliffe College, 1946, p. 316. Bouton found the *Picknell* to be one of Saint-Gaudens's least satisfactory reliefs. For a further discussion of the bronze, see the entry, pp. 314-316.

6. Hipkiss to Edgell, Oct. 30, 1935, BMFA, 1901-1954, roll 2476, in AAA, SI.

7. Edgell to Picknell, Oct. 31, 1935, BMFA, 1901-1954, roll 2476, in AAA, SI.

AUGUSTUS SAINT-GAUDENS
66
Francis Davis Millet, 1879
Bronze, dark brown patina, sand cast
H. 10⅝ in. (27 cm.), w. 6¹¹⁄₁₆ in. (17 cm.)
Signed (top): AVGVSTVS·SAINT-GAVDENS·FECIT·
Inscribed (bottom):·FRANCIS·DAVIS·MILLET· / AETAT[I]S·SV[A]E·XXXII ·:·PARIS· / MARCH·M·D·C·C·LXX· / IX:·
Gift of Sylvester Baxter. 21.2188

Provenance: G. Sylvester Baxter, Malden, Mass.
Exhibited: Lyman Allyn Museum, New London, Conn., *A Catalogue of Work in Many Media by Men of the Tile Club: Thirteenth Anniversary Exhibition* (1945), no. 137; BMFA, "Back Bay Boston: The City as a Work of Art," Nov. 1, 1969-Jan. 11, 1970.
Versions: *Bronze*: (1) American Academy and Institute of Arts and Letters, New York, (2) Douglas Berman, New York, (3) Brigham Young University Art Museum Collection, Salt Lake City, Utah, (4) Mattapoisett Historical Society, Mass., (5) The Metropolitan Museum of Art, New York, (6) Museum of Art, Carnegie Institute, Pittsburgh, Pa., (7) Museum of Fine Arts, Boston, apparatus, (8) National Academy of Design, New York, (9) present location unknown, formerly Cosmos Club, Washington, D.C., (10-12) private collections, Boston, Lenox, Mass., New York, (13) Saint-Gaudens National Historic Site,

Cornish, N.H. *Electrotype*: (1) principally copper, National Museum of American Art, Washington, D.C., (2) iron, present location unknown

Francis Davis Millet (1846-1912), known to his friends as Frank, was chiefly an easel painter, muralist, and illustrator, although he also achieved recognition as an author and war correspondent. His most popular works, especially in the 1880s and 1890s, were his genre paintings, which depict classical subjects as well as historical scenes in American and English locales. In these period pieces Millet meticulously researched the particular epoch at hand in order to render the costumes and settings in an accurate manner. His efforts as a muralist were notably realized in 1892 when he directed the planning and painting of the decorations for the World's Columbian Exposition in Chicago, 1893, and executed several murals himself for the fair buildings. In these murals and in later ones, as in his genre paintings, he selected classical themes and events in American history for representation.

Born in Mattapoisett, Massachusetts, Millet was the son of Dr. Asa Millet and Huldah A. (Byram) Millet. He was raised in East Bridgewater, Massachusetts, and graduated from Harvard University in 1869. Between 1869 and 1871 Millet reported for the *Boston Daily Advertiser*, became a local editor for the *Boston Courier*, and studied lithography with the Belgian publisher and lithographer Dominique C. Fabronius. In 1871 Millet departed for Europe where he dwelt for four years, first studying for two years at the Royal Academy in Antwerp, next passing several months in Vienna, then traveling in Hungary, Turkey, and Greece, and finally spending nearly two years in Italy.

In the summer of 1875 Millet returned to the United States, where he continued his dual activities of painting (portraits and work on John La Farge's murals in Trinity Church, Boston) and reporting (coverage for the *Boston Advertiser* of the Centennial Exposition in Philadelphia in 1876).

During the late 1870s and early 1880s Millet was a tireless globetrotter. Early in 1877 he left America for Europe again, where he briefly visited Belgium before settling in Paris. No sooner had Millet established a residence in Paris than he was sent by the *New York Herald* to cover the Russo-Turkish war. His marriage to Elizabeth Greeley Merrill in Paris in 1879 in no way altered his frequent sojourns, and after a honeymoon in London, they were off to America where they lived in Boston and in New York for three years. With artist friends Millet pro-

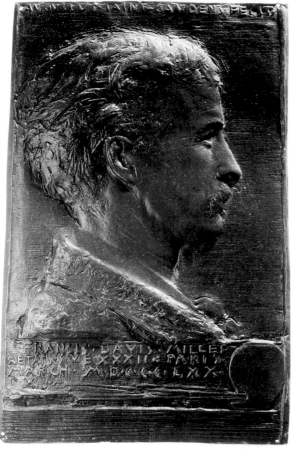

66

ceeded to tour Germany, Denmark, and Sweden, and in 1884 he passed some time in Broadway, Worcestershire, England. Smitten by Broadway's charm, Millet leased a house and studio as a base from which he traveled to New York to spend winters and to various assignments such as, in 1898 and in 1908, the Far East.

In addition to being a busy artist and writer, Millet was an extremely active and sought-after member of numerous arts organizations throughout his career. As early as 1878 he served on the fine arts jury at the Exposition Universelle in Paris, and twelve years later, in a much broader capacity, he helped organize and superintend the American section at the Exposition Universelle in 1900. His full schedule increased in the ensuing years. Indeed, the "story of his life is truly bewildering in its extent, variety, travels, achievements, associations, honors, and distinctions—a career which would enrich even a score of lives."[1] Millet's end came tragically: he went down on the *Titanic* in April 1912 as he sailed to New York from Italy, where he had been on urgent business in the service of the Ameri-

can Academy in Rome, one of the many institutions dear to his heart.

Saint-Gaudens and Millet probably met in Rome during the winter of 1873-1874, when both men were residing there. They certainly were acquainted by 1874, when they corresponded, Saint-Gaudens writing from Rome, discussing in one letter—among other topics—their painter friend William Gedney Bunce (1840-1916). Saint-Gaudens also mentioned having "dropped all the Americans" and being with "the Frenchmen" once more. "I'm already feeling the benefit of it," he wrote.[2] During the 1870s Saint-Gaudens and Millet had occasion to see each other in the various cities in which they were living and working. Late in 1876, for instance, they were in Boston, assisting John La Farge with the decorations of Trinity Church. The next year Millet and the newly married Saint-Gaudens moved to Paris, where they put down roots for a few years. Like William L. Picknell and John Singer Sargent, whom Saint-Gaudens portrayed in 1878 and 1880, respectively, Millet was equally at home in the United States and abroad. This cosmopolitanism, which Saint-Gaudens shared, seems to have been a product of the men's self-image as artists as well as a reflection of their youthful outlook—that the whole world was theirs for the taking.

Saint-Gaudens's portrait of Millet (of which the Museum's cast is one of about a dozen)[3] was created in Paris in March 1879 as a gift to the sitter. Similarly, other relief portraits of the late 1870s were fashioned as tokens for friends. Since Saint-Gaudens and the writer Samuel Clemens (Mark Twain) were witnesses to Millet's marriage on March 11, 1879, the relief is reputed to have been a wedding present.[4] Such a gesture appears to have been the first of its kind, since Saint-Gaudens subsequently made the reliefs of *Bessie Springs Smith* (Mrs. Stanford White), 1884 (The Metropolitan Museum of Art, New York), and *Mary Gertrude Mead* (Mrs. Edwin Austin Abbey), 1890 (Yale University Art Gallery, New Haven) as wedding gifts.

The *Millet* is the seventh portrait in the innovative series of reliefs of artist friends, including the relief of the architect Charles F. McKim (The New York Public Library), that Saint-Gaudens executed between 1877 and late 1880. In the *Millet*, as in the earlier bronzes, the sitter is shown in profile with head, neck, tie knot, and shirt and coat collars represented. Here, too, the inscription and signature are recorded in Roman capital letters. In contrast to the *Picknell* (q.v.), the inscription is not separated by

fillets, although it is "framed" or placed within a separate section. Differing also from the *Picknell* is Saint-Gaudens's signature, which is situated high enough above Millet's head to leave space in between for the background; in fact, the signature might be understood as part of the background. Palette and brushes are introduced in the *Millet* as attributes of the sitter's occupation as they are in *David Maitland Armstrong*, 1877 (Maitland A. Edey, New York), *Picknell*, and *Jules Bastien-Lepage* (q.v.). Perhaps as a device to echo the horizontal quality of the brushes, Saint-Gaudens cut deep striations beneath them.

In designing the portrait, Saint-Gaudens placed Millet's head slightly off center so that the hair touches the left edge of the relief. To counteract a possible sense of crowding and to give balance to the composition, the sculptor incised to great effect the outline of the sitter's forehead, nose, chin, and neck. This incised line can be seen in Millet's mustache and hair, the handling of which bears no resemblance to the thick clumplike treatment of the same features in the *Picknell*. The strokes in the hair and across the background are akin to lines in a print and are rendered in a fashion that Saint-Gaudens had used in the *Charles F. McKim* and that foretells similar results in some of his later reliefs: for example, *Rodman Gilder*, 1879 (private collection), and *Samuel Gray Ward*, 1881 (Erving and Joyce Wolf).

Saint-Gaudens was sufficiently pleased with the *Millet* to enter it (not necessarily the Museum's cast), along with four other reliefs and a plaster cast of the statue of Admiral Farragut, in the Paris Salon of 1880, where he won an honorable mention. He exhibited the *Millet* relief in a display of works by living American artists, held at the Museum of Fine Arts from November 9 to December 20, 1880, and was anxious to have the Museum purchase it at that time.[5] The Museum decided to acquire only the relief of Bastien-Lepage (q.v.), which had been shown in the same exhibition. In 1921 Sylvester Baxter (1850-1927), a writer, publicist, and brother-in-law of Millet (having married the painter's sister, Lucia Allen Millet in 1893), gave this cast of the *Millet* relief to the Museum. In Baxter's appreciation of Millet, written shortly after his death, he had commented on some of the character traits that Saint-Gaudens seems to have touched on in the portrait: "Frank Millet was companionable, lovable, quick-witted and congenial, scholarly, uncommonly talented, capable of doing extraordinarily well al-

most anything he chose to put his hands to. . . . So it was that in his open and above-board way he gained the confidence of many men standing high in the world, and was enabled to do many things of the sort best worth doing."[6]

K.G.

Notes

1. Spoken by Augustus Everett Willson at the class meeting, Commencement Day, 1912, and published in the Harvard College, Class of 1869, *Fiftieth Anniversary Report* (1919), p. 188. For more information about Millet, see *DAB*; Sylvester Baxter, "Francis Davis Millet: An Appreciation of the Man," *Art and Progress* 3 (July 1912), pp. 634-655; H. Barbara Weinberg, "The Career of Francis Davis Millet," *Archives of American Art Journal* 17 (1977), pp. 2-18; The Metropolitan Museum of Art, New York, *American Paintings in the Metropolitan Museum of Art*, vol. 3, catalogue by Doreen Bolger Burke (1980), pp. 3-5.

2. Letter from Saint-Gaudens to Millet, Aug. 7, 1874, miscellaneous manuscripts, roll 3161, in AAA, SI.

3. As early as 1881 Saint-Gaudens was intrigued by various methods of producing sculpture and had electrotypes of iron made of the *Millet* and *Jules Bastien-Lepage*. See Michael Edward Shapiro, "The Development of American Bronze Foundries," Ph.D. diss., Harvard University, 1980, pp. 151-154; idem, *Bronze Casting and American Sculpture 1850-1900* (Newark: University of Delaware Press, 1985), pp. 98-101, 188, n. 62. According to Shapiro, these are the first American sculptures known to have been reproduced by electrotyping.

4. Baxter, "Francis Davis Millet," p. 638.

5. Letter from Saint-Gaudens to Charles G. Loring, Dec. 18, 1880, BMFA, 1876-1900, roll 549, in AAA, SI.

6. Baxter, "Francis Davis Millet," pp. 635-636.

AUGUSTUS SAINT-GAUDENS
67 (color plate)
Jules Bastien-Lepage, 1880
Bronze, dark brown patina, sand cast
H. 14⁹⁄₁₆ in. (37.1 cm.), w. 10⁵⁄₁₆ in. (26.2 cm.)
Signed and inscribed: (at top) IVLES·BASTIEN·LEPAGE·AETATIS·XXXI·PARIS·MD·C·C·LXXX·AVGVSTVS·LOVIS / SAINT·GAVDENS·FECIT· (below figure) VERITE
Everett Fund. 81.39

Exhibited: Société des artistes français, Paris, *Salon de 1880: Explication des ouvrages de peinture, sculpture, . . .* (Paris: Imprimerie Nationale, 1880), no. 6662; BMFA, *First Annual Exhibition of Works by Living American Artists* (1880), no. 4; Society of American Artists, New York, *Fourth Annual Exhibition* (1881), no. 135; BMFA *Catalogue of Works of Art Exhibited on the Second Floor*, pt. 2, *Paintings, Drawings, Engravings, and Decorative Art* (1886), sculpture sec-

tion, no. 1; BMFA, *Renaissance and Modern Bronzes* (1908),
no. 208; Saint-Gaudens Memorial (later Saint-Gaudens
National Historic Site), Cornish, N.H., annual loan, 1946-
1970; National Portrait Gallery, Washington, D.C., *The
Portrait Reliefs* (1969), no. 18; The Metropolitan Museum
of Art, New York, *Augustus Saint-Gaudens, Master Sculptor*
(1985), p. 173.

Versions: *Plaster*: (1) Musée Historique Lorrain, Nancy,
(2) National Academy of Design, New York, (3) private
collection, Washington, D.C., (4) Saint-Gaudens National
Historic Site. *Bronze*: (1) The Art Institute of Chicago,[1] (2)
The Art Museum, Princeton University, N.J., (3) The
Brooklyn Museum, (4) The Century Association, New
York, (5) Corcoran Gallery of Art, Washington, D.C., (6)
David Daniels, New York, (7) Indianapolis Museum of
Art, Ind., (8) Mead Art Museum, Amherst College, Mass.,
(9) The Metropolitan Museum of Art, (10) Musée
d'Orsay, Paris, (11) present location unknown, formerly
Christopher Gibbs, London, (12-18) private collections:
Cambridge, Mass., Chicago, Cornish, N.H., Los Angeles,
Calif., Manchester, Mass., R.I., New York, (19) The R.W.
Norton Art Gallery, Shreveport, La., (20) Saint-Gaudens
National Historic Site, (21) The Saint Louis Art Museum,
Mo.; reduction, h. 6⅝ in., w. 4½ in.: (22) The American
Numismatic Society, New York, (23) Saint-Gaudens Na-
tional Historic Site. *Electrotype*: iron, h. 14⁹⁄₁₆ in.: (1) The
Detroit Institute of Arts, (2) Saint-Gaudens National His-
toric Site; reduction, h. 6⅝ in.: (3, 4) Musée d'Orsay

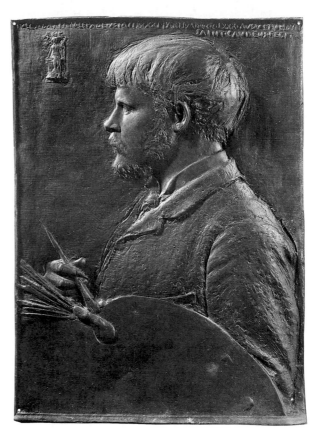

Jules Bastien-Lepage (1848-1884) was a French re-
alist painter best remembered for *Joan of Arc*, 1879
(The Metropolitan Museum of Art, New York).
The son of Claude and Marie-Adèle (Lepage) Bas-
tien, peasants of comfortable means, Jules was born
in the village of Damvillers (Meuse), in northeastern
France. Although his parents supported his youth-
ful efforts in drawing, they envisioned a future for
him as a civil servant. Bastien, however, was deter-
mined to become an artist. He satisfied both wishes
at first, working briefly as a postal clerk in Paris at
night and studying during the day at the Ecole des
Beaux-Arts. In 1868 he entered the atelier of Alex-
andre Cabanel (1823-1889) as a full-time student,
which brought his tenure as a bureaucrat to an end.
His painting career was of short duration, lasting
only from about 1870 until his early death in 1884.
Bastien profoundly admired Edouard Manet (1832-
1883) and the impressionist painters, but he drew
his chief inspiration from Jean François Millet
(1814-1875) and Gustave Courbet (1832-1883),
choosing scenes principally from peasant life as his
subject matter. He also executed numerous por-
traits, which, when exhibited, caused less contro-
versy among the critics than did his peasant
subjects.[2]

67

Like the *Picknell* (q.v.), *Millet* (q.v.), and *Sargent* (q.v.), *Bastien-Lepage* belongs to Saint-Gaudens's ground-breaking series of portraits of artist friends. The sculptor recalled how the portrait of Bastien, created in Paris early in 1880, came about: "Through a mutual friend I met Bastien-Lepage, who was in the height of the renown he had achieved by his painting of Joan of Arc. . . . Lepage was short, bullet-headed, athletic and in comparison with the majority of my friends, dandified in dress. I recall his having been at the Beaux Arts during the period I studied there, and my disliking him for this general cockiness. He asked if I would make a medallion of him in exchange for a portrait of myself. Of course I agreed to the proposal, and as his studio was not far from mine, the medallion was modeled during a period when he was unable to work on account of a sprained ankle. He moved away shortly afterward, and I saw little of him except for the four hours a day when I posed for the full-length sketch he made of me. This painting was destroyed in the fire which burned my studio in 1904."[3]

In comparison with the other portraits of his artist friends, Saint-Gaudens's relief of Bastien is more ambitious in composition, now representing the sitter in half-length instead of in bust form. According to Saint-Gaudens's son, Homer, none of the reliefs that his father modeled during the early part of his career satisfied him as much as that of Bastien-Lepage, "both because he believed the relief was as near perfection as he ever came, and because he was greatly interested in a rare combination of talent and vanity in his sitter."[4] Originally Saint-Gaudens envisioned a profile portrait cut off at midshoulder, as is evidenced by a plaster sketch (9⁹⁄₁₆ by 9⅛ in.) that has recently come to light (private collection). Ultimately, the scale and scope were enlarged and incorporated portions of the sitter's hands and attributes of his profession. The painter frequently asked that his hands not be drawn too large, since he felt that they were of small importance in comparison with the rest of the figure.[5] Despite Saint-Gaudens's amusement at this request, he was able to gratify Bastien's vanity by portraying him with hands partly concealed by brushes and palette. Although the palette (shown only in part, as in the *Picknell*) seems to have been incorporated as a means of obscuring Bastien's hands, it is perfectly well integrated into the relief's format, in contrast to its placement in the *Armstrong* (Maitland A. Edey, New York), *Picknell*, and *Millet*.

Such details as the boyish cowlick and deeply outlined, rounded upper torso and arm reveal Bastien at his youthful peak and offer no hint that his appearance, here so robust, would be rendered ghostlike by the cancer that terminated his life four years later.

The relief of Bastien-Lepage in the Museum's collection is an exceptionally fine, rich, and crisp cast and the example against which other versions of this subject should be measured. It was the first cast of Bastien that Saint-Gaudens exhibited, and, along with his other entries at the Paris Salon of 1880, it won an honorable mention. Later the same year the bronze was shown in the Museum's "Exhibition of Works by Living American Artists" and was purchased in January 1881, having the distinction of being the first work by the sculptor sold to a museum. Responding to an inquiry from Charles G. Loring, then curator at the Museum, as to where the *Bastien-Lepage* was cast and whether any others had been made, Saint-Gaudens wrote, "Rodier [*sic*, meaning Rudier, Paris] is the name of the Founder who cast the medallion you have (which is the one that was exhibited at the Paris Salon)—There are two duplicates that Bas had made, one for himself and one that he told me was for Mr. Andrieux, the Préfet de Police of Paris—Alden Wier [*sic*], Bastien's friend had another but it was not made from the first plaster."[6] Loring, who had a keen eye, commented in a letter to Olin Warner: "Judging from Mr St Gaudens' example here [the Museum's *Bastien-Lepage*] I have not formed a very high opinion of the bronze casting in N.Y.; his Paris medallions are incomparably finer."[7]

Several variants of the Bastien-Lepage portrait exist, differing in details, inscriptions, and method of production.[8] The Museum's cast, for instance, includes in the upper left-hand corner a nude female sitting on a bench under a tree, with the word VERITE inscribed beneath her, perhaps alluding to Bastien's adherence to a painting style of photographic realism. Of particular note is the inclusion of LOVIS in the signature, referring to Augustus's brother, who undoubtedly contributed in some fashion to the execution of the piece. Like many of Saint-Gaudens's portrait reliefs, this bronze was originally completed by a handsome wood frame (see illustration), probably designed by Stanford White. (Regrettably, the frame was removed before 1927 and is at present unlocated.)

K.G.

Notes

1. The bronze cast in the Art Institute of Chicago has been described as having the characteristics of an electrotype by Michael Edward Shapiro, in *Bronze Casting and American Sculpture 1850-1900* (Newark: University of Delaware Press, 1985), p. 99.

2. For information on Bastien, see Julia Cartwright, *Jules Bastien-Lepage* (London: Seeley, 1894); William Steven Feldman, "The Life and Work of Jules Bastien-Lepage, 1848-1884," Ph.D. diss., New York University, 1973; *Jules Bastien-Lepage (1848-1884)* [Bar-le-Duc: Conservation départmentale des Musées de la Meuse, 1984]; Marie-Madeleine Aubrun, *Jules Bastien-Lepage, 1848-1884: Catalogue raisonné* (Paris: Copyright by Marie-Madeleine Aubrun, 1985).

3. Saint-Gaudens 1913, vol. 1, p. 215.

4. Ibid., pp. 216, 219.

5. Ibid., p. 219.

6. Saint-Gaudens to Loring, Jan. 23, 1881, BMFA, 1876-1900, roll 550, in AAA, SI. Bastien himself was evidently pleased with the portrait, writing to Saint-Gaudens, "Your medallion is always greatly admired at home" ("Votre médaille est toujours fort regardé chez moi"). Bastien-Lepage to Saint-Gaudens, July 15, 1882, Saint-Gaudens Papers, Baker Library, Dartmouth College, Hanover, N.H.

7. Loring to Olin Warner, Feb. 1, 1881, BMFA, 1876-1900, roll 547, in AAA, SI..

8. For an account of Saint-Gaudens's interest, as early as 1881, in various methods of producing sculpture, with specific reference to electrotypes of the *Bastien-Lepage* and *Francis Davis Millet*, see Michael Edward Shapiro, "The Development of American Bronze Foundries," Ph.D. diss., Harvard University, 1980, pp. 151-154; idem, *Bronze Casting and American Sculpture 1850-1900* (Newark: University of Delaware Press, 1985), pp. 98-100, 188, n. 62.

AUGUSTUS SAINT-GAUDENS
68
John Singer Sargent, 1880
Plaster
Diam. 2½ in. (6.3 cm.)
Signed and inscribed: (at top and left)
MY·FRIEND·IOHN / SARGENT·PARIS· /
IVLY[?]·M·D·C·CCLXXX· / FECE· / A ST G (monogram) /
BRVTTO / RITRATTO
Bequest of Elizabeth Amis Cameron Blanchard; in memory of my friend, John Singer Sargent. 57.41

Provenance: Elizabeth Amis Cameron Blanchard, New York
Exhibited: University of Nebraska Art Galleries, Sheldon Memorial Art Gallery, Lincoln, *American Sculpture* (1970), no. 145.

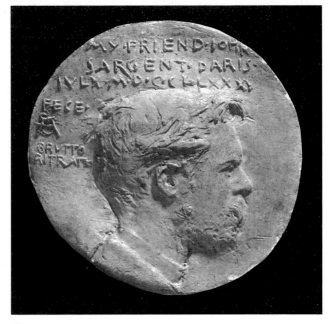

68

Versions: *Bronze*: (1) Addison Gallery of American Art, Andover, Mass., (2) American Academy and Institute of Arts and Letters, New York, (3) Annette and Rob Elowitch, Portland, Maine, (4) Isabella Stewart Gardner Museum, Boston, (5) The Metropolitan Museum of Art, New York, (6-13) private collections: Albuquerque, N.M., Bass River, Mass., Brookline, Mass., Cambridge, Mass. [3], Dobbs Ferry, N.Y., New York, (14) Saint-Gaudens National Historic Site, Cornish, N.H., (15) Sargent-Murray-Gilman-Hough House, Gloucester, Mass. *Electrotype*: (1) Musée d'Orsay, Paris

Of all the American painters Saint-Gaudens portrayed during his second residence in Paris, none was to become a greater artist or have a more celebrated reputation than John Singer Sargent (1856-1925). He was the most lionized American artist of his generation, sought after by an international group of society figures for their portraits, which he rendered with a virtuoso treatment of paint that was the hallmark of his style.

Born in Florence, Italy, to expatriate American parents, Sargent received his earliest art instruction in Rome in 1868 and attended the Accademia delle Belle Arti in Florence. He pursued his education in Paris, where in 1874 he entered the Paris atelier of the portraitist Emile Auguste Carolus-Duran (1838-1917). Sargent won recognition in Paris during the late 1870s for his genre subjects and portraits of fashionable Parisians, but the scandal that arose after he exhibited *Madame X*, 1884 (The Metropolitan Museum of Art, New York) in the Paris Salon of

1884 brought his years in that city to a close, and he moved to London in 1886.

Later in his career Sargent occupied himself with the medium of watercolor, for which his facile and brilliant hand was so perfectly suited. He also turned to mural painting, executing decorations for the following institutions: the Boston Public Library, on which he labored for some twenty-five years, beginning in 1890; the Museum of Fine Arts, Boston, the ceiling of its rotunda, commissioned in 1916 and unveiled in 1921, and of its staircase leading to the rotunda, installed in 1925, after his death; and Harvard University, Widener Memorial Library, unveiled in 1922.

Saint-Gaudens and Sargent began their acquaintance in the late 1870s, when both men were living in Paris, and they became devotees of each other's art. Sargent gave Saint-Gaudens a watercolor of a female figure created at Capri (destroyed)[1] in exchange for a cast of Saint-Gaudens's portrait relief of Bastien-Lepage. In 1890 another exchange took place: Sargent painted *Portrait of a Boy*, representing Saint-Gaudens's son, Homer, and his wife, Augusta, 1890 (Museum of Art, Carnegie Institute, Pittsburgh) in return for the sculptor's relief of Sargent's sister, Violet, 1890 (Saint-Gaudens National Historic Site, Cornish, New Hampshire). When Sargent was producing the sculptural decorations for his murals in the Boston Public Library, he frequently sought Saint-Gaudens's advice, especially about patination, and in thanks gave the sculptor a bronze cast of the crucifix he had made for the library's interior. Of Saint-Gaudens's later work, Sargent was particularly impressed with the *Sherman Monument*, 1903 (Grand Army Plaza, New York), which he had seen in Paris at the 1900 Exposition. He wrote Saint-Gaudens: "I thought the Sherman really splendid and if it conveyed that impression there, what must it be when it stands alone and disentangled from that rabble of statues—I hope it is not going to some way out of the way place in the Far West."[2]

For Sargent, Saint-Gaudens had the deepest respect. Rose Nichols, his niece by marriage, wrote of her uncle's regard for him: "Uncle Augustus felt an intense admiration for Sargent both as a man and an artist. He could not bear to hear the slightest criticism of Sargent's work. Their friendship was based on their admiration of each other's work. Otherwise they had but little in common. Uncle Augustus was shy and awkward in Sargent's presence. He said he impressed him as a great giant

whom he was incapable of resisting in any way. He felt oppressed by his own insignificance and even his work shrunk so in his own opinion that in speaking of it to S he was sincere in declaring it worthless."[3] Saint-Gaudens's esteem for Sargent is further recorded in a letter to Isabella Stewart Gardner dated November 7, 1887: "I enclose the Sargent medallion. I wish it were more worthy of the original."[4]

The *Sargent*, like the *Picknell* (q.v.), *Millet* (q.v.), and *Bastien-Lepage* (q.v.), is one in a series of affectionate portraits of the sculptor's artist friends. When Saint-Gaudens created the *Sargent* in July 1880 in Paris, he selected a circular design and made the piece only 2½ inches in diameter, more like a medal than a medallion. The modeling is extremely sensitive considering the diminutive size of the relief. Shown in profile, Sargent sports a beard and mustache, and his slender physique (at least during his youth), which Saint-Gaudens commented upon,[5] is indicated by the thin neck. Cornelius Vermeule, who placed the medallion in a Renaissance Greco-Roman idiom inspired by classical coins, gave an interesting interpretation of the inscription "BRUTTO RITRATO [*sic*]." Rather than translating it merely as "bad portrait," he viewed the phrase as meaning "brutal, vigorous, forceful, and consequently veristic."[6] Because of Saint-Gaudens's presumed familiarity with Roman Republican coins depicting Marcus Junius Brutus in which Brutus is presented in a vital and compelling way, the ancient coins do indeed seem logical as the sculptor's aesthetic point of departure. Saint-Gaudens's playfulness cannot be discounted as a reason for the tiny size of the medallion. He, like many others, found Sargent's height a distinctive characteristic, and there may well have been a charming irony in portraying the painter in such an exceedingly small form.

The Museum's relief of Sargent was given by Elizabeth Amis Cameron Blanchard in memory of her friend John Singer Sargent, and her will listed the piece as "the original plaster cast."[7]

K.G.

Notes

1. Saint-Gaudens 1913, vol. 1, p. 250.

2. Sargent to Saint-Gaudens, Nov. 24 [1900], Saint-Gaudens Papers, Baker Library, Dartmouth College, Hanover, N.H.

3. Rose Standish Nichols notebook, Nichols-Shurtleff Family Papers, Schlesinger Library, Radcliffe College.

4. Saint-Gaudens to Gardner, Nov. 7, 1887, Isabella Stewart Gardner Museum Archives.

5. Saint-Gaudens 1913, vol. 1, p. 250.

6. Vermeule 1971, p. 98.

7. See New York County Probate Records, P2569, 1956, in BMFA, ADA.

AUGUSTUS SAINT-GAUDENS

69

George Washington Inaugural Centennial Medal, 1889
Bronze, light brown patina, lost wax cast
Diam. 4⅝ in. (11.6 cm.)
Signed and inscribed: *obverse:*
·GEORGE·WASHINGTON · / ·PATER·PATRIAE·
/·M·D·C·C·L XXXIX · /
PHILIP·MARTINY·MODELER·DESIGN·AND· / COPY-
RIGHT·BY·AVGVSTVS ·SAINT-GAVDENS·; *reverse:*
TO·COMMEMORATE / THE·INAVGVRATION /
OF·GEORGE·WASHINGTON / AS·FIRST·PRESIDENT·OF·THE
/ VNITED·STATES·OF·AMERICA / AT·NEW·YORK·APRIL
·XXX / ·M·D·C·C· LXXXIX· / BY·AVTHORITY·OF /
THE·COMMITTEE / ON·CELEBRATION / NEW·YORK·APRIL
/ ·XXX· / ·M·D·C·C·C·LXXXIX· (on shield) E / PLVRIBVS /
VNVM

Gift of Henry G. Marquand. 89.251

Provenance: Henry G. Marquand, New York
Exhibited: BMFA, *Renaissance and Modern Bronzes Collected by the Visiting Committee on Western Art* (1908), no. 118.
Versions: *Silver:* (1) The American Numismatic Society, New York. *Bronze:* (1, 2) American Academy and Institute of Arts and Letters, New York, (3-8) The American Numismatic Society, New York (2 of which are uniface shells, 1 obverse, 1 reverse), (9) Boston Public Library, (10) The British Museum, London, (11) The Century Association, New York, (12, 13) Corcoran Gallery of Art, Washington, D.C., (14) Hirschl & Adler Galleries, New York, (15, 16) Johns Hopkins University, Baltimore, Md., (17, 18) The Metropolitan Museum of Art, New York, (19-26) National Numismatic Collections, Smithsonian Institution, Washington, D.C., (27, 28) The Newark Museum, N.J., (29-31) The New-York Historical Society, (32-44) private collections: Atlanta, Ga., Bethesda, Md., Boulder, Colo., Brookline, Mass. [4], Cambridge, Mass., Cornish, N.H., New York [2], Tyringham, Mass., Washington, D.C., (45) The R.W. Norton Art Gallery, Shreveport, La., (46-48) Saint-Gaudens National Historic Site, Cornish, N.H., (49) The Saint Louis Art Museum, Mo., (50) The Walters Art Gallery, Baltimore, Md., (51) William A. Farnsworth Library and Art Museum, Rockland, Maine, (52) Erving and Joyce Wolf

This medal, which was conceived in the winter of 1889 and was the sculptor's first effort in the medallic art form, commemorates the one hundredth

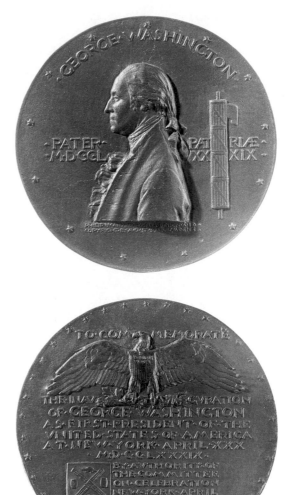

69

anniversary of George Washington's inauguration on April 30, 1789, in New York. Odd as it may seem, the commission of Saint-Gaudens to create the medal had its origin in a suggestion at a meeting on November 30, 1888, that it would be fitting if the stationery used by the Committee on Art and Exhibition, part of the Washington Centennial Celebration Committee, were marked by a suitable and artistic device.[1] The next day it was proposed that a commemorative medal would be an appropriate item to produce for the celebration and its design would be used as a device for the stationery.[2] With the addition on December 28 of Richard Watson Gilder, the poet and editor and a close friend of Saint-Gaudens, to a subcommittee charged with the responsibility of securing a scheme and proceeding

with its manufacture in bronze, little time was lost in asking Saint-Gaudens to compose the medal. The sculptor agreed to fashion the medal without compensation, but because he was already overburdened with commissions, Saint-Gaudens entrusted the modeling to an assistant, Philip Martiny (1858-1927), who executed the piece under his mentor's supervision.

Martiny's task was made difficult by Saint-Gaudens's habit of altering and refining a work in an attempt to improve on it, often at the expense of a contract's terms of completion.[3] Saint-Gaudens made so many changes in the design during the winter months that the earliest medals were cast only a few days before the opening of the Loan Exhibition of Historical Portraits and Relics, held at the Metropolitan Opera House in New York from April 17 through May 8, in conjunction with the centennial celebration. The "first" order given the Gorham Manufacturing Company, Providence, founders of the medal, was for two thousand copies in bronze, and these were placed on sale at the Loan Exhibition, after the opening. "It was the desire of the committee to put them within the reach of modest purses, and they were sold, in neat paper boxes lined with blue plush, at two dollars apiece."[4] An order for fifty silver medals (later reduced to ten) was also issued.[5] Plaster casts of the medal, as it existed on March 1, had been given to Tiffany and Company, which produced bronze ceremonial badges measuring 1⅜ inches, for the members of the New York committee of the centennial celebration. A comparison of the obverse of the badge with the obverse of the medal shows that details such as the placement of the inscriptions and the thirteen stars were modified in the final version of the medal.

The obverse of the medal bears a profile bust of Washington in a Continental army uniform, facing left. Fasces are at the right, and thirteen stars, representing the number of the original states, are carefully spaced around the medal near its rim. In the upper third of the reverse is an eagle with wings spread, head directed to the left, and arrows and an olive branch in its claws; across its chest is a shield with the legend E PLVRIBVS VNVM. The coat of arms of New York State is at the lower left, and the thirty-eight stars (the number of states in the union on April 30, 1889) form the border. Among artistic precedents, the medal recalls the art of Pisanello, the Renaissance master for whom Saint-Gaudens had a lifelong admiration, both in the composition and in the treatment of the lettering.[6]

Shortly after casts of the Washington medal were made, some were presented to various libraries and institutions, including the Museum of Fine Arts, which received this bronze as a gift in 1889 from Henry Gurdon Marquand, chairman of the Committee on Art and Exhibition.

K.G.

Notes

1. For information about the commission of the medal, see Committee on Art and Exhibition Folder, Records of the Washington Centennial Celebration Committee, NYHS, Manuscripts Division; see also Clarence Winthrop Bowen, ed., *The History of the Centennial Celebration of the Inauguration of George Washington as First President of the United States* (New York: Appleton, 1892), pp. 138-141.

2. Bowen, *History of the Centennial Celebration*, p. 139.

3. For an account of Martiny's travails, see the statement by William A. Coffin, manager of the Committee on Art and Exhibition and manager of the Loan Exhibition of Historical Portraits and Relics, quoted in Saint-Gaudens 1913, vol. 1, pp. 391-392.

4. Bowen, *History of the Centennial Celebration*, p. 139. As not all casts were sold, it seems unlikely that any more were made. On May 10, 1889, two days after the Loan Exhibition closed, 863 bronze medals were sent to Gorham Company to be sold by them (Statement, Alexander W. Drake to Richard Watson Gilder, May 10, 1889, Committee on Art and Exhibition Folder, NYHS). Five years later, in May 1894, Gorham sent a statement to the Centennial Committee with figures on a balance due and the number of medals that had remained unsold. At that time, Henry Gurdon Marquand, chairman of the Committee on Art and Exhibition, ordered that a final distribution of the pieces be made (Statement, Gorham Company, May 3, 1894, Committee on Art and Exhibition Folder). Apparently some, if not all, of the remaining medals were given away. For example, on May 14, 1894, Gorham wrote to the Corcoran Gallery of Art, Washington, D.C., "By order of the Committee on the Washington Memorial Arch, Mr. H.G. Marquand Chairman, we have the pleasure in sending you two copies of the St. Gaudens medal in bronze." (Information provided by Lynne Berggren, Corcoran Gallery of Art, accompanying a letter to Kathryn Greenthal, Mar. 29, 1982.) The Boston Public Library received its cast on May 18, 1894.

5. Minutes of the Committee on Art and Exhibition, Mar. 27, 1889, and Minutes of the Supervising Committee, Apr. 20, 1889, Committee on Art and Exhibition Folder, NYHS. At a meeting of the Committee on Art and Exhibition on May 2, 1889, William E. Dodge moved that Gilder, the secretary, "prepare an impression" of the medal in silver in an appropriate case for Saint-Gaudens as an expression of the committee's regard and "to place at his disposal such copies as he may desire of the medal in bronze" (Minutes, May 2, 1889). A silver medal was presented to Gilder by Marquand, on behalf of the committee, undoubtedly because he was the prime mover in

having Saint-Gaudens accept the commission to design the piece and in helping to push the work along to completion (Note, n.d., Committee on Art and Exhibition Folder).

6. For a discussion of the medal's prototypes and its place in the medallic arts, see Vermeule 1971, pp. 96-97.

AUGUSTUS SAINT-GAUDENS

70
Rejected design for the reverse of the *World's Columbian Exposition Commemorative Presentation Medal*, 1893
Plaster
Diam. 2⅞ in. (7.3 cm.)
Inscribed: THE / COLVMBIAN / EXHIBITION· / IN COMMEM- / ORATION· / OF· / THE· / FOVR HVNDREDTH / ANNIVERSARY / OF· THE LANDING / OF· COLVMBVS / TO / WILLIAMS / BRADFORD (on shield) E·PLVRIBVS / VNVM (near lower rim) MDCCCXCII [M]DCCCXCIII
Gift of Mr. and Mrs. Thomas Johnston Homer.
1975.757

Provenance: Mr. and Mrs. Thomas Johnston Homer, Sherborn, Mass.
Versions: *Plaster*, 4 in.: (1) Saint-Gaudens National Historic Site, Cornish, N. H., obverse and rejected reverse, mounted side by side. *Bronze*, 3⅞ in.: (1) The American Numismatic Society, New York, obverse and rejected reverse. *Electrotype*: (1-3) 2½ in., 2⅞ in., and 3¹⁵⁄₁₆ in., Musée d'Orsay, Paris, obverse and rejected reverse, (4) 8 in., National Numismatic Collections, Smithsonian Institution, Washington, D.C., (5) bronze, 8¼ in., Saint-Gaudens National Historic Site

This plaster model for the reverse of the World's Columbian Exposition Commemorative Presentation Medal is a rare example of Saint-Gaudens's first of three rejected designs for the piece. The final minted version included Saint-Gaudens's scheme for the obverse, but the reverse was revised by Charles E. Barber, chief engraver at the mint in Philadelphia.

In 1892 Saint-Gaudens was asked by the United States government to produce a medal that would be presented to the prize winners at the World's Columbian Exposition in Chicago in 1893. Initially, he refused, believing that neither he nor anyone else in the nation could fashion a good medal and that it would be necessary to have it made by a European artist.[1] However, he changed his mind. His reasons for deciding to compose the medal were made quite explicit in a letter of November 10, 1892, to Edward Atkinson, treasurer of the Robert Gould Shaw Memorial Committee, from whom, in

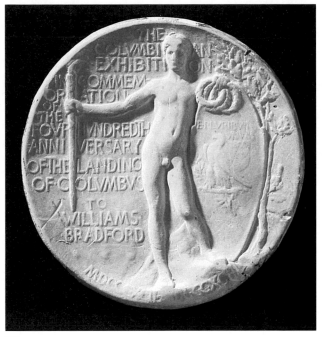

70

conjunction with other members of the committee, he had to receive permission to interrupt his labor on the *Shaw Memorial* (Boston Common) in order to design the medal. Saint-Gaudens stated: "I wish to do it [execute the medal] to keep it out of the hands of the man at the mint I am positively assured . . . will certainly do it if I don't. If I thought that it were at all possible that one of two or three other artists could obtain the work, I should certainly refuse to have anything to do with the matter. As that is not the case I should be glad to do it but it will take three months as it is a very serious matter."[2] (What Saint-Gaudens so fervently wanted to avoid was the creation of an important medal by a designer at the mint, and the irony of the situation was that, in the end, it partially came to pass. Moreover, by the substitution of Barber's conception on the reverse, the sculptor sustained a far greater personal indignity than he ever could have imagined.)

Saint-Gaudens proceeded to outline the two sides of the medal, completing them about the time the Exposition closed in the autumn of 1893. The obverse depicts Columbus, whose discovery of America was the cause for the fair's celebration. He steps ashore, arms extended away from his sides and palms turned outward in a gesture of thanks to God for his safe passage and for his achievement. Columbus is followed by a standard-bearer and two other men, and in the upper right corner is a device recalling the arms of Spain.

The sculptor's initial idea for the reverse, of which the Museum's plaster is an example, records an inscription stating the purpose for which the medal would be struck. In the center of the round is a young male nude, whom Saint-Gaudens described as representing the Spirit of America "in the full vigor of young life,"[3] holding a torch in one hand and grasping three wreaths in the other. His left hand rests on a shield bearing the motto E PLVRIBVS VNVM, an eagle, an olive branch, and a smaller shield. An oak tree is at the far right. In the Museum's plaster, the name of Williams Bradford (1823-1892), the landscape and marine painter, is inscribed in the space devoted to the recipient's name.

The figure's nudity caused the design to be rejected by the United States Senate Quadro-Centennial Committee after an advertisement illustrating the reverse was printed by the Page Belting Company of Concord, New Hampshire. Homer Saint-Gaudens called the reproduction a "caricature,"[4] with the boy appearing indecent rather than idealized. John C. Carlisle, secretary of the treasury department, wrote to Saint-Gaudens on January 23, 1894, notifying the sculptor that the committee objected to the nudity. He added that since 20,000 copies of the medal were to be struck, he was sure that the majority of people would criticize the piece in its then present form. He asked that Saint-Gaudens submit a plan to cover "the objectionable part of the figure."[5] Saint-Gaudens responded that the picture had been printed in violation of the rights of the government and of himself, and he wished to avoid reworking the design. Regarding the large number of medals to be struck and Carlisle's perception that countless individuals would not be pleased with the model, Saint-Gaudens commented that the treasury secretary should remember that most of the medals were to be sent to exhibitors from foreign countries, implying that abroad there was no impropriety in illustrating a nude on a medal. Concerned that someone else might tamper with his composition, Saint-Gaudens reluctantly agreed to make the alteration himself. At some point before the publication of the caricature, the design had been accepted, as Saint-Gaudens declared: ". . . if it is changed I shall in self defence [sic] be bound to see that . . . the people know what my original design was, and that the design as made by me and as accepted by your department several months ago, was not one to which they would have objected could they have seen it first."[6]

Not everyone in the Senate was in favor of changing the design. Senator Edward Wolcott of Colorado considered the issue "a belittling piece of business. The very suggestion of any impropriety in the medal is degrading. . . . This generation owes a debt to St. Gaudens that it can never pay. I feel a personal sense of shame, that instead of availing itself of a fair opportunity to express its appreciation of his artistic qualities and his genius, this government is inclined to an exhibition of a false modesty that would be ludicrous if it were not humiliating."[7]

Saint-Gaudens modified the format by adding, in one plaster replica, a leaf and, in two others, an exceedingly narrow bit of drapery—or "ribbon" Saint-Gaudens called it[8]—to conceal the figure's genitalia, perhaps making a mockery of the request rather than conceding to it. These proposals were rejected, too, and in May 1894 Saint-Gaudens, "setting aside his feelings,"[9] embarked on a third version. As he found it impossible to drape the figure without entirely destroying the composition, he eliminated it[10] and retained the inscription and the eagle, revising only their placement. He sent the model on June 23 and learned of the rejection of his third effort in a letter from Carlisle dated June 27, 1894. His disgrace was compounded by the announcement that a design by Barber had been adopted. What incensed the sculptor most was that at the moment he had been encouraged to produce a third scheme (which he was assured would be accepted), plans had been made for Barber to devise the reverse. Saint-Gaudens vehemently protested the government's right to combine his endeavors, without his consent, with that of another person. Barber altered Saint-Gaudens's final submission by placing the inscription between two flaming torches, and the medal was then struck.

According to John Dryfhout, the modeling of the rejected reverse was performed by Saint-Gaudens's brother, Louis.[11] Annette, Louis's wife, indicated in manuscript notes, in the Saint-Gaudens Papers at Dartmouth College, that her husband had done the work under his brother's direction, although Augustus executed the preliminary drawings (destroyed) and Augustus's signature appears on the obverse in the minted version. Louis often assisted his brother, and the nude figure bears a resemblance to the two nude boys holding torches of learning on the seal of the Boston Public Library, designed by Kenyon Cox (1856-1919) and modeled for the Copley Square entrance by Louis Saint-Gaudens in 1889-1890. These two figures were also

subjected to criticism for their nudity, but they remained inviolate.

The plaster cast was given to the Museum by Mr. and Mrs. Thomas Johnston Homer, he being a nephew of Saint-Gaudens's wife, Augusta Homer.

K.G.

Notes

1. Saint-Gaudens 1913, vol. 2, p. 66.

2. Saint-Gaudens to Atkinson, Nov. 10, 1892, Lee Family Papers, MHS.

3. Letter from Saint-Gaudens to R.C. Preston, Director of the Mint, Nov. 17, 1893, Saint-Gaudens Papers, Baker Library, Dartmouth College, Hanover, N.H.

4. Saint-Gaudens 1913, vol. 2, p. 66.

5. Carlisle to Saint-Gaudens, Jan. 23, 1894, Saint-Gaudens Papers.

6. Letter from Saint-Gaudens to Carlisle, Jan. 25, 1894, Saint-Gaudens Papers.

7. Letter from Wolcott to Charles C. Beaman, a lawyer and friend of Saint-Gaudens, Jan. 29, 1894, Saint-Gaudens Papers.

8. Letter from Saint-Gaudens to Carlisle, Mar. 15, 1894, Saint-Gaudens Papers.

9. Letter from Saint-Gaudens to R.C. Preston, May 17, 1894, Saint-Gaudens Papers.

10. Letter from Saint-Gaudens to Richard Watson Gilder, May 22, 1894, Richard Watson Gilder Collection, NYPL, RBM.

11. Dryfhout 1982, p. 202.

AUGUSTUS SAINT-GAUDENS
71
George Hollingsworth, 1893
Bronze, brown patina, lost wax cast
H. 68⅜ in. (174.4 cm.), w. 34⁹⁄₁₆ in. (87.8 cm.), d. 2¾ in. (7 cm.)
Signed (at left): A·SᵀG (initials) FECIT '92
Inscribed: (at top) GEORGE·HOLLINGSWORTH / TEACHER·OF·THE·LOWELL / INSTITVTE·DRAWING / SCHOOL·FROM·M·D·C·C·LI / ·TO·M·D·C·C·LXX·IX / THIS·BRONZE·TESTIFIES / TO·THE·LOVE·OF·HIS / MANY·FRIENDS·AND / TO·THE·GRATITVDE / AND·ESTEEM·OF·HIS / MANY·PVPILS· (below figure) ·M·D·C·C·C·XIII·/·M·D·C·C·C·LXXXII·
Foundry mark (lower right): Cast by The Henry-Bonnard Bronze Cᵒ. / NEW YORK. 1893.
Gift of the Pupils of George Hollingsworth. 93.98

Exhibited: BMFA, *Renaissance and Modern Bronzes* (1908), no. 210; idem, *Back Bay Boston: The City as a Work of Art* (1969), p. 125.

George Hollingsworth (1813-1882) was a landscape and portrait painter,[1] probably best known for his family portrait *The Hollingsworth Family*, about 1840 (Museum of Fine Arts, Boston). Born in Milton, Massachusetts, he studied abroad and returned from Europe in 1837. He took a studio in Boston and with fellow artists helped form the Boston Artists' Association, which held its first exhibition in 1842, with Washington Allston (1779-1843) as its president. Hollingsworth was both teacher and painter, and his talent as an instructor found expression at the Lowell Institute, where he lectured from 1851 to 1879. He had the distinction of being the first teacher in its drawing school, which, for a while, was the only institution in Boston and one of the few in the United States where training in drawing from real objects only, not from copies or from flat surfaces,[2] could be obtained.

Evidently Hollingsworth was a much loved man and a highly regarded educator since it was his friends and pupils who commemorated him with this bronze relief. Several years after Hollingsworth's death, they raised a subscription in his honor and commissioned Saint-Gaudens to create the posthumous portrait.

Hollingsworth is seen in three-quarter length, facing right, nearly in profile, with his right arm akimbo and his left arm resting on a book. The illusionistic effect of "framing" the portrait in bronze is handsomely achieved with the egg-and-dart molding and cornice. Two clay sketches for the relief, preserved only in photographs in the Saint-Gaudens Papers at Dartmouth College, Hanover, New Hampshire, reveal the sculptor's early ideas for the portrait: one shows Hollingsworth in half-length, facing left, holding an urn; the other represents him in just about the same manner as in the finished piece.

The bronze dates from slightly after Saint-Gaudens's midcareer and is close in composition and style to his earlier relief portrait of *S. Weir Mitchell M.D.*, 1884 (private collection). Saint-Gaudens would use a nearly identical pose for his subjects in two later reliefs, *Charles Cotesworth Beaman*, 1894 (National Museum of American Art, Washington, D.C.) and *Roger Wolcott*, 1903 (Saint-Gaudens National Historic Site, Cornish, New Hampshire). The *Hollingsworth* is not a widely known work by the sculptor and is the only bronze that was cast. Like many of the portraits Saint-Gaudens executed without the benefit of having the individual sit for him, his relief of Hollingsworth

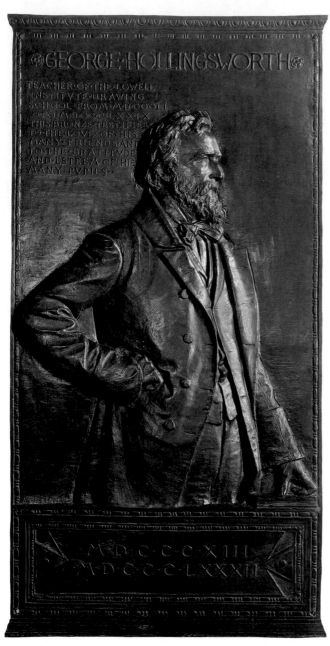

71

Pope, treasurer, and Edward H. Barton, secretary, offered the relief on behalf of Hollingsworth's friends and pupils.[3] The portrait is dated 1892, and was cast early in 1893 by the Henry-Bonnard Bronze Company, New York; it apparently went directly from the foundry to the Museum. Saint-Gaudens wrote Charles G. Loring, director of the Museum, on February 21, 1893: "I will send the Hollingsworth bronze within a day or two addressed to you at the Museum at the same time the marble on which it is to set [?] will be forwarded. When will action be taken by the Trustees with regard to its acceptance? If you will let me know the day and hour I will go on a day in advance to place it in a proper light for examination. You know bronze is very treacherous in indoor lighting."[4] The relief was voted for acceptance by the Committee on Collections on March 7 and shortly thereafter placed on the east wall of the Huntington Avenue entrance stairway, where it hung for many years.

K.G.

Notes

1. For information about Hollingsworth, see *Boston Evening Transcript*, Mar. 21, 1882, obit.

2. For an account of Hollingsworth's position at the Lowell Institute, see Barbara N. Parker, "George Hollingsworth and His Family," *Bulletin of the Museum of Fine Arts* 50 (Feb. 1952), pp. 30-31.

3. BMFA, ADA.

4. Saint-Gaudens to Loring, Feb. 21, 1893, BMFA, 1876-1900, roll 557, in AAA, SI.

AUGUSTUS SAINT-GAUDENS
72 (color plate)
Mildred Howells, 1898
Bronze, brown patina, lost wax cast
Diam. 21 in. (53.3 cm.); frame h. 31 in. (78.8 cm.), w. 29 in. (73.7 cm.)
Signed and inscribed (top left): MILDRED·HOWELLS· / NEW-YORK · M·DC·C·C· / ·XCVIII· / ·FROM·AVGVSTVS·SAINT-GAVDENS
Gift of Miss Mildred Howells. 57.558

Provenance: William Dean Howells, New York; Mildred Howells, Boston
Exhibited: The Metropolitan Museum of Art, New York, *Catalogue of a Memorial Exhibition of the Works of Augustus Saint-Gaudens* (1908), no. 84; Corcoran Gallery of Art, Washington, D.C., *Augustus Saint-Gaudens* (1908), no. 88; BMFA, "Back Bay Boston: The City as a Work of Art," Nov. 1, 1969 - Jan. 11, 1970; BMFA 1979, no. 20; Kathryn

falls slightly short of having the truly penetrating psychological understanding and the brilliant surface effects that in his finest likenesses are so superbly conjoined. Nevertheless, Hollingsworth is presented as a commanding and venerable figure, and the hair and facial features, elements Saint-Gaudens customarily took great pleasure in, are rendered with grace, strength, and real interest.

In an undated letter addressed to the trustees of the Museum of Fine Arts, the painter J. Wells Champney (1843-1903), president of the George Hollingsworth Memorial Association, Henry D.

Greenthal, *Augustus Saint-Gaudens, Master Sculptor* (New York: The Metropolitan Museum of Art, 1985), p. 175.

This medallion represents Mildred Howells (1873-1966), youngest of the three children of William Dean Howells and Elinor Gertrude (Mead) Howells. It is an excerpt from a rectangular relief (about 24 by 36 inches) of Mildred and her father, 1898 (present location unknown), and was executed shortly after the double portrait.

Mildred Howells was born into a talented family: her father was a celebrated writer, her mother was an artist, and she counted among her uncles the sculptor Larkin Goldsmith Mead and the architect William Rutherford Mead (1846-1928). Endowed with an artistic heritage, she studied art in Buffalo, New York, and became known chiefly as a poet and watercolorist. Her poems, stories, and drawings were published in *Harper's*, *Scribner's*, and other magazines between 1889 and 1924, and her watercolors were used as illustrations in many books, including some by her father. She had long been close to her father and became his companion, for her mother never fully recovered from the early death of Mildred's sister, Winifred, in 1889.[1] Mildred was betrothed in 1902, but she broke her engagement. After her mother's demise in 1910, she was a particular comfort to her lonely father for the last ten years of his life. With diligence and devotion she edited two volumes of his letters, *Life in Letters of William Dean Howells*, which appeared in 1928 and remain principal sources for the study of Howells.

Saint-Gaudens and William Dean Howells had met by 1890 and perhaps earlier, since they were in correspondence with one another by 1886.[2] Saint-Gaudens proposed making a portrait of father and daughter, which he modeled—according to the sculptor's son, Homer—" 'for fun,' in happy relaxation from the series of important commissions" (no doubt referring to monuments such as the *Shaw Memorial*, 1897 [Boston Common], and the *Sherman Monument*, 1903 [Grand Army Plaza, New York]).[3]

Saint-Gaudens had two specific reasons for wishing to portray the Howellses. In the issue of *Harper's Monthly* for July 1888, Howells, in his "Editor's Study," had praised Saint-Gaudens's bust of General Sherman, which he had seen in plaster at the sixty-third annual exhibition of the National Academy of Design in New York. The sculptor, in appreciation of the writer's flattering commentary about the *Sherman*, as well as of Howells's "achievement, his principles, and his delightful personality,"

begged to be allowed "to make his portrait and that of his daughter, Miss Mildred Howells."[4] Mildred was included quite simply because Saint-Gaudens was captivated by her. Rose Standish Nichols, a niece of Saint-Gaudens's wife, Augusta, wrote to Mildred from Cornish, New Hampshire, on June 11, 1896: "[Uncle Augustus] told me to tell you that he was crazy to return to New York and to go on with the bas-relief. He says that the reason he wanted to do it is because of your beauty and because he feels such an affection for your father and wishes that they might form a real lasting friendship."[5]

Sittings did not take place in earnest until nearly a year later when, on May 2, 1897, Saint-Gaudens wrote to Howells: "I dreamed last night that I was modelling your medallion, probably because my designs on you have matured within the last week. I should like to make a study of you and Miss Mildred, a sketch in clay which would require two or three long sittings from each of you."[6] Howells replied on May 4 that it was his dream, too, to be modeled by Saint-Gaudens, and that Mildred would be glad of the chance of immortality that the sculptor offered her.[7] Several sittings took place in May and June with father and daughter posing together and with Mildred posing, on at least one occasion, by herself.[8]

The original, unlocated double portrait was completed in New York before Saint-Gaudens departed for France in November 1897. A reduction of the relief was made in Paris and sent to Howells late in 1898.[9] In a letter to Augusta Saint-Gaudens, thanking the sculptor for the reduction, he remarked that Saint-Gaudens's portrayal of Mildred in the double portrait would be "forever the best likeness" of his daughter,[10] thereby ranking it higher than the lithograph by James Abbott McNeill Whistler (1834-1903) of 1895 (Museum of Fine Arts, Boston). Mildred stated that Saint-Gaudens's representation of her father was the best portrait ever made of him.[11] As for Saint-Gaudens, he was very pleased with the portrait of William Howells and unhappy about that of Mildred at the time he fashioned the relief. Ten years later, however, when preparing his reminiscences, he felt, in retrospect, that the "reverse would be the proper state of mind."[12]

During the summer of 1899 Saint-Gaudens sent Mildred the individual portrait (the Museum's relief), describing it as "a large copy in bronze of your side of the tablet." "I had had it cast to send to the Salon last year," he wrote, "but the patina was so

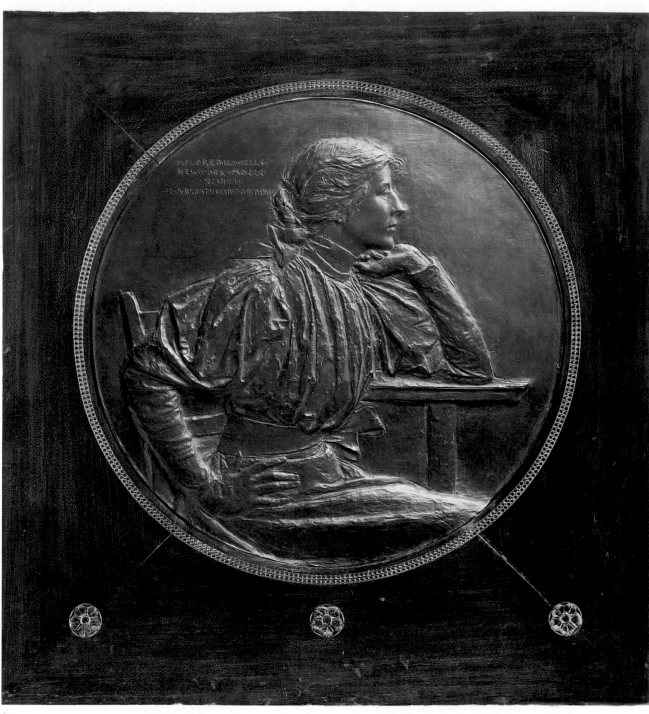

72

bad, I sent a plaster cast instead." The sculptor continued, "In clearing up the studio recently it was discovered modestly tucked away in a corner and time had done what man had failed to do, coated it with rather a pleasant dress of green. You like that color I know and that's why I send it to you."[13]

In the double portrait, Mildred and her father, both shown three-quarter length, sit in front of a table on which are several books. Wearing a blouse with fashionable leg-of-mutton sleeves, Mildred is seated at the left, facing right, with her left arm resting on the table and her left hand holding her chin. Her right hand is jauntily placed on her hip. Howells holds a manuscript in his left hand and spectacles in his right hand. Although the sitters look at each other, there is something oddly disconnected about them. The interaction, or lack thereof, between the two, with Howells pausing from reading to his daughter, is not entirely satisfying. More successful, it seems, is the Museum's portrait of Mildred alone. Here she is shown in the same attitude as in the double portrait, but she benefits from being the sole subject, for the viewer can concentrate on her self-confidence and elegance. (The only difference between the double and individual portraits lies in the treatment of the table and the inscription.)

One of Saint-Gaudens's finest female portraits, *Mildred Howells* can be compared with two splendid reliefs—*Sarah Redwood Lee*, 1881 (Mount Saint Mary's College, Emmitsburg, Maryland), and *Mrs. Schuyler Van Rensselaer* (Mariana Griswold Van Rensselaer), 1888 (The Metropolitan Museum of Art, New York)—in which the sculptor joined strength of character and nobility with charm and grace in a most remarkable way. For works that are so stylish, there is a solidness, in fact, a compelling iconic permanence in these three images. In the relief of Mildred Howells, as in the earlier portrait of Mrs. Van Rensselaer, it is the manner in which Saint-Gaudens combined forthrightness with a touch of vulnerability (hinted at by the delicate wisps of hair he sketched at the nape of the neck) that makes the medallion so powerful.

This relief was given to the Museum by Mildred Howells in 1957. It was set in a wood frame that Saint-Gaudens had made for it and, like most of his frames, was probably designed by Stanford White. Understanding that the frame was integral to the portrait, Mildred asked that it never be removed.[14]

K.G.

Notes

1. Margaret C.S. Christman, *Fifty American Faces from the Collection of the National Portrait Gallery* (Washington, D.C.: Smithsonian Institution Press, 1978), p. 194.

2. See Saint-Gaudens to Howells, Dec. 30, 1886, inviting him to join a group of men thinking of forming a club, William Dean Howells Papers, Ho, HU.

3. Saint-Gaudens 1913, vol. 2, p. 61.

4. Ibid., p. 77.

5. Nichols to Mildred Howells, June 11, 1896, Howells Papers.

6. Mildred Howells, ed., *Life in Letters of William Dean Howells* (Garden City, N.Y.: Doubleday, Doran, 1928), vol. 2, p. 78.

7. Howells to Saint-Gaudens, May 4, 1897, Saint-Gaudens Papers, Baker Library, Dartmouth College, Hanover, N.H.

8. Medallions, dated 1897, were executed of the individual heads of the sitters. Of the medallions of Mildred, measuring 2⅞ in. in diameter and showing only the head and shoulders, there are one gilded bronze in the Isabella Stewart Gardner Museum, Boston; two silvered bronzes in a private collection, Cambridge, Mass.; and one electrotype in the Musée d'Orsay, Paris.

9. In addition, several other reductions were made of the double portrait.

10. Howells to Augusta Homer Saint-Gaudens, Jan. 1, 1899, Saint-Gaudens Papers. Howells later observed that, like all artists, Saint-Gaudens had difficulty in "keeping his own portrait out. He especially kept giving my daughter's profile his noble leonine nose. He could not see that he did this, but when he was convinced of it, he forced himself to the absolute fact, and the likeness remained perfect." Howells to Homer Saint-Gaudens, Nov. 15, 1908, quoted in Saint-Gaudens 1913, vol. 2, pp. 62-63.

11. Mildred Howells, ed., *Life in Letters*, vol. 2, p. 78.

12. Saint-Gaudens 1913, vol. 2, p. 78.

13. Saint-Gaudens to Mildred Howells, Aug. 1, 1899, Howells Papers.

14. See letters from Mrs. Yves Henry Buhler, assistant curator, Department of Decorative Arts, to Mildred Howells, May 17, 1957, and Mildred Howells to Mrs. Buhler, June 15, 1957. BMFA, ADA.

AUGUSTUS SAINT-GAUDENS
73
Martin Brimmer, 1899
Marble
H. 30⅝ in. (77.8 cm.), w. 20 in. (50.8 cm.), d. 12¾
in. (32.4 cm.)
Signed (on right side): A ST G (initials)
Inscribed: (on base at front) MARTIN·BRIMMER /
M·D·C·C·C·XXIX - M·D·C·C·C·XCVI /
FIRST·PRESIDENT·OF·THE·MVSEVM·OF·FINE·ARTS /
M·D·C·C·C·LXX - M·D·C·C·C·XCVI (on back)
COPYRIGHT·BY·AVGVSTVS·SAINT·GAVDENS·MDCCCXCIX·
General Fund. 99.148

Exhibited: The Metropolitan Museum of Art, New York,
*Catalogue of a Memorial Exhibition of the Works of Augustus
Saint-Gaudens* (1908), no. 139; BMFA, "Back Bay Boston:
The City as a Work of Art," Nov. 1, 1969-Jan. 11, 1970;
*"The Second Greatest Show on Earth": The Making of a Mu-
seum*, sponsored jointly by AAA, SI and BMFA (1977), no. 8,
p.6.

Martin Brimmer (1829-1896), whom the Museum
of Fine Arts commemorated with this bust, was one
of the most widely known and public-spirited citi-
zens of Boston during his varied and active career.
Though admitted to the bar and elected to the
Massachusetts legislature, he gained his greatest sat-
isfaction from serving Harvard College and the
Museum of Fine Arts.

Brimmer was the only son of Martin Brimmer
III, a prosperous merchant and mayor of Boston,
who championed prison reform. After graduating
with highest honors from Harvard in 1849, young
Brimmer traveled abroad and attended lectures at
the Sorbonne. He returned to Boston in 1853 and
at the age of twenty-four became a trustee of the
Boston Athenaeum. Lameness and persistent deli-
cate health were no obstacles to his sense of respon-
sibility, and in time he became a member of the
boards of Massachusetts General Hospital and Per-
kins Institution for the Blind and of the vestry of
Trinity Church. Despite only a modest interest in
politics, he labored tirelessly as a state legislator, in
the House and in the Senate, for educational issues
in the 1860s. His dedication to excellence in school-
ing was clearly one of the reasons he became a
Fellow of Harvard College in 1864, a position he
held until 1868, and then again from 1877 until his
death.

Harvard's rival for Brimmer's attention was the
Museum of Fine Arts of which Brimmer was the
chief founder. He was elected president of the Mu-
seum in March 1870 and retained the office for the
next twenty-five years. Like William Morris Hunt,

he had a penchant for the paintings of Jean Fran-
çois Millet (1814-1875), but, in general, his taste in
art was eclectic. Along these lines, Brimmer's aim
for the Museum was to educate the public in the
broadest possible way by acquiring objects from all
nations and periods, including contemporary
American art of unquestionable quality.[1]

In the summer of 1896, about six months after
Brimmer's death, the trustees of the Museum com-
missioned Saint-Gaudens to execute a bust of their
first president. The sculptor received photographs
of Brimmer to work from, and after Saint-
Gaudens's arrival in France in November 1897, he
began to model the portrait. By November 1898, he
had finished the bust in clay. Brimmer's widow,
Marianne (Timmins), who was keenly interested in
the commission, was extremely pleased with it and
wrote to Charles G. Loring that it was a "speaking
likeness and a beautiful work of art."[2] Loring felt it
was "very fine," but added in a letter to Saint-
Gaudens that he thought it was of "a rather sterner
character than [Brimmer's]. . . . He was of a gentler
rather than a pugnacious character."[3] It was a tell-
ing observation for, apart from a perspicacity
hinted at in the eyes, the bust principally suggests a
dour personality, evidently conveyed by the photo-
graphs Saint-Gaudens made use of. John Jay Chap-
man, who married Brimmer's niece, presumably
would have concurred with Loring and wrote that
"there was in Mr. Brimmer nothing of that austere
look which comes from holding on to property and
standing pat. And besides this he was warm; . . .
much warmer than the average Beacon Street
mantel-pieces were."[4]

The portrait was not significantly altered, for
Mrs. Brimmer commented that her late husband
had had a serious expression and that the sculptor
had chosen the "juste milieu neither too smiling nor
too serious."[5] Later, she remarked that the bust was
notable for the different aspects offered, with the
full view having the "spark in it of an approaching
smile."[6] To satisfy Loring and Mrs. Brimmer (who
also had some reservations), minor changes were
made to the nose and the chin, the former having at
first been too heavy and the latter too broad. Saint-
Gaudens had the bust cut in marble during the
winter and spring of 1899, and it arrived in Boston
in August of that year. (He also provided Mrs.
Brimmer with a marble relief of her husband, 1900
[Trinity Church, Boston], which she ordered from
Saint-Gaudens after having decided not to have a
copy made for herself of the Museum's bust. A
bronze copy, 1900 [present location unknown], as

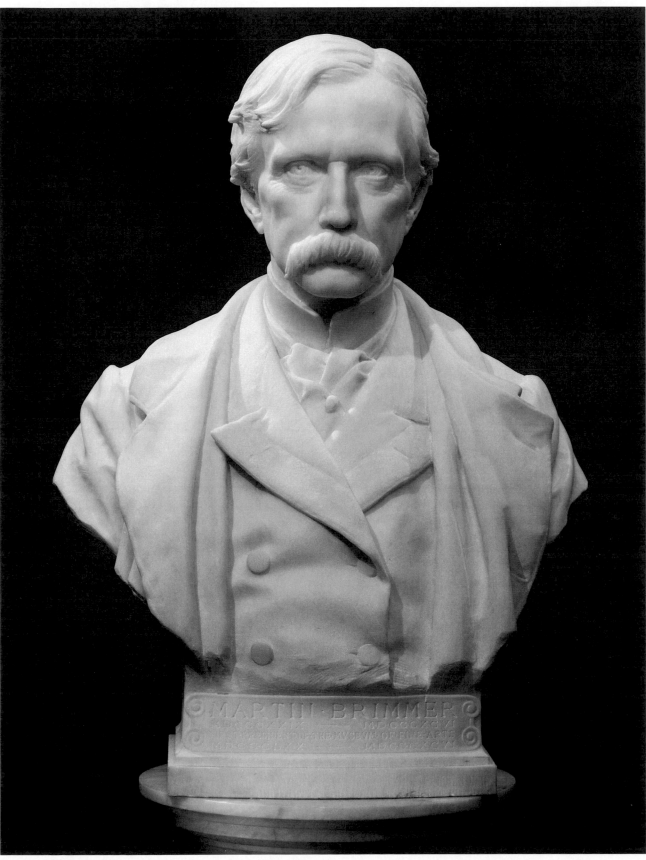

well as at least one bronze reduction of the relief were cast for Mrs. Brimmer as well.)[7]

In the bust, Brimmer is clothed in contemporary coat and double-breasted jacket and is shown frontally with eyes looking slightly to his right. Considering the constraints of having to create a portrait from photographic images, Saint-Gaudens was able to produce an accomplished but by no means inspired portrait. Within his oeuvre, it stands as one of a number of its type, in this instance a commission to gratify an august body of individuals representing a great institution who wished to honor one of their worthies.

According to Walter Whitehill, the bust was displayed in the Museum for many years near the Huntington Avenue entrance before being placed in storage during the 1950s.[8]

K.G.

Notes

1. For information about Brimmer, see Brimmer files at Harvard University Archives; and Wayne Andrews, "Martin Brimmer, the First Gentleman of Boston," *Journal of the Archives of American Art* 4 (Oct. 1964), pp. 1-4.

2. Marianne Brimmer to Loring, Dec. 1, 1898, BMFA, 1876-1900, roll 560, in AAA, SI.

3. Loring to Saint-Gaudens, Dec. 9, 1898, Saint-Gaudens Papers, Baker Library, Dartmouth College, Hanover, N.H.

4. Quoted in Edward Waldo Emerson, *The Early Years of the Saturday Club, 1855-1870* (Boston: Houghton Mifflin, 1918), p. 373.

5. Letter from Marianne Brimmer to Augusta Homer Saint-Gaudens, Jan. 1, 1899, Saint-Gaudens Papers.

6. Letter from Marianne Brimmer to Augustus Saint-Gaudens, Oct. 15 [1899], Saint-Gaudens Papers.

7. Saint-Gaudens's income figures notebook provides a record of the order in which payments for the various Brimmer images were received: Dec. 10, 1898, he received from the Museum of Fine Arts half-payment for the bust of Martin Brimmer; April 6, 1899, from Mrs. Brimmer, two-thirds payment for the marble relief of Brimmer; Sept. 25, 1899, from the Museum, the second and final payment for the bust of Brimmer; June 14, 1900, from Mrs. Brimmer, final payment for the marble and bronze reliefs and for the reducing of the bronze; Sept. 7, 1900, from Mrs. Brimmer, payment for a reduction of the relief. Saint-Gaudens Papers.

8. Walter Muir Whitehill, *Museum of Fine Arts, Boston: A Centennial History* (Cambridge, Mass.: Harvard University Press, Belknap Press, 1970), vol. 2, pp. 765-766.

AUGUSTUS SAINT-GAUDENS

74

The Puritan, 1899 or after

Bronze, brown patina; figure: lost wax cast; base: sand cast

H. 31 in. (78.8 cm.), w. 19½ in. (49.5 cm.), d. 13¼ in. (33.7 cm.)

Signed (on top of base at right side):
AVGVSTVS·SAINTGAVDENS

Inscribed: (on front of base) ·THE·PVRITAN· (inset on back of base) ·COPYRIGHT BY· / AVGVSTVS SAINT-GAVDENS / ·M·D·C·C·C·XCIX·

Edwin E. Jack Fund. 1980.5

Provenance: Neal Beckerman, Boston
Versions: *Plaster*, over life-size: (1) Saint-Gaudens National Historic Site, Cornish, N.H.. *Bronze*, over life-size: (1) Springfield, Mass.; reduction: h. 31 in.: (2) Addison Gallery of American Art, Andover, Mass., (3) Allentown Art Museum, Pa., (4) Brookgreen Gardens, Murrells Inlet, S.C., (5) Connecticut Valley Historical Museum, Springfield, Mass., (6) Fidelity Management and Research Company, Boston, (7) Herbert F. Johnson Museum of Art, Cornell University, Ithaca, N.Y., (8) Mead Art Museum, Amherst College, Mass., (9) The Metropolitan Museum of Art, New York, (10) Milwaukee Art Museum, Wis., (11) Museum of Art, Carnegie Institute, Pittsburgh, Pa., (12) The New-York Historical Society, New York, (13) North Carolina Museum of Art, Raleigh, (14) Princeton University, Scheide Library, N.J., (15-17) private collections: Birmingham, Mich., Lexington, Mass., Lindsborg, Kans., (18, 19) R.W. Norton Gallery, Shreveport, La., (20) Sagamore Hill National Historic Site, Oyster Bay, L.I., N.Y., (21) Saint-Gaudens National Historic Site, Cornish, N.H., (22) The Saint Louis Art Museum, Mo., (23) Thomas Gilcrease Institute of American History and Art, Tulsa, Okla., (24) University of Nebraska Art Galleries, Sheldon Memorial Art Gallery, Lincoln, (25) Virginia Museum of Fine Arts, Richmond, (26) Williams College Museum of Art, Williamstown, Mass., (27) Erving and Joyce Wolf

This figure is a reduction of Saint-Gaudens's heroic statue *The Puritan*, 1886, which was unveiled in Springfield, Massachusetts, on Thanksgiving Day, 1887.[1] Saint-Gaudens wrote that the statue "was to represent Deacon Samuel Chapin [one of the founders of Springfield and the ancestor of Chester W. Chapin, who commissioned the work], but I developed it into an embodiment, such as it is, of the 'Puritan.' "[2] The monumental bronze tribute to Deacon Chapin almost immediately became a symbol of the purposeful, austere mentality associated with the New England Puritan. Although the sculptor meticulously researched the costume accessories appropriate to a seventeenth-century cleric,[3] he did

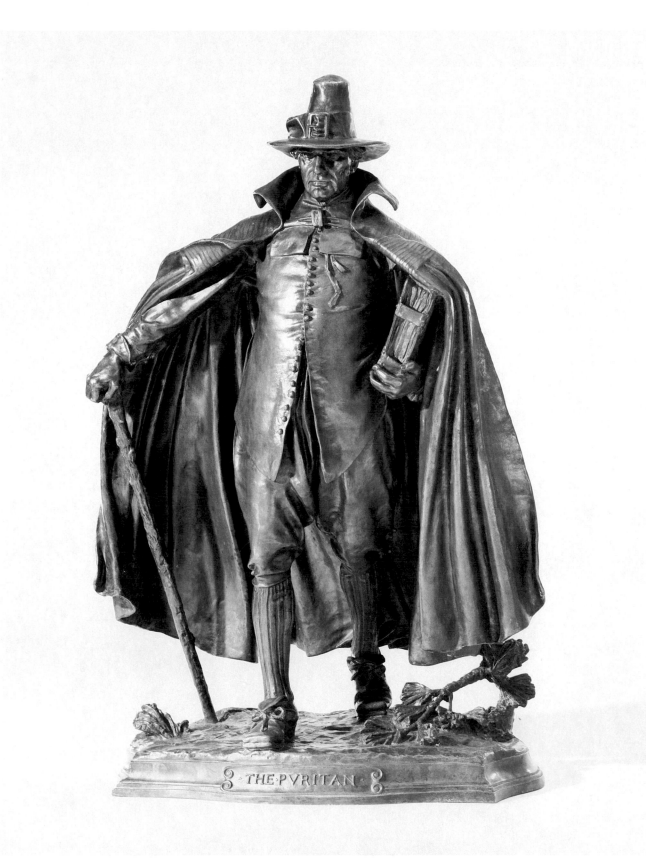

not permit the details of the period to overwhelm the character traits he wished to evoke. In fact, the clothing enhances the image: the sweep of the cloak adds great drama to the determined stride of the figure.

During the early to middle 1890s, Saint-Gaudens contemplated having reductions cast of some of his sculpture. In about 1894 Saint-Gaudens indicated to Paul Bion, a fellow sculptor and French friend from student days at the Ecole des Beaux-Arts, that he was certain that making editions of *Diana* and *The Puritan* would be a lucrative venture. Bion, who would soon become the negotiator (until his death in 1897) for the casting of Saint-Gaudens's small sculptures and reductions at Parisian foundries,[4] replied: "What story is this you're telling me about your Diana and your Puritan, that they're going to make a Niagara of gold flow into your pockets?"[5] With the invention of the Collas machine in France in 1836, speedy mechanical reductions of sculpture became a reality, and contemporary French artists such as Paul Dubois (1829-1905) and Antonin Mercié (1845-1916), whose work Saint-Gaudens esteemed, enjoyed enormous success with reductions of their pieces. Saint-Gaudens realized that large numbers of certain of his creations would not only provide him with an entirely new source of income but would also gain for him an even wider recognition. He first selected *Diana* and *Robert Louis Stevenson* to be issued in bronze editions,[6] probably choosing them for their popularity and suitability for a reduced format. *The Puritan* was the third subject to be reduced in bronze.

In 1890 the Museum of Fine Arts was interested in making a plaster cast of the over life-size *Puritan* from a plaster Saint-Gaudens would eventually send to Boston. At that time, the Museum, then in Copley Square, was avidly looking for important modern statuary to display, as it had recently expanded and was exhibiting plaster casts of both contemporary and earlier sculpture. Charles G. Loring, then director of the Museum, wrote to Saint-Gaudens: "As to the Puritan . . . Chico [the Museum's plaster molder], I think, can execute 4 copies for $400. I cannot say how grateful we shall be for giving us permission to mould it."[7] Loring kept pressing Saint-Gaudens on the Museum's desire to cast *The Puritan*, but the sculptor wanted to make a few changes on the statue before transporting it to Boston to have the replicas cast, and he was otherwise occupied: "You certainly should have the Puritan and your man shall do it but I have two or

three things [one of them the *Shaw Memorial*] to get off my hands first."[8]

It was not until 1897 that Saint-Gaudens turned his attention to the casting, and then he was thinking of having it done in New York rather than in Boston: "The studio is once more in a fearful condition with . . . the getting of the Puritan ready to photograph and cast for the Boston Museum and to send abroad to have the reductions made."[9] Loring wrote to Daniel Chester French in March 1897, saying that he was pleased that Saint-Gaudens had consented to have his Puritan cast: "I had been urging [this] . . . some years ago, but he put me off in his usual way."[10] Loring was not happy with the idea that the casting might be executed in New York since the cost for obtaining a cast would consequently be greater for the Museum. By March 24, however, the sculptor had decided that the Museum could cast the statue after all. Loring confirmed their agreement: "As I remember the arrangement between us some years ago, it was that I should take a gelatin mould, making four copies— one for you without expense; and the cost of the work to be divided among the three museums who might take the other three copies which were presumably this Museum, that at Chicago and the Corcoran Gallery."[11]

In July 1897 Saint-Gaudens asked Loring, "if I am not too late I should like to have Chico cast my copy of the Puritan in such a way that I may be able to send it to Europe where I wish to have a reduction of it made, it will be necessary for it to be in pieces that can be taken apart."[12] Loring honored Saint-Gaudens's request, sending seven cases of the statue in sections on August 27.

During the summer of 1897, while preparations were being made for the dispatch of Saint-Gaudens's copy of *The Puritan* to Paris, the sculptor was contemplating an appropriate height for the reduction. He wrote to his former assistant, Frederick MacMonnies, who was living in Paris: "I think of making two sizes unless you think it wiser to make only one."[13] During the mid-1890s, MacMonnies played an important role in advising Saint-Gaudens in New York about the manufacture of reductions —which foundries to use and what sizes to choose— having already had reductions cast of some of his own statues. Saint-Gaudens wrote to MacMonnies: "I think 70 centimetres or 27½ inches is the size for the Puritan, and of course only have one size, your Bacchante is 70 centimetres. I think the figure of the Puritan should be about the height of the Diana

and the hat en plus. Therefore *to the top of the hat* have it made *28½* high. That will make it more than 70 centimetres. I cannot tell as I have not a metre here at the studio. What I think best is that the figure shall give the same impression of size as the Bacchante, Nuff said."[14]

No sooner had Saint-Gaudens set foot in Paris in November than he started to obtain estimates for having a reduction made of *The Puritan.* The prominent bronze founder G. Leblanc-Barbedienne, successor to F. Barbedienne, responded with a fee of 1,300 francs for a figure of 75 centimeters.[15] Although *The Puritan* was in perfect condition upon its arrival, Saint-Gaudens did not like the cast itself, writing to Gaeton Ardisson, his plaster molder, that the plaster copy was abominably cast, yet adorably packed.[16] Perhaps because he was not satisfied with the Museum's job, but more likely because it was his custom to refine works even after their completion, he began to modify the plaster cast before having reductions executed. He added the inscription THE PVRITAN to the front of the plinth and inserted another pine branch. He also made some changes in the facial features. The modified plaster was then exhibited at the Société Nationale des Beaux-Arts Salon of 1898. (These alterations, which distinguish this plaster from the Springfield statue, were incorporated into the reductions that began to appear in the fall of 1898.) During July Saint-Gaudens and Leblanc-Barbedienne continued their correspondence about the reduction,[17] the latter quoting a fee of 1,300 francs to reduce the statue to 78 centimeters (3 centimeters larger than the size previously indicated, with each bronze costing 850 francs).

Years later Augusta Saint-Gaudens reported that her husband had never liked the appearance of a Barbedienne cast,[18] yet it seems as if the firm did produce some reductions since Saint-Gaudens wrote to Rose Nichols, Augusta's niece, that the reduction had been completed.[19] Throughout his stay in Paris, Saint-Gaudens sought estimates from other foundries. In October, E. Gruet gave a figure of 720 francs for the reduction with lettering,[20] and on February 2, 1900, Chartier gave an estimate of 400 francs.[21] In the end Saint-Gaudens had both of them make casts, and there were surely other foundries as well that he entrusted with commissions to fabricate reductions of *The Puritan.* Thus, Saint-Gaudens employed at least three French foundries for casting the reductions of *The Puritan* from late 1898 on.

Michael Shapiro found that in general Saint-Gaudens's choice of foundries both in France and in the United States was based principally on their estimates. After about 1900 Saint-Gaudens increased his use of American foundries for casting reductions, including *The Puritan,* and since the standards of workmanship were fairly equal among the major firms, he would usually select those making the lowest bid. As he did not patronize just one foundry, the plasters would be moved from firm to firm.[22] After the bronze reductions of *The Puritan* were cast, they, as well as those of *Diana* and *Robert Louis Stevenson,* were sold at Doll & Richards, Boston, and at Tiffany and Company and Gorham Company in New York.

In reductions of *The Puritan* variations in coloration, angle of the hat, and angle of the cane can be found. The Museum's cast, like that in the Metropolitan Museum of Art, for example, does not bear a foundry mark. Both reductions have the same markings, but consistent with Saint-Gaudens's eagerness to vary the colorations of his pieces, they have different appearances; the Metropolitan's is green, whereas the Museum's is brown.

K.G.

Notes

1. For an account of the history of the statue *The Puritan* and its later reworking into *The Pilgrim,* 1904 (Fairmount Park, Philadelphia), see Lois G. Marcus, "Studies in Nineteenth-Century American Sculpture: Augustus Saint-Gaudens (1848-1907)," Ph.D. diss., City University of New York, 1979, pp. 145-173; Dryfhout 1982, pp. 162-166.

2. Saint-Gaudens 1913, vol. 1, p. 354.

3. Louise Hall Tharp reported in *Saint-Gaudens and the Gilded Era* (Boston: Little, Brown, 1969), pp. 184-185, that "ladies of the Chapin family had found woodcuts and antique paintings to show the proper Puritan costume. A 'tailoress' was summoned to make a flowing cape, buttoned coat and knee breeches to fit the big model."

4. Michael Edward Shapiro, "The Development of American Bronze Foundries 1850-1900," Ph.D. diss., Harvard University, 1980, p. 156; see also Shapiro, *Bronze Casting and American Sculpture 1850-1900* (Newark: University of Delaware Press, 1985), p. 102.

5. ("Que me chantes-tu avec ta Diane et ton puritain qui vont faire couler un Niagara de pièces d'or dans ta poche?") Letter from Bion to Saint-Gaudens, Oct. 26 [1894?], Saint-Gaudens Papers, Baker Library, Dartmouth College, Hanover, N.H.

6. John H. Dryfhout, "Augustus Saint-Gaudens (1848-1907)," in Jeanne L. Wasserman, ed., *Metamorphoses in Nineteenth-Century Sculpture* (Cambridge, Mass.: Fogg Art Museum, 1975), p. 184.

7. Loring to Saint-Gaudens, Dec. 12, 1890, BMFA, 1876-1900, roll 547, in AAA, SI.

8. Letter from Saint-Gaudens to Loring, May 6, 1892, BMFA, 1876-1900, roll 556, in AAA, SI.

9. Letter from Saint-Gaudens to Rose Standish Nichols, the sculptor's niece by marriage, Feb. 17, 1897, quoted in Rose Standish Nichols, ed., "Familiar Letters of Augustus Saint-Gaudens," *McClure's Magazine* 31 (Oct. 1908), p. 608.

10. Loring to French, Mar. 22, 1897, BMFA, 1876-1900, roll 548, in AAA, SI.

11. Loring to Saint-Gaudens, Mar. 24, 1897, BMFA, 1876-1900, roll 548, in AAA, SI. According to Dryfhout 1982, p. 13, the plaster heroic-size casts of *The Puritan* were sold to Boston, Dresden, Chicago, and Philadelphia museums. The cast owned by the Museum of Fine Arts was disposed of by vote of the trustees, Jan. 19, 1933, as recorded in the minutes of the Committee on the Collections, Registrar's Office, BMFA.

12. Letter from Saint-Gaudens to Loring, July 28, 1897, BMFA, 1876-1900, roll 560, in AAA, SI.

13. Saint-Gaudens to MacMonnies, Aug. 3, 1897, Frederick W. MacMonnies Papers, Louise Wysong Rice, roll 3042, in AAA, SI.

14. Saint-Gaudens to MacMonnies, Sept. 2, 1897, MacMonnies Papers, Louise Wysong Rice, roll 3042, in AAA, SI.

15. Estimate, G. Leblanc-Barbedienne to L. Grandin, Nov. 15, 1897, Saint-Gaudens Papers.

16. Saint-Gaudens to Ardisson, Nov. 28, 1897, Saint-Gaudens Papers. Saint-Gaudens found that *The Puritan* had arrived in such good condition that he wished Chico to give instructions to his own packer, who was preparing the many sculptures he was having sent abroad. See Saint-Gaudens to Loring, Nov. 29, 1897, BMFA, 1876-1900, roll 560, in AAA, SI.

17. Leblanc-Barbedienne to Saint-Gaudens, July 4, 5, and 22, 1898, Saint-Gaudens Papers.

18. Letter from Augusta Saint-Gaudens to Edward Robinson, director, The Metropolitan Museum of Art, June 2, 1920, The Metropolitan Museum of Art Archives. (For a quotation from the letter, see cat. no. 78.)

19. "I have had a splendid reduction of the Puritan made [presumably by Barbedienne] and I will send some for you to put on the market." Saint-Gaudens to Rose Standish Nichols, Sept. 14, 1898, quoted in Rose Standish Nichols, ed., "Familiar Letters of Augustus Saint-Gaudens," *McClure's Magazine* 32 (Nov. 1908), p. 2. Saint-Gaudens took out a copyright on *The Puritan* dated Dec. 13, 1898. Saint-Gaudens Papers.

20. E. Gruet Jeune to Saint-Gaudens, Oct. 26, 1898, Saint-Gaudens Papers. Two casts by E. Gruet (one at the Addison Gallery of American Art, Andover, Mass., and the other at the Virginia Museum of Fine Arts, Richmond) have an inaccurate date inscribed on the base, MDCCCLXXXII instead of MDCCCLXXXVII, the date of the statue's unveiling in Springfield.

21. Letter from Chartier to Saint-Gaudens, Feb. 2, 1900, Saint-Gaudens Papers. On the letter Saint-Gaudens wrote "Chartier Estimate . . . Puritan Accepted." In a letter dated Dec. 27 [no year], Saint-Gaudens asked Ardisson to order two more casts of *The Puritan* from Chartier, who had the bronze model. The sculptor added, "I wish to have them done under the same conditions as to the chasing etc. as before and the patina done by Thiébaut." Saint-Gaudens Papers.

22. Shapiro, "American Bronze Foundries," p. 159; see also Shapiro's more recent and somewhat revised observations in *Bronze Casting*, pp. 103-104, 106.

AUGUSTUS SAINT-GAUDENS

75

Robert Louis Stevenson, 1902 or after
Bronze, green wash over brown patina, lost wax cast
H. 6⅝ in. (16.8 cm.), l. 13½ in. (34.3 cm.)
Signed and inscribed: (upper right) TO ROBERT LOUIS STEVENSON / FROM HIS FRIEND AVGVSTVS / SAINT GAVDENS NEW YORK / SEPTEMBER MDCCC / LXXXVII (upper left and center) YOUTH NOW FLEES ON FEATHERED FOOT / . . . LIFE IS OVER LIFE WAS GAY / WE HAVE COME THE PRIMROSE WAY
Bequest of Mrs. John Paramino. 1978.92

Provenance: Mrs. John Paramino, Wellesley, Mass.
Versions: *Plaster*, reduction, h. 6⅝ in.: (1) Saint-Gaudens National Historic Site, Cornish, N.H. *Bronze*, full size, dimensions unknown: (1) present location unknown; reduction, h. 6⅝ in.: (2) National Museum of American Art, Washington, D.C., (3, 4) private collections: Cambridge, Mass., Los Angeles, Calif., (5) Erving and Joyce Wolf. *Electrotype*: (1) Musée d'Orsay, Paris, (2) gilded copper, Saint-Gaudens National Historic Site

After reading *New Arabian Nights* (1882) by Robert Louis Stevenson (1850-1894), Saint-Gaudens enthusiastically told the painter Will H. Low (1853-1932), a friend of the author, that if the Scotsman ever came to America, he would be honored to model his portrait.[1] In 1887 and 1888 Stevenson sat for Saint-Gaudens several mornings in New York and in Manasquan, New Jersey, while reading and writing in bed, propped up with pillows, as was his custom. Stevenson is shown in profile, his left hand holding papers, and his right hand, an ever present cigarette. His long, graceful hands assume a prominent role, and Saint-Gaudens amusingly wrote of having to use Mrs. Saint-Gaudens's hands, which resembled those of Stevenson, as a model in the writer's absence.[2] The inscription (of which only the first line and last two lines are transcribed here) reproduces a poem from Stevenson's *Underwoods*

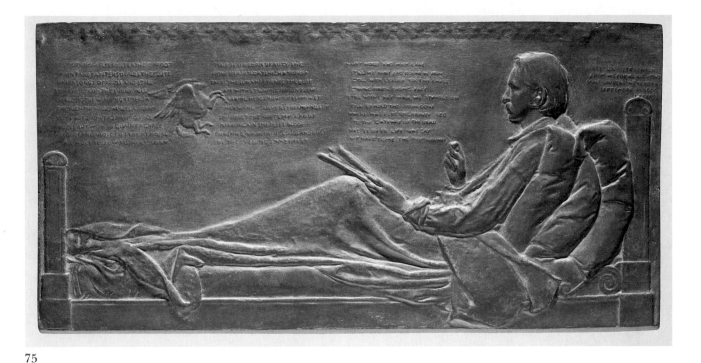

75

collection (1887), which he dedicated to Low. A charming border of ivy leaves and berries runs along the top of the bronze.

The *Robert Louis Stevenson* came to be the sculptor's best-known and most frequently reproduced portrait relief. Although he was delighted by its popularity, and pleased with the fresh source of income, Saint-Gaudens constantly varied the size, shape, inscription, and details of this one subject to avoid the mass production of the image and because it was in his nature to want to refine his work. For Saint-Gaudens, who was a curious and investigative artist, modifications in the modeling were merely part of the artistic process he wished to explore. The casting, finishing, and patinating of a sculpture—that is, all the traditional technical steps of production—were no less important aspects of its creation than the modeling. These last steps clearly determined the final appearance of an object and for him served as expressive elements as much as did a pose or gesture. Just as he persistently altered details of composition, so he tested various foundries, explored methods of fabrication, and, as early as 1881, experimented with electrotyping. Specifically, the *Stevenson* was subjected not only to casting by different foundries but also to changes in production techniques. Beginning in 1899 Saint-Gaudens had the Paris medallist Victor Janvier make copper electrotype reductions of the

horizontal, rectangular first *Stevenson* version (dimensions unknown), modeled in 1887 and 1888.[3]

John Dryfhout found that, starting in 1902, Saint-Gaudens had an edition of bronze cast reductions of the first *Stevenson* version made as well, which were identifiable by a copyright stamp in the lower right-hand corner of the relief.[4] The portrait in the Museum of Fine Arts, which is a reduction of the first version, has no copyright mark but has been proved through metallurgical analysis to be a bronze cast. The relief lacks crispness, quite possibly indicating that this example is not of the first quality and, further, that it may have been cast posthumously.

K.G.

Notes

1. Saint-Gaudens 1913, vol. 1, p. 373.

2. Ibid., p. 375.

3. See John H. Dryfhout, "Robert Louis Stevenson," in Jeanne L. Wasserman, ed., *Metamorphoses in Nineteenth-Century Sculpture* (Cambridge: Fogg Art Museum, 1975), p. 198, and Dryfhout 1982, p. 173. Michael Edward Shapiro, in "The Development of American Bronze Foundries, 1850-1900," Ph.D. diss., Harvard University, 1980, pp. 151-154, documented Saint-Gaudens's use of the electrotype as early as 1881 in reliefs of *Francis Davis Millet*, 1879, and *Jules Bastien-Lepage*, 1880. See also Shapiro's more recent observations in *Bronze Casting and*

American Sculpture, 1850-1900 (Newark: University of Delaware Press, 1985), pp. 98-101, 188, n. 62.

4. Dryfhout 1982, p. 173.

AUGUSTUS SAINT-GAUDENS

76

Jacob Crowninshield Rogers, 1902

Bronze, brown patina, lost wax cast

H. 9¹⁄₁₆ in. (23.1 cm.), w. 5⅞ in. (14.9 cm.)

Signed (at left by chair): A ST G (monogram) / ASPET

Inscribed: (at top) ·JACOB·CROWNINSHIELD·ROGERS·

(at bottom) ·M·D·C·C·C·XXVIII· ·M·D·C·C·C·

Gift of William Crowninshield Endicott. 27.583

Provenance: William Crowninshield Endicott, Boston
Exhibited: BMFA, "Back Bay Boston: The City as a Work
of Art," Nov. 1, 1969 - Jan. 11, 1970.
Versions: *Plaster*: (1, 2) Saint-Gaudens National Historic
Site, Cornish, N.H. *Bronze*, full size, h. 38¼ in., w. 22 in.:
(1) Essex Institute, Salem, Mass.; reduction, h. 9¹⁄₁₆ in.: (2-
4) present locations unknown. *Marble*: full size, h. 38¼
in., w. 22 in.: (1) present location unknown

A banker and a businessman, Jacob Crowninshield
Rogers (1828-1900) was born in Salem, Massachu-
setts, the son of Richard Saltonstall Rogers and
Sarah Gardner (Crowninshield) Rogers. In 1853 he
joined two distinguished families by marrying Eliza-
beth Putnam Peabody, a granddaughter of Captain
Joseph Peabody, a prosperous Salem merchant. Af-
ter their marriage Rogers and his wife resided in
Boston, where he was affiliated with J.B. Glover
and Company, brokers in East Indian merchandise.
From 1872 to 1879 they enjoyed an interlude in
England, during which Rogers served as a partner
in the firm of Junius S. Morgan and Company of
London. When they returned to Boston, he occu-
pied the positions of agent and attorney for the
company (which later became J.P. Morgan and
Company of New York). Prominent in financial
circles in Boston, Rogers was president of Edison
Electric and Illuminating Company, director of the
Boston and Albany Railroad Corporation, and di-
rector of the Boston Elevated Railroad Company.[1]

In 1877 the house called Oak Hill in Peabody,
Massachusetts, built in 1800-1801 probably by the
Salem architect Samuel McIntire (1757-1811), was
deeded to Elizabeth Rogers, and in 1879 she and
her husband selected it as their summer residence.
Mrs. Rogers, who lavished great attention on the
house, continued to pass the warm months there
until she died in 1921. During the early 1920s three
of the rooms (a parlor, diningroom, and a bed-

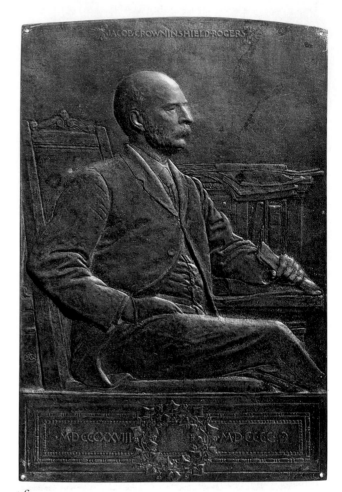

76

room) were acquired by and installed in the Mu-
seum of Fine Arts. The house, which had sat on a
knoll, was demolished in 1958, and the site was
leveled for the North Shore Shopping Center.[2]

A year after the demise of Elizabeth Rogers, her
cousin by marriage, William C. Endicott, acted as an
intermediary between the Peabody family and the
Museum of Fine Arts in attempting to have the
Museum purchase a marble version of the relief of
Jacob Crowninshield Rogers.[3] The sale was never
made, but in 1927 this bronze reduction entered
the Museum as a gift from Mr. Endicott.

One of the sculptor's lesser-known efforts, the
portrait of Rogers (The Essex Institute, Salem, Mas-
sachusetts) was commissioned by the sitter's family
and executed in 1901, following Rogers's death.
Near the end of his career, Saint-Gaudens was not
in the best of health and, in a note, Homer Saint-
Gaudens poignantly alluded to his father's failing
strength as he described the circumstances sur-
rounding the commission: "It was *interesting* for him

to *make a typical business man of the best type*. The conception was like the sole photograph though every detail 'treated.' It was finished in the early spring [1901]. He worked *more personally* on that than on others at the time. He worked on it sitting down and slowly."[4]

Even as the full-size bronze of Rogers was being cast, Saint-Gaudens turned his attention to having reductions made. He wrote to Gaeton Ardisson (1856-1926), his plaster molder, then in Paris on June 3, 1901: "I have sent to you two medallions (Mrs. Beaman and Mr. Rogers) I wish reductions made of them of the size of the papers which I enclose—I should like four replicas in bronze of the Rogers."[5] In a letter of July 4, 1901, to one of the members of the Peabody family, Saint-Gaudens wrote: "The medallion [Essex Institute] is cast and as soon as the frame is done I will send it to Mrs. Rogers. That may take a fortnight more. The reductions are now being made in Paris and I think that in a month from now I will be able to send her the little bronze replica."[6] Saint-Gaudens typically revised his ideas, and during the course of the summer he asked Ardisson to make changes in the reductions. He requested that an addition of a panel be made and later that a wreath be placed on it.[7] In the fall of 1901 he experimented with the size of the reductions before coming to a decision about the final dimensions.[8] The Museum's cast of the *Rogers* is a reduction of the Essex version and reflects the modifications Saint-Gaudens made in the smaller format.

Seen in three-quarter length, Rogers sits firmly in his chair, head in profile. His right hand is placed in the trouser pocket while his left hand firmly grasps a piece of paper. Although Homer Saint-Gaudens commented that his father worked on the piece "more personally" than on other reliefs during that period, the relief, lacking the dazzling surface treatment for which Saint-Gaudens was celebrated, reflects to some degree the hand of an assistant. James Earle Fraser (1876-1953), in fact, is known to have helped with the modeling of the portrait. A passage such as the clothing covering Rogers's stomach seems not especially well realized: the folds are not effectively handled, and there appears to be no clear understanding of how the body behaves beneath them. Nevertheless, Saint-Gaudens conveys with considerable success the sitter's patrician lineage and professional stature by the pose and careful characterization.

K.G.

Notes

1. For information about Rogers, see *Boston Globe*, Jan. 3, 1900, obit.

2. For a history of Oak Hill and its owners and an account of the installation of the rooms in the Museum, see *Museum of Fine Arts Bulletin* 81 (1983).

3. See letters from Charles Hawes, assistant director of the Museum, to William C. Endicott, Jan. 25, 1922, Endicott to Hawes, Jan. 26, 1922, Arthur Fairbanks, director, to Endicott, Jan. 28, 1922, Endicott to Fairbanks, Jan. 30, 1922, BMFA, 1901-1954, roll 2452, in AAA, SI.

4. Homer Saint-Gaudens, Notes, Saint-Gaudens Papers, Baker Library, Dartmouth College, Hanover, N.H.

5. Saint-Gaudens to Ardisson, June 3, 1901, Ardisson Scrapbooks, Saint-Gaudens Papers.

6. Saint-Gaudens to [?] Peabody, July 4, 1901, Mrs. Harold Peabody Collection, Ho, HU.

7. See letters from Saint-Gaudens to Ardisson, n.d. [July-Aug.?], Aug. 18, Sept. 3, Oct. 5, 1901, Ardisson Scrapbooks, Saint-Gaudens Papers.

8. Ibid., Nov. 1, Nov. 28, 1901, Ardisson Scrapbooks, Saint-Gaudens Papers. In Saint-Gaudens's income figures notebook, the following entries are recorded: Apr. 1, 1901, he received from Mrs. J.C. Rogers partial payment for the bronze relief of Rogers; Feb. 12, 1902, he received final payment for the bronze, as well as payment for a plaster cast; Aug. 12, 1902, he received from Mrs. Rogers payment for four bronze reductions of the full-size bronze of Rogers; and Feb. 1, 1903, payment for a marble replica. Saint-Gaudens Papers.

AUGUSTUS SAINT-GAUDENS
77
Anna Lyman Gray, 1904
Bronze, brown patina, lost wax cast
H. 11⅞ in. (30.2 cm.), w. 7¾ in. (19.7 cm.)
Signed (at right above chair rail): A ST G (monogram)
Inscribed: (at top) ·CORNISH·NEW·HAMPSHIRE· OCTOBER·M·D·C·C·C·II· (at bottom) ·ANNA·LYMAN· GRAY·
Gift of Mrs. John Chipman Gray. 20.599

Provenance: Mr. and Mrs. John Chipman Gray, Boston
Exhibited: BMFA, "Back Bay Boston: The City as a Work of Art," Nov. 1, 1969-Jan. 11, 1970.
Versions: *Plaster*, reduction, h. 8¾ in., w. 5½ in.: (1, 2) Saint-Gaudens National Historic Site, Cornish, N.H. *Bronze*, full size, h. 35⅛ in., w. 25⅝ in.: (1) Saint-Gaudens National Historic Site; reduction, h. 8¾ in., w. 5½ in.: (2) private collection, N.J. *Marble*, full size, h. 35⅛ in., w. 25⅝ in.: (1) Massachusetts General Hospital, Warren Library, Boston. *Electrotype*, reduction, h. 8¾ in., w. 5½ in.: (1) Musée d'Orsay, Paris, (2) copper, Saint-Gaudens National Historic Site

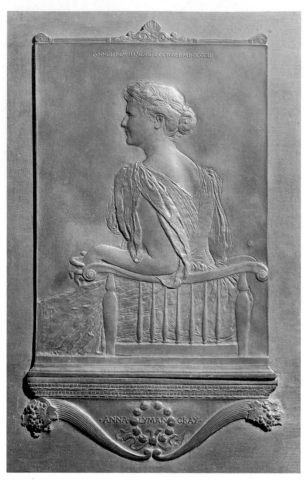

77

Anna Sophia Lyman (Mason) Gray (1854-1932), known to her friends as Nina, was the daughter of the Reverend Charles Mason, rector of Grace Church, Boston, and Anna Huntington (Lyman) Mason.[1] In 1873 she married John Chipman Gray, a prominent Boston lawyer, professor, author, and cofounder of the prestigious Boston law firm Ropes and Gray. Gray ably served the Museum of Fine Arts as a trustee from 1896 until his death and was a member of the Museum's Finance Committee during the last five years of his life.

Among Anna Gray's pursuits was the writing of poetry, and a selection of her works, which the historian Walter Whitehill described as "rather charming verses,"[2] was privately printed by the Riverside Press, Cambridge, in 1930 under the title *Along the Road*. One of the poems, *St. Gaudens Memorial Statue, Rock Creek Burial Ground*, has as its subject the sculptor's *Adams Memorial* of 1891.

Mrs. Gray was a dedicated philanthropist, serving on the ladies' visiting committee of the Massachu-

setts General Hospital and on the visiting committee of the kindergarten of the Perkins Institution for the Blind. She had great skill as a hostess and was active in entertaining foreign visitors. Daniel B. Updike, founder and proprietor of the Merrymount Press in Boston, wrote a moving tribute to Anna Gray in July 1932, shortly after her demise: "The recent death of Mrs. John Chipman Gray has brought forth some public and many private expressions of affection and admiration. One remarkable characteristic, however, has been little touched upon—her charm and ability as a hostess. . . . her drawing-room year after year, in good times and bad times, on summer afternoons at Cambridge or on winter Sundays in town [was] a meeting-place for people old and young, dull and clever, rich and poor, native and foreign, persons worldly and persons religious, who all found that some need, unsatisfied elsewhere, found satisfaction in her house.

"All this was quite unconsciously accomplished— by love. For Mrs. Gray loved people. She was interested in their thoughts, actions, and lives, and furthermore she loved affection from others—she loved to be loved."[3]

The portrait of Anna Lyman Gray (Saint-Gaudens National Historic Site, Cornish, New Hampshire), which is not well known in Saint-Gaudens's oeuvre, was commissioned by John Chipman Gray and executed in 1902[4] in Cornish, where the sculptor had a home and studio. Subsequently, a marble version was made (Massachusetts General Hospital, Warren Library, Boston), and later, reductions, both casts and electrotypes, were produced.[5] According to his custom, Saint-Gaudens varied details, and in the Museum's relief, which is a cast reduction, he had added to the base an architectural molding supported by cornucopias that enclose a beribboned wreath and the sitter's name.

The portrait shows Anna Lyman Gray seated in three-quarter length with her back turned partly toward the viewer and her head in profile. The relief is surmounted by an anthemion and scroll design, which, in the Museum's example, provides a pleasing counterpoint to the decoration at the base. It is a rather tame and undemanding object; to its credit, however, the face is sympathetically rendered, and the hair is masterfully treated, with fragile wisps at the nape of the neck in a manner that recalls the sculptor's splendid portraits of Mariana Griswold Van Rensselaer, 1888 (The Metropolitan Museum of Art, New York), and of Mildred Howells (q.v.). Like the *Jacob Crowninshield Rogers* (q.v.),

the relief is a late piece and was made during a period when Saint-Gaudens's physical and creative powers were on the wane. Not surprisingly, one of his assistants, Frances Grimes (1869-1963), collaborated on the portrait and, with the exception of the head, may have done the lion's share of the work.

K.G.

Notes

1. For information about Anna Lyman Gray, see *Boston Evening Transcript*, May 18, 1932, obit.

2. Letter from Walter Whitehill to Eugenia Kaledin, Apr. 18, 1972, BMFA, ADA.

3. See BMFA, ADA.

4. The relief may not have been cast until 1903, for Saint-Gaudens wrote to his plaster molder Gaeton Ardisson on May 18, 1903: "Would you go to Newark and see what the founder is doing with the medallion of Mrs. Gray" ("Voulez-vous aller a Newark voir ce que fait le Fondeur avec le medallion de Mme Gray"). Ardisson Scrapbooks, Saint-Gaudens Papers, Baker Library, Dartmouth College, Hanover, N.H. The founder was probably Ernest Vatier, whose name and address in Newark appear in Saint-Gaudens's address book dating from the early years of the twentieth century. On Oct. 12, 1903, Saint-Gaudens entered in his income figures notebook that he received from John Chipman Gray $6,000 as full payment for the relief.

5. Saint-Gaudens's income figures notebook records the following entries: June 23, 1904, he received from John C. Gray payment for a marble replica of the bronze portrait of Mrs. Gray; Jan. 9, 1905, he received from Gray payment for reducing the relief of Mrs. Gray and for one bronze replica. Saint-Gaudens Papers.

AUGUSTUS SAINT-GAUDENS
78 (color plate)
Head of Victory, 1907 or after
Bronze, green-brown patina, lost wax cast
H. 8 in. (20.4 cm.), w. 7 in. (17.8 cm.), d. 6¼ in. (15.9 cm.)
Signed (on left side of subject's neck): A·SAINT-GAVDENS·M·C·MV·
Inscribed: (on plaque at front) NIKH-EIPHNH (around support) COPYRIGHT BY / A SAINT-GAUDENS / MCMVII
Helen and Alice Colburn Fund. 1977.600

Provenance: Richard A. Bourne Co., Hyannis, Mass., Aug. 16, 1977, no. 96
Exhibited: BMFA 1979, p. 28, no. 21; BMFA, "Faces," Faneuil Hall, June-Dec. 1979.
Versions: *Plaster*: (1) National Museum of American Art,

Washington, D.C. (2, 3) private collections, Francestown, N.H., N.Y., painted. *Bronze*: (1) Mark Christy, Pittsburgh, Pa., (2) Marion Hunt, Santa Monica, Calif., (3) Paul Magriel, New York, gilded, (4) The Metropolitan Museum of Art, New York, (5) Museum of Fine Arts, Boston, apparatus, (6) The Newark Museum, N.J., (7) Nichols House Museum, Boston, gilded, (8-15) private collections, Hamilton, Mass., traces of gilding, Miami, Fla., New York [2], Northford, Conn., Pa., Providence, R.I., Solon, Ohio, (16) Saint-Gaudens National Historic Site, Cornish, N.H., (17) The Saint Louis Art Museum, Mo., on loan from the Saint Louis Science Center, (18) University of California, Santa Cruz, Adlai Stevenson College, (19) Erving and Joyce Wolf

Saint-Gaudens made several studies, of which this bronze is an example, for the head of the Victory figure in conjunction with the *Sherman Monument*, his last great public sculpture, erected under the auspices of the Chamber of Commerce of the State of New York.[1]

Much of the work on the *Sherman Monument* was carried out in Paris during Saint-Gaudens's stay there from November 1897 until the summer of 1900. After the sculptor returned to the United States in mid-1900, he had a heroic-size plaster sent from Paris to his studio in Cornish, New Hampshire. Convalescing from surgery and in the company of an army of assistants, Saint-Gaudens made changes in the equestrian statue right up to the

78

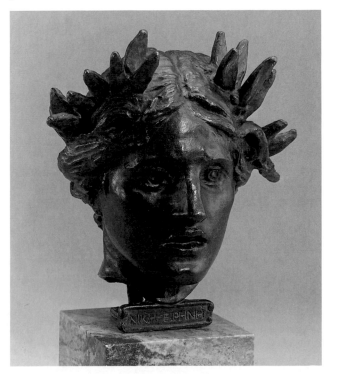

moment it was cast in bronze in 1901 by the French foundry Thiébaut. Indeed, his modifications, which included alterations of the Victory head, were carried on even after the bronze had been cast. Saint-Gaudens insisted that the adjustments be incorporated into the monument, and he sent the plaster casts of the new sections to Paris for the foundry to cast separately and insert in the already completed bronze.[2]

Getting the *Victory* head right was no easy task. "First, the initial study failed to content him, for therein he had copied certain beautiful features until he felt that he had filled it with overmuch 'personality.' Then the second attempt, although intrinsically of greater worth [and said to have been preferred by the sculptor], appeared even more out of keeping with the monument. So finally he was forced to return to his earlier model, and to labor over it indefatigably until he had developed it to his liking."[3]

Saint-Gaudens apparently kept reworking the *Head of Victory*, as is evidenced by the variety of dates, such as 1902, 1904, and 1905 (all inscribed in Roman numerals), inscriptions, and bases on different casts. The extremely handsome gilded bronze cast in the Nichols House Museum in Boston, for instance, is dated 1902 and inscribed to Rose Nichols. A plaster *Head of Victory* inscribed to John H. Spaulding (National Museum of American Art, Washington, D.C.) is also dated 1902. Many, probably most, of the Victory heads were not inscribed as gifts; they were marketed similarly to other Saint-Gaudens pieces after the mid-1890s and cast posthumously as well.

The Museum's cast, bearing the date 1905 and the copyright 1907 (both in Roman numerals), is a fine example of the second version, green-brown in color, with a surface of moderate sheen. Offended by how some of her husband's sculpture in the Metropolitan Museum of Art, New York, had been too highly polished, Saint-Gaudens's widow, Augusta, described what Saint-Gaudens had tried to avoid in his bronzes in a letter of 1920 to Edward Robinson, then director of the Metropolitan: "[The] color of my husband's bronzes is [such] that I know he would have disliked them as they are now. He was always striving to get away from what he called Barbedienne bronze, which is so hard, dark and shiny. His horror of statues looking like stove-pipes was why he was so insistent on gilding the Sherman."[4] Robinson responded saying that he had had the surface of the bust of Sherman, head of Far-

ragut, and relief of Stevenson (all posthumous casts Augusta had authorized and cast for the Metropolitan in 1910) toned, and the glossy effect to which she objected removed, so that the pieces look as they did when they were first received.[5]

Befitting her type, Victory wears a laurel crown on her hair, which is pulled together at the back of her head in a classical knot. Her features bear a strong resemblance to those in earlier works such as the marble caryatids in the Vanderbilt Mantelpiece, 1882, and *Amor Caritas*, 1898 (this cast 1918) (both in the Metropolitan Museum of Art), forming a leitmotiv in Saint-Gaudens's art.

K.G.

Notes

1. For a history of the *Sherman Monument*, see Saint-Gaudens 1913, vol. 2, pp. 124, 133-136, 227, 289-300; and Kathryn Greenthal, *Augustus Saint-Gaudens, Master Sculptor* (New York: The Metropolitan Museum of Art, 1985), pp. 156-162.

2. Dryfhout 1982, p. 254.

3. Saint-Gaudens 1913, vol. 2, pp. 290, 293.

4. Augusta Saint-Gaudens to Robinson, June 2, 1920, MMA, Arch.

5. Robinson to Augusta Saint-Gaudens, June 8, 1920, MMA, Arch.

AUGUSTUS SAINT-GAUDENS
79
Relief of Victory, 1907 or after
Bronze, brown patina, lost wax cast
Diam. 9½ in. (24 cm.)
Signed (lower right): A ST G (monogram)
Inscribed (near upper rim): NIKH-EIPHNH
(on lower rim): CO[PYRIGHT] BY A SAINT GAUDEN MCMX[?]II
Bequest of Mrs. John Paramino. 1978.93

Provenance: Mrs. John Paramino, Wellesley, Mass.
Versions: *Bronze*: (1) private collection, Waban, Mass., (2) Saint-Gaudens National Historic Site, Cornish, N.H., (3) Erving and Joyce Wolf

The image on this medallion is derived from Saint-Gaudens's second study for the *Head of Victory* (q.v.) that the sculptor modeled in relation to the *Sherman Monument*. Created independently of any commission, this object can be interpreted as an exploration in relief form of that which Saint-Gaudens had successfully executed in three dimensions. It is also related to the sculptor's studies for the obverse of

both the one-cent coin, 1906 (never minted), and the ten-dollar gold coin, 1907 (BMFA 1980.28).[1] In fact, the image on the relief is the same as that on the obverse of the plaster one-cent piece. The differences are in identifying details such as the inscriptions. One interesting feature of the relief is the placement of the head off-center (in contrast to the obverse of the plaster one-cent coin, where the head is firmly grounded in the center of the composition). The inscription NIKH-EIPHNH (Victory-Peace) is situated slightly off-center as well. Altogether, it is a very subtle and pleasing play of design.

This allegorical head is shown in profile, looking left. Victory's lips are parted, and she wears a wreath in her hair. Following his usual practice, Saint-Gaudens paid particular attention to the treatment of the hair, using its richly textured waves as a counterpoint to the strong outline of the profile.

The copyright notice scratched on the rim misspells Saint-Gaudens's name by omitting the "s" in Gaudens, and the date appears to read MCMXII rather than the MCMVII inscribed on another cast of the relief (Erving and Joyce Wolf). The medallion, together with Saint-Gaudens's reliefs of Francis Davis Millet and Robert Louis Stevenson and study for the head of Victory, was a gift to the Museum from the estate of Mrs. John Paramino, widow of the Boston sculptor (1888-1956).

K.G.

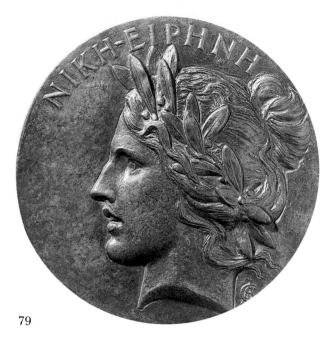

79

Notes

1. Saint-Gaudens 1913, vol. 2, pp. 291, 331.

Daniel Chester French (1850–1931)

Long considered the "dean of American sculptors,"[1] and perhaps the most popular, Daniel Chester French realized his early promise in a succession of notable public monuments, private memorials, and portrait busts. His work went beyond the idealism of his neoclassical predecessors, incorporating a naturalism that was closer to life and more appealing to his contemporaries. French was generous with his success, sharing his commissions with younger colleagues, encouraging new talent, and collaborating with some of the major architects of his generation.

Born in Exeter, New Hampshire, French moved to Concord, Massachusetts, in 1867, when his father, Henry Flagg French, took up the practice of law in Boston. French entered the Massachusetts Institute of Technology at seventeen but was a poor student and after a year gave up his academic studies. At home in Concord, he started modeling in clay with tools borrowed from his artist-neighbor Abigail May Alcott (1840-1879), a daughter of the celebrated transcendentalist Amos Bronson Alcott. French was chiefly self-taught, with his artistic instruction limited to beginning art classes with May Alcott in Concord, where he was the only male, and a month in New York in 1870, which he spent in John Quincy Adams Ward's studio, while also attending evening drawing classes at the National Academy of Design. In Boston during the winters of 1871 and 1872, he took lessons briefly from William Rimmer in artistic anatomy and from William Morris Hunt in drawing.

With the support of Ralph Waldo Emerson, Concord's illustrious philosopher, French was awarded the commission in 1873 to commemorate the Battle of Concord and the American centennial. Since the figure of the embattled farmer was to be carved in granite, he added a plow as a structural support in a brilliant adaptation of the *Apollo Belvedere* (Vatican Museums), a cast of which he knew from the Boston Athenaeum. Although the committee on the monument decided by November to have the statue cast either in zinc or bronze, French retained the plow in the enlargement. While he worked on the *Minute Man*, 1875 (Minuteman National Historical Park, Concord), the young novice consulted such established sculptors as Thomas Gould, Anne Whitney, and Rimmer, who gave him practical advice, and Ward, who encouraged him to prepare the model for bronze casting. During the two years he devoted to the sculpture, French helped to support himself

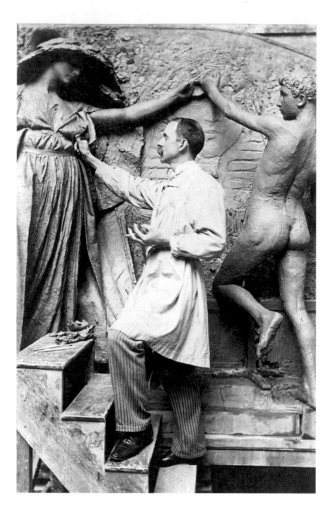

by making plaster figurines for the Boston ceramics firm of Clark, Plympton and Company.

In November 1874 the Concord committee selected the Ames Foundry, Chicopee, Massachusetts, to cast the *Minute Man* in bronze. French did not wait to see the result or the festive unveiling the following year since he had accepted invitations to go to Florence and work in Thomas Ball's studio and live with Preston Powers's family. *The Awakening of Endymion*, 1876 (Chesterwood, Stockbridge, Massachusetts), a sensitive interpretation of the antique *Barberini Faun* (Glyptothek, Munich), is the only full-size sculpture French created during the eighteen months he spent in Italy.

On his return to America in 1876, French opened studios in Washington and Boston, where he designed sculptural decorations for federal buildings in Boston, Saint Louis, and Philadelphia, contracts promoted by his father, then assistant secretary of the treasury. To augment his income, he also modeled portrait busts of a number of prominent Boston and Concord residents, including one of

Emerson, 1879 (Memorial Hall, Harvard University), and his first of Amos Bronson Alcott, 1881 (present location unknown). The *Emerson* bust was copyrighted in 1879, and numerous versions were made in plaster, marble, and bronze. French's intimate acquaintance with the celebrated intellectuals of his day helped infuse these distinguished likenesses with great sensitivity and warmth.

In 1883 French received his second important commission from Samuel J. Bridge, a Boston businessman and loyal Harvardian, to execute an idealized statue of John Harvard, 1884 (Harvard University), the Puritan clergyman, bibliophile, and founder of the college. He again sought the advice of Ward for costume detail and delegated to the Boston sculptor Edward Clark Potter the making of the armature and the plaster enlargement. Difficulties in preparing the model for bronze casting, however, convinced French that time spent in Paris would help perfect his technique. Beginning in October 1886 he spent almost a year there, modeling a statue of the Michigan senator Lewis Cass, 1899 (Statuary Hall, United States Capitol, Washington, D.C.), and taking classes with Paul Léon Glaize (1842-1932) but avoiding the overcrowded classes at the Académie Julian.

French returned to America in July 1887, and the following spring, confident that he would advance faster in New York, decided to settle there. He was also concerned that social disapproval of his intended marriage to his first cousin Mary Adams French would be too great if the couple remained in Concord or Boston.[2] That year he completed the model for the heroic bronze *Thomas Gallaudet Memorial*, 1889 (Gallaudet College, Washington, D.C.), awarded in 1887 by the Columbia Institution for the Deaf. A pioneering teacher of the deaf, Gallaudet is shown seated in an armchair with his first pupil, Alice Cogswell, standing at his side; both are absorbed in forming the letter A in sign language. Distinguished by its technical virtuosity and psychological insight, the *Gallaudet* marked a notable advance for French from his relatively austere and somewhat angular portrayal of John Harvard.

Now French's formative years were over, and at age thirty-nine he began his first ideal monument, the memorial to Martin and Joseph Milmore, dedicated in 1893 (Forest Hills Cemetery, Jamaica Plain, Massachusetts). In the high (almost freestanding) bronze relief, the Angel of Death, a hooded figure with great feathered wings, gently stays the hand of a young sculptor as he carves the figure of a sphinx,

in an allusion to Martin Milmore's own granite Civil War monument in Mount Auburn Cemetery, Cambridge.[3] Cast at E. Gruet Jeune, Paris, the *Milmore* was presented at the Salon of May 1892, where it won a third-class medal and praise for its mystical imagery and superb technique; it was then shown at the new Salon organized by the Societé Nationale des Beaux-Arts.[4]

A plaster cast of the *Milmore* was also exhibited at the 1893 World's Columbian Exposition, Chicago, where French was asked to create in staff both a colossal, gilded figure representing the Republic for the Court of Honor and, with Potter, the heroic-size quadriga group *Triumph of Columbus* for the arch of the Peristyle.[5] French's *Republic* dominated the international fair like a modern-day Colossus of Rhodes, "synonymous with American superiority," and, in its somewhat stylized verticality, complemented the Renaissance-style exposition buildings on an unprecedented scale.[6]

Other important commissions now followed with increasing frequency. For the *John Boyle O'Reilly Memorial*, 1896 (Fenway, Boston), awarded by the Boston Art Commission in 1892, French created a novel arrangement in which he placed three bronze allegorical figures, Patriotism, Erin, and Poetry, and the portrait bust of the Irish Nationalist poet and editor on either side of a tall granite slab with Celtic ornamentation. This design anticipated the elaborate exedra setting of his first public monument in New York, the memorial to the Beaux-Arts architect William Morris Hunt (Fifth Avenue at 70th Street), dedicated in 1898. French also began sketches in 1894 of his first life-size, low reliefs: three pairs of bronze doors for the entrance to the Boston Public Library, dedicated in 1904, which depict single female figures representing the themes of Knowledge and Wisdom, Music and Poetry, Truth and Romance. These efforts brought French the admiration of many Bostonians (long frustrated by Saint-Gaudens's difficulties in completing his own contracts for the city) and further orders for public sculpture.

French's professionalism—his respect for timetables and clients alike, the ease with which he went from small maquette to full-size model, and his desire to individualize each commission—ensured his success. Between 1896 and 1916 he completed nine major public sculptures in the Boston area, establishing in 1897 a summer studio called Chesterwood at Stockbridge, Massachusetts, where many of these were prepared.[7] For the State House, Bos-

ton, French designed an equestrian statue of the Revolutionary hero Major General Joseph Hooker, 1903 (East Wing grounds), a cooperative effort again with Potter; a standing figure of the Civil War General William Francis Bartlett, 1904 (Nurses Hall); and a seated portrait of Governor Roger Wolcott, 1907 (House of Representatives corridor), all done with the assistance of the architect Henry Bacon (1866-1924).

French's rich imagery, pictorial yet always subordinate to larger concepts and the overall design, was well suited to the grandiose architectural schemes of late nineteenth- and early twentieth-century industrial barons and federal bureaucrats, as translated by the eminent practitioners Charles Follen McKim and Cass Gilbert. His enthroned figure of *Alma Mater*, 1903, for the entrance steps of McKim's Low Library at Columbia University, was conceived as a symbol of welcome for new students and, like the *Republic's* beaconlike presence at the Chicago fair, relates well in scale to the open courtyard and surrounding structures. Similarly, *The Continents*, 1907, designed by French for the four entrance blocks of Gilbert's United States Custom House, New York, represents an Olympian celebration of the world's resources, with a plenitude of accessories, in keeping with the elaborate facade of the building.

Indisputably, the *Melvin Memorial*, 1908 (Sleepy Hollow Cemetery, Concord), a tribute to three brothers killed in the Civil War, remains French's finest ideal sculpture. Another combined effort with Bacon, the *Melvin*, also called *Mourning Victory*, represents a perfect balance of architectural and figurative elements that mirror the exquisite opposition of the spiritual and the physical. The otherworldly angel of the *Milmore* appears here half-nude, evoking an "almost sensual physical presence." Holding aloft a sprig of laurel and the American flag, which unfurls around her, she seems to emerge from the stone slab, as if "from darkness into light and by doing so affirms the sculptor's belief in life after death."[8]

French's treatment of the female form, so gracefully depicted in the *Melvin Memorial* and in the Boston Public Library doors, found its freest expression in the *Spencer Trask Memorial*, also known as the *Spirit of Life*, 1915 (Congress Park, Saratoga Springs, New York), and in the *George Robert White Memorial*, 1924 (Public Garden, Boston). In these later works, a new expressiveness and a bold sense of movement are evident, qualities that reflect the

great latitude French now enjoyed in interpreting his clients' wishes.

In all, French and Bacon collaborated on nearly fifty public monuments, none of which is more celebrated than the *Lincoln Memorial* (The Mall, Washington, D.C.), unveiled in 1922. Carved in marble by the Piccarilli Brothers, New York, the *Lincoln*, in its majestic characterization of the wartime president, quickly attained the power of a national icon.[9] Like French's earlier heroic bronze standing figure of Lincoln, 1912 (Lincoln, Nebraska), the ennobled leader is portrayed in a meditative pose that transcends temporal events.

French received many honors over his long career. In 1899 he became the first American to be admitted to membership in the Italian Accademia di San Luca, and in 1910 he was made a Member of the French Legion of Honor. Elected an Academician of the National Academy of Design, New York, in 1901, he went on to serve as a trustee of the Metropolitan Museum of Art, where from 1903 until the end of his life he chaired the Committee on Sculpture, setting acquisition policies for a generation. French's stature in the annals of American art was legendary long before he died at the age of eighty-one. As the historian Lorado Taft wrote in 1903, "It is his great distinction to have created good sculpture which the people could love; works which reveal their beauty to the most primitively informed in art, and which nevertheless are gratifying to the brother craftsmen. . . . No one has a greater following and yet, most agreeable paradox! no one has done better work."[10]

P.M.K.

Notes

1. Taft 1930, p. 542; and *New York Times*, Oct. 8, 1931, obit.

2. I wish to express my appreciation to Michael Richman for sharing his recent research on French's Boston associations.

3. Martin Milmore, however, was thirty-nine when he began the *Sphinx*; his older brother Joseph (1842-1886) did the actual carving.

4. The *Milmore* was the only public monument by French cast by a foreign foundry. During his long career, French used nine American firms, usually choosing the one with the lowest bid, but he did not promote an edition of his bronzes until the completion of his standing *Lincoln* in 1912. See Michael Richman, "Daniel Chester French, 1850-1931," Jeanne L. Wasserman, ed., *Metamorphoses in Nineteenth-Century Sculpture*, exhibition catalogue (Cambridge Mass.: Fogg Art Museum, 1975), pp. 222-223.

5. French and Potter also executed four groups that were placed in the Court of Honor. Like almost all of the exposition's exterior decorative sculptures, these groups were composed of staff, a mixture of plaster and hemp fiber that was easily worked and inexpensive but impermanent. For a discussion and photographs of the preparations for the exposition, see Wayne Craven, "Images of a Nation," in Whitney 1976, pp. 55-56.

6. For a recent interpretation of the World's Columbian Exposition as a symbolic frontier easing the public into the world of tomorrow with nostalgic reminders of the past, see Karol Ann Marling, *The Colossus of Roads: Myth and Symbol along the American Highway* (Minneapolis: University of Minnesota Press, 1984), pp. 17-30.

7. Chesterwood, designed by Henry Bacon, became the property of the National Trust for Historic Preservation in 1967.

8. Michael Richman, *Daniel Chester French, an American Sculptor* (1976; reprint ed., Washington, D.C.: Preservation Press, 1983), p. 118.

9. French's seated *Lincoln* may be compared with the *Olympian Zeus* by Phidias (destroyed; nineteenth-century reconstruction by Quatremère de Quincy) and Horatio Greenough's *George Washington*, 1841 (National Museum of History and Technology, Washington, D.C.); in all three, a colossal figure sits on a throne with a *suppedaneum*, or footstool, usually reserved for persons of divine or imperial rank in classical art. See John S. Crawford, "The Classical Tradition in American Sculpture: Structure and Surface," *American Art Journal* 11 (summer 1979), pp. 40-41. However, unlike the toga-draped *Washington*, whose obvious Graeco-Roman origins have always made Americans uncomfortable, the *Lincoln*, whose classical derivation is not apparent to the general viewer, enjoys continuing popularity.

10. Taft 1930, p. 331.

References

Adeline Adams, *Daniel Chester French, Sculptor* (Boston: Houghton Mifflin, 1932); *Boston Evening Transcript*, Oct. 7, 1931, obit.; Caffin 1903, pp. 55-70; William A. Coffin, "The Sculptor French," *Century Illustrated Magazine* 59 (Apr. 1903), pp. 871-879; Craven 1968, pp. 392-406; The Detroit Institute of Arts, *The Quest for Unity: American Art between World's Fairs, 1876-1893* (1983), pp. 154-155; Helen B. Emerson, "Daniel Chester French," *New England Magazine* 16 (May 1897), pp. 259-274; Kathryn Greenthal and Michael Richman, "Daniel Chester French's Continents," *American Art Journal* 8 (Nov. 1976), pp. 47-58; *New York Herald Tribune*, Oct. 8, 1931, obit.; Michael Richman, *Daniel Chester French, an American Sculptor* (1976: reprint ed., Washington, D. C.: Preservation Press, 1983); idem, "Daniel Chester French and Henry Bacon: Public Sculpture in Collaboration, 1897-1908," *American Art Journal* (summer 1980), pp. 46-64; idem, "The Early Career of Daniel Chester French, 1869-1891," Ph.D. diss., University of Delaware, 1974; idem, "The Early Public Sculpture of Daniel Chester French," *American Art Journal* 4 (Nov. 1972), pp. 97-115; Michael Edward Shapiro, *Bronze Casting and American Sculpture, 1850-1900* (Newark: University of Delaware Press, 1985), pp. 77-91, 146; Taft 1930, pp. 310-331; Lorado Taft, "Daniel Chester French, Sculptor," *Brush and Pencil* 5 (Jan. 1900), pp. 145-163; Whitney 1976, pp. 273-274.

DANIEL CHESTER FRENCH
80
Amos Bronson Alcott, 1890
Plaster
H. 23 in. (58.4 cm.), w. 13 in. (33 cm.), d. 10¾ in. (27.3 cm.)
Lent by the sculptor. 1419.90

Provenance: Daniel Chester French, New York; lent to Museum in 1890*
Exhibited: Society of American Artists, New York, *Catalogue of the Twelfth Exhibition of the Society of American Artists* (1890), no. 86; BMFA, *Catalogue of the Thirteenth Exhibition of the Society of American Artists* (1891), no. 77 or 78.
Versions: *Plaster*: (1) Orchard House, Concord, Mass., (2) present location unknown, formerly William Torrey Harris, Washington, D.C., (3) The Art Institute of Chicago (destroyed), (4) E. Gruet Jeune, Paris (destroyed). *Bronze*: (1) Chesterwood, Stockbridge, Mass.

Amos Bronson Alcott (1799-1888), educational reformer, feminist, and abolitionist, was "one of those curious, eccentric, and at the same time most attractive figures, that . . . made Concord, Mass., the home of their mystic transcendental philosophy."[1] Remembered mainly as the father of Louisa May, author of *Little Women* (1868), Alcott wrote a regular column, "Orphic Sayings," for the transcendentalist periodical the *Dial*. He also gave occasional arcane "Conversations" in Boston or at the home of his neighbor the eminent essayist Ralph Waldo Emerson before rapt audiences eager to hear him expound on topics "such as poetry, nature, fate, love, idealism, individuality, character—subjects so broad and deep as to be inexhaustible."[2] In 1843 Alcott, with the English mystic Charles Lane, attempted to set up an Edenic community called Fruitlands, at Harvard, Massachusetts, but this utopian effort was short-lived.

Daniel Chester French had first modeled a bust of Alcott in the fall of 1880, which was cast in plaster in 1881 (present location unknown). However, much to the sitter's dislike, he had been portrayed in contemporary dress. After Alcott's death, French was urged by the famed transcendentalist's friends to make another bust of him. Probably be-

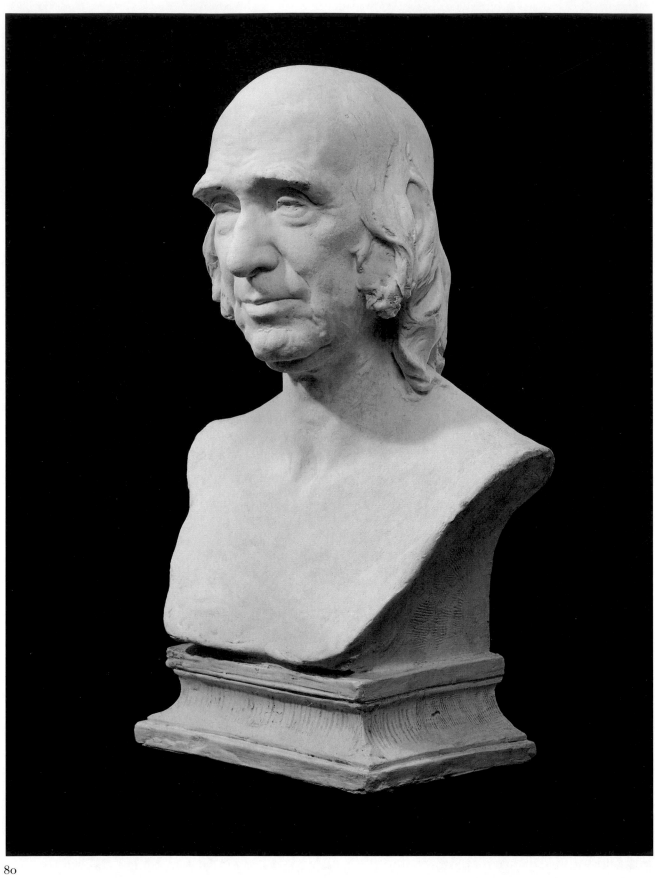

gun during the summer of 1889 in Concord, the second portrait depicts the philosopher with bare chest like a Roman senator, more in keeping with the pantheonlike eminence to which Alcott aspired. French planned from the beginning to have this cast in bronze and experimented with the design, accenting features to create a rich play of light over the tool-marked surface. Taking full advantage of Alcott's striking physiognomy, the sculptor modeled with great fluency the sitter's broad, high brow, deep-set eyes, and hawklike nose. The ten months French spent in Paris in 1886-1887 observing Beaux-Arts practices had served him well.

The Museum's bust is one of three made in plaster in early January 1890. French was concerned that the clay model he had finished the month before might be accidentally damaged. In a letter, December 28, 1889, to Franklin B. Sanborn, cofounder with Alcott of the Concord School of Philosophy, French explained, "I can keep the bust till Jan. 20 if you wish, though I should much prefer to get it cast at once. . . . I am particularly anxious in this case because my artist friends say I have made a decided 'hit' in this bust and several of them have expressed the wish that I not touch it again. . . . Even if you criticized it, I should be loth to change the clay."[3]

On February 17, 1890, French agreed, in a letter to Charles G. Loring, director of the Museum of Fine Arts, to lend the *Alcott* to the collection of over 1,600 plaster casts, which were arranged to illustrate "the history and development of sculpture from the earliest known examples to the present day."[4] "Perhaps you will think I respond with too much enthusiasm," he wrote, "when I tell you that I am going to send you the small model of my group of 'Gallaudet & his first deaf-mute pupil,' [probably destroyed, formerly the Detroit Institute of Arts] erected at Washington last June, and a new bust I have made of Alcott and a bust of Miss————."[5] The *Alcott* was also added to the Museum's 1891 summer show of the Society of American Artists, which came from New York.

In September 1891 French gave a second plaster of Alcott to the Art Institute of Chicago, where French's brother William was director, and in November he took a third plaster with him to Paris. This was cast along with the *Milmore* relief at E. Gruet Jeune Foundry. French kept the bronze bust (Chesterwood, Stockbridge, Massachusetts) and exhibited it at the World's Columbian Exposition, Chicago, in 1893. In contrast to the smooth surface of

his marble portrait of Emerson, 1879 (Memorial Hall, Harvard University), every line and curve of face and chest in the bronze version of Alcott is articulated, with a distinctive late-nineteenth-century naturalism.

P.M.K.

Notes

*This piece has been on loan to the Museum for so many years that it has become associated with the permanent collection and is therefore included in this catalogue.

1. *New York Times*, Mar. 5, 1888, obit.

2. Ibid. For a rich account of Alcott's philosophic life, see Van Wyck Brooks, *The Flowering of New England, 1815-1865* (New York: Dutton, 1936), especially pp. 231-236, 271-277, 426-428.

3. French to Sanborn, Dec. 28, 1889, Archives, Concord Free Public Library, published in Michael Richman, *Daniel Chester French, an American Sculptor* (1976; reprint ed., Washington, D.C.: Preservation Press, 1983), pp. 69-70. Richman discusses the history of the Alcott bust on these pages.

4. French to Loring, Feb. 17, 1890, BMFA, 1901-1954, roll 2454, in AAA, SI; BMFA, *Annual Report* 1891, p. 7.

5. French to Loring, Feb. 17, 1890, BMFA, 1901-1954, roll 2454, in AAA, SI. The bust of "Miss————" was sent back to French, May 12, 1896. Michael Richman thinks this probably refers either to the portrait of Florence Hoar Bradbury, 1885, or that of Elizabeth Richardson French, 1888 (both at Chesterwood). The Gallaudet group went to the Detroit Institute of Arts, Mar. 31, 1922, after the Museum requested that French remove it. See undated letter from French to the sculptor Andrew O'Connor, Daniel Chester French Family Papers, Library of Congress. Kathryn Greenthal provided this archival material.

Franz Xavier Dengler (1853 – 1879)

Franz Xavier Dengler's untimely death at the age of twenty-five was mourned by friends who felt that "with him went the possibilities of an artist such as America has not yet known."[1] His maturation as a sculptor was so swift, however, that he was able to establish a reputation as a skillful portraitist, creator of ideal figures, and decorator of redware vases despite a career that lasted no more than five years.[2] A contemporary critic, Samuel G.W. Benjamin, ranked him first among a number of "earnest and original young sculptors," including Olin M. Warner, Howard Roberts (1843-1900), and Jonathan Scott Hartley (1845-1912), who, after studying abroad, came home "to found, and grow up with, a new and progressive school of sculpture." Benjamin characterized their art as "stirring, realistic, and sometimes sensational."[3]

Dengler was born to German parents in Cincinnati, where he received instruction briefly at Saint Xavier's College. As a youth of seventeen, he learned to carve in wood at Schroeder & Brothers, a firm that produced images for churches. Desiring a formal artistic education, Dengler in 1872 chose to go to Munich (Paris's rival in the late nineteenth century for Americans training in Europe), owing perhaps to his German background and to the example of Frank Duveneck, his compatriot and fellow midwesterner. In Munich he entered the Royal Academy of Fine Arts and became a pupil of Josef Knabl (1819-1881). Only a short period elapsed before he was regarded as one of the most successful students in the department of sculpture.[4] In 1874 the academy awarded his group *The Sleeping Beauty*[5] its prestigious silver medal for excellence, an honor that reputedly had not been bestowed upon an American for seventeen years.[6]

Encouraged by his experience in Munich, Dengler returned to America and exhibited *The Sleeping Beauty* in 1874 in Cincinnati and in 1875 in Boston, where it generated considerable interest. Nonetheless, appreciation of his talent did not result in any major commissions. In 1874-1875 Dengler spent about a year in Cincinnati, sharing a studio during the winter months with Frank Duveneck, who was then preparing a large historical painting, *Prayer on the Battlefield* (present location unknown), in collaboration with Henry Farny (1847-1916). With no projects to keep him in the United States, Dengler embarked on a second trip to Europe in August 1875 in the company of Duveneck, Farny, and John

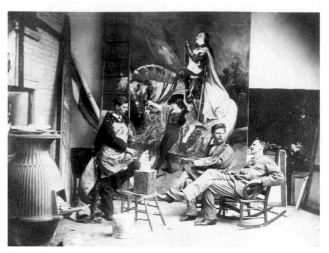

Franz Xavier Dengler, Frank Duveneck, and Henry Farny

Twachtman (1853-1902). In Munich once more, Dengler showed two portrait busts in the spring of 1876 at the Munich Art Association, where they were admired for their veracity.[7] Feeling the pull of his homeland again, Dengler left Germany for Cincinnati several months later. After a disappointing year that brought him few orders, he settled in Boston in the summer of 1877. At last, he found satisfactory recognition of his abilities, and the support gained in Boston stimulated in him a flurry of activity.

Within two weeks of his arrival, Dengler was offered the first position created for an instructor in modeling at the Museum's newly organized School of Drawing and Painting (later the School of the Museum of Fine Arts). The introduction of clay modeling into the school curriculum was intended, as stated in the school's annual report, "not so much for the benefit of those who might wish to take up sculpture as a special study, as for the benefit of the whole school, to give a more intimate knowledge of form and a readier perception than drawing alone could give. It was arranged, accordingly, that all the students should take their turn in the modelling-room, spending two weeks at a time under Mr. Dengler's instruction."[8] Although he was popular with the students and officers, Dengler was forced to resign that winter, having served barely one term, because of ill health.

During Dengler's half-year in Boston, he fashioned a variety of objects, such as a small group *Caught* (q.v.); sketches for three figures entitled *Painting* (q.v.), *Sculpture* (q.v.), and *Architecture* (q.v.); and a bust of the Reverend Doctor C.A. Bartol,

which remained unfinished. Versatile as well as energetic, Dengler executed thirteen vases of redware for the Chelsea Keramic Art Works, all designs of children and birds modeled in high relief.[9]

By September 1877 Dengler was clearly a person of note in the Boston art community, and Doll & Richards held a one-man exhibition of his sculpture that was favorably reviewed by the *Boston Evening Transcript*: "Mr. Henry [sic] Dengler's modelling . . . is of a very remarkable quality. This young artist . . . is of a different school from any commonly represented among us hitherto. His work is distinguished for combining a remarkable truthfulness of minutiae and detail with a bold and fearless freedom and breadth of handling. . . . His ideal figures, his vase decoration and modelling, show also a warm poetic love of beauty of form in rest and motion."[10] Further, one enthusiastic connoisseur declared: "All the other sculptors in America *boiled down* couldn't equal that boy!"[11]

Following the display at Doll & Richards, Dengler's health took a precipitous decline. Realizing how quickly he was succumbing to consumption, he departed Boston on Christmas Day 1877 and moved back to his parents' home in Covington, Kentucky, near Cincinnati. There he made and exhibited the group *Azzo and Imelda*.[12] Desperate for a locale where his physical condition might improve, Dengler traveled to Colorado and, in the autumn of 1878, to Florida. His search ended in Jacksonville, where he died in January 1879.

In addition to the four sculptures in the Museum of Fine Arts, Dengler conceived some twenty-five works.[13] The pieces most frequently commented upon in the literature are the portrait busts of William Merritt Chase (1849-1916), J. Frank Currier (1843-1909), and Henry Farny; an ideal head of America; *Wounded Duelist*; *The Pouting Boy*; *Tristram and Iseult*; a group of a blind mother and her children entitled *Blind*; and a sketch for the monument in Boston to Charles Sumner (for which there was a competition, won by Anne Whitney), ultimately realized by Thomas Ball.[14]

K.G.

Notes

1. *Boston Daily Advertiser*, Jan. 13, 1879, obit. The date given for Dengler's birth in this obituary and in BMFA, *Catalogue of Works of Art Exhibited on the Second Floor*, pt. 2, . . . (1886), is 1854. All other references consulted, however, indicate 1853.

2. Dengler also evidently tried his hand at painting. See letters from Mrs. Franz Xavier Dengler, Sr., to Charles G.

Loring, director of the Museum, Aug. 8, Sept. 5, Oct. 9, 1879, BMFA 1876-1900, roll 549, in AAA, SI; and from Loring to Mrs. Dengler, Aug. 26, 1879, BMFA 1876-1900, roll 547, in AAA, SI.

3. Benjamin 1880, p. 161.

4. *Boston Daily Advertiser*, Jan. 13, 1879, obit.

5. A plaster cast of *The Sleeping Beauty* came to the Museum as a gift of the artist's father in March 1879 along with a number of other works, of which *Caught* (q.v.), *Painting*, *Sculpture*, and *Architecture* (q.v.) remain in the collection. Reference in Loring's letter to Mrs. Dengler of Aug. 26, 1879, to "an earlier group of 'The Sleeping Beauty' which was left as a bequest to Mr. Baxter" suggests that there were two versions. BMFA 1876-1900, roll 547. *The Sleeping Beauty* was deaccessioned by vote of the trustees on Jan. 19, 1933. See also note 14 below.

6. George McLaughlin, "Cincinnati Artists of the Munich School," *American Art Review* 2, pt. 1 (1881), p. 46 (reprinted in Walter Montgomery, ed., *American Art and American Art Collections: Essays on Artistic Subjects* [Boston: Walker, 1889], vol. 1, p. 154).

7. "Sammlungen und Ausstellungen," *Zeitschrift für Bildende Kunst* 11 (May 1876), p. 533.

8. BMFA, School of Drawing and Painting, *Annual Report*, 1878, p. 1.

9. Edwin Attlee Barber, *The Pottery and Porcelain of the United States*, 3rd ed. (New York: Feingold & Lewis, 1976), p. 261.

10. "Art and Artists," *Boston Evening Transcript*, 2nd ed., Sept. 22, 1877.

11. Quoted in *Boston Daily Advertiser*, Jan. 13, 1879, obit.

12. This group, inspired by a poem, "Imelda," by the nineteenth-century English poet Felicia Dorothea Hemans, is referred to in Loring's letter of Aug. 26, 1879, to Mrs. Dengler as *Imelda and Arezzo [sic]*, as part of the gift of F.X. Dengler, Sr. There is no record of the Museum's acquisition of this piece; however, a *Tristram and Iseult* was received in March 1879 as a gift from Dengler, Sr., and deaccessioned in Jan. 1933. It is possible that there was confusion over the title of the work.

13. [H. Rattermann,] "Deutsch-Amerikanische Künstler, 4: Franz Xaver [sic] Dengler," *Der Deutsche Pionier* 12 (Mar. 1881), p. 464.

14. These pieces are all at present of unknown location. The following plaster casts came to the Museum in 1879, at the same time as *The Sleeping Beauty*, as gifts of F.X. Dengler, Sr., and were deaccessioned by vote of the trustees between 1932 and 1933: *The Pouting Boy*, *Henry Farny*, and *Tristram and Iseult*. Also acquired by the Museum as gifts of Dengler, Sr., in March 1879 were a bust of C.C. Mooar, which was returned to Mr. Mooar in 1886, and the plaster *Woman with a Ladybird*, deaccessioned in 1931.

References

Edwin Atlee Barber, *The Pottery and Porcelain of the United States*, 3rd ed. (New York: Feingold & Lewis, 1976), pp. 261-263; *Boston Daily Advertiser*, Jan. 13, 1879, obit.; BMFA 1979, p. 25; BMFA, *Annual Report*, 1878, pp. 6-7; BMFA, School of Drawing and Painting, *Annual Report*, 1878, pp. 1-2; Clement and Hutton 1894; Paul Evans, *Art Pottery of the United States* (New York: Scribner's, 1974), pp. 49, 51; George McLaughlin, "Cincinnati Artists of the Munich School," *American Art Review* 2, pt. 1 (1881), pp. 46-48 (reprinted in Walter Montgomery, ed., *American Art and American Art Collections: Essays on Artistic Subjects* [Boston: Walker, 1889], vol. 1, pp. 153-160); [H. Rattermann,] "Deutsch-Amerikanische Künstler, 4: Franz Xaver *[sic]* Dengler," *Der Deutsche Pionier* 12 (Mar. 1881), pp. 458-465; Taft 1930, p. 489; [idem,] "In Memoriam: Franz Xaver *[sic]* Dengler," ibid. 11 (Nov. 1879), p. 327.

FRANZ XAVIER DENGLER

81

Caught, 1877

Plaster

H. 12 in. (30.5 cm.), w. 5¼ in. (13.3 cm.), d. 6⅛ in. (15.6 cm.)

Signed (on top of base): FD (cipher) ngle

Inscribed (on front of base): Caught

Gift of Franz Xavier Dengler, Sr. 79.35

Provenance: Franz Xavier Dengler, Sr., Covington, Ky. Exhibited: BMFA, *Catalogue of an Exhibition of Contemporary Art*, directed by the Boston Art Club, the Boston Society of Architects, and the Schools at the Museum (1879), p. 42; BMFA, *Catalogue of Works of Art Exhibited on the Second Floor*, pt. 2, *Paintings, Drawings, Engravings, and Decorative Art* (1886), sculpture section, no. 8.

Franz Dengler executed *Caught* during his stay in Boston in the latter half of 1877. The group shows two children at play: a girl whose dress has slipped away from her right shoulder has "caught" a nude little boy. Alternatively, the group may be interpreted as illustrating the popular theme of "the first step"; here, the girl has saved the boy from a fall. *Caught* won the praise of Lorado Taft, who remarked that it is "not only cleverly modelled, but shows a genuine apprehension of the requirements of sculptural grouping."[1]

The sculpture is made of plaster, and the boy's right hand has broken off and has not been replaced. Dengler's signature on the base is composed of a cipher of the letters F and D (which is identical to the one he used on his redware) combined with four letters of his last name. *Caught* was created at the time Dengler was designing pottery for the

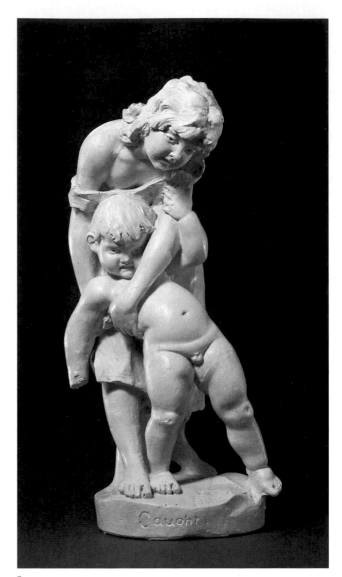

81

Chelsea Keramic Art Works, and the boy in his group can be compared with the children he modeled in high relief on the vases, such as one in the Worcester Art Museum, Massachusetts.[2] Decorative in form and with a motif suitable for wide distribution, *Caught* may have been made with an eye to the biscuit porcelain market.

The group, along with *Painting, Sculpture*, and *Architecture* (q.v.) and several other works by Dengler, was given to the Museum by the sculptor's father in March 1879, two months after young Dengler died.[3] P.P. Caproni and Brother, a plaster reproduction firm in Boston, produced twelve-inch copies of *Caught* into the twentieth century.

K.G.

Notes

1. Taft 1930, p. 489.

2. I am grateful to Alice Cooney Frelinghuysen of the Metropolitan Museum of Art, New York, for having brought the Worcester piece to my attention. Edwin Atlee Barber, *The Pottery and Porcelain of the United States,* 3rd ed. (New York: Feingold & Lewis, 1976), p. 263, illustrates a vase by Dengler, which was given to the Museum of Fine Arts in 1879 and deaccessioned in 1958.

3. See letters from Charles G. Loring to Franz Xavier Dengler, Sr., Mar. 12, 1879, and to Mrs. Dengler, Aug. 26, 1879; Dengler, Sr., to Loring, Mar. 28, 1879, BMFA, 1876-1900, rolls 547, 549, in AAA, SI. For reference to the works deaccessioned by the Museum, see the biography, note 14, above.

FRANZ XAVIER DENGLER
82–84
Painting, Sculpture, and *Architecture,* 1877
Plaster
Painting: H. 19¾ in. (50.2 cm.), w. 6½ in. (16.5 cm.), d. 4⅞ in. (12.4 cm.)
Sculpture: H. 20 in. (50.8 cm.), w. 6 in. (15.2 cm.), d. 4⅜ in. (11.2 cm.)
Architecture: H. 19¼ in. (48.9 cm.), w. 5½ in. (14 cm.), d. 5 in. (12.7 cm.)
Gift of Franz Xavier Dengler, Sr. 79.39-41

Provenance: Franz Xavier Dengler, Sr., Covington, Ky.
Exhibited: BMFA, *Catalogue of an Exhibition of Contemporary Art,* directed by the Boston Art Club, the Boston Society of Architects, and the Schools at the Museum (1879), p. 42; BMFA, *Catalogue of Works of Art Exhibited on the Second Floor,* pt. 2, *Paintings, Drawings, Engravings, and Decorative Art* (1886), sculpture section, no. 9; BMFA, "Confident America," Oct. 2-Dec. 2, 1973; *"The Second Greatest Show on Earth": The Making of a Museum,* an exhibition . . . sponsored by AAA, SI, and BMFA (1977), *Painting,* p. 7, no. 13; BMFA 1977, *Sculpture,* no. 7; BMFA 1979, *Sculpture,* no. 16.

The three figures personifying Painting, Sculpture, and Architecture were commissioned by the Museum of Fine Arts in the fall of 1877, when Dengler was residing in Boston and teaching modeling at the School of Drawing and Painting. They were intended to be enlarged and executed in terracotta for placement on three pedestals at the main entrance to the Museum (then located in Copley Square), designed by John Hubbard Sturgis (1834-1888) and Charles Brigham (1841-1925) in the Venetian Gothic style made popular by John Ruskin (1819-1900). However, all of Dengler's efforts on the project ground to a halt when failing health caused his abrupt departure from Boston. Accord-

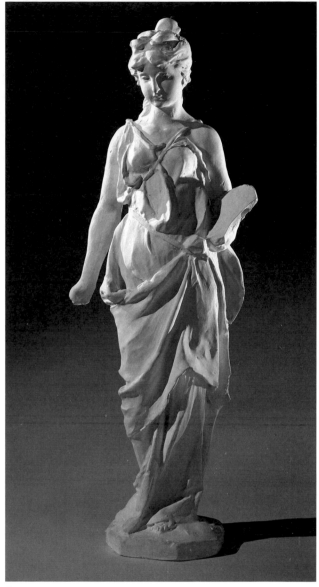

82

ing to the Museum's annual report for 1878, the sculptor "left moulds of the three figures in his studio. They have lately been cast in plaster but are unfortunately in too incomplete a state to be used as was originally intended."[1] No other sculptor was engaged to complete the commission, and the three pedestals in front of the Museum building remained vacant.[2]

Clearly, the subjects of the sculptures were selected to symbolize the function of the Museum edifice, and had the figures been set in place, they would have reinforced the cultural purpose for which the building was erected. As allegories of the arts, the figures are accompanied by attributes appropriate to their disciplines: Painting holds a

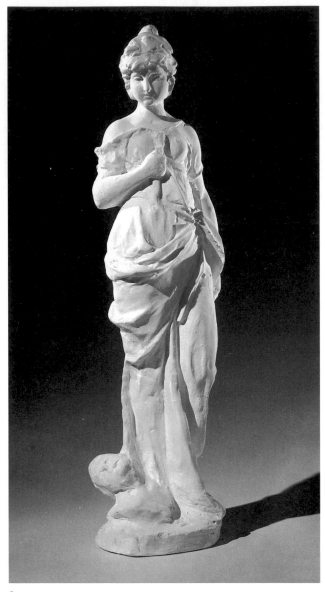

83

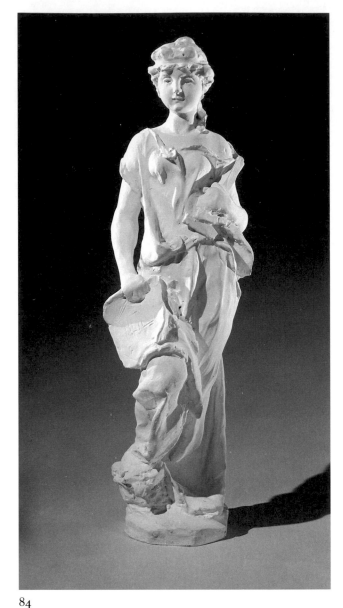

84

palette (which is broken and has not been repaired) in her left hand; Sculpture has a tool in her right hand, and a bust lies at her feet; Architecture rests a T-square against her torso in her left hand, grasps a plan for a building in her right hand, and positions her right foot on a Corinthian capital. It is interesting to note that the dress falls off one shoulder in the figures of Sculpture and Architecture in the same manner it slips away from the girl's shoulder in *Caught* (q.v.).

This group of three figures, along with *Caught* and several other works by Dengler, was given to the Museum by Franz Dengler, Sr., in March 1879, two months after the sculptor's death.[3]

K.G.

Notes

1. BMFA, *Annual Report*, 1878, p. 6.

2. See Walter Muir Whitehill, *Museum of Fine Arts, Boston: A Centennial History* (Cambridge: Harvard University Press, Belknap Press, 1970), vol. 1, p. 44.

3. See letters from Charles G. Loring to Franz Xavier Dengler, Sr., Mar. 12, 1879, and to Mrs. Dengler, Aug. 26, 1879; Dengler, Sr., to Loring, Mar. 28, 1879, BMFA, 1876-1900, rolls 547, 549, in AAA, SI. For reference to the works deaccessioned by the Museum, see the biography, note 14, above.

Edward Clark Potter (1857–1923)

Edward Clark Potter's career was characterized by commissions for public sculpture of a traditional nature—equestrian monuments and portrait statues—in a style that can be described as Beaux-Arts realism. While not an exceptionally prominent artist, he created the two highly visible lions in front of the main branch of the New York Public Library, and horses for a number of equestrian monuments by the busy Daniel Chester French. Indeed, Lorado Taft commented: "It is probable that no American sculptor knows the horse quite so well, structurally, as does Mr. Edward C. Potter."[1]

Born in New London, Connecticut, Potter was the son of Nathan Day Potter and May (Clark) Potter.[2] He attended local schools and Williston Seminary and in 1878 enrolled in Amherst College. Responding to his artistic inclination, he left Amherst and began classes at the School of the Museum of Fine Arts in 1879. F.W. Coburn of the *Boston Herald* described Potter as a "serious worker" who possessed "one of the mature minds" at the school in the early 1880s.[3] After learning to draw under Frederic Crowninshield (1845-1918) and Otto Grundmann (1844-1910), he became a studio assistant to French in 1883. For the next two years he earned his keep under French and experimented with studies of animals, especially horses. Potter also spent a period of time at Proctor's marble quarries in Vermont, where he primarily supervised the cutting of French's groups *Science Controlling the Forces of Electricity and Steam*, 1885, and *Labor Sustaining Art and the Family*, 1885 (both Franklin Park, Roxbury, formerly United States Post Office and Sub-Treasury, demolished).

With funds saved from his employment, Potter traveled in 1886 to Paris, where he trained with Antonin Mercié (1845-1916) and Emmanuel Frémiet (1824-1910) and was hired again by French, newly arrived there himself. While in Paris, Potter exhibited a plaster bust entitled *Negro* at the Salon of 1887, and at the Salon of 1888 he showed two groups, *Rabbits* and *Nomad* (present locations unknown). By 1889 he had made another genre group called *Sleeping Infant Faun Visited by an Inquisitive Rabbit* (The Art Institute of Chicago). In December 1890, following his return to the United States, Potter married May Dumont, to whom he had been introduced by French's wife, Mary. Having settled in Washington, D.C., Potter opened a studio and before long won a commission for a

Daniel Chester French, Edward C. Potter, and Augustus Lukeman

marble portrait bust of Vice-President William A. Wheeler, 1892 (Senate Chamber Gallery, United States Capitol, Washington, D.C.).

A turning point in Potter's budding career was his engagement in activities at the World's Columbian Exposition in Chicago in 1893. French, who in the summer of 1891 had received the commission for the *Republic*, a colossal statue for the fair, suggested to Potter that he come to Chicago, where there would be sculpture to fashion of greater interest than portrait busts. French and Potter (no longer the assistant, but now the collaborator) produced the first of their combined efforts, *The Triumph of Columbus*, a quadriga that was set atop the triumphal arch behind the *Republic*. The labors were divided, with Potter executing the horses and outriders and French modeling the allegorical figures and Columbus in a chariot. They also created four groups that were installed around the lagoon of the Court of Honor: *Farmer*; *Teamster*; *Indian Corn*, or *Agriculture*; and *Wheat*. For each of these Potter made the workhorses and oxen, and French designed the attendant figures.[4]

The collaboration suited both men, and they continued to work together on equestrian monuments,

including *General Grant*, 1899 (Fairmount Park, Philadelphia); *General Washington*, 1900 (Place d'Iéna, Paris); *Major General Joseph Hooker*, 1903 (State House, Boston); and *General Devens*, unveiled in 1906 (Worcester, Massachusetts). The customary pattern for French's and Potter's joint ventures was for French to accept the commission, prepare a preliminary model, and inform the client that Potter would be responsible for the enlargement of the horse.[5] In fact, their collaborations reflected freely exchanged views. As French explained, "On the 'Washington' I did not confine myself to the human figure; neither did Potter stick to the horse; we swapped work and ideas constantly, and I think the group benefited by it."[6] More than a mentor and collaborator, French used his influential position to help Potter obtain the important commission for *General George D. McClellan*, 1912 (Smith Memorial, Fairmount Park, Philadelphia). The commission for the equestrian figure had originally been awarded to Paul Wayland Bartlett (1865-1925) in 1898, but French recommended Potter to the Smith Memorial Committee when Bartlett failed to render the statue in a satisfactory manner. Potter took over the commission in 1909, and the statue was set in place three years later.

Potter conceived several other equestrian monuments independently of French: the much admired *General Henry Warner Slocum*, 1902 (Gettysburg, Pennsylvania); *General George Custer*, 1910 (Munroe, Michigan); *General Philip Kearny*, 1914 (Arlington National Cemetery, Washington, D.C.); and the spirited Civil War *Bugler*, 1915 (Brookline, Massachusetts). Just as picturesque as the *Bugler* was Potter's *De Soto Sighting the "Father of Waters,"* about 1904, an equestrian statue of the Spanish explorer that won a gold medal at the Saint Louis Exposition in 1904.

By no means limited to producing equestrian monuments, Potter was equally capable of executing statues of notable men and symbolic figures. For the rotunda of the Library of Congress, he was awarded the contract for the statue of Robert Fulton, about 1897, whom he represented holding a model steamboat. A sculptor of the mainstream, Potter participated in large, decorative projects in New York at the turn of the century by contributing *John Paul Jones* to the Dewey Arch, 1899 (destroyed); *Zoroaster*, 1900 (Appellate Court House); and *Indian Philosophy* and *Indian Religion*, 1909 (The Brooklyn Museum). Also by Potter's hand are the statue of Governor Austin Blair, installed in front

of the Capitol at Lansing, Michigan, in 1898, and that of Colonel Raynal C. Bolling, about 1922, a monument to the first high-ranking officer of the American Expeditionary Forces to fall in World War I, which was approved by the town of Greenwich, Connecticut, for its Havemeyer Building.

The works that gained Potter unsettling notoriety were his two marble lions, 1911, for the New York Public Library. Having already made lions for the Pierpont Morgan Library and the residence of Collis P. Huntington in New York, Potter was suitably versed in the anatomical intricacies of the beasts. When the plaster models were placed at the library in 1910 to test the general effect of the creatures before committing them to marble, the public felt entitled to comment on their appearance, and controversy—a common response to outdoor sculpture—erupted. Some passersby protested that the animals lacked sufficient majesty and ferocity.[7] Others complained that the chests of the lions were too hairy, causing Potter to consent to shave their manes. Within a few years the furor died down, and the lions, dubbed "Patience" and "Fortitude" by Mayor Fiorello La Guardia, became landmarks in the city.

Although Potter was overshadowed by French in their collaborations, he was a respected and successful sculptor in his own right. He was a member of the National Academy of Design, the Architectural League, the National Institute of Arts and Letters, and the National Sculpture Society. The final twenty years of his life were spent in Greenwich, Connecticut, where he died in 1923.

K.G.

Notes

1. Taft 1930, p. 474.

2. Potter's date of birth is generally given as 1857. However, Donald W. Howe, *Quabbin, the Lost Valley* (Ware, Mass.: Quabbin Book House, 1951) gives the date as 1854, and Taft 1930, pp. 474, 566, as 1859.

3. F.W. Coburn, "First Large Class Sheds Honor on Boston Museum of Fine Arts," *Boston Herald*, Feb. 27, 1921, magazine section, p. 2.

4. These decorative sculptures were made of staff, an impermanent material, and they no longer survive.

5. Michael Richman, *Daniel Chester French, an American Sculptor* (1976; reprint ed., Washington, D.C.: Preservation Press, 1983), p. 28.

6. McSpadden 1924, p. 134.

7. Michiko Kakutani, "Library's Lions Roar Thanks to New Yorkers," *New York Times*, Nov. 30, 1979, p. A1.

References

Art News 21 (July 14, 1923), p. 6; *Boston Globe*, June 22, 1923, obit.; BPL; Craven 1968, pp. 541-543; Gardner 1965, pp. 65-66; Donald W. Howe, *Quabbin, the Lost Valley* (Ware, Mass.: Quabbin Book House, 1951), pp. 153-154; Henry Wysham Lanier, "The Sculpture of E.C. Potter," *World's Work* 12 (Sept. 1906), pp. 7968-7982; MMA; NYPL; *New York Times*, June 23, 1923, obit.; SMFA; Rachel Stuhlman, "An American Late Romantic Bronze: Edward Clark Potter's *Dante*," seminar paper, spring 1980, BMFA, ADA; Taft 1930, pp. 474-475, 566.

EDWARD CLARK POTTER

85

Dante, 1917

Bronze, red-brown patina, sand cast

H. 24¾ in. (62.9 cm.), w. 13¾ in. (34.9 cm.), d. 12 in. (30.5 cm.)

Signed (on base at right): E C Potter Sc

Foundry mark (on back of base): GORHAM CO. FOUNDERS G, wolf, C QAWY

Mary E. Moore Fund. 1979.195

Provenance: Sotheby Parke Bernet, New York, sale 4211, Jan. 31, 1979, lot 506

Exhibited: The Pennsylvania Academy of the Fine Arts, Philadelphia, *Catalogue of the 113th Annual Exhibition* (1918), no. 535; New York Water Color Club, *New York Water Color Club: Twenty-ninth Annual Exhibition* (1918), no. 366; National Academy of Design, New York, *95th Annual Exhibition*, held at the Brooklyn Museum (1920), no. 911a.

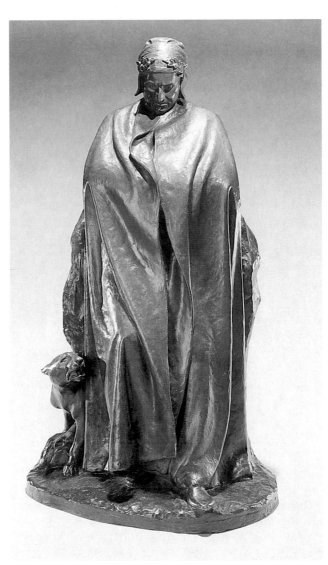

85

The statuette of Dante is a late and little known work by Potter. Apparently made independently of any commission, the piece was cast at Potter's request by the Gorham Manufacturing Company, Providence, on November 27, 1917, after which the model was returned to the sculptor. It has not been determined how many bronzes were cast.[1]

Although Potter's incorporation of a leopard in the group is uncommon in representations of Dante,[2] his treatment of the poet conforms to iconographic tradition: the figure is wrapped in a voluminous cloak, and his head is covered by a cap with ear flaps on which a laurel wreath rests. His sharply featured face is dominated by an aquiline nose and a prominent lower lip. With arms folded beneath the cloak and head bent, Dante appears to be absorbed in thought. Intense and awesome, he is the essence of the romantic sensibility that characterized much of late eighteenth-century and nineteenth-century art and literature. Indeed, Dante enjoyed an enormous vogue in the nineteenth cen-

tury. Sculptors, especially in France, found him a worthy subject and frequently portrayed him in conjunction with Virgil. Among the artists who paid him homage were Auguste Préault (1809-1879), in his reliefs *Dante*, 1852 (Louvre), and *Dante and Virgil in Hell* (Musée des Beaux-Arts, Chartres); Baron Henri de Triqueti (1804/7-1874/9), in his double, half-length portrait *Dante and Virgil*, 1862 (Museum of Fine Arts, Boston); and Jean-Paul Aubé (1837-1920), in a full-length statue, 1879 (square of the Collège de France, Paris).

This statuette of Dante was not Potter's first sculpture of the Florentine poet. By 1906, seemingly on his own initiative, he had created two bas-reliefs, one of Dante (present location unknown) and one of Savonarola, which were mentioned by Henry Wysham Lanier in his article "The Sculpture of E.C. Potter." Lanier gave no description of the *Dante*, but he included an illustration of a clay model of the *Savonarola*, which depicts the friar offering communion to his followers on his way to martyrdom. The *Savonarola* presumably was never finished but was to have been "completed with a square panel on each side showing other scenes of the tragedy, . . . the artist . . . had thought of it as possible for a bronze decoration for a pulpit."[3]

The reason Potter returned to the subject of Dante is a matter of speculation. Although he had made statues of historical figures, such as *Zoroaster*, 1900, for the Appellate Court House in New York, *Dante* was a departure from his customary type of image. Perhaps he conceived the figure in hope of obtaining a commission to honor the six-hundredth anniversary of the poet's death, which took place in 1921.[4] The statuette may have expressed Potter's own admiration of the writer, his penchant for heroic personalities, or an awareness of "les florentins," French nineteenth-century sculptors whose works recall Florentine sculpture of the late Middle Ages and the Renaissance. *Dante* is a finished object, not a sketch, and Potter may have produced it in an effort to enter the market for table-top decorative bronzes.

Whatever the impetus for its conception, *Dante* is a handsome piece that makes a strong impression. Its verticality, owing to the mass of the cloak, accounts in part for its power, but the source of its real impact is the contrast between Dante's quiet pose and evidently active mind. In creating such a tension, Potter provides a telling rendition of a particular kind of genius.

K.G.

Notes

1. See Rachel Stuhlman, "An American Late Romantic Bronze: Edward Clark Potter's *Dante*," seminar paper, spring 1980, p. 1; BMFA, ADA. See also Casting records of statuary and small bronzes owned by sculptors, 1906-1930, p. 199; Gorham Company Division Papers, Gorham Bronze Division of Textron, roll 3680, in AAA, SI.

2. Stuhlman observes that a leopard appears in Canto I and Canto XVI in the *Inferno* but concludes that the leopard in Potter's *Dante* originated in the sculptor's imagination. Ibid., pp. 47-48.

3. Henry Wysham Lanier, "The Sculpture of E.C. Potter," *World's Work* 12 (Sept. 1906), pp. 7977, 7979, 7981.

4. Monuments commemorating this anniversary were erected in a number of locations in America, e.g., a statue by Ettore Ximenes (1855-1926) in New York (Triangular Park, Broadway at 63rd Street), of which there is a replica in Washington, D.C. (Meridian Hill Park, 16th Street at Florida Avenue, N.W.). See James M. Goode, *The Outdoor Sculpture of Washington, D.C.* (Washington, D.C.: Smithsonian Institution, 1974), p. 416.

Edward R. Thaxter (1857–1881)

On August 9, 1881, the *New York Times* published a brief notice of the death of Edward Thaxter, a young sculptor who had succumbed to "brain fever." The author, James Jackson Jarves, lamented Thaxter's passing as "a severe loss to the young school of American sculpture" and eulogized the deceased as a man who showed "great promise . . . in his profession of taking a foremost position, and doing honor to his country."[1] Although the twenty-five-year-old Thaxter left only five finished statues in his studio in Florence, the solitary surviving example of his art, *Meg Merrilies* (q.v.), amply supports Jarves's judgment.

The facts known about Thaxter's brief life and career are sparse. He was born in Yarmouth, Maine, in 1857. Although his exposure to the fine arts was probably minimal, he is said to have been inspired to study sculpture by John Rogers's (1829-1904) anecdotal plaster groups, and at age sixteen he moved to Boston to receive instruction from John D. Perry, a local portrait sculptor. In 1878 he returned to Portland, Maine, with the intention of opening his own studio. His plans evidently changed, for the *American Art Review* reported that he arrived in Florence that same year, where he leased the studio space formerly occupied by the American sculptor John Adams Jackson (1825-1879), another native of Maine.

Thaxter's modest production of statues seems to have been exclusively in the ideal, neoclassical vein. Jarves, who wrote a short description of Thaxter's work for the *New York Times* the winter before the sculptor's death, catalogued his statues as *Reproof*, a study of a girl scowling at a cat that has killed a bird, and other small works titled *Thought, Absent-Mindedness, Sunrise,* and *Meg Merrilies.* Jarves was particularly impressed with a plaster group called *Love's First Dream*, which he called "exquisite."

In the spring of 1881 Thaxter was stricken with typhoid fever, which spared his life but left him weak. His physician recommended that he avoid the intense summer heat in Florence and continue his convalescence in the cooler climate of New England. Though reluctant to abandon his projects, the sculptor complied with the doctor's orders and embarked at Leghorn for a short sailing trip down the Italian coast, planning afterwards to return to America. He stopped briefly in Naples to enjoy some sightseeing, but the expedition proved too exhausting; his fever flared up and quickly killed him.[2] The "young school of American sculpture" lost a promising member whose artistic legacy, however limited, moved critics to praise his conceptual originality and poetic sensibility, and to regret that his talents were never able to mature.

J.S.R.

Notes

1. James Jackson Jarves, "Mr. Thaxter's Sad Death," *New York Times*, Aug. 9, 1881.
2. Thaxter's body was claimed in 1883 by his mother, who buried him in Italy, probably in the Protestant Cemetery in Naples. A typographical error in the spelling of Thaxter (Thacher) in late nineteenth-century indexes made it difficult, until recently, when the mistake was detected, to retrieve biographical information about the sculptor.

References

"American Art Chronicle: Necrology," *American Art Review 2*, pt. 2 (1881), p. 175; James Jackson Jarves, "Mr. Thaxter's Sad Death," *New York Times*, Aug. 9, 1881; Thieme-Becker.

EDWARD R. THAXTER
86 (color plate)
Meg Merrilies, about 1881
Marble
H. 25½ in. (64.8 cm.), w. 20 in. (50.8 cm.), d. 13 in. (33 cm.)
Signed (on back of base): E.R. Thaxter
William E. Nickerson Fund. 63.5

Provenance: The Crown Studio, through John J. Cunningham, New York
Exhibited: American Federation of Arts, New York, *Revealed Masters: 19th Century American Art*, text by William H. Gerdts (1974), no. 39; National Museum of Western Art, Tokyo, *Boston Museum Exhibition: Human Figures in Fine Arts* (1978), no. 46 (listed as *The Fury*); BMFA 1979, no. 14.

Sir Walter Scott's Waverley novels were widely read in the nineteenth century, particularly by Americans who were charmed by his grandiloquent prose and convoluted, dramatic plots. *Meg Merrilies* is based on a character of the same name drawn from one of Scott's more popular books in this series, *Guy Mannering*, first published in 1815. The novel's romantic plot centers on the difficulties of a forgotten heir attempting to regain his rightful fortune. Meg Merrilies, a half-mad, sibylline gypsy, serves as a prominent agent in the fortune's successful recovery.

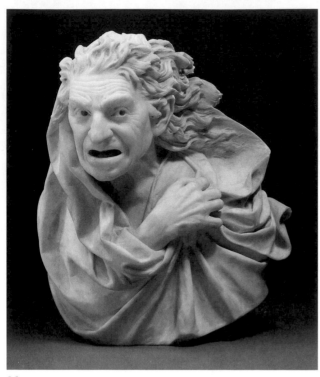

86

The decrepit ugliness and eccentricity of Meg Merrilies thrilled Scott's readers. The author devoted several graphic paragraphs to her physical appearance. "Full six feet high," "rather masculine than feminine," and over a century old by the novel's conclusion, the gypsy was also described as having hair that "shot out like the snakes of the gorgon." Her reptilian mane framed a face with "strong and weather-beaten features," highlighted by wild, rolling eyes "that indicated something like real or affected insanity."[1]

Edward Thaxter's bust of Meg Merrilies may have been inspired solely by Scott's descriptive text. It is possible, too, that the portrait was influenced by Charlotte Cushman's memorable performance as the gypsy in the play *Guy Mannering*. That popular production toured Boston for three weeks in November 1872 and again for three weeks in November and December 1873,[2] the year Thaxter arrived in town to pursue his sculpture studies. The role of Meg Merrilies is said to have been one of the famous actress's favorite parts. Although she had performed it for over thirty-five years, her dramatic flair for projecting Meg's wild frenzy remained undiminished when she gave her farewell Boston appearance in the play on December 13, 1873, as the reviews in local papers attest.[3] Certainly, the aged

but still talented Cushman (a woman whom Henry James charitably referred to as being "remarkably destitute of beauty")[4] would have made a strong impact on any impressionable art student sitting in the gallery of the Boston Theatre. It might be added that the part of Meg Merrilies was a role coveted by leading nineteenth-century actresses, since it permitted them to exploit the magic of theatrical makeup while demonstrating a broad range of melodramatic postures and hyperbolic facial expressions. Emma Waller's performance as the superannuated gypsy in a New York staging of *Guy Mannering* in the early 1870s vied with Cushman's for its picturesque impression and electrifying effect, earning the actress the ultimate compliment: "She looks the wreck of womanhood."[5]

Compared with the plethora of sweet, restrained marmoreal images of women associated with the neoclassical school, Thaxter's portrait diverges from the stylistic mainstream in its startling baroque emotion. It exemplifies the waning neoclassical impulse in American sculpture of the late 1870s and early 1880s that, as Cornelius Vermeule has argued, reached back to a different spirit of antiquarianism than had been consulted previously—"to the barbarians on the column of Marcus Aurelius (A.D. 190) or on Roman imperial sarcophagi of the decades of A.D. 190 to 260."[6] The bust's deeply drilled eyes and mouth cavity, and its artfully irregular contours find their counterparts in the marble productions of Bernini's school. Indeed, a specific prototype for Thaxter's bust can be identified in the Italian sculptor's own oeuvre: the grimacing *Anima Dannata,* or *Damned Soul,* about 1619 (Palazzo di Spagna, Rome), conceived by Bernini as a pendant to an *Anima Beata* of angelic aspect.[7] The American sculptor may have known the Bernini work through an engraving or direct encounter. At the same time, affinities also appear to exist between Thaxter's bust and the famous haggard image *The Old Market Woman* (Vatican Museums), a Hellenistic marble that served as the progenitor of a stock of later sculptural adaptations. Like so many products fashioned by the historically aware American neoclassicists, Thaxter's *Meg Merrilies* is more an amalgam of past sources than a studious interpretation or imitation of any one. Where the bust differs markedly from the works of most of his contemporaries is in its psychic energy.[8] Its agitated countenance seems to reflect an awareness, or the lingering influence, of Charles Le Brun's widely known illustrations of the human emotional states, published in the seven-

teenth century.[9] The fanatical facial cast also recalls the "têtes d'expressions" that were required matriculation exercises for students at the Ecole des Beaux-Arts.

In its total effect *Meg Merrilies* is a masterly incarnation of the "terribilatà," aligning the image with the strong strain of melodrama that pervades art and literature of the high Victorian period. The eerie yellow marble, a variation from the pure milk-white stone employed to carve Eves, Venuses, and virginal saints that was probably intentional on Thaxter's part, further heightens the subject's sublime ugliness. Both the conception and execution of the theme are remarkable accomplishments for a sculptor in his early twenties.

J.S.R.

Notes

1. Walter Scott, *Guy Mannering, The Astrologer* (Boston: De Wolfe, Fiske [1880]), p. 33.

2. Eugene Tompkins, *The History of the Boston Theatre, 1854-1901* (Boston: Houghton Mifflin, 1908), pp. 191, 203.

3. Ibid., p. 203.

4. Henry James, *William Wetmore Story and His Friends* (London: Blackwood, 1903), vol. 1, p. 260.

5. "Mrs. Waller's Meg Merrilies," *Watson's Weekly Art Journal*, Jan. 1, 1870, p. 6.

6. Vermeule 1975, p. 981.

7. See Rudolf Wittkower, *Gian Lorenzo Bernini, the Sculptor of the Roman Baroque* (New York: Phaidon, 1955), p. 3 and cat. no. 7; and Howard Hibbard, *Bernini* (Harmondsworth, Eng.: Penguin Books, 1965), pp. 31-32, 47. Scholars contend that the demonic physiognomy of the *Anima Dannata* reveals Bernini's awareness of the painter Caravaggio's studies of facial expression exploring intense reactive emotions such as surprise, horror, and alarm.
I am grateful to Kathryn Greenthal for calling my attention to the Bernini source.

8. Interesting comparisons can be made between Thaxter's bust and William Wetmore Story's full-length portrait of the wrinkled sorceress *Canidia*, about 1881 (art market, New York, formerly Carlos Conde, Puerto Rico), and J. Stanley Connor's (1860-after 1883) bust of *Cain*, about 1880 (The Metropolitan Museum of Art, New York).

9. Sébastien Leclerc, *Les Caractères des passions gravées sur les dessins de l'illustre M. Le Brun* (Paris, 1696).

Cyrus Edwin Dallin (1861 – 1944)

Cyrus Dallin was born in the Latter-day Saints settlement of Springville, Utah, which his English parents Jane (Hamer) and Thomas Dallin had helped to found. The Paiute and Ute Indians lived in nearby encampments, and, as Dallin later recalled, he learned to "make models of the animals that roamed the prairie in those days—antelope, wolves, buffalo, and horses."[1] Impressed with the dignity and harmony of Native American life, Dallin formed lasting memories that were to imbue his naturalistic portraits with noble sentiment.

At the age of eighteen, while Dallin was sifting ore in a local silver mine, saving money to attend school in Provo, he modeled two busts in white clay. Two wealthy mine investors, impressed by these efforts and convinced of his talent, sent him east the next year to study with Truman H. Bartlett (1835-1923), who ran the only sculpture school in Boston. Dallin earned tuition by helping in Bartlett's studio and supported himself by working nights at the nearby Boston Terra-cotta Works. Bartlett's conservative attitude and authoritarian nature proved too demanding for the sensitive novice, and he left after a year and entered the Quincy studio of Sidney H. Morse (1832-1903), one of Bartlett's former evening students. While the two men executed cemetery statues and reliefs for a local granite company, Morse, who was also a Unitarian writer and editor of the *Radical Review*, introduced his eager assistant to philosophy and literature. When orders ran out, Dallin returned to Boston and opened his own studio.

In 1883 Dallin modeled an equestrian figure of Paul Revere and became the winner in an open competition that included such recognized sculptors as Daniel Chester French and Thomas Ball. His relative youth and Bartlett's criticism of his ability and provincial background, however, defeated efforts by the Revere statue committee to raise public subscriptions to produce the piece in bronze. Dallin may have identified his feelings of rejection with those of Native Americans denied their rights, for the following year he began a full-length study entitled *An Indian Chief* (present location unknown).

Disheartened by his failure to become established in Boston, Dallin sought employment in Utah but received few requests. His commissions during this formative period consisted mainly of portrait busts and statuettes, with more dependable income coming from the sale of wax figurines to local department stores for window displays. Nonetheless, the

approval he received from artistic contemporaries like Augustus Saint-Gaudens, as well as from Charles Eliot Norton, professor of art history and literature at Harvard, evidently sustained his spirit, for in 1888, with money from a distant relative, he sought additional technical training in Paris. There he joined Hermon Atkins MacNeil (1866-1947), Charles Grafly, and Frederick MacMonnies at the Académie Julian to study under the classicist Henri Chapu (1833-1891). Writing to his parents on September 26, 1888, Dallin confidently reported that he was "working in the right direction"; "if I can have enough time to do what I want to," he continued, "I believe that I shall make a name here for myself."[2]

During the Paris visit of Buffalo Bill Cody's "Wild West" show in 1889 Dallin was inspired to create an equestrian sculpture of a Sioux chief entitled *Signal of Peace*, 1894 (Fairmount Park, Philadelphia), representing the friendly meeting of the white man and the Indian. In 1890 he submitted the plaster model to the Paris Salon and won an honorable mention, the only eligible prize for first-time entrants. Encouraged by the sculpture's favorable reception, Dallin had the piece cast in a life-size

bronze for the 1893 World's Columbian Exposition in Chicago. The simplicity and dignity of his portrayal of the Native American distinguished the work and won for him a first-class (gold) medal and an invitation to become a charter member of the National Sculpture Society.

On his return to America in 1891 Dallin married Vittoria Colonna Murray, a drawing instructor at Girls' High School (now Latin Academy), Boston, whose writing talents and interests in educational reforms proved to be a support for his own humanitarian concerns. From 1891 to 1895 he lived in Boston and Salt Lake City, seeking commissions for public sculpture and entering competitions despite continuing frustrations over the unfulfilled *Revere* contract. His earliest monumental sculptures, the gilded *Angel Moroni*, 1892, for the east central spire of the Mormon Temple and the *Brigham Young and the Pioneers Monument*, 1900, at Temple Square, Salt Lake City, were designed in 1891. Dallin's finances were meager during this period, and in 1895 he welcomed the opportunity to take Grafly's place for a year and teach modeling at Drexel Institute in Philadelphia. While there, he completed a statue of Sir Isaac Newton for the rotunda of the Library of Congress, an important commission since only the most respected artists of the day were invited to participate.

In 1896 Dallin went back to Paris for further study, refining his technique with classes under Jean Dampt (1853-1946) at the Ecole des Beaux-Arts. He produced a bronze equestrian of *Don Quixote*, 1898 (present location unknown), a romantic conception whose pathos was equal to that of Cervantes's character and a fine example of the impressionistic modeling espoused by the French school. He also created the *Medicine Man*, 1903 (Fairmount Park, Philadelphia), his second equestrian sculpture in what was becoming a series on the tragic history and destiny of Native Americans.[3] This depiction of the seer of the Crow nation, in feathered headdress with buffalo horns, warning his people of the white man's deceit, was strikingly realistic in contrast to *Don Quixote* and noticeably advanced from the *Signal of Peace*. The *Medicine Man* was exhibited at the Paris Salon of 1899 and in 1900 received a silver medal at the Paris Exposition. Lorado Taft, in his historical appraisal of American sculpture, declared the work to be Dallin's "greatest achievement," possessing "a sort of hieratic majesty."[4]

Up to this time, the subjects of equestrian monuments had been limited to military leaders, but in Dallin's oeuvre the genre was enlarged to include memorials to Native Americans. Neoclassical sculptors like Thomas Crawford and Erastus Dow Palmer had portrayed the Indian as "nature's nobleman,"[5] idealizing features, dress, and surroundings for their narrative content. This romantic treatment continued even after the settlement of the West and the decimation of much of the Native American population. While Frederic Remington's (1861-1909) and Hermon MacNeil's dramatic representations of Indian life depend upon action and picturesque detail, Dallin's faithful portrayals, often of solitary, quiet figures, reflect his reformist sympathies. For the sculptor from Utah, the history of the Native American people was a profound tragedy, and his sculpture was a means of protesting against their inhumane treatment by the United States government. Dallin's artistic credo, "I always strive to express some emotion because I believe that to be the only thing which constitutes art,"[6] found personal resonance in this profoundly American theme.

In the fall of 1899, Dallin returned to Boston and opened a studio. He began teaching modeling at the Massachusetts Normal Art School (now Massachusetts College of Art), where for the next forty years he was affectionately called "Cyrus the Great" by his students. In 1901 he settled in Arlington, Massachusetts, and maintained a second studio there.

The plight of Native Americans remained Dallin's primary interest, and in 1903 he created a third epic equestrian figure, *The Protest* (q.v.), for the Saint Louis World's Fair, and in 1908 a fourth, the *Appeal to the Great Spirit* (q.v.), which greatly added to his celebrity. His liberal philosophy also found expression in the memorial to the Puritan dissenter Anne Hutchinson, modeled in 1914 but not unveiled on the grounds of the State House, Boston, until 1922. In addition, Dallin executed a number of war memorials, including his largest, the *Soldiers and Sailors Monument*, dedicated in 1910 for the city of Syracuse (Clinton Square), New York, a somewhat Americanized version of François Rude's (1784-1855) *Departure of the Volunteers*, 1836, on the Arc de Triomphe, Paris.

Finally, in 1940 Dallin realized his lifelong obsession when the heroic-size *Paul Revere* was installed near the Old North Church in a formal ceremony, at which the people of Boston paid tribute to the sculptor's eminence. Dallin continued working until his death at the age of eighty-two. Of the over two hundred and fifty works he created, fifty were

equestrian sculptures, the last of which was a knight on horseback, entitled *The Challenge* (present location unknown). Remembered as a gifted and generous teacher, this "dean of New England sculptors"[7] has remained popular through small-scale plaster and bronze reproductions (some in innumerable versions) of his best-known works and through the over life-size *Appeal to the Great Spirit*, which is still a favorite with visitors to the Museum of Fine Arts.

P.M.K.

Notes

1. Quoted in E. Waldo Long, "Dallin, Sculptor of Indians," *World's Work* 54 (Sept. 1927), p. 565.

2. Dallin to his parents, Sept. 26, 1888, William Patterson collection, Salt Lake City, quoted in Francis 1976, p. 25. Rell Francis's definitive study of Dallin has been invaluable in the preparation of this text.

3. In 1979 the Museum acquired a 31½-inch plaster (1979.553) of the *Medicine Man* from a cast by P.P. Caproni and Brother, Boston.

4. Taft 1930, p. 500.

5. Proske 1968, p. xxiv.

6. Quoted in A. Seaton-Schmidt, "An American Sculptor: Cyrus E. Dallin," *International Studio* 58 (Apr. 1916), p. 112.

7. *New York Times*, Nov. 15, 1944, obit.

References

AAA, SI; BAC; Patricia Janis Broder, *Bronzes of the American West* (New York: Abrams, 1973), pp. 92-106; Caffin 1903, pp. 226-227; *Christian Science Monitor*, Nov. 15, 1944, obit.; Craven 1968, pp. 527-531; M. J. Curl, "Boston Artists and Sculptors in Intimate Talks I, Cyrus E. Dallin," *Boston Herald*, Dec. 12, 1920; James Spencer Dickerson, "Cyrus E. Dallin and his Indian Sculpture," *Monumental News* 21 (Sept. 1909), pp. 679-681; William Howe Downes, "Cyrus E. Dallin, Sculptor," *Brush and Pencil* 5 (Oct. 1899), pp. 1-18; idem, "Mr. Dallin's Indian Sculptures," *Scribner's Magazine* 57 (June 1915), pp. 779-782; John C. Ewers, "Cyrus E. Dallin, Master Sculptor of the Plains Indian," *Montana: the Magazine of Western History* 18 (winter 1968), pp. 35-43; Francis 1976; Rell G. Francis, "Cyrus E. Dallin, 1861-1944, Spokesman in Bronze for the American Indian," *Southwest Art* 11 (Oct. 1981), pp. 171-175; Waldo E. Long, "Dallin, Sculptor of Indians," *World's Work* 54 (Sept. 1927), pp. 563-568; M. Stannard May, "The Work of Cyrus E. Dallin," *New England Magazine* 48 (Nov. 1912), pp. 408-415; *New York Times*, Nov. 15, 1944, obit.; Proske 1968, pp. xxiv, 24-26; SMFA; A. Seaton-Schmidt, "An American Sculptor: Cyrus E. Dallin," *International Studio* 58 (Apr. 1916), pp. 109-114; Taft 1930, pp. 496-501; Whitney 1976, pp. 265-266.

CYRUS EDWIN DALLIN
87
Algerian Panther, 1880
Terracotta, painted brown
H. 8¾ in. (22.2 cm.), l. 16¾ in. (42.5 cm.), w. 5⅛ in. (13.1 cm.)
Signed and inscribed (on base at right side): ALGERIAN PANTHER / BY BARYE / COPIED BY DALLIN 1880
From the Estate of Isabella M. Hirst in her memory.
1980.403

Provenance: Isabella M. Hirst, Melrose, Mass.; Helen G. and K. Olive Hirst, Melrose, Mass.
Versions: *Terracotta*: (1, 2) present locations unknown

Shortly after Dallin arrived in Boston in the spring of 1880, he modeled a small head of a tiger (present location unknown) and the *Algerian Panther*, undoubtedly on the suggestion of his teacher Truman H. Bartlett, who had studied in Paris with Emmanuel Frémiet (1824-1910), the most celebrated French animalier after Antoine-Louis Barye (1796-1875). An enlarged copy of Barye's *Panther of Tunis*, 1840 (Walters Art Gallery, Baltimore), which measures 4 by 7⅞ inches,[1] the *Algerian Panther* closely follows the naturalistic details of the original plaster and wax model. For Barye, the romantic depiction of exotic animals had been tempered by his exacting scientific study of the species at the menagerie of the Jardin des Plantes, Paris, and Dallin carefully articulated the panther's musculature in similar fashion.

The Boston Terra-cotta Works may have supplied the material for the *Algerian Panther*, since Dallin made several copies (present locations unknown) in 1880 while he was working part-time for the firm.[2] Presumably they were done not only as an academic exercise but also as a means for the young sculptor to supplement his scanty allowance. Small animal studies were popular in Boston all through the nineteenth century as adornments for parlor and bedroom mantelpieces. Barye's own small-scale multiples, produced in bronze after 1847, were also cheap, plentiful, and of particular appeal to Victorians, who loved the romantic evocation of the exotic and the wild. The fashion for these often violent denizens of the jungle was duly noted by Henry James in the obituary for the great French sculptor in the *New York Herald Tribune*, December 25, 1875: "To have on one's mantel-shelf . . . one of Barye's business-like little lions diving into the entrails of a jackal . . . has long been considered the mark, I will not say of a refined, but at least of an enterprising taste."[3]

P.M.K.

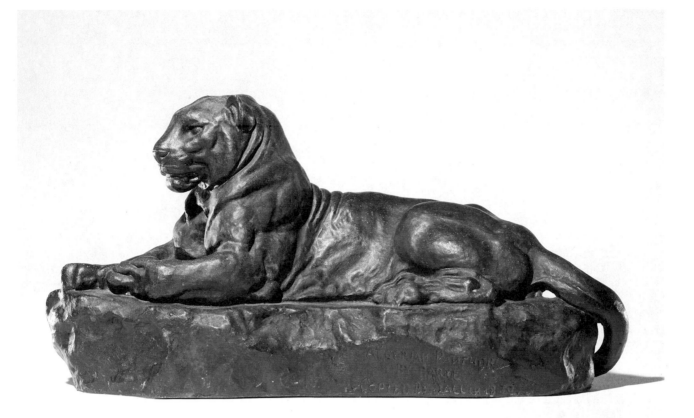

87

Notes

1. See Stuart Pivar, *The Barye Bronzes* (Woodbridge, Suffolk: Baron, 1974), no. A73. Nomenclature is difficult in identifying Barye's bronzes. *Panther of Tunis* is often confused with *Reclining Panther*, 1839 (Fogg Art Museum, Harvard University), and *Panther of India*, 1840, since Barye's own sales catalogues are not illustrated and all three panthers were also offered as reductions. Indeed, Pivar lists the *Panther of Tunis* (A71) as *Reclining Panther*. See also Jeanne L. Wasserman, *Sculpture by Antoine-Louis Barye in the Collection of the Fogg Art Museum* (Cambridge: Fogg Art Museum, 1982), nos. 21 and IV.

2. Francis 1976, p. 8.

3. Quoted in Ruth Butler, *Western Sculpture: Definitions of Man* (Boston: New York Graphic Society, 1974), p. 213.

CYRUS EDWIN DALLIN

88

The Protest, 1903

Bronze, brown patina, lost wax cast; copper wire

H. 20⅞ in. (53 cm.), l. 15½ in. (39.4 cm.), w. 5½ in. (14 cm.)

Signed (on base at right side): C.E. Dallin

Gift of Aimée and Rosamond Lamb. 67.1047

Provenance: Horatio A. Lamb, Boston; Aimée and Rosamond Lamb, Boston

Exhibited: Possibly Saint Botolph Club, Boston, *Paintings and Sculpture* (1903), no. 27; possibly The Mattatuck Museum of the Mattatuck Historical Society, Waterbury, Conn., Nov. 1916; BMFA, *Frontier America: The Far West* (1975), no. 293; The Copley Society of Boston, *A Centennial Exhibition: A Selection of Works of Members During Its First Half Century, 1879-1929* (1979), no. 12.

Versions: *Bronze*: (1) Heritage Plantation, Sandwich, Mass., (2) Arthur Rubloff, Chicago, (3) Springville Museum of Art, Utah, (4) Whitney Gallery of Western Art, Cody, Wyo.

The third equestrian sculpture in Dallin's series on Native Americans, *The Protest* portrays a mounted

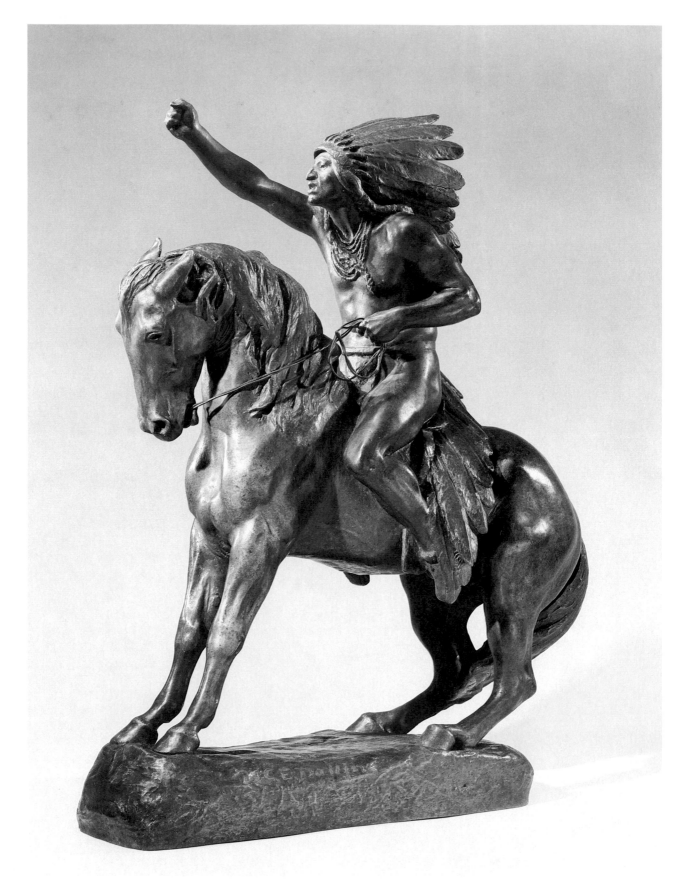

88

Lakota chief in war bonnet, defiantly gesturing with raised, clenched fist against the confiscation of his lands and buffalo by the white man. With his left hand, he abruptly reins in the horse, which pulls back on its haunches and braces its front legs.[1] The most militant and spirited of Dallin's works, *The Protest* depicts "the war stage,"[2] when the Indian, aware that his peaceful approaches to the white man have been fruitless, prepares to fight to protect his way of life. Horse and rider, all taut muscle and nervous energy, act as a springboard, hurling their defiance against the enemy.

Dallin created *The Protest* in 1903 for the Saint Louis World's Fair's Louisiana Purchase Exposition, whose theme, ironically, was "The Winning of the West." By this time the plight of Native Americans elicited sympathy and even feelings of guilt that went beyond romantic notions of the "noble savage." That summer Dallin sent a statuette of the work to Karl Bitter's (1867-1915) studio in Weehawken, New Jersey, where a large exposition staff under Bitter's direction prepared a colossal eighteen-foot statue of plaster and straw.[3] *The Protest* won a gold medal and high praise at the fair in 1904 but, unlike Dallin's other three epic equestrian figures, was never cast in heroic size. Perhaps civic leaders felt that this passionate reminder of the Native Americans' sense of outrage was too strong a political statement to be represented in a permanent memorial. As Dallin cynically commented in a 1924 interview, "in innumerable instances, it has seemed that the Indians had no rights which the white men were bound to respect."[4]

The Museum's version of *The Protest* may be the one cast in 1903 and exhibited in November at the Saint Botolph Club, Boston, as no. 27. Roman Bronze Works, New York, cast between ten and twelve of this 20½-inch size sometime before 1916, when Dallin also gave permission to the Gorham Manufacturing Company, Providence, to reproduce the statuette in an edition of forty-six.[5]

P.M.K.

Notes

1. The braced front legs are similar to Dallin's fourth model of *Paul Revere*, begun in 1884. Stillman Powers, Dallin's photographer and friend, suggests that Dallin's resentment over the Paul Revere affair may have inspired *The Protest*'s (and the *Appeal*'s) realism and dramatic power. See Francis 1976, p. 33.

2. William Howe Downes, "Mr. Dallin's Indian Sculptures," *Scribner's Magazine* 57 (June 1915), p. 782. Dallin's only sculpture of Native Americans in battle is *Conflict*,

about 1912 (present location unknown), which depicts two warriors on horseback. See Francis 1976, pp. 40-41.

3. Bitter was in charge of sculpture for the Buffalo (1901) and San Francisco (1915) expositions, which he also organized by theme.

4. Quoted in Katherine Thayer Hodges, "Dallin the Sculptor: His Indian Stories in Marble," *Magazine of Art* 15 (Oct. 1924), p. 524.

5. About eighteen of this size have been made to date. The Cyrus E. Dallin Society received permission from Dallin's son Lawrence in 1981 to make a modern 9-foot copy of *The Protest* to be placed in front of the Springville Museum of Art, Utah. Studio 27, Boston, received the commission in 1986 to prepare a 4½-foot model; Audio di Biccari made the clay model, and Robert Shure, the plaster cast. Information supplied by Arnold Mills, president, Cyrus E. Dallin Society, West Hanover, Mass., May 22, 1986.

CYRUS EDWIN DALLIN
89
Paul Revere, 1907 (modeled in 1899)
Plaster
H. 35½ in. (90.2 cm.), l. 34½ in. (86.3 cm.), w. 14⅞ in. (37.8 cm.)
Signed (on top of base): C.E. Dallin '99
Inscribed (on base at left side): COPYRIGHT BY C.E. DALLIN. SC PAUL REVERE
Caster's mark (on base at right side): Caproni and Brother, Boston
Gift of Mr. and Mrs. Edward O'Brien. 1973.162

Provenance: Mr. and Mrs. Wallace L. Pierce, Milton, Mass.; Mrs. Wilfred Metivier, Milton; Mr. and Mrs. Edward O'Brien, Needham, Mass.
Versions: *Plaster*: (1) Chapman School, East Boston, (2) Museum of Church History and Art, Salt Lake City, Utah, painted, (3) Paul Revere Life Insurance Co., Worcester, Mass., (4) Springville Museum of Art, Utah. *Bronze*: (1) Brigham Young University, Museum of Fine Arts Collection, Provo, Utah, (2) Robbins Memorial Library, Arlington, Mass., on loan to Smith Museum, Arlington Historical Society, (3) Arthur Rubloff, Chicago, (4) Springville Museum of Art

In 1899 Dallin created his fifth version (Springville Museum of Art, Utah) of a proposed over life-size equestrian sculpture of Paul Revere. As the sculptor wrote to the Boston Art Commission, October 24, 1899, "My model having been chosen by the [Paul Revere Monument] committee some years ago, and knowing the importance of this statue I have just completed a new model, which I wish to present to your honorable body before anything further is done. The model is at my studio No. 1 St. Botolph

Studios annex, and I should consider it a great favor if your Commission could find time within the near future to inspect it."[1]

On December 4 the commission voted their approval, which was duly noted in the *Boston Evening Transcript* with a brief history of the vicissitudes of the piece. Readers were reminded that no less an authority than Augustus Saint-Gaudens had endorsed the award-winning third model (present location unknown).[2] The article praised Dallin for tirelessly improving upon the sculpture: "remodeling it at least five times, until, in the judgement of experts, he had made of it a plastic work well worthy of a prominent location in Boston . . . one in which mobility and dramatic fire are well blended with harmonious lines and rhythmic poise."[3]

Dallin's fifth study of Revere, from which the Museum's version was cast, shows the Boston goldsmith (1735-1818), entrepreneur, and patriot, leaning back in his saddle and sharply reining in his horse, whose left foreleg is lifted high, right foreleg braced, and back legs bent on their haunches. Revere's expression evokes the excitement of his perilous journey on April 18, 1775, when he warned "every Middlesex village and farm" that the British troops were marching to Lexington and Concord.[4]

The original model, called *Waiting for the Lights* (present location unknown), was one of three prize winners in a March 1883 competition for an equestrian figure that best portrayed the ideas expressed in Henry Wadsworth Longfellow's *Paul Revere's Ride* (1860). Dallin shared honors with Daniel Chester French and James Edward Kelly (1855-1933) of New York in this well-publicized contest jointly sponsored by the city and three private groups associated historically with Revere. All three sculptors had to revise their entries, however, after a local historian pointed out that Revere did not wait for the lights from the Old North Church (Christ Church, Boston) before beginning his ride, Longfellow's poem notwithstanding. In May, Dallin's revision won first prize, but that August the committee asked him to correct the horse's left foreleg, which meant that he had to begin yet another version.[5]

In November Dallin's third model was accepted, and negotiations started on his contract for a twice life-size bronze sculpture to be mounted on a granite pedestal in Boston's Copley Square. Although the *Boston Advertiser* joined in the praise for Dallin's "dashing work,"[6] the young sculptor's efforts were soon aborted and the drive for public funds de-

feated when Truman H. Bartlett, his former teacher, in a scathing letter to the *Transcript*, criticized the committee for awarding the Revere contract to a "cowboy from Utah" who had designed "an impossible man on an impossible horse."[7]

Bartlett's outrageous attack evidently was in keeping with his contentious character,[8] but it left Dallin vulnerable in his relationship with the committee, which now continually revised the contract, increasingly limiting his artistic freedom. Although dismayed and embittered by the city's failure to back him, Dallin continued to work on the *Revere* until he left for Paris in 1888.

On his return to Boston in 1899, Dallin's hopes were revived when a new city government showed interest in reactivating the *Revere* commission. In January 1900 he displayed the latest model at his Boston studio, but despite appeals by the *Transcript* and a new Revere committee, the public failed to support the $20,000 fund drive to pay for the sculpture's execution and erection. By 1907 Dallin was sure that the *Revere* statue would never be dedicated in Boston, and he gave rights to P.P. Caproni and Brother, Boston, to create plaster statuettes of the fifth model, for which he received a royalty of ten dollars on each copy that was sold.[9]

In 1935, on the two hundredth anniversary of Revere's birth, Dallin began his own campaign to complete the commission. Now in his mid-seventies, he worked directly in clay on a heroic-size seventh and final version (present location unknown) in his Arlington studio. His own appeals for justice before the state legislature in March 1936 and his offer to sell the sculpture to the town of Arlington, as well as the display of a bronze-painted plaster enlargement on Boston's Charles River Esplanade in 1937, helped to revive the public's interest. Finally, Dallin submitted a parody of Longfellow's poem to the trustees of the city's George Robert White Fund in 1939. Appearing on January 7, 1940, before the venerable citizens' group that allocated income from the six-million-dollar fund to erect works of art in the city, Dallin read in stentorian tones:

Listen, my children, and you shall hear
Of the ignoble failure of Boston to rear
The greatest creation of my long career,
The Equestrian Statue of Paul Revere.
A citizens' committee of well known men
Selected my model from a competition of ten.
On July the Fourth, eighteen hundred and eighty-five,
The committee, of which not one now is alive
Made a contract with me all legally signed

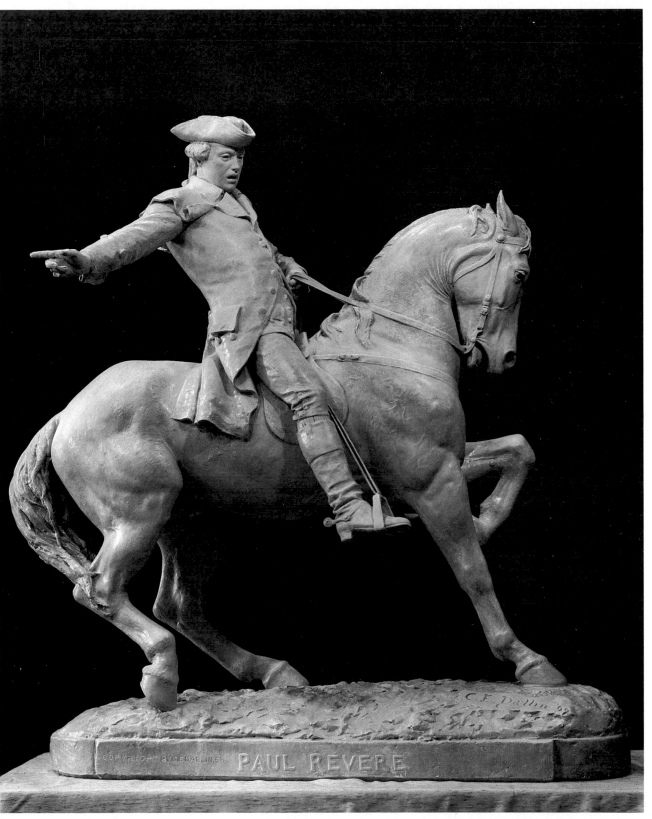

89

To erect in Copley Square my statue designed
To honor the hero whose cry of alarm
Aroused every Middlesex village and farm
For the country folk to be up and to arm.
Alas! no statue now graces Copley Square.
'Tis enough to make even an angel swear
But being only human I refuse to despair.
And I hope that means will be found somewhere
So after the lapse of many a year
Due honor be paid to Paul Revere.[10]

A month later the pedestal design and site for the *Revere* were agreed upon. Instead of Copley Square, the Art Commission chose the Paul Revere Mall, a small courtyard next to the Old North Church. In Dallin's seventy-eighth year, fifty-six years after its design was approved, the memorial to Paul Revere was unveiled on September 22, 1940. Cast in bronze at the T.F. McGann Foundry, Boston, the twenty-one-foot-high equestrian sculpture included a granite pedestal designed by J. Lovell Little, a Revere descendant, and Raymond Porter (1883-1949), Dallin's associate at the Massachusetts College of Art.

P.M.K.

Notes

1. Dallin to Boston Art Commission, Oct. 24, 1899, BAC. Archival material provided by Kathryn Greenthal.

2. The third model was lost in storage while Dallin was studying in Paris. A fourth model (Paul Revere Life Insurance Co., Worcester, Mass.), with the front legs of the horse braced as in the sixth model, 1912-1934 (present location unknown), may have been started as early as the fall of 1884 since it bears that date, but it evidently was reworked after Dallin's return from Paris since the modeling and technique appear quite advanced. See Francis 1976, p. 28.

3. "Mr. Dallin's Equestrian Statue of Paul Revere Approved," *Boston Evening Transcript*, Dec. 26, 1899.

4. Henry Wadsworth Longfellow, *Paul Revere's Ride* (1860).

5. The committee based their criticism on recent studies in motion picture photography. See "Statue of Revere," *New York Sun*, Oct. 31, 1934. Although Dallin has Revere mounted on a stallion, he actually rode a mare.

6. "The Fine Arts: Mr. Dallin's Paul Revere," *Boston Advertiser*, Dec. 19, 1884. The writer especially described Revere's horse as "full of spring and fire, elasticity and quivering life."

7. Quoted in A.J. Philpott, "Dallin Has Waited Fifty Years to Model Statue of Revere," *Boston Sunday Globe*, Oct. 22, 1933.

8. *DAB*, s.v. Bartlett, Truman H., as discussed in Francis 1976, pp. 21-23.

9. Francis 1976, pp. 32-33.

10. "Cyrus Dallin's Dream of Fifty Years Realized," *Boston Daily Globe*, Jan. 6, 1940, quoted in Francis 1976, p. 189. The last three lines of a manuscript version of the poem differ slightly; ibid., p. 237, n. 39.

CYRUS EDWIN DALLIN

90 (color plate)
Appeal to the Great Spirit, 1909
Bronze, green patina, lost wax cast
H. 122 in. (309.9 cm.); base h. 82 in. (208.3 cm.), l. 102½ in. (260.3 cm.), w. 43¾ in. (111.1 cm.)
Signed (on base at right side): C.E. Dallin 1908.©
Foundry mark (on base at left side): JABOEUF & ROUARD. FONDEURS. PARIS
Gift of Peter C. Brooks and others. 13.380

Provenance: Lent to Museum in 1912 by the sculptor
Versions: *Plaster*, half-life-size: (1) The Fine Arts Museums of San Francisco, (2) Springville Museum of Art, Utah, (3) Quincy High School, Mass., bronzed. *Bronze*, quarter-life-size: (1) Buffalo Bill Museum, Cody, Wyo., (2) Arthur Rubloff, Chicago, (3) Smith College Museum of Art, Northampton, Mass.; half-life-size: (4) Central High School, Tulsa, Okla., (5) Hood Museum of Art, Hanover, N.H., (6) Arthur Rubloff, (7) Springville Museum of Art; over life-size: (8) Minnetrista Boulevard, Muncie, Ind., (9) Woodward Park, Tulsa
(Many versions have been cast; see note 9 below.)

The *Appeal to the Great Spirit* was Dallin's fourth and final equestrian sculpture in his epic tribute to Native Americans. The over life-size mounted Lakota chief with outstretched arms represents the Indian people in defeat, "a lost cause appealed to the highest power"[1] and, for Dallin, the last stage in the drama of a noble race. As Lorado Taft noted at the Scammon Lectures on American sculpture in 1917, "Each version has been stronger and better than the last. . . . The climax was reached in the impressive 'Appeal to the Great Spirit' . . . which Boston has appreciated and so highly honored. It is worthy of its position in front of the monumental Museum of Fine Arts."[2]

Dallin's original 1907 plaster model (present location unknown) of the *Appeal* included two other figures. A Lakota with folded arms, perhaps symbolizing the spirit of nonviolent resistance, stood on the left of the mounted chief, and another figure holding a tomahawk, demonstrating the right of self-defense, stood on the other side.[3] Apparently, Dallin had considered showing that both responses were appropriate for Native Americans in the face of the many injustices perpetrated upon them. His decision to depict only a solitary equestrian figure reputedly was prompted by Daniel Chester French's

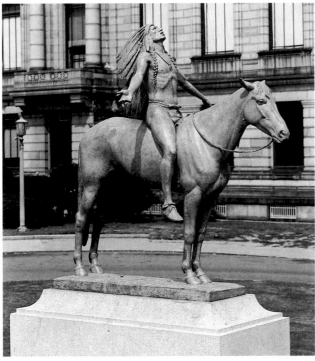

90

suggestions after a visit to Dallin's Arlington studio during the early stages of the *Appeal*.⁴

In the spring of 1908 Dallin exhibited a half-life-size plaster version of the *Appeal* (Springville Museum of Art, Utah)⁵ at the National Sculpture Society's exhibition in Baltimore, and in 1909 he took the sculpture with him to Paris to be enlarged and cast in bronze at Jaboeuf & Rouard.⁶ The plaster model was shown at the spring 1909 Paris Salon, where it took a third-class (gold) medal, the only one given for an American entry.

On its return to the United States, the *Appeal* was presented again at the 1911 winter exhibition of the National Academy of Design. Shortly after the bronze arrived in Boston, the Metropolitan Improvement League and a group of local artists that included Bela Pratt began a movement to raise Dallin's price of $12,000 to purchase the piece as an "ornament" for the park system. With the Boston Art Commission's approval, the Boston Park Commission selected a site in Frederick Law Olmsted's (1822-1903) "emerald necklace," the Fenway, not far from the Museum of Fine Arts. In April 1912 the statue was temporarily set up in front of the Museum's Huntington Avenue entrance in an effort to seek public contributions to secure the sculpture for the city. By October 1, however, a worried editorial writer for the *Boston Evening Transcript* noted that unless a more aggressive effort was made

to solicit funds, the *Appeal* might end up gracing one of three other cities that were negotiating for it with Dallin: Louisville, Kentucky, Washington, D.C., and Salt Lake City.⁷

Fortunately for Boston, which claimed Dallin for its own and yet had no public sculpture by him, Peter C. Brooks, whose family had been generous donors to the Museum, completed the subscription on November 19, 1912. His contribution, which included extra money for the pedestal, was given on the condition that the *Appeal* become the Museum's property. On December 23, 1912, Dallin signed a contract with the Museum, reserving the right to make and sell reproductions of the statue not exceeding three feet.

Dallin was encouraged by the *Appeal*'s success to create a number of other representations of Native Americans over the next eight years. In 1915 he entered into an agreement with P.P. Caproni and Brother, Boston, to sell plaster reproductions of fourteen of his Native American subjects,⁸ and in 1916 he arranged for the Gorham Manufacturing Company, Providence, to cast the *Appeal* in three sizes.⁹ Dallin also copyrighted the *Appeal* in 1918 since the sculpture in reduction was proving to be as popular as replicas of the *Statue of Liberty*, 1884 (New York).¹⁰ The decision on the pedestal design and placement of the sculpture was left to the Museum's trustees, with Dallin in the role of consultant. The permanent granite base, designed by Edwin J. Hipkiss, curator of decorative arts, was not put in place on Huntington Avenue until 1937.¹¹

P.M.K.

Notes

1. *Art and Progress* 4 (June 1913), p. 981.

2. Taft 1921, pp. 130-131. Adeline Adams, however, saw the paradox and the pathos of contrasting two cultures "the lower and the higher, the vanishing and the enduring. Does not that Indian," she asked, "remind us of great treasure which is ours, but in which he may not share?" Adeline Adams, *The Spirit of American Sculpture* (New York: National Sculpture Society, 1923), p. 140.

3. See illustration from *Boston Sunday Post*, 1907, reproduced in Francis 1976, p. 46. Francis suggests that the stoic figure may have been modeled after Chief Joseph of the Nez Percé nation, who had vowed in 1904 never to fight again, and the militant figure after the warrior in Dallin's *War or Peace*, 1905 (Springville Museum of Art, Utah). In 1911 Dallin made a high-relief plaster sketch *Passing of the Red Man* (present location unknown), in which a praying figure with arms outstretched is flanked by two men with heads bowed and arms folded.

4. See Loring Holmes Dodd, *Golden Moments in American Sculpture* (Cambridge: Dresser, Chapman, & Grimes, 1967), p. 37.

Dallin used several models for the Lakota chief, but their identification depends on later recollections by friends or family members of the sitters. The following may have sat for Dallin: Charles Hassel, Scottsdale, Ariz.; Joseph Baum, director of physical education, Harvard University; and Charles F. Foreman, Lincoln, Mass. The model for the horse, too, has several claimants: a Kentucky thoroughbred named Prince, owned by Dallin's neighbors the Livingstones, and Major, a carriage horse, belonging to Joseph Storer Hart, Lincoln, Mass. See BMFA, ADA.

5. This plaster, which is not a Caproni cast, may well be the original for the Museum's *Appeal*. Dallin gave the plaster to the Springville Museum in 1915.

6. The *Appeal* was cast in thirteen parts, according to Dallin, "the rider alone in as many as five pieces . . . the horse in as many more. The head and neck in one piece, the front legs and tail separate and the plinth one piece." See letter from Dallin to Edwin J. Hipkiss, curator of decorative arts, Nov. 10, 1933, BMFA, ADA.

7. See "An Appeal for the 'Appeal,'" *Boston Evening Transcript*, Oct. 1, 1912. On Nov. 20, 1912, the *Transcript* reported that Kansas City, Mo., was also interested in acquiring the statue.

8. See P.P. Caproni and Brother, Boston, *Caproni Casts: American Indians and Other Sculptures by Cyrus E. Dallin* (1915).

9. Gorham produced 285 casts of the *Appeal* in an 8- to 9-inch size; 109 casts of the quarter-life-size, or 21¾ inches; and 9 casts of the half-life-size, or 37½ inches. In addition, on April 25, 1973, Lawrence and Ruth M. Dallin, the sculptor's heirs, authorized a posthumous edition of 750 of the small size, under the direction of the Cyrus E. Dallin Society, West Hanover, Mass., from the original master patterns in Gorham's possession. About ninety of these have been cast to date.

In 1929 Dallin gave the Museum permission to sell a full-size replica of the *Appeal* to honor the glass jar manufacturer E.B. Ball in Muncie, Ind. Lawrence Dallin also authorized a 10 ft. 4 in. version, cast from a 39-in. bronze (Central High School, Tulsa, Okla.), which was erected in Woodward Park, Tulsa, in 1985. Information supplied by Arnold Mills, president, Cyrus E. Dallin Society, May 23, 1986.

10. By 1924 countless photographs of the *Appeal* had been sold without Dallin's permission. He sued for the infringement of his copyright, but the case was dismissed "without prejudice." See Francis 1976, pp. 161-162.

11. See letter from George H. Edgell to Edwin J. Hipkiss, Aug. 13, 1937, stating that the trustees had approved of Hipkiss and a Mr. Rausch making the pedestal for no more than $2,500; BMFA, ADA.

The *Appeal* was cleaned in 1918 and again in 1933 when it was repatinated, first in brown, then, on Dallin's request, changed to green, his original intent. In 1978 the Museum's Research Laboratory treated *Appeal* for corrosion damage. A new method was used to prevent further surface degradation. Tinted layers of lacquer (Incralac) were applied with a top coat of paste wax. See Lambertus van Zelst and Jean-Louis Lachevre, "Outdoor Bronze Sculpture: Problems & Procedures of Protective Treatment," *Technology & Conservation* 8 (spring 1983), pp. 18-24.

CYRUS EDWIN DALLIN
91
Julia Ward Howe, 1912
Marble
H. 37¾ in. (95.9 cm.), w. 28¾ in. (73 cm.)
Signed (at lower right): C.E. DALLIN. SC.
Inscribed: (at upper left) MINE EYES / HAVE / SEEN THE / GLORY / OF THE COMING / OF / THE LORD (at bottom) JULIA WARD HOWE
Gift of the New England Women's Club. 13.556

Version: *Plaster*: present location unknown, formerly New England Women's Club, Boston

By contemporary accounts, Julia Ward Howe (1819-1910) was "one of the world's most famous women," who devoted her mature years to the advocacy of "human liberty everywhere."[1] Immensely popular whenever she appeared in public, Howe was at the forefront of the women's suffrage movement. Her preparation for public service came during the Civil War, when she helped her husband, Samuel Gridley Howe, first director of the Perkins Institution for the Blind (now Perkins School for the Blind), edit the Boston abolitionist newspaper *The Commonwealth*. After his death in 1876 and the marriages of her five children, Howe led a vigorous life, preaching, lecturing, writing, and traveling around the United States and Europe, supporting international movements for world peace and equality for women.[2]

Howe was also recognized as the unofficial poet laureate of Boston, a celebrated essayist and epigramist who like a "romantic old sibyl, traveling with her lecture, her cap and her laces tucked away in her hand-bag, recited the *Battle Hymn* on every occasion."[3] In 1907 she was the first woman elected to the American Academy of Arts and Sciences. (Anna Hyatt Huntington was the second, elected in 1926.) Howe was also the recipient of honorary degrees from three academic institutions in New England: Tufts University, Brown University, and Smith College, whose award she accepted in her ninety-second year.

When Howe died on October 17, 1910, there was a spontaneous movement on the part of prominent Bostonians to find ways to honor her. On November 3, Mary H. Ladd wrote on behalf of the New England Women's Club to Thomas Allen, chairman of the Boston Art Commission, offering to donate a portrait of Howe, who had been club president from 1871 to 1910, and inquiring whether the commission would give permission to hang a woman's portrait in Faneuil Hall.[4] Since the club was planning to act on this matter on November 7, Ladd asked Allen for his informal consent. Presumably this was given, for at the club's next meeting the gift of the Howe memorial portrait and its suggested placement were approved.[5]

These plans were soon altered, however, when a similar request by the Julia Ward Howe Committee, a citizens' group headed by John F. Fitzgerald, mayor of Boston, was turned down by the commission on December 29 on the grounds that Faneuil Hall was "already overcrowded with portraits" and the "destructive atmospheric conditions" in the building negated the possibility of substituting a portrait of Howe for one already hanging there.[6] Although the memorial committee proceeded to give a painting of Howe by her son-in-law John Elliot (1858-1925) to the Bostonian Society (Old State House, Boston) in 1912, the New England Women's Club took up the commission's suggestion that "a marble bust be made of Mrs. Howe and, in consultation with the Trustees, placed in the Boston Public Library."[7] Sometime in the next year, the club commissioned Cyrus Dallin to create a portrait relief of Howe, probably choosing him as much for his well-known liberal sympathies as for his technical mastery of the medium. Moreover, their decision to give the sculpture to the Museum rather than to the library may have been influenced by the former's intention to hang the memorial tablet just inside the Huntington Avenue entrance.

On May 6, 1912, Mrs. True Worthy White read a detailed description to the club of Dallin's progress on the sculpture.[8] By November the relief was finished, and in the *New England Magazine* that month, the portrait was praised as a "reticent self-contained work and an accurate likeness" with "exquisite sincerity of line."[9] The following March Howe's portrait was put in place in the Museum, remaining at the front of the building until it was moved in 1918 to the newly constructed Evans Wing.[10]

In Dallin's relief Howe is seated in profile, with a book in her left hand. She wears a lace-bordered

91

cap and a lace fichu, or scarf, over her dress. (Born three days after Queen Victoria, whom she closely resembled, Howe, like the English monarch, adopted a mourning cap after she was widowed.) The first line of "The Battle Hymn of the Republic" (1862), the patriotic lyrics she wrote in 1861 after visiting an army camp outside Washington, D.C., is inscribed on the relief to her left.

Dallin made about forty-five portrait reliefs during his career. They were his "bread-and-butter," particularly in the depression years of the 1930s, when he received few sculptural commissions. Of these, the *Howe* relief is one of the finest, with its clarity of design, sensitively rendered facial features, and delicately handled costume details. Even at age ninety, Howe's energetic personality, proud carriage, and clear gaze were still evident, and this is the image that Dallin successfully portrayed.[11]

In 1914 Dallin took time out from his portrayals of Native Americans to model plaster busts of Julia Ward Howe and two other Boston women activists: Harriet Beecher Stowe, the abolitionist writer, and Frances E. Willard, the educator and temperance reformer.[12] It is not certain that any of these plasters have survived, although P.P. Caproni and Brother, Boston, sold casts of all three busts and the

Howe relief beginning in 1915.[13] Dallin also began the heroic-size figure of the Salem religious martyr Anne Hutchinson and her daughter, dedicated in 1922 (State House, Boston).

P.M.K.

Notes

1. *Boston Globe*, Oct. 17, 1910, obit.

2. See *DAB*, s.v. Howe, Julia Ward; Deborah Pickman Clifford, *Mine Eyes Have Seen the Glory: A Biography of Julia Ward Howe* (Boston: Little, Brown, 1978); *Boston Globe*, Oct. 17, 1910, obit.; Laura E. Richards and Maud Howe Elliot, *Julia Ward Howe, 1819-1910*, 2 vols. (Boston: Houghton Mifflin, 1915).

3. Van Wyck Brooks, *The Flowering of New England, 1815-1865* (New York: Dutton, 1936), pp. 486-487.

4. Ladd to Allen, Nov. 3, 1910, BAC.

5. Minutes of the Monday Afternoon Meetings of the New England Women's Club (NEWC), Nov. 7, 1910, Schlesinger Library, Radcliffe College. Howe was one of the first vice-presidents of the club, which was formed in 1868 to provide a convenient meeting place for women of Boston and the suburbs to receive "knowledge and inspiration" and to address their efforts toward various social causes. See Julia Ward Howe, "Associations of Women," *Art and Handicraft in the Woman's Building of the World's Columbian Exposition* (New York: Goupil, 1893), pp. 147-149.

6. Letter from Thomas Allen, chairman of the Boston Art Commission and secretary of the Julia Ward Howe Committee, to Rev. Charles W. Wendte, Dec. 29, 1910, BAC. Allen concluded his letter: "In view of the publicity already given to this matter, we reserve the right to publish this letter in the press." See "Replies as to Howe Portrait," *Boston Daily Globe*, Dec. 30, 1910, where the letter is published. This may explain how the New England Women's Club heard of the commission's recommendation.

7. Allen to Wendte, Dec. 29, 1910, BAC.

8. Minutes of the Monday . . . Meetings of the NEWC, May 6, 1912, NEWC.

9. M. Stannard May, "The Work of Cyrus E. Dallin," *New England Magazine* 48 (Nov. 1912), p. 414.

10. The *Christian Science Monitor*, Mar. 19, 1913, reported erroneously that the relief was made of plaster. In fact, a plaster cast (present location unknown) was given to the club by the family of Mrs. Edward Everett Holbrook, vice-president of the club and a close friend of Mrs. Howe. Two clubs with which Howe had been closely affiliated also contributed to the memorial: the Home Club and the Wintergreen. See Minutes of the Monday . . . Meetings of the NEWC, Apr. 28, 1913.

11. See photograph in Scrapbook, NEWC. See also photograph in the collection of Julia Ward Stickley, reproduced in Clifford, *Mine Eyes Have Seen the Glory*, facing p. 155.

12. See Francis 1976, pp. 85-86.

13. See P.P. Caproni and Brother, Boston, *Caproni Casts: American Indians and Other Sculptures by Cyrus E. Dallin* (1915), nos. 5503-5505.

CYRUS EDWIN DALLIN

92

Two Models for the "Pilgrim Tercentenary" Half-Dollar, 1920

Plaster

Diam. 13½ in. (34.3 cm.)

Signed (between HALF and DOLLAR): C.E.D.

Inscribed (in reverse): *obverse*: (near Bradford's neck) IN GOD / WE TRUST (near rim) UNITED · STATES · OF · AMERICA PILGRIM · HALF · DOLLAR; *reverse:* (near rim) PILGRIM · TERCENTENARY · CELEBRATION 1620-1920

Gift of a Friend of the Museum. 1981.66a,b

Provenance: Harold E. Whiteneck, Boston

Version: *Silver*, diam. 1 3/16 in.: (1) The American Numismatic Society, New York

On May 12, 1920, the United States Congress awarded Dallin the commission to execute a half-dollar commemorating the landing of the Pilgrims at Plymouth, Massachusetts.[1] The National Commission of Fine Arts had drawn up designs for the coin, and Dallin was their obvious choice since he already had produced a plaster model of William Bradford (Pilgrim Hall Museum, Plymouth), the first Pilgrim governor of the Plymouth Colony, for the Massachusetts Tercentenary Commission, and one of Massasoit (Springville Museum of Art, Utah), the Wampanoag chief who befriended the Pilgrims during their first difficult years in America, for the Improved Order of Red Men.[2] Although the *Bradford* was never cast in bronze because of insufficient funding, a heroic-size bronze of *Massasoit*, after a successful advertising campaign, was placed on Coles Hill facing Plymouth Rock in 1920.[3]

For the obverse of the Pilgrim coin, the half-figure bust of Governor Bradford appears in profile. The colonial leader, who was known for his piety, is shown gazing down at a Bible, which he holds in his left arm. Dallin may have been inspired by Augustus Saint-Gaudens's heroic statue *The Puritan*, 1886 (Springfield, Massachusetts),[4] but he chose to portray a contemplative subject rather than the striding, energetic figure of the monument.

On the reverse, the *Mayflower* is depicted sailing away into the distance. Despite the anachronistic triangular sail above the ship's bowsprit, the *Mayflower* is represented boldly, its billowing sails

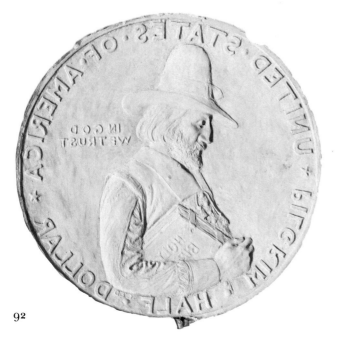
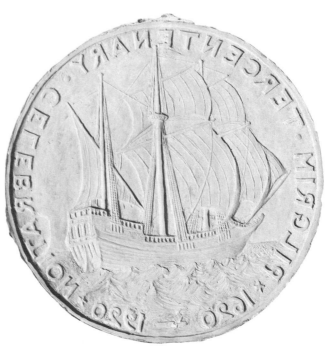

92

following the curve of the coin, which has an un-
usually high rim. The Pilgrim half-dollar's popular-
ity may account for the fact that images of sailing
ships were reproduced in five additional half-dol-
lars struck in the 1930s.

In 1920 Dallin's models were accepted by the
Treasury, although the National Commission of
Fine Arts found the lettering to be crude. In the
coin reduction, however, the letters appeared more
regular, and no attempt was made to improve on
them. The Massachusetts Tercentenary Commis-
sion was entrusted with distributing the Pilgrim
coins through the National Shawmut Bank of Bos-
ton, with national banks in other principal cities
receiving an allotment. The half-dollars were sold
for one dollar each, and the proceeds went to the
Massachusetts group to help pay for the celebra-
tion. In 1920 there were 152,112 coins minted, but
no date was given on the obverse. In 1921 an addi-
tional 20,053 were issued with the date added in the
field on the left above Bradford's chest. Of the total
number circulated, 128,000 were returned to the
Philadelphia Mint and melted down.[5]

In 1929 an impressive group of coins was shown
at the National Sculpture Society's exhibition at the
California Palace of the Legion of Honor in San
Francisco. Dallin's Pilgrim half-dollar was included
along with Victor Brenner's Lincoln penny, 1909;
James Earle Fraser's buffalo nickel, 1912; Hermon
MacNeil's quarter, 1916; Bela Pratt's Indian head
five-dollar gold, 1908; and Augustus Saint-Gau-

dens's double-eagle twenty-dollar gold, 1907. At no
time was American coinage better represented, a
signal honor for sculptors whose talent and versatil-
ity were now recognized internationally.[6]

P.M.K.

Notes

1. Dallin also made a model for a Pilgrim Tercentenary
Medal (present location unknown) showing the landing
of the Pilgrims, but there is no evidence that it was cast or
struck. The bas-relief *Treaty with Massasoit* (present loca-
tion unknown) may have been the design for the reverse.
See Francis 1976, p. 131, figs. 246-247.

2. See *Record of the Great Council of the United States, Im-
proved Order of Red Men* (1915), pp. 24-25, 37.

3. Souvenir bronze medals with a facsimile of the statue
on the obverse were sold nationally for twenty-five cents
each. Ibid. (1922), pp. 159-164. Later castings in bronze
of the heroic-size *Massasoit* stand on the grounds of the
Utah State Capitol and Brigham Young University,
Provo, Utah. See Francis 1976, p. 56.

4. See Vermeule 1971, pp. 160-162, who considers the
Pilgrim, or Mayflower, half-dollar a "masterpiece in the
conservative tradition" (p. 160).

5. R.S. Yeoman, *A Guide Book of United States Coins*, 23rd
rev. ed. (Racine, Wis.: Whitman, 1969), p. 209.

6. The Panama-Pacific Exposition, held in San Francisco,
1915, was also noteworthy for exhibiting so many coins of
different denominations, all issued that year and de-
signed by both mint artists and other well-known sculp-
tors. See Vermeule 1971, pp. 135ff.

Clyde Du Vernet Hunt (1861 – 1941)

Less talented and less well known than his uncles, the painter William Morris Hunt and the architect Richard Morris Hunt (1827-1895), Clyde Du Vernet Hunt enjoyed a moderately successful career as both a painter and a sculptor. The son of Leavitt Hunt, William and Richard's brother, and Katherine L. (Jarvis) Hunt, Clyde was born in Glasgow, Scotland. His parents, whose marriage had united two distinguished and wealthy Vermont families, were making a tour of Europe at the time of their first child's birth. Following the outbreak of the Civil War, the Hunts returned to the United States and settled in Virginia and then in Washington, D.C., while Leavitt supported the Union cause. After the war the family departed Washington for their home in Weathersfield, Vermont.

Hunt's early art instruction came at the hand of his Uncle William, who gave him lessons in charcoal drawing. Before Hunt decided to become an artist, he prepared for a career as an engineer at the Massachusetts Institute of Technology and also enrolled in a course at Harvard Law School. Nevertheless, his artistic instinct prevailed, leading him to Paris, where he studied painting under Jean-Paul Laurens (1838-1921) and Benjamin Constant (1845-1902). Later, he received training in sculpture from Jules Coutan (1848-1939). In 1898 Hunt exhibited a large genre painting, *Girl Milking a Cow* (present location unknown), at the Royal Academy of Arts, London, which won high praise from James McNeill Whistler (1834-1903), who "declared it to be one of the finest examples of the use of whites in the whole history of modern painting."[1]

Hunt's activities as an artist temporarily came to a halt when he volunteered in the Cuban army in its insurrection against Spain. On behalf of his own country, he served in the Spanish-American War and in the Philippines. Subsequent to his military duty, Hunt briefly went back to the United States. Residing abroad, however, had suited him so thoroughly that he set off for Paris again, where he lived for some thirty years.

In France once more, Hunt increasingly devoted his creative efforts to sculpture. In the spring of 1918, Hunt had the distinction of being the only American invited to exhibit at the Palais des Beaux-Arts (Petit Palais), Paris,[2] where he showed a full-length, standing bronze figure, *Fils de France* and a full-length, seated marble, *Nirvana* (both at Bennington Museum, Vermont.) These images absorbed Hunt to the degree that he also made a

bronze bust of *Fils de France* (q.v.) and a marble bust of *Nirvana* (q.v.). Although there is a paucity of information about his oeuvre, a heroic-size bronze trilogy illustrating Abraham Lincoln and two versions of the full-length figures of *Fils de France* and *Nirvana*, sometimes referred to as *The American Spirit* (Bennington Museum, Vermont),[3] is probably his most important piece. Such was Hunt's involvement with the sculpture that it preoccupied him in its various stages from before 1928 to 1941. To form the trilogy, Hunt incorporated representations of the two aforementioned subjects with a likeness of Abraham Lincoln, exhibiting it in plaster, under the title *Lincoln,* at the 1928 Paris Salon, sponsored by the Société des artistes français, where it was given sympathetic appraisal by the press. One reviewer commented: "The Lincoln group . . . is impregnated with an unusual sentiment of dignity. The composition of the great man and the feminine figure of Faith make a mass, while the nude boy, Young America, as Hope, looking into the kindly but austere face for counsel, lends a deep interest to the picture."[4]

Ten years later when the sculptor left France for America, he took the plaster group with him and, soon after arriving in the United States, had it cast in bronze. In 1939 the bronze group was displayed in front of the Illinois State Building at the New

York World's Fair. Hunt spent the last few years of his life making preliminary plans for placing *The American Spirit* in a permanent location, but before finalizing arrangements, he died of pneumonia in Washington, D.C.[5]

K.G.

Notes

1. Quoted in J[ohn] S[pargo], *The Spirit of America* (Bennington, Vt.: Bennington Museum, n.d.), p. 4. This pamphlet, by the first director of the Bennington Museum, gives the most detailed account of Hunt's life.

2. *New York Herald*, Paris edition, June 9, 1928. This exhibition, like the one at the Grand Palais in 1919, was mounted to promote the wartime works of art of the Société des artistes français and the Société nationale des Beaux-Arts, in lieu of their annual separate Salons, which had been suspended during the war years.

3. Hunt never called the sculpture *The American Spirit*. The title was coined by John Spargo, who believed that it reflected the meaning of the group.

4. Quoted in S[pargo], *Spirit*, p. 6.

5. Hunt's heirs presented *The American Spirit* to the Bennington Museum in 1949 in his memory and in memory of Abraham Lincoln.

References

BPL; Donald Charles Durman, *He Belongs to the Ages* (Ann Arbor, Mich.: Edwards, 1951), pp. 269-271; MMA; *New York Times*, Feb. 2, 1941, obit.; NYPL; J[ohn] S[pargo], *The Spirit of America* (Bennington, Vt.: Bennington Museum, n.d.).

CLYDE DU VERNET HUNT

93
Fils de France, about 1920
Bronze, brown patina, sand cast
H. 12⅝ in. (32.1 cm.), w. 11⅛ in. (28.2 cm.), d. 8¼ in. (21 cm.)
Signed (under subject's right shoulder blade): C.D.V. Hunt
Lent by Leavitt J. Hunt. 24.26

Provenance: Leavitt J. Hunt, New York; lent to Museum in 1926*

The Museum's bust *Fils de France* is an abbreviated version of Hunt's standing bronze boy (44 inches high), also entitled *Fils de France*, 1918 (Bennington Museum, Vermont).[1] The sculptor exhibited the full-length statue at the 1918 Salon of the Palais des Beaux-Arts (Petit Palais), Paris, and at the Paris Salon of 1920, sponsored by the Société des artistes français. Three days after the 1920 Salon began, the annual exhibition of the Royal Academy of Arts

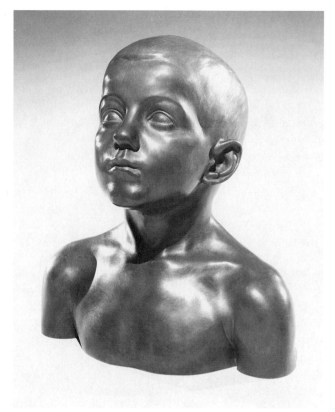

93

in London opened, and Hunt was represented there by a bronze listed as *Bust*, most likely the Museum's piece.[2]

Fils de France, created in Paris, was Hunt's tribute to a France he loved and revered, that he saw being devastated by war. The statue as well as the bust realistically portray a young boy gazing upward symbolizing France's future—its new generation.

During the 1920s Hunt combined a full-length *Fils de France* with a statue of Abraham Lincoln and a full-length *Nirvana*, a version of which, in the form of a marble bust (q.v.), is on loan to the Museum. *Abraham Lincoln* and *Nirvana* had been independent pieces, too, but by grouping the three figures together, Hunt produced a trilogy that was cast in bronze in about 1938 and eventually called *The American Spirit* (Bennington Museum). The manner in which Lincoln lays his hands on the heads of Nirvana, seated and emblematic of Faith, and the boy, who now stands for both youthful America and Hope, suggests the work's quasi-religious connotation.[3]

In 1926 Leavitt J. Hunt, brother of the sculptor, lent the bust of *Fils de France* to the Museum, where it has remained ever since.

K.G.

Notes

*This piece has been on loan to the Museum for so many years that it has become associated with the permanent collection and is therefore included in this catalogue.

1. In 1921 Hunt lent the standing figure to the Metropolitan Museum of Art, New York, where it was exhibited for several years. The patina may have been unsatisfactory, prompting Hunt in 1927 to send to that museum a gilded cast (present location unknown) that was never put on view. In 1933 Lincoln Cromwell wrote to William Sloane Coffin, president of the Metropolitan Museum, expressing the hope that the "copy in gold leaf patine which had been on exhibition in Philadelphia [at the Sesqui-Centennial Exhibition in 1926] after being shown at the Paris salon and the Royal Academy in London" would be "considered worthy a place in the gallery." The statue evidently could not be fitted into the museum's exhibition of modern American sculpture as then arranged, and both bronzes were returned to the sculptor in March 1933. See letters from Cromwell to Coffin, Jan. 9, 1933; and Herbert E. Winlock, director of the Metropolitan Museum, to Clyde Du Vernet Hunt, Mar. 23, 1933. MMA Archives. Subsequently, the ungilded figure was acquired by the Bennington Museum, Vermont.

2. In the letter from Lincoln Cromwell to William Sloane Coffin, Jan. 9, 1933, reference is made to a statue [of *Fils de France*] "in gold leaf patine" having been exhibited at the Royal Academy in London. However, Royal Academy exhibition records from the early years of the twentieth century list only a bronze bust by Hunt. (See Royal Academy of Arts, London, *The Exhibition of the Royal Academy of Arts: The One Hundred and Fifty-second* [1920], no. 1376.) Perhaps Cromwell confused the statue with the bust.

3. For a discussion of the Lincoln group, see J[ohn] S[pargo], *The Spirit of America* (Bennington, Vt.: Bennington Museum, n.d.), pp. 4-7.

CLYDE DU VERNET HUNT

94

Nirvana, about 1921

Marble

Signed (on top of base at back): C.D V. Hunt

H. 15⅜ in. (39 cm.), w. 16⅞ in. (42.8 cm.), d. 15 in. (38.1 cm.)

Lent by Leavitt J. Hunt. Res. 23.26

Provenance: Leavitt J. Hunt, New York; lent to Museum in 1926*

Hunt's bust of *Nirvana*, about 1921, on loan to the Museum since 1926, is an abbreviated and slightly modified version of a full-length, seated marble figure, about 50 inches high, of Nirvana, 1918 (Bennington Museum, Vermont).[1] The large *Nirvana*, which depicts a nude female, was exhibited in marble in 1918 at the Palais des Beaux-Arts (Petit Palais), Paris, and, in plaster, in 1920 at the annual Salon of the Société des artistes français.[2] At the Société's Salon of 1921, Hunt entered a marble head entitled *Dream*, which probably is the Museum's object.

The inspiration for *Nirvana*, like that for *Fils de France*, 1918 (Bennington Museum), appears to have sprung from Hunt's deeply felt response to World War I. The work may have been a symbol of the peace and harmony Hunt wished for. John Spargo interpreted the sculpture less specifically: "A Christian with a broad catholic sympathy and friendship for all religions . . . Hunt, who was much given to philosophic contemplation, gave homage in his heart to the essential core of the Buddhist conception of Nirvana; not to its mystical ideal of a beatific spiritual condition perhaps, but to one element of it which he regarded as essentially identical with Christian faith at its highest and best, the perfect faith that, as Saint John expressed it, 'overcometh the world.' "[3]

The bust of Nirvana differs from the full-length figure in that it is terminated in a roughly cut fashion, and the forward thrust of the head, neck, shoulders, and back is extremely pronounced, in contrast to the upwardly tilted head in the full-length figure. As a consequence of the dissimilar positioning of the head, the Museum's piece has a more striking effect and a greater sense of yearning. In appearance, the bust bears a resemblance to the marble bust *Inspiration* by Gutzon Borglum (1867-1941), of about 1910 (present location unknown, formerly Mrs. Henry Wadsworth, Washington, D.C.), in which a female head with closed eyes, also facing upward, emerges from a roughly hewn base. Ultimately, in spirit and in form, they are both clearly derived from the marble sculpture of Auguste Rodin (1840-1917).

During the 1920s Hunt combined the seated figure of Nirvana with a statue of Abraham Lincoln and with a full-length *Fils de France* (of which the Museum has a bust version [q.v.]) to make the group a trilogy, about 1938 (Bennington Museum).[4] At intervals for more than a decade, Hunt concentrated on the group, and it came to be his most significant contribution.

K.G.

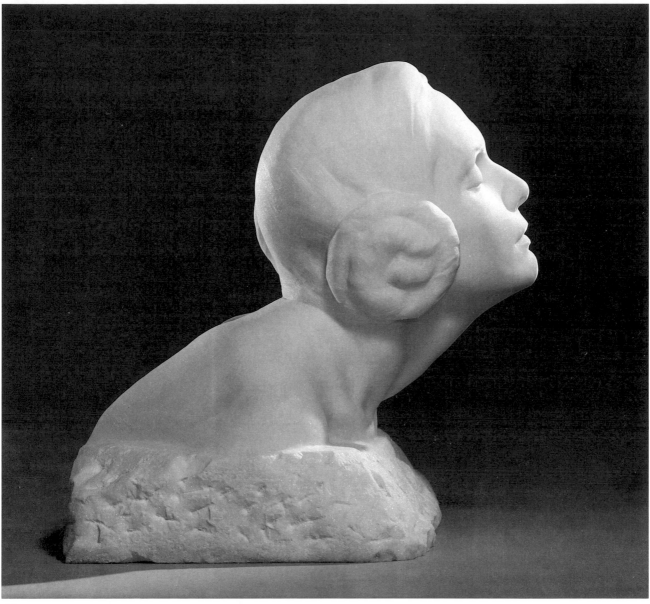

94

Notes

*This piece has been on loan to the Museum for so many years that it has become associated with the permanent collection and is therefore included in this catalogue.

1. The full-length, seated figure of Nirvana was on loan from Hunt to the Corcoran Gallery of Art, Washington, D.C., in the 1930s and early 1940s, before it was acquired by the Bennington Museum.

2. The plaster cast of Nirvana was selected as an illustration for the catalogue of the Salon.

3. J[ohn] S[pargo], The Spirit of America (Bennington, Vt.: Bennington Museum, n.d.), pp. 5-6.

4. In the trilogy Hunt enlarged Nirvana, changed the figure's hairstyle, and added drapery about her lower torso.

Charles Grafly (1862 – 1929)

Although Charles Grafly created ideal pieces and public monuments, he became known primarily as a portraitist and was "probably the foremost American sculptor of male portrait-busts."[1] He was Philadelphia's most influential Beaux-Arts sculptor, a talented artist who was also a gifted teacher at the Pennsylvania Academy of the Fine Arts for nearly forty years.

Born in Philadelphia, Grafly was the youngest of the eight children of Charles and Elizabeth (Simmons) Grafly. At seventeen he began a four-year apprenticeship as a carver in Struther's stone yard, where he helped execute the ornaments and figures for Philadelphia's new city hall. After attending drawing classes at the Spring Garden Institute, Grafly determined to seek a more vigorous education and enrolled in the Pennsylvania Academy of the Fine Arts in 1884. For two years he studied under Thomas Eakins (1844-1916), and from 1886 to 1888 he took lessons from Thomas Anshutz (1851-1912), receiving a thorough grounding in human anatomy from both instructors.

In the fall of 1888 Grafly went to Paris to prepare further for his career as a sculptor. At the Académie Julian, where he trained with diligence, he learned to model from Henri Chapu (1833-1891).[2] Within a year and a half after his arrival, Grafly was exhibiting at the Salon sponsored by the Société des artistes français; in 1890 he showed two plaster busts, *Saint John* (present location unknown) and *Daedalus*, the latter purchased that summer by the Pennsylvania Academy of the Fine Arts, which had it cast in bronze. At the Société's Salon of 1891, his entry was a life-size nude female figure in plaster, *Bad Omen* (present location unknown, possibly destroyed), which won an honorable mention.

Having accepted a teaching appointment at the Drexel Institute, an industrial school in Philadelphia, Grafly visited similar institutions throughout Europe for his edification before returning to the United States late in 1891. Soon he was instructing students at the Pennsylvania Academy of the Fine Arts as well. Influenced by his exposure abroad, above all in Paris, he revised the course in modeling at the academy with the idea of offering students a more professional program. Grafly even ordered two tons of French clay for his classes.[3] In spite of his pleasure in teaching and in being home, Grafly still felt that Paris was the place to be for a sculptor, and in 1895, newly married to Frances Sekeles, he settled there again.

Charles Grafly and Frederick Warren Allen

During the late 1890s and early 1900s Grafly was chiefly preoccupied with inventing sculpture of a symbolic character, sometimes monumental in scale and puzzling in meaning. In Paris he produced the huge plaster *Vulture of War*, 1896 (present location unknown; reductions at Brookgreen Gardens, Murrells Inlet, South Carolina, and the Pennsylvania Academy of the Fine Arts), his first symbolic work. With the aid of useful comments from the sculptor Jean Dampt (1853-1946), Grafly completed a personification of War in the form of a colossal male nude. Having originally contemplated a complex group of four figures, he ultimately chose to develop a single figure stepping on an orb—symbolic of the world he plagues—and dragging supposedly a bag of pestilence behind him.

Partly because of the birth of their only child in July 1896, the Grafly family departed Paris in September. Grafly resumed his teaching position at the Pennsylvania Academy of the Fine Arts and continued to make ideal images that reflected his appreciation of contemporary French sculpture, except that they were endowed with his own peculiar and, at times, unfathomable, symbolism. For example, the half-life-size bronze *Symbol of Life*, 1897 (The Pennsylvania Academy of the Fine Arts), is composed of two youthful allegorical figures striding

together; a nude male grasps a scythe (Man), and a larger, nude female holds an ivory globe from which wheat springs (Nature). *From Generation to Generation*, 1897-1898 (The Pennsylvania Academy of the Fine Arts), a 49-inch bronze, illustrates the notion of the continuity of life. An old man and a young boy, connected by a single thread, stand with their backs to a winged zodiac clock. The most enigmatic of these conceptions was the *Fountain of Man* (partially destroyed; remainder at the Wichita State University Endowment Association Art Collection, Edwin A. Ulrich Museum of Art, Kansas), an enormous group made of staff for the Pan-American Exposition held in Buffalo in 1901. The crowning figure expressed the dual nature of man, portrayed as two figures standing back to back, the juncture of their bodies hidden by flowing robes. Beneath were the Five Senses, five figures placed above the basin supported by four crouching groups, in which men and women represented vices and virtues. Like his compatriot George Grey Barnard (1863-1938), Grafly was interested in exploring the human condition; however, Grafly's ideal works, no matter how realistically modeled, occasionally featured subjects that were so personal that they drew criticism for their obscurity.

The symbolic groups were frequently exhibited, especially in the major national and international expositions, but they were not alone in establishing Grafly's reputation. Portrait busts, which Grafly had been modeling and displaying since the mid-1880s, were equally acclaimed during his early period, with *My Mother*, 1892, and *Frances Sekeles Grafly*, 1897 (both The Wichita State University Endowment Association Art Collection), winning particularly high praise. In fact, portraiture came to dominate Grafly's sculptural activities during his middle years, from 1900 to 1915. Although he executed many portraits on commission to supplement his income from teaching, the busts he took the greatest delight in making were of his artist friends and acquaintances, whom he in most cases invited to pose, often in exchange for a work of art. The sitters were almost exclusively painters, with the sculptor Paul Wayland Bartlett (1865-1925) being the notable exception. The portraits of this type, principally in the medium of bronze and of some fourteen individuals, are sensitively modeled and keenly observed. Of those in public collections, a few may be mentioned: *Hugh Henry Breckenridge*, 1898 (The Pennsylvania Academy of the Fine Arts), *William McGregor Paxton* (q.v.), *Thomas Pollock An-*

shutz, 1912 (The Pennsylvania Academy of the Fine Arts), and *Frank Duveneck*, 1915 (Cincinnati Art Museum).[4] Before long, Grafly realized he had created a series of portraits of artist friends, and he lost no opportunity to present these engaging studies at the annual exhibitions of the Pennsylvania Academy of the Fine Arts and the National Academy of Design, in New York, and at various museums throughout the country. The portrait of Frank Duveneck, for instance, was extremely popular and was displayed practically every year from the moment it was made until the sculptor's death.[5]

After 1915 Grafly devoted nearly all his energy to the *General George Gordon Meade Memorial*, his greatest achievement in monumental sculpture. Commissioned in 1915 and given by the state of Pennsylvania to the United States government in memory of a native son, the monument celebrates General Meade, who led the victorious Union army at the Battle of Gettysburg. Eighteen feet high and carved in marble, it shows the general flanked by nude and seminude allegorical figures of Military Courage, Energy, Chivalry, Loyalty, Fame, Progress, and War. Grafly labored on the monument for more than ten years, both in Philadelphia and in Lanesville (near Gloucester), Massachusetts, where he had been spending summers since the early 1900s. Unveiled on the Mall in Washington, D.C. in 1927, it was removed during the 1960s to make way for the construction of the reflecting pool at the east end. In the summer of 1983 the *Meade Memorial* was reinstalled on Pennsylvania Avenue near the Capitol.

In addition to the lengthy task of producing the *Meade Memorial*, Grafly maintained his position as head of the modeling department at the Pennsylvania Academy of the Fine Arts. Following the death of Bela Pratt in 1917, the School of the Museum of Fine Arts asked Grafly to become the chief instructor of its modeling department. He accepted and for the next twelve years pursued a demanding yet evidently satisfying schedule of teaching in both cities. For Grafly, training aspiring sculptors was a year-round endeavor, and in the summer, students came to Lanesville too. His skill as a tutor bore fruit, and Paul Manship, Katherine Lane Weems, and Walker Hancock are some of his pupils who attained distinction. The happy rhythm of Grafly's life was cut short when, one day in April 1929, while crossing a street in Philadelphia, he was struck by an automobile and died two weeks later.

K.G.

Notes

1. *DAB*, s.v. Grafly, Charles.

2. According to some biographical sources, Grafly studied at the Ecole des Beaux-Arts in Paris, but his name does not appear in the Registres matricules des élèves de sections de peinture et de sculpture, 1802-1894 (AJ52 234-236), Archives de l'Ecole Nationale Supérieure des Beaux-Arts, Archives Nationales, Paris. Also, the questionnaires completed by Grafly for the 1898 and 1912 editions of the *American Art Annual* do not list the Ecole in the section "pupil of." See MMA, ALS.

3. Doreen Bolger, "The Education of the American Artist," *In This Academy: The Pennsylvania Academy of the Fine Arts, 1805-1976* (Philadelphia: The Pennsylvania Academy of the Fine Arts, 1976), p. 70.

4. For the most thorough discussion of the portraits, and of Grafly's career in general, see Pamela H. Simpson, "The Sculpture of Charles Grafly," Ph.D. diss., University of Delaware, 1974. Simpson includes a catalogue raisonné and notes that in 1972 Grafly's daughter, Dorothy, gave his entire collection of plaster casts to Wichita State University. His papers were donated to Wichita upon Dorothy Grafly's death.

5. At least seven bronze casts were made by Grafly; see Simpson, "Sculpture of Charles Grafly," p. 385.

References

BPL; Caffin 1903, pp. 217-222; Craven 1968, pp. 437-442; Vittoria C. Dallin, "Charles Grafly's Work," *New England Magazine* 25 (Oct. 1901), pp. 228-235; Detroit 1983, pp. 155-156; MMA; *New York Times*, May 6, 1929, obit.; NYPL; W. Francklyn Paris, *The Hall of American Artists, New York University*, vol. 2 (New York: Architectural Forum, 1943), pp. 73-80; The Pennsylvania Academy of the Fine Arts, Philadelphia, *Memorial Exhibition of Work by Charles Grafly* (1930); Proske 1968, pp. 46-48; Anna Seaton-Schmidt, "Charles Grafly in His Summer Home," *American Magazine of Art* 10 (Dec. 1918), pp. 52-58; Pamela H. Simpson, "The Sculpture of Charles Grafly," Ph.D. diss., University of Delaware, 1974; SMFA; Taft 1921, pp. 134-135; Taft 1930, pp. 506-513, 579; Lorado Taft, "Charles Grafly, Sculptor," *Brush and Pencil* 3 (Mar. 1899), pp. 343-353; John E.D. Trask, "Charles Grafly, Sculptor: An Appreciative Note," *Art and Progress* 1 (Feb. 1910), pp. 83-89; Whitney 1976, pp. 71-72, 274-275.

CHARLES GRAFLY

95

William McGregor Paxton, 1909
Bronze, green over brown patina, lost wax cast
H. 24 in. (61 cm.), w. 12 in. (30.5 cm.), d. 9¼ in. (23.5 cm.)
Signed and inscribed (on back): WILLIAM McGREGOR / PAXTON DONE AT FOLLY / COVE CAPE ANN / MASSACHUSETTS AUGUST 1909 BY / Charles Grafly
Foundry mark (left side): ROMAN BRONZE WORKS N.Y.
Gift of Mrs. William McGregor Paxton. 41.852

Provenance: Lent to Museum 1910-1915, 1917-1941 by William McGregor Paxton
Exhibited: Probably The Pennsylvania Academy of the Fine Arts, Philadelphia, *Catalogue of the 105th Annual Exhibition* (1910), no. 887; National Academy of Design, New York, *Winter Exhibition* (1910), no. 140; Saint Botolph Club, Boston, *Catalogue of Sculpture by Charles Grafly and Paintings by Daniel Garber* (1911), no. 3; The Copley Society of Boston, Mar. 3- Apr. 15, 1966; BMFA 1977, no. 13.
Versions: *Plaster*: (1) The Wichita State University Endowment Association Art Collection, Edwin A. Ulrich Museum of Art, Kans. *Bronze*: (1) Philadelphia Museum of Art

"How like decaying vegetables are most of our portraits beside his!" commented the sculptor-critic Lorado Taft in alluding to the great esteem in which he, and others, held Charles Grafly's finest genre.[1] One of the busts that contributed to Grafly's success is the portrait of William McGregor Paxton. Paxton (1869-1941), who became affiliated with a group of painters known as the Boston School, which included Edmund Tarbell (1862-1938), Frank Benson (1862-1951), and Joseph DeCamp (1858-1923), specialized in portraiture and figure painting and is remembered above all for his views of fashionable ladies in elegant interior settings.[2] Grafly may have met Paxton when they were both art students in Paris during the late 1880s and early 1890s, or perhaps they became acquainted in 1902, when they first summered near one another on Cape Ann, Massachusetts, north of Boston. Whatever the year of their initial meeting, Paxton sat for Grafly in 1909, and the sculptor made the bust in a spirit of friendship. It was customary for Grafly to keep one cast (Philadelphia Museum of Art) and to give the other to the sitter;[3] in this case, in exchange for the bronze, Paxton painted a portrait of Grafly's daughter, Dorothy.[4]

The *Paxton* (probably the cast in the Museum of Fine Arts) was first shown in the annual exhibition of the Pennsylvania Academy of the Fine Arts in 1910. Executed during Grafly's middle years and

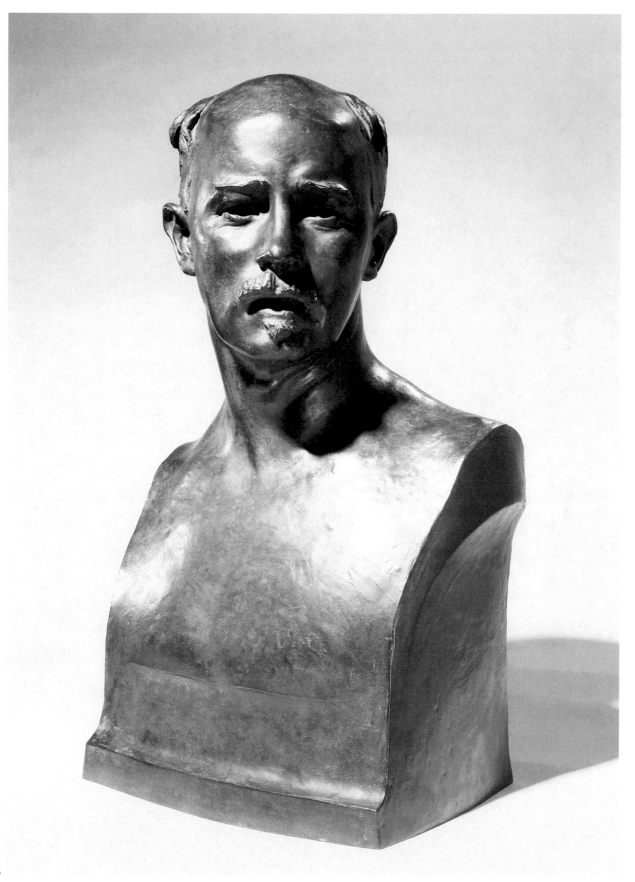

95

belonging to a series of portraits of artists, the bust reflects the style of his mature phase, demonstrating less concern than did his early work for bravura surface treatment and more interest in the underlying anatomical structure. In this piece, as in most of Grafly's portrait busts after 1900, he omitted contemporary dress, preferring to represent the sitter without clothing, undoubtedly to emphasize the head and to suggest the timelessness of the portrayal. He felt that props such as drapery did not necessarily enhance the image: "The elaborate over-decoration of the 18th century and the heavier decorative trend of the 19th found echo in the accessories of dress used by the portrait sculptor in his effort to establish the individual in point of time as well as in point of character. Externals thus leave their stamp upon the portrait bust as it marches through the ages, but externals have never made the portrait a finer work of art. It stands or falls by virtue of its construction, its modelling and the artist's own knowledge of human nature."[5]

To detach the *Paxton* further from association with a particular period and place, Grafly used the classical herm form for the base. He had already chosen this blocklike shape for his portraits on several occasions and would use it again in the busts of Frank Duveneck and Morris Gray (q.v.). Grafly countered the severe frontality of the base by turning Paxton's head to the left, a device that engages the viewer's attention in the most immediate manner. Further, the expressive eyes and lips give a wonderful sense of alertness to the face. In an article in the February 1910 issue of *Art and Progress*, John Trask marveled at the animation of the Paxton portrait: "Amazing in virtuosity as are the works he has shown in the last few years, two busts even now in the hands of the bronze founder mark still a forward step. Portraits, both of men, these were vacation recreations [the *Paxton* having been created at Folly Cove on Cape Ann in August 1909]. In them, to the truth of portraiture, the revelation of character, is added a quality unique. Paxton, the painter, Viereck, the entomologist, one dark, one light, are contrastingly presented with searching knowledge and consummate skill in the modeling of minute muscular individualities, where muscle and flesh are nervously alive. So vibrant are these busts with subtle differences that together they seem to set new limitations upon the artist's power to express color by form alone."[6]

Any hint of heroicism in the bust was intended, for Paxton was at the height of his ability in 1909

and 1910, producing two superb paintings in those years: *Tea Leaves*, 1909 (The Metropolitan Museum of Art, New York) and *The New Necklace*, 1910, in the Museum of Fine Arts.

<div align="right">K.G.</div>

Notes

1. Taft 1921, p. 135.

2. See BMFA, *William McGregor Paxton, N.A.: Memorial Exhibition of Paintings* (1941); and Indianapolis Museum of Art, Ind., *William McGregor Paxton 1869-1941 [Member of the National Academy]* (1979).

3. For correspondence relating to the gift of the *Paxton* bust in 1941 to the Museum from the sitter's widow, see Elizabeth Paxton to George H. Edgell, director of the Museum, Nov. 13, 1941; Edgell to Paxton, Nov. 15, Dec. 12, 1941. BMFA, 1901-1954, roll 2474, in AAA, SI.

4. For a discussion of Grafly's *Paxton*, see Pamela H. Simpson, "The Sculpture of Charles Grafly," Ph.D. diss., University of Delaware, 1974, pp. 67-71, 341-343.

5. Charles and Dorothy Grafly, "The Influence of Externals on Portraiture," *Encyclopaedia Britannica*, 14th ed., s.v. Sculpture, p. 208.

6. John E.D. Trask, "Charles Grafly, Sculptor: An Appreciative Note," *Art and Progress* 1 (Feb. 1910), p. 86.

CHARLES GRAFLY

96

Morris Gray, 1925
Marble
H. 26½ in. (67.3 cm.), w. 13 in. (33 cm.), d. 8⅞ in. (22.6 cm.)
Signed (on back): Chales [*sic*] Grafly / Aug 1923
Inscribed (on back): MORRIS GRAY / FIFTH PRESIDENT / OF THE MUSEUM / OF FINE ARTS / BOSTON
Martin Brimmer Fund. 26.24

Exhibited: BMFA, "The Memorial Exhibition of Sculpture by Charles Grafly," Mar. 17-May 3, 1931.
Versions: *Plaster*: (1) The Wichita State University Endowment Association Art Collection, Edwin A. Ulrich Museum of Art, Kans. *Bronze*: (1) Francis James Child Memorial Library, Widener Library, Harvard University, (2) The Metropolitan Museum of Art, New York

In 1896 the board of trustees of the Museum of Fine Arts commissioned from Augustus Saint-Gaudens a bust of Martin Brimmer (q.v.), its first president. Following this example, in 1923 the trustees again selected the finest contemporary sculptor of male portrait busts, Charles Grafly (who was familiar to them as a teacher at the School of the Museum of Fine Arts), to model one of Morris Gray, the fifth president, evidently as a pendant to

the marble *Brimmer*. Like most of Grafly's portraits, the *Morris Gray* was conceived for the medium of bronze. After inspecting the bronze bust that Grafly had made, however, the trustees put forward the idea that a version in stone be carved,[1] perhaps realizing that a marble would be more suitable for placement near the *Brimmer*. This proposal was approved and led to the production of the Museum's present bust.

Boston-born and Harvard-educated, Morris Gray (1856-1931) was described by the historian Walter Whitehill as "a lawyer and private trustee of the pattern so usefully familiar in Boston, looking after his own and other people's property and giving generously of his time to public institutions."[2] Gray is best recalled for his affiliation with the Museum, of which he was president from 1914 to 1924 and a trustee from 1902 until his death. During his tenure as president, which was marked by financial soundness and outstanding acquisitions, he advocated "soft-sell" fund raising and free admission (a policy that was introduced in 1918 and lasted until 1966). In 1923 Gray's health began to fail, and his doctors advised him to curtail his work schedule. During the early summer of 1924 a severe illness further debilitated him, and on July 17 of that year he resigned from the presidency.

It was probably because of Gray's weakening condition that the board of trustees had decided to commission his portrait. Gray started posing for Grafly in July 1923, and a bronze bust was completed by September. Upon examining the commissioned bust, Gray wrote to Grafly asking for a replica for his family and requesting that some provision be made so that "the Museum runs no risk of any possible mistake in the future about which is the original."[3] Grafly solved the problem by numbering the Museum's bronze "#1" and by shortening the inscription of the second cast, which, in addition, is marked "#2."

The first bronze bust was delivered to the Museum late in 1923 and was shown to the Committee on the Museum at their meeting of March 6, 1924. As mentioned earlier, the trustees, after seeing the bronze, suggested "that the bust be reproduced in marble."[4] Piccirilli Brothers in New York were entrusted to produce the marble version, which by June 1925 was progressing and by December of that year was finished.[5] Thus, the Museum's marble, the last of three busts that Grafly had made of Gray, was carved two years after the execution of the first of the two bronzes. Apparently, the carver at Picci-

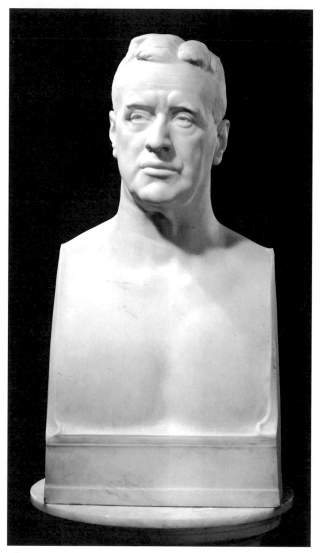

96

rilli's misunderstood Grafly's signature (an easy mistake since the signature on the bronze is virtually indecipherable) and inscribed the name on the marble "Chales Grafly." Though dating from Grafly's late period, the marble bust does not differ significantly in style or composition from portraits created during his middle phase, between 1900 and 1915. Grafly showed the sitter without clothing and, as in several of his portraits dating from after 1905, employed the classical herm form for the base. The *Gray* is less inspired than a work such as the *Paxton* (q.v.), which Grafly fashioned on his own initiative; nevertheless, it is sensitively rendered and conveys a dignified and still robust appearance of a gentleman who had so ably served the Museum.

As for the first bronze bust, on the recommenda-

tion of the Committee on the Museum, it was voted
at a meeting of the Board of Trustees on April 15,
1926, to offer it and its pedestal, then in the Mu-
seum, to Gray,[6] which he accepted. (His daughter,
Mrs. Cortlandt Parker, in turn gave it to the Metro-
politan Museum of Art, New York, in 1953.) When
Gray died in 1931, the second cast went to Harvard
University Library together with funds for the
purchase of books of modern poetry. In the winter
of 1926 the marble busts of Brimmer and Gray
were placed at each side of the entrance to the
library.[7] Sometime later they were removed. They
were again exhibited, until 1955, in proximity to
each other, this time, near the Museum's Hunting-
ton Avenue entrance.

K.G.

Notes

1. See Minutes of the Committee on the Museum, Mar. 6,
1924, BMFA, roll 539, in AAA, SI.

2. Walter Muir Whitehill, *Museum of Fine Arts, Boston: A
Centennial History* (Cambridge: Harvard University Press,
Belknap Press, 1970), vol. 1, p. 384. For biographical
information about Gray, see also Harvard College, Class
of 1877, *Class Reports*; *Bulletin of the Museum of Fine Arts* 22
(Oct. 1924), pp. 37-38; ibid. 24 (Apr. 1931), pp. 15-16;
Boston Evening Transcript, Jan. 12, 1931, obit.; and *The
National Cyclopaedia of American Biography* (New York:
White, 1968), vol. 50, pp. 405-406.

3. Gray to Grafly, Sept. 24, 1923, quoted in Pamela H.
Simpson, "The Sculpture of Charles Grafly," Ph.D. diss.,
University of Delaware, 1974, pp. 450-451. For the bust
of Morris Gray, see pp. 450-453.

4. Minutes of the Committee on the Museum, Mar. 6,
1924, BMFA, roll 539, in AAA, SI.

5. A letter from the Museum director's office, June 5,
1925, informed Morris Gray as follows: "I enclose a copy
of a letter from Mr. Grafly reporting progress on the
marble portrait bust of yourself." BMFA, 1901-1954, roll
2456, in AAA, SI. In a letter from the director's office to
William C. Endicott, treasurer of the Museum, Dec. 16,
1925, it was reported that the sculptor had finished the
bust. The letter continued: "As the pedestal maker is here
in Boston, I thought it wise to wait until the bust arrived
and try it on the pedestal we have for Martin Brimmer to
see if the size is right before ordering, if this meets with
your approval." BMFA, 1901-1954, roll 2452, in AAA, SI.

6. Minutes of the Meeting of the Board of Trustees, Apr.
15, 1926, BMFA, roll 537, in AAA, SI.

7. See *Bulletin of the Museum of Fine Arts* 24 (Dec. 1926),
p. 89.

Frederick William MacMonnies
(1863 – 1937)

Frederick MacMonnies, the protégé of Augustus Saint-Gaudens, was assured a position in the pantheon of American Beaux-Arts sculptors after his meteoric rise to fame at the World's Columbian Exposition of 1893. From then on, his special brand of naturalism, his gaiety and spontaneity, which so delighted the public, and his inventiveness and technical skill brought him numerous commissions and favorable recognition. He remained at the height of his profession until the early twentieth century, when his baroque compositions and decorative style no longer suited public taste.

MacMonnies was born in Brooklyn to Juliana Eudora (West), a first cousin, four generations removed, of the American painter Benjamin West (1738-1820), and William David MacMonnies, a prosperous importer of English saddlery and cutlery. Before he was thirteen, he left school and went to work when his father's business foundered.[1] Four years later he began an apprenticeship in Saint-Gaudens's busy studio, where he had the opportunity to observe the master's practices and meet some of New York's leading artists. Cosmopolitan painters such as John La Farge (1835-1910) and John Singer Sargent (1856-1925) and the architects Charles F. McKim (1847-1909) and Stanford White (1853-1906) were frequent visitors, kindling MacMonnies's ambition to achieve their high professional status.

Saint-Gaudens was slow to recognize his young helper's modeling skills, although MacMonnies won a first prize at Cooper Union in 1882, after only a year of evening classes. On seeing his copy of a Donatello bas-relief, Saint-Gaudens made sure that he enrolled in night drawing classes at the National Academy of Design and promoted him to assistant, giving him a chance to model forms for statues, enlarge sketches, and work on the lettering for inscriptions. MacMonnies was also involved with the decoration of the Cornelius Vanderbilt II mansion and the Villard House, designed by George B. Post (1837-1913) and White, respectively.

In September 1884 MacMonnies left for Paris, carrying with him warm letters of introduction from Saint-Gaudens to the artists Alfred Garnier (about 1848-after 1909) and Paul Bion (1845-1897), whose contacts enabled him to become acquainted with the city and its artistic community. Since MacMonnies could not afford to attend the Académie

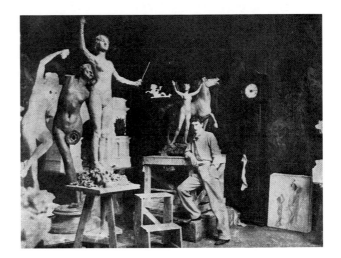

Julian, he took drawing classes at the Académie Colarossi. He also sketched from the antique at the Ecole des Beaux-Arts in morning classes that were open to everyone and where Jean Léon Gérôme (1824-1904) gave critiques twice a week. While MacMonnies was preparing for the difficult entrance examination to the Ecole, cholera broke out, and he fled to Munich. The next five months were occupied with studying charcoal drawing and modeling at the Royal Academy, but in the spring he was again in Paris, attending Colarossi's. That summer he returned to New York to oblige the overcommitted Saint-Gaudens. Once more in Paris in 1886, he began a two-year course of instruction at the Ecole, working in Jean Alexandre Falguière's (1831-1900) studio and taking private classes with Antonin Mercié (1845-1916). Both in 1887 and 1888 he won the Prix d'Atelier, the most prestigious award given to foreign students and second in honor only to the Prix de Rome. With Falguière's encouragement, MacMonnies opened his own studio in Paris and in 1889 submitted a life-size plaster of the Greek goddess Diana (bronze reduction, The Metropolitan Museum of Art, New York) to the Salon, where it received an honorable mention, his first international award.

At Saint-Gaudens's urging in the fall of 1889, the Sons of the Revolution awarded MacMonnies the commission for a statue of Nathan Hale to be placed in City Hall Park, New York, near the site of the American patriot's hanging by the British in 1776. The commission for a statue in Prospect Park, Brooklyn, of James S.T. Stranahan, a powerful New York developer and MacMonnies's future patron, was also given to him that year.[2] Both sculp-

tures were exhibited in plaster at the Paris Salon of 1891, where they won a second-class gold medal (the first to be awarded for an American sculpture) and plaudits from the press, with the *Hale* singled out for its lively, animated style.

MacMonnies's reputation was secured when Saint-Gaudens invited him to participate in the sculptural decoration for the 1893 World's Columbian Exposition in Chicago. MacMonnies's *Barge of State*, also called the *Triumph of Columbia*, was the favorite of the fair, demonstrating to Americans that sculpture could be as entertaining as it was uplifting. Placed at one end of the lagoon opposite Daniel Chester French's colossal personification of the Republic, the immense fountain, made of staff, represented in tableau fashion a great white ship (not unlike the one on which Columbus had sailed), propelled by eight maidens representing Arts and Industry. To a later generation, however, the sculpture has seemed more like "an ornate barge full of allegorical ladies struggling with improbable oars."[3]

After the Columbian Exposition, commissions were plentiful, and MacMonnies enjoyed considerable critical as well as financial success. On his return to Paris, he completed the *Bacchante and Infant Faun* (q.v.), capturing the gaiety and charm of his sitter with the same freedom of modeling that he had used in the Chicago fountain. During this time the popularity of his life-size garden figures prompted MacMonnies to authorize a series of bronze reductions that were sold by Durand-Ruel and others in New York and Paris.[4] Cast in several sizes by Roman Bronze Works, New York, and three Parisian foundries—E. Gruet Jeune, Jaboeuf & Rouard, and Leblanc-Barbedienne—these lighthearted groups, resembling the *Bacchante and Infant Faun* (which for a time was the subject of violent controversy) and reminiscent of Renaissance and classical fountain sculpture, caught the changing mood of the public and marked a shift in taste from the moral earnestness of neoclassical sculpture. Works such as the playful *Pan of Rohallion*, 1894, originally commissioned as a heroic bronze by banker Edward Dean Adams in 1890 for his home, Rohallion, in Sea Bright, New Jersey, were now available to the sophisticated collector in smaller versions at minimal cost. (An example of the thirty-inch size is in the Newark Museum, New Jersey.)

In 1888 MacMonnies had married Mary Louise Fairchild (1858-1946), a figure painter whose success at the Chicago fair with the mural *Primitive Woman*, 1893, for the Woman's Building, paralleled

his own.[5] Ten years later they were able to buy a former priory in Giverny, near Claude Monet's (1840-1926) studio, where they lived in grand style. MacMonnies kept a leopard (or panther) in one of his four Paris studios and during leisure hours spent time boxing, fencing, and bicycling. His handsome appearance and popularity drew a regular following of female admirers, especially after Janet Scudder (1873-1940), his first pupil, persuaded him to hold classes in Paris. MacMonnies's frequent absences—seeking commissions in the United States or working in Paris on large-scale sculptures—placed such a continual strain on his marriage, however, that in 1908 it ended in divorce.

At the Paris Exposition in 1900, MacMonnies received a grand prize for his collected works, but a year later, weary of the restrictions imposed on him by public commissions, he turned from sculpture to painting. Durand-Ruel gave him a one-person show in New York in January 1903 of fourteen paintings and eleven bronzes. The reviews of the paintings were generally poor, however, with the critic for the *New York Evening Post* finding them coarse, even though their "draughtsmanship, sense of light, and originality of conception"[6] were commended. Nevertheless, at the 1904 Salon he won a third-class medal for his paintings.

MacMonnies continued to teach at Giverny and, despite his protestations, to work on large-scale public sculptures, including commissions in 1908 for the *Princeton Battle Monument*, dedicated in 1922, and two marble fountains flanking the main entrance to the New York Public Library, *Truth* and *Philosophy*; in 1909 for another fountain personifying Civic Virtue for City Hall Park, New York; and in 1916 for the *Marne Battle Memorial* (Meaux, France), dedicated in 1932. *Civic Virtue*, in the guise of an eleven-foot male nude standing astride two writhing sirens representing graft and corruption, caused such an uproar at its unveiling in 1922, however, that it was eventually moved to Borough Park, Queens, in 1941. Like the earlier public clamor over his *Bacchante and Infant Faun*, the hostile reception for *Civic Virtue* came from women's groups protesting the sexual exploitation implicit in the allegory.[7] After that, MacMonnies vowed never again to accept public commissions, and he spent the remainder of his days doing portrait busts and reliefs.

In 1915 MacMonnies had returned to New York with his second wife and former pupil, Alice Jones, daughter of the United States senator John P.

Jones, the silver millionaire. They lived on Tenth Street, entertaining lavishly until the 1929 stock-market crash. When he died of pneumonia, the once acclaimed sculptor was all but forgotten and close to poverty.

By the 1920s the world of art had passed Mac-Monnies by, and the abstraction of modern art was a force beyond his understanding. The freshness of his earlier work, when the bravura of his technique was equal to the subject of his commissions and his own inspired pieces, had given way to a mannered and often ponderous style. For the most part, however, MacMonnies had been able to make up for a certain lack of feeling with the boldness and the beauty of his modeling. His stunning popularity during the 1890s was best explained by the sculptor-historian Lorado Taft: "His art is essentially plastic rather than glyptic. . . . He delights in the 'feel' of the clay, and handles it like a magician."[8]

P.M.K.

Notes

1. I wish to acknowledge Mary Smart's assistance and scholarship. She has generously shared information gathered for her planned biography on MacMonnies.

2. In 1894 Stranahan and Stanford White were instrumental in MacMonnies's receiving the Prospect Park, Brooklyn, commissions for the gatepost groups *The Horse Tamers*, 1899 (Park Circle Entrance), and the quadriga and army and navy groups, 1899, for the *Soldiers' and Sailors' Arch*.

3. Gardner 1965, p. 82. Most of the exterior decorative sculptures at the exposition were composed of staff, a mixture of plaster and hemp fiber, which was easily worked and inexpensive but impermanent. Wayne Craven illustrates the building of armatures for these staff creations in "Images of a Nation," in Whitney 1976, p. 56.

4. *Nathan Hale* was equally popular, with numerous reductions of the statue sold during the sculptor's lifetime. See Hirschl & Adler 1982, no. 32.

5. MacMonnies met Fairchild in November 1887 while they were both still students. After they were engaged in February 1888, they shared her studio, at first living mainly on the money she received from copying old masters, his commission from Stanford White for three gilded copper angels (Cathedral of Saint Paul the Apostle, New York), and his work for Falguière and Mercié. See Mary Smart, "Sunshine and Shade: Mary Fairchild MacMonnies Low," *Woman's Art Journal* 4 (fall 1983-winter 1984), pp. 20-25.

6. "Art Exhibitions," *New York Evening Post*, Jan. 21, 1903.

7. See Walter Muir Whitehill, "A Sequel to the Vicissitudes of Bacchante," *New England Quarterly* 30 (June 1957), pp. 249-251.

8. Taft 1930, pp. 333-334.

References

AAA, SI; BPL; Royal Cortissoz, "An American Sculptor: Frederick MacMonnies," *Studio* 6 (Oct. 1895), pp. 17-26; Craven 1968, pp. 419-428; Hildegarde Cummings, "Chasing a Bronze Bacchante," The William Benton Museum of Art, University of Connecticut, Storrs, *Bulletin*, 1984, no. 12, pp. 3-19; Edward J. Foote, "An Interview with Frederick W. MacMonnies, American Sculptor of the Beaux-Arts Era," *New-York Historical Society Quarterly* 61 (July-Oct. 1977), pp. 102-123; Gardner 1965, p. 84; H.H. Greer, "Frederick MacMonnies, Sculptor," *Brush and Pencil* 10 (Apr. 1902), pp. 1-15; Will H. Low, "Frederick MacMonnies," *Scribner's Magazine* 18 (Nov. 1895), pp. 617-628; McSpadden 1924, pp. 73-112; MMA; The Metropolitan Museum of Art, New York, *American Paintings in the Metropolitan Museum of Art*, catalogue by Doreen Bolger Burke, vol. 3 (1980), pp. 447-450; *New York Herald Tribune*, Mar. 23, 1937, obit.; *New York Times*, Mar. 23, 1937, obit.; W. Franklin Paris, "Frederick MacMonnies," *The Hall of American Artists Series*, vol. 3 (New York: Alexander, 1944), pp. 113-122; Post 1921, pp. 257-258; Proske 1968, pp. xxi, 33-35; Taft 1930, pp. 332-355; Walter Muir Whitehill, "The Vicissitudes of Bacchante in Boston," *New England Quarterly* 27 (Dec. 1954), pp. 435-454; Whitney 1976, pp. 53-55, 290-291.

FREDERICK WILLIAM MACMONNIES
97 (color plate)
Bacchante and Infant Faun, 1901 (modeled in 1893)
Bronze, black over green patina, lost wax cast
H. 85 in. (215.9 cm.), w. 25 in. (63.5 cm.), d. 32 in. (81.3 cm.)
Signed (on top right of base): F. MacMonnies / 1893
Foundry mark (on base at back): E. GRUET JNE FONDEUR PARIS
Bequest of Mrs. Harriet J. Bradbury. 30.521

Provenance: Charles Tyson Yerkes, New York; American Art Association, New York, Charles T. Yerkes sale, Apr. 11-13, 1910, lot 248; George Robert White, Boston; lent to Museum in 1910
Exhibited: BMFA, "Confident America," Oct. 2-Dec. 2, 1973; National Academy of Design, New York, *A Century and a Half of American Art* (1975), p. 142; BMFA 1979, no. 19.
Versions: *Bronze*, half-life-size: (1) Bennington Museum, Vt., (2) The Berkshire Museum, Pittsfield, Mass., (3) Cleveland Museum of Art, Ohio, (4) Miami University, Oxford, Ohio, (5) National Museum of American Art, Washington, D.C., (6) The New-York Historical Society, New York, (7) Philadelphia Museum of Art, (8) The R.W. Norton Art Gallery, Shreveport, La., (9) Sterling and Francine Clark Art Institute, Williamstown, Mass., (10) Virginia Museum of Fine Arts, Richmond, (11) Wadsworth Atheneum, Hartford, Conn., (12) The William Benton Museum of Art, The University of Connecticut,

Storrs; life-size: (13) Huntington Library, Art Collections, San Marino, Calif., (14) J.P. Jefferson, Montecito, Calif., (15) Music Academy of the West, Santa Barbara, Calif., (16) Post Road Gallery, Larchmont, N.Y.; over life-size: (17) The Metropolitan Museum of Art, New York, (18) private collection, England, (19) Town Hall, Sélestat, France. *Marble*, over life-size: (1) The Brooklyn Museum, (2) Hearst San Simeon State Historical Monument, Calif.

As described in the 1910 catalogue of the Charles T. Yerkes sale, the *Bacchante* "is in the act of dancing. On her left arm rests a young child, and she grasps it around the brest [sic] with her left hand. The child is anxiously looking with open mouth at a bunch of grapes which the Bacchante displays temptingly to the child's gaze by holding it up at arm's length. A smile is on the features of the Bacchante. . . . By many persons this work is considered the most artistic piece of bronze produced in the Nineteenth Century."[1]

First conceived early in 1893, the over life-size sculpture *Bacchante and Infant Faun* was inspired by a nineteen-year-old Parisian model named Eugénie Pasque, who had posed as one of the colossal rowers for the sculptor's *Barge of State* fountain at the World's Columbian Exposition, Chicago.[2] In May or June of 1894, when MacMonnies offered the *Bacchante* to Charles McKim out of gratitude for fifty dollars the architect had lent him in 1884 and several commissions after 1889, McKim realized his earlier desire to present a fountain figure for the courtyard of the new Boston Public Library in memory of his second wife, Julia (Appleton) McKim. As he explained to the sculptor, "This disposition of her, as the presiding spirit of the fountain and court, is the only excuse I can offer for excepting [sic] so undeserved and sumptuous an evidence of your regard."[3]

The French had also been entranced by the vivacity of the *Bacchante* from its first showing in the April 1894 Salon, and in the fall the government asked to purchase it for the Luxembourg Museum, Paris (the first American sculpture to receive such official approval).[4] When McKim heard of this, he wrote at once to MacMonnies, proposing to pay for a copy so that the Luxembourg could have the original, but MacMonnies replied: "I gave you the original and the original you are going to have, and I am going to pay for it—so that's the end of that."[5]

For MacMonnies, who was riding the crest of success after his great popularity at Chicago, it seemed that the *Bacchante* was about to establish his reputation in Boston. But despite McKim's approbation and its honors abroad, not everyone in that enlightened city approved of the dancing figure when she arrived in the early fall of 1896 from New York. The child, after all, was taken to represent Bacchus, the god of wine, and the carefree maiden a bacchante, who shared with other bacchantes or maenads, satyrs, and the old rural god Silenus the tutelage of the young divinity.[6] If some Bostonians objected to MacMonnies's sculpture as a symbol of mocked motherhood, they were not without grounds, for the passionate orgies of Bacchus's youth, initiated by his intemperate companions, were legion and licentious. Even more to the point, however, were the criticisms of MacMonnies's accurate likeness of the sitter and his naturalistic depiction of her nudity. In this regard, Parisians were far ahead of Americans, or at least Bostonians, in their delight in and acceptance of portrayals of contemporary women as mythological heroines even (or especially) when, like their classical sisters, they appeared unclothed. Falguière's *Diana*, 1887 (Toulouse Museum), for example, was extremely popular when it was shown at the 1887 Salon, its borderline pornography all the more titillating because the model was well known.[7] MacMonnies's own version of Diana (bronze reduction, the Metropolitan Museum of Art, New York), created two years later, closely follows the work by his teacher in its realistic technique but differs in the slender proportions and refinement of the figure.

Amidst the clamor over the *Bacchante*, the approval of the Boston Art Commission, as the preeminent authority, was now sought. But after months of looking at photographs and a small model, the commission, in a vote of four to one on October 12, 1896, declined to accept McKim's gift. No one seemed to question MacMonnies's skill; at issue, rather, was the subject's seeming "debauchery," which offended not only the Women's Christian Temperance Union but also such Boston luminaries as Harvard's Charles Eliot Norton and the social reformers Julia Ward Howe and the Reverend Edward Everett Hale. What might be appropriate in an art museum, Professor Norton prophetically counseled, was not necessarily suitable for a great public library.[8] An adulatory letter from Saint-Gaudens and the urging of Daniel Chester French, who were on the committee of experts, however, prompted the commission to agree to a November preview of the bronze in the library's courtyard, and two days after this showing, the group reversed its decision. This reprieve was

short-lived, however, since the inflammatory words of the press continued to exacerbate moral censure.[9]

By May 1897 McKim was so disgusted with the public's response to the *Bacchante* that he withdrew his gift and presented the original bronze instead to the Metropolitan Museum of Art, New York, whose trustees quickly accepted it. Moreover, he reassured MacMonnies, who by now was deeply troubled over this *cause célèbre*, that he did not "anticipate anything in the future but an increase of the prestige of your Classic and most beautiful creation. Removed from Puritan surroundings to the Metropolis, where she belongs, I think we may regard the question of her virtue as settled for all time."[10]

MacMonnies, however, had never been pleased with the smaller, life-size version cast by the Paris foundry Thiébaut Frères for the Luxembourg. In 1901 he had Gruet Jeune recast the work, using a model made from the Metropolitan's original bronze,[11] and at the same time ordered another version, which he sold to the American financier Charles Tyson Yerkes.[12] Streetcar magnate, sometime embezzler of public funds, and collector of European paintings, stained glass, and French and American sculpture, Yerkes had gone to England in 1900 with $15 million in cash, after selling his holdings in 1899 to Peter A.V. Widener and William L. Elkins, the Philadelphia street-railway kings. In London, Yerkes quickly took over control of the syndicate that built the London subways and avidly continued acquiring objets d'art and extraordinary European masterpieces. By the time of his death in 1905, however, his estate was bankrupt and was placed in receivership. At the subsequent New York sale in 1910 of the contents of Yerkes's Fifth Avenue mansion,[13] George Robert White, a multimillionaire in his own right, was high bidder on the *Bacchante* at $8,000, a fact not lost on the Boston press, which was quick to remind its readers of the "vicissitudes" of the original sculpture.[14] White, the great benefactor of the city of Boston and a trustee of the Museum of Fine Arts, promptly lent this version to the Museum until 1930, when it was bequeathed by White's sister Harriet Bradbury.

In 1903 MacMonnies executed a marble version of the *Bacchante*, though dating it from the original conception as 1894, and exhibited this at the 1905 Paris Salon; in 1906 it was purchased for the Brooklyn Museum. A second marble of the *Bacchante*, dated 1914 and entitled *Enchantée*, was acquired by William Randolph Hearst for his mother's home,

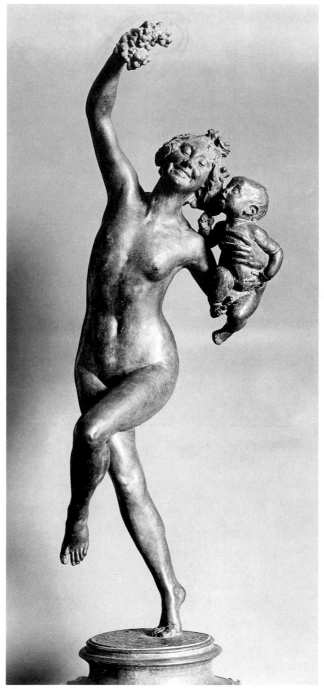

97

The Hacienda, in Pleasanton, California; in 1934 this sculpture was transferred to Hearst's estate at San Simeon, California. There are slight variations between the two marbles, but they differ mainly from the bronze versions in their lion-skin drapery and grapevine supports. According to MacMonnies, three bronzes were also cast in a life size "for small gardens or courtyards."[15] The notoriety surrounding *Bacchante and Infant Faun* ultimately worked to great financial advantage for MacMonnies, since numerous versions (34, 24, and 18 inches in height) were ordered. Altogether, these "parlor bronze" reductions were cast by at least four foundries and sold during MacMonnies's lifetime at Durand-Ruel, Theodore B. Starr, and Tiffany and Company in New York, among others.[16]

P.M.K.

Notes

1. American Art Association, New York, *Catalogue of the Statuary, Bronzes, the Costly Furniture and Embellishments Contained in the Mansion of the Late Charles T. Yerkes* (1910), lot. 248.

2. Eugénie Pasque also appeared in Charles Dana Gibson's (1867-1944) Paris scenes and "Gibson Girl" magazine illustrations. The New York Public Library has a copy of Gibson's biography annotated by MacMonnies, a friend from childhood, with the sculptor's note "Eugenie, the Model for the Bacchante" above a drawing entitled *A Café Artist*, which shows a man and a woman sitting at a table. New York Public Library Papers, roll N61, in AAA, SI. See Hildegard Cummings, "Chasing a Bronze Bacchante," The William Benton Museum of Art, The University of Connecticut, Storrs, *Bulletin*, 1984, no. 12, pp. 6-8.

3. McKim to MacMonnies, Nov. 2, 1894, MacMonnies Family Papers, Mr. and Mrs. Robert Strunsky, Princeton, N.J. MacMonnies had already given Stanford White bronze reductions of other works.

4. Paul L. Bion, Letter to Editor, *New York Critic*, Dec. 15, 1894.

5. MacMonnies to McKim, undated. MacMonnies's reply is written on the back of a letter from McKim, Jan. 4, 1895, MacMonnies Family Papers. MacMonnies had trouble with breaks in the model, and the first casting in July 1896 failed. A "green-painted plaster" cast was placed on view at the Luxembourg Gardens until another model was made from the original in 1897. See "More Pictures of Paris Life," *Springfield [Mass.] Republican*, Jan. 3, 1897, as noted in Cummings, "Chasing a Bronze Bacchante," p. 11.

6. See James Hall, *Dictionary of Subjects and Symbols in Art*, rev. ed. (New York: Harper & Row, 1979), pp. 37-38.

7. For a discussion of Falguière's conscious exploitation of the public, see *The Romantics to Rodin: French Nineteenth-Century Sculpture from North American Collections*, edited by Peter Fusco and H.W. Janson (Los Angeles County Museum of Art in association with George Braziller, 1980), no. 130. In the 1888 Salon, Falguière showed a second chubby, earthy *Diana*, which received no mention.

8. "Professor Norton's Objection," *Boston Post*, Nov. 16, 1896.

9. See Boston Public Library, Newspaper Clippings, Jan. 3, 1895-Jan. 25, 1897 (T.R. 27.21).

10. Letter from McKim to MacMonnies, Oct. 27, 1897, MacMonnies Family Papers. Nonetheless, the American Purity Alliance and Social Reform League, New York, waged its own war of words in the press.

11. See letter from MacMonnies to Edwin J. Hipkiss, curator of decorative arts, Feb. 8, 1932, BMFA, ADA. The Luxembourg Museum apparently sold its 1896 version to a private collector in England.

12. See Mary Frances Holter and Max Lerner, *DAB*, s.v. Yerkes, Charles Tyson. Theodore Dreiser immortalized Yerkes in his novels *The Titan* (1914) and *The Financier* (1927).

13. The Museum's version of the *Bacchante*, while in the Yerkes mansion, was illustrated in the *New York American*, Feb. 26, 1906, and entitled *Motherhood*.

14. In an interview at the time of his purchase, White disclosed that " 'the Bacchante' was the only thing in the Yerkes collection that interested me. . . . I felt that if I could bring the 'Bacchante' back to Boston I should be contented." Quoted in "Boston's Bacchante Is Not to Leave Us Bereft," unidentified newspaper clipping, BPL.

15. MacMonnies to Max Farrand, director of research, Henry E. Huntington Library and Art Gallery, Jan. 7, 1931, Huntington Library, Art Collections Archives, San Marino, Calif. In 1954 the Luxembourg's 1901 copy, cast by E. Gruet Jeune, was sent to Sélestat (Lower Rhine), France, and temporarily placed in the center of the General De Gaulle fountain, since the Luxembourg Museum removes the works of artists about a decade after their deaths. See letter from Albert Châtelet, Institut d'Histoire de l'Art, Strasbourg, to H.W. Janson, Sept. 28, 1981, with Janson's note to Kathryn Greenthal, Oct. 4, 1981, BMFA, ADA. This version now resides permanently in the provincial art gallery of the town hall at Sélestat. See also letter from Anne Pingeot, Musée d'Orsay, Paris, to Greenthal, May 16, 1984, BMFA, ADA.

16. See Cummings, "Chasing a Bronze Bacchante," pp. 14-16. Caproni and Brother, Boston, also sold 22½-inch plaster casts of the *Bacchante* in the 1920s for ten dollars. See *Catalogue of Plaster Reproductions* (1922), no. 2928.

Henry Hudson Kitson (1863 – 1947)

Best known for the statue *The Minute Man*, dedicated in 1900 (Lexington, Massachusetts), Henry Hudson Kitson was born to John and Emma (Jagger) Kitson near Huddersfield, Yorkshire, England.[1] As a child, he drew subjects from nature, such as ferns and flowers, and carved them with tools belonging to his eldest brother, John William, an architect and sculptor. What began as play, however, soon became a serious pursuit, and his interest was so great that his mother reputedly enrolled him in an evening drawing class at the Mechanics' Institute in Huddersfield. At a very early age, Kitson won several awards, including the first prize given by the Yorkshire Mechanics' Institute for design.[2]

Kitson persuaded his parents to send him, while in his mid-teens, to New York, where he could join his brother John William, who had preceded him to that city and who, with a partner, had established the firm of Ellin and Kitson. Henry began working for John William, and his first task was to help carve the Astor Memorial in Trinity Church; before long he and another sculptor brother, Samuel (1848-1906), were modeling most of the friezes and panels for the William K. Vanderbilt house. Kitson's skills developed quickly, and although he was still young, the most important carving was entrusted to him.[3]

In his late teens, Kitson went to Paris, where he studied under Augustin Dumont (1801-1884), entering his atelier in March 1882, and with Jean-Marie Bienaimé Bonnaissieux (1810-1892). Clearly talented, Kitson, with characteristic swiftness and ease, mastered figural modeling and by 1883 was exhibiting at the Paris Salon. That year he showed his first portrait from life, a plaster bust of his friend, the painter and musician Angelo Schütze, a version of which was placed on the latter's grave. In the Paris Salon of 1884 he exhibited two plasters, *The Fisherman's Wife* (present location unknown) and the highly regarded *Music of the Sea*. During that summer he was equally active, completing *The Singing Girl* (private collection) and a bust of Mr. Sturdee (present location unknown).

Kitson returned in the autumn of 1884 to New York, where he made a bust of the actor John McCullough (present location unknown). Several months later he visited Boston, possibly to see his brother Samuel, fell in love with the city, and within a year opened his own studio on Tremont Street. In 1886 he took on his first pupil, Theo Alice Ruggles (1871-1932), who in 1893 became his wife and with whom he would collaborate on various projects. For the memorial to Patrick Andrew Collins (mayor of Boston, 1902-1905), for instance, they both signed the bust and the two female figures, Erin and Columbia, that compose the monument, which was placed in Commonwealth Avenue at Charlesgate West in 1908 and moved to the Commonwealth Avenue Mall (between Clarendon and Dartmouth streets) in 1966.

It was not more than about two years after his arrival in Boston that Kitson won both the approval of local art critics and an order to execute a monument to the late Mayor Thomas A. Doyle of Providence, Rhode Island. In reporting Kitson's success in obtaining the commission, a writer for the *Boston Evening Transcript* called Kitson a "rising Boston sculptor" and noted the importance of the event, "not only for the young artist who received this public work over such competitors as Ward, St. Gaudens and Warner, but also to the public, which must be a gainer by every production of this rare genius, in whom the lost cunning of the ancient workers in bronze and marble seems to have been born again."[4]

Having secured a major commission, Kitson departed for Paris, where he fashioned the *Doyle* statue (exhibited in plaster at the Exposition Universelle, Paris, 1889) and entered in the Salon of 1888 the portrait bust of Theo Ruggles (q.v.) he had made in Boston the previous year. One of his greatest honors was the invitation to travel to

Bucharest in 1888 to create a bust of Queen Elizabeth ("Carmen Sylva") of Roumania, on which he labored into the 1890s and which received an honorable mention at the Paris Exposition of 1900. Kitson was without doubt making a name for himself in Paris and was singled out for a lengthy discussion in an article written there in 1888 for the *Boston Evening Transcript*: "I speak of Mr. Henry Kitson, . . . because the French artists acknowledge that of the younger sculptors from America he is by far the most notable, and will produce work of an influence and significance which cannot be overestimated. . . . The career of the young artist has been . . . one of unswerving, self-sacrificing devotion to a well-defined conception of what art ought to be made. Through difficulties and discouragements under which a less strong man would have despaired, Mr. Kitson has, by the exertion of an iron will, at last attained success, for he has succeeded in reaching a position from which he will be judged with fairness. That judgment, all who know him predict, will place him, at an age when most men are yet studying the rudiments of their art, easily among the very first American sculptors."[5]

In 1890 Kitson was back in Boston, giving shape to the *Admiral David G. Farragut Monument*, dedicated in South Boston in 1893. The *Farragut*, like the *Doyle Monument*, is an early example of the sort of commemorative statue with which this artist is primarily associated. The most famous of these is *The Minute Man*, an idealized statue of Captain John Parker, leader of the Minute Men at the Battle of Lexington, commissioned in 1898. Other freestanding figures of this type include *Roger Conant*, erected in 1913 (Salem, Massachusetts); *Robert Burns*, unveiled in 1920 in the Fenway and moved in 1975 to Winthrop Square (Boston); and *The Pilgrim Maiden*, unveiled in 1924 (Plymouth, Massachusetts). All bronzes, they are noteworthy for their forthright conceptions and historically accurate costumes. The heroic mannerism of an effort like the *Roger Conant* was not always maintained, and despite Kitson's early promise, a number of his statues display a rather awkward and forced sense of movement.

Kitson's contributions to the Vicksburg National Military Park, Mississippi, were, in his opinion, his most ambitious enterprise.[6] Executed over a period of about twenty years, they comprise a wide range of works (dates given here refer to their construction): bronze statues of General Stephen D. Lee, 1909, Admiral Farragut, 1917 (one of four statues set at the base of a 202-foot obelisk to form the U.S.

Navy Memorial), and Jefferson Davis, president of the Confederacy, 1927; a bronze relief of Major Gustavus Lightfoot, 1914; and heroic-size bronze portrait busts of Major-General Martin L. Smith, 1911, and Admiral Thomas Selfridge, 1913, as well as one smaller in scale of Captain William T. Rigby, 1928, who was instrumental in issuing many of the sculptural commissions at Vicksburg. Of all the sculpture in the park, Kitson lavished the most particular attention on the Iowa State Memorial—an equestrian color bearer surrounded by an elaborate exedra with six pictorial high-reliefs—which was built with the architectural assistance of Guy Lowell (1870-1927) and installed in 1912.[7] Among the young sculptors helping him on the memorial was Gaston Lachaise, who had arrived in Boston from Europe in 1906. When Kitson relocated to New York for several years in 1909 (after having left Boston for Quincy, Massachusetts, in 1904),[8] Lachaise remained to finish enlarging the central figure of the memorial. Three years thereafter Lachaise transferred to New York, too, and assisted Kitson and Paul Manship while embarking on his own endeavors.

Around 1916, Kitson settled in Tyringham, Massachusetts, living first with friends, Benjamin and Teresa Hobron and their daughter Marie, and later establishing his own home and studio. With enthusiasm and imagination, he renovated the buildings on his newly acquired property, to the extent of designing a fantastically wavy, "thatched" roof for the studio. Christened Santarella by the sculptor, the estate drew thousands of curious visitors because of its unconventional appearance. It nevertheless functioned well and for a time comfortably sheltered Kitson and Marie Hobron, who became his wife in 1934, two years after Theo's death. Kitson apparently never lost his youthful bravado (nor, for that matter, his temperamental nature) and remained a colorful, if not increasingly eccentric figure into his later years: "His long, white hair with his white mustache and beard certainly made him stand out in any crowd. He always wore a flowing, white silk cravat."[9] Although the demand for monuments by his hand subsided during the 1930s and 1940s, and a severe financial plight contributed to his decline, Kitson received modest commissions for small works, such as tablets, portrait busts, and reliefs, and pursued sculptural activities with undiminished vigor until the last years of his life.

K.G.

Notes

1. Kitson's birth date has been given variously in the references as 1863, 1864, and 1865; for example, Frank T. Robinson, Kitson's early biographer, gives 1864; and Lorado Taft, 1865. Nevertheless, 1863 is the date recorded on his birth certificate (copy available from General Register Office, London).

2. Frank T. Robinson, *Living New England Artists* (Boston: Cassino, 1888), p. 114.

3. Ibid.

4. *Boston Evening Transcript*, Feb. 24, 1887. Kitson did not receive the *Doyle* commission "over such competitors as Ward, St. Gaudens, and Warner." By the mid-1880s John Quincy Adams Ward and Augustus Saint-Gaudens were established and did not enter competitions, and Kitson, in fact, had written (Dec. 15, 1886) to Ward to ask for a recommendation regarding his "capability of modeling a figure." Most probably this request referred to the *Doyle* commission. I am grateful to Lewis I. Sharp of the Metropolitan Museum of Art, New York, for bringing to my attention this letter in the John Quincy Adams Ward Papers, NYHS. Manuscripts Divison.

5. F.E.E. Hamilton, "Some Artists in Paris: A Successful Boston Sculptor," *Boston Evening Transcript*, Oct. 13, 1888.

6. Clay Perry, "For the Glory: Poverty," *Yankee* 13 (May 1949), p. 48.

7. I am grateful to Michael W. Panhorst, who is writing a dissertation, "Monumental Sculpture on Civil War Battlefields before 1920," for providing information about Kitson's work at Vicksburg National Military Park.

8. One explanation for Kitson's move to New York may be that he had separated from Theo; see a letter from Elizabeth deBlasiis Karrick (a friend of the sculptor from 1928 until his death) to Wayne Craven, Oct. 30, 1971, in which she discusses Kitson in the years she knew him and refers to his earlier domestic life. Copy of letter in BMFA, ADA. See also H. Hobart Holly, in "Some Famous Quincy Sculptors," *Quincy History*, spring 1986, p. 2, who states: "The Kitsons separated around 1909 but he continued to be listed as a sculptor at the Quincy address until 1915 when his family moved to Sherborn, Massachusetts and he to Tyringham in the western part of the state."

9. Letter from Elizabeth deBlasiis Karrick to Kathryn Greenthal, Oct. 27, 1982, BMFA, ADA.

References

BAC; *Boston Globe*, June 27, 1947, obit.; *Boston Herald*, June 27, 1947, obit.; BMFA 1979, no. 17; BPL; Gordon Cotton, "Creator of Capt. Parker Statue: Massachusetts Couple Created Civil War Battlefield Monuments," *Lexington Minute-man*, Dec. 4, 1975, p. 11; S.C. de Soissons, *Boston Artists: A Parisian Critic's Notes* (Boston, 1894), pp. 80-81; Detroit 1983, pp. 156-157; Kathryn Greenthal, "Late Nineteenth Century American Sculpture in Its International Context," in *La Scultura nel* XIX *Secolo*, edited by Horst W. Janson, Atti del XXIV Congresso di Storia dell'Arte (Bologna: C.L.U.E.B, 1984), p. 243; C.S. Haywood, "Sculptor Kitson, 80 in April, Working on Huge Postwar Statue," *Springfield [Mass.] Sunday Union and Republican*, Mar. 18, 1945; "Henry Hudson Kitson, Berkshire Sculptor, Designs Jefferson Davis Statue in the Southland," *Berkshire Evening Eagle*, Aug. 27, 1927, p. 8; Elizabeth Newport Hepburn, "An Appreciation of a Boston Sculptor," *Art Interchange* 48 (June 1902), pp. 131-134; Judith H. Lanius, "Problems of Nineteenth Century Bronzes Revealed by Henry Hudson Kitson's *Music of the Sea*, 1884," seminar paper, 1974, BMFA, ADA; MMA; MMA, ALS; *New York Herald Tribune*, June 27, 1947, obit.; *New York Times*, June 27, 1947, obit.; Nordland 1974, pp. 11-16; NYHS, Manuscripts Division; NYPL; Clay Perry, "For the Glory: Poverty," *Yankee* 13 (May 1949), pp. 46-48; Frank T. Robinson, *Living New England Artists* (Boston: Cassino, 1888), pp. 113-119; "Secret Marriage Finally Revealed of Sculptor Kitson in September," *Springfield [Mass.] Daily Republican*, April 23, 1935, p. 4; "Sir Henry Hudson Kitson, Noted Sculptor, Is Dead," *Berkshire Evening Eagle*, June 26, 1947; Leonard Stewart Smith, "Sculptor Transforms Old Tyringham Farm," *Springfield [Mass.] Sunday Union and Republican*, Jan. 29, 1933; Taft 1930, pp. 489-490, 569; "Unique Summer Home in Tyringham, Once Owned by Sculptor, On Market," *Springfield [Mass.] Sunday Republican*, Jan. 21, 1951; Walter Muir Whitehill, *Boston Statues* (Barre, Mass.: Barre Publishers, 1970), pp. 54-55, 58-59, 72-73, 114-115.

HENRY HUDSON KITSON

98

Music of the Sea, 1884
Bronze, green over brown patina, lost wax cast
H. 44¾ in. (113.7 cm.), w. 24 in. (61 cm.), d. 29½ in. (75 cm.)
Signed (on rock under subject's left foot):
H.KITSON.PARIS / 1884
Foundry mark (on top of base at back): GRUET.J[NE]
FONDEUR PARIS
Gift of David P. Kimball. 20.1853

Provenance: Mrs. David P. Kimball, Boston
Exhibited: American Art Galleries, New York, *American Paintings and Sculpture Contributed to the "Second Prize Fund Exhibition"* (1886), no. 147; Boston Art Club, *Sixth Annual Exhibition of the Paint and Clay Club* (1887), no. 55; Massachusetts Charitable Mechanic Association, Boston, *Report of the Sixteenth Triennial Exhibition, 1887* (1888), no. 271; World's Columbian Exposition, Chicago, *Official Catalogue, Fine Arts, Department K, Part X* (1893), no. 75; BMFA, *Renaissance and Modern Bronzes Collected by the Visiting Committee on Western Art* (1908), no. 213; BMFA, "Confident America," Oct. 2-Dec. 2, 1973; BMFA, "Americans Outdoors: Painters of Light from Homer to Hassam," Aug. 12, 1980-Jan. 1981; Detroit 1983, no. 78.
Version: *Bronze*: (1) Pompeiian Villa, Port Arthur Historical Society, Tex.

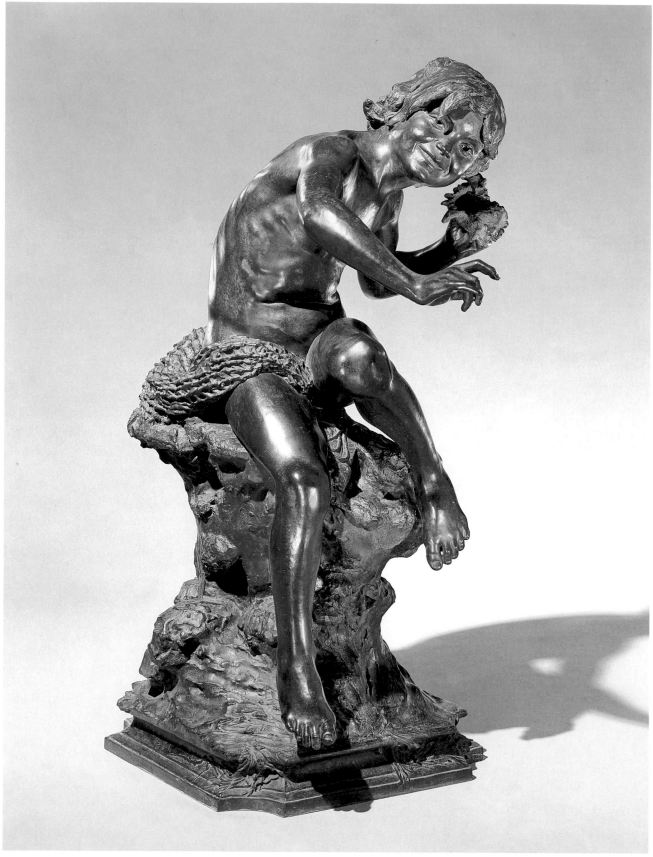

98

Kitson's early genre piece *Music of the Sea* was created during the sculptor's first stay in Paris. An example of his juvenilia, it bears no resemblance to his mature production of public monuments for which he is most remembered. Nonetheless, the statue is an effort of great ambition devised by the artist for entry into the Paris Salon, where he must have hoped it would bring him renown. Late in life, Kitson reminisced about the figure: "I was only eighteen [*sic*] when I finished my first work, '*Music of the Sea.*' Fame came to me like a stroke of lightning then. But I was so poor that I had to steal the fireplace furniture from Lorado Taft to form a frame for the statue. Of course, I told him about it, later, and that his tongs, shovel and poker was encased in plaster. I was so poor that I could not even afford a cab or truck to haul my heavy statue to the Ecole des Beaux Arts for the salon exhibition. A friend and I borrowed a handcart that was standing empty in the street near my door, loaded the statue onto it and dragged it by hand many blocks to the salon." Kitson also recalled a meeting with Rodin, perhaps not without some exaggeration: "I wanted to study with Rodin, so I invited him to come and see my '*Music of the Sea,*' and he came at the unearthly hour of six in the morning to my garret studio. He walked all around the piece, studying it. He said nothing, just walked around and around, for half an hour. Then he said, 'Young man, you do not want to have me try to teach you: I can not teach you. You have the facility to make statuary seem to be in motion, to flow. Keep on making them. Teach your self.' "[1]

Music of the Sea is said to have been inspired by the sculptor's memory of walks with his father along the west coast of England,[2] but surely it reflects Kitson's familiarity with the lighthearted image of the Neapolitan fisherboy. This romantic motif had been treated with considerable success by sculptors such as François Rude (1784-1855) in 1831, Francisque-Joseph Duret (1804-1865) in 1833, Jean-Baptiste Carpeaux (1827-1875) in 1858, and Vincenzo Gemito (1852-1929) in 1876; and Kitson, by adapting it, must have been making a direct reference to previous versions and thereby linking himself to the popular nineteenth-century subject. Kitson's figure, though not necessarily a Neapolitan, is extremely close in composition to Carpeaux's fisherboy, especially in the gesture of placing a shell to the ear. Other similarities include the grin, the disposition of the legs, and the fishnet across the thigh. Unlike Carpeaux, Kitson placed his figure on a rock

washed by waves (which serves as the base of the statue) instead of having him kneel on the shore. As a consequence of his precarious position, Kitson's boy extends his right arm as if to balance himself.

Music of the Sea was modeled in 1883.[3] It was first exhibited in plaster at the Salon of 1884, "where it drew forth universal admiration,"[4] and that same year the sculptor had it cast in bronze by the Gruet Jeune Foundry, Paris.[5] (A copy of the statue was made around 1940 for Port Arthur, Texas; and two plaster casts exist of the head of the boy: one in a private collection, Massachusetts, the other in the University Gallery, University of Delaware, Newark, both having come from the artist's studio.)[6]

After Kitson returned to the United States, he showed the statue on several occasions in the late 1880s, at which time it was invariably praised for its charming expression of the Beaux-Arts style and for its pleasingness. Upon seeing *Music of the Sea* at the Paint and Clay Club, Boston, in 1887, a critic for the *Boston Evening Transcript* remarked: "The delightful bronze representing a boy listening to the music of a sea-shell had been seen by many before, although its hearty, sympathetic touch of nature, its verve and its originality make it an ever-fresh delight."[7] Greta, the Boston correspondent for *Art Amateur*, in reviewing the piece at the club, noted: "Here is a work . . . so true in modelling, so nervous in muscle and vivacious in expression that it seems veritably alive, and *because* it is so true and is not in the conventionally smooth and impossibly symmetrical contours of form and limb, judged proper by Mr. and Mrs. Moneybags for parlor furniture, it may go begging for a purchaser among the wealthy connoisseurs of Boston and New England."[8]

Fortunately, *Music of the Sea* did not "go begging for a purchaser," as Greta had feared. On the contrary, it seems to have been enjoyed by everyone: at the Massachusetts Charitable Mechanic Association's exhibition in the autumn of 1887, together with *Miss Theo Alice Ruggles* (probably a plaster cast), it won a gold medal and in the end found a "purchaser" in Mrs. David P. Kimball of Boston, who acquired the piece sometime between 1887 and 1893. *Music of the Sea* was exhibited as belonging to her at the World's Columbian Exposition in 1893 in Chicago, where, with the marble version of *Miss Theo Alice Ruggles* (q.v.), it attracted much attention.[9] Mrs. Kimball subsequently lent the bronze to the Museum of Fine Arts, from 1894 to 1909, and in 1920 her husband gave it to the Museum.

K.G.

Notes

1. Clay Perry, "For the Glory: Poverty," *Yankee* 13 (May 1949), p. 47.

2. Frank T. Robinson, *Living New England Artists* (Boston: Cassino, 1888), p. 115.

3. Taft 1930, p. 490.

4. Ibid. According to the *Dictionnaire Veron* (Paris, 1884), p. 502, "there is vigor in the excellent movement, realistic and sensed, of this fine little figure" ("Il y a de l'élan dans l'excellent mouvement vrai et senti de cette bonne petite figure").

5. Judith H. Lanius, in "Problems of Nineteenth Century Bronzes Revealed by Henry Hudson Kitson's *Music of the Sea*, 1884," seminar paper, BMFA, ADA, 1974, raised the point that it seemed unlikely that a young man should have one of his earliest creations cast in bronze without benefit of a patron. She learned from Kitson's family that he had been friendly with the Gruets.

6. For information on the statue in Port Arthur, Tex., see BMFA, ADA. The plaster head in the University of Delaware, along with thirteen other works by Kitson, was given by Elizabeth deBlasiis Karrick. After the sculptor's death, Mrs. Karrick selected these pieces, which were presented to her by Henry Kitson's son, John.

7. *Boston Evening Transcript*, Feb. 24, 1887.

8. Greta, "Boston Correspondence," *Art Amateur* 16 (Feb. 1887), p. 54.

9. "By Boston Artists: Notable Array of Talent at the Big Fair," *Boston Globe*, July 3, 1893.

HENRY HUDSON KITSON

99

Miss Theo Alice Ruggles, 1888
Marble
H. 20 in. (50.8 cm.), w. 18½ in. (47 cm.), d. 10¾ in. (27.3 cm.)
Signed (on front at left): H.H.KITSON 1887
Anonymous gift in memory of John and Helen Kitson. 1973.495

Exhibited: Société des artistes français, Paris, *Salon de 1888: Explication des ouvrages de peinture, sculpture . . .*, 3rd ed. (Paris: Dupont, 1888), no. 4274; Exposition Universelle Internationale de 1889, Paris, *Catalogue général officiel, groupe 1, oeuvres d'art 1 à 5* (1889), no. 459; South End Free Art Association, Boston, *Catalogue of the South End Free Art Association* (1893); World's Columbian Exposition, Chicago, *Official Catalogue, Fine Arts, Department K, Part X* (1893), no. 76; BMFA, "Confident America," Oct. 2-Dec. 2, 1973; BMFA 1979, no. 17; BMFA, "Boston Dresses Up," April 15-Sept. 14, 1980.

Almost as precociously talented as Henry Kitson, her teacher and future husband, Theo Alice Rug-

gles (1871-1932) began studies with him at the age of fifteen in his Tremont Street studio in Boston. Born in Brookline, Massachusetts, daughter of Cyrus Washburn Ruggles and Anna Holmes (Baker) Ruggles, Theo took pleasure as a child in modeling, usually in clay; in one celebrated incident, however, she created a "reclining horse" in snow, which drew crowds of curious visitors from Boston to see the wonderful "sculpture" the girl had fashioned at her home.[1] Theo's parents supported her artistic inclination and placed her under Kitson's instruction. She took lessons from him for a year and a half before going to France with her mother for further training in the autumn of 1887.

In Paris she studied drawing under Pascal-Adolphe-Jean-Dagnan-Bouveret (1852-1929) and Gustave Courtois (1853-1923) and continued to work under the guidance of Kitson, who had also moved abroad. So plainly gifted was Theo as a sculptor that at each Salon during her three-year stay her pieces were readily accepted for display. Her first sculpture, a plaster bust of an Italian child, made about 1887 in Boston, and another plaster bust, *A Shepherd Lad*, about 1888 (present locations unknown), were included in the Salon of 1888. In 1889 Theo not only showed a plaster bust in the Salon but also exhibited a bronze bust of a child as well as *On the Banks of the Oise*, a life-size plaster statue of a seated boy by a river's edge (present locations unknown), in the Exposition Universelle, where both won an honorable mention. At the Salon of 1890 Theo presented *On the Banks of the Oise* in bronze (private collection, Massachusetts); like Kitson's *Music of the Sea* (q.v.), it was an early effort that was highly praised and frequently exhibited at the beginning of the sculptor's career. She showed in the same Salon a plaster cast of the statue *Young Orpheus*, about 1890 (present location unknown); and again her entries received an honorable mention. Given her age and gender, these accomplishments at the established Paris Salon and the prestigious Exposition Universelle were remarkable.

Returning to Boston, Theo exhibited her sculpture to equal acclaim in the United States. Four works were included in the World's Columbian Exposition, Chicago, 1893, and she won a bronze medal at the 1904 World's Fair in Saint Louis for *The Volunteer*, a Civil War statue, erected in 1902 (Newburyport, Massachusetts). After her marriage to Kitson in 1893, Theo's commissions in many instances paralleled those of her husband. For example, they each executed monuments for the

Vicksburg National Military Park, Mississippi, although Theo, with her fifteen heroic-size bronze portrait busts and forty-five bronze reliefs, was responsible for more sculpture there than her husband or indeed any other artist. She also produced the Massachusetts State Memorial, unveiled in 1903—a variant of *The Volunteer*—which was the first state monument set up in the park.

With certain exceptions, notably *Mother Bickerdyke*, the monument to the famous Civil War nurse, dedicated in 1906 (Galesburg, Illinois), and the statue of General Kosciuszko, installed in the Public Garden, Boston, in 1927, Theo became known chiefly for her war memorials, depicting an anonymous soldier representing his particular cause. *The Hiker*, a Spanish-American War monument of 1906, for the University of Minnesota in Minneapolis, became the most popular of this genre. Its portrayal of a young soldier, rifle in hand and ready for action, which resembles *The Minute Man* by Henry Kitson, is the embodiment of a vigilant, sturdy America that appealed to a patriotic public. Gorham Manufacturing Company, Providence, recognizing *The Hiker's* commercial marketability, paid a royalty to Theo for the right to reproduce the statue and during the twenties and thirties placed nearly fifty of them in cities and towns throughout the United States.[2] More often than not, Theo's statues of this type were modeled in a broad, realistic manner, but since her later, large pieces showed little stylistic development, her production came to possess a certain formulaic quality. Theo created most of her last sculptures in a studio near her home in Framingham, Massachusetts, where she moved a number of years before her death.

The portrait of Theo Alice Ruggles was made about one year after the sitter had become Kitson's pupil. Theo's features are rendered realistically with no attempt at idealization, and her expression reveals a serious and determined young woman. Loose curls partially cover her forehead, and a girlish braid, tied with a large ribbon, falls forward over her left shoulder. Altogether, Kitson has given Theo a most sensitive reading, resulting in an affecting portrait of uncommon power.

The design of the torso—the truncation of the arms between shoulder and elbow—and the border along the lower part of the marble are reminiscent of Renaissance portrait busts. Influenced by the Renaissance Revival style in sculpture that originated in France during the 1860s, this form

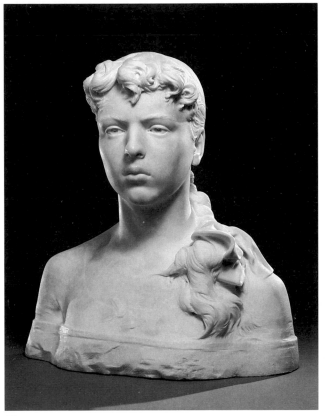

99

was widely adopted in America between 1875 and 1910 and was practiced by dozens of sculptors, among whom Herbert Adams (1858-1945) was perhaps the principal adherent.

Kitson finished the clay model in February 1887 and immediately submitted it for exhibition at the Paint and Clay Club in Boston, where it caused a sensation[3] and was lauded by a critic for the *Boston Evening Transcript*: "The clay portrait bust of a young girl, fresh from the sculptor's hands, with his tools and bits of shavings of the clay lying around it, was always the centre of the throng, so fascinatep [*sic*] and eager that it was apparently only with some watchfulness and difficulty that the perishable model was preserved from demolition. In subtlety of truth, beauty of finish and intimate suggestion of character, Mr. Kitson has surpassed himself in this work. The modest, yet self-possessed, carriage of the head, the delicate grace of the slender neck and bust, the absoluteness of the delineation of every minutest plane and contour, without a trace of labor, struggle or niggling, result in the actual embodiment of a real individuality. It is a revelation of the powers of sculpture; for here, indeed, clay seems almost breathing and warm with life, as is

often enough said, but very rarely seen in truth."[4]

The success of Theo's portrait at the Paint and Clay Club was compounded in the autumn of 1887 when it was shown, probably in a plaster version, at the Massachusetts Charitable Mechanic Association, where it won a gold medal. Kitson took the bust to Paris and exhibited it in the Salon of 1888, but it is uncertain whether it was displayed in plaster or in marble.[5] In the Exposition Universelle of 1889 the marble version of *Theo* won a bronze medal, as did a plaster of the statue of *Mayor Thomas A. Doyle*. During the 1890s Kitson entered the marble in several exhibitions, including the World's Columbian Exposition in Chicago in 1893, but it ultimately remained in his studio, where it was less formally referred to as *Theo at Sixteen*. In 1973 the portrait was given to the Museum in memory of the sculptor's son and daughter-in-law.

K.G.

Notes

1. Frances E. Willard and Mary A. Livermore, eds. *American Women*: *Fifteen Hundred Biographies*, rev. ed. (New York: Mast, Crowell and Kirkpatrick, 1897), s.v. Ruggles, Theo Alice. For information about Theo Alice (Ruggles) Kitson, see also *Art Digest* 7 (Nov. 15, 1932), p. 18, obit.; *Art News* 31 (Nov. 5, 1932), p. 8, obit.; *Boston Globe*, Oct. 29, 1932, obit.; BPL; Clara Erskine Clement, *Women in the Fine Arts* (Boston: Houghton Mifflin, 1904), s.v. Kitson, Mrs. H.H.; H. Hobart Holly, "Some Famous Quincy Sculptors," *Quincy History*, spring 1986, pp. 2-3; *New York Times*, Oct. 30, 1932, obit.; Rubinstein 1982, p. 106.

2. See Record of Royalties Paid, Gorham Company Bronze Division Papers, roll 3680 in AAA, SI.

3. F.E.E. Hamilton, "Some Artists in Paris: A Successful Boston Sculptor," *Boston Evening Transcript*, Oct. 13, 1888.

4. *Boston Evening Transcript*, Feb. 24, 1887.

5. One catalogue of the 1888 Salon, *Catalogue illustré*: *Peinture et sculpture*, published by Ludovic Baschet, lists the work as being in plaster, while another edition of the catalogue, *Explication des ouvrages de peinture, sculpture . . .*, 3rd ed., published by Paul Dupont, records it as being in marble.

William Frederick Pope (1865 – 1906)

William Frederick Pope's premature demise deprived America of a budding artistic talent. At the time of his death, he was lauded as "one of the most promising among the younger sculptors of this country."[1] Although he worked as a sculptor no more than a dozen years, having begun to model in his thirties, Pope's small output won the attention of art critics, who recognized in it "that painstaking quality and that originality of conception which amounts to genius."[2]

Despite the praise of Pope's accomplishments, his oeuvre is now unlocated, no detailed account of his career has been written, and the recorded facts of his brief life are few. He was born in Shirley, Massachusetts, near Fitchburg, in 1865. After receiving a high school education, Pope was employed in the office of the Manufacturers' Mutual Insurance Company in Boston. He had a great love for art, which deepened into a desire to practice it, and he commenced his studies with Henry Hudson Kitson. It was not long before Pope began exhibiting at the Boston Art Club, which was host to one portrait bust each year from 1894 through 1897 at the fiftieth, fifty-second, fifty-fourth and fifty-sixth exhibitions respectively. Determined to become a sculptor, Pope resigned his business position and departed for Paris in 1901. He is said to have enrolled in the Académie Julian and to have taken classes at the Ecole des Beaux-Arts, where he made such rapid progress that he reputedly won the Grand Prix de Rome.[3]

About half of Pope's modest production was created in Paris, presumably in the Beaux-Arts style he had recently mastered. During a period of three successive years, as a student of Raoul Charles Verlet (1857-1923), he exhibited at the Paris Salon of the Société des artistes français: *Brittany Fisherman* in 1903 and *Portrait of Mr. R--* in 1904, both plaster busts, and *The Little Brittany Girl*, a bronze bust, and *The Fisherman*, a plaster figure, in 1905. This last submission may also have been known as the *Breton Fisherman Drawing His Nets*, since a work with the latter title was referred to as having "received a great deal of comment" at the Salon.[4] Perhaps these were the same as a piece called *Hauling in the Nets*, which was described in an obituary as "too large for the [Boylston Place] studio . . . still in its packing case in a storage warehouse."[5] Be that as it may, Pope was evidently expanding his vision of a subject he had treated in bust form to a more ambitious scale.

Returning to Boston in 1905 with the hope of obtaining commissions in his native land, Pope took a studio at 2 Boylston Place. His aspirations were realized immediately with an order for a bust of Edward Atkinson, the eminent Boston statistician. Less successful was his entry in the competition for a memorial to Patrick A. Collins, mayor of Boston from 1902 to 1905. The commission was awarded to Kitson, Pope's former teacher, and to Kitson's wife, Theo Alice Ruggles Kitson. (The monument, dedicated in 1908, is now in the Commonwealth Avenue Mall.)

Pope's final endeavor, which apparently remained unfinished, was a portrait relief of Mary Baker Eddy, which "was pronounced, by all who had seen it, to be the best ever made of the Christian Science leader."[6] In October 1906 he traveled to New York in connection with the portrait of Mrs. Eddy. There he contracted influenza which developed into the pneumonia that caused his death in Boston one week later.

K.G.

Notes

1. *Boston Globe*, Oct. 23, 1906, obit.

2. *Boston Evening Transcript*, Oct. 22, 1906, obit.

3. References to Pope mention his having won the Grand Prix de Rome. At the Ecole des Beaux-Arts, however, there was a regulation that no foreigners were eligible for the prize. Furthermore, Pope's name does not appear in Jean-Paul Alaux, *Académie de France à Rome: Ses directeurs, ses pensionnaires* (Paris: Duchartre, 1933), in which the winners of the Grand Prix are listed. I am grateful to Anne M. Wagner, Department of Architecture, Massachusetts Institute of Technology, for bringing this book to my attention.

4. *Boston Globe*, Oct. 23, 1906, obit.

5. Ibid.

6. *Boston Evening Transcript*, Oct. 22, 1906, obit.

References

AAAn 6 (1907-1908), p. 114; *Boston Evening Transcript*, Oct. 22, 1906, obit.; *Boston Globe*, Oct. 23, 1906, obit.; *Fitchburg Daily Sentinel*, Oct. 22, 1906, obit.

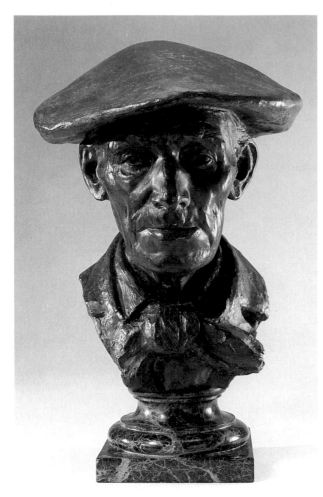

100

WILLIAM FREDERICK POPE
100
Brittany Fisherman, probably 1903
Bronze, red-brown patina, lost wax cast
H. 14½ in. (36.8 cm.), w. 11¼ in. (28.6 cm.)
Signed (on his right shoulder): William Frederick
Pope. Sculptor. Paris. 19[03]
Foundry mark (on back): VALSUANI FONDEUR
Gift of the family of the late W.F. Pope through
Mrs. N.H. Hamblett. 07.261

Provenance: Mary F. Pope and family, Fitchburg, Mass.
Exhibited: BMFA, *Renaissance and Modern Bronzes Collected
by the Visiting Committee on Western Art* (1908), no. 215.

A plaster cast of *Brittany Fisherman* was William
Frederick Pope's first entry in the Paris Salon of the
Société des artistes français. It was exhibited in 1903
and was subsequently cast in bronze by the French
foundry Valsuani, probably in 1903 or perhaps
later, that is, by 1905, when the sculptor returned to
Boston. The bust could have been inspired by a visit

Pope may have made to the Breton region during
his stay in France. He seems to have had a penchant
for fishermen and Bretons since two more of his
Salon submissions, which numbered only four alto-
gether, represent this subject. More popular as a
theme with European sculptors than with the
Americans, peasants and laborers offered artists
during the last quarter of the nineteenth century
and early part of the twentieth century an unsung
class of people to commemorate in marble and
bronze.

Pope's fisherman is portrayed with a cap he must
have worn to shield his eyes, which here are shown
in a vacant, downward gaze. The sculptor cut off
the shoulder but included part of the fisherman's
shirt, jacket, and kerchief. Like Anne Whitney in
her head of an old peasant woman, *Le Modèle* (q.v.),
Pope has drawn every wrinkle and furrow of the
brow in an effort to demonstrate the aging effects
of a life of toil out-of-doors. Prominent, too, are the
fisherman's sunken cheeks and impassive mouth.
What makes the features particularly striking is the
animated bronze surface, a hallmark of the Beaux-
Arts mode, which Pope has treated with a most
accomplished hand.

Pope's Boylston Place studio contained most of
his sculpture when he died. Among the objects were
Head of an Arab Sheik (present location unknown),
which had been one of the sculptor's favorite con-
ceptions, and the *Head of a Breton Peasant* described
in the *Boston Globe* as "the first piece he ever showed
at a salon."[1] Presumably, the latter is the Museum's
work, erroneously titled "Breton Peasant" in the
Globe, since the plaster cast was listed as "Pêcheur
breton" in the 1903 Salon catalogue, no. 3114, and
the Museum's bronze was called *Brittany Fisherman*
in its 1908 exhibition, "Renaissance and Modern
Bronzes . . . ," no. 215. Pope's family, which con-
sisted of his mother, Mary, brother, and sister, Mrs.
Nellie Hamblett, gave *Brittany Fisherman* to the Mu-
seum in 1907.

K.G.

Note

1. *Boston Globe*, Oct. 23, 1906, obit.

Bela Lyon Pratt (1867 – 1917)

A Connecticut Yankee of Puritan stock, Bela Lyon Pratt was Boston's counterpart to New York's Augustus Saint-Gaudens: an exponent of the Beaux-Arts tradition, who showed a generation of students at the School of the Museum of Fine Arts how to incorporate naturalism and pictorialism into their sculpture. In a wide range of commissioned and private works, from decorative friezes and public monuments to portrait busts and idealized female nudes, Pratt combined his French training with an innate reserve, prompting some critics to characterize his style as essentially American.[1]

Pratt was the son of Sarah Victoria (Whittlesey), whose father founded the first normal school of music in America, Music Vale Seminary in Salem, Connecticut, and George Pratt, a Norwich, Connecticut, lawyer. He began to draw and model at an early age and was only sixteen when he enrolled in the Yale School of Fine Arts, where he studied drawing with John Henry Niemeyer (1839-1932) and painting with John Ferguson Weir (1841-1926). At age twenty he moved to New York to attend the Art Students' League and for the next three years took classes in drawing and modeling given by the American impressionist painters Kenyon Cox (1859-1919) and William Merritt Chase (1849-1916), one of the most influential teachers at the league and president of the progressive Society of American Artists at that time. Pratt also attended classes in modeling with Francis Edwin Elwell (1858-1922), who had studied with Alexandre Falguière (1831-1900) and François Jouffroy (1806-1882) at the Ecole des Beaux-Arts, and Augustus Saint-Gaudens, whom he briefly assisted. Prophetically, the first piece Pratt prepared for Saint-Gaudens was a relief panel of two nude boys supporting a coat of arms for over the main doors of the Boston Public Library, a composition he would complement some twenty years later with the heroic figures *Art* and *Science* for the library's main entrance.

In 1890 on Saint-Gaudens's advice, Pratt went to Paris to study at the Ecole des Beaux-Arts under Henri Chapu (1833-1891) and Falguière. The combination of the former's classicism and the latter's daring sensualism exposed the young sculptor to the rich variety of artistic styles and experimentation then available in the French capital. He remained there until 1892, when Saint-Gaudens asked him to participate in the Columbian World's

Bela Lyon Pratt (on ladder) with studio assistants

Fair, Chicago, and recommended him for the position of instructor in modeling at the School of the Museum of Fine Arts.

The refined technique and restrained sentiment of Pratt's colossal groups representing the Genius of Navigation, 1893, made (of impermanent staff) for the Water Gate of the fair's peristyle helped to establish his reputation at home. These groups were followed shortly by a series of portrait bas-reliefs of prominent Bostonians executed in Saint-Gaudens's impressionistic style and an 1894 medal honoring President Eliot (q.v.) for his distinguished service to Harvard. For the Library of Congress in 1895 and 1896, he enlarged his relief format to create four medallions depicting the Seasons, and also fashioned three pairs of seven-foot spandrel figures personifying Literature, Science, and Art for the main entrance, and a twelve-foot figure of Philosophy for the rotunda.

In 1896 Pratt married Helen Lugarda Pray (1870-1965), a student of his, and returned to Paris for an extended honeymoon and year of study; at that time he won an honorable mention at the Salon for a reclining figure of the Reverend Dr. Joseph Coit, headmaster of Saint Paul's School, Concord, New Hampshire. (While raising a family, Helen continued modeling at a studio in their home in Jamaica Plain, Boston, exhibiting occasionally as a member of the Guild of Boston Artists.) The following year, the popular success of Pratt's bronze bust of Bishop Phillips Brooks, 1899 (Brooks House, Harvard University), the beloved Episcopal minister of Trinity Church, Boston, generated numerous orders for portraits of other clergymen in the city,

as well as requests from noted academics and professionals in the Boston community. Varying his format from bas-relief to sculptured bust, Pratt maintained a consistent note of seriousness that patrons and reviewers found entirely fitting in a city that prided itself on sobriety. His bronze bust of Major Henry L. Higginson, 1909 (Symphony Hall, Boston), founder of the Boston Symphony Orchestra, suggests the sitter's commanding presence through its direct gaze and proud stance. There is also a lively naturalism in the details of the benefactor's weathered features, scraggly mustache, and short beard, and an animation to the termination of the bust, which is repeated in the curves of the buttoned vest and coat lapel.

Pratt's respect for the courage of American youth was also demonstrated in his sensitive handling of three war memorials, beginning in 1902 with his tribute to the alumni of Saint Paul's School who had lost their lives in the Spanish-American War of 1898. Pratt portrayed a young soldier-volunteer standing in a relaxed attitude, looking steadfast and confident but without a hint of bravado. Similarly, his life-size statues *Andersonville Prisoner Boy*, 1907 (National Cemetery, Andersonville, Georgia), commissioned by the state of Connecticut, and *Nathan Hale*, 1914 (Yale University, New Haven), show dignified but modest-appearing young men, whose quiet heroism is implied.

An accomplished numismatist, Pratt was eagerly sought after by civic and ecclesiastical groups for his designs. Among these are centennial medals celebrating the birth of Henry Wadsworth Longfellow, 1907, for the Cambridge Historical Society; the founding of the Roman Catholic diocese of Boston (the *Archbishop O'Connell Medal*), 1908 (Archives, Archdiocese of Boston); and the birth of Abraham Lincoln, 1909 (The American Numismatic Society, New York). As Saint-Gaudens's protégé, Pratt was asked in 1908 to redesign the half-eagle, or five-dollar, and the quarter-eagle, or two-and-a-half dollar, gold coins. Mindful of Saint-Gaudens's successful adaptation of the Ptolemaic eagle with wings closed for the ten- and twenty-dollar gold coins issued in 1907, Pratt repeated this imagery on the reverse of his own pieces. For the obverse, he depicted a Native American in ceremonial war headdress, but in a realistic manner that was a departure from the usual "Pergamene heads in Indian bonnets."[2] In addition, the novel incuse, or engraved, technique suggested by Egyptian intaglios, which he adopted for the coins, proved to be one of the most

innovative designs in twentieth-century American medallic art.

After Saint-Gaudens's death in 1907, Pratt was selected to replace his mentor on two important commissions: in 1910, the heroic-size figures *Art* and *Science* for the entrance to the Boston Public Library and, in 1912, the life-size statue *Nathan Hale* for Yale University. Pratt was also at the center of a controversy regarding Saint-Gaudens's canopied memorial to Phillips Brooks, erected in 1910 on the lawn of Trinity Church, in Copley Square, Boston. A majority of members on the church's citizens' committee sought for over ten years to replace the statue by Saint-Gaudens, which they found to be overly sentimental, for one they funded in 1916 by Pratt.[3] A compromise measure to place Pratt's sculpture in the Copley Square triangle, but outside the church's precincts, was defeated by those who thought that such close proximity for the memorials would be incongruous. Therefore, when the trustees of the church refused to accept the substitution, the matter was brought before the Massachusetts Supreme Court, which, however, upheld the trustees' stand.[4] Until Pratt's statue found a permanent location in 1925 on the North Andover Common, Massachusetts, the *Brooks* first stood on the lawn of the Boston Society of Natural History (now Bonwit Teller) and then at the front of the Huntington Avenue entrance to the Museum of Fine Arts, where it formed a temporary pendant to his heroic seated figure of Nathaniel Hawthorne, dedicated in 1925 on the Salem Common, Massachusetts.

The years 1913 and 1914 marked Pratt's strongest involvement with the Museum. In 1913 he received the commission to decorate the unpedimented entablature of the new Evans Wing, which he generously shared with his talented assistants Richard Recchia and Frederick Allen. Pratt's central relief panel, *Sculpture*, depicts two semi-nude females: one *(Sculpture in Stone)* holding a mallet before a partly carved head, the other *(Sculpture in Bronze)* contemplating a small figure of Narcissus.[5] The flanking reliefs *Architecture* and *Painting* by Recchia and Allen, respectively, also portray allegorical figures practicing their art. During the preparation of the wing, the cordiality that Pratt showed the donor, Mrs. Robert Dawson Evans, inspired her to give an endowment of $50,000 to the Museum School's department of modeling, which Pratt headed for twenty-four years.[6]

In 1913 Pratt also completed work on the striding figure of the famed public orator Edward Everett

Hale (Public Garden, Boston), "nine-tenths over-coat and one-tenth Hale," [7] and the *Whaleman Memorial* (New Bedford Free Public Library, Massachusetts), both sculptures funded by public subscription. The following year, his memorial to the Civil War army nurses from Massachusetts was unveiled in the Senate Staircase Hall (now Nurses Hall), State House, Boston. The sculptural group, representing a nurse ministering to a wounded soldier, was well received for its narrative realism.

At the peak of his powers in 1915, Pratt was honored by the Harvard community with a degree of Master of Arts, the citation summing up the respect he now commanded: "Bela Lyon Pratt, Sculptor, who has taught bronze and marble to whisper his secrets of beauty and power."[8] That year he also received a gold medal at the Panama-Pacific Exposition, San Francisco, for seventeen of his pieces, which aptly demonstrated the breadth of his talents.

For all the public memorials and portrait busts of notable New Englanders that Pratt executed, contemporary critics seemed to prefer his small private studies of young females. In these usually noncommissioned works, Pratt expressed with delicacy and subtlety the sensuousness of the nude. Exploiting the tactile quality of marble through lighting in much the way Hiram Powers had done, Pratt introduced a distinctly modern touch with adolescent types and casual postures. "Strangely enough," Lorado Taft noted in a 1923 supplement to his pioneering survey of American sculpture, "this sad-eyed son of the Puritans was at his best in modeling youthful girlish forms."[9]

Pratt's health was never robust, but he enjoyed an active outdoor life, with pursuits such as fishing, golf, cycling, and archery. When he died suddenly at forty-nine, of a heart-related ailment, while working on a nine-foot statue of Alexander Hamilton for Grant Park, Chicago, his friends were shocked and saddened. The Boston art community immediately went about organizing memorial shows. In June 1917 the Boston Public Library exhibited fifty photographs and engravings, which enabled Bostonians to view in one place many of Pratt's public monuments, and in November the Guild of Boston Artists, of which he had been a founding member and the only sculptor on its original executive committee, brought together thirty-two of his smaller pieces in both bronze and marble. The following April the Museum of Fine Arts exhibited 125 of his sculptures in the Renaissance Court. The critics recalled his many kindnesses to artists, and in particular his championing of the cause to keep Cyrus Dallin's *Appeal to the Great Spirit* (q.v.) in Boston. Friends with Boston painters as well as sculptors, Pratt had participated in a number of group and two-person shows where the public became accustomed to seeing sculpture and paintings exhibited together.[10] The popularity of his classes at the School of the Museum of Fine Arts, too, was remembered by students who had appreciated his fairness and genial manner.

P.M.K.

Notes

I am grateful to Cynthia Pratt Kennedy Sam, Pratt's granddaughter, for making available to me the Pratt Family Papers in her possession. She is currently preparing a biography on Pratt in collaboration with Thomas W. Leavitt, a grandson of the sculptor and director of the Herbert F. Johnson Museum of Art, Cornell University, Ithaca, N.Y. Additional archival material used in this biography was provided by Kathryn Greenthal.

1. F. Ogden Cornish, "Bela Pratt—Citizen and Sculptor," *Boston Evening Transcript*, May 19, 1917: "His art is beautiful in the sense in which 'The Scarlet Letter,' 'The Raven,' 'The Commemoration Ode,' and 'Snow Bound' are beautiful literature. It is not epical, not sublime. Yet it has a certain universality. Its exquisiteness appeals to the uneducated many as well as to the cultivated few."

2. Vermeule 1971, p. 121.

3. Pratt wrote to Charlotte Barton West, a former model of his, Feb. 3, 1913, about the *Brooks*: "Here's a secret, some rich people wrote me to make a new Phillips Brooks and I have made a model which is a corker! It may replace St. Gaudens and it may be put somewhere else." Charlotte Barton West Papers, AAA, SI.

4. See "Would Erect New Statue of Bishop Phillips Brooks in Centre of Copley Sq.," *Boston Herald*, Jan. 10, 1919.

5. See letter from Bela L. Pratt to Gardiner M. Lane, president of the Museum, Jan. 5, 1914. Earlier, in a letter to Lane, July 15, 1913, Pratt had suggested that the "stones over the Huntington Ave. face of the Museum" be decorated and that he would like to do it at the same time that he was working on the Evans Wing. BMFA, 1901-1954, roll 546, in AAA, SI.

6. See letter from Pratt, May 6, 1914, reassuring Lane that Mrs. Evans's concern over Allen's relief was unnecessary since Allen seemed glad to have Pratt's help. BMFA, 1901-1954.

7. "The Hale Statue," *Boston Evening Transcript*, May 23, 1913.

8. "Honorary Degrees at Harvard," *Boston Herald*, June 25, 1915. In 1899 Pratt received an honorary B.F.A. degree from Yale.

9. Taft 1930, p. 541.

10. The first two-person show at the Guild of Boston Artists, Nov. 12-26, 1914, was of paintings by Edwin C. Tarbell (1862-1938) and sculpture by Pratt, including a bronze reduction of *Nathan Hale* (q.v.) and a bronze version of the *Water-Lily Girl* (q.v.). See "Work by Tarbell and Pratt," *Boston Transcript*, Nov. 17, 1914.

References

AAA, SI; BAC; *Boston Evening Transcript*, May 18, 1917, obit.; Christian Brinton, "Bela Pratt," *Century* 56 (Sept. 1909), pp. 722-724; Lorinda Munson Bryant, "Bela Lyon Pratt: An Appreciation," *International Studio* 57 (Feb. 1916), pp. CXXI-CXXV; Frederick W. Coburn, "Americanism in Sculpture as Represented in the Works of Bela Lyon Pratt," *Palette and Brush* (Feb.-Mar. 1910), pp. 95-97; F. Ogden Cornish, "Bela Pratt—Citizen and Sculptor," *Boston Evening Transcript*, May 19, 1917; Craven 1968, pp. 495-497; Charles Henry Dorr, "Bela L. Pratt, an Eminent New England Sculptor," *Architectural Record* 35 (June 1914), pp. 509-518; William Howe Downes, "Bela Pratt's Sculpture," *Boston Evening Transcript*, June 2, 1917; idem, "The Work of Bela L. Pratt, Sculptor," *International Studio* 38 (July 1909), pp. III-VIII; idem, "The Work of Bela L. Pratt, Sculptor," *New England Magazine* 27 (Feb. 1903), pp. 760-771; [Benjamin Ives Gilman], "Memorial Exhibition of the Work of Bela Lyon Pratt," *Bulletin of the Museum of Fine Arts* 16 (Apr. 1918), pp. 28-29; *New York Times*, May 19, 1917, obit.; Ed Reiter, "The Coins of Bela Lyon Pratt," *Coinage* 11 (Dec. 1975), pp. 24-26, 120; SMFA; "Some Recent Works by Bela L. Pratt," *Art and Progress* 2 (Nov. 1910-Oct. 1911), pp. 295-299; Taft 1930, pp. 491-496; Vermeule 1971, pp. 119-121; Whitney 1976, pp. 298-299; *Yale Obituary Record*, 1916-1917, pp. 486-488.

BELA LYON PRATT

101

Charles William Eliot Medal, 1894
Gold-plated copper electrotype
Diam. 3⅞ in. (9.8 cm.)
Signed: *obverse*: (at bottom) B.L. PRATT
Inscribed: *obverse*: (at left) MDCCC / LXVIIII (at right) MDCCCL / XXXXIIII; *reverse*: (at left on scroll) VERI / TAS (at center) CAROLO / GVILIELMO·ELIOT / VNIVER-SITATIS / HARVARDIANAE / VIGESIMVM·QVINTVM / IAM·ANNVM / PRAESIDI / OB·EXIMIA·EIVS ·MERIT·A / A·M·D·CCC·LXXXXIIII / ALVMNI
Gift of Dr. Charles W. Eliot. 18.1
Provenance: Charles William Eliot, Cambridge, Mass.
Exhibited: BMFA, "Memorial Exhibition of Sculpture by Bela Lyon Pratt," Apr. 3-May 5, 1918.
Versions: *Plaster*: (1-4) Cynthia Kennedy Sam, Cambridge, Mass. *Bronze*: (1) The American Numismatic Society, New York

At the Harvard commencement day alumni dinner, June 28, 1894, in the twenty-fifth year of his presidency, Charles William Eliot (1834-1926) was presented this "gold" medal, designed by Bela Pratt.[1] Joseph H. Choate, then president of the New York Constitutional Convention, spoke on behalf of the Harvard alumni, as he had at Eliot's first dinner as college president, assuring the celebrants that Eliot had fulfilled his promise for a new Harvard, which would "justify and glorify the old Harvard of whom her sons were so proud."[2]

During his tenure, Choate related, Eliot had developed the elective system introduced by Josiah Quincy in 1826; expanded the science curriculum, Eliot's own specialty; instituted the Graduate School in 1872; and brought to the Law School Christopher Columbus Langdell, pioneer of the case method and dean from 1870 to 1895. His humanism had ensured that poor boys could attend Harvard with the aid of generous scholarships and that no one would be refused because of race, creed, color, or nationality. Under Eliot's leadership, it was said, Harvard had emerged from a provincial college to a great national university.[3]

The Museum's medal, a gold-plated copper electrotype, was also cast in bronze in an edition of six or seven.[4] Eliot is shown in profile on the obverse, wearing an academic robe. The commemorative dates appear in fields to the left and right of his head. On the reverse, within a border of laurel and flanked by burning torches, the Latin inscription translates: "To Charles William Eliot, president of Harvard University for twenty-five years, the alumni [present this medal] because of his exceptional merits." The clarity of Pratt's design underscores the strength and dignity of the subject's position and reputation, investing Eliot, as one reviewer commented, with "an air of classic serenity and poise."[5]

Pratt's first effort in this field, the medal came as a surprise to Eliot. Its merits, however, the president quickly noted in his acceptance speech: "It is fortunate when the lineaments of an individual who will be forgotten are given in a work of art which will be cherished for its own sake. Another piece of good fortune has befallen me to-day in this beautiful memorial gift."[6]

Eliot, an original incorporator of the Museum of Fine Arts and a trustee until his death in 1926, gave the medal to the Museum in January 1918, and it was exhibited in the Museum's memorial exhibition of Pratt's work in April 1918. The sculptor, who

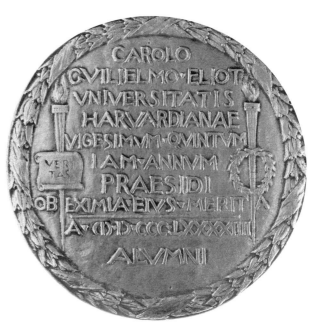

101

"remained in this Harvard Community a consistent 'shouter' for Yale,"[7] also designed the Yale University bicentennial medal in 1901.

P.M.K.

Notes

1. See "Commencement-Alumni Dinner," *Harvard Graduates Magazine* 3 (Sept. 1894), pp. 62-77.

2. Choate, in "Commencement," p. 65.

3. For more on Eliot's life, see Theodore W. Richards, "Charles William Eliot, 1834-1926," in M.A. de Wolfe Howe, ed., *Later Years of the Saturday Club, 1870-1920* (Boston: Houghton Mifflin, 1927), pp. 3-13; Harvard College, Class of 1853, *Sixtieth Anniversary Report* (1913), pp. 95-116. For a recent assessment, see also Donald Fleming, "Eliot's New Broom," Bernard Bailyn et al, *Glimpses of the Harvard Past* (Cambridge: Harvard University Press, 1986), pp. 63-76.

4. According to Dudley Pratt (the sculptor's son), the Eliot medal was produced in one gold cast and seven bronzes; see "List of the Work of Bela L. Pratt" (corrected list), 1934, no. 5. BMFA, ADA. But the notation by Helen Pratt, the sculptor's widow, on the back of a photograph of the medal, reads: "Six bronze casts made"; see Photographs of the Sculpture of Bela Lyon Pratt, Book I, Pratt Family Papers. When Pratt wrote to Charles Eliot Norton, Apr. 25, 1907, about the *Longfellow Medal* he had designed for the Cambridge Historical Society, he recommended that Tiffany and Company, New York, strike the medal unless "it was to be a 'cast' medal like the Eliot." Charles Eliot Norton Papers, Ho, HU. Kathryn Greenthal kindly showed me this letter.

5. William Howe Downes, "The Work of Bela L. Pratt, Sculptor," *International Studio* 38 (July 1909), p. x.

6. Eliot in "Commencement," pp. 74-75.

7. F. Ogden Cornish, "Bela Pratt—Citizen and Sculptor," *Boston Evening Transcript*, May 19, 1917.

BELA LYON PRATT
102, 103
Art and *Science*, 1910
Bronze, green over brown patina, lost wax cast
Art: H. 10 in. (25.4 cm.), w. 6¼ in. (15.9 cm.), d. 6⅛ in. (15.6 cm.)
Signed (on front of base at left): Bela L. Pratt
Foundry mark (on back): ROMAN BRONZE WORKS N-Y-
Science: H. 10 in. (25.4 cm.), w. 7 in. (17.8 cm.), d. 6⅛ in. (15.6 cm.)
Signed: (on top of base at right front) 1910 / BL Pratt (on front of base) Bela Pratt
Gift of Jo Ann and Julian Ganz, Jr., Los Angeles. 1979.386, 387

Provenance: Jo Ann and Julian Ganz, Jr., Los Angeles
Exhibited: Doll & Richards, Boston, Oct. 1918; BMFA 1979, no. 23.
Versions: *Plaster*: (1) Thomas W. Leavitt, Ithaca, N.Y.; over life-size: (2) present location unknown. *Bronze*, over life-size: (1) Boston Public Library

These studies for the heroic bronze figures *Art* and *Science* flanking the entrance to the Boston Public Library closely resemble the final versions, although they are more sketchily modeled.[1] Two hooded, robed females, the personifications of complementary disciplines, sit enthroned. Art looks to the left (toward Science, in the library's bronzes) and holds a palette in one hand and a brush in the other; Science looks down at a globe that she holds in her left hand. Like the finished sculptures, the small bronzes have voluminous draperies that accentuate mature bodies and *contrapposto* poses.[2] The Museum's examples were cast by Roman Bronze Works, probably in the late spring of 1910, after Pratt's clay models were accepted by the library's trustees.

Initially, Augustus Saint-Gaudens was given the commission in 1892 to design two sculptural groups for the front entrance of the library, an idea that Charles McKim, the architect for the building, had first entertained in 1887.[3] Saint-Gaudens's plan was to have two female figures personifying Science and Art flank Labor (a male figure) on one pedestal, with Religion and Force, or Power (both females), positioned on either side of Law (male) on the other. Later his design changed so that Law was flanked by Executive Power and Love (females) and Science by Labor and Art. Although Saint-Gaudens agreed to finish the sculpture within two years and received a small advance, only plaster sketches with little detail (Saint Gaudens National Historic Site, Cornish, New Hampshire) remained at the time of his death in 1907.[4] Shortly thereafter, his widow tried to convince the library trustees that these casts could be completed by Saint-Gaudens's studio assistants, but her request to keep the commission was turned down.[5]

The sculpture project remained stalled until November 1909, when Sylvester Baxter, secretary of the Metropolitan Improvement League, and Colonel Josiah H. Benton, chairman of the Public Library Committee, suggested that Pratt, one of Saint-Gaudens's most successful pupils and known for promptly meeting his commitments, submit his own ideas to the board. On December 31, 1909, Pratt wrote to Charlotte Barton West, a former model, about the possibility of receiving the commission. "There seems to be a chance that I may get the groups in front of the Public Library to do and if I do it will be the greatest chance I have ever had or ever can have. That library is the finest building in America and I would rather do those groups than

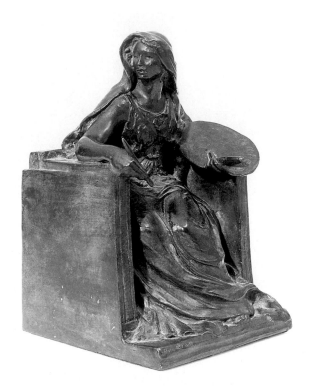

102

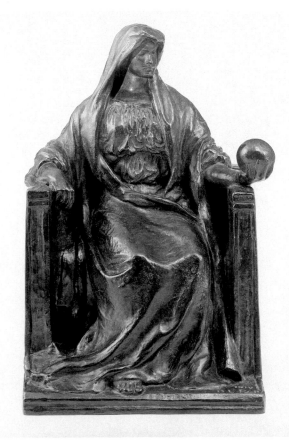

103

be president of the U.S.! which is not my kind of job anyhow! I've got the models made for both groups, which by the way are not groups at all but single figures. I would tell you about them only it would be too hard to do without a photo and I have not had any taken yet."[6]

In January Pratt proposed that the center of each granite block, put in place at the time of the library's dedication (March 11, 1895) be removed and single, seated female figures be inserted in the resulting niches. Asked by the trustees for proof that such sculptures could be easily read from below, he arranged to have photographic enlargements made of his clay studies and on April 10, 1910, placed them at the library's entrance for the trustees' review.[7]

On April 28, 1910, Pratt received the library commission from the trustees and sent West photographs of his clay models for comments. He beseeched her, however, not to "be too hard on them" since they were only "from the small studies."[8] In November he reported again that he was "getting on first rate with the big Library figures," and continued: "They will be done by spring and up by next fall unless all signs fail." He also shared with her his worry that there might be trouble since the Boston Art Commission was claiming that "*they* should have signed the contract for those Library figures instead of the Library trustees!"[9]

Indeed, the political argument over who had jurisdiction for awarding the commission frustrated Pratt and caused him delays. On January 24, 1911, he wrote to the Art Commission imploring them to come to his studio and pass on his designs: "I make this request in the name of Art, in the preservation of whose dignity we are all deeply concerned."[10] Pratt's efforts were soon rewarded, and on March 24 his designs were approved provided that he consult with McKim's firm on how the figures would relate to the pedestals. Three days later the architects sent a telegram to the commission suggesting that Saint-Gaudens's plan be adapted and the figures seated in bronze chairs on top of the pedestals, and on April 14 they sent two drawings to show how it might be done.

Pratt's response was unfavorable, however, since he believed that elevating the figures would clash with the ironwork above the library doors, especially when seen by passersby on the sidewalk below, and he refused the trustees' request to try life-size plaster casts on top of the pedestals.[11] His view prevailed, and by the end of October, the full-size

plaster models were sent for casting to Gorham Manufacturing Company, Providence. On November 28, Pratt notified the commission that the unveiling should be postponed until spring since the figures would not be ready for another month. On May 20 and June 6, 1912, *Science* and *Art*, respectively, were unveiled informally, but their warm reception by the public was duly noted in the press. One letter-writing wag in the *Boston Herald* could not resist reminding Bostonians of their prudish past. "The interest has certainly been healthier and more intelligent than that shown in regard to the joyous 'Bacchante' of the Library, whose innocent gaiety was such a reproach to pleasure-hating Boston."[12]

The placement of *Art* and *Science* near the main doors to the Boston Public Library follows a long tradition of embellishing entrances to public buildings with sculptural figures representing civic virtues or mythological deities. Other examples of this genre in American sculpture are Daniel Chester French's symbolic figure *Alma Mater*, unveiled in 1903 on the steps of the Low Library at Columbia University, New York, and his monumental seated female groups *The Continents*, 1907, located in front of the United States Custom House, New York.[13]

P.M.K.

Notes

Archival material used in this entry was provided by Kathryn Greenthal and Cynthia Pratt Kennedy Sam.

1. The library's versions are inscribed on their pink Tennessee marble pedestals with the names of famous artists and scientists; before they were cast, Pratt altered his design, replacing Phidias's name with that of Saint-Gaudens.

2. *Art* and *Science* follow Pratt's earlier treatment of these allegorical subjects in four heroic spandrel figures for the Library of Congress, 1896. Ethel Nash, a woman of medium height and dark complexion, was the model for *Art* and *Science*, according to the *Boston American* ("Boston Girl Model for Library Statue"), Jan. 8, 1911.

3. See Walter Muir Whitehill, "The Making of an Architectural Masterpiece—The Boston Public Library," *American Art Journal* 2 (fall 1970), p. 18.

4. See Dryfhout 1982, no. 173. The library's advance of $6,000 was returned by Saint-Gaudens's widow Nov. 26, 1908. Bronze casts (The Freer Gallery, Washington, D.C.) were made by Tiffany Studios, New York, and purchased by Charles L. Freer in 1915 for $15,000.

5. Since Saint-Gaudens's models of Art and Science each have one bare breast, the trustees may have wished to avoid another scandal like the one occasioned by Freder-

ick MacMonnies's nude *Bacchante and Infant Faun* (q.v.) when it was placed in the library's courtyard in 1897.

6. Pratt to West, Dec. [31], 1909, Charlotte Barton West Papers, AAA, SI. Pratt also spoke about his assistant Richard Recchia: "Recchia is pointing up one of the library groups from my sketch in a fancy Italian way, which means a lot of work for me in getting it back to earth."

7. See Frederick W. Coburn, "Improving Copley Square," *Art and Progress* 2 (Dec. 1910), pp. 39-42. Photographs taken of the library that day are with the Pratt Family Papers.

8. Pratt to West, May 25, 1910, West Papers. The final preliminary clay sketches were about 16 inches high; after this, a bronzed plaster cast was made that also reproduced the pedestals, and then the full-size plasters were prepared, under the direction of Recchia. See "Figures That Are to Embellish Boston Public Library Parvis Under Way in Sculptor's Hall," *Christian Science Monitor*, Oct. 15, 1910. Life-size heads of the library figures were shown at the Museum's memorial exhibition in 1918 but later destroyed at Helen Pratt's request.

9. Pratt to West, Nov. 28, 1910, West Papers. The Boston newspapers played up the controversy and tried to involve Mayor Fitzgerald as an arbiter between the two groups. See "Battle Coming on Library Statuary," *Boston Journal*, Jan. 21, 1911.

10. Pratt to Boston Art Commission, Jan. 24, 1911, BAC.

11. Pratt to Boston Art Commission, June 1, 1911, BAC. Pratt was to be paid $30,000, as opposed to Saint-Gaudens's fee of $50,000. Pratt did not feel this was enough compensation to warrant his making "any radical change," especially when his clay models had already been approved.

12. Alfred B. Kellogg, letter to editor, *Boston Herald*, May 25, 1912.

13. See also the figures *Art* and *Science* by the French sculptors Laurent-Honoré Marqueste (1848-1920) and Jules Blanchard (1832-1916), respectively, for the new Hôtel de Ville, Paris, completed in 1892 while Pratt was living in Paris. See BMFA 1979, no. 23.

BELA LYON PRATT
104
Nathan Hale, probably about 1912 (modeled in 1898)
Bronze, dark brown patina, lost wax cast
H. 35 in. (88.9 cm.), w. 11 in. (28 cm.), d. 8⅞ in. (22.5 cm.)
Signed and inscribed (on front of base): NATHAN HALE / by BELA L. PRATT
Foundry mark (on back of base): ROMAN BRONZE WORKS N-Y-
Joint gift of Joseph Pellegrino and George Seybolt. 1984.501

Provenance: Samuel Feldman, New York; private collection, New York; Conner-Rosenkranz, New York
Versions: *Plaster*: (1) Executive Residence, Hartford, Conn., on loan from Yale University, New Haven, bronzed; life-size: (2) Lyman Allyn Museum, New London, Conn. *Bronze*: (1, 2) Nathan Hale Homestead, Coventry, Conn., (3) present location unknown, formerly Timothy Dwight College, Yale University, (4) private collection, New York, (5) William Benton Storrs Museum, collection of University of Connecticut, Storrs, (6) Woodbridge Hall, Yale University; life-size: (7) Central Intelligence Agency Headquarters, Langley, Va.; (8) Connecticut Hall, Yale University; (9) Department of Justice, Washington, D.C., (10) First Congregational Church, Bristol, Conn.; (11) Nathan Hale Court, Tribune Plaza, Chicago, (12) Nathan Hale House, Phillips Academy, Andover, Mass.

On September 30, 1914, Bela Pratt's life-size bronze sculpture of Nathan Hale (1755-1776) was unveiled outside Yale University's Connecticut Hall (the last remaining building on Old Brick Row), where Hale, class of of 1773, reputedly roomed as an undergraduate.[1] Captured by the British while on an espionage mission for General George Washington, Hale was hanged in Artillery Park, New York (now City Hall Park), on September 22, 1776, but not before uttering his famous words: "I only regret that I have but one life to lose for my country."[2] Yale's sculpture, cast by Roman Bronze Works, New York, bears this brief but patriotic expression on its circular granite pedestal.

The half-life-size version of the Yale monument in the Museum of Fine Arts, which differs only in its rectangular base, was also cast by Roman Bronze Works after Pratt's bronze sketch model (Executive Residence, Hartford, Connecticut) of 1912. Examples of this early cast were shown at the Guild of Boston Artists, 1914, the Panama-Pacific International Exposition, San Francisco, 1915, and memorial exhibitions of Pratt's work at the guild and at the Museum of Fine Arts in 1917 and 1918, respectively. In 1917 A.J. Philpott reviewed the piece favorably in the *Boston Sunday Globe*. Praising Pratt for his restraint and his idealism, the critic noted: "the whole sentiment that has grown around the memory of this revolutionary martyr has been crystallized in a brave, dignified figure."[3] Unlike the fastidiously costumed and defiant hero portrayed by Frederick MacMonnies in his bronze sculpture of Hale, 1893 (City Hall Park), Pratt's unpretentious figure, dressed in the homespun clothes of a school teacher, with hands tied behind his back and feet bound, exemplifies Hale's sweet youthfulness and simple courage.

The idea for a Hale memorial on the Yale campus had originated about 1898 with George Dudley Seymour, a New Haven lawyer and antiquarian, and the Reverend Theodore T. Munger (class of 1851), a leader in the Congregational Church, who felt that Hale's sacrifice typified Yale's highest ideals. At their urging, the Yale Corporation appointed a committee of alumni to select a sculptor with the hopes that a memorial could be completed in time for Yale's bicentennial in 1901. Pratt (Yale School of Fine Arts 1887), whose refined modeling and nonbombastic style had been demonstrated at the Chicago World's Fair and in his spandrel figures for the Library of Congress, submitted a sketch model on Seymour's suggestion.⁴ Since there was no available portrait of Hale, the Reverend Edward Everett Hale, grandson of the patriot's brother Enoch Hale (also Yale class of 1773), supplied a portrait of his own son who had died at Hale's age. Photographs survive of two early sketches: one shows the patriot in an open shirt with hands behind his back, standing in a *contrapposto* pose; the other portrays Hale wearing a cap and roped at the waist, standing beneath a columned arch, flanked by British soldiers holding flags. In both studies, the effect is more mannered than in the final version.⁵

The committee, however, was impressed by the celebrity of Augustus Saint-Gaudens, then at the peak of his career, and awarded the commission to him rather than to Pratt, who was a relative newcomer in the field. On December 26, 1899, Seymour wrote to Saint-Gaudens assuring him that the sculptor's fee of $20,000 could probably be raised "outside of college circles."⁶ Although Saint-Gaudens replied on February 1, 1900, that he was "touched by the earnestness of the desire" that he should undertake the *Hale*, he refused to commit himself at this time, "for I have been asked to do a large mon. [the Sherman monument] in which I am deeply interested."⁷

The Hale project apparently was then put aside until December 16, 1905, when Seymour wrote to Saint-Gaudens "unofficially," inquiring whether he would now accept Yale's offer. Saint-Gaudens responded in the affirmative on January 3, 1906, but three days later was regretfully informed that his new fee of $40,000 could not be met by the Yale treasury, which was already overtaxed. Seymour doubted, however, that "the corporation would consent to giving a place to a memorial" to "Yale's ideal hero" from any other hand. Seymour then described Hale as he wished him to be por-

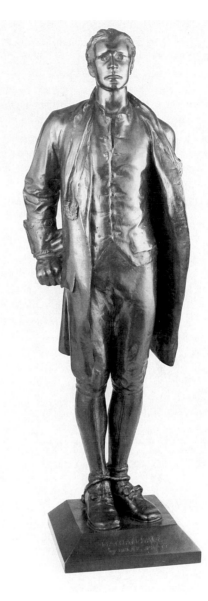

104

trayed—"tall, fair, and athletic . . . an ideal figure of a young man of the period—not a man of elegance and polish, so much as a man of nobility and courage."⁸

On January 23, 1907, Pratt wrote to his mother, Sarah V. Pratt, that he had received a letter from Seymour saying that he was "going to push the [Hale] matter" and an article which was going to be published in the New Haven papers "on the model I made for the Hale and on me and my work in general. . . . This would be quite a triumph after such a long delay and so much talk. It is nine years since I first began to think of doing the Hale!"⁹ In March Pratt wrote again, telling her that the committee had taken the commission away from Saint-

Gaudens and now wished to exhibit his model and publish it in the *Yale Alumni Weekly*. In April Seymour's essay appeared and included a warning that "unless the statue takes its place on Yale's Old Campus as naturally as the students of today take their places there, it must be counted a failure."[10]

After Saint-Gaudens's death in August 1907, Pratt clearly became the logical choice to receive the *Hale* contract. His *Andersonville Prisoner Boy*, 1907 (National Cemetery, Andersonville, Georgia), an understated portrayal of a "thin-faced lad from the farm,"[11] seemed to epitomize the kind of idealism that Seymour was seeking. Pratt was also a former student and had designed the college's bicentennial medal in 1901. The alumni, however, were now involved in other fund-raising activities and deferred further action on the *Hale* until October 5, 1912, when the Committee on Memorials agreed to award Pratt the commission. According to Seymour, "it was the casting of the bronze statue from the plaster model that finally put Hale on the campus."[12]

On November 1 the *Weekly* announced the acceptance of Pratt's design and on November 15 illustrated the model, accompanied by a solicitation from the Nathan Hale Memorial Fund for Pratt's fee of $15,000.[13] Although some Yale men objected to Hale being portrayed bound and manacled, the *Weekly* remained staunchly behind Pratt's intent to show the patriot in the last moments before he was hanged by the British. By the following April, almost half of the subscription was raised, and Pratt began a life-size plaster (destroyed by fire in 1966) of the clay model. On commencement day that year Seymour was given an honorary degree of Master of Arts from Yale for his dedication to the cause of preserving the memory of Nathan Hale in the hearts and souls of Yale men. As his citation acknowledged, "Hale and Yale . . . [had become] well nigh synonymous."[14] Although the alumni committee hoped to dedicate the *Hale* at the 1914 June commencement, the work was not completed until September, when it was unveiled at a simple ceremony, where, according to Seymour, the eloquence of the sculpture was allowed to speak for itself.[15]

Pratt had given the "little plaster-model" of Hale to Seymour in 1911 "to make any disposition of it" that he chose.[16] The figure was stored at the Art School until it was sent to Roman Bronze Works, Brooklyn, later that year to be cast. The bronze sketch model was cast in 1912, and after Pratt was awarded the commission, each of the twelve members of the Committee on Memorials received a bronze replica of that model. In 1918 Helen Pratt gave the life-size plaster to the Rhode Island School of Design, Providence, but reserved the right to withdraw it for reproduction; in 1939 this was lent to the Gargani Foundry, Brooklyn, which paid over $2,000 for the rights to make a cast.[17] The plaster was then given in 1946 to the Lyman Allyn Museum, New London, Connecticut, which lent it in 1966 to the Renaissance Art Foundry, South Norwalk, Connecticut, so that a life-size bronze could be cast for a new dormitory, the Nathan Hale House, at Phillips Academy, Andover, Massachusetts. The bronze was made, but the plaster was destroyed in a fire at the foundry. In 1969 Renaissance Art borrowed Yale's memorial to Hale so that another plaster model could be reconstituted for the Lyman Allyn Museum. At that time the Yale sculpture was cleaned and the bronze repatinated.[18] In 1970 the Yale alumni office authorized Renaissance Art to cast eight additional bronzes from a mold of Yale's half-scale plaster (which was in fragile condition), which were dispersed at a cost of $450 per copy.[19]

P.M.K.

Notes

1. It is known, however, that Pratt's father, George (class of 1857), roomed in Connecticut Hall.

2. Hale's words recall the speech made by Marcus Porcius Cato, the Republican, before taking his own life, in Joseph Addison's tragedy *Cato* (1713), act 2, scene 4: "What pity is it / That we can die but once to serve our country!"

3. A.J. Philpott, "Bela Pratt as Artist and as Man Shown by Memorial Exhibition," *Boston Sunday Globe*, Nov. 4, 1917.

4. See Seymour's Letter Book, Connecticut Historical Society, Hartford, Conn. I wish to thank Arthur W. Leibundguth, director, The Antiquarian and Landmarks Society, Hartford, Conn., and Paula B. Freedman, assistant curator, Department of American Paintings and Sculpture, Yale University Art Gallery, New Haven, for generously sharing their curatorial files on Seymour and Pratt, respectively.

5. See also Photographs of the Sculpture of Bela Lyon Pratt, Book I, Pratt Family Papers.

6. Seymour to Saint-Gaudens, Dec. 26, 1899, Saint-Gaudens Papers, Baker Library, Dartmouth College, Hanover, N.H. Archival material was provided by Kathryn Greenthal.

7. Saint-Gaudens to Seymour, Feb. 1, 1900, Saint-Gaudens Papers.

8. Seymour to Saint-Gaudens, Jan. 6, 1906, Saint-Gaudens Papers.

9. Pratt to his mother, Sarah V. Pratt, Jan. 23, 1907, Pratt Family Papers.

10. George Dudley Seymour, "The Familiar Hale," *Yale Alumni Weekly*, Apr. 3, 1907, p. 640.

11. F. Ogden Cornish, "Bela Pratt—Citizen and Sculptor," *Boston Evening Transcript*, May 19, 1917. Charles Eliot Norton, according to a reporter for the *Boston Herald*, Aug. 21, 1907, had favorably compared Pratt's *Andersonville Prisoner Boy* to Saint-Gaudens's *Robert Gould Shaw Memorial*, 1897 (Boston Common).

12. Seymour to Helen Pratt, Feb. 10, 1919, Pratt Family Papers.

13. "The Week" and "Nathan Hale Statue," *Yale Alumni Weekly*, Nov. 1, 1912, pp. 152-153; "The University," ibid., Nov. 15, 1912, pp. 198-199. The success of this venture later inspired the Yale Alumni Fund to adopt the *Hale* sculpture as their logo in 1960.

14. Professor Theodore Woolsey, presenting the honorary M.A. degree to Seymour, at Yale commencement, June 1913, as quoted in the *New Haven Register*, Jan. 22, 1945, obit. Seymour was also largely responsible for placing a tablet in Hale's memory in Battell Chapel, Yale, and suggesting the idea of issuing a Nathan Hale postage stamp, which appeared as a half-cent stamp in 1925 and bears an engraved reproduction of Pratt's statue. In Seymour's 1945 bequest, the Yale University Art Gallery received the bronze foundry model, a half-life-size plaster model, and two half-life-size bronze casts of the life-size sculpture of Hale.

15. See "A Brief History of the Statue of Nathan Hale on the Yale Campus," The Antiquarian and Landmarks Society files.

16. George Dudley Seymour to Helen Pratt, Feb. 10, 1919, Pratt Family Papers.

17. See letter from Gordon B. Washburn, director, Museum of Art, The Rhode Island School of Design, to Theodore Sizer, director, Yale University Art Gallery, Nov. 24, 1945, American Art curatorial files, Yale University Art Gallery.

18. See George D. Vaill, "Only One Life, But Three Hangings," *American Heritage* 24 (Aug. 1973), unpaginated.

19. See letter from Vaill, assistant secretary, Yale University, to Alumni Committee, Nov. 24, 1970, Yale University Alumni Records.

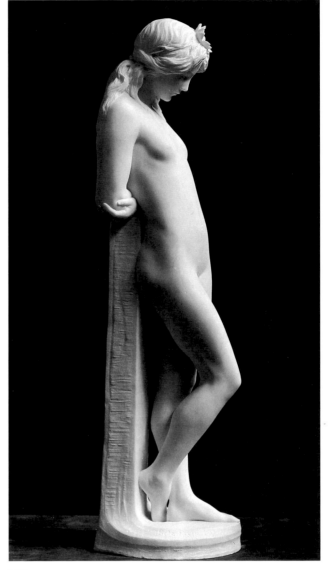

105

BELA LYON PRATT
105
Water-Lily Girl, 1914
Marble
H. 30 in. (76.2 cm.), w. 7 in. (17.8 cm.), d. 8¼ in. (21 cm.)
Signed (on base at left side): Bela Pratt 1914
Julia Bradford Huntington James Fund. 16.96

Exhibited: BMFA, *Guild of Boston Artists: A Retrospective Exhibition of Paintings . . . Sculpture* (1942), no. 275; Boston Symphony Orchestra Ball, Apr. 27-28, 1970; BMFA 1979, no. 24.
Versions: *Bronze*: (1) Frank L. Kennedy II, Exeter, N.H., (2) Matthew Pratt, Seattle, (3) present location unknown, formerly Mrs. George E. Belcher, Boston

"A master in the matters of posing and lighting,"[1] Pratt was at his freest in his noncommissioned work to explore psychological states of mind. In *Water-Lily Girl*, which the sculptor had called *Figure of a Young Girl*,[2] a nude adolescent leans against a column, with head lowered and hands clasping elbows behind her. Appearing to flow from the base, the column is incised in the rear with a water lily stem, a favorite Art Nouveau motif. A lily crowns the girl's hair, which is caught in the back and falls below her shoulders. While her facial expression is demure, her posture is coy, suggesting that she is responding to the presence of another person.[3] The young girl's nascent sexuality is heightened by the tactile quality of the marble.

First shown in bronze at the opening exhibition of the Guild of Boston Artists in 1914, *Water-Lily Girl* was singled out by F.W. Coburn, art critic for the *Boston Herald*, as being "one of the most delicately beautiful [statues Pratt] has ever made; in it he appears to work from an analogy between the youthful figure and the water lily."[4] The piece was shown a second time in bronze by the guild in 1916 and again in 1917 (the cast then owned by Mrs. George E. Belcher) in their memorial exhibition of Pratt's sculpture. During the guild's 1916 show, the Museum of Fine Arts purchased this marble version from the sculptor, prompting one reviewer to see the Museum's acquisition as a "hopeful and welcome indication of the policy of building up the permanent collection by the addition of American work and at the same time of encouraging worthy native talent."[5]

Although most sculptors still believed that recognition was measured by commissions for civic memorials often personifying lofty ideals, private works like *Water-Lily Girl*, which held no moral overtones or literary allusions, were increasingly preferred by the public. William H. Downes, writing for the *Boston Evening Transcript* in 1917, welcomed the modernism he found in Pratt's small figure studies and praised the sculptor for his originality and technical skill in portraying intimate, contemplative moments.[6]

The bronze owned by the sculptor's son, Dudley Pratt, was lent to the Seattle Art Museum by Helen L. Pratt, the sculptor's widow, in 1934; in 1971 this was given to Matthew Pratt, Dudley Pratt's son. Another bronze, owned by the sculptor's daughter, Elisabeth Pratt Kennedy, was given to her son, Frank L. Kennedy II, in 1965.

P.M.K.

Notes

1. A.J. Philpott, "Bela Pratt as Artist and as Man Shown by Memorial Exhibition," *Boston Sunday Globe*, Nov. 4, 1917.

2. After the Museum acquired the marble version of the sculpture, it became known by the more figurative appellation, *Water-Lily Girl*.

3. See BMFA 1979, no. 24.

4. Frederick W. Coburn, "Sculptures Are an Essential Part of the [Guild's] Opening Exhibition," *Boston Herald*, Nov. 8, 1914.

5. "More Pictures for Museum," *Boston Evening Transcript*, Apr. 13, 1916.

6. William H. Downes, "Mr. Pratt's Sculpture," *Boston Evening Transcript*, Oct. 30, 1917.

BELA LYON PRATT
106
Harriett Lawrence Hemenway, 1915
Sterling silver, lost wax cast
H. 16⅞ in. (42.9 cm.), w. 16⅞ in. (42.9 cm.)
Signed (lower left): B.L.P. 1915
Foundry mark (on underside): lion, anchor, G
STERLING GORHAM CO FOUNDERS
Gift of John T. Hemenway. 1975.736

Provenance: Augustus Hemenway, Readville, Mass.; Harriett Lawrence Hemenway, Readville; John T. Hemenway, Milton, Mass.
Exhibited: BMFA, "Memorial Exhibition of Sculpture by Bela Lyon Pratt," Apr. 3–May 5, 1918; BMFA 1977, no. 22.

This portrait of Harriett Lawrence Hemenway (1858-1960) was modeled in Bela Pratt's studio in Harcourt Street, Boston, "from a painting on Ivory made in Italy from life."[1] Depicted in profile, Harriett looks into a mirror held in her left hand. At fifty-seven she still appears as soft and feminine as she did in John Singer Sargent's (1856-1925) portrait, 1890 (private collection, Florida), done when she was thirty-two.[2] Delicate tendrils of hair frame her silken complexion in both the bas-relief and the painting. An unlined face and steady gaze convey the picture of a woman who, despite a busy life as the mother of six children, faced life easily and to whom life brought few troubles. Indeed, Harriett's serene spirit apparently contributed to her longevity, for she lived to be 102. Pratt's idyllic representation parallels the sheltered, domestic world described by the Boston impressionist painter Edmund C. Tarbell (1865-1932), a close friend and colleague of Pratt's at the School of the Museum of Fine Arts.

Pratt's sterling silver relief is a novel treatment in

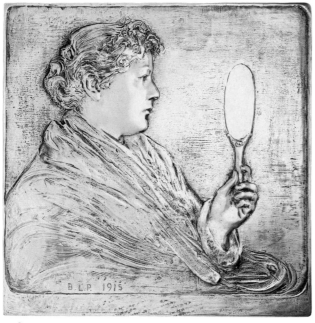

106

medium, though not in style or technique. His apprenticeship in Augustus Saint-Gaudens's studio had shown him how versatile the sculptor could be when working in low relief. The remarkable sensitivity to chiaroscuro that Saint-Gaudens demonstrated in his bronzes Pratt interpreted here, contrasting the swirling Art Nouveau lines of the sitter's shawl with the broadly modeled planes of face, hand, and mirror. The luxurious metal's satiny sheen also adds an animated note and tactile sense to the tranquil pose, contributing to the *fin-de-siècle* mood.

Harriett Hemenway was the daughter of the textile manufacturer Amos A. Lawrence, whose father and uncle had founded the city of Lawrence, Massachusetts; her brother was the Right Reverend William Lawrence, Episcopal bishop of Massachusetts. A founder and director of the Massachusetts Audubon Society and a benefactor of the Massachusetts Hospital School for Crippled Children in Canton, she also helped to establish the Association for Independent Co-operative Living, which provided a home for working girls in Boston.[3]

Harriett's marriage to Augustus Hemenway of fifty years was a close, harmonious one, with Augustus, known for his even-tempered nature, devoting considerable time to his family and his home. Their life was similar to that of English landed gentry, with an extensive farm estate at Readville, Massachusetts. Like Harriett, Augustus served on a number of charitable, civic, and cultural boards, notably

as trustee of the Museum of Fine Arts and the Boston Public Library, overseer of Harvard University (where he donated the Hemenway Gymnasium when he graduated in 1875), and treasurer of the Massachusetts Eye and Ear Infirmary.[4]

Augustus knew Pratt well and often came to his studio in Boston's Back Bay near the exclusive Tavern Club, where both men were members.[5] According to the Hemenways' daughter, Mary H. Homans, Pratt's commission for the bas-relief came during such a visit in October 1914, when Augustus saw a piece of silver and thought of honoring his wife. The hand mirror and shawl are presumably studio props added by the sculptor.[6]

P.M.K.

Notes

1. See notation by Helen Pratt, the sculptor's widow, on the back of a photograph of the clay model of the Hemenway relief, BMFA, ADA.

2. Sargent was visiting his sister in Nahant, Mass. and planning to paint the Hemenway's children, but gave up and did Harriett instead. See David McKibbin, *Sargent's Boston with an Essay & a Biographical Summary & a Complete list of Sargent's Portraits* (Boston: Museum of Fine Arts, 1956), pp. 40, 43, 101. Harriett Hemenway had a copy of Sargent's portrait made for her by Marion Lawrence Peabody (1875-1974), who studied at the Museum School.

3. See *Boston Globe*, July 2, 1960, obit.

4. See *Boston Evening Transcript*, May 25, 1931, obit.; *New York Times*, May 25, 1931, obit.

5. Pratt designed the Tavern Club medal in 1910. That year, Augustus Hemenway guaranteed Pratt's performance on the Boston Public Library's sculptures *Art* and *Science*.

6. Letter from Mary H. Homans to Kathryn Greenthal, Apr. 23, 1981, BMFA, ADA. See also letter from Pratt to his mother, Sarah V. Pratt, Oct. 11, 1914, in which he reported: "Gus asked me to do a relief portrait of his wife." Pratt Family Papers.

BELA LYON PRATT
107 (color plate)
Blind Cupid, 1917
Marble
H. 24⅛ in. (61.3 cm.), w. 22½ in. (57.2 cm.), d. 16 in. (40.7 cm.)
Signed (on base at right side): B.L. Pratt / 1917
Inscribed (on top of base at left): ΕΡΩΣ ΤΥΦΛΟΣ
Gift of Mrs. Bela L. Pratt. 48.350

Provenance: Mrs. Bela L. Pratt, Jamaica Plain, Mass.
Exhibited: Guild of Boston Artists, *Memorial Exhibition of Sculpture by Bela Lyon Pratt* (1917), no. 8; BMFA, "Memorial Exhibition of Sculpture by Bela Lyon Pratt," Apr. 3-May 5, 1918; The Copley Society of Boston, Mar. 25-Apr. 15, 1966; idem, *A Centennial Exhibition: A Selection of Works of Members During Its First Half Century, 1879-1928* (1979), no. 35.
Version: *Bronze:* (1) present location unknown, formerly Mrs. Guy Lowell, Brookline, Mass.

Despite Pratt's busy schedule of teaching and filling orders for public memorials and private portraits, he found time to create, often without commissions, a series of idealized studies representing American youth. Among these, his figures of young women, such as *River Nymph*, 1908 (The Metropolitan Museum of Art, New York), *Young Mother*, 1911 (Worcester Art Museum, Massachusetts), *Water-Lily Girl* (q.v.), and *Blind Cupid* have a lightness of spirit that the art-viewing public readily appreciated.

The marble group *Blind Cupid*, modeled in 1916, was Bela Pratt's last figure study. The Greek inscription on the base, translates as "blind love," an allusion to Eros, or Cupid, the mischievous god of love, and Aphrodite, the Greek goddess of love and beauty, sometimes shown together as mother and child. A seated female nude with eyes closed plays hide-and-seek with a pudgy cupid who crouches behind her. Meant to be seen in the round, her firm, young body turns slightly to the left while her head bends to the right. Pratt's rhythmic design, from the undulating shape of the base to the woman's upswept hairdo, has Art Nouveau qualities, but its complexity at times disturbs the delicate modeling, creating slightly awkward passages, such as in the hands and feet of both figures.

By consensus, the Boston art critics of Pratt's time considered *Blind Cupid* the sculptor's "most beautiful creation."[1] In a review of his memorial exhibition at the Guild of Boston Artists, November 1917, A.J. Philpott of the *Boston Globe* described the work as "a superb bit of sculpture," typical of Pratt's small, ideal females, which he characterized as "lithe, dainty, healthy." The charm of these pieces, Philpott felt, was that they were "refined, never voluptuous" and portrayed "adolescence rather than maturity."[2]

In 1927 when Helen L. Pratt, the sculptor's widow, offered to sell *Blind Cupid* to the Museum of Fine Arts, she was turned down, but her later donation of the piece, in 1948, was happily accepted.[3]

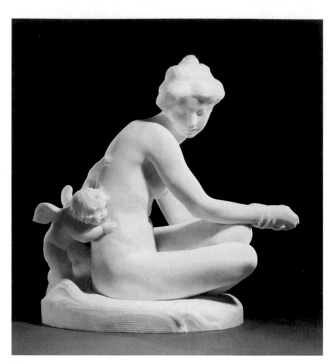

107

The bronze version of *Blind Cupid*, lent to the Museum's 1918 exhibition of Pratt's sculpture, was owned by Mrs. Guy Lowell, wife of the Museum's architect.

P.M.K.

Notes

1. William H. Downes, "Mr. Pratt's Sculpture," *Boston Evening Transcript*, Oct. 30, 1917. John Nutting, "Memorial Exhibit of Pratt's Works," *Boston Daily Advertiser*, Nov. 1, 1917, thought *Blind Cupid* was "in some ways his most beautiful work."

2. A.J. Philpott, "Bela Pratt as Artist and as Man Shown by Memorial Exhibition," *Boston Sunday Globe*, Nov. 4, 1917.

3. See letter from Charles W. Hawes, associate director, to Helen L. Pratt, June 7, 1927, and her letter to the Museum's trustees, Mar. 25, 1948, BMFA, 1901-1954, roll 2476, in AAA, SI.

Philip Shelton Sears (1867 – 1953)

Trained in his youth as a lawyer and businessman, Philip Shelton Sears possessed an artistic inclination that expressed itself when he took up sculpture at the age of fifty-two. The son of Frederick Richard Sears and Albertina Homer (Shelton) Sears, Philip was born into a Boston family of wealth and privilege. He attended the J.P. Hopkinson School and graduated from Harvard University in 1889 and Harvard Law School in 1892. From 1892 to 1898 he practiced law in Boston and, for more than thirty years, acted as a trustee of estates.

It was while serving as camp adjutant at Camp Devens in Ayer, Massachusetts, in 1918, that in spare moments Sears began modeling in clay. In addition, he tried his hand at wood carving. Determined to become a sculptor, Sears enrolled in classes taught by Charles Grafly at the School of the Museum of Fine Arts in 1919 and, side-by-side other students, many of them thirty years his junior, learned a new profession. After two-and-a-half years at the Museum School he received informal instruction from Daniel Chester French, then in his seventies, in Stockbridge, Massachusetts.

From time to time during the early 1920s Sears would enter a sculpture in group exhibitions at the Boston Art Club or at the Museum of Fine Arts, where his submissions were judged favorably yet briefly; however, on the occasion of his first one-person display, held at the Guild of Boston Artists in January 1925, his twenty-one pieces won considerable local attention. Harley Perkins of the *Boston Evening Transcript* praised Sears's nudes as his most outstanding efforts: "Such studies as 'Man Throwing the Hammer' and 'Stepping Stones,' the latter showing a boy apparently essaying the insecure footing afforded by the borders of an outdoor swimming pool, have notable qualities. An appearance of swinging action has been achieved without over dramatization, but with a sense of sturdy force, while the modeling of the nude figures of these typical athletic American youths is most commendable."[1] F.W. Coburn of the *Boston Herald* called Sears's portraits in this exhibition "almost Venetian in their clearness of characterization and nobility of style."[2]

In the spring of 1925, all except one of the same objects were shown in New York at the Ferargil Galleries. A reviewer for the *New York Post* gave this appraisal: "Mr. Sears' sculpture is realistic, a fact which gives some prosaicness to his portraits and

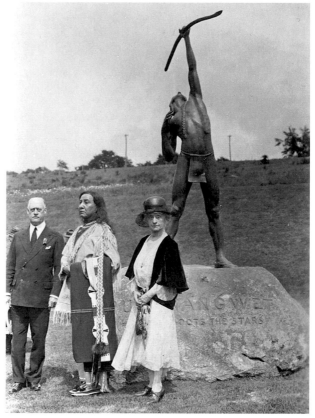

Philip Sears, David Buffalo Bear, and Clara Endicott Sears

much vitality to his nude studies, where the thorough appreciation of structure gives resilience of pose and a fine muscular balance. The fountain figures are, in consequence, the most interesting of the pieces." Nevertheless, the same writer noted a "tendency to overwork surfaces gives much of the portrait work a fussy impression,"[3] and another critic, in the *New York Times*, remarked that Sears's sculpture revealed "little imagination and less sense of design."[4]

Throughout the mid- and late 1920s, at his winter home and studio in Brookline, Massachusetts, and at his summer residence in Prides Crossing, Massachusetts, Sears executed a great number of portraits, many of them heads, in his preferred scale: two-thirds-life-size. The posthumous bust of Percy Haughton, Harvard University football coach, 1925 (Harvard Varsity Club, Cambridge) and the bust of Guy Lowell (q.v.), Boston architect, likenesses of two of Sears's friends, were the most commented-upon portraits from this period. The *Haughton* was much admired: "The sensitiveness and expressiveness of the great football expert's features have been beautifully wrought out in this

bust and it is stamped all over with the character of the man. . . . Only one who had known the man intimately could have made such an animated and life-like bust. And it is splendidly modeled."⁵ Bronze casts of these and other portraits were exhibited along with seven garden figures in Sears's second one-person show at the Guild of Boston Artists early in 1929. The reviewers again complimented Sears's sound knowledge of anatomy, which he demonstrated most frequently in his young, lithe, nude male figures. An athlete and champion tennis player, Sears enjoyed modeling figures in motion, although he was equally capable of illustrating the body in repose, as in *Sleeping Youth*, 1928 (Beverly Hospital, Massachusetts), which represents a seated nude boy, head resting on the hand that is placed on his drawn-up knees. Primarily a sculptor of male images, Sears also exhibited a languid standing nude female figure entitled *Awakening*, about 1929 (present location unknown), who, eyes still closed, has just risen from sleep and stretches her arms to rouse herself.

In general, Sears's trademark is his precision, be it in the careful rendition of a human body or the exact delineation of an accoutrement. In the portrait of his twin brother, Herbert, 1920 and his self-portrait, 1926 (both Mrs. Mason Sears, Dedham, Massachusetts)—each a bronze bust —the sitters' jowls and loose flesh are dutifully recorded, and in the bronze portrait bust of the anatomist Thomas Dwight, 1931 (Warren Anatomical Museum, Harvard Medical School), the physician's extraordinary beard is meticulously drawn, as is a bald spot at the top of his head. Whereas the anatomical details of these busts are handled with some degree of success, less convincing is Sears's treatment of accessories in the portrait relief of the educator and author Ella Lyman Cabot, 1935 (King's Chapel, Boston), in which a cross and hair comb, complete with teeth, are distracting elements. Sears's keen interest in accurately modeling the human form is especially apparent and more pleasing in his garden statuary. Among his contributions to this genre are the fountain figures *Stepping Stones*, about 1924 (private collection, Hamilton, Massachusetts), and *Piping Boy*, about 1925 (Peter Abate, Brookline), which are quite satisfying and effective.

Sears did not confine himself exclusively to small-scale portraits and garden sculpture. His best-known works, in fact, are two heroic-size bronze statues of Indians at Fruitlands Museums, Harvard, Massachusetts: *Pumunangwet* (*He Who Shoots the Stars*), dedicated in 1931, and *Wo Peen, the Dreamer*,

a companion piece, unveiled in 1938. Dating from the 1930s as well, though of an entirely different nature, is Sears's third major large sculpture, the World War I memorial in Manchester-by-the-Sea, Massachusetts, set in place in 1931. A variant of an earlier conception, it depicts a spirited, twelve-and-a-half-foot, standing bronze doughboy, with one arm raised in salutation and the other holding the American flag.

By no means an influential sculptor, Sears was nonetheless rarely without portrait commissions (often from friends in his social milieu), and he exhibited widely during the period of his greatest activity, 1925-1938. He put his art on view not only in the United States, for example, at the annual exhibitions of the Pennsylvania Academy of the Fine Arts between 1926 and 1931, but also in Europe, in the eleventh Olympic exhibition in Amsterdam in 1928 and in the Royal Academy of Arts in London. The Guild of Boston Artists hosted two more installations devoted exclusively to Sears's sculpture: early in 1934 and in the winter of 1936-1937. Versions of the following portrait busts were highly regarded and singled out for their strong characterization: *Henry Cabot Lodge*, 1929 (State House, Boston), from the 1934 exhibition; and *Franklin D. Roosevelt*, 1934 (The Franklin D. Roosevelt Library, Hyde Park, New York), and *His Eminence William Cardinal O'Connell*, 1936 (present location unknown, formerly Saint John's Seminary, Brighton, Massachusetts), from the 1937 display. The 1940s were quieter years for Sears's sculptural endeavors, and in 1953, at the age of eighty-five, he died at his home in Brookline.

K.G.

Notes

1. H[arley] P[erkins], "The Fine Arts: Sculptures by Mr. Sears," *Boston Evening Transcript*, Jan. 13, 1925.
2. F.W. Coburn, "In the World of Art," *Boston Sunday Herald*, Jan. 18, 1925.
3. Philip S. Sears Papers, AAA, SI.
4. "Art: Exhibition of the Week; Other Exhibitions," *New York Times*, May 3, 1925.
5. A.J. Philpott, "Bust of Percy D. Haughton Is Work of His Friend Philip Sears," *Boston Globe*, June 16, 1925.

References

AAA, SI; *Boston Herald*, Mar. 11, 1953, obit.; BPL; Quinquennial File, HU; Harvard College, Class of 1889, *Twenty-Fifth Anniversary Report* (1914), pp. 568-569; idem, *Fiftieth Anniversary Report* (1939), pp. 356-358; MMA; *New York Herald Tribune*, Mar. 11, 1953, obit.; SMFA.

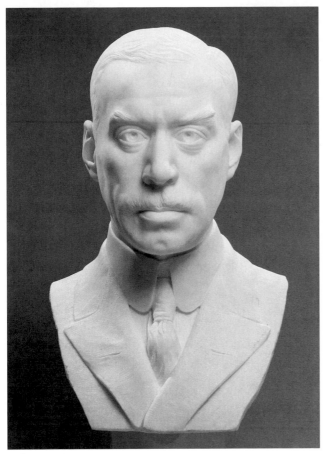

108

PHILIP SHELTON SEARS
108
Guy Lowell, 1927
Marble
H. 17¼ in. (44 cm.), w. 10⅝ in. (27 cm.), d. 9⅜ in.
(23.9 cm.)
Signed (on subject's left shoulder): P. S. SEARS Sc.
1927
Inscribed (under subject's left shoulder): GUY LOW-
ELL / P.S. SEARS Sc / 1927
Gift of Philip S. Sears. 32.52

Provenance: Philip S. Sears, Brookline, Mass.
Versions: *Bronze*: (1) Mrs. Mason Sears, Dedham, Mass.,
(2) present location unknown, formerly Mrs. Mason
Sears, Dedham, (3) New York County Court House. *Mar-
ble*: (1) Conner-Rosenkranz, New York

Dated the year of the subject's death, Sears's bust of
the architect Guy Lowell (1870-1927) is probably a
posthumous portrait.[1] Lowell, who was born in Bos-
ton, received a thorough education during the
1890s at Harvard University, the Massachusetts In-
stitute of Technology, and the Ecole des Beaux-
Arts, Paris. After returning to the United States in

1899, Lowell immediately opened an office in Bos-
ton (and, later, one in New York) for the practice of
architecture. He was soon designing private resi-
dences, many of them in Massachusetts, Maine, and
on Long Island, and planning public structures.
Landscape architecture was another interest of
Lowell's: he laid out gardens in connection with
estates, lectured on the topic at the Massachusetts
Institute of Technology, and enriched the literature
with his publications *American Gardens* (1902), *Small
Italian Villas and Farmhouses* (1916), and *More Small
Italian Villas and Farmhouses* (1920).

Lowell's production was refined, conservative,
and, above all, classical. Among his finest contribu-
tions are the New Lecture Hall, Emerson Hall, and
the president's house at Harvard University; build-
ings at Phillips Academy, Andover, Massachusetts;
the Museum of Fine Arts, Boston (Huntington Ave-
nue); and the Piping Rock Country Clubhouse on
Long Island.[2] Few would dispute that his most nota-
ble achievement is the New York County Court
House, for which he executed the winning design in
1913. Lowell's success in the competition provided
him with a national reputation, but it was attained
at a heavy price, for obstacles delayed the Court
House's completion. It was not until one week after
Lowell's death that it was dedicated.

Sears and Lowell had been well acquainted, and
the portrait may have been created by the sculptor
to commemorate his friend without any specific
plan for its location. In the late winter of 1928, a
marble bust, possibly the one in the Museum of
Fine Arts, was exhibited at the Guild of Boston
Artists. The portrait depicts Lowell in contempo-
rary dress, as a forceful personality, a man whose
"method of ascending a flight of stairs was by run-
ning."[3] At that time the press reported that a
bronze replica was to be installed in the New York
County Court House.[4] Actually, several bronze rep-
licas were made, with variations in their bases, and
in 1929, at Sears's one-person show at the guild,
one of these casts was displayed. Many of the re-
viewers regarded the portrait as a good likeness,
and F.W. Coburn of the *Boston Herald* remarked
that it emphasized "a cranial structure that one used
to notice in Guy Lowell years ago," as "he came in
panting at the end of his gruelling half-mile, the
whipcord muscles showing over the jaw and along
the neck."[5]

Not everyone was pleased with the portrait, and
Lowell's widow liked it least. Following Sears's gift
of the bust to the Museum in 1932, it was placed
on view. In 1938, however, it was removed for cleaning

at the request of Mrs. Lowell, who later clearly indicated her intense aversion to the bust. Partly in deference to her wishes, the piece has apparently never been exhibited since then.[6]

K.G.

Notes

1. Since Lowell died suddenly in Madeira on Feb. 4, 1927, while on a visit to Europe, one may surmise that this bust was made after his passing during the course of the year.

2. Arthur Stanwood Pier, "Guy Lowell," *Harvard Graduates' Magazine* 35 (1926-1927), p. 631. For information on Lowell, see also Harvard College, Class of 1892, *Reports*, 1893, 1907, and especially 1922, 1927; *DAB*; and Douglas Bonnell, "Boston Beaux-Arts: The Architecture of Guy Lowell, with a Documentary Catalogue of His Work," 2 vols., Master's thesis, Tufts University, 1980.

3. Pier, "Guy Lowell," p. 638.

4. *Boston Evening Transcript*, Mar. 14, 1928.

5. F.W. Coburn, "In the World of Art—Marceau's French Touch—Sculpture by Mr. Sears," *Boston Sunday Herald*, Jan. 27, 1929, magazine section.

6. In 1938, while visiting the Museum, Mrs. Lowell discovered that the bust was dirty. She wrote to Edwin J. Hipkiss, curator of decorative arts, expressing horror at "the way Mr. Lowell's head looked with the nose black" and asked whether it could "just disappear (at once) for a long cleaning." "That would be a good excuse," she added, "if Mr. Sears inquired about it!!" On November 21, 1938, Hipkiss answered that the bust would be removed from exhibition that day. "If you really wish it so," he proposed, "we can keep it in the laboratory a long, long time. On the other hand, it can be cleaned in half an hour." On March 24, 1953, two weeks after Sears's death and within a month of her own, Mrs. Lowell wrote Hipkiss from the Phillips House, Massachusetts General Hospital, Boston, again raising the subject of the portrait: "Do you remember the agreement, that when Mr. Sears died, the bust he made of Mr. Lowell . . . that I hated so was to be destroyed? Will you see now that Mr. Sears has died that it is destroyed as agreed?" Two days later, Hipkiss responded: "I remember well your feeling about the marble bust for we sent it to the laboratory long ago for 'cleaning.' It has not been on exhibition for about ten years. . . . I shall talk with Mr. Edgell about your request." However, according to Hipkiss, there was no agreement, and he felt that the Museum had no right to destroy the bust unless the trustees so voted. On April 9 the Committee on the Museum voted not to destroy the bust but to keep it off exhibition. See letters from Henrietta Lowell, undated, 1938, to Edwin J. Hipkiss, and Hipkiss to Mrs. Lowell, Nov. 21, 1938, BMFA, ADA; letters from Mrs. Lowell to Hipkiss, Mar. 24, 1953; Hipkiss to Mrs. Lowell, Mar. 26, 1953, and to George H. Edgell, director, Mar. 26, Apr. 21, 1953; Edgell to Hipkiss, Mar. 31, Apr. 10, 1953. BMFA, 1901-1954, roll 2465, in AAA, SI.

PHILIP SHELTON SEARS
109
Pumunangwet (He Who Shoots the Stars), 1929
Bronze, brown patina, sand cast; bow formerly gilded
H. 46⅛ in. (117.2 cm.), diam. of base 16⅝ in. (42.3 cm.)
Signed (on top of base near subject's left foot): Philip S. SEARS Sc. 1929 / ©
Foundry mark (on base below signature): KUNST FDRY.NY.
Gift of Mrs. Mason Sears. 1981.346

Provenance: Mrs. Mason Sears, Dedham, Mass. Exhibited: The Pennsylvania Academy of the Fine Arts, Philadelphia, *Catalogue of the 125th Annual Exhibition*, 1930, no. 711; Guild of Boston Artists, *Exhibition of Sculpture by Philip S. Sears* (1934), no. 16; BMFA, *Exhibition of Paintings and Sculpture by the Guild of Boston Artists in the New Special Exhibition Galleries* (1934), no. 308; World's Fair, New York, *American Art Today* (1939), no. 756. Versions: *Bronze*, about 12 in.: (1) present location unknown, formerly Mrs. Mason Sears, Dedham, Mass; over life-size: (2) Fruitlands Museums, Harvard, Mass.

Like Hermon Atkins MacNeil (1866-1947), in his *Sun Vow*, created in 1898 (The Art Institute of Chicago), Philip Sears explored American Indian initiation rites. His bronze statue is called *Pumunangwet*, a term that can be translated as "he who shoots the stars," and symbolizes the ritual in which young braves who are entering manhood gather together to shoot arrows to the stars. Here, as in many of Sears's earlier male figures, the pose provided the sculptor with an opportunity to display his mastery of anatomy by modeling a powerful athletic body in the most realistic manner. Stretched to the limit, the figure's whole being is tightened, every rib is articulated.

From available evidence, it appears that the sculpture in the Museum of Fine Arts, which is finished in every detail, was made independently of any commission. Nevertheless, since the sculptor's cousin Clara Endicott Sears founded the American Indian Museum at Fruitlands Museums in Harvard, Massachusetts, in 1929, it is possible that Sears conceived this statue for eventual placement there, although, in the end, an over life-size version was selected for that location. Completed in the autumn of 1929, the Museum's bronze was first put on view in the one hundred and twenty-fifth annual exhibition of the Pennsylvania Academy of the Fine Arts in 1930 with the title *Shooting Stars*. A French critic felt that the figure was one of the most interesting

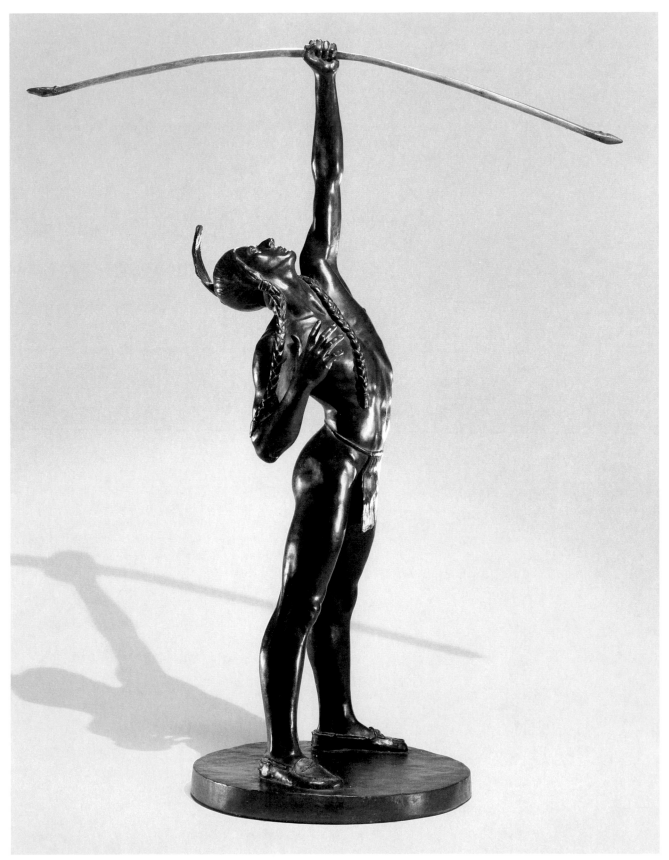

in the exhibition and found its head, neck, and upper torso, thrown backwards, and legs, so muscular and taut, remarkably rendered.[1] Another French writer reported that he spent a long time studying *Shooting Stars*, which he described as superb, and then commented that Sears was among the best sculptors of the day.[2]

By July 1930 Sears had made plans to enlarge the image to heroic size the following winter.[3] In addition to executing the ten-foot statue, the sculptor fashioned a bronze reduction about one foot high, which seems to be the size of the cast shown at the Royal Academy of Arts, London, in 1931 and listed in the catalogue as Sears's "*Shooting at the Stars—statuette, bronze.*"

In its over life-size form, *Pumunangwet* differs from the Museum's piece in that it stands on top of a large granite boulder instead of on a circular bronze base. On June 12, 1931, the figure, which came to be Sears's most famous statue, was dedicated in Harvard (See photograph, p. 323). Under the patronage of Clara Sears, it was installed overlooking the Nashua Valley, where the Indian once made his home. The unveiling was as romantic in its celebration as the statue was in its subject. A.J. Philpott of the *Boston Globe* described the scene: "Nothing quite so picturesque and original in the way of a ceremony was ever seen in this part of the world. . . . A full-blooded Sioux Indian—David Buffalo Bear—in native costume and wearing a war bonnet of eagle feathers that touched the ground, conducted the exercises. . . . Beside him stood a Boy Scout holding in his arms an otter skin, on which was the pipe of peace. . . . Then a bugler sounded 'reveille' to awaken the soul of the Statue, after which David Buffalo Bear lifted his arms and shouted: "Awake! awake Algonquin brother!" The Indian blankets in which the statue had been enshrouded were then removed and Pumunangwet . . . stood revealed in beautifully tinted bronze."[4]

K.G.

Notes

1. "Philip S. Sears," *La Revue moderne des arts et de la vie*, May 1930.

2. Comte Chabrier, "Philip S. Sears," *La Revue du Vrai et du Beau*, May 1930.

3. "Arts and Artists," *North Shore Breeze and Reminder*, July 11, 1930, pp. 57-58. For a discussion of how the heroic-size bronze became part of the Fruitlands Museums's collections, see Clara Endicott Sears, "Pumunangwet, 'He Who Shoots the Stars,' " in Corporation Records, Fruitlands Museums, Harvard, Mass.

4. A.J. Philpott, "Statue of Indian Brave Unveiled at Exercises," *Boston Globe*, June 13, 1931.

Victor David Brenner (1871 – 1924)

Remembered more for his medallic art and coinage than for his sculpture, Victor David Brenner is best known for the Lincoln penny, designed in 1909 and still in circulation today.

Brenner was born in 1871 to George and Sarah (Margolis) Brenner in the Russo-Germanic Baltic (Latvian) town of Shavely. He was exposed at an early age to a number of skills by his father, who earned his living as a metalworker but whose artisanal abilities ranged from cutting gravestones to smaller, more delicate endeavors such as snipping out silhouettes and engraving elaborate rings and brooches. At thirteen Victor was apprenticed to his father, and after three years of learning a craft, he set off for a year or two as an itinerant journeyman. He was briefly hired by a jewelry engraver in Riga and subsequently cut dies and illustrations for advertisements in a rubber stamp and type foundry in Mitau. In 1889 he engraved jewelry and cut seals in Kovno. By 1890 Brenner had saved enough money to pay for passage to the United States and, following in the footsteps of thousands of emigrants who saw America as a land of opportunity, he left for New York in possession of little more than his lofty ideals, talent, and determination.

Brenner quickly progressed from selling matches on Fulton Street to cutting dies and engraving jewelry for several employers. Like others who were ambitious but insolvent, Brenner enrolled in free night classes at Cooper Union while practicing his trade during the day. His attendance at Cooper Union was of short duration, and it was not until 1896 that he pursued additional formal training, this time at the National Academy of Design. Meanwhile, Brenner concentrated his energies on cutting dies for firms specializing in jewelry and silver. Here and there he would obtain a commission, and among his first recorded pieces are a badge for the Saint George Athletic Association, 1895 (present location unknown), and a medal for the Society of the Cincinnati, 1895 (The American Numismatic Society, New York). Brenner's tiny relief head of the composer Ludwig van Beethoven, about 1895 (present location unknown), used as a pendant to a badge for a singing society, came to the attention of the American Numismatic Society which, recognizing the artist's worth, commissioned from him the medal (in honor of William Augustus Mühlenberg) commemorating the opening of the new Saint Luke's Hospital, 1896, and the medal observing the

Twenty-Fifth National Conference of Charities and Corrections, 1898.

In the late 1890s Brenner became acquainted with two of his staunchest advocates, the philanthropist and art advisor Samuel P. Avery and the philhellene James Loeb, who gave the Museum of Fine Arts its Brenner medals (q.v.). It was Brenner's industry and charm that brought him to their notice and made him a patron's delight. Although there was a modest but growing demand for his work, Brenner saw the need for rigorous instruction, which, for an enterprising sculptor in 1898, meant a trip to Paris to study at the art schools and with individual masters.

During the course of his stay in Paris, Brenner acquired a thorough education in modeling from Denys Puech (1854-1942) and Raoul Charles Verlet (1857-1923) at the Académie Julian and then enriched his knowledge of the medallic arts with lessons from Alexandre Charpentier (1856-1909) and Oscar Roty (1846-1911). Before long, Brenner became Roty's assistant and was productive in his own right, executing, among others, the seven specimens in the Museum's collection and a plaquette of the numismatist and philanthropist J. Sanford Saltus, 1900 (The American Numismatic Society). He also started exhibiting his work in Paris—models of *Clovis Delacour*, *George Lucas*, and *Anita Stuart*—at

the Salon of 1900 sponsored by the Société des artistes français, where they won Brenner an honorable mention. At the Paris Exposition of 1900 he was awarded a bronze medal for the three medals he submitted. Having benefited from his experience in France, Brenner traveled in Italy and Germany for a year before returning to New York in 1901. For the next three years he juggled the professions of medallist, die-cutter, and badge-maker and taught the newly organized class in coin and medal design at the National Academy of Design.

Brenner had a keen desire to be back in France, where a renaissance in the medallic arts was in full swing, initiated chiefly by the efforts of Hubert Ponscarme (1827-1903), Jules Chaplain (1839-1909), Roty, Charpentier, and Ovide Yencesse (1869-1947). Indeed, in 1899 Roger Marx observed that "apart from engravings and posters, I can scarcely think of anything now enjoying so large a share of favour as the medal."[1] In Paris again in 1905, soaking up the atmosphere that measurably influenced his art, Brenner made one of his most inspired medals, the three-quarter-length plaquette of James McNeill Whistler (1834-1903) (The American Numismatic Society). The art critic Adeline Adams commented that Brenner often overelaborated the anecdotal details in his medals but praised the *Whistler*, saying it "escapes the snare of pictorial insistence. Its reverse, dominated by a peacock crying 'Messieurs les Ennemis,' is a triumph of imaginative suggestion, with a tang of satire."[2]

By the autumn of 1906 Brenner was in New York once more, intent on establishing himself strictly as a sculptor and medallist. Despite this resolve, what brought him fame, as previously mentioned, was a coin—the Lincoln cent. In 1908 Brenner was modeling the *Panama Canal Service Medal* (The American Numismatic Society), and while he was receiving a sitting from Theodore Roosevelt, whose portrait is on the obverse, he showed the president a handsome plaquette of Abraham Lincoln. Roosevelt was highly enthusiastic about the Lincoln portrait and recommended to Secretary of the Treasury Franklin MacVeagh that it be placed on a coin.[3] In August 1909 the Lincoln penny appeared and met with admiration for its composition as well as disapproval for the conspicuous placement of the artist's three initials. More than 22 million coins were circulated, however, before the initials were removed from the design.

Brenner was surely more renowned as a result of the Lincoln penny's success, yet he had already achieved a sizable reputation as a medallist before 1909. He had won a bronze and a silver medal, respectively, for his entries at the expositions in Buffalo in 1901 and Saint Louis in 1904, and by 1903 his work was represented in the collections of the Paris Mint, the Munich Glyptothek, the Vienna Numismatic Society, and the Metropolitan Museum of Art, New York. So expert was he in the field that in 1910 he published *The Art of the Medal*. Brenner had long been sought after by societies, universities, institutes, and clubs to execute prize medals, commemorative medallions, and tablets, and those he made during the second decade of the century— some with portraits, others with allegorical figures— were as diverse as the early ones. Examples from this period include: *Ralph Waldo Emerson Plaquette*, 1911, *Clark University Twenty-Fifth Anniversary Medallion*, 1914, *Calumet and Hecla Mining Company Medal*, 1916, *Music Medal*, 1917, and *Warner and Swasey Co. Lick Telescope Medal*, 1920 (all in the American Numismatic Society).

A small portion of Brenner's oeuvre was devoted to sculpture,[4] such as the portrait busts of Simon Sterne, before 1904 (New York Public Library), Charles Eliot Norton, 1906 (Fogg Art Museum, Harvard University), and Samuel P. Avery, 1912 (The Brooklyn Museum), George Walter Vincent Smith, 1913, and Belle Townsley Smith, 1913 (both at George Walter Vincent Smith Museum, Springfield, Massachusetts), the statue *The Lily*, about 1911 (present location unknown), and the group *A Song to Nature*, for the Mary E. Schenley Memorial Fountain, dedicated in Pittsburgh in 1918.

Brenner was capable of fashioning virtually anything in small relief. He appears to have been as much at ease with the nude as with the draped figure and was equally proficient in modeling in low and in high relief. Of Brenner's gift for relief portraiture, the art critic Charles Caffin wrote that the sculptor had "an extraordinarily direct vision, quickened by experience in so exacting an occupation as die-cutting, and, moreover, a very mobile sympathy. The latter helps him to be interested at once in this subject, and with so much affection and reverence for the personality that his portrayal exhibits a very unusual degree of intimacy."[5] At the turn of the century there were few individuals as knowledgeable in the designing, engraving, and cutting of medals as Victor Brenner. In his curious and experimental nature, Brenner resembled Saint-Gaudens, investigating several processes and testing a variety of surface treatments to see different ef-

fects. He bridged the gap between creator and technician and grew to consider himself an "artist." In the end his transition from craftsman to artist was of great significance in helping to raise medal-making in America from a trade to an art.

K.G.

Notes

1. Roger Marx, "The Renaissance of the Medal in France," *International Studio* 6 (1899), p. 17.

2. *DAB*, s.v. Brenner, Victor David.

3. For a discussion of the Lincoln cent, see Vermeule 1971, pp. 121-124.

4. For the most complete catalogue of Brenner's work, see Glenn B. Smedley's lists in *Numismatist* 94 (Feb. 1981), pp. 333-342; 96 (July 1983), pp. 1361-1392, (Aug. 1983), pp. 1598-1606; 97 (Dec. 1984), pp. 2513-2516.

5. Caffin 1903, p. 169.

References

AAAn, 1924-1925, p. 283, obit.; The American Numismatic Society, New York; The American Numismatic Society, *Catalogue of the International Exhibition of Contemporary Medals* (1911), pp. 26-33; Victor D. Brenner, *The Art of the Medal* (New York: De Vinne, 1910); Caffin 1902, pp. xci-xciv; Caffin 1903, pp. 163-171; Grolier Club, New York, *Catalogue of Medals and Plaques by Victor D. Brenner* (1907); Grace Humphrey, "A Song to Nature," *International Studio* 61 (Apr. 1917), pp. LVII-LVIII; Paul U. Kellogg, "Two New Worlds and a Sculptor's Clay," *Survey* 35 (Oct. 1915), pp. 19-22; MMA; MMA, ALS; *New York Times*, Apr. 6, 1924, obit.; Glenn B. Smedley, "What Do You Know about Victor David Brenner's Works?" *Numismatist* 94 (Feb. 1981), pp. 333-342; idem, "The Works of Victor David Brenner," ibid. 96 (July 1983), pp. 1361-1392, (Aug. 1983), pp. 1598-1606; idem, "The Works of Victor David Brenner: A Supplement," ibid. 97 (Dec. 1984), pp. 2513-2516; Taft 1930, pp. 448, 554-555; Vermeule 1971, pp. 121-124, 241, n. 11; Whitney 1976, p. 262.

VICTOR DAVID BRENNER

110

George Aloysius Lucas, 1899
Silver-plated copper electrotype
Diam. 5¾ in. (14.6 cm.)
Signed (at lower right): V.D. BRENNER PARIS '99.
Inscribed (at top): · GEORGE · ALOYSIVS · LVCAS ·
Gift of James Loeb. 04.247

Provenance: James Loeb, New York
Versions: *Bronze*: (1) The American Numismatic Society, New York, (2) The Baltimore Museum of Art, (3) The Grolier Club, New York, (4) The Metropolitan Museum of Art, New York, silvered. *Electrotype*: reduction, silvered copper, 2¼ in.: (1) The Metropolitan Museum of Art

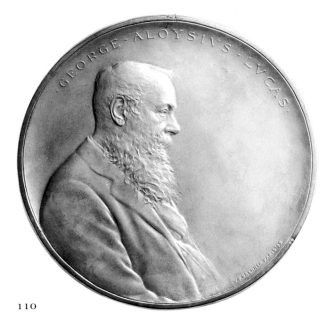

110

Before Brenner departed for Paris in 1898, his patron Samuel P. Avery provided an introduction to the art agent and collector George A. Lucas (1824-1909), who had taken up residence in Paris in 1857. According to Lucas's diaries, he received his first call from Brenner on June 13, 1898.[1] After several more visits in 1898 and early 1899, Lucas kindly arranged for Brenner to meet Oscar Roty, who soon became the young sculptor's teacher. Lucas was equally generous in furnishing Brenner with a number of commissions, which he executed during the period he worked in Roty's atelier.[2]

Three entries in the diaries, dated August 21, September 8, and September 25, 1899, record Lucas's sitting for his portrait, and on October 22, Brenner brought and offered him the medallion.[3] Shown in profile, rotund and stooped in the shoulders, Lucas looks his seventy-five years of age. The long, full beard is lavishly displayed, but Brenner did not permit it to overpower the sitter's face, in which the well-practiced eye is handled with skill and sensitivity. The medallion was initially exhibited as a model, along with models for *Anita Stuart* and *Clovis Delacour* at the Salon of the Société des artistes français in 1900, where all three won a collective honorable mention.

Charles Caffin commented that the *Lucas* belonged to a category of Brenner's oeuvre that was distinctly sculptural in contrast to reliefs such as the *Delacour*, *M.P. Vadé*, and *Edward B. Fulde*, which he described as painterly and which he apparently preferred. Nonetheless, Caffin found that the *Lucas* had "a compensating virility of expression, a

greater dignity of structure and of character."[4]

The *Lucas* was designed in both plaquette and medallion form. Plaquettes measuring 5⅛ by 4⅛ inches were made in silver-plated electrotype, gold-plated electrotype, and cast in bronze. The medallions were executed in silver-plated copper electrotype, of which the Museum's piece is an example, and in a bronze and silvered bronze cast. A reduction of the medallion, measuring 2¼ inches in diameter, was also fabricated in silver-plated electrotype. It is not known how many plaquettes and medallions were produced by these processes, but they are believed to be few.

K.G.

Notes

1. *The Diary of George A. Lucas: An American Art Agent in Paris, 1857-1909*, transcribed and with introduction by Lilian M.C. Randall (Princeton, N.J.: Princeton University Press, 1979), vol. 1, p. 863.

2. Caffin 1902, pp. xcii-xciii.

3. See *Diary of Lucas*, vol. 1, pp. 881-884. Long after the completion of the medallion, Brenner and Lucas remained acquaintances, as is evidenced by entries in the diaries.

4. Caffin 1903, p. 170.

VICTOR DAVID BRENNER
111
Anita Stuart, 1899
Silver-plated copper electrotype
H. 4¼ in. (10.8 cm.), w. 3%6 in. (9.1 cm.)
Signed (at lower right): V.D BRENNER PARIS '99.
Inscribed (at bottom on ribbon): ANITA / STUART
Gift of James Loeb. 04.248

Provenance: James Loeb, New York
Version: *Bronze*: (1) The Metropolitan Museum of Art, New York

Created in 1899 during Brenner's period of study in Paris, the portrait plaquette *Anita Stuart* dates from the early part of the artist's career. It was probably commissioned from Brenner by the family of the sitter. The young girl is shown, eyes uplifted, in three-quarter profile and in bust form. Her most notable feature is her loose and wavy hair that spills over her shoulders. In the upper left corner is a heraldic device of a pelican in her piety. A long spray of poppies, almost Art Nouveau in style, decorates the exergue and charmingly echoes the swirls of Anita's hair. The modeling is kept in fairly low relief, with the exergue offering the most interest-

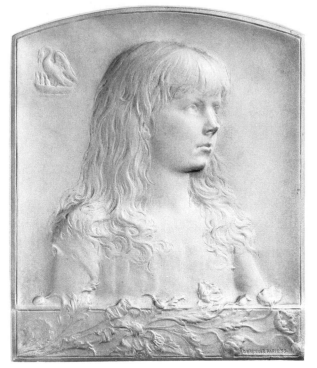

111

ing excursion in spatial relations in the way the poppies creep up into the field of the portrait. The poppies are further emphasized by being tied with a ribbon inscribed with the name of the sitter. Clearly the flowers and the hair provide the textural richness in the piece.

Models for the reliefs *Anita Stuart*, *George Aloysius Lucas*, and *Clovis Delacour* were exhibited at the Salon of 1900 sponsored by the Société des artistes français, where they won a collective honorable mention. In addition to executing this silver-plated copper electrotype, Brenner made a plaquette cast in bronze. It has not been ascertained how many plaquettes were produced by these processes, but they are believed to be few.

K.G.

VICTOR DAVID BRENNER
112
Clovis Delacour, 1899
Silver-plated copper electrotype
H. 5¹¹⁄₁₆ in. (14.5 cm.), w. 6⁷⁄₁₆ in. (16.3 cm.)
Signed (at lower right): V.D. BRENNER PARIS '99.
Inscribed: (at top) · A · L'AMI · C · DELACOVR · (at bottom) · TEMOIGNAGE · DE · BON · SOVVENIR ·
Gift of James Loeb. 04.245

Provenance: James Loeb, New York
Version: *Bronze*: (1) The Metropolitan Museum of Art, New York

Clovis Delacour (1859-1929) was a French sculptor and medallist who exhibited at the Salon of the Société des artistes français in the last two decades of the nineteenth century and at the Royal Academy of Arts, London, in the late 1890s and early 1900s. He won honorable mentions at the Salon in 1891 and at the Exposition Universelle in 1900.

Within a year of Brenner's arrival in Paris in 1898, Delacour had become his friend, for he was called such in the inscription at the top of Brenner's plaquette of 1899. Brenner added the phrase "Témoignage de bon souvenir" which translates loosely as "In witness of happy memories." Delacour is shown in profile, wearing an artist's smock, and he holds in front of him a statuette of a nude female figure, presumably one of his own creations. The relief plaquette was first exhibited as a model along with models for *George Aloysius Lucas* and *Anita Stuart*, at the Salon of the Société des artistes

français in 1900, where the three won a collective honorable mention.

Charles Caffin grouped Brenner's *Delacour* together with the *Edward B. Fulde* and the *M.P. Vadé*, believing that the three reliefs were treated in a painterly manner that was unlike the sculptural quality expressed in the *George Aloysius Lucas*. Caffin referred to the "colour qualities" in the *Delacour* and *Fulde*, "represented by delicate variations in the planes, which produce a corresponding warmth of delicate light and shade."[1] Elsewhere, Caffin praised the *Delacour*, *Fulde*, and *Vadé* as the sculptor's best pieces, "worthy to rank with the best modern work."[2]

As well as executing this silver-plated copper electrotype, Brenner made a bronzed electrotype and a bronze cast. The number of plaquettes produced by these processes is thought to be quite small.

K.G.

Notes
1. Caffin 1903, p. 170.
2. Caffin 1902, p. xciv.

VICTOR DAVID BRENNER
113
René, 1899
Silver-plated copper electrotype
H. 4¼ in. (10.7 cm.), w. 3⁷⁄₁₆ in. (8.7 cm.)
Signed (above exergue at lower right): V.D. BRENNER PARIS '99
Inscribed: (at upper left) RENÉ (at right) 23.FEVRIER / 1895
Gift of James Loeb. 04.243

Provenance: James Loeb, New York
Version: *Bronze*: (1) The Metropolitan Museum of Art, New York

The portrait plaquette of the four-year-old child René is an early work executed during Brenner's student days in Paris. Presumably it was commissioned by the family of the sitter, whose surname is not recorded. Shown in profile and in bust length, René wears a sailor's blouse and cap. His date of birth, February 23, 1895, is inscribed in French. The plaquette is modeled in moderately low relief with the highest area reserved for the exergue on which three rosettes are placed in a decorative manner like that in the portrait reliefs of Augustus Saint-Gaudens. For the most part, the surface is

112

113

signature and inscription. It is also an example of the lowest relief Brenner attempted during this period. So subtle, in fact, is the modeling that there is barely any transition from background to foreground. This quality was admired by Charles Caffin, who singled out the *Vadé* for praise: "Here there is but little resort to line, the modelling being effected almost entirely by planes. And how beautiful it is, at once broad and subtle, and what a sense of color it conveys! Moreover, the head and bust emerge so sensitively from the background and also belong to it so completely; qualities of relief that cannot be too highly commended."[1]

In addition to executing this silver-plated copper electrotype, Brenner made a bronzed electrotype, the two thought to be part of a small edition.

K.G.

Note

1. Caffin 1902, p. xciv.

rendered smoothly, although modest textural variety is provided by the contrast between the clothes and the boy's skin and the background of the piece. Neither notable in Brenner's production nor ambitious in format, *René* is a competent portrait created at a time when the sculptor was still learning his art.

Besides this silver-plated copper electrotype, Brenner produced a bronzed electrotype and a bronze cast. It is probable that few plaquettes were made by these processes.

K.G.

114

VICTOR DAVID BRENNER

114

M.P. Vadé, 1899
Silver-plated copper electrotype
Diam. 5½ in. (14 cm.)
Gift of James Loeb. 04.242

Provenance: James Loeb, New York

M.P. Vadé was a French painter about whom little is known. Brenner must have met him shortly after his arrival in France in 1898 since the piece dates from the following year. Within the group of early portraits Brenner executed in Paris between 1899 and 1901, the *Vadé* is noteworthy for the absence of

VICTOR DAVID BRENNER

115

Edward B. Fulde, 1900
Silver-plated copper electrotype
Diam. 3¹¹/₁₆ in. (9.4 cm.)
Signed: (at left of bow tie) V.D. Brenner (at right of shoulder) MDCCCC.

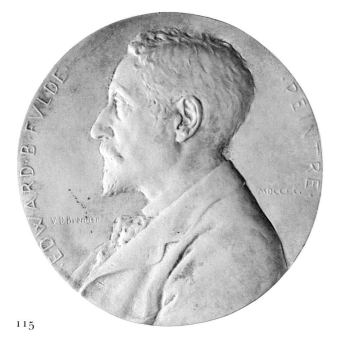

115

Inscribed (near rim): · EDWARD · B · FVLDE ·
· PEINTRE ·
Gift of James Loeb. 04.246

Provenance: James Loeb, New York
Version: *Bronze*: (1) The Metropolitan Museum of Art,
New York

Edward B. Fulde, an obscure American painter,
was born in Saint Louis, Missouri, and studied and
worked in France. He exhibited landscapes and
genre subjects at the Salon of the Société des artistes
français from 1896 to 1912. Shown in contempo-
rary dress and in profile, Fulde's head fits neatly
between the almost symmetrically placed signature
and inscriptions.

Charles Caffin grouped Brenner's *Fulde* together
with the *Clovis Delacour* and *M.P. Vadé*, believing
these three reliefs were treated in a painterly man-
ner that was unlike the sculptural quality expressed
in the *George Aloysius Lucas*. He hailed these three as
the sculptor's finest pieces, which "are worthy to
rank with the best modern work."[1]

As well as executing this silver-plated copper elec-
trotype, Brenner made a bronze cast. It is not
known how many medallions were produced by the
processes, but they are thought to be few.

K.G.

Note

1. Caffin 1902, p. xciv.

VICTOR DAVID BRENNER
116
Madame Ernest Raynaud, 1901
Silver-plated copper electrotype
Diam. 3⅝ in. (9.2 cm.)
Signed (at left): V.D. BRENNER / 1901
Inscribed (near rim): · M^ME ·ERNEST· ·RAYNAVD·
Gift of James Loeb. 04.244

Provenance: James Loeb, New York
Version: *Bronze*: (1) The Metropolitan Museum of Art,
New York

Madame Ernest Raynaud was the wife of the
French poet and editor who was the honorary presi-
dent of the French Society of Poets and instrumen-
tal in founding *Mercure de France*. The medallion of
Madame Raynaud, an early work in Brenner's oeu-
vre, was executed in 1901 at the end of his first stay
in Paris. Shown in bust length, Madame Raynaud
wears her hair coiffed high on the crown and held
in place by beaded combs. Although the head is in
profile, the upper torso is in three-quarter view, and
the pose is most successfully rendered. The hair
and dress provide the textural interest in the piece,
whereas the flesh and background are quite
smooth. The beading, which Brenner may have
adopted from the medallions of Hubert Ponscarme,
Alphée Dubois (1831-1905), and Jules Chaplain, is
gracefully echoed in the hair combs. Besides exe-
cuting this silver-plated copper electrotype, Bren-
ner produced a gold-plated electrotype and a
bronze cast. More than likely few medallions were
made by these processes.

K.G.

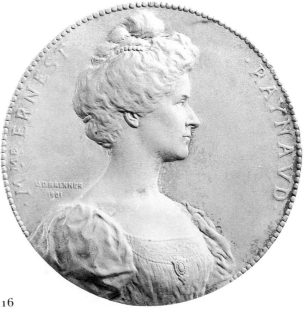

116

Nanna Matthews Bryant
(1871 – 1933)

Nanna Matthews Bryant was able to demonstrate feelings of an inward-directed nature in her intimately proportioned sculpture. Absorbed in their thoughts, her allegorical images tend to reveal more with their bodies than with their faces. Her figures are now and then joyful but more commonly sober, and even her fountain nymphs and Piping Pan motifs present a cheerless aspect unencountered in that segment of the genre in which gleeful expressions were the routine.

Annie B. Matthews was born in 1871, the daughter of William and Annie Bolton (Fay) Matthews. Part of Matthews's childhood was spent in Rome, where, on outings, she was frequently taken to see the Vatican collections. Her exposure at an early age to the great art around her left a powerful impression and evidently helped to awaken her creative abilities. Her formal artistic education, however, was obtained in Paris at the Académie Julian and in Boston at the School of the Museum of Fine Arts, where she registered for a single term in 1895 and 1896.

Matthews used Nanna as her first name and after her marriage to the painter Wallace Bryant (by 1900) called herself Nanna Matthews Bryant. Trained first as a painter, she had By the Edge of the Wood (present location unknown) included in the sixteenth autumn exhibition of the National Academy of Design, New York, in 1897. Bryant produced miniatures as well and had one accepted at the academy's annual exhibition in 1900. A few months later she entered five miniatures in the Boston Art Club's sixty-second exhibition, "Water Colors and Black and White." Feeling the need for further instruction, she again attended classes at the Museum School in 1903 and enrolled once more from 1904 to 1906, studying for a brief time under the painter Frank W. Benson (1862-1951).

Around 1912 Bryant took up sculpture, a medium she had always loved but had rejected because she was repelled by the coldness of and lack of color in the statues in stone she had seen in the Vatican galleries. Her decision to become a painter had been prompted by a desire to try color, yet all during the years she painted, her thoughts kept reverting to sculpture. Finally, Bryant reconciled her interest in the two media by deciding she could express color in stone as she had in painting. She described her method as "painting in marble" and

explained it thus: "After all, why not paint in stone? By 'painting in stone,' I mean the expression of color in the tones of the shadows. . . . It should be just as much of the sculptor's effort to obtain harmony of color as it is to obtain value of line and mass. Light and shade can be made to impart color."[1] Although Bryant concentrated on sculpting from the moment she began to model, she continued to paint and occasionally designed and executed stained glass windows.

As a sculptor, Bryant exhibited at every opportunity, showing her pieces on a regular basis at the Pennsylvania Academy of the Fine Arts between 1918 and 1931, at the National Academy of Design between 1919 and 1929, and with the National Association of Women Painters and Sculptors between 1922 and 1931. From the start, her inventions received critical approval. A review in the Boston Evening Transcript of The Flower of the Earth, about 1918 (present location unknown), which was destined to become one of her most popular contributions, offers a typically favorable appraisal of her endeavors: "At the store of Bigelow, Kennard & Co. [Boston], . . . there is . . . a notable statuette in marble. . . . The figure is about eighteen inches high, and symbolizes 'The Flower of the Earth.' It is a nude figure of a handsomely proportioned young woman, standing, with her arms upraised, as if supporting the weight of a bank of earth which hangs over her head, which is bowed, the face being invisible. The modelling of the figure is distinctly fine, and the pose brings out very advantageously the beautifully subtle curves of the contour of the figure. Mrs. Bryant is a pupil of Mr. F.W. Allen and a graduate of the Museum School. This figure, one of her first productions to be shown in public, has been exhibited at the Gorham Gallery in New York, where it was much admired."[2]

During the 1920s several exhibitions were dedicated exclusively to Bryant's conceptions. About a dozen marbles were placed on view in 1920 at the Sculptors' Gallery, New York, for which she won praise as a "smooth and facile modeler of the nude."[3] Her exhibition at the Kingore Galleries, New York, in 1921 met with such success that it traveled immediately to the Art Club of Washington, D.C. A critic, in evaluating her second show at the Kingore Galleries in 1923, recognized her talent with the remark: "She has filled the large room devoted to her marble with a variety of animated figures and groups which display a versatility, energy, and imagination quite unique."[4] McClees Gal-

leries in Philadelphia hosted a selection of Bryant's marbles and bronzes in the winter of 1924.

In addition to her one-person presentations, Bryant participated in group installations. In 1923, for instance, she submitted the acclaimed *Wings of the Morn*, about 1923 (present location unknown), to the competitive show of works by Boston artists at the Museum under the auspices of the Copley Society (of which she became a member in 1893). She entered *The Flower of the Earth* in a special exhibition of paintings and sculptures by contemporary New England artists sponsored by Vose Gallery, Boston, in 1924.

Bryant's last two important one-person displays were held in 1925 at the Durand-Ruel Galleries, New York, where she exhibited nine marbles and sixteen bronzes, and in 1930 at Dartmouth College, Hanover, New Hampshire, where she included a number of pieces that had never been available for public scrutiny. In 1932, the year before she died, at her summer home, Angleside, in Waltham, Massachusetts, Bryant was honored by the New Haven Paint and Clay Club with the award of the Sterling Memorial Sculpture prize.

Bryant's choice of subjects reflects her penchant for poetic and mythological themes. She fashioned portraits, too, but the majority of her creations, whether in marble or in bronze, bear titles such as *La Source*, about 1921, *Medea*, about 1922, *La Pensierosa*, about 1923, *The Wave*, about 1925, *Allegra*, about 1929 (present locations unknown), *Ariadne*, about 1930 (Hood Museum of Art, Dartmouth College),[5] *The Young Moon*, about 1930 (Hood Museum of Art), and *The Moon*, about 1930 (private collection, London).[6] Most often female and usually nude, the figures are imbued with a *fin de siècle* spirit, bending, twisting, and, acting out their emotion-laden stories in three dimensions. Bryant's bronze fountains in which figures stand on top of spouting dolphins or decorative basins sometimes have an Art Nouveau flavor discernible in a nude's swirling hair or in the curving lines of a supporting vessel.[7] It appears that Bryant customarily made the fountains on a relatively modest scale, occasionally in two sizes, the larger no more than about three feet high. Nevertheless, an example in the Hood Museum measures four feet in height. Stylistically, her oeuvre belongs in the broadest sense to the naturalism of the Beaux-Arts tradition, which lingered long into the twentieth century and, like the work of other lesser-known artists of the period, was profoundly influenced by the sculpture, especially the marbles, of Auguste Rodin (1840-1917).

Apart from pursuing her profession as a painter and sculptor, Bryant took pleasure in music. She owned a Stradivarius violin, which she would invite musicians to play at her Boston residence. Her elaborate Christmas parties were renowned, not so much for the sumptuous food she served, as for the costumes she provided for her guests.

K.G.

Notes

1. "Pictures Painted in Marble," *International Studio* 76 (Jan. 1923), pp. 339-340.

2. "The Flower of the Earth," *Boston Evening Transcript*, Jan. 2, 1919.

3. "Random Impressions In Current Exhibitions," *New York Tribune*, Mar. 28, 1920.

4. D.G., "Two Women of Talent," *Christian Science Monitor*, Jan. 25, 1923.

5. The Hood Museum dates its bronze version of *Ariadne* about 1930. The image existed in 1923, when a marble version of the Hood's bronze was illustrated in "Pictures Painted in Marble," p. 338. It may have been created as early as 1919, for an *Ariadne* was shown at the winter exhibition of the National Academy of Design, Dec. 1919-Jan. 1920, no. 10, unillustrated and with no medium given.

6. The titles of Bryant's works vary; e.g., a bronze in the Hood Museum catalogued as *Diana* is illustrated in the *Boston Herald*, July 20, 1930, Rotogravure Section, p. 5, with the caption *The Young Moon*, and a photograph of the object in Gorham Company Bronze Division Papers, Photograph files of statuary and small bronzes, roll 3680, in AAA, SI, is entitled *The New Moon*. *The Moon*, about 1930 (private collection, London), may have been *The Moon Man*, shown in the thirty-seventh annual exhibition of the National Association of Women Painters and Sculptors at the Brooklyn Museum in 1928, no. 283.

7. See photographs of Bryant's sculpture, Gorham Company Bronze Division Papers, Photograph files of statuary and small bronzes.

References

AAAn 30 (1933), p. 386, obit.; *Boston Evening Transcript*, June 29, 1933, obit.; BPL; MMA; Chris Petteys et al., *Dictionary of Women Artists: An International Dictionary of Women Artists Born before 1900* (Boston: Hall, 1985); "Pictures Painted in Marble," *International Studio* 76 (Jan. 1923), pp. 338-341; SMFA.

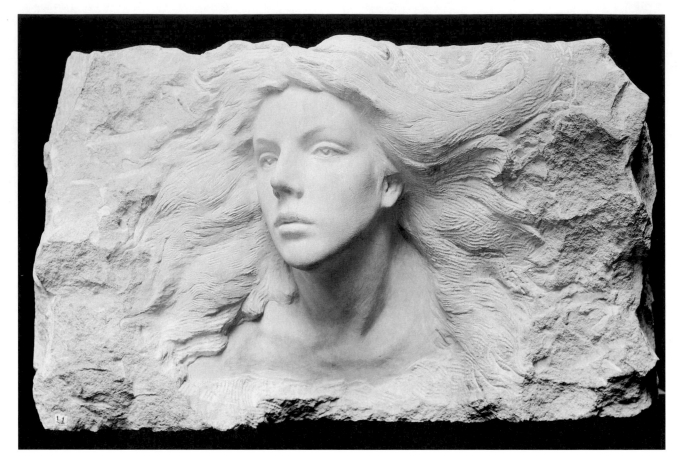

117

Nanna Matthews Bryant
117
Head of a Woman, about 1920
Marble
H. 15¾ in. (40 cm.), w. 26 in. (66 cm.), d. 12¼ in. (31.1 cm.)
Julia Henrietta Copeland Fund. 21.2277

Bryant created *Head of a Woman* midway through her career as a sculptor. The head is not an allegorical type; nor is it a conventional portrait. Nonetheless, the features are individual enough to suggest a specific model, although her identity is unknown.

The head, which is smooth and brought to completion, contrasts with the seemingly unfinished carving of the surrounding marble from which it projects. Bryant's use of *non-finito* elements was undeniably suggested by the marble sculpture of Auguste Rodin. Her *Head of a Woman* may even have been directly inspired by Rodin's *The Tempest*, before 1910 (The Metropolitan Museum of Art, New York), in which the head thrusts forward from the roughly cut encompassing stone. The hair in both examples flies away from the face, as if windblown, and merges with the sketchlike block. Bryant also adopted the manner in which the French sculptor fused the head with the base so that it is no longer simply a traditional support but has become a fundamental component of the object's formal design and expressive content.[1]

Rodin's marble sculpture had such a powerful effect on Bryant's production that a critic for the *Christian Science Monitor* commented, in reporting on her display at the Kingore Galleries in 1923, "The Rodin formula of smoothly rounded forms emerging from rough-hewn blocks of marble occurs frequently in her work."[2] This particular treatment of the stone by Bryant was highly successful and prompted a reviewer of her show at Durand-Ruel Galleries in 1925 to observe that the sculptor was "at her best when she does not work in the entire round, but allows the figure to emerge from the block."[3]

Whether *Head of a Woman* was ever placed on view before its acquisition by the Museum from the sculptor in 1921 is uncertain. Since departmental files indicate that the material of the head is Caen stone, it may be the piece described as "a head cut in Caen stone which boldly fronts the sky" in a critique of Bryant's exhibition at the Sculptors' Gallery, New York, in 1920.[4]

K.G.

Notes

1. See Daniel Rosenfeld, "Rodin's Carved Sculpture," in *Rodin Rediscovered* (Washington, D.C.: National Gallery of Art, 1981), p. 96. In his essay Rosenfeld discusses in detail Rodin's works in stone.
2. D.G., "Two Women of Talent," *Christian Science Monitor*, Jan. 25, 1923.
3. "Sculpture," *New York Times*, Dec. 6, 1925.
4. *Evening Sun* (New York), Mar. 27, 1920.

Bessie Potter Vonnoh (1872 – 1955)

Bessie Potter Vonnoh made her mark as an artist with charming small genre groups of mothers and children, dancing girls, and ladies in fashionable attire or classicizing dress. Called "Potterines" by the sculptor, these statuettes were much admired by critics and highly sought-after by the public during her period of greatest creativity, 1895-1920.

Born in Saint Louis, Bessie Onahotema Potter was the daughter of Alexander C. Potter and Mary E. (McKenney) Potter. In 1876, two years after her father died, Bessie and her mother moved to Chicago. Her childhood, from age two to ten, was spent as an invalid, and her inactivity permanently stunted her development so that Potter never grew beyond four feet eight inches. Eventually she was able to attend school, taking enormous pleasure in modeling clay in a sculpture class.

When Potter was fourteen, she met the sculptor Lorado Taft (1860-1936). In 1886, having just returned from Paris, where he had trained at the Ecole des Beaux-Arts, Taft had settled in Chicago, opened a studio, and begun teaching at the Art Institute. He permitted Potter the use of his studio every Saturday, and in 1889 she became his pupil at the institute for three years. To prepare his two groups for the Horticultural Building at the World's Columbian Exposition in Chicago in 1893, Taft selected as assistants a number of his women students—Janet Scudder (1869-1940), his sister Zulime (1870-after 1940), and Potter, among them. Potter was given a statue to execute independently, an eight-foot figure representing Art for the Illinois State Building, and also had two of her portraits, both plasters, exhibited in the fine arts section.

In 1894, Potter rented her own studio, an event she described thirty years later: "I left behind me forever the swaddling clothes of art student life and became a professional." She continued: "I invited my girl friends to pose, making little statuettes of them just as they dropped in, dressed in all the incongruities of the day.

"Like all young things I was radical in art. Greek sculpture did not appeal to me at all. It seemed a far cry, and cold. What I wanted was to look for beauty in the every-day world, to catch the joy and swing of modern American life, using the methods of the Greeks but not their subject matter. I was equally determined to prove that as perfect a likeness and as much beauty could be produced in statuettes twelve inches in height, and in busts six

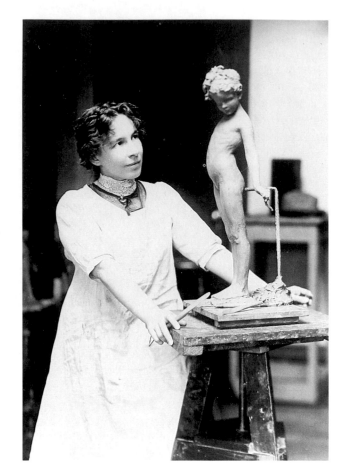

inches, as could be had in the life-size and colossal productions suitable for so few houses.

"With this ideal before me, and barely enough orders to keep me going, I struggled along in obscurity for a number of months. Then suddenly, almost overnight, I found my little statuettes had become the fashion."[1]

Such was her growing proficiency that at the sixty-fourth annual exhibition of the Pennsylvania Academy of the Fine Arts, Philadelphia, in late 1894 and early 1895, she had five works accepted; and at the seventeenth annual exhibition of the Society of American Artists, New York, held in the spring of 1895, she showed four pieces, including *The Rose*, about 1895 (present location unknown), which was illustrated in the catalogue. Not one to eschew experimenting with materials, Potter occasionally used terracotta and, in rare instances, colored her plasters. As Helen Zimmern observed, "in the petals of a rose or the heavy folds of a gown she introduces a faint suggestion of tints which add to the beauty and the transparency of effect."[2]

In the company of her mother and Lorado and Zulime Taft, Potter took a three-month trip to Paris in 1895, where she visited Auguste Rodin (1840-1917) in his studio, then went back to Chicago to resume her sculptural endeavors. She received several portrait commissions in 1896, one of which came from Mrs. S.E. Gross for a double portrait (present location unknown) of herself with the reformer Susan B. Anthony. Potter's most widely replicated statuette, A Young Mother, 1896 (The Metropolitan Museum of Art, New York), is thought to be the first of the sculptor's many intimate quotidian groups of mothers and children. Together with two other works of the same year, Twin Sisters and The Spirit of the Water, a statue of a girl about to drink from a shell in her hand (present locations unknown), a version of A Young Mother was shown at the sixty-sixth annual exhibition of the Pennsylvania Academy of the Fine Arts in 1896-1897.

As more of her sculpture was placed on view in various exhibitions, articles devoted exclusively to Potter began to appear. Alice Severance, in Godey's Magazine of October 1896, found: "an extreme delicacy of touch is one of the predominant traits of her work. . . . Her dainty little figurines are imbued with artistic feeling and are full of the grace of the Tanagra statuettes."[3] Both Arthur Hoeber, in Century Magazine, and William Dean Howells, in a letter to his brother-in-law, the sculptor Larkin Goldsmith Mead, commented that, although Potter's statuettes were similar to the ancient Greek Tanagra figures, especially in their illustration of the manners and customs of the day, they were essentially modern.[4] Potter addressed the issue of whether her creations were specifically influenced by these Hellenistic terracottas by asserting that "she had not even heard of them until she was told that they had suggested her own work."[5] Desiring to link her production with different antecedents, Taft proposed that the bronzes of Paul Troubetzkoy (1866-1938), exhibited in the Italian section at the World's Columbian Exposition, were the true inspiration for Potter's sculpture. "These remarkable plastic sketches quite captivated Miss Potter, and she forthwith set about 'doing Troubetskoys' [sic] as she termed her new diversion."[6] However, the pieces Troubetzkoy exhibited—for instance, The Indian Scout and The Arabian Steed, examples of which are in The Fine Arts Museums of San Francisco—were not the precise subjects of Potter's efforts,[7] and Taft conceded as much by saying that Troubetzkoy's conceptions "gave the suggestion merely."[8]

With funds earned from the sale of her sculpture, Potter embarked in 1897 on an eight-month trip to Europe, where she spent many weeks in Italy, particularly enjoying Florence. Upon her return to the United States, she had tired of making portraits of society ladies and, perhaps as a result of art she had seen abroad, planned instead to "retreat to the fields and study the American workingman in his habit as he lives."[9] Nevertheless, Potter's intentions were cast aside, for in 1898 she was executing two major projects: a portrait bust of Major General S.W. Crawford for the Smith Memorial in Fairmount Park, Philadelphia, and a life-size statue of the actress Maude Adams, intended to be cast in gold and to be known as "The American Girl," for the Colorado State Exhibition at the Paris Exposition of 1900. After completing the two commissions in 1899, she married the painter Robert Vonnoh (1858-1933), and, the following year, they honeymooned in Paris. As a consequence of a scandal surrounding payments for and the casting of Vonnoh's Adams, the statue was withdrawn from the Colorado exhibition and installed in the Palais de l'Optique. Vonnoh suffered the indignity of having it placed next to a large telescope,[10] but she won a bronze medal for her two additional pieces at the exposition, the frequently cast Dancing Girl, or Girl Dancing, 1897 (The Metropolitan Museum of Art), and A Young Mother. In 1901, after establishing herself in New York with her husband, Vonnoh sent A Young Mother and Midsummer, 1898 (present location unknown), to the Pan-American Exposition in Buffalo, where they won an honorable mention. Popular and critically acclaimed, the statuettes symbolizing motherhood recurred in Vonnoh's oeuvre during the early 1900s, and one such subject, Enthroned, 1902 (The Metropolitan Museum of Art), was awarded the Julia A. Shaw Memorial Prize by the Society of American Artists in 1904. (Also in 1904, Vonnoh won a gold medal at the Louisiana Purchase Exhibition in Saint Louis for her ten entries.) One departure from maternal motifs is Day Dreams, 1903 (Corcoran Gallery of Art, Washington, D.C.), unmatched in American sculpture for its masterly evocation of an indoor environment that suggests a distinctive turn-of-the-century milieu. Rich in narrative and atmosphere, Day Dreams is the closest analogue in plastic form to certain paintings of girls at leisure by James McNeill Whistler (1834-1903), Thomas Dewing (1851-1938), and John White Alexander (1856-1915).

After the early years of the twentieth century,

Vonnoh increasingly chose classicizing draperies rather than modern outfits for her figures. She thus joined Augustus Saint-Gaudens, Herbert Adams (1858-1945), and other artists here and abroad who, in the context of the aesthetic movement and the Renaissance revival, had already started clothing their figures in similar antique costumes. She used Grecian garb on relatively static statuettes like *The Scarf* (q.v.) and *In Grecian Draperies*, 1913 (The Art Institute of Chicago), as well as on active, dancing girls like *Girl with a Garland*, completed by 1922 (present location unknown). Perhaps the most exuberant illustration of this type is *Allegresse*, about 1920 (American Academy and Institute of Arts and Letters, New York), a group (25¾ inches in height) of three dancing girls, two of them nude, which was awarded the Elizabeth N. Watrous Gold Medal at the National Academy of Design in 1921. The impetus for these images sprang in part from the tremendous success of the American dancers Loie Fuller (with whom Vonnoh was in correspondence), Isadora Duncan, and Irene Castle.

During the 1920s and 1930s, Vonnoh devoted considerable energy to modeling fountain groups. *Waterlily*, 1913 (Brookgreen Gardens, Murrells Inlet, South Carolina), a 2½-foot statue of a nude girl contemplating a drooping water lily in her left hand, is an early work of this genre. A bird fountain, 1913-1925 (Ormond Beach Park, Florida) was followed by a bird bath, 1925-1927 (Roosevelt Bird Sanctuary, Oyster Bay, Long Island), a composition of two figures, in which a seated boy grasps a pigeon in one hand, while an older girl stands lifting above her head a bowl from which water falls. Vonnoh's *Frances Hodgson Burnett Memorial*, 1937 (Central Park, New York), also a bird bath, bears a strong resemblance to the Oyster Bay twosome in the way a young boy is positioned on a rock next to a standing girl who holds a feeding basin.

Vonnoh's career as a sculptor came to an end in the late 1930s, and she ceased to exhibit her pieces with the regularity of previous years. After the death of her husband in 1933, she married the urologist Dr. Edward Keyes in 1948. Keyes passed away nine months following the wedding, and Vonnoh died in 1955 at the age of eighty-two. Although many of her statuettes and portrait busts are characterized by a realistic rendering of facial features, a distinctive note in her style is the generalized manner in which she modeled these areas. With a touch that was soft and impressionistic, Vonnoh would simply make a depression to hint at the eyes. Practi-

cally from the beginning, her modeling had exceptional fluidity and spontaneity. Vonnoh cannot be seen as an influential sculptor, but her oeuvre has enduring appeal, and its significance lies in its inherent pleasingness.

K.G.

Notes

1. Bessie Potter Vonnoh, "Tears and Laughter Caught in Bronze," *Delineator* 107 (Oct. 1925), p. 9.

2. Helen Zimmern, "The Work of Miss Bessie Potter," *Magazine of Art* 24 (Sept. 1900), p. 524.

3. Alice Severance, "Talks by Successful Women: X. Miss Bessie Potter, Sculptress," *Godey's Magazine* 133 (Oct. 1896), pp. 359-360.

4. Arthur Hoeber, "A New Note in American Sculpture," *Century Magazine* 54 (Sept. 1897), pp. 732, 734; Howells to Mead, quoted in Vonnoh, "Tears and Laughter," p. 78.

5. Lucy Monroe, "Bessie Potter," *Brush and Pencil* 2 (Apr. 1898), p. 32.

6. Taft 1930, p. 449.

7. I am grateful to May Brawley Hill for pointing out that the pieces Troubetzkoy exhibited at the World's Columbian Exposition bore little relation to the kind of work Vonnoh was creating in the early 1890s.

8. Taft 1930, p. 449.

9. Monroe, "Bessie Potter," p. 34.

10. See May Brawley Hill, "Three Women Sculptors: Bessie Potter Vonnoh, Janet Scudder, Evelyn Longman Batchelder," student paper, Graduate Center, City University, New York, 1983, pp. 8-9.

References

Berry-Hill Galleries, *The Woman Sculptor: Malvina Hoffman and Her Contemporaries*, essay and exhibition catalogue by May Brawley Hill (New York: Paul-Art Press, 1984), pp. 12-13, 22, 24-25, 29, 51-53; BMFA 1979, no. 22; BPL; Charles L. Buchanan, "The Vonnohs," *International Studio* 54 (Dec. 1914), pp. XLVIII-LII; Janis C. Conner, "American Women Sculptors Break the Mold," *Art & Antiques* 3 (May-June 1980), pp. 82-83; Craven 1968, pp. 501-502; Gardner 1965, pp. 112-113; Arthur Hoeber, "A New Note in American Sculpture," *Century Magazine* 54 (Sept. 1897), pp. 732-735; De Witt M. Lockman, Interview with Bessie Potter Vonnoh, roll 504, AAA, SI; "Miss Bessie Potter's Figurines," *Scribner's Magazine* 19 (Jan. 1896), pp. 126-127; McSpadden 1924, pp. 360-368; MMA; MMA, ALS; Lucy Monroe, "Bessie Potter," *Brush and Pencil* 2 (Apr. 1898), pp. 29-36; *New York Times*, Mar. 9, 1955, obit.; NYPL; Proske 1968, pp. 81-83; "A Sculptor of Statuettes," *Current Literature* 34 (June 1903), pp. 699-702; Elizabeth Anna Semple, "The Art of Bessie Potter Vonnoh," *Pictorial Review* (Apr. 1911), p. 12; Alice Severance, "Talks by Successful Women: X. Miss Bessie Potter, Sculptress," *Godey's Magazine* 133 (Oct. 1896), pp. 356-360; "Some

Sculpture by Mrs. Vonnoh," *International Studio* 38 (Aug.
1909), pp. 121-124; Taft 1930, pp. 449-450, 571; Roslye
B. Ultan, "Bessie Potter Vonnoh, American Sculptor
(1872-1955)," Master's thesis, American University, 1973;
Bessie Potter Vonnoh, "Tears and Laughter Caught in
Bronze," *Delineator* 107 (Oct. 1925), pp. 8-9, 78, 80, 82;
Whitney 1976, pp. 316-317; Helen Zimmern, "The Work
of Miss Bessie Potter," *Magazine of Art* 24 (Sept. 1900), pp.
522-524.

BESSIE POTTER VONNOH
118
The Scarf, 1908
Bronze, brown patina, lost wax cast
H. 13½ in. (34.3 cm.), w. 4½ in. (11.4 cm.), d. 5½
in. (14 cm.)
Signed (on top of base at back right): Bessie Potter
Vonnoh / 1908
Foundry mark (on top of base at back left): CIRE / C.
VALSUANI / PERDUE
Anonymous gift in memory of John G. Pierce. Res.
65.62
Exhibited: BMFA 1979, no. 22 (incorrectly titled *Dancing
Girl*).
Version: *Bronze*: (1) May and Frederick Hill, New York

Dated 1908 and cast by the French founder Val-
suani (as indicated by the firm's stamp), *The Scarf*
was most likely made in Paris during the Vonnohs'
stay there in 1908. Typical of the kind of statuette
Vonnoh created during the first decade of the twen-
tieth century, *The Scarf* falls into the category of her
oeuvre in which figures are clothed in classicizing
dress. The bronze represents a young lady dancing,
her left leg gracefully extended, a scarf held in both
hands, with the bulk of the material falling behind
her. Utterly self-absorbed, the figure conveys a
quiet mood. Although the girl is perhaps perform-
ing for many, there is, at the same time, the sense
that this is a private moment and she could be
dancing for herself alone. The image is thoroughly
engaging, and feminine details, such as the bow tied
at the waist and the drapery piquantly slipping off
one shoulder, make the dancer all the more en-
chanting. Here, as in other pieces, Vonnoh has
sketchily drawn the facial features, barely sug-
gesting the eyes. She also has handled the drapery
in an impressionistic fashion. Clearly Vonnoh was
interested in achieving a suffused appearance in the
bronze surface, and the lost wax casting technique
has heightened this effect.

It is not known how many casts of *The Scarf* were
made by Valsuani; Roman Bronze Works of New

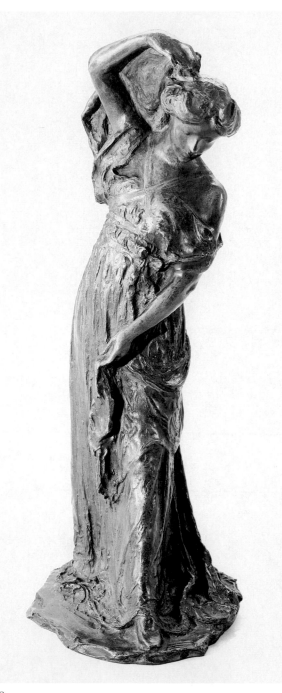

118

York cast an edition of at least eleven examples. *The
Scarf* (not necessarily the cast in the Museum of
Fine Arts) was shown quite frequently between
1910 and 1925. It seems to have been first placed
on view at an exhibition of Vonnoh's work at the
Corcoran Gallery of Art, Washington, D.C., in
1910. The sculptor also exhibited a cast of it in
Paris, at the 1911 Salon of the Société Nationale des
Beaux-Arts.

K.G.

Charles Keck (1875–1951)

Monuments, memorials, statues, and architectural decorations in large measure form the body of Charles Keck's oeuvre. These works, executed over a period of nearly forty-five years, from 1907 to 1951, are in a realistic and classic style that reflects the traditional artistic values Keck learned as a student and from which he never deviated.

Keck was born in New York to Henry Keck, a stained glass artist, and Elizabeth (Kammerer) Keck both of whom had emigrated from Germany in 1870. As a boy, he found employment in an architect's office and attended the Mechanics Institute at night.[1] In 1890 he was hired by the sculptor Philip Martiny (1858-1927) for three years, during which time he progressed from sweeping and cleaning the studio to mixing clay and finally to modeling. From 1893 to 1898, Keck served as an assistant to Martiny's former master, Augustus Saint-Gaudens. Of particular life-long use was the experience Keck gained as an apprentice in the production of large-scale pieces. For instance, he helped Martiny with his architectural sculpture for the World's Columbian Exposition held in Chicago in 1893 and aided Saint-Gaudens with the drapery for the 13-foot *Diana* (Philadelphia Museum of Art), which was installed on top of New York's Madison Square Garden in 1894. To supplement this training Keck enrolled in the National Academy of Design and in the Art Students League, where he obtained formal classroom instruction. After Saint-Gaudens left for Paris in late 1897, Keck subsisted on wages earned from the sculptor John Massey Rhind (1860-1936), with whom he stayed for two years.

In 1900, ready to end his days as a studio assistant, Keck competed for and was awarded the Rinehart Scholarship, which provided him for a four-year term with lodging and a studio at the American Academy in Rome.[2] From early 1901 to early 1905 Keck benefited from an idyllic interlude abroad. As stipulated in the conditions of the grant, he traveled to Florence, France, and Greece but remained chiefly in Rome, where he created statues, historical groups and reliefs, and portrait busts and plaques, some of which were prescribed exercises. *Sleepwalker*, or *Somnambulist*, 1900 (formerly The Peabody Institute of the Johns Hopkins University, Peabody Collection, Baltimore, probably destroyed), a statue of a standing shrouded, yet nude female, was the first of Keck's required compositions completed in Rome as a holder of the Rinehart Scholarship. His second was *Thetis Consoling*

Achilles for the Death of Patroclus, 1901, a medallion rendered in a thoroughly academic manner, and his third was *The Awakening of Egypt*, 1904 (present locations unknown). In a letter to Henry Walters, chairman of the Rinehart Scholarship, Keck described the thrill of visiting the ancient cities of Italy, whose glorious monuments and ruins reminded him of their noble past. Seeing these sights stirred his desire to have those days return, and that is the feeling he wished to express in *The Awakening of Egypt*. Keck selected the Egyptian style because he wanted to show the head of a sphinx buried in the sand, which suggested to him "the passing away of a grand monument and the great people that built it."[3] The group consists of two figures—one kneeling, the other seated on the sphinx—reaching out as if to recall the past.

Together with submissions of students in other fields, Keck's three required sculptures and six more of his conceptions were placed on view in early 1905 at the American Academy's annual exhibition, and Keck (the only student in sculpture) was singled out as the winner of the honors of the day. Writing about the display, a reporter for the *New York Herald* remarked: "The most ambitious work of the sculptor is his last envoy, just completed. It is a group called 'The Awakening of Egypt.' In this Mr. Keck has endeavored to portray the longing of the Egyptians for their lost empire. In addition . . . Mr. Keck has accomplished several other pieces of striking merit."[4]

While in Rome Keck enjoyed a friendship with the painter Elihu Vedder (1836-1923), collaborating on a fountain, *Nude Boy*, 1902 (J.B. Speed Museum of Art, Louisville, Kentucky), which Vedder designed and Keck modeled, and paying the older man homage in a bronze bust dating from about 1903 (The Metropolitan Museum of Art, New York). Another artist Keck portrayed in Rome was Maurice Sterne, who is represented holding a palette and brushes in a bronze medallion dated September 1904. In style and in composition, the portrait is reminiscent of the reliefs of Saint-Gaudens, and during his years in Europe, Keck continued to seek criticisms of his sculpture from his former teacher.[5]

Broadened and enriched by his foreign exposure, Keck returned to New York in 1905, set up a studio, and almost immediately began to receive commissions. *Youthful America*, a seated symbolic figure, was executed in 1907 (Allegheny County Soldiers' Memorial, Pittsburgh, Pennsylvania), and the turbaned *Mohammed*, a standing bearded figure holding the Koran and a sword, in 1909 (The Brooklyn Museum, New York). In a decorative vein, Keck created elaborate candelabras for the State Education Building in Albany, New York, in 1911 and 1912. His two principal monuments between 1910 and 1920 were a statue of George Washington, unveiled in 1913 (Palermo Park, Buenos Aires, Argentina), and the *Lewis and Clark Monument*, erected in 1919 (Charlottesville, Virginia). The *Washington*, though noble in feeling, is essentially stiff, whereas the *Lewis and Clark*, showing the two explorer-frontiersmen guided by a crouching Indian squaw, is picturesque, expressive, and elicits from the viewer the sense of danger inherent in their calling.

Keck's career flourished, and the twenties and thirties were extremely busy decades for him. He married Anne Collyer in 1923, taught at the National Academy of Design in the 1930s, and produced dozens of works in his home and studio at 40 West Tenth Street. Among the symbolic statues he fashioned is *Amicitia*, in which a bronze female figure holds a spray of laurel and the flags of the United States and Brazil. Rising above a column, the figure occupies the upper portion of a colossal monument (approximately 60 feet in height), which includes representations of George Washington, Abraham Lincoln, Jose Bonifacio, and Rio Branco, standing on top of the base. It was designed in 1921 and dedicated in 1931 in Rio de Janeiro as a gift of the American people to the citizens of Brazil on the occasion of the centennial of Brazil's independence. Other symbolic figures are *Liberty*, dedicated in 1924 (*Ticonderoga Monument*, New York); *Victory*, unveiled in 1925 (*Soldiers' Memorial*, Montclair, New Jersey); *Peace*, unveiled in 1926 (*Soldiers' Monument*, in Harrisonburg, Virginia); and *Angel*, erected in 1930 (*Shriners' Peace Monument*, Toronto).

Of two significant equestrian statues, *Stonewall Jackson*, dedicated in 1921 (Charlottesville, Virginia), is perhaps more highly regarded than *Andrew Jackson*, unveiled in 1934 (Kansas City, Missouri), especially for its spirited and colorful forward movement. From a lengthy list of Keck's monuments to various individuals dating from these years the following may be mentioned (dates given here refer to the unveiling): *Booker T. Washington*, 1922 (Tuskegee Institute, Alabama), in which the figures are arranged similarly to those in Thomas Ball's *Emancipation Monument*, 1876 (Lincoln Park, Washington, D.C.); *Abraham Lincoln*, 1932 (Wabash, Indiana);[6] *Father Duffy*, 1937 (Times Square, New York); and *Father Isaac Jogues*, 1939 (Lake George, New York). On a smaller scale, Keck made busts of James Madison, 1929, Patrick Henry, 1930, and Elias Howe, 1930, for the Hall of Fame in the Bronx, New York, and a bust of President John Tyler, 1931 (Capitol, Richmond, Virginia).

Keck also designed coins and medals. For the Panama-Pacific Exposition held in San Francisco in 1915, he made a commemorative gold dollar (The American Numismatic Society, New York), which shows a man in a cap, symbolizing a laborer on the Panama Canal.[7] His Vermont sesquicentennial half-dollar (The American Numismatic Society), was created in 1927, and his Lynchburg, Virginia, sesquicentennial half-dollar (The American Numismatic Society) in 1936. Keck's output of architectural decorations was prodigious, particularly during the 1930s. Two examples are the twenty-three panels depicting the development of the West, 8 feet high and 272 feet long, rendered in 1932 for the Nelson-Atkins Museum in Kansas City, Missouri, and the frieze of bas-reliefs illustrating the Triumph of Good Government, 6½ feet high and 330 feet long, produced in 1933 for the Bronx County Court House in New York.

With fewer commissions, the pace of Keck's activities slowed during his last decade. Even so, they were numerous and several of his late contributions are the sarcophagus of Alfred E. Dupont, dedicated in 1940 (Wilmington, Delaware); the *Huey Long Monument*, unveiled in 1940 (Baton Rouge, Louisi-

ana); and a bust of Harry Truman, installed in 1949 (Senate Wing, United States Capitol, Washington, D.C.). His statue of Alfred E. Smith (Governor Smith Memorial Park, New York) was dedicated in 1950 on the grounds of the housing project that bears the politician's name. Keck died the next year of heart failure at his country home in Gipsy Trail Club, Carmel, New York.

Although Keck's professional commitments were many, he never hesitated to give support and comfort. One of his students, reminiscing about the sculptor many years after his death, paid him the following tribute: "He had the personality, the dignity and all the fine qualities of [a professor]. . . . He helped students, needy friends, fellow artists, relatives—all without hurting anyone's pride."[8]

K.G.

Notes

1. Agop Agopoff, "Charles Keck, 1875-1951, Twelfth President, National Sculpture Society, 1931-1934," *National Sculpture Review* 15 (spring 1966), p. 22.

2. For information on the Rinehart Scholarship and its recipients, see William Henry Rinehart Fund Papers, The Peabody Institute, Baltimore, Md., roll 3162, in AAA, SI.

3. Keck to Walters, June 18, 1904, Rinehart Fund Papers.

4. "He Would Be a Sculptor," *New York Herald*, Apr. 23, 1905; magazine section.

5. See correspondence between Keck and Saint-Gaudens, 1896-1906, Saint-Gaudens Papers, Baker Library, Dartmouth College, Hanover, N.H.

6. A replica was unveiled in Hingham, Mass., in 1939. A second statue of Lincoln, *Lincoln and the Boy*, showing him with a black child, was dedicated in 1949 at the Abraham Lincoln Houses in New York, and a third, *The Young Lincoln*, dating from the late 1940s, was unveiled in 1980 at the Chicago Public Library Cultural Center. Keck considered *The Young Lincoln* one of his major pieces. According to his son, John W. Keck, it was one of a few works his father made entirely to please himself rather than to satisfy an art commission. See letter to Kathryn Greenthal from John W. Keck, Apr. 8, 1984, BMFA, ADA.

7. Vermeule 1971, pp. 135-136.

8. Agopoff, "Charles Keck," p. 28.

References

AAA, SI; Agop Agopoff, "Charles Keck, 1875-1951, Twelfth President, National Sculpture Society, 1931-1934," *National Sculpture Review* 15 (spring 1966), pp. 22, 26-28; "Amicitia, by Charles Keck," *American Magazine of Art* 13 (Sept. 1922), p. 287; BPL; Arthur G. Byne, "The Salient Characteristic of the Work of Charles Keck," *Architectural Record* 32 (Aug. 1912), pp. 120-128; Donald Charles Durman, *He Belongs to the Ages: The Statues of*

Abraham Lincoln (Ann Arbor, Mich.: Edwards, 1951), pp. 216-220; Gardner 1965, pp. 118-119; "He Would Be a Sculptor," *New York Herald*, Apr. 23, 1905, magazine section; Fiske Kimball, "Monument to Lewis and Clark, Charlottesville, Virginia, Charles Keck, Sculptor," *Art and Archaeology* 8 (Nov.-Dec. 1919), pp. 362-363; MMA; *The National Cyclopaedia of American Biography* (New York: James T. White, 1966), vol. 49, pp. 275-276; *New York Times*, Apr. 24, 1951, obit.; NYPL; Proske 1968, pp. 129-131; Taft 1930, p. 555; Vermeule 1971, pp. 105, 135-136, 174, 188, 196-197, 201.

CHARLES KECK
119
Martie, probably 1916
Marble
H. 26⅛ in. (66.3 cm.), w. 16⅛ in. (41.0 cm.)
Inscribed: MARTIE
Gift of Mrs. Charles Keck. 1972.897

Provenance: Mrs. Charles Keck, Carmel, New York
Exhibited: Probably National Academy of Design, New York, *Catalogue of the National Academy of Design, Winter Exhibition, 1916* (1917), no. 36; Probably The Pennsylvania Academy of the Fine Arts, Philadelphia, *Catalogue of the 112th Annual Exhibition* (1917), no. 584.

A relatively early work by Keck, this marble relief entitled *Martie* is a portrait of Martha Pilcher. Born in 1897 in Brooklyn, New York, she was the only child of Mary Belle (Wooden) and Lewis Frederick Pilcher, state architect of New York, 1913-1916, commissioner of new prisons for New York, 1916-1923, and professor of fine arts at Vassar College, Poughkeepsie, New York, 1923-1926. Martha graduated from Vassar College in 1918 and married Lloyd Percy Chittenden in August of that year. In 1939 she married A. Willard Dudley.

Martie was made about the time Keck created a 2¼-inch gold portrait medal of Martie's grandfather Dr. Lewis S. Pilcher, 1916 (a larger bronze copy of which is owned by her cousin, Dr. Lewis S. Pilcher, West Newton, Massachusetts) to commemorate the eminent surgeon's fifty years of practice. It has been suggested that Dr. Pilcher commissioned Keck to portray his eldest granddaughter.[1] Or perhaps Keck produced the relief for Martie's father, who, as state architect, may have been responsible for the sculptor's receiving some of the commissions he executed for the State Education Building in Albany between 1911 and 1917.

Shown in two-thirds-length profile, the sitter holds a sheaf of papers, which would befit her status

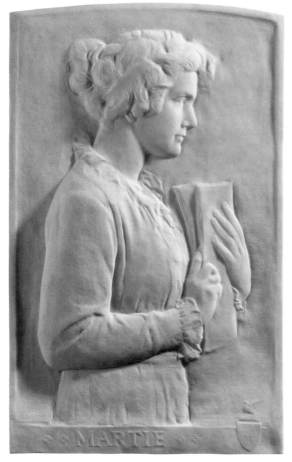

119

as a college student. The Pilcher coat of arms is recorded in the lower right corner of the marble. Stylistically, the portrait reflects Keck's knowledge of Augustus Saint-Gaudens's relief sculpture, in its sensitively carved high and low relief and in the hatching marks in the ground. Details such as the inscription, the accompanying rosettes, and incorporation of the family crest are also legacies of Saint-Gaudens's decorative touch.

Although *Martie* is not a well-known example of Keck's oeuvre, the portrait was exhibited (probably in marble) on several occasions shortly after its completion. It is not known whether the piece ever belonged to the Pilcher family. For many years the relief was kept in Keck's Tenth Street studio and was given to the Museum of Fine Arts by the sculptor's widow.

K.G.

Note

1. This suggestion was made by Dr. Lewis S. Pilcher in a letter to Kathryn Greenthal, Mar. 19, 1983, BMFA, ADA.

CHARLES KECK
120
Father Duffy, 1935
Plaster (bronzed)
H. 52¼ in. (132.7 cm.), w. 19½ in. (49.6 cm.), d. 15½ in. (39.4 cm.)
Gift of Mrs. Charles Keck. 1979.194

Provenance: Mrs. Charles Keck, Carmel, New York

The Museum's bronze-tinted plaster of Father Duffy is the half-size working model of what is generally considered Keck's most famous statue. Because of its location in New York's busy Times Square, at the triangle of Forty-sixth and Forty-seventh streets between Broadway and Seventh Avenue, the *Father Duffy Memorial* became a familiar landmark to New Yorkers and tourists from the moment it was unveiled on May 2, 1937.

The memorial commemorates Francis Patrick Duffy (1871-1932), an exemplar of Irish-American Roman Catholicism. Chaplain of the Fighting Sixty-ninth Regiment of the New York National Guard, Duffy continued as its chaplain when it became the 165th Regiment of the American Expeditionary Force during World War I. His courageous service in France won him the names Iron Man and Front Line Duffy and earned him many decorations. Determined that the regiment's efforts be chronicled, he published *Father Duffy's Story: A Tale of Humor and Heroism, of Life and Death with the Fighting Sixty-Ninth* in 1919. Following the war Duffy was assigned the pastorate of Holy Cross parish on West Forty-second Street in New York. Productive and popular, he held the post from 1920 until his death, raising money and befriending actors, politicians, and panhandlers. In addition to being celebrated in Keck's statue, Father Duffy was honored as the principal character in the 1940 Warner Brothers film *The Fighting 69th.*

Shortly after Duffy's death, a nonsectarian memorial committee was organized to erect a statue of the chaplain, with Colonel William J. Donovan, former commander of the Fighting Sixty-ninth, as chairman. By late December 1933 the Times Square site in the center of Duffy's parish was approved by New York's Board of Estimate. Originally, the Irish-American sculptor Andrew O'Connor (1874-1941) was selected to execute the statue, but he resigned from the commission in early July 1935. Having already raised $15,000 for the statue by voluntary subscription, the committee lost no time in signing a contract with Keck on July

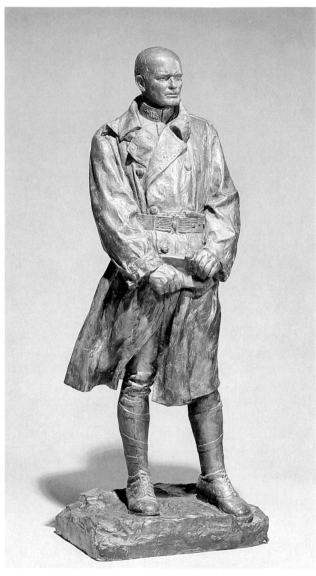

120

9, 1935. In September of that year, Keck submitted a small plaster model of the entire memorial, complete with a large Celtic cross, which was to bring to mind Father Duffy's ancestry and to emphasize his role as clergyman. Hardly differing from the finished monument, it was favorably reviewed and accepted by the committee. During the autumn of 1935 Keck enlarged the model in his Tenth Street studio to the half-size figure, now in the Museum of Fine Arts, omitting the doughboy helmet that had been worn by his subject in the earlier model. In the final 9-foot statue (which stands in front of a highly polished granite 12-foot Celtic cross), signed and dated 1936, Keck reversed the stance of the figure and the position of the hands, and reinstated the helmet, placing it at Duffy's feet. Also, in the

bronze, the knee-length trench coat is blown back by the wind to show Duffy's left leg in a manner reminiscent of Saint-Gaudens's *Admiral Farragut*, 1879-1880 (Madison Square Park, New York); in the Museum's half-size plaster, the coat reveals his right leg.

In an interview for the *New York Herald Tribune* in 1936, Keck described the way he had envisioned Duffy: "He stands on the field, watching the battle, seeing his boys fighting and being shot down. He has no rifle, of course [clergymen were forbidden to carry arms], and can take no active part in their struggle, but his hands clench the prayer book in an agony of self-control."[1] A reporter for the *New York American* commented that Keck had never been acquainted with the clergyman and had based his statue on photographs, using as a model a private from the Sixty-ninth Regiment who reputedly resembled the chaplain;[2] on the other hand, a journalist for the *New York Sun* contradicted this statement, saying that Keck had been Duffy's friend and was familiar with his mannerisms and expressions.[3]

Nearly fifty thousand people attended the dedication ceremonies on what would have been Duffy's sixty-sixth birthday. Mayor Fiorello LaGuardia, in accepting the statue for the city, observed that Father Duffy could "do more with a shake of his finger than a lot of statues or a posse of deputized sheriffs."[4] (A visitor to New York can see another version of Keck's *Father Duffy* in the form of a bronze bust [Art Commission Gallery, City Hall]). A particularly good example of the sculptor's production, the *Duffy* succeeds in reminding the spectator that the chaplain was a brave man of action as well as a compassionate man of the cloth. In a period when public memorials in a naturalistic style were becoming increasingly outmoded, *Father Duffy* conveys heroism with a spiritedness and sensitivity that rings true.

K.G.

Notes

1. "Sculptor Ready With Memorial to Father Duffy," *New York Herald Tribune*, July 8, 1936.
2. "Memorial Statue of Father Duffy of the '69th' Ready for Casting," *New York American*, July 31, 1936.
3. Martin Green, "Memorial to Father Duffy To Be Unveiled Next Month," *New York Sun*, Apr. 17, 1937.
4. "Duffy Statue Is Unveiled," *New York Sun*, May 3, 1937.

Roger Noble Burnham (1876 – 1962)

A gifted thespian as well as a sculptor, Roger Noble Burnham was born in Hingham, Massachusetts, the son of Arthur Burnham and Katherine Davenport (Bray) Burnham. After attending the Shaw School and Hale's School in Boston, he enrolled in Harvard University, from which he earned a bachelor of arts degree in 1899. His predilection for art manifested itself while he was in college, where he specialized in architecture and in the fine arts. No sooner had Burnham graduated from Harvard than he turned seriously to modeling in his own studio in Boston, studying anatomy with the sculptor Caroline Hunt Rimmer (1851-1918), daughter of the artist William Rimmer.

In the spring of 1903 Burnham moved to New York and found employment with Karl Bitter (1867-1915), who was head of the sculpture department for the 1904 Saint Louis World's Fair. Burnham labored not only in Bitter's private studio, but also in the large shop in Weehawken, New Jersey, where the enlarging of statuary for the fair was carried out. Within a matter of months he was assisting George Brewster (1862-1943) in New York in the preparation of large medallions that were placed on the exterior of the Fine Arts Building in Saint Louis. The practical experience with Bitter and Brewster prepared Burnham more than adequately for his professional life, and he was evidently not hindered by his lack of formal classes in modeling. In fact, twenty years later, Burnham himself wrote that he had not been interested in "the theory of art for art's sake."[1]

Burnham's talent and growing expertise were rewarded in 1904 when he won the Henry O. Avery Prize for sculpture at the annual exhibition of the Architectural League of New York. By this time he was skillful enough to have private orders for portraits, and for the next few years he modeled relief portraits, worked in advertising, and collaborated with interior decorators and other sculptors.

Burnham pursued his love for the theater to the point of taking the full curriculum at the American Academy of Dramatic Arts in New York, receiving his diploma in 1907. He was so enthralled with performing that he temporarily interrupted his career as a sculptor to go on tour in Richard Sheridan's *The Rivals* in 1908, visiting the South and Midwest and traveling as far as Oklahoma and Texas. As a result of the hectic pace, Burnham fell ill and was sent home to Boston to recuperate. He

resumed modeling, although acting would always be his most cherished secondary activity. In the ensuing years, he even wrote a number of plays and pageants.

Restored to health, Burnham found his sculptural abilities were in demand in Boston. He executed portraits of the following individuals: the poet Olive Tilford Dargan, Helen Robinson, the children of Bertha Cushing Child, and the children of Mrs. John C. Havemeyer (née Polly Mitchell). Eleanor Howard Waring, a southern writer who shared Burnham's enthusiasm for the stage, sat for her portrait in his studio and subsequently became his bride. After a celebration of their marriage in June 1909 with a four-hour, 120-mile honeymoon trip from Pittsfield to Holbrook, Massachusetts, in a balloon (complete with a wedding breakfast consumed 4,500 feet above the ground), they resided in the greater Boston area until 1917.

In 1909 Burnham had the opportunity to create the Harvard Decennial Medal for his class of 1899. His first foray into the medallic arts, it was shown along with eight other pieces by him in the International Exhibition of Contemporary Medals, March 1910, sponsored by the American Numismatic Society. He spent the winter of 1910-1911 in Rome, where he exhibited in the International Exposition of History and Art, and then returned to Boston. Barely resettled, he was extremely busy with several projects. He entered and won the University of California's national competition to design its scholarship medal. In 1912 the Boston Art Commission

appointed him as sculptor for four 16-foot female figures representing Justice (or Administration), Charity, Education, and Industry, set in place in 1914 on the facade of the City Hall Annex on Court Street. (These were destroyed in 1947.) In 1914 he fashioned bronze doors for the Forsyth Dental Infirmary for Children, also in Boston. In addition to carrying out these major commissions, Burnham was exhibiting widely—for instance, at the Kansas Art Institute in 1912, Boston City Club in 1913, International Exposition in Ghent, Belgium, in 1913, John Herron Art Institute in 1914, Panama-Pacific Exposition in 1915, and the Pennsylvania Academy of the Fine Arts, Philadelphia, in 1914 and 1917—and teaching modeling at the school of architecture at Harvard University from 1913 until 1917.

In June 1917 Burnham and his wife settled in Honolulu, Hawaii, so that he could serve as executive in Honolulu of the Boy Scouts of America. He was devoted to this organization, which had consumed his energies since 1915 and which he felt was more worthwhile than art to a world at war, yet he was frustrated by the lack of opportunity for him in Hawaii as a sculptor. Instead of going back to the East Coast, Burnham established himself in 1922 in Berkeley, California, where he and his wife had been invited to live by the city's chamber of commerce. In 1923 Burnham was summoned to Los Angeles by Luther Burbank, the botanist known as "the plant wizard," to make his half-length portrait bust (present location unknown; originally planned for Burbank Memorial Park, Santa Rosa, California). Finding southern California more to his liking, he relocated to Los Angeles and remained there until his death.

Between 1926 and 1932 Burnham taught modeling at the Otis Art Institute, Los Angeles, and continued to produce sculpture that, as in his early period, varied considerably in size and subject. His work ranged from the official medal for the International Exposition, Long Beach, California, 1928, to an 18-foot elk that adorned the front of J.W. Robinson, a Los Angeles department store, during an Elks convention in 1929, to a 7½ foot figure of a Trojan warrior made for the University of Southern California in 1930. Other pieces include architectural sculpture that decorates the exterior of the Busch-Reisinger Museum, Harvard University, representing a bust of Minerva, tritons, and a centaur, about 1916; a figure of Aspiration as a memorial to Rudolph Valentino, 1930 (Delongpre Park, Hollywood, California, since removed because of vandalism); a portrait bust of Frances Willard, 1932 (Southern California headquarters, Woman's Christian Temperance Union, Los Angeles); the dramatic *Astronomers Monument*, unveiled in 1934 (Griffith Observatory, Los Angeles), in collaboration with other artists; a bronze bust of the painter Frank Tenney Johnson (1874-1939), 1939 (National Academy of Design, New York); United Spanish War Veterans Memorial in Los Angeles, about 1950; and an 8-foot bronze statue of General Douglas MacArthur, (MacArthur Park, Los Angeles).

Although Burnham's career has not been extensively studied, his sculpture appears to have been executed primarily in a straightforward manner and realistic style. His efforts demonstrate competence and dignity, even if they are neither profound nor original. In later years, particularly in the 1940s, Burnham occupied a position of some authority in Los Angeles, where he served on the board of directors of several art clubs and was vice-president of the city's Painters and Sculptors Club.

K.G.

Note

1. Harvard College, Class of 1899, *Twenty-Fifth Anniversary Report* (1924), p. 91.

References

The American Numismatic Society, *Catalogue of the International Exhibition of Contemporary Medals* (New York, 1911), pp. 35-36; BAC; *Boston Globe*, Mar. 16, 1962, obit.; BPL; Harvard College, Class of 1899, *Third Report*, (1909), pp. 45-46, *Fourth Report* (1914), pp. 45-46; *Twenty-Fifth Anniversary Report* (1924), pp. 90-95; *Fortieth Anniversary Report* (1939), pp. 31-33; *Fiftieth Anniversary Report* (1949), pp. 111-114; The John Herron Art Institute, Indianapolis, *Sculpture by Roger Noble Burnham* (1914); Quinquennial File, HU; Nancy Dustin Wall Moure, *Dictionary of Art and Artists in Southern California before 1930* (Los Angeles: privately printed, 1975), p. 34; National Sculpture Society, New York, *Contemporary American Sculpture* (1929), p. 36; *New York Times*, Mar. 16, 1962, obit; Glenn B. Opitz, ed., *Dictionary of American Sculptors* (Poughkeepsie, N.Y.: Apollo, 1984).

ROGER NOBLE BURNHAM
121
Johann Ernst Perabo, 1914
Bronze, brown patina, lost wax cast
Diam. 15⅝ in. (39.7 cm.)
Signed (at right): RNB (monogram)
Inscribed: (at top) IOHANN ERNST PERABO MDCCCCX

(at left) RES / SEVERA / EST / VERVM / GAVDIVM
Foundry mark (on rim, lower right): GORHAM CO
FOUNDERS
Gift by Subscribers through Nathan Haskell Dole.
15.147

Versions: *Bronze*: (1) present location unknown, (2) present location unknown, gilded bronze, (3) reduction, dimensions unknown, present location unknown

Ernst Perabo (1845-1920), as he was professionally known, was a prominent composer, pianist, and teacher in Boston, where he lived for more than fifty years. Although his compositions are for the most part forgotten, his *Pensées* (opus 11) can be cited as an important contribution.

Born in Wiesbaden, Germany, into a family in which all nine children became musicians, Perabo took his first piano lessons at the age of five from his father, a schoolteacher, organist, pianist, and violinist. In 1852 the family emigrated to America. Young Perabo continued studying the piano and violin in New York and in Boston before training at the Leipzig Conservatory for three years. In 1865 he returned to the United States and began to give concerts, which had a limited audience but were highly acclaimed. Settled in Boston, Perabo was sought after as a concert soloist and as a teacher, and for a long period he retained his music studio on Beacon Hill, where his gift for pianoforte instruction nurtured the musical talent of at least a thousand pupils.[1]

In 1910, when Roger Noble Burnham was living in Boston, he executed a relief portrait of the sixty-five-year-old Perabo for one of the composer's friends in London. Four years later, friends of Perabo subscribed to a fund for the creation of a medallion of the musician, which they intended to give to the Museum of Fine Arts. They agreed to use Burnham's 1910 relief portrait and had a replica cast by the Gorham Manufacturing Company, Providence. The medallion was exhibited for the first time in Burnham's studio on November 14, 1914, on the occasion of Perabo's sixty-ninth birthday. The subscribers feted the composer with speeches, and Nathan Haskell Dole, the author, wrote a poem in Perabo's honor.[2]

The relief shows Perabo in profile seated in a characteristic pose playing the piano. Possessed of a full head of hair, a beard, and mustache, he wears a jacket and tie. Burnham signed the relief with his monogram and included a Latin inscription, "Res severa est verum gaudium," which translates as "The serious thing is the true joy."

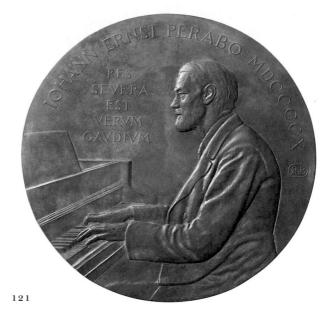

121

Hardly experimental in form or in style, the medallion is conscientiously modeled and is typical of the kind of relief portraiture that was being produced during the early twentieth century. The Beaux-Arts style, which triumphed between 1875 and 1900 and was most successfully represented in the work of Augustus Saint-Gaudens, is seen here on the wane, with a rather uninspired flat surface and little textural variety. In addition to the Museum's relief, a reduction was made as well as a gilded bronze version.[3] The portrait of Perabo (not the Museum's cast) was one of Burnham's most frequently exhibited subjects and between 1910 and 1915 was entered in shows on both sides of the Atlantic (the International Exposition of History and Art, international section, in Rome, 1911; the International Exposition in Ghent, 1913; a one-person presentation of his sculpture at the John Herron Art Institute, Indianapolis, 1914; and the Panama-Pacific Exposition in San Francisco, 1915).

K.G.

Notes

1. *DAB*, pp. 457-458; *Boston Evening Transcript*, Oct. 29, 1920, obit.

2. "Burnham's Medallion of Ernst Perabo, the Pianist," *Boston Evening Transcript*, Nov. 14, 1914.

3. A reduction was exhibited in the John Herron Art Institute, Indianapolis; see *Sculpture by Roger Noble Burnham* (1914), no. 25. The gilded bronze was shown in the Exposition Universelle et Internationale de Gand; see *Beaux-arts, oeuvres modernes*, vol. 2: *Miniature, médaille, architecture* (Brussels, 1913), section 211, no. 5.

Anna Hyatt Huntington (1876–1973)

Anna Hyatt Huntington, the most accomplished woman animalier in America in the early twentieth century, was as comfortable fashioning intimate portraits of domestic and wild animals as she was designing heroic-size equestrian figures for public places. The first woman artist elected to the American Academy of Arts and Letters (1932), she served her profession well through her natural talents, dedication, and great generosity. Brookgreen Gardens, the superb outdoor sculpture garden and nature reserve that she and her husband created in the 1930s, rivals her own production in its contribution to the advancement of American sculpture.

Hyatt was born in Cambridge, Massachusetts, to Audella (Beebe), an amateur landscape painter, and Alpheus Hyatt II, professor of paleontology and zoology at Harvard University and the Massachusetts Institute of Technology.[1] Vacations spent on a Maryland farm provided her with a Giotto-like childhood where she drew farm animals before she had learned to read. Anna prepared for a career as a concert violinist and did not think of becoming an artist until she was nineteen. During a brief illness in 1895 she helped model the animal in *Boy with Great Dane* (present location unknown, formerly Society for the Prevention of Cruelty to Animals, New York) for her sister Harriet (1868-1960), who already enjoyed local fame as a portrait and figure sculptor. Encouraged by her family, Anna joined Harriet at the Cowles Art School, Boston, in drawing classes given by the landscape painters Dennis Bunker (1861-1890) and Ernest L. Major (1864-1950). On Bunker's suggestion, both women studied with Henry Hudson Kitson, then the city's most prolific sculptor of war memorials. The sisters shared a studio in their Cambridge home and dreamed of founding an American school of sculpture, but the partnership ended when Harriet was married in 1900 and moved to Princeton, New Jersey.[2]

At age twenty-six, Hyatt had her first one-person exhibition at the Boston Art Club, where twenty-five of her small animal studies were shown. Her production was accomplished with noticeable ease, a facility that she enjoyed throughout her career. After her father died in 1902, she and her mother moved to New York. In the spring of 1904 Hyatt briefly took classes at the Art Students League with the equally talented and economically secure Gertrude Vanderbilt Whitney (1875-1942) and Malvina

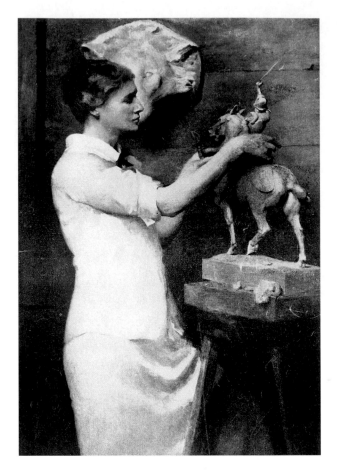

Hoffman (1863-1966), and was introduced to Beaux-Arts naturalism by Hermon MacNeil (1866-1947) and George Grey Barnard (1863-1938). For a short while, she also received private criticism, along with Harriet Frishmuth (1880-1979) and Abastenia St. Leger Eberle (1878-1942), from Gutzon Borglum (1867-1941), whose Rodin-inspired, impressionistic modeling encouraged Hyatt's own spontaneous essays in romantic naturalism.

Preferring to study animals at first hand, as she had in Boston at Bostock's Live Animal Show, Hyatt frequented the Bronx Zoo. She also made plaster restorations of three prehistoric animals (Brookgreen Gardens, Murrells Inlet, South Carolina) for the Brooklyn Museum. From 1903 to 1905 she and Eberle shared an apartment on Thirty-third Street, and the two collaborated on several sculptural groups, with Eberle composing the human figures and Hyatt the animals. *Men and Bull*, 1904 (destroyed), received high praise from Augustus Saint-Gaudens in the 1904 exhibition of the Society of American Artists and won a bronze medal at the 1904 Louisiana Purchase Exposition, Saint Louis;

their life-size plaster model of *Boy and Goat Playing*, 1905 (destroyed), was shown at the Society of American Artists, New York, in 1905.

In 1906 Hyatt received the commission for a colossal lion (Dayton Art Institute) from Steele High School in Dayton, Ohio, and decided that she was now ready to meet the challenges of traveling and working in Europe. That fall she went to France and stayed in the former studio of Barbizon painter Charles-François Daubigny (1817-1878) at Auvers-sur-Oise, where she continued modeling animals, including her own Great Danes and a jaguar she had seen at the Bronx Zoo. (A pair of jaguars crouching on a rock, derived from this original model, were cast in bronze in 1926 [The Metropolitan Museum of Art, New York].) After returning briefly to America in 1908 and then arranging the casting of the Dayton lions in Naples, Italy, she rented the spacious Paris studio of Jules Dalou (1838-1902). Perhaps challenged by these surroundings, she began a life-size equestrian study of Joan of Arc (destroyed), armor-clad before her battle at Orléans. Completing the plaster without any help in only four months, she entered the sculpture in the 1910 Salon and won an honorable mention, although the judges could not believe the spirited piece had been modeled by a woman.

Shortly after Hyatt created *Joan of Arc*, a committee in New York, headed by J. Sanford Saltus of Tiffany and Company, organized a competition for an equestrian statue to honor the saint's five-hundredth birthday. In 1914 she was given the commission and became the first woman to memorialize the saint in bronze. Unveiled at Riverside Drive and Ninety-third Street, New York, in December 1915 by Mrs. Thomas A. Edison, the inventor's wife, with the French ambassador Jean J. Tusserand present, the heroic sculpture was acclaimed by the critics. Lorado Taft called it "one of the notable achievements of recent years. . . . No doubt the author of the wonderful jaguars of the gateposts and of so many other virile studies had this power all the time; how fortunate that opportunity permitted its complete expression in a major work!"[3]

An expert horsewoman, Hyatt executed a number of other equestrian works during her career: notably, a heroic bronze commemorating the Castilian conqueror *El Cid Campeador*, 1927, for Seville, Spain (a replica, cast the same year, stands in the terrace of the Hispanic Society of America, New York), and an over life-size romantic evocation of *Don Quixote* in aluminum, 1947 (Brookgreen Gardens). In these, as with the *Joan of Arc*, her understanding of the character of her subjects is sympathetically rendered. The horses, for instance, perfectly suit their riders: Joan's steed is young and spirited, El Cid's heavier and dignified, and Don Quixote's emaciated yet valiant. For *Joan of Arc*, Hyatt was made a *chevalier* of the Legion of Honor in 1922. (Her other awards included honorary doctorates from the Universities of Syracuse [1932] and South Carolina [1962], a gold medal for distinction in sculpture from the American Academy of Arts and Letters [1930], and a Special Medal from the National Sculpture Society [1940] in recognition of her achievements and contributions to her fellow sculptors.)

While organizing a major exhibition for the National Sculpture Society, funded by and held at the Hispanic Society of America, in 1923, Anna became engaged to Archer Huntington, the founder-director of the Hispanic Society (1904) and heir to the Central Pacific Railroad fortune.[4] Archer was a Hispanic scholar, the patron of at least fifteen art museums, and a wildlife fancier. In March 1923 they were married, and to their separate accomplishments were now added their combined philanthropic efforts. On the eve of the Depression, Archer gave $100,000 to the National Sculpture Society for an exhibition of American sculpture that, like the earlier New York show, was truly representative of the country's diverse talents. Held in San Francisco at the California Palace of the Legion of Honor in 1929, the exhibition of 1,300 contemporary American works brought together 258 artists. Archer also gave an additional $100,000 to establish an emergency fund to aid indigent sculptors.

In 1927 Anna Huntington contracted tuberculosis and over the next seven years greatly reduced her work schedule. In 1930 the Huntingtons purchased a 6,635-acre estate at Murrells Inlet on the coast of South Carolina, attracted by the temperate climate, abundant wildlife, and colorful vegetation of that area. Within a year their plans for a nature reserve had expanded to include a garden showcase for Huntington's sculpture and that of her contemporaries, many of which depict animals and birds native to South Carolina. By 1935, Brookgreen Gardens had become the largest outdoor sculpture garden in the United States, providing an outlet for other figurative sculptors at a time when there was a growing shift in taste toward nonobjective art. During this period the Huntingtons also built Atalaya, a Moorish-style, thirty-room house with a central

forty-foot tower overlooking the dunes and the sea, where they spent winters (except during World War II) until 1947.

In 1936 the American Academy of Arts and Letters honored Huntington, still its only woman artist member, with a retrospective of 170 of her pieces, many of which she had cast in the new medium of aluminum. Reviewers, however, questioned the relevancy of her academic style now that modernism and social realism were increasingly preferred. Nonetheless, Huntington arranged, with the help of Leila Mechlin, the influential Washington art critic and editor, for a traveling exhibition of seventy of her works after the academy's show closed. In 1937 when she began offering her sculpture to schools, colleges, museums, and garden parks, representatives of more than two hundred museums and garden parks in major cities throughout the world proved willing recipients.

During the 1940s Huntington spoke out against modern art, which she described as the product of "a tasteless machine age,"[5] and in 1952 she refused an invitation to submit one of her pieces to a show of contemporary sculpture at the Metropolitan Museum of Art. She had been a pioneer in her profession, however, creating opportunities for other women, such as Katherine Lane Weems, with her success in the genres of animal and garden sculpture. Indeed, her animal studies may be considered modern in the sense that they often serve as metaphors for personal feelings and moods, with their emphasis on characteristic behavior rather than realistic details.

Huntington continued working until a year before her death at ninety-seven. In 1958 she completed a heroic equestrian statue of José Marti, the poet-liberator of Cuba, which she gave in 1965 to the city of New York for Central Park (Fifty-ninth Street and Sixth Avenue). In her studio at Stanerigg Farm, the seven-hundred-acre estate near Bethel, Connecticut, that she and Archer purchased in 1939, Huntington produced at age eighty-six *The Prairie Years*, another equestrian, of Abraham Lincoln as a young lawyer, dedicated in 1961 (New Salem, Illinois), and at ninety-one a memorial to the American revolutionary war hero Major General Israel Putnam, unveiled in 1969 (Putnam Memorial State Park, Redding, Connecticut).

P.M.K.

Notes

1. A pupil of the famed naturalist Louis Agassiz, Alpheus Hyatt II established the first marine biological laboratory in America (later the Marine Biological Laboratory, Woods Hole, Mass.) at his summer home in Annisquam, Mass.

2. Harriet Hyatt Mayor was an instructor in modeling in Princeton, N.J., for many years. Her portrait bust of Anna Hyatt as a young woman (The American Academy and Institute of Arts and Letters, New York) dates from 1895.

3. Taft 1921, p. 131.

4. Archer Huntington had been a patron member of the National Sculpture Society from 1895, two years after its founding. In 1904 he planned Audubon Terrace (at Broadway and 155th Street), one of the earliest architectural complexes in New York to include an indoor sculpture courtyard. The Hispanic Society was the first of the cultural institutions to be located there and in 1923 hosted the National Sculpture Society's first open-air exhibition with over one thousand works. See Beatrice Proske, "Huntington: Art Patron *Extraordinaire,*" *National Sculpture Review* 33 (fall 1984), pp. 26-27.

5. *Notable American Women* 1980, p. 35.

References

AAA, SI; BMFA, *Sculpture in Stone*, filmstrip (Boston: University Film Foundation, 1938); *Boston Globe*, Oct. 6, 1973, obit.; Pauline Carrington Bouvé, "The Two Foremost Women Sculptors in America: Anna Vaughn Hyatt and Malvina Hoffman," *Art and Archaeology* 26 (Sept. 1928), pp. 77-82; Doris E. Cook, *Woman Sculptor: Anna Hyatt Huntington (1876-1973)* (Hartford: D.E. Cook, 1976); Craven 1968, pp. 545-557; Susan Harris Edwards, "Anna Hyatt Huntington: Sculptor and Patron of American Idealism," Master's thesis, University of South Carolina, 1983; May Brawley Hill, *The Woman Sculptor: Malvina Hoffman and Her Contemporaries*, exhibition catalogue (New York: Berry-Hill Galleries, 1984), pp. 17-18, 28, 44-46; Anna Coleman Ladd, "Anna V. Hyatt—Animal Sculptor," *Art and Progress* 4 (Nov. 1912), pp. 773-776; McSpadden 1924, pp. 340-351, 377; Leila Mechlin, "Anna Hyatt Huntington, Sculptor," *Carnegie Magazine* 11 (June 1937), pp. 67-71; MMA; *New York Times*, Oct. 5, 1973, obit.; Proske 1968, pp. xxiv, 168-180; Beatrice Gilman Proske, "Anna Hyatt Huntington," *Brookgreen Bulletin* 13 (1983); Rubinstein 1982, pp. 202-204; Bertha H. Smith, "Two Women Who Collaborate in Sculpture," *Craftsman* 8 (Apr.-Sept. 1905), pp. 623-633; George Arents Research Library, Syracuse University, N.Y.; Whitney 1976, p. 281.

ANNA HYATT HUNTINGTON
122 (color plate)
Young Diana, 1923
Bronze, brown patina, lost wax cast
H. 94¼ in. (239.4 cm.), w. 26½ in. (67.3 cm.), d. 33
in. (83.8 cm.)
Signed (on top of base at front): ANNA HYATT
HUNTINGTON
Inscribed (on top of base at back):
Kunst·Foundry·N.Y.
Gift of M. Virginia Burns and Harriet Otis Cruft
Fund. 1979.121

Provenance: Mr. and Mrs. John Hays Hammond, Look-
out Hill, Gloucester, Mass.; Richard Hammond, Lookout
Hill; John Hays Hammond, Jr., Lookout Hill; Jay Chap-
man, Gloucester; H.M. Burns, Gainesville, Ga.; Virginia
Burns, East Gloucester
Exhibited: BMFA 1979, no. 25; The Parrish Art Museum,
Southampton, N.Y., *Fauns and Fountains: American Garden
Statuary, 1890-1930*, essays by Michele H. Bogart and
Deborah Nevins (1985), no. 11.
Versions: *Bronze*: (1) Brookgreen Gardens, Murrells In-
let, S.C., (2) Fine Arts Gallery, San Diego, (3) Fort Ticon-
deroga Museum, N.Y., (4) present location unknown,
formerly Mr. and Mrs. Eugene Dixon, Elkins Park, Pa.,
(5) Queens College, Charlotte, N.C. *Aluminum* or *bronze*,
half-life-size: (1) present location unknown

For successful sculptors like Anna Hyatt Hunting-
ton, Daniel Chester French, and Paul Manship, gar-
den commissions usually meant a congenial collabo-
ration between patron, sculptor, architect, and
landscape designer, with each given wide latitude
for his or her talents. Wealthy patrons, in particu-
lar, welcomed new concepts of form and design that
might reflect their own cultural sophistication. At
the height of its popularity, garden sculpture, often
representing such lighthearted subjects as neoclassi-
cal nymphs, frolicking children, and playful ani-
mals, provided some women artists with their only
opportunities for work.[1]

On January 16, 1923, Huntington signed an
agreement with Boston's North Shore socialite Mrs.
John Hays Hammond to execute a bronze fountain
for the English Tudor garden of the Hammond's
summer estate Lookout Hill (now the Unification
Church) in Gloucester, Massachusetts.[2] The con-
tract specified, according to the sculptor's design, a
six-foot bronze sculpture of a youthful Diana stand-
ing on a decorative base, made up of three twisted
dolphins holding a shell. Huntington promised to
deliver a plaster cast of the full-size model that
summer to decorate the garden until the bronze
was finished. Hammond, in turn, agreed to be re-

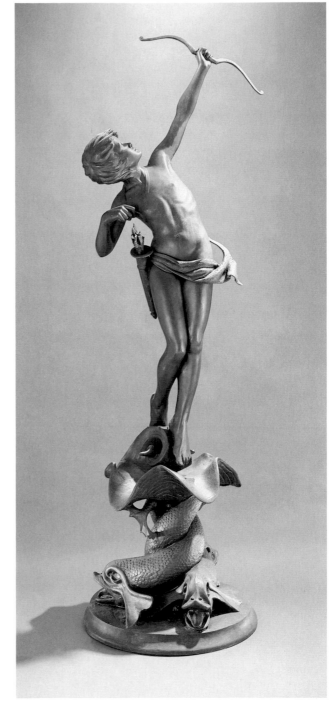

122

sponsible for the pool's cement base that would hold the plaster and later the bronze. Sometime before the end of 1923, the fountain was cast by the Kunst Art Foundry in New York and placed at Lookout Hill; it appeared the same year in a photograph illustrating the Hammonds' garden in a souvenir brochure celebrating the three hundredth anniversary of Gloucester and Cape Ann.[3]

Huntington had known the Hammonds from the time her family started summering in nearby Annisquam, and her father's scientific interests had brought the two families together. John Hays Hammond was a noted geologist and mining engineer who had worked in Africa with Cecil Rhodes in the 1890s and the Guggenheims in the 1900s. His son, John Hays Hammond, Jr., who lived in the Bungalow (later the Hammond Castle Museum) on the easternmost point of the estate, was equally renowned as an electronics inventor with over eight hundred patents to his credit.

In 1923 Huntington's stone portraits of the Hammonds' Great Danes were placed on the entrance gates at Lookout Hill.[4] The boldness of her execution obviously pleased the Hammonds, and she was asked to share in the plans for renovating the grounds of the estate. Between 1920 and 1923 the Victorian main house was extensively remodeled and transformed into a Tudor cottage by the New York architects Frohman, Robb, and Little, at a cost reportedly of over half a million dollars.[5] Francis Howard, the prominent New York landscape architect who had a summer studio in Rockport, designed the English garden of boxed yews and cherubic statuettes, with *Young Diana* serving as the focal point. In its elaborate but tranquil setting high above the Atlantic, the fountain figure commanded a panoramic view of Gloucester Harbor and the ocean beyond.

Huntington had received the Saltus Gold Medal from the National Academy of Design in 1922 for her first statue of Diana, an over life-size garden fountain entitled *Diana of the Chase*, 1922 (Brookgreen Gardens, Murrells Inlet, South Carolina). This idealized, full-bodied figure with classical coif, representing the Roman patroness of the hunt, moon, and chastity, undoubtedly pleased the conservative members of the academy with its stereotypical view of woman as goddess. Standing tiptoe on an orb (perhaps the moon), *Diana of the Chase* gazes upward like *Young Diana*, but with a hound leaping between her feet. A piece of drapery falls discreetly from her right arm over her lower body.

Only a year later, Huntington created *Young Diana*, a more contemporary interpretation of *Diana of the Chase*, simplified and streamlined. The slender adolescent, with short cropped hair casually blown forward around her face, holds a bow in one hand, while the other is drawn back, having just released the arrow. A quiver hangs on a narrow piece of drapery that swirls around her lower body. Her androgynous figure gracefully turns in a spiral movement, which is repeated by three dolphins forming the base at her feet. The cult of adolescence, fashionable in the 1920s and typified in *Young Diana*, is no different in kind from the celebration of mature beauty embodied in *Diana of the Chase*. As objects of delight, both vulnerable maiden and sensuous goddess offer pleasurable escape from the weariness and demands of contemporary life.

Huntington's rethinking of the popular Diana theme was undoubtedly influenced by Edward McCartan's (1879-1947) elegantly designed, Art-Deco *Diana*, 1920 (Brookgreen Gardens), which shows the goddess holding back a leaping greyhound. His *Diana* was included in the 1923 National Sculpture Society exhibition that she helped organize at the Hispanic Society of America. Huntington may also have been familiar with Hermon MacNeil's *Sun Vow*, 1898, the well-known portrayal of an adolescent Indian boy shooting an arrow toward the sun, which the Metropolitan Museum of Art, New York, acquired in a full-size (73-inch) cast in 1919.

Huntington retained the plaster model for the Hammonds' *Young Diana* and in 1926 had it cast for a private garden in Philadelphia. The model was cast again in 1928 for the fifth Open Air Exhibition in Philadelphia, and this bronze was placed in a garden pool at Brookgreen Gardens in 1934. Three more casts were made and given by the sculptor between 1937 and 1941 to museums in San Diego, Fort Ticonderoga, New York, and Charlotte, North Carolina. In 1936 *Young Diana* was lent to the Huntington retrospective in New York, organized by the American Academy of Arts and Letters. A half-life-size (33-inch) aluminum version (present location unknown) was also included in a group of fifteen of her works that traveled on a Mediterranean tour in 1954.

P.M.K.

Notes

1. For the professional implications of garden sculpture for women, see Michele H. Bogart, "American Garden

Sculpture: A New Perspective," in The Parrish Art Museum, Southampton, N.Y., *Fauns and Fountains: American Garden Statuary, 1890-1930* (1985), especially pp. 20-23.

2. Contract, Natalie H. (Mrs. John Hays) Hammond and Anna V. Hyatt, Jan. 16, 1923, Anna Hyatt Huntington Papers, George Arents Research Library, Syracuse University. Archival information was provided by Kathryn Greenthal.

3. Alexander G. Tupper, ed., *Gloucester and Cape Ann the Beautiful* (Manchester, Mass.: North Shore Press, 1923), p. 35.

4. The original Great Danes were damaged in transit and replaced; the repaired originals were installed on the gateposts at Brookgreen Gardens. Information supplied by Robin Salmon, archivist, Brookgreen Gardens, Murrells Inlet, S.C.

5. See James F. O'Gorman, "Twentieth Century Gothick: The Hammond Castle Museum in Gloucester and Its Antecedents," *Essex Institute Collections* 117 (Apr. 1981), pp. 82-83.

ANNA HYATT HUNTINGTON
123
Elephants Fighting, about 1933 (modeled between 1905 and 1912)
Granite
H. 15 in. (38.1 cm.), w. 26¼ in. (66.7 cm.), d. 12½ in. (31.7 cm.)
Gift of Anna Hyatt Huntington. 37.615
Provenance: Anna Hyatt Huntington, Rocas, Haverstraw, N.Y.
Exhibited: American Academy and Institute of Arts and Letters, New York, *Catalogue Exhibition of Sculpture by Anna Hyatt Huntington*, foreword by Royal Cortissoz (1936), no. 53.
Versions: *Bronze*: (1) Carnegie Institute, Pittsburgh, (2) present location unknown, formerly University of North Dakota, Grand Forks, (3) Smith College Museum of Art, Northampton, Mass.

Anna Hyatt Huntington often depicted animals in pairs, fighting savagely or innocently playing.[1] In the example in the Museum of Fine Arts, two spirited pachyderms are locked in mortal combat, their movements seemingly alive as they strain and butt against each other, with muscles rippling under leathery skin. First modeled in clay, *Elephants Fighting* was cast in bronze three times between 1911 and 1917, and then carved in granite by Robert A. Baillie (1880-1961), probably around 1933.[2] The stone version is so close to the bronze that the two are often confused in photographs.[3] The stone, however, gives the flesh a more supple, softer ap-

pearance, more like the characteristic stretched and aged skin of this jungle beast. The bronze, on the other hand, seems to capture best the tension and power of the battling figures as the light flickers over the surface of the sculpture.

Elephants Fighting may have been modeled as early as 1905, the year before Huntington left for Europe. During this time she often went to the Bronx Zoo where, according to a reporter for the *New York Times*, "the keepers let out the elephants for the young artist's delectation."[4] For Huntington, the daughter of an eminent zoologist, this firsthand experience enabled her to combine scientific observation with her own keen sense of animal life. One of her earliest pieces, *Two Elephants* (Society of Fine Arts and History, Evansville, Indiana) had been modeled in 1898 when Bostock's Live Animal Show came to Boston and she was allowed to enter the stalls between performances.

Huntington may not have begun *Elephants Fighting*, however, until she returned from France in 1911, when the model was cast by Roman Bronze Works, New York, in time for the 1912 winter exhibition in New York of the National Academy of Design.[5] During this period she also did studies of tigers and rhinos, as well as one of an elephant running (Butler Art Institute, Youngstown, Ohio), which display the same fluid grace as the Museum's piece. The sculptor Anna Coleman Ladd, in a review for *Art and Progress* at this time, heralded the artist as "a new power in American sculpture," and noted that "in all her bronzes there is the same intense joy in free movement and the play of muscles, controlled by a severe sense of form. A happy differentiation of texture in skin, hair and bone, a sympathy and insight in all forms of animal life, and a sane sense of clean-cut design make this sculptor's work one to be enjoyed by all lovers of life in art."[6]

Gorham Manufacturing Company, Providence, cast a second example of *Elephants Fighting* in 1914, which was shown in their New York gallery along with forty-two other small animal bronzes by Huntington. A bronze version of *Elephants Fighting* was also exhibited at the Pennsylvania Academy of the Fine Arts, Philadelphia, in 1913 and at the Panama-Pacific International Exposition, San Francisco, in 1915. The Gorham copy was again shown in 1916 at the Art Institute of Chicago, where it was purchased by the Carnegie Institute, Pittsburgh. Gorham cast a third bronze in 1917 and then in 1923 returned the model to the sculptor.[7]

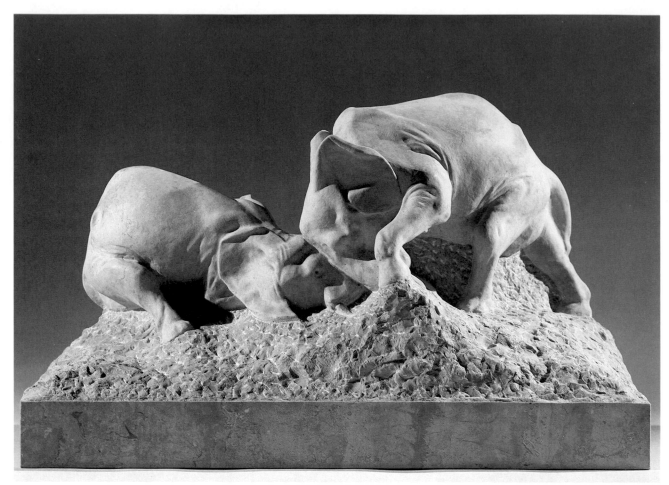

123

From 1923 to 1927, during one of Huntington's most prolific periods, Baillie spent most of his time cutting her work in limestone and marble. *Elephants Fighting* may have been carved at this time or early in the 1930s, when Brookgreen Gardens was created and Baillie was asked to reproduce some of Huntington's bronze sculptures along with the work of other artists. From Closter, New Jersey, Baillie met Huntington in 1904, when he assisted her teacher Gutzon Borglum.[8] Baillie was also involved in the transporting and arrangement of sculpture at Brookgreen Gardens and came regularly to maintain the collection; in 1941 he was appointed curator of sculpture.

The Museum's version was included in Huntington's 1936 retrospective, organized by the American Academy of Arts and Letters,[9] along with *Seal Group* (Norton Gallery of Art, West Palm Beach, Florida), which Baillie had also cut in stone in the early 1930s from a 1911 bronze (present location unknown). In February 1937 Leila Mechlin, who was circulating the New York show for Huntington, wrote to George Edgell, the Museum's director, suggesting that he show the sculptor's works after the exhibition closed in May. Edgell replied that the Museum was not in the practice of holding one-person exhibitions of living artists but in November accepted Huntington's later offer to give the Museum the stone *Elephants Fighting*, which she considered one of her most successful works.[10]

P.M.K.

Notes

Archival material used in this entry was provided by Kathryn Greenthal.

1. Huntington's *Bulls Fighting*, 1905 (Museum and Art Center, Roswell, N.M.) won the Julia A. Shaw Memorial Prize awarded by the National Academy of Design in 1928; her *Greyhounds Playing*, 1936 (Art Gallery of Toronto, Canada), received the Widener Gold Medal of the Pennsylvania Academy of the Fine Arts, Philadelphia, in 1937.

2. See letter from Beatrice Proske to Paula M. Kozol, May

3, 1986, BMFA, ADA. Proske remembers seeing the Museum's version at Rocas, which the Huntingtons owned from 1933 to 1939.

3. See National Sculpture Society, *Anna Hyatt Huntington* (New York: Norton, 1947), p. 40, illustrating a bronze version credited to the Museum of Fine Arts. George Edgell, the Museum's director, also had mistaken the stone for the bronze in a photograph Leila Mechlin, acting for Huntington, sent him on Sept. 7, 1937, offering to give *Elephants Fighting* to the Museum. See Edgell to Mechlin, Oct. 21, 1937, BMFA, 1901-1954, roll 2459, in AAA, SI.

4. Quoted in Kineton Parkes, "An American Sculptress of Animals, Anna Hyatt Huntington," *Apollo* 16 (Aug. 1932), p. 66. Huntington also collected photographs of wild animals; see especially an elephant fight in India, Anna Hyatt Huntington Papers, George Arents Research Library, Syracuse University.

5. According to a letter from R. Sands, Huntington's secretary, to Elizabeth H. Payne, assistant to the director of the Smith College Museum of Art, Northampton, Mass., Jan. 17, 1938, this first cast was at one time in a private collection in Boston. Smith College Museum of Art Archives. It may be the one that was given by Huntington to the University of North Dakota's Art Department in 1941.

6. Anna Coleman Ladd, "Anna V. Hyatt—Animal Sculptor," *Art and Progress* 4 (Nov. 1912), pp. 773, 776.

7. See letter from William J. Drake, Bronze Division, Gorham Company, to Sands, Jan. 11, 1938, Huntington Papers. The 1917 cast may be the one that was given by Huntington to Smith College in 1937.

8. For Baillie's career, see Proske 1968, pp. 213-216.

9. The 1936 catalogue dates the modeling of *Elephants Fighting* as between 1911 and 1922, but as stated above, the first cast was executed by 1912.

10. See correspondence between Mechlin and Edgell, Feb. to Nov. 1937, BMFA, 1901-1954, roll 2467, in AAA, SI.

Johan Selmer-Larsen
(1876 – after 1946)

Johan Selmer-Larsen was born in Norway and attended the Royal School of Art, Oslo, from 1902 to 1905. From 1922 to 1946 he was an instructor in modeling at the Massachusetts Institute of Technology (M.I.T.) School of Architecture, where he specialized in architectural decoration, a required subject for students in the 1920s and 1930s.[1] Three bronze busts of M.I.T. professors by Selmer-Larsen are on deposit at the institute's museum.[2]

Selmer-Larsen's activities and whereabouts are unknown after he retired in 1946 from part-time teaching at M.I.T. His early career in the United States is also difficult to determine since he changed his name after immigrating. When he first started teaching at M.I.T., his name was Johan Selma Larson. Later, he changed to a hyphenated last name, Selma-Larsen, and eventually finalized this to Selmer-Larsen.[3] On the relief in the Museum of Fine Arts his name appears as "J. Selmer-Larsen," which establishes that he had adopted this spelling by 1929.

J.S.R.

Notes

1. I am grateful to Lawrence B. Anderson, dean emeritus of M.I.T. School of Architecture, for providing this information.

2. These were busts of Boyd Goodwin, 1935, William Emerson, 1937, and Richard C. MacLaurin, 1942.

3. The staff of the M.I.T. Museum kindly provided the information on Selmer-Larsen's name changes. The institute's files contain little further biographical data on the sculptor.

JOHAN SELMER-LARSEN
124
Frank Gair Macomber, 1929
Bronze, brown patina, lost wax cast
Diam. 6¼ in. (16.0 cm.)
Signed (at right): J·SELMER- / LARSEN·SC / ·1929
Inscribed (lower left): FRANK·GAIR / MACOMBER
Gift of Frank Gair Macomber. 31.392

Provenance: Frank Gair Macomber, Boston

The subject of this relief, Frank Gair Macomber (1849-1941), was a prominent insurance executive who presided over corporations bearing his name in Boston and New York.[1] Also recognized as one of the leading art connoisseurs of his day, Macomber proved an invaluable ally of the Museum of Fine Arts, working tirelessly on its behalf in a number of different capacities. In 1893 he helped to organize the largest and most varied loan exhibition of tapestries held to date in the United States and wrote the accompanying catalogue. He later assembled a representative collection of Whistler's works, which at the time was considered the best of its kind.

As a collector, Macomber's tastes and interests were broad in scope. In his lifetime he amassed an important library of rare books as well as significant holdings of antique armor and paintings by masters of the Flemish, Spanish, and Italian schools of the sixteenth through the eighteenth centuries. He also gave generously to the Museum. Among the notable acquisitions that came to the Museum through

Macomber was Edouard Manet's (1832-1883) dra-matic full-size oil sketch *Execution of the Emperor Maximilian*, about 1867, donated to the Department of Paintings in 1930, the year after Macomber sat for this portrait relief. In recognition of his scholar-ship and patronage, Macomber received the ap-pointment of honorary curator of the Museum's Department of Western Art in 1910.[2]

Selmer-Larsen's portrait of Macomber demon-strates the artist's ability to model a strong silhou-ette in low relief, a format favored for architectural ornament in the late 1920s and Art Deco period. The clarity of features achieved in the bronze is partially attributable to the lost wax casting method the sculptor chose to employ.

J.S.R.

124

Notes

1. *Boston Herald*, Dec. 19, 1941, obit.; *New York Times*, Dec. 19, 1941, obit. Beyond his interest in the Museum of Fine Arts, Macomber was active in a number of other arts organizations, including the American Federation of Arts and the Marblehead Art Association, which he served as president.

2. For an overview of Macomber's contribution to the Museum, see Walter Muir Whitehill, *The Museum of Fine Arts, Boston: A Centennial History* (Cambridge: Harvard University, Belknap Press, 1970), vol. 1, pp. 91, 241, 310, 314, 356. See also BMFA, *The Great Boston Collectors: Paint-ings from the Museum of Fine Arts* (1984), p. 28 and no. 36.

Robert Ingersoll Aitken (1878 – 1949)

A talented Californian, Robert Ingersoll Aitken graced San Francisco, the city of his birth, with a style of architectural decoration and monumental sculpture that recalls Medicean Florence. In early works such as the spandrel figures he executed for the Claus Spreckles Music Pavilion, 1900, at Golden Gate Park, and the *Goddess of Victory*, 1903, for Union Square, designed to commemorate Admiral Dewey's battle of Manila Bay, Aitken concentrated on sensuous poses and intricately detailed draperies. But in 1912 with *Michelangelo* (present location unknown), his sculptural group representing the artist at work on his figure of Day (Tomb of Guiliano, Medici Chapel, San Lorenzo, Florence), shown at the winter exhibition of the National Academy of Design, New York, he established his muscular, heroic style. The impressive *Fountain of the Earth* and the *Four Elements* (both of artificial travertine) that he created for the Courts of Abundance and Honour, respectively, at the 1915 Panama-Pacific Exposition, San Francisco, were logical aftermaths. Illuminated by electricity, the boldly conceived *Fountain* portrayed the evolution of man, with four heroic-size figural groups explicitly depicting modern and, for its day, controversial themes. For his efforts that year, Aitken was awarded the gold medal of honor for sculpture from the Architectural League of New York.

Later works, including the pedimental sculpture *Equal Justice Under Law* (with likenesses of three former chief justices as well as the architect Cass Gilbert and the sculptor himself), designed for the United States Supreme Court, 1935, and the allegorical figures for the entrance to the National Archives Building, Washington, D.C., also demonstrate Aitken's debt to the Italian Renaissance. In 1937 he completed a 100-foot frieze *Great Masters of Art* for the Gallery of Fine Arts, Columbus, Ohio, a seven-year project that included portraits of sixty-eight painters, sculptors, and architects from Phidias to George Bellows (1882-1925), arranged in a rhythmic procession. The impressionistic modeling he had learned in France proved to be merely an overlay for a basically neoclassical approach.

Early recognition marked Aitken's career, beginning with the support of a high-school teacher who paid his tuition for a year at the Mark Hopkins Institute of Art, San Francisco, where he studied under the Paris-trained sculptor Douglas Tilden (1860-1935). At eighteen he opened his own studio and then went to Paris for three months, but spent

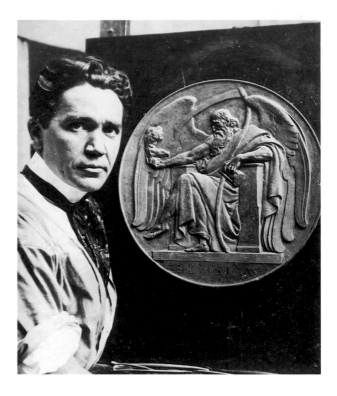

his time visiting galleries and museums rather than taking classes with a French master.

Once more in San Francisco, Aitken showed his work at the Bohemian Club, where he was a member. From 1901 to 1904 he taught sculpture at the Mark Hopkins Institute and then returned to France to work for three years. In 1907 he moved permanently to New York and began teaching at the Art Students League. The next year he became the first recipient of the Helen Foster Barnett Prize given by the National Academy of Design for *The Flame*, 1908 (National Academy of Design, New York), a Rodin-like composition of two lovers in passionate embrace. His ties with the academy continued with election as associate in 1909, academician in 1914, and vice-president from 1929 to 1933. He was also a member of the faculty from 1919 to 1934. A natural leader in conservative sculpture circles, Aitken was president of the National Sculpture Society from 1920 to 1922 and vice-president of the National Institute of Arts and Letters from 1921 to 1924.

Aitken never used calipers like other academic sculptors, however, and refused to take measurements. "After all," he explained, "the only thing there is to a man is the impression that you have of him and that you can never convey by measuring."[1] Aitken also chiseled his own marbles, often taking his figures from the model to a final heroic size.

Aitken was as adept at the diminutive as he was at the monumental. In 1915, the year after he created the *Watrous* medal (q.v.) for the National Academy of Design, Aitken was asked to design the commemorative fifty-dollar gold piece in both a round and an octagonal form for the Panama-Pacific Exposition. Adapting the coinage of ancient Athens and Syracuse, Aitken caused a numismatic sensation and won a silver medal with his imaginative combination of rich archaeological details and naturalistic features.[2] In these coins, he achieved a harmony of subject matter and mint technique that helps to place him with the best of modern American medallic artists, a ranking that parallels his prominent role among early twentieth-century American sculptors.

P.M.K.

Notes

1. Quoted in "Robert Ingersoll Aitken," *California Art Research* 6 (Jan. 1937), p. 85.

2. See Vermeule 1971, p. 136.

References

AAA, SI; O.H. Dodson, "The Coin Sculptors," *Coinage* 13 (Apr. 1977), p. 106; Alex J. Ettl, "Robert I. Aitken, 1878-1949—Eighth President, National Sculpture Society, 1920-1922," *National Sculpture Review* 13 (winter 1964), pp. 19ff.; Arthur Hoeber, "Robert I. Aitken, A.N.A., an American Sculptor," *International Studio* 50, suppl. 3 (July 1913), pp. III-VII; idem, "Sculpture of Robert Aitken, N.A.," *International Studio* 54, suppl. 15 (Nov. 1914), pp. XV-XVIII; MMA; *New York Herald Tribune*, Jan. 4, 1949, obit.; *New York Times*, Jan. 4, 1949, obit.; Proske 1968, pp. 142-144; "Robert Ingersoll Aitken," *California Art Research* 6 (Jan. 1937), pp. 60-94; Taft 1930, pp. 558-561; Vermeule 1971, pp. 136, 142, 162-163, 190-191; Whitney 1976, p. 118.

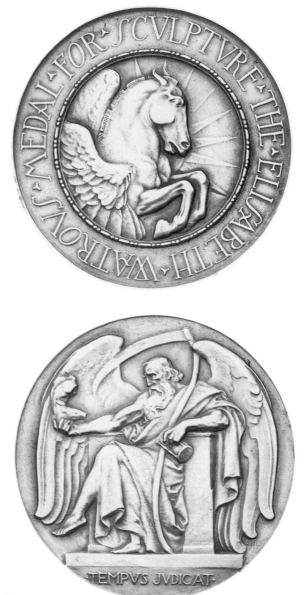

125

ROBERT INGERSOLL AITKEN

125

Elizabeth N. Watrous Gold Medal for Sculpture, 1944 (designed in 1914)
Gold
Diam.: 2 in. (5.1 cm.)
Signed: *reverse*: (at lower right) AITKEN / FECIT
Inscribed: *obverse*: (near rim) ·THE·ELISABETH·WA-TROVS·MEDAL·FOR·SCVLPTVRE; *reverse*: (at bottom) ·TEMPVS JVDICAT· (around rim) RICHARD H. RECCHIA
Foundry mark: (around rim) MEDALLIC ART CO N.Y.
10K GOLD / FILLED
Bequest of Richard H. Recchia. 1984.747
Provenance: Richard H. Recchia, Rockport, Mass.

Designed by Robert Aitken in 1914, the *Elizabeth N. Watrous Gold Medal for Sculpture* is awarded by the National Academy of Design, New York, at its annual juried exhibition.[1] Harry N. Watrous (1857-1940), a painter and member of the academy council, established the fund in 1914 in memory of his wife, Elizabeth. Among the winning sculptors represented in the collection of the Museum of Fine Arts are Charles Grafly, in 1918, Bessie Vonnoh and Aitken himself in 1921,[2] and Anna Hyatt Huntington, both in 1948 and 1958. Richard H. Recchia was awarded the medal for his bronze portrait bust of Raymond Porter (q.v.) in 1944 and received it (the Museum's example) at the opening reception

of the academy's 118th annual exhibition on March 28.

For the *Watrous* medal, Aitken chose two popular myths: the winged horse Pegasus, symbol of fame and heroism, and Father Time, overseer of the artist's earthly tenure. On the obverse (in detail), Pegasus appears set for adventure, rearing upward, against a background of the sun's pointed rays. According to Greek mythology, the horse became the favorite of the nine Muses after he flew to Mount Helicon and, with a kick of his hoof, opened the Hippocrene fountain, the source for poetic inspiration and the gift of song. Later, his riders Bellerophon and Perseus performed heroic deeds and conquered their enemies while on his back. A popular emblem for artistic effort, Pegasus appears also on the reverse of Adolph Alexander Weinman's (1870-1952) design for the J. Sanford Saltus Award for Medallic Art, given by the American Numismatic Society since 1919.[3]

Aitken's selection of Father Time for the reverse of the *Watrous* medal is also fitting, if more unusual, since the aged deity gazes at a small replica of the *Belvedere Torso* (Vatican Museums), supported in his outstretched right hand. Father Time's attributes—the hourglass (given him by early Renaissance illustrators), held in his left hand, and the scythe (associated with the old god of agriculture Cronus, whom the Greeks confused with their word for time *chronos*), which leans against his left side—suggest the artist's mortality. The fragmentary nature (and unrestored condition) of the Hellenistic torso, emulated by Michelangelo in his figure of Day, and later by Rodin in his numerous, purposely incompleted works, as well as by Aitken in *Michelangelo*, 1912 (present location unknown), may also stand for the transitory quality of men's creations.[4] Like the image on the reverse of Aitken's medal commemorating the visit of Marshall Ferdinand Foch to the United States in 1921 (The American Numismatic Society, New York)—which includes a winged female fitted out with three shields, a radiating crown, and voluminous draperies—the representation of Father Time in the *Watrous* all but overpowers the viewer with detail, as it stretches the limits of the medal's confined space.[5]

P.M.K.

Notes

1. The Medallic Art Company, Danbury, Ct., has retained the die for the *Watrous* medal and strikes the piece as needed. After the jurors select the current winner(s), the academy sends the medal(s) out to be inscribed. Conversation between Paula M. Kozol and Abigail Booth Gerdts, archivist, National Academy of Design, New York, May 16, 1985.

2. Artists' files, National Academy of Design. Aitken won the *Watrous* medal for *Conquest of the Northwest*, 1921 (University of Virginia, Charlottesville), a monument to General George Rogers Clark, revolutionary war hero and brother of William Clark of the Lewis and Clark Expedition.

3. The obvious Greek prototype for modern medals incorporating Pegasus, according to Vermeule 1971, p. 243, n. 9, is the large Carthaginian dekadrachm from the third century B.C.

4. For a discussion of the influence of the *Belvedere Torso*, see Francis Haskell and Nicholas Penny, *Taste and the Antique: The Lure of Classical Sculpture, 1500-1900* (New Haven: Yale University Press, 1981), no. 80.

5. See Vermeule 1971, p. 142. Aitken's 1929 *Michael Friedsam Medal for Industrial Art*, awarded by the National Sculpture Society, also has a crowded composition, with Mercury crouching beside a seated angel, who takes up most of the room. But the *President's Medal*, designed by Aitken in 1929 for the National Academy of Design, has a much simpler design, with the head of Minerva on the obverse and an arm aiming a bow and arrow at the stars on the reverse.

Anna Coleman Ladd (1878 – 1939)

In September 1910 Anna Coleman Ladd wrote to Leila Mechlin, Washington art critic and editor, about her hopes and plans for a career as a sculptor: "For now I know what I want: not to do 'official sculpture,' or busts (unless of our beautiful people) or mortuary monuments: but to express the joy and youth and dreams of human nature—through beautiful human bodies, sad or gay,—for gardens, for the open road, for children's places."[1]

Ladd's independence can be traced to her childhood, which she spent mainly in Paris and Rome. Born in Bryn Mawr, Pennsylvania, to Mary (Peace) and John S. Watts, Ladd was educated at Miss Yeatmann's School in Neuilly, France, and by private teachers. In her early twenties she began to model from life, receiving individual criticism from the sculptors Ettore Ferrari (1848-1929) and Emilio Gallori (1846-1924) in Rome, Auguste Rodin (1840-1917) in Paris, and Charles Grafly in Philadelphia. In June 1905 she married Dr. Maynard Ladd, a Boston pediatrician, and that fall enrolled in the School of the Museum of Fine Arts, where she took classes for three years in anatomy and perspective, studying with Bela Pratt and winning the Kimball Prize for modeling in 1906. Settling in the Boston area, with a studio at 270 Clarendon Street and a summer home in Beverly Farms, Ladd found time for writing as well as for sculpture, and in 1912 she had two novels published, *Hyeronymus Rides* and *The Candid Adventure*, the latter a humorous study of Boston manners.

At the beginning of 1911 the Ladds took their first vacation in six years and rented a villa in Rome for five months. From their balcony they had "a marvelous view of the Villa Borghese & Villa Ludici, San Pietro and the Campagna." As she confided to her friend, the celebrated Boston art patron Isabella Stewart Gardner, "It will be a wrench, leaving Rome, - it always was - it's the Place! One would be homesick in heaven. . . . I love it all so desperately! But America is the place to live and work."[2] After traveling to Naples to study Graeco-Roman bronzes and visiting the studios of other American sculptors in Rome, she resumed work begun in America on sculptural groups commissioned for estate gardens on Boston's North Shore, including a figure of Saint Francis (q.v.), intended as a bird fountain.

On her return to Boston, Ladd prepared for three one-person shows in 1912 and 1913: at the galleries of William Macbeth and Gorham, New

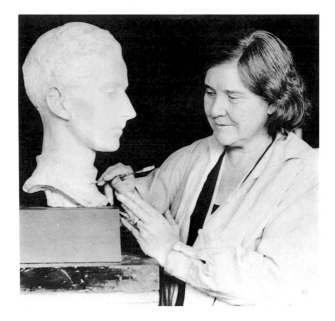

York (where forty of her bronzes were shown), and at the Corcoran Gallery of Art, Washington, D.C. In May 1912 she successfully talked Thomas Allen, chairman of the Boston Art Commission, into arranging in the Public Garden a small outdoor exhibition of bronze fountain groups that had been lent to the Pennsylvania Academy of the Fine Arts, Philadelphia. This included her own animated *Water Sprites at Play*, 1912 (present location unknown, formerly Mrs. E. S. Grew, Manchester-by-the-Sea, Massachusetts), and works by Bela Pratt, Janet Scudder (1873-1940), and Isador Konti (1862-1938). That December, Doll & Richards, Boston, chose eleven of her bronzes for a group show of prominent Boston and New York artists; Pratt, who enjoyed a much greater reputation than Ladd, was represented by only four works. Ladd was also invited to submit five fountain groups for the 1915 Panama-Pacific International Exposition, San Francisco, and received an honorable mention for these and seven other pieces exhibited there. *Wind and Spray*, 1915 (private collection), a bronze figural group of five nude males and females arranged on a ring of waves, was placed in the lagoon at the entrance to the Palace of Fine Arts. (In 1933, when *Wind and Spray* was installed in the Public Garden, its nudity caused such controversy that the sculpture was returned to the artist. *Triton Babies* has fared better; the popularity of these playful children has been constant since they were placed in the park in 1921.)

A founding member of the Guild of Boston Artists in 1914 (with one-person shows there in 1915,

1916, 1919, and 1922), Ladd supported the group's protest against the Boston Art Club's discriminatory policies in dealing with local artists. Despite her democratic sympathies, however, she depended on the tastes of the wealthy and the celebrated. Her portraits, such as the seated figure of the well-known Italian actress Eleanora Duse, 1914 (Farnese Palace, Florence), and the bust of the theatrical luminary Ethel Barrymore (private collection), are sleek, mannered depictions of these sophisticated personalities. Typical of her fashionable portraits of Boston socialites is the bronze bust of Maria de Acosta Sargent, 1915 (Isabella Stewart Gardner Museum, Boston).

In 1917 the Ladds became deeply involved in the war effort and went to work for the American Red Cross in France. While Dr. Ladd was in charge of the Red Cross hospital near Toul, Ladd established a Paris studio, where she made new faces—thin copper plate masks, silvered and colored—for disfigured soldiers awaiting reconstructive surgery. For this humanitarian work, she was made a *chevalier* of the French Legion of Honor in 1934.

In 1920 a group of Ladd's sculpture was presented at Fenway Court (incorporated in 1925 as the Isabella Stewart Gardner Museum), one of the few exhibitions of contemporary artists ever held there. Although the spirit of youth and hope continued to dominate Ladd's work, her symbolism deepened. The *Manchester War Memorial*, 1924 (Rosedale Cemetery, Manchester, Massachusetts), is particularly uncompromising in its realistic depiction of the horrors of war. Commissioned by the Manchester-by-the-Sea American Legion, the memorial plaque consists of two bronze medallions *Dawn* and *Night* set into a rough granite slab. *Night* illustrates the decaying corpse of a soldier, hanging on a barbed-wire fence above the remains of his compatriots; *Day* highlights two male figures clasping hands in the spirit of peace and brotherhood.

Similarly, *The Risen Christ*, 1927 (Forest Hills Cemetery, Jamaica Plain, Massachusetts), originally commissioned for Bellevue Cemetery, Lawrence, Massachusetts, "avoided the obvious, ringletted, effeminate type." As Ladd explained, "I went back to the early ivories, marbles and mosaics for a young, beardless, heroic Church."[3] A virile, six-foot-two figure holding a child tenderly in his arms, Ladd's portrayal echoed the sentiments of church leaders who were calling for artists to represent a muscular Christ, without sentimentality, which would appeal to the youth of their generation.

From 1922 to 1936 Ladd often worked in Rome and Paris as well as in New York. She practiced a qualified modernism whereby she thought primarily in terms of mass—shaping the torso in block form and modeling the subject's character, after which she eliminated or submerged details. Her sense of design was strong, and although she did not create architectural sculpture, her garden pieces relate to their surroundings through scale and a lively sense of movement.

In 1936 Maynard Ladd retired, and the couple moved to Montecito, a suburb of Santa Barbara, California, where Anna Ladd gave lectures, as she had done since 1920, on the relationship of art and society. The following year she was asked by the architect Ralph Adams Cram (1863-1942) to design three niche figures—saints Margaret of Scotland, Helena of Constantinople, and Elizabeth of Hungary—for the north transept of the Cathedral of Saint John the Divine, New York. Like earlier religious figures Ladd had created, these full-length bronzes were modeled after contemporary women and convey a more personal message than their Gothic counterparts. (She did not receive the commission, however, and the three bronzes remain in private collections.)

During her lifetime, Ladd enjoyed an international reputation for work that, in combining simplified forms with humanist sentiments, helped to bridge the gap between academic and modern sculpture. In 1939 she died after a brief illness. Although Dr. Ladd tried to operate Arden, their Beverly Farms estate, as an art center, he was unsuccessful, and after his death in 1942, it was sold. Robert Edwards, a family friend, assumed the care of the remaining sculpture at Arden, and for the next forty years displayed the collection in a gallery and outdoor garden at Paradise, his Prides Crossing home.[4]

P.M.K.

Notes

Archival material for Ladd's biography and catalogue entries was provided by Kathryn Greenthal.

1. Ladd to Mechlin, Sept. [no day] 1910, Philadelphia Museum of Art Archives, roll P11, in AAA, SI.

2. Ladd to Gardner, Mar. 30, 1911, Isabella Stewart Gardner Papers, roll 402, in AAA, SI.

3. Quoted in "A Virile Christ in Sculpture," *Boston Sunday Herald*, Dec. 18, 1927.

4. Forty-six lots of sculpture from the Anna Coleman Ladd Collection were sold at the Robert W. Skinner auc-

tion, Bolton, Massachusetts, Sept. 29, 1983, lots 301-346. Eight sculptures, including *The Risen Christ*, were purchased for Forest Hills Cemetery, Jamaica Plain, the second oldest "garden cemetery" in America, which has an impressive collection of American funerary monuments dating from its establishment in 1848.

References

AAA, SI; BPL; William H. Downes, "Garden Pieces, War Pieces, Portraits, Imaginative Works and Reliefs, at the Guild of Boston Artists," *Boston Evening Transcript*, Nov. 22, 1916; [Isabella Stewart Gardner], *The Work of Anna Coleman Ladd* (Boston: Seaver-Howland, 1920); Anna Coleman Ladd, "Some Ideas on Present Day Art," *Art Digest* 5 (Oct. 1930), p. 36; Anna Coleman Ladd Papers, Robert Edwards, Beverly, Mass.; *New York Sunday Times*, June 4, 1939, obit.; Proske 1968, pp. 203-205; Anna Seaton-Schmidt, "Anna Coleman Ladd, Sculptor," *Art and Progress* 2 (July 1911), pp. 251-255; SMFA; Julia R. Tutwiler, "Women Who Achieve: Anna Coleman Ladd," *Harper's Bazaar* 50 (Mar. 1915), p. 39; "Two Fountains by Anna Coleman Ladd," *Art and Progress* 3 (Oct. 1912), pp. 740-742.

ANNA COLEMAN LADD

126

Saint Francis, 1911

Bronze, black over green patina, lost wax cast

H. 48 in. (122 cm.), w. 14¾ in. (37.5 cm.), d. 16 in. (40.7 cm.)

Signed (on top of base at back): A Ladd, Sc Roma 1911

Inscribed (around side of base):

FONTI·PER·BERE·SIROCCHIE·MIE·IDDIO·DAVVI

Gift of Mr. and Mrs. Edward Jackson Holmes.

40.551

Provenance: Mrs. Walter Scott Fitz, Manchester-by-the-Sea, Mass.; Mr. and Mrs. Edward Jackson Holmes, Boston

Exhibited: Prouty Terrace, Children's Hospital, Boston, 1957-1980.

Versions: *Plaster*, half-life-size, painted: (1) present location unknown. *Bronze*, half-life-size: (1) present location unknown; life-size: (2) present location unknown, formerly Arthur W. Lawrence, Bronxville, N.Y., (3) present location unknown, formerly private collection, Ill., (4) private collection, Mass.

Ladd's naturalistic portrait of Saint Francis follows closely the popular depictions of the saint by his contemporaries in the thirteenth century, as in the fresco by Bonaventura Berlinghieri, dated 1235, which shows Saint Francis preaching to the birds (S. Francesco, Pescia). In Ladd's bronze, the bearded

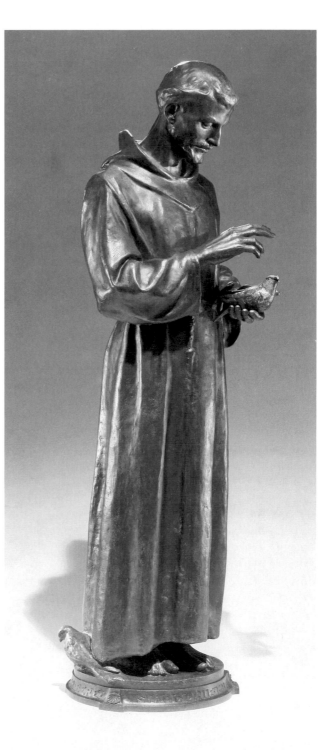

126

saint is dressed in a monk's habit and stands bare-foot on the rounded base, a dove by his side. Looking down at the bird he holds in his left hand, he blesses it with his right.

Saint Francis (1182-1226) was born in Assisi, the son of a wealthy cloth merchant. After being taken prisoner during a war between Assisi and Perugia when he was twenty, Francis began to question the meaning of his life. His conversion to the vows of total poverty date from his encounter with a leper, whom he embraced when asked for alms.

The warmth of Francis's personality, his love for birds and animals, and his empathy with the poor and sick soon attracted followers. He was a fine poet as well and couched his preaching in the popular troubadour style of the day. About 1209 Francis started the order of Friars Minor, and by 1220 the Franciscans numbered more than five thousand. Francis was never ordained a priest but two years after his death was canonized by Pope Gregory IX.

At the beginning of September 1910, Ladd wrote to Leila Mechlin from Hancock, New Hampshire, that in the past week she had "[thrown] up the sketch of St. Francis-with-the-birds."[1] Within two months she was finished and, in another letter to her influential friend and art critic, said that she was now thinking ahead to the spring and the possibility of showing the piece in Washington, D.C., at the Corcoran Gallery of Art. She planned to wait until she got to Rome, however, to have *Saint Francis* cast "among Franciscans where studios, models and———can be had for very little. Then I would visit the best things in Paris," she confessed, "learning—but not 'studying' with anyone and return in time to install it on the North Shore in May."[2]

Ladd spent the early part of February working in the Rome studio of her former teacher Emilio Gallori, "six hours a day standing, even Sundays" on the "four-foot high" *Saint Francis*.[3] On March 30 she sent photographs of the saint to Isabella Stewart Gardner, whose Renaissance palazzo Fenway Court, in Boston's Back Bay, housed the best private collection of medieval and Renaissance art in America. The figure had been cast at Angelo del Nero's bronze foundry on the Greci, and many sculptors, both American and Italian, as well as "Monsignor Pryor of the English college, the Duchess de Arcos, Princess Borghese, Mrs. Sam Abbott, Mr. Crownin-shield, and many others," had come to see it. "I got from the first good criticisms," she recounted to Gardner, "and from others, some tears—I don't quite know why, for he *is* supposed to be a figure of

gladness."[4] Ladd included in the letter the Latin inscription she was considering for the base of the fountain, alluding to the saint's praise of water. She later simplified the inscription, which, on the Museum's bronze, translates "God Gave You, My Sisters, Springs for Drinking."

Soon after, William Phillips (ambassador to England and Italy), and his future bride, who were to be given a *Saint Francis* as a wedding gift, wrote to Ladd that they did not need the figure for two years. Ladd was further set back by their request that the saint look "like Della Robbia's—forty, and sad and bleeding!" As she explained to Mechlin, "I had made a young poet-saint singing to the birds—serene and tender and a sturdy lily." Fortunately, when they arrived in Rome at Easter, however, the Phillipses found they "loved" the statue and took one in bronze back to England with them "until their American garden could be ready."[5]

That summer Ladd had two more fountains of the saint cast with marble bases for two North Shore, Massachusetts, residences: one for Mrs. Scott Fitz's Italian garden at Manchester-by-the-Sea (now in the Museum of Fine Arts) and another "with a wide basin of yellow Siena marble" for the Phillips's estate in Wenham.[6] The latter version differs from the Museum's example in that the bird faces in and the saint's head is only slightly bent.

By the end of 1911 Ladd had received four orders for *Saint Francis* "in different sizes . . . in Europe and America (by non-Catholics)."[7] The following spring, a smaller (18-inch) version of *Saint Francis*, which Ladd called *Little Brother of the Birds*, was shown with another of her fountain groups, the wantonly pagan *Water Sprites at Play*, also modeled that year (present location unknown, formerly Mrs. Edward S. Grew, Manchester-by-the-Sea) for the 107th annual exhibition of the Pennsylvania Academy of the Fine Arts, Philadelphia, "without passing through the jury."[8] Anna Seaton-Schmidt, writing for the Philadelphia *Public Ledger*, compared the two works favorably, finding Ladd's conception of Saint Francis "intensely human . . . sensitive, tender, and strong," the two sculptures giving evidence of her "imaginative genius."[9] That fall *Little Brother* was shown in New York at Macbeth's and, in January 1913, at the Gorham Gallery on Fifth Avenue, in a one-person show of forty bronzes. In February the piece went by invitation, as Ladd had originally wished, to the Corcoran Gallery of Art, for an exhibition of her sculpture. One of her most popular works, *Little Brother* was also included in the Ladd

retrospective held at Vose Galleries, Boston, in 1933.

In 1912 Henrietta Wigglesworth (Mrs. Walter Scott) Fitz, a member of the Museum's Committee on Paintings, lent her version of *Saint Francis* to the Museum, and it was placed in the modern picture gallery. After her death in 1929, Edward Jackson Holmes, her son by a previous marriage and a grandson of the illustrious conversationalist Dr. Oliver Wendell Holmes, inherited the work. This was given to the Museum in 1940 at the time of Holmes's retirement after thirty years as Museum president. A noted collector of contemporary American art, Holmes, who also owned Ladd's *The Slave* (q.v.), was the donor of Maurice Sterne's Art Deco bust *Senta* (q.v.) and Boris Lovet-Lorski's allusive *Female Torso* (q.v.). From 1957 until 1980, *Saint Francis* was on loan from the Museum to the Children's Hospital, Boston; there it decorated the Prouty Terrace, which was given by Lewis Isaac Prouty, the former roommate, at both Phillips Exeter Academy and Harvard University, of Maynard Ladd, the sculptor's pediatrician husband.

P.M.K.

Notes

1. Ladd to Mechlin, Sept. [no day] 1910, Philadelphia Museum of Art Archives, roll P11, in AAA, SI.

2. Ibid., Nov. 14, 1910, Philadelphia Museum of Art Archives.

3. Ladd to Isabella Stewart Gardner, Mar. 30, 1911, Isabella Stewart Gardner Papers, roll 402, in AAA, SI.

4. Ibid.

5. Ladd to Mechlin, May 18, 1911, Philadelphia Museum of Art Archives. Ladd also mentioned that she sold the bronzed plaster cast of Saint Francis (present location unknown) before Easter for $1,000.

6. Ibid., Aug. 31 [1911].

7. Ladd to the New York art dealer William Macbeth, Mar. 26 [1912], Macbeth Gallery Papers, AAA, SI.

8. Ibid.

9. Anna Seaton-Schmidt, "A Memorable Art Show," *Public Ledger* (Philadelphia), Feb. 7, 1912.

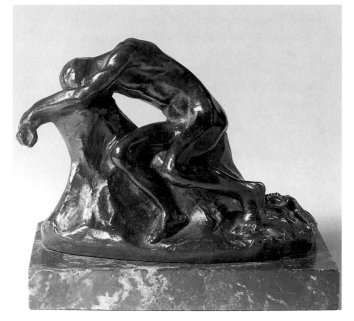

127

ANNA COLEMAN LADD
127
The Slave, 1911
Bronze, black over brown patina, lost wax cast
H. 4 in. (10.2 cm.), w. 5½ in. (14.1 cm.), d. 2¾ in. (7 cm.)
Signed (on back of base): A. [C.? L]add
Gift of Emily W. McKibbin. 62.23

Provenance: Comtesse K. d'Orda, Rome; Edward Jackson Holmes, Boston; Emily W. McKibbin, Detroit, Mich.
Exhibited: Possibly Doll & Richards, Boston, "Small Bronzes by American Sculptors," Dec. 6-25, 1912, no. 47; SMFA 1977, no. 73.
Versions: *Bronze*: (1) present location unknown, formerly Professor Mari Vlastos, Berkeley, Calif., (2-4) present locations unknown, formerly Paris, Rome, and the American West.

On November 14, 1910, Ladd informed Leila Mechlin, then critic for the *Washington Evening Star*, that she was finishing in her Boston studio the *Saint Francis* and "a little statue, modelled of a man's back, in despair, his feet caught in a swirl of hair and a [female] mask." The nude figure sitting on a rocky formation, she explained, had been "inspired simply by the play of light on muscles in a big wrestling match I watched." Since she was planning to have *The Slave* cast in bronze to fill several orders, Ladd offered to send Mechlin an example. Ladd also questioned whether the Corcoran Gallery of Art, Washington, D.C., might be interested in show-

ing "a dozen or more bronzes or tinted casts—half-life—no busts" of her sculpture in the spring.[1]

On December 31 Ladd reported to Mechlin, just before leaving New York for Rome, that she had cast her new things, including *The Slave* but not the *Saint Francis*, which she intended to have done later.[2] When *The Slave* was shown the following March in New York at the Macbeth Gallery, one of the most progressive in the city, Ladd suggested an asking price of $50.[3] In June she offered to send Macbeth marble bases made in Rome for the replicas that were being cast by Roman Bronze Works. By then, four bronzes of the statuette had been sold: one "in Rome, another in Paris, another on the steamer [on Ladd's return to America], and a fourth (Macbeth tells me) out West."[4] In addition, a "bigger marble 'Slave' " (present location unknown) had been carved before Easter, when Ladd "was down to [her] last penny."[5]

The "dark impressionism" of *The Slave*, sketchy, even crude in its modeling, with fractured surfaces that glisten in the light, finds parallels in the romantic-realistic sculptures of laborers and prize fighters done in the 1920s by Mahonri Young (1877-1957). Ladd had studied briefly with Auguste Rodin in 1900, and the moltenlike flow of the bronze and elongation and summary treatment of the limbs in this piece also follow the French master's expressionist style. According to Ladd, when she showed Rodin *The Slave* along with other small bronzes, he exclaimed, "Very good! That's well modeled!"[6] Ladd's symbolic portrayal of a man ruled by passion and enslaved by his own moral weakness is enhanced by the monolithic treatment of the figure and its support. In an article on Ladd written in 1911 by Anna Seaton-Schmidt, the artist was praised for her consummate knowledge of anatomy, which made possible the harmony of spiritual concept with "the architectural lines of 'The Slave.' "[7]

<div align="right">P.M.K.</div>

Notes

1. Ladd to Mechlin, Nov. 14, 1910, Philadelphia Museum of Art Archives, roll P11, in AAA, SI.

2. Ibid., Dec. 31, 1910, Philadelphia Museum of Art Archives.

3. Ladd to William Macbeth, Mar. 12, 1911, Macbeth Gallery Papers, AAA, SI.

4. Ladd to Mechlin, May 18, 1911, Philadelphia Museum of Art Archives.

5. Ladd to Macbeth, June 7, 1911, Macbeth Gallery Papers. Ladd also called *The Slave*, *The Three Ages*, and a similar but larger work in marble or limestone, dated 1931, *Depression* (present location unknown, formerly Vernon Abbott Ladd). See photograph album, annotated by Ladd, Anna Coleman Ladd Papers, Robert Edwards, Beverly, Mass.

6. ("Très bien! C'est modelé, ça!") Ladd to Mechlin, May 18, 1911, Philadelphia Museum of Art Archives.

7. See Anna Seaton-Schmidt, "Anna Coleman Ladd: Sculptor," *Art and Progress* 2 (July 1911), pp. 254-255.

Maurice Sterne (1878 – 1957)

Draughtsman, etcher, and painter, Maurice Sterne turned to sculpture as an outlet for his preoccupation with the representation of weight and volume. Three years before the epoch-making New York Armory Show in 1913, Sterne produced his first sculptured head, *The Bomb-Thrower* (The Metropolitan Museum of Art, New York), a portrait of an Italian anarchist, which, in its emphasis on mass, form, and emotional expressiveness, can be considered one of the earliest examples of modern American sculpture.[1] In the words later used by the sculptor himself to describe the artistry of the post-impressionist Paul Cézanne (1839-1906), Sterne's best works have "the body of sculpture, the containment of space of architecture, and the spirit of painting fused in one."[2]

Sterne was born in the Latvian village of Memel to Gregor and Naomi (Schlossberg) Sterne, a family rich in revolutionary idealism but short of material possessions. When his father, who was a rabbi, died of tuberculosis, the family moved from their home in Libau to Moscow. Sterne attended a polytechnical school, where an art teacher encouraged his talent for drawing and painting. In 1889, at age ten, he was awarded a scholarship to the Kommisarsky Art Academy. That year, however, when all Russian Jews who were not university graduates or First Guild merchants were ordered out of Moscow, Sterne, his widowed mother, and his sister Lena emigrated to America.

Arriving in New York in 1889, Sterne labored for four years in a variety of factory jobs on the Lower East Side and then was apprenticed to a map engraver. With the wax he used to etch, he started modeling figures in his free moments. On the suggestion of his employer, he enrolled in night classes in mechanical drawing at Cooper Union. His sketches soon attracted considerable notice, and he decided to take life classes at the National Academy of Design under the painter Thomas Eakins (1844-1916), who taught anatomy once a week. For the next four years he spent days taking art classes and nights serving in a Harlem bar, winning most of the prizes at his graduation in 1899. A series of delicate etchings he made between 1900 and 1902 led to his appointment as assistant to his former etching teacher James D. Smillie (1833-1909) in 1903, and a year later he received the academy's first Mooney Traveling Scholarship for composition.

Between 1904 and 1907 Sterne lived and painted in Paris. Through his friendship with the avant-

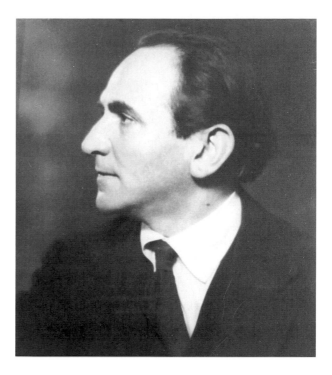

garde collectors Gertrude and Leo Stein, he began his informal education in modernism, meeting Pablo Picasso (1881-1973), Henri Matisse (1869-1954), and the influential Parisian art dealer Ambrose Vollard. At the Salon d'Automne of 1904 and 1905, he discovered Cézanne, whose modeling, through color, of form in space profoundly changed his thoughts about the appearance of reality.

After leaving France, Sterne went to Greece and for eight months roomed in an abandoned monastery at Mount Hymettos, drawing from antique sculpture in nearby Athens and in Delphi, as he searched for a way to add strength to his figural studies. In Italy he found a studio in the medieval hill town of Anticoli-Corrado,[3] about sixty miles north of Rome, where he spent the summers of 1910 and 1911 and, on the suggestion of the painter Edward Bruce (1879-1943), took up modeling in wax again.

With funds provided by the wealthy DuBois Reymond family of Potsdam, Germany, whose portraits he painted in 1911, Sterne embarked on a trip in the fall to India, Burma, Java, and finally Bali, where he stayed from late 1912 until May 1914. There, he produced over two thousand drawings and paintings, attesting to the remarkable sympathy he had for the Balinese people. As Sterne explained, "I wanted to see the people of the East, and I particularly wanted to go where I could study the

nude human body among people who were not self-conscious when they were nude."4 For him, the daily rituals of the Balinese were carried out with a singular grace and balance. As in his earlier drawings, he eliminated all but the essentials and depended on the rhythm of his unbroken lines to convey form. The "static ideal of the East" now informed his aesthetic and helped deepen his commitment to modernism.5

Returning to New York in 1914, Sterne joined the same kinds of advanced intellectual circles that he had known earlier in Paris. Mabel Dodge's "evenings" at her Fifth Avenue apartment were run like Gertrude Stein's salons, with such experimental artists as Marsden Hartley (1877-1943), Francis Picabia (1878-1953), Andrew Dasburg (1887-1979), John Marin (1870-1953), and Sterne in attendance. Radical thinkers, too, like Emma Goldman, Lincoln Steffens, and John Reed, met there, and as Dodge described, stammered "in an unaccustomed freedom a kind of speech called Free, [and] exchanged a variousness in vocabulary called in euphemistic optimism Opinions."6 In 1917 Dodge and Sterne were married, but their short-lived, tempestuous relationship ended when Dodge joined Sterne in New Mexico, where he had gone to distance himself from her and to paint the Pueblo Indians.

Sterne went back to Italy in 1918 and from then on lived for part of each year in Anticoli-Corrado, far removed from the frenetic New York art scene. He now regained the inner harmony he had experienced earlier in Bali. In 1921 he created *The Awakening* (q.v.), an ambitious effort to explore in sculpture the dimensionality he sought to realize in painting. Although the early twenties were a time of financial struggle for him, Sterne continued to experiment with various media. In 1926 his solo show at Scott and Fowles, New York, was a sell-out, and for the first time he could turn down the lucrative portrait commissions that he had always resented undertaking. Stark Young, who reviewed the exhibition for the *New Republic*, found that Sterne's sculpture and paintings shared the same "superb economy of surface and the same rich subtlety of tones" without either partaking too much of the other's nature.7

In 1927 Sterne won a major competition, over such prominent sculptors as Paul Manship, Leo Friedlander, and John Gregory (1879-1958), for a monument honoring the early settlers of New England. Erected in 1929 in Elm Park, Worcester, Massachusetts, the *Rogers-Kennedy Memorial* consists of heroic bronze figures of a pioneer couple sharing the burden of a plow, and sixteen limestone reliefs that portray daily activities such as "housebuilding, harrowing, harvesting, spinning, dairying, fishing, and educating . . . children."8 An inventive design, the arcaded division of the reliefs provides a visual support for the towering figures as well as a unifying element for the two materials. Although Sterne's monument proved too modern for many Worcester citizens, who also questioned whether a Russian immigrant could properly interpret American history, the *Rogers-Kennedy Memorial* was well received by the critics. Henry Francis Taylor, director of the Worcester Art Museum from 1931 to 1940, declared the work to be "the finest piece of outdoor sculpture in America."9

Sterne was elected president of the Society of American Painters, Sculptors, and Gravers in 1929 and, three years later, opened a school on East Fifty-seventh Street to teach his methods of drawing to students of sculpture and painting. As he advised, "from the very beginning [the student] should learn to draw, not what he sees but what he has seen. When [he] first looks at the model he is likely to see all sorts of unimportant details when he should be concerned with the movement of the form."10 In his own paintings, Sterne tried to perfect "a pictorial art resembling music and literature."11

In 1933 Sterne was the first living American artist to be given a one-person show at the Museum of Modern Art, New York. Although Gaston Lachaise had been Lincoln Kirstein's selection, Sterne was the choice of Samuel Lewisohn, a trustee whose collection the director, Alfred H. Barr, Jr., hoped to acquire for the museum. Organized by Lewisohn, the exhibition of Sterne's paintings, drawings, and sculpture covered his Whistlerian etchings of 1902, a post-impressionist phase from 1910 to 1917, an Italian period, and his excursions into large-scale and monumental sculpture. Sharing honors with *The Awakening* was another over life-size marble figure, entitled *Seated Female* (Museum of Art, Rhode Island School of Design, Providence).

By the 1940s Sterne's health had deteriorated, and his early modernism had been eclipsed by the growing acceptance of abstract art, a direction he refused to take. Now in his sixties, he moved to Provincetown, Massachusetts, and began painting light-filled seascapes, in a style far removed from the dark, patterned Balinese and Italian canvases. Nevertheless, in recognition of his influence as an

early modernist, Sterne was appointed to the National Fine Arts Commission in 1945, a position he held until 1952. When he could no longer paint and draw or model, he worked on his memoirs. At age seventy-nine Sterne died in Mount Kisco, New York, where he had maintained a studio for many years.

P.M.K.

Notes

1. As Roberta K. Tarbell points out, *The Bomb-Thrower* predates Raymond Duchamp-Villon's (1876-1916) strikingly similar head of the poet Charles Baudelaire, 1911 (The Museum of Modern Art, New York), which was exhibited at the Armory Show; see "Sculpture in America Before the Armory Show: Transition to Modern," in Rutgers University Art Gallery, New Brunswick, N.J., *Vanguard American Sculpture, 1913-1939*, (1979), pp. 3-4.

2. Maurice Sterne, "Cézanne Today," *American Scholar* 22 (winter 1952-1953), p. 47.

3. Anticoli-Corrado has been an artists' colony since Michelangelo reputedly used local models for his Sistine Chapel frescoes.

4. Maurice Sterne, quoted in Joyce Kilmer, "Develops His Art in Savage Bali," *New York Times Magazine*, Mar. 21, 1915, p. 16.

5. Ibid., p. 17. Sterne's Bali pictures were shown in 1915 and 1917 at the Bourgeois Galleries, New York; at Martin Birnbaum's Berlin Photographic Company, New York, in 1916; and at the Boston Art Club in 1919. His Bali sojourn was compared to Paul Gauguin's (1848-1903) Tahiti period and his mystical rhythms credited to Sterne's Russian background.

6. William Innes Homer, "Mabel Dodge and Her Salon," in *Avant-Garde Painting & Sculpture in America 1910-25*, co-sponsored by the University of Delaware and the Delaware Art Museum (Wilmington: Delaware Art Museum, 1975), p. 19. Dodge had been involved in the Armory Show, contributing money and writing a seminal article on Gertrude Stein entitled "Speculations, or Post-Impressionism in Prose," for *Arts and Decoration* 3 (Mar. 1913), pp. 172-174. For a fuller account of Mabel Dodge Luhan's unconventional life and her influence on Sterne, see Lois Palken Rudnick, *Mable Dodge Luhan: New Woman, New Worlds* (Albuquerque: University of New Mexico Press, 1984).

7. Stark Young, "Maurice Sterne's Exhibition," *New Republic* 45 (Feb. 17, 1926), p. 355.

8. "Unveil Sterne Statue to the Early Settlers," *Chicago Post*, Dec. 17, 1929. See also archival files on the *Rogers-Kennedy Memorial*, Worcester Historical Museum Library. I wish to thank Sarah Callahan Lenis, guest curator of a forthcoming exhibition on Sterne at the Worcester Historical Museum, for sharing her research on the sculptor.

9. *New York Herald Tribune*, July 24, 1957, obit. The Worcester Art Museum, long a leader in championing

contemporary art, had acquired a cast of *The Bomb-Thrower* in 1928, the year before the memorial was dedicated. *The Bomb-Thrower* had been in the museum's 1926 loan show, *Exhibition of Painting and Sculpture by Emilé Branchard, Arnold Friedman, Robert Laurent and Maurice Sterne* (1926), no. 26.

10. "An Hour in the Studio of Maurice Sterne," *American Artist* 5 (Dec. 1941), p. 6.

11. Maurice Sterne, quoted in Horace M. Kallen, "Maurice Sterne and His Times," in The Museum of Modern Art, New York, *Maurice Sterne: Retrospective Exhibition, 1902-1932: Paintings, Sculpture, Drawings* (1933), p. 8.

References

AAA, SI; Martin Birnbaum, *Introductions: Painters, Sculptors, and Graphic Artists* (New York: Sherman, 1919), pp. 40-50; " 'The Awakening' by Maurice Sterne," *Bulletin of the Museum of Fine Arts* 25 (June 1927), pp. 35-36; "Conservative Youth," *Art Digest* 6 (Jan. 15, 1932), p. 29; "An Hour in the Studio of Maurice Sterne," *American Artist* 5 (Dec. 1941), pp. 5-9, 39; Edward Alden Jewell, "A Sterne Retrospective," *New York Times*, Feb. 19, 1933; Charlotte Leon Mayerson, ed., *Shadow and Light: The Life, Friends and Opinions of Maurice Sterne* (New York: Harcourt, Brace & World, 1965); MMA; The Museum of Modern Art, New York, *Maurice Sterne: Retrospective Exhibition, 1902-1932: Paintings, Sculpture, Drawings*, essay by Horace M. Kallen and note by Maurice Sterne (1933); *New York Times*, July 24, 1957, obit.; Maurice Sterne, "Cézanne Today," *American Scholar* 22 (winter 1952-1953), pp. 40-59; Italo Tavolato, *Maurice Sterne* (Rome: Valori Plastici, 1925); Herbert B. Tschudy, " 'The Awakening' by Maurice Sterne," *Brooklyn Museum Quarterly* 14 (Jan. 1927), p.1.

MAURICE STERNE
128
Senta, 1919
Bronze, dark green patina, lost wax cast
H. 16⅜ in. (41.6 cm.), w. 13 in. (33 cm.), d. 10½ in. (26.7 cm.)
Gift of Mrs. Edward Jackson Holmes in memory of Edward Jackson Holmes. 52.194

Provenance: Scott and Fowles, New York; Edward Jackson Holmes, Topsfield, Mass.; Mary Stacy Beaman (Mrs. Edward Jackson) Holmes, Topsfield
Exhibited: Bourgeois Galleries, New York, *Exhibition of Paintings, Drawings, and Sculpture by Maurice Sterne* (1922), no. 41; Scott and Fowles, New York, *An Exhibition of Recent Works by Maurice Sterne* (1926), no. 29; Worcester Art Museum, Mass., *Exhibition of Painting and Sculpture by Emilé Branchard, Arnold Friedman, Robert Laurent and Maurice Sterne* (1926), no. 40.
Version: *Bronze*: (1) Vassar College Art Gallery, Poughkeepsie, N.Y.

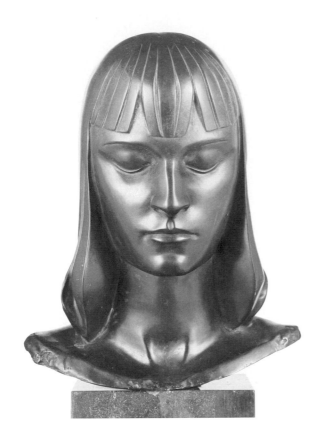

128

Sterne probably began this bust of a young woman shortly after returning to New York from New Mexico in 1918.[1] The stylized features and bold simplification of form follow two other powerful portraits in bronze: *Pueblo Indian* (present location unknown, formerly Mabel Dodge Luhan, Taos, New Mexico), executed the previous year while he was living with the San Ildefonso Indians, and *The Bomb-Thrower* (The Metropolitan Museum of Art, New York), his arresting image of an Italian anarchist, modeled in Italy in 1910.

Senta's sleek, contemporary hairstyle, with full bangs and shoulder-length pageboy, is enhanced by the highly polished, dark green patina. An elegant, Art Deco arrangement of broad planes, clear silhouettes, and smooth, flowing lines, the bust idealizes the sitter's youth. Her closed eyes convey a mood of harmony and serenity. Sterne's Bali paintings and drawings (1912-1914) come to mind: black-outlined figures with sharp, angular features, caught in the rhythmic patterns of daily rituals.

Sterne had two bronze casts made of *Senta* in 1919. One version was sold that year to Adolphe

Lewisohn, the brother of Samuel Lewisohn, who became the owner of the first bronze cast of *The Awakening* (q.v.). The other version, now in the Museum of Fine Arts, was shown at the Bourgeois Galleries, New York, in 1922, along with *The Bomb-Thrower*. *Senta* was also in a group exhibition at the Worcester Art Museum, Massachusetts, and included in Sterne's one-person show given by Scott and Fowles in 1926, when it was bought by Edward Jackson Holmes, a trustee and acting director of the Museum and an early collector of contemporary sculpture.[2] Adolphe Lewisohn's bust was shown in the 1933 Sterne retrospective at the Museum of Modern Art.

In 1952 when the Museum received *Senta* as a gift from Mrs. Holmes in memory of her husband, Sterne wrote to Edwin J. Hipkiss, curator of decorative arts: "It is very gratifying that I am so well represented in your superb collection, both in sculpture and painting."[3]

P.M.K.

Notes

1. Sterne does not mention *Senta* in his memoirs.

2. Holmes was acting director of the Museum from 1925 to 1934, and then president until his death in 1950. Holmes also purchased Sterne's paintings *Green Apples* and *Nasturtiums*, both 1924, at the 1926 show at Scott and Fowles, subsequently giving the former to the Museum in 1941 and bequeathing the latter in 1965. He presented the Museum as well with Anna Coleman Ladd's *Saint Francis* (q.v.) and Boris Lovet-Lorski's *Torso* (q.v.).

3. Sterne to Hipkiss, Mar. 17, 1952, BMFA, ADA.

MAURICE STERNE
129
The Awakening, 1926
Marble
H. 67 in. (170.2 cm.), w. 68 in. (172.7 cm.), d. 30½ in. (77.5 cm.)
Gift of Mrs. Galen L. Stone in memory of her husband. 27.216

Provenance: Mr. and Mrs. Galen L. Stone, Boston
Versions: *Bronze*: (1) The Brooklyn Museum, (2) present location unknown, formerly Ralph Pulitzer, Long Island, N.Y.

The Awakening represents a young woman who seems about to rise from a reclining position. She leans slightly backward; her right arm supports her body, while her left arm is raised and bent around her head. The triangular openings left by her pose

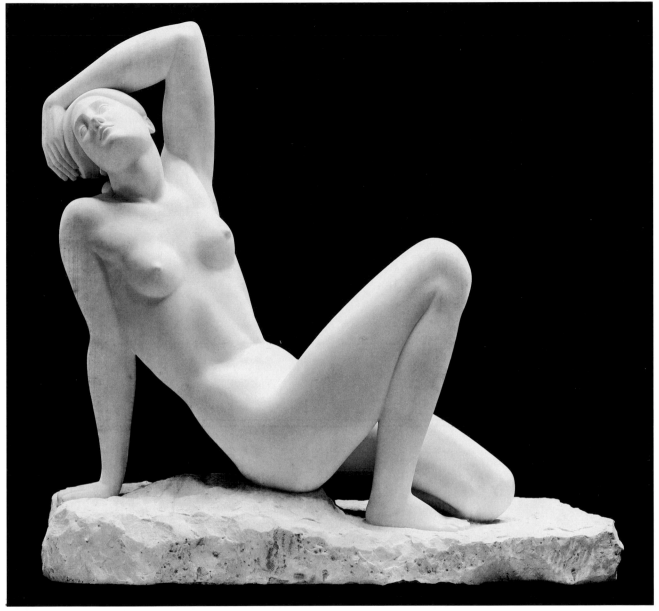

129

and the subtle gradations of surfaces help establish the spatial integrity of the work. In a stunning modern interpretation of classical Greek sculpture, *The Awakening* combines movement and repose, power and restraint.

Begun in Rome in 1921, the heroic-size figure was created over a four-year period. According to Sterne, the first version "committed suicide" after six months, when it fell from the modeling stand.[1] He then took another year to rework the piece. After the plaster cast was made, Sterne cut the sculpture into eight parts to test whether the cross sections were in harmony. Horrified by what he had done, he tried to reassemble the work but after a month destroyed it in a fit of rage. Long months of depression followed, and he retired to his studio in Anticoli-Corrado. There he was able to redo the figure with comparative ease and within nine months had the plaster ready for the Third Biennial International Exhibition in Rome. Sterne was the only American artist invited to participate in the biennial and shared with Picasso the distinction of being his nation's sole representative.[2] Before the bronze version's New York debut in 1926, *The Awakening* was also shown in Vienna, Prague, Cologne, and Ulm.

The Awakening may embody Sterne's emotional response to the end of World War I or his celebration of the emergence of modern woman, both possibilities suggested by the sculptor himself.[3] A number of women were used as sitters, including friends, professional models, and Sterne's second wife, Vera Segal, whom he described as having a "magnificent figure, broad-chested and slim-hipped." "She had powerful thighs and the legs of a Michelangelo Sistine youth," he wrote in his memoirs. "It was a body free and innocent, yet with Rubens breasts; a strange combination of the masculine, feminine, and child."[4] Sterne's geometric simplification of the nude recalls the remote, Amazon-like figures of the Renaissance painter Piero della Francesca, as well as the flattened forms of Cézanne and Gauguin, influences that date from his early years in Paris and Rome.

In February 1926 *The Awakening* was shown with twenty-seven paintings and the busts of *Senta* (q.v.) and *The Bomb-Thrower* in Sterne's one-person show at Scott and Fowles, New York. The reviews were all favorable, with some critics in ecstasy and everyone in agreement that *The Awakening* was the star attraction. The reporter for *Art News* was "bowled over by its sheer exuberance. . . . Arrogantly pagan, the heroic nude so dominated the scene by the splendour of its proportions that the eye is at first unable to adjust itself to the calmer plane of the paintings."[5] Another reviewer noted: " 'The Awakening' has 'registered' in New York so to speak, for the bronze nude figure, rather daring in execution and virile in its revelation of what a sculptor can accomplish, was sold to a collector on the opening day of the exhibition, and a replica was also ordered by another collector, this time in marble."[6] In fact, the bronze was acquired by the publisher Ralph Pulitzer for his Long Island, New York, estate. Adolphe Lewisohn, who had purchased *Senta* from the sculptor in 1919, ordered a bronze version, which he gave to the Brooklyn Museum in 1926, and Galen Stone commissioned the marble copy. Sterne promised that the marble would be the last version he would make of *The Awakening*, and Stone agreed to bequeath it to the Museum of Fine Arts.[7]

The following December Sterne excitedly informed Martin Birnbaum, who had been instrumental in arranging for the 1926 show at Scott and Fowles: "By the way, the marble 'Awakening' is beautiful beyond all expectations. A thousand times lovelier than the bronze."[8] When Stone suddenly died in 1927, his widow presented the marble to the Museum. Sterne then sent a note to the Museum, expressing appreciation that the sculpture had "found such a fine home," adding, "I don't know of any place in the world where I would rather have it."[9]

In 1933 at the Sterne retrospective at the Museum of Modern Art, Brooklyn's *Awakening* was prominently displayed, prompting Margaret Breuning of the *New York Post* to suggest that "if this versatile artist should lay down his brush he undoubtedly could establish himself as a significant sculptor."[10]

<div align="right">P.M.K.</div>

Notes

1. "Mussolini Collects Modern Art, Says Maurice Sterne," *Art News* 24 (Dec. 12, 1925), p. 3.

2. Ibid., p. 1. Although the conservative members of the committee selecting the artists wavered on Sterne's admission, a subcommittee made up of radical artists insisted that Sterne's modernism be accepted or they would resign.

3. Maurice Sterne, quoted in Charlotte Leon Mayerson, ed., *Shadow and Light: The Life, Friends and Opinions of Maurice Sterne* (New York: Harcourt, Brace & World, 1965), p. 165.

4. Ibid.

5. "Sterne's 'Awakening' Sold Twice Over on Opening Day," *Art News* 24 (Feb. 6, 1926), pp. 1, 3.

6. "Maurice Sterne's Awakening," unidentified newspaper clipping, MMA.

7. Mayerson, ed., *Shadow and Light*, p. 197.

8. Sterne to Birnbaum, Dec. 20, 1926. Martin Birnbaum Papers, AAA, SI. In an article entitled " 'The Awakening' in Marble in Boston," *Art News* 25 (May 14, 1927), p. 4, the writer agreed that the marble appeared more subtle and delicate than the bronze. Kineton Parkes, on the other hand, found the design less satisfactory in marble, since the right arm must support the whole weight of the torso. See Kineton Parkes, *The Art of Carved Sculpture*, vol. 1 (London: Chapman & Hall, 1931), p. 153.

9. Sterne to Alice B. Jenckes, assistant to the director, May 14, 1927, BMFA, 1901-1954, roll 2484, in AAA, SI.

10. Margaret Breuning, "Museum of Modern Art Presents Maurice Sterne," *New York Evening Post*, Feb. 18, 1933.

Albert H. Atkins (1880 – 1951)

Albert H. Atkins was one of a small but influential group of New England artists who, from 1916 to 1922, used the Gallery-on-the-Moors in Gloucester, Massachusetts, to showcase their sculpture and paintings. Other sculptors participating in the gallery's annual exhibitions were Anna Coleman Ladd, Anna Hyatt Huntington, and Charles Grafly.

Born in Milwaukee, Wisconsin, Atkins received his early training at the Cowles Art School in Boston from 1896 to 1898, where he probably studied with C. Howard Walker (1857-1936), instructor in architecture and architectural sculpture. In 1898 Atkins went to Paris for two years' study at the Académies Colarossi and Julian. In spite of the noisy and crowded studio conditions that prevailed at the schools, both were popular with American art students because of their open admission policies. Atkins's mature oeuvre would reflect the romantic content and academic mode of composition advocated by the French faculty connected with these institutions, recalling in particular the work of Alexandre Falguière (1831-1900) and Antonin Mercié (1845-1916), who were affiliated with the Académie Julian while Atkins was attending classes there.

After his return from Europe, Atkins settled in Boston, dividing his time between his city residence and a summer home he maintained in Gloucester. From 1909 to 1925 he taught in the department of sculpture at the Rhode Island School of Design, Providence. Beginning in 1916, he and the sculptor Louise Allen Hobbs (whom he married in 1929) were annual exhibitors at the Gallery-on-the-Moors, which also served as a New England salon for the French-trained painters Childe Hassam (1859-1935), Maurice Prendergast (1859-1924), and John Henry Twachtman (1853-1902), whom Atkins had known at the Académie Julian. The collective work of this fraternity of American impressionists was highlighted at a special exhibition held in April 1917 at Boston's Saint Botolph Club, where Atkins's sculpture (the sole sculptural examples represented) was featured in company with canvases by Hassam, Edmund C. Tarbell (1862-1938), Frank W. Benson (1862-1951), and Julian Alden Weir (1852-1919). Atkins's work gathered widening critical attention from that time forward and remained in high esteem through the following decade.

By the thirties Atkins's reputation, which rested on a body of work indebted to his Beaux-Arts training, seems to have been lost in the looming shadow of modernism and its widening influence on sculptural aesthetics. Despite Atkins's relative obscurity in standard surveys of twentieth-century sculpture, the critical consensus of his contemporaries acknowledged his technical facility, versatility, and extraordinary industry as an artist. His etchings were well known locally, and his studio on Dartmouth Street issued a steady production of portrait busts, medals, fountains, public monuments, decorative accessories, and ecclesiastical sculpture. The level of activity his studio maintained is impressive considering the simultaneous demands of the sculptor's teaching schedule.

The small group of ideal works by Atkins gathered in museums today charts his cautious transition from the academic conventions of the Beaux-Arts style, with its naturalistic modeling and invigorating surfaces, to a bolder, architectonic approach to composition and experimentation with linear decorativeness and sleek, stylized contours of stone and bronze. Representative of the stylistic and narrative temperament of the former are Atkins's studies of male archers flexed in tension: *War*, about 1911 (Museum of Art, Rhode Island School of Design, Providence), and *Telesis*, 1915 (present location unknown); his athletic Dianas and lithe wood nymphs: for example, *Crouching Woman*, 1912 (Museum of Art, Rhode Island School of Design); and sporting satyrs and naiads. All are routine subjects in the repertoire of sculptors specializing in garden statuary and other ornamental open-air figures. The fountain composition *Spirit of the Sea*, about 1915 (present location unknown), a version of which was shown at the Albright Art Gallery, Buffalo, in 1916 and again at the 1923 exhibition of the National Sculpture Society, New York, perfectly expresses the exuberant spirit and rhythmic movement Atkins managed to inject into his garden sculpture.

Of a different character altogether were the religious sculptures, furniture, and altar grille work Atkins designed for churches in the first two decades of this century. In collaboration with the prominent architectural firm of Cram, Wentworth and Goodhue, he executed interior work for All Saints' Church, Ashmont, Dorchester, Massachusetts, in 1911, and chancel screens, chapel ornaments, and a baptismal font for the Cathedral of Saint John the Divine, New York, about 1928. Writing of the brilliant program conceived for All Saints' Church, and praising in particular Atkins's

statue *Our Lady and Holy Child*, 1911, for the church's Lady Chapel, the *Boston Transcript* (June 4, 1915) proudly announced: "This work suggests that while European belligerents are doing away with ecclesiastical sculpture of the ages of faith, our energetic, farseeing Mr. Cram is filling this country with little Rheims . . . of his own." Such activity, the writer concluded, certainly helped "the cause of good sculpture."[1] During the prime of Atkins's sculpture career, 1915-1930, he also produced a figure of Christ for Saint Mary's Church, Rockport, Massachusetts; a plaque of the Stations of the Cross for Trinity Chapel, Washington, D.C.; altar rail ornaments for Saint Patrick's Cathedral, New York; and various architectural sculptures for Christ Church, Ansonia, Connecticut, and for the Cathedral of Saint Paul, Saint Paul, Minnesota.

Although Atkins's work continued to elicit favorable response from critics through the twenties, and his memberships in the National Sculpture Society, the American Art Association, the Architectural League, and the Copley Society of Boston secured him professional stature within his field, his career seems to have been on the eclipse after 1930. He retired to his summer home in Gloucester around the outbreak of World War II and died in Winter Park, Florida, in March 1951, after an extensive period of sculptural inactivity. Upon the death of his wife in 1954, the Atkins's home at Eleven Lincoln Street, West Gloucester, was acquired by the Cape Ann Historical Association, and the house and its collection of furnishings from the seventeenth and eighteenth centuries was opened to the public. The house has since passed back into private ownership.

<div style="text-align: right">J.S.R.</div>

Note

1. "Boston Sculptor's Work," *Boston Transcript*, June 4, 1915.

References

"Art Institute Medals," *Milwaukee Journal*, Apr. 21, 1917; "Badger Artists Show Works Here," *Milwaukee Sentinel*, Apr. 22, 1917; BMFA, WMH; "Boston Sculptor's Work," *Boston Transcript*, June 4, 1915; BPL; Cape Ann Historical Association, Gallery-on-the-Moors scrapbook of clippings, Gloucester, 1916-1922; Susan Montgomery, "In Pursuit of Peace by Albert Henry Atkins," seminar paper, Boston University, fall 1982, BMFA, ADA; National Sculpture Society, New York, *Contemporary American Sculpture* (1929), pp. 16-17; idem, *Exhibition of American Sculpture* (1923), p. 10; *New York Times*, Mar. 13, 1951, obit.; James F. O'Gorman, *This Other Gloucester* (Boston: privately printed, 1976); Saint Botolph Club, Boston, *Pictures by Ten American Painters; Sculpture by Albert H. Atkins* (1917); Douglass Shand Tucci, *All Saints' Ashmont* (Boston: published by the Parish, 1975).

ALBERT HENRY ATKINS
130
Peace, 1915
Bronze, brown patina, lost wax cast
H. (with base) 24 in. (61 cm.), w. 8¼ in. (21 cm.), d. 7⅝ in. (19.4 cm.)
Signed (on top of base at front): ALBERT·H· ATKINS
Foundry mark (on back of base): GORHAM CO. FOUNDERS QABX
Helen and Alice Colburn Fund. 1981.93

Provenance: Roland B. Hammond, North Andover, Mass.
Exhibited: Gallery-on-the-Moors, Gloucester, Mass., "4th Annual Exhibition," 1919; National Sculpture Society, New York, *Exhibition of American Sculpture* (1923), p. 10.
Versions: *Plaster*, half-life-size: (1) present location unknown

This bronze personification of Peace occupies a confused place in the history of Boston's public sculpture. One of a long line of humanized representations of universal virtues and uplifting sentiments that sculptors routinely incorporated into building facades and civic monuments,[1] Atkins's statue interprets Peace as a youthful goddess arrayed in loose classical robes, holding an olive branch in one hand and a downward-turned sword symbolic of war's cessation in the other. The figure's tranquil expression and *contrapposto* stance (indicated through her robes) reiterate the appearance and composition of hundreds of such feminized conceits preceding Atkins's idealization in both American and European sculpture. The open-mouthed countenance and shrouded head of *Peace*, for example, seem a facial synthesis of the statue of Victory in the *Sherman Monument*, 1903 (Grand Army Plaza, New York) and the mysterious hooded figure seated on the granite pedestal of the tomb of Mrs. Henry Adams, 1891 (Rock Creek Cemetery, Washington, D.C.), both well-known creations of Augustus Saint-Gaudens.

Several revisionist scholars of American sculpture have contended that the scheme of depicting a sexually ambiguous human face obscured in shadows cast by a shroud of protective drapery was an innovation of American Beaux-Arts sculptors like Saint-Gaudens and Daniel Chester French. French used the convention with particularly apt thematic intent in the majestic figure of Mourning Victory that

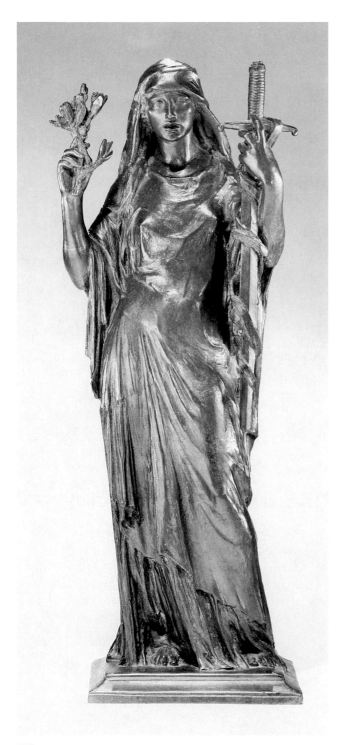

130

dominates his Civil War monument, the *Melvin Memorial* 1908, in Concord, Massachusetts (Sleepy Hollow Cemetery). As sunlight moves across the monument, the angel's beautiful face becomes gradually visible despite its placement within the structural shaft and the concealing shadows cast by the flag surrounding the head. In its emergence from darkness into light, French's angel dramatizes the concept of life after death.[2] Atkins's *Peace* continues this tradition: the notion of darkness yielding to light finding pertinent application in a memorial designed to address the idea of war giving way to peace.

Atkins's specific purpose in composing *Peace* is a matter of speculation, although symbolic figures of this type, commonly associated with grand Beaux-Arts architectural and plaza schemes, retained their heroic visual appeal as public monuments through World War I. Atkins may have modeled this figure as a study sketch for some anticipated commission that he sensed the outbreak of war might occasion, since its lack of defined details and curiously limp drapery suggest an unperfected design rather than a fully realized sculpture. According to the records of the Gorham Manufacturing Company, Providence, *Peace* was one of six works that Atkins had cast there in June 1915;[3] a plaster maquette or sketch presumably predated the bronze. Once he obtained this more durable bronze image, the sculptor apparently sought public exposure for the newly cast composition. In 1919 he submitted two proposed peace memorials to the fourth annual exhibition of Gloucester's Gallery-on-the-Moors and, in 1923, showed a figure titled *Peace* at the National Sculpture Society exhibition in New York.

Assuming that the sculptor executed this *Peace* prototype in expectation of its applicability to a future monument, then Atkins's investment in time and materials was proven justified when, in 1921, the town of Roslindale, Massachusetts, approached him about designing a peace memorial for Irving Adams Park in Roslindale Square.[4] The committee charged with overseeing the monument's planning on behalf of the Roslindale War Memorial Association had already submitted preliminary proposals for a monument and landscaped park (based on a scheme conceived by the Boston landscape architect Arthur Shurtleff) to the Boston Art Commission on December 2, 1920.[5] The commission responded by suggesting that the committee solicit additional designs for the monument from the local sculptor Richard Recchia and from Albert Atkins, whose

Coppenhagen Fountain, a drinking fountain "for persons and animals,"[6] erected in Edward Everett Square, Dorchester, was already familiar to the committee. Atkins, the final choice as sculptor, appeared before the Boston Art Commission in January 1921[7] to present two preliminary designs for the memorial. One of these was probably the concept represented by the bronze figure (at the time, over five years old) now in the Museum of Fine Arts, and the other a variation of the same theme, presumably the second version of *Peace* he had exhibited at Gallery-on-the-Moors in 1919. The Roslindale War Memorial Association reportedly selected "one" of these designs "subject to suggestions as to architectural features" by the Boston Art Commission.[8]

Work progressed rapidly on the monument, for on April 10, 1921, a Boston newspaper published a photograph and description of Atkins's planned scheme with the announcement that the monument was to be 16 feet in height.[9] The photograph illustrates his revised design for the architectural setting, but the central standing figure of Peace is still recognizable as the portrayal in Atkins's small-scale bronze, much expanded and slightly modified in pose. It is curious, therefore, to note the radical changes in composition existing between the Museum's model and the final Roslindale War Memorial, unveiled in 1921. Not only was the stepped platform structure indicated in the photograph significantly altered in the monument erected, but the image itself also underwent metamorphosis from a free-standing bronze to a high-relief format, carved in granite. The gestures of the arms in the Roslindale memorial were completely rearranged, and a palm branch draped at the figure's side substituted for the loosely modeled olive branch, which the earlier version had held in her right hand. Long, curly hair also falls freely to the shoulders of the Roslindale figure, with the woman's head no longer cowled by a hood. The differences, aesthetic and structural, between the model and actual monument are noticeable enough to invite the conclusion either that Atkins's original 1915 figure was abandoned as a model (perhaps in favor of his second proposal for the peace monument) or that budgetary problems encountered by the Roslindale memorial committee (which had raised $15,000 toward the monument) forced them to drastically modify their original choice of design and adopt a more modest solution.

J.S.R.

Notes

1. Atkins was familiar with this allegorical genre, having produced an idealized head of Victory, about 1915 (present location unknown), *Holy Madonna*, 1911 (All Saints' Church, Ashmont), and a bas-relief personification of Maternity, before 1915 (present location unknown).

2. See Michael Richman, *Daniel Chester French, an American Sculptor* (1976; reprint ed., Washington, D.C.: Preservation Press, 1983), p. 118.

3. See letter from Douglas S. Ward, manager, Special Projects, Gorham Bronze Division of Textron, to Charles H. Carpenter, Jr., May 7, 1981, BMFA, ADA. Other figures listed as having been cast by Gorham for Atkins were *Head of Victory*; three statuettes: *David*, *Telesis*, and *Nude Female on a Rock*; a portrait medallion of a woman (*Maternity*?); and a fountain figure, *The Siren*.

4. See "Roslindale to Honor Heroes," unidentified Boston newspaper clipping, Apr. 10, 1921, BAC.

5. Boston Art Commission, Minutes, Dec. 2, 1920, BAC.

6. The fountain was a gift to the city through the bequest of Mehitabel Coppenhagen Wilson in 1913. The Boston Art Commission approved Atkins's design for the fountain in 1914. The piece was cast by Gorham the same year and installed in the late spring of 1915.

7. Boston Art Commission, Minutes, Jan. 27, 1921, BAC.

8. Ibid.

9. "Roslindale to Honor Heroes."

Gaston Lachaise (1882 – 1935)

"Too modern, too willful, too individual in his vision of the sculptural object to rest easily among [Americans],"[1] the French-born Gaston Lachaise remained throughout his life a maverick in America, his adopted land. And yet, the classical sense of structure and design that underlies his bold and often provocative imagery and his radical experiments with form helped his newfound countrymen to understand the extreme changes taking place in twentieth-century art.

Born in Paris to Marie (Barre) and Jean Lachaise, Gaston learned to carve in the shop of his father, a master cabinetmaker and wood carver from Auvergne. From 1895 to 1898 he attended the Ecole Bernard Palissy, a school for artisans and craftsmen, and from 1898 to 1904 the Ecole des Beaux-Arts. Although he preferred the bohemian life to the conventional routine of sculpture classes with the neoclassicist Gabriel-Jules Thomas (1824-1905), on two occasions Lachaise was one of twenty students out of three hundred competing for the Prix de Rome, and between 1899 and 1903 he exhibited regularly in the Salons of the Société des artistes français.

About 1902 Lachaise met Isabel Dutaud Nagle in Paris. A married woman from Boston, of French parentage, she "immediately became the primary inspiration"[2] of his life. In order to earn passage to join her in America, he gave up his studies and went to work for René Lalique (1860-1945), designing Art Nouveau jewelry and decorative ornaments.

In January 1906 he arrived in Boston and for the next six years assisted Henry Hudson Kitson in Quincy, Massachusetts, carving uniform accessories for Civil War memorials. During his free time, Lachaise made clay, Tanagra-like figurines of standing women that reveal, through rhythmic gestures and exaggerated features, his growing preoccupation with the mystery and voluptuousness of the female nude.

Moving to New York in 1912, a few years after Kitson's relocation there, Lachaise began his first life-size sculpture. Modeled after Nagle, the six-foot figure called *Standing Woman* or *Elevation*, 1927 (Albright-Knox Art Gallery, Buffalo, New York), idealized her mature body, poised presence, and essential sexuality.

In 1913 Lachaise left Kitson's employ and opened his own studio. One of his small plasters, *Nude with a Goat*, modeled about 1912 (Lachaise Foundation, Boston), was exhibited at the 1913

New York Armory Show, but the piece attracted little notice. In order to secure a steady income, Lachaise became Paul Manship's chief assistant and for the next seven years worked days for him and nights on the *Standing Woman* and other pieces of his own. Among their collaborative efforts, the *J. Pierpont Morgan Memorial*, 1920 (Fifth Avenue entrance, The Metropolitan Museum of Art, New York), a limestone relief for which Lachaise did all the carving, is surely the most inventive.

Lachaise became a United States citizen in 1916, and in 1917 he married Nagle, who was now divorced. The following year he had his first one-person show at the Fifth Avenue gallery of Stephan Bourgeois. Henry McBride, the influential critic for the *New York Sun*, recalled later that *Standing Woman*, shown with twenty-nine sculptures and some drawings, astonished him with a beauty "that though new was dateless and therefore as contemporary as it was 'early.' "[3] The reviewer for the *New York Times*, however, shared the general view that Lachaise's works, though appropriately modern in their freedom from archaisms, were too physically real. "The only excuse for the use of the nude form in modern art," the reporter argued, "is the expres-

sion through it of an abstract conception which obliges it to exchange personality for architectural and monumental character."[4]

Championed by American critics in the *Dial*, the magazine of formalist criticism in the 1920s, Lachaise's sculpture became well known to the international literary and artistic community. Illustrations of his work appeared in eighteen different issues, with laudatory essays by the poet E.E. Cummings, McBride, and others. Cummings attacked the sculptor's critics with a passion equal to that which Lachaise invested in his own works: "The reason why all official and unofficial 'criticism' OF The Elevation fails and fails so obviously as in the specimens quoted is this: The Elevation is not a noun, but a 'modern statue,' not a statue OF Something or Some One By a man named Gaston Lachaise—but a complete tactile self-orchestration, a magnificently conjugating largeness, an IS. The Elevation may not be declined: it should not and cannot be seen; it must be heard, heard as a super-Wagnerian poem of flesh, a gracefully colossal music. In mistaking The Elevation for a noun the 'critics' did something superhumanly asinine. In creating the Elevation as a verb Lachaise equalled the dreams of the very great artists of all time."[5]

Moreover, Lachaise received portrait orders from most of the *Dial* staff and a number of the magazine's contributors, including E.E. Cummings, 1924 (Fogg Art Museum, Harvard University); the artist Georgia O'Keeffe (1887-1986), 1927 (The Metropolitan Museum of Art); and McBride, 1928 (The Museum of Modern Art, New York). Lachaise's interest in portraiture continued in the 1930s with studies of some notable New York intellectuals. His small-scale standing nude of his great patron Lincoln Kirstein, entitled *Man Walking*, 1933 (Whitney Museum of American Art, New York), resembles an Egyptian pharaoh and is a particularly novel treatment of the celebrated dancer, writer, and founding trustee of the Museum of Modern Art. Stylistically, Lachaise varied the surface treatments of his portraits in response to the subject's personality, at times carving directly in stone or marble, and sometimes adding color in the manner of ancient Greek and Egyptian sculptors. Usually he modeled in clay, and in the finished bronze he either left evidence of his efforts or polished the patina to a gleaming smoothness.

Lachaise's forthright personality and uncompromising attitude about his work, as well as his wife's own extravagant habits, contributed to his financial difficulties even after he received critical acclaim

with one-person shows in New York at Alfred Stieglitz's (1864-1946) Intimate Gallery in 1927 and at Brummer Gallery in 1928. To supplement his earnings, he accepted commissions for garden sculptures and architectural decorations. His animal and bird figures, such as *Dolphin Fountain*, 1924 (Whitney Museum of American Art), and *Sea Gull*, 1928 (Arlington National Cemetery, Washington, D.C.), for the United States Coast Guard Memorial, demonstrate the same love of swelling forms and flowing lines found in his female nudes. For the American Telephone and Telegraph Building, New York, in 1921, he executed a frieze of singing and dancing boys; in 1932 he designed two multi-panel reliefs representing modern allegories for the Sixth Avenue facade of the R.C.A. Building, Rockefeller Center, New York.

Throughout his career Lachaise's compelling drive was to create an idealization of woman. Because of his awe of female generative powers and his obsessive love for his wife, Lachaise sought in countless nude studies to realize her presence. In the process, he transcended portraiture and achieved a personification that is often godlike. In *Standing Woman*, or *Elevation*, Lachaise accentuated the upward thrust of the proud figure so that she seems, in his own words, "nearly detached from earth."[6] *Floating Figure*, 1927 (The Museum of Modern Art), extends this imagery by effortlessly balancing the voluminous nude in a posture that recalls Indian temple art. The third monumental female, *Standing Woman*, also called *Heroic Woman*, 1932 (The Museum of Modern Art), returns the figure to earth to stand triumphant with hands on hip and thigh. As Lachaise became more confident, he increased the scale of his figures while simplifying the transitions between parts of the body. His technical skills emboldened him to experiment with bodies in motion such as *Acrobat Upside Down Figure*, 1927 (Fogg Art Museum) and anatomical fragments like *Classic Torso*, 1928 (Santa Barbara Museum of Art, California). While his public works remained within the restrained classicism of Aristide Maillol (1861-1944) and the romantic idealism of Auguste Rodin (1840-1917), his private sculpture grew increasingly erotic.

In 1935 Lachaise was the second living American artist to have a retrospective at the Museum of Modern Art. (Maurice Sterne had been given one in 1933, despite Kirstein's efforts to have Lachaise be the first.) In his review of the exhibition, which Kirstein organized, McBride reminded the *Sun*'s readers that Lachaise had already suffered enough

neglect and like the poet Walt Whitman had much to show Americans about the joys of maturity. Most of the sixty sculptures were plaster casts since only a small number of his works had been commissioned. Lachaise was given the freedom to select and arrange the show, and he left out his animal and bird sculptures, as well as his architectural designs. He also excluded his erotic late pieces, believing that controversy over them might overshadow the significance of the major works being shown. Nonetheless, nothing was sold, and when Lachaise died, possibly of leukemia, six months after the exhibition closed, recognition of his genius was limited to the cognoscenti. A pioneer of American modernism, however, Lachaise had taken the figurative tradition to its limits and paved the way for others to exalt sculptural form for its own sake.

P.M.K.

Notes

1. Hilton Kramer, *The Sculpture of Gaston Lachaise* (New York: Eakins, 1967), p. 12.

2. Gaston Lachaise, "A Comment on My Sculpture," *Creative Art* 3 (Aug. 1928), p. xxiii.

3. Henry McBride, "Gaston Lachaise Proclaimed," *New York Sun*, Feb. 2, 1935.

4. *New York Times*, Feb. 21, 1918.

5. E.E. Cummings, "Gaston Lachaise," *Dial* 68 (Feb. 1920), p. 7.

6. Lachaise, "Comment," p. xxiii.

References

AAA, SI; Bourgeois Galleries, New York, *Exhibition of Sculptures and Drawings* (1920); John Canaday, "Art: Lachaise Exhibition," *New York Times*, Feb. 20, 1964; Carolyn Kinder Carr and Margaret C.S. Christman, *Gaston Lachaise: Portrait Sculpture* (Washington, D.C.: National Portrait Gallery in association with the Smithsonian Institution Press, 1985); Craven 1968, pp. 598-601; A.E. Gallatin, *Gaston Lachaise* (New York: Dutton, 1924); Donald B. Goodall, "Gaston Lachaise, 1882-1935," *Massachusetts Review* 1 (Aug. 1960), pp. 674-684; idem, "Gaston Lachaise, Sculptor," Ph.D. diss., Harvard University, 1969; Janet Hobhouse, "The Anatomy of Love," *Connoisseur* 215 (Dec. 1985), pp. 88-93; Lincoln Kirstein, *Gaston Lachaise: Retrospective Exhibition* (New York: The Museum of Modern Art, 1935); Knoedler Galleries, New York, *Gaston Lachaise, 1882-1935* (1947); Hilton Kramer et al., *The Sculpture of Gaston Lachaise* (New York: Eakins, 1967); Gaston Lachaise, "A Comment on My Sculpture," *Creative Art* 3 (Aug. 1928), pp. xxiii-xxviii; Los Angeles County Museum of Art, *Gaston Lachaise, 1882-1935: Sculpture and Drawings*, introduction by Gerald Nordland (1963); Memorial Art Gallery, University of Rochester, N.Y., *Gaston Lachaise: Sculpture and Drawings*, essay by Gerald Nord-

land (1979); *New York Times*, Oct. 19, 1935, obit.; Nordland 1974; Gerald Nordland, "Gaston Lachaise Portrait Sculpture," *American Review* 2 (Mar.-Apr. 1975), pp. 109-118; Portland Museum of Art, Maine, *Gaston Lachaise: Sculpture and Drawings*, essay and notes by John Holverson (1984); Proske 1968, pp. 409-412; Gilbert Seldes, "Hewer of Stone," *New Yorker*, Apr. 4, 1931, pp. 28-31; Roberta K. Tarbell, "Sculpture, 1900-1940," in Whitney Museum of American Art, New York, *The Figurative Tradition and the Whitney Museum of American Art* (1980), pp. 97-98; Jeanne L. Wasserman, *Three American Sculptors and the Female Nude: Lachaise, Nadelman, Archipenko* (Cambridge, Mass.: Fogg Art Museum, 1980); Whitney Museum of American Art, New York, *Gaston Lachaise: A Concentration of Works from the Permanent Collection of the Whitney Museum of American Art*, exhibition catalogue by Patterson Sims (1980).

GASTON LACHAISE

131

Head of a Woman, 1918
Polychromed marble
H. 10¾ in. (27.3 cm.), w. 9 in. (22.9 cm.), d. 10½ in. (25.7 cm.)
Gift of Mrs. Margarett Sargent McKean in memory of Nathaniel Saltonstall. 68.789

Provenance: Mr. and Mrs. Quincy Adams Shaw McKean, Boston; Mrs. Margarett Sargent McKean, Boston
Exhibited: The Harvard Society for Contemporary Art, Cambridge, *An Exhibition of American Art* (1929), no. 15; The Museum of Modern Art, New York, *Gaston Lachaise: Retrospective Exhibition* (1935), no. 9; Knoedler Galleries, New York, *Gaston Lachaise, 1882-1935* (1947), no. 5; BMFA, *The Rathbone Years* (1970), no. 117; Portland Museum of Art, Maine, *Gaston Lachaise: Sculpture & Drawings*, essay and notes by John Holverson (1984), no. 30; Carolyn Kinder Carr and Margaret C.S. Christman, *Gaston Lachaise: Portrait Sculpture* (Washington, D.C.: National Portrait Gallery in association with the Smithsonian Institution Press, 1985), no. 9.
Versions: *Plaster*: (1) The Lachaise Foundation, Boston. *Bronze*: (1) Mr. and Mrs. Jerome Hellman, Malibu, Calif., (2) The Lachaise Foundation, (3) *Los Angeles Times* Collection, (4) National Museum of American Art, Washington, D.C., formerly Sara Roby Foundation, New York, (5) present location unknown, formerly Kraushaar Galleries, New York, (6) private collection, New York, (7) Mr. and Mrs. Meyer P. Potamkin, Philadelphia, (8) Mr. and Mrs. John Sawyer, London, Ohio, (9) Wichita Art Museum, Kans.

Between 1915 and 1928 Lachaise made a series of ideal female heads based on observations of his wife, Isabel. Created without commissions, they parallel his other works at this time in their ever increasing expressiveness and debt to a variety of traditions, both Eastern and Western.

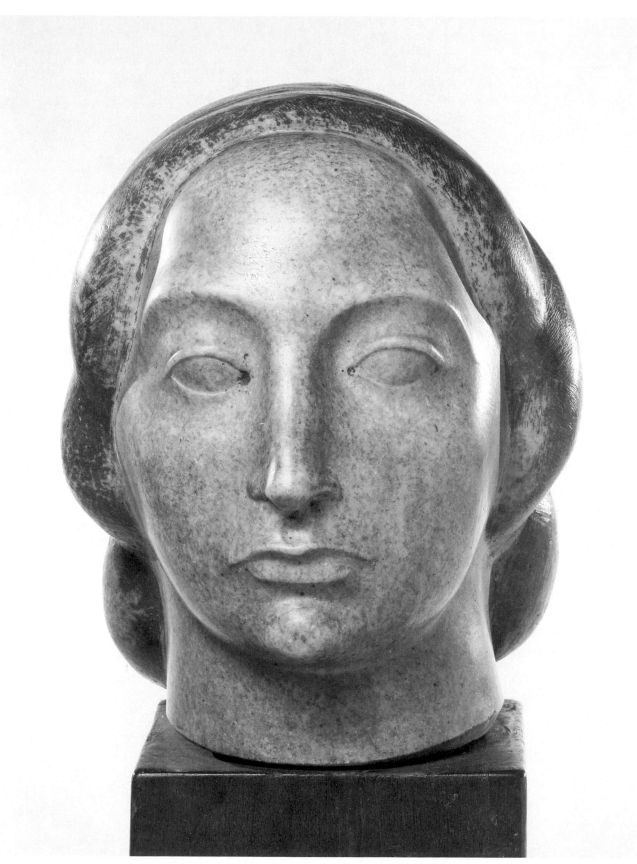

131

In the *Head of a Woman*, the "strong-minded force of Isabel"[1] is realized in the firmly set jaw, frontal stare, and archaizing symmetry of high, arched brows and incised upper and lower lids. Framed by helmet-style hair with thick rolls at the neck, the head's "awesome power"[2] comes from a sense of energy flowing from contour to contour and from the contrast of broad planes with sharply articulated features. Carved directly by Lachaise without intermediate modeling in clay, the mottled, pink Tennessee marble appears fleshlike, enhanced by brown tint at the corners of the eyes, under the nose, and on the chin. The hair is slightly textural, with the same brown tint. Like other avant-garde artists during this period, Lachaise experimented with colors and patinas, taking his inspiration from Egyptian and classical art.

According to Madame Lachaise, the bust was "cut direct in Tennessee marble in 1918," and three bronzes in a golden patina were cast from a plaster model (The Lachaise Foundation, Boston), two ordered by Lachaise and a third by Madame Lachaise after his death.[3] Two of the bronzes were shown in 1941 at Kraushaar Galleries, New York, where one of them (cast by Roman Bronze Works, New York) was acquired for the Wichita Art Museum, Kansas, and took on the appellation *Wichita Head*. Lachaise also made a plaster version of the marble, with a longer neck, in 1923, and had this cast in bronze (both in the Lachaise Foundation). In 1957 an edition of six bronzes, cast from a plaster of the Museum's marble, was authorized by the Lachaise Foundation. These were produced in 1963 by the Modern Art Foundry, Long Island City, New York.

The Museum's head and its bronze versions are related to the "defiantly upright pose"[4] of the six-foot *Standing Woman*, or *Elevation*, 1927 (Albright-Knox Art Gallery, Buffalo, New York), as well as to the nine-inch bronze *Head of a Woman* of 1915 (Maxon Collection, Grosse Point, Michigan), the so-called *Medium Head* with its arched brows, stylized features, and subtly modeled surfaces.[5] The 1918 head may also be compared to the more exotic bronze *Head of a Woman* (*Egyptian Head*), 1923 (Whitney Museum of American Art, New York), and the dreamlike, polychromed Tennessee marble *Head of a Woman* of the same year in the Cleveland Museum of Art, Ohio.

During the time that Kraushaar was representing Lachaise from 1922 to 1926, Margarett and Quincy Adams Shaw McKean acquired the *Head of a Woman* now in the Museum. In 1929 they lent the piece to the seventh exhibition of the Harvard Society for Contemporary Art, Cambridge—an undergraduate organization founded by Lincoln Kirstein, Edward M.M. Warburg, and John Walker—and in 1935 to the sculptor's retrospective at the Museum of Modern Art. The McKeans were avid art collectors and gave generously to the Museum of Fine Arts, notably bronzes by Edgar Degas (1834-1917) and paintings by Mary Cassatt (1845-1926) and George Luks (1867-1933). Margarett Sargent McKean (1892-1978), a nationally known landscape architect and horticulturist, was herself an avant-garde artist in the 1920s and 1930s.[6] In 1928 Kraushaar gave her a one-person show that included nineteen pastels and a group of drawings; Doll & Richards, Boston, showed forty of her works in 1932. McKean undoubtedly knew Lachaise personally since she delighted in entertaining artists as well as art collectors and held regular soirées for them at her handsome home in Prides Crossing, Massachusetts. Although Lachaise referred to the Museum's bust as the McKean head in a letter to Madame Lachaise in 1933, he was designating ownership not subject.[7]

P.M.K.

Notes

1. Nordland 1974, p. 87.

2. Ibid.

3. Mme Lachaise to Elizabeth S. Navas, undated, Elizabeth Navas Papers, AAA, SI, as noted in Wichita Art Museum, Kans., *Catalogue of the Roland P. Murdock Collection*, text by George R. Tompko (1972), p. 133, n. 78. Navas was interested in the Lachaise head, which she had helped to acquire for the Roland P. Murdock Collection. Gerald Nordland, however, dates the Museum's head 1923, when *Standing Woman* may have been modeled again; see Nordland 1974, p. 86.

4. Donald B. Goodall, "Gaston Lachaise, Sculptor," Ph.D. diss., Harvard University, 1969, p. 345.

5. Ibid., pp. 420, 428.

6. See *Boston Globe*, Jan. 23, 1978, obit. The McKeans were divorced in 1947.

7. Lachaise to Mme Lachaise, Oct. 5, 1933, Gaston Lachaise Papers, Collection of American Literature, Beinecke Rare Book and Manuscript Library, Yale University. I wish to thank Carolyn Kinder Carr, National Portrait Gallery, Washington, D.C., for calling this letter to my attention, and Honor Moore, in a telephone conversation, Apr. 3, 1985, for confirming that the Museum's head is not a study of her grandmother, Margarett Sargent McKean.

GASTON LACHAISE
132
John Marin, about 1955 (modeled in 1927)
Bronze, brown patina, lost wax cast
H. 12½ in. (31.7 cm.), w. 8¾ in. (22.2 cm.), d. 9⅜ in. (23.8 cm.)
Signed (on back, below neck): G. LACHAISE / ©1928
Helen and Alice Colburn Fund. 56.508

Provenance: Weyhe Gallery, New York.
Exhibited: Universal and International Exhibition, Brussels, *American Art: Four Exhibitions* (1958), no. 165; Colby College Museum of Art, Waterville, Maine, *Maine and Its Artists, 1710-1963, An Exhibition in Celebration of the Sesquicentennial of Colby College, 1813-1963* (1963), no. 80.
Versions: *Plaster*, painted: (1) The Lachaise Foundation, Boston. *Bronze*: (1) Des Moines Art Center, Iowa, (2) Andrew Keck, Washington, D.C., (3) Mr. and Mrs. John C. Marin, Jr., (4) Milwaukee Art Museum, Wis., (5) The Minneapolis Institute of Arts, Minn., (6) The Museum of Modern Art, New York, (7) The Nelson-Atkins Museum of Art, Kansas City, Mo., (8) Norton Gallery and School of Art, West Palm Beach, Fla., (9) The Phillips Collection, Washington, D.C., (10) private collection, Conn., (11) private collection, New York, (12) University of Nebraska Art Galleries, Sheldon Memorial Art Gallery, Lincoln, (13) Wadsworth Atheneum, Hartford, (14) Whitney Museum of American Art, New York

During a twelve-year period, from 1923 to 1935, Lachaise executed portraits of some of the most notable American writers, artists, and intellectuals of the day. Physically accurate and psychologically penetrating, his images of E.E. Cummings, 1924 (Fogg Art Museum, Harvard University), John Marin, and Lincoln Kirstein, 1932 (The Lachaise Foundation, Boston), for example, capture the very essence of the sitter. Lachaise enjoyed making such likenesses and explained his interest in them: "a portrait of an individual is a synthesis of the prevalent forces within that individual, and in this process there is expansion for the creator."[1]

Of all the portraits of these worthies, the sturdy, earthbound head of the painter John Marin (1870-1953) is the best known and is generally considered the most insightful characterization. Lachaise and Marin had been in contact through their association with Alfred Stieglitz,[2] at whose Intimate Gallery in New York the sculptor had exhibited in the spring of 1927. Everything about Marin—his art, his determination, and his unpretentious manner—engaged Lachaise. In looking at his subject, Lachaise saw "the face of a man who had suffered, sacrificed and triumphed without vanity."[3] In contrast to the smooth treatment of the bronze in heads such as *Scofield Thayer*, 1923 (The Metropolitan Museum of Art, New York) and *Carl Van Vechten*, 1931 (The Art Institute of Chicago), Lachaise gave the *Marin* a rugged surface that is handled "with an expressionist boldness that is the most free and inventive of any Lachaise portraits."[4] Shown with his hair cropped low over his broad forehead, Marin looks straight out above a firmly set jaw. His features, so often discussed, are as craggy as the Maine shore he loved and painted. Apparently, by 1907 Marin already possessed what Henry McBride called "the hatchet-hewn face,"[5] which Jo Davidson, twenty years before Lachaise, recorded as rough in texture in his bronze portrait of Marin, 1908 (National Portrait Gallery, Washington, D.C.).

The Museum's bronze dates from about 1955 and almost certainly was cast by the Modern Art Foundry, Long Island City, New York. At that time, Weyhe Gallery represented Madame Lachaise, who had granted the gallery permission to have a limited number of casts made of the *Marin*. Years before, not long after the *Marin* was modeled, the first cast was exhibited at the Brummer Gallery, New York, in February and March 1928. Nine more heads were cast in the fall of 1930,[6] and five casts were made in the Weyhe edition from about 1955 to 1957.[7] Thus, fifteen bronze casts are recorded as having been produced prior to the establishment of the Lachaise Foundation, which has not made any additional casts.

K.G.

Notes

1. Gaston Lachaise, "A Comment on My Sculpture," *Creative Art* 3 (Aug. 1928), p. xxiii.

2. Whitney Museum of American Art, New York, *Gaston Lachaise: A Concentration of Works from the Permanent Collection of the Whitney Museum of American Art*, exhibition catalogue by Patterson Sims (1980), p. 23.

3. Letter from Lachaise to Mme Lachaise, undated, quoted in Nordland 1974, p. 95.

4. Nordland 1974, p. 93.

5. Henry McBride, in his essay "John Marin," in The Museum of Modern Art, New York, *John Marin: Watercolors, Oil Paintings, Etchings* (1936; reprint ed., New York: Arno, 1966), p. 11, recalled having several chats with Marin in Venice, when they were there in 1907.

6. Carolyn Kinder Carr and Margaret C.S. Christman, *Gaston Lachaise: Portrait Sculpture* (Washington, D.C.: National Portrait Gallery in association with the Smithsonian Institution Press, 1985), p. 110.

7. See letters from Martha Dickinson, manager of the Weyhe Gallery, to Mme Lachaise, Nov. 3, 1955, and Oct. 16, 1956; and from Weyhe Gallery to C. Oliver Welling-

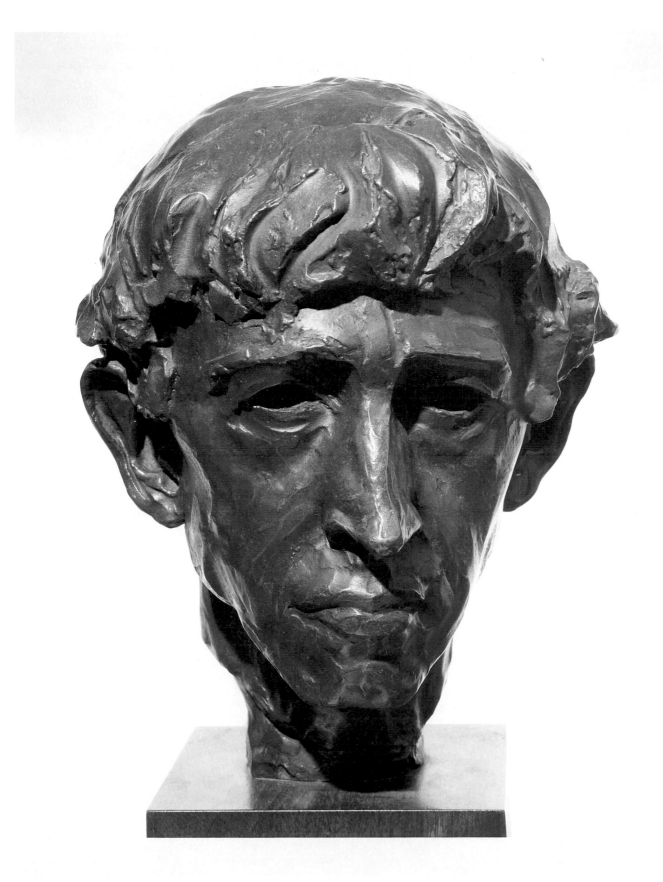

ton, business manager for Mme Lachaise, Apr. 6, 1957, Isabel Lachaise Papers, The Lachaise Foundation, roll 1034, in AAA, SI.

For information about the location of the *Marin* casts, I am grateful to John B. Pierce, Jr., managing trustee of the Lachaise Foundation, Boston, Robert Schoelkopf of Robert Schoelkopf Gallery, New York, and Gertrude Dennis of Weyhe Gallery, New York.

GASTON LACHAISE
133 (color plate)
Torso of Elevation, 1964 (modeled in 1912-1927)
Bronze, red-brown patina, lost wax cast
H. 44¼ in. (112.5 cm.), w. 22 in. (55.9 cm.), d. 12⅞ in. (32.7 cm.)
Signed (on base at left side): LACHAISE / ESTATE ²/₇
Foundry mark (on back of base): MODERN ART / N.Y. / FOUNDRY
William Francis Warden Fund. 65.569

Provenance: The Lachaise Foundation, Boston; Robert Schoelkopf Gallery, New York
Exhibited: Jeanne L. Wasserman, *Three American Sculptors and the Female Nude*: *Lachaise, Nadelman, Archipenko* (Cambridge, Mass.: Fogg Art Museum, 1980), no. 4.
Versions: *Plaster*: (1) present location unknown, formerly Knoedler Galleries, New York. *Bronze*: (1) Corcoran Gallery of Art, Washington, D.C., (2) The Lachaise Foundation, Boston, (3) National Gallery of Victoria, Melbourne, Australia, (4) Munson William Proctor Institute, Utica, N.Y., (5) Stanford University Museum and Art Gallery, Calif., (6) University of New Mexico Art Museum, Albuquerque, (7) Williams College Museum of Art, Williamstown, Mass.

Torso of Elevation is derived from the six-foot *Standing Woman*, also called *Elevation*, 1927 (Albright-Knox Art Gallery, Buffalo, New York). The original model for the posthumous cast in the Museum of Fine Arts[1] dates from 1927, when the full figure was executed in bronze by the Modern Art Foundry, Long Island City, for a 1928 exhibition at Brummer Gallery, New York. Since the arms of the figure were cast separately and welded at the shoulders, Lachaise may have thought of producing the torso independently as it stood in the studio at that time.[2]

Lachaise began *Standing Woman* in 1912, using the small-waisted, full-breasted, proud — if unconventional — body of Isabel Nagle, his lover and future wife, as his model. The sculpture became a surrogate for her, since they were frequently separated. Lachaise reputedly destroyed the work at some point and then redid it completely in plaster for its first showing in 1918 at the Bourgeois Gal-

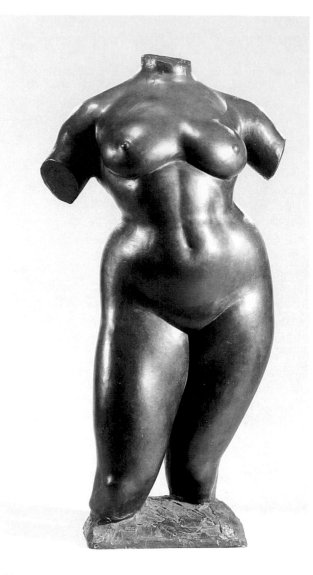

133

leries, New York.[3] Stephan Bourgeois is credited with calling the sculpture *Elevation*, a title that well describes the majestic upward movement and lyric buoyancy of the piece.

Although the work found a champion in Henry McBride, the *New York Sun*'s art critic, Daniel Chester French, leader of the conservative National Sculpture Society, reacted to the sculpture with shock and outrage. Lachaise's financial difficulties all through the 1920s and the slow public acceptance of *Standing Woman* may help to explain why the figure was not cast in bronze until 1927. In an era when the portrayal of adolescence was preferred and the flapper girl in vogue, Lachaise had chosen to glorify maturity and full-blown sexuality. "Through him," Bourgeois wrote in the catalogue

to the second Lachaise exhibition at his gallery in 1920, "woman reentered art as a power, expressing in that way the final equality with men."[4]

Like the full figure, the arched back of the Museum's *Torso of Elevation* accentuates the breadth of the shoulders and the outward and upward thrust of breasts, abdomen, and hips. The subtle balancing of these volumes is enhanced by the ebony patina, rubbed to a golden tone at projecting points and crosshatched and scratched in shadow areas.

Torso has been compared to the simplified classicism of Aristide Maillol's nudes, the sensuousness of Indian temple goddesses, and the voluptuousness of paleolithic earth-mothers. For Gerald Nordland, *Standing Woman* remains the central achievement of Lachaise's art: "She is an icon of femininity, exuding a powerful sense of fecundity, and a mysterious inward divinity."[5]

Although Lachaise had been familiar with Rodin's experiments with figurative fragments from his student days and was an admirer of Constantin Brancusi's (1876-1957) expressive primitivism, he did not turn to the creation of partial figures until the late 1920s. By then, the classical traditions that Lachaise had called upon for *Standing Woman* could no longer contain his "quest for an heroic image."[6] In his later torsos, such as the bronze, shell-like *Ogunquit Torso*, 1928 (Fogg Art Museum, Harvard University), which appears three-dimensional in its rhythmic relationships, he gained a greater, even erotic, expressiveness through the exaggeration and isolation of bodily parts.

P.M.K.

Notes

1. The Museum's *Torso of Elevation* was cast in 1964, the second bronze of an edition of seven, authorized by the Lachaise Foundation after the death of Mme Lachaise in 1957. See Nordland 1974, pp. 173-174.

2. See essay by Gerald Nordland in Memorial Art Gallery, University of Rochester, N.Y., *Gaston Lachaise: Sculpture and Drawings* (1979), pp. 8-9.

3. Nordland 1974, p. 74.

4. Bourgeois Galleries, New York, *Exhibition of Sculptures and Drawings* (1920), preface. *Elevation* may also be interpreted as the trivialization of woman as sexual object.

5. Memorial Art Gallery, *Gaston Lachaise*, p. 5.

6. Hilton Kramer et al., *The Sculpture of Gaston Lachaise* (New York: Eakins, 1967), p. 12.

Mary Orne Bowditch (1883 – 1971)

Born in Roxbury, Massachusetts, Mary Orne Bow-
ditch (known as Mea or Orne) was the second
daughter[1] of the prominent financial trustee Alfred
Bowditch and Mary Louise (Rice) Bowditch and a
great-granddaughter of the distinguished navigator
and mathematician Nathaniel Bowditch. Her child-
hood was spent at her family's estate, Moss Hill, a
two-hundred-acre parcel of land that had been di-
vided among Bowditch descendants in the Boston
suburb of Jamaica Plain. In 1896 the Alfred
Bowditches moved to Boston for the winters, and
the Jamaica Plain house was occupied only in spring
and autumn. Summers were passed in North Ha-
ven, Maine.

Mea's initial exposure to plastic form came
through the friendship of her parents with the
sculptor-art critic Truman Bartlett (1835-1923),
whom she described as "by far the most colorful of
the people who came to our house."[2] Her father's
brother Henry had introduced Bartlett to the
Bowditches in the late 1880s, and from then on he
was a constant visitor. His influence on her future
occupation was not inconsiderable, for she wrote:
"I think he had designs on me to study sculpture,
but I didn't take it seriously until many years later
when I wanted to try modeling and turned to him
for help."[3]

Bowditch received instruction in earnest when
she enrolled in the School of the Museum of Fine
Arts in November 1910. She attended Bela Pratt's
modeling classes for three years, winning the Kim-
ball Prize in May 1912. Bowditch continued her
education at the Académie Colarossi in Paris and
trained under Antonin Injalbert (1845-1933) and
Paul Wayland Bartlett (1865-1925), Truman's
gifted son.[4] Whatever assistance Truman Bartlett
may have given her, it was Paul who provided the
critical judgment she desired and the guidance she
sought throughout the early years of her profes-
sional life.[5]

The period of Bowditch's greatest activity dates
from 1917, when she began to enter her sculpture
at the annual exhibitions of the Pennsylvania Acad-
emy of the Fine Arts, to 1941, the year she had
thirteen objects in a display devoted exclusively to
her art at the Galleries of James St. L. O'Toole in
New York. Her work was also featured at a joint
exhibition with that of Amelia Peabody in February
1930 at the Guild of Boston Artists and at a one-
person show in 1940 at Doll & Richards, Boston,

her agent. In his critique of the 1940 installation,
William H. Downes of the *Boston Evening Transcript*
reported: "Doll & Richards are showing a dozen
pieces of sculpture by Mary O. Bowditch, in her
first one-man show. They range from small figures
to full-size portrait heads. Hardly on the explora-
tive side, they show evidence of grappling with
problems of modeling and composition, materials
and expression. In some pieces the effect is indeci-
sive, but the fountain figure is especially joyous, and
the portraits are thoroughly straightforward."[6] In
1949 a number of Bowditch's productions were in-
cluded in two separate exhibitions: in April at the
Guild of Boston Artists and during the summer at
the William A. Farnsworth Library and Art Mu-
seum in Rockland, Maine.

Bowditch's oeuvre, for which there is a paucity of
documentation, consists mainly of portraits in the
form of busts, heads, and reliefs. The portraits,
many of relatives and friends, are principally in
marble, terracotta, and plaster and are character-
ized by a smooth and careful treatment as well as a
simple and direct charm. Bowditch was particularly
adept at modeling the likenesses of children. The

plaster bas-relief of her niece Hannah Hallowell, about 1916 (private collection), has remarkable sensitivity and grace, as does the terracotta bust of her great niece, Ellen Hallowell Pratt, 1940 (private collection). Her terracotta bust of John Crocker, Jr., 1927 (private collection), another young relative, captures with tender understanding the mischievous restlessness of an active four-year-old boy. A more ambitious creation is a portrayal in marble of an unidentified model (private collection) with head turned to the left. Reminiscent of the marble sculpture of Auguste Rodin (1840-1917), the smoothly carved face is contrasted with the more roughly hewn hair, suggestion of shoulders, and base.

In addition to heads and busts, Bowditch executed complete figures. The *Fountain Figure* (private collection), mentioned in the *Transcript* review, is a stone garden sculpture that represents a child holding a vessel, with clusters of grapes at her feet. A small bronze group of a seated nude, *Salome with the Head of John the Baptist* (private collection), is an interesting departure from the sculptor's usual subject matter. Although Bowditch's style appears to have remained unchanged throughout the years, her diminished stamina in later life precipitated her turning to wood as her preferred material. She made a number of carvings, of which an owl and a pair of chickadees (both in private collections) are especially delightful.

Bowditch's career was a quiet one, and she gained little public recognition. Based in Boston and in North Haven, Maine, she persevered admirably in the face of interruptions peculiar to her social position. Her situation was described in this way: "She was very talented and I only wish she'd worked at it a bit harder. She seemed to always have to stop what she was doing to go to a luncheon party or the Symphony or something, so she broke her train of thought and creativity."[7] Bowditch enjoyed travel and the company of good friends, journeying to Egypt in the 1920s to visit Helen and Herbert E. Winlock, a curator in the Department of Egyptian Art at the Metropolitan Museum of Art, New York.

Despite her participation in social and cultural events, Bowditch was a private, rather withdrawn woman. Modest and reserved, she was incapable of promoting her sculpture in the manner of Anna Hyatt Huntington and Anna Coleman Ladd. As a result, most of her output can be found in the collection of her family, with the exception of an occasional piece in a public institution, such as the two portraits at the William A. Farnsworth Library

and Art Museum in Rockland: a terracotta head and *Hope, Head of an Island Girl,* a marble study. Her professional affiliations were memberships in the Guild of Boston Artists, the National Association of Women Painters and Sculptors, and the Copley Society of Boston, from which she resigned in 1967 because of poor health. Bowditch cleaned out her studio and destroyed most of her plasters, leaving, at the time of her death, a small group of accomplished works.

K.G.

Notes

1. Mary Orne Bowditch's siblings were Margaret Bowditch Hallowell and Rosamond Bowditch Loring. For information about Rosamond Loring and her practice of bookbinding and endpaper design, see Rosamond B. Loring, *Decorated Book Papers: Being an Account of Their Designs and Fashions,* 2nd ed., Philip Hofer, ed. (Cambridge: Harvard University Press, 1952).

2. Mary Orne Bowditch, "Moss Hill," 1950, p. 108. Mary O. Bowditch Collection, MHS. The text is a detailed reminiscence of Bowditch's childhood in Jamaica Plain.

3. Ibid., p. 109.

4. Galleries of James St. L. O'Toole, New York, *Sculpture by Mary O. Bowditch* (1941), unpaginated.

5. See correspondence between Alfred Bowditch and Paul Bartlett, 1914, and between Mary Bowditch and Paul Bartlett, 1914-1925, and undated. Paul Wayland Bartlett Papers, Library of Congress, Manuscript Divison, Washington, D.C.

6. W.G. [sic] D[ownes], "Gallery Shows: Mary O. Bowditch and Kitty Parsons," *Boston Evening Transcript,* Mar. 2, 1940.

7. Letter from Mary Clapp, a niece of the sculptor, to Kathryn Greenthal, July 27, 1981, BMFA, ADA.

References

Mary Orne Bowditch, "Moss Hill," 1950, Mary O. Bowditch Collection, MHS; Galleries of James St. L. O'Toole, New York, *Sculpture by Mary O. Bowditch* (1941).

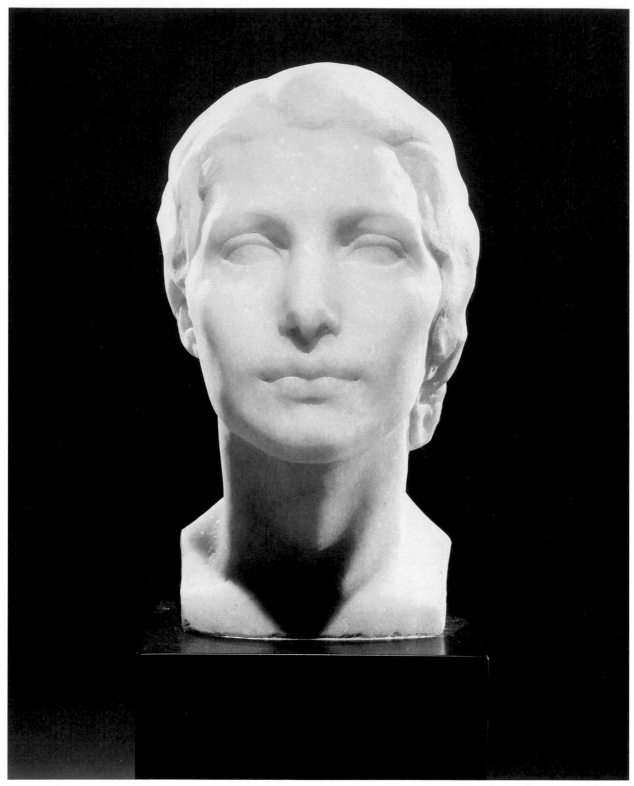

134

MARY ORNE BOWDITCH
134
Bettina, about 1933
Marble
H. 8¼ in. (21 cm.), w. 4⅛ in. (10.5 cm.), d. 5⅝ in.
(14.4 cm.)
Signed (on back, below neck): MB (monogram)
Anonymous gift in memory of Alfred Bowditch.
35.742

Exhibited: Possibly BMFA, *Exhibition of Paintings and Sculpture by the Guild of Boston Artists in the New Special Exhibition Galleries* (1934), no. 286; Doll & Richards, Boston, *Exhibition of Sculpture by Mary O. Bowditch* (1940), no. 5; possibly Galleries of James St. L. O'Toole, New York, *Sculpture by Mary O. Bowditch* (1941), no. 11.

Signed with Bowditch's monogram, this marble head is undated but is thought to have been created during the early 1930s. The sitter was a model named Bettina, about whom little is known. She is shown with her hair in a contemporary style, parted on the right and brushed back to a cluster of curls on the left side of her neck. Her lips are perhaps her least regular feature and have a curvy fullness. Bettina's pupils are undelineated, making the image appear to be a less specific portrayal. A work of considerable elegance, *Bettina* has a haunting classical beauty and is typical of Bowditch's refined portraits.

The head was given to the Museum of Fine Arts in 1935 in memory of the sculptor's father, a great friend of the donor. It was presented without a pedestal, and at the request of the donor, a black marble base was made.[1] Late in 1939[2] the Committee on the Museum granted Bowditch permission to borrow the head for her one-person exhibition at Doll & Richards in 1940, after which it was returned.[3] That the Museum registrar has no record of lending the head in 1941 to the exhibition at the Galleries of James St. L. O'Toole, New York, in which a *Bettina* was shown, opens the possibility that another portrait of Bettina exists.

K.G.

Notes

1. Letter from the donor to George H. Edgell, director of the Museum, June 12, 1935, and from donor to Edwin J. Hipkiss, curator of decorative arts, Nov. 18, 1935, BMFA, 1901-1954, roll 2436, in AAA, SI.

2. Letter from Edgell to Bowditch, Dec. 15, 1939, BMFA, 1901-1954, roll 2442, in AAA, SI.

3. A shipping-room receipt for the return of *Bettina* dated Mar. 12, 1940, is preserved in the files of the Museum's registrar.

Jo Davidson (1883 – 1952)

Calling himself a "plastic reporter" and a "plastic historian," Jo Davidson recorded the features and captured the spirit of hundreds of the twentieth-century's most distinguished individuals. His attraction to the movers and shakers of politics, industry, and the arts knew no bounds, and according to Wayne Craven, this "fascination with the personalities of his sitters was one of the prime ingredients in the success of his portraiture."[1]

Born on the lower east side of New York, the sculptor was the son of Jacob and Haya (Getzoff) Davidson. As a child he delivered neckties, designed and made by his mother, and sold newspapers to augment his family's meager earnings. After finishing elementary school, he held a variety of jobs and attended drawing classes at the Educational Alliance. The idea of becoming an artist appealed to Davidson, and a scholarship for one year was provided for him at the Art Students League. His parents, however, wanted their son to have what they thought was a proper profession and selected medicine. Davidson was sent to New Haven, Connecticut, where he stayed with a sister whose husband had worked his way through Yale Medical School. While studying for equivalency examinations, Davidson, not surprisingly, continued to draw, and before long, he was invited by the head of the Yale Art School to take courses there. One day he wandered into the room where plaster casts, modeling stands, and materials were kept, and later, recounting the moment when he put his hand into the clay bin, wrote, "I touched the beginning of my life."[2]

Resolved to take up sculpture, Davidson went back to New York and to the Art Students League, where he enrolled in modeling classes, and from about 1901 to 1904 he was employed in the studio of Hermon Atkins MacNeil (1866-1947). Feeling ready to strike out on his own, Davidson rented a studio on East Twenty-third Street, New York, in 1906. At that time, few commissions came his way, and realizing that his education was incomplete without a sojourn in Paris, he sailed for Europe the next year. Once in Paris, Davidson entered a sculpture class at the Ecole des Beaux-Arts,[3] but believing the teaching was banal, he remained only three weeks. The city, nevertheless, enthralled him, and he was determined to establish a name for himself without the benefit of formal training at the Ecole.

In Paris Davidson counted among his friends the

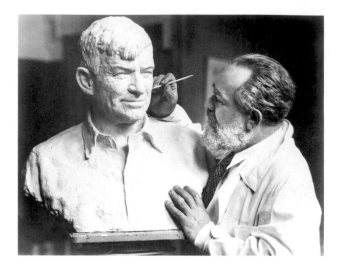

painters Alfred Maurer (1868-1932) and John Marin (1870-1953), of whom he executed a bust in 1908 (National Portrait Gallery, Washington, D.C.). Through the sculptor John Gregory (1879-1958), Davidson was introduced to Gertrude Vanderbilt Whitney (1877-1942), the sculptor and art patron, who bought from him the first piece of sculpture he sold abroad.[4] Soon word began to spread that he could model a bust in a single sitting, and Mrs. Whitney left her daughter Flora in Davidson's studio for him to portray. (After his return to New York in 1916, he made a marble bust, about 1917, and a bronze statuette of Mrs. Whitney, 1917 [both Whitney Museum of American Art, New York]). Although Davidson's reputation as a portraitist was growing, he was fashioning ideal and imaginary pieces as well, such as *La Terre*, 1910 (Muskegon Museum of Art, Michigan), and studies like the bronze *Nude*, 1910, and the bronze *Kneeling Woman*, 1910 (both Whitney Museum of American Art). His efforts drew attention in London in 1910, and that same year he had a one-person show at the New York Cooperative Society. More exhibitions of his output followed, and he was represented by seven sculptures and ten drawings at the Armory Show in 1913.

Davidson turned increasingly to portraiture, producing heads and busts that were fundamentally naturalistic and based on keen observation: "My approach to my subjects was very simple. I never had them pose but we just talked about everything in the world. . . . As they talked, I got an immediate insight into the sitters. . . . I often wondered what it was that drove me to make busts of people. It wasn't

so much that they had faces that suggested sculpture. . . . What interested me was the people themselves—to be with them, to hear them speak and watch their faces change."5

In 1918, when the men of the hour were political leaders and military chiefs, Davidson hit upon the idea of making a plastic history of the period by creating portrait busts of the major World War I figures. He had already modeled one of Woodrow Wilson in 1916 (Princeton University Art Museum, Princeton, New Jersey), and in 1918 he inaugurated the series with a portrait of Marshal Ferdinand Foch (The Metropolitan Museum of Art, New York). Among the eminent soldiers and statesmen of whom he also made busts were General John Pershing, 1919, Field Marshal Joseph Joffre, 1919, and Georges Clémenceau, 1920 (all in the Fogg Art Museum, Harvard University).

Perhaps Davidson's best known sculpture is the portrait of the writer Gertrude Stein, 1920 (Whitney Museum of American Art). He had met her on his first voyage to Europe and later commented that to "do a head of Gertrude was not enough—there was so much more to her than that. So I did a seated figure of her—a sort of modern Buddha."6 The painter Guy Pène du Bois (1884-1958) said the likeness "shows very palpably that she is not a faddist and that she is not one of those people, a Dadaist as an example, who go through the world with a tricky tongue stuck in a thin cheek. This is one of the most, if not the most, dignified of the Davidson portraits."7 Another memorable portrait from the early twenties was Davidson's colossal marble bust of John D. Rockefeller, 1924, executed during one of Davidson's frequent trips to America and placed in the Standard Oil Building in New York.

The 1920s brought the sculptor undeniable fame. His newly acquired prosperity enabled him to purchase an old manor house, Bécheron, near Tours, France, and he converted the barn into a studio. Davidson became a celebrity, appearing at social events of every kind. He was deluged with work—men as dissimilar as Charlie Chaplin, 1925, and Andrew Mellon, 1927, sat for their portraits (the former in bronze, the latter in terracotta, in the National Portrait Gallery)—and he needed three assistants in his Paris studio. (Davidson produced posthumous portraits, too; for instance, the seated marble *Robert M. La Follette, Sr.*, 1928 [National Statuary Hall, United States Capitol, Washington, D.C.], was executed three years after La Follette's

death.) A particularly satisfying enterprise at the end of the decade was the commission from George Doran of Doubleday, Doran and Company to do the heads of prominent English and American writers. This project provided Davidson with the opportunity to model James Joyce, 1929 (University of Texas, Austin), and in 1930, H.G. Wells (The Metropolitan Museum of Art) and Aldous Huxley (National Portrait Gallery).

Despite the somber mood of the 1930s, deepened by the death of his first wife, Yvonne de Kerstat, in 1934, Davidson maintained his busy schedule, traversing the globe to portray gifted and powerful people. In 1931 Mahatma Gandhi (Hammer Galleries, New York) sat for him in London; in 1933 Franklin Roosevelt (Vassar College Art Gallery, Poughkeepsie, New York) was his host at the White House in Washington, D.C.; and in 1934 Albert Einstein (Whitney Museum of American Art) posed for the sculptor in Princeton. When the Spanish Civil War broke out, Davidson traveled to Spain to fashion portraits of the Loyalist leaders. As a group, these busts and heads, including one in bronze of "La Pasionaria" (pseudonym of Dolores Ibarruri), 1938 (Museum of Modern Art, New York), were exhibited in New York for the benefit of the Spanish Children's Milk Fund. During the late thirties, Davidson demonstrated that he was equally capable of making inspired full-length standing statues: one of the humorist Will Rogers, 1938 (House Connecting Corridor, United States Capitol) — who, in denying Davidson a sitting, had jokingly called him a "head hunter" — and another of the poet Walt Whitman, 1939 (Bear Mountain State Park, near West Point, New York). In 1940 Davidson was in the West Indies painting watercolors, and the following year he sailed farther south to create portraits of the rulers of ten South American countries.

After such a peripatetic interlude, Davidson reestablished himself in the United States and settled down in Bucks County, Pennsylvania, with his second wife, Florence Gertrude Lucius. A heart attack slowed his pace near the end of his life, yet he was able to visit Israel where he modeled a portrait of David Ben-Gurion, 1951 (The Jewish Museum, New York). Davidson passed his last years at his beloved Bécheron and died there in January 1952.

As a portraitist, Davidson worked in a naturalistic vein throughout his career, but his touch was more varied, resulting in a smooth and highly finished surface or a more characteristically vigorous and active texture. For his materials, he used marble

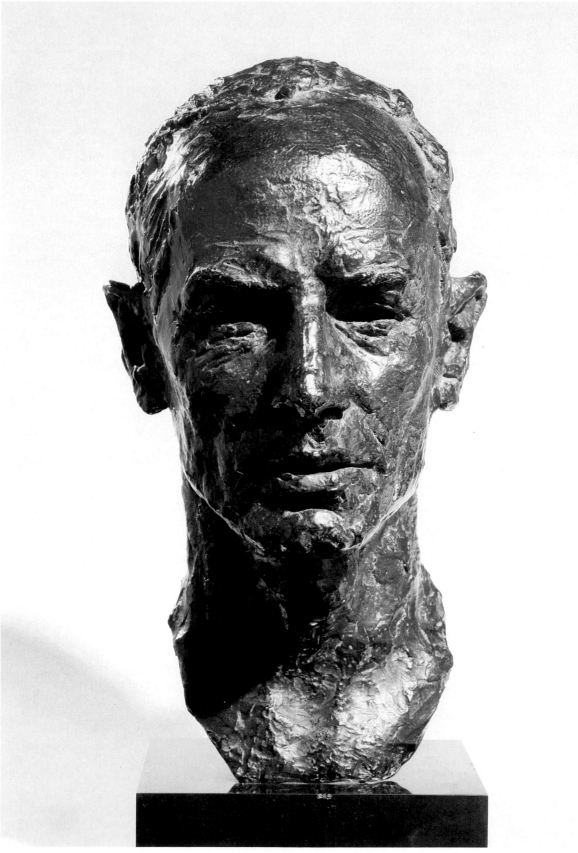

135

and experimented with terracotta, sometimes polychroming it, but more often than not, he prepared his sculpture for bronze. An indefatigable witness to the greatest talents of his age, Davidson modeled their heads, gave them permanent life, and left his own imprint by chronicling an entire era.

K.G.

Notes

1. Craven 1968, p. 557.

2. Jo Davidson, *Between Sittings* (New York: Dial, 1951), p. 12.

3. Admitted to Injalbert's studio, Oct. 23, 1907, AJ52343, Sculpture, Atelier de M. Antonin Injalbert, Archives de l'Ecole Nationale Supérieure des Beaux-Arts, Archives Nationales, Paris.

4. National Portrait Gallery, Washington, D.C., *Jo Davidson: Portrait Sculpture*, biographical entries prepared by Marc Pachter and Amy E. Henderson (1978), unpaginated.

5. Davidson, *Between Sittings*, pp. 86-87, 117.

6. Ibid., p. 174.

7. Guy Pène du Bois, "Art by the Way," *International Studio* 76 (Nov. 1922), p. 180.

References

American Academy of Arts and Letters and The National Institute of Arts and Letters, New York, *Catalogue of the First Retrospective Exhibition of Sculpture by Jo Davidson* (1948); "An American Creator of the 'New Statuary,'" *Current Literature* 52 (1912), pp. 99-101; Eulalia Anderson, "Jo Davidson's Portrait Busts," *American Magazine of Art* 11 (Nov. 1920), pp. 469-472; "Biographer in Bronze," *MD* 22 (1978), pp. 121-126; Craven 1968, pp. 557-560; Jo Davidson, *Between Sittings* (New York: Dial, 1951); idem, "Tendencies in Sculpture," *Vanity Fair* 7 (Oct. 1916), p. 73; Guy Pène du Bois, "Art by the Way," *International Studio* 76 (Nov. 1922), pp. 180-181; "Jo Davidson," *Art Digest* 26 (Jan. 15, 1952), p. 5; Karl Freund, "Five Busts by Davidson," *International Studio* 79 (Sept. 1924), pp. 425-432; Gardner 1965, pp. 146-148; Henry F. Griffin, "Jo Davidson, Sculptor," *World's Work* 22 (Aug. 1911), pp. 14746-14755; Edwin J. Hipkiss, "'A New Englander': A Portrait Head in Bronze by Jo Davidson," *Bulletin of the Museum of Fine Arts* 34 (Aug. 1936), p. 60; CAA, *Index* 2 (Aug. 1935), pp. 447-449, supplement, p. 459; "Jo Davidson Exhibits in London," *Creative Art* 9 (Sept. 1931), pp. 228-229; Lois Harris Kuhn, *The World of Jo Davidson* (Philadelphia: Jewish Publication Society, 1958); Alonzo Lansford, "Reviewing Jo Davidson, Biographer in Bronze," *Art Digest* 22 (Dec. 15, 1947), p. 20; Jo Davidson Papers, Library of Congress, Manuscript Division, Washington, D.C.; MMA; The National Portrait Gallery, Washington, D.C., *Jo Davidson Portrait Sculpture* (1978); "New Portrait Busts by Jo Davidson," *Vanity Fair* 6 (June 1916), p. 56; *New York Times*, Jan. 3, 1952, obit.; Kineton Parkes, "Sculpture in June: Jo Davidson at the Knoedler Galleries," *Apollo* 14 (July 1931), pp. 42-45; Proske 1968, pp. 263-267; Mary Siegrist, "Jo Davidson—Philosopher in Stone," *Arts & Decoration* 18 (Nov. 1922), pp. 18-19, 86; Gertrude Stein, "A Portrait of Jo Davidson," *Vanity Fair* 19 (Feb. 1923), pp. 48, 90; "Studio Talk," *International Studio* 56 (Aug. 1915), p. 133; F.T., "Profiles: Sculptors Are Different," *New Yorker*, Mar. 26, 1927, pp. 27-29; Taft 1930, p. 569; "Two Notable New Sculptures," *Vanity Fair* 6 (July 1916), p. 40; Whitney 1976, pp. 137-138, 266; Whitney Museum of American Art, New York, *The Figurative Tradition and the Whitney Museum of American Art: Paintings and Sculpture from the Permanent Collection* (1980), pp. 92-94; Ella Winter ["Jo Davidson"], *Creative Art* 1 (1927), pp. 302-303; Raymond Wyer, "A New Message in Sculpture—The Art of Jo Davidson," *Fine Arts Journal* 26 (Apr. 1912), pp. 262-270; Mahonri Sharp Young, "The American Houdon," *Apollo* 116 (Dec. 1982), pp. 422-423.

JO DAVIDSON
135
A New Englander, 1935
Bronze, red-brown patina, lost wax cast
H. 15⅛₆ in. (38.3 cm.), w. 8 in. (20.3 cm.), d. 10 in. (25.4 cm.)
Signed (on back of neck): JO DAVIDSON 1935
Foundry mark (on back below signature): BRONZE / CIRE / C. VALSUANI / PERDUE
Anonymous gift. 36.290

In 1936 this head was given to the Museum of Fine Arts by a donor who requested anonymity. Since he was also the sitter and preferred his name not be used in the portrait's title, he called the piece *A New Englander*, which reflected his origins. A graduate of Harvard University and an architect and interior designer, he lived in France for nearly twenty years before returning to Exeter, New Hampshire, his birthplace, where he remained until his death.

The head was created in 1935 at Bécheron, Davidson's manor house and studio near Tours, France. The two men had been neighbors and friends for several years, and according to the sitter, the portrait was something Davidson "started to amuse himself while waiting for lunch and finished in two or three sessions like that."[1] Before departing for New York in the fall of 1935, Davidson gave the head to the sitter, who asked the sculptor if he could donate the portrait to a museum. Davidson replied that he could do with it whatever he wished. The sitter had it cast in bronze by Valsuani (identified by the firm's stamp) in Paris and then offered it

to the Museum, which accepted it in the spring of
1936. The original plaster was destroyed, but a
terracotta mask is in the collection of the sculptor's
son, Jacques, in Tours.

The donor characterized the portrait as vigorous
and typical of Davidson's work; the sculptor called it
"satisfactory."[2] It is roughly modeled, with marks of
both the sculptor's thumb and tools clearly evident.
Although the portrait is not one of Davidson's well-
known sculptures, it is reportedly a superb likeness
of the sitter.[3]

K.G.

Notes

1. Sitter-donor to Edwin J. Hipkiss, curator of decorative
arts, Feb. 4, 1936, BMFA, ADA. Jacques Davidson, the
sculptor's son, wrote that his father made the portrait in
exchange for the sitter's posing, in the nude, for the Walt
Whitman statue now in Bear Mountain State Park, near
West Point, N.Y. (See letter from Jacques Davidson to
Kathryn Greenthal, undated [Jan. 1983], BMFA, ADA.) It
appears, however, that Davidson had modeled the por-
trait before the sitter posed for the *Whitman*. See Jo
Davidson, *Between Sittings* (New York: Dial, 1951), pp.
294-297.

2. Ibid.

3. Hipkiss to sitter-donor, June 9, 1936, BMFA, ADA.

Paul Manship (1885 – 1966)

At the time of Paul Manship's New York debut in 1913, he was already a mature artist, with a perfection of technique to match his individuality. Phenomenal and immediate success ensured that his bold linearism, simplification of forms, and poetic expression would be emulated by others. To a large degree, Manship anticipated the Art Deco aesthetic in America and in the process showed the way to modernism.

Born in Saint Paul, Minnesota, the seventh child of Mary Etta (Friend) and Charles H. Manship, Paul seemed to know from an early age that he would become an artist. With his family's encouragement, he attended Mechanical Arts High School, taking courses in drawing, painting, ceramics, and sculpture, and paying little attention to his academic studies. At seventeen he dropped out of school and took evening classes at Saint Paul Institute of Art. The next year he divided his energies between Minneapolis and Saint Paul, working as a photoengraver and free-lance designer. About this time he realized that he was color-blind and in 1904 gave up his work in graphics.

Although he had never modeled before, with the financial help of his father, Manship moved to New York in 1905 to seek professional instruction in sculpture. He studied artistic anatomy briefly with George Bridgman (1864-1943) and modeling with Hermon MacNeil (1866-1947) at the Art Students League and from the spring of 1905 to the fall of 1907 assisted Solon Borglum (1868-1922). Borglum was then designing the equestrian monuments to General John B. Gordon (Atlanta, Georgia) and Captain "Bucky" O'Neill of the Rough Riders (Prescott, Arizona), both unveiled in 1907, and Manship's *Horses in a Storm*, 1906 (Paul K. Manship, Mahtomedi, Minnesota) shows the influence of the older sculptor's impressionistic style. In 1907 Manship took life-modeling classes with Charles Grafly at the Pennsylvania Academy of the Fine Arts, and in 1908 he worked in the studio of the French-trained, Viennese-born Isidore Konti (1862-1938), who particularly fostered his interest in classical sculpture.

Manship's official recognition came early when, in 1909, he won the American Prix de Rome offered by the Rinehart Fund of the Peabody Institute, Baltimore, for *Rest After Toil* (destroyed). The fellowship at the American Academy in Rome provided $1,000 yearly, a studio and lodging, and an allowance that he used for extensive travel in Italy

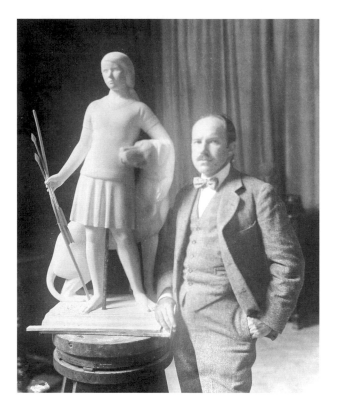

and Greece. The first recipient to capitalize on his archaeological "finds,"[1] Manship drew extensively on the rich traditions embodied in Minoan friezes, archaic Greek statues, ancient Egyptian and Assyrian reliefs, as well as Italian Renaissance bronzes.

In the fall of 1912 Manship returned to New York with four plaster studies, *Mask of Silenus, Lyric Muse* (q.v.), *Playfulness*, and *Centaur and Dryad*, and a bronze cast of *Duck Girl*.[2] In February 1913 these statuettes and five pieces modeled after his return, three of which were life-size, were shown at the Architectural League, New York. Manship was at once acclaimed for the lyric beauty and subtle humor of his work. Disassociating himself from Beaux-Arts naturalism, the twenty-seven-year-old artist emphasized silhouetted forms, smoothly finished surfaces, and stylized features. Corresponding to a European interest in archaism,[3] Manship's "borrowings" from the past offered an alternative to American collectors weary of the prevailing academic style but fearful of the challenge of modernism.

Manship's "new-old" treatment of mythological themes[4] dazzled sophisticated New Yorkers, and at the National Academy of Design's 1914 winter exhibition, his *Centaur and Dryad* (The Metropolitan Museum of Art, New York) won the Helen Foster Barnett Prize. The following year he also received

the George D. Widener Gold Medal from the Pennsylvania Academy of the Fine Arts, Philadelphia, for *Duck Girl*, placed in Rittenhouse Square, Philadelphia, in 1917, and was awarded a major commission from the trustees of the Metropolitan Museum of Art for a commemorative limestone relief honoring J. Pierpont Morgan. Over the next six years, with the help of his studio assistant Gaston Lachaise, Manship created an allegorical tour-de-force representing the commercial and cultural interests of the late president of the institution, one of its great benefactors. Installed in 1920 in the Great Hall of the Fifth Avenue entrance, the tablet was later moved to the vestibule.

Manship's technical mastery of materials pleased the conservative establishment as well. In 1914 Herbert Adams, president of the National Sculpture Society, noted the distinct contribution that Manship's small bronzes would make to the advancement of American sculpture. At a time when, according to Adams, this medium was suffering from the eccentricities of modernism, Manship's "ability and skill in design and execution" might do "American art an incalculable good."[5] Like a Renaissance goldsmith, Manship treated bronze as a hard material to be chased, and he prepared for this by meticulously carving and filing the final plaster mold. He sometimes modeled in wax rather than in clay, a method he found difficult but rewarding. His interest in Indian bronze sculpture, which had begun in 1913, went far beyond the design and symbolism to the material itself as he sought to realize the flow of the molten metal in the lines of his own pieces.[6] A close friend of Riccardo Bertelli, owner of Roman Bronze Works, Manship demanded and received the best patinas for his bronzes, achieving a subtlety and richness of finish unsurpassed by any sculptor of his generation. If his forms were traditional, their polished perfection was eminently modern and close to the sleek, burnished style of Alexander Archipenko (1887-1964) and Constantin Brancusi (1876-1957).[7]

Manship's first one-person show in New York was held in 1916 at Martin Birnbaum's Berlin Photographic Company. From editions of the forty-four sculptures listed in the catalogue, ninety-six pieces were sold, averaging $1,000 each. *Dancer and Gazelles*, 1916 (Corcoran Gallery of Art, Washington, D.C.), seemed to be the public's favorite, a rhythmic creation that captured the spirit of Indian art, with a free-flowing grace that found parallels in the advanced choreography of Ruth St. Denis and Isadora Duncan and the exotic costumes of Léon Bakst (1866-1924), designed for the Ballet Russe.

Manship's approach to sculpture was more practical than theoretical, however, and his imagery was chosen for glyptic effect rather than literary symbolism. Architects soon discovered that his streamlined forms were well suited to modern buildings and city plazas. His earliest architectural commission came from Welles Bosworth (1869-1966) in 1914 for four bronze reliefs of the elements Earth, Water, Fire, and Air to adorn the facade of the Western Union Building, New York (now 195 Broadway). When, in 1934, his *Prometheus Fountain* (Rockefeller Center, New York) was unveiled, the intent to meld architecture and sculpture remained the same. The gilded bronze figure of the mythical fire-giver relates well in design to the superstructure surrounding it, despite the relative disparity of scale.

Over the length of his career, Manship produced more than seven hundred works. To handle the many orders that came to him in the 1920s and 1930s, he employed a number of assistants, including Leo Friedlander and Gaston Lachaise, and maintained studios not only in New York and later, during summers, in Lanesville, Massachusetts, but also in Paris from 1921 to 1935, and Rome, where he was appointed annual professor of sculpture at the American Academy in 1922.

Like Anna Hyatt Huntington and Lachaise, Manship was fortunate to have patrons who gave him free scope in their commissions for garden sculpture. In 1914 for the gardens of Harold McCormick, Lake Forest, Illinois, he created twelve marble terminal figures and busts of Greek heroes and deities. Three years later he designed for Herbert Pratt's estate, The Braes, Glen Cove, New York, the bronze figures *Indian* and *Pronghorn Antelope*, 1917 (Mead Art Museum, Amherst College, Massachusetts), which show his debt to non-Western sources. Many of his animal sculptures were also conceived for this genre. By far his most demanding project, however, came in 1926 with the commission for the *Paul Rainey Memorial Gateway*, dedicated in 1934 (New York Zoological Park, Bronx). This imaginative design includes ten easily identifiable species of birds and ten animals, which were modeled in the round and cast in bronze and gilded. During this period, Manship's figures also became more volumetric with fewer details. In the monumental bronze statue of Abraham Lincoln, unveiled in 1932 (Lincoln National Life Insurance Company,

Fort Wayne, Indiana), he portrayed the president as a young poet in buckskin clothing, book in hand, but still shaped the naturalistic elements to the overall design.

Manship regularly won honors, including the gold medal of the American Institute of Architects in 1921 and the J. Sanford Saltus Award for Medallic Art, given by the American Numismatic Society in 1924. Among his numerous one-person shows was an exhibition in 1927 at the Renaissance court of the Museum of Fine Arts, where forty sculptures, ranging from over life-size figures to low-relief medals, were displayed. The Tate Gallery in London hosted a noteworthy exhibition of his work in 1935, as did the Corcoran Gallery of Art in 1937, and the National Institute of Arts and Letters, which organized a major retrospective in 1945. Manship was made a *chevalier* of the French Legion of Honor in 1929 and a fellow of the American Academy of Arts and Letters in 1932, serving as its president from 1948 to 1953. He was a leading spokesperson for the sculptural community, from his early election to the National Academy of Design in 1916 through his presidency of the National Sculpture Society from 1939 to 1942. A trustee of the American Academy in Rome, Manship was also the sculptor member of the Fine Arts Commission, Washington, D.C., and chairman of the Smithsonian Institution Art Commission from 1944 until his death.

After World War II, Manship's eclectic, decorative style no longer commanded critical favor, and his reputation declined. America's favorite sculptor of the 1920s and 1930s, he now relied on commissions from those who shared his distaste for abstraction. Manship acknowledged that his arrival on the New York art scene in 1912 had come propitiously, when the public was receptive to change. As he stated simply in a 1952 interview: "I had no great talent, but was free and unencumbered; I was the right man at the right time."[8] Whereas Saint-Gaudens's brilliant achievements helped other American sculptors profess their independence of Europe, Manship's organizing principles of design, archaistic forms, and mastery of materials provided them with a new sculptural style. His sculpture remained representational and within the figurative tradition, but his underlying aesthetic asserted the transcendence of form over narrative content.

The critical revival of interest in Manship's work during the 1980s has both reflected and contributed to changing tastes in America (the theme of a recent Manship retrospective organized by the Minnesota Museum of Art, Saint Paul). Once again the beauty of his line, the purity of his form, and the sensuous delight he found in the human figure are welcome in a society that seeks to reconcile the humanist tradition with modern urban life.

P.M.K.

Notes

1. Manship's successors, notably Carl Paul Jennewein (1890-1978), who designed the gilded bronze figures for the entrance to the British Empire Building, Rockefeller Center (near the *Prometheus Fountain*), Leo Friedlander, and Sidney Waugh (1904-1963), continued Manship's archaizing style well into the 1930s.

2. According to Edwin Murtha, two life-size bronzes were made of *Duck Girl*, *Mask of Silenus* was destroyed by the artist, *Lyric Muse* and *Playfulness* were cast in editions of fifteen, and five bronzes were made of *Centaur and Dryad*. See Edwin Murtha, *Paul Manship* (New York: Macmillan, 1957), pp. 149-150. Roman Bronze Works, New York, cast some of these statuettes in time for the 1913 show.

3. For a discussion of Manship's archaism in relation to his European counterparts, see Susan Rather, "The Past Made Modern: Archaism in American Sculpture," *Arts Magazine* 59 (Nov. 1984), pp.111-119. Rather distinguishes early twentieth-century archaism from primitivism in its affinity with late Western art.

4. Taft 1921, p. 144.

5. Herbert Adams, in a letter to Grant La Farge, secretary of the National Academy of Design, published in "Paul H. Manship," *Art and Progress* 6 (Nov. 1914), p. 20.

6. For a contemporary sculptor's evaluation, see Walker Hancock's essay in National Collection of Fine Arts, Washington, D.C. , and Saint Paul Art Center, Minn., *Paul Manship, 1885-1966* (1966), pp. [9-11].

Susan Rather points out that by 1917 Manship had joined the India Society, founded in 1910 by Ananda Coomaraswamy, curator of Indian Art at the Museum of Fine Arts, to promote the understanding of Indian culture in America; see "Past Made Modern," p. 113.

7. See John Manship, "Paul Manship: A Biographical Sketch," in Minnesota Museum of Art, Saint Paul, *Paul Manship: Changing Taste in America* (1985), p. 137.

8. Paul H. Manship to Paul K. Manship, 1952, quoted in Minnesota Museum of Art, Saint Paul, *Paul Howard Manship: An Intimate View: Sculpture and Drawings from the Permanent Collection of the Minnesota Museum of Art* (1972), p.2.

References

AAA, SI; Berlin Photographic Company, New York, *Catalogue of an Exhibition of Sculpture by Paul Manship,* introduction by Martin Birnbaum (1916); Brookgreen Gardens, Murrells Inlet, S.C., *Sculpture by Paul Manship* (1938); Stanley Casson, *Twentieth Century Sculptors* (London: Oxford University Press, 1930), pp. 41-54; Royal Cortissoz,

"A Brilliant and Exotic Type in American Art," *New York Tribune,* Sunday, Feb. 20, 1916; idem, *American Artists* (New York: Scribner's, 1923), pp. 285-292; Craven 1968, pp. 565-568; A.E. Gallatin, "An American Sculptor: Paul Manship," *Studio* 82 (Oct. 1921), pp. 137-144; Gardner 1965, pp. 150-153; Walker Hancock, "Paul Manship," *Fenway Court* 1 (Oct. 1966), pp. 1-7; Minnesota Museum of Art, Saint Paul, *Paul Howard Manship: An Intimate View: Sculpture and Drawings from the Permanent Collection of the Minnesota Museum of Art* (1972); idem, *Paul Manship: Changing Taste in America* (1985); Edwin Murtha, *Paul Manship* (New York: Macmillan, 1957); National Collection of Fine Arts, Smithsonian Institution, Washington, D.C., *A Retrospective Exhibition of Sculpture by Paul Manship,* essay by Thomas M. Beggs (1958); *New York Herald Tribune,* Feb. 2, 1966, obit.; "Paul H. Manship," *Art and Progress* 6 (Nov. 1914), pp. 20-24; Proske 1968, pp. 305-313; Cameron Rogers, "The Compleat Sculptor," *New Yorker,* Sept. 1, 1928, pp. 21-23; Jacques Schnier, *Sculpture in Modern America* (Berkeley: University of California Press, 1948), pp. 8-11, 42-43; Robert Taylor, "Manship Exhibition Focuses on the Issue of Taste," *Boston Sunday Globe,* May 11, 1986; Paul Vitry, *Paul Manship, Sculpteur Américain* (Paris: Editions de la Gazette des Beaux-Arts, 1927); Whitney 1976, pp. 291-292.

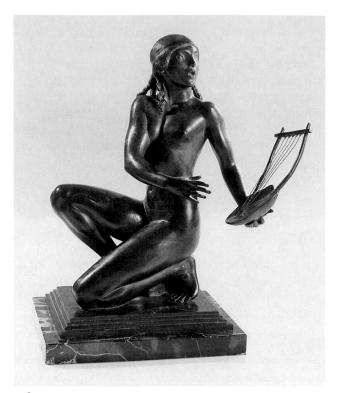

136

PAUL MANSHIP
136 (color plate)
Lyric Muse, 1912
Bronze, dark green patina, lost wax cast; copper wire
H. 12¾ in. (32.4 cm.), w. 6⅞ in. (17.5 cm.), d. 5½ in. (14.0 cm.)
Signed (on top of base at front): PAUL MANSHIP / ROME 1912
Foundry mark (on base at right side): ©ROMAN BRONZE WORKS. N.Y.
Gift of Mary C. Wheelwright. 42.373

Provenance: Mary C. Wheelwright, Boston; lent to Museum in 1933
Versions: *Bronze:* (1) Cincinnati Art Museum, Ohio, (2) The Detroit Institute of Arts, (3) George Kemeny, Pittsburgh, (4) Paul Magriel, New York, (5) Minnesota Museum of Art, Saint Paul, (6) Munson-Williams-Proctor Institute, Utica, N.Y., (7) National Museum of American Art, Washington, D.C., (8) present location unknown, formerly Eleanor Mellon, New York, (9) University of Minnesota Gallery, Minneapolis

This statuette of a kneeling adolescent female who sings as she plays the lyre is an early work of Manship's, modeled in 1912 at the end of his term at the American Academy in Rome. During his fellowship, Manship had become enamored of the lyricism of Greek mythology and the beauty of line and design in late archaic Greek sculpture and black-figure vase painting. In *Lyric Muse* the almond-shaped eyes, rippled hair with headband, and separate locks falling over the girl's shoulders are clearly derived from these traditional Mediterranean sources. On the other hand, the open mouth and spiral pose suggest baroque sculpture,[1] while the outstretched hand and animation of the figure have a playfulness that seems distinctively modern. The modeling, too, is firm and rounded, offering another departure from the stylized earlier borrowings.

Lyric Muse probably represents Erato, one of the nine Muses of Greek mythology. The goddess of lyric and love poetry as well as mime, she holds a lyre, which distinguishes her from Euterpe, the other muse of lyric poetry and music, who usually plays the flute. Manship also depicted Erato on the obverse of the *Saint Paul Art Institute Medal,* 1916 (Minnesota Museum of Art, St. Paul).[2]

Manship used the same model, a woman named Marietta from Anticoli-Corrado, Italy, for *Lyric Muse* as he did for *Yawning* (present location unknown)[3] and *Playfulness* (National Museum of American Art, Washington, D.C.), both also created in 1912. A sense of pulsating life is evident in all these pieces — a spontaneous note that was wel-

comed by some critics who worried that Manship's schematic renderings of hair and drapery might be a regressive tendency. Promoted by the National Academy of Design and the National Sculpture Society, which were eager to attract new collectors, small, lighthearted works like *Lyric Muse* with rich, variegated patinas found a ready audience.

Lyric Muse was first exhibited in January 1913 at the Architectural League, New York; it was then cast in an edition of fifteen[4] at Roman Bronze Works, New York, in time for the 1914 winter exhibition of the National Academy of Design, New York, and the 109th annual exhibition of the Pennsylvania Academy of the Fine Arts, Philadelphia. At the Saint Botolph Club, Boston, in the winter of 1915, *Lyric Muse* was shown with thirty-one of Manship's sculptures. The piece was also included in a 1915 exhibition of thirty-eight works by Manship that traveled to Pittsburgh, Saint Louis, Chicago, Buffalo, and Detroit and was one of a group of ten that won a gold medal for the sculptor that year at the Panama-Pacific International Exposition, San Francisco. *Lyric Muse* was exhibited at each of Manship's one-person shows, beginning with his first at the Berlin Photographic Company, New York, in 1916, and in 1917 the statuette received the Helen Foster Barnett Prize at the National Academy of Design's exhibition in Detroit.

Mary C. Wheelwright was a Boston collector of note, with an interest in early New England paintings as well as contemporary art. In 1933, at a time when Manship's popularity was still high, she lent *Lyric Muse* to the Museum, giving it in 1942.

P.M.K.

Notes

1. Harry Rand points out that the helix form employed in *Lyric Muse* was used again in *Europa and the Bull*, 1935 (Minnesota Museum of Art, Saint Paul). See "The Stature of Paul Manship," in Minnesota Museum of Art, Saint Paul, *Paul Manship: Changing Taste in America* (1985), pp. 26-27.

2. See Minnesota, *Manship*, no. 9, catalogue entry on *Lyric Muse* by Leanne A. Klein and Susan Levy.

3. Telephone conversation between Paula M. Kozol and John Manship, a painter and the sculptor's son, Apr. 18, 1986; and see A.E. Gallatin, *Paul Manship: A Critical Essay on His Sculpture and an Iconography* (New York: Lane, 1917), pp. 6-7.

4. Paul Vitry, *Paul Manship, Sculpteur Américain* (Paris: Editions de la Gazette des Beaux-Arts, 1927), p. 35.

Cartaino di Sciarrino Pietro
(1886 – 1918)

Cartaino di Sciarrino Pietro died two-and-a-half months before his thirty-second birthday, yet during his brief career he attained prominence as an exceptionally gifted sculptor. The *American Art News* observed that, had he been spared, his considerable talents would have brought him "into the very forefront of American sculpture."[1]

Born in Palermo, Italy, to Salvatore and Marianna (Sciarrino) Cartaino, Pietro was most commonly known as Cartaino di Sciarrino Pietro, but he also went by the name of Pietro Cartaino Sciarrino. Principally self-taught, he won a scholarship and studied for a time in Rome. He crossed the Atlantic in either 1909 or 1911[2] and settled in New York, where, initially, he supported himself by cutting blocks of stone, reserving his meager free hours for his own creative efforts.

Pietro's reputation became firmly established with his first major success, a bust of J.P. Morgan, 1913, which was commissioned by the Italian town of Ascoli Piceno to be placed in its Municipal Building as a token of gratitude from the mayor, Chevalier Mazzoni. The over life-size bust honored Morgan for returning a cope he had purchased that later proved to have been stolen from the local cathedral. The portrait was so highly regarded that marble and bronze replicas were requested, one for Morgan's office and another for his library.[3] Such was the acclaim for the *Morgan* that orders for portraits poured into Pietro's hands, enabling him to set up a large studio in which assistants found steady employment.

Although much of Pietro's sculpture was consumed by a fire in his studio in April 1916, some works survived, and others are preserved apparently only in published photographs. Among those presumed destroyed, the following, all dating before 1914, may be mentioned for their superb quality and bravura technique. *The Veteran*, whose sad eyes, stout nose, and sour mouth speak of world-weariness, was compelling in its ugliness. Two figure studies, *The Stonecutter* and *Proletarian*, demonstrate Pietro's mastery of muscular male anatomy. He was equally capable of producing some very fine literary and allegorical subjects: for example, the emotion-laden *Nydia* and *Dream*, two Rodinesque conceptions in which a woman's head and shoulders emerge from rough-hewn blocks of marble.

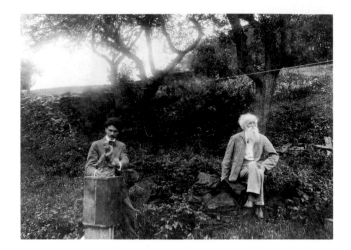

Of existing imaginary pieces, an important sculpture was *Mother of the Dead*, 1914 (present location unknown),[4] Pietro's expression of the ravages of war, in which a somber old woman holds her fatherless grandchild. It was shown at the 1915 Panama-Pacific International Exposition, San Francisco, and was awarded an honorable mention. Of existing portraits, the bust of the composer Giuseppe Verdi, before 1914 (present location unknown, previously owned by the house of Ricordi), is an extraordinarily impressive likeness—boldly drawn with powerful features. It compares favorably with the bust of Verdi, 1873 (The Metropolitan Opera House, New York) by the Neapolitan sculptor Vincenzo Gemito (1852-1929). Both heads are bent downward with the eyes sheltered by massive brows, and each conveys a sense of Verdi's impassioned genius. "General" *William Booth*, 1914 (Salvation Army School for Officers' Training, Suffern, New York), founder of the Salvation Army, is almost as commanding. (A bas-relief, part of a design for a monument to Booth—destroyed in the 1916 conflagration—illustrated an emotional procession of the needy and the suffering and was a deeply moving composition of profound sensitivity.) Special praise was given Pietro's numerous representations of the naturalist John Burroughs (q.v.), images that were immensely popular with critics and the public alike. No less worthy for its excellent characterization is a bronze bust of the explorer and naturalist John Muir, unveiled in 1916 at the University of Wisconsin, Madison. In addition, Pietro made a bronze bust of the statesman Elihu Root in 1915 (Fred L. Emerson Gallery, Hamilton College Collection, Clinton, New York) and portrayed Charles Sprague Sargent, professor and author on

the subject of forestry, whose bust was received by the American Museum of Natural History, New York, in 1917.

Pietro seems to have been most responsive to notable men, for usually in his female sitters he could find little more to describe than their outward appearance. *Dorothy and Helen Gould*, before 1914 (Lyndhurst, Tarrytown, New York), for instance, a double portrait of two young sitters, is elaborate in form but lukewarm in spirit and lacks the spark that imparts a heroic quality to his male figures. His *Baby Betty*, before 1917 (Albright-Knox Art Gallery, Buffalo, New York), nevertheless, is an enchanting evocation of childhood, a seven-inch portrait of a seated little girl, legs splayed, in the rough impressionistic style of bronzes by Medardo Rosso (1858-1928).

Pietro gained further recognition for organizing exhibitions that were held in his studio at 630 Fifth Avenue under the auspices of his newly formed Friends of Young Artists. For the relief of those artists whose earnings had been diminished as a result of World War I, Pietro interested several art patrons in a plan to offer awards of $250, $150, and $100 for the three best sculptures and ten awards of $25 each for contributions by the younger men.[5] Beginning in 1912 his sculpture was exhibited regularly at the annual exhibitions of the National Academy of Design in New York. Pietro's rising fame was arrested when Spanish influenza claimed his life in 1918. He left a host of admirers who mourned his premature passing, among them, Laura Mackay, a sister of John Burroughs's daughter-in-law, who remarked that Pietro "planned great things, great groups, and hoped to do all the crowned heads of Europe. He might have been unsurpassed had he lived!"[6]

K.G.

Notes

1. "C.S. Pietro," *American Art News* 17 (Oct. 19, 1918), p. 4, obit.

2. Jessie Lemont, "The Art of C.S. Pietro," *International Studio* 51 (Dec. 1913), p. cxv, states that Pietro moved to New York in 1909, but *Who Was Who in America*, vol. 1: *1897-1942* (1942), reports that he came to the United States in 1911.

3. Lemont, "Art of Pietro," p. cxix. It is not known whether the replicas were executed. The Pierpont Morgan Library, New York, has no record of them.

4. Presumably *Mother of the Dead* survived the fire since it, or a plaster version, is identifiable in a photograph show-

ing the studio after the disaster; see "Statuary, Portraying Society Children, Destroyed in the Fire Which Wrecked Pietro's Studio," *New York Tribune*, Apr. 30, 1916.

5. "Bust of Professor Sargent in our Natural History Museum," *New York Herald*, Aug. 12, 1917.

6. Laura Mackay to Elizabeth Burroughs Kelley, n.d. (1950s), Collection of Mrs. Kelley, West Park, N.Y. I am grateful to Mrs. Kelley, a granddaughter of Burroughs, for this information.

References
AAAn 16 (1919), p. 223, obit.; Clara Barrus, *The Life and Letters of John Burroughs*, 2 vols. (Boston: Houghton Mifflin, 1925); Jeanne Bertrand, "The Spirit of Today and the Work of C.S. Pietro," *Arts and Decoration* 3 (June 1913), pp. 271-272; BPL; "C.S. Pietro," *American Art News* 17 (Oct. 19, 1918), p. 4, obit.; Jessie Lemont, "The Art of C.S. Pietro," *International Studio* 51 (Dec. 1913), pp. cxv-cxxii; MMA; Matthew Morgan, "The Statuary of C.S. Pietro," *Art and Archaeology* 7 (Sept.-Oct. 1918), pp. 313-322; "Mr. Bock's Gift of the Burroughs Statue," The Toledo Museum of Art, *Museum News*, no. 37, Oct. 1920, unpaginated; W.H. de B. N[elson], "In Memoriam," *International Studio* 66 (Nov. 1918), pp. x-xi; idem, "Portraits in Sculpture by C.L. [sic] Pietro," *American Magazine of Art* 9 (July 1918), pp. 356-357.

CARTAINO DI SCIARRINO PIETRO
137
The Summit of the Years (Portrait of John Burroughs), 1915
Bronze, green over brown patina, lost wax cast
H. 24½ in. (62.2 cm.), w. 11 in. (28.9 cm.), d. 8½ in. (21.6 cm.)
Signed (on base at left side): C.S. PIETRO / © 1915
Foundry mark (on back of base): ROMAN BRONZE WORKS N-Y-
Gift of Mrs. James M. Curley. Res. 18.1

Provenance: Mrs. James M. Curley, Boston
Version: *Bronze*: (1) Edison Institute, Henry Ford Museum and Greenfield Village, Dearborn, Mich.

John Burroughs (1837-1921) was one of America's most skillful practitioners of the literary genre known as the "nature essay." In his writings Burroughs celebrated the glory of the natural universe—birds, flowers, and rural scenes—and reported on his extensive travels throughout the world.

It was the bearded sage, not the anonymous young admirer of Ralph Waldo Emerson and Henry David Thoreau, who sat for Cartaino di Sciarrino Pietro on a number of occasions between

1912 and 1915. Pietro was introduced to Burroughs in July 1912 by a photographer friend, Jeanne Bertrand, who had been camping on the author's Catskills property in Roxbury, New York, with her student Laura Mackay, a sister of Burroughs's daughter-in-law. The two women arranged for Pietro to visit while Burroughs was summering at Woodchuck Lodge, a farmhouse on the grounds. On July 27 Burroughs recorded in his journal: "An Italian sculptor began to make a clay bust of me on Monday, doing well."[1] This was the first of Pietro's portraits of Burroughs. That summer the sculptor also executed a seated statuette (American Museum of Natural History, New York), which the naturalist posed for under an apple tree (see photograph). The statuette was shown in the 1912 winter exhibition at the National Academy of Design and in 1913 at the annual exhibition of the Pennsylvania Academy of the Fine Arts, Philadelphia.

Burroughs sat again for Pietro on November 17 - 19, 1913, in New York City for a bust-length portrait in marble (American Museum of Natural History, New York) that the naturalist pronounced a success: "*That* head looks like the man who can dream dreams It is the best thing that's ever been done of me, by far."[2] This noble bust of Burroughs is one of Pietro's greatest works. It belongs to a group of portraits of illustrious men in which the sculptor brilliantly captured the force of the individual's personality and called to mind the extent of his accomplishments.

By 1915 Pietro was Burroughs's devoted friend, and he returned to Roxbury in August of that year with the idea of having the naturalist pose once more. Writing in his journal on August 13, 1915, Burroughs, who did not relish posing, stated: "Pietro comes to sculpture model [*sic*] me again . . ."; on August 21, "Posing for Pietro since the 14th . . ."; and on August 25, "Am done posing for Pietro. A great relief."[3] During these two weeks the sculptor fashioned a life-size seated statue of Burroughs called *The Seer* (now simply called *John Burroughs*), which was unveiled by the naturalist at the Toledo Museum of Art, Ohio, in April 1918. At the same time he made a life-size bust (present location unknown), possibly in relation to *The Seer*, with the head turned as though to catch the note of a distant bird.

The third portrait that Pietro modeled in August 1915 was the standing statuette *The Summit of the Years*, which derived its name from the title of a book by Burroughs published in 1913, and a cast of

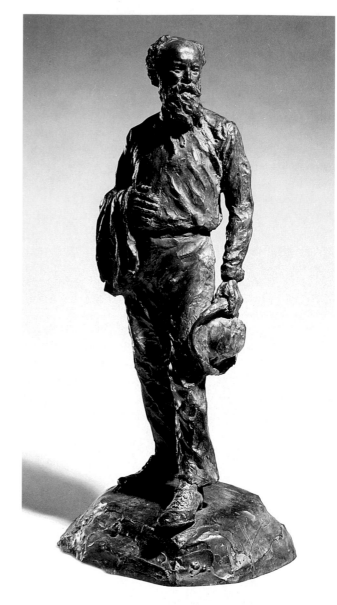

137

which is owned by the Museum of Fine Arts. Clara Barrus, the biographer of the naturalist, described the genesis of the figure: "Shortly before the completion of the large statue, the sitter went away for over Sunday. Not to be outdone, the sculptor said, 'I will do him, even if he has run away.' And with a small pile of clay, he started a statuette on the veranda, at first in jest, merely playing with the clay, getting his revenge by putting his subject in absurd poses; but later, working in earnest, soon, to the onlooker's amazement, the little figure began to live, becoming uncannily like the absent subject. On return, mystified to be confronted by himself, and relieved at having escaped posing for it, Mr. Burroughs willingly consented to the short pose necessary to complete the work."[4]

In late August Pietro left Roxbury with the three portraits in plaster, having cast them at the home of neighbors with whom Pietro stayed during his visits. The standing statuette was well received in the New York press. The *Tribune* reported on September 5, 1915, that Pietro's recent efforts in modeling the naturalist had resulted in contributions "of unusual strength and originality. The most popular, doubtless, will be the statuette, showing Mr. Burroughs in full length."[5] A cast of *The Summit of the Years* was placed above a bird fountain less than one year later in Dearborn, Michigan, at Fair Lane, the home of his friend Henry Ford, before entering the collection of the Edison Institute in the Henry Ford Museum in Dearborn.

The Museum's bronze shows Burroughs amazingly vigorous and almost youthful, with hat in hand. The beard and clothing, especially the legs of the trousers, are swept by a stiff mountain breeze. The general effect is of a man who is at one with the outdoors. It is an imposing figure, which belies the small size of the piece. Characteristic of a sketch, the modeling is broad in handling, particularly in the shirt and pants. Pietro's immense admiration for Burroughs is clearly expressed in the standing statuette and is touchingly summarized in a letter:

Dear Master,
To think of you and to know that I was so near to you is a rare blessed thing to me. I wish a few of those days would come back.

I am so sorry now I didn't take a little more of your company. I felt such a high reverence for you that I never dared be expansive. I hesitated to everything and I wish I could have a little now of your charming company. It would fill a deep penetrating desire. I beg you let me know once in a while how you will be. I shall be

so honored and so thankful I remain your humble servant.[6]

K.G.

Notes

1. Journal entry courtesy of Elizabeth Burroughs Kelley, West Park, N.Y., quoted in Clara Barrus, *The Life and Letters of John Burroughs*, vol. 2 (Boston: Houghton Mifflin, 1925), p. 181. The bust was destroyed by a major fire in the sculptor's studio in 1916. Burroughs had never been fond of it, saying: "That is the head of a statesman — not mine. It looks like Roscoe Conkling." Ibid., p. 225.

2. Barrus, *Life of Burroughs*, p. 225. A bronze copy went to Public School 188 (later officially named the John Burroughs School) in New York; see p. 199.

3. Journal entries courtesy of Elizabeth Burroughs Kelley and Vassar College Library, Poughkeepsie, N.Y.

4. Barrus, *Life of Burroughs*, p. 223.

5. "Patriarchal John Burroughs Dominated Clan More Festival," *New York Tribune*, Sept. 5, 1915.

6. Pietro to Burroughs, mailed Apr. 12, 1916; information kindly provided by Elizabeth Burroughs Kelley.

Frederick Warren Allen (1888 – 1961)

Frederick Warren Allen's career as an artist spanned nearly fifty years, of which forty were spent teaching modeling at the School of the Museum of Fine Arts. Born in North Attleboro, Massachusetts, the son of Frank West Allen and Esther (Belcher) Allen, he was raised in East Attleboro, where in his youth he was employed in jewelry shops, learning a variety of techniques. After graduating from high school, Allen studied at the Rhode Island School of Design, Providence, and was introduced to the medium of sculpture. Having determined to become a sculptor, he enrolled at the Museum School in 1908. For three-and-a-half years he attended Bela Pratt's modeling classes, winning a number of prizes and scholarships. At the beginning of Allen's professional life, Pratt was his most valued supporter, providing him with studio privileges in the evenings and in 1912 helping him secure a position as assistant instructor of modeling at the School.

In the summer of 1913 Allen and his bride, Agnes (Horner), departed for Paris where he briefly trained at the Académie Julian under Paul Landowski (1875-1961) and at the Académie Colarossi under Paul Wayland Bartlett (1865-1925). The stay in Paris afforded Allen the opportunity to leisurely see contemporary sculpture at the Luxembourg Museum, where he passed many hours sketching in the galleries. He also made several portrait reliefs while abroad, among them, one of the sculptor John Storrs, 1913 (present location unknown), a compatriot at the Académie Julian.

Thanks to the continued generosity of Pratt, Allen had work waiting for him when he returned to Boston in the fall of 1913. Pratt had obtained the commission to create three granite reliefs for the Fenway facade of the new Evans Wing of the Museum, and he gave *Painting* to Allen, *Architecture* to Richard H. Recchia, another of his former pupils, and kept *Sculpture*, the central relief, for himself. Although Allen had already received orders for portraits and had been awarded the *Attleboro War Memorial*, 1912, a tablet given by the Daughters of the American Revolution to his hometown, *Painting* was his earliest major piece. A panel measuring about 25 feet long, with two figures—one symbolizing Execution, and the other, Conception—it immediately brought him attention from leaders of Boston's art community.

Allen produced many sculptures between 1913 and 1920, and as a founding member of the Guild

of Boston Artists, he had in its galleries a setting where he could regularly place his objects on view. At the guild's first annual spring exhibition in May and June 1915, Allen entered three small bronzes: a charming fountain figure of a nude boy holding up a distended goatskin, 1914 (Piping Rock Country Club, Locust Valley, Long Island, New York); *Torso*, 1914, another cast of which had recently been exhibited at and purchased by the Boston Art Club; and *Primeval Prayer*, 1915 (present location unknown), illustrating a kneeling male figure with head bowed and arms outstretched. The guild's traveling exhibition of 1915, which initiated its itinerary at the Worcester Art Museum, Massachusetts, in October, included four sculptures by Allen: *Torso*, *Primeval Prayer*, *Nydia*, 1914 (Concord Art Association, Massachusetts), an exceptionally handsome, bronze mask of Sir Edward Bulwer-Lytton's blind heroine of *The Last Days of Pompeii*, and *Cain*, or *Cain and His Conscience*, 1915 (private collection), a bronze statuette of the biblical figure who, here, raises one arm to ward off the apparition of his murdered brother.

In 1916 Allen enjoyed favorable reviews of a display held in April at the Saint Botolph Club, where eighteen of his sculptures were featured, together with paintings by Frederick C. Frieseke

(1874-1939). Some of these were shown at the Guild of Boston Artists' second annual spring exhibition in May and June 1916, causing John Singer Sargent (1856-1925) to single Allen out on the opening day and congratulate him on the high quality of his endeavors.[1]

Allen continued to exhibit regularly at the guild even though during the 1920s his energies were increasingly directed toward teaching, privately and at the Museum School. He was promoted from assistant instructor to full instructor shortly before Pratt's death in 1917, yet he was overlooked when it came time to name Pratt's successor, and Charles Grafly was selected as head of the sculpture department. Since Grafly commuted from Philadelphia to give classes and criticisms every other week, the day-to-day supervising of activities fell to Allen. Perhaps through his association with Grafly, who was closely tied to the Pennsylvania Academy of the Fine Arts, Allen started to exhibit there in 1919 and submitted his works to the academy's annual shows throughout the 1920s.

After about 1920, Allen fashioned fewer of the small Beaux-Arts bronzes he had been known for, such as *The Wave* (William A. Farnsworth Library and Art Museum, Rockland, Maine), and concentrated instead on portraiture, commemorative tablets, architectural sculpture, and memorials. For the Boston Public Library he made a bronze lettered tablet with an inscription honoring the employees of the library who served in World War I. It was erected by fellow workers and placed on the north wall of the courtyard of the main branch in Copley Square in 1924. More ambitious were the bronze portrait of Arnold Shuman, 1920 (Administration Building, Boston City Hospital), an administrator and chairman of the hospital's board of trustees; the gray slate and marble plaque of Annie Talbot Cole, first wife of Samuel Valentine Cole, president of Wheaton College, Norton, Massachusetts, dedicated in 1928 in the college's chapel; and the bronze relief of John P. Sutherland, a dean of Boston University, 1938 (Library, School of Medicine, Boston University). Allen modeled portrait busts as well, an example being the marble *Le Baron Briggs*, unveiled in 1936 (Faculty Room, University Hall, Harvard University).

Allen's most important commission came in 1924 when he was chosen to execute the pediment for architect Guy Lowell's New York County Court House in New York City. Both in Boston, in his newly acquired Tavern Road studio, and in New

York, Allen devoted three years to the pediment, which, when completed in granite, measured 104 feet long and, at its apex, 16 feet high. In addition, it is surmounted by three acroteria in the guise of three figures symbolizing Law, Truth, and Equity. Clearly no minor effort, the pediment incorporates sixteen heroic-size figures, whose subjects befit a courthouse. The central three are Justice, Courage, and Wisdom, flanked by various figures like Philosophy and two groups guarding the record of the Law. Allen conceived the pediment as classical in style and in composition, with the seated and kneeling pendant figures kept in subordination to the central group. Another architectural sculpture, hardly as ambitious as the Court House pediment, was the tympanum for the Church of the Advent in Boston. Dating from 1931 and his only ecclesiastical contribution, it is a memorial to the men of the church who fell in World War I and represents Saint Gabriel and Saint Michael in adoration of the Lord. That same year, Allen provided the town of Dedham, Massachusetts, with a pediment for a World War I memorial, and in 1942 he won a competition for a memorial to George Washington that was installed in Fall River, Massachusetts.

Of particular interest is Allen's turning to direct carving during the 1930s. Using granite rocks he discovered on New England shores that ranged in size from eight-inch stones to large boulders, he carved about eight sculptures by this method, three of which are worth mentioning for their great merit: a green granite *Torso*, 1938 (private collection), big, strong, and timeless; *Elephant*, about 1938 (private collection), powerful, endearing, and not unlike the art of John Flannagan (1895-1942); and *Head* or *Egyptian Head*, 1938 (National Museum of American Art, Washington, D.C.), exhibited at the New York World's Fair in 1939, massive and impressive and Allen's own favorite invention. In fact, Allen wished to be remembered not for his memorials or architectural sculpture but for his direct carvings.

After the 1940s Allen sculpted with less frequency. Nevertheless, until the mid-1950s he retained his position as the gifted head of the sculpture department at the Museum School, of which he became the chief instructor in 1929 upon Grafly's death, and where he was affectionately called "F.W." by the students. In 1954 Allen sold his studio and moved to West Rumney, New Hampshire, where he died in 1961.

K.G.

Notes

1. F.W. Coburn, "Strong Sculptures Shown at Art Guild," *Boston Herald*, May 28, 1916.

References

AAA, SI; BMFA 1977, pp. 34, 106; *Boston Globe*, Jan. 7, 1961, obit.; BPL; Gardner 1965, pp. 161-162; MMA; *New York Times*, Jan. 7, 1961, obit; NYPL; SMFA; Elizabeth MacLean Smith, "Frederick Warren Allen, 1888-1961," *Museum School News and Alumni Bulletin* (June 1962).

FREDERICK WARREN ALLEN
138
Torso, 1914
Bronze, green patina, lost wax cast
H. 11⅜ in. (29 cm.), w. 4½ in. (11.5 cm.), d. 3⅝ in. (9.3 cm.)
Signed (on back of subject's left leg): F.W. Allen
Foundry mark (on back of subject's right leg): MC-GANN CO / FDY
Gift of Mrs. Horatio Greenough Curtis in memory of her husband, Horatio Greenough Curtis. 24.142

Provenance: Mrs. Horatio Greenough Curtis, Boston
Exhibited: BMFA, Exhibition by the Guild of Boston Artists, Mar. 1916.
Versions: *Bronze*: (1) Corcoran Gallery of Art, Washington, D.C., (2) The Metropolitan Museum of Art, New York, (3) present location unknown, formerly Boston Art Club, (4) present locations unknown. *Marble*: (1) Concord Art Association, Mass., (2) private collection

Allen's early *Torso*, or *Torso of a Dancing Girl*, was one of the sculptor's first works executed after his trip to Paris. Allen created the bronze independently of any commission, and he may have chosen this most traditional of subjects as an exercise in treating the human body. Its genesis could have been prompted by any one of hundreds of torsos with which he might have been familiar, perhaps by examples he saw in Paris or by those his teacher Paul Wayland Bartlett had been producing. An appealing rendition of a figure in motion, it is smoothly modeled except for the less finished areas where the limbs and collarbone are cut off.

The *Torso* (not the cast in the Museum of Fine Arts) was first exhibited at the Boston Art Club in April 1915 and was immediately purchased for the club by its artist members.[1] Another cast was shown at the first annual spring exhibition of the Guild of Boston Artists in May and June 1915, and it received words of praise from Marian P. Waitt of the *Boston Journal*, who wrote that it "has all the finish

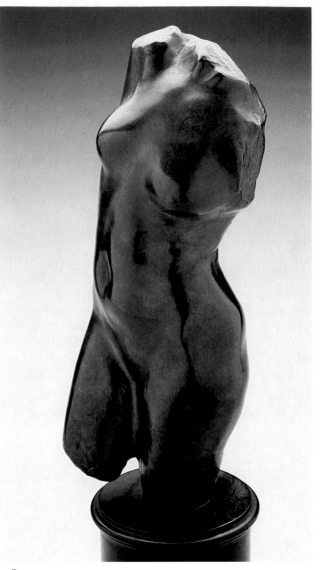

138

and beauty of surface, delicacy and sensitiveness of modeling adequate to express the loveliness of the female figure. In this, again, he expressed only that which was necessary. Head, feet and hands would not have added one whit to its beauty."[2] William H. Downes of the *Boston Evening Transcript* called it "a capital bit of sensitive modeling, suggesting the softness and elasticity of the flesh, without wanting in firmness."[3] The success of the *Torso* was instrumental in gaining recognition for the artist and thus played a role in launching his career. The sculpture also proved to be one of Allen's most frequently exhibited pieces into the 1920s. A bronze was shown at the Museum in March 1916 under the auspices of the Guild of Boston Artists and apparently became the Museum's cast. It was acquired by the sculptor Horatio Greenough's nephew, Horation Greenough Curtis, who lent it to the Museum in 1919 for six months, and again in 1921. The bronze remained in the Museum as a loan until 1924, when Mrs. Horatio Greenough Curtis gave it in memory of her husband, who had died in 1922. It is not certain how many bronzes were cast, but five are thought to have been made. By 1920 a marble version of the *Torso* had been carved as well.[4]

Small in scale yet graceful in movement, Allen's *Torso* is entirely different in conception from his large, sturdy, granite *Torso*, 1938 (private collection). Late in life, Allen came to the conclusion that the lithe and supple forms were more beautiful than the heavier ones.[5]

K.G.

Notes

1. "The Fine Arts: Mr. Allen's 'Torso,' "*Boston Evening Transcript*, May 25, 1915.

2. Marian P. Waitt, "Allen Statuette Draws Attention at Exhibit," *Boston Journal*, May 26, 1915.

3. W[illiam] H[owe] D[ownes], "Sculpture at the Guild," *Boston Evening Transcript*, May 22, 1915.

4. There seem to be discrepancies in references to the number of bronze casts that were made of *Torso*. Gardner 1965, p. 162, in his entry for the cast of *Torso* in the Metropolitan Museum of Art lists four "replicas": the one in the Museum of Fine Arts and three "said to be in private collections in Boston." In an article in the *Boston Evening Transcript* entitled "Shuman Bas Relief," Dec. 21, 1920, the reporter related: "The sculptor [Allen] is also represented just now at the Guild gallery by a marble version of his admirable statuette of a torso, bronze versions of which belong to the Metropolitan Museum of Art in New York [purchased in 1919] and the Boston Art Club, as well as two notable private collections."

5. Elizabeth MacLean Smith, "Frederick Warren Allen: Sculptor-Teacher-Friend," p. 9. Frederick Warren Allen Papers, roll 2329, in AAA, SI.

Leo Friedlander (1888 – 1966)

Imbued with the spirit of the Renaissance, Leo Friedlander approached sculpture from an architect's point of view. Basic to his philosophy was the belief that the mass of a building dictated the style and proportion of any sculptural decoration to be incorporated into its design. He was too much of a classicist to embrace Art Deco's angular, decorative style, but in the 1920s and 1930s he successfully collaborated with contemporary architects, simplifying and flattening the human form in monumental bas-reliefs and freestanding sculptures.

Friedlander's parents, David and Margarethe, were German immigrants who came to New York some years before he was born. His early talent for drawing was rewarded with classes at the Art Students League when he was twelve. At fourteen he was apprenticed to the Klee Brothers ornamental shop, where he constructed scale models for prominent New York architects in a variety of historic styles. In 1908 he went to Europe and studied for three years at the Ecoles des Beaux-Arts in Brussels and in Paris, taking not only life classes and anatomy but also the "Cours Décoratif" in Brussels, for which he was required to design architectural sculpture in both two and three dimensions. Later, he would follow this practice in line drawings that look more like blueprints and in scale models that include architectural settings.

In 1913 Friedlander won the prestigious Prix de Rome for three years of study at the American Academy in Rome. The small figures he produced during this period are similar to those created by Paul Manship during his term there—decorative, stylized pieces with mythological themes that were inspired by archaic Greek sculpture and Egyptian relief carvings. Friedlander's compositions, however, are less rhythmic than Manship's and more enclosed in form, already suggesting his talent for monumental design.

Following his return to New York in 1917, Friedlander went to Washington, D.C., and helped in the war effort by designing aircraft and ships for the navy. After World War I he assisted Manship and Hermon MacNeil (1866-1947) until the 1920s, when he received commissions from the well-known architect Bertram Grosvenor Goodhue (1869-1924) for ecclesiastical sculpture in the Midwest and West. During this time he was also kept busy with the relief decoration (eight metopes) for the facade of the Lee Higginson & Company Bank, New York

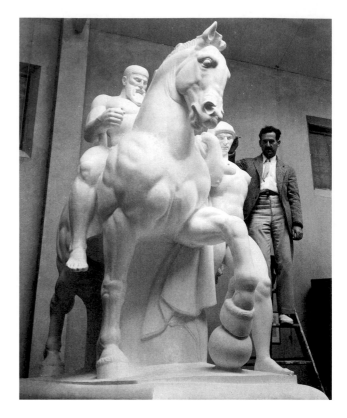

(now the Bank of America, Broad Street), completed in 1929. To facilitate the process of roughing out masses and outlines, Friedlander, with the use of lantern slides onto which he had copied line drawings, projected images onto a flat box of modeling clay. He thus saved the time it would have taken to enlarge the scale in succeeding models. His columnar figures admirably suited the severe classicism of the bank building and were an excellent preparation for his later work on the RCA building at Rockefeller Center, New York. In 1929 he was awarded his most important and best-known commission by the New York architectural firm of McKim, Mead and White: the pair of colossal equestrian groups, entitled *The Arts of War*, that flank the entrance to the Arlington Memorial Bridge in Washington, D.C. Both *Valor* and *Sacrifice*, modeled respectively in 1916 (while Friedlander was in Rome) and 1929, represent heroic virtues on a grand scale. Originally planned to be carved in granite to match the material of the bridge, they were finally cast in the less costly medium of gilded bronze in 1950 from funds donated by the Italian government in appreciation of America's economic assistance after World War II.

By 1933 Friedlander was well established and the

recipient of other notable commissions. For the RCA building he was asked to create two pairs of reliefs for the north and south entrances: *Radio* and *Television*, and *Transmission* and *Reception*, a commission that epitomized for him the aims of modern architecture. Friedlander's concept was bold, and he persuaded Raymond Hood (1881-1935), the building's architect, to plan a height of 18 rather than 12 feet for the relief figures. Furthermore, he conceived of the reliefs as decorative adjuncts that should not interrupt the vertical thrust of the building. For the New York World's Fair in 1939, Friedlander designed the colossal figures *The Four Freedoms*, representing speech, press, assembly, and religion, in a streamlined style that pleased the public and the majority of the members of the National Sculpture Society, if not those with more advanced artistic tastes.

During World War II, with few orders for public monuments, Friedlander taught sculpture at New York University's School of Architecture, as he had since 1936, and at his studio in White Plains, New York.[1] In the 1950s he was once again involved with architectural projects designing sculptural reliefs for office buildings as well as monuments honoring American war heroes, such as the 22-foot figure called *Memory*, a combined World War II and Korean War Memorial, for Richmond, Virginia, dedicated in 1956.

An outspoken critic of avant-garde art and congressional efforts to legislate the direction of cultural life, Friedlander took full advantage of his presidency of the National Sculpture Society from 1954 to 1957 to air his views on the editorial page of the organization's journal, *National Sculpture Review*. In the spring 1955 issue, aligning himself with the traditions of the Renaissance and antiquity, he attacked those who wished to eliminate decoration from the facades and interiors of buildings. He also took the opportunity to equate the avant-garde with artistic extremists and labeled their efforts "a wild and vicious circle of blind experimentation with the obscure fantasies of a weird expressionism."[2]

At a panel on government and the arts in 1957, Friedlander objected to a proposal for the establishment of a federal advisory commission on the arts, fearing that such a group would be made up of nonpractitioners—museum directors, art historians, critics, patrons, and teachers—rather than the artists themselves. He worried that personal taste would determine the awarding of contracts and the selection of projects and competitors and that those

individuals with radical tastes would set the tone for the rest.[3]

Commissions for a war memorial at Hamm, Luxembourg, dedicated in 1960, and ecclesiastical sculpture for the Cathedral of Mary Our Queen in Baltimore and the Wesley Theological Seminary in Washington, D.C., unveiled in 1956 and 1960, respectively, occupied Friedlander in the later years of his life. He died at the age of seventy-eight in White Plains, New York.

In 1984 the Hudson River Museum, Yonkers, New York, organized a retrospective of Friedlander's work featuring his early pieces and drawings, plaster models, and bronze studies. This exhibition helped to remind contemporary viewers of the sculptor's versatility in adapting the rich academic traditions of the past to meet the demands of contemporary architecture.

P.M.K.

Notes

1. Friedlander's studio, designed by Riccardo Bertelli of the Roman Bronze Works, New York, in 1908, was listed on the National Register of Historic Places by the United States Department of the Interior in 1982.

2. Leo Friedlander, "Architecture and Sculpture," *National Sculpture Review* 4 (spring 1955), reprinted from *Journal of the American Institute of Architects* 23 (May 1955), pp. 220-222.

3. The National Commission of Fine Arts, established in 1910, which governs and initiates architectural and fine arts projects for the District of Columbia, is composed strictly of architects, sculptors, and painters. Both Daniel Chester French and Paul Manship served as chairmen of its board.

References

AAA, SI; Gordon D. Friedlander, "Friedlander's Arlington Bridge Equestrians," *National Sculpture Review* 17 (fall 1968), pp. 21-24; idem, "Leo Friedlander, Twenty-first President, National Sculpture Society, 1954-1957," *National Sculpture Review* 17 (winter 1968-1969), pp. 22, 27; Leo Friedlander, "Dexterous Hands," *Liturgical Arts* 17 (May 1949), pp. 88, 95; idem, "Panel: Government and the Arts," *Journal of the American Institute of Architects* 28 (June 1957), pp. 111-113; idem, "Historic Buildings—Landmarks and Monuments," *Journal of the American Institute of Architects* 27 (Mar.-Apr. 1957), pp. 102-105, 152-155; idem, Letter to the Editor, *New York Times*, Mar. 21, 1955; idem, "Line Drawing Composition in Three Dimensions," *Pencil Points* 7 (1926), pp. 45-47; idem, "Modern—and All Too Modern," *Journal of the American Institute of Architects* 24 (Aug. 1955), pp. 81-84; idem, "The New Architecture and the Master Sculptor," *Architectural Forum* 46 (Jan. 1927), pp. 1-8; Leo Friedlander et

al., "The American Academy in Rome: What Is Its Educational Value Today?" *Journal of the American Institute of Architects* 18 (July 1952), pp. 27-28; The Hudson River Museum, Yonkers, N.Y., *Sculpture on a Grand Scale: Works from the Studio of Leo Friedlander*, exhibition catalogue by Joel Rosenkranz (1984); *New York Times*, Oct. 25, 1966, obit.; "Some Recent Sculpture by Leo Friedlander," *Architecture* 60 (Sept. 1929), pp. 159-164; "Studio of Leo Friedlander, White Plains, New York," *National Sculpture Review* 32 (winter 1983-1984), p. 29; Ralph T. Walker, "Architectural Sculpture by Leo Friedlander," *Architectural Forum* 65 (Dec. 1936), pp. 533-538.

Leo Friedlander
Abraham Lincoln, about 1932
139
Bronze, dark brown patina, sand cast
H. 15 in. (38 cm.), w. 10¼ in. (26 cm.), d. 9¼ in. (23.5 cm.)
Foundry mark (on back of base): KUNST F. DRY, NY
Gift of Mr. and Mrs. Joseph P. Pellegrino. 1984.560

Provenance: Gordon D. Friedlander, White Plains, N.Y.; Conner-Rosenkranz, New York; Mr. and Mrs. Joseph P. Pellegrino, North Andover, Mass.
Exhibited: The Hudson River Museum, Yonkers, N.Y., *Sculpture On a Grand Scale: Works From the Studio of Leo Friedlander*, exhibition catalogue by Joel Rosenkranz (1984).

139

Early in the 1930s Leo Friedlander designed four scale models representing Abraham Lincoln, Paul Revere, and personifications of peace and war. Although he hoped to secure commissions for them as colossal sculpture, each survives only as a maquette.[1] The Museum's *Lincoln*, intended to be cast from sixty to eighty feet high, manages to convey a sense of monumentality and nobility despite being quarter-life-size.

One of the most revered figures in American history, the Civil War president (1809-1865) is portrayed as a standing figure in a pensive mood, with head bowed and arms held close to his body. A draped cloak falls over his arms in deep folds. Facial features are barely articulated; the emphasis, rather, is placed on broadly handled, frontal planes. A raised platform with side ramp, which Friedlander planned for pedestrian traffic, further adds to the containment of the blocklike composition.

Ralph Walker (1889-1973), the noted New York architect, had suggested the idea of a Lincoln monument to Friedlander, whose heroic but severe style he thought would admirably reflect the majestic simplicity of the Illinois plains.[2] Friedlander began

the study hoping that the city of Springfield, Illinois, where Lincoln had practiced law, would commission the work. But when Walker's firm, Voorhees, Gmelin, and Walker, submitted a plan for a Chicago civic center with war memorial, Friedlander's design for a colossal standing Lincoln was included. Three surviving photographs and a pencil and watercolor drawing, rendered by the architectural illustrator John C. Wenrich (1894-1970) in 1931, show this proposed sculpture to be close in mood to that of the Museum's model, although the figure, as shown from the rear in the sketch, clasps his hands behind him and the drapery appears more classically inspired, with a pattern of vertical folds.[3]

Walker's firm did not win the competition, but in 1936 Walker and Friedlander successfully collaborated on the *Roger Williams Memorial* (Columbia Terrace, Providence, Rhode Island), which was obviously inspired by their earlier efforts. The sculpture's commanding site, overlooking the Old State House and the city, provides an ideal background for the colossal granite statue, terrace, and garden park.

Apparently Friedlander's plans for executing a Lincoln memorial were dropped until 1961, when the New York builder Erwin S. Wolfson, acting as the sculptor's agent, submitted sketches of the *Lincoln* to Carl Haverlein, president of Broadcast Music, New York, who represented a group of art collectors.[4] Nothing, however, came of this effort.

In Friedlander's earlier work, such as *Mother and Infant Hercules*, 1916 (private collection, Southbury, Connecticut), there is the same stylized, architectonic form as in the *Lincoln*. The president's brooding nature also echoes that of other somber, weighty figures such as the 12-foot-high granite group, *Three Wise Men*, 1924, which he designed for a private chapel in Berkeley, California. The *Lincoln* was probably first begun as a drawing, although no copy survives. A mock-up plaster of the architectural setting was modeled, for which a photograph exists.[5] The study was then formed in clay or plaster, and the Museum's bronze was cast from that. In the spring of 1984, the maquette was exhibited for the first time at the Hudson River Museum in a Friedlander retrospective.

<div align="right">P.M.K.</div>

Notes

1. See list of sculpture and drawings remaining in Friedlander's White Plains studio at the time of his death, Leo Friedlander Papers, AAA, SI.

2. Telephone conversation between Paula M. Kozol and Gordon D. Friedlander, the sculptor's son, May 2, 1985. Walker was chairman of the design board for the 1939 New York World's Fair.

3. Two photographs, one a three-quarter view and one showing the figure on a tiered ramp, are in the Friedlander Papers; a third, frontal view, is in BMFA, ADA. Wenrich's drawing, which explores the relationship between the colossal figure and the slablike skyscrapers, is at the Art Institute of Chicago; it was published first in *Pencil Points* 12 (Nov. 1931), p. 823, with description on p. 824, and again in Walker's memoirs, *Ralph Walker, Architect* (New York: Henahan, 1957), p. 132.

4. See letter from Wolfson to Haverlein, Jan. 31, 1961, Friedlander Papers. There is also an undated letter from the New York architect Francis Keally (1889-1978) to Friedlander, wishing him well on the proposed contract and praising him for his "beautiful concept of Lincoln! Peaceful, meditating, and a sense of the ages!" Friedlander Papers. Keally had designed the World War II chapel and cemetery at Hamm, Luxembourg, for which Friedlander created the granite statue *Archangel* and the chapel's panel door in 1960.

5. BMFA, ADA.

Richard H. Recchia (1888 – 1983)

A charter member of the Guild of Boston Artists, first secretary of the Boston Society of Sculptors (both formed in 1914), and a founding member of the Society of Boston Sculptors (1923), Richard Recchia was in the vanguard of Boston art in the 1920s and 1930s, promoting cooperative shows and the acceptance of Boston as an art center. Though trained in the Beaux-Arts tradition under Bela Pratt, he responded to the simplified and stylized forms of Art Deco and early modernism and became one of the first of his generation in Boston to experiment with abstraction.

Born in Quincy, Massachusetts, to Louise (Dondero) and Frank C. Recchia, Richard Recchia received his earliest training in the shop of his father, an expert marble carver from Verona, Italy. Recchia was apprenticed to him for two years after leaving school in the eighth grade. The bust of Beethoven, which he modeled at fifteen, was shown by his proud father to Pratt, who encouraged the talented novice to enroll in the School of the Museum of Fine Arts. From 1904 to 1907 he studied modeling and anatomy there, while helping in Pratt's Harcourt Street studio in Boston's Back Bay. Recchia won the Kimball Prize in modeling, two years in a row, concentrating his efforts on reliefs of arcadian subjects.

After graduation, Recchia remained in Pratt's studio until January 1912, when he sailed for Europe with the financial support of Pratt as well as Daniel Chester French, who had known him as an apprentice in his father's shop. Before Recchia left, French had reminded him that he needed "the influence of Paris much more than that of Rome," since his work at that time had "enough of the Roman or Greek spirit."[1] Pratt, on the other hand, advised the aspiring sculptor to stay in Rome "long enough so that you can feel that you know the place pretty well and then, in imagination, you will always be able to go back an [sic] see things that most impressed you."[2]

Recchia did not arrive in Paris until April, when he wrote to French about his impressions. The older sculptor responded to his apparently negative criticisms, assuring him that "the more familiar you become with the things that are being produced there, the more good you will see in them. There is more for the modern artist in Paris than anywhere else in the world and I cannot help thinking that you have made a mistake in spending so much time in Italy."[3]

Despite French's misgivings, Recchia seemingly made the most of his brief time in Paris, sharing a studio and garden off the Boulevard Montparnasse with the French painter Felix Eysken, studying at the Académie Julian, and even falling in love and marrying Anita Diaz, a young woman from Chile, before he returned to Boston in the fall. His bas-reliefs of John Storrs (q.v.) and other students at the Académie Julian, however, continued in the same manner as his 1910 portraits of Pratt (q.v.) and his father (q.v.), suggesting that the strongest influence on him remained his early training.

The next five years Recchia spent assisting Pratt in the mornings and working on his own in the afternoons in an adjoining studio on Saint Botolph Street. His first important commission came in 1913 when Pratt invited him to design one of the relief

panels for the entablature of the Museum's new Evans Wing. Recchia's contribution, two kneeling allegorical figures, Building and Design, 1914, personifying Architecture, proved to be as accomplished as the two panels created by Pratt and his other assistant, Frederick W. Allen.

In 1915 at the Panama-Pacific International Exposition in San Francisco, Recchia received a bronze medal for *Golden Age*, 1909 (Katharine Lane Weems, Manchester, Massachusetts), the nude figure of a boy, and a gold medal for his bust of A. Piatt Andrew, United States congressman from Boston's North Shore. From then on, he exhibited regularly in Boston, at the Rockport Art Association, and at the North Shore Arts Association's annual summer shows in Gloucester, Massachusetts, where he was best known for his portraits and his garden sculpture. The Boston critics found him to be "the most sensitive of local modellers."[4] Frederick W. Coburn, in a review of Recchia's one-person show at the Saint Botolph Club in 1926, praised his "exquisite artistry, creative ability and disposition to venture into exploration of the psychological possibilities of his art."[5] Those who remembered his early promise now watched as he began to move away from portraiture and ideal subjects, modeled impressionistically, toward an increasing simplification of form.

Widowed in 1926, Recchia married the poet and painter Kitty Parsons (1889-1976) the following year and moved permanently to Rockport in 1928. The ample studio and sculpture garden he added in 1935 to their home, Hard Scrabble, became a regular destination for those attracted to this famous artists' colony. *Baby and Frog*, 1923 (Rockport Art Association), an animated bronze group modeled after his daughter and a leaping frog, held center stage in their outdoor fountain, except for the occasion when it was placed at the entrance to "Gardens on Parade" at the New York World's Fair in 1939. Brookgreen Gardens (Murrells Inlet, South Carolina) acquired a reduction (14½ inches high) of this in 1936.

During the 1930s Recchia's work took on a decidedly humorous tone, with animal and bird studies often seeming more like caricatures than objects for contemplation. Even here, the critics respected his integrity and found to their surprise that such pieces as *Dozing Duck*, 1931, *Great Horned Owl*, 1931 (both Rockport Art Association, Massachusetts), and *Persian Cat* (q.v.) were quite modern in their simplicity.

In 1941, to please the children of Massachusetts, Recchia designed a tribute to Elizabeth Foster Vergoose, the purported creator of Mother Goose. Cast in bronze, 29 inches high, the sculpture depicts Mother Goose telling stories to two children; around the base, twelve characters illustrate scenes from the beloved nursery tales. Although Recchia tried to have a heroic-size monument placed either on the Boston Common or in the Public Garden, he was unsuccessful and in 1976 gave the small bronze to the Carnegie Public Library, Rockport. He was more fortunate with his only equestrian figure, a stylized, heroic-size bronze of General John Stark, 1948 (Stark Park, Manchester, New Hampshire), the revolutionary war hero who led the Green Mountain Boys to victory in the battle of Bennington, Vermont, and shared command at the battle of Bunker Hill. In 1945 Recchia won the competition for the memorial from among eighty-four entrants, submitting a model he had begun in 1935.

Among the works that Recchia considered his best was *Peace*, which he completed in 1941 and first called *Cannon Fodder* (Gordon College, Beverly, Massachusetts). An over life-size plaster, this portrayal of a woman standing with head bowed and supporting a baby in her outstretched palms, was shown at the National Academy of Design, New York, in 1954.

In 1944 Recchia was elected an academician of the National Academy of Design, winning the prestigious Elizabeth N. Watrous Gold Medal for his bronze bust of the Boston sculptor Raymond Porter (q.v.). With the growing popularity of nonfigurative sculpture after World War II, however, Recchia's more conservative style became increasingly outmoded. Nonetheless, he continued to exhibit at the Rockport Art Association and mounted his own campaign to interest municipal groups and public galleries in acquiring his sculpture. He continued to work in his studio well into his nineties, although after his wife died he became something of a recluse.

P.M.K.

Notes

I acknowledge with gratitude the assistance of Frederik C. Hoffmann, senior vice-president and trust officer, Bank of New England, North Shore, and Margaret Cassidy Manship, a sculptor and archivist in Rockport, who generously gave of their time in showing me Recchia's studio and papers.

1. French to Recchia, Nov. 22, 1911, Richard H. Recchia Papers, Sawyer Free Library, Gloucester, Mass.

2. Pratt to Recchia, Feb. 15, 1912, Recchia Papers.

3. French to Recchia, June 14, 1912, Recchia Papers.

4. "Recchia Works Shown Here," *Boston Traveller*, Dec. 15, 1926.

5. Frederick W. Coburn, "In the World of Art," *Boston Herald*, Dec. 19, 1926.

References

Boston Globe, Aug. 19, 1983, obit.; John Cooley, "The Recchias of Rockport," *North Shore '74*, Oct. 19, 1974, pp. 10-12; Michael Lantz and Theodora Morgan, "Richard Recchia of Rockport," *National Sculpture Review* 27 (summer 1978), pp. 20-22, 26-27; A.J. Philpott, "Recent Sculptures of Recchia on Exhibition," *Boston Globe*, Dec. 19, 1934; Proske 1968, pp. 216-218; Richard H. Recchia Papers, Sawyer Free Library, Gloucester, Mass.; SMFA.

140

RICHARD H. RECCHIA

140

Head of an Athlete, 1906

Marble

H. 15¼ in. (38.7 cm.), w. 16 in. (40.6 cm.), d. 7⅜ in. (18.8 cm.)

Signed (on back at right shoulder): BY-R.H. RECCHIA. / 1905

Bequest of Richard H. Recchia. 1984.740

Provenance: Richard H. Recchia, Rockport, Mass. Exhibited: The Copley Society of Boston, *Loan Collection of Paintings by American Artists* (1907), no. 133; Saint Botolph Club, Boston, *An Exhibition of Sculpture by Richard Recchia* (1926), no. 22.

While studying antique casts in 1905 during his second year at the School of the Museum of Fine Arts, Richard Recchia created his first life-size figure in plaster, *The Shot-Putter* (present location unknown). Judging from an extant photograph of this sculpture,[1] the Museum's *Head of an Athlete* is probably a variant that was executed in marble at the shop of his father, Frank C. Recchia, on Warren Avenue, Boston, in 1906.[2] A remarkably sensitive portrayal, the well-modeled bust demonstrates Recchia's precociousness at seventeen. The taut neck and facial muscles, as well as the subject's sharply turned head, illustrate the moment before the athlete puts the shot. Though perhaps inspired by Hellenistic prototypes, the young sculptor's school exercise is "more of the modern gymnasium type."[3] Indeed, the bust appears to be a close likeness of Joseph L. Baum, an instructor in physical training from East Boston.[4]

Recchia had learned to carve marble as an apprentice in his father's shop, but in his later sculptures he relied on others to point up as well as carve marble versions of his clay and plaster models, which he then would bring to completion himself. While assisting in Bela Pratt's studio, Recchia modeled the bas-relief representing Architecture for the Fenway facade of the Museum in 1912, and his father translated the design into stone.

In 1929 Recchia engaged in vigorous debate with Albert Franz Cochrane, the art critic for the *Boston Evening Transcript*, who protested the practice of sculptors leaving the pointing and finishing of their sculpture to others. Reviewing a current show of the Boston Society of Sculptors at the Boston Art Club, Cochrane noted that only one piece was cut in marble, with the remaining pieces left in plaster, waiting to be commissioned.[5] In several letters to the editor of the *Transcript*, Recchia defended this tradition, reminding the newspaper's readers that no less a sculptor than Michelangelo had relied on the talents of others to help complete his work.[6]

P.M.K.

Notes

1. See Recchia's scrapbook of newspaper clippings concerning his early pieces, Richard H. Recchia Papers, Sawyer Free Library, Gloucester, Mass.

2. See unidentified newspaper clipping, summer 1906, SMFA, vol. 3, p. 7.

3. A.J. Philpott, "Young Boston Sculptor," *Boston Globe*, Sept. 22, 1907.

4. See note 2 above.

5. Albert Franz Cochrane, "Small Sculpture at Art Club," *Boston Evening Transcript*, Jan. 19, 1929.

6. See letters to the editor from Richard Recchia, *Boston Evening Transcript*, Jan. 29 and Feb. 7, 1929. On Feb. 10, 1929, Cyrus Dallin wrote approvingly to Recchia: "I am glad you have taken up the cudgels as I was tempted to again jump on the Transcript—as the present critic is quite as incompetent as the former one." Recchia Papers. (Dallin was no doubt referring to the difficulties he had experienced in rallying public support for his equestrian sculpture of Paul Revere [Paul Revere Mall, Boston].) The Boston sculptor Albert Henry Atkins, three days earlier, also complimented Recchia for giving Cochrane "a darned good licking. . . . I should think [t]hat the galleries could see the advantage of having the pest removed and an advertisement written by themselves . . . [then] their current exhibitions would draw a more sympathetic public to their galleries." Letter from Atkins to Recchia, Feb. 7, 1929, Recchia Papers.

RICHARD H. RECCHIA

141

Bela Lyon Pratt, 1910
Bronze, dark brown patina, sand cast
H. 22¼ in. (56.5 cm.), w. 14½ in. (36.8 cm.)
Signed (at lower left): R·H·RECCHIA·1910
Inscribed (at bottom): BELA·LYON·PRATT
Foundry mark (on underside at left): ROMAN BRONZE WORKS N.Y.

Bequest of Richard H. Recchia. 1984.742

Provenance: Richard H. Recchia, Rockport, Mass.
Exhibited: BMFA, *Exhibition of Works by Recent Graduates of the Museum School* (1911), no. 70; Poland Spring Art Gallery, South Poland Spring, Maine, *Seventeenth Annual Exhibition of Paintings and Sculpture by Prominent Painters and Sculptors* (1911), T.; Buffalo Fine Arts Academy and Albright Art Gallery, N.Y., *Contemporary American Sculpture* (1916), no. 639; BMFA, *Exhibition of Paintings and Sculpture by Alumni of the School of the Museum under the Auspices of the Copley Society* (1921), no. 167; Guild of Boston Artists, *Exhibition of Sculpture by Richard H. Recchia* (1923), no. 3; BMFA, *Exhibition of Works by Members of the Boston Society of Sculptors* (1925), no. 86; North Shore Arts Association, Gloucester, Mass., *Fourth Exhibition* (1926), no. 9; Saint Botolph Club, Boston, *An Exhibition of Sculpture by Richard*

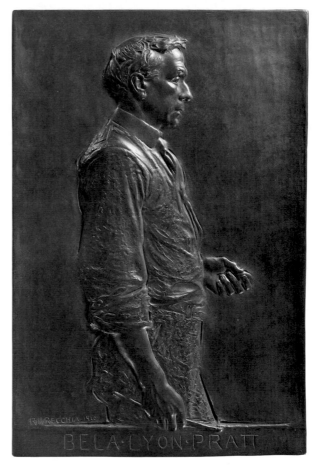

141

Recchia (1926), no. 26; Fitchburg Art Association, Mass., *Exhibition of Small Bronzes by Richard H. Recchia and Water-Colors by Charles Austin* (1929), no. 12; Guild of Boston Artists, *Exhibition of Sculpture by Richard H. Recchia* (1934), no. 16; Fifty-Sixth Street Galleries, New York, *Exhibition of Sculptures by Richard H. Recchia* (1931), no. 22; The Architectural League, New York, May 19-20, 1939.
Version: *Bronze*, dimensions unknown: (1) present location unknown, formerly Bela Lyon Pratt, Boston

In 1910, the year Recchia graduated from the School of the Museum of Fine Arts, he failed to win the Rinehart Scholarship to study at the American Academy in Rome. Bela Pratt, in whose studio Recchia had been working since 1906, tried to console him for taking second place. "I am very much surprised that you did not get the Roman prize, but I don't think it need disturb you in the least. All you have got to do is to keep on improving as fast as you have and very soon you will force them to give you whatever you want. There is nothing like sticking to it, with your ideals well in advance."[1]

Recchia's father, Frank, had been instrumental in securing his son's place as an assistant in Pratt's

studio in 1906, and Pratt had assumed the responsibility for Recchia's development. The warmth Pratt felt for his young apprentice is apparent in a series of letters the older man wrote during the summers he spent in North Haven, Maine, while Recchia remained in the city.

"How have you managed to exist in the studio the past hot days?," Pratt inquired on August 19, 1906. "If you find it too warm take as many days off as you feel like. A trip down the harbor now and then will do you a lot of good."[2]

The following spring Pratt felt it necessary to reassure Recchia that suggestions for taking a little vacation were only because Pratt thought he "looked rather used up and tired. You went off so subdued that I thought you might think I did not want you here. That is as far from the fact as possible. I am always glad to have you here."[3]

Sometime during 1910 Recchia modeled two bas-reliefs of Pratt; one of these (present location unknown) was bought by the sitter, and the other is the Museum's example. Close in style to that of Pratt's reliefs, Recchia's treatment is understated, with details reduced to the sitter's short, wavy hair, furrowed brow, high cheekbones, and the natural wrinkles of his dignified work clothes—a tie and rolled up shirt-sleeves. Short in stature but, at forty-three, assured in his profession, Pratt stands in profile, calmly gazing ahead, a modeling tool in his right hand.

Often exhibited with Recchia's bas-relief of his father (q.v.), the portrait of Pratt is generally considered "more successful, the figure being more subtle and less obviously projected."[4] In May 1939, in a competition for small reliefs, medals, and plaques sponsored by the National Sculpture Society, New York, the *Pratt* relief won the Lindsey Morris Memorial Prize.

P.M.K.

Notes

1. Pratt to Recchia, July 21, 1910, Richard H. Recchia Papers, Sawyer Free Library, Gloucester, Mass.

2. Pratt to Recchia, Aug. 19, 1906, Recchia Papers.

3. Pratt to Recchia, Mar. 25, 1907, Recchia Papers.

4. H.P., "Sculptures by Recchia," *Boston Evening Transcript*, Nov. 27, 1923.

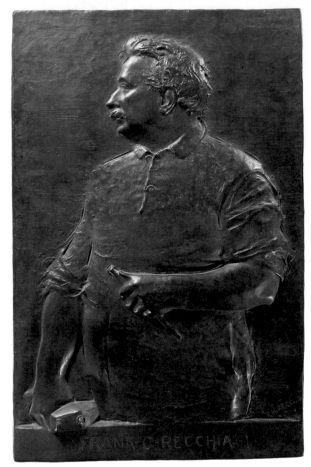

142

RICHARD H. RECCHIA

142

Frank C. Recchia, 1910

Bronze, dark brown patina, sand cast

H. 21½ in. (54.6 cm.), w. 13¾ in. (34.9 cm.)

Signed (at lower right): R·H·RECCHIA / 1910

Inscribed (at bottom): FRANK-C-RECCHIA·

Foundry mark (on underside at right): ROMAN BRONZE WORKS N.Y.

Bequest of Richard H. Recchia. 1984.741

Exhibited: National Academy of Design, New York, *Winter Exhibition* (1910), no. 13; BMFA, *Exhibition of Works by Recent Graduates of the Museum School* (1911), no. 73; Guild of Boston Artists, *Exhibition of Sculpture by Richard H. Recchia* (1923), no. 4; Guild of Boston Artists, *Exhibition of Sculpture by Richard H. Recchia* (1934), no. 15.

Born in Verona, Italy, where he studied with the sculptor Grazioso Spazzi, Francesco Recchia, father of Richard H. Recchia, came to America at twenty-five, an experienced marble carver. Shortening his name to Frank C. Recchia, he was soon assisting such eminent New York sculptors as Daniel Chester French; Karl Bitter (1867-1915); Richard Brooks

(1865-1919), with whom his son Richard later studied; Augustus Lukeman (1872-1935); Evelyn Longman (1874-1954), French's only woman assistant; and Hermon A. MacNeil.[1] Frank Recchia's contribution to the development of sculpture in America epitomizes that of countless nineteenth- and early twentieth-century European immigrants who gave their talent, for the most part anonymously, to support many of this country's leading artists.

After moving to Quincy, Massachusetts, a city of granite quarries, which attracted such prolific sculptors as Henry Hudson Kitson and enjoyed more than its share of stone-carving shops for the production of cemetery memorials, Frank Recchia settled in Boston in 1896 and opened a studio and shop at 68 Warren Avenue, near the Museum of Fine Arts.[2] Around 1907 he established a new shop at 79 Main Street, Cambridge. He continued his New York connections, notably carving for French in 1906 the highly experimental design for the nine-foot granite Indian on the *Parkman Memorial* (southwest shore of Jamaica Pond, Boston). Principally assisting Bela Pratt, the elder Recchia carved the bust of Bishop Phillips Brooks, 1899 (Brooks House, Harvard University); the pedestals for the New Bedford *Whalers' Monument*, 1913; the relief entablature for the Fenway facade of the Museum, 1914; and the *Civil War Army Nurses Memorial*, 1914 (Nurses Hall, State House, Boston). In 1920 Frank Recchia returned to Italy, just three weeks before he died. He is buried there in the hill town of Arco, at the head of Lake Como.

Richard Recchia's bronze bas-relief of his father is a tender tribute to their close relationship. Frank was his first teacher, and in the older man's busy shop Richard learned how to carve and model. There he met French and Pratt and received encouragement for his early efforts.

Appropriately, Richard's likeness of Frank is a close one; contemporary photographs show the same fleshy cheeks and thick neck, Roman nose, and bushy mustache. A broad-chested man with a steady hand, Frank engendered a trust that is readily conveyed in a straightforward representation. In this restrained portrait, which is similar to his likeness of Pratt (q.v.), Recchia highlighted the carver's strong, muscular arms and the tools of his profession, a mallet and chisel. The inscription is simply rendered but placed cleverly on a parapetlike lower edge, a device he also used for the *Pratt* relief.

This bas-relief was first shown in plaster at the Poland Spring Art Gallery's seventeenth annual ex-

hibition of painting and sculpture, in South Poland Spring, Maine, in 1910. At Recchia's one-person show at the Guild of Boston Artists in 1923, E.C. Sherburne, critic for *Art News*, was enthusiastic in his praise of Recchia's portraits, which he reported "long ago took their place in the local art world because of their vigor and charm."[3]

P.M.K.

Notes

1. See letter from Richard Recchia to Frederick A. Davis, F.P. Davis Monumental Works, Inc., Feb. 20, 1965. Richard H. Recchia Papers, Sawyer Free Library, Gloucester, Mass. For a description of Frank Recchia's working methods, see "Recchia, Master Craftsman in Marble Sculpture," [Boston] *Sunday Herald*, Sept. 27, 1908, magazine section.

2. Frank Recchia's letterhead advertised "Stairway, Modeling, Artistic Memorial Monuments and Ornamental Work," Recchia Papers.

3. E.C. Sherburne, *Art News*, Dec. 1, 1923, p. 11.

RICHARD H. RECCHIA
143
John Storrs, 1912
Bronze, dark brown patina, lost wax cast
H. 8⁵⁄₁₆ in. (21.1 cm.), w. 6³⁄₈ in. (16.2 cm.)
Signed (at top right): R·H·RECCHIA
Inscribed (at bottom): - JOHN·STORRS- / PARIS·JUNE·20· 1912
Foundry mark (at top right): ·CIRE / C. VALSUANI / PERDUE
Bequest of Richard H. Recchia. 1984.743
Provenance: Richard H. Recchia, Rockport, Mass.
Exhibited: Doll & Richards, Boston, *Small Bronzes by American Sculptors* (1912), no. 82; Guild of Boston Artists, *First General Spring Exhibition* (1915), no. 63; idem, *Exhibition of Sculpture by Richard H. Recchia* (1923), no. 2; Saint Botolph Club, Boston, *An Exhibition of Sculpture by Richard Recchia* (1926), no. 31; North Shore Arts Association, Gloucester, Mass., *Fifth Exhibition* (1927), no. 9; Fitchburg Art Association, Mass., *Exhibition of Small Bronzes by Richard H. Recchia and Water-Colors by Charles Austin* (1929), no. 9; Guild of Boston Artists, *Exhibition of Sculpture by Richard H. Recchia* (1934), no. 18.

On December 31, 1912, Daniel Chester French wrote to Richard Recchia, thanking him for sending photographs of his Paris work. "I like particularly the portrait reliefs, which seem to me to have much of character and artistic feeling."[1]

That fall Recchia had modeled this bas-relief of his friend and fellow student at the Académie Ju-

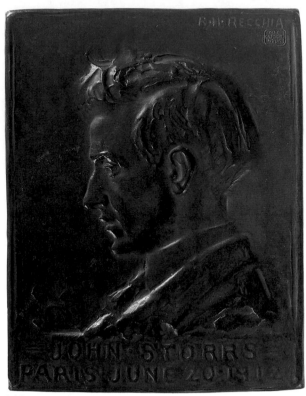

143

lian, John Storrs (1885-1956). A sensitive likeness of the young sculptor, whom Recchia had met for the first time in Bela Pratt's classes at the School of the Museum of Fine Arts, the profile portrait recalls Pratt's own teacher Augustus Saint-Gaudens's flair for texture and lighting. Recchia has accented Storrs's thick hair and brows with roughly modeled strokes, playing these against the softly modeled facial planes, albeit in a more cautious manner than that of Saint-Gaudens. The inscription, too, as in the reliefs by Saint-Gaudens, is integral to the image, with a clarity and boldness of execution to match the treatment of the sitter.

Unlike Recchia, John Storrs embraced modernism early in his career. Although he studied modeling and anatomy with Lorado Taft (1860-1936) in his hometown of Chicago from 1908 to 1909, with Pratt in Boston from 1909 to 1910, and life-modeling with Charles Grafly at the Pennsylvania Academy of the Fine Arts, Philadelphia, from 1910 to 1911—all of whom were strong proponents of the Beaux-Arts tradition—by 1917 Storrs was experimenting with the nonrepresentational, futurist style of Umberto Boccioni (1882-1916) and the cubist principles of Alexander Archipenko (1887-1964).[2] Storrs was a favorite student of Rodin's from 1912 until the French master's death in 1917, however,

and helped to arrange Rodin's exhibition at the Panama-Pacific International Exposition, San Francisco, in 1915. Storrs's close association with Rodin during these years may help to explain why his constructivist, blocklike simplifications of form did not begin until the early 1920s. Yet Storrs remained eclectic, his sculpture ranging from nonobjective works like *Stone Panel with Black Marble Inlay*, 1919 (The Museum of Modern Art, New York), to figurative pieces such as *Le Sergeant de Ville*, about 1920 (Corcoran Gallery of Art, Washington, D.C.), with his cubist borrowings chiefly a surface mannerism.[3] Although Storrs was an expatriate, he chose an aesthetic with deep ties to the skyscrapers of Chicago and Manhattan and the symbols of a machine technocracy.

Ironically, this student portrayal of Storrs at age twenty-seven marked Recchia's finest period; Storrs, however, was only beginning his most creative work.

P.M.K.

Notes

1. French to Recchia, Dec. 31, 1912, Richard H. Recchia Papers, Sawyer Free Library, Gloucester, Mass.
2. For Storrs's life and work, see Edward Bryant, "Rediscovery: John Storrs," *Art in America* 57 (May-June 1969), pp. 66-71; Abraham A. Davidson, "John Storrs, Early Sculptor of the Machine Age," *Artforum* 13 (Nov. 1974), pp. 41-45; Sterling and Francine Clark Art Institute, Williamstown, Mass., *John Storrs & John Flannagan: Sculpture & Works on Paper*, catalogue by Jennifer Gordon, Laurie McGavin, Sally Mills, and Ann Rosenthal (1980).
3. See Roberta K. Tarbell, "Early Nonobjective Sculpture by Americans" and "Figurative Interpretations of Vanguard Concepts," in Rutgers University Art Gallery, New Brunswick, N.J., *Vanguard American Sculpture, 1913-1939* (1979), pp. 23-26, 33-35.

RICHARD H. RECCHIA
144
Echo or *Siren*, 1914
Bronze, dark green patina, sand cast
H. 14 in. (35.5 cm.), w. 9⅛ in. (23.2 cm.), d. 15¼ in. (38.7 cm.)
Signed (on base at right side): R·H·RECCHIA / 1914
Foundry mark (on back): T.F. MCGANN & SONS C. F.DY
Bequest of Richard H. Recchia. 1984.745

Provenance: Richard H. Recchia, Rockport, Mass.
Exhibited: Guild of Boston Artists, "First General Exhibition," Nov. 2-14, 1914; idem, *First General Spring Exhibition* (1915), no. 62; Worcester Art Museum, Mass., *Guild*

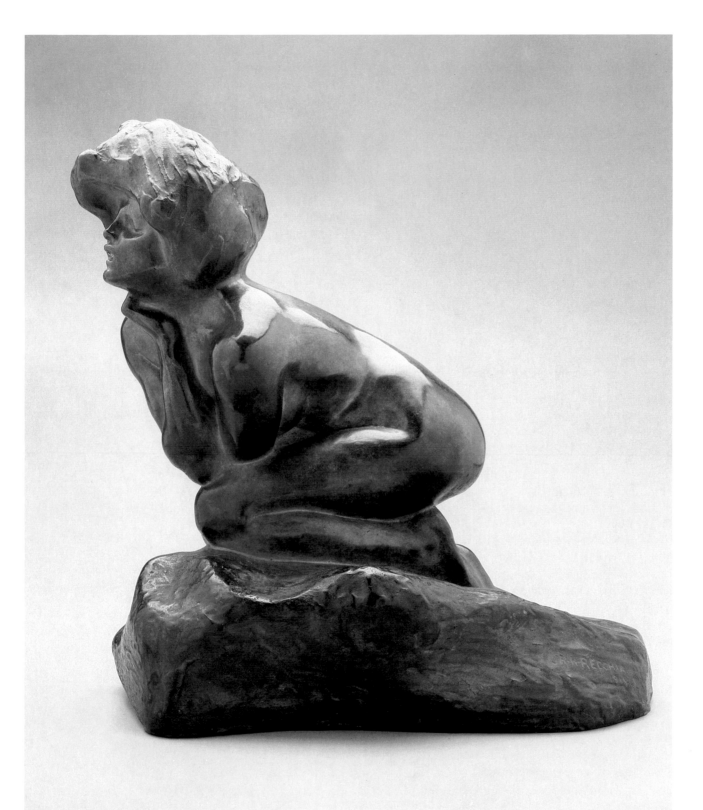

of Boston Artists Travelling Exhibition (1915); idem, *First General Exhibition* (1915), no. 62; idem, BMFA, May 1917; The Pennsylvania Academy of the Fine Arts, Philadelphia, *114th Annual Exhibition of the Pennsylvania Academy of the Fine Arts* (1919), no. 365; Buffalo Fine Arts Academy and Albright Art Gallery, N.Y., *Thirteenth Annual Exhibition of Selected Paintings by American Artists and a Group of Small Selected Bronzes by American Sculptors* (1919), no. 59; BMFA, *Exhibition of Works by Boston Artists under the Auspices of the Copley Society* (1920), no. 143; Baltimore Museum of Art and the Peabody Institute, *Exhibition of American Sculpture* (1923), no. 175; Guild of Boston Artists, *Exhibition of Sculpture by Richard H. Recchia* (1923), no. 18; BMFA, *Exhibition of Works by Members of the Boston Society of Sculptors* (1925), no. 82; Gloucester Society of Artists, *First Exhibition, Fourth Season* (1926), no. 87; idem, *Third Exhibition, Fourth Season* (1926), no. 161; Saint Botolph Club, Boston, *An Exhibition of Sculpture by Richard Recchia* (1926), no. 10; North Shore Arts Association, Gloucester, Mass., *Eighth Exhibition* (1928), no. 3; The Art Institute of Chicago, *Forty-third Annual Exhibition of American Paintings and Sculpture* (1930), no. 259; Doll & Richards, Boston, *Richard H. Recchia, N.A.* (1961), no. 5.
Versions: *Plaster*: (1) Gordon College, Wenham, Mass., bronzed. *Bronze*: (1,2) present locations unknown, formerly McGann Bronze Company, Boston, (3) present location unknown, formerly Charles H. Woodbury, Boston. *Marble*: (1) present location unknown, formerly Dr. William S. Bigelow, Boston

This figure of a voluptuous female kneeling on a rock has been alternately titled *Echo* and *Siren*, names that conjure up traditional views of woman's alluring and eternal sexuality, at times threatening but always fascinating.

According to Ovid, Echo was a woodland nymph whose loquacity caused Juno, the wife of Zeus and queen of the heavens, to change her into a being that spoke only when spoken to and repeated only the words she heard. Echo fell in love with the ill-fated Narcissus, who became enamored of his image reflected in a pool, thinking it was the water-spirit of the place. While he sought in vain to approach this beautiful creature, Echo pined away for him until only her voice remained.

Far more provocative in character than Echo, a siren, in Greek mythology, was one of the group of sea nymphs whose melodious voices lured unwitting sailors, causing them to founder their ships on the shoals and then die from lack of food. As narrated in the *Odyssey*, Ulysses prepared for the sirens' seductive charms by tying himself to the mast and stopping up the ears of his companions. With the title *Siren*, the figure was shown at the 1920 Copley Society members' show at the Museum of Fine Arts and was found to be "full of a wild, eerie quality."[1]

Recchia created *Echo* in 1914, using his first wife, Anita Diaz, as his model. A lyrical interpretation of a classic pose, the statuette combines the bold modeling of Auguste Rodin (1840-1917) with the sinuous curves of Art Nouveau. *Echo's* "immense mass of hair overshadowing her face, turban-like in effect,"[2] as described by one critic, resembles the stone burdens carried by the French sculptor's caryatid figures.

Recchia did not believe in large productions of his work, and despite the popularity of *Echo*, he ordered only two bronzes cast and one version cut in marble. In 1931 at the time of his one-person show at the Fifty-Sixth Street Galleries, New York, he was quite dismayed to discover that T.F. McGann, Boston, had cast two more bronzes of *Echo* without his permission and kept them on display in their offices.[3] In a letter to the founder, he requested that all his plasters be returned and that no bronzes of his work be cast or exhibited there.[4]

P.M.K.

Notes

1. M.F.B., "Boston Artists' Exhibition," *Boston Evening Transcript*, Mar. 15, 1920.

2. William H. Downes, "Sculpture at the Guild," May 26, 1915.

3. See handwritten note by Recchia, undated, on back of catalogue of Fifty-Sixth Street Galleries, New York, *Exhibition of Sculptures by Richard H. Recchia* (1931); the marble version of *Echo*, then called *Siren*, was illustrated on the cover. Richard H. Recchia Papers, Sawyer Free Library, Gloucester, Mass.

4. See Recchia to Thomas McGann, undated, Recchia Papers. The McGann Bronze Company was bought out by McGann Bronze Inc., Somerville, Mass. A 1979 fire at the foundry destroyed their records, and the present location of the two bronzes is unknown.

RICHARD H. RECCHIA
145
Raymond Porter, 1914
Bronze, brown patina, lost wax cast
H. 22½ in. (57.2 cm.), w. 15⅞ in. (40.3 cm.), d. 10½ in.
Signed and inscribed (on back of shoulder): TO·RAYMOND·PORTER·/·BY·R·H·RECCHIA·1914·
Foundry mark (on back at lower left): T·F·MCGANN·&·SONS·CO·/·FOUNDERS·BOSTON·
Bequest of Richard H. Recchia. 1984.744

Provenance: Richard H. Recchia, Rockport, Mass.
Exhibited: Worcester Art Museum, *Guild of Boston Artists Travelling Exhibition* (1915); Guild of Boston Artists, BMFA,

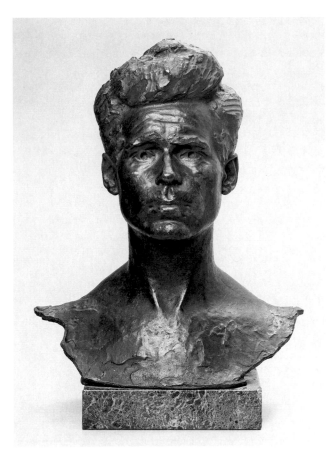

145

Apr. 1916; The Pennsylvania Academy of the Fine Arts, Philadelphia, *One-hundred-and-fifteenth Annual Exhibition of the Pennsylvania Academy of the Fine Arts* (1920), no. 420; Guild of Boston Artists, *Exhibition of Sculptures by Richard H. Recchia* (1923), no. 31; BMFA, *Exhibition of Works by Members of the Boston Society of Sculptors* (1925), no. 84; North Shore Arts Association, Gloucester, Mass., *Fourth Exhibition* (1926), no. 9; Saint Botolph Club, Boston, *An Exhibition of Sculpture by Richard Recchia* (1926), no. 21; Guild of Boston Artists, *Exhibition of Sculpture by Richard H. Recchia* (1934), no. 12; National Academy of Design, New York, *118th Annual Exhibition* (1944); Doll & Richards, Boston, *Richard H. Recchia, N.A.* (1961), no. 10; The Copley Society of Boston, "An Exhibition of Works by Ten Distinguished Artists, Members for At Least Half a Century, 1930-1980," Apr. 24-May 14, 1981, no. 30.

In 1944 Recchia received for his bust of Raymond Porter the Elizabeth N. Watrous Gold Medal, designed by Robert Aitken in 1914 (q.v.). Awarded by the National Academy of Design, New York, the honor included his election to the academy as an associate. Juried by the conservative establishment during wartime, Recchia's early work affirmed the continuing strength of the Beaux-Arts tradition.

From the first showing of the portrait in the 1915 traveling exhibition organized by the Guild of Bos-

ton Artists, where both Recchia and Porter were charter members,[1] it received favorable attention from the critics. Recchia's impressionistic modeling, bold without fussiness, accentuates Porter's wavy hair, high pompadour, deep-set eyes, bushy brows, and firm chin. Praised as a "highly characteristic study of one of Boston's well-loved teachers,"[2] the *Porter* bust conveys the feeling of virility and forthrightness, fitting for a man well over six feet tall, who was known for his commanding appearance.

Raymond Averill Porter (1883-1949), an associate and close friend of Cyrus Dallin at the Massachusetts Normal Art School (now the Massachusetts School of Art), was born in Hermon, New York, but grew up on a Colorado ranch. Like Dallin he had begun modeling at a young age and recommended an early start for those who hoped to become professional sculptors. An expounder of practical philosophy, according to his obituary, Porter used to tell his students that "genius is 90 per cent enthusiasm."[3]

In 1924 Porter and Dallin collaborated on the Massachusetts Normal Art School's Medal of Honor for the fiftieth anniversary of the school's founding. Porter did the reverse design as a spray of laurel enclosing the seal of Massachusetts.[4] Later, he helped design the pedestal for Dallin's equestrian memorial to Paul Revere (Paul Revere Mall, Boston). After Dallin's death in 1944, Porter replaced him as head of the school's sculpture department, retiring in 1947 to Pueblo, Colorado.

Among Porter's public statues are the *Green Mountain Boy*, 1915 (Rutland, Vermont), for which Recchia served as the model;[5] the *World War Monument*, 1929 (Monument Square, Leominster, Massachusetts); and the *Spanish-American War Monument*, 1929 (Somerville, Massachusetts). His bronze heroic-size sculpture of Senator Henry Cabot Lodge was placed on the front grounds of the State House, Boston, in 1932.

P.M.K.

Notes

1. Porter also served on the Boston Society of Sculptors' first Board of Council, of which Recchia was secretary.

2. "Works by Recchia at Artist's Guild," *Boston Globe*, Dec. 19, 1934.

3. Arthur Riley, "Boston Was His 'City of Dreams,'" *Boston Globe*, Dec. 18, 1949, obit.

4. See "Art School Will Confer Degrees," *Christian Science Monitor*, June 4, 1924.

5. See "Common Ground, 1775-1975," *Rutland Historical Society Quarterly* 5 (summer 1975), pp. 28-29.

RICHARD H. RECCHIA
146
Persian Cat, 1931
Bronze, black patina, lost wax cast
H. 19 in. (48.2 cm.), w. 11 in. (27.9 cm.), d. 11¾ in.
(29.9 cm.)
Signed (on back of base): R.H.RECCHIA·1931-©
Foundry mark (on base at left side): GORHAM CO.
FOUNDERS / 01JC
Bequest of Richard H. Recchia. 1984.746

Provenance: Richard H. Recchia, Rockport, Mass.
Exhibited: North Shore Arts Association, Gloucester,
Mass., *Tenth Exhibition* (1932), no. 13; The Art Institute of
Chicago, *American Paintings and Sculpture: Forty-Fifth An-
nual Exhibition* (1933), no. 246; Guild of Boston Artists,
Exhibition of Sculpture by Richard H. Recchia (1934), no. 27;
Addison Gallery of American Art, Phillips Academy,
Andover, Mass., *New England Sculptors* (1942), no. 28;
Doll & Richards, Boston, *Richard H. Recchia, N.A.* (1961),
no. 19; Gloucester, Mass., *Cape Ann Festival of the Arts*
(1963), no. 211; The Copley Society of Boston, "An Exhi-
bition of Works by Ten Distinguished Artists, Members
for At Least Half a Century, 1930-1980," Apr. 24-May
14, 1981, no. 39.

Recchia is generally credited with being one of the
earliest Boston sculptors to create abstract sculp-
ture. In 1929 he began producing small-scale
bronzes of birds and animals, often with a painted
black patina, that were shaped as simple, geometric
volumes. The *Persian Cat* of 1931 is typical of these
stylizations, with the face and body depicted as one
rounded form, and the eyes, ears, nose, and mouth
as projections and indentations of the solid mass.

At the North Shore Art Association's ninth sum-
mer exhibition in Gloucester, July 1931, Frederick
W. Coburn, the *Boston Herald* art critic, reported
that among the show's few experimental pieces,
those by Recchia had "created a veritable sensa-
tion." With tongue in cheek, Coburn observed that
"Mr. Recchia learned in New York last winter that
literal likeness is unspeakably bad and, apparently,
that abstraction ranks even higher than distortion
in the scale of modernistic fine art values."[1]

By 1934, however, there was a ready audience for
these streamlined forms. The Guild of Boston Art-
ists gave Recchia a retrospective of twenty-nine
works that year, including nine pieces from this
period. Alice Lawton, writing for the *Boston Sunday
Post*, found in them a "subtlety of modelling" and a
"skill of characterization," and described with pleas-
ure "the smugly complacent 'Persian Cat,' its fea-
tures almost lost in wellfed plumpness."[2]

In 1981 at the Copley Society's exhibition cele-

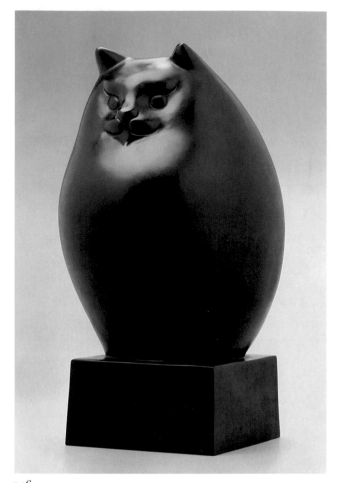

146

brating ten distinguished artists who had been
members for fifty years, Recchia selected *Persian Cat*
as one of his four submissions. (The others were
Raymond Porter [q.v.], *Echo* [q.v.], and *Leaping Frog*,
1931 [present location unknown].)

P.M.K.

Notes
1. F.W. Coburn, "Cape Ann Art Season to Open Today
with Private Views and Receptions," *Boston Herald*, July 3,
1931.
2. Alice Lawton, "Richard H. Recchia's Sculpture at Guild
of Boston Artists," *Boston Sunday Post*, Dec. 16, 1934. A.J.
Philpott thought the *Persian Cat* to be a "thoroughly self-
satisfied, pompous individual." See "Artistry and Origi-
nality Shown in Recchia Sculpture Exhibit," *Boston Globe*,
Dec. 19, 1934.

Amelia Peabody (1890 – 1984)

Amelia Peabody was born in Marblehead Neck, Massachusetts, the only child of Frank and Gertrude Peabody. A descendant of one of New England's most prominent families, Peabody, when asked about herself, said matter-of-factly, "Well, I am one of the Kidder Peabody Peabodies."[1]

Peabody was raised in Boston and attended the Winsor School. In October 1909 she enrolled in the School of the Museum of Fine Arts for three years, where she received formal training from Bela Pratt and from the painters Frank Benson (1862-1951) and Edmund Tarbell (1862-1938). Peabody's determination and seriousness of purpose prompted her to continue taking classes at the Museum School where, in 1918, she won a grand prize in a sculpture *concours* with a bronze statuette. After more study at the School in the mid-1920s, this time as a pupil of the sculptors Frederick W. Allen and Charles Grafly, Peabody pursued further instruction in New York with Alexander Archipenko (1887-1964), who had founded an art school following his immigration to America in 1923.

During the 1920s and early 1930s, Peabody was a frequent contributor to the annual exhibitions at the Pennsylvania Academy of the Fine Arts, Philadelphia, where she entered pieces ranging from a portrait to an amphibian to *The Flight into Egypt*, about 1922 (The Dover Church, Massachusetts). She exhibited at the National Academy of Design, New York, as well, in 1929, 1931, and 1934. It was in her hometown of Boston, however, with the showing of the highly praised *End of an Era* (q.v.) in 1927 at Horticultural Hall, that Peabody attained the first significant recognition of her talent. From the moment she presented *End of an Era*, her place in the Boston art community was assured, and her output began to turn up regularly in displays sponsored by important associations in the city such as the Guild of Boston Artists and the Copley Society. Upon becoming a member of the guild, Peabody had her works put on view, along with those by Mary O. Bowditch, in the guild's Newbury Street gallery. The show was held in 1930, and a writer for the *Boston Evening Transcript* considered the *Four Horsemen*, about 1928 (present location unknown, formerly Amelia Peabody until 1984), the outstanding conception: "The 'Four Horsemen' is only about two feet tall, and the figures are quite tiny, yet they are splendidly done—four riders ascending in a curve, the last one, Death, a skeleton, and helpless naked figures left trampled behind. The horses are

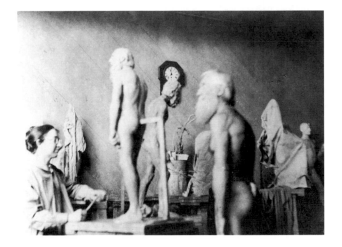

glorious creatures, and so is the horsemanship of the four riders fine."[2]

Between 1930 and 1932 Peabody concentrated on modeling sporting scenes, which were specifically personal. Although she was reluctant to become known exclusively for sculpture with this theme, it came to her naturally, for she was an ardent equestrienne and an active member of the Norfolk Hunt Club. Her one-person debut, at the guild in the spring of 1932, was given over almost entirely to horses and riders of the drag-hunt. In reviewing the exhibition, a reporter admired her gift in animating the torsions of the horses with a whirl of curving motifs and in conveying sweeping movement with conviction.[3] One small submission portrayed Peabody herself, riding sidesaddle on her favorite mount.[4] Of other examples of this genre, the bronze *Dr. Strong Being Run Away*, or *Runaway*, 1925 (private collection, Dover), is a fine illustration of a rider desperately tightening the reins to restrain his galloping steed, and *Bucks the Perfect Hunter*, 1935, also a bronze (School of Veterinary Medicine, Tufts University, North Grafton, Massachusetts), depicts a startled but infinitely less energetic stallion.

At Peabody's one-person exhibition of sixteen sculptures at the guild in the winter of 1937, a critic commented approvingly upon a "modern feeling" and a "certain stylization for decorative effect" in her recent works.[5] A stylization in Peabody's oeuvre was evident, in fact, as early as the mid-twenties in *Hurricane*, about 1924 (Dover Public Library), in which two figures, a male and a female, hug one another as they are buffeted by a strong wind. *Bicycle Boy*, or *Telegram*, in stone (The Waring School, Ecole Bilingue de Beverly, Massachusetts), which appeared at the New York World's Fair in

1939 in plaster, is equally distinguished by a blocky, stylized quality and, like *Hurricane*, is imbued with an Art Deco spirit.

Peabody stood apart from the conservative attitudes of fellow Boston artists Mary O. Bowditch and the painter R. H. Ives Gammell (1893-1981), who loathed modern art. "Modernism," Peabody said in 1932, "is a step toward the right place. . . . Change . . . is always a good idea. . . . I would like to see some modern buildings in Boston."[6] No sooner had Peabody made this observation than she embarked on a fruitful relationship with the architect Eleanor Raymond (born 1887) that resulted in thirteen innovative projects executed over several decades. For her enlightened friend's estate in Dover, Raymond designed an undeniably modern studio in 1933, an experimental plywood house in 1940, an all-Masonite residence in 1944, and, in 1948, one of the first solar dwellings. Peabody's espousal of the new, nonetheless, never extended to her fashioning abstract sculpture. Instead, she maintained a basically realistic style.

Rarely a year passed when Peabody's sculpture was not represented in an exhibition, and her art could be found in shows held by organizations of which she was a member, for instance, the North Shore Arts Association, Gloucester, Massachusetts; the National Association of Women Artists, New York; the National Sculpture Society, New York; and the New England Sculptors Association, Cambridge, Massachusetts. Peabody was treated to a third one-person installation at the guild in 1967, and the Boston Athenaeum Gallery hosted a number of displays of her sculpture in the 1970s. In addition to her objects in bronze and stone, Peabody produced ceramics, and one of her last sculptural efforts, dating from the 1970s, is a biographical series of six ceramics entitled *My Life: My First Boat at Marblehead, My Father's Dogs, My First Pony, New Riding Club, "Vision" at the Museum of Fine Arts—Degas Show, The Golden Years* (present location unknown, formerly Amelia Peabody until 1984). The series was part of an exhibition at the Copley Society of Boston in the spring of 1981 in honor of ten distinguished artists who had been members for at least half a century.

After the 1940s, Peabody's became a decidedly local reputation, and the majority of her sculpture is in Massachusetts: the endearing *Boy with Cat* (Prouty Memorial Garden, Children's Hospital, Boston); a baptismal font for a church in Oxford, 1948; portrait relief of Dr. Elliott P. Joslin, 1951

(New England Deaconess Hospital, Boston); the rather perfunctory portrait plaques of William L. Shearer, Captain Joseph R. DeLamar, and Dr. Hsien Wu, about 1965 (all at Harvard Medical School, Boston); and woodchucks and pheasants, 1970, for the entrance gate of Groton Memorial Park (now Groton Place, Groton, Massachusetts). Tributes to Peabody's ability as a sculptor came from local sources too: the Society of Arts and Crafts, Boston—its Award of Merit—and from Northeastern University, Boston, a prestigious degree of Doctor of Fine Arts.

A woman of diverse interests, Peabody dedicated countless hours to running a farm in Dover and to raising Hereford cattle, Yorkshire pigs, and thoroughbred racehorses. The pigs, which Peabody, with her characteristic affection for the animal kingdom, called "lovely and gentle," were long pampered in a sty so elegant it was dubbed the "pig palace."[7] Whimsy and enthusiasm for all sorts of beasts can be seen in her stone *Lamb*, about 1965 (Massachusetts General Hospital, Boston); marble *Frog*, about 1970 (Donald Kelley, Charlestown, Massachusetts); and the cast stone *Garden Stele* (Boston Athenaeum), in which Peabody has knowingly captured a delicious battle of wits played out by a cat peering up at birds perched in alternate sprays of leaves.

Possessed of an admirable sense of responsibility to the community, Peabody was particularly committed to the American Red Cross Arts and Skills Service, to which she devoted many years as chairman and teacher of the pottery courses. She generously served as a trustee of Northeastern University, New England Deaconess Hospital, Massachusetts Eye and Ear Infirmary, Joslin Diabetes Foundation, the Boston Society of Natural History (Museum of Science), and as a member of the corporations of the Children's Hospital Medical Center and Massachusetts General Hospital.

Self-effacing and modest, Peabody was never inclined to discuss her accomplishments. When reminded of the success that *End of an Era* enjoyed when it was exhibited initially, she responded, "Yes, wasn't that funny?"[8] Peabody's moderately taciturn manner reflected her Yankee heritage, yet it masked a marvelous inventive joy that came to the fore in her sculpture, especially in the animal subjects, and a delightful curiosity about all that life offered.

K.G.

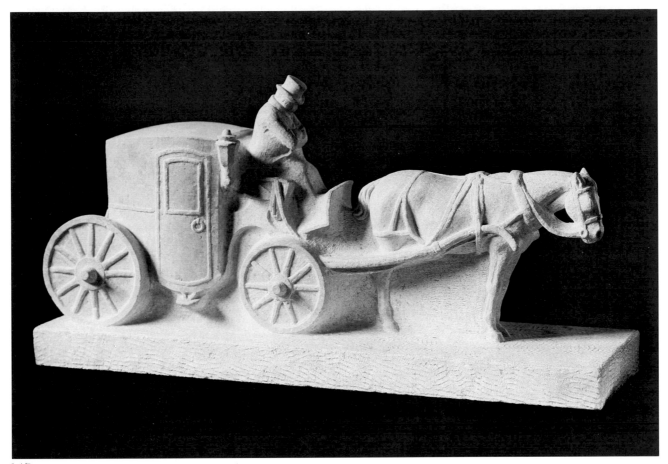

147

Notes

1. Karl Schriftgiesser, "Miss 'Amy' Peabody Enters the 'One-Man' Class," *Boston Evening Transcript*, Mar. 30, 1932.

2. G. K., "Two Sculptors and One Painter Make Their Bow," *Boston Evening Transcript*, Feb. 26, 1930.

3. See D. A., "Boston Art Notes: Guild of Boston Artists," *Christian Science Monitor*, Mar. 31, 1932.

4. "Amelia Peabody," *Boston Evening Transcript*. Apr. 2, 1932, book section.

5. " 'Three Portraits' by Amelia Peabody at the Guild of Boston Artists," *Boston Post*, Jan. 1, 1937.

6. Schriftgiesser, "Miss 'Amy' Peabody."

7. Jane Harriman, "Amelia Peabody: Never a Dull Moment," *Boston Sunday Globe*, Apr. 26, 1964.

8. Interview by Kathryn Greenthal with Amelia Peabody, Aug. 26, 1980.

References

AAA, SI; BMFA, ADA; The California Palace of the Legion of Honor with the National Sculpture Society, San Francisco, *Contemporary American Sculpture* (1929), p. 253; SMFA.

AMELIA PEABODY

147
End of an Era, after 1920 - by 1927
Marble
H. 9½ in. (24.1 cm.), w. 19 in. (48.3 cm.), d. 5⅞ in.
Frederick Brown Fund. 27.214

Exhibited: Boston Society of Sculptors, Boston Society of Landscape Architects, and Massachusetts State Federation of Women's Clubs, Horticultural Hall, Feb. 1927; The Copley Society of Boston, *Exhibition of the Work of Painters and Sculptors of Boston and the Vicinity through the Courtesy of the Museum of Fine Arts* (1927), no. 19; Guild of Boston Artists, *Exhibition of Paintings by Marguerite Pearson, Sculpture by Amelia Peabody and Mary O. Bowditch* (1930), no. 22; William Hayes Fogg Art Museum, Harvard University, *New England Genre* (Cambridge, 1939), no. 63; The Copley Society of Boston, *A Centennial Exhibition: A Selection of Works of Members during its First Half Century 1879-1928* (1979), no. 31.
Versions: *Stone*: (1) present location unknown, (2) present location unknown.

In February 1927 Amelia Peabody submitted *End of an Era* to the exhibition held in Horticultural Hall

under the auspices of the Boston Society of Sculptors, the Boston Society of Landscape Architects, and the Massachusetts State Federation of Women's Clubs. It was singled out not only as "the unique piece in the show"[1] by Harley Perkins in the *Boston Evening Transcript*, but also as "one of the finest pieces of sculpture Boston has seen in a long time"[2] by the renowned sculptor Cyrus Dallin, who added that it was an object he would like to own.[3] Thomas Carens wrote the most enthusiastic review: "Once in a while there comes along a genius who takes the most commonplace of objects and impresses it upon us as something of lasting beauty. Amelia Pearson [*sic*] has done that in her marble sketch, 'The End of an Era,' which proved one of the most popular of the 386 exhibits placed on view last night in Horticultural Hall."[4]

According to Peabody, the subject for *End of an Era* was inspired by a one-horse cab and its driver that she saw on the corner of Berkeley Street and Commonwealth Avenue in Boston, on her way to the Museum School.[5] Peabody gave the sculpture its epitaphic title to suggest that such a conveyance, familiar in the nineteenth century, was fast becoming obsolete.[6] The work represents the last of the old cabbies, seated with bowed head and folded arms. The sculptor, in a style typical of her production dating from the 1920s and 1930s, left the marble intact between the spokes of the wheels and in the area under the cab and the horse, where voids ordinarily would be, giving emphasis to a feeling of being "frozen in time" and to the driver's interminable wait for a passenger. *End of an Era* was carved after 1920 but before 1927 in Quincy, Massachusetts, by Caesar Vanelli. The Museum purchased the sculpture in April 1927, when it was hosting an exhibition sponsored by the Copley Society. Two replicas were executed in stone[7] and related drawings are in the collection of the Archives of American Art, Smithsonian Institution, Washington, D.C.

K.G.

Notes

1. Harley Perkins, "Boston Art in Clay and in Paint," *Boston Evening Transcript*, Feb. 19, 1927, book section.

2. Thomas Carens, " 'End of an Era' Best Sculpture," *Boston Herald*, Feb. 15, 1927.

3. "White Marble Against the Cool Green of Growing Things, Harbinger of Spring," *Boston Evening Transcript*, Feb. 14, 1927.

4. Carens, " 'End of an Era.' "

5. Interview by Kathryn Greenthal with Amelia Peabody, Aug. 26, 1980.

6. William Hayes Fogg Art Museum, Harvard University, *New England Genre* (Cambridge, 1939), p. 72.

7. Letter from Amelia Peabody to Charles H. Hawes, associate director of the Museum: "Please thank the Committee for giving me permission to make two more replicas of the 'End of an Era.' The condition that the words 'The copy made in . . .' be cut in the stone, is perfectly satisfactory to me." Oct. 10, 1927, BMFA, 1901-1954, roll 2474, in AAA, SI.

Bashka Paeff (1893 – 1979)

One member of the sorority of skillful and sensitive women sculptors working in Boston during the early part of the twentieth century was Bashka Paeff, whose most popular and visible contribution is the delightful *Boy and Bird Fountain*, originally modeled in 1914 (copy, Public Garden, Boston).

Paeff was born in Minsk, Russia, to Louis and Fanny (Kischen) Paeff, who emigrated to America when their daughter was a child. The family settled in the North End of Boston, and Paeff was educated at Girls' High School, from which she graduated in 1907. Although her father wanted her to become a musician, it was evident Paeff had an aptitude for drawing since, more often than not, she sketched during the hours she was supposed to be practicing the piano and violin. As a consequence, she was sent to the Massachusetts Normal Art School (now the Massachusetts College of Art), which she attended for four years, preparing to be a drawing instructor. Paeff discovered her interest lay in modeling, which she explored under the guidance of Cyrus Dallin. Her ability to handle clay was so pronounced that her instructors advised her to specialize in sculpture. She abandoned her plans to teach drawing and enrolled in the Museum School in 1911, where for three years she trained with the sculptor Bela Pratt, winning many prizes and scholarships.

Paeff's talent, quickly recognized in her early efforts, was not the only reason she gained public attention. To help support herself while taking courses, Paeff sold subway tickets in the Park Street station, where, during lulls, she modeled in clay. Paeff's activities in the ticket booth caused much comment in the newspapers, and she soon became known as the "subway sculptress."[1] Anthony J. Philpott, art critic for the *Boston Globe*, however, chose to emphasize her accomplishments as an artist rather than her status as a curiosity. In an article of June 3, 1914, he discussed Paeff's entries in the current Museum School show as well as some pieces in her studio: "That little figure of a crouching, nude boy, intently watching a bird that has alighted on the tips of his outstretched fingers was suggested by the boys and girls whom she sees daily feeding the pigeons on the Common. . . . The spirit of the happiness in the faces of these children when the timid pigeons flutter and alight and feed out of their hands impressed Bessie Paeff for years, and in this little statuette she has symbolized the idea or the impression which it made on her mind. It is

intended as a model for a garden fountain [*Boy and Bird Fountain*]. . . . But her genius is best shown in the little group compositions that are in the exhibition. . . . There is splendid unity in the design of every one of these, and the figures are accurate anatomically and are modelled with both strength and refinement."[2]

Within a few years after leaving the Museum School, the energetic and enterprising Paeff made reliefs of individuals such as Jane Addams, 1915 (Hull-House, Chicago), and Oliver Wendell Holmes, 1917 (Langdell Hall, Harvard Law Library). In 1916 the sculptor joined the Guild of Boston Artists, beginning a long association with an organization she could rely on to display her works. Paeff's most prolific years were 1916 through 1930; the type of sculpture she produced then and throughout her career was executed in a fundamentally realistic style and included portrait busts and reliefs, war memorials, animal subjects, and garden statuary. Praising her entries in an exhibition at the guild in January 1917, F.W. Coburn of the *Boston Herald* observed: "Her refined, subdued and yet highly expressive style should carry her far. . . . One is conscious . . . of the quest of delicately modulated surface, even where the larger expressive intents are very plain."[3]

At her show at the guild in March 1919, which

was favorably reviewed, Paeff demonstrated her characteristic industry by placing on view almost all new conceptions: an elaborate frieze of Wagner's *Vision of the Ring of the Nibelung*, 1917 (private collection, Quincy, Massachusetts); two full-length figures; small studies of dogs; and portraits of children. Fountains were Paeff's favorite creations, and in April 1921 her two most important submissions at the guild were the bronze *John E. Warren Memorial Fountain*, 1920 (Westbrook, Maine), and the plaster for the *Julius Rosenwald Memorial Fountain* (Ravinia, Illinois). The charming *Warren Fountain* is composed of a seated nude boy who bends over a basin and guides the water with his right hand. He is accompanied by a reclining dog at the base. The *Rosenwald Fountain* depicts a mother tenderly holding the wrists of her child, who, with back turned to her, timidly ventures into the shallow water.

In 1922 Paeff completed the first of three major bronze war memorial plaques: the World War I memorial to Massachusetts chaplains (State House, Boston), representing a stricken soldier and two attendant figures; the World War I memorial, installed in 1925, on the War Memorial Bridge in Kittery, Maine; and a six-figure memorial to the Minute Men of April 19, 1775, dedicated on April 19, 1949, in Lexington, Massachusetts.

Paeff took a long-deferred trip to Europe in 1930, staying two years, during which she traveled and made use of a studio in Paris. World War I had interrupted her goal to study with Auguste Rodin (1840-1917), and by the early 1930s he had long since died. Instead, she benefited from the criticism of Naoum Aronson (1872-1943), one of Rodin's disciples. In 1931 Paeff exhibited a fountain group of two children (destined for the garden of a private collector in Chestnut Hill, Massachusetts) in the Salon of the Société des artistes français.

After returning to Boston, Paeff continued to receive various requests, ranging from a statue of Phantom (Lowell House, Harvard University), the cocker spaniel of Harvard president Abbott Lawrence Lowell, made as a gift for him from the Harvard class of 1933, to a bas-relief of James Geddes, Jr. (Geddes Language Center, Boston University), retiring chairman of the Romance Language Department of Boston University, commissioned by Samuel Waxman, Geddes's successor. In 1940 Paeff married Waxman, gave up her studio on Beacon Hill, and built a new one in their home in Cambridge. Marriage altered none of Paeff's professional endeavors. Her exhibition at the Guild of

Boston Artists in March 1941, in which she presented mostly portraits, was no less a success than her shows from twenty years before. Further, a reporter for the *Christian Science Monitor* claimed that Paeff's sculpture revealed "a growing profundity."[4] One of her last subjects was a relief of the Reverend Dr. Martin Luther King, made for Boston University when Paeff was seventy-six years old.

Paeff's reputation was fundamentally local, but her objects can be found in collections throughout the country: for example, a life-size statue of President Warren Harding's Airedale, Laddie Boy, 1923 (National Museum of American Art, Washington, D.C.); a bas-relief of the composer Edward MacDowell (Dodge Hall, Columbia University, New York); and a marble bust of Louis Brandeis, about 1953 (Olin-Sang Building, Brandeis University, Waltham, Massachusetts). Paeff was a fellow of the National Sculpture Society and a member of the Cambridge Art Association. At the time of her death, plaster casts and some marbles and bronzes abounded in her Cambridge and Greenbush, Massachusetts, studios, and in the autumn of 1981, they were sold by Hubley Auctioneers Company of Cambridge.

K.G.

Notes

1. "Uses Subway Ticket Booth as Art Studio," *Boston Herald*, Apr. 17, 1913; A.J. Philpott, "Wins Sculpture Prize," *Boston Evening Globe*, June 3, 1914; "Ticket Girl Wins Big Sculpture Prize," *Boston Herald*, June 4, 1914; Laura A. Draper, " 'L' Ticket Seller Is Wonderful Sculptress," *Boston Journal*, July 6, 1914.

2. Philpott, "Wins Sculpture Prize."

3. F.W. Coburn, "Dwight Blaney and Bashka Paeff at the Art Guild," *Boston Herald*, Jan. 7, 1917.

4. Quoted in "Praise for Bashka Paeff," *Art Digest* 15 (Mar. 15, 1941), p. 21.

References

Mabel Ward Cameron, comp., *The Biographical Cyclopaedia of American Women* (New York: Halvord, 1924), vol. 1, pp. 140-141; *Boston Globe*, Jan. 25, 1979, obit.; Proske 1968, pp. 219-220; Agnes Ryan Papers, Schlesinger Library, Radcliffe College; SMFA.

BASHKA PAEFF
148
Anthony J. Philpott, 1922
Bronze, green patina, lost wax cast
H. 17 in. (43.2 cm.), w. 11⅜ in. (28.9 cm.), d. 12¾
in. (32.4 cm.)
Signed (on base at left side): BASHKA PAEFF·
FECIT·1921·
Foundry mark (on back of base): IDEAL CASTING CO
PROV. R.I.
Anonymous gift. 36.642

Exhibited: BMFA 1977, no. 76; The Society of Arts and
Crafts, Boston, *Sixty-Five Years of Sculpture by Bashka Paeff*
(1979).
Versions: *Plaster*: (1) present location unknown. *Bronze*
(or bronzed plaster?): (1) present location unknown

Beginning in 1893, Anthony J. Philpott (1862-1952)
worked at the *Boston Globe* for fifty-nine years, serv-
ing as a reporter, feature writer, desk editor, and
art critic.[1]

Born in Ireland, Philpott came to America and
settled in Boston, where, for about ten years, he was
employed in the printing trade. He was then hired
by Philadelphia, Chicago, and New York newspa-
pers before joining the editorial staff of the *Globe*.
Few artists exhibiting in Boston during the early
part of the twentieth century escaped Philpott's ap-
praising eye. Viewed as fair-minded and authorita-
tive, he received many tributes for his fine judg-
ment, and Bashka Paeff honored him by modeling
a bust in 1921. Philpott had begun writing highly
sympathetic reviews of Paeff's sculpture in 1914. He
usually discussed her oeuvre in detail and, on more
than one occasion at the start of her professional
life, predicted a bright future for her as an artist.
Paeff is said to have asked Philpott to sit for her,
perhaps in gratitude for his being instrumental in
furthering her career.[2]

Although the bust is an early piece, it is represen-
tative of Paeff's portraiture. Philpott is shown in a
serious and thoughtful mood, with brow furrowed
and head slightly bowed. The lips are parted be-
neath a full mustache. Upon seeing the portrait in
Paeff's studio before it was cast, William H. Downes,
art critic for the *Boston Evening Transcript*, com-
mented: "The likeness is remarkable, and the inter-
pretation of the personality is not by any means
devoid of that sympathetic insight which is essential
to a real portrait of a character. It is analytical, yet it
is not impersonally so; it is intensely human in its
aspect; and especially noteworthy for its implication
of a keen intellectual activity and concentration."[3]

148

When the bust was placed on view, apparently for
the first time, at an exhibition of sculpture by Paeff
at the Guild of Boston Artists from October to mid-
November 1923, F.W. Coburn of the *Boston Herald*
offered the following consideration: "Here one
feels that the fundamentals of expressive sculpture
have been well observed. The long-headed type has
been portrayed with emphasis upon its
dolichocephchaly [*sic*]. The modeling, at the same
time, is close enough to go far beyond the exposi-
tion of a symbol, a type. If, indeed, this work
were . . . recovered by an archaeologist a thousand
years hence, his first thought would be of the in-
tense individualism of the subject about whom, his
personality and occupations, he would long to learn
something."[4]

The bust, possibly the cast in the Museum of Fine
Arts, was one of Paeff's most frequently exhibited
subjects during the 1920s and 1930s, having been
shown at the 1926 winter exhibition at the National
Academy of Design, New York; the Tricennial Ex-
hibition of Boston's Society of Arts and Crafts held
at the Museum in March 1927; the National Sculp-
ture Society Exhibition of Contemporary American
Sculpture at the California Palace of the Legion of
Honor, San Francisco, in 1929; the Boston Tercen-

tenary Fine Arts Exhibition at Horticultural Hall in
1930; a one-person exhibition of her sculpture at
the Guild of Boston Artists in spring 1933; Vose
Galleries, Boston, 1933; and at the Museum's Exhi-
bition of Paintings and Sculptures by the Guild of
Boston Artists in the autumn of 1934. It is not
known whether other bronze casts of the *Philpott*
exist. A bronze cast or bronzed plaster appeared in
a photograph taken of Paeff in her Cambridge stu-
dio late in her life, and a plaster version was sold at
Hubley Auctioneers Company of Cambridge, Mas-
sachusetts, along with other contents of her studio
in the autumn of 1981.

<div align="right">K.G.</div>

Notes

1. See *Boston Globe*, Mar. 1, 1952, obit.

2. I am grateful to Herbert Philpott, of Belmont, Mass.,
son of Anthony Philpott, for providing this information
in a telephone conversation, Apr. 1, 1982.

3. W[illiam] H[owe] D[ownes], "Fountain and Bust," *Bos-
ton Evening Transcript*, Jan. 16, 1922.

4. F.W. Coburn, "In the World of Art," *Boston Sunday
Herald*, Nov. 4, 1923.

Boris Lovet-Lorski (1894 – 1973)

Romantic in his choice of subjects and attentive to the nature of the precious materials he loved to carve, Boris Lovet-Lorski approached sculpture as a means of transcending life's transient and often painful experiences. His Slavic background and eclectic borrowings from the past helped to temper his modernism with a lyricism and a sense of mystery.

Born on a remote ancestral estate in Lithuania, Lovet-Lorski demonstrated a contemplative and artistic nature, which was given early encouragement at the local gymnasium, where he took Latin, music, and art. At age twenty he moved to Saint Petersburg to attend the Imperial Academy of Art. While taking classes there in sculpture under Hugo Salemann and architecture with L.N. Benoit, he also spent time studying painting as well as learning to play the cello at the Conservatory of Music. His studies were often interrupted, however, as the aristocratic society under Czar Nicholas II began to crumble. In 1916 amidst the growing chaos of the city before the Bolshevik Revolution, Lovet-Lorski fled to Lithuania with a small group of fellow students. For the next three years he traveled through Poland, Germany, and France with an acting group, ending up in 1919 in Rotterdam. There he modeled his first life-size portrait bust (present location unknown) of the mother of his artist friend Paul Schuitema in appreciation for their hospitality.

In 1920 he arrived in Boston, where an older brother lived, and sought work as a draughtsman. With encouragement from an architect who appreciated his true inclination, Lovet-Lorski prepared himself for the life of a struggling artist. Within a short time, however, he was given a one-person show at the Grace Horne Gallery, where nine examples of his sculpture and thirteen of his drawings were exhibited. A.J. Philpott, critic for the *Boston Globe*, praised the young artist's "rare power of plastic feeling" and noted his "tendency toward the French moderns in expression."[1] Lovet-Lorski's melancholy temperament and wartime experiences were given symbolic expression in a group of vigorously modeled male figures. One, entitled *Effort* (present location unknown, formerly Rockford Art Association, Illinois), showed a man half-kneeling, straining to rise despite the heavy load on his back. Another, called *Memories* (present location unknown), depicted a half-nude man tied to a stake. Lovet-Lorski's portrait busts also gave evidence of his strengths and his promise.

In 1921 Lovet-Lorski moved to New York, where he met the art patron Lydia Avery Coonley Ward, who invited him to stay at Hillside Farm in the western part of the state. Run like an artist's colony, Ward's farm provided the recent immigrant with a chance to get to know people of note in the art world, including Dudley Crafts Watson, director of the Milwaukee Art Institute, who encouraged him to move to Milwaukee. Lovet-Lorski spent two years there, teaching at the newly formed Layton School of Art and, before returning to New York, gained local recognition at an Art Institute show of thirteen of his compositions.

Lovet-Lorski celebrated becoming an American citizen in 1925 with his first major exhibition at the Reinhardt Galleries, New York. A series of romantic, winged creatures in flight, entitled *From a Cycle of Sorrow*, 1925, were described by one reviewer as "spirited and original."[2] Stylizations of Cretan horses and bulls, their Art Deco design found favor as well with the public. African goddesses and Egyptian heads were also shown; they, too, seemed to echo mythical fantasies.

In 1926 Lovet-Lorski moved to Paris, where he felt more comfortable pursuing his growing interest in direct carving in stone and wood. Three of his pieces produced that year were accepted for the Salon d'Automne, quickly establishing his reputation. Seldom using preliminary models, he spent long periods carefully studying a block of stone or wood before deciding on the composition. Parts of a sculpture were often left seemingly unfinished, in the manner of Rodin or Michelangelo, thereby revealing the essential character of the rare stones he gravitated toward, perhaps a result of his Russian heritage. Besides black marble, lava, onyx, jade, and slate, he also carved in ivory and exotic woods like Assyrian lemonwood, letting these materials dictate his choice of subject. Lovet-Lorski described his method as intuitive, alluding to it in spiritual terms. "Sculpture seems to me like the work of God, for it is creation . . . something from nothing; first a lump of clay, then something that expresses life, beauty."[3]

Influenced by primitivism in the oeuvre of both Pablo Picasso (1881-1973) and Constantin Brancusi (1876-1957), Lovet-Lorski flattened and thinned his figures and introduced such archaizing features as almond-shaped eyes. The further he removed himself from contemporary concerns, the more he was drawn to the sensual dualism of Charles Baudelaire and the illusionistic poetry of Arthur Rimbaud and Paul Verlaine. A detached, even dreamy quality is evoked in much of his sculpture from the late 1920s, as in the handsome black Belgian marble head of Salome, 1927 (John P. Axelrod, Boston). Dance and music also inspired the rhythms of his flowing contours.

At the same time, in such works as the aluminum torso of a young woman called *Adolescence*, 1929 (San Francisco Museum of Modern Art), Lovet-Lorski seemed ready to adopt Art Deco's machine aesthetic. Undoubtedly, in this example the metal enhances the robotlike quality of the figure, with the helmet-covered head and the body cast as one sleek, stylized volume.

Commissions for portrait busts continued to serve as lucrative diversions for him. Hollywood personalities, such as Lillian Gish, 1924, and Mary Pickford (present locations unknown) and musical celebrities like Arturo Toscanini, 1933 (National Portrait Gallery, Washington, D.C.), provided him with the means to travel freely and maintain studios in New York, Paris, and Rome. In 1929 Lovet-Lorski was the first foreign artist to be asked to model portraits of the Italian royal family.

As Lovet-Lorski became more successful and more confident in the 1930s, his forms became pure aesthetic creations, although they remained representational. From more linear sculpture created in the late 1920s, his art evolved into a classical stage with the sculptured female form emphasized for its evocation of inner peace and beauty. From a series of exhibitions in major cities in America, as well as in Paris and London, his creations became well known, and by 1934 the critics were uniform in their praise of his efforts.

In 1939 Lovet-Lorski was crippled by an arthritic attack, and from then on he concentrated on modeling bronze figures and portrait busts, rather than on direct carvings in stone, which he preferred. He continued to receive favorable reviews from the New York critics, however, with a show of fifty pieces of sculpture and numerous drawings at Wildenstein Galleries in 1940 and his retrospective there in 1945. Edward Alden Jewell of the *New York Times* characterized the sculptor's growth as evolving from a period of stylization, even "slickness," to one of increasing simplicity, directed toward what the sculptor himself called "inner permanence."[4] His heroic head of President Franklin Delano Roosevelt, 1945 (Petit Palais, Paris), was acclaimed for the ease with which he conveyed the famous subject's magnetic personality. His highest tribute came in 1950 when the French government made him a *chevalier* of the Legion of Honor "for the high character of his artistic achievement."

Lovet-Lorski's monumental commissions were limited to his bronze over life-size statue of Abraham Lincoln as a young lawyer, 1946 (Court House, Decatur, Illinois), and the *Manila War Memorial*, dedicated in 1957 (American Military Cemetery, Fort McKinley, The Philippines), a tribute to the 54,000 American men who died or were listed missing in action in the South Pacific during World War II. The 50-foot marble bas-relief, modeled in his Staten Island studio, consists of six symbolic figures that form a pyramid: at the apex Columbia holds a child who represents the rebirth of American youth; in the middle are Liberty, Justice, and Patria; and at the bottom an American soldier, like a modern Saint George, stands over a slain dragon, the incarnation of evil. Richly symbolic, the memorial remains within the decorative architectural tradition of the 1920s.

In the late 1950s and early 1960s, when Lovet-Lorski could no longer raise his arms above his shoulders, he still did busts of such noted political

leaders as General Charles de Gaulle, 1959 (City Hall, Paris); Secretary of State John Foster Dulles, 1962 (Dulles International Airport, Washington, D.C.); and President John F. Kennedy, 1964 (Brandeis University, Waltham, Massachusetts). He now also turned to painting, creating hundreds of abstract compositions, which added another dimension to his already versatile career. As he explained, these "fantasies, compositions and abstractions [are] rooted in deliberate, disciplined and reasoned intent, as distinct from work based on a happy accident."[5] Early architectural training and the influence of Art Deco undoubtedly contributed to his stylized forms, but increasingly his art was guided by a personal aesthetic based on nature's own beauty.

<div align="right">P.M.K.</div>

Notes

1. A.J. Philpott, *Boston Globe*, Nov. 12, 1920.

2. R.F., "Lovet-Lorski at Reinhardt's," *Art News* 23 (Feb. 21, 1925), p. 2.

3. *Milwaukee Journal*, Jan. 21, 1923, quoted in Syracuse University, N.Y., *Boris Lovet-Lorski: The Language of Time*, text by Martin H. Bush (1967), pp. 33-34.

4. Edward Alden Jewell, "Lovet-Lorski Art Placed on Display," *New York Times*, May 19, 1945.

5. Boris Lovet-Lorski, quoted in World House Galleries, New York, *Paintings by Boris Lovet-Lorski* (1963), unpaginated.

References

AAA, SI; Magdeleine A-Dayot, "Boris Lovet-Lorski," *L'Art et les artistes*, n.s. 34 (Apr. 1937), pp. 243-245; Merle Armitage, *Sculpture of Boris Lovet-Lorski* (New York: Weyhe, 1937); Gaston Derys, "Les Sculptures de Boris Lovet-Lorski," *Mobilier & Decoration*, May 1937, pp. 160-162; Donald Charles Durman, *He Belongs to the Ages: The Statues of Abraham Lincoln* (Ann Arbor, Mich.: Edwards, 1951), pp. 258-259; John Erskine, *Tribute to Woman: Boris Lovet-Lorski Sculpture* (New York: Barnes, 1965); Fine Arts Museums of San Francisco, *American Sculpture: The Collection of the Fine Arts Museums of San Francisco* (1984), pp. 78-79; Edward Alden Jewell, "Lovet-Lorski Art Placed on Display," *New York Times*, May 19, 1945; Hilton Kramer, "Lovet-Lorski Sculpture Is Revived," *New York Times*, Dec. 23, 1972; Boris Lovet-Lorski, *Lithographs by Boris Lovet-Lorski* (Paris 1929); MMA; *New York Times*, Mar. 5, 1973, obit.; Syracuse University, N.Y., *Boris Lovet-Lorski: The Language of Time*, text by Martin H. Bush (1967); Wildenstein, New York, *Boris Lovet-Lorski*, text by Merle Armitage (1945); idem, *Boris Lovet-Lorski*, text by John Erskine (1940); World House Galleries, New York, *Paintings by Boris Lovet-Lorski* (1963).

BORIS LOVET-LORSKI

149

Torso, mid-1930s

Marble

H. 13 9/16 in. (34.3 cm.), w. 5 7/16 in. (13.8 cm.), d. 5 1/4 in. (13.3 cm.)

Bequest of Mrs. Edward Jackson Holmes, Edward Jackson Holmes Collection. 65.260

Provenance: Mr. and Mrs. Edward Jackson Holmes, Topsfield, Mass.; Mrs. Edward Jackson Holmes, Boston

This cream-colored marble torso of a young woman is set on a rough-cut base. The body terminates above the knees and is turned to the right, the head sharply bent like that of Russian icons. The figure's right arm is in full view, but the left arm is partially hidden behind abundant, stylized hair, which falls to the waist. Almond-shaped eyes add a note of exoticism to the coquettish pose and delicate carving of the marble.

Torso represents the mature phase of Lovet-Lorski's career, executed during what one reviewer has described as his classical period. "It is classicism in the Greek sense of the word. By classicism is meant not naturalism but stylization of the human body carried to such a degree of perfection it creates real life."[1]

Like Aristide Maillol (1861-1944), Lovet-Lorski resisted abstraction and the distortion of the human figure. But in the subtlety and refinement of his style during this period, his work is closer to the sensuous, sweeping, and sometimes abstracted lines of Alexander Archipenko (1887-1964) than to the blocklike forms of other direct carvers like John Flannagan (1895-1942), who altered their materials as little as possible in the belief that the stone or wood itself would release the image.

The *Torso* in the Museum of Fine Arts is strikingly similar to another by Lovet-Lorski entitled the *Dance*, which was in a private collection in Paris in 1965.[2] The figure is also close to *Torso No. 19* (present location unknown), shown at Wildenstein, New York, in 1945, which Margaret Breuning, critic for *Art Digest*, singled out for praise: "On non-rhythmic material he has imposed rhythmic structure, idealizing, generalizing, but preserving the harmony of inward and outward planes so that forms appear to grow freely into a final clarity of unified expression."[3] His marble torso *Ariadne*, 1937 (The Metropolitan Museum of Art, New York), is basically the same as the Museum's, although the former is fully in the round above a more stylized base and lacks some of the delicacy of this smaller-scaled piece.[4]

149

Edward Jackson Holmes, director of the Museum from 1926 to 1934 and then president until his death in 1950, from whose collection the Museum received *Torso*, also owned a portfolio of twenty untitled lithographs by Lovet-Lorski, dated Paris 1929, which were given by his widow to the Museum in 1951.[5] Number 2 of this portfolio shows the same bent-neck pose as *Torso*. Number 19 is a headless torso, close in style to the Metropolitan's *Ariadne*. In number 3 a wind-swept mountainous landscape provides a poignant setting for one of the sculptor's ethereal nudes. In the artist's preface, Lovet-Lorski described these prints as "expressions of distant ideas—thoughts—music and moods—memories of childhood create dreams which often find their way into a casual drawing that truly expresses the innermost self of the artist—."[6]

P.M.K.

Notes

1. Merle Armitage, *Sculpture of Boris Lovet-Lorski* (New York: Weyhe, 1937), p. 13.

2. See John Erskine, *Tribute to Woman: Boris Lovet-Lorski Sculpture* (New York: Barnes, 1965), p. 49.

3. Margaret Breuning, "Lovet-Lorski," *Art Digest* 19 (June 1, 1945), p. 17.

4. See Gardner 1965, p. 167.

5. See Boris Lovet-Lorski, *Lithographs by Boris Lovet-Lorski* (Paris, 1929), unpaginated (numbered in pencil 1-20), Department of Prints, Drawings, and Photographs, 51.452-471, BMFA. The Holmeses were early collectors of contemporary art. In 1940 they lent Lovet-Lorski's *Daphne*, a torso of Algerian onyx, to Wildenstein's show of the sculptor's work. See Wildenstein, New York, *Boris Lovet-Lorski*, text by John Erskine (1940), no. 30. The Holmeses also gave the Museum, by bequest in 1952, Maurice Sterne's bronze portrait bust *Senta* (q.v.).

6. Lovet-Lorski, *Lithographs*, p. [1].

George Aarons (1896 – 1980)

Modest but distinctly independent, George Aarons transcended his early Beaux-Arts training to become a modernist, translating his deep concern for humanity into sculptural forms that at times verge on abstraction. The development and range of his style, moreover, document the profound societal changes of the twentieth century.

In 1906 Aarons came to America from Kovno, Lithuania. He attended the Boston public schools and at age fifteen took his first drawing lessons. Recognizing his artistic talent and his lack of interest in academics, his teachers encouraged him to finish high school at night and enroll in afternoon classes at the School of the Museum of Fine Arts. From 1911 to 1916 he studied there, taking drawing from antique casts with the painters Ralph Mc-Clellan (born 1884) and Leslie P. Thompson (1880-1963) and modeling from Bela Pratt. In 1915 he won the School's Kimball Prize. The following year he moved to New York to attend the Beaux-Arts Institute, where Jo Davidson introduced him to Rodin's impressionistic technique.[1] Aarons then apprenticed in the New York studios of Paris-trained Richard Brooks (1865-1919), Solon Borglum (1868-1922), and the English sculptor Robert Baker (1886-1940), an experience that more than compensated for his lack of European study.

Returning to Boston, Aarons engaged in a variety of odd jobs to support himself while waiting for commissions. In 1922 he received his first critical acceptance for the sensitive but vigorous Rodin-like study of his friend Leah Rabinowich (q.v.). *Girl on the Rock* (q.v.), another piece with erotic overtones inspired by the French master, followed in 1926, impressing Boston critics and proving to be one of his most exhibited works.

By the 1930s Aarons was well known locally, and his sculpture was shown regularly in national exhibitions. At his studio in Brookline, Massachusetts, he executed a number of architectural reliefs and portrait busts, including a head of Dorothy Adlow, 1933 (Hilles Library, Radcliffe College), the popular Boston art critic, who had been one of the earliest to review his work. His powerful portrayal of Edgar Allan Poe, 1932 (Sawyer Free Library, Gloucester, Massachusetts), the nineteenth-century romantic writer and poet of the occult, first exhibited at the West End Branch of the Boston Public Library, drew Adlow's favorable comparison with the French sculptor Antoine Bourdelle's (1861-

1929) emotionally charged bust of Beethoven, 1902 (The Metropolitan Museum of Art, New York).[2]

Around 1936 Aarons met his future wife and lifelong companion, Gertrude (Band), a promising young dancer who was taking classes in the building where his studio was located. Soon his blocklike, Promethean figures, such as the sketch of a man struggling to be free, 1936 (Gertrude Aarons, Gloucester), designed as a war memorial for the Works Progress Administration's (WPA) Federal Art Project, gave way to more expressive subjects, which seemed to be inspired by the dance and pantomime.

An active member of the Boston art community, Aarons joined the American Artists Congress in 1936, lending his support to this newly formed organization in its opposition to growing racism in America. His *Negro Head*, 1936 (Gertrude Aarons), made of cast stone, was shown at the Congress's 1937 and 1938 traveling exhibitions. Aarons's democratic sympathies found even wider public expression in the monument to labor he created in 1938 for the courtyard at Old Harbor Village, South Boston, one of the first federal housing projects in America. Among the largest commissions awarded by the Treasury Relief Art Project (funded by the WPA), and the only one of its kind in Boston, the work combined a 15 by 34-foot limestone wall relief

depicting seven types of laborers employed in construction trades, and a heroic-size, cast stone sculptural group (demolished in 1948). A fisherman in a sou'wester, a longshoreman hauling a sack of grain over his shoulder, and a black construction worker holding a sledge hammer—flanked by a young girl and boy at play—were chosen to represent South Boston's three major industries and the children that would live in the housing project. Dedicated on Labor Day by Mayor Maurice Tobin before a crowd of five thousand, the Old Harbor Village monument dramatized the dignity of labor in an idealized, muscular style that was easily understood by the public.[3]

At a one-person show in the foyer of Symphony Hall, Boston, during November and December of 1938, Aarons's "acute social consciousness, keen understanding, and deep sympathy"[4] were again demonstrated in three diverse portraits: *Orientale*, 1931 (Gertrude Aarons), a Carrara marble bust of a Japanese woman in a traditional hairstyle; *Negro Head*, which had now been seen in numerous cities in the United States; and *Serge Koussevitzky*, 1940 (Gertrude Aarons), a plaster bust of the symphony's renowned conductor.

When war enveloped Europe in 1940, Aarons found solace in his humanist philosophy. While his portraits generally remained straightforward, his figural studies became increasingly stylized and simplified. Alternating between classical references and cubist elements, Aarons created a body of work that expressed his hopes and fears for the future. *Seated Dancer*, 1941 (Gertrude Aarons), an idealized nude, was modeled at the same time as *Europa* (q.v.), a deeply moving but nonheroic and generalized personification of the continent in defeat. After the war Aarons responded to the renewal of life in Europe with bronzes like *Rebound*, 1947 (Gertrude Aarons), and *Jeremiah, Pour Forth Thy Wrath*, 1947 (Brandeis University, Waltham, Massachusetts), both of which recall in their flat planes and dramatic gestures the German sculptor Ernst Barlach's (1870-1938) *The Avenger*, 1914, cast after 1930 (Hirshorn Museum and Sculpture Garden, Washington, D.C.).

Aarons also continued experiments begun earlier with direct carving in wood. A female figure called *Adolescence*, 1949 (Cape Ann Historical Association, Gloucester), which was exhibited at the annual exhibition of the Whitney Museum of American Art, New York, for 1949, appears as if emerging from a tree trunk like some "mythological Daphne in reverse."[5] His first efforts in cutting marble were

made soon after, with his head of a Peruvian woman (q.v.). Always free of fashion and eager to try out new ideas, Aarons provided "interesting contrasts in his portrayals, between moods of meditation, abnegation, and outflung assertiveness."[6]

In 1951 Aarons built a studio in Gloucester, where he had summered since 1945. Nearby in Rockport were his contemporaries Richard Recchia and Paul Manship, and he became an active member of the Rockport Art Association. From then on he commuted regularly between his Brookline and Gloucester homes, where he gave private instruction in modeling. During this time he received a major commission to design nine reliefs of Old Testament subjects for the facade of the Baltimore Hebrew Congregational Building that were unveiled in 1955.

By the 1960s Aarons's sculpture had become increasingly abstract. His new interest in space and flight found expression in figures that seemed to "soar, loop or thrust outward from their bases."[7] In *Galaxy*, about 1965 (Gertrude Aarons), a design in metal that suggests celestial movement, he employed welding and brazing techniques. For his portrayals of dancers or women held in the uplifted arms of men, separate figures now merged into one fluid form. *Unison II* (q.v.), which depicts the united torsos of a male and female, is all but indistinguishable in gender and seems reminiscent of Constantin Brancusi's (1876-1957) birdlike, nonrepresentational works.

Aarons's compassion for the anguish of others imbued his sculpture with an emotional expressiveness. He remains within the figurative tradition precisely because of this awareness. As Aarons said of his art: "I am essentially interested in humanity, and have a sympathetic feeling and consciousness of the process man must experience to achieve his aspirations: the suffering, struggle, the pleasures and pains. I try to express these things in as forceful and interesting a manner as it is within my power to do so. The spirit of my expression is more important than the style or form it takes."[8]

P.M.K.

Notes

1. From 1911 to 1935 the Beaux-Arts Institute of Design (founded in 1894 as the Society of Beaux-Arts Architects) held sculpture classes for men. Taught mainly by members of the National Sculpture Society, who were not paid, students were trained to be craftsmen-sculptors and the concentration was on architectural design problems.

See Fritz Cleary, "Last Days at the Beaux-Arts," *Sculpture Review* 34 (spring 1985), pp. 24-25, 33.

2. See Dorothy Adlow, "Boston Art Notes," *Christian Science Monitor*, Jan. 20, 1933.

3. See "Tobin Will Dedicate Old Harbor Monument," *Boston Sunday Post*, Sept. 11, 1938. See also De Cordova Museum, Lincoln, Mass., *By the People, for the People: New England* (1977), p. 25, no. 92.

4. "Symphony Hall Show of Aarons's Sculpture," *Boston Evening Transcript*, Nov. 26, 1938.

5. "Whitney Museum Annual," *Art News* 48 (May 1949), p. 42.

6. Dorothy Adlow, "Stuart Gallery Shows Work by George Aarons," *Christian Science Monitor*, June 29, 1949.

7. Edgar Driscoll, Jr., "The Art World: There's Plenty That's New," *Boston Sunday Globe*, Nov. 26, 1967.

8. Letter from Aarons to Philip Desind, May 21, 1956, which includes a biographical statement for Desind's projected book on American and Canadian contemporary wood sculpture. George Aarons Papers, Gertrude Aarons, Gloucester, Mass.

References

AAA, SI; George Aarons Papers, Gertrude Aarons, Gloucester, Mass.; Dorothy Adlow, "In the Boston Galleries," *Christian Science Monitor*, Nov. 28, 1938; C. Ludwig Brummé, *Contemporary American Sculpture* (New York: Crown, 1948), pl. 1; *Gloucester Daily Times*, Nov. 25, 1980, obit.; *National Sculpture Review* (summer 1981), p. 24, obit.; Peter Olson, "Sensitivity to Life Reflected in Aarons' Sculpture," *Gloucester Daily Times*, Feb. 18, 1970; Elizabeth O'Toole, "Human Forms Sublime," *Gloucester Daily Times*, Aug. 12, 1971; Jacques Schnier, *Sculpture in Modern America* (Berkeley: University of California Press, 1948), pls. 14, 43; SMFA.

GEORGE AARONS

150

Leah, 1924

Plaster, painted black

H. 12⅜ in. (31.4 cm.), w. 9 in. (22.8 cm.), d. 11¾ in. (30 cm.)

Signed (on back of neck): G. Aarons / 1924

Gift of Gertrude Aarons. 1982.534

Provenance: Gertrude Aarons, Gloucester, Mass.
Exhibited: The Copley Society of Boston, BMFA, *Exhibition of the Work of Painters and Sculptors of Boston and the Vicinity* (1927), no. 3; Symphony Hall, Boston, Nov. 26 - Dec. 3, 1938, no. 5.
Versions: *Plaster*, bronzed: (1) Gertrude Aarons, (2) Dr. Larry Nathanson, Cambridge. *Bronze*: (1) Gertrude Aarons

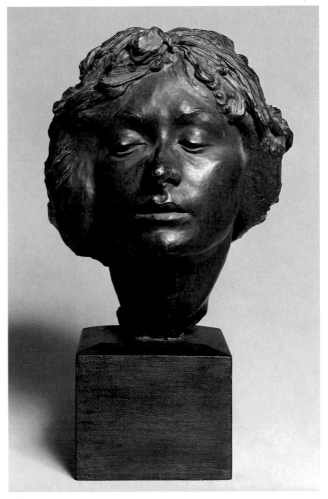

150

Leah Rabinowich Nathanson (1899-1986) was an artist friend of Aarons's from Cambridge, Massachusetts.[1] Like his family, hers had emigrated from Russia, and the two had known each other since childhood. From 1925 to 1926 Leah attended the School of the Museum of Fine Arts, where she concentrated on portraiture. She then moved to New York, working for a time as a commercial illustrator designing magazine advertisements. After returning to Cambridge, she married Robert Nathanson, a Boston cloth manufacturer. Although Leah Nathanson never pursued a career as an artist, she painted all her life and was an active member of the Cambridge Art Association. Her curvilinear, Art Nouveau style of the 1930s and 1940s evolved after World War II to one that was more controlled, with forms simplified.

In 1922 Aarons modeled a plaster bust of Leah Rabinowich, with a directness and liveliness that are similar to his naturalistic portrayal of the French

writer Henri Barbusse, about 1930 (Musée de Saint Denis, France), of which he was particularly proud.[2] During the 1920s and early 1930s, Aarons sought to emulate in his own portraits both Auguste Rodin's and Antoine Bourdelle's strongly emotional and impressionistic styles. His romantic study of Edgar Allen Poe, 1932 (Sawyer Free Library, Gloucester, Massachusetts), for example, is close to Bourdelle's dramatic head of Beethoven, 1902 (The Metropolitan Museum of Art, New York), the emphasis in both being placed on the massive foreheads of these towering geniuses.[3]

When *Leah* was shown at Grace Horne's Boston gallery in 1922, Frederick W. Coburn, critic for the *Boston Herald*, proclaimed the head a "quite exquisite portrait."[4] Two other plaster versions of *Leah* are dated 1924; after Gertrude Aarons gave one of these to the Museum of Fine Arts in 1982, she had the other, which she owned, cast in bronze the following year by Paul King Foundry, Kingston, Rhode Island.

<div align="right">P.M.K.</div>

Notes

1. *Boston Globe*, July 15, 1986, obit.; telephone conversation between Paula M. Kozol and Dr. Larry Nathanson, Leah's son, Aug. 8, 1986.

2. Interview by Paula M. Kozol with Gertrude Aarons, Mar. 19, 1985, BMFA, ADA.

3. See Dorothy Adlow, "Boston Art Notes," *Christian Science Monitor*, Jan. 20, 1933.

4. F.W. Coburn, "In the World of Art," *Boston Sunday Herald*, Jan. 15, 1922.

GEORGE AARONS

151

Peruvian Head, 1951
Marble
H. 11 in. (28 cm.), w. 5½ in. (14 cm.), d. 10¼ in. (26 cm.)
Gift of Gertrude Aarons. 1982.530

Provenance: Gertrude Aarons, Gloucester, Mass.
Exhibited: Fitchburg Art Museum, Mass., *George Aarons: One-Man Exhibition of Sculpture* (1965), no. 18.

Aarons carved this head using as a model photographs a friend of his had taken about 1951 during a trip to Peru.[1] Fascinated by both the variety of racial types and the formal qualities of primitive art, Aarons joined other twentieth-century artists in their exploration of the indigenous cultures of Oceania and Africa, as well as South America.

A unique piece, *Peruvian Head* marked a turning point for Aarons, away from more conventional portraiture. Carving for the first time directly in marble, he concentrated on the strong bone structure of the subject's head, abruptly terminating the bust just below the firm chin to heighten the effect. To create the sculpture's varied textures, Aarons left the stylized, wavy hair rough and polished the finely carved contours of the face, highlighting the woman's high cheekbones, long nose, and broad, full mouth. The braided hair band adds a further decorative note.

<div align="right">P.M.K.</div>

Note

1. See four photographs of a Peruvian woman, taken about 1951, BMFA, ADA.

GEORGE AARONS

152

Europa, 1960 (modeled in 1941)
Bronze, brown patina, lost wax cast
H. 10¼ in. (26 cm.), w. 9¾ in. (24.8 cm.), d. 9⅝ in. (24.5 cm.)
Signed and inscribed (on top of base at back): ⁵⁄₁₂
G. Aarons / 1941
Gift of Gertrude Aarons. 1982.531

Provenance: Gertrude Aarons, Gloucester, Mass.
Exhibited: Guild of Boston Artists, *Sculpture by George Aarons* (1948), no. 14, as *Despondency*.
Versions: *Plaster*: (1) present location unknown. *Bronze*: (1, 2) Gertrude Aarons, Gloucester, Mass., (3) Doris Vidavir and Dr. Maynard Cohen, Chicago, (4) present location unknown, formerly private collection, Brookline, Mass., (5) present location unknown, formerly private collection, Lexington, Mass., (6, 7) private collections, Brookline, (8) private collection, East Dennis, Mass.

Aarons began this defeated figure of Europa in 1940 as a response to the war raging in Europe. Hitler's army had invaded Poland, Norway, Denmark, Belgium, and the Netherlands, while Italy had declared war on France and Great Britain. Aarons's personification of the continent obviously reflects the deep anxiety he felt at the time over Europe's seemingly tragic destiny.

A popular theme in the history of art, Europa is generally shown as a young, spirited maiden being carried off by Zeus.[1] Aarons's figure, in marked contrast, is earthbound, a woman of solid build, with head bent over her waist and arms hanging down close to her sides. She wears a long, sleeveless dress and sturdy shoes and bears comparison with

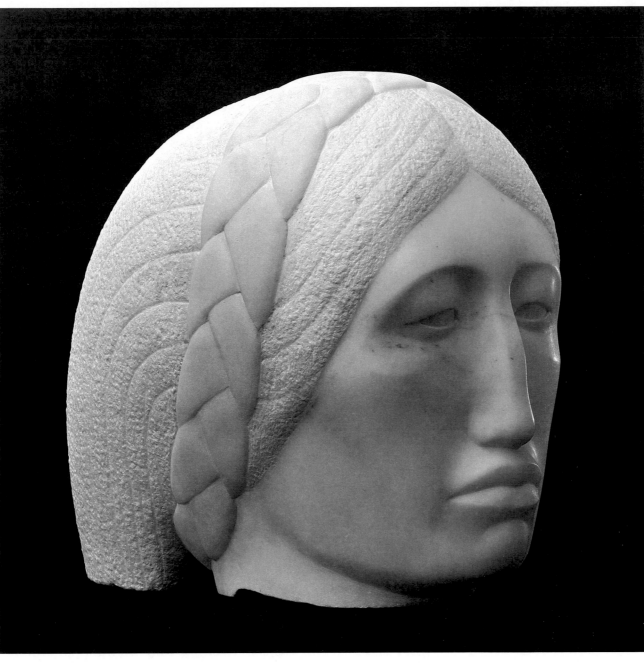

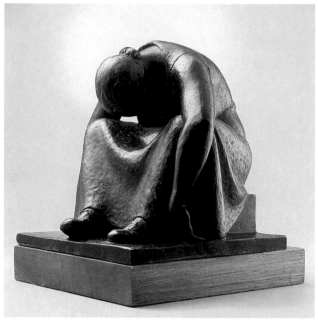

152

the type of peasant woman that the German artist Käthe Kollwitz (1867-1945) memorialized in her lithographs, woodcuts, and small but powerful sculptures. Monumental in effect, Aarons's simplification of form depersonalizes his subject. Only a few rhythmic folds of the heavy garment, as it falls around her legs, and the womblike hollow of her lap relieve the sense of weightiness.

Aarons acknowledged the influence of Ernst Barlach, whose expressionistic sculpture in wood *Sorrowing Woman*, 1909 (present location unknown), is close both in spirit and in treatment to *Europa*. Barlach's mournful, seated figure, too, wears a plain, long dress that contains her massive shape. Like the German sculptor, Aarons sought in his work to evoke varying moods and spiritual conditions, with titles—such as *Compassion*, *Forsaken*, and *Striving*—that helped to express the suffering and hopes of his generation. *Europa*, for example, was first called *Despondency*.

In 1944 the plaster model of *Europa* (present location unknown) was awarded third prize at the annual members' exhibition of the Institute of Modern (now Contemporary) Art, Boston. The Museum's bronze was cast in 1960 at the Giovanni and Angelo Nicci foundry in Rome.

P.M.K.

Note

1. According to Homer (*Iliad*, 14, 321), the beauty of Europa, a Phoenician princess, fired the love of Zeus. Disguised as a white bull, the ruler of the gods cast a spell

on Europa with his gentle manner, and when she climbed on his back, he leaped into the sea and swam away with her to the island of Crete. There, she bore him three sons, Minos, Rhadamanthys, and Sarpedon. After her death, Europa was worshiped as the goddess of the dawn in whom the contrasting principles of virginity and motherhood were combined. Her name originally stood for central Greece but by 500 B.C. had extended to the entire continent of Europe.

GEORGE AARONS

153

Girl on the Rock, 1960 (modeled in 1926)
Bronze, brown-green patina, lost wax cast
H. 26 in. (66 cm.), w. 12 in. (30.5 cm.), d. 10¼ in. (26 cm.)
Signed and inscribed (on rock below left foot):
Geo. Aarons / 1926 ⅛
Gift of Gertrude Aarons. 1982.532

Provenance: Gertrude Aarons, Gloucester, Mass.
Exhibited: BMFA 1977, no. 62; Equitable Gallery, New York, *"Vita Brevis, Ars Longa"*: *45th Annual Exhibition of the National Sculpture Society* (1978), no. 1.
Versions: *Plaster*: (1) Gertrude Aarons, Gloucester, Mass. *Bronze*: (1) Gertrude Aarons, (2) Mr. and Mrs. Macklen Kleiman, Marblehead, Mass., (3) present location unknown, formerly Dr. and Mrs. Archangelo D'Amore, Washington, D.C., (4) private collection, East Dennis, Mass., (5) Mr. and Mrs. David Wolf, Newton, Mass.

This small-scale bronze portrays a nude female sitting in a crouching position on top of a boulder. Like one of the voluptuous sirens of classical mythology who lured sailors to their doom, *Girl on the Rock* radiates erotic tension, from strained neck and hunched shoulders to tautly held arms and legs. Her head is thrown back and an anguished expression comes from her wide-open mouth.

Shown for the first time in 1927 at a Copley Society of Boston group show of local painters and sculptors, *Girl on the Rock* drew the warm praise of the critic for the *Boston Herald*, who found it to be "one of the high lights [*sic*] of a collection that matches up well against the paintings."[1] The following year, in her review of the Philadelphia Art Alliance exhibition of American sculptors, in which Aarons's sculpture was included, Dorothy Adlow waxed poetic in her description of, and admiration for, the piece: "If violence is the idea, it is softened with an ingratiating line, with a full ample comforting curve; it is alleviated by rhythmic movement, by the delicacy of clinging textures."[2]

Aarons originally called the work *Despair*, then *Chaos*, to describe the spent emotion of the figure.

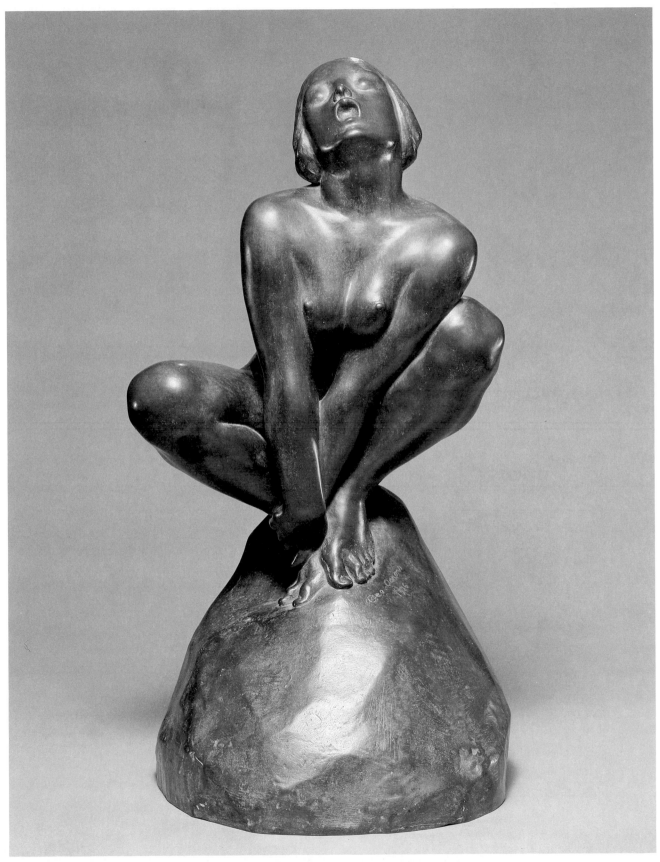

He later changed the title to *Girl on the Rock*, allowing the viewer to form a more personal interpretation of the piece.[3] The bronze in the Museum of Fine Arts was cast in 1960 at the foundry of Giovanni and Angelo Nicci in Rome. In 1977 this version was shown at the centennial exhibition of the Museum School.

P.M.K.

Notes

1. "The Copley Society Show," *Boston Herald*, Apr. 17, 1927.
2. Dorothy Adlow, "Work of George Aarons on Display in Philadelphia," *Boston Herald*, Dec. 23, 1928.
3. Interview by Paula M. Kozol with Gertrude Aarons, Mar. 19, 1985, BMFA, ADA. In the exhibition of Boston sculptors held at Harvard University's Germanic Museum in the summer of 1933, a plaster version of *Girl on the Rock* was called *Despair* (no. 1).

GEORGE AARONS

154
Unison II, 1964
Marble
H. 11¾ in. (29.9 cm.), w. 11 in. (28 cm.), d. 7 in. (17.8 cm.)
Signed (on front of base): Geo. Aarons / 1964
Gift of Gertrude Aarons. 1982.533

Provenance: Gertrude Aarons, Gloucester, Mass.
Exhibited: Fitchburg Art Museum, Mass., *George Aarons: One-Man Exhibition of Sculpture* (1965), no. 20.

Unison II was a favorite work of George and Gertrude Aarons. Modeled in 1964, it represents a radical simplification of the more representational bronze *Unison I*, 1964 (Gertrude Aarons, Gloucester, Massachusetts), which consists of two seated figures, male and female, with one head. This abstraction of a male and a female torso joined at the shoulders and thighs represents the culmination of a lifetime effort to illustrate the union and conflicts between man and woman. For Aarons, the age-old tension between the sexes epitomized both the joy and the pain of being alive. In the Museum's piece, a sense of oneness predominates, enhanced by the highly polished French Champville marble.

Aarons also created a number of fragmented, sculptural groups symbolizing the desire of people everywhere to live in harmony. In *One World*, 1949 (Gertrude Aarons), three heads, each with the characteristic facial features of a different race, are cut into one block of limestone. Similarly, *Cycle*, 1957

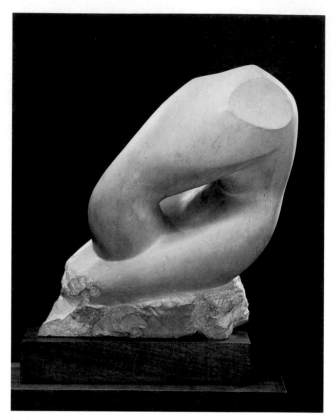

154

(Gertrude Aarons), depicts two figures carved in mahogany, their intertwined limbs caught in a seemingly eternal embrace.

By the time Aarons attempted partial figures like *Unison II*, there was a general acceptance of this novel form. Auguste Rodin and Gaston Lachaise had prepared the way by isolating and exaggerating parts of the body, which challenged viewers' notions on the sensuality and sexuality of the nude. Then the Rumanian Constantin Brancusi (1876-1957) and the Swiss Hans Arp (1887-1966) reduced the human body to basic organic shapes, requiring the public to find their human references in new associations with nature and technology. Aarons's own preoccupation with the relationships between the sexes found its strongest statement in such simplifications.

P.M.K.

Donald Harcourt DeLue (born 1897)

Donald Harcourt DeLue, a native of Boston, currently has a studio and lives in Leonardo, New Jersey. His production represents an important but neglected phase in the history of American sculpture, with work that was central to the concerns of members of the National Sculpture Society, New York, in the 1930s and 1940s. His commitment to heroic groups and figures, modeled in a robust, manneristic style, resulted in pieces that mediated well between the human dimension and the new scale of pre-World War II architecture.

DeLue's artistic development was profoundly shaped by his experiences at the Museum of Fine Arts. His interest in modeling was awakened at the age of twelve, when his mother, Ida Martha (Hawkins) DeLue, took him to the Museum. She wanted to encourage DeLue's proclivity for drawing. However, after viewing a gallery that contained plasters of Michelangelo's Medici tombs, part of the frieze from the Temple of Zeus at Pergamum, Verrocchio's *Colleoni Monument*, and Donatello's *Gattamelata*, DeLue realized that "there was nothing that could stop me from being a Sculptor." The powerful impact was fresh in DeLue's mind seventy-five years later: "My heart still sings every time it comes to my mind. . . . Such power such strength and volume I have never seen since."[1]

After this visit, DeLue's mother further encouraged her son by taking him, with his drawings, to Bela Pratt, the leading sculptor in Boston at that time and a faculty member at the School of the Museum of Fine Arts.[2] Pratt was impressed with DeLue's talent but informed the aspiring artist that he was too young for admission to the Museum School.[3] Instead, Pratt suggested that DeLue become an apprentice in a sculptor's studio. In 1909 DeLue began to study with and work for Richard Recchia, then twenty-five. Among his duties there, DeLue posed for the bronze figure *Pan*, 1913 (Katharine Lane Weems, Manchester, Massachusetts). Later that year DeLue quit high school to study full time with Recchia, copying casts and doing some work of his own. DeLue even performed some restoration work for the Museum, fixing the left arm of the ancient Cretan ivory and gold *Snake Goddess*. When Robert Baker (1886-1940), an English sculptor, opened a studio next to Recchia's in 1914, he hired DeLue as an assistant. Baker had many commissions, several of them over life-size, and as a result, DeLue gained considerable experience with large sculpture.

Because of World War I, Baker's studio closed down in 1918. Earlier, DeLue had sought the advice of his mentor Pratt, who had advised him to seek employment in New York. Instead, DeLue enlisted as a sailor on a ship delivering ammunition to France. Once in France, DeLue jumped ship and headed for Paris, where he survived for four years on odd jobs, visiting art institutions as well as the studios of the city's sculptors, whom he befriended. For part of the time he worked for Alfred Pina (born 1883), who at the time was modeling large, well-developed female torsos. During this four-year period he traveled to Meudon, hoping to see the studio of Auguste Rodin (1840-1917), which was closed. In 1923 DeLue moved to Lyons, where he worked for two years, with the sculptor Charles-Jules DeBert, on projects of an architectural sort, modeling saints and madonnas in the Gothic style to replace those from war-damaged cathedral interiors. In 1924, the sculptor went to Limoges, seeking a position in the china factories, as many sculptors did. Unfortunately, the factories were not hiring foreigners, so DeLue returned to Paris but soon left for England. He worked for six months for Bryant Baker (1881-1970), the brother of Robert, traveled to Scotland, and then returned to New York in 1925.[4]

Upon his return to the United States, DeLue refused a job with the sculptor Lee Lawrie (1877-

1963) in New York. In 1926 Bryant Baker came to New York and hired DeLue as his assistant, specializing in figures. By the late 1930s DeLue had established his own career, entering many competitions. These brought him critical attention and resulted in his first commission in 1940: four granite panels depicting Law and Justice for the Federal Courthouse in Philadelphia. Many commissions soon followed, with DeLue often working closely with the architects: a marble garden fountain with a figure of Triton, 1940 (Federal Reserve Bank, Philadelphia); *The Alchemist*, 1940 (Chemistry Building, University of Pennsylvania, Philadelphia); and two large marble eagles, 1941 (Federal Courthouse). These projects allowed DeLue to establish a studio in New York in 1940.

In the years after World War II DeLue continued his distinguished career in monumental sculpture. He is perhaps best known for *Spirit of American Youth*, 1952 (Saint Laurent, Normandy, France), a memorial to the fallen American soldiers of D Day, and *The Rocket Thrower*, 1964 (Flushing Meadow, New York), one of the largest bronzes ever made, executed for the New York World's Fair. As a mature artist, DeLue received the Herbert Adams Memorial Gold Medal from the National Sculpture Society, the American Numismatic Association Gold Medal for Sculptor of the Year in 1979, and the Samuel F.B. Morse Gold Medal of the National Academy of Design, New York, to name three of the more than twenty such honors. He was also a president and fellow of the National Sculpture Society.

DeLue's creative process and style derive from early experiences, when he relied heavily upon drawing to sharpen his ideas prior to making a plaster or small bronze. DeLue has said, "I almost never use a model if it is well in my head. I draw incessantly as a way of expression, again no models. It is all in my mind."[5] His sculpture demonstrates artistic links to both Graeco-Roman and late Renaissance sculptors. He emulated the exuberant gestures and energetic compositions such as those found on the Pergamum. The mature Michelangelo, especially, inspired DeLue to compose his figures with manneristic proportions, emphasized with highly articulated musculature. However, by combining these older influences with the ideas and techniques acquired during his French tour, DeLue developed his own synthesis. As he admits, "Although my work is traditional, it is a tradition of my own."[6]

E.S.C.

Notes

1. Letter from Donald H. DeLue to Jonathan L. Fairbanks, 1984, BMFA, ADA.

2. Much of the biographical information for this entry was gathered from a reminiscence by DeLue, 1984, BMFA, ADA.

3. Since there was no age limitation for entrance to the Museum School, it is possible that Pratt meant DeLue was too young to benefit from the School.

4. For information regarding DeLue's activities and travels between 1918 and 1940, I am deeply indebted to Carl Palusci, who is conducting research on DeLue for Childs Gallery, Boston.

5. DeLue reminiscence, p. 8.

6. Ibid.

References

Mary Angers, "Sculptor DeLue Wins Acclaim," *Monmouth* [Schrewsbury, N.J.], Aug. 12, 1979, pp. 3, 4, 8, 9; *Donald DeLue*, American Sculptors Series, 15 (Athens, Ga., 1955); Harold Flartey, "DeLue Captures Sculptor of Year Laurels," *Coin World*, Sept. 12, 1979, p. 66; idem, "Donald DeLue, Sculptor," *Numismatist* 92 (Dec. 1979), pp. 2629-2635; N. Kent, "Recent Sculpture of Donald DeLue," *American Artist* 21 (Oct. 1957), pp. 49-51; M. Lantz, "Reminiscing with Donald DeLue," *National Sculpture Review* 23 (summer 1974), pp. 26-27; Proske 1968, pp. 375-379.

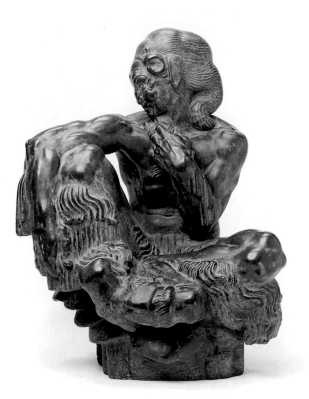

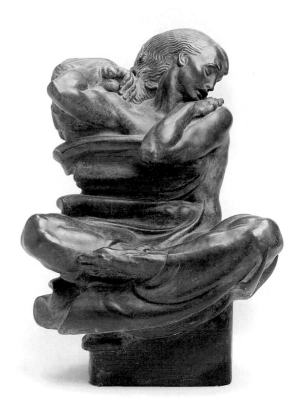

155

156

DONALD HARCOURT DELUE
155, 156
Faun and *Nymph*, 1937
Painted plaster
Faun: H. 22½ in. (57.1 cm.), w. 16½ in. (42 cm.),
d. 13 in. (33 cm.)
Nymph: H. 22 in. (55.9 cm.), w. 15¾ in. (40 cm.),
d. 12 in. (30.5 cm.)
Gift of the sculptor. 1985.381, 2

Provenance: Donald Harcourt DeLue, Leonardo, N.J.

While developing his career in the years prior to the
establishment of his own studio in 1940, Donald
DeLue made two seated plaster sculptures: the
woodland creature *Faun* and his sweetheart *Nymph*.[1]
They were intended to be models for two bronze
garden statues, which were never executed. *Faun*
and *Nymph* demonstrate DeLue's style on an inti-
mate level, showing the manneristic treatment of
proportion and anatomy for which he revered Mi-
chelangelo. The scale of the figures (about ten
head-lengths) emphasizes the power of the human
form. The pose is a good, rather convulsive, exam-
ple of *contrapposto*, the turning of one part of the

body in a different direction from the rest of the
form. The pose and treatment are inspired by Mi-
chelangelo, and *Faun* and *Nymph* owe a particular
debt to his Medici tombs.

Under the supervision of the artist, an edition of
twelve bronzes of *Nymph* and *Faun* was cast in 1986
by Tallix Foundry, Beacon, New York, from molds
of the plasters in the Museum of Fine Arts. The
artist's proofs no. 1 were donated to the Museum in
1986 by D. Roger Howlett, of Childs Gallery, Bos-
ton, and John P. Axelrod, of Boston.

E.S.C.

Note

1. The date 1937 for the *Faun* and *Nymph* is published in
Glenn B. Opitz, ed., *Dictionary of American Sculptors*, *18th
Century to the Present* (Poughkeepsie, N.Y.: Apollo, 1984),
p. 505. Conversations with the sculptor reveal that he
worked on the plasters for a number of years in the late
1930s but that they were fully realized by 1937.

Avard Tennyson Fairbanks
(born 1897)

Born in Provo, Utah, Avard Fairbanks was the tenth son in a family of eleven children who were unusually successful in their various artistic pursuits. His father, John B. Fairbanks (1855-1940), was a well-known painter from Salt Lake City; his older brother J. Leo Fairbanks (1878-1946) distinguished himself as a painter and sculptor, and several other brothers were active artistically. Both John B. and Leo Fairbanks were early involved with the teaching of art at Latter-day Saints University (now defunct), and with the painter John Hafen (1856-1907) helped organize the art program at Brigham Young Academy (today Brigham Young University).

By the age of twelve, having demonstrated a serious interest in and aptitude for sculpture, Avard Fairbanks accompanied his brother Claude to New York. There, living with his father, he embarked on a course of self-instruction based on copying animal sculpture at the Metropolitan Museum of Art. He soon expanded this activity to include work trips to the Bronx Zoo, where, like so many of his colleagues, he gained invaluable experience sketching animal studies from live models. The accuracy of line and dynamics of action he infused into these zoo studies, together with the copies of sculpture he had executed at the Metropolitan, gained him, in 1910, a scholarship to study at the Art Students League with James Earle Fraser (1876-1953). Fairbanks's teachers marveled at his natural gift for expressing and capturing the distinctive and often vigorous motion of animals; one of these early compositions, *Buffalo Charging*, 1911 (private collection), was accepted for exhibition at the National Academy of Design, New York, making Fairbanks, who was fourteen at the time, one of the youngest artists to be represented in the academy's exhibition program. While in New York, he received technical assistance and helpful criticism from Anna Hyatt Huntington, Charles R. Knight (1874-1953), and from the animalier A. Phimister Proctor (1862-1950).

After a brief return to Salt Lake City, Fairbanks left for Paris in 1913 to continue his studies at the Ecole des Beaux-Arts with Antonin Injalbert (1845-1933). There, he carved his first marble, a head of Michelangelo. He also took classes in drawing and painting at the Académie Colarossi and the Ecole de la Grande Chaumière. In 1914 *Baby Pierrepont* (pri-

vate collection), a bronze sculpture of Mary Rutherford Stuyvesant Pierrepont modeled the previous year, was shown at the Grand Salon, sponsored by the Société des artistes français.

The outbreak of World War I terminated Fairbanks's art studies abroad and compelled his quick departure for the United States. Although examples of the young sculptor's work had been shown in scattered exhibitions by 1915, the first major display of his sculpture, a selection consisting of five animal studies and two portraits — that of veteran *Old Bill Keddington*, about 1912 (sculptor's collection), and *Baby Pierrepont*—occurred at the 1915 Panama-Pacific International Exposition, San Francisco. Fairbanks's representation there concurrently in the Utah pavilion and the rotunda and general exhibition halls of the Palace of Fine Arts inaugurated a tradition of his artistic participation in similar world's fairs. When his brother Leo won a contract in 1916 for the sculptural program planned for the new Mormon temple in Laie, Oahu, Avard was invited to collaborate on the commission. Thus, in 1917 the two brothers traveled to Hawaii to work on this ambitious scheme that included the production of sculptural friezes, high-relief panels, a baptismal font (featuring an undersupport of a dozen realistically modeled oxen of life size), and a free-standing sculpture *Lehi Blessing Joseph*.

Upon returning to Salt Lake City from the Islands in 1918, Fairbanks attended the University of Utah. When the notorious 1919 influenza epidemic closed the school, he embarked on a national tour to promote the cause of commissioning sculptural monuments to commemorate the war's conclusion. Several important commissions for war memorials

went to Fairbanks, including those for a bronze monument entitled *The Idaho Doughboy*, 1922 (placed in the cities of Saint Anthony and Moscow, Idaho), and *Service Memorial*, about 1923, for Oregon State College at Corvallis (now Oregon State University). In 1920 the sculptor's connections with the state of Oregon evolved into a professional and residential association with his appointment as assistant professor of art at the University of Oregon, Eugene. From that time forward, teaching at the university level became a principal interest and commitment of Fairbanks's. Fortunately, he managed to preserve a balance between instructing others and creating his own art. During the seven years he held this teaching post, he continued to design monuments and other sculptural works for various cities and institutions in the West and Midwest.

In 1924 Fairbanks took a year's leave of absence from his academic duties to study at Yale University, which awarded him a bachelor of fine arts degree the following year. A Guggenheim fellowship in 1927 enabled him to pursue post-graduate training in Florence, Italy, under the sculptor Dante Sodini (1858-1935) and at a school of fine arts. The marble fantasy *La Primavera* (destroyed during World War II) and idealized figural group *Motherhood* (Springville Museum of Art, Utah), representing a young mother nursing her child, date from this period. The sculptor also used his fellowship year to develop maquettes and models for two of his finest memorial sculptures: the *91st Division Memorial* (Fort Lewis, Washington), finished in 1928, and the *Pioneer Mothers Memorial*, erected in Vancouver, Washington, a year later.

At the conclusion of his fellowship, Fairbanks returned to the West Coast and pursued his master of fine arts degree at the University of Washington in Seattle while teaching classes at the Seattle Institute of Art. Upon the receipt of his degree in 1929, he accepted an appointment as associate professor of sculpture and sculptor-in-residence at the University of Michigan, Ann Arbor. He remained on the Michigan faculty for eighteen years, obtaining a master of arts degree from the institution in 1933 and, three years later, a Ph.D. In preparation for his dissertation on anatomical proportion and design, he engrossed himself in an extensive dissection study of facial musculature as well as in a project modeling reconstructions of the musculature of the neck, arms, legs, torso, and other systems of the human body. Fairbanks's distinguished

career at Michigan ended in 1947 when he accepted a proposal from the University of Utah, Salt Lake City, to organize the College of Fine Arts, which he would serve as dean. In 1955 he left the deanship to become resident sculptor and consultant in fine arts at the university, an arrangement affording him more creative time in his studio. Ten years later Fairbanks retired, accepting an appointment as resident sculptor and consultant to the president at the University of North Dakota, Grand Forks.

Over the course of his long career in art, Fairbanks earned wide acclaim for his innovative teaching methods and academic contributions to the field of art instruction. He also won international recognition as a sculptor of powerful public monuments and anniversary memorials, humane yet probing portraits, and charming fountains and fantasy figures. As a member of the Church of Jesus Christ of Latter-day Saints (Mormon) and as a descendant of a pioneer family, he instinctively gravitated toward historical subjects reflecting the stalwart courage, faith, and perseverance that sustained the Mormons and other early settlers who migrated to the American West. He executed over a dozen sculptures in a broad range of forms for Salt Lake City, as well as other American cities, that celebrate spiritual themes and historical incidents drawn from his Mormon heritage. Western history in general served as a source for many of the sculptor's other memorable inventions, including the *Old Oregon Trail Medallion*, 1924, bronze markers for the Oregon Trail Memorial Association (two of which are located in Seaside and Baker, Oregon); the *Pioneer Mothers Memorial*; two versions of the *Pioneer Family*, one made in 1947 (State Capitol, Bismarck, North Dakota) and the other in 1958 (Bush Park, Salem, Oregon); the *Pony Express*, 1963 (Harrah's Club, Lake Tahoe, Nevada); and *The Sioux Warrior*, 1965 (University of North Dakota). The concept for *Pony Express*, a tribute to the brave determination of the early riders, was initially constructed as a float for the 1947 Mormon Centennial parade. Subsequently, a new composition was developed and cast in bronze for Harrah's on the pony express trail through the Sierras.

Fairbanks admitted feeling especially close sympathy with the pioneer rearing and democratic ideals of Abraham Lincoln, an admiration that he converted into a series of evocative portraits dramatizing Lincoln at crucial phases in his moral and intellectual development. The subject of Lincoln occupied Fairbanks intermittently over a quarter

century, beginning with the monument *Lincoln, the Frontiersman*, 1941, executed for the Ewa Plantation School in Hawaii, and culminating in *Lincoln, the Congressman*, a colossal marble made in 1985 for the United States Capitol, House Document Door, Washington, D.C. Perhaps the best-known image in this impressive series of character studies is the *New Salem Lincoln*, 1954 (New Salem Village, Illinois), a heroic bronze depicting Lincoln at the crossroads of decision as he rests his ax to pick up the law books that will influence his future career.

In addition to his Western-inspired sculptures, Fairbanks explored numerous other idealized conceits and realistic subjects in a variety of media, including bronze, marble, and cast stone. Chief among these works are a colossal bronze head of George Washington, 1975 (George Washington University, Washington, D.C.); the heroic-size *Lycurgus, the Lawgiver*, 1955 (Sparta, Greece), for which he was awarded the Knights of Thermopylae Medal; and the four marble heads of Lincoln, 1959 (Ford's Theatre, Washington, D.C.), for which he was awarded a medal by the U.S. Congress. Three other bronze portraits of famous Americans by Fairbanks are represented in the National Statuary Hall, United States Capitol: that of Marcus Whitman, 1953, a pioneer physician from the state of Washington; that of Esther Morris, 1956, a Wyoming resident active in that state's equal rights campaign for women; and that of John Burke, 1963, former governor and distinguished Supreme Court justice of North Dakota.

Versatility characterized Fairbanks's extensive oeuvre. Representative of his work in the ideal mode are such stylized figures of women as the fantasy *Rain*, 1933, chosen for the renowned Brookgreen Gardens, Murrells Inlet, South Carolina, and the lyrical *Nebula*, 1933 (private collection), shown at the New York World's Fair in 1939. His medallic and numismatic designs also garnered critical praise, especially the *Courage* medal that Canadian Prime Minister W.L. Mackenzie King presented to Sir Winston Churchill during World War II. While on the faculty at the University of Michigan, Fairbanks organized and taught classes in industrial design. His success in that endeavor prompted the American Society of Automotive Engineers to seek his services to structure a course program in automotive body design and styling, a collaborative venture resulting in Fairbanks undertaking a project to model small radiator ornaments for several prominent Detroit car manufacturers.

Avard Fairbanks accumulated numerous awards and honors through his career, notably the Herbert Adams Memorial Medal for distinguished service to American sculpture, awarded by the National Sculpture Society, of which he is a fellow. An outspoken advocate for the teaching of excellence and of high principles in art, he invariably strives to express the enduring ideals that shaped and sustained American culture. Believing that the sculptor's products "become great factors in large-scale education and community uplift and pride," he asserts in a philosophic turn of phrase that is characteristic: "The hope of the world lies in our faith and in our spiritual ideals. Such ideals we express in material form. If we possess these and strive vigorously for the accomplishment of these, we will produce a great culture."[1]

J.S.R.

Note

1. Quoted by Eugene Fairbanks, *The Life and Work of Avard T. Fairbanks, Sculptor* (privately printed), pp. 19-20. BMFA, ADA. Paraphrased in O.D. Quinlan, "The Works of a Western Master," *Utah* 13 (winter 1954), p. 8.

References

Architects of the Capital, *Art in the United States Capital* (Washington, D.C.: Government Printing Office, 1976), pp. 222, 224, 233, 256, 271; Patricia Janis Broder, *Bronzes of the American West* (New York: Abrams, 1947), p. 383; Brookgreen Gardens, Murrells Inlet, S.C., *Sculpture by Avard Fairbanks* (1937); Church of Jesus Christ of Latter-day Saints, Salt Lake City, Utah, publications division; Avard T. Fairbanks, "Engineering in Sculpture," *Michigan Technic* 60 (Feb. 1942); idem, "Making the Lincoln Statue for New Salem," *Journal of the Illinois State Historical Society*, summer 1954, pp. 3-16; idem, "Proportions," Ph.D. diss., University of Michigan, 1936; Eugene F. Fairbanks, comp., "Chronology of Avard T. Fairbanks," BMFA, ADA; Eugene F. Fairbanks, *A Sculptor's Testimony in Bronze and Stone: The Sacred Sculpture of Avard T. Fairbanks* (Salt Lake City, Utah: Publishers Press, 1972); Celest Lowe, "Anatomist Sculptor," *MD* 15 (Oct. 1971), pp. 101-103; idem, "Avard Fairbanks, Sculptor and Teacher," *Town and Country Review* (July 1934), pp. 26-29; National Sculpture Society, New York, *Contemporary American Sculpture* (1929), pp. 96-97; "A Notable War Memorial," *American Magazine of Art* 21 (Sept. 1930), pp. 527-528; Proske 1968, pp. 268-271; Taft 1930, p. 586.

AVARD TENNYSON FAIRBANKS
157
A Tragedy of Winter Quarters, 1934
Bronze, light brown patina, lost wax cast
H. 21½ in. (54.6 cm.), w. 11½ in. (29.3 cm.), d. 11⅛
in. (28.3 cm.)
Signed (on top of base at front): Avard Fairbanks /
1934
Gift of Jonathan and Louise Fairbanks, Westwood,
Mass. 1978.676

Versions: *Plaster*, over life-size: (1) Latter-day Saints
Church Office Building, Office of History, Salt Lake City,
Utah. *Bronze*, 32 in.: (1) Latter-day Saints Church, New
York; over life-size: (2) Florence (North Omaha), Neb.

For his sculpture based on Western subjects, Avard
Fairbanks often drew inspiration from his ances-
tors' history as Mormon pioneers. This bronze
study for an heroic-size monument memorializes
the suffering that many Mormon families exper-
ienced during the bitter winter of 1846 while sta-
tioned in the Nebraska Territory, near the present
town of Florence outside Omaha. After the murder
of their leader Joseph Smith, the saints, as the
Mormons were known, had left Nauvoo, Illinois,
under the direction of Brigham Young and set up
winter quarters near the Missouri River. Many of
these courageous Mormon pilgrims lost their lives
at the encampment; others were forced to bury
friends and family members who had succumbed to
disease, famine, and cold, in shallow unmarked
graves. The poignant scene dramatized in Fair-
banks's sculpture depicts a pioneer and his wife
huddled together under a windswept cloak, at-
tempting to console each other as they stare into
their baby's grave. The shovel held in the father's
right hand foretells the sorry task he must perform.

The heroic-size monument of *A Tragedy of Winter
Quarters*, which is recognized as one of the sculptor's
most moving creations,[1] was erected in 1936 by the
Latter-day Saints Church on the site of the Mormon
encampment and burial grounds at Florence, Ne-
braska.[2] Although the characters featured in the
group are idealized, the incident portrayed may
have been suggested by the loss Fairbanks's own
grandparents, Mr. and Mrs. John Boylston Fair-
banks, suffered when their first-born child died of
exposure enroute to Salt Lake City in 1846. The
historian of the American West Wallace Stegner
called the work "history made memorable in sculp-
ture," an observation that applies equally well to the
other historical tableaux represented in Fairbanks's
series of pioneer monuments. Stegner's admiring

account continues, "The man is booted, bearded,
mightily-thighed, as becomes a pioneer; the woman
hides her grieving face in the cloak that blows about
her . . . Leaning against the mound of the new
grave, a plaque lists the six hundred names of
known Winter Quarter dead. Anyone who is curi-
ous . . . can run through the list and discover that
nearly a quarter of them were children under six."[3]

Created during Fairbanks's tenure at the Univer-
sity of Michigan, the Museum's model reveals the
sculptor's grounding in the aesthetic tradition of
the Beaux-Arts style. It exhibits evidence of the
brushlike strokes and vigorous textures imparted by
the sculptor's clay modeling tools — a free handling
of material and gestural vitality conveyed in the
full-size monument as well. A version of the study
was first displayed in the Hall of Religion at the
1934 Chicago World's Fair. The Richard Young
Foundry in Salt Lake City subsequently cast an edi-
tion of over twenty 21½-inch versions of the work,
including the Museum's, and at least three interme-
diate-size copies (32 inches) were cast at Yellow
Springs, Ohio, about 1936.

A Tragedy of Winter Quarters is a fitting image for
New England, as this region was the ancestral home
of so many of the pioneers who joined Brigham
Young's western expedition. Reflective of Fair-
banks's deep humanistic confidence and faith in his
religion's mission is the plaster group sculpture he
conceived as a thematic complement to the *Winter
Quarters* monument: *Youth and New Frontiers*, 1934
(Temple Square Museum, Salt Lake City). Also ex-
hibited at the 1934 Chicago World's Fair, this com-
panion sculpture symbolized the indomitable spirit
of the descendants of the Mormon pioneers.

J.S.R.

Notes

1. A representative sampling of the favorable criticism the
monument elicited can be found in the following: "Win-
ter Quarters Monument, Omaha, Nebraska," *Electrical
Workers Journal* 65 (Mar. 1966), p. 16; "Pioneer Monu-
ment Leading Figures in Dedication Rites — Winter
Quarters Monument," *Deseret News*, Sept. 17, 1936; Jo-
seph Fielding Smith, "Latter-day Saints Settlement at Win-
ter Quarters," *Improvement Era* 55 (Apr. 1952), pp. 224-
226; John A. Widstoe, " 'Winter Quarters' Is Immortal-
ized in Stone," *Improvement Era* 39 (Oct. 1936), pp. 595-597.

2. Nearly six hundred bodies are buried in the Pioneer
Mormon Cemetery, including three of the sculptor's
ancestors.

3. Wallace Stegner, *The Gathering of Zion* (New York:
McGraw Hill, 1964), p. 308.

Katharine Lane Weems (born 1899)

An only child, Katharine Ward Lane was born into a socially prominent family whose affluence excused her from any obligation other than to marry and pass her fortune on to the next generation of heirs. Her birthright gave her immediate entrée into the most exclusive echelon of Boston and Baltimore society. Her grandfathers, both distinguished classical scholars, were teachers, one at Harvard and the other at Johns Hopkins University, and her father, Gardiner Martin Lane, a senior partner in the Boston investment firm of Lee, Higginson Company, served as president of the Museum of Fine Arts from 1907 until his death in 1914.

Popular, attractive, and witty, "Kay," as she was known to friends, spent part of her adolescence humoring her mother's high social ambitions. She attended debutante parties, dances, and similar functions designed to expose her to the "right" eligible bachelors. While she accumulated her share of beaux, she also refused their marriage proposals, balking at the prospect of a future confined to respectable Brahmin matronhood.

Lane acquired an early love of art from her father, who encouraged his daughter's curiosity by escorting her on special private tours of the Museum's galleries. Gardiner Lane's death, when Kay was still in her teens, prompted her to pursue this interest and seek formal training in sculptural modeling, a hobby in which she had displayed natural if unguided ability. In 1917 she completed her secondary education at the May School, Boston, and in the winter of 1918-1919, enrolled in classes at the School of the Museum of Fine Arts, determined to make art her career.

Although the Museum School faculty were aware of Lane's status as the privileged daughter of the Museum's late president, they avoided showing any favoritism in their treatment of her. In fact, Charles Grafly, the eminent Philadelphia sculptor, who came up from Philadelphia on alternate Wednesdays, openly denounced her novice efforts at modeling. Humbled but not deterred, Lane persevered, working diligently to develop her technique. As her skills improved, her relationship with Grafly warmed, and she became the object of his special encouragement. In later years she credited him as her first mentor and most penetrating teacher.

Lane was introduced to Anna Vaughn Hyatt (later Huntington) on July 15, 1918. Hyatt offered to look at Lane's work, and thus began informal instruction. Regarded as one of America's preemi-

nent animaliers, Hyatt arranged for Lane, her favorite Boston pupil, to take private modeling lessons with her in 1921 at the New York studio she shared on West Twelfth Street with Brenda Putnam (1890-1975), another prominent sculptor. The experience proved exhilarating for Lane, professionally and socially. Under Hyatt's supervision she refined her compositional skills and extended her scientific knowledge of animals, particularly of their body structures and movement, by frequently sketching at the New York Zoological Garden, in the Bronx. Lane was also welcomed into the influential circle of artists, gallery owners, and patrons who were close friends of her teacher. Among these new acquaintances were the prominent contemporary sculptors Paul Manship, Herbert Haseltine (1877-1962), and Malvina Hoffman (1887-1966), all of whom befriended Lane and encouraged her efforts. Putnam also provided invaluable instruction by tutoring her in drawing and anatomy. The latter was Putnam's particular expertise, and thus she insisted that Lane master the fine points of animal musculature and skeletal structure before proceeding with more ambitious modeling projects.

Apart from spending winter months in New York, Lane lived in Massachusetts, dividing her time between quarters at Fenway Studios in Boston and the studio she maintained at her family's summer home, The Chimneys, in Manchester. By the mid-1920s Lane had produced a strong and sizable enough body of work to put her talent to critical test by submitting selected compositions to art competitions. She rapidly compiled an impressive list of

awards, including the George D. Widener Gold Medal from the Pennsylvania Academy of the Fine Arts (1927), the Joan of Arc Medal from the National Association of Women Painters and Sculptors (1928), of which she was a member, and an honorable mention at the 1928 Paris Salon. With this increasing recognition came offers from museums and galleries to exhibit her work. In 1924 the Baltimore Museum of Art mounted a small exhibition of her animal bronzes, which critics praised for their beautiful expression and poise. Various pieces by Lane were also shown at this time at the Arden and Grand Central Galleries in New York. In Boston her work premiered at the Copley Society in 1927 and at Doll & Richards Gallery, which organized a special exhibition of fourteen of Lane's bronzes in 1928. Her career, like that of many sculptors of her generation, benefited from the vogue for small art bronzes that evolved in the wake of the National Sculpture Society's popular traveling exhibition of 1909, an event serving to alert commercial galleries to the sales potential represented in such small-scale statuettes.

Unaffected by the general view, probably held out of envy, that wealth invariably interfered with an artist's professional dedication and output, Lane devoted herself to her studio projects with great vigor of purpose. She regarded her financial independence as an unusual creative advantage since it enabled her to produce to the best of her ability and imagination. As the public and critics became increasingly familiar with her art, she achieved distinction as one of the country's most promising animaliers. Her studies of wild and domestic animals alike were keenly observed; her individual compositions convincingly embodied the natural grace, physical power, and capacity for movement peculiar to each creature. Such work aligned her with the tradition of animal sculpture that had commenced abroad with the towering figure of nineteenth-century French art, Antoine-Louis Barye (1796-1875), and was experiencing a revival under the art critic Armand Dayot. By the turn of the century, America boasted an active equivalent of this European school. Lane knew and studied the work of these animaliers, including that of her teacher Anna Hyatt Huntington and of her contemporaries Albert Laessle (1877-1954) and Frederick G.P. Roth (1872-1944).

Lane's oeuvre was not strictly confined to animal sculpture. She executed portrait medallions and other decorative designs in low relief, as well as occasional freestanding figures such as the magnificently muscular woman personified as *Revolt*, or *Striding Amazon* (q.v.). Nevertheless, her design instincts seem to have been best satisfied by canvassing the animal kingdom for subjects, which, in her opinion, offered a challenging diversity of forms for interpretation. Months of self-imposed study at zoos, where she watched, sketched, and often constructed on-the-spot clay models, trained Lane's eye to differentiate and register with precision the anatomical features of individual animal species. She came to consider animals the ideal source for sculpture since they permitted the artist unusual freedom to explore various textural effects and to focus on translating pure form unburdened by costume or content. When questioned about her predilection for portraying animals, Lane explained, "When you're doing a human figure you're always working on the same fundamental chassis; but with an animal the variation in composition is infinite; an animal is forever in movement, in different, unconscious grace. And, finally, you never have the relatives to contend with!"[1]

Unlike the carnal, agitated predators represented in bronze by Barye and his school, Lane's menagerie of subjects is decidedly domesticated, even when they are exotic zoo animals. Whether of a rare rhinoceros, a wild gazelle, or an ordinary rabbit, her studies project a tameness and intimacy through their informal, often playful poses. While some of her creatures effectively distill the character of a particular mammal, they rarely resonate with the spirit of charged passion or feral athletic force found in French sculpture. Instead, a decorative elegance and mood of gentle sport or benign repose suffuse her animal compositions. Lane has been a frequent and appropriate recipient of the Speyer Prize, through the National Academy of Design, an award recognizing excellence and humaneness in an artist's study of animals.

Lane employed her talent in a variety of interesting projects during her long career. In 1930 she and a pet greyhound, Dark Warrior, starred in the film *From Clay to Bronze*, which featured Lane demonstrating the complicated steps involved in transferring an original clay sketch to a finished bronze cast.[2] In the early thirties Harvard University engaged Lane to design an ambitious program of architectural decoration and ornamental friezes for its biological laboratory built by Coolidge, Shepley, Bulfinch, and Abbott. The series of friezes, depicting a phalanx of elephants and thirty other animals

from different regions of the world, was incised directly into the brick with pneumatic drills. The stylistic effect was purposely reminiscent of Chinese limestone tomb carvings of the Han Period. Lane's scheme culminated in two disarmingly realistic, rhinoceroses, 6 feet high and 13 feet long, which flank the laboratory entrance. These massive bronzes, dubbed "Bessie" and "Victoria" (after two English queens), were cast separately at the Kunst Foundry and the Roman Bronze Works, New York, respectively, and attracted immediate votaries among the university's undergraduates.

Important examples of Lane's work were acquired by Archer and Anna Hyatt Huntington for Brookgreen Gardens, Murrells Inlet, South Carolina. The sculptor herself presented a fine collection of her animal bronzes and drawings to the Museum of Science, Boston, in honor of her mother, Emma Gildersleeve Lane, whose name the gallery bears. The scope of Lane's artistry can also be appreciated in Boston in the *Lotta Fountain*, about 1940 (Esplanade), and the beloved *Dolphin Fountain*, commissioned when Lane was seventy-five and dedicated in 1977 (New England Aquarium).

In 1947 Katharine Lane married an engaging southerner, F. Carrington Weems, a banker and fellow animal enthusiast. Her professional enthusiasm and expertise have been tapped by numerous art organizations and institutions over the years. She has been a vital member of the National Association of Women Painters and Sculptors, the National Sculpture Society, and the Guild of Boston Artists. Both the National Academy of Design and the National Institute of Arts and Letters have elected her to their membership, and she has served on the State Art Commission of Massachusetts. International recognition also has been conferred on her in the form of the title of *chevalier* of the French Legion of Honor. In 1985 the sculptor published her memoirs, *Odds Were Against Me*, a collection of anecdotes and reminiscences through which she recorded her efforts to win serious acclaim in her profession.

J.S.R.

Notes

I acknowledge with appreciation the assistance of Louise Todd Ambler, Harvard University Portrait Collection, who is currently writing a book on the sculpture and drawings of Katharine Lane Weems.

1. Katharine Lane Weems, *Odds Were Against Me: A Memoir*, as told to Edward Weeks (New York: Vantage, 1985), p. 67.

2. Produced by Harvard Film Service for the Museum of Fine Arts, the film was part of a unique educational series that illustrated the technical procedures and discrete craft techniques applied in various art disciplines.

References

Louise Todd Ambler, "About Those Rhinos," *Harvard Library Bulletin* 21 (July 1973), pp. 271-276; "Boston Sculptress Is Gaining Renown at Home and Abroad," *Boston Evening Transcript*, May 8, 1926; BPL; "Katharine Lane, Animalier," *Baltimore Evening Sun*, Jan. 18, 1924; "Katharine Ward Lane, Animal Sculptor," *Boston Herald*, Nov. 16, 1947; "Manchester Woman Named to State Art Commission," *Boston Evening Transcript*, Mar. 12, 1941; National Sculpture Society, New York; SMFA; Katharine Lane Weems, *Odds Were Against Me: A Memoir*, as told to Edward Weeks (New York: Vantage, 1985).

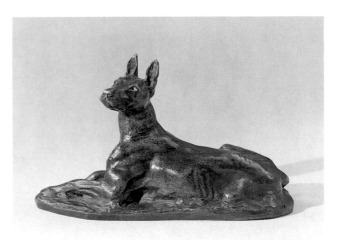

158

KATHARINE LANE WEEMS
158
Bull Terrier, about 1920
Bronze, brown patina, lost wax cast
H. 4½ in. (11.5 cm.), l. 7¾ in. (19.7 cm.), d. 3¾ in. (9.5 cm.)
Signed (on top of base at back): KATHARINE W. LANE
Foundry mark (on back of base): IDEAL CASTING CO. PROV. R.I.
Gift of Gerald Horrigan. 1980.259

Provenance: John Kitson, Boston; Gerald Horrigan, Braintree, Mass.
Version: *Bronze*: (1) Katharine Lane Weems, Boston

This diminutive bronze of a bull terrier, the short-haired breed that is supposed to have originated in England by crossing a bulldog with a white English terrier, was probably modeled by Lane around

1920. The dog is posed lying attentively on the ground, with ears erect as if in anticipation of his master's whistle. Noted for its courage and strength, the bull terrier takes its build from the terrier, whose slim lines are captured with eloquent economy in Lane's statuette.

The piece was designed for use as a paperweight. Its utilitarian function recalls a tradition that evolved from the Italian Renaissance, when small animal bronzes were adapted for practical service as candlesticks, ink pots, oil lamps, and other items, while retaining their decorative appeal.

J.S.R.

KATHARINE LANE WEEMS

159

Baby African Elephant,[1] 1926
Bronze, dark brown patina, sand cast
H. 10 in. (25.4 cm.), l. 14½ in. (36.8 cm.), d. 6½ in. (16.5 cm.)
Signed (on top of base at back): KATHARINE W. LANE
Samuel Putnam Avery Fund. 27.299

Provenance: Katharine W. Lane, Boston
Exhibited: The Pennsylvania Academy of the Fine Arts, Philadelphia, *121st Annual Exhibition* (1926), no. 335; National Society of Women Painters and Sculptors, New York, 1926; Philadelphia, Sesqui-centennial International Exposition (1926), no. 1198; BMFA, *Exhibition of the Work of Painters and Sculptors of Boston and the Vicinity, Copley Society of Boston* (1927), no. 17.
Version: *Bronze:* (1) Morris Kinney, Philadelphia

Exotic yet earthy, the elephant has enjoyed enduring popularity with animaliers. During a fieldwork expedition to the Bronx Zoo in the spring of 1925, Katharine Lane conceived the idea of modeling this marvelous midget pachyderm. In her memoir she recalled her enchantment with a baby African elephant that stood only four feet high and whose mother had recently died.[2] The orphaned creature's playful clowning greatly amused her, kindling her interest to capture its character in a clay sketch, which she modeled while stationed next to the animal's pen. The finished composition, cast in bronze in 1926, ranks among the most pleasing of the sculptor's designs.

The statuette projects a simplified silhouette of solid mass counterbalanced by the curling lines of the elephant's trunk and slender tail. Lane delineated specific features of the elephant (loose, wrinkled skin, polished tusks, and ponderous hooves) to endow the diminutive statue with scientific authenticity, but her primary purpose was to project a

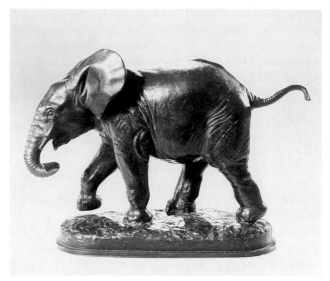

159

sense of the animal's impish vitality. The composition suggests Lane's attentiveness to her teacher Brenda Putnam's dictum that "action in sculpture appeals to everyone" and is best conveyed when combined with poise and balance.[3]

Baby African Elephant proved to be a critical success for its young author, receiving acclaim at the 121st annual exhibition at the Pennsylvania Academy of the Fine Arts in 1926, site of its initial public display, and then at the National Society of Women Painters and Sculptors in New York. Lane was encouraged to submit the piece to the Philadelphia sesquicentennial exposition of 1926, where it earned a bronze medal.[4] Within weeks of the *Elephant*'s Boston debut at the Copley Society in 1927, the Museum's associate director wrote to Lane, expressing interest in purchasing the bronze for the Museum's permanent collection. Honored by the official approbation, she promptly communicated her consent to the sale, acknowledging that such "recognition of my work is very stimulating."[5]

After the Museum acquired its cast of *Baby African Elephant*, Lane slightly revised the original model. The resulting composition, cast in bronze in 1928, was included in an exhibition and sale of her work at Doll & Richards. Contemporary newspapers reported the mysterious disappearance of the *Elephant* from the exhibition (presumably abducted under the raincoat of an adroit passerby).[6] The theft of the piece prompted Lane to issue six additional replicas, one of which received an honorable mention in the Paris Salon of 1928. Because it was one of her earliest compositions, Lane admits to feeling a special personal attachment to the baby

Elephant. She reserved a cast of it for her own collection, which was included in the membership exhibition of Paintings and Sculpture of the Guild of Boston Artists, held at the Concord Art Association in the autumn of 1976.[7]

J.S.R.

Notes

1. The bronze has been exhibited both as *Pigmy African Elephant* and *Baby African Elephant*. In Lane's memoir she refers to the piece as the latter.

2. Katharine Lane Weems, *Odds Were Against Me: A Memoir,* as told to Edward Weeks (New York: Vantage, 1985), p. 36.

3. Ibid., p. 55.

4. Morris Kinney purchased his copy at the time of the Philadelphia exposition.

5. Lane to Charles H. Hawes, May 9, 1927, BMFA, 1901-1954, roll 724, in AAA, SI.

6. See "Who Has This Elephant?" *Boston Herald,* May 18, 1928. The illustration probably represents the Museum's cast.

7. Weems, *Odds Were Against Me,* p. 78.

KATHARINE LANE WEEMS
160 (color plate)
Narcisse Noir, 1927
Bronze, black-brown patina, lost wax cast
H. 13½ in. (34.3 cm.), l. 30½ in. (77.5 cm.), d. 9½ in. (24.1 cm.)
Signed (on top of base at right side): KATHARINE W LANE / 1926
Foundry mark (on back of base): ROMAN BRONZE WORKS NY
Samuel Putnam Avery Fund. 27.300

Exhibited: The Pennsylvania Academy of the Fine Arts, Philadelphia, *122nd Annual Exhibition* (1927), no. 397; Doll & Richards, Boston, *Exhibition and Sale of Bronzes by Katharine W. Lane and Small Landscapes by Donald V. Newhall* (1928), no. 9.; National Academy of Design, New York, *Winter Exhibition* (1932), no. 211; Guild of Boston Artists, *Exhibition of Sculpture by Katharine Ward Lane* (1932), no. 7; The Dog Museum of America, New York, *Fidos and Heroes in Bronze,* exhibition catalogue by Janis Conner and Joel Rosenkranz (1983).
Versions: *Bronze:* (1) Museum of Science, Boston, (2) Reading Museum, Pa., (3) Brookgreen Gardens, Murrells Inlet, S.C.

This elegant study of a whippet, a small greyhound-type dog, won the George B. Widener Gold Medal for excellence of execution at the 122nd annual

exhibition at the Pennsylvania Academy of the Fine Arts, Philadelphia, in 1927.[1] It was also the first composition for which Charles Grafly, Lane's mentor, professed unreserved enthusiasm. Although the sculptor was surprised by the critical praise, she viewed this early success as a major stimulus to her career as a sculptor. That *Narcisse Noir* merited the contemporary acclaim awarded it is unquestionable. The statue perfectly embodies the svelte gracefulness of this particular breed of dog, while its pose and attitude convey a sense of the nervousness, speed, and arrogance for which whippets are celebrated.

Beyond its intrinsic appeal as sculpture, *Narcisse Noir* attracted considerable public notice because of its notorious personal associations. The dog memorialized was the real-life pet of a colorful roué named Harry Crosby, a childhood acquaintance of Lane's whose adult activities she kept abreast of through the close friendship of their respective mothers. After disappointing proper Boston society by abandoning a promising banking career for which he had been groomed, Crosby moved to Paris to enjoy a lively if dissolute existence as a poet, publisher, and womanizer. In the late 1920s his life turned calamitous when he was implicated in an illicit affair with the wife (of six months) of another Boston man. The entanglement ended tragically in the young woman's murder and Crosby's suicide.[2]

Addicted to gambling large sums of money at the racetrack, Crosby had purchased Narcisse Noir, a champion racing whippet, in 1926. The dog afterward captured a number of first prizes at Parisian shows and is said to have been one of the fastest race dogs in France for a short time. Lane's introduction to the dog occurred during Crosby's visit to his family's home in Manchester, Massachusetts, during the summer of 1926. Watching Narcisse Noir engaged in his fleet yet elegant gambols across

160

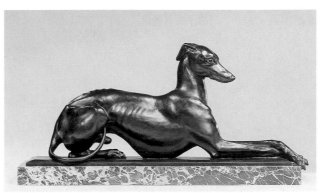

the sand at Singing Beach, she became quickly fascinated by the dog's exquisite form and jet-black silken beauty. She requested and received permission to model him over five consecutive mornings at the Crosbys' stable.[3]

The pose Lane sought to reproduce in her sketch was one that Narcisse Noir struck after he relaxed in the makeshift studio, "his slender legs stretched out before him,"[4] with proud head held high, cocked in an alert manner. The sleek contours and finely modeled details of the composition create an effect of unexpected fragility. Mindful, however, that whippets were bred for strength and stamina as well as for physical beauty, Lane also articulated the tensed, sinewy musculature beneath the dog's glossy coat, thereby conveying a feeling of restrained energy and imminent action.

Several months ensued before Lane refined the clay model of Narcisse Noir to her satisfaction. By the late fall, however, it was ready for release to the foundry. For dramatic impact she had the bronze patinated in black and mounted on a black marble slab; at least four casts were issued. After *Narcisse Noir*'s publicized success at the Pennsylvania Academy of the Fine Arts in 1927, the Museum of Fine Arts acted quickly to obtain the original cast. In a letter to Lane dated May 7, 1927, the Museum's associate director communicated that the vote had passed to acquire *Narcisse Noir* and humorously interjected that, since the statue had yet to be priced, she had "the opportunity of charging $1,000,000!"[5] Replying that her fee would be "slightly under a million this time," the sculptor readily agreed to the sale and specified that the price of the piece, which came "directly from the foundry," was $600.[6]

Shortly after the Museum concluded the purchase agreement, *Narcisse Noir* was lent to the 1928 exhibition of Lane's bronzes at Doll & Richards, Boston. Reviewing the works on display at the Newbury Street gallery, a critic for the *Boston Herald* judged *Narcisse Noir* the "most appreciated of Miss Lane's works, for in it modeling lies less obviously with the shaping of externals, and in sweeping and generalized lines becomes more instinct with life than any hesitancy and piecemeal work could possibly be."[7] The following year the statue toured to New York, where it became the object of a farewell pilgrimage by Harry Crosby before he committed suicide. In 1932 the piece was included in the annual exhibitions of the National Academy of Design, where it won the Helen Foster Barnett Prize for the best sculpture by an artist under thirty. In

1983 *Narcisse Noir* was included in the exhibition organized by the Dog Museum of America. Chosen for the show because it represented the sculptor's "elegant portrait style"[8] as an animalier, the piece was also presented as epitomizing the uniquely personal and affectionate regard for animal subjects that Lane, together with Anna Hyatt Huntington, brought to her work.

J.S.R.

Notes

1. See Dorothy Grafly, "The Pennsylvania Academy's 122nd Annual Exhibition," *American Magazine of Art* 18 (Mar. 1927), pp. 128-134.

2. See Geoffrey Wolff, *Black Sun: The Brief and Violent Eclipse of Harry Crosby* (New York: Random House, 1976).

3. Katharine Lane Weems, *Odds Were Against Me: A Memoir*, as told to Edward Weeks (New York: Vantage, 1985), pp. 62-64.

4. Ibid., p. 63.

5. Charles H. Hawes to Lane, May 7, 1927, BMFA, 1901-1954, roll 2463, in AAA, SI.

6. Lane to Hawes, May 9, 1927, BMFA, 1901-1954, roll 2463, in AAA, SI.

7. *Boston Herald*, Apr. 21, 1928.

8. The Dog Museum of America, New York, *Fidos and Heroes in Bronze*, exhibition catalogue by Janis Conner and Joel Rosenkranz (1983).

KATHARINE LANE WEEMS
161
Pointing Setter, 1927
Silver-plated bronze, lost wax cast
H. 10¼ in. (26 cm.), l. 15⅜ in. (38.8 cm.), d. 3¾ in. (9.6 cm.)
Signed (on top of base): KATHARINE W. LANE
Foundry mark (on back of base): 1927 / ROMAN BRONZE WORKS N- Y-
Inscribed (on dog's collar): CHARLES H. TYLER
Bequest of Charles Hitchcock Tyler. 44.62

Provenance: Charles Hitchcock Tyler, Boston
Exhibited: Doll & Richards, Boston, *Exhibition and Sale of Bronzes by Katharine W. Lane and Small Landscapes by Donald V. Newhall* (1928), no. 3; The Dog Museum of America, New York, *Fidos and Heroes in Bronze*, exhibition catalogue by Janis Conner and Joel Rosenkranz (1983).

The English setter that inspired this statuette was the favorite shooting dog of Charles Hitchcock Tyler, a prominent Boston collector of early American decorative arts. When Lane composed this

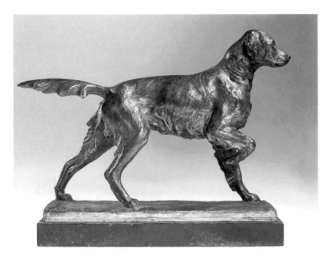

161

study of Tyler's pet, known officially as Willow Brook Rupert, the dog enjoyed considerable celebrity for the cluster of prizes he had won at local and national shows, including the coveted Bob White Trophy for best appearance and behavior at the annual English Setter Club trials in Medford, New Jersey.[1] The sculptor recollected that soon after she modeled Rupert, he ran away, immediately enhancing the statuette's sentimental value to the animal's downcast owner.

The composition captures the dog in a characteristic hunting pose. Modeled in a sketchlike manner, it forms an interesting stylistic contrast with the more severe lines and sleek surfaces of other animal studies from this period. The sculptor personalized the statuette for Tyler by inscribing his name on the dog's collar and signing her own name near the dog's left forepaw.

The Museum of Fine Arts acquired the piece through the bequest of Tyler, who also willed a number of fine examples of seventeenth- and eighteenth-century American furniture, which became the cornerstone collection of the Museum's Department of American Decorative Arts and Sculpture.

J.S.R.

Note

1. See "Charles H. Tyler's Willow Brook Rupert," *Boston Herald*, Dec. 30, 1927. One of Lane's favorite pastimes was attending dog shows, where she may have witnessed one of Rupert's victories.

KATHARINE LANE WEEMS
162
William McHenry Keyser, 1929
Bronze, brown patina, lost wax cast
H. 15 in. (38.1 cm.), w. 11¾ in. (29.8 cm.)
Signed (at lower right): KLW (monogram)
Inscribed (top): WILLIAM·McHENRY ·KEYSER
Foundry mark (on underside at right): IDEAL CASTING CO. PROV. R.I.
Gift of Mrs. Yves Henry Buhler. 1979.462

Provenance: Yves Henry Buhler, Brookline, Mass.; Mrs. Yves Henry Buhler, Brookline
Version: *Bronze*: (1) Keyser family, Baltimore

Best known for her animal bronzes, Katharine Lane occasionally experimented with portraiture, modeling exercises that reveal an ability to sensitively capture the personalities of her sitters. A particularly well-known example of this genre was the relief she produced of Mrs. Quincy Adams Shaw, Jr. (present location unknown), which traveled to several exhibitions.

William McHenry Keyser (1897-1928), a young Harvard graduate from Baltimore, Maryland, served as the subject for this posthumous portrait. Keyser, whom the sculptor had known through her Baltimore grandparents, was tragically killed in an automobile accident in the spring of 1928. Con-

162

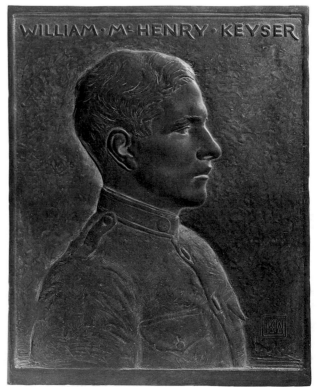

ceived as a memorial, the relief shows Keyser appropriately dressed in the army uniform of a second lieutenant. In 1918 Keyser had left college to enlist in the United States army as a private, receiving his commission as second lieutenant of Field Artillery, assigned to the Sixth Regiment at Camp Zachary Taylor, Kentucky, in June of that year. After his discharge from the army in January 1919, Keyser returned to join his classmates at Harvard, where he was remembered as an active participant in undergraduate theatrical productions and as an editor of the *University Register*. He returned to Baltimore after graduation, married, and, as his Harvard classbook notes, "quickly made a place for himself in the social and business life of that city."[1] After his death, Keyser's Harvard friends eulogized him as a man of "unusual ability, possessed of great personal charm and a rare sweetness of character."[2] Lane recalls having produced two casts of the relief, one for the deceased man's family and another for his former Harvard roommate, Yves Henry Buhler, whose version is that now owned by the Museum of Fine Arts.

J.S.R.

Notes

1. Harvard College, Class of 1920, *Twenty-fifth Anniversary Report* (1945), p. 446.

2. Ibid., p. 447.

KATHARINE LANE WEEMS
163
Dancer, 1937
Bronze, green patina, lost wax cast
H. 20 in. (50.8 cm.), w. 10¼ in. (26 cm.), d. 6 in. (15.2 cm.)
Signed (on top of base at left front): 1937/ K. LANE ©
Foundry mark (on back of base): E GAGANI FDRY. N.Y.
Gift of Katharine Lane Weems. 1983.208

Dancer exemplifies Katharine Lane's figural work of the 1930s. The rhythmic folds of the figure's costume generate a stylized, swirling movement in sympathy with Art Deco sensibility. Although its spirit connects the image with decorative trends expressed in sculpture of the period, the figure's action and sturdy simplicity of form recall the unassuming studies of women in action modeled by Abastenia St. Leger Eberle (1878-1942) twenty years earlier, such as *The Windy Doorstep*, 1910 (The Newark Museum, New Jersey), and *Girls Dancing*, 1907 (Corcoran Gallery of Art, Washington, D.C.)[1]

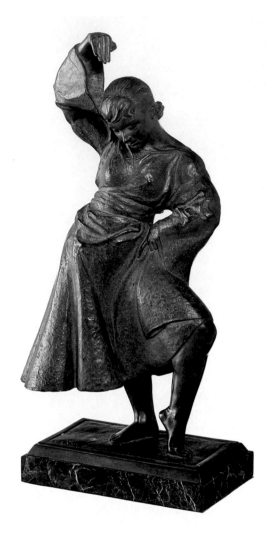

163

The model for *Dancer* was an Italian girl who arrived to pose at Lane's studio one day, attired in an unusual outfit. When the girl began to dance, her robes flowing and twirling, everyone present was so captivated by the performance that they were moved to join in, including the sculptor.[2] Only one bronze cast was produced of the piece. According to Lane, the New York foundry entrusted with the project, E. Gagani, squandered the funds designated for the cast before the job was finished, and thus it was difficult for her to obtain even this solitary version.

J.S.R.

Notes

1. Lane probably knew Eberle's work through her former teacher Anna Hyatt Huntington, who had shared her New York studio with Eberle.

2. Interviews by Jan Seidler Ramirez with Katharine Lane Weems, Mar. 9 and Apr. 11, 1983.

KATHARINE LANE WEEMS
164
Rabbit, 1947
Bronze, green patina, lost wax cast
H. 4⅛ in. (10.5 cm.), l. 5 in. (12.7 cm.), d. 2⅞ in.
(7.2 cm.)
Signed (on back of base): K. LANE WEEMS
Foundry mark (on side of base at back): R.B.W.
Gift of Katharine Lane Weems. 1983.209

Version: *Plaster*: (1) Katharine Lane Weems, Manchester,
Mass.

As indicated by the signature on the base, this appealing facsimile of a rabbit was cast in bronze by the sculptor after her marriage in 1947 to F. Carrington Weems. When asked about her inspiration for modeling the piece, the artist recalled that she had felt special empathy for this gentle, often capricious animal—a household pet—perhaps because she saw reflected in the rabbit something of her own playful but sensitive nature. Presented to her by a friend, the rabbit became the object of affectionate tending by the newly married sculptor, who remembers alternating its quarters from the front porch by day to the warmer bathroom in her house at night. This attention provoked her husband to complain, good-naturedly, that the house was not big enough to accommodate them all.[1]

The statuette is an unpretentious portrayal of an indulged domestic pet. At the same time it exhibits the scientific accuracy the sculptor characteristically brought to her animal portraits: the animal's plump ruff, for example, immediately identifies the rabbit as a female. Although the subject was one the sculptor returned to frequently, this example represents a unique bronze cast.

J.S.R.

Note

1. Interview by Jan Seidler Ramirez with Katharine Lane Weems, Mar. 9, 1983.

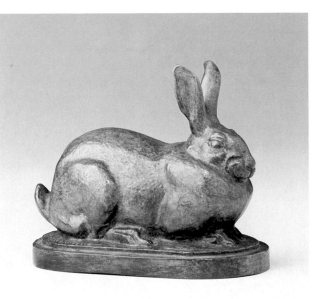

164

KATHARINE LANE WEEMS
165
Revolt or *Striding Amazon*, 1980 (modeled in 1926)
Bronze, brown patina, lost wax cast
H. 30½ in. (78.5 cm.), l. 19¼ in. (48.9 cm.), d. 6 in.
(15.3 cm.)
Signed (on top of base at front): 19 © 80 / K. LANE
WEEMS
Foundry mark (on top of base at front): TX
(monogram)
Gift of Katharine Lane Weems. 1981.664

Projecting intense concentration and brawny vitality, this figure was initially conceived by Katharine Lane in the mid-1920s under the title *Striding Amazon*. According to the sculptor, her intent was to symbolize feminine athletic prowess through the image of a woman whose muscular physique suggested enormous strength and whose pose dramatized the vexation women of her day felt toward the unfair tradition permitting only men to win honors for athletic daring and display.[1]

Striding Amazon attracted special comment from critics who saw the plaster model in Lane's Boston studio. Not only did it confirm her talent for figural sculpture, but it also provided an insight into her personal vision of contemporary life, an intrusion of opinion rarely detectable in her animal studies. The *Boston Globe* described the model as a "magnificently vigorous piece of work," suggestive of a "creature of nature who has no fear of sunlight, air, and hard physical labor."[2] Its crude power and veracious muscular development invited a compari-

Notes

1. Interview by Jan Seidler Ramirez with Katharine Lane Weems, Jan. 13, 1982.

2. "Boston Sculptress Is Gaining Reknown at Home and Abroad," *Boston Globe*, May 8, 1926.

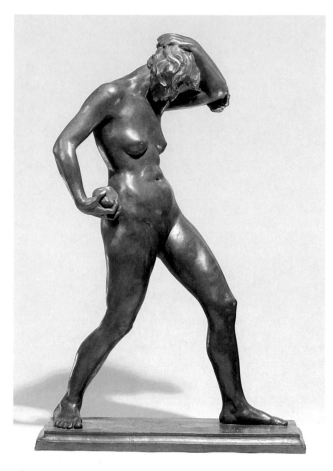

165

son with Rodin's school of realism. "Miss Lane points fondly to the statue's firmly developed legs, which are really legs to walk on and not graceful curved stilts," the writer also observed. According to the same source, the model for the statue was the director of the McKinley School of Dancing, New York.

In April 1981 Katharine Lane Weems submitted the original plaster figure to the National Sculpture Society's annual exhibition in New York under a new title, *Revolt*. In recognition of its strong but sensitive rendering of the female body, the piece received the Kalos Kagathos Foundation's prize. For the sculptor the frustration that she had attempted to translate into the striding Amazonian image in 1926 still seemed a timely mood to feature in the figure of a woman; the change in the work's title made the emotion more emphatic. After the plaster model was retouched by Mrs. Weems, in 1981 the Tallix Foundry in Peekskill, New York, was commissioned to produce this modern cast in bronze.

J.S.R.

Walker Hancock (born 1901)

The son of Anna (Spencer) and Walter Scott Hancock, a lawyer, Walker Kirtland Hancock was born in Saint Louis in 1901.[1] After attending local schools, in 1917 he acquired his initial art instruction at the Saint Louis School of Fine Arts, where he was a pupil of Victor Holm (1876-1935) and Edmund Henry Wuerpel (1866-1958). He then trained at the School of Fine Arts at Washington University between 1918 and 1920 and at the University of Wisconsin in 1920. Among Hancock's earliest efforts were four bronze, lettered tablets in Saint Louis: a *War Memorial* at the Central High School, about 1918; the *Scruggs Memorial* at the Scruggs School, about 1919; and the *Cannon Memorial* and *War Memorial* for the Westminister Presbyterian Church, both about 1919.

From 1921 to 1925 Hancock was a student at the Pennsylvania Academy of the Fine Arts, Philadelphia, under the tutelage of the highly regarded sculptor Charles Grafly. Hancock demonstrated considerable talent, winning the academy's Cresson Traveling Scholarship in 1922 and 1923. Working in a style that was and would remain realistic, he entered three sculptures—two portraits, and *Sea Weed*, 1920 (The Pennsylvania Academy of the Fine Arts), a bronze fountain figure of a nude boy clutching seaweed in his hands—in the 117th annual exhibition of the academy in 1922. This was the first year he participated in the academy's annual displays, and he continued to show there with regularity during the next four decades. At the 120th annual presentation, in 1925, one of his two submissions, *Toivo*, 1924, a bust of a young man, earned the George D. Widener Memorial Gold Medal; a bronze version of *Toivo* was subsequently acquired by the Saint Louis Art Museum. Cut off at midshoulder in a form reminiscent of Renaissance portraiture, it was a departure from the small, sketchlike anecdotal bronzes—such as *After the Bath*, *Wet*, *Stubbed Toe*, and *Bather*, all 1924 (private collection, Friday Harbor, Washington)—that had been put on view by the academy the previous year. In 1926 he sent *Water Lily*, 1925 (private collection, Topsfield, Massachusetts), to the academy's annual exhibition. A charming bronze figure of a nude girl grasping a lily in her right hand and cautiously placing one foot in front of the other, it is characteristic of traditional garden statuary produced in the 1920s.

Hancock was awarded the coveted Prix de Rome in 1925, and between 1925 and 1929 he spent most

of his time pursuing sculptural endeavors at the American Academy in Rome. Dating from his stay in Italy are the classical *Roman Bagpiper*, 1927 (private collection, Mercer Island, Washington), and *Boy and Squirrel*, 1928 (Brookgreen Gardens, Murrells Inlet, South Carolina), a stone figure of a seated nude boy holding a shell from which a squirrel is about to eat. Clearly, statues for gardens and fountains were a specialty of Hancock's in the 1920s and early 1930s. About 1928 in Florence, he fashioned the joyous *Triton Fountain*, or *Twin Naiads at Play*, for the Parrish Art Museum, Southampton, New York, and in 1930 he executed the *Maschmeyer Memorial Fountain*, commissioned for a site in front of the flight cage (the Smithsonian Institution's exhibit at the 1904 World's Fair in Saint Louis) in the Saint Louis Zoological Park. Representing a kneeling Zuni Indian *Bird Charmer* with a bird on each wrist, the fountain won the Fellowship Prize at the 127th annual exhibition of the Pennsylvania Academy in 1932. Less lighthearted in spirit, yet still within the genre of fountain statuary, is the figure of the Good Shepherd for the *Bowker Memorial Fountain*, 1957, at All Saints Church, Worcester, Massachusetts.

In 1929, following his return to the United States, Hancock was chosen to replace Grafly, who had recently died, as head of the sculpture department

at the Pennsylvania Academy. (Hancock's association as a teacher at the academy lasted nearly forty years.) At the beginning of his tenure, he resided in New York and went to Philadelphia once a week to criticize the students' output. Like Grafly before him, Hancock started summering on Cape Ann, Massachusetts, and in 1931 he had a studio built in Lanesville (near Gloucester), where he eventually settled year-round.

After the 1930s Hancock was occupied less with garden statuary and turned his attention to portraiture, figure studies, and architectural sculpture. His statue of the first bishop of Pennsylvania, William White, 1931, was cast in bronze for the Divinity School of the Protestant Episcopal Church in Philadelphia. Although his seated marble *Judge Charles Lincoln Brown*, placed in 1947 (Municipal Court House, Philadelphia), is a rather routine specimen, his standing bronze *John Paul Jones*, installed in 1957 (Fairmount Park, Philadelphia), is an inspired portrayal of the naval officer, and his seated marble *James Madison*, dedicated in 1981 (Madison Building, Library of Congress, Washington, D.C.), is a noble image of the nation's fourth president. Of his portrait busts of well-known individuals, *Booth Tarkington*, 1934 (Indianapolis Museum of Art, Indiana); *Stephen Foster*, unveiled in 1941 at the Hall of Fame in the Bronx, New York; *Robert Frost*, 1950 (National Portrait Gallery, Washington, D.C.), all bronzes; and the marble *Chief Justice Earl Warren*, 1977 (Supreme Court, Washington, D.C.), may be mentioned.

In the 1930s and 1940s Finnish boys who lived near Hancock's home in Lanesville posed for portraits and figure studies. Their sturdy, muscular bodies served as models for athletic subjects, for example, *Diver*, 1933 (private collection, Lanesville), which received the Helen Foster Barnett Prize of the National Academy of Design, New York, in 1935 and was exhibited at the New York World's Fair in 1939. These young men, with high cheekbones and a mien suggesting an active, outdoor life, can also be seen in Hancock's handsome bronze *Young Lobsterman*, 1934 (The Pennsylvania Academy of the Fine Arts); a particularly fine terracotta *Head of a Finnish Boy*, 1939 (The Pennsylvania Academy of the Fine Arts); and the bronze *Ahti*, 1939 (Saint Louis Art Museum).

Hancock's varied architectural sculpture includes three contributions in limestone—evangelical symbols for the Girard College Chapel, Philadelphia, unveiled in 1933; a frieze for the City Hall, Kansas City, Missouri, mid-1930s; four heroic groups for the Saint Louis Memorial Building, late 1930s—and relief figures in *pietra d'istria* mounted on black Belgian marble, symbolizing different modes of communication in memory of the founders of the Bell Telephone Company of Canada, Montreal, late 1950s.

World War II provided Hancock with the opportunity to design two of his most important memorials: the three angels of victory on the tower at the Lorraine American Cemetery at Saint Avold, France, 1960, and the 40-foot bronze *Pennsylvania Railroad War Memorial*, begun in 1948 and dedicated in 1952 (Thirtieth Street Station, Philadelphia). Probably Hancock's greatest conception, the *Pennsylvania Railroad War Memorial* is a deeply affecting tribute to the more than thirteen hundred employees who perished in the war. It shows a sorrowful angel, with enormous wings that point straight up, lifting a soldier out of the flames of battle (see *Head of an Angel*). A worthy, though more somber, descendant of *Gloria Victis*, 1874 (Petit Palais, Paris) by Antonin Mercié (1845-1916), and *The Kiss of Victory*, 1881 (Minneapolis Institute of Arts, Minnesota) by Alfred Gilbert (1854-1934), it is a powerful sculpture that ranks above most of the figurative war memorials made after the 1940s.

With respect to scale, certainly the grandest enterprise Hancock was involved in was the *Stone Mountain Memorial*, outside Atlanta, Georgia. Measuring 69 feet in height, the granite bas-relief memorial commemorates the Confederacy generals Robert E. Lee and Thomas (Stonewall) Jackson, and Confederate President Jefferson Davis, each on horseback. Originally, between 1915 and early 1925, Gutzon Borglum (1867-1941) was in charge of the scheme; however, owing to a dispute, he left the monument unfinished. (Eventually, Borglum realized his dream of carving colossal images from the live rock of a mountainside by creating the presidential portraits at Mount Rushmore, South Dakota, 1930-1941.) Augustus Lukeman (1871-1935) succeeded Borglum, drew up a new composition, and managed to complete the head of Lee and rough out much of the group before the funds were exhausted in the late 1920s. It was not until the 1960s that labor on the memorial was resumed. The state of Georgia bought the mountain, turned the area into a state park, and hired Hancock to supervise the project, which was concluded in 1970.

Hancock taught briefly at the Art Students League and the National Academy of Design, both

in New York, and was sculptor-in-residence at the American Academy in Rome in 1956-1957 and in 1962-1963. Vigorous and industrious, Hancock has brought forth many pieces late in his career: for instance, the over life-size male figure *Air*, 1981 (Civic Center, Philadelphia), and *Abraham Lincoln*, an over life-size bronze statue, 1983 (National Cathedral, Washington, D.C.), which were executed with the same care he devoted to his works throughout his professional life.

K.G.

Notes

1. I am grateful to Walker Hancock for graciously providing information about his life and work.

References

AAA, SI; Fairmount Park Art Association, *Sculpture of a City: Philadelphia's Treasures in Bronze and Stone* (New York: Walker, 1974), p. 295; Walker Hancock, "The Pennsylvania Railroad Memorial," *American Artist* 16 (Oct. 1952), pp. 28-31, 68-70; MMA; Proske 1968, pp. 352-354.

WALKER HANCOCK
166

Fallen Boxer, 1934
Bronze, dark brown patina, lost wax cast
H. 9 in. (22.8 cm.), l. 15½ in. (39.9 cm.), d. 10¼ in. (26 cm.)
Signed (on back of base): W. HANCOCK 19©34
Foundry mark (on back of base): CELLINI BRONZE WORKS N-Y-
Gift of Walker Hancock. 1980.425

Provenance: Walker Hancock, Lanesville, Mass.
Exhibited: Whitney Museum of American Art, New York, *Second Biennial Exhibition Part One—Sculpture, Drawings, and Prints*, 1936, no. 22; The Pennsylvania Academy of the Fine Arts, Philadelphia, *Catalogue of the 133rd Annual Exhibition*, 1938, no. 371; The Mint Museum of Art, Charlotte, N.C., "Works by Walker Hancock and George Demetrios," Oct. 1940; Addison Gallery of American Art, Andover, Mass., *New England Sculptors*, 1942, no. 16.
Version: *Bronze*: (1) private collection, Lanesville

Fallen Boxer resulted from Walker Hancock's desire to create a composition that could be viewed from all angles. No model posed for the piece, and the sculptor explained that it was executed expressly as "an experiment and exercise in simplification."[1] He made it as compactly as possible and found, in the end, that he had never before simplified natural forms to that extent.

Fallen Boxer can be grouped together with several

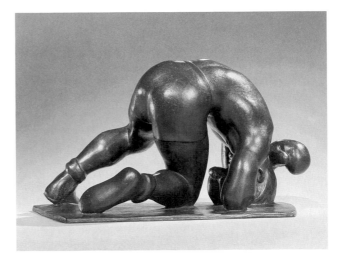

166

other works that have athletic themes. His *Roman Pugilist*, 1928, a nude figure in the act of fighting, and his equally muscular but more quiescent *Diver*, 1933 (both private collection, Lanesville, Massachusetts), also deliberately explore mass and void in space. By the time Hancock produced the *Boxer*, however, he appeared to be less concerned with the narrative, since the subject of the fallen figure seems almost incidental to the sculptor's intent to display open and closed shapes from different vantage points.

Though not one of Hancock's best-known efforts, the *Fallen Boxer* was exhibited on several occasions and was well received by critics. Edward Alden Jewell of the *New York Times* mentioned Hancock's "excellent little 'Fallen Boxer'" in writing about a number of sculptures that "tended less assertively away from naturalism" in the second biennial exhibition at the Whitney Museum of American Art, New York, in 1936.[2] Alice Lawton of the *Boston Sunday Post* described the *Boxer* as being "economical of detail yet keenly characterized" in her review of an exhibition of sculpture at the Addison Gallery of American Art, Andover, Massachusetts, in 1942.[3]

K.G.

Notes

1. Telephone conversation between Walker Hancock and Kathryn Greenthal, fall 1980.

2. Edward Alden Jewell, "Museums Set the Pace: The Whitney's Second Biennial—Museum of Modern Art Presents a Triple Bill," *New York Times*, Jan. 19, 1936.

3. Alice Lawton, "New England Sculptors at Addison Gallery of Art," *Boston Sunday Post*, Jan. 18, 1942.

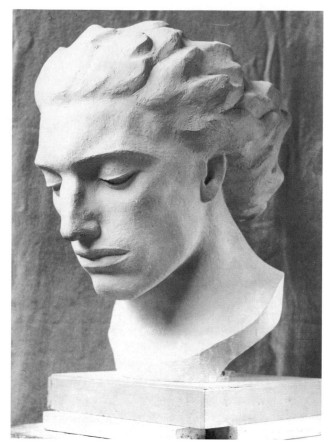

167

WALKER HANCOCK
167
Head of an Angel, 1950
Plaster
H. 32½ in. (82.5 cm.), w. 21 in. (53.4 cm.), d. 27 in.
(68.6 cm.)
Gift of Walker Hancock. 1980.426

Provenance: Walker Hancock, Lanesville, Mass.

Head of an Angel is part of the final, over life-size
model for Walker Hancock's *Pennsylvania Railroad
War Memorial*, unveiled on August 10, 1952, in the
Thirtieth Street Station, Philadelphia. Designed for
the station's great concourse, which measures 95
feet high and 250 feet in length, the bronze memo-
rial is 40 feet high, with a strong sense of vertical
movement; represented is an angel with enormous,
raised wings, which lifts the limp body of a soldier
out of the symbolic flames of battle. On the base are
inscribed the names of over thirteen hundred em-
ployees of the Pennsylvania Railroad who died in
World War II. Among Hancock's monumental
sculpture, the *War Memorial* is considered the finest.

The features of the angel and the soldier are
treated naturalistically and modeled with great sen-
sitivity. Originally, Hancock conceived the angel as
Saint Michael wearing a suggestion of armor, but as
the work evolved, he simplified the figure to be
representative of all men. Just as the sculptor kept
the size of the group in a reasonable scale relative to
those who would view it, so he gave the angel a
compassionate expression that could be easily read
by passersby in the busy terminal.

Hancock began the memorial in 1948 with a
number of 12-inch plastiline sketches, from which
the railroad's board of directors selected the one
that emphasized a strictly frontal view with winged
shaft. After this, a 3-foot study model was made
and then the clay scale model, one-third the final
size, which helped to establish the head of the angel
as the central focal point. The enlargement of this
model was made by Gene Leofanti in his Staten
Island, New York, studio, and the lower third of the
group and the angel's wings were finished there by
Hancock. The upper two-thirds of both figures
were brought to the sculptor's studio in Lanesville,
Massachusetts, where Hancock spent five months
making necessary modifications. Attilio Contini and
Sons, plaster molders in New York, made the work
in sixteen sections, and Roman Bronze Works, New
York, cast the group by the lost wax process.[1] A
plaster model, one-third the size of the memorial
remains in Hancock's studio.

P.M.K.

Note

1. See Walker Hancock, "The Pennsylvania Railroad Me-
morial," *American Artist* 16 (Oct. 1952), pp. 28-31, 69-70.

Anonymous Sculptors

ANONYMOUS SCULPTOR
168
Liberty (?)
Probably Massachusetts, about 1790-1800
White pine and paint
H. 53⁷⁄₁₆ in. (135.8 cm.), w. 24½ in. (62.3 cm.),
d. 12¼ in. (31.1 cm.)
H.E. Bolles Fund. 1979.163
Provenance: Boston area; Kenneth Snow, Newburyport, Mass.; Dillingham House Antiques, Sandwich, Mass.

As the human body is justly esteemed the most perfect original, it has been customary, in all time, to enrich different parts of buildings with representations thereof. Thus the ancients adorned their temples, basilicas, baths, theaters, and other public structures . . . and the moderns still preserve the same custom; placing in their churches, palaces, houses, squares, gardens, and public walks, the busts and statues of illustrious personages, or bas-reliefs, and groupes [sic], representing memorable occurrences, collected from the histories, fables or traditions of particular times.[1]

This observation by the influential English architect William Chambers, published in *A Treatise on the Decorative Part of Civil Architecture* (1791), reflects the revived taste for allegorical figures as sculptural adornments that English architectural books of the eighteenth century helped to introduce into American building design in the post-revolutionary period. By this date, New England's coastal towns, like shipping ports in other regions, supported a practiced trade of resident wood carvers and craftsmen who specialized in the production of figureheads, nautical ornaments, and decorative shop signs. During the embargo of 1807 and War of 1812, which caused a recession in New England's shipbuilding industry, craftsmen who had formerly concentrated on prow and stern-board sculpture found incentive to expand their services to include carving decorative elements suitable for architectural schemes then coming into fashion.

If there was ever a philosophical principle meriting sculptural embodiment on an American building, it was surely liberty, an ideal that spawned scores of visual personifications after the Revolution, most of these interpretations derived (ironically enough) from prototypes and iconography found in English and European art, owing their strongest debt to the well-known image of *Britannia-Libertas*.[2] The nearly freestanding carved figure in

the Museum of Fine Arts portrays a woman presumed to represent Liberty; its New England provenance and probable date of manufacture at the end of the eighteenth century suggest the image was intended to personify the hard-won freedom lately secured by the new American Republic.

When the Museum acquired the piece in 1979, it was missing a portion of one hand, a section from the wreath held in the left hand, and the staff, or rod, that the figure is presumed to have grasped in her right hand. The staff and its Phrygian cap (known in ancient Roman times as the *pilleus libertatis*) are modern replacements supplied by the Museum's furniture conservator; the designs of these traditional attributes, however, are based on similar props illustrated in historical prints and extant sculptural effigies of Liberty dating from the late eighteenth century. The wooden figure is in otherwise good condition in spite of its age.

The facility of carving exhibited in the garland of flowers encircling *Liberty's* head, as well as the adroit tooling demonstrated in the original part of her victory wreath, are impressive in their skill of definition and expert undercutting. The craftsman's attention to detail extended throughout the composition, quite literally from top (note the convincing blossoms that form *Liberty's* crown) to toe (even the toenails have been articulated realistically). Although the carver appears to have encountered difficulty in his rendering of drapery and translation of female anatomy, he ventured with evident knowledge of academic models and procedures to impart a sense of flowing rhythm, undulating line, and dramatic shadowing to the figure's classical robes, even if the results prove awkward in certain passages. The treatment of the figure's overmantle, in particular, manifests the same quality of rigid yet graceful carving seen in the early wooden figures of the Philadelphia sculptor William Rush (1756-1833), as well as in several of Rush's more chronologically advanced compositions, such as the neoclassical cedarwood sculpture *Allegory of the Waterworks*, 1825 (The Fairmount Park Commission, Philadelphia, on deposit, Philadelphia Museum of Art).[3] *Liberty's* full face and dimpled double chin also recall the plump-cheeked cherubs and fleshy goddesses found in baroque sculpture.

Liberty is carved from eastern white pine, a wood favored by New England craftsmen not only because of its accessibility but also because it was inexpensively acquired, easy to manipulate, and light in weight. It is not, however, a particularly durable

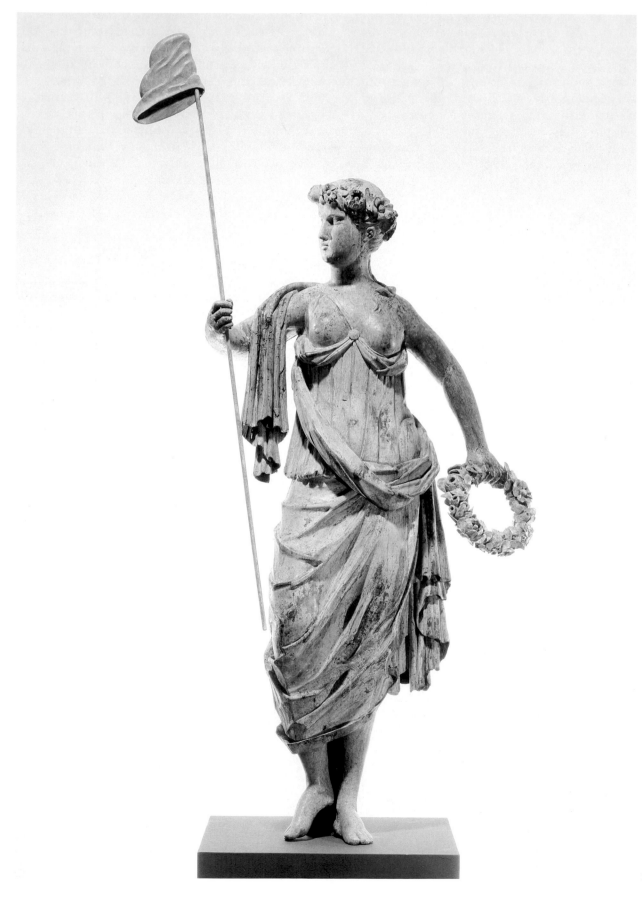

168

wood, as time has proven. Unlike the approach commonly taken in contemporary figurehead construction, *Liberty* was not carved from a hollowed-out log but was composed from several pieces of solid wood joined together, a method necessitating the use of pinning devices. Accordingly, as joints dried out and shrank over the years, the original nails employed by the craftsman (in this case, a hand-cut nail type used before 1800) became visible, enabling researchers to assign an approximate date of manufacture to the figure of about 1790-1800, based on the nail design. The figure's stylized mannerism, an attitude it shares with much provincial sculpture of the eighteenth century, also supports the validity of a turn-of-the-century dating.

When *Liberty* first arrived at the Museum, the figure had been overpainted with coats of varnish and blue-based pigment. Conservators removed six successive layers of paint from the figure[4] and, in this removal process, revealed that the original image had been toned white, probably in an effort to lend it the appearance of marble. For the carver who produced *Liberty*, painting was also a requisite finishing step in order to disguise the joints where the wooden sections had been glued together.

The provenance of *Liberty*, together with the fact that it is made of white pine, suggest that it was made by a Boston-area craftsman, although there were established carving shops in other regional port towns from which the figure could have originated. (A previous owner of the piece claimed that it had never been out of the Boston area.) That its design was influenced by the tradition of figurehead carving seems apparent from its implied forward movement and strong silhouette, and from the way the figure is mounted on a heavy chamfered shaft, corresponding to the stem of a ship's bow. *Liberty* is also roughly finished at the back, indicating that it was intended to be attached to a wall or other type of support rather than be viewed in the round. Its lack of significant weathering raises the possibility that the figure was never exposed to the elements and instead found shelter under an architectural niche or porch. If its purpose involved placement in a decorative program for architecture, an allegorical personification of Liberty would have made logical sculptural adornment for a local courthouse or other civic structure. It is also possible that the figure never left the shop of its creator, being retained as a display item vouching for the abilities of the craftsman.

Until more extensive research is undertaken on New England wood carvers and sculptors of the late eighteenth and early nineteenth centuries, it would be premature to assign a specific maker to this figure. The quality of the carving suggests the work of an individual who had progressed beyond the stage of executing ship figureheads, and who, furthermore, had a passing familiarity with the relatively new neoclassical style in sculpture and access to European drawing books and architectural manuals. As Jonathan Fairbanks observes in his introduction to this catalogue, the anonymous craftsman who carved *Liberty* clearly was conversant with the modular system for measuring and estimating ideal figural proportions employed by Samuel McIntire (1757-1811) of Salem, Massachusetts; that apparent knowledge bolsters the supposition of the carver's familiarity with a methodology of figural composition practiced in prominent Boston-area and other coastal New England carving shops of the period.

By 1800, most of the members of Boston's preeminent wood-carving dynasty, the Skillins family, were either deceased (Simeon Skillins, Sr., died in 1778; his son John died in 1800) or failing (Simeon, Jr., died in 1806);[5] however, a surviving Skillins, Samuel, remained active as a carver until 1816, according to city directories and tax lists. It is conceivable that *Liberty* could have been carved by him or someone earlier trained in the Skillinses' shop. Among the recognized wood carvers in the Boston area who competed with Samuel Skillins in the early nineteenth century were Isaac Fowle, Laban S. Beecher, and Solomon Willard, any one of whom might have been capable of producing such a figure, together with dozens of other carvers whose identities and careers have yet to be documented.

J.S.R.

Notes

1. William Chambers, *A Treatise on the Decorative Part of Civil Architecture* (1791; reprint ed., New York: Blom, 1968), p. 122.

2. See Frank H. Sommer, "The Metamorphoses of Britannia," in *American Art 1750-1800: Towards Independence*, exhibition catalogue (Boston: New York Graphic Society for Yale University Art Gallery and The Victorian and Albert Museum, 1976), pp. 40-49.

3. For a review of this important artist's sculpture, see *William Rush, American Sculptor*, exhibition catalogue (Philadelphia: Pennsylvania Academy of the Fine Arts, 1982); for further reading on the subject of early American wood carvers, see also selected bibliography compiled on early American wood carving, p. 191.

4. See Furniture Conservation Laboratory Reports, BMFA, ADA.

5. Leroy L. Thwing, "The Four Carving Skillins," *Antiques* 43 (June 1938), pp. 326-328. The Skillins brothers (John and Simeon) are known to have produced sculpture other than figureheads.

References

M. V. Brewington, *Shipcarvers of North America* (New York: Dover, 1972); Erwin O. Christensen, *Early American Wood Carving* (Cleveland: World Publishing, 1952); Craven 1968, pp. 1-45; Sylvia F. Lahvis, "The Skillins of Boston and the Eighteenth-Century Woodcarving Tradition," Ph.D. diss., The University of Delaware, in progress; Pauline Pinckney, *American Figureheads and Their Carvers* (New York: Norton, 1940); Edouard Stackpole, *Figureheads and Ship Carvings at Mystic Seaport* (Mystic, Conn.: Marine Historical Association, 1964); Mabel Swan, "Boston Carvers and Joiners," *Antiques* 53 (Mar. 1948), pp. 198-201, 281-285; Whitney 1976, pp. 27-33.

169

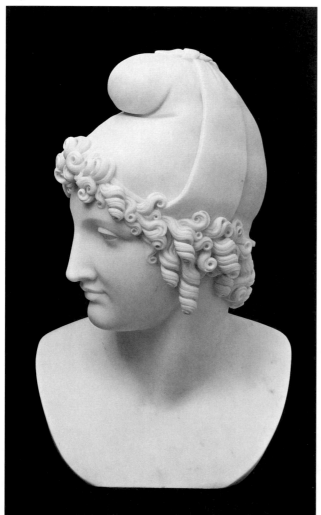

ANONYMOUS SCULPTOR
169
Ganymede, about 1850
Marble
H. 21 in. (53.3 cm.), w. 12½ in. (31.3 cm.), d. 10⅛ in. (25.8 cm.)
Gift of Mrs. Henry Lyman. 56.82

Provenance: Theodore Lyman, Brookline, Mass.; Mrs. Henry Lyman, Canton, Mass.

The author of this idealized head of Ganymede, the beautiful Trojan boy who served as cupbearer to the Olympian gods, is unknown but may be the artist who carved the head of Mercury (q.v.) for the Lyman family of Brookline, Massachusetts. Classic in inspiration, the bust incorporates the Phrygian cap and loose coils of curling hair traditionally associated with the mythological Ganymede. This bust is a freer adaptation of an antique prototype than the *Mercury*, however, which seems to have been copied with more precise fidelity.

J.S.R.

ANONYMOUS SCULPTOR
170
Mercury, about 1850
Marble
H. 18 in. (45.7 cm.), w. 13½ in. (34.3 cm.), d. 14⅛ in. (35.9 cm.)
Gift of Mrs. Henry Lyman. Res. 56.83

Provenance: Theodore Lyman, Brookline, Mass.; Mrs. Henry Lyman, Canton, Mass.

For many years this head of Mercury, together with that of Ganymede (q.v.), ornamented the library of Theodore Lyman's home in Brookline, Massachusetts. The marble is based directly on an ancient model or a restoration of the same, probably the widely admired antique *Mercury* in Pentelic marble once owned by the Marquess of Landsdowne in England. Undated and unsigned, the bust could have been ordered from one of any number of nineteenth-century sculptors who lived in Italy, where customers sought out copies of famous classical images and paid handsomely for such purchases. Although the production of antique facsimiles did not enable the sculptor to display much inventive skill, it was a remunerative exercise that brought American sculptors sought-after contacts with affluent patrons in Boston, New York, and other native centers of culture and erudition.

J.S.R.

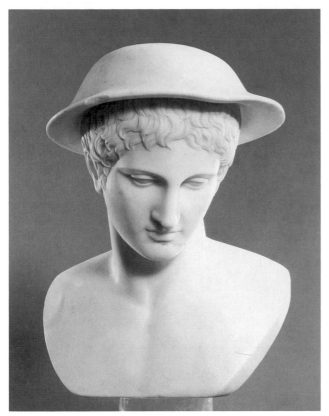

170

ANONYMOUS SCULPTOR

171

Young Woman, about 1860

Marble

Diam. 22½ in. (57.2 cm.); frame diam. 29½ in.
(75 cm.)

Gift of Mrs. Henry Lyman. 56.68

Provenance: Theodore Lyman, Brookline, Mass.; Mrs.
Henry Lyman, Canton, Mass.

The identity of the young woman featured in this
tondo, or circular, marble relief is undocumented.
She may have been a relative of the Lyman family
of Boston, whose descendants gave the piece to the
Museum of Fine Arts in 1956, possibly Ella Ban-
croft Lowell Lyman (1837-1894), the wife of Arthur
Theodore Lyman (1832-1915), or Elizabeth Russell,
who in 1858 married Theodore Lyman (captured
in a bust [q.v.] by Henry Dexter).[1] The sitter's cos-
tume and jewelry suggest a well-to-do person who
chose to be immortalized in attire reminiscent of
fashionable Empire costumes worn during the Na-
poleonic era. Her crossed-laced bodice with ribbon
straps (perhaps adapted from a peasant dress),
pleated blouse, hoop earrings, and strand of gradu-
ated pearls (or other gems) have been meticulously

recorded by the sculptor, as have the complex con-
tours and patterns of her braided hair and bead-
garnished chignon.

The medallion format of this high-relief profile
portrait, ultimately derived from classical coinage,
enjoyed sustained popularity as a portraiture mode
in America through much of the nineteenth cen-
tury.[2] Stylistically, the piece resembles portrait stud-
ies produced by the second generation of American
neoclassical sculptors who worked in Italy (1845-
1870), who typically lavished as much energy inven-
torying costume details and textural effects as they
did delineating the features of their sitters. Mar-
garet Foley (1827-1877), in whose oeuvre the por-
trait medallion predominated, excelled at this par-
ticular form, and it may be that she or one of her
circle of compatriots in Rome executed this relief.
The piece retains its original, decoratively carved
wooden frame.

J.S.R.

Notes

1. See Mary Caroline Crawford, "The Lyman Family," in
Famous Families of Massachusetts (Boston: Little, Brown,
1930), vol. 2, pp. 253-258.

2. Prototypes are found in Ptolemaic coins. The marble
profile medallion also evolved from the tradition of neo-
classical cameo portraits. See the discussion in Brown
University, Dept. of Art, Providence, R.I., *The Classical
Spirit in American Portraiture*, exhibition catalogue (1976),
p. 95.

171

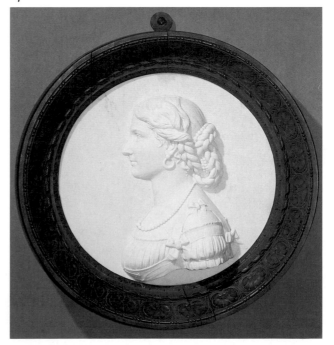

Abbreviated References Used in the Catalogue

Archives

AAA, SI
Archives of American Art, Smithsonian Institution

BAC
City of Boston Art Commission. Records

BMFA, ADA
Museum of Fine Arts, Boston. Department of American Decorative Arts and Sculpture. Curatorial Files

BMFA, 1876-1900; BMFA 1901-1954
Museum of Fine Arts, Boston. Director's Correspondence

BMFA, WMH
Museum of Fine Arts, Boston. The William Morris Hunt Memorial Library, Artist File (microfiche)

BPL
Boston Public Library. Fine Arts Department, Boston-New England Art Archives

HO, HU
Houghton Library, Harvard University

HU
Harvard University Archives

MHS
Massachusetts Historical Society, Boston

MMA
The Metropolitan Museum of Art, New York. Thomas J. Watson Library, Artist File

MMA, ALS
The Metropolitan Museum of Art, New York. Thomas J. Watson Library, Autograph Letters from American Sculptors

MMA, Arch
The Metropolitan Museum of Art, New York. Archives

NYHS
The New-York Historical Society, New York

NYPL
The New York Public Library, Art Division: Artist File; Scrapbooks

NYPL, RBM
The New York Public Library, Rare Books and Manuscripts Division

SMFA
School of the Museum of Fine Arts. Archival Scrapbooks

UTA
Harry Ransom Humanities Research Center, University of Texas at Austin

Publications

AAAn
American Art Annual

Ball 1891
Ball, Thomas. *My Threescore Years and Ten: An Autobiography.* Boston: Roberts, 1891.

BMFA
Museum of Fine Arts, Boston (abbreviation used for all publications by the Museum)

BMFA 1916
Museum of Fine Arts, Boston. *William Rimmer Centennial Exhibition.* 1916.

BMFA 1977
Museum of Fine Arts, Boston. *Art in Transition: A Century of the Museum School.* Exhibition catalogue by Bartlett Hayes. 1977.

BMFA 1979
Museum of Fine Arts, Boston. *The Sublime and the Beautiful: Images of Women in American Sculpture, 1840-1930.* Exhibition catalogue by Jan Seidler and Kathryn Greenthal. 1979.

Benjamin 1880
Benjamin, Samuel G.W. *Art in America: A Critical and Historical Sketch.* New York: Harper, 1880.

Boston Athenaeum 1984
Boston Athenaeum. *Pre-Twentieth Century American and European Painting and Sculpture: The Boston Athenaeum Collection.* Catalogue by Jonathan P. Harding. 1984.

CAA, *Index*
College Art Association, New York. *The Index of Twentieth Century Artists.* 4 vols. 1933-1937.

Caffin 1902
Caffin, Charles H. "Victor D. Brenner, Medallist." *International Studio* 17 (Sept. 1902), suppl., pp. xci-xciv.

Caffin 1903
Caffin, Charles H. *American Masters of Sculpture.* New York: Doubleday, Page, 1903.

Clark 1878
Clark, William J. *Great American Sculptures.* Philadelphia: Gebbie & Barrie, 1878.

Clement and Hutton 1894
Clement, Clara, and Hutton, Laurence. *Artists of the Nineteenth Century and Their Work.* 7th ed. Boston: Houghton, Mifflin, 1894.

Crane 1972
Crane, Sylvia E. *White Silence: Greenough, Powers and Crawford, American Sculptors in Nineteenth-Century Italy.* Coral Gables, Fla.: University of Miami Press, 1972.

Craven 1968
Craven, Wayne. *Sculpture in America.* New York: Crowell, 1968.

DAB
Dictionary of American Biography. Under the Auspices of the American Council of Learned Societies. New York: Scribner's, 1927-1974.

Detroit 1983
The Detroit Institute of Arts. *The Quest for Unity: American Art between World's Fairs, 1876-1893.* 1983.

Dryfhout 1982
Dryfhout, John H. *The Work of Augustus Saint-Gaudens.* Hanover, N.H.: University Press of New England, 1982.

Francis 1976
Francis, Rell G. *Cyrus E. Dallin: Let Justice Be Done.* Springville, Utah: Springville Museum of Art and Utah American Revolution Bicentennial Commission, 1976.

Gardner 1945
Gardner, Albert Ten Eyck. *Yankee Stonecutters: The First American School of Sculpture, 1800-1850.* New York: Columbia University Press, 1945.

Gardner 1965
The Metropolitan Museum of Art, New York. *American Sculpture: A Catalogue of the Collection of the Metropolitan Museum of Art,* by Albert Ten Eyck Gardner. 1965.

Gerdts 1973
Gerdts, William H. *American Neo-Classic Sculpture: The Marble Resurrection.* New York: Viking, 1973.

Greenough 1887
Greenough, Horatio. *Letters of Horatio Greenough to His Brother, Henry Greenough.* Edited by Frances B. Greenough. Boston: Ticknor, 1887.

Hirschl & Adler 1982
Hirschl & Adler Galleries, New York. *Carved and Modeled: American Sculpture 1810-1940.* Exhibition catalogue by Susan E. Menconi. 1982.

Jarves 1864
Jarves, James Jackson. *The Art-Idea: Sculpture, Painting, and Architecture in America.* 3rd ed. New York: Hurd & Houghton, 1864.

Lee 1854
Lee, Hannah. *Familiar Sketches of Sculpture and Sculptors.* 2 vols. Boston: Crosby, Nichols, 1854.

McSpadden 1924
McSpadden, Joseph. *Famous Sculptors of America.* New York: Dodd, Mead, 1924.

MMA 1970
The Metropolitan Museum of Art, New York. *19th-Century America: Paintings and Sculpture.* Exhibition catalogue. Texts by John K. Howat, Natalie Spassky, and others. 1970.

Michigan 1916
Biographical Sketches of American Artists. 4th ed. Lansing: Michigan State Library, 1916.

Nordland 1974
Nordland, Gerald. *Gaston Lachaise: The Man and His Work.* New York: Braziller, 1974.

Notable American Women
Notable American Women: The Modern Period: A Biographical Dictionary. Edited by Barbara Sicherman and Carol Hurd Green. Cambridge: Harvard University Press, Belknap Press, 1980.

Post 1921
Post, Chandler Rathfon. *A History of European and American Sculpture from the Early Christian Period to the Present Day.* 2 vols. Cambridge: Harvard University Press, 1921.

Proske 1968
Proske, Beatrice Gilman. *Brookgreen Gardens Sculpture.* rev. ed. Brookgreen Gardens, S.C.: Brookgreen Gardens, 1968.

Rubinstein 1982
Rubinstein, Charlotte Streifer. *American Women Artists from Early Indian Times to the Present.* Boston: Hall, 1982.

Saint-Gaudens 1913
Saint-Gaudens, Augustus. *The Reminiscences of Augustus Saint-Gaudens.* Edited and amplified by Homer Saint-Gaudens. New York: Century, 1913.

San Francisco 1929
National Sculpture Society, New York, in Cooperation with the Trustees of the California Palace of the Legion of Honor, San Francisco. *Contemporary American Sculpture.* New York, 1929.

Sharp 1974
The Metropolitan Museum of Art, New York. *New York City Public Sculpture by 19th Century American Artists.* Exhibition catalogue by Lewis I. Sharp. 1974.

Soria 1982
Soria, Regina. *Dictionary of Nineteenth-Century American Artists in Italy, 1760-1914.* London: Associated University Presses, 1982.

Taft 1921
Taft, Lorado. *Modern Tendencies in Sculpture.* The Scammon Lectures at the Art Institute of Chicago, 1917. Chicago: University of Chicago Press, 1921.

Taft 1930
Taft, Lorado. *The History of American Sculpture.* New edition with supplementary chapter by Adeline Adams. New York: Macmillan, 1930. (First published 1903.)

Thieme-Becker
Thieme, Ulrich, and Becker, Felix, eds. *Allgemeines Lexikon der bildenden Künstler.* Leipzig: Engelman, 1907-1950.

Thorp 1965
Thorp, Margaret. *The Literary Sculptors.* Durham, N.C.: Duke University Press, 1965.

Tuckerman 1853
Tuckerman, Henry T. *A Memorial of Horatio Greenough.* New York: Putnam, 1853.

Tuckerman 1867
Tuckerman, Henry T. *Book of the Artists.* New York: Putnam, 1867.

Vermeule 1971
Vermeule, Cornelius. *Numismatic Art in America: Aesthetics of the United States Coinage*. Cambridge: Harvard University Press, Belknap Press, 1971.

Vermeule 1972
Vermeule, Cornelius. "America's Neoclassic Sculptors: Fallen Angels Resurrected," *Antiques* 102 (Nov. 1972), pp. 868-875.

Vermeule 1975
Vermeule, Cornelius. "Neoclassic Sculpture in America: Greco-Roman Sources and Their Results," *Antiques* 108 (Nov. 1975), pp. 972-981.

Weidman 1982
Weidman, Jeffrey. "William Rimmer: Critical Catalogue Raisonné." Ph.D. dissertation, Indiana University, 1982.

Whitney 1946
Whitney Museum of American Art, New York. *William Rimmer 1816-1879*. Exhibition catalogue by Lincoln Kirstein. 1946.

Whitney 1976
Whitney Museum of American Art, New York. *200 Years of American Sculpture*. Exhibition catalogue. Essays by Tom Armstrong, Wayne Craven, Norman Feder, Barbara Haskell, Rosalind E. Krauss, Daniel Robbins, and Marcia Tucker. 1976.

Wright 1963
Wright, Nathalia. *Horatio Greenough, the First American Sculptor*. Philadelphia: University of Pennsylvania Press, 1963.

Wright 1972
Wright, Nathalia. *Letters of Horatio Greenough, American Sculptor*. Madison: University of Wisconsin Press, 1972.

Appendix

Analysis of Bronzes

The alloy compositions of most of the metal sculpture in this catalogue have been analyzed. The majority are copper alloys that contain variable amounts of tin or zinc, or both, sometimes with lead. In general usage, alloys in which tin predominates over zinc are referred to as bronzes, and those in which zinc is predominant as brasses. In this catalogue, all these alloys are called "bronzes," with the term used in its most generic sense. A few of the more recently cast pieces were formed from copper alloys that contain relatively small amounts of silicon or manganese, or both, sometimes with zinc or tin. Such alloys are usually referred to as silicon bronzes.

The analytical technique most frequently used was atomic absorption spectrophotometry (AAS): this method requires that a sample of metal (5-10 mg) be removed from the object. Where sampling was not feasible, nondestructive energy dispersive x-ray fluorescence spectrometry (XRF) was employed. As XRF is a surface technique, the results that it yields are not as reliable an indication of the alloy composition as are those obtained from the AAS analysis. The silicon bronzes were analyzed by emission spectrography (ES), which also requires removal of a sample.

The determination of various casting techniques was based on visual analysis of any remnant core material and on the surface profiles and textures as seen inside the casts. The conclusions therefore are in many cases speculative and not scientifically confirmed.

OBSERVATIONS ON THE ANALYSIS OF BRONZES

Where particular foundry marks were present on (or documentation was available for) more than two objects, generalizations may be made concerning that foundry's alloying procedures. The foundry mark was usually stamped or incised onto the model and was frequently sharpened by later cold-working of the metal. (A list of abbreviations of foundry names used in this report precedes the table.)

Gorham (nos. 56, 69, 85, 121, 130, 146): Three brasses occurred in this group (56, 69, 146) and two low-zinc (0-0.4%) bronzes (nos. 121, 130). The range of compositions cast by Gorham might suggest that the sculptor requested a particular color for the finished piece or that the founders selected an alloy composition most appropriate for the size or complexity of the casting.

Gruet Jeune (nos. 47, 97, 98): No particular pattern is observable here, although moderately high zinc contents (6.8-8.8%) seem to be favored.

Ideal (nos. 148, 158, 162): These three are low-zinc bronzes in which the tin content varies from 7.9-12.6%.

Kunst (nos. 109, 122, 139): These are moderately high-zinc (6.7 - 7.4%) bronzes.

McGann (nos. 138, 144, 145): All three are bronzes, two of which contain no zinc, the third (no. 138) contains 5.0% tin and 3.4% zinc.

Roman Bronze (nos. 95, 102, 103, 104, 127, 136, 137, 141, 142, 160, 161, 164): Of the bronzes, two (nos. 104, 142) contain no zinc, four (nos. 95, 136, 137, 160) contain 1.1-1.6% zinc, and two others (nos. 141, 161) higher zinc (3.2, 5%). Two (nos. 102, 103) are brasses, with low lead (0.9, 1.2%), while no. 127 is a brass with much higher lead (6.4%). A 1937 casting (no. 164) is a silicon bronze.

Valsuani (nos. 100, 118, 135, 143): Three of these objects were cast in a high-zinc (12-13.3%) bronze. The composition of no. 43 (determined by XRF) has more tin and less zinc.

SCULPTURE BY SAINT-GAUDENS

Twelve bronzes spanning the years from 1878 to 1907 or after were analyzed. Three early pieces (nos. 65, 66, 67) are all sand-cast reliefs with a varied alloy composition of which only two (nos. 66, 67) are similar: low zinc (2.2-2.4%) bronzes. Number 75 is a lost wax cast in bronze (no zinc and a little lead). The next group (nos. 69, 71, 72, 74), cast between 1889 and 1899 or after, tends to have a higher zinc content (6-9%). The later group (nos. 76, 77, 78, 79), cast between 1902 and 1907 or after, has a lower zinc and higher tin content, including one true bronze (no. 79). Only one of these bronzes has a foundry mark (no. 71).

PAMELA ENGLAND
Research Laboratory

ABBREVIATIONS OF FOUNDRY NAMES

Ames
Ames Manufacturing Company, Chicopee, Mass.

Angelo del Nero
Angelo del Nero, Rome

Cellini
Cellini Bronze Works, New York

Gagani[1]
E. Gagani, New York

Gorham
Gorham Manufacturing Company, Providence, R.I.

Gruet Jeune
E. Gruet Jeune, Paris

Henry-Bonnard
The Henry-Bonnard Bronze Company, New York

Ideal
Ideal Casting Company, Providence, R.I.

Jaboeuf & Rouard
Jaboeuf & Rouard, Paris

Kunst
Kunst Foundry, New York

McGann
T.F. McGann & Sons, Boston

Modern Art
Modern Art Foundry, New York

Nicci
Giovanni and Angelo Nicci, Rome

Roman Bronze
Roman Bronze Works, New York

Tallix
Tallix Foundry, Beacon, N.Y.

Valsuani
C. Valsuani, Paris

Williams
John Williams, New York

Young
Richard Young Foundry, Salt Lake City, Utah

1. Possibly the Gargani Foundry, Brooklyn.

Cat. No.	Artist	Title	Date	Foundry	Casting Technique	Copper	Tin	Zinc	Lead
28	William Rimmer	*The Falling Gladiator*	1907 (modeled in 1861)	John Williams	Lost wax	86.3	2.6	7.6	3.5
35	Thomas Ball	*Daniel Webster*	1853	Ames	Sand	89.6*	10.4*		
47	Anne Whitney	*Le Modèle*	1875	Gruet Jeune	Sand	86.2	3.0	8.8	2.0
53	John Quincy Adams Ward	*The Indian Hunter*	about 1860		Sand	87.7	3.5	7.0	1.8
54	Charles Calverley	*James Russell Lowell*	1896	(John Williams)	Lost wax	91.8	2.6	5.3	0.3
56	George Edwin Bissell	*Abraham Lincoln*	1906 or after	Gorham	Lost wax	90.5		9.5	
65	Augustus Saint-Gaudens	*William L. Picknell*	1878		Sand	92.6	2.4	3.8	1.2
66	Augustus Saint-Gaudens	*Francis Davis Millet*	1879		Sand	88.7	8.7	2.4	0.3
67	Augustus Saint-Gaudens	*Jules Bastien-Lepage*	1880	(Rudier [probably Alexis])	Sand	89.1	8.5	2.2	0.2
69	Augustus Saint-Gaudens	*George Washington Inaugural Centennial Medal*	1889	(Gorham)	Lost wax	90.6	2.5	6	0.9
71	Augustus Saint-Gaudens	*George Hollingsworth*	1893	Henry-Bonnard	Lost wax	88.9	4.5	6.4	0.2
72	Augustus Saint-Gaudens	*Mildred Howells*	1898		Lost wax	87.7	3.0	9.0	0.3
74	Augustus Saint-Gaudens	*The Puritan*	1899 or after		Figure: Lost wax	88.5	4.1	7.2	0.2
					Base: Sand	86.9	2.1	9.7	1.3
75	Augustus Saint-Gaudens	*Robert Louis Stevenson*	1902 or after		Lost wax	92.3	7.5		0.2
76	Augustus Saint-Gaudens	*Jacob Crowninshield Rogers*	1902		Lost wax	89.1	8.3	2.3	0.3
77	Augustus Saint-Gaudens	*Anna Lyman Gray*	1904		Lost wax	89.7	8.0	1.9	0.4
78	Augustus Saint-Gaudens	*Head of Victory*	1907 or after		Lost wax	90.1	6.7	2.2	1.0
79	Augustus Saint-Gaudens	*Relief of Victory*	1907 or after		Lost wax	91.3	8.6		0.1
85	Edward Clark Potter	*Dante*	1917	Gorham	Sand	87.7	5.7	5.0	1.6

Note: Foundries known only from documentary evidence are indicated in parentheses.

*Analysis Method: XRF

Cat. No.	Artist	Title	Date	Foundry	Casting Technique	Copper	Tin	Zinc	Lead
88	Cyrus Edwin Dallin	*The Protest*	1903	(Gorham or Roman Bronze)	Lost wax	87.2	11.7	1.0	0.1
90	Cyrus Edwin Dallin	*Appeal to the Great Spirit*	1909	Jaboeuf & Rouard	Lost wax	91.5	2.8	4.7	1.0
93	Clyde Du Vernet Hunt	*Fils de France*	about 1920		Sand	88	3.1	9.1	0.8
95	Charles Grafly	*William McGregor Paxton*	1909	Roman Bronze	Lost wax	90.7	7.4	1.6	0.3
97	Frederick William MacMonnies	*Bacchante and Infant Faun*	1901 (modeled in 1893)	Gruet Jeune	Lost wax	88.5	2.8	8.6	0.1
98	Henry Hudson Kitson	*Music of the Sea*	1884	Gruet Jeune	Lost wax	85.1	5.9	6.8	2.2
100	William Frederick Pope	*Brittany Fisherman*	probably 1903	Valsuani	Lost wax	82.6	5.1	12.0	0.3
102	Bela Lyon Pratt	*Art*	1910	Roman Bronze	Lost wax	82.6	4.2	12	1.2
103	Bela Lyon Pratt	*Science*	1910	Roman Bronze	Lost wax	83.9	3.4	12	0.9
104	Bela Lyon Pratt	*Nathan Hale*	probably about 1912 (modeled in 1898)	Roman Bronze	Lost wax	90.9*	9.1*		
109	Philip Shelton Sears	*Pumunangwet (He Who Shoots the Stars)*	1929	Kunst	Sand	89.4	3.6	6.7	0.3
118	Bessie Potter Vonnoh	*The Scarf*	1908	Valsuani	Lost wax	80.8	5.5	13.3	0.4
121	Roger Noble Burnham	*Johann Ernst Perabo*	1914	Gorham	Lost wax	91.5	8.4		0.1
122	Anna Hyatt Huntington	*Young Diana*	1923	Kunst	Lost wax	89.2	3.4	7.4	0.1
124	Johan Selmer-Larsen	*Frank Gair Macomber*	1929		Lost wax	80.6	12.6	1.0	5.8
126	Anna Coleman Ladd	*Saint Francis*	1911	(Angelo del Nero, Rome)	Lost wax	84.6	1.5	12	1.9
127	Anna Coleman Ladd	*The Slave*	1911	(Roman Bronze)	Lost wax	81	3.4	9.2	6.4
128	Maurice Sterne	*Senta*	1919		Lost wax	82.1	6.9	7.7	3.3
130	Albert H. Atkins	*Peace*	1915	Gorham	Lost wax	91.7	7.9	0.4	
132	Gaston Lachaise	*John Marin*	about 1955 (modeled in 1927)	(Modern Art)	Lost wax	84.5	4.5	9.6	2.4

*Analysis Method: XRF

Cat. No.	Artist	Title	Date	Foundry	Casting Technique	Copper	Tin	Zinc	Lead
133	Gaston Lachaise	*Torso of Elevation*	1964 (modeled 1912-1927)	Modern Art	Lost wax	90.9	3.4	3.3	2.6
135	Jo Davidson	*A New Englander*	1935	Valsuani	Lost wax	85.1	3.8	13	0.1
136	Paul Manship	*Lyric Muse*	1912	Roman Bronze	Lost wax	89.8	9.1	1.1	
137	Cartaino di Sciarrino Pietro	*The Summit of the Years (Portrait of John Burroughs)*	1915	Roman Bronze	Lost wax	90.4	7.7	1.5	0.4
138	Frederick Warren Allen	*Torso*	1914	McGann	Lost wax	91.3	5.0	3.4	0.3
139	Leo Friedlander	*Abraham Lincoln*	about 1932	Kunst	Sand	88.2*	4.5*	7.3*	
141	Richard H. Recchia	*Bela Lyon Pratt*	1910	Roman Bronze	Sand	79.1*	15.9*	5*	
142	Richard H. Recchia	*Frank C. Recchia*	1910	Roman Bronze	Sand	86.3*	12.7*		1.0*
143	Richard H. Recchia	*John Storrs*	1912	Valsuani	Lost wax	81.5*	11.1*	7.4*	
144	Richard H. Recchia	*Echo* or *Siren*	1914	McGann	Sand	93*	7*		
145	Richard H. Recchia	*Raymond Porter*	1914	McGann	Lost wax	86*	14*		
146	Richard H. Recchia	*Persian Cat*	1931	Gorham	Lost wax	92.4*		6.5*	1.1*
148	Bashka Paeff	*Anthony J. Philpott*	1922	Ideal	Lost wax	86.6	12.6	0.5	0.3
152	George Aarons	*Europa*	1960 (modeled in 1941)	(Nicci)	Lost wax	78.6*	8*	7.3*	6.1*
153	George Aarons	*Girl on the Rock*	1960 (modeled in 1926)	(Nicci)	Lost wax	81.3*	8.9*	6.6*	3.2*
157	Avard Tennyson Fairbanks	*A Tragedy of Winter Quarters*	1934	Richard Young	Lost wax	Silicon bronze**			
158	Katharine Lane Weems	*Bull Terrier*	about 1920	Ideal	Lost wax	90	9.8	0.1	0.1
159	Katharine Lane Weems	*Baby African Elephant*	1926		Sand	86.8	4.0	8.9	0.3
160	Katharine Lane Weems	*Narcisse Noir*	1927	Roman Bronze	Lost wax	87.8	9.5	1.6	1.1

*Analysis Method: XRF **Analysis Method: ES

Cat. No.	Artist	Title	Date	Foundry	Casting Technique	Copper	Tin	Zinc	Lead
161	Katharine Lane Weems	*Pointing Setter*	1927	Roman Bronze	Lost wax	88.6	7.6	3.2	0.6
162	Katharine Lane Weems	*William McHenry Keyser*	about 1929	Ideal	Lost wax	92.1	7.9		
163	Katharine Lane Weems	*Dancer*	1937	Gagani	Lost wax	86.9	11.9		1.2
164	Katharine Lane Weems	*Rabbit*	1947	Roman Bronze	Lost wax	Silicon bronze**			
165	Katharine Lane Weems	*Revolt* or *Striding Amazon*	1980 (modeled in 1926)	Tallix	Lost wax	Silicon bronze**			
166	Walker Hancock	*Fallen Boxer*	1934	Cellini	Lost wax	89.3	10.2	0.5	

**Analysis Method: ES

Addenda

The following acquisitions were made after completion
of the catalogue:

ATTRIBUTED TO JOHANN CHRISTIAN RAUSCHNER
(1760-after 1812)
Henry Bigelow, about 1810
Wax
Gift of Charles A. Morss, Jr., Sylvia Morss Page, and
Marilyn Morss MacLeod. 1985.981

MALVINA HOFFMAN (1885-1966)
Sorrow, 1926
Marble
Gift of Daniel and Jessie Lie Farber. 1985.856

WILLIAM ZORACH (1889-1966)
Kiddie Kar, about 1923
Bronzed plaster
Gift of John P. Axelrod. 1985.671

ANTHONY DiBONA (born 1896)
Thomas Allen, about 1924
Bronze
Gift of Mr. and Mrs. William B. Osgood. 1985.820

DONALD DeLUE (born 1897)
Arcturus and *Fisherman*, 1970s
Painted plaster
Gift of Donald Harcourt DeLue. 1985.383, 384

KATHARINE LANE WEEMS (born 1899)
Rooster, 1984 (modeled in 1940)
Bronze
Gift of Katharine Lane Weems. 1985.84

WALKER HANCOCK (born 1901)
Spiral, 1968
Bronze
Gift of Katharine Lane Weems. 1985.338

CHAIM GROSS (born 1904)
Two Acrobats Balancing, 1957
Lignum vitae
Gift of the Ferkauf Foundation. 1985.809

ANONYMOUS
Napoleon, 1825-1850
Limestone
William E. Nickerson Fund. 1986.238

Index

Numbers refer to catalogue entries. The sculptor's biography precedes the first catalogue entry.

Aarons, George, 150-154
Adams, John (H. Greenough), 5
Adams, John Quincy (H. Greenough), 4
Aitken, Robert Ingersoll, 125
Akers, Benjamin Paul, 49
Alcott, Amos Bronson (French), 80
Algerian Panther (Dallin), 87
Allen, Frederick Warren, 138
Allen, Thomas, Jr. (Warner), 62
Anonymous Sculptors, 168-171
Appeal to the Great Spirit (Dallin), 90
Appleton, Samuel (Akers), 49
Architecture (Dengler), 84
Arno (H. Greenough), 12
Art (Pratt), 102
Ascension of a Child Conducted by an Infant Angel (H. Greenough), 9
Augustus, Young (H. Greenough), see *Young Augustus*
Atkins, Albert H., 130
Awakening (Sterne), 129
Baby African Elephant (Weems), 159
Bacchante and Infant Faun (MacMonnies), 97
Bacchus (Story), 41
Bacchus on a Panther (Story), see *Infant Bacchus on a Panther*
Ball, Thomas, 35-38
Bastien-Lepage, Jules (Saint-Gaudens), 67
Bettina (Bowditch), 134
Bissell, George Edwin, 56
Blind Cupid (Pratt), 107
Bowditch, Mary Orne, 134
Brackett, Edward Augustus, 32
Brenner, Victor David, 110-116
Brimmer, Martin (Saint-Gaudens), 73
Brittany Fisherman (Pope), 100
Bryant, Nanna Matthews, 117
Bull Terrier (Weems), 158
Burnham, Roger Noble, 121
Burroughs, John (Pietro), see *Summit of the Years*
Calverley, Charles, 54
Castor and Pollux (H. Greenough), 14
Caught (Dengler), 81
Christ (Story), 46
Cleopatra (Gould), 34
Clevenger, Shobal Vail, 22
Columbian Exposition Medal, rejected reverse (Saint-Gaudens), see *World's Columbian Exposition Commemorative Presentation Medal,* rejected reverse
Corwine, Aaron (H. Powers), 15

Crawford, Thomas, 23-26
Dallin, Cyrus Edwin, 87-92
Dana, Francis (Brackett), 32
Dancer (Weems), 163
Dante (Potter), 85
Davidson, Jo, 135
Delacour, Clovis (Brenner), 112
DeLue, Donald Harcourt, 155, 156
Dengler, Franz Xavier, 81-84
Despair (Rimmer), see *Seated Man*
Dexter, Henry, 20
Diana, Young (Huntington), see *Young Diana*
Duffy, Francis Patrick, Father (Keck), see *Father Duffy*
Duveneck, Elizabeth Boott (Duveneck), see *Tomb Effigy of Elizabeth Boott Duveneck*
Duveneck, Frank, 64
Dying Centaur (Rimmer), 29
Eaton, Joseph (Rauschner), 1
Echo (Recchia), 144
Elephants Fighting (Huntington), 123
Eliot, Charles William, Medal (Pratt), 101
End of an Era (Peabody), 147
Europa (Aarons), 152
Eve Disconsolate (H. Powers), 18
Everett, Edward (Ball), 36
Fairbanks, Avard, 154
Faith (H. Powers), 19
Fallen Boxer (Hancock), 166
Falling Gladiator (Rimmer), 28
Father Duffy (Keck), 120
Faun (DeLue), 155
Fils de France (C. Hunt), 93
Flight of Night (W. Hunt), 48
French, Daniel Chester, 80
Friedlander, Leo, 139
Fulde, Edward B. (Brenner), 115
Ganymede (Anonymous), 169
Girl on the Rock (Aarons), 153
Gould, Thomas Ridgeway, 33, 34
Grafly, Charles, 95, 96
Graupner, Catherine C. Hillier (Rauschner), 3
Graupner, Johann Christian Gottlieb (Rauschner), 2
Gray, Anna Lyman (Saint-Gaudens), 77
Gray, Morris (Grafly), 96
Greenough, Horatio, 4-14
Greenough, Horatio (H. Powers), 16
Greenough, Richard Saltonstall, 39, 40
Hale, Nathan (Pratt), 104
Half-Dollar, "Pilgrim Tercentenary" (Dallin), see *"Pilgrim Tercentenary" Half-Dollar*

Hamilton, Alexander (H. Greenough), 7

Hancock, Walker, 166, 167

Hawthorne, Nathaniel (?) (P. Powers), 61

Head of an Angel (Hancock), 167

Head of a Woman (Bryant), 117

Head of a Woman (Lachaise), 131

Head of an Athlete (Recchia), 140

Head of Victory (Saint-Gaudens), 78

Hebe and Ganymede (Crawford), 26

Hemenway, Harriett Lawrence (Pratt), 106

Hollingsworth, George (Saint-Gaudens), 71

Hosmer, Harriet Goodhue, 52

Howe, Julia Ward (Dallin), 91

Howells, Mildred (Saint-Gaudens), 72

Hunt, Clyde Du Vernet, 93, 94

Hunt, William Morris, 48

Huntington, Anna Hyatt, 122, 123

Hyatt, Anna, see Huntington, Anna Hyatt

Imogen (Gould), 33

Indian Hunter (Ward), 53

Infant Bacchus on a Panther (Story), 42

Ives, Chauncey Bradley, 21

Jochebed, the Mother of Moses (Simmons), 57

Keck, Charles, 119, 120

Keyser, William McHenry (Weems), 162

Kitson, Henry Hudson, 98, 99

Lachaise, Gaston, 131-133

Ladd, Anna Coleman, 126, 127

Lafayette, Marquis de (H. Greenough), 8

Lane Weems, Katharine, see Weems, Katharine Lane

Lawrence, Abbott (H. Powers), 17

Lawrence, Annie Bigelow (Clevenger), 22

Lawrence, Elizabeth Prescott (Ball), 37

Leah (Aarons), 150

Liberty (Anonymous), 168

Lincoln, Abraham (Bissell), 56

Lincoln, Abraham (Friedlander), 139

Love Prisoner to Wisdom (H. Greenough), 10

Lovet-Lorski, Boris, 149

Lowell, Guy (Sears), 108

Lowell, James Russell (Calverley), 54

Lucas, George Aloysius (Brenner), 110

Lyman, Theodore (Dexter), 20

Lyric Muse (Manship), 136

MacMonnies, Frederick William, 97

Macomber, Frank Gair (Selmer-Larsen), 124

Manship, Paul, 136

Marin, John (Lachaise), 132

Martie (Keck), 119

Matthews, Nana, see Bryant, Nana Matthews

May, Augustus Edward (R. Greenough), 39

Mead, Larkin Goldsmith, 55

Medea (Story), 45

Mercury (Anonymous), 170

Merrilies, Meg (Thaxter), 86

Millet, Francis Davis (Saint-Gaudens), 66

Milmore, Martin, 59, 60

Modèle (Whitney), 47

Morgan, Charlotte Wood (Palmer), 31

Music of the Sea (Kitson), 98

Napoleon I (H. Greenough), 13

Narcisse Noir (Weems), 160

New Englander (Davidson), 135

Nirvana (C. Hunt), 94

Nydia (Rogers), 51

Nymph (DeLue), 156

Orpheus and Cerberus (Crawford), 25

Paeff, Bashka, 148

Paine, Robert Treat (Simmons), 58

Painting (Dengler), 82

Palmer, Erastus Dow, 31

Pandora (Ives), 21

Parker, Harvey D. (Perry), 63

Paxton, William McGregor (Grafly), 95

Peabody, Amelia, 147

Peace (Atkins), 130

Perabo, Johann Ernst (Burnham), 121

Perry, John D., 63

Persian Cat (Recchia), 146

Peruvian Head (Aarons), 151

Philpott, Anthony J. (Paeff), 148

Phosphor (Milmore), 60

Picknell, William L. (Saint-Gaudens), 65

Pietro, Cartaino di Sciarrino, 137

Pointing Setter (Weems), 161

Pope, William Frederick, 100

Porter, Raymond (Recchia), 145

Potter, Bessie, see Vonnoh, Bessie Potter

Potter, Edward Clark, 85

Powers, Hiram, 15-19

Powers, Preston, 61

Pratt, Bela Lyon, 101-107

Pratt, Bela Lyon (Recchia), 141

Protest (Dallin), 88

Pumunangwet (He Who Shoots the Stars) (Sears), 109

Puritan (Saint-Gaudens), 74

Rabbit (Weems), 164

Rauschner, Johann Christian, 1-3

Raynaud, Madame Ernest (Brenner), 116

Recchia, Frank C. (Recchia), 142

Recchia, Richard H., 140-146

René (Brenner), 113

Revere, Paul (Dallin), 89

Revolt (Weems), 165

Rimmer, William, 27-30

Rinehart, William Henry, 50

Rogers, Jacob Crowninshield (Saint-Gaudens), 76

Rogers, Randolph, 51

Rotch, Edith (Milmore), 59

Ruggles, Miss Theo Alice (Kitson), 99

Saint Francis (Ladd), 126

Saint-Gaudens, Augustus, 65-79

Sappho (Story), 43

Sargent, John Singer (Saint-Gaudens), 68

Scarf (Vonnoh), 118

Science (Pratt), 103

Sculpture (Dengler), 83

Sears, Philip Shelton, 108, 109

Seated Man or *Despair* (Rimmer), 27

Selmer-Larsen, Johan, 124

Senta (Sterne), 128

Simmons, Franklin, 57, 58

Siren (Recchia), see *Echo*

Slave (Ladd), 127

Sleeping Children (Rinehart), 50

Sleeping Faun (Hosmer), 52

Sterne, Maurice, 128, 129

Stevenson, Robert Louis (Saint-Gaudens), 75

Storrs, John (Recchia), 143

Story, William Wetmore, 41-46

Striding Amazon (Weems), see *Revolt*

Stuart, Anita (Brenner), 111

Summit of the Years (Portrait of John Burroughs) (Pietro), 137

Sumner, Charles (Crawford), 24

Thaxter, Edward R., 86

Tomb Effigy of Elizabeth Boott Duveneck (Duveneck), 64

Torso (Allen), 138

Torso (Lovet-Lorski), 149

Torso (Rimmer), 30

Torso of Elevation (Lachaise), 133

Tragedy of Winter Quarters (Fairbanks), 157

Unison II (Aarons), 154

Vadé, M.P. (Brenner), 114

Venezia (Mead), 55

Venus Anadyomene (Story), 44

Venus as Shepherdess (Crawford), 23

Victory, Head of (Saint-Gaudens), see *Head of Victory*

Victory, Relief of (Saint-Gaudens), 79

Vonnoh, Bessie Potter, 118

Ward, John Quincy Adams, 53

Warner, Olin Levi, 62

Washington, George (H. Greenough), 6

Washington, George (attributed to R. Greenough), 40

Washington, George, Inaugural Centennial Medal (Saint-Gaudens), 69

Water-Lily Girl (Pratt), 105

Watrous, Elizabeth N., Medal for Sculpture (Aitken), 125

Webster, Daniel (Ball), 35

Weems, Katharine Lane, 158-165

Whitney, Anne, 47

Wigglesworth, Edward (Ball), 38

World's Columbian Exposition Commemorative Presentation Medal, rejected reverse (Saint-Gaudens), 70

Young Augustus (H. Greenough), 11

Young Diana (Huntington), 122

Young Woman (Anonymous), 171

Photograph Credits

The Museum of Fine Arts Photographic Studio provided photographs of sculpture from the Museum's collection. All other photographs have been supplied by the following individuals and institutions, whose courtesy in permitting reproduction is gratefully acknowledged.

Mrs. Gertrude Aarons, Gloucester, Mass.: p. 439; Albany Institute of History and Art, N.Y.: p. 80 (Tompkins H. Matteson, *A Sculptor's Studio*); Mrs. Frederick W. Allen, Foxboro, Mass.: pp. 286, 408; American Museum of Natural History, Department Library Services, New York: p. 404 (Charles S. Olcott); Archives of American Art, Smithsonian Institution, Washington, D.C.: pp. 27, 107, 201, 371; p. 107 (John Neal Tilton Papers), p. 136 (J.W. Black & Co.), p. 168 (Pach Brothers), pp. 209, 256 (Duveneck Family Papers), p. 344 (Dorothy Gale), p. 362 (Robert I. Aitken Papers), p. 427 (Amelia Peabody Papers); *Art Quarterly* 25 (autumn 1962), p. 244: p. 131; The Bennington Museum, Vt.: p. 282; Mrs. Nelson Bigelow, Westwood, Mass.: p. 390; Boston Athenaeum, Mass.: p. 93 (Thomas Ball, *Self-Portrait*); Boston University Archives, Mugar Memorial Library: frontispiece, pp. 181, 268, 309, 329, 431; Brookgreen Gardens, Murrells Inlet, S.C.: p. 352; (Marion Boyd Allen, *Anna Vaughn Hyatt*); Dorothy P. Cavanagh, Milton, Mass.: p. 299; Chesterwood (A Property of the National Trust for Historic Preservation), Stockbridge, Mass.: pp. 250, 261; Hayward and Blanche Cirker, eds., *Dictionary of American Portraits* (New York: Dover, 1967), pp. 429, 520: pp. 67, 192; Donald DeLue, Leonardo, N.J.: p. 447; Robert A. Edwards, Beverly, Mass.: p. 365; Avard Fairbanks, Salt Lake City, Utah: p. 450; Charles E. Fairman, *Art and Artists of the Capitol of the United States of America* (Washington, D.C.: U.S. Government Printing Office, 1927), p. 389: p. 196; Gordon D. Friedlander, White Plains, N.Y.: p. 412 (Paul J. Woolf); Robert L. Gale, Pittsburgh, Penn.: p. 52; Walker Hancock, Lanesville, Mass.: p. 465; Harvard University Archives: p. 349; The Lachaise Foundation, Boston: p. 381; Maine Historical Society, Portland: p. 142; John Manship, Gloucester, Mass.: p. 399; M.I.T. Museum, Cambridge, Mass.: p. 360; Mead Art Museum, Amherst College, Mass.: p. 177 (Larkin Goldsmith Mead, *Self-Portrait*); National Academy of Design, New York: p. 173 (Benjamin F. Reinhart, *Charles Calverley*); National Portrait Gallery, Smithsonian Institution, Washington, D.C.: p. 159 (Jeremiah Gurney & Son), p. 394 (Kollar ?); National Sculpture Society, New York: p. 435; The William Benton Museum of Art, Storrs, Conn.: p. 214 (Maria Olga Kobbé); Portland Museum of Art, Maine: p. 186; Richard H. Recchia Estate: p. 416 (Peter A. Juley & Son); Mrs. Mason Sears, Dedham, Mass.: p. 323; Janet Scudder, *Modeling My Life* (New York: Harcourt, Brace, 1925), p. 22: p. 293; The Society for the Preservation of New England Antiquities, Boston: p. 41 (Southworth & Hawes); Mrs. Robert Rowe Thompson, McLean, Va.: p. 340; Valentine Museum, Richmond, Va.: pp. 4, 153 (William Hubard, *Horatio Greenough*); Walters Art Gallery, Baltimore, Md.: p. 147 (Frank Blackwell Mayer, *William Henry Rinehart*); Katharine Lane Weems, Boston: p. 455; Nathalia Wright, Maryville, Tenn.: p. 102.

ERRATA

Page xvii	col. 2: *For* Katherine Lane Weems *read* Katharine Lane Weems
Page xxxvii	caption: *For* Katherine Lane Weems *read* Katharine Lane Weems
Page 136	col. 2, last line: *For* William Kirke Brown *read* Henry Kirke Brown
Page 176	col. 2, note 1: John Flanagan's dates should be 1865-1952
Page 182	col. 2, References, line 5: *For* Durham *read* Durman
Page 252	col. 2, line 7: *For* Piccarilli *read* Piccirilli
Pages 299-306	For correct chronology, the biography and entries for Henry Hudson Kitson should precede those for Frederick William MacMonnies, pages 293-298